VICTORIAN PAINTING
ESSAYS AND REVIEWS
Volume One:
1832–1848

Garland Reference Library
of the Humanities
(Volume 208)

VICTORIAN PAINTING
ESSAYS AND REVIEWS
Volume One:
1832–1848

John Charles Olmsted

Garland Publishing, Inc.
New York & London
1980

Library of Congress Cataloging in Publication Data

Main entry under title:

Victorian painting, essays and reviews.

(Garland reference library of the humanities ;
v. 208–)
Bibliography: p.
CONTENTS: v. 1. 1832–1848.
1. Painting, Victorian—Great Britain—Bibliography.
2. Painting, British—Great Britain—Bibliography.
I. Olmsted, John Charles.
Z5947.3.G7V53 [ND467] 016.7592 80-65711
ISBN 0-8240-2742-6 (v. 1)

Printed on acid-free, 250-year-life paper
Manufactured in the United States of America

For Jeff

Contents

Preface

The best of the pioneering work on Victorian painting has been done by scholars who have drawn heavily on nineteenth-century periodicals. A. Paul Oppé's long essay, first published in 1934, and T.S.R. Boase's volume in the Oxford History of English Art both used periodicals, particularly the *Athenaeum* and the *Art-Union*, to gauge critical response to major exhibitions, to trace the growth of government support of art and to assemble a wealth of detail concerning provincial exhibitions, attitudes towards painters of previous generations and debates within the community of artists about issues as diverse as hanging practices in the Royal Academy, the relative importance of genre and of history painting and the techniques of fresco.*

This anthology of fifty-three essays drawn from eleven weekly, monthly and quarterly periodicals was assembled in order to reproduce in convenient form some of the more important articles on English painting published from 1832 to 1848 in Great Britain. Reviews of major exhibitions form a large part of the collection, but essays treating individual artists, discussions of the effect of state patronage of the arts and attempts to assess the uniqueness of the English tradition of painting are also included. A selected checklist based on a study of the relevant volumes of the *Athenaeum* and the *Art-Union* (after 1849 called the *Art Journal*) and of articles identified in the three published volumes of the *Wellesley Index* provides access to a good deal of relevant material which could not be included in this volume.

I am grateful to Oberlin College for a research grant which greatly assisted me in compiling this volume. I am indebted to the

*A. Paul Oppé, "Art," *Early Victorian England 1830–1865,* ed. G.M. Young (Oxford University Press, 1934), II: 101–76; T.S.R. Boase, *English Art 1800–1870* (Clarendon Press, 1959). For a useful survey of materials on Victorian painting see David Robertson, *Sir Charles Eastlake and the Victorian Art World* (Princeton University Press, 1978), pp. 424–53.

staffs of the University of Michigan Graduate Library, the Oberlin College library and the libraries at Yale and the University of California, Berkeley, for access to their collections. Robert Longsworth, Larry Buell and Robert Pierce have been as always supportive colleagues and friends.

Introduction

In 1844 an anonymous writer for the *Westminster Review* remarked that "there are few subjects which are just now exciting more attention in England than the present state of the Fine Arts" (p. 473). Writing in the same year, Thackeray noted a striking increase in the quality of the art criticism appearing in the major newspapers and journals (*Fraser's Magazine* 29 [June 1844], 700–16). The modern reader who moves in any organized way through the major periodicals of the 1830s and 1840s readily agrees with both these assessments. Reviews of annual exhibitions appear in more and more journals throughout the two decades, and the increasing sophistication of the reviews of annual exhibitions suggests the growth of a public with at least a rudimentary knowledge of the fine arts. Efforts at state patronage of the arts, and later the Prince Consort's lively interest in advancing the arts in England, no doubt helped to make more people aware of the work of contemporary painters, but there seems to have been a genuine and spontaneous growth of interest in painting throughout the period.

The best journals of the day regularly devoted space to coverage of the fine arts. A favorable review in the *Times* could make the reputation and often the fortune of a young painter. Reviews in the *Athenaeum* or, after 1839, in the *Art-Union* (later the *Art Journal*) were almost as influential. Readers of *Blackwood's Edinburgh Magazine* read lively accounts of the annual exhibitions by John Eagles, a writer perhaps best known for his role in irritating the young John Ruskin into writing *Modern Painters*. Occasional reviews of exhibitions appeared in the *Examiner, Fraser's Magazine,* the *Gentleman's Magazine,* the *Literary Gazette,* the *Monthly Review* and the *New Monthly Magazine.* While essays on the arts often focused on the work of individual artists or explored such heated topics of the time as the techniques of fresco and the influence of the Royal Academy schools, most writing on the arts was prompted by

the great annual exhibitions held in London. The first of the exhibitions each year, that of the British Institution, was by common agreement among critics the last in quality and importance. Reviews of the late winter showings regularly lamented the low quality of the pictures displayed. The Institution was praised, however, for its regular exhibitions of "Old Masters" which, in a country notoriously provincial in its views of European art, provided aspiring painters the opportunity to study and copy major paintings drawn from private collections. Retrospective exhibitions of British masters no doubt also provided a sense of context and tradition for young artists.

The next of the annual exhibitions was that of the Society of British Artists. These March showings were somewhat less harshly treated than those of the British Institution, but both were looked on as feeble anticipations of the great exhibitions held each May by the Royal Academy and by the two societies of painters in water colors: the "old" society, founded in 1804, and the "new," established in 1831. Special exhibitions, such as those of the cartoons for the state competitions to decorate the Palace of Westminster, and private exhibitions, such as the famous displays by John Martin and Benjamin Robert Haydon, also drew lively comment from reviewers.

Much of the writing about the exhibitions is more descriptive than critical. "Important" pictures are identified and described, a number of others are briefly touched upon, and an attempt is made to gauge the "progress" (or lack of it) of English painting for the year. A careful reading of the notices does reveal, however, certain implicit criteria employed by all the reviewers. For at least one commentator writing in 1843 these criteria were all too obvious:

> Criticism on art is at the lowest ebb in this country, consisting of very little more than the application of a catalogue of cant terms and phrases, many of them conveying no definite ideas, and but few of them distinctly understood by those who use them most frequently [p. 439].

There is a good deal of truth to this assessment. Most of the reviews from the 1830s and 1840s are rather tired and mechanical in their application of hazy and arbitrary standards. An appeal is regularly made to "nature," there is some perfunctory discussion of technique, and the subject of each painting is identified, assessed and all too often made the excuse for an associationist ramble. Most critics would no doubt have agreed with the anonymous writer for the

Athenaeum who remarked in 1835 that he preferred at an exhibition "such works as touch our heart and interest our fancy" (p. 99). Critics insisted on a single and immediate emotional experience in a painting, and after identifying that emotion were often content to move on. Thackeray is typical. In a review of Charles Eastlake's "Our Lord and the Little Children," exhibited in 1839, he made a revealing admission:

> These pictures come straight to the heart, and then all criticism and calculation vanishes at once, — for the artist has attained his great end, which is, to strike far deeper than the sight; and we have no business to quarrel about defects in form and colour, which are but little parts of the great painter's skill [p. 297].

The danger of this kind of response, of course, is that reviewing can easily degenerate into impressionist twaddle. Sir Charles Morgan, in one of the few general essays on taste published in the 1830s, warned that making "feeling" the sole criterion in art can lead only to "endless and unsatisfactory debate" (p. 96).

To the modern reader, the most perplexing of all of the standards of judgment regularly employed in art reviews is that of "truth to nature." For there is nothing approaching intellectual rigor in any of the implied definitions of the term as it is regularly employed. Once again, Thackeray is typical: *"On n'embellit pas la nature,* my dear Bricabrac" (p. 296). Accurate representations of observable nature were praised, deviations from a kind of photographic realism gave evidence of a "mannered" approach that critics united in deploring. The *Art-Union* on this issue was, as always, magisterial:

> Among the few professed figure painters of the Society — ten or a dozen members — there is a *quota* of poetry, picturesque feeling, taste and colour; but there is yet that wanting, in the absence of which nothing good can be effected — NATURE; and for this, *manner,* however seductive, can never be substituted with advantage [10 (May 1848), 138].

At times, reviewers seem to mean by nature the eighteenth-century notion of "general nature" as defined by Reynolds in his *Discourses,* so often mentioned (if not in fact read) by early Victorian reviewers. But more often paintings are criticized simply for being inaccurate in rendering observable nature. A humorless reviewer for the *Art-Union* dismissed a painting of a fisherman's catch with the damning observation that the artist was obviously not an angler "or he would

have known that roach and jack are seldom caught together, and never with the same tackle and bait" (1 [February 1839], 7–8). A reviewer for the same periodical was capable of even greater heights of inspired foolishness: "The artist has committed the not infrequent blunder of placing a more than half nude woman in the open air, and as it seems, in the midst of a desert—needless and useless departure from fact" (4 [March 1842], 76). Reviewers seemed to take a delight in searching out errors of fact in dress or in landscape. Artists joined them in this obsessive search for exact representation: the Pre-Raphaelite painters' celebrated disregard for the sufferings of drenched models or tethered goats in their pursuit of mimetic accuracy is typical. Wilkie was praised by the *Art-Union* because "like all really great men, he looked at nature for himself, not through the work of others; and painted so faithfully that which he saw, that his every production is a moving appeal to the heart" (3 [July 1841], 115).

Yet despite their own insistence on accuracy in rendering detail, many critics lamented the public's taste for merely "imitative" painting. "It surely argues no good public taste," John Eagles wrote, "when the eye seeks a gratification unconnected with intellectual and moral feeling" (p. 343). This obsession with carefully wrought images drawn from nature was ruefully noted by Eagles in his report that a foreign critic could praise a Royal Academy exhibition only for its "exquisitely-painted dogs" (p. 396). Some critics were willing to let accuracy of representation fall before more important considerations. "By a wise falsification," Charles Lamb wrote in 1833,

> the great masters of painting got at their true conclusions; by not show-
> ing the actual appearances, that is, all that was to be seen at any given
> moment by an indifferent eye, but only what the eye might be supposed
> to see in the doing or suffering of some portentous action [p. 30].

Artists could, by this rendering of impassioned observation, escape from "the grovelling fetters of externality." The source of this heightening and universalizing of the observable world took its origin, according to most critics, in the temperament and personality of the artist himself. Edward Chatfield called paintings of this higher kind "poetic" and argued that they drew their power from "a certain imaginative temperament in the artist, which raises his work beyond a close imitation of life, distinguishing it from mere skilful mechanism" (p. 259). Such imaginative heightening could of course

go too far. A Fuseli picture was to Chatfield a "nightmare of the heat-oppressed brain" (p. 260), and Lamb found John Martin's "hyperbole of pencil" appalling:

> His landscapes are like the flying island, floating between heaven and earth, exciting only wonder. Creation, as God has made it, will not suit him; he must have a world of his own to paint. His pictures are opium dreams, a phantasmagoria of landscape and architecture, as Fuseli's and Blake's designs were of human beings [p. 53].

An acceptable compromise between a mechanical exactitude of representation and imaginative excess was effected by John Eagles in his definition of "the natural in art." Nature, he wrote in 1842, is "whatever the mind, in its most sane, healthy, imaginative, comprehensive state, can conceive" (p. 357).

Closely related to the criterion of "nature" in exhibition art reviews are speculations about the appropriate subject matter for painting. J.B. Pyne identified the categories of subject matter in a rather muddled analysis of "style" in art published in 1844: "first, high, grand, and impressive; second, learned, imaginative, and elegant; third, close, compact, and literal; and fourth, little, mean, and quibbling" (p. 563). By the first category, Pyne undoubtedly meant history painting, by the second what Chatfield had meant by "poetic" painting, usually of subject matter drawn from literature. By the third he might well have meant the better kind of landscape, portrait and genre painting. By the fourth he seems to have meant those paintings which render some trivial subject with a slavish "Dutch" exactness. Like most of his fellow art critics and artists, Pyne preferred those subjects which "improved the mind." A reviewer for the *Art-Union* condemned a painting by William Etty because it failed "in that which should be the noblest object of ambition—to teach some ennobling lesson, to inculcate some moral duty, to perpetuate some high example—in short, to elevate the mind" (2 [February 1840], 21). Wilkie, the most characteristic painter of the first third of the century, was admired for his attempt at "a radical change in his style of subject, effected with an ardent wish to base his fame upon something morally higher than domestic painting" (p. 389), although most critics felt that this praiseworthy effort was not entirely successful.

Despite the critics' preference for a subject matter drawn from history or literature, the public preferred to purchase canvases treat-

ing less exalted subject matter, like the genre paintings of Wilkie or the admirable stags and dogs of Landseer. Thackeray commented wryly: "Art is a matter of private enterprise here, like everything else: and our painters must suit the small rooms of their customers, and supply them with such subjects as are likely to please them." The public taste was in this case, Thackeray admitted, close to his own: "we want pleasant pictures, that we can live with" (p. 369).

Other critics were less indulgent. Noting the increasing number of domestic paintings designed for the middle-class drawing room, the *Athenaeum* commented disapprovingly, "In truth, our artists are accommodating their works more than ever to suit the public taste, and their reward will be accordingly" (p. 85).

Although critics were by the 1840s prepared to find some value in paintings with comparatively trivial subject matter, they took care to warn painters against choosing subject matter too irredeemably "low." The *Art-Union,* in a typical review, made a comment that would surely have amused Manet or Toulouse-Lautrec a few decades later: "When an artist condescends to celebrate a café, the want of a subject must have been most severely felt. Such a picture can surely be only intended to hang in the place it represents" (7 [March 1845], 73). Alfred Fripp's "Irish Reapers" is similarly criticized:

> We cannot but lament, . . . as a serious drawback from the merits of the picture, a degree of vulgarity unnecessary and untrue: the Irish peasant is never vulgar; rustic he undoubtedly is, but there is even a delicacy mingled with his rusticity, which prevents it from degenerating into coarseness. We by no means insist always upon the poetical rendering of a homely fact—but grossness is not to be pardoned [*Art-Union* 8 (June 1846), 191–92].

At times criticism of a choice of subject could become decidedly personal. R.W. Buss's "A Sketch from Nature" drew this sharp comment from the *Art-Union:* "A production unredeemably vulgar: to paint it was worse than time misspent, and we should form a very low idea of the person who desired to possess it" (10 [March 1848], 83).

The *Art-Union* was, however, willing to praise the domestic subject matter so favored by the public. The viewer can easily identify himself with such subjects "which can hardly be expected, when he is called upon to weep with Hecuba, or to rage with Achilles" (p. 334). But this admission leads the reviewer to a warning that sums up, as

much as any single paragraph can, the self-satisfied tone of this, the most important art journal of the time:

> We must . . . clear ourselves from the suspicion of admiring or advocating the treatment of *common* every day scenes, exhibiting either the meannesses and vulgarities of low, or the equally objectionable littlenesses, speaking *artistically*, of more polite life. Subjects of affecting interest, of deep expression, of great beauty, and often conveying a fine moral, are to be found without degrading the pencil to common-place. The object of art is not to gratify the taste of tinkers and cobblers; but there are minds in various states of advancement, and by attracting the attention of that class which may be uneducated, and perhaps even coarse and vulgar, even they may be improved, and, by degrees, acquire a relish for that which is beyond the usual range of their observation and preference [p. 334].

Despite a general acquiescence among artists and critics to the vogue for domestic painting, a few academicians and journal critics still argued for the importance of that highest of all categories of art, history painting. Sir Martin Shee, President of the Royal Academy and himself a historical painter, reported gloomily in 1839 that the British School was flawed by its neglect of "the higher departments of historic and poetic art" (*Art-Union* 1 [December 1839], 179). Nine years later, the *Art-Union,* in many ways the voice of the art establishment and of the Academy itself, intoned,

> High Art, for National purposes,—as a means of Education; as the annalist of our History; as the promoter of Commerce; the agent towards Social Refinement;—this only is worth promoting, worth struggling for to promote [10 (January 1848), 3–4].

Yet despite this belief, in the 1830s and 1840s history painting clearly declined in quality and in popularity with the general public. In 1833 the *Athenaeum* reported that of the 481 works displayed in the three principal galleries at an Academy exhibition, 217 were portraits of men and women, 131 were landscapes and only 130 were of the "poetic or historic stamp." Portraits of dogs and horses the critic declined to count (p. 35). Often paintings purporting to be historical were little more than anecdotal painting tricked out in fancy dress (p. 105). Time and again, critics noted the disparity between high achievement and public recognition. The Royal Academy exhibition of 1838 boasted a William Hilton history canvas which belonged to "the highest branch of art," but, the *Athenaeum* sadly reported,

Wilkie's "The Queen holding her first Council" was "the object of most general attraction" (p. 216). Attempts to raise the prestige of history painting through state competitions reached their culmination in the Westminster Hall cartoon competition of 1843 which the *Art-Union* loyally called "the worthiest exhibition that ever took place within the walls of any building in England" (p. 449). More discriminating observers were likely to agree with the *New Monthly Magazine*'s comment that the display was "the worst Exhibition of cartoons and frescos that was ever got together in this or any other country, at any period in the history of the world" (p. 559). More astute critics saw the failure of history painting in England as inevitable. Thackeray cheered its decline and the more circumspect T.H. Lister drew on an analogy to poetry in his disparagement of history painting: "The vital spark of poetry, if embodied in a sonnet, will outlive the uninspired bulk of twenty cantos" (p. 72). John Eagles was perhaps the most unrelenting foe of the "Grand Style" of history painting. "The superior charms of art," he wrote in 1836, "are produced in portraying the gentler passions, in tone, sympathy, and a thousand mixed feelings" (p. 151).

For most reviewers in the 1830s and early 1840s history painting was synonymous with that ridiculous yet curiously touching figure, Benjamin Robert Haydon. Himself a painter of little talent, Haydon was above all a publicist for "high art." By tormenting several generations of government officials, by winning the friendship and support of the literary establishment of the day and by his own efforts as a painter, Haydon kept the public and critics alike aware of the claims of history painting. His suicide in 1846 was treated by some as a martyrdom for high art, but more realistic observers saw his death as the last bungled act of a largely wasted life. While the *Athenaeum* in a charitable assessment of his work published in 1832 could grant that Haydon was "worthy of ranking with the most distinguished artists of the age" (p. 3), the advice it then went on to give reveals the inevitable fate of history painting in what Boase has accurately called the "age of Wilkie":

> We wish so well to Haydon, as to wish that he would choose canvas of a moderate size, and subjects of a character which include fireside sympathies; that he would give his genius fair play and work more in the spirit of his country [p. 4].

Although discussions of subject matter and endless debates about the relative merits of landscape, genre painting and history painting are found in almost every exhibition review, there is also a good deal of discussion of technique, although it tends to be of a superficial kind. Most reviewers seem to have agreed with the *Athenaeum* in its insistence that all that English art needed to render it perfect was good design (p. 255). Mastery of color was assumed to be characteristic of the English school. That "perfection of detail combined with unity of effect and generality of expression" that for Archibald Alison was the mark of great art (p. 127) could be achieved only if English painters were skilled equally in design, color and "finish." When writing of color, critics inevitably drew comparisons with Titian; when writing of design, the model and absolute standard was Raphael. B.R. Haydon was lavishing the highest praise on his friend and rival Wilkie when he called him "the great Raphael of domestic life."[1]

The paintings of J.M.W. Turner provided the greatest challenge to critics of the 1830s and 1840s. Many painters and critics shared Haydon's belief that Turner represented an extreme of the English school since his paintings were without form, devoted "solely to the effects & colour of what he sees." Haydon was characteristically vehement in his hostility towards Turner:

> *Turner*'s Pictures always look as if painted by a Man who was born without hands, and having contrived to tie a brush to the hook at the end of his wooden stump, he managed by smudging, bungling, scrawling, twisting, & splashing, to convey to others a notion of his conceptions. His Pictures and his drawings have this look—they are the works of a savage, suddenly excited to do his best to convey to his fellows his intense impression of the scenery of Nature.[2]

The *New Monthly Magazine* credited Turner's popularity to the public's habit of swearing "by that which nobody in the world understands" (71 [June 1844], 249). The *Art-Union*, while admitting Turner's genius, warned the painter that he was sporting "with his pencil as if his sole ambition was to show the freaks and follies a

[1]*The Diary of Benjamin Robert Haydon*, ed. Willard Bissell Pope (Harvard University Press, 1960–63), III: 421.

[2]*Diary*, III: 370.

great mind may perpetrate with impunity" (p. 306). Most critics were simply confused by Turner's later works. Of the "Slave Ship," exhibited in 1840, Thackeray wrote, "Is the picture sublime or ridiculous? Indeed I don't know which" (p. 328).

Those who defended Turner did so on the grounds that his paintings were a personal, imaginative response to the natural world and therefore beyond the reach of conventional criteria. A Turner painting for the *Athenaeum* critic of 1836 was "another of his rainbow hued rhapsodies, a thing like much of Shelley's poety, to be felt rather than to be understood" ([May 14], 34). Others were less vague in their admiration. The *Athenaeum* critic had written in the previous year that a Turner landscape represented a fusion of real and ideal, of minutely observed landscape and of imaginative recreation (p. 101). In 1832 a critic wrote of Turner in terms that would be repeated over the next two decades: "the whole kingdom of inanimate nature is his: his whirlwinds have words, his tempests speak, and the air which he breathes over his matchless landscapes has something of the creator in it" (*Athenaeum* [June 16, 1832], 387).

The ability of some critics of the 1830s and 1840s to come to terms, however grudgingly, with the genius of Turner suggests a flexibility of mind that is one of the most appealing aspects of the art reviewing of the period. While much of what was written was admittedly conventional and all too obviously written under the pressures of a deadline, the essays which follow suggest that there is still much of value for the art historian and the student of critical theory to be found in the pages of nineteenth-century periodicals.

Checklist

Abbreviations

A	*Athenaeum*
A-U	*Art-Union*
B	*Blackwood's Edinburgh Magazine*
FM	*Fraser's Magazine*

1832

"Living Artists.—No. XI. R.B. [*sic*] Haydon." *A* (January 14), 32.

"Living Artists.—No. XII. Thomas Phillips, R.A." *A* (February 4), 80–81.

"British Institution. Exhibition of Paintings for 1832." *A* (February 11), 98–99.

"Living Artists.—No. XIII. Henry Bone, R.A." *A* (March 3), 145.

"Exhibition of the Society of British Artists." *A* (March 24), 195–96; (March 31), 211–12; (April 7), 228.

"Living Artists.—No. XIV. William Hilton, R.A." *A* (March 31), 209–10.

"Exhibition of the Society of Painters in Water Colours." *A* (May 5), 290–91; (May 19), 324–25.

"Exhibition at Somerset House." *A* (May 12), 308–09; (May 19), 323–24; (May 26), 339–40; (June 2), 355–56; (June 16), 387–88; (June 30), 419.

"Living Artists.—No. XV. George Jones, R.A." *A* (August 4), 505–06.

"Living Artists.—No. XVI. William Allan, A.R.A." *A* (September 8), 586–87.

"Living Artists.—No. XVII. C.R. Leslie, R.A." *A* (November 24), 760–61.

1833

Lamb, Charles. "On the Total Defect of the Quality of Imagination, Observable in the Works of Modern British Artists." *A* (January 19), 42–43; (January 26), 57; (February 2), 73–74.

"Exhibition of the Society of British Artists." *A* (March 23), 185–86; (March 30), 203; (April 13), 233–34.

"Exhibition of the Painters in Water-Colours, Suffolk Street." *A* (April 27), 266; (May 4), 280–81.

F., G. "The Royal Academy Exposed: From Authentic Documents and Undoubted Facts." *New Monthly Magazine* 38 (May), 73–82.

"Exhibition of the Associated Painters in Water-Colours." *A* (May 4), 281.

"Exhibition of the Royal Academy." *A* (May 11), 297–98; (May 25), 329–30.

Morritt, J.S. "Cunningham's *Lives of the Painters*." *Quarterly Review* 50 (October), 56–88.

1834

"British Institution." *A* (February 8), 107.

Horne, R.H. [?]. "Martin's *Illustrations of the Bible*." *Westminster Review* 20 (April), 452–65.

Lister, T.H. "Cunningham's *Lives of British Artists*." *Edinburgh Review* 59 (April), 48–73.

"Water-Colour Exhibition." *A* (May 3), 338–39.

"The Exhibition of the Royal Academy." *A* (May 10), 355–56; (May 17), 378–79; (May 31), 418–19.

"Haydon's *Reform Banquet*." *FM* 9 (June), 702–10.

Williams, D.E. [?]. "Notes on the Life of the Late Sir Thomas Lawrence." *New Monthly Magazine* 41 (June), 199–206.

Banks, P.W. "Some Passages in a Visit to the Exhibition of the Royal Academy." *FM* 10 (July), 106–19.

Morgan, Sir Charles. "Of Certainty in Taste." *A* (November 2), 804–07.

1835

"Water-Colour Exhibition." *A* (May 9), 360–61.

"Exhibition at the Royal Academy." *A* (May 16), 378–79; (May 23), 394–95.

Leeds, W.H. "The Somerset House Annual." *FM* 12 (July), 49–62.

1836

"British Institution." *A* (February 20), 147.

"Society of British Artists." *A* (March 26), 226–27.

"Society of Painters in Water Colours." *A* (April 30), 314.

Bray, Anna Eliza. "Reminiscences of Stothard." *B* 39 (May), 669–88; 39 (June), 753–68.

"Exhibition at the Royal Academy." *A* (May 7), 330–31; (May 14), 347–48.

"History of Painting," *British and Foreign Review* 3 (July), 150–67.

Alison, Archibald. "The British School of Painting." *B* 40 (July), 74–85.

Eagles, John. "The Arts. Hints to Amateurs." *B* 40 (July), 131–38.

Eagles, John. "The National Gallery." *B* 40 (August), 207–18.

Chatfield, Edward. "Painting and Painters: The Commercial Spirit and the Spirit of Genius." *New Monthly Magazine* 48 (September), 43–48.

Eagles, John. "British Institution for Promoting the Fine Arts in the United Kingdom, Etc. – 1836." *B* 40 (October), 543–56.

Eagles, John. "Historical Painting." *B* 40 (November), 663–73.

1837

Eagles, John. "Historical Painting. Report from the Select Committee on Arts, and Their Connexion with Manufactures." *B* 41 (February), 183–99; 41 (March), 343–56.

"British Institution." *A* (February 4), 90–91.

"Society of British Artists." *A* (March 25), 219–20.

"Society of Painters in Water Colours." *A* (April 29), 308.

"New Society of Painters in Water Colours." *A* (April 29), 308–09.

"Royal Academy." *A* (May 6), 330; (May 13), 346–47; (May 20), 371.

Eagles, John. "Exhibitions – The Royal Academy." *B* 42 (September), 330–41.

Eagles, John. "Exhibitions — British Institution, &c." *B* 42 (October), 493 – 505.

Eagles, John. "The National Gallery." *B* 42 (November), 693 – 701.

1838

"British Institution." *A* (February 17), 129 – 30.

"Society of British Artists." *A* (March 31), 241 – 42.

Horne, R.H. "British Artists and Writers on Art." *British and Foreign Review* 6 (April), 610 – 57.

"New Society of Painters in Water Colours." *A* (May 5), 330.

"Society of Painters in Water Colours." *A* (May 5), 330.

"Royal Academy." *A* (May 12), 346 – 47; (May 19), 362 – 64; (May 26), 378.

Egerton, Francis. "Art and Artists in England." *Quarterly Review* 62 (June), 131 – 61.

Jameson, Anna. "The Exhibition of the Royal Academy. English Art and Artists." *Monthly Chronicle* 1 (June), 348 – 55.

Thackeray, W.M. "Strictures on Pictures." *FM* 17 (June), 758 – 64.

"Waagen's *Works of Art and Artists in England*." *Edinburgh Review* 67 (July), 384 – 415.

Review of B.R. Haydon and William Hazlitt, *Painting and the Fine Arts*. *A* (July 14), 482 – 84; (July 21), 510 – 12; (July 28), 526 – 28.

1839

"The Influence of the Annuals upon Art." *Monthly Chronicle* 3 (January), 63 – 67.

"The British Institution: The Exhibition of 1839." *A-U* 1 (February), 7 – 8; 1 (March), 21 – 22.

Chatfield, Edward. "Poetic Painting and Sculpture." *New Monthly Magazine* 55 (February), 196 – 205.

"British Institution." *A* (February 9), 117 – 18.

"Society of British Artists." *A* (March 30), 245 – 46.

"The Society of British Artists. Sixteenth Exhibition, 1839." *A-U* 1 (April), 43 – 44.

"New Society of Painters in Water Colours." *A* (April 20), 301.

"The Royal Academy. The Seventy-first Exhibition. 1839." *A-U* 1 (May), 65–71; (June), 85–86; (July), 101–02.

"The Society of Painters in Water Colours." *A-U* 1 (May), 72–73.

"Society of Painters in Water Colours." *A* (May 4), 337–38.

"Royal Academy." *A* (May 11), 356–57; (May 25), 396–97; (June 1), 418.

Scott, David. "On the Genius of Raphael." *B* 45 (June), 809–18.

Thackeray, W.M. "A Second Lecture on the Fine Arts, by Michael Angelo Titmarsh, Esq." *FM* 19 (June), 743–50.

"On Albert Durer, and the Modern German and English Schools of Painting." *Monthly Chronicle* 4 (July), 41–51.

Ogle, Nathaniel. "Works of Art and Artists in England." *British and Foreign Review* 9 (July), 1–63.

"On the Present State of the Fine Arts in Great Britain." *A-U* 1 (August), 113–14; 1 (September), 129–30.

Eagles, John. "Royal Academy — and its Exhibition." *B* 46 (September), 304–16.

"The Progress of Painting in Water Colours." *A-U* 1 (October), 145–46.

Eagles, John. "Picture Exhibitions — National Gallery — British Institution." *B* 46 (October), 467–74.

"Portrait Painting in England, with the Comparative Merits of Vandyke, Reynolds, & Lawrence." *A-U* 1 (November), 161–62; 2 (January 1840), 1–2; 2 (March 1840), 33–34.

Thackeray, W.M. "On the French School of Painting: With Appropriate Anecdotes, Illustrations, and Philosophical Disquisition." *FM* 20 (December), 679–88.

Shee, Sir Martin. "The Address of Sir Martin Shee, P.R.A., on Distributing Premiums to the Students of the Royal Academy on the 10th December, 1839." *A-U* 1 (December 15), 177–80.

1840

"The British Institution. The Exhibition, 1840." *A-U* 2 (February), 17–22.

Review essay on Historical Painting. *A* (February 1), 95–96; (February 8), 111–12.

"British Institution." *A* (February 8), 117–18.

Eagles, John. "Proposed Galleries for Pictures and Statues at the University of Oxford." *B* 47 (March), 362–67.

"Society of British Artists." *A* (March 21), 236–37.

"Remarks on Painting, Varnishing, and Varnishes." *A-U* 2 (April), 49–50.

"Society of British Artists. The Exhibition—1840." *A-U* 2 (April), 53–55.

"The New Society of Painters in Water-Colours." *A-U* 2 (April), 55.

"New Society of Painters in Water Colours." *A* (April 18), 317–18.

"Historical Painting in England." *A-U* 2 (May), 65–66; 2 (July), 105–06; 2 (October), 153–54.

"The Royal Academy. The Exhibition—1840." *A-U* 2 (May), 73–78.

"Society of Painters in Water-Colours." *A-U* 2 (May), 78.

"Society of Painters in Water Colours." *A* (May 2), 354.

"Royal Academy." *A* (May 9), 372–73; (May 16), 400–02; (May 23), 419–20.

Thackeray, W.M. "A Pictorial Rhapsody by Michael Angelo Titmarsh." *FM* 21 (June), 720–32; 22 (July), 112–26.

"Encouragement of Art." *A-U* 2 (August), 121–23; 2 (September), 137–39.

"Reflections Arising Out of the Late 'Exhibition.'" *A-U* 2 (August), 126–27.

Eagles, John. "Royal Academy Exhibition, &c." *B* 48 (September), 374–86.

Eagles, John. "National Gallery—Exhibitions, Etc." *B* 48 (October), 481–86.

Eagles, John. "A Few Hours at Hampton Court." *B* 48 (December), 764–71.

1841

"The Treatment of Pictures of Fancy Subjects, and Familiar Life." *A-U* 3 (January), 3–4.

"The British Institution. The Exhibition—1841." *A-U* 3 (February), 27–30.

"British Institution." *A* (February 6), 117–18.

"Exhibition of the Royal Scottish Academy." *A-U* 3 (March), 46–47; 3 (April), 62–63; 3 (May), 83.

"Society of British Artists." *A* (March 27), 244–45.

"Society of British Artists. Exhibition —1841." *A-U* 3 (April), 66–68.

"The Royal Academy. The Exhibition —1841. The Seventy-third." *A-U* 3 (May), 75–79; 3 (June), 101–04.

"The Society of Painters in Water Colours." *A-U* 3 (May), 81–82.

"New Society of Painters in Water Colours. Seventh Exhibition." *A-U* 3 (May), 82.

"New Society of Painters in Water-Colours." *A* (May 1), 345.

"Royal Academy." *A* (May 8), 367–68; (May 15), 388–89; (May 22), 406–07; (May 29), 427; (June 5), 443–44.

"Society of Painters in Water Colours." *A* (May 8), 368–69.

"A Paper on Painters." *New Monthly Magazine* 62 (June), 258–64.

"Sir David Wilkie." *A* (June 12), 459–60.

"Sir David Wilkie." *A-U* 3 (July), 115–16.

Thackeray, W.M. "On Men and Pictures. À Propos of a Walk in the Louvre." *FM* 24 (July), 98–111.

"Pictures and Picture-Dealers." *New Monthly Magazine* 62 (August), 445–53.

Eagles, John. "Exhibitions—Royal Academy and British Institution." *B* 50 (September), 340–51.

Eastlake, Charles. "On Fresco Painting." *A-U* 3 (October), 163–64.

Pyne, W.H. "Sir David Wilkie and His Friends." *FM* 24 (October), 443–54.

Eagles, John. "Report from the Select Committee on Fine Arts. Together with Minutes of Evidence, Appendix, and Index. — June 1841." *B* 50 (November), 585–95.

1842

"The National Commission. British Art." *A-U* 4 (January), 3–4.

Review of Mrs. Anna Jameson's *A Handbook to the Public Galleries of Art, &c. in and near London. A* (February 12), 139–40.

"British Institution." *A* (February 19), 171–72; (February 26), 194.

"The British Institution." *A-U* 4 (March), 57–60; 4 (April), 75–77.

Eagles, John. "Thoughts Upon the Modes of Ornamenting the New Houses of Parliament." *B* 51 (March), 388–97.

H., S.R. "Fresco Painting; Ancient and Modern." *A-U* 4 (March), 39–43.

Lewes, G.H. "Philosophy of Art: Hegel's Aesthetics." *British and Foreign Review* 13 (March), 1–49.

"Society of British Artists. Suffolk-Street, Pall-Mall East." *A-U* 4 (April), 85; 4 (May), 103–04.

Eagles, John. "The Natural in Art." *B* 51 (April), 435–44.

"Society of British Artists." *A* (April 2), 298–99.

Severn, Joseph. "On Fresco-Painting." *A* (April 9), 314–17; (May 7), 405–06; (August 6), 709–11.

"New Society of Painters in Water-Colours." *A* (April 23), 362–63.

"New Society of Painters in Water-Colours." *A* (April 30), 382–83. (Despite title, a review of the Old Society Exhibition.)

"The Society of Painters in Water Colours." *A-U* 4 (May), 100–01.

"New Society of Painters in Water Colours." *A-U* 4 (May), 102–03.

"Sale of Wilkie's Drawings and Pictures." *A* (May 7), 406–07.

"Royal Academy." *A* (May 7), 409–11; (May 14), 433–35; (May 21), 455–58; (May 28), 481–83.

"The Royal Academy. Seventy-fourth Exhibition. — 1842." *A-U* 4 (June), 119–29; 4 (July), 160–62.

Cunningham, Allan [?] or Peter Cunningham [?]. "Doings in Fresco." *FM* 25 (June), 669–73.

Thackeray, W.M. "An Exhibition Gossip. By Michael Angelo Titmarsh. In a Letter to Monsieur Guillaume, Peintre." *Ainsworth's Magazine* 1 (June), 319–22.

"Exhibition of the Ancient Masters." *A* (June 11), 530; (June 18), 547–49; (June 25), 565–67; (July 2), 584–86. (Includes paintings by Wilkie.)

"The British Institution. Exhibition of the Works of the Late Sir David Wilkie, R.A." *A-U* 4 (July), 159–60.

Cole, Henry. "Prospects of the Fine Arts: Decoration of the Westminster Palace." *Westminster Review* 38 (July), 168–93.

Eagles, John. "Exhibitions — Royal Academy." *B* 52 (July), 23–34.

"Report of Commissioners on the Fine Arts." *A* (August 27), 763–72.

"Report of the Commissioners on Fine Arts." *A-U* 4 (September), 199–211.

Cunningham, Peter. "Wilkie and His Works." *FM* 26 (September), 265–71.

Eagles, John. "Exhibitions." *B* 52 (September), 319–37.

Willmott, R.A. "Some of the Picture-Galleries of England," *FM* 26 (September), 335–47; 26 (October), 466–76.

Review article treating books on fresco. *A* (September 10), 795–97.

Eagles, John. "Sir Joshua Reynolds's Discourses. With Notes by John Burnet, F.R.S." *B* 52 (December), 767–82; 53 (February 1843), 181–202; 53 (May 1843), 589–602.

1843

Wyse, Thomas. "Aesthetical Study of Art: Kugler's *Hand-Book of Painting*." *British and Foreign Review* 14 (February), 512–54.

"British Institution." *A* (February 18), 165–66; (February 25), 195.

Howard, Henry. "Royal Academy: Professor Howard's Lectures on Painting." *A* (February 25), 181–85; (March 11), 235–39; (March 25), 285–88; (April 8), 335–38; (April 29), 413–16; (May 13), 461–65.

"The Cartoon Competition." *A-U* 5 (March), 55–58.

"The British Institution. The Exhibition — 1843." *A-U* 5 (March), 64–70.

"Society of British Artists. Twentieth Annual Exhibition." *A-U* 5 (April), 93–94.

Wyse, Thomas. "*Report of the Commissioners of the Fine Arts*." *British and Foreign Review* 15 (April), 193–246.

"Society of British Artists." *A* (April 1), 315.

"Society for the Formation of a Public Gallery of the Works of Living British Artists." *A* (April 22), 390–91.

"New Houses of Parliament." *A* (April 29), 417–18; (May 6), 440–41.

"On the Decoration of the New Houses of Parliament." *FM* 27 (May), 535–42.

"The Water-Colour Exhibitions." *A* (May 6), 443–44; (May 13), 468–69.

"Royal Academy." *A* (May 20), 492–93; (May 27), 511–13; (June 3), 530–33; (June 10), 551–52; (June 17), 570–71.

"Society of Painters in Water Colours. Gallery, Pall-Mall East." *A-U* 5 (June), 135–37.

"New Society of Painters in Water-Colours." *A-U* 5 (June), 137–40.

"The Royal Academy. Seventy-fifth Exhibition, 1843." *A-U* 5 (June), 159–78.

"The Exhibition of Ancient Masters, Pall Mall." *A* (June 24), 591–93. (Sir Joshua Reynolds.)

"The British Institution: Works of Sir Joshua Reynolds." *A-U* 5 (July), 188–89.

"On Aesthetical Criticism as Applied to Works of Art." *FM* 28 (July), 72–79.

"The Cartoon Exhibition." *A* (July 8), 633–34; (July 15), 652.

"The Cartoons. Westminster Hall." *A-U* 5 (August), 207–12.

Eagles, John. "Exhibitions." *B* 54 (August), 188–206.

Pyne, J.B. "The Nomenclature of Pictorial Art. Part I. Breadth." *A-U* 5 (August), 213–14.

"The Decoration of the Houses of Parliament." *A-U* 5 (September), 231–35.

Lockhart, J.G. "Life of Sir David Wilkie." *Quarterly Review* 72 (September), 397–452.

Pyne, J.B. "The Nomenclature of Pictorial Art. Part II. Clearness." *A-U* 5 (September), 239–40.

"A Few Words about the Cartoons." *New Monthly Magazine* 69 (October), 260–65.

"The Late Richard Dadd." *A-U* 5 (October), 267–71.

Eagles, John. "[Ruskin's] *Modern Painters*." *B* 54 (October), 485–503.

Pyne, J.B. "The Nomenclature of Pictorial Art. Part III. Finish." *A-U* (November), 288–89.

Eagles, John. "Lectures at the Royal Academy: Henry Fuseli." *B* 54 (December), 691–708.

Pyne, J.B. "The Nomenclature of Pictorial Art. Part IV. Execution." *A-U* 5 (December), 303–04.

Green, J.H. "Royal Academy. Professor J.H. Green's Lectures. Beauty and Expression as the Elements of the Fine Arts." *A* (December 16), 1108–11; (December 23), 1134–37.

1844

Pyne, J.B. "The Nomenclature of Pictorial Art. Part V. Composition." *A-U* 6 (January), 16–17; 6 (February), 42–44.

Jameson, Mrs. Anna. "Washington Allston." *A* (January 6), 15–16; (January 13), 39–41.

"The Queen's Summer House, Buckingham Gardens." *A-U* 6 (February), 37–38.

Eagles, John. "Sitting for a Portrait." *B* 55 (February), 243–56.

Review of John Ruskin's *Modern Painters. A* (February 3), 105–07; (February 10), 132–33.

"British Institution." *A* (February 10), 139; (February 17), 156–57.

"The British Institution. Exhibition, 1844." *A-U* 6 (March), 55–60.

"Parallel Between the Collections of Science and Art in London and in Paris." *FM* 29 (March), 261–72.

"Progress of Art." *Westminster Review* 41 (March), 73–109.

S., R. "Character of Paintings." *A* (March 9), 226–27.

"Society of British Artists." *A* (March 30), 298–99.

"Sir Charles Bell's Essays: Expression in the Fine Arts." *British and Foreign Review* 17 (April), 199–214.

"The Society of British Artists. Exhibition, 1844." *A-U* 6 (April), 97–99.

Pyne, J.B. "The Nomenclature of Pictorial Art. Part VI. Tint and Tone." *A-U* 6 (April), 95–96.

"New Society of Painters in Water Colours." *A* (April 27), 386–87.

"Society of Painters in Water Colours." *A* (May 4), 410–11.

"Royal Academy." *A* (May 11), 432–34; (May 18), 459–60; (May 25), 482–85; (June 1), 503–05; (June 8), 532–33.

M., S. "The English Academy at Rome." *A* (May 11), 428–29; (May 18), 452–53; (May 25), 477–78.

"Daniel Maclise, R.A." *Ainsworth's Magazine* 5 (June), 510–12.

"The Exhibition of the Royal Academy." *New Monthly Magazine* 71 (June), 247–55.

"The Royal Academy. The Seventy-sixth Exhibition." *A-U* 6 (June), 153–72.

"Society of Painters in Water Colours. Fortieth Exhibition, 1844." *A-U* 6 (June), 172–74.

"New Society of Painters in Water Colours. Tenth Exhibition, 1844." *A-U* 6 (June), 174–75.

Godwin, George [?]. "The Art-Unions." *Westminster Review* 41 (June), 515–21.

Pyne, J.B. "The Nomenclature of Pictorial Art. Part VII. Vehicle." *A-U* 6 (June), 141–43; 6 (July), 189–90.

Thackeray, W.M. "May Gambols; or, Titmarsh in the Picture-Galleries." *FM* 29 (June), 700–16.

"Exhibition at Westminster Hall." *A* (July 6), 627–28; (July 13), 651–52; (July 20), 674.

"The Art Exhibition in Westminster Hall." *New Monthly Magazine* 71 (August), 549–57.

"Westminster Hall. The Frescoes and Sculpture." *A-U* 6 (August), 211–18.

Pyne, J.B. "The Nomenclature of Pictorial Art. Part VIII.—Style." *A-U* 6 (September), 284–85; 6 (October), 305–06; 6 (December), 348–50.

"Apology for Art-Unions." *FM* 30 (October), 471–78.

"The Progress and Patronage of British Art." *A-U* 6 (October), 299–302; 6 (November), 323–25.

Eastlake, Charles. "On the Nature and Various Styles of the Formative Arts." *A-U* 6 (November), 326–27.

Review of B.R. Haydon's *Lectures on Painting and Design*. *A* (November 9), 1025–27.

"Sir Augustus Wall Callcott, R.A." *A* (November 30), 1097–98.

1845

"The Future of British Art." *A-U* 7 (January), 5–7.

Alison, Archibald. "Homer, Dante, and Michael Angelo." *B* 57 (January), 1–17.

Pyne, J.B. "The Nomenclature of Pictorial Art. Part IX. Chiaroscuro." *A-U* 7 (February), 42–43; 7 (May), 130–31; 7 (September), 281–83.

"British Institution." *A* (February 15), 177–78; (February 22), 203–04; (March 1), 226.

"The British Institution Exhibition, 1845." *A-U* 7 (March), 73–78.

"Conversations in the National Gallery." *New Monthly Magazine* 73 (March), 378–88; 73 (April), 534–42.

"Society of British Artists." A (March 29), 313–14.

"Society of British Artists. Twenty-second Exhibition—1845." A-U 7 (April), 105–07.

G., J. "Art and the People." A (April 12), 360–61.

"New Society of Painters in Water Colours." A (April 26), 417.

"Thomas Phillips, Esq. R.A." A (April 26), 417–18.

"New Society of Painters in Water Colours. Eleventh Exhibition—1845." A-U 7 (May), 128–30.

"The Royal Academy of Arts, Its State and Prospects." FM 31 (May), 583–97.

"Society of Painters in Water Colours." A (May 3), 438.

"Royal Academy." A (May 10), 465–68; (May 17), 495–99; (May 24), 520–22; (May 31), 546–47.

"A Peep into the Royal Academy." *New Monthly Magazine* 74 (June), 191–200.

"The Royal Academy. Seventy-seventh Exhibition. 1845." A-U 7 (June), 179–96.

"Society of Painters in Water Colours. Forty-first Exhibition—1845." A-U 7 (June), 197–98.

Thackeray, W.M. "Picture Gossip: In a Letter from Michael Angelo Titmarsh." FM 31 (June), 713–24.

"The Cartoon and Fresco Exhibition, Westminster Hall." A (July 5), 663–64; (July 12), 693–95; (July 19), 720.

"The Summer-House at Buckingham Palace." A (July 19), 719–20.

"Westminster Hall. The Cartoon Exhibition, and New Houses of Parliament." A-U 7 (August), 253–59.

"The Garden Pavilion in the Grounds of Buckingham Palace." A-U 7 (August), 259.

Moir, George. "English Landscape—Constable." B 58 (September), 1–17.

P., I. "Fresco Painting." *Westminster Review* 44 (September), 108–41.

1846

Pyne, J.B. "Letters on Landscape." A-U 8 (February), 55–56; 8 (March), 83–84; 8 (May), 127–28; 8 (June), 163–64; 8 (July), 196–97; 8

(September), 243–44; 8 (October), 275–76; 9 (April 1847), 121–22; 9 (July 1847), 235–37; 9 (September 1847), 305–06; 9 (December 1847), 393–95.

"Art-Union Cartoons." *A* (February 7), 154–55.

"British Institution." *A* (February 14), 179–80; (February 21), 202–03.

"Exhibition of Pictures by Late and Living French Artists." *A* (February 28), 227–29.

"The British Institution." *A-U* 8 (March), 75–78.

Eastlake, C.L. "Styles and Methods of Painting Suited to the Decoration of Public Buildings." *A* (March 7), 248–50; (March 14), 274–76.

"Society of British Artists." *A* (April 4), 354; (April 11), 378–79.

"Haydon's New Pictures." *A* (April 18), 401.

"The Society of British Artists. Twenty-third Exhibition. 1846." *A-U* 8 (May), 129–30.

"Society of Painters in Water Colours." *A* (May 2), 457–58; (June 13), 609–10.

"Royal Academy." *A* (May 9), 479–82; (May 16), 502–04; (May 23), 526–28; (May 30), 558; (June 6), 582; (June 13), 607–08.

"New Society of Painters in Water Colours." *A* (May 9), 482.

"The Exhibition of the Royal Academy. The Seventy-eighth. 1846." *A-U* 8 (June), 171–89.

"Society of Painters in Water Colours. Forty-second Exhibition—1846." *A-U* 8 (June), 190–92.

"The New Society of Painters in Water Colours. Twelfth Exhibition—1846." *A-U* 8 (June), 192–94.

"A Flit Through the Royal Academy." *New Monthly Magazine* 77 (June), 242–45.

"Mr. B.R. Haydon." *A* (June 27), 662–63. See also *A* (July 11), 713.

Review of B.R. Haydon's *Lectures on Painting and Design. A* (July 18), 737–38.

"Obituary. B.R. Haydon. Esq." *A-U* 8 (August), 235–36.

"Progress of English Fresco Painting." *A* (August 29), 889–90.

"Frescoes in Buckingham Palace." *A-U* (September), 246–50.

1847

"Address. The Prospects of British Art." *A-U* 9 (January), 3–6.

"The National Gallery. The Picture Cleaning." *A-U* 9 (January), 34–35; 9 (February), 63.

"The Picture-Cleanings in the National Gallery." *A* (January 23), 101–03.

"British Institution." *A* (February 13), 177–78; (February 20), 205–06; (March 6), 263.

"The British Institution. Exhibition—1847." *A-U* 9 (March), 77–83.

"Portraits of British Artists. No. 1—Charles Lock Eastlake, R.A. No. 2 George Lance." *A-U* 9 (March), 96.

"The National Gallery." *A-U* 9 (March), 97.

Ker, Bellenden. "Schools of Design." *Edinburgh Review* 85 (April), 452–61.

"Society of British Artists." *A* (April 3), 367; (April 10), 391–92; (April 17), 416.

"New Society of Painters in Water Colours." *A* (April 24), 438–39.

"The Society of British Artists. Exhibition 1847." *A-U* 9 (May), 149–51.

"The Exhibition of the New Society of Painters in Water Colours." *A-U* 9 (May), 151–52.

"Portraits of British Artists. No. 3—Daniel Maclise. No. 4—William Powell Frith." *A-U* 9 (May), 164.

"Society of Painters in Water Colours." *A* (May 1), 471; (May 8), 496; (May 15), 528.

"Royal Academy." *A* (May 8), 494–96; (May 15), 526–28; (May 22), 552–54; (May 29), 575–77; (June 5), 600–02.

"Exhibition of the Royal Academy." *New Monthly Magazine* 80 (June), 215–18.

"The Exhibition of the Royal Academy. The Seventy-ninth. 1847." *A-U* 9 (June), 185–200.

"The Society of Painters in Water Colours. The Forty-third Exhibition—1847." *A-U* 9 (June), 201–02.

"The Royal Family. By M. Winterhalter." *A-U* 9 (June), 227.

"The New House of Lords." *A-U* 9 (July), 233–35.

"Portraits of British Artists. No. 5—E.H. Baily, Esq., R.A. No. 6—E.M. Ward, A.R.A." *A-U* 9 (July), 260.

Redding, Cyrus. "Wilkie and Haydon." *FM* 36 (July), 53–61.

"Exhibition in Westminster Hall." *A* (July 3), 704–05; (July 10), 735–37; (July 17), 765–66.

"The Place of the Fine Arts in the Natural System of Society." *Douglas Jerrold's Shilling Magazine* 6 (July 31), 72–81.

"The Exhibition at Westminster Hall, Under the Auspices of Her Majesty's Commissioners on the Fine Arts." *A-U* 9 (August), 265–72.

"The New Houses of Parliament." *A* (August 21), 891.

"Portraits of British Artists. No. 7 Thomas Unwins, R.A., No. 8 Augustus Leopold Egg." *A-U* 9 (September), 312.

"The Vernon Gallery. The Gallery of British Art of Robert Vernon, Esq., No. 50, Pall-Mall." *A-U* 9 (November), 365–72.

"Portraits of British Artists. No. 9. Thomas Duncan, R.S.A., A.R.A. No. 10. Horation M'Culloch, R.S.A." *A-U* 9 (November), 380.

W., M.D. "The Art of Painting in England During the Thirteenth and Fourteenth Centuries." *A* (November 20), 1200–01.

1848

"The Progress of British Art." *A-U* 10 (January), 3–4.

Review of C.L. Eastlake's *Materials for a History of Oil Painting*. *A* (January 15), 62–64.

"The National Gallery." *A-U* 10 (February), 60.

Eagles, John. "Subjects for Pictures. A Letter to Eusebius." *B* 63 (February), 176–92.

"British Institution." *A* (February 12), 167–68; (February 19), 194–95; (February 26), 223–24.

"Royal Academy. Professor Leslie's Lectures on Painting." *A* (February 19), 191–94; (February 26), 220–23; (March 4), 247–50; (March 11), 270–74.

"The British Institution. Exhibition—1848." *A-U* 10 (March), 81–84.

"The Frescos and the Houses of Parliament." *A-U* 10 (April), 103–04.

Ker, Bellenden. "English Landscape Painters." *Edinburgh Review* 87 (April), 472–91.

"Society of British Artists." *A* (April 8), 370–71; (April 15), 393–95.

"New Society of Painters in Water Colours." *A* (April 22), 417–18; (April 29), 440–42.

"Effects of the European Revolutions on British Industry and Art." *A-U* 10 (May), 136–38.

"The Society of British Artists. Twenty-fifth Exhibition — 1848." *A-U* 10 (May), 138 – 41.

"New Society of Painters in Water-Colours. Fourteenth Exhibition — 1848." *A-U* 10 (May), 141 – 42.

"The Free Exhibition. First Exhibition — 1848. Hyde Park Corner." *A-U* 10 (May), 142 – 44; 10 (June), 198.

"Royal Academy." *A* (May 6), 463 – 65; (May 13), 489 – 90; (May 20), 511 – 14; (May 27), 535 – 37; (June 3), 562 – 63; (June 10), 584 – 85; (June 17), 609 – 10.

"Society of Painters in Water Colours." *A* (May 6), 465 – 66; (May 13), 490 – 91.

"The Exhibition of the Royal Academy." *New Monthly Magazine* 83 (June), 230 – 33.

"The Royal Academy. The Eightieth Exhibition — 1848." *A-U* 10 (June), 165 – 80.

"Exhibition of the Society of Painters in Water-Colours." *A-U* 10 (June), 181 – 82.

"Mr. Mulready's Pictures." *A* (June 10), 583 – 84.

"Cultor." "The National Gallery. Past, Present, and Future." *A-U* 10 (July), 205 – 08.

"The Works of W. Mulready, R.A." *A-U* 10 (July), 208.

"Cultor." "Schools of Art in England." *A-U* 10 (August), 233 – 37.

"Cultor." "The Royal Commission; Its Immediate Consequences and Probable Results." *A-U* 10 (September), 261 – 64.

"Institution for the Free Exhibition of Modern Art." *A* (September 9), 910 – 12.

"Exhibition of Art-Union Prizes." *A* (September 16), 936 – 37.

Review of C.L. Eastlake's *Contributions to the Literature of the Fine Arts*. *A* (September 23), 962 – 63; (December 23), 1301 – 02.

"The National Gallery. Report of Parliamentary Committee." *A-U* 10 (October), 305 – 06.

Townsend, H.J. "On the Study of Picturesque Anatomy." *A-U* 10 (November), 327 – 28.

"Frescoes in the New Houses of Parliament." *A* (November 4), 1104 – 05.

Eagles, John. "Eastlake's Literature of the Fine Arts." *B* 64 (December), 753 – 66.

"Living Artists. — No. XI.
R.B. [*sic*] Haydon"

Athenaeum (January 14, 1832), 32

Of the merits of Haydon much has been written, and more has been said: his friends, and they are many, have not left his fine genius unnoticed; while his un-friends, to use a northern phrase, and they are numerous, have dwelt more than was courteous on his defects. Nor has he been slack himself in making the world acquainted both with his labours and his sufferings. As he is not a common man, neither has he been treated in a common way: he has been lauded by critics and poets; noblemen have held out their hands to aid him; and many modes have been tried to make the world feel his genius and reward it accordingly. But the world is an obstinate world: in vain have men of talent and rank praised, patronized, and subscribed —all will not do: in truth, admiration must come of free-will: in vain is the world told that it lavishes its thousands and tens of thousands on men, and on women too, who have not a tithe of the talents of Haydon: the world smiles and squanders away, and there is no help for it. Those who desire to excuse the coldness of the public seek the reason in the artist: his vanity, say they, is equal to his skill; he will not allow his genius to have fair play—he is generally writing, and petitioning, and talking about it; he painted his name up, but then he set to work and talked and wrote it down, and other men of genius, more tractable and more conversant with the world and its ways, rose and reigned in his stead. There is, perhaps, some truth in this; but it is also true that his talents are of a high order, and that he is worthy of ranking with the most distinguished artists of the age.

The pencil of Haydon gave early notice of something more than common—indeed, the character of the man may be guessed from his compositions: he desired to be thought daring, and, selecting his subjects from history or from Scripture, showed an inclination to measure himself with the race of giants in art who had preceded him. It would be unjust to say, that his powers were wholly unequal to the task: like the vision in the Castle of Otranto, he showed the foot if he did not show the body of the giant. But it is one thing to grapple with a grand subject, and another thing to master it: those who examine the works of the painter will find that he fails, not so much in the conception or the handling as in the propriety of action—in short, that he misses those subordinate, yet necessary delicacies, which contain beauty and character. There are, doubtless, portions of his pictures which justify the praise of those friends who call him a second Raphael; and he has a glow of colouring which sometimes equals the finest specimens of his native school of art. But he is often deficient in the dignified gravity— the severe serenity—which Scripture or history require; he also fails frequently in the action of his figures—they do everything with all their might, and seem to feel a difficulty in accomplishing a task which should be performed with ease. That his works were worthy of opening the doors of the Academy to Haydon, was the opinion of his friends: and it is but justice to say, that twenty out of the forty are not so good as he. It was natural too that he should look to the Royal Academy for approbation, if not for help: he followed the precepts of Reynolds and others who lectured on art: he studied Michael Angelo, and imitated Raphael—nay, to such a height did his devotion to the latter reach, that he is said to have affected the open collar and square-toed shoes of the illustrious Italian. Be that as it may, he devoted himself to that department of painting called the historical, yet he did not obtain the countenance of the Academy. In truth, the Forty are reckoned slow in holding out their hands: they must be wooed to be won; and when they yield, they yield, like women, less to real merit than to agreeable manners and courteous solicitation. Though Haydon, as a genius, would be an honour to any Academy, such was the difficult disposition of the man, or such the terror of his brethren for his powers of conversation and controversy, that his name to this day remains without any addition. It is the practice of the Royal Academy not to ask a man of talent to become a member: they cannot imagine that a brother may be too modest or too proud to express such a wish, and so the matter rests between them and those men of genius, who, like Martin and Haydon, have painted pictures rivalling those of Professors and Presidents.

No doubt an academic distinction would

be useful to Haydon : it is like a degree taken at college in a question of learning, and confers a dignity in the eyes of the world which is not unbeneficial. As such he regarded it; and, when it could not be obtained, he considered himself deprived of what was justly his due, and more—that he was robbed of the pride of place and also of the rewards which he imagined belonged to it. He filled the town with complaints of neglected talent and public disregard for art; he pleaded, he criticised, he complained, and he importuned; and, when all these were unsuccessful, he petitioned the House of Commons. Now, when the labours of a man of genius fail of themselves to bring him bread and fame, he had better give up the contest with the world and try some more profitable profession : for he may be assured, if he fails to rouse that drowsy monster, the Public, with what he can do, he will be less able to move it with what he can say. The complaints of authors and artists are unregarded things. Nay, such is the nature of the Public, that it dislikes a man the more for setting himself up against its decisions: in proportion as he is presuming it is disdainful : it cared as much for Haydon as it cared for any one else ; and, as Parliament is but a committee of the public, he was but appealing from the right hand to the left. That an artist should call upon Government to vote historical paintings for churches and public buildings, is scarcely to be credited. Government, for these hundred years, at least, have divorced themselves from genius ; and neither Literature nor Art have been encouraged in our opulent isle half so much as they have by some of the petty kingdoms on the continent. A man of genius, in France or in Germany, has the consequence in the land which is due to his mind : in England, he is nothing; or, the miserable pittance bestowed on him, when old, by the generosity of one king, may be withheld by the frugality of another.

For Haydon to propose that the Commons should vote the manufacture of historical works, could only arise from a belief that he could himself create whatever they commanded. He thought, perhaps, that his colours were equal to the brightest period of our national glory. We give him full credit for the sincerity of his opinion in his own powers, and likewise for his readiness to colour canvas, in a civil or religious way, according to the new Act for promoting the manufacture. Nay, we are certain, from the proofs which he has in many instances given, that he would have executed a series of pictures not unworthy of public approbation :

we only marvel that he thought of applying to the House of Commons. Individuals of that house—Sir Robert Peel, for instance,—have been munificent patrons of art; but the House, as a body, patronizes nothing which has its rise from genius. Painting, and Sculpture, and Architecture, were taken under royal favour when the Academy was founded; but we are not sure that they are much improved. What Art failed to do, Literature accomplished without fee or reward : works of genius, equal in mind and imagination to aught else of ancient or modern times, have been produced, without Acts of Parliament, in this country for centuries. We wish so well to Haydon, as to wish that he would choose canvas of a moderate size, and subjects of a character which include fireside sympathies; that he would give his genius fair play and work more in the spirit of his country. He would thus gain better bread, and obtain higher fame, than have hitherto fallen to his lot: nay, were he to practise a little courtesy of speech, he might be admitted into the Royal Academy, and so rest in peace.

"Living Artists.—No. XII. Thomas Phillips, R.A."

Athenaeum (February 4, 1832), 80–81

for natural elegance and fine breeding. To return to our subject:—it is the object of Phillips to paint minds as well as persons. To endow each head with thought suitable to its character, and exalt and ennoble all that he touched, was the aim of Vandyke, and perhaps of Reynolds—it is assuredly the aim of Phillips. It is true, that, in his wish to render form subordinate to thought, he sometimes makes men of genius look too soft and fine; and more—from a desire to poetize the dress of the passing day, he occasionally approaches to affectation : yet these faults are but casual, and are forgotten when we look on his portraits of Crabbe, Blake, Chantrey, Coleridge, Byron, and many others of the distinguished men of the day.

The poetic taste of Phillips induced him to employ his pencil among the poets—a race too poor or too proud to pay; and, consequently, the labours which he performed in honour of the chief heirs of Parnassus, have been unrewarded with money, though they have been with fame. Of these songsters, in addition to Crabbe, and Byron, and Coleridge, he has painted Sir Walter Scott, Robert Southey, Thomas Campbell, and, we believe, Rogers; but no one has painted Scott so well as Chantrey has sculptured him, though Lawrence, Raeburn, Phillips, Wilkie, Newton, Leslie, and other skilful artists, have tried their hands. The look of Campbell is as changeful as a cloud, and difficult to seize; and in Southey, the natural look is lofty and epic, and certainly has not been truly caught by either Phillips or Lawrence. The Poet Gallery, however, of Phillips, is well worth a visit, were it but for the rarity of seeing so many eminent heads together; we would advise him to finish it, by admitting the portraits of Wilson, Hogg, Joanna Baillie, and Montgomery, and then it would be a purchase worthy of a British king to make. A gallery of this kind was begun by Raeburn; but the heads are chiefly those of northern luminaries; nor are they all poets, for ravens appear among the singing birds—the "toothy critics by the score," of whom Burns wrote. The portrait of Crabbe, in the Phillips Gallery, is a vigorous and happy work; so is that of Coleridge ; and his head of Byron is the only thing we ever saw resembling the great original. Yet we hold, that Blake is his masterpiece; nay, we have seen no portrait of modern times, at all to be compared to it, for a certain solemn grandeur of look, which lifts it at once into the region of poetry. Had he always painted thus, he would have ranked with the proudest masters of the calling.

LIVING ARTISTS.—No. XII.

THOMAS PHILLIPS, R.A.

The works of Phillips are chiefly portraits; but these, from their peculiar merit, deserve particular notice. His graceful colouring and softness of touch, together with his true perception of character and poetic feeling, have raised him to a high station in art; while his good scholarship, his extensive knowledge, and his pleasing manners, render his company desirable by the witty and the accomplished. It was a sense of those qualities, which gave him the situation of Professor of Painting, on the death of Fuseli ; and the honours gained by his talents, he is sure to preserve, by his winning and conciliatory manners. We are not the less disposed to mention those personal advantages, from having just read an article in the *Edinburgh Review*, claiming for Sir Thomas Lawrence a monopoly of talent and courtesy, which is neither very true to the character of that distinguished man, nor very just to his remaining brethren. In genius, he was excelled by some, and in courtesy equalled by many members of the Academy; his manners were not a little affected and artificial; and we think that the writer of the article has mistaken the French nods, and smiling, and bowing condescensions of the late President,

His portraits of ladies are graceful and un-affected; but he seems to take their charms more as he finds them than did the politic Lawrence, who scrupled not to confer attrac-tions, both of shape and colour, which the originals never had perhaps, save in some lucky moment. Nevertheless, we love much the female heads of Phillips; there is an air of tranquil modesty about them more cap-tivating than the put-on-graces of the ladies of the late President: there is a domestic sort of beauty, too, in them, which justifies the say-ing imputed to a certain witty poet—" If I wanted my mistress painted I would go to Lawrence—if my wife, I would go to Phil-lips." We consider this very high praise—nay, we conceive, that, to deserve it, as we think the painter does, a genius of a finer kind is required than that which lavishes loose looks and lascivious airs on the wives and daughters of men. Be that as it may, we are sure that it will bring fame as lasting, because it is true to nature and to purity.

Of the merits of Phillips in literature we can only speak from his Lectures delivered at the Royal Academy, and certain articles im-puted to him in the Encyclopædias. His style of composition is free from faults; it is easy and graceful: he uses his knowledge in a ready and agreeable way; and through the whole a fine and cultivated taste is visible, and an inborn sense of all that is noble and beautiful manifest. His acquaintance with the best works in poetry and history has opened and expanded his mind, and he has perhaps a deeper sympathy with all collateral labours of genius than any of his brethren: he looks beyond his easel. We must, how-ever, acknowledge, that while his lectures have none of the startling atrocities of style which marked those of Fuseli, neither have they that occasional rapture and strength which distinguished the libellous harangues of the fierce and fantastic Swiss. The wish of the latter was to astonish, and the wish of the former to instruct; and this will account for their dissimilarity of style. It should be borne in mind, too, that the Lectures are addressed to a youthful and rather unlearned auditory, to whom all should be simple and plain. We shall, however, have a better op-portunity of examining the literary merits of the Professor soon, for it seems he has under-taken to write some volumes on the art in which he excels for Dr. Lardner's Cyclo-pædia. That he will bring much skill and long experience to this task, we are certain: we know not that he will write a popular book. In truth, true art is like a wizard's wand: we can see and feel its effects;—but how

these effects are produced, who can describe with pen and ink? The rod that the pro-phet stretched over the land of Egypt, which brought down the plague, looked probably like a mere shepherd's staff: that it wrought through God we know—but *how* it wrought, is the question. The skill of hand, the happy delicacy of touch, the fine proprieties and unities of parts, together with the conception of the whole, cannot, we apprehend, be de-scribed in such a way as a young artist can work by: we have never yet seen what we consider true tangible descriptions of either painting or sculpture: nor have we said this without glancing again at the Childe Harold of Byron, where there is rapture enough poured over the antique statues. That Phil-lips will be able to fill up this want in the history of art we dare hardly predict: but we are sure that he will write a valuable and accurate book—till we see it we bid him fare-well.

"Exhibition of
the Society of British Artists"

Athenaeum (March 24, 1832), 195–96

is gradually rising. It would be doing great injustice if we imputed this ascent entirely to the male members of the Society; no one can look along the walls of the galleries without perceiving that to female hands they owe much that is natural in colour, and beautiful in conception—nor do we think that we go too far when we say that some of the fairest works in the exhibition are from the easels of ladies. We shall now proceed, and point out a few of those which we have marked for approbation: and we shall name them according to their numbers, reserving for next week such as we cannot now make room for.

8. '*A Cameronian Sunday Evening;*' CHARLES LEES.—This is a natural scene—an old grey-headed man is reading his Bible in the open air, his wife is listening demurely to the WORD, and his daughter's eyes are turned aside, perhaps to watch the coming of a lover, or from the vagrant inattention of the young to matters of such gravity.

18. '*Ruins, a composition;*' ROBERTS.—This artist having excelled all his brethren in the art of exhibiting, in picturesque elegance and truth, the ruins of our Gothic churches and cathedrals, has, in this composition, employed the Roman architecture, and we cannot say with less success. He has endeavoured to embody these lines by Mrs. Hemans—

There have been bright and glorious pageants here,
 Where now grey stones and moss-grown columns lie;
There have been words which earth grew pale to hear,
 Breathed from the cavern's misty chambers nigh;
There have been voices through the sunny sky,
 And the pine woods their choral hymn-notes sending,
And reeds and lyres their Dorian melody
 With incense clouds around the temple blending,
And throngs with laurel-boughs before the altar bending.

The work of the painter more than embodies these fine lines; he has perhaps filled his scene too full of the golden temples and theatres of antiquity—but this will rather be said than felt.

32. '*Windsor;*' CHILD.—The artist has taken his view of Windsor Castle from the Thames bank; time, an autumnal evening. It is not an easy task to paint up to human recollection, any more than it is to equal expectation: we imagine that the castle on Windsor hill stands nearer the sky than it has been the pleasure of the artist to represent it on canvas; this has little, however, to do with the merits of the work, which are very great—the whole is airy and beautiful, and worthy of being the dwelling of a king.

36. '*Poacher's Confederate;*' HANCOCK.—The poacher's confederate is a quick-footed sagacious dog, which, in this little clever picture, has run down a hare, and stands, with its prey held gently in its mouth, waiting the coming of its master.

39. '*Mountain Pass near Sorrento;*' WATE.—A very pretty picture of a scene which dwells on the memory of every visitor. It is seldom that a true copy of a landscape makes a graceful composition.

EXHIBITION OF THE SOCIETY OF BRITISH ARTISTS.

YESTERDAY the Society of British Artists opened their fine galleries in Suffolk Street to the friends and patrons of art; it was what is called the private view; and the pleasure received could not be little, for near one thousand works, many of them of high merit, were exhibited. This is perhaps one of the best exhibitions of the Society: and the interest of the scene is not a little heightened by the absence of all works of overwhelming dimensions, and by an agreeable intermixture of portrait and landscape—scenes from fancy and from nature. There is, indeed, an uncommon variety of subjects; there is little of what is commonly called the historical, and, what we wondered at, less portraiture than usual; fewer windmills after life, or cow-houses after nature—an abatement in the amount of stall-fed oxen, and a falling off in the staple commodity of three-acre parks, painted and framed, and called landscapes. But there is an increase in works of fancy and feeling: domestic history and social songs furnish more topics than usual for the pencil; poetic landscape has risen two or three degrees in the scale of excellence—studies from nature, of the heads of children, and groups of rustics abound, while over some of our baronial or ecclesiastical ruins the charm of colour and exquisite drawing is thrown:—on the whole, in purity of conception, and elegance of handling, we think the Society

52. '*The Town of Menagio, on the Lake of Como;*' HOFLAND.—In this picture the sky is serene, the air soft and balmy, the verdure tender and naturally green, and the lake itself lies unruffled as a mirror, showing the hills and sky: like many of the scenes from those sunny climes, it is more soft than we could wish—we like the grand and the severe.

61. '*View on the Serchio, near the Baths of Lucca;*' P. NASMYTH.—This Italian scene seems to have borrowed something of sterile grandeur from the native mountains of Peter Nasmyth, who painted it; it is coarse and vigorous, and perhaps not less Italian because it wears a rougher exterior than what we are accustomed to see in the landscapes of that country.

66. '*Study from Nature;*' INSKIPP.—All the works of this artist are distinguished by an air of originality, both in conception and colour. He deals, too, with the most simple subjects, rarely giving us more than one small figure at a time, and never laying the burthen upon them of labours difficult to perform, or of sentiments too complicated to express. He seems also to have dipped his brush in the self-same colour with which nature has bepainted her eastern brood, called gipsies; and, moreover, he is far from fastidious in the matter of elegant outline, or the grace of just proportion. The vigorous—the wild originality of the man, is a threefold recompense for all this, and, were we called upon to name the artist most to our liking, in his line, we would name Inskipp.

75. '*The Lady Chapel, Church of St. Pierre, at Caen;*' ROBERTS.—This is another of those picturesque things which show how strong the artist is in all that belongs to architecture.

80. '*Portraits of Lord Trentham and Lady Caroline Gower, Children of the Earl and Countess Gower;*' HURLESTONE.—This is a charming group, easy and natural, with no put-on looks nor assumed graces: we should have liked it the better had the sashes been more delicately blue, and the dresses less snowy.—130. '*Sons of B. Goad,*' is by the same hand, and every way equal in beauty and simplicity: the colouring is more subdued. The only rival of Hurlestone, in expressing the sweetness of youth, is Mrs. Carpenter, of whom we shall speak presently.

115. '*Baptism in the Days of the Persecution;*' G. HARVEY.—There is more variety of character in this picture than in any other work in these galleries. The subject was supplied by Professor Wilson's 'Lights and Shadows of Scottish Life'—a work abounding in fine pictures. The Covenanters have sought refuge in one of their wild glens, down which a stream is running: sentinels stand armed at the passes, and enclosing the pastor and his people; while young women in white present infants to be baptized. Old men and matrons gaze in silence and without fear; and the minister, taking water from the brook in his hands, calls on his people to witness the admission of a new member to God's

people. The artist has acquitted himself with no little skill in this important task: there is, it is true, something like a monotony of character among the heads; yet, on the whole, the scene is impressive, and continues present to the fancy, in spite of all the glowing cheeks and splendid dresses of more showy, but less substantial works, of which there are not a few around.

121. '*Study from Nature;*' MRS. HAKEWILL.—This study from nature is the head of an acquaintance, raised some twenty degrees in the glass of elegance and beauty, by the poetic mind of the fair artist. It is one of the loveliest faces in the room: the hand which performed this little miracle endeavoured to do the same for a male head, which, if we remember right, she calls the Portrait of a Gentleman; but a long nose, and a face moderate in its meaning, seem to have been too much for her, skilful as she is.

151. '*Caution;*' INSKIPP.—This represents a girl, bare legged and bare footed, gliding timidly onward to a foaming brooklet, over which her way lies. Little caution seems necessary, for feet so nimble as hers might skip across the stream at once; and we are quite sure that no country-bred girl, such as the artist imagined when he painted this, would hesitate a moment, but bound over it like a roe. The picture, in all other respects, is a fine one.

156. '*The Grecian Choirs at the Temple of Apollo;*' LINTON.—This splendid scene was suggested by a passage in Plutarch. "Nicias caused a bridge to be constructed at Athens, before his departure for Delos, magnificently decorated with gold and garlands, rich stuffs and tapestry; and on his arrival there, during the night previous to the ceremony, threw it across the narrow strait, between that island and Rhenia, at which latter place they landed. Early in the morning the procession marched over the bridge, and up to the temple, singing hymns to the deity." On each side of the strait the hills are crowned with temples; and on the bosom of the water the Greek ships are seen moving on to the sound of music: the scene is light and elegant, and the picture cannot fail to find many admirers.

162. '*In Peace Love tunes the Shepherd's Reed;*' MRS. HAKEWILL.—A pretty pastoral scene, such as poets dream, rather than such as nature presents. The Ettrick Shepherd piping on the Braes of Yarrow, would make a characteristic Corydon, true to the verses of Scott, and in better keeping with old Scotland than this, which is rather too Arcadian.

171. '*The Tomb of Hermione;*' MADDOX.—There is some good colouring here, and nature such as any one may praise.

185. '*Portrait of a Lady;*' DAVIS.—There are not many very good portraits in these galleries: those which represent gentlemen are the worst: we can praise this likeness in the spirit of meekness and moderation; there is good colouring and character in it.

194. '*Mrs. Selwyn and Child;*' MRS. CAR-PENTER.—A mother and child, and a very lovely pair: this is the finest picture of the kind in the place; and did we not dislike comparing one artist with another, we would say it is worthy of Lawrence. The maternal loveliness of the one, and the reposing beauty of the other, are such as few pencils of these days can rival. The colouring, too, is natural and becoming.

195. '*Edinburgh Castle, from the Grass-Market;*' ROBERTS.—The castle-crowned crag, with the wide grass-market at its base, is faithfully delineated: we wish Roberts, when he visits the gude town again, would go into the Lawn-market some clear moonlight evening, and look along one of those narrow openings called Closes, which lead towards the Firth of Forth. There he will see dyers' poles, with all their many-coloured streamers flying—women in mutches looking out of windows seven and eight stories up in the air—he will get a cut out of the New Town—the Firth, with its ships passing and repassing—a slip of the shore of Fife, and a broad strip out of the sky, with the moon, it may be, and a star or two by her side. Let him paint this, and he will soon find a customer —the picture would be beautiful.

207. '*Landscape;*' SIMS.—This picture seems to grow the more beautiful the longer we look at it. There is a rude hut filled with gipsies, and asses, relieved from their panniers, grazing at hand; while for miles beyond them we can see into a country, rich neither in corn nor poultry, or such things as those vagrants love to pitch their tents near. We wonder, therefore, what they are doing there; but we do not admire the skill of the artist the less, that, out of an unpromising subject, has evoked such a picture.

208. '*The Ettrick Shepherd in his Forest Plaid;*' GORDON.—This is, no doubt, a good resemblance of our inspired friend of Ettrick: the expression is, however, a shade too severe; and it would have been better had some sunshine found its way to his brow. We hear he has been cut as large as life, and at full-length, in stone, by Greenshiels,—a work which the poet, it is said, calls a capital performance: the authority may be strong in matters of verse—we doubt its accuracy in matters of art.

213. '*Group of Children;*' MRS. CARPENTER. —This lady deserves all the praise here, which we bestowed upon her picture of 'Mrs. Selwyn and Child,' with the addition, that in these innocence and beauty are in action. Graceful playfulness and arch simplicity unite here with fine natural colouring.

224. The first picture of a series to represent the '*Procession to the Abbey at the Coronation of William the Fourth; containing Portraits of distinguished persons who attended on that occasion.*' Painted for His Majesty: DAVIS. We need only say of a performance executed to royal commands, that it seems, as far so it goes, to accomplish the King's and the artist's wishes.

Patronage, they tell us, is a fine thing, and yet Mr. Davis would protest, we have no doubt, against our criticising this picture as a work of art.

238 and 262. '*Autumn,*' and the '*Coming Shower,*' are both by INSKIPP, and exhibit the same original qualities which we noticed in his other works: there are two others, 443 and 461, by the same artist, which he calls '*Studies from Nature,*' which surpass for truth and force all that surround them. They haunted us round the room, and, though now far removed from them, we see them as we write.

244. '*The noble Polish Girl;*' MISS A. BEAU-MONT.—This little picture has some agreeable light and shade, and is not deficient in character.

246. '*Wayside Cross;*' VICKERS.—There is considerable poetic feeling in this and other productions by the same artist; he has also a good sense of harmony in colouring, and meddles but with subjects which belong to history or imagination. '*The Crucifixion,*' and '*Rowena's Bower,*' are both performances of a poetic order; were the painter to make the atmosphere of his pictures a little clearer, he would extend the number of his admirers.

273. '*Portrait of John Taylor,*' by LONSDALE, is, perhaps, the best male portrait in the exhibition; there is a small-size picture of Lord Brougham and Vaux, by the same hand, which is also good, though less to our liking.

352. '*The Courier; or, Fate of the Battle;*' KIDD. — This is a little picture, full of indescribable drollery. It is a capital burlesque on the practice of the Fancy, of despatching pigeons to distant parts with the name of the victor in the pugilistic ring. A battle has been fought between two rustics; victory has just been declared, and the dove despatched with the glad tidings, is no other than an ass adorned with ribbons, and mounted by two boys, who are urging on the reluctant messenger, with all the speed that stupidity and stubbornness will permit, to diffuse the intelligence through the neighbouring villages. One of the riders is a little chimney-sweeper: he is holding on by his comrade's waist, and nothing is white about him, save the whites of his eyes and his teeth.

We must have done for this week. There is little that we have not seen before in the Sculpture Gallery; and the engravings are chiefly old acquaintances. There are some very pretty works in the Water-Colour Gallery;—ladies in all the glow of youth and beauty; old abbeys, with all the reverence about them which the sight of beauty in ruins excites; and flowers which rival nature in all save in fragrance.

"Living Artists.—No. XIV.
William Hilton, R.A."

Athenaeum (March 31, 1832), 209–10

HOGARTH, in one of his satiric works, represents the influence of patronage upon English painting by the symbol of a tree with three branches: the bough, which implied Landscape, kept green, but did not grow—that which stood for History was shrivelled in the bark and withered in the leaf—while the third, which perfigured Portrait, flourished like the green bay-tree. As painting was in those days, so is it still: the historic branch is shrunk and withered for want of public aid, while the great watering pipe of patronage flows continually for that of portraiture, and likenesses flourish in the land. One of the chief apostles in the unprofitable line of historic painting, is William Hilton; for these many years he has continued to swim against the running stream of public inclination: he has resisted discouragement in silence and tranquillity of heart—other artists have murmured much, but he has been resigned: he has neither submitted to subscriptions, nor petitioned the House of Commons. Year after year has witnessed the appearance of some new and noble performance ‘of his: as many of his works are purchased as enable him to live, and he paints on, in hope that better days are at hand. We heard, indeed, several years ago, that, weary of working on the barren branch of history, he had set his brushes in order, and mixed his palette for portraits; but the rumour died away, nor were we at all sorry; for though we know that following the muse of history has “damned his fortune to the groat,” yet we feel that the recompense in fame will hereafter not be small. Indeed, we would rather see him striving, like Wilson or Barry, to keep soul and body coldly together, with a pint of porter and a crust of bread, while he painted scenes from Milton and Spenser, than see him grow rich in likeness-taking, and riding out with lacqueys behind him, to get an appetite for dinner.

To the task of historical painting Hilton has brought a correct eye, a clear sense of form and quantity, considerable skill in colour, and unrivalled accuracy in drawing. He conceives well, groups naturally, and works freely. There is much beauty and grace in his productions: he has so much softness in his flesh, and fascination in his outlines, that he has half enticed us into a liking for allegory. He makes himself intimate with the poet, whose ideas he desires to embody. Spenser seems a great favourite; yet he disdains not to find subjects in obscurer authors: one of his pictures in Lord de Tabley's gallery was from a ballad called ‘The Mermaid,’ by Allan Cunningham. There is sometimes, however, a deficiency of dramatic power observable in his works: he has too little of that intense earnestness of purpose, which compositions of the kind demand. In this he resembles West more than any painter we know: all that the most perfect art demands is there, save a little vitality—that ethereal touch, which sets all in motion, and which may be called the soul of the performance. To paint fine groups, admirable in outline, graceful in attitude, and dipped in the fairest hues of heaven, is certainly a great achievement; but to inspire them with sentiment and feeling, and make them live in every limb, is a higher achievement still. Now, we do not mean to apply all this to the performances of Hilton; on the contrary, we have seen several of his pictures inspired as high as we could wish, and life and action impressed till we were even more than content. But these were,—and we were glad of it,—all subjects taken from the poets. Of his performances from Scripture we are not at all admirers; and we may say of his ‘Release of St. Peter,’ as a poet said of the Scriptural works of Blackmore,—

He undid creation at a jerk,
And of redemption made damned work.

We confess that we love Scripture as it stands, without painter's gloss or grammarian's comment: and we may moreover add, that we never saw a single painting,—and noble ones we have seen,—which raised us one iota higher than the simple words themselves had before raised us. We wish he would dip his brushes in things equally noble, though less sacred: a gallery formed from Spenser, and Thomson, and Collins, and Byron, would find many admirers.

Hilton, on the resignation of Thomson, who succeeded the captious Fuseli, was made Keeper of the Royal Academy. There is a small salary attached—there is also an apart-

ment for study, and another for repose—and, on the whole, his brethren have endeavoured to recompense him, as far as they could, for the sacrifices which he has continued to make in the cause of historical painting. As he is a man with a gentle voice, and mild and unassuming manners, he is much liked by the students, who compare him with Fuseli, as they would sunshine with storm. If we have not the learning of the Swiss, we have the gentlemanly ease of the Englishman ; and though he cannot reprimand the students in fifteen living languages, he can give them most useful instructions in their native tongue, which is sufficient for the purpose. There is no doubt, that had Hilton given way to despondency, and lifted in his vexation the pencil of portraiture, he would have succeeded in becoming popular. His fine drawing, his agreeable colouring, and his knowledge of nature, as well as art, would have made the labour easy ;—ladies who covet divine shapes and heavenly hues, would have flocked to his easel ; and gentlemen, desirous of having their heads made historical, would have followed. Then the painter would have avoided all the cost of fancy and outlay of invention, which the historic style requires. Reynolds, according to Northcote, complained that the historic style cost him too dear ; that is to say, it ate up time, required reading, a little thought, and a poetic feeling akin to that which inspired the historian or the poet. This did not suit Sir Joshua : to him portrait painting, with the shape and expression ripe and ready to be stamped off at so many hours' sitting, was a kind of royal mint engine, which coined gold at the rate of five guineas per hour : whereas, in historical painting, he had to sink his shaft, find the vein, dig the gold, and wash, refine, melt, and stamp it—a toil which made, even when payments were sure, a very niggardly return compared to the Aladdin lamp sort of work to which he was accustomed.

"Living Artists. — No. XVI. William Allan, A.R.A."

Athenaeum (September 8, 1832), 586–87

WILLIAM ALLAN, A.R.A.

THERE are but two Scotchmen connected with the Royal Academy, and Allan is one of them : he is, however, only an Associate, and has had the pain of seeing artists preferred, in the distribution of honours, whose works, in point of original conception and character, cannot be compared with his. How this has happened, no one out of the Academy can tell; it has not, however, been unobserved by others ; and we mention it to show, that some who have not the honour of being artists sympathize with a worthy and an ingenious man, who has been treated with injustice.

Allan conceives his subject well ; and in embodying it on canvas, he follows nature step by step, like one resolved to vindicate her works by his example. He has travelled in far lands, and taken sittings of beauty and character in other climates. His ' Sale of Circassian Slaves' is not one of those scenes which are created by the force of a teeming fancy alone : the artist was in the market and viewed the commodity ; and all the looks, and forms, and dresses of that very enchanting composition, are true to the land where the scene is laid. He travelled in Russia : hence his studio teems with the wild men of the desert; and it cannot be denied that he has caught the savage grandeur of the untameable Cossac. He was not long ago in Constantinople, and in the isles of Greece : we saw his portfolio ; it was filled with groups copied from nature ; with heads, bits of rocks, scraps of ruins, and all those picturesque materials, which talent can readily work into its more studied compositions : nor has he been unheedful of the attractions of his native land : his sketches of the beauties of Caledonia were to us far more interesting than all else he had to show ; and the groups which he drew of the Edinburgh lasses waiting round the well in the Lawn Market, till their turn came to obtain water, were full of natural elegance. Though he began with far lands, he has lately sought his subjects at home ; and it must be owned that he is skilful in choosing. His ' Circassian Slaves' is a splendid thing —glowing, but not gaudy, and realizing, in no small degree, those images of beauty with which the ladies of Circassia have bewitched the eastern world ; but his ' John Knox admonishing Queen Mary,' and his ' Balfour of Burley slaying Archbishop Sharpe on Magus Moor,' though of a sterner stamp, are of a higher kind of composition ; inasmuch as mental power and sentiment are more visible in them. One of the most beautiful of his works, is that of ' Sir Walter Scott reading in his Study at Abbotsford': the poet's back is to the window—the sunshine comes full on the paper he is intent on—and his face is seen by the reflected light : something, but not much, of that sad illness which has robbed us of many fine works, is written on his face : the grave, considerate look— the hair thin, white, and long—his peculiar way of sitting,—nay, the dress in which he delighted—all are there : we never saw any thing more real or natural.

All Allan's works show skill in grouping and knowledge of character ; but his sense of the importance of a historic subject often abates that ease and confidence of execution which produces excellence : he has few lucky hits : all is elaborated slowly and circumspectly out. He goes to work, too, in historical painting, in a way which we cannot help thinking is wrong ; instead of conceiving heads expressive of the characters with which he proposes to people his canvas, he seeks them among the living friends around him ; and we sometimes think he sets an ordinary head to a task too high for its faculties. He is much too fastidious, too, we apprehend, in small and subordinate matters : a button or a tassel, a sword-knot or a shoe-tie, are with him things of great weight. With less labour he would produce a better effect. We point out these imperfections—they are not called imperfections by some—in no other spirit but that of brotherly kindness : in an ordinary painter we should have laughed and allowed them to pass ; but Allan has almost all the fine elements of a true painter about him : he has pathos deep and touching— humour of a keen and original kind—a sense of character both rustic and heroic—a power of fancy equalled by few—and a skill which can delineate whatever his eye sees or his spirit conceives. We may add, that he is of pleasant address, agreeable manners, has a hearty enthusiasm for his profession, and is ever ready to aid young artists in the way most acceptable to genius—by judicious praise and kind encouragement.

In 1826 Allan succeeded Wilson as Master of the Edinburgh Academy of Arts ; and we hear that the institution prospers in his hands. He himself studied in the place where he is now master, and was the companion of Wilkie during the days of Grahame. To be so honoured in his own land, must be some consolation for the slight put upon him in England : he will, it is said, be elected at the first vacancy ; in truth, he cannot well be longer kept out, and so must come in. It is to the credit of Wilkie that he has ever contended and voted for the admission of Allan. The love of art, particularly of painting, is spreading in the north ; and we could name several young men of genius who will be heard of at no distant day.

"Living Artists. — No. XVII. C.R. Leslie, R.A."

Athenaeum (November 24, 1832), 760–61

LIVING ARTISTS.—No. XVII.

C. R. LESLIE, R.A.

Leslie stands high in the rank of our painters of domestic scenes, or subjects connected with life and manners. He is all nature, not common, but select—all life, not muscular, but mental. He delights in delineating the social affections, in lending lineament and hue to the graceful duties of the fire-side. No one sees with a truer eye the exact form which a subject should take; and no one surpasses him in the rare art of inspiring it with sentiment and life. He is always easy, elegant, and impressive: he studies all his pictures with great care, and, perhaps, never puts a pencil to the canvas till he has painted the matter mentally, and can see it before him shaped out of air. He is full of quiet vigour: he approaches Wilkie in humour, Stothard in the delicacy of female loveliness, and has a tenderness and pathos altogether his own. His action is easy: there is no straining: his men are strong in mind, without seeming to know it, and his women have sometimes an alluring *naïveté*, and unconscious loveliness of look, such as no other painter rivals.

It is so easy to commit extravagance—to make men and women wave their arms like windmill wings, and look with all their might —nay, we see this so frequently done by artists who believe all the while that they are marvellously strong in things mental—that we are glad to meet with a painter who lets nature work in a gentler way, and who has the sense to see that violence is not dignity, nor extravagance loftiness of thought. We could instance many of the works of Leslie in confirmation of this: nor are his pictures which reflect the manners and feelings of his native America more natural or original than those which delineate the sentiments of his adopted land. In this he differs from the best American writers: they are strong upon transatlantic earth, but the moment they set their foot upon British ground, their spirit languishes, and much of their original vigour expires. We are inclined, indeed, to look upon some of Leslie's English pictures as superior even to those which the remembrance of his native land has awakened. Roger de Coverley going to Church amid his Parishioners— Uncle Toby looking into the dangerous eye of the pretty Widow Wadman, and sundry others, are all marked with the same nature and truth, and exquisite delicacy of feeling. He touches on the most perilous topics, but always carries them out of the region of vulgarity into the pure air of genius. It is in this fine sensibility that the strength of Wilkie and Leslie lies: there is a true decorum of nature in all they do: they never pursue an idea into extravagance, nor allow the characters which they introduce to over-act their parts. In this Leslie differs from Fuseli, who, with true poetic perception of art, seldom or ever made a true poetic picture: Leslie goes the proper length, and not one step farther; but Fuseli, in his poetic race, always ran far past the winning-post, and got into the regions of extravagance and absurdity. When Leslie painted Sancho Panca relating his adventures to the Duchess, he exhibited the sly humour and witty cunning of the Squire in his face, and added no action: when Fuseli painted the Wives of Windsor thrusting Falstaff into the bucking-basket, he represented Mrs. Ford and Mrs. Page as half-flying: the wild energy with which they do their mischievous ministering, is quite out of character with nature, with Shakspeare, and with the decorum of the art.

The pictures of Leslie are a proof of the fancy and poetry which lie hidden in ordinary things, till a man of genius finds them out. With much of a Burns-like spirit, he seeks subjects in scenes where they would

25

never be seen by ordinary men. Some of his brethren single out nothing but the most magnificent themes for the pencil, as if their object was to show how low their flight is, compared to the height which the matter requires: but it is the pleasure of Leslie to take such subjects as are fit for mortal skill to delineate—which are out of the common road, because they are common, and to treat them in a way which surprises us with unexpected pleasures, and far exceeds our hope. His judgment is equal to his genius. His colouring is lucid and harmonious; and the character which he impresses is stronger still than his colouring. He tells his story without many figures: there are no mobs in his compositions: he inserts nothing for the sake of effect: all seems as natural to the scene as the leaf is to the tree. His pictures from Washington Irving are excellent: 'Ichabod Crane' haunts us; 'Dutch Courtship' is ever present to our fancy; 'Anthony Van Corlear leaving his Mistresses for the Wars' is both ludicrous and affecting; 'The Dutch Fire-side,' with the negro telling a ghost story is capital, and ' Philip, the Indian Chief, deliberating,' is a figure worthy of Lysippus.

We wish Leslie would seek more than he does for subjects in the poetry of the country: there are more of a nature to suit his feelings in the songs of Scotland alone than would form a gallery. The images contained in that splendid minstrelsy are defined and graphic, and are of all characters and kinds: all is limned visibly to the eye: you see men's faces, and hear them speak—nay, the very place where the story is laid is given, to the life. An artist would have really less to do in giving shape and colour to these vivid embodiments of the northern muse than in making pictures where he had to provide all that is to render them beautiful. We are induced to point to the north for another reason than the exquisite lyrics of Caledonia: Leslie, we are told, is of Scottish extraction, and has a liking to " Albyn's hills of wind." But we have no wish to lure his mind wholly from his native America, to which his genius is an honour: there are poets across the Atlantic whose strains abound with pictures according to his spirit. Let him paint what he likes—and what he likes alone: he can do nothing that will be unwelcome. We may look for many paintings from his hand, for he is but a young man.

Charles Lamb

"On the Total Defect
of the Quality of Imagination,
Observable in the Works of
Modern British Artists"

Athenaeum (January 19, 1833), 42–43; (January 26, 1833), 57; (February 2, 1833), 73–74

ON THE TOTAL DEFECT OF THE QUALITY OF IMAGINATION, OBSERVABLE IN THE WORKS OF MODERN BRITISH ARTISTS.

BY THE AUTHOR OF 'ELIA.'

THE paintings, or rather the stupendous architectural designs of M—, have been urged as objections to the theory of our motto. They are of a character, we confess, to stagger it. His towered structures are of the highest order of the material sublime. Whether they were dreams, or transcripts of some elder workmanship—Assyrian ruins old—restored by this mighty artist, they satisfy our most stretched and craving conceptions of the glories of the antique world. It is a pity that they were ever peopled. On that side, the imagination of the artist halts, and appears defective. Let us examine the point of the story in the 'Belshazzar's Feast.' We will introduce it by an apposite anecdote.

The court historians of the day record, that at the first dinner given by the late King (then Prince Regent) at the Pavilion, the following characteristic frolic was played off. The guests were select and admiring; the banquet profuse and admirable; the lights lustrous and oriental, the eye was perfectly dazzled with the display of plate, among which the great gold salt cellar, brought from the regalia in the Tower for this especial purpose, itself a tower! stood conspicuous for its magnitude. And now the Rev. * * * the then admired court Chaplain, was proceeding with the grace, when, at a signal given, the lights were suddenly overcast, and a huge transparency was discovered, in which glittered in golden letters—

'BRIGHTON—EARTHQUAKE—SWALLOW-UP-ALIVE!'

Imagine the confusion of the guests; the George and Garters, jewels, bracelets, moulted upon the occasion! The fans dropped, and picked up the next morning by the sly court pages! Mrs. Fitz-what's-her-name fainting, and the Countess of * * * holding the smelling-bottle, till the good-humoured prince caused harmony to be restored by calling in fresh candles, and declaring that the whole was nothing but a pantomime *hoax*, got up by the ingenious Mr. Farley, of Covent Garden, from hints which his Royal Highness himself had furnished! Then imagine the infinite applause that followed, the mutual rallyings, the declarations that " they were not much frightened," of the assembled galaxy.

The point of time in the picture exactly answers to the appearance of the transparency in the anecdote. The huddle, the flutter, the bustle, the escape, the alarm, and the mock alarm; the prettinesses heightened by consternation; the courtier's fear which was flattery, and the lady's which was affectation; all that we may conceive to have taken place in a mob of Brighton courtiers, sympathising with the well-acted surprise of their sovereign; all this, and no more, is exhibited by the well-dressed lords and ladies in the Hall of Belus. Just this sort of consternation we have seen among a flock of disquieted wild geese at the report only of a gun having gone off!

But is this vulgar fright, this mere animal anxiety for the preservation of their persons—such as we have witnessed at a theatre, when a slight alarm of fire has been given—an adequate exponent of a supernatural terror? the way in which the finger of God, writing judgments, would have been met by the withered conscience? There is a human fear, and a divine fear. The one is disturbed, restless, and bent upon escape. The other is bowed down, effortless, passive. When the spirit appeared before Eliphaz in the visions of the night, and the hair of his flesh stood up, was it in the thoughts of the Temanite to ring the bell of his chamber, or to call up the servants? But let us see in the text what there is to justify all this huddle of vulgar consternation.

From the words of Daniel it appears that Belshazzar had made a great feast to a thousand of his lords, and drank wine before the thousand. The golden and silver vessels are gorgeously enumerated, with the princes, the king's concubines, and his wives. Then follows—

"In the same hour came forth fingers of a man's hand, and wrote over against the candlestick upon the plaster of the wall of the king's palace; and the *king* saw the part of the hand that wrote. Then the *king's* countenance was changed, and his thoughts troubled him, so that the joints of his loins were loosened, and his knees smote one against another."

This is the plain text. By no hint can it be otherwise inferred, but that the appearance was solely confined to the fancy of Belshazzar, that his single brain was troubled. Not a word is spoken of its being seen by any else there present, not even by the queen herself, who merely undertakes for the interpretation of the phenomenon, as related to her, doubtless, by her husband. The lords are simply said to be astonished; *i.e.* at the trouble and the change of countenance in their sovereign. Even the prophet does not appear to have seen the scroll, which the king saw. He recalls it only, as Joseph did the Dream to the king of Egypt. "Then was the part of the hand sent from him [the Lord], and this writing was written." He speaks of the phantasm as past.

Then what becomes of this needless multiplication of the miracle? this message to a royal conscience, singly expressed—for it was said,

"thy kingdom is divided,"—simultaneously impressed upon the fancies of a thousand courtiers, who were implied in it neither directly nor grammatically?

But, admitting the artist's own version of the story, and that the sight was seen also by the thousand courtiers—let it have been visible to all Babylon—as the knees of Belshazzar were shaken, and his countenance troubled, even so would the knees of every man in Babylon have shook, and their countenances, as of an individual man, been troubled; bowed, bent down, so would they have remained, stupor-fixed, with no thought of struggling with that inevitable judgment.

Not all that is optically possible to be seen, is to be shown in every picture. The eye delightedly dwells upon the brilliant individualities in a 'Marriage at Cana,' by Veronese, or Titian, to the very texture and colour of the wedding garments, the ring glittering upon the bride's fingers, the metal and fashion of the wine pots; for at such seasons there is leisure and luxury to be curious. But in a " day of judgment," or in a " day of lesser horrors, yet divine," as at the impious feast of Belshazzar, the eye should see, as the actual eye of an agent or patient in the immediate scene would see, only in masses and indistinction. Not only the female attire and jewelry exposed to the critical eye of fashion, as minutely as the dresses in a lady's magazine, in Mr. M.'s picture,—but perhaps the curiosities of anatomical science, and individuality of posture in the falling angels and sinners of Michael Angelo, have no business in their great subjects. There was no leisure for them.

By a wise falsification, the great masters of painting got at their true conclusions; by not showing the actual appearances, that is, all that was to be seen at any given moment by an indifferent eye, but only what the eye might be supposed to see in the doing or suffering of some portentous action. Suppose the moment of the swallowing up of Pompeii. There they were to be seen—houses, columns, architectural proportions, differences of public and private buildings, men and women at their standing occupations, the diversified thousand postures, attitudes, dresses, in some confusion truly, but physically they were visible. But what eye saw them at that eclipsing moment, which reduces confusion to a kind of unity, and when the senses are upturned from their proprieties, when sight and hearing are a feeling only? A thousand years have passed, and we are at leisure to contemplate the weaver fixed standing at his shuttle, the baker at his oven, and to turn over with antiquarian coolness the pots and pans of Pompeii.

" Sun, stand thou still upon Gibeah, and thou, Moon, in the valley of Ajalon." Who, in reading this magnificent Hebraism, in his conception, sees aught but the heroic son of Nun, with the outstretched arm, and the great and lesser lights obsequious? Doubtless there were to be seen hill and dale, and chariots and horsemen, on open plain, or winding by secret defiles, and all the circumstances and stratagems of war. But whose eyes would have been conscious of this array at the interposition of the synchronic miracle? Yet in the picture of this subject by the artist of the ' Belshazzar's Feast'—no ignoble work neither—the marshalling and landscape of the war is everything, the miracle sinks into an anecdote of the day; and the eye may " dart through rank and file traverse" for some minutes, before it shall discover, among his armed followers, *which is Joshua!* Not modern art alone, but ancient, where only it is to be found if anywhere, can be detected erring, from defect of this imaginative faculty. The world has nothing to show of the preternatural in painting, transcending the figure of Lazarus bursting his grave-clothes, in the great picture at Angerstein's. It seems a thing between two beings. A ghastly horror at itself struggles with newly-apprehending gratitude at second life bestowed. It cannot forget that it was a ghost. It has hardly felt that it is a body. It has to tell of the world of spirits. Was it from a feeling, that the crowd of half-impassioned by-standers, and the still more irrelevant herd of passers-by at a distance, who have not heard, or but faintly have been told of the passing miracle, admirable as they are in design and hue—for it is a glorified work—do not respond adequately to the action—that the single figure of the Lazarus has been attributed to Michael Angelo, and the mighty Sebastian unfairly robbed of the fame of the greater half of the interest?

Now that there were not indifferent passersby within actual scope of the eyes of those present at the miracle, to whom the sound of it had but faintly, or not at all, reached, it would be hardyhood to deny; but would they see them? or can the mind in the conception of it admit of such unconcerning objects? can it think of them at all? or what associating league to the imagination can there be between the seers, and the seers not, of a presential miracle?

Were an artist to paint upon demand a picture of a Dryad, we will ask whether, in the present low state of expectation, the patron would not, or ought not to be, fully satisfied, with a beautiful naked figure recumbent under wide-stretched oaks? Disseat those woods, and place the same figure among fountains, and falls of pellucid water, and you have a—Naiad! Not so in a rough

print we have seen after Julio Romano, we think—for it is long since—*there*, by no process, with mere change of scene, could the figure have reciprocated characters. Long, grotesque, fantastic, yet with a grace of her own, beautiful in convolution and distortion, linked to her connatural tree, co-twisting with its limbs her own, till both seemed either —these, animated branches; those, disanimated members—yet the animal and vegetable lives sufficiently kept distinct—*his* Dryad lay—an approximation of two natures, which to conceive, it must be seen; analogous to, not the same with, the delicacies of Ovidian transformations.

To the lowest subjects, and, to a superficial comprehension, the most barren, the Great Masters gave loftiness and fruitfulness. The large eye of genius saw in the meanness of present objects their capabilities of treatment from their relations to some grand Past or Future. How has Raphael—we must still linger about the Vatican—treated the humble craft of the ship-builder, in *his* ' Building of the Ark"? It is in that scriptural series, to which we have referred, and which, judging from some fine rough old graphic sketches of them which we possess, seem to be of a higher and more poetic grade than even the Cartoons. The dim of sight are the timid and the shrinking. There is a cowardice in modern art. As the Frenchmen, of whom Coleridge's friend made the prophetic guess at Rome, from the beard and horns of the Moses of Michael Angelo collected no inferences beyond that of a He Goat and a Cornuto : so from this subject, of mere mechanic promise, it would instinctively turn away, as from one incapable of investiture with any grandeur. The dockyards at Woolwich would object derogatory associations. The depôt at Chatham would be the moat and the beam in its intellectual eye. But not to the nautical preparations in the ship-yards of Civita Vecchia did Raphael look for instructions, when he imagined the Building of the Vessel that was to be conservatory of the wrecks of the species of drowned mankind. In the intensity of the action, he keeps ever out of sight the meanness of the operation. There is the Patriarch, in calm forethought, and with holy prescience, as guided by Heaven, giving directions. And there are his agents—the solitary but sufficient Three—hewing, sawing, every one with the might and earnestness of a Demiurgus; under some instinctive rather than technical guidance; giant muscled; every one a Hercules, or liker to those Vulcanian Three, that in the sounding caverns under

Mongibello wrought in fire—Brontes, and black Steropes, and Pyracmon. So work the workmen that should repair a world!

ARTISTS err in the confounding of *poetic* with *pictorial subjects*. In the latter, the exterior accidents are nearly everything, the unseen qualities as nothing. Othello's colour —the infirmities and corpulence of a Sir John Falstaff—do they haunt us perpetually in the reading? or are they obtruded upon our conceptions one time for ninety-nine that we are lost in admiration at the respective moral or intellectual attributes of the characters? But in a picture Othello is *always* a Blackamoor ; and the other only Plump Jack. Deeply corporealized, and inchained hopelessly in the grovelling fetters of externality, must be the mind, to which, in its better moments, the image of the high-souled, high-intelligenced Quixote—the errant Star of Knighthood, made more tender by eclipse —has never presented itself, divested from the unhallowed accompaniment of a Sancho, or a rabblement at the heels of Rozinante. That man has read his book by halves ; he has laughed, mistaking his author's purport, which was—tears. The artist that pictures Quixote (and it is in this degrading point that he is every season held up at our Exhibitions) in the shallow hope of exciting mirth, would have joined the rabble at the heels of his starved steed. We wish not to see *that* counterfeited, which we would not have wished to see in the reality. Conscious of the heroic inside of the noble Quixote, who, on hearing that his withered person was passing, would have stepped over his threshold to gaze upon his forlorn habiliments, and the " strange bed-fellows which misery brings a man acquainted with"? Shade of Cervantes! who in thy Second Part could put into the mouth of thy Quixote those high aspirations of a super-chivalrous gallantry, where he replies to one of the shepherdesses, apprehensive that he would spoil their pretty net works, and inviting him to be a guest with them, in accents like these : " Truly, fairest Lady, Actæon was not more astonished when he saw Diana bathing herself in the fountain, than I have been in beholding your beauty : I commend the manner of your pastime, and thank you for your kind offers ; and, if I may serve you, so I may be sure you will be obeyed, you may command me : for my profession is this, To show myself thankful, and a doer of good to all sorts of people, especially of the rank that your person shows you to be; and if those nets, as they take up but a little piece of

ground, should take up the whole world, I would seek out new worlds to pass through, rather than break them: and [he adds], that you may give credit to this my exaggeration, behold at least he that promiseth you this, is Don Quixote de la Mancha, if haply this name hath come to your hearing." Illustrious Romancer! were the "fine frenzies," which possessed the brain of thy own Quixote, a fit subject, as in this Second Part, to be exposed to the jeers of Duennas and Serving Men? to be monstered, and shown up at the heartless banquets of great men? Was that pitiable infirmity, which in thy First Part misleads him, *always from within*, into half-ludicrous, but more than half-compassionable and admirable errors, not infliction enough from heaven, that men by studied artifices must devise and practise upon the humour, to inflame where they should soothe it? Why, Goneril would have blushed to practise upon the abdicated king at this rate, and the she-wolf Regan not have endured to play the pranks upon his fled wits, which thou hast made thy Quixote suffer in Duchesses' halls, and at the hands of that unworthy nobleman.†

In the First Adventures even, it needed all the art of the most consummate artist in the Book way that the world hath yet seen, to keep up in the mind of the reader the heroic attributes of the character without relaxing; so as absolutely that they shall suffer no alloy from the debasing fellowship of the clown. If it ever obtrudes itself as a disharmony, are we inclined to laugh; or not, rather, to indulge a contrary emotion?— Cervantes, stung, perchance, by the relish with which *his* Reading Public had received the fooleries of the man, more to their palates than the generosities of the master, in the sequel let his pen run riot, lost the harmony and the balance, and sacrificed a great idea to the taste of his contemporaries. We know that in the present day the Knight has fewer admirers than the Squire. Anticipating, what did actually happen to him—as afterwards it did to his scarce inferior follower, the Author of 'Guzman de Alfarache'—that some less knowing hand would prevent him by a spurious Second Part; and judging, that it would be easier for his competitor to out-bid him in the comicalities, than in the *romance*, of his work, he abandoned his Knight, and has fairly set up the Squire for his Hero. For what else has he unsealed the eyes of Sancho; and, instead of that twilight state of semi-insanity—the madness at second-hand—the contagion, caught from a stronger mind infected—that war between

native cunning, and hereditary deference, with which he has hitherto accompanied his master—two for a pair almost—does he substitute a downright Knave, with open eyes, for his own ends only following a confessed Madman; and offering at one time to lay, if not actually laying, hands upon him! From the moment that Sancho loses his reverence, Don Quixote is become a—treatable lunatic. Our artists handle him accordingly.

† Yet from this Second Part, our cried-up pictures are mostly selected; the waiting-women with beards, &c.

"Exhibition of
the Royal Academy"

Athenaeum (May 11, 1833), 297–98; (May 25, 1833), 329

EXHIBITION OF THE ROYAL ACADEMY.

It is now seventy years and odd, since the Royal Academy was founded, and Reynolds averred that painting would in consequence go on improving in lustre and sentiment till it all but reached perfection. Were we to compare the pictures of that day with the works of this, we should find that the prophecy of the President is neither fulfilled nor fulfilling ; and that the propriety of establishing an Academy at all, is at least questionable. We see no works in the present exhibition, but such as might have been produced had the Academy never been ; and we see many very indifferent productions, which the facilities the institution holds out to dulness, have called into existence. Sir Walter Scott, in one of the introductions to his inimitable novels, calls portrait-painting the art of " levying a tax upon the vanity of mankind, which could not have been extracted from their taste or liberality." This tax has been levied with a merciless hand by the artists of the year 1833 : out of eleven hundred and seven paintings and drawings, there are not less than six hundred portraits, and of one hundred and eighteen pieces of sculpture, eighty are busts. To be more particular, the three principal galleries where the Royal Academicians exhibit their own pictures, contain in all four hundred and eighty-one paintings : two hundred and seventeen of these are portraits of men and women—we don't reckon horses and dogs: one hundred and thirty are of a poetic or historic stamp, and the remaining one hundred and thirty-one may be arranged under landscape. Portrait, therefore, everywhere prevails—nor is it, with a few exceptions, of the first order : Wilkie has, indeed, burst out like a comet ; the President too has one or so of high merit, Phillips has perhaps more, and Pickersgill one at least worthy of his reputation : others might be named, but the vast residue are of that kind, which neither gods nor men love. Some of the stars of the Academy are waxing dim : Turner has his usual nature, but wants his usual poetry ; Leslie, though full of character, is scarcely so happy as

heretofore ; Callcott, were it not for his Highland landscape, might be reproached with feebleness ; Landseer is less brilliant than we remember him—we say this without forgetting his *Scott in the Rhymer's Glen ;* if Wilkie surpasses all his brethren in portraiture, his *Spanish Monks,* though admirable, are not equal to his *John Knox ;* Etty has not advanced a step ; Pickersgill, in all save his fine portrait of Humboldt, has retrograded ; Howard has come down a little in his poetry, and Hilton is stationary. On the other hand, it is cheering to think that Allan is stronger in genius and science than we have ever seen him ; Collins has risen higher than he has hitherto done : nay, we even see amendment in the works of Westall—some of his landscapes are well conceived. With regard to sculpture, Chantrey maintains his high station, and Baily has a noble figure of Marius seated on the ruins of Carthage. We hope, however, that Scotland will forgive the indignities offered to two of her brightest sons : the head of Scott by H. Westmacott, and the statue of Thomson by Rossi, are enough to breed discord between the countries, and if it be true that the Lord Chancellor is a Scotchman, we think his bust by Francis will dissolve the Union, for our sensitive brethren of the north cannot but consider these things as a premeditated insult. On the whole, we think that five exhibitions during the last seven years, have been superior to the present—the torpedo touch which took the spirit out of our literature, has had its influence, we fear, on art. We now proceed to notice more in detail the works which pleased us most.

6. This portrait of *Baron Humboldt* was painted, PICKERSGILL says, in Paris, during the autumn of 1831 : it is a very noble performance ; the attitude is easy, the colouring natural, and the head full of thought.

7. Spenser provides the subject of this picture, and ETTY has treated it in a way not unworthy of the illustrious poet : it represents *Amoret rescued by Britomart :* the contrasts are fine ; an almost naked virgin ; a lady "like Bellona armed in proof," with flashing eyes and brandished sword ; and " the Enchanter Vilde," grovelling on the ground, and vanquished in spite of his spells, unite in forming a fine composition: the colouring is rather extravagant.

8. *Rotterdam Ferry-boat.* What seamen call the "carry of the cloud," is painted in this picture as true as nature itself, by the hand of TURNER ; nor is the sea or the sea-craft less happily represented.

16. It was to this picture, *The Murder of Rizzio,* we alluded, when we said that ALLAN was stronger in science and genius than we had ever seen him. This is, in truth, a fine historical work : we need not describe an event which history has made familiar to all : the beauty and terror of the Queen, the fear which has come on her maidens, and the fierce barbarity of the assassins, are delineated with much truth of character and depth of colour ; but the

most impressive touch in the composition, is the brandished arm and dagger of the remorseless Ruthven: the shadow moves on the wall, seeming to threaten Darnley, and mystically intimates his approaching fate. This is truly poetic.

22. *Godiva preparing to ride through Coventry*, is a picture which cannot fail to increase the reputation of JONES. The extreme loveliness and unaffected modesty of that generous princess are embodied in rich and natural colours; she is seated on horseback, and her tresses, descending in a shower about her, show more beauty than they can conceal. The picture is worthy of the inimitable Stothard.

25. KNIGHT, who painted this little picture, calls it *Sunset*. It is a group, and an interesting one. The beams of the setting sun attract the notice of a cottage matron and her children, and—

In his cheering rays
The unskilled peasant learns to contemplate.

27. The eastern scenes of W. DANIELL are generally airy and graceful. *The Falls of Courtallum*, in Southern India, form a fine picture.

33. We cannot say more in praise of this portrait of the Speaker of the House of Commons, by PICKERSGILL, than that the likeness is good; it is too literal, and bears an every-day look.

34. CONSTABLE has used more natural colours in this picture of the morning breaking on the groves and pinnacles of Englefield House, than what is usual with him.

40. These peasants of the kingdom of Naples, —a girl and two children,—are from the pencil of HOWARD; the drawing is defined and distinct, and the colouring, though not vigorous, is agreeable.

45. MRS. CARPENTER seldom displeases us with her portraits; she has some poetry in her nature, and calls it forth when she sits down to her easel; her portrait of the Countess of Denbigh may be compared, without fear, with the female heads of most of the Academicians, from some of whom she would surely win the honours of the Academy, were a lady allowed, as of old, to become a competitor.

50. LESLIE—a great favourite of ours—is hardly so happy in his pictures as usual: this can scarcely apply to *Tristram Shandy recovering his lost Manuscript*. Our readers may remember how the astonished author discovered that the lady of the house where he lodged had used his writings in curling her hair. She takes them from her curls with the most ludicrous composure, and drops them, one by one, into Tristram's hat, who receives his lost treasure back with a look which partakes both of displeasure and joy.

51. This picture, representing boys returning from the haunts of the sea-fowl, is one of the happiest of all the works of COLLINS. Two adventurers have descended half way and more down some perilous cliffs; two of their companions await their coming below, while two wounded fowls flutter along the face of the

rock, and seem clinging with all their remaining strength to haunts they must for ever abandon.

57. *Portrait of Sir Gilbert Blane, Bart.* The President has given us a happy, and not ungraceful likeness of this venerable person. We have seldom seen SHEE in greater force than in the present exhibition.

59. CLINT has considerable talent for humour; he has managed the difficult duel between Sir Toby and Sebastian, in the Twelfth Night, with no little skill: the knight and his companion, Sir Andrew Aguecheek, are masterly: not so Olivia; she inclines to be stumpy,—when we say this we see she is stooping forward somewhat.

70. This is one of the finest pictures in the Exhibition: the name is *Harvest in the Highlands*. The figures are by LANDSEER, and the landscape by CALLCOTT. There is a rivalry between the nature living and the nature inanimate, and we know not how to decide between them; we half incline to the landscape, for the splendid mountains seen dimly amongst the mist, the wild heath, the standing grain, and the clump of dark desolate-looking firs, gain upon us greatly; but then these fine peasants, and still finer animals, in the foreground—we cannot decide.

78. The carousing scene in the Twelfth Night, wherein Malvolio reproaches Sir Toby, is not quite so effective as the duel scene with Sebastian; it has, nevertheless, some characteristic parts. CLINT has a number of clever pictures this season: when he becomes an Academician himself he will find better places to hang them in.

84. There is much fine fancy in this picture by HOWARD. It represents a Chaldean shepherd contemplating the heavenly bodies: the artist has revealed to his sight—

Celestial shapes that wait upon the moon
In her swift course, or rise from ocean's lap
Continuous.

88. This *Portrait of the Earl of Eldon for Merchant Tailors' Hall*, is from the easel of PICKERSGILL—the likeness is good, though a little heavy.

94. The sky is a touch or so too blue in this landscape; but the heath, seen at noon through the moist air, may be compared, for truth and vigour, with anything in the Academy: it is by CONSTABLE.

106. *Venice, and the Bridge of Sighs*, by TURNER, is more his own than he seems aware of: he imagines he has painted it in the Canaletti style: the style is his, and worth Canaletti's ten times told.

117. In this picture of *Rebecca and the Servant of Abraham*, the hue is eastern, the character Jewish, and the drawing and grouping worthy of the painter—HILTON.

125. It is related of John Van Goyen, that when he wished for a subject to his pencil, he manned a yacht, stood out to sea, and often, in a stiff breeze, and sometimes on the edge of battle, sketched the war ships of his country—

hence the truth and beauty of his delineations. TURNER, in this picture, has given us Van Goyen looking out for a subject: it is a happy production.

132. *The Retreat at Naseby* is from the pencil of COOPER, and every way worthy of this truly English artist. The skirmish of the hurrying cavalry is very animated: horse and man seem of a piece. Like the pictures of Clint it is not so well placed as it deserves.

133. COLLINS has painted *The Stray Kitten* in his best manner; it is a picture that many will covet, for it cannot but be felt by all.

134. This is the finest picture of the kind in the exhibition: when WILKIE was in Spain, he saw a young monk on his knees confessing or whispering to one of his elder brethren: from that he conceived the present work: the earnest but perturbed look of the former, and the mild but judge-like expression of the latter, are masterly. The proprieties of both character and art are well observed—when were they otherwise by Wilkie?, The colour, too, is deep and harmonious.

138. A mother has placed her infant on a chair, and stands before it smiling and cracking her thumbs: the picture is by LESLIE, and, like all he does, natural.

139. This is much made out of little. A child is placed in a washing-pail, and guided down the stream by some urchins scarcely older than itself MULREADY calls it *The First Voyage*, and we see nothing to find fault with, but something to praise both in the name and the picture.

140. We wish WILKIE had not painted this: as a likeness it is as good nearly as any other of His Majesty in the galleries; and, as a work of art, it is superior: but he has not dared perhaps to handle it with the freedom which insures a fine picture: it is too formal.

145. The President, in this portrait of Sir George Staunton, has excelled himself. It is a graceful and becoming work, and, like the original, mentally and bodily.

170. *A Jack in Office*, is a well-fed and much caressed dog, who, like his friend of the manger, keeps others from tasting the food of which he has too much. We do not profess to be admirers of this sort of animal portraiture, but the works of LANDSEER are always characteristic and worthy of notice.

185. *Entrance to Pisa, from Leghorn:* the sea is still, the air calm, and the whole scene in the best manner of CALLCOTT.

207. This is by far the noblest portrait picture in the exhibition: WILKIE has imagined the Duke of Sussex

All plaided and plumed in his tartan array,

as Earl of Inverness: a ruin is on one side— a wild heath beyond him—a noble stag-hound looking up in his face—and a dead eagle lying at his feet. The manly freedom of posture— the wild highland air of the expression—and the matchless vigour and untameable splendour of the colours raise it twenty degrees above all

surrounding portraits. The likeness is a little modified from the original.

214. *Greek Fugitives: an English Ship sending its boats to rescue them.* EASTLAKE has told this story of Grecian wo charmingly: the characters are varied—the colours vivid—and the groups huddled together in a way that shows the poet as well as painter.

We have now gone through the Great Room: on looking over it again, we see there are many pictures not included in our list, which are too valuable to be forgotten; we can make room only for the numbers and names of the artists. 1. Mrs. Robertson; 14. Kennedy; 23. Callcott; 46. Newton; 47. Daniell; 52. Phillips; 76. Shee; 97. Collins; 101. Jones; 107. Reinagle; 108. Ward; 126. Watts; 144. Patten; 148. Hayter; 150. Ward; 161. Reinagle; 163. Linnell; 168. Etty; 175. M'Call; 179. Robson; 198. Phillips; 206. Phillips; 215. Linnell; 229. Cooper; 232. Clint; 238. Patten. We must defer the other rooms till next week.

EXHIBITION OF THE ROYAL ACADEMY.

[Second Notice.]

BEFORE we resume our notices of the leading works in the Exhibition, we wish to say a few words regarding the Academy itself. It is the practice of the President and the members to invite to their private views and entertainments, such persons only as sit for portraits, commission pictures, or fill official situations. A man of genius sometimes may be found amongst them; but it is neither talent nor taste which they desire to honour. When a poet writes a poem, he commonly sends copies to his tuneful brethren, because he considers them judges: he usually sends copies to critics, because he wishes to hear the opinion of men of taste, but he seldom or ever wastes his treasures on mere men of rank, because he neither regards their opinion nor their station. It is otherwise with the Royal Academy. We do not blame them in one sense for this: the Academy is a manufactory where forty persons have obtained the privilege of preparing a certain quantity of coloured canvas and hewn stone, for market; and as there are not more than a dozen men of high natural genius amongst them, the duller residue do well for themselves in keeping away the tasteful and the talented, till their works are surveyed by those

Who wonder with a foolish face of praise,

and then put their hands in their pockets and purchase. Even this long established and long successful system of management has failed at last: the Royal Academy have got a lesson, which, as it is addressed to that sensitive part the pocket, the dullest may understand: among all the titled and the wealthy, who at the private view wandered through their wilderness of works, the artists were not able, we are told, to dispose of one article. This hint to the pocket is worth ten thousand counsels to the ear: let the Academy profit by it.

R.H. Horne (?)

"Martin's
Illustrations of the Bible"

Westminster Review 20 (April 1834), 452–65

ART. XI.—*Illustrations of the Bible.* By John Martin. Parts I to VI.—4to.

JOHN Martin is the most universally popular painter of the day. His reputation was as rapid in its growth as it was wide in its spread. No painter ever took so sudden and violent a hold upon the fancy of the public. All at once he blazed a meteor in the world of art. The multitude were astonished. and they admired. His first great picture, ' Belshazzar's Feast,' startled like a brilliant firework ; which it very much resembles. The *coup d'œil* of this picture produced an electrical effect. It required no effort of the mind to comprehend or appreciate it. People who could see no beauty in the Cartoons of Raphael, were captivated by its novelty and splendour. They were at no trouble to explain the rationale of their admiration. Their praises were re-echoed by the universal voice of the public. It was a bold experiment on the public taste, and its success was complete. There seemed to be no difference of opinion as to the surpassing merits of the picture ; no question as to the extraordinary genius of the painter. The language was beggared of epithets to characterize this pictorial wonder. All the attributes of sublimity were assigned to it. ' If such be the outset of Martin's career,' thought the public, ' what may we not expect ?' The painter did not disappoint his admirers. He followed up his successful hit by fresh displays which were only less rapturously received because the style had no longer the charm of novelty to recommend it. He seized upon other supernatural events recorded in the Bible. The preternatural seemed the

only field where his imagination could find scope. To 'Belshazzar's Feast' succeeded 'Joshua commanding the Sun to stand still;' 'The Deluge;' 'The Fall of Babylon;' 'The Fall of Nineveh.' If Martin was not equally successful in such subjects as Macbeth, it was only because there was not room for the wings of his fancy to expand. He next multiplied his pictorial creations by means of engraving. Here was new cause for wonder. To think that such a mighty genius could condescend to acquire a mechanical art, and stoop to the drudgery of a copyist! The necessity was easily accounted for; no engraver could be found to do justice to these marvellous productions of the pencil. Thenceforth every engraving bore the stamp of originality. It was soon perceived that the strong contrasts of black and white were no less striking in their effects than the glare of colour. The black of mezzotint admirably imitated the palpable obscure of darkness, and the pitchy clouds of tempest and fiery rain. Next it was discovered that Martin's pictures contained many in one; whereas the pictures of other artists could hardly be curtailed of their proportions without injury. Here was new ground for admiration; and it was gravely proposed, as Juliet said of her lover, to cut them into little stars, each one in itself a world of invention.

Martin now took Milton for his guide to scenes of celestial beauty and infernal horrors; where his genius might revel in the unearthly splendours of Pandemonium, and roam in the antediluvian bowers of Eden, getting bright glimpses of the gates of Heaven. His first publication of the Illustrations to Milton was in two editions, the plates being engraved of different sizes from the same designs; and he has since engraved some of the most striking and popular subjects on a still larger scale, to range with his great prints. Not content with having both amplified and reduced the scale of these designs, he has introduced several of them into the Bible Illustrations. These repetitions are considered to be proofs of the unimprovable excellence of the designs, as well as of their extensive popularity.

This is but a faint sketch of Martin's triumphant career. His progress has been like the journey of a king or a conqueror; —one perpetual succession of shoutings and homage. The appearance of a new print from his hands is, like the raising of a standard, the signal for his followers to rally round it; and their loud notes of praise, reverberated by the press, are borne upon the wings of the broad sheet to distant lands. But each successive burst of applause now becomes fainter; and a brief interval of pause, which may probably be succeeded by another great shout, gives a chance for the still small voice of reason and argument to be heard.

It would be as easy to deny as to assert the claims of Martin to the high distinction he has attained as an epic painter. But little has been said to prove either the one or the other. Those who have questioned the degree of his merits, have of necessity done most towards proving their case. To his admirers the language of encomiastic praise has been most congenial; and it must be confessed they have made abundant use of it. The why and the wherefore, is too much disregarded by *soi-disant* critics of pictures. The productions of the pallet have been scurvily treated by them. The phraseology of the painting-room, and the cabala of connoisseurship are ready substitutes for proofs by reasoning; and the mere dictum of the writer is all that is vouchsafed in the way of argument. Indeed he has commonly no other reason to give for his praise or blame, than his like or dislike. The judgment of the press is almost as false as the taste of the public. To criticise painting requires a knowledge of the art, as well as of its productions. Few modern critics are thus qualified. Hazlitt was the only great critic of paintings in the recent period. He understood them both theoretically and practically. He brought to bear upon the subject, a mind stored with knowledge, a fine taste, an acute intellect, and an enthusiastic love of the art. He described and analyzed a fine picture, with glowing eloquence. It has been beautifully said of his writings, that 'they threw a light upon the subject, like that of a painted window.'

That Martin is a painter of genius, no one will dispute. A man endowed with superior faculties for some particular art, possesses genius for that pursuit. It is the quality and capacity of his genius that is to be determined, by an examination of his works. Their value as pictures depends upon the inventive power evinced in their conception, and the skill displayed in their execution.

The invention of the painter consists not only in the originality and fertility of his conceptions, but in the power with which his imagination brings before us past scenes and events. His executive skill is shown in the spirit and correctness of his delineation, and the vividness and reality with which the whole scene is represented.

The executive part of painting is a mechanical art requiring a quick and correct eye and a ready hand. It is the mind that gives value to a picture, A lively and vigorous imagination is requisite to constitute a great epic painter. The picture that carries us into the time and place of the event, placing before us the actors in the scene, depicting the character and feelings natural to each, realizes all that the art is capable of. What

the poet has conceived and described, the painter has embodied. In Raphael's Cartoons of the Death of Ananias, Elymas struck blind, Paul preaching at Athens, the actual reality seems brought before us. Had Raphael painted Belshazzar, he would have represented his face blank with terror and dismay; his concubines looking to him for support, and aghast at finding his dread greater than their own; while the guests would be gazing with awe and alarm, or hiding their faces in their garments unable to bear the fearful sight. He might have left out the hand that wrote on the wall; for the story would be read in the faces. How has Martin treated the subject? Belshazzar is Wallack the actor, in an affected attitude, with a common-place look of fear; the prophet is the Rev. Mr. Irving; the soothsayers resemble the vocal priests of the opera, arrayed in cumbrous draperies; and the concubines are a mob of females with preposterous trains, fainting in the most extravagant postures. Instead of ' the fingers of a man's hand writing over against the candlestick on the plaster of the wall of the king's palace,' there is a pyrotechnic display of colossal hieroglyphics on the marble frieze of a stupendous temple, lighted by beacons, and filled with crowds of people numerous enough for a whole nation; and what is the effect? Are we sensible of the finger of God; or impressed with awe at the event? Not at all; we admire the brilliancy of the light, the vastness and theatric splendour of the scene. The shew is the main feature, and the event itself a mere opportunity for its introduction. The picture has no moral sublimity. It is a gorgeous imposition. Martin is a wonderful scene-painter. His picture addresses the eye only; and by producing a strong sensation, deludes the spectator into the notion that he is affected by the moral of the event; just as the effect on the senses, of the music, pomp, and incense of the Romish church, is often mistaken for religious feeling.

His Joshua is another instance; but there is no need to multiply proofs. The comparison between Raphael and Martin may be thought unfair, because the styles of the two painters are so different; but as Martin treats the most sublime subjects, his pictures heightened as they are by the aids of splendid scenes and effects, should produce an impression upon the mind equal at least to the unadorned creations of Raphael. But as has been shown, he fails in conveying the sentiment of his subject. He not only does not delineate character nor depict emotion, but his pictures have no human interest. Let him be tried by a lower standard—Rembrandt; and no picture

can be more apt for this purpose than ' Jacob's Dream*.'
The subject is visionary ; and the picture depends entirely
on effect. Jacob is a Dutch boor asleep in one corner, and
his dream is shadowed forth on the clouds. Heaven seems
to open, and the spectral forms of angels appear to ascend
and descend on a ray of light. The undulating outline of the
homely landscape is seen in the distance through the twilight.
Nothing can be more simple or more impressive. You
are touched with a feeling like that experienced in reading
the description of the incident in the Bible. The rude and
homely figure has the effect of heightening the sublimity and
supernaturalness of the scene, and of bringing its beauties
home to us. Rembrandt has represented the vision of Jacob
as the patriarch might have dreamed it ; and if he had
represented it literally as described,—a ladder instead of a
beam of celestial light,—the effect would not have been less
solemn. It is the feeling of the painter that enters into
the picture, which affects the beholder. We view the scene
through the medium of his mind, and are impressed in
proportion to the truth and vividness of his perception. Were
Martin to paint such a subject, he would project a stupendous
flight of steps so far into infinite space that we should feel we
had no right to see the end of it, and people it with myriads of
winged forms, the visions being steeped in light, and set in a
frame of black clouds, while a city of palaces built on rocks
would be seen in the distance, and a melodramatic figure sleeping
in the foreground ; yet this display of vast pictorial machinery
would not affect the mind so powerfully, as the modest and
natural representation of Rembrandt. And why ? The more
remote a thing is from our habits, the less it affects us.
The most powerful way to address the imagination is through
the habits, not through the senses. Martin can only do the
latter. If he could do both, he would indeed be the great and
wonderful painter he is thought. Rembrandt's Belshazzar is
only a sensual burgomaster in a jewelled turban and robes ; but
the abject terror in his brutal face makes us lose sight of its
vulgarity, and see only the human being. A coal-heaver
horror-stricken, would be a more sublime sight than Macready in
Macbeth. The extrinsic aid of splendid dresses and gorgeous
scenes, has a less share in producing strong emotions in a
picture than on the stage, and in real life none at all. The mind
is so absorbed by the passion of the scene, that the decorations

* In the Dulwich Gallery.

are impertinent intrusions, which if taken into account, only make their nothingness more evident. Yet these are all that Martin gives us. The characters are lay figures—and as stiff and unnatural—on which to hang showy draperies.

But to consider Martin's merits as a scene-painter. The grand principle of scenic effect is illusion. Illusion implies the reality of the thing imitated as well as of the imitation. Martin's scenes want the elements of reality and probability. They are monstrous creations. If unreality and ideality were convertible terms in art, then indeed, Martin would be ideal. They are not sublime pictures, simply because they do not awaken sublime emotions. The mind is not elevated by the ideas they convey of vastness, grandeur, and splendour; because the vastness is impossible, and the grandeur exaggerated. The eye is dazzled by meretricious glare and glitter, but the sight moves us not. The glories of Martin's pictures 'play round the head but never reach the heart.' If to surprise and amaze were the end and aim of painting, they would accomplish it. Martin's is the hyperbole of the pencil, the bombast of painting. He is to Raphael and Michael Angelo, what Lee and Blackmore are to Shakspeare and Milton. He paints nature upon stilts. His solemn scenes are as gloomy as Young's Night Thoughts; his beauties as artificial as the descriptions in Hervey's Meditations. His fancy has a monomania; it sees all things through the medium of one set of ideas. His imagination is morbid and feeble; morbid, because it never produces a scene of simple and natural beauty; feeble, because it does not conceive new scenes, but only reproduces new combinations of the same materials on the same principle and with similar effects. His pictures are made by recipe; differing only as the views produced by that ingenious toy 'the myriorama,' which by means of a few landscapes drawn with the same height of horizon, produces by shifting the portions an infinite variety of sameness that teazes till it disgusts; or like scenes composed out of the same set of models variously placed, and viewed under one kind of artificial light, only moved a little this way or that. If you have seen one or two of Martin's pictures, you have in a manner seen all; for you know by anticipation, how he will treat the subject, and are sure to find it composed of the same elements. With him every thing is in excess; multiplication is his favourite rule. But excess is the evidence of a feeble rather than a luxuriant fancy. His cities are composed of palaces piled one upon another with domes and towers; and whether it is the abode of mortals, devils, or angels,—Babylon, Pandæmonium, or the

Celestial City,—there is no essential difference. His landscapes are all alike. The scene of the Paphian Bower is only one of Paradise with a Grecian temple. His mountains and crags too, are all of a pattern ; and whether it rains hail or fire, the clouds are equally black.

The only novelty is in his original idea of accumulating an immensity of stupendous objects by means of perspective, and heightening the most obvious and palpable sources of the sublime. It is a grand and striking idea, but much better adapted to the stage than to a picture. It was an improvement upon Gandy's architectural visions of Pandæmonium, &c.— strange aggregations of enormous structures ; castles in air with geometrical plans and elevations, each a night-mare to the fancy. Martin cut and set in the foil of effect, the rough gem which Gandy had dug up. He massed and laid out these crowded heaps of buildings into long vistas, piled temple on temple, terrace on terrace, multiplied columns *ad infinitum,* scattered pyramids in profusion, and made Babels as common as shot-towers. Instead of the light elegance of Grecian temples, he chose the cumbrous masses of Egyptian architecture ; and substituted for the statues and classic decorations of Gandy, barbarous and uncouth figures of monsters, and the chimæras of modern furniture ;—the funeral pyre of his Sardanapalus is a heap of couches like the furniture piled up in an upholsterer's ware-room. He sets off the whole with an *ad libitum* effect of light and dark, garnished with the accompaniments of lightning and fire. To return to the illustrations of the Bible, — or rather illustrations of Martin's style of treating subjects in Scripture History ; of which nearly all, it should be observed, have appeared in his Milton. In 'The Creation,' the Creator is represented as usual by a venerable old man with a high forehead, long beard, and voluminous drapery, who is skimming over the surface of the waters, his hands extended in opposite directions, as though he was tossing the planets round him like a juggler, and was about to catch the sun with one hand, and had just flung the moon behind him with the other. The admirers of Martin mistake their astonishment at his boldness in personifying the Deity, for awe at the sublimity of the idea. The scene, strange to say, wants vastness ; for the crags that protrude above the waters are not the summits of mountains, but only masses of rock that diminish the vast expanse of water to a little lake ; besides its being evident from their forms, that they could not resist the volume of water that is supposed to be in motion over them.

In the ' Fall of Man,' and in all the scenes of Paradise, Adam looks like a Hercules ; and both he and Eve seem conscious, not only of the want of clothes, but of the loss of them ; the universal mother of mankind treads the ground like a modern fine lady stepping through the mud to her carriage. The scenes in Eden convey no idea of the youth and luxuriant freshness of the spring-time of nature in its primæval state ; nor of the repose, the seclusion, the security, and the bliss of Paradise. Lakes and alpine mountains, rocks and stunted old trees, are intruded ; and the scene looks bleak and gloomy, wild and comfortless. The idea of luxurious plenty is intended to be conveyed by pine-apples growing like weeds. The trees are artificial almost to caricature ; and the whole scene looks like a ' composition.' In ' The Expulsion,' Adam and Eve walk upon a rocky causeway that seems purposely prepared for them. The ' Death of Abel' is a similar scene ; and the altars are erected on the summit of a rocky steep, in order to enhance the horror of the whole; but it is evident that the contrast of a deed of blood with a smiling landscape would be greater, independently of the probability that the place of offering would be a pastoral scene.

In the ' Deluge' the water descends in a mass on each side of the picture and rushes down a semicircular abyss, carrying with it fragments of rock and myriads of bodies, leaving a central platform of rock for a great heap of human beings, with elephants and camelopards intermixed ; while in the distance is the bed of a huge waterfall greatly magnified. The groups are in the most extravagant and unnatural attitudes, and awaken no feelings of sympathy or horror. The blank desolation and leaden aspect of all nature in Poussin's Deluge, convey the idea of a vast flood, and a sense of universal calamity ; but in this picture we only perceive the efforts of the artist to bear down the senses with substantial evidences of destruction. There is an utter want of pathos.

In 'The Covenant,' instead of the face of nature having resumed its serenity, and looking hopeful at the revival of her beauty, the scene is made more desolate by an array of rocky mountains. The animals are very orderly descending an inclined plane of rock in pairs, like school-boys going to church, instead of roaming abroad as rejoicing in their liberty. Noah, instead of being a simple patriarchal old man surrounded by his family, looks like a necromancer with his muslin robes ; and the rainbow, instead of spanning the heavens, forms a semicircle above the head of Noah.

The ' Destruction of Pharaoh's Host' is a plagiarism from

Danby's picture of the same subject; especially one beautiful natural effect of the pyramids seen in the distance, their sublime and simple forms rising up against the light of the setting sun. Martin's pillar of fire is much better than the sharp streak of phosphoric light, looking like a slit in the canvas in Danby's picture. But why this sooty cloud of rain? Is not the incident itself grand and appalling enough, but the painter must dress it up with his cloudy pall and the pictorial pomp of effect with which he ushers in all preternatural events?

The 'Seventh Plague,' is merely one of Martin's cities of Egyptian temples with pyramids and beacons, and vast floors of polished marble, with confused crowds flying hither and thither; while a priest in robes is commanding a tempest like another Prospero. A vivid flash of forked lightning serves to relieve the gloom; but it does not give the effect of that pervading brightness that accompanies the appearance of lightning; it only lasts for a moment, it is true, but it lasts as long as the lightning.

The 'Destruction of Sodom and Gomorrah,' is a bird's-eye view of another vast city of palaces; but as they were cities of the plain, the artist surrounds them with rocks instead of raising them thereupon;—the artist can do nothing without rock. An arch of pitchy clouds covers the devoted cities, from which pour like an infernal shower-bath, thin streams of liquid fire setting the distance in a blaze, and only throwing down the central parts; the falling buildings looking like a mass of loose types,—what printers call 'in pie.' Over the rocks in the foreground Lot and his daughters are making their way, past a very modern-looking villa, and Lot's wife is standing on a lower crag in the favourite attitude of Miss Fanny Kemble, her arms upraised, and one foot stretched out to give height to her form. This single figure is proof sufficient that the artist did not truly conceive the spirit of the scene. The 'Pillar of Salt' which she became, conveys the idea of the fixed attitude of one who had deliberately stopped, and was looking back with a settled expression of regret at leaving the city.

In 'The Finding of Moses,' neither the scene nor the persons are Egyptian; and the infant Moses is laid in a little tuft of weeds, instead of 'among the flags' which furnished the 'bulrushes' of which the 'ark' was made. In 'Moses and the Burning Bush,' the scene is no place to keep sheep; but a rocky desert, with a mountain piled up with forests and a great light shining through a tree; it is a mere piece of effect conveying none of the sentiment belonging to the event.

In speaking of these plates little has been said of the drawing

of the figures. Bad drawing is not the only defect of Martin, though it is the only one that his admirers will recognize. As mere executive skill is too narrow a basis upon which to raise a reputation for an artist, so also it is too unimportant a defect, palpable and lamentable though it be, upon which to impugn the character of his genius. This discussion of the merits of Martin's pictures, however, cannot be dismissed without considering their execution. And first of his figures. To take only the groups of Adam and Eve in 'The Expulsion' and 'The Death of Abel,' where the figures are prominent. The drawing is execrable; displaying a merely mechanical knowledge of the exterior markings of the figure, without the power of altering it to suit the action of the body. In the 'Expulsion' Eve looks like a lay figure—a great jointed doll; the group of Adam and Eve lamenting over the dead body of Abel, is a burlesque of nature, both in the attitude and expression. The smaller figures are less faulty, because there is little room for the display of ignorance of drawing and anatomy. But this is no excuse for representing Adam receiving the sentence of God in the attitude of an injured husband watching the approach of the man with whom his wife, who kneels at his feet in the attitude of Canova's Magdalene, has just acknowledged she has committed a *faux pas*. It would be waste of time to go into the long catalogue of Martin's enormities in designing and drawing groups of figures. The taste displayed in their drapery is worthy of the forms they clothe; being not only tawdry and theatrical, but unwearable. The dignity and elevation of his principal personages are represented by the length of their trains. Priests, prophets, and magicians, all look as though they were attired in a suite of window curtains,—Noah, Moses, or Daniel, differing only in the colour of their drapery. Of Martin's colouring little need be said; it is admitted on all hands to be glaring and unnatural, the consequence of his early practice as a painter on glass; and he has himself in a manner abandoned it, by resorting almost exclusively to engraving,— which medium is a great improvement to the effect of his pictures. His effects of light and dark are arbitrary; —that is, they are not to be accounted for on principles of nature. He extends the dominion of light or shade just as it suits his purpose. One of the most difficult parts of landscape painting, is to give to the various objects the proper quantity of local colour, and light and shade, and at the same time to make them harmonize with the pervading effect of the scene; Martin avoids this altogether. He subjects himself to no laws of nature. He may say as Fuseli did when he was painting his

monstrosities;—'*Dum* Nature! she puts me out.' Martin however is subject to the laws of perspective,—or rather, he is master of them, and makes use of his sovereign power to put himself above the law. In order to produce the most powerful effect of perspective he raises the point of sight to an aerial height, so as to make his landscape almost what is termed a bird's-eye view; and also brings the plane of the picture close to the eye, by which the diminution of objects is rendered extremely violent. He further gives a perspective of depth below, as well as distance before, the eye; and not content with that, he diminishes the size of objects in the same plane right and left, making a kind of focal perspective, the objects graduating in size as the light does in vividness in a scene viewed from a central fixed point; thus making an exaggeration of an effect which is in itself so slight as to be cognizable by theory only. This is a license not borne out by truth, nor justified by the beauty of the effect, for the eye being accustomed to the perspective of nature, the appearance is unpleasing because it overstrains the senses and perplexes the understanding. In the instance of a panoramic view,—that is, a scene where more is represented in a picture than can be taken in by the eye at one time,—wherever the eye turns, the plane of the picture turns with it, and it is governed by the same laws as a view taken from one point of sight. But not content with these advantages, Martin purposely exaggerates and even falsifies the perspective of his pictures upon occasion. He often shows distant figures larger and more distinctly than they would appear in nature; satisfied with obtaining the effect of violent diminution in his fore-grounds. He also violates the ordinary scale of proportion in objects near the eye. In the 'Deluge' in these illustrations of the Bible for instance, there are two or three figures on the point of the crag which are gigantic in size compared, not only with those about them, but with those near the eye. Another method which Martin resorts to in order to impress the sense with ideas of vastness, is the application of the well-known rule of relative proportion as a standard of size. The height of a column, a tree, or a mountain, is determined by the size of the man, or animal, or other familiar object of unvarying size. Upon *their* dimensions it depends whether the column shall be twenty or fifty feet high; whether the mountain shall be of the height of Highgate-Hill, or the Himalaya; whether a fragment of rock shall be of a size that Ajax might have thrown, or a crag to support a host of people. So far as mere relative proportion of size is concerned, this holds good; but there are other circumstances that enter into the consideration in a

pictorial view ; viz. the texture of the masses of rock consti-
tuting the mountain ; the size of the blocks of marble forming
the pillar ; the natural consistency between the comparative
height of the tree and the man ; and the probability of the
architecture being of such stupendous vastness as is repre-
sented. For example, if a view of a street with people be
drawn, and a female be represented sitting at a window with a
very tiny figure of a man in her hand, this alone does not
suffice to convey the idea of Glumdalclitch amusing herself
with Gulliver ; because to our eyes, as beings of Gulliver's race,
the coarseness of the flesh of the female, and of all the
materials, is not made evident. This incoherence would pre-
vent the sense from being impressed with an idea of the
actuality of the scene. Gulliver would be Lilliputian in size,
while Glumdalclitch would only appear an ordinary mortal.

In Martin's pictures of Satan floating on the fiery gulf, in
order to convey an idea of his immense bulk and stature, the
rest of the fallen angels are represented no bigger than so many
shrimps thrown up in shoals on the forked waves of flame ; but
the deception is rendered transparent by the fact that rocks and
caverns are drawn to the scale of the figure of Satan, who
therefore appears only of the size of ordinary mortals, instead of
' floating many a rood.' The proportions of the caverns of Hell
should be on the scale of the ordinary devils, not only to give
magnitude to Satan, but to impress us mortals with due notions
even of their vastness. It is an argument worthy of Mr. Mar-
tin's consideration,—that magnitude beyond probability or be-
lief, fails to impress the imagination ; because the senses refuse
to deal with it as a reality, and its effect upon the habitual feeling
fails accordingly. Again, in the picture of the Deluge, the ark
was a little floating barge, instead of looming in the distance
like the floating cradle of a future creation. It would be su-
perfluous to multiply examples ; the mention of these will
serve as a key to other discrepancies ; such, for instance, as
showing rows of columns in perspective so thickly placed that
there is not room for their bulk ; pyramids so close together,
that their bases would intercept one another ; landscapes piled
up to the clouds, as though the surface of the earth were con-
cave instead of convex. Another trick of expediency may
be mentioned to show how much the artist is in the habit of
' begging the question' in his designs. In the scene of the
falling Angels from Milton, the artist has drawn them as though
they were projected horizontally from the clouds ; and then
turned the plate end-upwards, in which position, from the
inscription beneath, it is intended to be viewed ; though the

proper way to look at it is evidently the way in which it was drawn, for the action of the figures is not that of falling.

These are only a few of the many proofs that are afforded by Martin's works, that his aim is to impose on the senses; and to effect this object, he resorts to all kinds of expedients. Yet with these 'appliances and means to boot,' his pictures fail in impressing the imagination or enlisting the feelings, as has been shown. Their grand deficiencies are in moral qualities. He does not project his mind into past ages, live in the scene and bring it before us on the canvas. His conceptions are not one and indivisible; they are vast aggregations of huge structures, with crowds of people, and images of physical grandeur, heaped up so as to cram the picture, and fill the immensity of space. The eye is bewildered, and seeks in vain for some place to rest; the attention is distracted, and at a loss for some one incident to fix upon; there is no repose, no point of attraction, and therefore no interest. One single incident vividly portrayed, would be worth the whole of the picture besides. In Poussin's picture of the Deluge, a pair of hands seen emerging from the flood, conveys a fine idea of a man drowning; Martin introduces this image on every occasion, and more than once in the same picture. In the same way, a beautiful group of figures, a striking attitude, some peculiar effect in nature which the artist has seen and admired, is lugged in on every occasion; so that it would seem as if he calculated the value of his pictures according to an inventory of pictorial effects, which is much the same as if a person should sit down and compose a poem or a play out of beautiful passages from others, to fill up a frame-work of his own invention. It is on this principle that Martin employs and judges the effect of vastness and obscurity as sources of the sublime; forgetting that the vastness to be impressive, must be proportioned to our sense of reality; and that the obscure is only sublime when what is shown conveys a coherent idea of the grandeur of the whole. Martin's scenes are neither natural nor ideal. They are the likeness of nothing ' either in heaven above or on the earth beneath.' Instead of partaking of the unearthly glories of the one and the human interest of the other, they share neither. His landscapes are like the flying island, floating between heaven and earth, exciting only wonder. Creation, as God has made it, will not suit him; he must have a world of his own to paint. His pictures are opium dreams, a phantasmagoria of landscape and architecture, as Fuseli's and Blake's designs were of human beings. His style is to the true and genuine art, what the hallucinations of the visionary

are to the realities of life. The time is not far distant when his merits will find their true level, and his pictures be appreciated as the inventions of an ingenious scene-painter, well suited to form the back-ground of an acted oratorio.

T.H. Lister

"Cunningham's
Lives of British Artists"

Edinburgh Review 59 (April 1834), 48–73

ART. III.—*Lives of the most Eminent British Painters, Sculptors, and Architects.* By ALLAN CUNNINGHAM. 6 vols. 12mo. London: 1830-1-2-3.

THIS is a very entertaining collection of biography—entertaining, much to the author's credit, in spite of the barrenness of the subject. The lives of painters are comparatively uneventful—their professional achievements have scarcely any influence upon the more important interests of society—and their works, however charming, have little interest in description. Nevertheless Mr Cunningham, by a lively style, the frequent interspersion of anecdote, much judicious quotation from good writers, and a prominent exhibition of his personages in their literary and social capacities, wherever circumstances admitted, has produced six volumes, containing more amusing reading, of a biographical kind, than it has often been our fortune to meet with. Perhaps it may be objected, that his anecdotes are sometimes trivial, irrelevant, and superfluous. For example—and this example shall suffice—of the forgetfulness of the Rev. Samuel Reynolds, the father of Sir Joshua, it is said, ' that in performing a journey on ' horseback, one of his boots dropt off by the way, without being ' missed by the owner; and of his wit—for wit also has been as- ' cribed to him!—it is related, that in allusion to his wife's name,

' *Theophila,* he made the following rhyming domestic arrange-
' ment,

> ' When I say The,
> Thou must make tea;
> When I say Offey,
> Thou must make coffee.'

As for the former of these anecdotes, it is probably a fabrication;
perhaps sportively attributed, without the expectation of being
seriously believed. Boot and stirrup must have been as remarkable
in their idiosyncrasy as the worthy divine, and must have strange-
ly conspired with absence of mind, to make any part of the story
possible. As for the latter, though the Rev. Samuel Reynolds
might, without serious impeachment of his understanding, *impro-
vise* such nonsense to his wife and children by his own fireside,
we think he would have marvelled not a little at the *labor
ineptiarum* of succeeding ages, if he could have been told that
nearly a hundred years afterwards, a biographer would insert, re-
vise, print, correct, and publish such trash for the edification of
the nineteenth century.

It may also be objected, that partialities and prejudices are
but too apparent in this work. Some persons are the objects
of eulogy, others of a dislike, which nothing recorded in the text
appears to justify. Reynolds is evidently the object of ill-will.
Praise is grudgingly bestowed, and censure industriously insert-
ed, even sometimes at the expense of consistency. If a good
trait is mentioned, it must be immediately neutralized by some-
thing unfavourable; and a qualification must be inserted in the
midst of the praise, which makes it scarcely of any value. Thus
—' Reynolds was commonly humane and tolerant; *he could in-
' deed afford,* both in fame and in purse, to commend and aid the
' timid and the needy. When Gainsborough asked sixty guineas
' for his Girl and Pigs, Sir Joshua gave him an hundred; and
' when another English artist of celebrity, on his arrival from
' Rome, asked him where he should set up a studio, he informed
' him that the next house to his own was vacant, and at his ser-
' vice.' Mark how Sir Joshua's merit is studiously lessened.
He could ' afford' to do these gracious actions! Mr Cunningham
has nevertheless, in another place, made Reynolds jealous of this
same Gainsborough, whom he could thus ' afford' to encourage.
But lest the qualifying clause should not sufficiently lower our
estimation of Reynolds, we are told immediately afterwards, that
' he could be sharp and bitter on occasions;' and that one day,
' fixing his eye on a female portrait by a *young and trembling
' practitioner,* he *roughly* exclaimed, " What's this in your hand?

' A portrait! You should not show such things:—what's that
' upon her head—a dish-clout?" The student *retired in sorrow,*
' *and did not touch his pencil for a month.*' How skilfully is this
told! How well are our sympathies enlisted on the side of the
young and trembling practitioner! How ably is our indignation
excited against the brutality of Reynolds! How dexterously is
our disapprobation ensured by the unfortunate result! Mr
Cunningham does not give his authority for a statement so little
in conformity with Sir Joshua's general character; but we pre-
sume he must have had authority, or he would not have made
such a statement: we do not, therefore, dispute the fact,—we
only admire the manner in which Mr Cunningham has intro-
duced it. We will give one more instance of ingenious depreciation.
Reynolds sometimes asked Burke's opinion about his paintings—
' it was given readily. Sir Joshua would then shake his head and
' say, " Well, it pleases you ; but it does not please me ; there is
' a little sweetness wanting in the expression, which a little pains
' will bestow. There! I have improved it." This,' adds Mr
Cunningham, ' when translated into the common language of
' life, means, " I must not let this man think that he is as wise
' as myself; but show him that I can reach one step at least
' higher than his admiration." ' We have seldom witnessed a
more elaborate and wanton endeavour to affix an unfavourable
construction to a very natural and innocent speech. Again, after
saying that Reynolds ' had the singular art of summoning the
' mind into the face, and making sentiment mingle in the por-
' trait,' he concludes, and neutralizes his eulogy, by adding, that
' he was a mighty flatterer;' and, had Colonel Charteris sat to him,
' he would,' Mr Cunningham doubts not, ' have given him an
' aspect worthy of a President of the Society for the Suppression
' of Vice.' We know not if Charteris looked the scoundrel that
he was, or if he could assume the appearance of amiability. If
he could, it was Reynolds' part to portray that appearance, and
not to enquire if the sitter's private character corresponded with
his benignant countenance. If Charteris could not help looking
like a scoundrel, he could not have been painted with the coun-
tenance of a good man, except at the expense of likeness; and
we are not told that Sir Joshua ever sacrificed likeness to this
imputed disposition to flatter. Nay, it might have been remem-
bered, that in the case of Johnson, to whom Reynolds surely
would have been as much disposed to administer flattery as to a
Colonel Charteris, that the rigid fidelity of his delineation piqued
the vanity even of the Doctor, who protested against being
handed down to posterity as ' Blinking Sam.' We therefore see
no good ground for this assertion, on a point respecting which

Mr Cunningham can know no more than anybody else; and which serves only to convey the impression, that Reynolds was willing to prostitute his pencil to the despicable work of investing moral turpitude with a delusive charm.

We may here observe, that there is much confusion of thought in the verbiage lavished, both in this and other works on art, in praise of what is called an ' honest pencil.' Some persons speak as if portraits were painted for the public at large ; as if any want of the most rigid fidelity of representation was a dereliction of duty towards that public; and as if the painter was bound to be as accurate as an historian. Now, though portraits *may* become ' historical,' they are almost invariably painted originally for some private individual—for the person represented, or his friend or relation ; and their tastes must necessarily be consulted respecting pictures which are to become their property, and which they are about to purchase at considerable cost. This seems a very plain way of viewing the subject; yet, somehow, in the warmth of declamation, persons of very respectable acuteness contrive to lose sight of it altogether.

We find other instances of confusion of thought into which Mr Cunningham's imagination leads him. ' The painter,' he says, ' who wishes for lasting fame, must not lavish his fine colours and ' his choice pictures on the rich and titled alone; he must seek ' to associate his labours with the genius of his country.' It is painful to be obliged to interrupt this eloquence, to intimate the homely facts, that portrait-painters do not select their subjects, but must paint those who may choose to sit to them ; and that if they are dependent on the profits of their profession, they must paint those who can afford to pay them. But let us listen again to Mr Cunningham, and we shall be informed, that ' the most ' skilful posture, and the richest colouring, cannot create the repu- ' tation which accompanies genius ; and we turn coldly away from ' the head which we happen not to know, or to have heard of. ' The portrait of Johnson has risen to the value of five hundred ' guineas ; whilst the heads of many of Sir Joshua's grandest lords ' remain at the original fifty.' We should be glad if we could draw any appropriate conclusion from this tissue of truisms. Far from questioning the concluding facts, we will imagine a still stronger case of a similar description. The vilest daub, if it could be ascertained by indubitable proof to convey a faithful representation of the features of Shakspeare, would probably bear a higher value than the most exquisitely painted portrait of an undistinguished person from the hand of Vandyke. But what would this prove? Would it place the dauber, who was so fortunate as to have Shakspeare for a sitter, on a level with Vandyke? Would

it prove any thing with respect to *painting* ? Just as much as the undubitable circumstance, that a lock of Shakspeare's hair would be infinitely more prized than a lock of one unknown to fame ; and if Mr Cunningham had said that an autograph letter of Johnson's had been sold for a considerable sum, whilst the autographs ' of ' many of Sir Joshua's grandest lords' were held comparatively valueless, he would have adduced a fact as incontestable, and at the same time just as apposite, as that with which he has favoured us.

The portrait of a distinguished person may be valuable and admirable as a picture, but it is valuable chiefly as a memorial or relic ; and the value which it thus acquires, belongs wholly to the subject. Mr Cunningham writes as if it had not occurred to him, that a portrait could be regarded in more than one point of view—that it could be valued on more than one account—and as if all the interest and estimation arising from the distinguished subject, was a clear addition to the reputation of the artist. Far from this being true, the reverse of it is the case. The tenfold increase in the case of Johnson's portrait was a tribute, not to Reynolds, but to Johnson. When the subject is eminently distinguished, we feel, while contemplating the portrait, that the fame of the artist is completely merged and lost in that of the eminent person he has painted ; and, in fact, we can attend to the merits of the artist, and do full justice to his ability, chiefly while looking at the portraits of those who interest us comparatively little. We find many other instances of this want of correctness of thought. Thus he says, ' the capital old paintings of ' the Venetian school which Sir Joshua's experiments destroyed, ' were not few ; and it may be questioned if his discoveries were a ' compensation for their loss. The wilful destruction of a work of ' genius, is a sort of murder committed for the sake of art, and the ' propriety of the act is very questionable.' The exercise of a little plain sense might have relieved the work from this last sentence. To attach any sort of moral guilt to what Reynolds did is absurd. The expediency of the attempt depended, of course, upon the probability of a successful result. It cannot be supposed that Sir Joshua would destroy valuable paintings, without the confident hope of a valuable discovery ; and if his hope had been fully realized, and if the secrets of Venetian art had been so elicited, as to be thenceforward practised by him, and communicated to others, surely it would be as wise to say, that sowing wheat is shameful waste, as to complain, in a tone of sentimental regret, of the ' murder committed for the sake of art,' which was to bring forth fruit an hundredfold.

Of Mr Cunningham's partialities in favour of some artists, we

are inclined to speak much more indulgently than of his dis-
likes; for excess of praise is an amiable error, and to be visited
only with our mildest censure: but we must observe, that par-
tiality is a little shown even in the selection of some of those
who have been recorded among ' *eminent*' British painters;—that
Cosway, Runciman, Ramsay, and perhaps Bird, are hardly en-
titled to the appellation of *eminent*—that Blake, the able, but, alas!
insane author of some very striking and original designs, could
scarcely be considered a painter—and that Sir G. Beaumont's
highly commendable patronage of art, and presumed natural talent
for painting (if ' fortune' had not ' rendered the gift unavailing'),
cannot, in the absence of higher practical proofs of his talent than
the world is acquainted with, quite entitle him to a place in these
volumes. Still more leniently will we advert to symptoms of a
national partiality towards the late excellent and accomplished
Raeburn (in which, peradventure, we are fellow-culprits); and of
a literary leaning towards artists in whom literary talent was more
evident than pictorial merit—as, for example, Fuseli and North-
cote. We must not, however, omit to state, that there is an evi-
dent partiality towards those who were coarse, unrefined, and
repulsive in their habits, in preference to those who were po-
lished and refined. We have seen how Sir Joshua's rebuke to a
' trembling' student, is made to appear harsh and odious. But
when we turn to the life of Wilson, who was ' a drinker of ale
' and porter, one who loved boisterous mirth and rough humour
' —things not always found in society which calls itself select'—
it is curious to mark, how that which had been condemned in
Reynolds is not merely described in milder terms, but actually
made matter of commendation. ' Such was the *blunt honesty* of
' his (Wilson's) nature,' says Mr Cunningham, ' that when draw-
' ings were shown him which he disliked, he *disdained*, or was
' unable to give a *courtly* answer, and made many of the students
' his enemies.'
 Having noticed these faults, we gladly return to the more plea-
sing office of commendation. We think that Mr Cunningham
has not only collected, with commendable diligence, whatever was
worthy to be recorded respecting the various subjects of his
memoirs, but has portrayed them in a lively, picturesque, and
attractive style—skilfully avoiding whatever was dull or unim-
portant, and introducing, easily and naturally, much pertinent
and pointed remark.

 The retrospect of British art is not a glorious and inspiriting
theme. Horace Walpole assuredly erected no monument to the
fame of his country, when he composed his ' Anecdotes of Paint-

' ing.' It is an elaborate record, not of our pictorial affluence and successes, but of our poverty and failures. There is no work by which we are more inevitably led to draw an inference as unfavourable as we now know it to be unjust. An examination of the history of painting in England, from the earliest times to the commencement of the reign of George I., would lead us only to this conclusion, that there was such an inaptitude in the English people, a spirit so uncongenial with the growth of art, that patronage, and example, and rivalry, and the presence of foreign competitors, and the sight of the collected treasures of foreign art, could not stimulate our sluggish natures to even a creditable aspiration after excellence in painting. If any one in the reign of George I. should have held it to be impossible that Englishmen could become painters, he might be considered excusable for an assertion which we should now hear only with pity and derision. Perhaps in no other art or calling was the supply so inadequate to the demand. Perhaps in no other branch, whether of art or manufacture, was the English public so long and so largely indebted to foreigners, and so sparingly to native skill. Of painters in England, from the commencement of the art, to the beginning of the reign of George I., Walpole enumerates 255. Of these, only 103 were English; and even this small number cannot be made up without including amateurs; and the list is swelled by some professed artists of such signal obscurity, that the diligent annalist who has recorded their names, could not even ascertain the kind of subjects which they painted. But the insignificance of this list (the harvest of two centuries) will be better understood, if we enquire who among the 103 had the slightest pretensions to celebrity. Unless we attach a very humble meaning to the term celebrity, it will be necessary to deny that there were any; for there were only *seven* English artists whose names will even be noticed —Hilliard and the two Olivers, painters in miniature—Dobson, who produced a few second-rate portraits, and fewer third-rate historical compositions—Barlow, a respectable painter of birds—and two portrait-painters, Walker and Riley. These were the most eminent native artists whom England produced during two centuries! Nor were there symptoms of improvement; on the contrary, the art declined. ' We are now,' said Walpole, in speaking of the reign of George I., ' arrived at the period in ' which the arts were sunk to the lowest ebb in Britain.' The two best who appeared in that reign were Richardson, better known as a writer than as a painter; and Sir James Thornhill, scarcely remembered but as the father-in-law of Hogarth, and the painter of some bad frescoes in the cupola of St Paul's, for which he was remunerated as if he were only a plasterer of a

more costly description, at the rate of forty shillings the square-yard.

We find it difficult to assign a satisfactory reason for this long-continued absence of even respectable proficiency. National inaptitude would be the sweeping reason which might have been plausibly offered a century ago ; but we cannot admit that reason *now*, and we have no other to supply its place. There was no want of encouragement and demand. Mr Cunningham says, that artists never stood lower in the estimation of mankind, than on the accession of Henry VIII. ' They were numbered ' with the common menials of the court; they had their livery ' suit, their yearly dole, and their weekly wages.' True : but similar, at a later period, was the condition of players ; yet these found among their ranks a Ben Jonson, and a Shakspeare. Besides, Henry VIII. honoured and encouraged painting. He first formed the nucleus of the Royal Collection, which was augmented by succeeding monarchs, but which contained at his death no less than 150 pictures. He patronised Holbein, employed him, and admired him ; and told a petulant courtier, who complained of the painter, that ' of seven peasants he ' could make seven lords, but he could not make one Hans.' There is no evidence, as Walpole tells us, that Elizabeth had much love of painting ; and there is evidence that she did not understand it ; for she once ordered her portrait to be painted ' with the light coming neither from the right nor from the left, ' without shadows, in an open garden light.' But it was not absolutely necessary for the encouragement of painting that the sovereign should be a judge of art. Elizabeth loved to be painted, and to tax the skill of the artist in ingenious flattery. This was sufficient, if not to circulate a correct taste, at least to set a fashion favourable to artists, and to disseminate a love of portrait-painting among the more opulent portion of her subjects. In the reign of Charles I. there was positive encouragement given to art, and of a kind which ought to have elicited pictorial talent if the germs of it had anywhere existed. Charles understood and valued painting. He collected munificently and judiciously, thereby raising the standard of the public taste, and making his people familiar with the contemplation of excellence. The cartoons of Raphael, and the splendid gallery of the Duke of Mantua, were brought to England during his reign ; and the royal collection at Whitehall was augmented to 460 pictures ; among which were nine by Raphael, eleven by Correggio, sixteen by Julio Romano, and twenty-eight by Titian. Not only by the display of beautiful pictures, but also by the presence of distinguished artists, might the national taste have been stimulated ; for Eng-

land was within a short period visited by Rubens and Vandyke. During sixteen years of the reign of Charles, the arts of peace might be securely cultivated; but no great artist was called into notice by all the encouragement and example with which that period had been more than usually replete. No native talent appears to have been elicited, which, struggling through the storms of civil war, and suppressed for a while by the discouraging frown of sectarian austerity, was ready to revive under the countenance of Cromwell (of Cromwell, who sat to Lely, and was chiefly solicitous that he might not be flattered, but that all the warts on his face should be accurately painted), and would have burst forth with elastic vigour in the joyous reign of Charles II., when all that the austerity of the puritan had discountenanced, was lauded and followed with prodigal excess. But no such Englishman appeared. Only one distinguished artist was alike favoured by the Protector and the King, and he was a foreigner, Sir Peter Lely. And who succeeded—some say supplanted—him? Another foreigner, Sir Godfrey Kneller. To four distinguished foreign artists, Holbein, Vandyke, Lely, and Kneller, we had thus been almost entirely indebted for portraits of the most eminent persons who had appeared in England during a century and a half. Scarcely any Englishman was found to follow, even at a humble distance, in the pursuit of so popular an art. We may lament the circumstance, but we cannot explain it. To say that the English of that period were of a nature too coarse and rugged to excel in an art requiring such delicacy and refinement of taste, is to advance a reason which facts will not support. We could certainly compete in refinement with Flanders; and there was in the dress, manners, and amusements of those times, much that was more akin to, and conducive to painting, than is to be found in the more sobered habits of the present day. Men who spent half an income in adorning their persons, were likely to desire that some memorials of their splendour might be handed down to posterity through that most appropriate channel—a portrait. Men who sought pleasures which addressed themselves to the eye, and planned and exhibited splendid pageants, were likely to desire to see them painted. We cannot, in a word, discover any specific cause of the fact in question; and must content ourselves with saying, that it fortuitously happened that England did not during that period produce any persons in whom the love of art, and the disposition to adopt it as a profession, so concurred, as to produce a great painter. Portrait-painting was throughout this period the style most cherished. Only one other kind enjoyed much vogue. It was introduced during the reign of the Stuarts, and might be called the architectural.

' It professed,' says Mr Cunningham, ' to be the handmaid of architecture; when the mason, and carpenter, and plasterer, had done their work, its professors made their appearance, and covered walls and ceilings with mobs of the old divinities—nymphs who represented cities—crowned beldames for nations—and figures, ready ticketed and labelled, answering to the names of virtues. The national love of subjecting all works to a measure-and-value price, which had been disused while art followed nature and dealt in sentiment, was again revived, that these cold mechanical productions might be paid for in the spirit which conceived them.

' The chief apostles of this dark faith were two foreigners and one Englishman—Verrio, La Guerre, and Sir James Thornhill. Rubens, indeed, and others, had deviated from nature into this desert track—only to return again to human feelings with a heartier relish. But Thornhill and his companions never deviated into nature. The Shepherdesses of Sir Peter Lely were loose in their attire, loose in their looks, and trailed their embroidered robes among the thorns and brambles of their pastoral scenes, in a way which made the staid dames of the puritans blush and look aside. But the mystic nymphs of Thornhill or La Guerre, though evidently spreading out all their beauties and making the most of their charms, could never move the nerves of a stoic. It is in vain that a goddess tumbles naked through a whole quarter of the sky. It is astonishing how much and how long these works were admired, and with what ardour men of education and talent praised them.'

The first native spark of what could deserve to be called genius, appeared in the person of Hogarth. Genius it certainly was, and of a very remarkable description, and one which has never yet found a successful imitator ; but it did not afford us, what we still wanted—a great painter. We do not quite go the same length as the Royal Academician quoted by Mr Cunningham, who said that Hogarth was ' no painter;' and that Sir Joshua, who never mentioned him, might as well be censured for not naming Richardson and Fielding. But we concur with him to a considerable extent ; and we feel that the merits of Hogarth were those of the moral satirist rather than of the artist. He was at any rate a designer rather than a painter. His fame rests upon his designs ;—his being a painter was a circumstance of which that fame holds little cognizance. If Hogarth had never touched a brush—if he had been merely an engraver—nay, if his *Marriage-à-la-Mode*, and other admirable satires, had come from his hand merely in the simple form of drawings, from which engravings had been made by others, the fame of Hogarth would scarcely have been less, or of a different kind from that which his name enjoys at present. Yet Mr Cunningham devotes half a page to a most superfluous contention with Horace Walpole's very intelligible distinction, that ' as a *painter* Hogarth has slender merit.' ' I ' claim,' says Mr Cunningham very emphatically, ' a significa-

' tion as wide for the word painter as for the word poet.' When
Mr Cunningham sets up a dictionary of his own, he may of course
claim his own signification for that or any other word at his own
will and pleasure ; but, in this case, it would have been more pro-
fitable to consider, first, what Walpole meant by the word 'painter,'
and, next, what is commonly meant by the public at large.

Our first great painter was undoubtedly Reynolds. ' He was,'
in the words of Burke, ' the first Englishman who added the
' praise of the elegant arts to the other glories of his country.'
No man has ever raised art from such low estate to the height
at which he left it. At the commencement of his career, Thorn-
hill, Jervas, and Hudson, were the best representatives of Eng-
lish art. He died the brightest star among a thick galaxy of
great names. He was the imitator of none. He formed a style
which was all his own. ' To portrait he communicated,' says
Burke, ' a variety, a fancy, and a dignity, derived from the higher
' branches, which even those who possessed them in a superior
' manner, did not always perceive when they delineated individual
' nature. His portraits remind the spectator of the invention
' and the amenity of landscape. In painting portraits, he ap-
' peared not to be raised upon that platform, but to descend upon
' it from a higher sphere.'—' His influence,' says Mr Cunning-
ham, ' on the taste and elegance of the island was great, and will
' be lasting. The grace and ease of his compositions were a
' lesson for the living to study, while the simplicity of his dresses
' admonished the giddy and the gay against the hideousness of
' fashion. He sought to restore nature in the looks of his sitters,
' and he waged a thirty years' war against the fopperies of dress.
' His works diffused a love of elegance, and united with poetry
' in softening the asperities of nature, in extending our views,
' and in connecting us with the spirits of the time. His cold
' stateliness of character, and his honourable pride of art, gave
' dignity to his profession : the rich and the far-descended were
' pleased to be painted by a gentleman as well as a genius.'

Since the death of Reynolds, we can scarcely speak with cor-
rectness of the *progress* of British art. Its condition is certainly
as good as it was then—perhaps at some intervening periods it has
been better; but it cannot be said that from that time there has been
any progressive advancement. Neither in landscape, in portrait,
nor in historical composition, can we now boast of better artists
than flourished in the days of Reynolds. Yet we do not doubt
that the average is raised; and we can certainly point to one
branch of art which in his time scarcely existed, but in which
British artists have now attained an excellence unrivalled in any
other country. We mean the art of painting in water-colours,—

an art of rapid growth, and which, for the representation of some subjects, is, in our opinion, superior to painting in oil.

The dewy freshness of a spring morning—the joyous brightness of a summer's day—the passing shower—the half-dispelled mist—the gay partial gleam of April sunshine—the rainbow—the threatening storm—the smiles and frowns of our changeful sky, or their infinite effects upon the character of the landscape—the unsubstantial brightness of the grey horizon—and the fresh vivid colouring of the broken foreground—all these features in the ever-varying face of Nature can be represented by the painter in water-colours, with a grace, a vividness, a freedom, a fidelity, a soft, yet day-like brightness and truth, which we will not say *cannot* be produced in oil-painting, but which we at least have never yet witnessed. There is a look of daylight in a water-colour painting, which oil-painting has never yet so successfully expressed. Nature, in the former, is represented as we really see it—in the latter, as it appears reflected in a blackened glass. The effect of daylight has, it is true, sometimes been tried in oil-paintings, and with some success ; but too much of the truth, force, and richness of colouring, has invariably been sacrificed in the attempt. There is a chalkiness in the colouring which prevented them from being entirely successful. They cannot, while clear, bright, and day-like, combine softness, richness, and vividness, so well as is possible in water-colour painting. Many able approaches towards a successful representation of daylight landscape have been made by painters in oil, ancient and modern. Rubens made a few coarse, but brilliant experiments, and attained brightness without being chalky. But still he did not succeed. His landscapes are not nature—they want softness, delicacy, and truth. They overshoot the mark. They are only dim and somewhat eccentric hints at what ought to be the true effect,—failures, but still the failures of a man of genius, and perhaps as useful for the consideration of artists as the more successful performances of inferior men. Teniers is bright and clear ; but we have always a feeling as if his landscapes were painted, not on wood or canvass, but on *tin*, and the cold hue of the metal shone through, and mingled itself with his painting. Hobbima is sometimes day-like ; but there is apt to be a blackness in the shadows, and a rawness in the lights of his fresh-coloured landscapes, which is to our eyes neither true nor agreeable. Cuyp has perhaps united softness and richness of tint with daylight brilliancy as skilfully as any artist ; but he effects this combination chiefly by means of that golden haze which he sheds so beautifully over all his landscapes. Even in the clearest and brightest, there is always a haze. Perhaps from consciousness that he would fail

without it, he seems never to have ventured to dispense with it; and therefore never to have achieved that undimmed clearness of perfect daylight, which is our grand desideratum in landscape. Neither Wilson nor Gainsborough seem to have attempted to carry the experiment very far. Among recent artists, we have seen this effect most successfully expressed in some of the few, too few, paintings of which we have not been deprived by the untimely death of Bonnington; and amongst those still living, sometimes in the works of Collins, Callcott, Constable, and Lee. The last-mentioned has succeeded, perhaps, better than any other in expressing the fresh clear natural mid-day tint of English scenery, and approximating in his oil-pictures to the brightness and pearliness of a water-colour painting. Still it is only approximation; and all that we have yet seen inclines us to think, that, in the representation of land, sea, and sky, the art of water-colour painting which has so recently begun to be cultivated, and is probably so little advanced towards its possible perfection, is superior to the long-established art of painting in oil. The depth, strength, and richness of the latter, it cannot emulate; but it is more applicable to those subjects which demand clearness, vividness, and airiness of effect.

The claim of any kind of superiority for water-colour over oil will, we doubt not, seem strange and unpalatable to many of the admirers of art. It seems to be regarded as a settled point, that oil-painting is the superior branch. Art has its etiquettes and its titles of precedence, and the painter in oil is held to stand higher than the drawer in water-colour. What is the ground of this assumed superiority? It is a more difficult art, say some. Perhaps it is; but enamel painting is more difficult still. If difficulty is to be the true criterion, let painters in enamel take the lead. It is more durable: very true; but painting in enamel is more durable still—so is painting on glass—so, too, is mosaic. The painter in enamel and on glass, and the worker in mosaic, would be entitled to preeminence on the ground of durability. But these distinctions are vain and puerile. Those only who take a grovelling and mechanical view of art can attach importance to the mere material with which it works, and can consent to investigate seriously the respective dignities of canvass and pasteboard, oil and water. As for durability, it is, unquestionably, an important merit; but we cannot allow art to be measured by this standard as exclusively as Napoleon did. ' A fine immortality!' said he contemptuously to Denon, when he told him a picture would last 500 years; and he preferred the statue solely because it might probably last as many thousands. The conqueror regarded art, not as a source of present gratification, but as a means of transmitting the

fame of his exploits.. Viewing it as he did, he was justified in his preference ; but to the generality of the lovers of painting, who regard it as a source of present pleasure, durability is a consideration of less vital importance. Still it is not to be denied that even present pleasure may be much affected by the want of durability ; for an impression that the work we are viewing is of a very frail and perishable nature, will cause a feeling of regret to be mingled with our admiration, painful in the same proportion as that admiration is strong. Durability, however, is not an essential quality in art, nor to be taken into account in our estimate of the abilities of the artist. Canova might have modelled a figure of snow, as beautiful as some of those models formed in clay, which he afterwards transferred to the more durable marble. The figure melts and disappears, but, during its brief existence, it might as plainly have borne the stamp of the creative genius of the artist, and conveyed to those who saw it an impression of his skill, as if it had been cast in brass. Durability is highly to be prized ; but it is to be prized upon grounds entirely distinct from an abstract admiration of art ; and we must not fall into a too common confusion of ideas, by blending together considerations so different. The more durable work of art is of course more valuable as a possession ; but considered simply as a work of art, it is neither better nor worse than that which may possess the quality in a minor degree.

The durability of painting in water-colours remains to be tried. No really good ones have been painted long enough to afford any satisfactory proof. The purchaser of a water-colour painting can only rest assured, that, with tolerable care, it will probably remain unimpaired during his own lifetime. Whether his children's children are likely to view it unfaded and undecaying, is more than he has the means of judging. The question is deserving of much attention among artists ; for if it be proved that the colours are not permanent, and no means can be discovered to obviate the evil, it is unquestionable that the encouragement of the public would be considerably withdrawn from this very beautiful branch of painting. Many of its admirers will be unwilling to purchase that which they know will quickly fade, and it will then cease to be cultivated with equal success.

It is difficult to speculate upon the *prospects* of painting in this country. It must be evident to whoever looks back upon its history, that it is greatly dependent upon chance. Encouragement and demand may do much ; but they cannot create the genius which is a fortuitous and spontaneous gift of nature, and which is essential to the production of real excellence in painting. For two hundred years there had been demand sufficient to have call-

ed forth a great painter, if any such had happened to have been born amongst us; and when, at length, Reynolds, Hogarth, Gainsborough, and Wilson, shone forth about the same time, it was not in consequence of increased encouragement, but in spite of that deadening apathy towards native talent which the long absence of it had naturally produced. The appearance of great painters will be in a considerable degree accidental; yet it is not to be denied that the stimulus of demand will effect much. We must, however, look for its effects less in the production of pictorial excellence, than in the determination of the line it is to follow. A talent for painting is a gift of nature; but the selection of that branch of art in which this talent is to display itself, is greatly influenced by the public taste. If, therefore, we seek to know what species of painting is most likely to be successfully cultivated, we must enquire in what direction individual patronage will most probably tend. First in request will be portraits; landscapes, sea-pieces, and paintings of animals, will occupy a prominent place; then what, in the language of art, are called ' conversation pieces,'—subjects such as have been so beautifully illustrated by Wilkie, and in various agreeable styles by Newton, Leslie, Knight, Landseer, Collins, Inskipp, and M'Clise. Historical painting, of the old academic style, is not, and will not, be popular amongst us. Some pieces there will be of which the intrinsic excellence will force their way into public favour; but they must either descend from their epic dignity, and partake a little of the domestic interest of the ' conversation piece,' like Wilkie's ' Knox preaching,' or ' Russell's trial' by Hayter, and some paintings by Allan and Cooper,—or they must attract, like Etty's, by the graces of colouring,—or they must be such as, by their poetical power, take a strong hold upon our imaginations, like Danby's ' Passage of the Israelites,' and Martin's ' Belshazzar's Feast.'

We are often told that historical painting ought to be encouraged. We ask, ' Why?' We are informed by some, ' because it is the ' highest branch of art.' Now, in this there may be *some* truth; because, unquestionably, the production of a first-rate historical painting is a very high—if not the highest—exercise of pictorial genius; but nevertheless, in the sense in which it is commonly made and accepted, much error lurks in this assertion. The error lies in the application of the word ' high' rather to the subject, than to the manner in which it is treated—in attaching to classification an undue importance—and in giving to the accidents and accessories of painting that preeminence which is due only to the essential qualities inherent in what is universally good in art. If ' high' means difficult, an historical picture is

doubtless always a high exercise of a painter's skill; and even so, an epic poem is a high exercise of the powers of the poet. But there is no better reason for forcing the production of historical pictures, than for giving premiums for epic poems. Happily, we believe, the time is past when an epic poem was held entitled to precedence, merely because it was an epic—when it was regarded as the greatest exertion of poetical genius, not on account of the genuine spirit of poetry which it contained, but chiefly by reason of the vast amount of *un*poetical labour, ingenuity, and arrangement, which had been expended on its composition. No British successor to the Blairs of the last century would now marshal our epics in the front ranks of his poetical array, and attempt to settle the respective claims of different countries, according to the number of these literary giants which they could bring into the field. Critics have agreed that the fine and subtle spirit of poetry cannot easily be weighed and measured; and that form, bulk, and dimensions, may be omitted in their estimate. The vital spark of poetry, if embodied in a sonnet, will outlive the uninspired bulk of twenty cantos. The lamented author of an elegy on the death of Sir John Moore, has gained as sure a renown by those few stanzas, as if he had turned a hundred gazettes into verse,—described the retreat in Spain with allegories and machinery in twelve ' books,' and called it ' The Corunniad.' An improved spirit of criticism equally prevails with respect to historical painting. It is not the subject, but the manner of treating it, which is held entitled to estimation; and though perhaps less than usual is now said about the propriety of encouraging historical painting, we believe that at no time would an historical picture, really well treated, be so thoroughly appreciated by the public at large. There is, however, no reason to believe that historical painting will be much encouraged in this country by private patronage—the only patronage which it is necessary to consider; for it would be useless to take into account the very small patronage that can be expected from the Government, or from corporate bodies. That individuals will not buy pictures of a size unsuitable to the scale of their rooms, must be obvious almost to a child; but it may with equal truth be said, that there is no probability of an extensive demand for historical paintings, even of moderate dimensions. In the first place, the number of those who can relish the excellence of a really good historical painting, is much smaller than that of those who can comprehend the merits of portrait, landscape, animals, or ' still life.' Historical painting is addressed to persons of cultivated and imaginative minds, and these are comparatively few. The majority would rather see the likeness of something they have seen before, than stretch

their faculties to understand a story told on canvass, or try to imagine whether a great event in history is adequately represented in the picture before them.

But if it is difficult to attract and inform the *un*imaginative, it is also difficult, in the next place, to satisfy the imaginative. Persons of a lively and powerful imagination, the highest class of those to whom this branch of art is peculiarly addressed, are apt to form in their minds a visible image of a recorded event, to which no representation will appear comparable. Like the scene, or the music of a dream, which seem more beautiful or sublime than any scene or music that was ever viewed or heard in reality, their unembodied impressions will have a force and splendour, compared with which, the actual picture set before their eyes will probably appear tame, mean, and cold. Even if not inferior, it will at any rate be different; and this will cause a certain feeling of disappointment. How rarely do we see the imaginary representation of some great personage, real or fictitious, without feeling that it is a very inadequate personification of those great attributes with which he is invested in our minds ! Though the picture is still a fiction, yet it is, as compared with our impressions, a substantial truth ; and we feel the sort of disenchantment which, to every imaginative person, a descent from romance to reality too often produces. Some artists are aware of this difficulty, and prudently avoid the dangerous combat with preconceived impressions, by selecting subjects that are little known, or have hitherto excited little attention, and of which few persons have previously attempted to form to themselves a distinct image. Those artists are most safe who can grapple with subjects which scarcely any have ventured to figure to themselves,—who can far outsoar the imaginations of others, and leave spectators wondering at a distance. But those are the possessors of a rare gift,—exceptions in art, and not to be circumscribed by common rules. Such were Fuseli and Blake ;—such, each different, and in a higher degree, are Martin and Danby—of which two, the former overwhelms with the vastness of his conceptions, the latter dazzles and surprises with the magic light of a poetical fancy.

In speculating upon the prospects of art, it is, perhaps, not immaterial to consider whether it is likely to be more widely cultivated ; and whether there is reason to hope that its practitioners may be supplied from a more extensive circle than they are at present. ' Art,' as Mr Cunningham says with truth, ' has not ' yet become with us a fashionable profession for the gentleman ' and scholar.' The parents of the best born among our artists have belonged scarcely to the class of gentry, and many have

been of still more humble extraction. Sir Thomas Lawrence
was the son of an innkeeper—Jackson, of a tailor ; Gainsborough
and Bird were the sons of clothiers—Opie and Romney, of car-
penters—and Mortimer, of a miller. No one, of what is called
' a good family,' or nearly connected with persons of rank, has
ever yet become a painter ; nor is painting considered a liberal
profession, and one of those which the junior members of our
aristocracy are at liberty to embrace. The first nobleman in the
land may practise painting as an amusement, may devote to it
much of his time, and may attain a proficiency equal to that of a
professional artist, without its being considered derogatory to his
rank ; but if the tenth son of the lowest Baron were to follow
painting as a profession, there would be many well-meaning
persons who would hold up their hands in surprise and hor-
ror at the degradation of such a step. They could scarcely be
more shocked at his keeping a shop, than at the idea of his paint-
ing for money. Painting is treated as a mechanical art, and the
man of rank would be considered to lose caste by following it.
Now, without summoning to our aid that undeniable principle,
that there is no real disgrace in any honest calling, or taking
higher and sounder ground of argument than the customs and
prejudices of society, we must say, that there seems to be some-
thing very unreasonable in this exclusion of the art of painting
from the list of such professions as a gentleman is considered at
liberty to follow. Why should the announcement from a noble-
man that one of his younger sons discovers a strong bent for
painting, and will, therefore, become a painter by profession, be
answered (as it would) by a stare and a shrug, and remain a theme
for wonder and reproach ? Society admits that a peer may, with-
out shame, sell the productions of his pen : why might he not
dispose of the productions of his pencil ? If the Honourable Mr
Such-a-one, a barrister, may take guinea fees without contami-
nation, why may he not, equally without disgrace, paint a pic-
ture, send it to an exhibition, and sell it for a hundred pounds ?
But literature and law, it will be said, are more dignified, useful,
and important, than painting. True : nor do we claim for paint-
ing an equality with them in those respects. We only mean to
show, that what is analogous in the mercenary part of the pro-
fession, has no adverse effect in the case of literature and
law ; and we can conceive no other grounds on which the profes-
sion of painting can be placed under the ban of society at all.
 There is nothing degrading in the course of study which is neces-
sary to prepare the student to be a successful painter. He need un-
dergo no humiliating apprenticeship to art. It is no dull drudgery
to which he is bound. He must love his art, and follow it with

enthusiasm. He must be naturally gifted, and be directed to painting by the bent of his genius, if he would hope to be eminently successful. It is not unrefined, or unintellectual. On the contrary, it is allied to refinement and intellectual pursuits. Every branch of painting requires somewhat of a poetical turn of mind—many require imagination—and some, that the artist should be conversant with society. The highest excellence in portrait-painting, for example, is unattainable, without that delicate perception of manner and expression, and the graces of deportment, which only habits of society can give. Painting is no bar to cultivation of mind ; on the contrary, it is often found connected with literary ability. Our own brief history of the fine arts, contains a larger proportion of instances of the combination of pictorial with literary talents than that of any other country. Hogarth, Richardson, Reynolds, Gainsborough, Opie, Barry, Romney, Lawrence, Fuseli, and Northcote, were all men who, if they did not employ the pen much, at least evinced the power of using it with respectable ability ; and we can close this list of learned artists with an eminent living example—the present President of the Royal Academy. But the caprice of society is the more remarkable and unreasonable, because, though it refuses to smile upon the painter's outset, and frowns upon the adoption of painting by those who are of gentle blood, it warmly hails the successful artist, and accords to him a social position as secure and honourable as to the untitled followers of other professions. Sir Joshua Reynolds, West, Cosway, Hoppner, and Lawrence, were the companions even of royalty, and mixed with the most aristocratic society in the land ; and the same may be said of some eminent artists of the present day. We trust that the favour never withheld from such successful artists as may choose to seek it, will erelong be extended to the art. Our refusal to extend such favour, is, we fear, a proof of imperfect civilisation ;—a proof that the spirit of feudalism is not yet extinct amongst us. There have been times and countries, in which no profession but that of arms was deemed worthy of a gentleman ; and in some of the least civilized parts of Europe, that of law is still held to be degrading. As civilisation advances, it tends to liberalize, to break down prejudices, and to throw open a wider sphere for the exercise of each man's ability. We shall be glad if, in course of time, it throws open the study of painting to all whose circumstances forbid them to be idle, and who are directed, by the inborn gift of nature, to seek this species of employment. Since painting can be successfully cultivated only by those few who are imbued with a natural genius for the art, it is more desirable than in the

case of professions, which depend comparatively little upon a peculiar bent, that the sphere out of which its votaries are collected should be as extensive as society can make it.

Many lovers of painting sincerely regret that we have no Public Collection worthy of the country. We can sympathize not a little with the wounded spirit of national vanity, which, after contemplating the splendour of the Louvre, or of the galleries at Dresden or Munich, contrast with these magnificent and well-stored repositories the meagre homeliness of that handful of good but ill-arranged pictures which were huddled together in the National Gallery in Pall-Mall. We can enter into this feeling, and should be well pleased if we could have pointed out, as the property of the nation, to a foreign friend, who might be visiting London, something more dignified than the very small collection just mentioned. If the nation were to possess a gallery of painting, equal to that at Paris, or Dresden, or Florence, the lover of painting would, of course, rejoice in the facilities afforded him for the frequent contemplation of excellence in art, and would, as one of that body of joint-proprietors—the nation—feel a certain satisfaction in his fractional proprietorship, akin to that which he would feel, in a greater degree, in possessing a good collection exclusively his own. We sympathize with this feeling; but if seriously asked, whether we believe that the possession of a national collection of paintings, as good as those of Paris, Dresden, and Florence united, would give a vast impulse to British art,—would render the annual exhibitions of the works of our artists much better in all the essential elements of excellence than they are at present,—we cannot answer in the affirmative. Far from being certain that the effect would be favourable, we are not even without fear of the reverse. We fear the possession of such standards would tend to check the spirit of originality, and convert our artists into servile copyists. They would look more at art, and less at nature. They would gaze at excellence beyond their reach; and their emulation, depressed by the sight, would too probably prefer the safer and easier course of mechanically following in the steps of their predecessors, to the bolder effort of seeking to catch inspiration from the same source. The contemplation of certain attained and recognised beauties in painting would too probably contract their view of the domain of art—would bind them down to the narrow faith, that nothing good could be done in painting that did not resemble and conform to something approved and distinguished that had been done already—and would render them insensible to the inexhaustible wealth of that extensive sphere in which the painter may expatiate.

If we want some practical criterion, by which to judge of what a great collection would do for this country, let us ask what it has done for others. Has modern art been found to spring up refreshed and exuberant wherever a splendid public gallery has been opened? Does it thrive at Dresden and at Munich? Have even all the treasures of Italy saved the modern paintings of that land from tame mediocrity and imitative stiffness? Does that land, so long the favoured dwelling-place of art, send back its foreign pupils evidently imbued with the fruits of example, exhibiting an increased proficiency which can be attributed solely to the contemplation of Italian art? Is it so? Or is it not rather to the contemplation of nature under another and a more attractive aspect, that we may attribute all the truly remarkable proficiency and success that some of our travelled artists have attained? Wilson studied not Claude, but Italy; and the paintings of Eastlake, the most successful of our modern artists who have resided for any length of time in Italy, though they bear indisputable evidence of his having successfully studied in that country, treat subjects such as were never treated by the great masters of Italian art, and handle them in a style which these masters never exhibited; and we would say, not in disparagement of his performances, but admiring and approving, that we can conceive that they might equally have been painted, if the galleries and churches of Italy had been emptied of their treasures, and nothing were left but its picturesque people. Painting, although, like poetry, it is imaginative and inventive, is, still more than poetry, an imitative art; and it signifies much whether imitation be at second or at first hand, whether it is merely the copy of a copy, or is drawn directly from the natural object. The latter of these processes will exhibit an originality, a vigour and a truth, which in the former will be greatly wanting. Now, unquestionably, a study of even the most approved standards of excellence in painting would tend to produce that which should be rather the copy of a copy, than a performance exhibiting that subtle spirit of grace and truth, that unequivocal reflex from nature itself, which constitute the principal merit of the great originals. ' I consider general copying,' says Sir Joshua Reynolds, ' a delusive kind of industry. The student satisfies him-
' self with the appearance of doing something; he falls into
' the dangerous habit of imitating without selecting, and of la-
' bouring without any determinate object. As it requires no
' effort of the mind, he sleeps over his work; and those powers of
' invention and disposition, which ought particularly to be called
' out and put in action, lie torpid, and lose their energy for want
' of exercise. How incapable of producing any thing of their own

' those are who have spent most of their time in making finished
' copies, is an observation well known to all who are conversant
' with our art.' Let us not, however, be supposed to deny, that
great advantage may be derived by the artist from the study of
excellent paintings. They may be highly useful, if rightly treated.
But in order to be profitable to modern art, they should be em-
ployed not as constant guides, but as occasional tests,—rather to
correct and elevate the taste, than to exercise an influence on the
minutiæ of art. The artist who would truly profit, should try
rather to imbue himself with their *spirit*, than to adopt their *man-
ner*. He should attempt, by their aid, to place himself in imagination
on that vantage-ground, on which stood the great painters who con-
ceived and executed them. From models treated in this spirit great
benefit might accrue to art. But this is not, as it may at first
appear, an available argument in answer to our fears respecting
the probable effect of a great national collection. We must con-
sider, not how it *may*, but how it *will* be employed; and we fear
the *abuse* is more probable than the *use*. It is easy and tempting
to employ these models of excellence in such a manner as would
be injurious to art. For one who catches the subtle spirit of the
original, and attempts to paint with a kindred feeling, twenty will
exercise their ingenuity in acquiring the trick—the manner—the
handling—the accessories, and not the essentials—the marks and
signs by which indeed the master may be distinguished, but which
do not constitute his merit. We say, therefore, not that the fre-
quent contemplation of the works of the old masters cannot do
good, but that the good is too often more than counterbalanced
by the harm.

But it may be urged, that the sight of celebrated paintings may
have a favourable effect, not by direct impression upon the art-
ists, but indirectly through the public. It will raise the standard
of public taste; it will create a demand for works of art of a su-
perior class; and the artist will be stimulated to greater care and
exertion by the increased fastidiousness of his employers. In this
we admit there is some degree of truth, and the whole sounds
plausible in theory. But it has been practically proved, that
adoration of the works of the great masters of Italian art is quite
compatible with the most chilling disinclination to encourage a
contemporary—with the most depressing apathy towards modern
merit—with the most supercilious and pedantic derision of all
originality, all deviations from recognised standards. How was
the proud spirit of Hogarth made to writhe under the neglect
and parsimony of those would-be patrons of art, who were squan-
dering hundreds on bad copies of the old Italian masters, of
which even the originals did not display half the genius which

might have been discovered in his despised performances! His
' Strolling Actresses,' that ' wondrous picture,' as Mr Cunning-
ham justly calls it, of which ' the wit, the humour, are without
' end ;' where ' into the darkest nook the artist has put meaning,
' and there is instruction or sarcasm in all that he has introduced,'
—this picture was sold for L.27, 6s. to the wealthy Beckford, who
' thought the price *too much*, and *returned* it to the painter !' In
1745, Hogarth sold this and eighteen others of his best pictures,
—the paintings of the ' Harlot's Progress,' the eight paintings
of the ' Rake's Progress,' and the ' Four Times of the Day,'—
for L.427, 7s., or little more than L.22 a-piece. Such was the
reward of the only artist of whom, at that time, England had
reason to be proud. Yet these pictures wanted not such advan-
tages as competition could afford—for they were sold by auction,
and the sale, we are told, was well attended. Discouraging as
was the result, Hogarth, despairing of other means, attempted,
five years afterwards, to dispose also by auction of his celebrated
series, the ' Marriage-à-la-mode.' The result of the experiment
shall be told by the purchaser, Mr Lane :—' On the 6th of June,
' 1750, which was to decide the fate of this capital work, when
' I arrived at the Golden Head, expecting, as was the case at
' the sale of the Harlot's Progress, to find his study full of noble
' and great personages, I only found Hogarth and his friend Dr
' Parsons, secretary to the Royal Society. I had bid L.110;
' no one arrived ; and, ten minutes before twelve, I told the
' artist I would make the pounds guineas. The clock struck,
' and Mr Hogarth wished me joy of my purchase, hoping it was
' an agreeable one ; I said, perfectly so. Dr Parsons was very
' much disturbed, and Hogarth very much disappointed, and
' truly with great reason. The former told me the painter had
' hurt himself by naming so early an hour for the sale, and Ho-
' garth, who overheard him, said in a marked tone and manner,
' " Perhaps it may be so." I concurred in the same opinion, said
' he was poorly rewarded for his labour, and, if he chose, he
' might have till three o'clock to find a better bidder. Hogarth
' warmly accepted the offer, and Dr Parsons proposed to make it
' public. I thought this unfair, and forbade it. At one o'clock,
' Hogarth said, " I shall trespass no longer on your generosity,
' you are the proprietor, and if you are pleased with the purchase,
' I am abundantly so with the purchaser." He then desired me
' to promise that I would not dispose of the paintings without
' informing him, nor permit any person to meddle with them
' under pretence of cleaning them, as he always desired to do
' that himself. The excellence of these six noble pictures was
' acknowledged by the whole nation, and they were in frames

'worth four guineas each; yet no one felt them to be worth
'more than ninety pounds six shillings.' These six *chef-d'œu-
vres* of Hogarth's pencil were then valued by the public at
less than a fourth of what was given at an auction a few
years afterwards for a single moderately good picture,—' Sigis-
' munda,' attributed to Correggio, but really by Furino, and
which now owes its whole celebrity to the rivalry which it exci-
ted in Hogarth. But Hogarth was not doomed to perpetual ne-
glect. The pictures thus contemned by the discerning public of
1750,—who professed more than at any other period to idolize the
works of the old masters,—were sold in 1797 to Mr Angerstein
for L.1381, and are now among the ornaments of our National
Gallery. The history of the period when Hogarth lived thus
affords abundant proof, that an admiration of works of established
artists, and a reverence for great names, is, if not absolutely
inimical to the encouragement of modern art, at any rate com-
patible with extreme neglect of it.

But if we are sceptical with respect to the benefits to art to be
expected from the possession of a great national collection, we
are not insensible to the useful stimulus afforded by frequent
exhibitions of the works of living artists, and of those selections,
both of old and modern art, which pass annually in review before
the eyes of the public, in the rooms of the ' British Institution.' By
these, interest in the fine arts is kept alive—the energies of the
artist are advantageously stimulated by comparison and competi-
tion, and the taste of the public is improved. It is essential to the
improvement of the taste of the public, that they should see good
pictures ; but it is still more essential that they should see them
often, and in great variety. Frequent exhibitions do not the less
tend to improve the public taste, because the majority of these
pictures may be bad ones. A taste for the fine arts becomes
matured and polished by the frequent exercise of the faculty of
comparison ; and the more extensive are the means of comparison,
the more perfect will that taste become. Some connoisseurs
appear to think that it is desirable to exclude the sight of all but
the best models, and that the sight of bad pictures is capable of
neutralizing whatever benefit to taste is derivable from good ones.
We cannot admit this narrow doctrine : we hold, on the con-
trary, that he who has seen both good and bad, will be better
able to appreciate the former, than he who has seen the former
only. We should have more confidence in the taste and discri-
mination of one who had viewed all the manifold varieties of art,
from the ' Transfiguration of Raphael,' to the lowest daub that
deserves to be dignified by the name of a picture, than of one

whose attention had been exclusively occupied by twenty of the finest paintings in the world.

Since the chief object of a National Gallery is the encouragement of national art, through the improvement of the public taste—and since it is no longer a question whether we shall have one or not, it only remains to be asked, What kind of collection is to be preferred? Some will tell you it ought to be extremely select; it should contain, if possible, none but paintings of ' the highest class ;' it should be such as might purify the public taste, as might guide the artist, and not mislead him; it should be a collection of such pictures as might be safely followed as models; and none but ' pictures of the highest class' can be safe models to the student in painting. Now, what is the ' highest ' class ?' If the forty Royal Academicians were called upon to define it, we doubt not they would furnish a considerable number of definitions widely different. And as for its consisting of eligible models, far from assenting to this, we do not believe that any painting can be named in which it would not be possible to detect something that should render it unfit to be implicitly followed as a model for imitation. Be it remembered, too, that it can scarcely with truth be said that there is any thing absolutely high or low, or good or bad, in works of art, although the oracles of taste are often pleased to make a peremptory use of these sweeping distinctions. Even if we could render excellence in painting something much more positive and definable than it is, we should still find that it is merely comparative—that it has infinite degrees, —and that the best is merely an approximation to some ideal point of unattained and unattainable perfection. No work of art is so good that we may not find in it some imperfection; and few so bad that the acute and candid observer may not discover in them some particle of merit. Instead of the well-winnowed *élite* of a fastidious selection, from which all should be excluded except celebrated *chef-d'œuvres*, we would rather see a more numerous collection, less exquisite in quality, but more diversified. It should exhibit, as much as possible, an illustrative history of painting; it should contain at least one good specimen of every artist of merit and celebrity, both foreign and native; it should comprise all styles, all schools, all subjects. The humblest subjects, if ably treated, should find a place, as well as the most elevated. Such early specimens as might enable the visitor to trace the progress and improvement of the art, should also be included; in short, it should be a collection which, although containing much that failed to satisfy the fastidious critic, might tend to imbue the visitor with an extensive knowledge of painting—might display

to him the wide domain of art, its capabilities and varieties—might correct a narrow and exclusive taste, and a slavish veneration for great names (that blinding impression which leads some persons to think that every *soi-disant* Raphael must be good, and that no nameless picture can be worth looking at)—might give extensive exercise to the faculty of comparison, and a liberal and quick appreciation of excellence, under however humble a form it may appear before him. Such a collection would be very extensive : some will object that it would be too extensive, and that attention would be distracted by variety and number. But this is not an unavoidable evil—it is one which may be obviated by classification and dispersion. Nor would it be an evil seriously felt, except through indulgence in the foolish vanity of a very large and splendid room. The *coup-d'œil* of the Louvre is very magnificent ; but it is not an example to be followed. If we had funds sufficient to build such a gallery, and pictures enough to fill it, we should decidedly prefer, instead of a gallery a quarter of a mile long, to have twenty rooms of moderate dimensions. We have sketched our *beau-ideal* of a National Collection, but without much expectations that our own in London will at any time resemble it closely. It is not probable that extensive purchases will ever be made at the public expense ; and the accumulation will chiefly take place by means which will set at nought the power of selection,—namely, by gift and bequest, of which numerous examples are before us already. We have, nevertheless, stated our opinion of what such a collection ought to be, in the hope that those who may happen to agree with us, and intend to give or bequeath any paintings to the public, may promote that object by their contributions. They will remember that a picture, good of its kind, but which is not of the highest class, may, nevertheless, be an acceptable accession, if it be of a style, or school, or master, of which the National Gallery already possesses no good specimen.

"The Exhibition of
the Royal Academy"

Athenaeum (May 10, 1834), 355–56

THE EXHIBITION OF THE ROYAL ACADEMY.

On Friday week the Members of the Royal Academy opened the doors of their Exhibition of Painting and Sculpture to the princes, peers, and chief men of the land ; on Saturday they entertained them with a sumptuous dinner, spread out among works of art ; and on Monday they permitted the commoner spirits of the earth to pay their shilling, and gaze their fill at the chiselled stones and the coloured canvas which cover the walls and occupy the floors. We were there among the mob ; nor did this circumstance hinder us from being much interested in the Exhibition. There is little, indeed, to move us deeply or excite astonishment : we have frequently seen pictures, in the same place, of a higher order, and statuary expressing more elevated sentiments ; but we are not sure that we have seen more works at once of a pleasing nature—a collection more likely to gratify the public taste. The exhibitors are less ambitious in the choice of their subjects than formerly, and more happy in handling them. Pictures of a domestic nature are plentiful : those of a strictly historical nature are few : portraits are not numerous. The picture of a full-fed mortal of twenty stone is not set off against the likeness of a pig a stone heavier ; neither have we so many horses in harness, or racing mares labelled with their lineage ; nor vulgar facsimiles of particular spots of earth, erroneously called landscapes. The pictures, too, are not so stupendous in their dimensions as formerly. A large picture is a great evil : our churches will not admit them, for divines allow no one to expound Scripture but themselves ; and our dwelling-houses are not gigantic enough for canvas seven yards square. In truth, our artists are accommodating their works more than ever to suit the public taste, and their reward will be accordingly.

On looking over the Catalogue, we miss the names of some artists whom we can ill spare. Stothard will charm us no more with his natural and graceful fancies ; Constable is absent—we are concerned to hear, from ill health ; Mulready chooses to instruct the young, rather than charm the old with his characteristic compositions ; Leslie is on his way back from America, and one who will be more warmly welcomed could not be sent to us ; Newton, alas ! is a sore sufferer, and hope of his recovery is, we hear, denied to us ; Etty, who pleased us so fre-

quently with his classic conceptions and vigorous colouring, has nothing of the kind this season— he, too, is ill, we are told ; Boxall, who has the art of infusing poetry into female beauty, is busy in the city of the seven hills, and has transmitted nothing : while in Sculpture we miss—and so will the public—the works of Chantrey and Gibson.

Though the absence of these lights is felt ; yet others of equal brightness have not refused to shine. Edwin Landseer has painted the best picture : Allan has displayed the finest feeling ; Wilkie the most original and striking characters ; Callcott the most natural scenes ; and Turner the most poetical landscapes. In portraiture we have much that is excellent : Phillips has several manly and well-imagined heads ; Pickersgill keeps his place—one of his works, at least, is not surpassed in the Exhibition ; the President has handled the full-length of His Majesty with no little elegance ; Wilkie has done as much, or more, for Her Majesty ; Geddes, too, exhibits one portrait—that of Sir James Stuart, which ought to bring sitters ; and Clint has limned ' La Palermitana' with equal simplicity and elegance. Nor ought we to neglect the female exhibitors : Mrs. Carpenter charms us with her delicate and beautiful delineations ; and Mrs. Robertson has a full-length of Lady Rolle, which will not suffer by being compared with full-lengths done by one or more of " the lords of the creation."

In Sculpture there seems a falling off. Pitts is the most poetic : his ' Shield of Hercules' is a fine composition ; Wyatt is the most elegant : his ' Cupid and Psyche' is a delicate group ; Baily exhibits at least one fine female head worthy of his high reputation for the beautiful ; Westmacott has given us a statue of the illustrious John Locke, which we will allow others to admire ; and younger artists have supplied figures, some of them natural and neatly handled —and busts, impressed with considerable originality of character, so that the room is well filled—nay, approaching to the crowded. There are in all 1121 works of Art—of these about 100 are pieces of sculpture ; not a few are architectural drawings—some of which have high merit ; but they must be seen to be understood—description cannot cope with them.

The picture by Edwin Landseer, which we consider so exquisitely handled, is 13, ' Scene of the olden time at Bolton Abbey.' It seems a day of payment in kind, and the Abbot, with another of his brethren, has come forth to receive it. One man lays down a noble buck on the floor, extends his hand along its breast to show where the fat lies, while two dogs, that are all but living, look on as if they claimed a share ; a girl, and a handsome one, with a humility not unmingled with fear, presents a dish of delicious trout ; they seem fresh from the river, and to be just gasping their last. A youth has got a wild heron slung on his back, and, without the fear of the Abbot before his eyes, is peeping at the

back of a letter which his reverence holds in his hand. The colouring of this truly splendid picture is clear, deep, and harmonious. 'A Highland Breakfast,' No. 96, is by the same hand, and of almost equal merit ; a group of terriers and hounds are socially toiling with their teeth on the floor, while seated apart is a young mother giving her babe the breast; the innocence of the latter, and the truth and nature of the former, are equally striking.

The poetic creations of TURNER form a striking contrast to the vivid realities of Landseer. This great landscape painter has five pictures in all ; they are mostly imaginative, and, with the exception of a splendid view of Venice, may be accused of being too slight, and in some parts slovenly. The first, and perhaps the best, of these compositions, is called 'The Fountain of Indolence;' the scene is magnificent—golden palaces, silver fountains, romantic valleys, and hills which distance makes celestial, are united into one wondrous landscape, over which a sort of charmed light is shed, that is almost too much for mortal eyes. Perhaps the artist, in reading Thomson's ' Castle of Indolence,' desired, in embodying some of the poet's descriptions, to imitate the example of one of the members of that " pleasant land of drowsy-hed," who " fond to tegin, but for to finish loth," never communicated the last touch to any of his compositions. This remark applies still more forcibly to 75, 'The Golden Bough,' by the same hand ; the scene is wild and splendid—almost dim through excess of brightness, and the conception is wonderful, yet the slight and slovenly handling presses sorely upon us, and we mingle regret with admiration.

But it is time to speak of WILKIE, perhaps the first artist of the age in delineating action and character ; but we have seen pictures of his more to our taste than even his admirable No. 122, 'Not at Home.' A country landlord—a shrewd and knowing one, with his dog at his foot, his whip under his arm, his hat plucked over his brow, and a look of mingled distrust and determination in his face, pays a visit to a house in London, to demand rent or some such trifle. A servant—a smooth, cool, plausible knave, has opened the reluctant door, and placing himself, as if by accident athwart the breach, replies " Master's not at home." If ever a lie was painted, it is painted on that man's face ; but to prevent all misconception, the " master," a sharper questionless, slips his hand slyly out at another window, and claps a lighted cigar to his landlord's wig. The scene is quiet, but irresistibly comic. No. 148, ' The Spanish Mother,' is another of Wilkie's works, and a fine one ; the colouring is deep and vigorous ; a child has its little arms twined round the mother's neck, and is pulling her off her balance ; the posture is almost extravagant, but is brought back to truth and nature by a happy hand that has never been known to fail.

To ALLAN we have awarded the high praise of deep feeling : let those who doubt this, look at 169, ' The Orphan,' or at 309, ' Polish Exiles conducted by Bashkirs on their way to Siberia.' In the former, a beautiful girl is kneeling beside the chair, now made empty by the death of her parent ; her heart is in her face ; a venerable domestic follows to offer aid, which he evidently dreads will be wanted. The young lady is like no one so much as Miss Scott, and the chair is that left empty at Abbotsford. She is

Mouldering now in silent dust,

as well as her illustrious father. ' The Polish Exiles' is a well-conceived and well-composed picture ; we would have preferred woe more tranquil, but, perhaps, nothing less than strong action would have made any impression on a couple of Bashkirs, who, mounted on horses as wild as themselves, seem impatient to hurry their wretched prisoners forward. These " lads of the desert" are no fanciful creations—they were drawn by the adventurous artist in their own land ; they sit as easily on their high trotting horses and high saddles, as birds sit on the bough. The picture is a fine one.

We dislike portraits of horses; but the horses of WARD are much better than portraits; they have life and elegance, we had almost said feeling. 211, ' Portrait of an Arabian,' is in his best style ; the form is beautiful, and such an air of reality is shed over the animal, that we almost expect to see him bound away to the desert beyond the bondage of saddle or rein. 290, ' The Yeldham Oak at Great Yeldham,' is of another stamp, though by the same hand. This venerable tree was of a girth and a beauty worthy of being recorded in the Essex Court Rolls of the manor, six hundred years ago; it now is the worse for its encounters with time. The village is cleverly painted, and the whole forms a scene elegant and English.

Those who desire to look abroad, cannot well look at any composition more beautiful than 64, ' The Escape of Francesco di Carrara, last Lord of Padua, and Taddea d' Este, his wife, (who was ill at the time,) from the power of Galeazzo Visconti, Duke of Milan,' by EASTLAKE. The flight of the fugitives has grace mingled with alarm ; they see their enemy hurrying in pursuit, yet betray no unseemly terror : some will think them too serene, not that they are so, but because we are accustomed to see other artists make action painful and extravagant. This painter has poetry in his soul, and a taste for harmony—these are scarce commodities.

HOWARD has a poetic fancy, and a pure taste. 80, ' The Gardens of Hesperus,' shows a good deal of both. We always like to see the works of this artist ; he comes in the company of Milton, and Spenser, and Shakspeare : not as one thrown into their society by accident, but as one who feels and understands them. In the present picture he has interpreted with the pencil the meaning of that exquisite passage in ' Comus,' beginning,

> There I drink the liquid air,
> All among the gardens fair
> Of Hesperus and his daughters three,
> That sing around the golden tree.

It is no easy task to equal Milton; nor do we say that Howard has succeeded where others have failed: he has, however, made a beautiful picture, and if poetic subjects were not at a sad discount, it would soon find a purchaser.

We have, with difficulty, been silent till now about the pictures of CALLCOTT; they are numerous, and one and all stamped with elegance and nature. He is poetic, yet he mixes reality with his dreams: he is scientific, yet the ease of nature is not neglected, nor is he deficient in either airiness or vigour. 106, 'The Port of Leghorn,' is a brilliant thing: the sun comes dancing along he waters, which are curling and dimpling in the light, while the lofty buildings, and the ships moored, come in for a little of the radiance. Some one at our elbow exclaimed, " What a Claude-like scene." There is something in this; yet it is not so much like Claude as it is like Callcott, for, like all great artists, he has a style of his own. 189, 'Dutch Peasants waiting the Return of the Passage-Boat,' is handled in another manner: the scene, in other hands, would likely have been coarse or common-place, but Callcott has communicated a certain air of freedom, and even elegance, to his rustics: the water, too, has its beauties. 154, 'Cologne' has been frequently painted, but this gives the place a new aspect; and those who are curious in such matters may compare the ' Cologne' of TURNER with that of his brother Academician, and will find great and peculiar beauties in both.

We have said that pictures of a strictly historical kind are not numerous: HILTON, as usual, has not forgotten the art in which he excels. 194, ' Editha and the Monks searching for the body of Harold,' was suggested by the page of the ancient Chronicler, who says, "The body, stripped of its armour, was so disfigured, that the monks were unable to distinguish it. In this emergency they had recourse to Editha, ' the lady with the swan's neck,' who, with the keen eye of affection, recognized the remains of her lover." The slain are splendidly grouped: the bodies are lying in the easy posture into which nature always throws herself: the monks are looking on with something of sympathy, while Editha seems about to precipitate herself upon the body of him who, by dying for his country, shows he was worthy of her love. She seems a little too much moved; her eyes are too staring: there is a gracefulness in grief, as well as a decorum in painting, which should not be forgotten.

Sir Charles Morgan

"Of Certainty in Taste"

Athenaeum (November 2, 1834), 804–07

it will be widely different: *quot homines, tot sententiæ.* In some, perhaps, it will excite no sensation of pleasure or pain whatever; and scarcely any idea, beyond that of a variously-coloured canvas. The greater number will, in all likelihood, praise or censure it in the gross; thereby proving, that their sensations concerning it are vague and indistinct. A few, more discriminating, will each seize upon some speciality for remark—its colouring, grouping, drawing, design, or execution; and, judging the picture exclusively on that ground, prove that their pleasure is of a different origin from that of their neighbour.

On the other hand, there are, confessedly, certain points on which most sane men agree: there are particular forms, colours, and sounds, in nature and art, which generally please, and the manner in which their combinations affect mankind at large, is visibly subordinated to general laws. The more any art is cultivated, the greater is the tendency in its professors to lay down certain rules for governing their designs;—and to believe that there exists in nature something absolute and definable, by which individual taste may be estimated and corrected. It is, however, chiefly by the contemplation of generalities that the mind is led to this conclusion; for, the more it descends to particulars, the greater is the evidence of innate and acquired differences of feeling between man and man, and the greater the difficulty of getting society to agree on specific truths.

Pressed upon by two orders of facts thus contradictory, philosophy has hitherto been unable to arrive at any universally admitted opinions, concerning abstract beauty, or the possibility of arriving at certainty in matters of taste. This obscurity, overhanging a subject after the lapse of so many ages of dispute, is clearly referable to the mode in which it has been treated, and to the bad metaphysics in which it has been involved. The doctrines of taste lie not in that imaginary world, yclept, " the eternal nature of things;" nor do they depend merely upon the physical properties of external nature. Taste is altogether an affair of sensation; and its laws are, and can be, no other than those of the living machines of which sensation is the attribute. The theory of taste is part of the natural history of man; and, if its doctrines are of uncertain application, it is only in as far as that history is incomplete, or is ill-understood by the æsthetic philosopher.

If there be any physiological truth more clearly ascertained than another, it is this: that nature is made up of individuals—that species and genus are the figments of the human brain—and that their common identity is obtained by the ideal abstraction of an infinity of particulars. The sensitive susceptibilities of individual men, like their minute organization, are strictly personal; and they differ as to a multitude of nameless phenomena, not only in different persons, but in the same individual at different epochs of

OF CERTAINTY IN TASTE.
BY SIR CHARLES MORGAN.

" Et sapit et mecum sentit."

Pleasure and pain are ultimate facts in the animal economy. To perceive, and to judge them, is the same act; and simply to name them, is to define their character. To the percipient, their quality is matter of absolute certainty, and their nature cannot be made clearer by reasoning. But this distinctness of our sensations is confined to the being in whom they exist. No language can explain to the inexperienced bystander what is passing within, or convey to him the remotest idea of the impression in question. He must have felt the affection himself before he can understand it. The sensorium of each individual is, therefore, at once its own world, and its own law; and all judgments of external nature in its relations to sensation can have no other standard. This truth is embodied in the familiar adage, *de gustibus non est disputandum.*

But this very intensity of our own sensations, the certainty we feel of what passes within us, creates a disposition at every instant to dispute the tastes of others, and to assert the supremacy of our own judgments in matters of feeling. The constant operation of this tendency has led to inquiries into the nature and causes of our sensations; and to an attempt to discover some general and abstract type of beauty and of good, by which the particular sensations of individuals may be safely compared.

Experience, however, exhibits a marked and rather extensive range of differences in the results of sensitive impression, when made by the same object on several individuals. If a picture, for example, be presented to the consideration of a mixed company, the judgments passed upon

his existence. This may be affirmed, generally, of all our pleasures and pains; but it is more exquisitely true, with respect to the more refined and delicate sensations, to which the term Taste is more especially confined.

In respect to these sensations, mankind may be roughly divided into three classes—the intellectual—the sensitive—and the sensual. The first class embraces those in whom the reflective faculties predominate over the organs of sense ; their vitality is internal, and is habitually concentrated on the operations of their own minds, almost to the exclusion of the phenomena of the external world, where these are not immediately concerned in the preservation of life. In the second class, on the contrary, the intellect is all abroad : all the external impressions are vivid ; and, the parties being occupied but little with reflection, they exist almost entirely in their sensations. The third class contains those whose moral existence is of the lowest order—whose nature is most purely animal—and whose being is principally wrapped in the gratification of their appetites. The types of these classes are sometimes found in considerable accuracy and perfection : more usually, it is a simple predominance of one set of faculties over the others, that constitutes the sub-genus. The predominance exists under an infinity of shades and gradations ; and each shade is accompanied by its own especial range of sensibility and affection, from external objects. The devotees to the fine arts belong, principally, to the second class ; for, the qualities of objects must be distinctly perceived before they can become the causes of pleasure, or of pain. The intensity of that pleasure or pain, however, seems to depend on some other peculiarity of the constitution. The power of perceiving, though essential to a susceptibility to emotion, does not always awaken it. There are men, in whom deformity, when rendered an object of distinct cognizance, excites no disgust, and who behold the most admirable works of art and nature with a stupid indifference.

Besides these broader distinctions between man and man, which may be designated as temperaments of the sentient complex, there are personal idiosyncracies as to minuter particulars, too numerous for arrangement. Some persons exhibit in their observation of the arts a peculiar sensibility to form ; others to colour; others again, uninfluenced by form or colour, are especially alive to the pleasures of sound. There are men exclusively affected by sequent sounds, on whom the combinations of harmony produce no definite effect ; and there are exquisite harmonists, who are little touched by the effects of melody. There are also those who (probably through defect of the organ of sense) dislike music of all sorts. Descending to more minute particulars, there are persons exclusively attached to vocal music; others requiring the stimulus of powerful bands: some touched by martial, others by plaintive melodies. Savage nations appear generally to affect the minor keys. The amateurs of painting may,

in like manner, be divided into three distinct classes—those most touched by the ideal—those chiefly curious as to the mechanical departments of art—and, lastly, the lovers of nature, who are the most powerfully affected by the beautiful in landscape. The determination to any one of these preferences, whether it be considered as innate, or acquired, is a fact which detracts from the universality of the principles of taste. The preference is a phenomenon natural to the being in which it is manifested ; and, as it is a natural, so it is a true taste. Between the several schools of painting, therefore, there can be no common *beau idéal* to which to appeal : on the contrary, each has its own laws—its own canons of criticism ; and the same picture may be perfection to one man, without exciting an emotion of pleasure in another. Who then shall decide between them ? Another great physiological truth that bears against the certainty of taste, is, that the specific pleasures and pains attached to externals in any one organization, are liable to be loosened from the causes by which they were originally excited. It is a law of the animal economy, that use shall blunt the force of sensitive impression, while it developes the intellectual clearness of the idea excited by an external. Thus, experience in the arts, by diminishing enthusiasm, abates the sum of pleasure derivable from that source ; and a greater degree of merit becomes requisite to produce an equal sum of agreeable effect : at the same time, the increasing accuracy of perception opens a new range of ideas for comparison ; and that which formerly excited pleasure as a merit, may be afterwards a source of pain as a defect. Every new sensation that we receive may be rendered a means of modifying the range of pleasures and pains ; and there is, consequently, an education both of the organs of sense and of the intellect, that unsettles taste, and subjects it to a perpetually progressive refinement. Under the influence of habitual exercise, the eye sees more and more of its object,[†] and the mind judges with greater *finesse*. The observer thus arrives at a more exquisite perception of beauty, and rejects with disgust the objects of his previous admiration. It is by these means that a single artist, dissatisfied with the works of his predecessors, and with his own progress, may be driven to look beyond what actually exists in art, and to go in search of hidden sources of beauty, by which, when attained, he creates new standards of excellence, to influence the general sentiments of an entire nation. Each age thus acquires a taste of its own ; and the hard lines and unreal flatness of Giotto, which were, to Dante, the perfection of painting, were thus rendered intolerable, when Raffael and Domenichino had taught Italy a better style. Dante's criticism on Cimabue,

> Credette Cimabue nella pintura
> Tener lo campo, ed ora ha Giotto il grido,

contains the whole history of the arts. *Le mieux est l'ennemi du bon :* and, for aught we can tell,

† Condillac, Logique.

a future race of artists may lay open a new series of beauties, that will discredit all that has hitherto been effected in painting and sculpture. In judging, therefore, of any specific work of art, the learned critic makes reference to the age in which it was produced ; and, by a curious particularity in the phenomena of sensation, not only does the intellect decide in favour of any work, which exceeds the average merit of its own time, but the sensorium derives pleasure from it when so judged ; whereas, if viewed without reference to such a principle, pain might be the only result.‡

Connected with this law of the economy, is an uncertainty in taste, of an opposite tendency. The liability to satiety, leading to the pursuit of novelty, produces, from time to time, a conventional and vitiated love of certain mere extravagances, by which the arts are degraded.

> Annoia il buon sovente, annoia il bello,
> Ed oggetto si segue ognor novello.

Such caprices, indeed, are seldom permanent ; nor are they, even for the time, largely participated by those, who feel, or who think for themselves. Still, while the fashion lasts, the pleasure excited is real ; and it detracts, *pro tanto*, from the universality of principles. Occasionally, however, traces of such ephemeral judgments may remain to after times, and modify, to a certain extent, the sensibility of future generations.

In enthusiastic temperaments, it is the sensation of pleasure or pain which a work of art excites, that fixes the attention upon it, and provokes criticism. Such persons *judge because they feel.* There are others in whom this process is reversed. The love of the arts, as marking a finer organization, is regarded as a distinction ; and many are drawn to their study by vanity, ambition, and the instinct of imitation. This class, if they really feel, *feel because they judge.* Their pleasures pass through their understanding, and are founded on the perception of fitness, rather than on mere physical sensation. The certainty of their judgments does not extend beyond the sphere of their experience, and is confined usually to some particular school or master, beyond which, their notions are vague, vacillating, and undirected by general principle, or by sentiment. These stop-watch critics, as Sterne has called the brotherhood, form a school of taste apart, and their judgments follow a different law from that which directs the opinions of the man of feeling. Their " Correggio and stuff " disgusts the genuine enthusiast ; but still it *is* their taste.

A large part of the pleasures of taste arises from association of ideas, a circumstance powerfully tending to vary men's affections by works of art. The simplest sensations we receive, involve a judgment : we judge that we are changed in our own being, by the sensation ; and we judge something concerning its external

cause.† In our ordinary existence, there are very few sensations that do not excite several such judgments ; and such judgments, when of frequent occurrence, become so closely associated with the sensation, as to be mistaken for a part of itself. Thus, to take a familiar instance, the unlearned think they see distance. There are certain particular forms, which, by a very obvious causation, provoke judgments concerning the utility of the object, and this judgment powerfully influences our sense of its beauty. A high-blooded racer, and a strong bony carthorse, are diametrically opposed to each other, in the details of their form. There is in each of these animals, however, a certain symmetry of parts which fits it especially for a specific purpose ; and the specimen that possesses these distinctives in an exquisite degree, is, in both cases, deemed beautiful. It is true, that as far as natural objects are concerned, there may be a necessary harmony in the parts, whose organization all tends to one given end : so that the perfection of function and beauty may go together : but we apply the epithet of beautiful to artificial machinery, and speak even of a beautiful experiment in chemistry. In these cases, the pleasure derived from a sense of the utility connected with a form, seems to the percipient to flow from the form itself, and to be really a physical quality. By a similar mental process, moral antipathies engender the idea of ugliness, while physical deformity sometimes excites moral aversion. Hogarth's waving line of beauty, is to many persons odious in a serpent, and in all serpentine movements; and it is likely that the popular reputation of the toad for possessing poisonous qualities, is derived from the unpleasant aspect of the animal. The influence of this association is strong in our perceptions of physiognomy. A sinister expression of countenance destroys the effect of beauty of feature ; while an expression of benevolence redeems a face decidedly plain. If by time or accident, such associations become dissevered, the judgments also respecting beauty are changed. A spider is considered beautiful by those, whose nursery notions are superseded by juster impressions of the industry, sagacity, and harmlessness (to ourselves) of the animal. The story of ' Beauty and the Beast' is an illustration of this law.

It is a matter of surprise to many, that objects, in themselves ugly, may become agreeable in imitation. A trim architectural drawing of a commodious house, is less pleasing than the picture of a dilapidated cabin ; a soldier in regimentals makes a less effective picture than a beggar in rags ; and a park is not so picturesque as a wild forest. This seems to result from an association of ideas. The idea of utility is in this case totally dissevered from the sensation, and is superseded by another. The pleasure excited by picturesque objects consists in a certain exaltation and poetic enthusiasm ; and ex-

‡ The pictures of Van Eyck and Hemelink, by many are esteemed absolutely barbarous, for want of the power or the will to enter into such considerations.

† De Tracy, Idéologie.

perience abundantly shows, that the organization is the most susceptible of this condition, when the frame is braced by exercise, and by the pure air of the country. It is then, that visible objects produce their strongest effect, and that the senses go as it were abroad, in search of the sources of this species of pleasure. The escape, too, from the trammels of society, and from the low cares of business, favours this predisposition. It should seem, then, that those objects which habitually present themselves to contemplation, in such moments of exaltation, have a tendency to reproduce the state, when seen in imitation; while the familiar objects of our artificial life in cities, tend, when painted, to chill and to narrow the feelings. In the works of man, also, straight lines (the shortest in statistics, as in geometry,) predominate; their beauty, therefore, is naturally small, consisting principally in utility; and it disappears when that utility becomes too obviously a secondary consideration. In these works also, all is violence and restraint: they are indications of difficulties surmounted, of labour exerted, and of a mind painfully fixed on a few disgracious ideas. In nature, on the contrary, the productions seem more spontaneous; its pleasures appear a free gift of Providence to man, inviting the mind to repose, to reverie, and to tranquil enjoyment. Almost every natural object, therefore, pleases in painting, from its power of producing an associated reminiscence of the excitement which that or similar objects have occasioned in the original. One almost fancies the cool breath of the wind passes over one's face in viewing a well-painted piece of forest scenery; and all the pleasing reverie of "the melancholy Jacques" seizes on the mind, as the contemplation lingers over it.

What the picturesque is in art, the noble is in poetry. A recurrence to the miserable necessities of humanity, destroys alike the sublime of both; and it is the moral association that makes the beauty of either. Whatever tends to disturb this association of ideas, destroys the picturesque: a group of modern hunting squires, in red coats, would assuredly spoil the effect of forest scenery, as far as this beauty is concerned; whereas a boar hunt, conducted by persons habited in the costume of a remote and poetic age, would enhance it. Further, it may be remarked, that any other association capable of producing the same tone of mind, creates picturesque beauty. A fine piece of Greek architecture, recently constructed, however beautiful, will not be deemed picturesque; but the same forms and proportions, partially overthrown, and ruined, become picturesque, by the grandeur of the historic ideas they are calculated to recall. Certain forms, not improbably, receive this quality through an exaltation of mind, produced by a mere sense of the art, bestowed on their representation. All broken forms, creating minute diversities of lights and shades,—the fluttering rags of the beggar,—the lichen on the stone, —the diversity of rock, &c. &c. require a far

higher exercise of imitative power to reproduce, than smoother, and in themselves more elegant forms. The pleasure which the knowledge of this fact creates, and the feeling it excites, constitute the charm of the accurate imitations of the Dutch school.

Inappropriateness, by interfering with association, destroys picturesque effects. The ass, which paints so well in a woodland scene, has no such charm if placed in a garden; nor would the peasant's cottage be picturesque, as part of a street of palaces.

To the sense of picturesque beauty, education and a cultivated enlargement of mind powerfully contribute. In proportion to the variety of the beholder's knowledge, is the sphere of his possible associations. A work of art, acting upon the *elegans formarum spectator*, the accomplished amateur and scholar, excites long trains of reflection, embracing numerous analogies in the physical and ideal world, comparisons with former experience, poetic illustrations, historical remembrances, speculations on cause and effect, &c. &c. by which an enthusiastic elevation or ecstasy of the mind is begotten—an exaltation of which the ruder intellect is not susceptible. This pleasure, though reflective, is ultimately referred to the senses, with whose impressions it is so intimately connected, and to the external objects by which they are excited. In this vast and extended field, circumstances are all-powerful to determine specific tastes. The Dutch, who, by nature and social position, were cut off from the access of such enthusiasm, had little feeling for ideal beauty. They saw in the arts nothing that was not imitative; and they had no taste for anything in representation, but the naked matter of fact. Whatever transcends the ordinary aspect of ordinary nature, was lost upon them; and their minds, preoccupied with the positive ideas of commerce, were excited by the metallic lustre of a brass pot, or an effect of light on a glass bottle, well represented, more than by all the splendour of a landscape of Claude, or the divine beauty of a Madonna of Murillo.

Inasmuch, then, as every man is born with his own peculiar temperament, and is exposed by the accidents of life to his own specific moral and intellectual education, he is liable to be affected, in his own peculiar manner, by external objects. The same is true, also, respecting nations; insomuch, that each separate community has its own specific taste in literature and the arts, and cannot be brought to acknowledge beauties which do not harmonize with it. But amidst the infinite varieties of idiosyncrasy, temperament, and education, there is a general tendency in the human organization towards a middle term, or common character, which lies equally distant from all extremes. To this middle term, no man perhaps has ever absolutely attained; yet all approach it in some particulars. To it, as M. Quetelet, of Brussels, has well observed, all general reasonings on man, whether physiological, moral, political, statistic,

or æsthetic, should be referred. It is the universal scope of all abstract reasoning on our nature. It is by the contemplation of the largest number of individuals, that the most accurate notion of this middle man is derived, and by abstracting from each all that is personal and exceptional, we arrive at what is embraced by the term human nature.

By the study of this middle man, the philosophical artist is enabled to arrive at certain general truths, or principles of taste, which are susceptible of a more or less happy application, in his attempts to captivate the applause of society, by his labours. To this middle nature alone is any abstract doctrine at all applicable. But the tendency of society and civilization, is to bring all men nearer to such a type ; and the cultivation of the intellectual powers, consequently, produces a closer agreement of opinion, as to the sources of pleasurable sensation. What thus takes place among individuals, occurs equally among nations. The steps by which society in one country advances in civilization, may differ in many particulars from those of others. The "middle man," or ideal type of humanity, therefore, differs in each. The Frenchman differs in his tastes, as in his prejudices, from him of Germany, or of England, as to almost everything, not derived from the common fountains of classical antiquity, or of the Christian religion. The Italian, Flemish, French, and English schools of painting, stand upon distinct canons of criticism, derived from distinct habits, respecting pain and pleasure ; and they are perfect incommensurably. But from the moment when the printing press, and improvements in communication, brought the nations of Europe into a closer contact, these national peculiarities began to give way ; and a continual approach has been making towards a middle nature, which will eventually constitute the common type of civilized man. The French, under this progress, have abandoned their ancient tastes in tragedy. Shakspeare is esteemed in Paris, and Goethe has his admirers in London.

But if the doctrines of taste are calculated upon this middle nature, it is obvious that, as in every individual, there is a more or less near approach to that condition,—and as there is a large mass of particulars which are common to all, the susceptibilities to pleasure and pain (however they may differ in different persons,) must be governed by one common law in every man. There are, accordingly, some principles of taste arising out of these universals, which are equally universal ; and upon which every sane man is agreed. The certainty of these principles is absolute. Next in order to these, are the points on which all large communities are agreed. The maxims of taste, governing any great national school of art, are certain, with respect to all the individuals rigorously bred in that school ; and the individual who presumes to impugn them on the spot, will infallibly lose his character, there, for taste and judgment. After such national peculiarities, follow the peculiarities of taste arising from differences of temperament and idiosyncrasy. These, respectively, are sufficiently common to be acknowledged as part and parcel of humanity ; and a man is not sent to Coventry or to Bedlam for confessing that he indulges them. There are other less common deviations of feeling and judgment, which are laughed at as eccentricities and oddities, or, haply, repudiated as affectations ; while the lowest degree of toleration only is given to the still less frequent peculiarities, which are attributed to vicious or defective organization.

Good taste therefore stands upon the same foundation as orthodoxy in religion : it exists only by the suffrage of the majority. To each man his own affections are the standards of taste, as his opinions are the standards of orthodoxy, and it is only when he meets with a formidable opposition from a numerous body differently constituted from himself, that he can be persuaded to tolerate any deviations from these standards : an isolated individual necessarily knows no others. "*Lorsqu'on sent, on tient à son sentiment parcequ'on est sûr de ne point se tromper.*"[†] Experience alone can teach us that other men are differently affected, and that their affections are entitled to an equal respect with our own. Thus it is that knowledge of the world cures men of arrogance and intolerance, and enlarges their sympathies. The steps of this progress are distinct. We first sympathize only in the affections which we have ourselves experienced ; afterwards we learn to tolerate those the most analogous to our own ; and finally, we are patient of feelings, which, not sharing ourselves, we yet perceive to be common to many sane and worthy fellow creatures.

In proportion as our idea of human nature is extended, by the aspect of man under a greater variety of circumstances, the field of taste is enlarged, and the tolerance of other forms than those which the individual has been accustomed to regard as pleasing, insensibly leads to a change in his own sensations.

In proportion, then, as a judgment or sentiment is divergent from the feelings common to society, it is censured as bad in morals, erroneous in opinion, or false in taste. We do not insist on our friend's liking the same meats as ourselves, because diversity on this point is of every day's experience ; so society tolerates the forms of religion with which it is familiar, while it refuses liberty of conscience in favour of opinions which are new and strange. Whatever, on the contrary, is common to the majority, passes for truth, rectitude, and good taste. The preference of one art or one school over another is sufficiently common to exempt it from the imputation of bad taste ; but if we should meet with an individual delighted with the music of a penny trumpet, in ecstasies over a drawing on a Chinese saucer, or preferring a Nuremberg doll to a

[†] Bozelli, ' Esquisse politique,' &c.

statue by Chantrey, it would be a great stretch of charity not to set him down as utterly mad.

A feeling for the fine arts being, however, the result of a peculiar organization, common only to a few individuals, and the sensitive faculties being capable of great developement by exercise, it has come to pass that the civilized world has taken its judgments very much at second hand. *Cuilibet in arte sua credendum*, is here a maxim of especial applicability. The rules of taste are generally adopted from the professors of art, and, in proportion as the arts are cultivated, a greater certainty is given to such rules, and the more safely may bad taste be inferred from their violation. But rules, after all, are only the means to an end ; the great fundamental consideration is the effect produced. If that be consonant to the feelings of the sensitive and the educated, the main end of art is obtained. In all, therefore, that is not merely mechanical, rules are conventional chains, and genius is right in neglecting them. Still, to violate a rule without obtaining a redeeming excellence, is bad taste—to obtain new beauties, no matter how, is good taste. In modern music, discords are used which would have startled and shocked the ancient theorists ; in these cases success alone justifies ; and public opinion, consequently, is the sole criterion of right and wrong.

If due consideration be given to what is universal in the nature of man, and what is divergent and particular to individuals, there can be little difficulty in determining the bounds of taste as a science, and of deciding what is and what is not within its domain.

There are objects which confessedly affect all mankind alike—the murmuring of waters, the singing of birds, the freshness of the morning, the still repose of evening, the majestic spectacle of the starry heavens, the refreshing verdure of the earth, produce their common influence upon the well-organized of all natures and ages. With respect to these, and to other such generalities of our nature, general reasonings may be indulged, and a corps of doctrine laid down, which, as a theory, may be made to throw valuable light on the subject of art. But, even within this limit, the application to specific instances is difficult and fallacious.

The comparison of such archetypal ideas with individual works of art is a pure operation of judgment ; and the judgment of the individual is the result of his personal tastes, of the degree of culture his senses have received, of his associations and his prejudices ;—while rules thus obtained are worth nearly nothing when applied to what is absolutely new in art. The most experienced critics often err, and but seldom agree with each other, if not as to the specific merits of a master or a work, at least as to the relative degree in which these merits are predicable. With respect to the mass of mankind, the little unity of opinion subsisting among them may, after all, arise as much out of deference for established authorities, as from a want of common feeling.

It is, however, on the ideal points that this difficulty is chiefly felt ; with respect to the mechanical departments, decision is more easy. Errors of drawing, or of perspective, are matters of demonstration ; a false insertion of a muscle can be compared with the human subject ; a displaced line can be detected by a diagram : even defects of drawing and aerial perspective may be shown by comparison. It is on these little matters that little critics are great ; but when the more transcendant order of ideas and sensations comes in question, there is no criterion but feeling, which, in each individual, is a definite fact *sui generis*, from which there is no appeal but to the feelings of another observer ; and whatever is so circumstanced remains an object of endless and unsatisfactory debate.

"Exhibition at
the Royal Academy"

Athenaeum (May 16, 1835), 378–79; (May 23, 1835), 394–95

nature; we desire to have justice done to the human mind and the human heart: it is not pleasant to look at a picture, in which two-footed creatures are auxiliars to the four-footed; to see splendid robes thrown over figures as cold and heartless as stocks and stones; to see soldiers whose plumes are the only martial thing about them; and a green hill and a running stream, with more of heaven in them than has been bestowed on their inhabitants: to this we may add, the utter absence of all propriety in many compositions; we mean propriety of action as well as of colour—propriety of everything.

We miss, too, what we shall never more see, the exquisite natural grace and unconscious loveliness of the maidens of Stothard—we know of no one worthy of taking his place: we may say the same of Flaxman in sculpture; in truth of detail, many excel him, but who can be named with him in that serene and poetic loftiness which made him the Milton of his art? Others are absent who might well have been present: Chantrey, who excels in ease and graceful expression, has sent neither bust nor statue: we miss also the English battle scenes of Cooper; he cannot have given form and colour to half the heady combats in which his country has triumphed. Rome has sent us several sculptures; nor are we insensible to their beauty, when we say they are surpassed by our home manufacture. We observed some errors of arrangement; dull pictures have found good places at the expense of brighter works: 'The Eventful Conversation,' by CROWLEY, occupies a very humble situation in the ante-room; and 'Nutting,' by KENNEDY, has been excluded from the principal rooms altogether: both merited better places; at least, inferior pictures have been more fortunate. Errors of a similar kind might be pointed out in the sculpture-room; young artists of promise should be tenderly, nay, encouragingly treated—but let it pass.

When we visit the Exhibition, we look out for such works as touch our heart and interest our fancy, and write them down good—no matter who produced them. The picture which dwells most on our mind, is the 'Columbus' of WILKIE; it is an honour to British art: for dignity of conception, manliness of character, force of colour, and, above all, propriety of action and expression, it is unequalled in the Exhibition—perhaps not surpassed by any modern work. The names of Velasquez, of Rembrandt, and of Titian, have been called in by some of our critical brethren to explain, by comparison, what words cannot describe—the high, the wonderful merits of this performance. As this easy mode of criticism insinuates that the painter has imitated his elder brethren, we shall not follow it, because it is unjust to one who, in colouring as well as conception, is original. The subject is Columbus submitting to Friar Juan Perez, Garcia Fernandez, and Alonzo Pinzon, the imaginary chart of his future wondrous voyage.—'Young Sancho Pança at the Fountain,' No. 127, and 'The

EXHIBITION AT THE ROYAL ACADEMY.

THIS is the sixty-seventh Exhibition of the works of the British painters, sculptors, and engravers composing the Royal Academy, and there are in all one thousand one hundred and thirty-eight pictures, drawings, and pieces of sculpture. Few are of colossal dimensions, and portraits are far from abounding: but there are pictures of surpassing excellence, both in history and imagination. The poetry of domestic life, too, has been perceived by several exhibitors, and there are not so many literal copies from rough raw nature as formerly. Our painters have, perhaps, found it unprofitable to take unpurified fac-similes from hill and dale—from stable and cow-house: they have found out that a cart-horse may be seen at any time in the streets; that a grazing cow may be found in every meadow, and that a flying crow or a snappish dog is a matter not at all remarkable, and unworthy of any great outlay of colour. This newly-awakened feeling has united, with the falling off in the public demand for portraiture, to render this one of the best exhibitions within our remembrance. There are still, however, many things to be amended: we wish to see more scenes of a historic and poetic

First Ear-ring,' No. 88, are hasty and happy little pictures by the same hand; nor should the portrait of Sir James Macgrigor, No. 137, be overlooked by those who admire the fine sentiment and colouring of Wilkie:—in his Wellington and Irving we think him less fortunate.

The picture which, in truth and expression, and happy handling, comes nearest to Wilkie, is the ' Highland Drover's Departure,' by EDWIN LANDSEER. The scene is the Grampians; a long winding line of cattle, on their way to the south, are descending by a picturesque road; an old highlander has come to the door of his cottage, and sits helpless and gazing, like one doomed never to head a drove again; friend is bidding farewell to friend—parting cups are filling and emptying—parting words of love or of business are uttering—dogs are gamboling—the very cattle seem conscious of what is passing, and are gathered here and there into groups equally natural and picturesque. Words cannot convey a sense of the glory of colours, nor do justice to the expression of the pencil; any account of this excellent picture we feel must be very imperfect; we shall, therefore, say no more in detail. The animal nature is, we fear, too strong for the human nature: the clucking-hen is equal to the highland wife; and there is a black bull which some prefer to the man who drives him. There are other pictures by the same artist, but we have no particular fancy for either dogs or horses.

Some of the members of the Academy will, we fear, pity our taste, when we say that we admire—and that not a little—' The Chivalrous vow of the Ladies and the Peacock,' by MAC CLISE. It is in vain that we are told of deficiency in historic propriety; that the chief figure, the knight taking the vows, is much too theatrical, and that the artist has attempted more than he has performed: we look, and see and feel that the light of an original genius brightens the whole picture. There is a true and vivid image given of those times, when love, and war, and wine, wrought wild things with men's imaginations; when ladies' sighs and minstrels' songs inspired the young and animated the old. The painter has introduced matters of a pathetic, a serious, and a humorous kind: some are thinking of their loves, some of their vows, some of themselves, and some of strong drink: here we have a lady with charms sufficient to drive three knights crazy; there a warrior ready for strife with windmills; while, we grieve to write it, a group of friars are crushing the wine cup with a fervour not at all holy. We have intimated the faults as well as beauties of this performance; the former are nothing compared to the latter: nor do we see a work in the place exhibiting higher dramatic powers or greater variety of human character: the artist must, however, subdue a little his love of strong contrasts; his mirth is too boisterous, his grief too great, and his action too impetuous; we desire him to look at Wilkie's ' Columbus,' and study the meaning of the word " propriety."

EASTLAKE has fallen into none of the errors of the painter of the ' Chivalrous Vow,' in his ' Peasants on a pilgrimage to Rome,' No. 114. It is a scene of quiet beauty; though jubilee time, and Rome bursts upon their sight, the pilgrims preserve a due decorum, and seem desirous of doing nothing out of harmony with the serenity of the landscape. ALLAN, too, has brought us a scene from a far land: ' The Moorish Love-Letter' has much force of colour as well as of character; the half-released bird—the messenger of love—and the captive maiden, attract the eyes of many fair visitors. UWINS, likewise, has found a subject in another country; his ' Festa della Madonna del Arco' is a graceful record of Italian customs; the characters are few, and the story well and poetically told.

From the hand of LESLIE we have two fine pictures—viz. ' Columbus and the Egg,' and ' Gulliver's introduction to the Queen of Brobdignag.' We prefer the former: the scene from Swift was, however, the more difficult to manage. The queen and her ladies are seated round the table, and Lemuel bows with true French grace to all; this is well told, and much more, for there is no little variety of character exhibited: yet, to us, the queen and her ladies, instead of looking like female ogres, colossal dames, seem of the ordinary dimensions of the daughters of men; and Gulliver appears as a puppet made of wax and wire, bowing at the touch of the show-woman. Leslie is one of the first of living painters, but no art can triumph over an intractable subject: painting is a more limited thing than either prose or verse. Northcote and others have averred, indeed, that poetry is not poetry, unless it can be embodied in form and colour; but there is much high poetry, and many flights of imagination beyond the reach of art: it would be but a waste of fine colours, we fear, to try to paint the cestus of Venus.

WE have already noticed some of the principal poetic or domestic pictures in the Exhibition; others merit examination and praise. ' The Refractory Model,' No. 12, by KIDD, is at once ludicrous and natural: an artist, desirous of delineating an ass on canvas, has brought one into his studio: the stupid animal, unaware that the honours of the pencil are awaiting it, brays, and kicks, and plunges,—destroying, at once, models casts, and all hopes of a happy portraiture. ' Morning,' by HOWARD, No. 78, is a scene—and a beautiful one—from the ' Paradise Lost': the drawing is accurate, the colouring subdued, and the expression in strict keeping with the poetry. ETTY, in ' Venus and her Satellites,' No. 94, exhibits the same correct and classic taste as heretofore, united with a gentler tone of colour: the figure of the goddess is graceful, and her charms are modestly —nay, unconsciously displayed. MULREADY has given us a school scene of ludicrous distress: the picture is called ' The Last In,' and represents a boy, who has the double misfortune of being dull and dilatory, appearing both with reluctance and

fear before an irascible pedagogue, who, while bowing to his victim in mock humility, intimates an immediate application of the birch. This artist seems fond of subjects unwelcome to our feelings; the inimitable ' Wolf and the Lamb' was one, and others might be named : but he soothes us by touches of humour and pathos, and we part only with the desire of seeing him again. HIL-TON is a great master of the human figure; his colouring, too, is agreeable, and both these qualities are visible in the ' Nymph and Cupid,' No. 136; we have met him in a happier mood, and we despair not of seeing him so again. The ' Tiger Hunting in India,' No. 152, by W. DANIELL, has the eastern climate and character very naturally impressed upon it; the dying tiger, the enraged elephant, the resolute hunters, and the bright cloudless sky, are all in the artist's best manner. ' War's Alarms,' No. 197, is a very clever little picture by FRASER: a boy comes suddenly to the door of a cottage with a trumpet, and blows a blast so loud and startling, that a girl shrieks aghast with fear, while her brother, much her junior, looks up, and seems to welcome it. In such simple things as this, more genius is sometimes shown, and deeper emotions awakened, than by works embodied from either history or verse. There are one or two noble figures in the picture by HART, No. 395, from Scott's romance of ' The Talisman': Saladin more than approaches the idea we have conceived of that great leader; nor is stout ' Tom o' the Gills' less to our taste: not so the stout King Richard; the fore-shortening is portentous—the expression not at all heroic: with such a look we suppose his brother John signed Magna Charta. JONES has one or two pictures which, at least, sustain his reputation for character and colour: nor has COOPER altogether neglected us, though he fills not his canvas with " armed men and caparisoned steeds."

The landscapes are more natural, and, perhaps, less poetic than we have seen them. Callcott has four pictures, Turner five, Constable one, Collins four, and Stanfield three: some of them exhibit nature, mingled with fancy, others are almost wholly imaginative, while one or two aspire not above the honours of correct copyism. ' Keelmen heaving in coals by night,' No. 24, is from the hand of Turner: we have often seen men working by torch-light on the river, but who can hope to see such scenes as present themselves to the eye of this artist? At the first glance, the word " extravagant" rose to our lips; but as we lingered before the scene, other feelings triumphed, and we could not help pronouncing it a striking, if not a wondrous performance. We may say nearly the same of No. 294, ' The Burning of the Houses of Lords and Commons.' Of the thousands and tens of thousands who saw those ancient edifices

Redden the midnight sky with fire,

not one of them, we would be sworn, thought the scene half so portentous—nay, supernatural, as

the artist has delineated it on his canvas : flames are flashing out, of a far fiercer nature than ever earthly fuel could produce ; and the air above, and the river below, may be said to express surprise at the sight; in extravagant words, an extravagant picture may be criticized. The next, and last work we shall notice by Turner, is one of a nobler kind,—' Ehrenbreitstein, or the bright stone of honour and tomb of Marceau, from Byron's Childe Harold.' Imagination and reality strive for mastery in this noble picture: there is an aerial splendour about it, such as the poetic love, and at the same time such a truthful representation of the real scene, as satisfies those who conceive that a landscape should be laid down with the accuracy of a district survey.

We have seldom seen CALLCOTT in greater force : ' The Genoese Coast near Ricco,' No. 13, ' Mid-day, resting from the Harrow,' No. 66, ' Approach to Vienna from the Tyrol,' No. 101, and ' Composition from the Lago di Garda,' No. 118, are the names of his pictures, and one and all are poetically treated. Callcott never dismisses a hasty or imperfect work from his hand ; his earth, and air, and sky, are in harmony ; the figures with which he peoples his landscape, are not dropped in by chance, or set down at random ; their duty calls them there— they belong to the place as much as flowers to the field. The more we look at his scenes, the more we are pleased with them: he is never tame, and never extravagant. CONSTABLE is an original in everything; he must be compared with nature, and not with art, and when that is done by no superficial observer, his pictures will be found more in harmony with hill and tree, and dale and stream, than some of his critics seem to imagine. When seen with other pictures, his works are rather startling ; the lights dancing upon the moist leaves of the greenwood seem snow, and the fields enamelled with flowers, such as no hasty botanist has any chance of finding as he saunters among the meadows. There are other defects; but what are they all to the force and wondrous light and shade of his compositions? We lately saw a little sketch from his hand : a storm was sweeping over Hampstead Heath, and a tinker, with his children and asses, were huddling together in a sand-pit, to elude the watery blast ; it was quite sublime. No. 145, ' The Valley Farm,' his present picture, is a tranquil scene, and finds admirers in visitors to whom rustic life is not alone known through the accurate medium of panoramas, and who know more of woods and purling brooks than can be witnessed at a melo-drama. Of COLLINS we always speak with readiness; his pictures are true as well as poetic, his landscapes are full of life and sentiment, his human nature lends a tongue to his lonesome shores, and his sea-beat rocks. ' Children launching a Boat,' No. 107, ' The Mariner's Widow,' No. 126, ' Welch Peasants crossing the Sands to Market,' No. 180, and ' Cromer, on the Coast of Norfolk,' No. 298, are works in which

all, and more than all, the merits we have
alluded to are visible. STANFIELD was elected
a member of the Royal Academy this season;
and whatever honours that elevation may bring,
the pictures before us prove that he deserves
them. He has the same truth, the same bril-
liancy, and more than the force of his earlier
works. His scenes are poetic, yet real; he
dreams splendid landscapes, but he paints them
in no visionary manner.

PHILLIPS has several fine portraits: the
modest grace and unassuming beauty of his
female, and the dignified, and sometimes poetic,
expression of his male heads, have been often
noticed, and will not now be sought for in
vain. The portrait of the accomplished Hallam
is equal to any we have seen from the artist's
hands, always excepting his inimitable Blake.
There is a matronly serenity and elegance in the
portraits of Mrs. Richard Cooper and Mrs. Pres-
ton. There is much in the saying attributed to
Rogers the poet, that Lawrence should paint his
mistress, and Phillips his wife. BRIGGS has sur-
passed himself this season: perhaps his portrait
of Lord Eldon is the best in the Exhibition;
other heads by the same pencil are of high, but
unequal, merit: though we admire his likeness
of our gifted authoress, Mrs. Jameson, there is
an expression—a something more exquisite still
—in the living face, which we desire to see on
canvas. We are becoming too fastidious, we
fear: Briggs has made a long step, and we fret
because he has not stepped as far as Reynolds
and Lawrence. Of the portraits of PICKERSGILL,
we may say, that they are carefully, if not always
happily, studied, and that the colouring is vigorous
and harmonious: he never fails to seize the
likeness, but he sometimes errs in copying the
living person before him too closely: the mis-
takes of nature should be corrected by the artist:
a large head, for instance, should be painted in
unity with the body: this may—nay, must pass
muster in life, but it becomes intolerable in art,
where we look for harmony of proportion. ROTH-
WELL is returned from Rome: he has all his
original elegance; but, in seeking for the beau-
tiful, he occasionally neglects the vigorous.
There are other portrait-painters of talent and
reputation, but we have no leisure just now to
describe their labours, or weigh their merits.

The Sculpture Room has many attractions.
The faults are so few, and the beauties so great,
of No. 1046, 'A Mother and Child,' by BAILY,
that we cannot help regarding it as one of the
finest productions of modern times. The waist
is, indeed, too depressed for the form to be per-
fectly beautiful, and the bosom too much ex-
posed for the otherwise modest serenity of the
figure, but maternal affection and youthful love-
liness triumph over the coldness of criticism;
and, as we think of the work, we almost wish
our words of censure unsaid. 'Devotion,' a statue
in marble, No. 1045, by WESTMACOTT the elder,
No. 1047, 'A Nymph of Diana,' by WYATT, 'A
sleeping Shepherd Boy,' No. 1048, and 'Paris,'

No. 1050, by GIBSON, with 'Girl and Carrier
Pigeon,' No. 1051, by MACDONALD, are all works
of taste and talent, and one or two of them rise
into the poetical. The same may be said of
'The Dream of Io,' by WATSON, and 'The
Creation of Eve,' by PITTS; these latter works
are not well placed, but they cannot be
passed by a visitor who, amid the heavier reali-
ties of life, is in quest of the fanciful or the
poetic. The busts are, as usual, numerous, but
why have we no male heads by CHANTREY, or
female heads from the hand of BEHNES? BAILY,
too, who now and then contributed à work of
this kind, has not sent one: MOORE seems to have
withdrawn also. The bust of His Majesty, by
JOSEPH, is placed in a conspicuous situation, and
we believe it is regarded as a good likeness: a
marble bust of a Bacchante, by SHARP, is clever,
and, we are told, a portrait: there are four male
busts by BEHNES, in marble; the expression is
pleasing, and the workmanship skilful. The bust
of the Earl of Winchilsea, by WEEKS, is worthy
of a better light; it is most perversely placed.

We have marked some threescore pictures, and
about a dozen pieces of sculpture, for future no-
tice, if the pressure of literary matters will
permit.

W.H. Leeds

"The Somerset House Annual"

Fraser's Magazine 12 (July 1835), 49–62

A POEM, says Horace, is a picture. Is not the converse of the proposition as true? Poet and artist, however, would both err, if they carried either maxim to extremes. Darwin and Fosbrooke wrote poems on the principle of using only precise images of picturesque effect, chiefly founded upon the sense of vision. We know not that either can be said to have prospered in so partial an aim, and must be ignorant of this branch of literature altogether to assert that it is or has been approved by the judicious. It has been justly said, that the very remembrance of " blind Thamyris and blind Mæonides " might have induced hesitation before such a theory was adopted. A poem, therefore, is something more than a picture, since it admits of images derived from the ear, the taste, the touch, and the smell, as well as the eye. In a similar manner a picture, though it may be truly said to be a poem in a certain sense, is at the same time something different. It may, indeed, suggest impressions of all the senses ; but its direct province is with the sense of vision, and only through the medium of sight may it excite the soul.

The president of the Royal Academy is commendable, not only as a painter, but as a poet, and will therefore take the above observations in good part. We indeed hope that the motto to this year's catalogue, *Non seppon tutti far benè tutte le cose*, &c. (which is, by the by, far more to the purpose than generally happens), may not be applied by the malicious as a reflection upon the president himself, who is far from being a proficient in " *tutte le cose*," and is less to be commended for what he produced with his pencil than for what he once executed with his pen. If there be any thing that can reconcile us to the neglect of theoretical studies, it is Sir MARTIN SHEE's own example ; which demonstrates how little they of themselves alone conduce to superiority in practice. He affords a still more striking instance than his predecessor, Sir Joshua, of the difference between laying down doctrine to others and adhering to it ourselves. With enthusiastic admiration of Michael Angelo

upon his lips, Reynolds affected an entirely opposite style of art, and founded his merits upon qualities scorned by the great Florentine master. So, too, does Sir Martin appear entirely to forget his counsels and precepts, as soon as he takes his palette in hand. Never very powerful, he is this season more than usually tame, whether the fault rests with himself or those who have sat to him. In his large portrait of the king, the grandeur of drapery and robes has been in his favour ; but in all the rest he stands lower than some others in the Academy. His colouring is rather plausible than meritorious, and too indiscriminate withal ; nearly the same complexion prevailing in every face: while to none has he imparted much of character or expression. His portrait of Lady Vivian (No. 57) looks neither like truth nor flattery, but has a kind of wax-work air about it and a vagueness of drawing that are very far from captivating ourselves. Our wonder increases, however, when we find the President venturing to challenge a comparison with his immediate predecessor, whose charming and animated portraits of children, replete with the most winning graces peculiar to that age, are so strong in the recollection of every one. The two children in No. 108 are intended to look particularly innocent, nor do we deny that they do so ; yet there was no occasion to make their innocence of such a sheepish cast. Both (the elder one especially) seem to be over-acting the part the artist has given them, to a degree that borders upon silliness : so far the portrait of Sir J. Campbell's son (No. 161) has the advantage of them, and, although not particularly striking in itself, is quite as good as any thing Sir Martin exhibits this year.

Out of several hundred pictures in this year's exhibition, there are hardly half-a-score that can claim to belong to historical or poetical painting ; and some of these might be more correctly termed *anecdote pictures*: for beyond such subjects very few now-a-days aspire. We require not to be told, that even productions of this description are preferable to much that has hitherto been palmed upon the world

under the imposing title of historical painting, while it has, in fact, been little else than graphic bombast, unmeaning show, and pompous frivolity. Equally ready are we to admit, that among the more familiar subjects — those which do not aspire even to the dignity of *anecdote* — there are many that may be viewed with pleasure *en passant*, yet no great number which a collector would care to possess; although we observed none of those low, vulgar "comicalities" upon canvass, which we have frequently met with, and which seem intended only to be translated into "popular prints," to attract a crowd at a shop-window. We may deceive ourselves, but we trust that the day for such manufacture is going by; and, indeed, it is astonishing how it could ever have obtained patronage — that is, purchasers — since people rarely buy pictures without the intention of displaying them, and no one could hang up "furniture" productions of this class without betraying the vulgarity of his own taste. If those who give us mere graphic buffoonery conceive, either that they are treading in the steps of Hogarth or countenanced by his example, they err most deplorably. Hogarth was frequently coarse, but not often vulgar; his unpolished energy was that of a mind which, conscious of its integrity of moral purpose, disregarded mere pharisaical decorum —the decorum that is more scrupulous as to expressions than as to meanings, and is less shocked at immorality attired *comme il faut*, than at the honest reprobation of vicious feeling and criminal indulgence. Some wholesome, although homely-expressed, ethic lesson, discovers itself in nearly every one of his productions; and although we neither admire nor defend his indelicacies, as such, we do not consider them as the offspring of a corrupt mind, or likely to corrupt by seductive allurement. He did not exactly paint, indeed, *virginibus puerisque;* neither

did Shakespeare himself always so write : still a depraved taste alone will direct its attention to, and especially single out from their works, what is objectionable in itself, and, by separating such parts from the rest, exhibit them distinct from the antidote of their context. Perhaps none of our modern humourists of the pencil have ever been guilty of the offences against propriety which Hogarth allowed himself; most certainly they have never, like him, attempted to instruct, to warn, to correct : their utmost ambition is to divert by graphic farce and joke ; yet even when they do exhibit some cleverness on the part of the painter, jokes upon canvass are apt to become wearisome and dull as soon as the first surprise has worn off.[*]

When, by first descending to them himself, a man can elevate such subjects to a higher grade, and infuse into them (as Hogarth did) some strong redeeming quality, he may safely be left to pursue that track ; yet, unless we are greatly mistaken, most of those who conceive they have a talent for it, do so on no better ground than their consciousness that they have no talent for any thing superior — that, in any thing more elevated, their failure would be signal.

We have said that there are this season very few pieces that aspire to the rank of legitimate historical painting. Is not, then, the lion of the exhibition, WILKIE's "Columbus in the Convent of La Rabida," to all intents and purposes an historical subject? It is an admirable picture, nevertheless; and if not quite equal to any work of any master, old or new, is yet, at any rate, one of the best ever produced in this country. It has all the action, all the expression, the subject admits — is founded upon an anecdote of high historical value — and were it a group of portraits by a contemporary of the characters here introduced, would then possess an historic interest of the strongest kind :

[*] The late Michael Sharp may be said to have completely wrecked himself upon this fatal quicksand of vulgar drollery. With talents that promised to raise him to distinction, and which, had they been properly directed, would have earned for him an honourable reputation, he chose to enter upon the meanest and most contemptible walk of his art,—to paint mere fun and whim ; until at length he sunk into downright imbecility both of ideas and execution. Many of his later productions were no better than *maculatur*,—what no one would give house-room to, except it were in a servants'-hall, or else in the " travellers'-room " of an inn. Nevertheless, some of them were puffed off at the time of their appearance ; but it would not do : poor Sharp fairly painted himself down ; and at last went out of the world without a single newspaper's saying " Good bye " to him.

for such, in fact, they might almost be taken. There is an air of veracity so forcibly impressed upon the whole, that the artist appears to have drawn from actual observation rather than from his own ideas. There is a quiet, unaffected simplicity, that is truly captivating ; no aiming at effect, no theatrical display, no mere filling-up, none of that exuberance that is frequently poured forth in order to catch attention, and divert it from the pauperism and meagreness of the painter's imagination. The colouring is forcible, yet sober; the execution truly admirable, finished, without being at all laboured, and free and masterly, although the reverse of negligent. The details are most happily managed, most carefully worked up, yet not in the least obtrusive. There is, for instance, a silver tankard upon the table, which, although kept duly subordinate, as a mere accessory, would, if detached from the rest, form a very fine bit of " still-life." There are two minor subjects by Wilkie, the " First Ear-ring " (No. 83), and " Sancho Panza in the Days of his Youth" (No. 127). The former of these is in a rather light and sketchy manner, and equally slight in subject,—a familiar incident, yet happily told, and expressed with a sufficient relish of comic humour. In the tanned-hide urchin we are presented with a well-conceived image of the future squire to the renowned Quixote, the antithesis to his master in chivalric enthusiasm, yet confessedly his co-partner in fame. He is altogether, nationally and phrenologically, marked out for the cunning, anti-romantic Sancho—the lover of good cheer and shrewd proverbs. This little picture is a charming specimen of colouring, is freely handled, and, although not highly, is studiously finished.

Unless our memory deceives us, EASTLAKE's " Peasants on a Pilgrimage to Rome " (No. 114) is a subject that has been before, although differently, treated by him; and is one too congenial with his *penchant* for Italian peasantry and their costume not to exhibit much of his peculiar talent, and that to advantage : at the same time it does not please us so well as most of his banditti groups, which had a certain quality of originality our eye misses here. The scene, however, is picturesque enough, and conveys a more honest than flattering idea of

Catholic devotion of that frequently sincere, though superstitious and idolatrous feeling, which calls up so much transport at the first coming in sight of the " Holy City."

UWINS also treats us with a tid-bit of Catholicism in No. 283, the " Festa della Madonna del Arco ;" but there is a great deal of puerility in this artist's works — one of the hundred who paint Italian subjects in the same manner.

In his " Vow of the Ladies and the Peacock " (No. 270), MACCLISE is not only not sparing of figures, but actually prodigal of them ; and may almost be said to have put a quartetto of pictures upon one canvass. It does not often happen that our artists afford any occasion for complaining of exuberance ; but we do think that in this instance the subject would have been all the better had there been less variety and more unity in it,—there being too much by-play, too many episodical groups, that divert attention from what should be the principal point of interest ; and this want of unity is the rather felt because some of the episodes are treated more *con amore*, as it appears to us, than the main action. The picture is of a most ambitious order, nevertheless, and exhibits equal promptitude both of mind and hand. Great mastery of pencil is displayed, and wonderful facility of execution. There are beauties in this production of no ordinary quality ; it manifests equal fertility of ideas and ability in embodying them ; an eye for colour, and facility of design ; invention and character. After all, too, Mr. MacClise's error—if error it be to have put forth too much strength—is of a sufficiently laudable kind ; nor should we be sorry to find it infectious, as there are many who would be greatly benefited by receiving the contagion. He is inspired with the true spirit of romance—an imagination overflowing in action, and expending itself recklessly from a consciousness of inexhaustible opulence. The " years that bring the philosophic mind" will find him a master indeed in this most delightful of the arts.

It would be no very great compliment to ETTY to say that even the most ordinary of his damsels eclipses the Pandora who is to preside over the Soanean museum. It is rather through excess than from deficiency of blandishments that his females are apt to

offend— at least to startle the prudish. Some of them are " archetypes of voluptuousness"— more " *gymnastical*" — or, ταις γραφαις απογυμνουμεναι, than is altogether becoming, except in an academy of the living model ; for Etty too frequently indulges in a prurient obtrusion of nudity upon the eye, as if willing to ascertain to what length his admirers will allow him to proceed. " Venus and her Satellites" (No. 94) is not altogether so striking an instance of this as some productions before exhibited by him. We apprehend, however, he would not be mightily pleased were he to be told there is nothing whatever in it to stimulate the fancy. In fact, it breathes an air of Idalian luxuriousness all the more seductive for being refined into bewitching elegance. His " Phœdria and Cymocles" (No. 310) is not in a more splendid, but in a more boudoir-like style — for " meretricious" would seem too pointed an epithet ; and the amorous pair who are so closely entwined together in their tiny mother-of-pearl boat— perhaps the better to preserve its balance, seem to be altogether denizens of a holiday world, where people can live most jollily without any more substantial fare than transports and kisses. Etty is apt to *poetise* with his pencil much after the fashion that Darwin piqued himself upon *painting* with his pen, rather too flowerily and lusciously : they cloy us with sweets till we feel surfeited and out of conceit with them. This artist's ladies are addicted to attitudinising more than decorum warrants ; yet few of them throw themselves into such unseemly postures as one of those in No. 325 (" Wood-nymphs Sleeping") : we might almost fancy that satyrs as well as the graces occasionally inspire him, and direct his pencil. As we cannot notice every one of his subjects, we shall, in addition to the preceding, mention only " the Bridge of Sighs, Venice" (No. 235), for a peculiar moonlight effect, in which the painter has perhaps sought to encroach too much on the poet's province. He has endeavoured to give sentiment to stonework, and make colours perform the office of words. While Turner delights to fling a misty indistinctness over his most sunny scenes, and introduces in the broadest light of day, figures, buildings, and other objects, of such hazy, air-

woven tenuity that they seem to flicker before our eyes, Etty has here shewn noontide glare and garishness contending with night for mastery. As the moon itself is not visible, only the intense violet-blue of the sky, with a star sparkling upon it, informs us what is the luminary whose beams are thus powerful. Every outline is so sharp and cutting, the colours so " uncorrupt" and clear, that this picture has the look of being a piece of inlay work or veneering. It would be doing injustice to this great artist were we to pretermit his " Warrior Arming" (No. 287), which is characterised by a grand and noble expression, and a fine head of antique chivalry, testifying a master's mind and hand. It is, in fact, a specimen of the *beau idéal* which cannot be too highly praised.

We regret to say that HILTON has but one subject ; and our regret is not unmingled with disappointment at being obliged to add that, instead of being an historical one, it is of a kind which possesses neither novelty nor interest in itself. " Nymph and Cupid " is as trite a theme as the Roman Catholic " Madonna and Child." It is, however, a fine picture. There is an exquisite tone of suavity in the colouring, and not a little *naïveté* in the figure of the infantine Cupid ; if we are not mistaken, he bears a striking similarity of physiognomy to Sir Joshua's Puck. Still, however creditable the work is in itself, it is not commensurate with the artist's powers, who must have felt himself in the situation of Hercules employed at the distaff.

For admirable propriety and correctness of execution, we have few artists who can more safely be recommended as a model than EDWIN LANDSEER ; and he may all the more safely be pointed out as such, because exempt from any of those obvious peculiarities upon which a copyist can fasten. They who could follow him, would hardly need any other guide than the one he has chosen, and to whom he faithfully adheres — Nature itself. The felicity with which he expresses its most delicate and evanescent *nuances*, is a secret he could not divulge, were he ever so much inclined to do so. It consists in something very far superior to mere accuracy, for, like a mirror, it softens and irradiates what it reflects. With powerful truth of local colouring, he knows also how to combine the most

captivating general colour, and a liquid transparency of tone that is most grateful to the eye. That department of the art which he has selected for himself, is very far from being the most elevated or the most intellectual; but it must be admitted that he has conferred upon it, if not positive dignity, a refinement of which it might be thought scarcely susceptible: and it is more meritorious to ennoble a lower rank of art than to degrade and vulgarise a higher one, as generally happens when our painters attempt subjects that call for intellectual qualities, for passion, or imagination. No. 303, "Favourites, the property of H.R.H. Prince George of Cambridge," would alone justify all that we have said of Landseer. Much is it to be wished, that every one of those who undertake to paint "ladies" or "gentlemen," would exhibit along with such subjects the spirit, the truth, and the happy *non so che*, which give such interest and animation to those portraits of a dog and horse, and to all the accessories of the composition. As generally represented, portraits of horses, however satisfactory they may be to those who look at them with the eye of a groom or a jockey, are graphic abominations, fitter to swing upon sign-posts than to be hung up in gilt frames. But it is to "A Scene in the Grampians — the Drover's Departure" (No. 167), that particular attention must be directed. This is the crowning picture of the exhibition. Here, in exquisite developement, we detect all Landseer's peculiar excellences. It is impossible to praise the grouping too highly; both men and animals are equally well executed. Every part is so beautifully detailed, that no specification is possible of distinct beauties, else we would select the hen defending her chickens against the little dog. The execution, it may be safely said, cannot be surpassed. Cows, bulls, sheep, all are lifelike — nay, all are living. In fine, though there be no particular point of interest, the entire performance is full of elaborate and characteristic finish.

This is lofty praise — yet let us not be misunderstood. This picture is the best, certainly, in this year's academy:

it is, however, not the best in that wider school, the world. It is far from being a key-picture; and, if this be not such, we must look in vain for one in the present exhibition. This is a sad want. We have nothing, consequently, by which to compare and contrast the different works. Of the most worthy productions, cleverness is the proper characteristic. If this be all we can say of the greater efforts, what shall be now said of the less? Reader, permit us a few remarks.

Had Mr. Bell succeeded with the notable scheme he would fain have prevailed upon Sir John Soane to patronise, it is possible that the same principle would by this time have been extended to the other arts, and painters, as well as architects, have been debarred from practising, unless duly qualified by taking a degree, and obtaining a diploma. Similar testimonials of professional capability might also very properly be made a *sine qua non* in the case of those who practise either as poets or novelists; for that there are quacks and interlopers in all these professions, as well as in that of architecture, no one who is in the least acquainted with them can doubt. Nevertheless, it may be questioned whether any real advantage would be gained by such a scheme, or the public at all better secured against impostors and pretenders than at present. Unluckily, no one has yet hit upon any infallible test as respects taste. There is no unerring standard of orthodoxy in such matters; consequently, *that* must be left altogether out of the question, and the candidates could be examined only in what appertains to the mere mechanical part of their respective pursuits. A diploma for painting might, indeed, be reasonably refused to one who could not draw a decent outline; an ignorance of grammar would afford just ground for sending back a candidate ambitious of setting up as a manufacturer either of poetry or of fashionable novels; and an aspirant for the honours of translatorship would hardly be allowed to pass his examination, if unable to construe a sentence in any of the languages from which he purposes to overturn foreign books into his own vernacular tongue.*

* Had such wholesome regulation existed, Bowring would never have set up as translator-general from all the tongues and dialects throughout Europe. Almost every one of his "specimens" bears strong internal evidence of the manner in which

When we find so many inferior productions admitted into exhibitions, it would be altogether preposterous to suppose that a college for artists would exclude candidates on the mere grounds of insufficiency, while a Royal Academy makes no scruple of receiving, and so far giving some sanction to, things that are as little creditable to them as judges, as to the ability of their authors. We believe the evil must be left to correct itself. When the public shall cease to tolerate mediocrity on the one hand, and sheer extravagance on the other; when it shall demand a higher intellectual tone—more study on the part of artists—a more sterling and equable degree of merit in their works,—we may begin to hope for a change, which now we dare hardly anticipate.

To say the truth, we have strong doubts in our own mind whether, as at present conducted, the different annual exhibitions are altogether calculated to bring about such a result. Undoubtedly they give a certain stimulus: the question is, whether that stimulus is a salutary one? Exhibitions themselves are almost certain of being encouraged: they afford a cheap amusement, and every visitor is sure of the pleasure of hunting after something to his own peculiar taste; yet unless he bring some judgment along with him, he is not likely to be burdened by any that he will carry away after lounging an hour or so amidst an indiscriminate mass of pictures. That there must be a vast alloy of mediocrity, including much that does not rise even to the level of respectability, may be inferred from the number of productions annually received; else, were quantity any criterion of merit, England would at this moment rank as high for its proficiency in painting as almost any other nation, ancient or modern. The Royal Academy, and not that body alone, but those who have the management of other exhibitions, err not a little in reversing a sound maxim, transposing it into the

new reading of *multa haud multum* Convenience, rather than any discretionary principle of selection, seems to be their guide; since, without attributing to them such a degree both of unfairness and bad policy as to reject what is good, they certainly do condescend to hang up a very great deal that has nothing to recommend it to public notice—most probably for no better reason than because they can thus fill up many vacant spaces, and cover all their walls from top to bottom. In our opinion this system calls loudly for correction; for admitting that an alteration in it would not increase the number of good works, it would be a positive gain to decrease the number of those which verge upon the ignominious distinction of being very bad. Exhibitions would no longer be clogged, as they now generally are, with so many pieces of painted and framed canvass, whose only merit is that they operate as foils to what deserve the name of pictures—causing even mediocre performances to appear respectable, in comparison with themselves. Were some little regard paid to quality, some preliminary ordeal established, it might be better both for the profession and the public—certainly more creditable to those who officiate as caterers for the latter on such occasions. Artists—or we should perhaps say professional persons—would then have a twofold stimulus: they would be aware that they must exert themselves in order to make their performances pass muster; and they would also work with the consciousness of knowing that nothing could be rejected for want of room, and that admission would imply—which at present it does not—some acknowledged merit. Specious cleverness and dexterity rather abound than the contrary; but then it is for the most part a species of cleverness whose after-performances seldom fulfil its earlier promises, and a dexterity that settles down into a mere knack of practice. However

they were manufactured; otherwise the blunders into which he has frequently fallen would be more unaccountable than they now are. Not long ago, a German journal, then recently established, upset the *übersetzer*, by confronting some *soi-disant* translations by him from the Lettish with the originals,— printing the latter in one column, a verbatim German version in another, and Bowring's translation in a third. In many instances the ideas were as dissimilar as they could well be; still, we do not say that the Doctor intended to impose upon his readers; we rather suspect that he was imposed upon himself: at all events, it seems he imposed upon himself a task to which he was unequal —a fine illustration of the value of the Bell system of diplomas!

successfully it may take with the public at first, talent of this description rarely maintains its lustre long, but is neglected for something newer to the town, if not more deserving of its favour. Strenuous application in the path he has chalked out for himself, and study with the mind no less than with the hand, are indispensable even for the most gifted, if they would do justice to themselves, and not accept ephemeral applause instead of permanent fame. Now it unfortunately happens that the ambition which looks to the former, rather than to the latter of these objects, is fostered more than there is any occasion for by the system of public exhibitions of pictures. Artists are apt, and not unnaturally so, to prefer the ready cash of popularity to the long-dated bills of sterling reputation; and, in order to secure the popularity, the taste of the many must be consulted in preference to that of the few. Accordingly we are of opinion, that although we have some able painters, they are more indebted to themselves for being so, than to such institutions for having made them so. "Our heart is wae" for TURNER. The "Burning of the Houses of Lords and Commons"(No. 294) is a great curiosity. The light is that of an English November day, while the flames are of more than November dulness. As the poetic style disdains to be cramped by matter of fact, we must, we suppose, excuse Mr. Turner for his pictorial amplification of the scenery, and the daring licenses and liberties he has taken with perspective, which do not exactly become one who is a professor of it. "Keelmen heaving in Coals by Night" (No. 24) is thought highly of; it is nevertheless a failure. The night is not night; and the keelmen and the coals are any thing. The "*Ehrenbreitstein*" (No. 74) is, however, beautiful. His "Venice" (No. 155), on the other hand, is a piece of brilliant obscurity; where, depending entirely upon colour, he has dispensed with drawing and form, as unnecessary for his purpose. As Mr. Turner seems to be afflicted with a singular delusion, and to fancy that in order to be poetical it is necessary to be almost unintelligible, we would recommend him to go, and not only look at, but attentively study a "Venice," of a very different character from his own — that exquisitely fine scene of the

"Grand Canal," by Harding, in the Water-colour Exhibition. That is the genuine poetry, both of nature and of art, in such subjects! The architecture is beautifully expressed with all the feeling of a painter: while the buildings are lucidly defined, no parts are harsh or obtrusive, but all made to contribute to the general effect: there is a powerful breadth of execution, and the colouring is glowing and brilliant, at the same time that it is free from artifice or exaggeration. We would further advise him to make use of the same opportunity, and examine Cattermole's pieces there; in which he may observe a masterly freedom of execution and original vigour of colouring, combined with a no less masterly intelligence of form.

PHILLIPS displays great power as a portrait-painter. There is an unaffected vigour both in his drawing and colouring, accompanied with a gracefulness of composition that, independently of likeness, renders his works highly pleasing as pictures; at the same time that it is impossible to question their fidelity as likenesses, the individuality of the persons being so markedly expressed. Mrs. Preston (No. 38) is a fine specimen of his talent; a charmingly painted figure of a lady, who, although past her first bloom, retains attractions which the artist's pencil appears to have done justice to, without exaggerating them. A chastened elegance of taste displays itself throughout; and whether it be that of the lady herself, or of the artist for her, the style of her dress offers a model of simplicity combined with richness. The prevailing colours are so chosen as to set off the complexion to advantage, and nothing can be more happily imagined than the *ensemble* of her whole attire, which preserves a most felicitous medium between that frigid plainness with which some painters rather *drape* than dress their sitters, unwilling, perhaps, to have any thing at all to do with so mutable a concern as fashion; and that excess of finery with which others heap them, in hope of thereby making them look like persons of consequence. No changes of fashion can possibly render obsolete the beauty of dress which is truly becoming in itself; and in this respect the artists of the present day have a decided advantage over Sir Joshua and his contemporaries, who, unless

they chose to put their female sitters into complete masquerade, had to contend with the most preposterously unnatural sophistications of the female form and face.* It is true, Mr. Allan Cunningham would fain persuade us, that there is much " simplicity of costume" in Sir Joshua's portrait of Mrs. Molesworth; nevertheless, in our opinion, not only the dress but the whole figure is exceedingly quaint and formal, if compared with any thing short of an Egyptian mummy.

There is also great merit in GEORGE PATTEN'S " Portrait of William Dickenson, Esq. late M.P. for the county of Somerset" (No. 286). It is, *par excellence,* a portrait. The same observation is in a degree applicable to his " Rev. R. Dalton, late minister of St. Jude's, Liverpool" (No. 138). Of both it may be remarked, that they are free from all that is foreign to the purpose of the picture. Neither is filled up with trash, as is the case with every other portrait in the rooms, with the single exception of Wilkie's. But this artist has higher claims than these in the minds of those who recollect his " Cymon and Iphigenia" last year. They will seek with anxiety his " Venus caressing her favourite Dove" (No. 194). Tenderness is the prevalent expression of this exquisite picture. Grace and gentleness constitute the character and sentiment of the composition. The attitude of the Venus, and the flattered sense of complacent gratitude with which the bird returns the attention of its mistress, is indicated in the action of the head, neck, and wing. Too much praise cannot be bestowed on what, for want of a better term, we will call the Calibre of Form — that noble and ideal style of limb by which the Elgin marbles are distinguished. The flesh, as to colour, is conceived in the same spirit as the form, and removed from the common and the actual. The subdued tone of light and shade, so far from impairing what would be esteemed by a vulgar mind the richness of the effect, contributes to what is really and properly to be so termed in the estimation of the judicious. This work influences

the mind like a picture of Correggio's, without his inaccuracy of drawing. The perfect and gentle gradation of light from the head to the feet gives a varied effect to each part, and preserves a due subordination from the principal point of interest in the centre, where the light highly illuminates the neck and shoulders of the Venus, and glances over the dove, which she is caressing, and melts in tender tints into the background of foliage, which, though deeply subdued, possesses the transparent juiciness of Rembrandt. A few more brilliant touches in the centre were advisable; the effect, on account of the excessive softness of the whole, being drowsy overmuch, and wanting in firmness and decision of contrast. We have before given this artist credit for the classical walk which he has assumed ; and we were particularly impressed with his merits in this respect, when we found that in this exhibition, as in the last, he stood alone in his attempt, and, so far as he has prospered, in his attainment. It only remains to add, that the chastity of the style and tone of feeling and thought in which the picture is conceived and executed, bestows upon it a refinement which will recommend it to every spectator of cultivated taste, capable of enjoying the higher beauties of the fine arts.

Concentrating their forces forms no part of the Royal Academy's tactics, otherwise they would have selected HART's " Richard the First and the Soldan Saladin" (No. 395), as one of the ornaments of the great room, instead of hanging it up in the ante-room, where —we cannot say it is lost — but it does not make the display it would have done in the other. Mr. Hart is particularly happy in his choice of subjects, —for, while he selects such as favour his peculiar *forte* in respect to romantic costume and accessories, he takes care that they shall not be deficient in historic importance and value. Although a matter of very secondary importance, it may be added that the dimensions of this picture are such as to render it not unfit for a moderately spacious apartment; though, as for the matter of that, we are inclined to question

* If Mr. Pitt's tax on hair-powder was the cause of that article being banished from the toilette, or even one among other causes, the premier would deserve the thanks of his countrymen, and particularly the painting part of them, for that most essential service ; although we suppose that such desirable result did not at all enter into his calculations.

whether size, as is generally alleged, operates unfavourably in regard to the cultivation of historical painting among us, when we behold canvasses ample enough to cover the side of a wall, if not an " acre of ground," occupied with " family groups," in which there is no grouping whatever. In fact, there is a performance that nearly answers to this description hanging opposite the picture we have been speaking of.

ALLAN is an absentee — not from the walls of Somerset House, but from Scotland, which he has exchanged, and certainly without at all bettering himself, for a warmer, yet to him less genial clime ; where he seems to feel himself so little at home, that we did not recognise him in the " Moorish Love-letter " (No. 49). As a bit of pictorial romance, it is less romantic than any of Lewis's Spanish scenes at the Water-colour Exhibition, which are marked by a descriptive vivacity and unaffected energy truly delightful.

If Allan be a deserter from Scotland, KNIGHT — who, by the by, is as good a knight as any of those enrolled among the academicians — has travelled thither for a subject, and, what is more to the purpose, has treated it excellently well, for his " Tam O'Shanter " (No. 406) might have inspired Burns himself, had this painting preceded his poem in its date. The pencil of the artist has most successfully identified itself with the pen of the Scottish bard. We need not the quotation given from the latter to convince us that Tam is " o'er all the ills of life victorious." His countenance, his attitude, attest it ; nor do we remember ever to have seen the reckless gaiety of inebriety more ably expressed — with power, but perfectly free from vulgar coarseness, on the part of the artist. The whole scene, too, consisting of only four figures, is well conceived ; and the effect of the light thrown upon them from the fire is exceedingly well managed. We almost fancy that we feel the cheerful blaze which irradiates the countenances of this merry quartetto group. The warmth of illumination reminds us of Scalken.

Far be it from us to reproach the national taste for the encouragement it gives to portrait painting — being of opinion, with the author of *The Doctor*, that it has its source in the more amiable feelings of our nature ; we only censure the taste for exhibiting indis-

criminately things that are recommended neither by their merit as pictures nor by any interest attached to the individuals whose faces they represent. Among BRIGGS's eight portraits — for he this year exhibits no other subjects,— those of Charles Kemble and Mrs. Austin are attractive in both these respects ; not so the one of Mrs. Jameson, whose appearance little corresponds with the image we had formed of her from her writings. Wilkie's portrait of the late Rev. Edward Irving is a very singular production. It is, notwithstanding, deserving of consideration, as doubtless the qualities in it to which we might feel willing to object were not accidental, but elected. The artist evidently did not mean to give a mere likeness, as not a single feature resembles the original ; yet the expression is so perfect, that none can doubt a moment for whom it is intended. This effect is very remarkable : nothing, at the same time, was so like and unlike. The head, in fact, is ideal, and is treated in a Rembrandt style — the face being greatly enveloped in shade and illuminated by reflection. Wilkie has undoubtedly a right to a caprice of this kind, however we might deny it to an inferior artist. His portrait of Sir James M'Gregor is excellent.

BEECHEY has done more service to his brother knight than to the exhibition,— his portraits serving well enough to keep Sir Martin's in countenance. Miss Emma Roberts, on the contrary, he seems to have put quite out of countenance,— so little does the face he has bestowed on her resemble that which Lover has given her.

T. C. THOMPSON has an excellent whole-length of the Bishop of Derry (No. 469), that deserved to have occupied a place in the great room, instead of being hung up amidst the flutter of drawings, miniatures, and medley subjects in the Antique Academy. It is in a bold yet chaste style, carefully pointed, and free from all trickery and artifice. His portrait of Mr. Spring Rice was one of the best works of its class exhibited last season, yet was not allowed to be seen to the greatest advantage ; although, had it exchanged places with some that were more conspicuous, the visitors would have been double gainers thereby. We should not at all object to there being so many places which the eye can never explore, were we

sure they were invariably assigned to those productions which seem intended for modest retirement and shade. Instead of which, however well they may observe their own bye-laws, the Academy do not attend to the laws of composition,— for they frequently thrust into the back-ground what would bear to be displayed, and drag into the fore-ground what might very judiciously be put as far out of sight as possible. They have poked poor old Coke (No. 222) quite into a corner; yet we do not blame them for that, because, although he looks rather miserable there, and as if conscious of the affront, we are not quite certain that he would cut a better figure any where else. Had they treated OLIVER'S "Portraits of Sisters" (No. 334) after the same fashion, or rather put them topmost, above all the crowd, we are certain that, however displeased the artist might have been, the ladies would have had no reason to complain of any injury. In giving this hint, we are perfectly disinterested, since it is we who should have been losers, and have been deprived of the amusement of contemplating one of the most seriously droll productions in the whole exhibition. Doubtless the Academy would rather receive such subjects from Mr. Oliver as his " Mouse and Filberts" (No. 240)— not quite so delectable a combination as " Wine and Walnuts" — or his " Puss" (No. 373), than any other kind of portraiture. What sort of a subject was turned out to make way for his Grimalkin we cannot divine; since, notwithstanding she is far more comely than either of the two ladies, we should as soon have expected to find living "pusses" as this painted one within the exhibition-rooms of the Royal Academy. Nothing can be more disagreeably and uncleverly natural,— for it has no more pretensions to rank as a work of art than a stuffed cat with artificial eyes would, which is exactly what it looks like. In the great room there is the head of a lap-dog, a beautiful little spaniel, by Edwin Landseer (No. 130), which is the very antipode to " Puss." That it is more natural, more deceptive, than the cat, we dare not affirm; but, although it shews little more than the animal's head, with a bit of blue riband round its neck, it is quite a picture,—not a dull *pattern*, such as, when samplers were in date, a school-girl would have

worked upon one;— it has all the living expression of nature, set off by the happiest execution of art. However, if any old ladies wish to have their favourite tabbies' likenesses taken to their perfect satisfaction, we would recommend Oliver to them rather than Landseer: we cannot afford to spare the latter for such humdrum work as that. Mr. Oliver may shew exemplary discretion in treating the public, as he annually does, with plates of walnuts and baskets of filberts; and, as we have said, doubtless the Academy hang up his pictures of that kind with the view of excluding, if possible, his portraits: in which latter he evidently gets quite *ultra crepidam*, and exemplifies more strikingly than is desirable the undeniable truth couched in their motto. There are likewise many others, whose performances would serve as a literal — by far too literal a translation of the same; inasmuch as they convince us it is not every one who understands every thing, namely, every thing that he has occasion for in a single picture. Some succeed well enough in painting objects, who are utterly unable to produce any subject; others give us colour with the omission of drawing, or else, *vice versá*, drawing with little more than dead colouring. There are those who paint entirely for effect at a certain distance, closer than which the spectator should not approach, if he would not be shocked by trowelling and daubing; while the pictures of others require to be very closely looked into indeed, in order to detect all that exactitude in their minutiæ which constitutes their chief recommendation. Rarely, indeed, are we struck by any of that poetical invention which may be applied even to the most prosaic materials, so as to invest them with all the charm of novelty; not because foreign to nature, but because the artist knows how to bring out and set in the most forcible light those qualities which most others having but imperfectly felt, have still more imperfectly described. Portrait painting itself, which seems least of all favourable to it, far from excluding this kind of invention, admits of it in a higher degree than the generality of those who practise are aware. A happy turn of attitude, be it ever so little, from any of those usually employed, an attention to characteristic air and expression, will go far

towards producing a decided originality.

As an academician, Leslie ought perhaps to have had precedence of notice bestowed upon him; yet, as we are not very methodical in our examination, he will hardly consider what we have done him an intentional slight. He has two pictures, both of which are very cleverly painted, and shew much ability; and are, withal, of a class likely to captivate the multitude,—of course we mean the multitude who pay their shillings at Somerset House; yet, in our opinion, both the subjects are of an ungrateful kind, being hardly worth the pains that have been bestowed upon them. Neither of them is by any means so well imagined as his " Sancho and the Duchess," or the " Dinner Scene at Page's House;" nor do we think that even as pictures they are in any degree superior or equal to that of the " Grosvenor Family." In that of " Columbus and the Egg" (No. 89), the incident upon which the subject is founded is little more than an episode in a showy banquet scene; and in itself is one of those which rather lose than gain any thing by being represented to the eye. " Gulliver's Introduction to the Queen of Brobdignag" (No. 131), is even more objectionable,—for the Brobdignagians appear no other than ordinary-sized people—and all perfectly English ones, by the by—while Gulliver himself might be mistaken for a tiny puppet, instead of a living figure, placed upon the table, and which they are all admiring. The surprise variously expressed on the different countenances is well hit of; and the whole is in that respect so pleasingly natural, that we only regret the artist did not either invent or select some less trivial subject for the exercise of his pencil. The subject perhaps is better suited to the style which Mr. Leslie has fallen into of late than one more dignified would be,—for it is almost too deceptive to observe the due bounds of pictorial illusion. It is possible to make pictures too much like realities,—so much so, that the figures become akin to waxwork and real dresses.

By way of turning to one who affords a sufficiently strong contrast to Leslie, let us look at the poetical compositions painted by Howard, for three compartments, or rather small panels, in a ceiling of Sir John Soane's Museum (Nos. 243, 4, 5); though we certainly should not have conceived them intended to be so placed, since they are evidently fitted only to be hung up according to the usual mode. However, they will not suffer much by being fixed where they can hardly be distinguished. We had hoped that this style of painted poetry was now utterly exploded, and sent into banishment with the Damons, Strephons, and Chloes, who used, some century ago, to figure in rhyme, much after the fashion Mr. Howard's figures here do upon canvass. His ideas may be remote from prose,—most assuredly they are not couched in the usual and intelligible language of the art; but of poetical sentiment, vigour, or expression, they appear to us to possess not a particle. Pandora,

> " whom the gods
> Endowed with all their gifts,"

has received none at the hands of the painter; neither do the divinities themselves, as depicted by him, appear to have had any excellence to bestow upon her. They are all wonderfully tame and insipid creatures; and the colouring is no less flat and insipid than the figures,—gaudy without being gay, and weak without being sober. Whether this Pandora is intended to be a hieroglyphical personification of the museum it is intended to grace is more than we affect to know; but we surmise that, had the artist been left to choose his own subject, he would have exercised his imaginative and poetic powers upon the apotheosis of Sir John himself.*

We have seen better pictures by Roberts than his " Cathedral of Burgos" (No. 359), although seldom a finer architectural subject, or a more interesting specimen of the Gothic style. The colouring is heavy, and totally devoid of transparency in the shadows; and his outline much enfeebled by being clogged with paint, instead of being kept well defined, without being offensively harsh. Some-

* This august ceremony took place a few weeks ago, when the knight was liberally incensed with more than classical adulation; or he may be said to have received the honours of an *ante mortem* canonisation,— being assured by one of his flatterers of obtaining " *the grace of God!!*"

times, too, he is given to sin very disagreeably against perspective, without a perfect knowledge of which an architectural painter is like a navigator steering without compass. However, we trust that this is not the only subject Burgos Cathedral will afford him, and that he will do more justice to that edifice on other occasions ; and we would advise him to be less afraid in future of giving the full expression to its details. There is a picture of Ionic Ruins, by his friend Maddox, in the Suffolk Street Exhibition (where, we should remark, he himself this year plays the truant), that may serve to convince him it is possible to preserve outline and minutiæ without impairing breadth or degenerating into hardness. In Roberts's picture there is an opaqueness of tone, both in the lights and shadows, that diminishes much of pleasure we should otherwise receive from it; and an engraving from it would no doubt shew to greater advantage than the painting itself does. Notwithstanding that his style of painting architecture holds a middle course between those of Turner and Etty, Roberts has not hit upon an exactly happy medium. We miss the distinct articulation, if we may so express ourselves, which architecture requires.

CONSTABLE, on the contrary, is generally all articulation, even in landscape ; his "Valley Farm" (No. 145) is a strong sample of this peculiarity. As Etty's picture conveys the idea of veneering, so does Constable's seem to be executed in tesselated work, or mosaic ; it being rather spotted with paint than painted. It is, therefore, more remarkable for spirit and sparkle than for breadth ; it has brilliancy, but it has also too much glitter. Now although we hold it to be of very little importance *how* an artist obtains the result he seeks, whether by the usual means, or others he has discovered for himself, we must confess that we do not admire artifices so barefaced that they are detected as soon as we look upon the picture. Far easier is it to produce *curiosities* in this way, than a work of genuine art. Thieving was not considered immoral by the Lacedemonians, yet to be detected in the act was ignominious : so, too, all kinds of tricks and stratagems may be tolerated in painting, and only then severely reprobated when they happen to be found out. However, Mr. Constable will hardly

do much harm to others, whatever he may to himself; for his manner is not likely to make many proselytes. Still we would not have him imagine, that his oddity of manner blinds us to his merits ; for merits he undoubtedly has. If through whim he is voluntarily unnatural, he also shews that he can both feel and express some of the most lovely qualities in English rural scenery ; and although his skies are too literally "pure *marble* air," he at the same time makes us sensible of the fresh and refreshing breeze.

Mr. T. SYDNEY COOPER's cattlepiece (No. 365) deserves to be pointed out, as a fine specimen of the pictorial treatment of animal portraiture. We should think that a connoisseur in " Stock" must be delighted with the fine marking and character of the bull and cows, while a connoisseur in painting must be equally so with the beauty of the grouping and composition, and the admirable colouring and handling of the piece. That a man gifted with such powers as are here displayed should have ever been reduced to the necessity of making lithographic drawings of bonnets and caps, would seem almost incredible, had not Miss Mitford vouched for the fact in a very interesting anecdote, introduced in her new work, entitled *Belford Regis*. Unlike *this* Mr. Cooper (for he must not be confounded with the namesake, the R. A., who is also an animal-painter), there are many who might be recommended to take up what he has, we are happy to say, laid down for ever, and confine the exercise of their skill to the likenesses of fashionable caps and bonnets.

We have seen some very superior things of their class from MULREADY's pencil, but "The Last in" (No. 105), the only picture he exhibits, is hardly worthy of the reputation he has gained by them. Though the name given to it is unintelligible without seeing the picture, the latter would not be very well comprehended were it not for the title bestowed on it in the catalogue. We are to suppose that the village pedagogue is ironically complimenting the loitering urchin who has just sneaked into the school-room for his punctuality of appearance. So far this piece of familiar tragic-comedy is natural enough, in the ordinary sense of the term ; yet there is a lack of that which art should add to nature, so as to render what is

trivial as an incident valuable as a subject. In the picture itself, there is little either to captivate the eye or excite admiration.

Other names require notice, though brief. STANFIELD's " Scene near Levinza, in the Gulf of Venice " (No. 8), is marked by his usual manner ; and his " Fisherman's Abode at Mazzerto ; Torcello in the Distance " (No. 315), is decidedly pretty. PICKERSGILL's " Portrait of the Duke of Wellington " (No. 166), is the best of the three portraits of his grace in the exhibition. A. E. CHALON has some splendid specimens of fashionable portraiture. Ross's are all beautiful. For the rest — the unmentioned, we mean — let them be satisfied with having escaped being distinguished by us even *en passant*. Were the Academy to consult its own character, and the interests of art, more strictly than it does at present, it would be less liberal of its passports. The system pursued by them certainly tends to dilute their exhibitions, and impoverish the flavour of them ; and has, moreover, a tendency injurious to art itself; except, indeed, it can be shewn, that as in arithmetic the number of ciphers give an additional value to the other figures, so do the numerous *nulls* that are allowed to display themselves among a paucity of good pictures, increase the sum total of aggregate talent and merit. Whether a change of habitation will produce any corresponding change in the habits of the Royal Academy, or whether they will carry the latter along with them to their new domicile in Trafalgar Square, time will ere very long prove. At all events, it is to be hoped that the pictures will have more elbow-room there, so that, if not actually more select, they will form a more orderly assembly. With this and other good wishes for their improvement, we here take leave of them and their sixty-seventh annual ; in which we have certainly met with several, though comparatively few, handsome embellishments, and offer in return these illustrations of our own.

In conclusion, we would beg to remark, that though we think they might be far better managed, we are ready to allow that annual exhibitions are to a certain extent serviceable in a country where it is nearly they alone which keep up any kind of public attention to the fine arts. Were it not for the fillips thus periodically administered to them, the arts would, if not exactly go to sleep, seem to be in a very drowsy condition among us. Painting is literally a dumb art in England : it has no regular organ of communication, no specific journal devoted to its concerns, as is the case with almost every other pursuit. As far as singularity can confer distinction, it is pre-eminently distinguished by refusing to avail itself of similar aid in an age when fashion and railroads, phrenology and jockeyship, music and corn-laws, have their representatives in the congress of periodicals. Of the several attempts hitherto made to establish something of the kind in the service of the fine arts, every one has failed, and that, too, in a very short time. This certainly does not say much either for the public spirit of artists as a body—and they now form a tolerably numerous corps—or for the interest taken in the subject by those who affect to have a sympathising taste for all that is connected with art. At the same time we must acknowledge, that if very little encouragement was bestowed on any of the publications alluded to, by some of them very little was merited, so carelessly were they conducted, and so little did their contents agree with their professed object. When the editor of one was obliged to eke out his pages with a list of most vulgar and stupid puns on the names of living artists, or to transplant into his periodical the whole of such an exceedingly rare and unknown *morçeau* as Sir Walter Scott's " Dick Tinto ;" when another thought fit to enliven the dulness of the fine arts by such very lively and appropriate papers as " On Arrest for Debt," " Effects (of capital) on the Wages of Labour," " Repeal of the Stamp-duties on Newspapers," &c.;—it was plainly telling their readers how affairs stood with them, and what must speedily be the result of such admirable management. Accordingly, the very last of them, after boasting of the great and increasing patronage it was receiving, suddenly expired in a plethora of doggrel rhyme and balderdash, entitled " The Painter's Progress;" whereas it ought rather to have been called " The Stoppage of the Editor's Career." That any similar experiment will be made again for some time to come is not likely, since, although the cause of failure has in

almost every instance been palpable enough, such a repetition of it has thrown some discredit on the attempt itself, and has led to the disagreeable conclusion that there exists very little relish for the fine arts as a study deserving serious attention.

Perhaps our artists themselves have no great inclination to encourage that which ought in turn to foster criticism. The majority of them practise quite empirically, with no more than a smattering of general principles; certainly without that comprehensive grasp of theoretical knowledge, and that earnest application to it, which should ever go hand in hand with practice. To this neglect of scientific preparation is to be ascribed much both of pedantry on the one hand, and plausible yet empty superficialness on the other; since originality—at least, sterling originality— is likely to abound most where the mind has been assiduously cultivated and well trained. For want of this, few care to aim at more than some one particular quality — merit it may not always be — which they consider not only their *forte*, but of such excellence in itself as to atone for all other deficiencies. Instead of studying colouring in its whole compass, many are apt to manifest a predilection for certain of its effects and phenomena, to the exclusion of every other; and, in regard to some, we might add, almost to the exclusion of whatever else

is required in a picture. Exactness in costume is expected to indemnify the beholder for the absence of all other learning — to make amends both for inanity of subject and for the inanity with which such subject is treated; or else the interest of materials is thought sufficient to conceal the painter's own poverty of ideas. The most glaring violation of perspective, and other absurdities in composition, are indulged in, as if the neglect of preparatory knowledge of that kind was rather a merit than a defect — an indication of a mind superior to ordinary drudgery; consequently, a proof that the artist is guided by the intuition of genius. Hence mannerism is the besetting sin of the greater number who addict themselves to the arts, fancying they have received " a call;" and they seem to trust more to chance and circumstance than to studious exertion for success in their career.

It is to be feared that the present English school (if school it may be named, where every one follows his own whim and fancy) estimates colouring, and general catchiness of effect, more than is altogether prudent; because it is pursued to the neglect of what is equally essential, both as regards the other manual parts of the art, and that finer spirit of it which ought to predominate above all the rest.

Archibald Alison

"The British School
of Painting"

Blackwood's Edinburgh Magazine 40 (July 1836), 74–85

WHY have we not as great painters in England as Raphael, Claude Lorraine, and Michael Angelo? That genius to conceive, and taste to execute great designs in the fine arts are not awanting, is obvious from the immortal works which we have produced in other departments. What modern state can compare with the nation which can boast of Shakspeare and Milton, of Gray and Thomson, of Scott and Byron, of Wordsworth and Southey, not to mention a host of others who have won the highest renown in the field of poetry? In the higher branches of music, also, in sacred oratorios, and the simplicity and pathos of pastoral or lyric song, we occupy at least a respectable place in the great republic of genius. But in painting, whether in the historical, landscape, Flemish, or portrait school, we are still decidedly inferior not only to our continental predecessors, but in some of these branches even to the artists who formerly flourished in our own country. This is a melancholy truth; we are aware it will be felt as a severe, perhaps an unjust observation, by the many men of genius who now adorn our galleries; but knowledge of error is the first step to excellence, and undeserved flattery, by relaxing the efforts of industry, is the certain road to mediocrity.

The true test of the excellence of any production of the human mind is to be found in the estimation in which it is held long after the author's decease, and when all the adventitious circumstances which formerly threw a false lustre or unjust gloom around it have long ceased to exist. Fortune has a large share in the celebrity of every living author, whether in literature or art; the race is in the end to the swift, and the battle to the strong, but this is far from being the case in the outset, or even during the lifetime of the artist himself. The well-known anecdote of Milton selling the Paradise Lost for five pounds, and of Campbell being long unable to find any bookseller who would buy the Pleasures of Hope, are instances of the extreme inequality with which the smiles of public favour are often in the first instance dealt out to the greatest works of genius. But in painting, and especially portrait painting, chance and fashion have so large a share in the formation of public opinion on every artist's merits, especially in this country, that no opinion can be formed of what celebrity is likely to be durable till after, and long after, the artist's

death. A fashionable and beautiful woman, a statesman of celebrity, a hero of renown, sits for their picture, the likeness is happy, the original is celebrated; a few of the leading journals dwell on the merits of the picture! it becomes a matter of fashion to go and see it; a sign of taste and travelled acquirement to admire it; and very soon the artist, with perhaps no very large stock of real ability, finds himself at the head of his profession, flattered on all sides, overloaded with orders, and in his opinion at least equal to Titian or Vandyke.

Then begins, and that rapidly too, the period of decline. He comes to grudge his labour on each picture, when he knows that so many other orders are awaiting him, from which to gain greater celebrity and more extensive riches. He soon discovers that nine-tenths of the world who come to sit for their pictures, to wonder or admire, are totally unable to judge of any thing but the likeness, and he insensibly acquires the habit of throwing in as much merit as will satisfy the public, *and no more.* He finds that he gets his two or three hundred guineas, provided only that his pictures are like, equally whether they are good or bad; and thus, between the prestige of fashion, the intoxication of flattery, the love of money, and the seductions of ease, the artist, surrounded by an ignorant, wealthy, and indiscriminating body of admirers, is gradually led down from all his youthful aspirations of excellence and talents, which, if cherished and hardened in the school of severe competition, and under the eye of a public who could distinguish good works from bad, might have led, after ten years of poverty and twenty years of labour, to the highest excellence in his noble art, and descends by regular gradations through fame, fashion, wealth, and celebrity, to mediocrity and ultimate oblivion. We have no individuals in view in these remarks; we speak of the tendencies of things, not particular men. And we know not one but many artists, both in England and Scotland, who, by being chastened by reflection, and possibly chilled by early criticism, have talents at this moment adequate to render

them, after half a lifetime of laborious exertion, rivals of the greatest masters of the Italian and Flemish schools. It is not men or talents which we want, it is customs and habits, and a discerning public to form men.

Time, it is often said, makes sad havoc with a gallery of beauties. With equal truth it may be said, that it makes sad havoc with the painters of beauties. The reputation of West as an historical painter is almost extinct; even the great reputation of Sir Thomas Lawrence is sensibly declining, as his portraits cease to be the image of living beauty or celebrity, and are transformed into the gallery of the dead, where each work is estimated by its intrinsic worth. The genius and talent, the vigour and originality of Sir Joshua Reynolds, indeed stand pre-eminent, and as indications of a great mind must ever command the admiration of mankind; but considered as monuments of art, and compared with the great works of the Italian school, with Raphael, Titian, or Correggio, or with Velasquez or Murillo in the Spanish, though equal in conception, they are altogether inferior in colouring and execution. Such as they are, however, they are beyond all question at the head of the English school of historical and portrait painting. This distinctly and at once appeared at the exhibition of the works of Reynolds, West, and Lawrence, in Pall Mall some years ago. Sir Joshua stood immeasurably at the head; next came Lawrence, whose full length portrait of Kemble in the character of Hamlet showed what a glorious artist he *might* have been, while most of his other works demonstrated what he actually was, under the combined influence of fashion, high prices, and an undiscerning public. West's immense historical pieces, amidst some talent, exhibited far too much of the French opera school of painting to be worthy of being named as rivals of the great works of ancient art.

Turn to landscape painting, the branch of art in which England has been long supposed to stand unrivalled, and in which certainly a greater degree of encouragement is afforded to professional men at this time, than in the same line over all Europe be-

sides. Beautiful colourists, admirable draughtsmen, authors of undoubted genius and prolific fancy we undoubtedly have; but is there one whose works are to be compared with

" Whate'er Lorraine light touched with softening hue,
Or savage Rosa dashed, or learned Poussin drew ? "

Unquestionably there is not. There is a richness, a combined generality of effect, with accuracy of detail ;— in technical language, a union of breadth with finishing, which we look for in vain in any works of the present or last century. Turner ! we hear our partial and enthusiastic countrymen exclaim, — Turner at least is superior to them all; in him are to be found alternately the softness and glow of Claude's sunsets, the savage grandeur of Salvator's conceptions, and the classic erudition of Poussin's scenes of ruin. Most certainly it is far from our design to depreciate the wonderful originality and variety of Turner's imagination; or to deny that the artist who could conceive the scenes in the *Liber Studiorum*, and draw the series of views in the valley of Aosta, possessed gigantic powers, capable of combating each in his own line the great masters of Italian landscape. But has he done so ? Has he produced scenes which will stand the test of ages, like the Claudes in the Doria Palace at Rome, or the National Gallery in London, or the Salvators in the Palazzo Pitti at Florence ? That is the point: not what could he do, but what has he done ? With the highest and profoundest admiration for the powers of his mind, truth here compels the admission, that none of his works will bear a comparison with the masterpieces of these great men; and his genius is too great to descend to a competition with artists of inferior reputation.

In other living artists, the attention is forcibly arrested by Copley Fielding in London, and Thomson at Edinburgh. No one will be so bold as to deny to the former the merit of consummate delicacy in the management of the pencil; a Claudelike richness in foliage, and the happiest delineation of the varying effects of coast scenery; or to the latter a depth of shade, vigour of conception, and strength of colouring, which place him among the most accomplished artists of the present day; but will either the one or the other stand the ordeal with Poussin, Ruysdael, Claud Lorraine, or Salvator Rosa ? That is the question; and these truly eminent men will see at once in what rank we estimate their genius, when we place them in line with such compeers. And why should they not equal, nay, excel them ? Why should not the wild magnificence of the Scottish lakes, cr the rich finishing of the Cumberland valleys, or the savage grandeur of the coast scenery of Devonshire, inspire our painters as they have done our poets, and produce a Scott, a Wilson, or a Southey in the sister art ?

Turn to the minute and Flemish school : is Great Britain equal to its continental rivals in that department ? Great efforts have there unquestionably been made, and the names of Wilkie and Allan will at once occur to every one, as affording decisive evidence, that in that line at least these strictures are undeserved. Highly, however, as we estimate the admirable works of these truly original and gifted men, we yet must admit that much remains for them to do ere they attain to the highest honours of their own branch of art. In conception and drawing they are admirable; but it is breadth and generality of effect which are awanting. Masses of shade, dark colours, great surfaces of brown and black, are what we desire in their works. They have had their attention so riveted by the details which they finish with such admirable skill, that they have lost sight of the general impression of the picture. Hence their works have a partial and spotted appearance, which offers a striking contrast to the uniform effect and breadth of shade which characterise the works of Rembrandt, Teniers, and Ostade. The admirable pieces of these British artists appear excellent when seen by themselves ; but place them in a gallery of old pictures in the same line: transport them to the Stadthouse at Amsterdam, the King's Gallery at Munich, or the Flemish Room at Dresden, and the truth of this will appear at once conspicuous. Each figure is

shaded perfectly in itself; but the general massing of the whole is forgotten, and there is no one definite impression made on the mind of the spectator;—each group is well rounded in itself; but a general light and shade over the whole bunch is awanting.

It is in vain to assert, as a reason and excuse for this manifest inferiority, that we have not yet arrived at that age of national existence, or that period in the history of art when excellence naturally arises. Experience proves the reverse in every department. In truth, so far is art from advancing, like national wealth or power, to eminence by slow degrees, that it usually ascends at once by a sudden flight to the utmost excellence, and declines through a long succession of ages. Compare the marbles of Egina with those of the Parthenon : yet no long period intervened between the erection of the former in a stiff, homely style, and the formation of the latter with the incomparable ease, life, and animation, which has defied the rivalry of every succeeding age.

Look at the stiff pictures of Pietro Perregino, or the early paintings of his scholar Raphael, and you see what the art was in the youth of that wonderful man. Turn to the Assumption of Dresden, the Madonna del Foligno, or the Madonna della Sedula at Florence, and you see that painting had advanced from mediocrity to perfection in the lifetime of one individual, who died at the age thirty-seven. The immortal designs of Michael Angelo on the Sistine Chapel, the exquisite finishing of Leonardo da Vinci, at Milan, were all completed in the infancy of the art to the south of the Alps ; and at a period, to the north of them, when the savage Barons of England sat in rooms strewed with rushes, and dipped their gauntlet in ink to sign deeds from inability to write. It is the same in architecture : the imposing monuments of ancient Egypt arose in the very infancy of art, with a sublimity which subsequent ages have sought in vain to imitate; and the stately piles of the Gothic Cathedrals, a vast and original step in architectural knowledge, were brought to perfection in England and France within fifty years, amidst the bloodshed of a barbarous age, and by a race of men of whose existence and attainments history has hardly preserved a record.

Nay, what is still more striking, and tells with decisive effect upon this argument, painting, at least in one branch, had attained much greater excellence, both in England and Scotland, at a remote period, than it has since attained. Take any person moderately versed in art into a picture gallery, where modern and ancient portraits are blended together, and, neglecting the works of West, Lawrence, and Beachy, he will fix at once on the old paintings of Vandyke and Sir Peter Lely. Raeburn, of Edinburgh, will strive in vain, except in a few of his most admirable pieces, to maintain his ground against Jamieson, who flourished in Scotland two hundred years before. There is a depth of shade, a minuteness of finishing, a perfection of detail, and, at the same time, a generality of effect about these old portraits which rivets the admiration through every succeeding age. Observe that bearded old senator of Titian ; the face is brought out in bold relief by a profusion of dark shadow—the thin locks of the hair, the thick curls of the beard are represented with miniature accuracy —beneath the shaggy eyebrows the dark eyes still gleam forth with the fire of talent—the rich velvet robe glistens as if the light was yet shining on its glossy surface—every vein in the hands is pourtrayed to the life. Draw near to that inimitable portrait by Vandyke; it is a nobleman of the seventeenth century, a compeer of Charles I. The dark curls of the hair hang down on either side of the manly but melancholy visage; handsome features, a Roman cast of countenance, an aristocratic air, bespeak the object of lady's love; armour glances beneath his rich cloak, a broad ruff surrounds his neck, a brilliant scarf adorns his breast; every object in the whole piece is finished with the pencil of the finest miniature painter, while over the whole genius has thrown the broad and uniform light of its own illumination. You are captivated by that full-length portrait of a celebrated beauty in the galaxy of Charles II.—the auburn locks, with

playful grace, descend upon the exquisite neck and shoulders; the laughing eyes, the smiling lip, the arched eyebrow, tell the coquetry of youth and beauty; the envious veil half conceals, half displays the swelling bosom; the delicate waist, clad in satin stomacher, tapers almost beyond what modern fashion can imitate or modern beauty desire; the rich Brussels lace is pourtrayed with inimitable skill on the shoulders; every fold of the satin dress still shines with the lustre of day. The drapery behind, whose dark shade brings out the figure; the rich Turkey carpet; the white satin slipper and slender ancle, resting on a velvet stool; the little lap-dog in the corner of the piece; the gorgeous jewels in the bosom, are all delineated with the skill of the greatest master of still life—it tells you that the fame of Sir Peter Lely stands on a durable foundation. After drinking down draughts of admiration at these admirable models, which stand in fresh and undecaying brilliancy on the canvass after the lapse of centuries, turn to that half-faded portrait a century younger; the colours have in great part disappeared; the dress is so grotesque, and in such an extreme of now antiquated fashion, as to excite surprise rather than admiration; the face evinces the traces of loveliness, the figure and air give unequivocal marks of no ordinary talent; but the background is unfinished; the drapery is coarse; the whole is the ghost of genius, not its finished and living offspring; it shows that Sir Joshua, with all his genius, is not destined in portrait painting to stand the test of ages. Turn next to that smiling cherub whose face shines like the sun emerging from clouds, from amidst the blue and misty atmosphere with which it is surrounded; the eyes are beautiful; the golden locks lovely; the lips seem made for love; but the whole is a brilliant sketch, not a finished picture; the figure is evanescent and misty; the background hardly distinguishable; the extremities finished by an inferior hand; an hundred years hence it will be deemed the dream of genius, not its waking monument; and the great name of Sir Thomas Lawrence will be consigned

to comparative obscurity. That illustrious man's picture of George IV. excited unqualified admiration in this country; but when it was sent as a present to the Pope, and placed beside the monuments of ancient art in the Vatican, it fell at once from its lofty pedestal, and was felt to be a third-rate production when compared to the great works of ancient days.

The defect which runs through modern paintings, and renders them unfit to bear a comparison with the masterpieces of the Italian school, is, that they are either too general or too special; in technical language, breadth or detail has too exclusively riveted the artist's attention; they want that combination of minuteness of finishing with generality of effect which characterises the scenes of nature, and is to be seen in the productions of all the artists who have risen to durable eminence in imitating her works. Draw near to that masterpiece of Claude; the sun is setting behind the bay of Naples; a golden light illuminates the horizon, which blends by imperceptible gradation with the cerulean blue of the upper part of the firmament; a rich mass of foliage overhanging the water on the right hand is projected on the glowing surface; every leaf appears on the almost insufferable brightness of the illumination behind; a ruined temple rises in shadow beneath its broad extending branches; a light breeze sweeps over the surface of the waters; the little waves rise and dance to catch the dying radiance, then sink into the shades of night; light barks seem to sport on the glittering bosom of the main; the branches of wood on the other side, gently fanned by the breath, turn their fairy ringlets to the refreshing gale; all nature seems to enjoy the delicious fragrance of the hour.

" Ah, County Guy, the hour is nigh,
 The sun has left the lea;
The orange-flower perfumes the bower,
 The breeze is on the sea.
The lark his lay who trilled all day,
 Sits hushed his partner nigh;
Breeze, bird, and flower, confess the hour,
 But where is County Guy?"

You are intoxicated with the beauties of this inimitable work; turn to

yonder dark and savage piles which rise up under the magic hand of Salvator. Harsh and gloomy are its features; a scene in the wilderness of rocks and woods,

" Where Nature loves to sit alone,
Majestic on her craggy throne."

In the centre of the piece a torrent issues from an obscure recess overhung with dark embowering woods, and approaching the edge of a precipice, descends in foaming volumes to the abyss beneath; blue rocks clothed with pine fill up the distant parts of the landscape; the foreground is choked with a chaos of rocks and stems; on the right is a precipice, in whose savage recesses, a scanty brushwood can hardly find space for its roots; on the left a vast tree scathed by lightning, has fallen across the stupendous masses of rock which obstruct the lower part of the valley, and compose the foreground; a bright gleam has fallen on their broad surface, and in the crevices between them, the spears and helmets of armed men tell that the den of banditti is at hand. A "browner horror" seems to have been thrown over the woods; a savage grandeur characterises the whole; but examine the details; look into the corners of the piece, scan the objects which lie hid to ordinary eyes under the broad masses of shade, and you will see the minuteness, the perfection of nature. The whole is sketched with the rapidity of a master's hand, but finished with the accuracy of a consummate artist's execution. Turn to that admirable piece of Ruysdael; it is a scene in the forest of Ardennes; old oaks in the front stretch their gnarled and twisted arms across the piece; in the huge bulk of their stems is to be seen the furrows and the decay of age; a profusion of ferns and weeds, finished with inimitable skill, compose the foreground. A solitary river spreads its still surface; in the middle-ground beneath, luxuriant woods, which close it in at a little distance; wild-fowl are to be seen on its banks; the long neck of the crane, the thin shanks of the heron, rise amidst the reeds which encumber its margin; a rustic path winds through this scene of solitude; and a little vista seen under the branches of the oak on the right hand, looks out into sunshine and palings, and the cottage of man embosomed with trees. These are the immortal works of landscape painting; and widely as they differ in character and external appearances, the ruling principle which regulated the artist's thought is the same in them all. In all one prevailing thought is to be seen, one general impression was sought to be awakened, one emotion excited in the breast of the spectator; and the artist's skill consisted in the felicity with which he conceived, and the truth with which he executed that combination of objects which were calculated to unite in the production of that prevailing feeling. Painting has its laws as well as the drama; but it is not a unity of time, place, and action which is required, but of sentiment, association, and emotion.

It is the same with historical painting. Behold that exquisite Mother and Child of Raphael. Benevolence, sweetness, maternal love are radiant in her countenance; she embraces her infant with all the fondness of a mother's heart; the cherub is fondling the much loved bosom; St John is kneeling at her feet; his wild eye and camel hair garb bespeak the child of the desert; his elbows rest on her knees; he is looking up the envied smile to share; it is not a Hebrew woman, nor a Grecian woman, nor a Roman woman that is here delineated; it is WOMAN and woman's love that is expressed in a manner which has no locality, and will speak to the end of the world to all the best, the holiest, because the earliest feelings of Man. Mark that hero who is riding on a snowy charger through the ranks of death; blood-stained ice is beneath his horse's hoofs; black volumes of smoke are blowing over his head; clad in the richest furs his attendant officers are shivering under the blasts of winter; the savage wildness of the Cossack, the stern resolution of the Russian, the enthusiastic gallantry of the Frenchman, are still pourtrayed in the corpses which in mingled confusion cumber the plain; but the soul of the hero, superior alike to the fury of the elements and the horrors of war, looks with mild equanimity over the ghastly scene,

and the eye of the Emperor fascinates the soul from the steadfast lustre of its gaze. It is Napoleon riding over the battlefield of Eylau, in which the genius of Le Gros has produced, untainted by the meretricious fantasy of Parisian taste, the severe simplicity of ancient art.* From this scene of horror turn to the deathbed of yonder saint, where breathes the chastened piety and divine conceptions of Domenichino. The clay is not yet deserted by its earthly tenant; the smile of hope, the radiance of faith, the sweetness of charity still linger round his expiring lips; the grief of his earthly attendants is passionate and uncontrollable; but the closing eyes of the dying saint are fixed on the choir of angels, which give, even in the hour of death, a foretaste of the joys of eternity, and from the lustre of whose heavenly glow a serene radiance is thrown over the scene of dissolution. These are the great and immortal works of art; and in all is to be seen the same principle clearly exemplified — perfection of detail combined with unity of effect and generality of expression.

It is the same, in a still more striking manner, with the works of nature. What miniature hand can ever rival the minuteness with which every leaf, every pebble, every cloud is finished; and what inspiration of genius can pour over the whole the harmonious expression with which in her brighter moments she is invested? Ascend yonder rocky eminence, on whose embattled summits the gigantic columns of former days still stand, as if imperishable amidst the revolution of ages; the setting sun throws a flood of liquid gold over the exquisite remains; every niche in the cornice, every flute in the pillars, every projection in the sculpture, stands forth as sharp as if the sun shone for the first time on the inimitable work; dim descried through the purple glow which the setting luminary throws over the distant landscape, the slopes of Hymettus catch his parting rays; gleaming through projecting moun-

tains, the gulf of Salamis is resplendent with light; while on the verge of the horizon the citadel of Corinth, the mountains of Peloponnesus, stand forth like distant giants in that sea of glory. Climb to the summit of that lofty peak, the grisly Craon, on the southern side of the valley of Aosta. It is the hour of noon; silence deep as death prevails in those lofty solitudes; not the flutter of an insect, not the wing of a bird is to be heard in the dread expanse. Right opposite, face to face with the pinnacle on which you rest, stands the hoary summit of Mont Blanc; a precipice ten thousand feet in depth, furrowed by innumerable cliffs, bristling with innumerable peaks, descends from its snow-clad heights to the glaciers of the Allée Blanche, which lies spread like a map at your feet. In still and awful solitude the monarch of the mountain rears his head into the dark blue vault of Heaven; a glittering mantle of snow covers his shoulders; the eternal granite has spread a rugged girdle round his breast; in peace and silence the summer sun sleeps on his bosom; even the thin clouds of an Italian sky hover at a distance from the resplendent throne. Drink! drink deep of the draught of admiration at the matchless spectacle; life has not a similar moment of heaven-born rapture to bestow! † Descend from the dizzy pinnacle, enter the glades of yonder aged forest, where the stems of the chestnut of primeval growth arise in wild confusion from a wilderness of rocks; darkness deep as night lies beneath this massy shade, not a ray of the sun can pierce their leafy canopy, rude crosses placed at intervals guide the traveller in the steep ascent; but far distant on the right, in the mountain above, a vista opens; a verdant plain amidst wooded cliffs is seen, the pine-trees overhang a monastic pile, and the sun of Italy shines on the towers of Vallombrosa. Turn to the beetling cliffs of that raging ocean, which foams and boils against its immovable barrier; the dark rocks stand in grim horror amidst the dri-

* This admirable painting is to be seen in the Luxembourg of Paris. When the British artists have equalled they may criticise it.

† We are not singular in this opinion. "Unquestionably," says Saussure, "the two hours I spent on the summit of the Craon, on two different occasions, were the most delicious of my life."— *Voyages aux Alpes.*

ving tempest; heaving on "its mighty swing" the billows rise, with a sound like thunder, midway up the steep; with frightful rapidity wave after wave is rolled to its foot; black rocks surmounting the eddying surge at times appear, and speedily are lost amidst the roar of waters; the clouds drive in gloomy grandeur against the heath-clad cape which breasts the storm, on whose bosom, far above the rage of the waves, stands the dark and unshaken castle of feudal power; and say if Scotland has no scenes of sublimity to exhibit, and aught in Europe exceeds in awful grandeur the northern ocean breaking on the rocks of St Abb's Head and Fast Castle. You are attracted by the blue and silvery light which swims over that lovely lake; not a breath disturbs its sweet expanse; not a dimple breaks its blue serene; pictured in the glassy mirror the mountains, the villages, the woods of its overhanging banks are given again with more than the freshness of nature; every headland and cliff on its broken amphitheatre of mountains is clothed with wood; the vine and the olive are sheltered in every nook; white and glittering villages rise in "gay theatric pride" up the almost precipitous slopes, while innumerable churches on every projecting point tell that it is the blessings of Christianity which have peopled the mountain sides with happy flocks; and bless the God of nature which gave to the world the surpassing beauty of the Lago Lugano.

Evening has spread its russet mantle, and the light of day has long ceased in the depths of yonder Alpine valley. Through overhanging woods, interspersed with detached blocks of rock, meadows shaven with more than a gardener's care, and wooden cottages bespeaking the comfort and neatness of the inhabitants, a mountain torrent brawls over its rocky bed; the sound of labour, the noise of the day has ceased; the summit of the sky is of darkest blue; the evening star is beginning to shine in the firmament; but the tops of the stupendous precipices which shut in the valley on either side are still illuminated by the ruddy glow; and far above all the pure summit of the Jungfrauhorn is resplendent with

rosy light. It is the hour of noon; the heat, the rare heat of a summer day has spread a languor over the face of Nature; its numerous wooded islands are clearly reflected in that lovely lake; each rock, each headland, each drooping birch is pictured in the expanse beneath; the rowers rest on their oars as if fearful to break the glassy surface; the yellow corn fields at the foot of the mountains, the autumnal tints of the woods above, the grey faces of rock on their shaggy sides, shine again in the watery mirror; you can reach with an oar from the picture of the hills on either side of the valley; you can touch with your hand the purple summit of the mountains;

"Each weather-tinted rock and tower,
Each drooping tree, each fairy flower,
So pure, so fair the mirror gave,
As if there lay beneath the wave,
Secure from trouble, toil, and care,
A world than earthly world more fair."

Whoever has seen that magical scene at such a moment will deem that the travelled Clark has not overstated its beauty when he said that a Swedish lake " excelled the lake of Locarno in Italy, and *almost rivalled* Loch Lomond in Scotland."

Has England no equal beauties to exhibit? Enter that remnant of Sherwood which her noble Peers still preserve with religious care in the shades of Walbeck; you there behold the genuine magnificence of the Saxon forest. With lofty growth, but not disproportioned stems, the oaks rise in surpassing grandeur; the lapse of centuries has added to their strength, but not induced their decay; ferns in wild luxuriance rise at their feet; here and there an old gnarled stem with a few branches on its top may have witnessed the chivalry of Richard and the archers of Robin Hood; but in general a dark fresh green prevails over the scene, bespeaking the glowing health and luxuriance of middle age, and occasionally the antlers of a deer appear—the fitting accompaniments of the silvan scene. Can France exhibit nothing to be placed in comparison? Ascend that wild road which leads over black and desolate piles of rock to a wilderness of crags; high as you mount, with faltering step, still higher cliffs arise on every side; the path, now shut in by enor-

mous rocks, now turning on the dizzy edge of a projecting angle, exhibits alternately the walls of a gloomy prison or the distant vistas of a savage wilderness. But stop! an impassable barrier arises; a precipice, two thousand feet in height, closes in the upper extremity of the valley, the glitter of snow is seen on its summit, the spray of cataracts dashes down its sides; the black face of the rock is furrowed by innumerable waterfalls; a continued roar is heard as you advance; a cleft in the rocks above exhibits the breach of Roland, and marks the frontier of rival kingdoms; the sublimity of the Pyrenees is concentrated in the circle of Gabarnie. Enter yonder Gothic gateway that leads between overhanging precipices to the stately forests of the Grande Chartreuse; vast trees overshadow the road; a sounding torrent roars in its rocky channel far beneath; through the openings of their thick branches are to be seen vast piles of rock, which rise to a prodigious height on either side; their white cliffs glitter in the sun; bars of pine forest intersect their breasts; their splintered pinnacles are clear defined on the dark blue vault; but on every summit the cross is to be seen; devotion has spread its sway over the wilderness; a feeling of religious awe impresses you as you advance.

Præsenteorem conspicimus Deum
Fera per juga, clivosque præruptos,
Sonantes inter aquas, nemorumque noctem.

Has Germany no scene of equal interest to exhibit? Enter that little bark which lies moored on the edge of a verdant close-shaven meadow, beneath luxuriant beech-trees at the foot of the rocky barrier of the Konig See in the territory of Salsbourg. The sun is yet high in the heavens; you may reach the farther extremity of the lake, far up in the recesses of the mountains, before the shades of night have fallen. Its extent at first seems little larger than what would suit a fairy dell; but let us double that awful cliff that rises in impassable grandeur from the water's edge to the height of three thousand feet. What a prospect opens to the sight! Right before you lies the glorious expanse of waters, broad, still, and deep, but appearing as nothing

amidst the stupendous mountains by which it is environed; its farther extremity is lost in the obscurity which their awful shades cast around the scene; ten thousand feet of rock, or forest, or snow rise from the level surface to their pure and glittering summits; dark forests of pine clothe every ravine on their precipitous flanks; bold precipitous fronts, with bare sides, of immeasurable elevation, start forth into the water, and encircle at their feet little green meadows intersected with wood, and accessible only by water where industrious man has fixed his abode. A cloudless declining sun, as you advance, throws a delicious lustre, intermingled with shadow, over the scene; autumn has spread its richest colours over the woods which clothe the mountain sides; every headland is tinted with yellow, every forest is intermingled with fire; the unruffled surface of the lake seems almost to burn with the insufferable glow.

Switzerland! Switzerland! is your grandeur then surpassed by the rival beauties of the Tyrolese or Styrian Alps? Embark on that frail skiff, and approach the foaming abyss where the Rhine is precipitated with matchless violence down the cliffs of Schaffhausen. St Paul's would in an instant be swept away by its fury. The waters which have passed the descent are tossed in wild and seemingly frantic agitation, even at a great distance; your bark trembles and cracks as it approaches the awful gulf; down, down comes the mighty mass of waters, shaking the earth with its fall, rending the air with its spray; thunder would not be heard at its foot, embattled nations would be scattered by its force. Is this the sublimest scene in Europe, and has water borne away the palm from fire in the production of sublimity? Ascend at nightfall that black and scorched mountain, down whose sides the streams of recent lava have furrowed far and deep into the cultivation of man; you toil, you pant, as, amidst the stillness of a Neapolitan night, you painfully ascend the scorched and blackened steep. But hark! the mountain shakes, a rending sound succeeds, a report like the discharge of a thousand cannon is heard, and instantly the dark vault of heaven is filled

with innumerable stars, and as you pauee at the awful spectacle, a sharp rattle on all sides announces the fall of burning projectiles for miles around. Still advance, if your courage does not fail, and you may reach the summit of the steep ascent ere another explosion. Watch! watch! the dark cone in the centre of the rugged summit, on whose sides the red embers are still glowing, begins to shake; it heaves—it bursts—a frightful volume of smoke is driven forth into heaven ; right upwards does the fiery discharge spread from the gaping furnace ; the pyramids would be blown into the air by its violence. A thousand rockets are bursting in the heavens—perfect stillness for a few seconds succeeds, and then on all sides is heard the roar of the falling stones over the dark and desolate slopes of the mountain.*

The reader will probably think we have revelled long enough in the glowing recollections of earlier years: but in truth these illustrations, multifarious and rhapsodical as they may appear, are not foreign to this argument. They show both the dignity and grandeur of the art which has such magnificent materials at its command ; and the elevated conceptions, as well as persevering industry essential to success in its pursuits. To make a great, a truly great painter, requires as powerful and original a mind as to make a great statesman, or poet, or orator. It requires the ardent disposition, the *jeu sacré*, which, early fixing its desire on great achievement, disregards all labour, endures all fatigue in its prosecution: the eye of genius, which can discern the truly grand and beautiful in all things ; the industrious hand which can undergo the years of toil requisite to the skilful management of the pencil, and the combining mind which can unite a variety of separate objects in the production of one uniform emotion. The man who can do these things in their full perfection must have a mind, the rival of the greatest of his age. Michael Angelo, Leonardo da Vinci, Rubens, or Titian would

have been illustrious in any line of life. Mr Pitt or Mr Burke, if greatness had in Britain been accessible by such a channel, would have made magnificent painters. Milton spoke historical pictures in the Paradise Lost : Thomson breathed landscape beauty in the Seasons : Scott burned with the soul of painting in his poetry and his prose : Byron dipped his pen in its brightest colours, in his Oriental Fictions : Chateaubriand poured forth all its lustre in his resplendent descriptions. Strange, that when prose and poetry, in the hands of such masters, should all but put the colours on the canvass, Painting itself, in the midst of such mighty allies should still slumber on in comparative mediocrity.

To these remarks, two illustrious exceptions exist in Martin and Danby. The authors of the Deluge and of the Valley of the Upas-Tree may well claim, even from the most enthusiastic admirer of nature, the most fervent worshipper of poetic genius, the tribute of unqualified admiration for the grandeur of the conceptions which they have brought forth. Nor is detail awanting : these great works are finished with admirable minuteness, while a gloomy grandeur breathes over the whole composition. But the imagination of these eminent men, especially Martin, grows wild and runs riot in its own luxuriance. In the surpassing magnificence of his Asiatic palaces, the countless myriads of his crowds, the gorgeous splendour of his feasts, is developed rather the boundless power of a magician, than the faithful chronicler of existing things. We feel at once that such scenes never existed : and the Fables of Ariosto or Spencer will never rival in their influence with the great bulk of mankind the simple tales in which Burns and Scott and Shakspeare have drawn characters and awakened emotions familiar and common to all mankind.

The world in general is far from being aware of the excessive labour as well as exalted imagination requisite to form a great painter. Ten years' incessant drawing from nature,

* The travelled reader will easily recognise in the preceding descriptions many scenes, only accessible during the buoyancy of youth and health, and the recollection of which, like the music of former days, is now, after the lapse of twenty years, as fresh and vivid in the author's recollection, as if they had just been visited.

and diligent application, are requisite to gain a tolerable command of the pencil : ten years more to learn the magic of colouring, and unweave the varied hues of nature's robe. The labour requisite to master these objects with consummate skill is not less than is required to form a leader in civil life or warlike achievement, to form a Peel, an Eldon, or a Wellington. It is in some degree from not being aware of the long years of preparation requisite for success in this, as in every other liberal and difficult art, that we see such numbers who never get beyond mediocrity ; and such multitudes of paintings which pass muster tolerably well with the world in general, and yet bear the same proportion to the works of the great masters which the skill of an ensign or cornet in wheeling his company or squadron, does to the vast combinations of Hannibal or Napoleon, by which the destinies of the world were determined.

This language will pass with many as exaggerated or surcharged ; we are persuaded it will not do so with any who have themselves practised, even in the slightest degree, or studied in the works of others this captivating art. But to its successful cultivation it is indispensable, that not merely the aim of the artists, but the taste of the public should be formed on an elevated standard ; and it is here that the great difference between painting and the sister arts of poetry, oratory, and history consists, and that the chief difficulty which obstructs its successful cultivation in this country is to be found. In all these arts the taste of all persons of education is early fixed, and their ideas of perfection raised to the very highest standard by the study of the classical remains or the immortal works of modern genius. In poetry every man's soul is warmed in infancy by Virgil and Homer ; in maturer years by Tasso, Racine, and Milton. In history, the pictured page of Livy, the condensed energy of Sallust, the instructive wisdom of Thucydides, the lucid narrative of Xenophon, the caustic depth of Tacitus form every mind before the glowing pages of Gibbon, the eloquent descriptions of Robertson, or the profound views of Hume form

the subject of study ; Sophocles, Euripides, and Corneille in tragedy, Shakspeare and Schiller in the romantic drama, Molière and Terence in comedy, are in every person's hands who has the slightest pretensions to mental cultivation. But where are the materials for a similar early tuition to be found in painting or sculpture ? Who is to place the works of Raphael and Titian and Velasquez in every schoolboy's hands, to form the mind by the study of things that are excellent to a correct appreciation of modern art ? Yet in what department are study and experience, and a familiarity with good models, and the advantages of early tuition so conspicuous as in the formation of taste ? And is there one in a thousand of our educated classes who, when he enters upon the business of life, or is intrusted with the patronage of wealth, has the slightest acquaintance with an art, a tolerable familiarity with which can be acquired only by years of travel or diligent application ?

It is here that the vast, the incalculable advantage of foreign study consists. In Italy, models of art are so common, that every one's taste is in some degree formed on the habitual study of excellence. Mediocrity will not for an instant be tolerated ; and hence, in a great degree, the extinction of modern art ; the national wealth is not adequate to the purchase of old and new pictures ; and the ancient models drive all younger competitors out of the field. Rich as this country is in great models of art, it is not rich to any useful purpose ; and the great collections in the country seats of our nobility are so scattered, or so hedged in with powdered lacqueys or cringing domestics expecting half-a-crown at every turn, that to all practical purposes of forming the public taste they do not exist. Till this grand impediment is removed, it is utterly impossible that a great school of painting can arise amongst us, because the public, whether the buyers or criticizers of pictures, will never be brought to distinguish a good picture from a bad one. Let every possible facility, therefore, be given to the formation of public exhibitions of old masters, to which admission,

at a trifling cost, may at all times be had. The National Gallery, in London, is a fair beginning; the Royal Institution, at Edinburgh, a creditable attempt; but every city of note in the empire must have similar establishments before any thing like a due formation of the public taste can be effected.

In all such institutions the works of the old masters and the modern paintings should be exhibited TOGETHER; the latter should on no account be removed to make way for the former. Our landscape painters should be forced to stand the competition with Holborne, Ruysdael, and Claude; our sea painters with Vandervelde and Vernet; our historical composers with Caracci, Domenichino, Guido, and Albano; our portrait painters with Titian and Vandyke. Till this is the case the marked inferiority of modern art will never become generally felt, nor the lucrative mediocrity of modern indolence ever adequately censured. Our painters must, in common estimation and to the ordinary observer, stand the competition which our poets, orators, and historians do with the great masters in their several departments of ancient days, or they will never equal the national genius in these rival arts. We are well aware that at present the merit of these old models would be little felt, that few persons would resort to them, and that the modern artists would run away with all the admiration, because they painted living people on known scenes; but by degrees a better spirit would arise, and many who went to see the portrait of a cousin or a daughter, or wonder at the staring likeness of a grandmother or a hussar, would come away with a new view of enjoyment opened in their minds, and with the doors opened to the appreciation of a Raphael or a Correggio.

This is a department in which munificent bequests might be of certain and incalculable advantage. We daily hear of vast fortunes, two and three hundred thousand pounds, left to form colleges or endow hospitals, but never of one to bestow the durable blessing on his country of a great public gallery of pictures or statues; yet the utility of the former is often doubtful or disputed.

But nothing but refinement and enjoyment, the cultivation of mind, and the improvement of manners, could result from such establishments for opening refined and elevating sources of pleasure to the people. L.200,000 left to a national institution would yield L.8000 a-year FOR EVER, for the purchase of pictures. Such an income, steadily and faithfully applied, would in a few generations produce the noblest gallery to the north of the Alps. It would stamp immortality on the munificent testator, and do more than all the insulated efforts of individuals to refine and purify the public taste. Moral blessings of no light character would flow from such an institution; it is a proof how far we are behind in real civilisation, amidst all our boasting of the march of intellect, that no such bequest has hitherto been made.

It is high time that, by this or some other means, the stigma of mediocrity which has so long lain on British art should be removed. We are in that stage of national existence when excellence in the fine arts might naturally be expected, in which Athens raised the matchless portico of the Parthenon, and Rome the stately dome of the Pantheon, and modern Italy gave birth to Raphael and Domenichino. Unless something is done now, and that, too, speedily, we shall arrive at the stage of the corruption of taste before we have passed through its excellence; like the Russians, we shall be rotten before we are ripe. The vast growth of opulence, the taste for gorgeous display and rich decoration, the passion for theatric spectacles, the turn of our literature and manners, all mark too clearly the approach of the corrupted era of national feeling. Now, then, is the time, before it has yet arrived, and the vigour of growing civilisation is not extinguished, to give it a refined and classic direction, and afford some ground for our boasted refinement by producing and encouraging works in the fine arts worthy of being placed beside the productions of ages, who, from being trained to emulation with greater things, are less loud in the praise of their own proficiency, and therefore have acquired the undying admiration of subsequent ages.

John Eagles

"British Institution
for Promoting the Fine Arts
in the United Kingdom, Etc. — 1836"

Blackwood's Edinburgh Magazine 40 (October 1836), 543 – 56

THOUGH we have formerly spoken, as it might be thought, somewhat disrespectfully of the taste and judgment of the Governors of the British Institution, in their selection of presents for the National Gallery, we give them full credit for their liberality, and believe them to be anxious to promote the " Fine Arts," their professed object. Words are wanting to express the pleasure that their Exhibitions have afforded us ; we believe the modern artists have there found patrons ; and that thence the public have acquired an accession of good feeling in art. We are disposed to think that since the commencement of this Institution, the Italian School of Art, for which the country had previously but little love, has greatly risen in estimation, and that thus a more solid foundation is laid for public taste; for the mind that can once comprehend and feel all that is great, sublime, and pathetic in art, will never revert with too great fondness to the less important but fascinating beauties of the schools of mechanical precision and dexterity. There will be henceforth for these a just admiration, but not a love. The nobler works create for themselves an enthusiasm, a passion—and such passion, when once raised, is perfect and permanent. But is it not extraordinary that our artists are the last to receive such an impression? It must be a very striking fact to the eyes of the most careless observer, that the aim of modern art is in direct opposition to the old. *Toto cœlo* they differ. There appears an absolute jealousy of approach. The old masters delighted in shade and depth, and above all in an unpretending modesty, without which there is no dignity—modern artists delight in glare and glitter, foil and tinsel, in staring, bare-faced defiance of shade and repose, as if quietness were a crime, and as if there were no greatness but in protrusion. You go into an Exhibition of the Old School, satisfied with the eyes that nature has given you; but if you come out of Somerset House with any remnant of eyes not put out, you would require a month's preparation, under the hands of oculist and optician, to reconstruct the organs and modify their vision. We should be almost inclined to believe that there was some truth in the remark we have often heard, that there is no use in painting other than the lightest pictures for the London Galleries, which are said to be half the year obscured by our fogs, did we not, in addition to a dislike to this malevolent satire upon our climate, see in the numerous collections of fine Italian masters in our metropolis a contradiction to the assertion ; nor can we conceive such an argument of more avail now than in the days of Sir Joshua Reynolds, Wilson, and Gainsborough, from whose depth of tone, and indeed from that of every known school previous to our day, we are departing with a speed and haste that bespeak an antipathy to excellence, not originating in ourselves. Our enmity to this false English School of Art shall never cease ; we have taken out " letters of marque" to " sink, burn, and destroy"—and we will wage perpetual warfare with extravagant absurdities, though they be sanctioned by the whim of genius, academical authority, or the present encouragement of foolish admirers. We would suggest an experiment which might be beneficial to artists and collectors, and might be the source of a noble emulation. Let the old masters and the modern be exhibited together, at least, occasionally.

The Catalogue of the British Institution of this year contains a list of one hundred and twenty-two pictures. The Gallery would therefore contain upwards of fifty of each. The admission of so small a number would be an honour to those selected of the modern, and the portion of the old masters should be as choice as possible. As the light is from above, and equally distributed, there can be no preference as to position : we would not intermix them, but let them each have a side

of the room to themselves. We really think that this would greatly benefit art. If we *have* really advanced in art, comparison would be at hand, and judgment would be the more readily formed; if not, it would be seen wherein we were deficient—whether in execution, in materials, design, colour, or the very principles of art. We would have a high premium given to the first, second, and third best pictures; nor would we exclude the old masters from the competition—the possessors might bestow their premiums on the encouragement of modern art, or in purchases for the National Gallery. We are aware that a jealousy might exist of subjecting pictures to this judgment; but, as so few would be acquired, we think the difficulty not very great. A committee should be formed, of judges not necessarily Members of the Institution, and certainly neither possessors nor painters of the works exhibited. We believe that the emulation to obtain these prizes would be very great; whilst it would ensure pecuniary rewards, it would confer much greater distinction. The hope of a proud eminence would be a spur to very great efforts. The artist would not be painting ·for striking effect in a particular Gallery, where the vulgar that are attracted by show are the judges, but for the scrutiny of judges who will not fail to see merit though it be retiring and modest : they would paint, not for partial collectors fascinated with the fashionable style of the day, but for real, lasting reputation—for the large applause of the world, where those who are to decide upon merit are of the most acknowledged taste, and above suspicion of partiality. It might be found advisable in some degree, to class subjects, that every walk of art should have scope for exertion. There might be competition for the best historical—the best landscape—the best sea piece—portrait, or any other branch of art, the advancement of which the governors of the Institution might consider honourable and beneficial to the country. Nor does there appear any reason why this Institution, whose professed object is the advancement of the fine arts, should not offer rewards

for discoveries, for chemical proofs of the colours and medium of the best masters, and for such inventions as may appear wanting for the bringing every process to greater perfection.

The selection of this year consists, as we have before remarked, of 122 pictures — in comparison with other exhibitions, a very small collection. But, as journeys are better estimated by days than by miles, so would we speak of galleries, and consider those the greatest where we are oftenest and longest detained. We often pass over multitudes, and find resting-places frequent amongst a few. But let us enter the room. We have not made many notes, nor shall we offer all we have made. We hope not to weary the lovers of art who read Maga by copying a few from our note-book.

No. 1. " The Assumption of the Virgin.—Guido." Without the possibility of for a moment questioning the excellence of this picture, you are a little startled first by its colour—and indeed in its present light it may be somewhat out of harmony. The yellow of the background, purposely of that colour to set off the blue and pink hues in the figures, appears not sufficiently to recede, it is scarcely aerial ; but it is hardly fair to judge of these pictures, which have been painted for chapels with subdued and peculiar lights, when removed into an Exhibition-room. We can easily believe the colouring of this beautiful picture to have been perfect in the place for which it may have been painted; and seen with a judiciously managed light, and by itself, it must have a very surprising effect. Never was angelic purity more exquisitely embodied than in the face and attitudes of the attendant angels. And how serenely yet sublimely beautiful is the Virgin! They are all rising together into regions of blessedness. Their very drapery seems losing its earthly weight and substance, and its colours appear purified into celestial brightness; but it is observable that the drapery of the angels, though of the same colours and texture, is yet of a fainter hue. By this means greater power is given to the principal figure, and the

picture, as a whole, has a better keeping. Guido has here shown that he fully deserves the great name he has acquired. His work is that of a worshipper, conceived in a moment of ecstasy, and executed under a lasting enthusiasm. No painter, not excepting Raphael, ever more excelled in embodying the high ideal of female grace, purity, and innocence. His style is very peculiar; in it are united the beauties of the Carracci, improved by his admiration of Raphael, with whom, if he has less strength, he may yet often vie in expression, particularly in that of maternal tenderness and infant sweetness.

We have the same subject in "The Assumption of the Virgin, No. 3, by Murillo," but how inferior is the conception and the execution! There are no less than nine pictures by Murillo in this Gallery, of large size, and high pretensions, and, to speak as a merchant, we presume them to be estimated at great value. Now and then we see a Madonna and Child by Murillo (as in the Dulwich Gallery), which justifies a high reputation, but how seldom are we entirely satisfied with his works! His taste was too much steeped in vulgarity — so that he rarely exhibited any grace or dignity. In his Holy Families even, his vulgarity is too often conspicuous. The study of beggar-boys seems to have been ever uppermost in his mind.

No. 4, " St Francis with the infant Saviour," does not rescue him from this charge. We believe that the two most highly estimated pictures by him in this gallery, are No. 10, " The Angels coming to Abraham," and No. 22," The Return of the Prodigal." These are said to have been purchased at a very high price from the collection of Marshal Soult, who robbed the Spaniards of them.

There is a fashion in masters, and it sometimes happens that such a fortuitous circumstance as a great purchase from some public robber of note, will, in no common degree, direct the attention of the public to a painter. We should not be surprised, if shortly Murillos were to be sought after with new eagerness, and be more valued than Raphaels or Correggios. It is safest to judge of pictures without any reference to

this fictitious value—and we could wish it were altogether omitted in the catalogues that such and such a picture came from such or such a Collection. It can only deceive the ignorant, and looks very much as if the possessor had not a confidence in his own taste, and would therefore make some by-gone Italian prince responsible for it. We should only laugh if introduced to a beggar on the apology that he *had* kept good company. We observed this folly in looking down the page in the Catalogue. It is true that the Murillos are not so ushered in with a flourish of trumpets; but there is much talk about them, and a little trickery of silk-curtaining, that is unworthy and undignified, because it looks like an advertisement for admiration. The two pictures from Marshal Soult's collection do not please us. We look to the one subject for supernatural dignity and awe, and have a right to expect a hue of solemnity suiting the mystery of a celestial embassage; to the other subject we would turn for deep pathos, penitence, commiseration, and paternal tenderness ; and taking into account the further scope of the parable, the occasion upon which it was given, the sanctity of the narrator, and its reference to the goodness of our Heavenly Father, we should expect, both by the composition, expression, effect, and colour, to have our thoughts raised to so great an argument. In all that we should have expected from these subjects is Murillo deficient. Of these two pictures, the " Return of the Prodigal Son" is the best; but though in some respects painted with a master's hand, it is, if not vulgar, commonplace. Somehow or other, it excites but little sympathy; and the colour is to our unfortunate eyes disagreeably grey and misty, and the execution uncertain. This is perhaps the prevailing fault of Murillo—but the grey tones of the other — " The Angels coming to Abraham," is still more unpleasant. With regard to the angels we should certainly wish their " visits to be few and far between." But for some angelic indications, we should have thought the apparent unwillingness of Abraham to receive them. quite justified, and should such suspicious-looking

characters darken the door of any respectable citizen of Cheapside, there is little doubt but that he would look out for the policeman. No. 29. " The St Joseph leading the Infant Saviour, who carries a basket of Carpenter's Tools," is more rich in colour, and painted with more decision and vigour; but there is neither the dignity nor divinity in it that the holy subject should demand. His " Portrait of Don Andres de Asdrade and his favourite Dog " is certainly finely painted, though we should be sorry to have such a face often before our eyes. The dog is by far the more human brute. We cannot but suspect that among the great masters Murillo has been vastly over-rated. He is too apt to be either vulgar or weak, and seldom rises to uncommon grace or dignity.

Now, then, quitting Murillo, let us bury ourselves in the deep wood with Mercury and the Woodman—" No. 8, Landscape with Mercury and the Woodman—Salvator Rosa." — Are we stayed at the very entrance ? No entrance amongst those dark masses ! How beautiful this picture might be, if the dirt were removed from it; how strange it appears, sky, distance, wood, water, figures, all enveloped in the haircloth of penance. All is covered with one brown stain. We have not the slightest doubt but that under this coat of tobacco water, or whatever it be, there are fine fresh colours in every variety of tone—that the hills are ultramarine, the sky blue, and that there is plenty of full colour throughout. And why do we think so ? Because we have seen another picture of it, which has all that we look for in vain here. One would almost be inclined to believe that this picture had fallen into Gainsborough's hands at the time that he forswore colour, and exactly in this manner stained over his works. Salvator was a noble painter of landscape, as this of Mercury and the Woodman testifies. Salvator had lived amongst robbers, and knew how to paint a ruffian to admiration. Mercury is, however, somewhat between the robber and the petty thief. The trees do not much like to see the hatchet in his hand, though offered as a reward for honesty, to which the God himself had so little claim. They shrink back with affright, and

show by the fallen limbs around them, that there has been a deadly warfare between them and the hatchet. The composition is very finely managed, and the forms bold and expressive. How much should we rejoice to see this picture exhibited again, after being cleaned ; even as it is, it is very attractive; we long to penetrate the shade, but it is opaque—the very birds have stuck to it, fastened though in the act of flight.

No. 11, "Venus rising from the Sea —Titian," is rather too stainy and hard ; Venus from the sea should come forth fresh and clean, if not rosy.

No. 12, " The Watering-Place— Rubens" This is a very well-known and celebrated picture, wonderfully executed and richly coloured, and is such a landscape as no painter would or could have painted but Rubens ; yet we greatly prefer the Wood Scene by his hand, exhibited last year. There is much more detail, and more careful painting in this, but the intention is not so evident. It would puzzle Sylvanus himself to specify the trees, but we will not quarrel with it on that account.

" Titian's Four Ages," No. 14, is warm and rich in colour ; but is not the composition very odd ?

Is it a sign of very bad taste to say that there is a something that does not quite please in Vandyke's Holy Families? Nor is No. 13 an exception. Perhaps the defect is mostly in the faces, they appear loaded ; is this strange in one who so excelled in portrait, or does it arise therefrom ? There are here many good portraits by Vandyke—perhaps that which is least pleasing and shows the least skill, possesses the highest historical interest. " The Portrait of Lord Stafford," No. 88. — The aspect is forbidding, and there is an unpleasing stiffness in the figure, nor is there that easy and graceful blending of light and shade and colour throughout, which in Vandyke's pictures is so remarkable in general, whereby every inch of the canvass is united with and necessary to the portrait.

There are two very quiet landscapes by Claude. Nos. 20, and 23 " The Enchanted Castle." It is quite refreshing now-a-days to

see a cool and modest landscape. Nothing can be more quiet than these pictures, both as to colour and effect. They are deep in tone, and rich, but not rendered so by forced browns and reds, but by the transparency of the dark greys which pervade them. They exhibit Claude's peculiar excellence, distance and atmosphere. The subject of the first it may be difficult to conjecture. The female in the water with the Cupid does not betray any peculiar emotion, and the few figures in the second distance looking on, do not appear very much concerned about the matter; not so, however, the spectators out of the picture; and if the subject be known, we wish it had been mentioned in the Catalogue. The lucid veil of atmosphere between us and the Enchanted Castle, and which throws such an air of mystery over it, which yet is far from gloom, clearly intimates the subject of No. 23. It is very simple in composition, perhaps too much so, but the aerial effects are perfect. Might not the varnish, which is become dirty, be taken off with advantage? There are two other Claudes in the collection; perhaps the most pleasing is No. 90, "Landscape with a bridge;" it is remarkably clear.

We will not say that No. 26, "The Holy Family," from the Collection, &c., is, or is not, as it came from Raphael's pencil. We saw it by daylight and by lamplight—by the latter it was in much better keeping. The offensive yellow in the background was then reduced and not observable; the accessaries are perhaps more minutely made out than was usual in Raphael's best time. We thought the expression in the face of the Virgin very beautiful, but rather hard about the mouth. The face of the St John we thought not agreeable.

The great ornaments of the "middle room," and perhaps of this Collection, are "The Seven Sacraments, Nos. 27 to 33, inclusive— N. Poussin." We cannot imagine how any one can look at these very fine pictures and pronounce N. Poussin to be a bad colourist. In these seven paintings there is, perhaps, but one spot of colour offensive, a piece of red drapery, which is so evidently wrong that we can-

not doubt but that it has changed or lost its glazing—we suspect the last, for it is likewise weak, and wants its due depth of light and shade, or rather distinction of parts. This is a mere trifle, and has little to do with the reputation of the master. But if that be a well-coloured piece, in which the colour is most appropriate to the subject, and constitutes much of the poetry of it, we think that from these works the reputation of N. Poussin should, in this respect, stand high. It is true that you seldom see in his pictures any forced brilliancy or violent contrasts, unless his oppositions of blues and reds may sometimes be so called; but we think that he has almost always previously determined the cast of colour which his subjects required, and managed it with much skill. We might instance the cold green hue of his Deluge; but we consider the Seven Sacraments are good examples. They are all of a solemn religious shade. In some indeed, there is, as it were, a palpable obscurity—the shadow, the atmosphere of sanctity pervading the scene, and consonant with a religious conception of the several enactments. Much as we admire the grouping and character, our minds are more impressed with awe from the poetry of the colour than from the other excellences which these pictures possess. Yet through these pervading hues has he, without in the least injuring the general effects, contrived to introduce a great variety of colours, and some in strong lights, but in such keeping and subordination, that they obtrude not to the detriment of the whole. We have, in No. 37, a picture by N. Poussin of a different character from any of the last mentioned, but equally admirable. It is rich, and of that conventional character for which he is often blamed, we think, without reason. It just sufficiently differs from that of common nature, to *throw* the imagination back into antiquity; the rocks, the trees, the fields that we saw yesterday will never do for transactions of the earlier periods of the world. The mind would suffer under an ideal anachronism. This Nicolo Poussin knew; and we do not question the reality of his scenes because they are not circumstantial-

ly our realities. By demanding and engaging our faith, we submit to his impression as of perfect truth. How very masterly is the grouping of the figures; with great variety there is no confusion, and the parts of the composition are so connected that the unity of design is well kept up. The women and children are exquisitely managed, and the incidents have a charming air of truth and nature.

No. 48, " Dead Game, with Dog in a Landscape.—Weenix." The dog is wonderfully painted; the rest of the piece is dirty.

Here is a beautiful clear sunny picture by Berghem. No. 50, "Landscape with a Bridge." This evening effect is delightful, the cool tones run into the warm, and both are so fascinatingly blended that we are not in the least offended with the hot tan colour which is often too predominant in the works of this master. The figures are cheerful, and just what they ought to be in such a scene. The long bridge encompassing the valley connects one part of the picture well with the other. How very superior is this little piece to the larger one, No. 104, which is throughout dreadfully hot; there is not sufficient boldness in the composition to draw our attention from the unnaturalness of the colouring. We learn from the Catalogue, that it was painted in 1655 by order of Sir Peter Lely, and, including the frame, for about thirty pounds sterling.

No. 51, "Landscape with Cattle and Figures—A. Vanderveld." How exquisite are always the figures by this painter! not so his background. In this picture it is not agreeable, and is glaring.

There is no painter more peculiar in his manner than Wouvermans—his pictures have the softness of enamel, and are rich and exquisite in their tones, but often appear as if laboured and finished in separate parts — so that there is sometimes a clearness and unity wanting throughout. His pencil is excellent at all times. No. 52 and No. 53 are good specimens; and but for the vile subject, we should decidedly prefer No. 57, " Grey Horse in a Landscape."

For touch and finish we must admire No. 55, " Goats in a Land-

scape—P. Potter." But it is disagreeably monotonous in colour.

We never yet saw a landscape by Sebastian Bourdon that gave us pleasure; nor is No. 68 an exception; nor that in the National Gallery. Nor can we in the least comprehend why his landscapes are said to be like Titian's. If it be true, as it is said of him, that he was so struck with a picture of Claude's, that having seen it but once, he copied it from memory, to the surprise of Claude himself, it is strange that he did not adopt something of the style of a master he so much admired. His pictures, to our eyes, are not agreeable in colour, texture, effect, or composition.

Nos. 80 and 82, are certainly fine Canalettis—yet we can scarcely think he left them so hard—they would unquestionably be improved by some glazing, and if they had been in some parts more transparently painted. They are, however, vigorous, and that is a great merit.

We looked long with interest at No. 84, " An ancient Fresco painting, representing the half-bust of a Tibicen, or player on the double Flute, from the roof of the Columbario, discovered about the year 1823, in the vineyard of Signor Sante Amanendola, in the Via Appia." If this was the work of an ordinary painter in ancient days, we may fully believe the accounts given of the higher by Lucian, Pliny, and others. The hands of the figure are particularly in the manner of Correggio, admirably drawn and painted. There is a companion to it, No. 122, " Ganymede," found in the same place. This is likewise an extraordinary and interesting performance—it is like a good water-colour drawing, on a coarse paper showing the grain. The sky reminds one of that of a Venetian picture.

No. 92, " Landscape with Cattle and Figures—Both," has both the beauty and defects of this master. It is rich and freely painted, but too hot, and perhaps would be more pleasing in a winter exhibition.

We turn with great satisfaction to No. 96, " Landscape and Figures —G. Poussin." This is a beautiful specimen of the pastoral; cool, and refreshing in colour, and perfect in arrangements of parts, as the works of this master of composition ever

are. How tranquil and quiet is the scene, yet how fresh the atmosphere pervading it—what admirable execution and finish, yet is there no laborious working thrown away; every thing is in its proper place, and has its proper force and execution. It is of the country of the peaceful and the happy; it does not appear a selected spot, one that has none like it; for such is the peculiar excellence of the compositions of Gaspar Poussin, that you have indications that cannot be mistaken, in the folding of his woods and hills, of a large continuation of similar and perfectly corresponding scenery. You would imagine that your foot was as free to wander as your eye, and that you might have rest and repose where you would. All his territory is under the protection of good Sylvanus.

No. 102, " Portrait of the Painter Parmegiano." This is a most powerful portrait. It is quite life; painted with great firmness and vigour, and yet highly finished. It is surprisingly forcible. It is a face of keen observation and sense; it looks into you. If of Parmegiano himself, he had a countenance strongly indicative of his power.

We have not spoken of any of the Sea-pieces — there are some good Vanderweldt's; but we have seen better of the master on these walls.

We will make no further use of our note-book. We are thankful for the gratification afforded us, and again earnestly recommend the plan of Exhibition and Rewards for the works of ancient and modern masters to the serious attention of the Governors of the British Institution.

The catalogue of the Somerset House Exhibition is now lying on our table, and we make no apology for offering a few of the notes we made while the pictures were before us. The first on the list is " No. 8, Gathering Sea-weed. F. R. Lee, A." It is too white, of that faulty school which aims at uninterrupted light, which is always disagreeable to the eyes; yet we have seen pictures by this artist that persuade us to believe he sometimes paints against his own taste.

No. 9, " Cenotaph to the memory of Sir Joshua Reynolds, erected in the grounds of Coleorton Hall, Leicestershire, by the late Sir George Beaumont, Bart. J. Constable, R.A." If ever subject required chaste and sober colouring it is this; yet is it flickering throughout with impertinent lights, and dots of all colours, utterly ruinous to the sentiment; but lest we should mistake the sentiment intended, the painter has added to the description the following lines from the pen of Wordsworth:

" Ye lime-trees, ranged before this hallow'd urn,
Shoot forth with lively power at spring's return,
And be not slow a stately growth to rear,
Of pillars branching off from year to year;
Till they have framed a darksome aisle,
Like a recess within that sacred pile,
Where Reynolds, midst our country's noblest dead,
In the last sanctity of fame is laid:
And worthily within these sacred bounds,
Th' excelling Painter sleeps—yet here may I
Unblamed amid my patrimonial grounds,
Raise the frail tribute to his memory—
An humble follower of the soothing art
That he professed—attached to him in heart,
Admiring, loving—and with grief and pride,
Feeling what England lost when Reynolds died.

Inscribed by Wordsworth, at the request, and in the name, of Sir George Beaumont."

The intention of the poetry is solemn, sepulchral; the lime-trees planted by friendship are to grow, and overarch as some sacred aisle, fit repository for the dead. If there be light, it should be the " dim religious," and that green and melancholy monumental tree of perpetual repose. But this is not the picture. We do not say that it is all light—it may be considered in the Academy a dark picture, but its darks are interrupted by spots of white, and other colours, and are not cool and sombre, but brown, and consequently too violent for repose. The picture has not a melancholy sentiment. It is scratchy, and uncomfortable in exe-

cution, painted, it should seem, on a principle of contrast and intercep-tion, ill suited to the subject. We were recently in some beautiful grounds where the landscape-garde-ner had with great taste formed such an aisle as the great poet describes; the level path was narrow, and the stems of two large trees were mag-nificent pillars, so near the eye, that they were, as in a cathedral, only seen in part; not a dot of blue sky was visible through the thick foliage, but the light was all green, and that faintly touching the large trunks was most lovely—it seemed radiating around the mystery of some sa-cred aisle. Pursuing our walk, we were struck with the variety in the continuation of the one character. Now some such hue should have pervaded this sepulchral subject. We remember last year a picture by Mr Constable, which we heard generally animadverted upon se-verely, and we thought justly, for the powdering the artist had be-stowed upon it. This picture has the same fault, though in a much less degree. We remark it now, as we verily believe there is no virtue in the dredging box; and as these are the days when imitators out-herod Herod, we would caution younger artists, in this respect at least, not to outrun the Constable.

No. 339, Landseer's " Mustard, the son of Pepper, given by the late Sir Walter Scott to Sir Francis Chantrey, R. A.," &c. Now, this is an immortal picture, whatever some may think of the subject ; it has all the poetry of which it is capable—you see into the character of Mustard as if it had been drawn by Sir Walter himself. It is a life, a perfect reality. Mus-tard is sitting guard over some wood-cocks, to which, under the table, a cat is creeping up. Mustard does not see the thief, but has a knowledge of her presence by an instinct pecu-liar to his race. There is not a muscle that does not bespeak fidelity. The brilliancy, colour, and execu-tion—all so true to the subject, are quite charming.

No. 22, " Macbeth, and the Weird Sisters. Macready as Macbeth. J. Maclise, A." We know not how to congratulate the three Macs—Mac-ready, Macbeth, or Maclise. Did Shakspeare mean his Macbeth to look so frightened, and so undigni-fied ? No compliment to Macready—and we doubt if the witches, ludi-crously horrible as they are, do not look as much scared as Macbeth. The clever artist has here mistaken the outrageous for the sublime—a common failing in subjects from the Drama, especially where portraits of actors are to be idealized. The ac-tor's contortions in a large theatre, where every thing is forced, are softened to the eye, and admitted by the excited imagination to be na-tural; but in a private room, and to a more sober judgment, are extrava-gant. If Macready sat—or stood, rather—for the picture, he forgot he had not theatrical space and accom-paniments for his action.

No. 60. D. Wilkie, R.A. Whilst admiring this picture—for we did admire it—we heard it both greatly commended and abused. The fe-male—which is, in fact, the picture —is very good in form and expres-sion; perhaps there may be too much grace and beauty for the scene in which we find it—she might be the heroine of a better tale—but it is, if a fault, one on the right side. Bearing in remembrance Wilkie's pictures last year, we think him very greatly improved. His portrait of the Duke of Wellington, represent-ing his Grace writing to the King of France the night before the battle of Waterloo, is very happy in effect; and the omission of the last year's manner of staining his faces with pink glazing is surely an advantage; but we think still there is a manner which many imitate, and in whose hands it is more strikingly faulty— the too great a transparency, parti-cularly in his flesh; it gives the fi-gures an unsubstantial look—you could almost imagine them ghosts, and that you could see through them—nor is this an improvement on nature. This manner is certainly conspicuous in his Napoleon, No. 124, in his interview with Pope Pius the Seventh. The Emperor is gauzy, shadowy, and the face remarkably so ; the Pope and accessaries are excellent—indeed, we have seen no-thing of Wilkie's superior to this portion of the picture. It is quite painful to come to the next object of our criticism.

No. 73, " Juliet and her Nurse. J. M. W. Turner, R.A." This is indeed

a strange jumble—"confusion worse confounded." It is neither sunlight, moonlight, nor starlight, nor firelight, though there is an attempt at a display of fireworks in one corner, and we conjecture that these are meant to be stars in the heavens—if so, it is a verification of Hamlet's extravagant madness—

" Doubt that the stars are fire ;
Doubt that the sun doth move;
Doubt Truth to be a liar;"

but with such a Juliet you would certainly doubt " I love." Amidst so many absurdities, we scarcely stop to ask why Juliet and her nurse should be at Venice. For the scene is a composition as from models of different parts of Venice, thrown higgledy-piggledy together, streaked blue and pink, and thrown into a flour tub. Poor Juliet has been steeped in treacle to make her look sweet, and we feel apprehensive lest the mealy architecture should stick to her petticoat, and flour it. And what is this great modern's view of " Rome from mount Aventine ? " A most unpleasant mixture, wherein white gambouge and raw sienna are, with childish execution, daubed together. But we think the " Hanging Committee " should be *suspended* from their office for admitting his " Mercury and Argus, No. 182." It is perfectly childish. All blood and chalk. There was not the least occasion for a Mercury to put out Argus's eyes ; the horrid glare would have made him shut the whole hundred, and have made Mercury stone blind. Turner reminds us of the story of the man that sold his shadow, and that he might not appear singular, will not let any thing in the world have a shadow to show for love or money. But the worst of it is, there is so great a submission to Turner's admitted genius, that his practice amounts to a persuasion to hosts of imitators to reject shadows, find them where they will. They would let in light into Erebus, and make " darkness " much beyond the " visible " point. Turner has been great, and now when in his vagaries he chooses to be great no longer, he is like the cunning creature, that having lost his tail, persuaded every animal that had one, that it was a useless appendage. He has robbed the sun of his birthright to cast sha-

dows. Whenever Nature shall dispense with them too, and shall make trees like brooms, and this green earth to alternate between brimstone and white, set off with brightest blues that no longer shall keep their distance ; when cows shall be made of white paper, and milk-white figures represent pastoral, and when human eyes shall be happily gifted with a kaleidoscope power to patternize all confusion, and shall become ophthalmia proof, then will Turner be a greater painter than ever the world yet saw, or than ever the world, constituted as it is at present, wishes to see. It is grievous to see genius, that it might outstrip all others, fly off into mere eccentricities, where it ought to stand alone, because none to follow it.

No. 96, " Psyche having, after great peril, procured the casket of cosmetics from Proserpine in Hades, lays it at the feet of Venus, while Cupid pleads in her behalf. W. Etty, R.A." There is always something to please us in Etty's works. His Psyche is very beautiful, and we are sure for her Cupid would not plead in vain ; but we fear that box of cosmetics; it must contain some very potent poison, for laid at Venus' feet, see how the mischief has worked upwards, and poor Venus' limbs are immensely swollen. We thought it had only been among the Hottentots and some savage Indian tribes that magnitude of limb made beauty a divinity. His Venus, No. 187, is a little too blowzy for her doves.

No. 195, " Portrait of a Lady in an Italian costume. C. L. Eastlake, R.A." This is very happily coloured. Though gay, it is not glaring in light, as in inferior hands attempts at gaiety are. There is much natural air, pleasing expression, and the colouring in harmony.

No. 225, " Sowing corn. F. R. Lee, A." In this picture the artist is inferior to himself. We like not such subjects, but they should have more pleasing colour for repose to the eye. We congratulate him on his " Salmon trap," No. 344, which has much of the repose of Nature. It is clearly painted and well coloured, and is perhaps the nearest approach to a landscape than we have seen in the Exhibition. We were very much struck with the talent displayed in " The Wreckers." Three

pictures, Nos. 244, 245, and 246. They are very powerful in effect, vigorously conceived and painted. We think the female figure might have been more graceful, and the man near her is somewhat extravagant. The tale is well told in this trilogy.

No. 290, " The Battle of Trafalgar, painted for the Senior United Service Club. C. Stanfield, R. A." This does not give us the least idea of a sea-fight. There is a tameness in it throughout—there is none of the bustle and stir and grandeur of a sea-fight, matters which we can by no means believe to be imaginary. It is tame in composition and in colour, which is generally drab. We have seen subjects of this kind by Loutherberg, which strongly impressed us with the terrific vigour of a sea-fight, and the energy of which the vessels themselves, as living beings of bulk and grandeur, partook. We are sorry to think this a failure, because we greatly admire Stanfield's powers. The mechanical part deserves great praise, but that is not enough.

No. 306, " Petworth Park, Sussex, as it appeared June 9, 1835, during the anniversary dinner given by the Earl of Egremont to upwards of 5000 women and children. W. F. Witherington." It is somewhere said, that no picture requires more than twelve figures, but what would such a critic say to 5000? We hope it was not only a good order to the painter, but that he was paid for as at an ordinary at so much per head. How weary poor Witherington must have been of his work! He must have worn down his fingers and brushes, and then, like his namesake, have " fought upon his stumps." We hope this picture will serve more as a warning than example; we should be much vexed to see the multitudinous school take root. It is very well, and we are not afraid of it in Martin, but we protest strongly against its increase, and the union of the hob and multitudinary school will be intolerable. The next 5000 we see painted, if the scene be out of doors, we shall raise an outcry for 5000 umbrellas.

Now it is quite refreshing to pass on to the unaffected quiet picture of Cooper, R. A., No. 308, so true to nature, we scarcely like these subjects in other hands.

No. 400, " A summer noon, F. S. Cooper." This is from Thomson's Seasons. We very much admire the skill of the artist in the grouping of his cattle, and indeed in the general management of his composition. It is very unpresuming and well coloured. If disposed to find fault, it would be with the texture—with a good medium, we should expect much from this artist's pencil. There is something very complete in this picture, there is nothing attempted beyond his reach; though such subjects are not very much to our taste, we see in this " Summer noon " the painter's discretion and power, and hope to see him again, and would recommend him some more shady scene from nature, and such we think he would paint with truth.

No. 422," The Chapel of Ferdinand and Isabella at Granada, D. Roberts," is very powerful in effect. Effect has been evidently the aim of the artist, and he has succeeded.

No. 429, " Richmond, Yorkshire," is from the white school—and the hot glare of 473, " Morning, Windsor Castle from the Thames, J. B. Pyne," which we believe is very much admired, is to our eyes disagreeable. We feel not the slightest desire to walk about the scenery, but lacking shade and real refreshing verdure, feel a lassitude of limbs as we look into the landscape. If nature always wore this aspect, we should seldom stir out, and be tempted even within doors to shut the window shutters to keep out daylight. Mr Pyne is a very clever man, and we are sorry to find him " following the leader " in this faulty course.

Let us now imagine ourselves in the Suffolk Street Gallery, Pall Mall East. Here we have pretty much a repetition of Somerset House. Here perhaps the race of imitators more conspicuously *shine*.

No. 11, " Ancient Jerusalem during the approach of the miraculous darkness which attended the crucifixion. W. Linton." We see no reason why the darkness should be supposed to proceed out of a furnace. The long quotations in the catalogue to impress an idea of the grandeur and beauty of Jerusalem surely should not be needed—the picture should perform the office—and it is brazen enough to be its own trumpeter.

No. 50, "Ullswater, from the river Aira, Gowbarrow Park. T. C. Hofland." Here we have glare again enough to put out one's eyes; what shades there are, are all brown. Yet is Mr Hofland a clever man. We have remarked that artists in their attempt to be warm, totally mistake nature; it is true there is some warmth in shade, but there is that for which it is given us, coolness. A similar mistake is often made with regard to trees; they are nature's *cool* green, to refresh the eye, to throw cool shade for silvan repose, yet how often are they mere daubs of brown—hot as if baked in the oven of art—for what object? Because reds and browns, which are made from them, have a more pungent effect upon the eye, and force observation.

No. 149, "Christ Raising the Widow's Son. B. R. Haydon." We are quite at a loss to understand Mr Haydon. He is either much above or below our taste and comprehension; he must have some unexplained theories of art, for nothing can be more unlike nature, under any form, shape, or colour, than his practice. Here are strange mixtures of red, blue, lamp black, and treacle. The figure raised from the dead should surely appear free from pain, or there is a sad deterioration of a miracle. Here, however, is the expression of fever, the rolling eyeballs and stricken forehead are all indicative of intense pain. The background is strangely coloured, raw blue stained over with dirty colour, as in imitation of old pictures uncleaned, by putting on all one would wish to see cleaned off; and how weak is the principal figure, the Christ—the only miracle appears that such a hand and arm should support such a heavy leaden cloak. But let us see Mr Haydon on a classical subject.

No. 221, "Discovery of Achilles, &c." He must have very strange notions of an Achilles, such as are not to be found in Homer certainly; but the colouring is the most extraordinary on record—never was any thing like it; there is nothing like blue and red in his estimation—every shadow is as red as vermilion-cake can make it—it is all so bloody, it would shame a butcher. One of the female figures covers her eyes with her hand, and no wonder, all the rest have dots for eyes. Achilles is a great striding ninny, red, red, red. We at first thought he had been wounded, his very arm pits are what Mr H. may call shaded, with raw vermilion; the only cool part about him seems to be his heel, where he really was vulnerable; with that exception he seems wounded all over—there never was so great an absurdity. Then we have Mr Haydon, No. 287, "Falstaff." His ideas are not princely, for such a prince it is to be hoped was never seen. Here we have reds again; one would suppose he had been fascinated by the description of Bardolph's nose, and painted the picture to show how he could make it resemble a red-hot poker. What theory of colouring can he have with such a jumble of green, red, blue, and yellow? A parrot is sober to it.

No. 276. "Morning—Windsor Castle from the meadows; cattle by T. S. Cooper. J. B. Pyne." Has the defect of most of Pyne's pictures. He has strangely fallen into an abhorrence of shade—you have here the promise of a soaking hot day, enough to scare the poor cattle to think of—and what a scene has he chosen for all this day heat! Old Solemn Windsor. We are shocked at the ancient sombre towers evaporating under a hot reform sky—would that painters would consult the beasts of the field for the value of shade. The very cattle have more intuitive taste than our modern painters in this respect.

No. 112, "A Bull Fight at Seville. J. F. Lewis." Mr Lewis is master of composition—every thing is in its place; amidst all the seeming confusion, there is not one object, however partially seen, that does not tell. The life, vigour, activity, are drawn with full power, and all is set off with most appropriate colour—a most perfect interest is excited—his animals are as true as his human figures, and his females have grace and beauty. Beautiful as these water colours are, we regret Mr Lewis does not apply himself to oil; we do not believe he would lose any power from the change of his material.

No. 156, "Scene from Kenilworth, F. Stone," is very good and strong in character. Water colour painters have certainly taken a new walk in

the historical upon a large scale. The "Murder of Bishop Liege," 125, by Cattermole, is a specimen of very great power; still we doubt if subjects of this kind belong to water colours. The faults we have to find with modern art in general, notwithstanding our admiration of the abilities of many artists, are still conspicuous among the painters in water colours. There is too little poetry—too little imagination, and too little sentiment.

Is it true that, after Sixty-eight Royal Exhibitions, the arts have retrograded ? We fear it is. It is with vexation we admit it. Our best painters were before the Royal Academy. Among the first exhibitors (and certainly there were many bad enough, but they have easily dropped down into oblivion) were the giants of English art. These are *our* " old masters," and have not only not been excelled in whatever upholds the dignity of art; but their names stand upon an eminence that, in our annual retrogression, appears ascending out of our reach. We say in all that upholds the dignity of art, they are greatly our superiors; in the mechanical and manual, in dexterity of the pencil, and profusion of the pallet, the painters of the present day will not find in them rivals. We have left the poetry for the drudgery or mere mechanism of the art, feeling for display, and exhibit and admire our glittering gaudy wares like a nation of shopkeepers, whose glory is in the workshop and manufactory. What is the cause of this ? Independently of something wrong, morally and intellectually wrong, in the public taste, which is in a state of alternate languor and feverish excitement, and looks with suspicion on whatever is offered, but with the profession of modern improvement, we fear it is in the nature of Academies and their Exhibitions to multiply artists, but not to promote genius. Every exhibitor must strive to attract, and this endeavour leads him beyond the " modesty of nature." Talent is even afraid of imitation. Painters who have acquired fame are under apprehension of the imitators to whom they have given rise, and lest they should tread too closely upon their heels, dart off in some eccentric course, that for a

time throw out their pursuers ; and are ever more alive to invent novelties to catch the public eye with glitter and glare, than to sit in dignity and tranquillity awhile under the shade with truth. Artists are, like cucumbers in a hot-bed, forced, and no wonder they run more to belly than head. There is an impulse that is ever urging them to think more of themselves than the art. Hogarth, Sir Joshua Reynolds, Gainsborough (as a portrait, not landscape painter), and Wilson, are still at the head of the English school. That there is and has been genius among us since their days, none can doubt; it has occasionally shown itself in the promise of power, nay, occasionally in real power, and vanished. It has not been suffered to establish itself. There is still, we are persuaded, no lack of genius, but it is under deteriorating circumstances. And some, it must be confessed, have with original talent burst forth into the true, grand, and sublime; but somehow or other their promise has been blighted, and has altogether died, or sunk, satisfied with our admiration, into the practice of endless repetitions. We scarcely indeed know a picture so truly grand, so terrific, as Danby's " Opening of the Sixth Seal." It is perfect in effect and colour, and there is no part of the composition or execution that mars the one grand conception. The print gives not the composition, for even composition is often made out by light and shade and colour, which, where the tones are so varied, the graver will fail to give. This picture and some few others, not altogether out of this class, are striking exceptions amidst glaring absurdities, presuming nothings, the bustling efforts of tame mediocrity and endless imitation. And in works of a more moderated cast and character, where finish and execution may be more judiciously displayed, a walk unknown to the founders of the English School, we have artists of very great talent. The productions of Calcott, Landseer, Cooper, and some others, will ever be admired for their general truth and purity; yet even these are too frequently below themselves, under a compulsion fancied or real, of keeping up to the Somerset House mark. The practice, by-the-by, of touching and re-

touching, on the walls, before the public are admitted, should on no account be allowed; for how can pictures painted in one light and retouched under another, and with all meretricious glare about them, be expected to look well when removed to the quietness of a private gallery? We know not how to account for nearly the total absence of landscape in Somerset House. Is it that real proper landscape is too sober and modest for that display of colours and execution which hold the public taste under a false fascination? We have hills and valleys, lakes and rivers, glens and forests, for ample combination for the scope of genius. The birds have not deserted our woods, nor shadows our hills; (if they had they would be more painted perhaps). The clouds of heaven, carrying shadow and illumination, still deign to visit our mountains, and " drop fatness" into our vales. Here are all the materials for the painter's creation. But our artists must be at the Rhone or the Rhine for views, fortunate if they can outface the sun flaring in the middle of the picture, and build up the dilapidated ramparts of town and castle on each side, according to the most approved academical receipt. Vistas of towns and towers, and eternal Venice, in more than Venetian glory, of old carpets and turbaned Turks, are far more favourable objects for the *raw* materials, gambouge, cobalt, and vermillion, than such sombre scenes or quiet shades as

" Savage Rosa dash'd, or learned Poussin drew!"

And then, artists, if they happen awhile to " batten on a moor " and exhibit a common with all its geese, fancy *they* are landscape painters. The public are ignorant of the very principles of landscape painting; they have in general no conception that it is any thing but the taking " views from nature," no matter what; they will scarcely be brought to believe that it should be found to exist in composition, in artful arrangement; that it requires genius to combine—that it is open to poetry. It is therefore in its highest properties defunct; now and then we see, but even that rarely, a pleasing scene from nature, some river scene paint-

ed with considerable truth, but the art does not dive into the great mystery and depth of nature's feeling, as formerly. Oh, why this insensibility to God's most rich, most beautiful, most peaceful, and most awful works? Over which he has given us unlimited control and power, if we will but cultivate the genius bestowed on us, to combine in endless variety, to imitate his creation, and build up worlds of our own from the profusion of the materials his great wonders have thrown around us. There was once a promise in this walk of art, but it is gone. We recollect, when the first great change in water colours began with landscape, many very beautiful and original specimens of English genius. When Turner was really great; when Havill and Varley felt a love and passion among the mountains and waters. We have seen no such beautiful drawings since those days; perhaps there may be, but that we doubt, some more power over the materials, but it has left landscape. We quarrel not with those who have chosen the field of men and manners, and with unmixed satisfaction delight in Lewis's Spanish Bull-fights; and see more than the power of watercolours in the works of Chalon, Mrs Seyforth, and her sisters the Miss Sharpes; but we shall ever regret that landscape should have been deserted by those who showed at one time they possessed a genius equal to its best aim. How, in these days of extravagant excitement, shall the quiescent taste for landscape arise? At the revival of art in Italy, religion gave a mighty impulse; feeling was in the line of encouragement; churches were to be filled with representations of divine subjects; the Bible was truly the painter's manual. Then every church had its many chapels; the fortitude and suffering of saints and martyrs; the Holy Virgin and Angels; Sanctity the most sublime and most pure, all were to be portrayed, imagined, embodied; the very works were the objects of adoration, and painters partook of the incense of praise and glory; hence the wondrous works of Raphael and Michael Angelo. This could not last for ever; the churches became full; with some deterioration of feeling, as under a weaker inspiration, the art reverted to the luxu-

riant beauties of heathen fables. It became in unison with, and borrowed from, the antique statues; woods, and rivers, and hills, were in requisition, habitations for silvan and other deities, and under the hands of Titian and Nicholo Poussin, trees, rocks, and foliage put on an antique air, and became recipients for metamorphoses. That field occupied, Gaspar took the pastoral with a nearer approach to common nature, but yet retaining the poetic veil. But it was likewise the age of somewhat of the feeling of courtly romance. Claude threw himself into that feeling, and created his more dressed and precise style, intermingling landscape and sea views with legendary tale, courtly elegance, and pride of merchandise. Salvator, born but a few years after him, but in less settled regions, threw himself, in all the freedom of genius, into wilds, amidst ravines, and rocks, and precipices, investing all with a poetical depth, power and solemnity, a fit territory for his lawless figures. Nothing of this had been before attempted. Thus were all these great men original; landscape arose with them at first as an adjunct only to the figures of fable, but under their hands it assumed a consequence of its own. None of these, however, forgot to invest it with some mystery or charm of poetry. Since those days it descended to more common representations : it became a mere vehicle and means to exhibit dexterity of handling and harmony of colour—and is now rapidly losing even that poor ground. But from landscape-painting, as founded by those great Masters, has arisen a new art, to which the painter has scarcely yet deigned to hold out the hand of fellowship—landscape-gardening. The followers of that art are greatly improving, and if we may speak of their works as pictures, we do not hesitate to say, that they know more of light and shade, their proportions, relative values, depths and tones, than any of our modern painters, and often afford us a pleasure that in vain we look for at Exhibitions.

We are forced to admit that the progress of our painters has been in the lower departments of art. The great encouragement given to portrait prevents higher efforts, where

they might have been expected. And we are persuaded the faulty practice of some Royal Academicians, whose favour is to be obtained, and whose works are therefore imitated, inflicts the greatest injury on British taste. They have neglected nature, and run into bad systems which they call art. They are at total variance with all that has obtained the admiration of the world in the old masters; and we will determinedly, to the best of our power, expose the errors into which the rising artists may too readily fall.

We have not hesitated to be free with our remarks; because we are persuaded that it is only by public criticism that artists will learn to see themselves. The leaders in art have so many injudicious admirers, and so many followers, that they scarcely ever hear any thing but praise. The whispers of severity in the exhibition-rooms do not reach their ears. We are persuaded they are in a wrong course—we give our reasons, and hope sincerely others more able than ourselves will endeavour, by a strict line of criticism, to rescue art from eccentricity, and to restore it to greater simplicity and truth.

Artists may be multiplied, and yet art not advanced. We would impress upon the younger artists the necessity of thinking deeply on art and reasoning truly; of thinking for themselves, unshackled by the admiration bestowed on those who have hitherto taken the lead in public estimation; unbribed by patronage, and not depressed nor self-degraded by its loss, or by too earnest a search after it. None will make great painters but such as seek the art for the art itself—who are contented to be poor, rather than degrade their tastes—yet we verily believe the surest way in the end to fame, present and future, and to the many immediate advantages it may bring, is strictly to cultivate and follow the dictates of their own genius, and then to think themselves worthy to direct the public taste. There is one reflection we would urge upon their attention—what is to become of our thousand artists who are now running a fallacious course, if the public taste should recover or acquire more sound principles ?

John Eagles

"Historical Painting"

Blackwood's Edinburgh Magazine 40 (November 1836), 663–73

WHAT is usually meant by " Historical Painting?" The term has been so vaguely used by the professors of the art, that we are often at a loss how to apply it. Does it mean painting passages of history, or the ideal and poetical in almost any given subject? It has always seemed to us not only ill defined, but foolishly held up as containing the excellence of art, and as alone worth the ambition of an artist. If, however, we look to the examples generally given by professors of the art in their public lectures, and by no means exhibited in their own works, the historical painting recommended would appear to be an imitation of Michael Angelo; particularly in that in which is said to consist the " Grand Style." That the real merit of this grand style lies deep, and that it is the invention of a wondrous genius, we fully believe; but we very much doubt if the general conception of it extends beyond the mere visible exaggeration of limb and muscle in depicting the naked figure, and that in Michael Angelo it is the ideal force of power so effected. But it requires the genius of the original inventor, of a Michael Angelo, to reconcile the truth of nature with the exaggeration of art; and we may easily believe, that in inferior hands, in imitations, this grand style would descend to most laughable contortion, and terminate in ridiculous or tame fury. The large scale of his works, the necessity of their being painted on walls, and seen only under particular and unvarying lights, and from below, may have created a necessity for the exaggeration, which, for easel pictures, which can be brought to any focus of the eye, would be entirely misplaced. Even theatrical display, to appear natural, must be something above nature. Were no other passions of the human breast but the violent fit for the scope of genius—were power alone, whether to inflict or to bear, the admitted divinity of art—were the race of painters compelled, under penalty of degradation, to perpetuate designs of Prometheus, his tormentors, and his

vulture, and to seek varieties only in the tortures of the Inferno, and to forswear all portraiture below a thundering Jupiter, we should bewail their pitiable necessity, and cry up Michael Angelo and the sublime for ever. But totally denying any such necessity, and believing that the superior charms of art are produced in portraying the gentler passions, in tone, sympathy, and a thousand mixed feelings, and that mankind at large really find more delight out of, than in this grandeur of art, and that genius no less superlative is required for these than conception—we protest against the directions and authority of professors in general, and would by no means concede the eminence, the invidious distinction they would bestow on their "historical painting." Indeed, their own practice has generally been the very reverse of all they seem mostly to admire, and what miserable failures have been the few attempts to revive this " grand art."

Then there is something in insinuating that you have all the requisites of the most ample genius, but that the public want taste. Now, we firmly believe the contrary, and that excellence will, sooner or later, raise the public to its admiration, that artists are to make the public taste by constantly showing what is good, and that they are not to be led to it by the dictates of an ignorant, previously uninstructed people. It is undignified to pander to a weak and depraved taste, and then querulously to lament that it is no higher. But we are persuaded that the public taste is daily looking for higher gratification than it receives, and too frequently, at our exhibitions, looks for food which it does not receive; but whether the wholesome food is that prescribed and but seldom offered, may be a question that more are inclined to raise than to sift and solve.

But let us allow historical painting a more unlimited range, and still we would avoid the invidious distinction. There are many elevated walks of art that we only object to; we

detest vulgarity; the whole range of poetry and of nature blended is open to the artist. Whether he choose the fabulous, the landscape, or mixed design, we ask not. He is the man for our admiration, and for public admiration, if he rival Claude, the Poussins, or even Vanderwelde, and some of the Flemish painters. Let him paint strictly history, if he will; but if it be mere matter of fact, it certainly will not bear the highest rank in our estimation. We protest against the continued professional jargon on this subject, and the unmanly complaints of want of encouragement, which, we believe, have the additional demerit of being utterly false. The fact is, that there is an increasing love of art in this country, and in consequence, there is no conceivable style that does not meet with patronage of some sort or other. Hence the multiplication of artists to a fearful extent.

The walls of our Exhibitions have their pictures by thousands, and it is fair to presume that all these artists are maintained in some way by their profession. We think the professors wrong in proposing to mediocre talent too high an aim, and the pride unpardonable and almost unpitiable that, folding itself in the splenetic conceit of neglected merit, will persevere " *Crassa invitâ Minervâ* " in ridiculous aspirations, neglecting to bring saleable commodities of ready talent to a willing market. It is possible for artists to have very inflated notions both of the objects of their pursuit and of their own means of perfecting them —and such are seldom satisfied with the fair merited rewards they meet with, and would appropriate fame and fortune. The returns not equalling their desires (overlooking the real cause of failure, if it be failure, for the world is still liberal even to them), they vent their ill-humour on the public taste. If you presume to criticise an artist's work, and press him hard with your reasons, it is ten to one but he will agree to your remarks, and defend himself upon the plea that he must do wrong to please the public. Others again, and happily they are few, if asked why they persevere in works which they say the public do not like, assume an air of contempt for present gene-

rations, and go on daubing, prophetic of future fame, in the spirit of martyrs.

But, as we said before, he must be a very bad performer who will meet with no encouragement. We should like to see the true Dr. and Cr. account with the public of some of these discontented artists, and are sure that in many instances the sums received would show a very decent maintenance for any given number of years. With regard to some we know this to be the case. Yet are they lavish of abuse upon the tasteless and illiberal public. " I said the world was mad," exclaimed the lunatic, " and they said I was mad; they were too many for me, and here I am." We look upon replies not very dissimilar as lamentable instances of the insanity of pride.

With great pity for the sufferings of individuals, we must not, even in their cases, permit the public taste to be unjustly treated, we had almost said insulted, nor the arts in general degraded by an attempt at particular and unmerited exaltation. It is with no small pain that we have noticed a recent correspondence in the newspapers—the consequence of an appeal to the public from Mr Haydon, headed " Historical Painting." Were this only an appeal from Mr Haydon as a sufferer, from whatever cause, we should join in general sympathy in his behalf; but he is suing in the name of the " Neglected Arts." He is putting forth the arts in a beggarly position, to sue in *forma pauperis.* We would rescue the arts from this unworthy position, and entreat for Mr Haydon the substantial commiseration to which his mistaken course in his profession may entitle him. The first appeal from Mr Haydon appeared in the *Morning Chronicle*, September 12; but as one in the *Spectator*, September 17, contains some addition, we prefer an extract from that paper.

" HISTORICAL PAINTING.

" *To the Editor of the Spectator.*

" King's Bench,
15th September, 1836.

" SIR—I appeal to the English People, the Nobility, the Government, and the

King, if the condition of historical painters for a hundred years has been honourable to or worthy of the rank of the country in science and art? Regard a moment the historical painters of France, Germany, and the Netherlands; are they not more employed, better off, and in higher rank? Since Thornhill's time, has any historical painter made a decent competence? Is not their condition become a proverb all over Europe? Hussey retired to Devonshire in disgust; West, but for the King, would have starved; Barry was always in struggles; Fuseli escaped to the Keepership; Proctor died of want, after carrying both medals for painting and sculpture; Howard was glad to be Secretary; Hilton to succeed Fuseli; Westall has been in great afflictions; Etty has left off great works; and I am in a prison.

" There is but one cause for this—the want of State encouragement.

" The Duke of Bedford has presented my Xenophon to the Russell Institution. Suppose the Government gave two commissions annually for different institutions, and offered premiums for the best designs for the interior of the Lords : we should cease to hear of the necessities of historical painters. It will be done sooner or later: would it not be a pleasure to Lord Melbourne to start the thing ?

" If I may be allowed to intimate my own cause of affliction, it is from paying L.303, 8s. 6d. law costs, in addition to losing L.240, 16s. 8d. on the Banquet, and paying L.592 this last year *in toto* to the greater portion of my creditors, leaving the remainder angry and disappointed. But I am nearly out of debt; and could I be placed again before my canvas, and three fine subjects I have left (Poictiers, Saragossa, and Samson), I would pay the balance in a year, or less. I am in prison for L.30; my friends would pay it, but unless my peace is guaranteed by the rest, I should be in confinement again in a week.

" You have always been kind, and seemed to consider my troubles not quite private, caused as they have been solely by beginning great works in early life without capital.

" Your obedient servant,
" B. R. HAYDON.

" P. S. So completely had lawyers stripped me, I had scarcely *clothing* left: on L.7, 10s. I paid L.8, 10s. costs; on L.15, L.19 costs! and could not help it. And now I am locked up, as an additional assistance—a profitable labourer!"

Now what reply might " the People, the Nobility, and the King " make to this appeal to them ? " The King" (Heaven give him, notwithstanding, a long reign), simply that he is no great judge of painting, but that he will encourage that or any thing else that may be good, and that his Ministers may recommend. " The Nobility," that they have purchased, at large prices, historical pictures of modern artists ; and "the People" (the patrons of art among them, referring to their bankers' books) and all to exhibition catalogues, that they were not aware of any lack of patronage of historical painters, or that, if there were, it was or ought to be dishonourable.

It may seem invidious to remark upon the several living artists whose names are brought forward by Mr Haydon; we only hope, and suspect that the case is not so bad. Do not most of them still paint historical pictures which sell at a fair price ? Etty's fanciful pieces we delight in, and sincerely hope that he will never resume his " Great Works." But Westall—why, we have seen large sums given for his pictures; and has he not been fully employed all his life in illustrating literary works, and we presume was not unpaid for his labours. We know not the cause of his afflictions; but must have better proof than Mr Haydon's assertion, that they are from lack of patronage—for his assertion with regard to Mr West is most palpably wrong. Did he not receive from the British Institution L.3000 for his picture, and that a copy ? And have we not seen many of his pictures in private collections, for which large sums were given ? And was, after all, the admitted patronage of the King nothing ? Then what sums did he obtain from publishers for permission to engrave from his pictures ? Did loved and honoured Stodhart leave behind him acres of painted and unsold canvas ? Was not his profession a badge of unworthiness to him ? Was not his honest industry in enthusiastically applying his talents for a series of years to a marketable commodity, and which still the public, however multiplied be their heads, including minds and eyes, delight in, in working for the

engraver—and his designs may yet be thought " great."

We have seen galleries of Fuseli's pictures, and never heard that he gave them away. Barry, strange being as he was, sold—and Northcote's large pictures sold—go back to Opie, he sold—and we would ask, if their pictures did not yield these artists a fair price? And if, now when the value may be better understood, they were brought to market, the purchasers or their families would be found great gainers, or to have been illiberal paymasters? We recollect a year or two ago some statement in the *Morning Chronicle* of a sale of modern pictures that had been purchased, and an account of the prices paid, and the sums they produced at auction. The statement was highly in favour of the liberality of the purchasers. But does not Mr Haydon strangely omit the notice of some who have recently, as in the instance of Sir D. Wilkie, left other walks for the historical? We see historical subjects in every print shop, the engravings are costly; and what publishers would engage in such undertakings if the public taste did not give them hope of remuneration? And can this hope be, or is it realized without benefit to the artist?

Mr Haydon ends his catalogue of the unfortunate with himself, and we lament the extent of his personal calamity—" And I am in prison." But still Mr Haydon, far from showing that he has received no patronage, that he has many and important pictures that nobody will buy, shows that there are considerable sums that he has received, though unfortunately very much has been expended in law; he shows that " beginning great works without capital," notwithstanding their heavy expenses, he is nearly out of debt, and no allusion being made to other parties, the finishing of three only would extricate him from debt, and that in fact he is now nearly so. It appears that, though beginning without capital, he has been enabled to pay L.592 to his creditors; we find sums stated

to have been paid, and therefore' we presume, previously received, amounting to . L.303 8 6 In addition to loss on the

Banquet . 240 16 8
And the above mentioned 592 0 0

L.1136 5 2

Here is above eleven hundred pounds, the result of patronage to an historical painter. It is, however, true that all this may fall short of what Mr Haydon may think a just remuneration for his labours and rewards for his genius. He has rather been unfortunate in his self-estimation, or in his means of making his merits known. His means were certainly of his own choice—his name has been much before the public, as well as his works, and we believe what has been excellent in them pointed out by himself in literary accompaniments. He has not shunned observation or notoriety. We recollect the time when if we met a strangely-dressed figure in the streets, we were told it was one of Mr Haydon's pupils. It was industriously circulated that his views of art were in total opposition to those of the Academy—and they have not acknowledged his superiority. He seems to have considered himself a Gulliver in art in the hands of vexatious Lilliputians who pertinaciously tied him down with their small threads, walked over his person, and inflicted on him innumerable wounds with their small arrows, yet has he himself been a pugnacious competitor for fame.*

We are not at all aware that historical painting in France, Germany, and the Netherlands is either in higher repute, or has more substantial rewards than in this country. Mr Haydon asserts it, but we doubt the fact. Nor does he, when he makes his appeal to our Government, show *how* the governments of those countries encourage their painters. He says that the last encouragement in this country was given to Sir James Thornhill (he died in 1732). Now, if the State be

* Who criticized in the public papers Bird's picture, when he and Mr Haydon were competitors for the prize offered by the British Institution? We remember a clever caricature that came out at that time on " High Art."

requested to inflict on the country a repetition of allegorical history, by way of encouraging high art, we most sincerely hope that they will not listen to such appeals, nor even petitions, for a moment. Not even the Luxembourg nor Whitehall specimens of art to be admired, but neither felt nor loved, can reconcile us to such historical painting. Whatever skill they show in the craft and mystery of the art, we deplore their waste on such subjects, and the waste of genius which might have been so much better employed. Mr Haydon proposes two things:— 1st. That the government should give two commissions annually. 2d. That they should offer premiums for the best designs for the House of Lords. We fear that two annual commissions would ill satisfy the many competitors; and though Mr Haydon thinks that this State patronage would set all right, we much doubt if it would extricate him from his difficulties. But we do most sincerely hope that pictorial decorations for the House of Lords will never take place. What could the historical decorations be? Allegory is totally gone by; never, in the name of common sense, let it be revived; it would but excite public ridicule, and is scarcely in itself a step higher than caricature. It has even been rejected for frontispieces to works of puerile erudition. Shall we have the old siege of Troy?* The repainting of Dido's Palace? Or shall we have English History? And where commence? By all means with the naked Picts, and Prince Vortigern—and an Act of Parliament to constitute and certify the likenesses.

Every nation's history will unfortunately furnish battles enough to fight over again on canvas, but what are to be distinguished? We should have an animated debate now whether we should complete the Barons of England on Magna Charta—or shall all give place to two splendid pictures, to occupy two whole sides, of Lord Grey's Reform Dinner and

the Battle of Waterloo? Alas! the public have already seen enough of the former to Mr Haydon's cost, who is a loser by it of L.240, 16s. 8d. sterling. And is there no room to be left for future great doings, whether by statesmen, heroes, or artists; or are we to consider England's glory in arms, arts, wisdom, and artists to be finally closed for ever with this one grand national decoration? The fact is, all this kind of historical painting is gone by; writers have taken the place of painters. Mankind were formerly taught by sights, but now by reading. Even the ornamental part, the decoration and the effect of history, have passed off from the painter to the romance-writer. It is found that in this walk the pen excites more than the pencil, and that truth may go to which side she pleases, for few care which. Both may have their share of ambiguous facts; but in the written the imagination is not too definitely fastened down, and when duly fevered, will delight more in its dreamy liberty. We say not that this is altogether desirable—history has been declared but an old almanac only fit for historical novels. They have absolutely superseded strict historical painting. We no longer want public documents in paint; nor shall we ever again light our religious lamps for devotion or knowledge from illuminated missals. The superstition of the arts, historical and otherwise, if we may be allowed the term, is irrevocably gone by, and with it those pictorial appeals to nations' eyes on a large scale to which it gave rise. They are gone with the very means of art that brought them forth—fresco painting. Popedom has no more churches to fill; and Mars and Bellona, and Venus and Cupid, and even blind Justice holding the scales to the wisdom of Solomon, will never again raise recruits or insult municipal authorities with dictations as to how they should act, and with doubts of their most perfect wisdom.

* If the Trojan war be determined on, we enter a caveat against Mr Haydon's Achilles, exhibited in the Suffolk Street Exhibition. He is a great striding, naked, ruffian, bathed in blood to the very arm-pits. And this, before he had, according to Homer, fleshed his sword.

There is no hope of Gog and Magog ever appearing in fresco, though admirable subjects for the Angelesque grand contour and amplitude of limb. Genius must henceforth, we are fully persuaded, be content with oil painting, easel pictures, and moderate-sized galleries; and we have not the slightest doubt that real genius will have no reason to complain that it is cramped and limited; but will take as it is, or make the humour of the times subservient to the native richness of invention. Nature, in her gifts, is jealous even of her own work, and will rather create a difference than allow a repetition. We must be content, in some respects, to let the old masters, particularly of the great school, stand unrivalled in their own niches in the Temple of Fame, and trust in the power that makes geniuses, for finding other temples and other niches for all who will merit places in them. No—let these public decorations be no more thought of. They do not suit our climate; if in oil, they must be varnished—damp destroys them.—We know not of a single attempt to renew them that has not been a failure—from the talked-of encouragement of Sir James Thornhill to Barry's inconsistencies at the Adelphi. Even Sir Joshua's Window at New College is in entire mistake of the effect most desired, and within the scope of painting on glass—rich colours that are to throw around mysterious and religious light, for his design is without colour. And as to patronage for the mere design, the conception of which is stolen from Correggio's Notte, we believe he was paid an enormous sum—we think as much as L.2,500.

The parishioners of St Mary Radcliffe, Bristol, liberally ordered sacred subjects, on a large scale, from Hogarth. They had better have fed him at much less cost to caricature the vestry. The Italian painters had not only the freshness and enthusiasm from the novelty and extent of their employment, but had devotional feeling from the superstitions that blended with their love of art itself, and gave a character to their conceptions, which we fear English artists will not acquire. The great works of the ancient Greeks were performed with this feeling too, and exhibited to a people who believed in their miraculous power. A willing, perhaps adoring people in both instances, the old Greeks and the Italians, acknowledged the very impress of Divinity in the works of men. Can we wonder, therefore, if artists felt an inspiration which they were allowed to have, and conceived from it extraordinary energy and power. Much of this will never, can never return. Still genius is as unlimited as the creation which is given it for materials, and where it finds the ground too beaten for its feet, will show that it has wings, and liberty to use them. We would even venture to assert that there is something gained in the rejection of a large class of historical subjects. Mere figures, in Roman or Grecian costume, telling an ambiguous tale, too insipid to excite even curiosity to prove what it be, however dexterously handled, are happily now considered lumber. Troy and Carthage have even faded from the tapestry, and will no more be renovated. We are satisfied with Virgil's description of the Picture Gallery; Achilles is best in Homer, since the grand style leads us to burlesque; and we dread calling up the ghosts of English history to daylight, and ushered into our Houses of Parliament, either headed by Angelica Kauffman, or Mr Haydon.

With regard to Mr Haydon's disappointments, we have but one word to say—we would recommend him earnestly, if he finds his branch of his profession not sufficiently profitable, to change it for another. If he does not find, or cannot make the public taste answerable to his views, it would surely be more honourable to transfer his talents, if to less agreeable, to more certain and profitable employment, than to persist in incurring debts which complaints against the public will not pay, and which his experience must have shown him his own works do not pay! This would be a far more honourable and worthy condition, and a far happier one, than any that can be acquired by forced and solicited Government patronage, or bounty arising from commiseration. Surely portrait-painting is lucrative and open to him, or the illustration of

literary works. Raphael himself did not consider himself degraded by painting the arabesque at the Vatican, nor by designing for China plates. If he delights in unprofitable history, let him look forward to it as the luxury of his leisure hours, which honest industry in a new line will be sure to give him.

Mr Haydon's appeal called forth a very ably written letter, signed " Pictor," in the *Morning Chronicle* of September 14, to much of which we fully assent. But as the writer, in misconception of the appeal, and evidently with a strong political bias, rather misnamed liberal, is alarmed at the idea of a premium for artists, we think it right to make some comments on his letter, which follows.

" PENSIONS TO AUTHORS AND ARTISTS.

" *To the Editor of the Morning Chronicle.*

" SIR—A painful appeal in your paper of this morning should awake the attention of Government and the people to the heartless imprudence of granting pensions occasionally to the professors of art and literature, thus creating a fund of false hope, on which unborn thousands will noisily starve ; and alluring the indolent, the sanguine, and the vain from the remunerating pursuits of laborious industry, by the expectation so easily formed, where one's own merit is the condition, of living in lazy glory upon the public purse.

" What ! is the claim of the poet, poetess, sculptor, electrician, artist, and literary composer, or compiler, to be maintained at the national expense ? Are not the present incumbrances of the nation, the dubious spinsters of Mr D. W. Harvey's aversion, as dear to the Irish peasant and the Scotch weaver, as lyrics, odes, green statues, and books of the church ? Why, in the name of Mercury, are we, having paid for our book, our bust, or our historic picture—why are we, personally or nationally, to be called on again to contribute to support the artist or author ? Is there any want of poetry that it must be raised by bounties ? or is it so unnatural to Englishmen to have any enjoyment untaxed, that the arts and sciences beg so loudly and so sturdily to be made at once British, oppressive, and unpopular ? Does a doubled pension make ? ? * readable ? Should not failure serve as a salutary notice, and sink an aspirant into utility instead of raise

him into a pensioner? And might not the incomes of many have been deferred until their paymasters, the mighty, active, and struggling population of this busy land, had found time to master the longer published and somewhat, as I understand, superior works of Shakspeare and Milton ?

" No one will raise a voice on this subject, because these gentlemen hold the penny trumpet of ephemeral fame, and because every trickster in politics can now charge the pension list with the pamphlets and paragraphs he was formerly obliged directly to pay for ; but this question must be seriously settled, and it should be agitated by men who fear neither the bitterness of a bitter race nor the short-sighted liberality of a munificently-disposed public.

" It should first be determined whether there is to be a pension list, its extent and resources, and then the creatures who are to feed on it, whether by absolute nomination in the Monarch and Minister, with the invariable qualification of partisanship and servility, or after receiving the approbatory fiat of a public investigation into their claims? When the authority which is to confer this pleasant chaplet is established, I shall take an early opportunity of presenting to it the condition and wants of a manufacturer, who, after feeding hundreds for years by his capital and enterprise, had his fortunes destroyed by the vacillating foreign policy of this country—of a banker's family, whose father inclosed commons and planted heaths, and died soon after failure in consequence of the monetary change of 1819—of a high-minded and generous merchant, now a lunatic, who traded largely with Denmark (after being shut out from almost every port in Europe by our external wars, and from India and China by our home impolicy), and who lost his all in that country when we seized on the property of the Danes in this. I have thousands of cases, from the noble ruined in raising the honour of the country at Newmarket by improving the breed of horses, down to the last sanguine inventor of the last invaluable patent which nobody uses or appreciates ; I will bring them all into court—we will learn where we are to begin and to end—we will establish a principle, and perhaps uproot a prejudice—the records of the new tribunal will either prove that Governments have nothing to do with such questions, or that, if they should interfere, there are cases in every pursuit and in every grade which call as loudly for aid, in the name of the honour of old England, as the

miseries of the votaries of the pen and pencil.

" I am Sir, your obedient servant,
" London, Sept. 12. PICTOR."

Now, Mr Haydon does not ask for a pension, but for encouragement, for employment; nor do we agree to the republican view, that every one must take care of himself, and that governments are never to reward. Governments may be said to contract with every individual for common labour and common talent, because, in a general way, they have no reason to expect more. But if superior talents, and more than common labour, produce greater benefits to the public than they expected when their services were contracted for, it is manifestly to the common interest that the overplus of talent and labour should be considered as entitling the possessor to an additional claim; and if such claim be not admitted, there is not that due encouragement to stimulate gifted persons to extraordinary exertion, from which the general good is so much advanced. Surely it is neither liberal nor just to receive a great deal, and make a very small return, because there is no legal demand for a greater.

The cases brought by the author of the letter are lamentable, and we read them with a feeling of great pain as common incidents in the diary of human life. It may, however, be allowed that these unfortunate persons commence with speculations in which their own good is alone the object. But this is not the case where the advantages brought to the common stock are very great—yet consist not of marketable productions in a pecuniary point of view.

It is possible for a man without any view, or without the possibility of payment, to make known inventions of the greatest importance to human life. Philanthropy and a love of science alone may have been the motives. Yet, in the prosecution of these inventions, and in bringing them to bear, the personal interests of the individual may have been greatly neglected.

Is the government just or wise in letting that man starve, thereby killing the very source of the great-

est advantages to mankind ? For example's sake, we would instance the inventions of Davy, particularly the safety-lamp,—and that of vaccination, by Jenner. Such cases are innumerable, and will generally be found in the products of genius—seldom in the products of mere labour. Great victories have been won by a song, by which perhaps the author did not gain five shillings. The writer is very splenetic against poets; and though ready to admit the superiority of Shakspeare and Milton, yet, were they living, and had not made the most provident bargain with their publishers (as was certainly the case with Milton), and were they, from ailments and infirmity, unable to produce saleable works, the principles of Pictor would send them both to the workhouse, and inflict upon the country the stigma of ingratitude for having received the greatest benefits, and having left their benefactors to starve. We humbly think that this is not honesty.

If to raise the moral feeling of a people—if to engender in them a love and a taste for the highest qualities that adorn and civilize mankind be deserving of the reward, let not governments, with a narrow policy, miscalled liberal, neglect their poets. An old Grecian dramatist well observes—" Masters are for children, but poets are for men." And we can easily imagine that what may be said of poets may be said of painters. Who will deny that Raphael, Michael Angelo, and the great painters who have made Italy illustrious, and visited by all the world for its treasures, have given more to their country than their country has given to them. Their works sell at something more than prime cost. We think it fair to add Mr Haydon's reply to both correspondents:—

" HISTORICAL PAINTING.

" *To the Editor of the Morning Chronicle.*

" SIR—In reply to both of your correspondents, I beg to say the historical painters neither will expect or desire to be *provided* for by pensions. They only desire that the State would annually afford them that employment which all States have done when historical painting

has flourished, and which was done here by the State before the reformation in religion. With respect to the second correspondent, I cannot approve of his plan of public sale, because works are depressed or kept up by so many tricks at sales that it would be a very unfair criterion of an artist's value.

" There is nothing to be done that will be ever effectual but employment by a sum set aside in the estimates annually for that purpose.

" It will, it must take place—it would be popular, and carried with acclamation.

" Your obedient servant,
" B. R. HAYDON.
" King's Bench, Sept. 19."

We dislike proposing schemes—for every one you propose twenty will arise, and perhaps all impracticable; but we have suggested before, and now repeat the suggestion, that nothing would so much both improve the public taste and raise artists to the most honourable condition, as the establishment of professorships of painting, sculpture, and architecture (perhaps united) in our universities. The principal advantage that we see in this is, that the youth of England who attain the highest education would, at their most docile years, acquire a taste, and consequently a love of art, and would become judicious patrons. It would tend greatly to rescue them from lower or frivolous pursuits, too often the resource of those who have nothing to do, and would perhaps, even to them, be of equal advantage with the usual doubtful acquirements of the dead languages. If this scheme were thought an interference with the Royal Academy, visitors might be appointed from thence; but we would invariably have the professors Masters of Arts, and a peculiar degree, on examination, conferred on students;—a school of painting should be annexed, in which lectures might be given, and the art practised. We learn that the ancients did make painting a necessary part of education, and that they forbade it to be taught to slaves—thereby establishing for it an " honourable condition." With regard to the House of Parliament, on September 16, we find another letter on the subject, in the *Morning Chronicle*, addressed to Mr Haydon, signed " Volksfreund" (the People's Friend) :—

" HISTORICAL PAINTING.

" *To B. R. Haydon, Esq.*

" SIR—As one of the ' Public' to whom you address yourself, in conjunction with the other (generally so considered) more potential patrons of the fine arts, I venture to suggest what I have long thought a much better remedy for the evil of which you complain than ' State patronage' or aristocratic support, however generous and splendid; *splendid!* because *rare.* Nothing can be splendid (that is, remarkable) that is not rare—uncommon; and historical painters starve upon *splendid* patronage; that is, they are *rarely* employed, and *rarely* paid.

" Historical painters have often been told, that the only support the ' State' can and ought to afford, is the protection it gives to the arts of life in general. No exclusive or extraordinary aid can be challenged for what is rather a luxury than a necessary.

" But the luxury of one generation becomes the necessary of the next; and in this, as in all other things, ' the appetite grows by what it feeds on.' We have lived to see a great change in the public taste for music; there has been a great elevation of the standard in my time; and is not the commodity of readier sale, and higher in the market?

" My remedy, then, is open market—public sale—sale by auction—sale for all paintings, and at any price—for what they will fetch—the price of the canvas, if more cannot be obtained. Leave the ' cold shade of aristocracy,' and bring your wares to public market. Create a taste for painting, by feasting the eye in proportion as music has been poured into the ears of the public, still greedy for more. What becomes of all the pictures that remain unsold at the end of every annual exhibition at Somerset House? Why are they not sold for what they would fetch? Why should such a procedure be derogatory to the character of the painter? And is not the chance of now and then a good painting being sold for less than its real value likely to sharpen the desire of purchasers, and compensated by the diffusion of a taste for more?

" Under whose auspices did the Italian and Flemish schools begin to flourish? The patronage of the merchants of Florence and of Venice, the burgomasters of Antwerp and Amsterdam.

popes, princes, priests, and potentates followed in their train—they did not lead them. Did Pericles create, or did he take up, the public taste and advance it? Painters and sculptors are not made in a day, and neither the 'State' nor the 'Lords' of Athens could, by any possibility, raise a race of artists by their exclusive patronage. Before Apelles painted for Aspasia he painted for Aspasia's father, the merchant of the Pireus. Work for 'the many-headed monster.' Paint and sell—not for high prices, but for what you can get. Let no man put up his canvas a second time. Let the historical painter court a large, not a select, market, remembering (in homely phrase) that the nimble ninepence is better than the slow shilling.

"Of your individual case, sir, I do not venture to speak. I address this to you in answer to your appeal to the 'Public' in favour of historical painting in general. "VOLKSFREUND."

The writer seems very jealous that an aristocracy should be supposed for a moment to be patrons of art,—though we really think that those who have large estates, and leisure, and means by education to cultivate their tastes, are after all likely to be the best purchasers. But his plan for promoting the arts is somewhat whimsical: he would have artists sell all their pictures, all of them, though they should cry,— "What, all my little ones"—Yes, all,—" for what they will fetch?" Must they sell to a loss? Yes, surely, valuing the canvas as spoiled. We have heard that the Altieri Claudes were on the point of being knocked down at a custom-house sale for a very few pounds; and we should, under this remedy, certainly frequently tremble for the labour of months.

Volksfreund is very zealous to show his friendship for the people, and has the common fault of popular zealots, that of not saying who the people are; but we are sure that the purchasers of pictures must be an aristocracy, whether solely of wealth or rank.* "Popes, princes, priests,

and potentates," if it be true (which we very much doubt) that they followed in the train of merchants in their patronage, certainly very greatly advanced art. However the writer may rail at "the Lords of Athens as incompetent" to raise a race of artists, we suspect that without "Prince Pericles," Athens never would have been adorned with the wonders of the world. For the suspicious people looked upon Phidias as a thief, and banished him from Athens. And what was the consequence? He enriched another state with a work that eclipsed his Minerva—his Jupiter Olympius. The Eleans, however, were not too enlightened to discard gratitude from their code of public laws or virtues, for they appointed, doubtless with odious pensions, his descendants to keep clean the wondrous statue. We should be glad, not so much for the artist's benefit, as for the country's honour, if a permanent committee were established, and suitable galleries constructed, that the portraits of the best of all men in the country who most eminently distinguish themselves, might be deposited as monuments of the glory of the country. How valuable, how gratifying a legacy would this be to posterity, and how cheap and honourable a mode of both raising and rewarding great men.

Though we think Mr Haydon's complaint in reality groundless, and would reverse the saying, "Were there Macenases there would be Maros;" believing that good artists, as bad ones do, will make their own way, yet we see no very great objection to government encouragement, even in the way that Mr Haydon proposes, excepting the decorating of the House of Lords. We fear that the competitorship for "two annual prizes" would not, as Mr Haydon thinks, put an end to all complaints; for it by no means follows that the commissions would be given to those whom Mr Haydon might think the most worthy. Besides, the complaint, is a very old one, and was

* We know but of three aristocracies, rank, wealth, and talents, and believe that there is a strong party in America furiously opposed to all these, and are jealous even that one man should be educated above another, and therefore set their faces against all intellectual improvement. We see nothing in this but the extension of the first principle of Democracy.

made in the days of Raphael and Michael Angelo, who, in spite of the evil of their time, arrived at the greatest glory. And so will artists now, if in their excellence they will rival those great men, and will most effectually ameliorate and lead the public taste by their works. But do yet such works exist? It may not be unprofitable to quote a passage from Castiglione's Cortegiano, which fully verifies our assertion. " Before," said he, " I undertake this, there is one thing more I desire to mention, which, because in my judgment it appears of importance, ought by no means to be omitted by our courtier; and that is the skill in drawing, and a competent knowledge in the very art of painting, nor think it strange that I require this skill in him, *which in these days is looked upon as mechanical and little becoming a gentleman.*"— *The Courtier, Book 1st.* We perfectly agree with Castiglione, and wish that the art of painting was considered a necessary part of the education of a gentleman. Mr Haydon will know that the author was the intimate friend of Raphael, who had at that time greatly distinguished himself.

R.H. Horne

"British Artists and Writers on Art"

British and Foreign Review 6 (April 1838), 610– 57

Article VIII.

British Artists and Writers on Art.

1. *Lectures and Discourses of Sir Joshua Reynolds, West, Barry, Opie, Northcote, Burnet, Fuseli, Lawrence, Flaxman, Westmacott, J. Landseer, &c.*
2. *Disquisitions on Art, by Hazlitt, C. Lamb, Sir Charles Bell, Professor Milman &c.*
3. *Criticisms of West, Barry, and Haydon, on their own pictures.*
4. *Writings of Hogarth.*
5. *Sir Martin Archer Shee's " Rhymes on Art" and " Elements of Art."*
6. *Dictionaries, Histories, Biographies, &c., by Vertue, Walpole, Pilkington, Bryan, Cunningham, Elmes, Gould, and Callcott.*
7. *Barry's " Letter to the Dilletanti Society ;" Haydon " On the Judgment of Connoisseurs compared with that of Professional Men ;" Richardson " On the Science of the Connoisseur."*

IT is one of the commonest as well as greatest delusions of our self-love, to suppose that we see everything which is placed visibly before our eyes. Thousands of delicate textures, harmonies, contrasts and fluctuating expressions and shades exhibited in objects of nature and art, are never observed by those whose senses and intellect are deficient in the requisite sensibility, knowledge and refinement. If the mind owes half its knowledge to the eye, the eye owes far more than half its sight to the mind. But admitting the recipient powers in an individual to be naturally of a quality suitable to the ingress of all visible images of impassioned feeling, grandeur, sentiment and beauty ; we should never forget that the medium through which they are transmitted must be equally qualified by outward exercise and experience for its important task. Inasmuch as the fingers, however well adapted by nature, cannot play upon a musical instrument without practised art, no less true is it that the eye requires practice and knowledge, before it can be enabled to see and judge of what is placed before it in the forms of nature and of art.

The sight, like the other faculties, must *learn*; nor is there any other sense which absolutely requires so much, and so careful, because so complex, a cultivation.

The opinions and criticisms of artists and literary men, on modern paintings especially, are continually at variance ; each party treating the disquisitions of the other with something close bordering on contempt and ridicule. Scarcely any attempt has hitherto been made to investigate the cause ; and chiefly because neither party has thought the dissentient opinions of the other worthy of the necessary tracing and weighing. It seems to us, however, that the point at which they both come in contact, with all the impulsive force of their several "foregone conclusions," and as suddenly recoil and become incorrigible in their opposite courses, is sufficiently evident. It will generally be found that the literary or intellectual man of high endowments decides, perhaps unconsciously to himself, from a first impression of the strength or deficiency of nature in the work before him, and of the presence or absence of the ideal ; the artist from a rapid yet elaborate view of its merits or defects as a production of art. With the former, the just development of passion, imagination or intellect is his chief standard of excellence. He neither seeks for nor admits anything else as an equal test of genius, and probably declines to be enlightened in details or mechanical perfections. He may have—nay, to be able to judge at all, he *must* have—a strong sense of the grace or grandeur of design, the beauty of colour, the effect of *chiaroscuro* ; but he is generally insensible as to whether harmonies are preserved, the lights correctly distributed ; whether the drawing be accurate, the draperies well cast, the perspective geometrically true ; and he neither knows, nor cares to know, if a general or particular design be original, borrowed from a contemporary, or any old academy figures :—in short he is all feeling and thought ; but his eye is not well-read. He not only does not consider it " worth all the other senses "; he does not attach a due importance to its proper schooling. He only sees the end, and despises, because he is ignorant of, the means. With the professional artist, collectively speaking, all these rudiments and details are of the greatest importance. He contemplates the multitude of parts till they blind him to the real object of the whole. He

does not see the result as one, but as many. The circles of nature and of the ideal are forgotten in the points of art. The latter are the excellencies he has most studied; they have cost him a world of labour to acquire in any degree approaching perfection; and what with a bit of light here, and a bit of drapery there, a front figure in this place, and a fore-short-ened limb coming so happily just in that particular spot,—grouping, drawing, colouring and touch,—the spirit of the scene, the very "heart of the mystery" is entangled, absorbed and lost to every suggestion of high thought and feeling. He is all eye. It "makes fools of the rest of the senses," being "worth all the rest," according to his notion, with the intel-lectual faculties in the back-ground. His heart and head are made subservient to the scholastic acumen and acquired pleasures and refinements of the visual organ, instead of founding his Art on the grand principle of following the sug-gestions of passion, imagination and intellect, acting upon that organ, and re-acted upon by its practised strength, variety and refinement. The artist and the intellectual amateur start-ing thus in their different courses of criticism from opposite quarters and on different grounds,—the one an ethereal exclu-sive, the other a mechanical conservative,—they pass and re-pass above and below each other, and their judgments being summed up from quite different premises, their hostile conclu-sions at last meet face to face, exhausted and confused upon that neutral line which separates art from nature. They quickly turn their backs on each other, and pursue their several courses with dignified contempt or loud indignation; and they must ever continue thus inimical until intellectual amateurs acquire a learned eye, and artists cease to forget the end in the means.

Painting and sculpture, indeed the whole range of the Fine Arts, require some degree of practical knowledge to enable the critic to estimate their various productions justly and compre-hensively. It is not meant that an individual cannot appre-ciate sculpture unless he has been accustomed to the use of the chisel, or the model tools; and that he who has never la-boured at seal and copper-plate engraving and etching can be no judge of an antique gem, an intaglio, or the masterly exe-cution of a Piranesi and a Woollet. All we mean is, that

without having made copies from paintings, or drawings from sculpture;—in short, without some actual study of outline and *chiaroscuro*, added to a long acquaintance and devoted contemplation of fine works of art, the eye will not be qualified as the medium of a just and entire impression on the mind. The proof of this is found in the fact, that almost every one of the writers on the present subject have been either professors or amateurs in practice. Charles Lamb is one of the very few exceptions; and the severity of the test he applied was in proportion to his fine comprehension of the *end*, and circumscribed knowledge of the *means*. His criticisms are of the highest order of intellect, and will form the future groundwork of some interesting investigation as we proceed. The distinction, therefore, we would make, is that of the opinions and criticisms of professional artists and intellectual lovers of art, Charles Lamb being an extreme instance of the latter, and standing as the representative of a class, whose requisitions of Art in its highest walks not a great many of the old masters, and scarcely any of the moderns, can perfectly satisfy.

We must here premise that it is our intention to confine ourselves in the present article solely to the writings of our own country, in order that we may have space for some notice of almost every work of any importance on the subject that has appeared from an English pen. This attempt being in itself sufficiently extensive, we cannot pretend to give an elaborate or minute criticism of more than a few. It is the *principles* they severally advocate, the spirit and tendency of their disquisitions, which we chiefly propose to examine. In doing this we shall be as exact and comprehensive as we can; not discussing them in any regular sequence, but taking them according as they fall in with the general current, or with particular branches of the subject.

The Discourses of Sir Joshua Reynolds have long borne a high and extensive reputation: private libraries have been considered incomplete without them, and the favourite "precepts" of their accomplished author continue at the present time not only to be frequently quoted as "authority," but to influence artists in their practice, their opinions of themselves and others, and their most ardent hopes. It is therefore of

the utmost importance that the *æsthetic* or metaphysical principles enforced throughout these Discourses should be founded on unalterable truth and nature, and the soundest theories of Art. We think it will be made apparent that such is by no means the case; and chiefly by Sir Joshua's own words, for his theory continually varies with his subject. It is the more important that these fundamental errors should be generally known, since they are of that peculiar practical tendency which is calculated to retard the progress of British Art by destroying, if possible, the individuality of original genius, and all distinction of characters and passions in works of Art. But even if this were not the case, the prevailing tone of philosophical disquisition in which they are written, (the mechanical details and instructions being carefully avoided, and left to the respective academical professors,) would claim some observation as advocating sundry very questionable abstract theories.

We would not have it conjectured from the remarks we are about to quote, or from those we may offer, that the least depreciation of the real merits of Sir Joshua as a painter or writer is intended. His Discourses,—barring the consequences of personal character and idiosyncrasy, the awe in which he stood of Burke and Dr. Johnson, and the ardent wish he had to please them,—are worthy of most attentive perusal by the student and general reader, as they are full of information and excellent advice, always excepting his favourite metaphysical positions. As a painter, we cannot think with his greatest admirers among the present members of the Royal Academy, that, in illustration of his own theory, he *united* all the excellencies of the best masters; but we do consider that he possessed great excellence. He was deficient in invention, for his composition, though generally fine, is mostly borrowed from various quarters (in illustration of his theory); and in character and expression he continually fell short, not so much in accordance with his crotchet about a "central form" and a generalised idea of beauty, as because it was not his forte. He could not invent or conceive a striking original beauty, (unless indeed in the style of his portraits and their admirable back-grounds,) and, therefore, worked incessantly—often with great dissatisfaction at the natural result—to compound it from all quarters, in order to produce an excellence in which

all identities should be merged. The consequences of this are beautifully expressed by a poet, in describing the restless and erroneous craving after "perfection" among his fraternity:

> "Beauty through all Being
> Sheds her soul divine;
> But our spirits, fleeing
> Still from shrine to shrine,
> To kneel to her delights, far in the midst repine."
>
> WADE's *Mundi et Cordis.*

Instead, therefore, of accomplishing an original and ideal, Sir Joshua only produces a nobly vague generality, the substantive materials of which are but too often plainly traceable to their sources. But although his breadth wants mental purpose, and his outline precision, owing both to a mistaken theory of a central or middle form, whereat we "*far* in the midst repine," and also to his being an indifferent draughtsman; still, he always aims at elevation and refinement. There is never anything vulgar or mean in his pictures. His design is generally selected with consummate judgment; there is a peculiar grace and mastery in his touch, and he is admirable in composition as a colourist. In one sense Sir Joshua Reynolds may be considered as the father of British Art. He uplifted and redeemed it from the mawkish depravity into which it had fallen during the reign of Charles II. by the preposterous artizanship of Verrio, (the "worthy" who introduced himself and Sir Godfrey Kneller, in flowing periwigs, as courteous and approving spectators of "Christ healing the Sick") and the pencils of other foreign charlatans; by the foul patronage conferred upon Lely, who was capable of far better things, and upon Kneller, who was not; and sweeping away the bare-faced dominion of bare-breasted doll-like courtezans and ladies of the court, established a nobleness of style in design and colouring which entitles him to the admiration and gratitude of all British Artists.

Our business, however, is with Sir Joshua's principles as a writer on Art. We shall examine them in conjunction with Hazlitt's essay "On certain Inconsistencies in Sir Joshua Reynolds's Discourses." From the style in which, at the very outset, the lecturer denounces all argument or difference

of opinion, one might expect something unsound or illogical, though scarcely so much equivocation and contradiction as they continually display.

" There is one precept in which I shall only be opposed by the vain, the ignorant, and the idle. I am not afraid that I shall repeat it too often. You must have *no dependence on your own genius.*"—*Discourses*, vol. i. p. 44.

It is thus admitted that there *is* such a thing as genius, although we are exhorted upon various occasions to depend upon that of *others* for advancement.

" If you have great talents, industry will improve them : if you have but moderate abilities, industry will supply their deficiency."—*Ibid.*

True, to a limited extent only. No industry will supply an *essential* deficiency.

" Nothing is denied to well-directed labour."—*Ibid.*

This is utterly false. The proofs of the preposterous fallacy are manifest in the works of the majority of the most assiduous professors as well as students of the Academy. Their labours we presume are " well-directed " under such auspices ; but if nothing has been denied, surely very little must have been sought.

" Not to enter into metaphysical discussions on the nature and essence of genius, I will venture to assert that assiduity unabated by difficulty, and a disposition eagerly directed to the object of its pursuit, will produce effects *similar* to those which some call the result of natural powers."— *Ibid.*

—as the shadow is similar to the substance ! Sir Joshua, upon various occasions, shifting his theories with his subject, admits the existence of natural powers, and declares that " *in* " *this, certainly, men are not equal*; and a man can bring home " wares only in proportion to the *capital* with which he goes " to market." So that, however well-directed might have been his labour, he is denied everything for the " acquisition " of which he has not " capacity of mind," " strength of parts," or " natural faculties." If the term " well-directed " be meant to involve a quibble, to the effect that it is well to direct a man to the kind of labour only for which his nature is adapted, the fallacy of Sir Joshua's much-quoted maxim is equally apparent.

In warning the student against " inspiration " (not the most

necessary of all warnings in these our modern days of universal criticism and superficial refinement) which he contemptuously styles a "phantom,"—Sir Joshua observes, with *recoiling* sarcasm,—

> "He examines his own mind, and perceives there nothing of that divine inspiration with which he is told so many others have been favoured. He never travelled to heaven to gather new ideas; and he finds himself possessed of no other qualifications than what mere common observation and a plain understanding can confer."—*Ibid.* p. 56.

All this was of course very applicable, as in the nature of things it is likely always to be, to the great majority of professors as well as students; and no doubt they derived much comfort from such a confusion of distinctions. If the ostensible object of the lecturer had only been to excite his hearers to persevere in manual labour on given principles, or even in " common observation " and mental labour suitable to the purposes of collection and compilation, or other proper occupations for "a plain understanding," it would have been well enough; but is this the philosophy or aim of Art? Is it not deliberately uplifting every industrious artizan into the Sanctuary of Genius, and convincing him, with exhortations and elaborate dogmatism—little as human self-love would need such pains—that there are *no* "more things in heaven and earth, than are dreamt of in his" handicraft?

> " If he 'examines his own mind, and finds nothing there of that divine inspiration with which he is told so many others have been favoured,' but which he has never felt himself; if 'he finds himself possessed of no other qualifications' for the highest efforts of genius and imagination 'than what mere common observation and a plain understanding can confer,' he may as well desist at once from 'ascending the highest heaven of invention.' If the very idea of the divinity of Art deters instead of animating him; if the enthusiasm with which others speak of it damps the flame in his own breast; he had better not enter into a competition where he wants the first principle of success;—the daring to aspire and the hope to excel. He may be assured he is not the man."—*Hazlitt's Table Talk*, vol. i.

The mischief of the theory is not confined to painting and sculpture: it extends over the whole region of Art,—using the term in the most comprehensive sense; and if it could be brought into general practice would produce a general blight among all the noblest fruits of Art.

> " All the great works of Art have been the offspring of original genius,

either projecting itself before the general advances of society, or striking out a separate path for itself; all the rest is but labour in vain. For every purpose of emulation or instruction, we go back to the original inventors, not to those who imitated and, as it is falsely pretended, improved upon their models : or if those who followed have at any time attained as high a rank or surpassed their predecessors, it was not from *borrowing* their excellencies, but by unfolding *new and exquisite powers of their own*, of which the moving principle lay in the individual mind, and not in the stimulus afforded by previous example and general knowledge. Great faults, it is true, may be avoided, but great excellencies can never be attained in this way."—*Ibid.*

Continuing his investigation in another essay, Hazlitt thus proceeds :—

" The first inquiry which runs through Sir Joshua Reynolds's Discourses, is, whether the student ought to look at nature with his own eyes, or with the eyes of others ; and on the whole, he apparently inclines to the latter. The second question is, what is to be understood by nature; whether it is a general and abstract idea, or an aggregate of particulars; and he strenuously maintains the former of these positions : yet it is not easy always to determine how far, or with what precise limitations he does so.

" Sir Joshua seems to have been led into his notions on this subject, either by an ambiguity of terms, or by taking only one view of nature. He supposes grandeur, or the general effect of the whole, to consist in leaving out the particular details, because these details are sometimes found without any grandeur of effect, and he therefore conceives the two things irreconcileable, and the alternatives of each other. This is very imperfect reasoning. Grandeur depends on a distinct principle of its own, not on a negation of the parts ; and as it does not arise from their omission, so neither is it incompatible with their insertion or the highest finishing."—*Ibid.*, vol. i.

The finest works of the ancient Greek sculptors are undeniable proofs of the truth of Hazlitt's argument; yet Sir Joshua endeavours to show, in one part of his Discourses, that they worked upon an opposite principle, omitting all details of finishing and distinctions of character; while in another part, he praises them for their " nice discrimination of character." He tells us that " the whole beauty and grandeur of the art " consists in being able to get above all singular forms, local " customs, peculiarities and details of every kind "—and yet that these things " frequently tend to give an air of truth to " a piece, and interest the spectator in an extraordinary " manner." Howbeit, he strikes a sweeping death-blow at impassioned expression, by declaring that *all* the passions produce " distortion and deformity, more or less, in the most

beautiful faces ! " Thus, the deformity of humanity is in proportion to its depth of thought and feeling !

We must cut short the discussion by placing the opponent propositions in close array before the reader.

" It is in vain to attend to the variation of tints, if in that attention the general hue of flesh is lost ; or to finish ever so minutely the parts, if the masses are not observed, or the whole not well put together."—*Reynolds.*

" Nothing can be truer : but why always suppose the two things at variance with each other ? "—*Hazlitt.*

" Titian's manner was then new to the world, but that unshaken truth on which it is founded has fixed it as a model to all succeeding painters ; and those who will examine into the artifice, will find it to consist in the power of generalizing, and in the shortness and simplicity of the means employed."—*Reynolds.*

" Titian's real excellence consisted in the power of generalizing and of individualising at the same time : if it were merely the former, it would be difficult to account for the error immediately after pointed out by Sir Joshua in the very next paragraph."—*Hazlitt.*

" Many artists, as Vasari likewise observes, have ignorantly imagined they are imitating the manner of Titian, when they leave their colours rough, and neglect the detail : but not possessing the principles on which he wrought, they have produced what he calls *goffe pitture*, absurd, foolish pictures."—*Reynolds.*

" Many artists have also imagined they were following the directions of Sir Joshua when they did the same thing ; that is, neglected the detail, and produced the same results—vapid generalities."—*Hazlitt.*

The figures in the pictures of Martin, and both the figures and the surrounding scenery to a still greater degree in those of Turner, notwithstanding their great and original merit in other respects, are striking instances of the latter remark.

" The reasoning of the Discourses is, I think then, deficient in the following particulars :

" 1. It seems to imply, that general effect in a picture is produced by leaving out the details ; whereas the largest masses and the grandest outline are consistent with the utmost delicacy of finishing in the parts.

" 2. It makes no distinction between beauty and grandeur, but refers both to an *ideal* or middle form, as the centre of the various forms of the species, and yet inconsistently attributes the grandeur of Michael Angelo's style to the superhuman appearance of his prophets and apostles.

" 3. It does not at any time make mention of power or magnitude in an object as a distinct source of the sublime, (though this is acknowledged unintentionally in the case of Michael Angelo, &c.,) nor of softness or symmetry of form as a distinct source of beauty, independently of, though still in connection with another source arising from what we are accustomed to expect from each individual species.

"4. Sir Joshua's theory does not leave room for character, but rejects it as an anomaly.

"5. It does not point out the source of expression, but considers it as hostile to beauty; and yet, lastly, he allows that the middle form, carried to the utmost theoretical extent, neither defined by character, nor impregnated by passion, would produce nothing but vague, insipid, unmeaning generality."—*Hazlitt.*

We earnestly recommend all those to whom a right estimate of the truth or fallacy of these propositions is of importance—and to all students it is of the deepest—to read the Essays from which we have quoted, and compare the reasoning with Sir Joshua's Discourses on those particular points. Many valuable suggestions will be found in the Essays, which our space would not permit us to notice; and, without denying the great merit in other respects, many false or equivocal propositions and illogical conventionalisms will be found in the Discourses, which have not been noticed in the above Essays, or in the present article. As a writer on Art, or perhaps even as a painter, it may be questioned whether Sir Joshua's intimacy with Burke and Johnson did him any good. Neither of them appears to have known much about the matter. Johnson's remarks on painting or pictures are mere pompous generalities, applicable sometimes to all pictures, sometimes to none; and as to Burke's " Letter to Barry,"—intended to be highly instructive,—it is very poor indeed; quite unworthy of the genius of either party.

Concerning this discussion, which we venture to believe must be interesting to every lover of Art, and especially to those who wish to see painting and sculpture in England progress, it may be proper to add a few brief remarks. Mr. Hazlitt began life as a portrait-painter, and relinquished the profession because he had so fine an apprehension of the higher aims and ideal excellences, that he found, or fancied, he could never approach his own standard in practice. The bulk of his argument is not respecting *design,* but the proper method of *accomplishment.* Much of what he says is applicable chiefly to heads and faces, and the best means of giving them truth of nature, expression and character, whether real, ideal, or both. Such heads are not to be confounded with mere portrait-painting, or mere likeness of feature, costume and local habitudes. They are the

epitomes of human history in various classes of the family of mankind, by means of the choice and finished specimens of such classes.

His strictures are not equally applicable to landscape scenery. Though we consider Claude a far finer landscape painter than Turner, because the former united the real and ideal in perfect consummation, yet we greatly prefer the masterly blot and daub of a fine ideal landscape to a human face suggested by the same process; i. e. so built up with patches that it is only healthy or human at a safe and comfortable distance. Our actual knowledge of landscape scenery is derived from a distance; our knowledge of the human face is from close approximation. The mind can therefore coincide with the former, but revolts at the latter. The principle and precept of Sir Joshua makes no distinction, although the one is a second-rate excellence, and the other intolerable. In short, when we recapitulate his maxims,—that no artist is to have any confidence in his own powers, but only in those displayed in the works of his predecessors; whereby a barbed and poisoned arrow is launched at the very heart of all originality and enthusiasm;—and that common sense, a plain understanding and a Whittingtonian industry will supply the place of genius; whereby every apprentice who might otherwise have swept and scraped his way up to a civic chair, may consider himself a likely person to ascend into the temple of Art; and hence a swarm of brush-and-chisel artizans, holding common-councils with equally sensible views of arts, manufactures and commercial relations;—when we see the mischievous effect these precious maxims have had, and the deep-perverting influence they still exercise, not only over students, but over the large majority of the present Members of the Royal Academy, at bottom of whose most cherished opinions they will be found in all the ineradicability of early associations, we feel bound to declare our conviction (*distinctly, but solely, alluding to philosophical theories*), that one of the first steps towards an advance of Art upon sound principles in this country, is to destroy the Discourses of Sir Joshua Reynolds, as an authority.

It is our wish, as an important part of the subject, to take a view of the qualifications for critics and instructors which

have been displayed by the various Presidents, Professors and leading Members of the Royal Academy. In pursuing this plan, we would fain, on general principles, have selected those who lived at periods remote from each other, so that we might have given the different opinions and exhortations of the individuals as influenced by different times. But the age of the British School of Art is not yet of sufficient surface to admit of any breadth of design, and we must be content with a less systematic elaboration. We have said that Sir Joshua was the father of the British School; we now proceed to show how far the principles he inculcated have influenced most of his principal contemporaries and successors; and how far they have *not* influenced some among them.

The lectures of Barry and Opie are the production of strong and original minds, thinking for themselves, and communicating the results in a style of clear and unaffected eloquence. They are equally characterized by manly feeling and enthusiasm for Art, tempered with sound judgment and knowledge derived from practical experience. They are thoroughly English, in the best sense of the term. They are without any of the laboured metaphysics, the cold Roman-like severity of style, the erudite research and elaborate disquisition of Sir Joshua; but they contain much of the best advice that can be given to students in general, by combining sound principles equally applicable to natural and acquired qualities. Always treating Sir Joshua with great and deserved respect, they yet pursue their own independent, and for the most part unbiassed course. They do not endanger genius by leading it into neglect and presumption; nor do they endanger talent by generating fallacious hopes of the highest excellence, or discouraging it from healthy energetic efforts, and the just anticipation of proportionate results. This rare union of the best principles for general adoption would have been an arduous and perhaps impossible task for the majority of writers to accomplish, however philosophical and well-versed in the subject. To Barry and Opie the task was easy and straightforward; for their lectures are exactly in accordance with their own genuine and energetic natures, their continuous studies, and noblest aspirations.

" Of all the parts of painting, practical or intellectual, the first in im-

portance by the universal acknowledgement of all ages and nations ; the quality of all others the most rare, the most beneficial, and that which bears the most unequivocal marks of its divine origin ; is undoubtedly invention. Its possessors are therefore justly considered as aspiring to the highest honours of genius, and entitled to be regarded as the Newtons, the Columbuses, and the Alexanders of painting, who have discovered new principles, increased the possessions, and extended the dominions of art.

"Unfortunately, this most inestimable quality, in which genius is thought more particularly to consist, is, of all human faculties, the least subject to reason or rule ; being derived from Heaven alone according to some, attributed by others to organization, by a third class to industry, by a fourth to circumstances, by a fifth to the influence of the stars, and, in the general opinion, the gift of Nature only. But, though few teach us how to improve it, and still fewer how to obtain it, all agree that nothing can be done without it. Destitute of invention, a poet is but a plagiary, and a painter but a copier of others."—*Opie, Lect. II.*

With what truth and clearness do we thus find all the main points fairly stated and settled, of a question which many are so fond of surrounding with equally unnecessary and futile difficulties ! But let us observe how finely his enthusiasm is tempered with practical philosophy.

" But, however true it may be, that invention cannot be reduced to rule and taught by regular process, it must necessarily, like every other effect, have an adequate cause. It cannot be by chance, that excellence is produced with certainty and constancy ; and, however remote and obscure its origin, thus much is certain, that observation must precede invention, and a mass of materials must be collected before we can combine them.

" It is moreover absolutely requisite, that *man, the epitome of all* his (the painter's) principal subjects and his judge, should become a particular subject of his investigation : he must be acquainted with all that is characteristic and beautiful, both in regard to his mental and bodily endowments ; must study their analogies, and learn how far moral and physical excellence are connected and dependent one on the other. He must, further, observe the power of the passions in all their combinations, and trace their changes, as modified by constitution, or by the accidental influences of climate or custom, from the sprightliness of infancy to the despondence of decrepitude : he must be familiar with all the masses of life, and, above all, endeavour to discriminate the essential from the accidental, to divest himself of the prejudices of his own age and country, and, disregarding temporary fashions and local taste, learn to see nature and beauty in the abstract, and rise to general and transcendental truth, which will always be the same."—*Ib. Lect. II.*

The above are among the fundamental principles of Art, nor are they less fine from the additional advantage of being

perfectly intelligible, consistent and practical. The feeling which Barry manifests, with respect to genius and invention, as well as philosophical observation, is similar to that of Opie.

" I have omitted to speak of invention, because it can hardly be considered as an acquirable quality; since the vigor, spirit and felicity of invention are the peculiar emanations of that genius which shall be in vain sought for where Heaven has not bestowed it.

" It is in the design, and in that only, that men can recognize those operations of imagination and judgment which constitute the ideal of Art, and show its high lineage as the offspring of philosophy and sister of poetry."—*Barry, Lect. II.*

The criticisms of Opie are for the most part of a superior kind, but not always equal to those of Barry, nor is Opie so entirely and determinedly independent of the opinions of others. But if he manifest an occasional inconsistency, it will be traceable to the influence of associations with, or *passing* recollections of, the particular " precepts " of Sir Joshua, and to a sense of the fame of that painter and the estimation in which his Discourses were held. Thus, in Lect. I., p. 43, Opie says, " I cannot *quite* agree with our revered and excellent painter, that nothing but labour is necessary to attain perfection." According to Opie's principles, so eloquently expressed in other parts of his Lectures, he could not consistently have agreed at all with such an opinion. But at page 21 of the same Lecture he is absurd enough to say, and without marking it as a quotation—acting apparently under an unconscious impulse,—"Nothing is denied to persevering and well-directed industry !"

Passing over these few defects and inconsistencies, we are bound to give very high praise to Opie's writings. We consider them greatly superior to his paintings. Lectures on painting and other arts, or indeed on most other subjects, should have been his chief employment; and painting, the occupation and delight of his leisure hours. He was unable to embody his own great principles, and even unconscious how far he departed from them. After writing so finely about the study of character and the passions, we find him painting the same face of the same model for very different or opposite characters. Fuseli says that Opie's head of Wolsey, of the assassin of James I., and of Friar Lawrence, are the same man ! Opie had a fine eye for colour, but not for the com-

plex forms of impassioned expression. His pictures want
ideality. His natural powers were far better adapted to ad-
dress the understanding and the feelings through the medium
of words, than the imagination through the medium of the
eye. Notwithstanding his ardent ambition, his sincere love
for his profession, and the noble breadth of the philosophical
principles on which his opinions and advice are founded; not-
withstanding his inexhaustible perseverance, patience and
well-directed labour,—pursued even while he lay upon his
death-bed,—to Opie it was denied ever to become a great
painter. The life and works of this amiable and talented in-
dividual may be instanced among the many practical refuta-
tions of Sir Joshua's favourite precept.

Equally superior to his paintings are the Lectures and ge-
neral writings of Barry. He mistook colossal proportions for
artistical power, and preternatural fancies for ideal excellence.
When we call to mind his gigantic school-girls made into
archangels; his modern heroes and worthies of philosophy
and science in full dress, with bag-wigs and knee-breeches
walking in Elysium; and his angelico-nautical band singing
Odaic hymns, accompanied by themselves on fiddles and vio-
loncellos, while seated on the backs of dolphins or porpoises;
we cannot but regard such productions with that deep regret
which we must always feel at the aberration or misdirection
of the powers of genius. But perhaps we ought rather to say
he mistook his true mission when he aimed at being a great
painter: his real genius is in his writings, and it is of an order
that commands our respect, and excites our admiration, en-
thusiasm and regard. Their inherent fine qualities render
Mr. Haydon's furious defences and staggering eulogiums of
Barry quite unnecessary. Mr. Haydon's sympathy apparently
resulted from certain resemblances between himself and Barry,
in the over-grown style which they both fancied was "great";
in temper or temperament, and in proud scorn of the say-
ings and doings of the Royal Academy: there the resemblance
ends; for whatever Mr. Haydon may think, or whatever cri-
ticisms he may have put forth upon his own powers and pro-
ductions, his writings are no more equal to those of Barry,
than the pictures of either of them are equal to those of Ti-
tian or Murillo.

There is something humorous in the idea of a man writing criticisms upon himself and his works. It is perhaps enhanced by the singular fact, that only in such cases does criticism generally proceed on a right plan, viz., that of first pointing out the artist's, or author's intention, and the merits of his production. Other systems of criticism seek only for faults, and leave the merits, if there be any, quite out of the estimate. However humorous, therefore, the idea of self-criticism, we are very much disposed to wish the custom were general. It would save a world of idle talking and writing and vapouring about a man's "meaning" in parts, and "intentions" on the whole, and would show at once the standard of his mind. William Blake's estimate of himself as a man of genius, (visions inclusive,) was a just one. If he saw no faults in his works, it has been a pleasant occupation for others to discover them for him. But then, we would always have it *known* when an author or artist had written such an account of his doings. His name should be appended to his memorial. He would then be put upon his modesty as well as his metal, and thus be checked in eulogies which are apt to swell into gross puffs—whereof instances are not wanting. Under this latter imputation we do not think that either West or Barry can be shown to fall. Whether the accounts, evidently "by authority," of West's pictures, especially the one which discourses of his "Death on the Pale Horse," were written by himself, or under his direction, they certainly do not contain anything worthy of much notice : they are mere literal accounts of what he intended to effect, with minute descriptions of the parts. As to criticism, they are totally innocent of all attempts beyond the surface of the design and colour; while the spirit of the philosophy may be understood by Mr. West's " seeing the necessity" for representing the figure of Death as possessing great *physical strength* in order to convey an impression of essential power. The Life of West was written by his personal friend Mr. Galt, during the painter's life; and it would appear that he availed himself of the opportunity to endeavour to be classed with Raphael and Michael Angelo. Barry's account of his own pictures in the Society of Arts, &c., is a clear statement of what he intended to perform,—in which intention, so arduous and noble-

spirited, it is painful to think he has failed;—and of the public good which he believes his labours calculated to promote. The account is elaborated, enhanced and immensely prolonged by digressions which display enlarged views on politics, commerce and general philanthropy, far in advance of his time. He is the champion who fights single-handed against all abuses and dishonourable doings, and advocates the cause of all genius, virtue and the rights of honest men. Mr. Haydon's criticisms are far more concentrated. They relate to himself and his works; are full of explosive words, energetic arrogance and adulation of the Whig nobility, with all other nobility who frequent his painting-room. The "Annals of the Fine Arts" quake beneath his stentorian vanities. His account of his picture of the "Reform Banquet" is one of the most preposterous productions that ever issued from the press. The outrageous effects of the picture, as well as the pamphlet, strike us the more forcibly when contrasted with the high hopes we had once entertained of Mr. Haydon.

Writers on these branches of the Fine Arts may be divided into different sects or classes. Thus: we have the mathematical, mechanical and anatomical class; the colour class; the religious class,—sometimes comprising the highest appreciation;—the reality class,—usually among the lowest, and by far the most numerous;—and the character and expression, or purely intellectual class, which, when involving a religion of Art, is the highest and of course the least numerous of all classes. Could all these qualities be comprised in an individual we might perhaps have a perfect judge of Art; whereas we have each of the above sectarians uttering one-sided fiats, always unreasonable, and often ridiculous, and laying claim to exclusive perfection of judgment.

We do not know a more complete specimen of the first class we have mentioned than Mr. Benjamin West. As this class is the most numerous (except the reality, or popular class), it may not be uninstructive to give a brief examination of the philosophy, advice and practice of one of its greatest men.

The Discourses of Benjamin West, President of the Royal Academy, and successor to Sir Joshua, are very characteristic of the individual, but of no use whatever to the advance

of Art. They could scarcely have effected even a temporary benefit. No class of hearers could possibly have been inspired by them to any spiritual purpose. His addresses to the students manifest a quantity of good common sense, perfectly adapted, as Sir Joshua would say, to a plain understanding; and are not without some of the ordinary professional information as to fact and details, though the mechanical rules he instils are far more profuse of iteration than variety. A student might, nevertheless, have a chance of becoming a great artisan in painting, by rigidly following out his principles. The style is peculiar, and in good keeping.

" In every branch of art there are certain laws by which genius may be chastened; but the corrections gained by attention to those laws, *amputate* nothing that is legitimate, pure and elegant."—*Discourse 1., Galt's West*, chap. viii.

The above is well-meant enough, though we think that the expression of " legitimate," as applied to genius, might be subject to an equivocal, and often an injurious acceptation; to say nothing of the wooden-legged halting and limitation of its course by arbitrary dismemberments, instituted according to the legitimate opinions of what is pure and elegant.

" That the arts of *design* were among the first suggestions vouchsafed by Heaven to mankind, is not a proposition at which any man needs to start. This truth is indeed manifested by every little child, whose first essay is to make for itself the resemblance of some object to which it has been accustomed in the nursery."—*Discourse I.*

The foregoing is quite characteristic of the worthy President, who has drawn the fact expressly from his own juvenile practice and subsequent labours. It is plain that he thus mistook mechanical imitation for " design." Of course we agree with all he says, and continually repeats, concerning the importance of drawing the human figure correctly; but he seems to dwell upon this as one of the great aims of Art, instead of a means. He thus concludes his " dull delivery."

" The heart of every artist, and of the friend of art, glowed with mutual congratulation to see a British king, for the first time, at *the head* of the Fine Arts! "

His Majesty George III., whose favourite hobby so notoriously ambled among heads of cattle, and the rural *cognoscenti* in farming and grazing, and from whose royal-national purse

Mr. West received, in the course of thirty years, the sum of
£31,187 for pictures, which the peculiar "turn" of His Ma-
jesty's mind made him fancy,—his was the head alluded to
above. So noble and numerical had been the efforts " against
time," of painters, resulting, we presume, from the patronage
awarded to Mr. West, that he prognosticates the greatest
things in consequence.

" 'I may confidently say that our annual exhibitions, both as to *number
and taste* engrafted on nature and the fruit of mental conception, are such,
that all the *combined* efforts in art on the continent of Europe, *in the same
time*, have not been able to equal, &c.' He then talks of the ' crumbs
from the national table being given to cherish the fine arts, which, if done,'
he says, ' we might pledge ourselves to *dispute* the prize with the proud-
est periods of Grecian or Italian Art. But, gentlemen, let us not despair :
we have heard, from this place, the promise of patronage from the Prince
Regent, &c.' "—*Galt's Life of West*, chap. xii.

It is scarcely necessary to say, that in everything relating
to the higher walks of Art, the Discourses of Mr. West are
worthless. Admitting all his mechanical excellencies, we think
much the same of his paintings. In his attempts at impas-
sioned expression, we see that he always meant well, and fre-
quently accomplished the muscular ground-work justly; but
there his power became stagnant. The informing spirit is
wanting. His figures and faces are like those of second-rate
actors. His thought (like theirs) does not spring sponta-
neous from his feeling; but his feeling is the slow result of
his thought.

There have been many writers, as well as admirers, of the
mathematical, mechanical and anatomical class. One of the
works of this description, which might stand as the type of
hundreds, has been entitled " Anatomy applied to Art."
Death applied to Life would be an equally appropriate title,
as far as the spirit of humanity is concerned. The applica-
tion of anatomy (and the same may be said of the work just
published, entitled " Chemistry applied to Art,") must, of
course, be strictly understood as a mechanical means only.
In this sense does Sir Charles Bell regard it, who stands, not
merely at the head of writers of this class, but as much above
them as a philosopher is above an artisan.

" The painter must not be satisfied merely to copy and represent what
he sees ; he must cultivate this talent of imitation merely as bestowing

those facilities which are to give scope to the exertions of genius, as the instruments and means only which he is to employ for communicating his thoughts, and presenting to others the creations of his fancy. It is by his creative powers alone that he can become truly a painter ; and for these he is to trust to original genius, cultivated and enriched by a scrutinizing observation of nature," &c.—*Anatomy of Expression, Preface.*

We must remark that the foregoing brief paragraph embodies more of the right spirit of Art than the vast majority of volumes which have been written on painting and sculpture, not by any means excepting those which have emanated from professors' chairs.

" By anatomy, considered with a view to the arts of design, I understand not merely the study of the individual and dissected muscles of the face, or body, or limbs. I consider it as including a knowledge of all the peculiarities and characteristic differences which mark and distinguish the countenance, and the general appearance of the body, in situations interesting to the painter or statuary.

" One noblest aim of painting unquestionably is to reach the mind, which can be accomplished only by the representation of sentiment and passion, of the emotions of the mind as indicated by the figure, and in the countenance."—*Ib., Essay I.*

The illustrative sketches are admirably adapted to make the author's meaning palpable, although some of them are too extravagant and grotesque, like Le Brun's masks of the passions. But, perhaps, in the present instance, this was not only excusable but necessary, in order to show more plainly the anatomy or means employed towards the high end of expression ; which means would not, of course, have been so apparent, had they been melted and merged in the spiritual result, as required by Art. The author's cautions against the indiscriminate imitation of the anatomy of the antique and the " Academy figure," are sound and valuable. His work is full of information, interest and well-directed science, combining broad principles with deep and extensive observation. In speaking of the external characteristics of pleasurable emotion, he says,—

" There is a sense of languor ; the body reclines ; the lips are half opened ; the eyes have a softened lustre from the falling of the eye-lids ; the breathing is slow ; and from the absolute neglect of bodily sensation, and the temporary interruption of respiration, there is a frequent low-drawn sigh."—*Ib., Essay VI.*

We pass on to the colourists, meaning those who place the

chief excellence in the composition of the colours of a picture,
and to the study of which they direct an almost exclusive ad-
miration and attention. We cannot give a better idea of this
class than by quoting a passage from Burnet, who always
writes with sincere earnestness.

> " In representing an effect of sunshine, De Hoage has confined his light
> to small portions, thereby giving these portions a greater value. He has
> kept his middle tint of a low tone ; and, to prevent the whole having a
> heavy effect, he has kept his blacks firm and positive. The yellow lights
> of the sunshine he has extended by repeating them by a range of red co-
> lours, viz., the woman's jacket, the chairs and shoes on the floor. He
> has also given a little of the same colour in the window, by representing
> the tiling, &c., of the houses without. He has brought the red in contact
> with the blue of the woman's petticoat, and carried it across the picture
> by the colour of the Dutch tiles skirting the wall, and by the plate upon
> the chair."—*Burnet on Painting*, part iii. p. 61.

The serious care and important precision displayed in ana-
lysing low or poor-minded subjects like the above, has a kind
of misapplied gravity bordering upon the ridiculous. Yet,
in this fashion, will artists continually stand and discourse in
front of pictures where the subject is high and apart, seizing
instantly upon all the qualities and details of artistical com-
position and execution, never observing, and refusing to ob-
serve when solicited, anything beyond. But if Burnet has
furnished us with a good illustration of the worst of this class,
his work is so truly that of a genuine lover of his art, that it
will be perfectly easy to produce an illustration of the best
among them from almost every page devoted to the subject.
What can be more full of tone than the following passage al-
luding to Correggio, wherein he speaks of colour, with an eye
so saturated and instinct with delicious appreciation, that he
seems to taste it, as though one sense had borrowed aid from
another to enhance his perceptions !

> " His lights are much imparted with white, over which are laid colours
> of the most delicate nature, or semi-transparent washes, which permit
> the ground to shine through, giving a luminous effect ; or tints in which
> a considerable portion of white is mixed, thus preserving the rotundity of
> his figures, while his shadows are filled with a juicy vehicle, in which
> transparent particles of rich warm colour are floating ; thereby leading
> the light into the darkest masses, without its being refracted from the
> surface. This property of the illuminated parts to give back the light,
> and the absorption of it in the shadow, Correggio may have learned in

studying his models by lamp-light, as his breadth of light and shade leads us to suppose was his practice."—*Ib.*, part iii. p. 17.

We feel it impossible to quarrel with a man who advocates and luxuriates in his ruling passion with such rich *gusto*. On the contrary, we will give another specimen. He is alluding to the advice of Sir Joshua concerning a unity of colour in the shadows.

" This, however, must be done with caution, as we find in Nature and the best colourists exceptions in the colour of many of the shadows. For instance, in the shadows of red we find the local colour preserved more strongly than in the shadows of other colours, and white when warm in the light is cool in the shadow. When the mass of shadow is warm, the introduction of some dark blue or coal black will be of service to clear it up and give it air ; while the introduction of red will often focus the warm colours, and give them a richness with more appearance of truth. I may also notice here that nothing gives a more natural look than preserving the local colours of the objects in shadow, provided they are not too light to disturb the breadth."—*Ib.*, p. 18.

Burnet does not write so finely on the higher principles, though his book is truly excellent throughout. With respect to light and shade, and the composition of colour, he is admirable: the rest is like his paintings. His opinion, however, concerning the golden precepts of Sir Joshua, is worth quoting.

" I cannot here refrain from noticing the high opinion entertained by Barry of P. Veronese, as his lectures contain some excellent remarks ; and though they are not so much known as those of Reynolds, yet in many instances they may be read as an antidote to some of the doctrines even of his more fortunate predecessor. We cannot but regret the direction given to Barry's studies, and must consider him one of those noble minds ruined by a close adherence to the dry manner of the early masters."— *Ib.*, p. 29.

We, also, coinciding with the foregoing, cannot but regret the direction given to Burnet's studies, who devoted so much canvas to painting mediocrities, and so little paper to writing excellent essays. The few pages he has left are most useful: so far as they go, they are unrivalled, and may almost be called the poetry and practice of colouring, for " each seems either."

The religious class may be divided into those whose chief sympathies with Art are limited to subjects which form a connecting link between our hopes here and hereafter, and

those whose sympathies are merely doctrinal. If the former are too much "dreamers of dreams," the latter are too much dealers in texts. Mr. Cattermole, in his "Book of the Cartoons," appears to amalgamate the mounting and descending vein and metal of both classes in his discourses, and to hold them fused over an ideal furnace in the steady ladle of an inconsequential sermon. The *Athenæum*, in a series of able articles on the subject, suggests that the work would be more appropriately entitled "Tracts on the Cartoons," or a "Family Expositor" of the Cartoons. Perhaps this designation does not quite do it justice, as it contains nothing pernicious or meanly conventional. We think it would be a beautiful new-year's gift, and would place it at the head of the annual, or ornamental literature.

Individual character, like general human nature, is made up of all manner of opposite qualities, and we are consequently anxious to avoid the "rage for classification," which, as Charles Lamb justly remarked, is so liable, "in matters of taste, to perplex instead of arranging our ideas." We do not intend to establish any formal system of classification, since one and the same individual will often be observed to belong to nearly all the classes described. We speak only of predominant sympathies and propensities, and in the average. Thus, it would be easy to show the religious feelings for Art entertained by all those who have written or spoken finely about its productions, to say nothing of people's thoughts. Hazlitt's works are all full of it.

We might also quote, among other fine writers, sundry passages from the works of Charles Lamb, of a deep religious tendency in the feeling for Art. But we shall confine ourselves to the predominant bent and feature of his criticism, which is almost exclusively that of intellect, character and the expression of sentiment and passionate emotion. He tries everything by the highest possible test, and the simplest. He deals only with elementary principles, and these he carefully abstracts from all their splendour of colour, and even from their beauty of external form. Hazlitt is fond of dwelling upon tints, tones, textures and harmonies: Lamb always speaks from the text of "fine, rough, old, graphic *prints*." This apparent preference given to prints over pictures might,

in a measure, arise from the possession of them enabling him
to choose his leisure and take his own time for contempla-
tion; but this is by no means sufficient to account for it,
since he had access to fine picture-galleries, as well as other
devotees, who could no more afford to purchase any of them
than he, yet who were eloquent in recalling their grand and
lovely hues of truth. Lamb had not a fine eye for colour;
he was by no means particular to a shade in *chiaroscuro*, nor
to a hair in anatomical lines and proportions: but he had an
eye of the finest kind for the soul of Art made visible by its
radiant emanations. He did not possess any artistical accom-
plishment himself, and was one of the very few instances
among all the writers on Art,—perhaps the only instance
among the finest writers,—of inability to use a pencil in some
way or other. Lamb was therefore one of the intellectual
exclusives. He neither understood, nor cared to understand,
the means; the scope and influence of the result was all he
appreciated. All that he has written on Art scarcely amounts
to more than fifty pages; yet every sentence is admirable and
unique, like the whole.

His " Essay on the Genius of Hogarth " is full of fine
perception and discrimination of character, and of the rare
faculties and talents of that extraordinary artist, satirist and
moral philosopher. Lamb successfully combats the vulgar
idea, that Hogarth was only a painter of vulgarities; and
puts down Barry's high-flying tirade against him for not
being a master of " the figure " and the " difficult junctures
of the limbs," by showing that Hogarth did not aim at
the antique or classical, but at the anatomy of character,
and its modes of thought and passion, its manners and ac-
tions. Besides all this, he says that there is in Hogarth
the " scorn of vice " and " the pity of it " also, which he con-
siders a far better and higher order of Art than can be pro-
duced by any mere " academical skill." In the same essay
Lamb notices Sir Joshua's opinion concerning " the presum-
ption of Hogarth for attempting the grand style," referring
to " certain scriptural subjects." Without denying that such
things were out of Hogarth's way, Lamb replies that they
have, at least, the merit of possessing " expression of some
" sort or other,—the *child Moses, before Pharaoh's daughter,*

" for instance,—which is more than can be said of Sir Joshua's
" *Repose in Egypt*, painted for Macklin's Bible; where, for a
" Madonna, he has substituted a sleepy, insensible, unmotherly
" girl, one so little worthy to have been selected as the Mother
" of the Saviour, that she seems to have neither heart nor
" feeling to entitle her to become a mother at all." With re-
gard to Barry's opinion, however, we ought not to forget that
he *also* said of Hogarth :—" But what would atone for all his
" defects, even if they were twice told, is his admirable fund
" of invention, ever inexhaustible in its resources; and his
" satire, which is always sharp and pertinent, and often highly
" moral," &c. Lamb says " Other pictures we look at,—his
" prints we read." From a similar feeling, Hazlitt, in his
" Lectures on the English Comic Writers," has placed the
Works of Hogarth among those of Fielding, Congreve, Butler
and the rest. His criticism manifests a subtle perception of
the fine wit as well as artistical merits of Hogarth; and his
remarks are highly original, notwithstanding his friend's pri-
ority in the subject, which is no small praise.

Hogarth's writings with the pen are very small in quantity,
and the matter not so good as his writings with the brush;
still, truly good as far as they go, and amusing to read. They
are like his pictures in their humour, though without the
same causticity and subtlety of insinuation. His jests are
often dry and grave, and his gravity seems half in jest, as in
his paintings, only in a very inferior degree. In his " Ana-
lysis of Beauty," nearly all his illustrations are taken from
visible objects, and he considers the requisites to be " fitness,
variety, uniformity, simplicity, intricacy and quantity." The
connection of these sounds rather paradoxical; he has some-
thing good, however, to say about each, and the union of all.
The " simplicity " being with reference to the general effect;
he thus speaks of " intricacy."

"Intricacy in form I shall define to be that peculiarity in the lines
which compose it, that *leads the eye a wanton kind of chase*, and from the
pleasure that gives the mind, entitles it to the name of beautiful."—*Ana-
lysis of Beauty*.

His illustrations are—a common jack, a country-dance,
" watching a favourite dancer through the windings of the
" figure; the hair of the head, the flowing curl, and many

" waving and contrasted turns of intermingling locks ravish
" the eye with the pleasure of the pursuit, especially when
" they are put in motion by a gentle breeze."

In treating of " quantity " he gives some fine images, and
some that are very amusing. Thus, " huge shapeless rocks
" have a pleasing kind of horror in them, and the wide ocean
" awes us with its vast contents. How solemn and pleasing
" are groves of high-grown trees, great churches and palaces !
" * * * The full-bottom wig, like the lion's mane, hath
" something noble in it." But he cautions the student against
excess, by fancying the wig or the mane made twice as large,
which would attain the ridiculous. Again, he says, if a man
with a great fat face were to put on an infant's cap, it would
be " an excess in quantity " destructive to the beautiful. He
declaims, in the same style, against *inconsistency*; as in an
opera dancer representing a deity, a monkey with a coat on,
&c. But he makes an exception in favour of " an infant's
" head with a pair of duck's wings under its chin, supposed
" always to be flying about and singing psalms." These and
other things are introduced with the grave face of a " wicked
wag "; but his penmanship is not necessary to his fame. We
proceed to one whose writings are all gravity.

Of the Lectures on Sculpture, by John Flaxman, as deli-
vered by him before the President and Members of the Royal
Academy, and published by Mr. Murray in an expensive
form, with large type, large margin, plates, &c., we regret not
to be able to speak in any terms commensurate with the po-
sition they have obtained among artists and general readers.
As to its rank as a work on the Fine Arts, any intelligent
mason, or other person, possessing the historical, anatomical
and other matter-of-fact knowledge, might have made just as
good a compilation. That it is a clearly-expressed compen-
dium, or mechanical grammar for the younger students, is
not to be denied; and if this was really the end intended by
the writer, the remarks that may be offered concerning it are
to be understood with reference only to the mistaken estima-
tion in which it is held by others. It is a work of sensible
rudiments and received principles, illustrated, or rather ac-
companied (for the former term can only be applied to the
plates) with dry, accurate descriptions, and geometric or ana-

tomical measurements. The criticisms are of the most ordinary, common-place kind, and without one atom of poetry or power of expression ; in short, there are no criticisms properly so called, but bald accounts, and such literal and detailed descriptions as might be found in any auctioneer's catalogue. Let us give a few examples. Particular selection is unnecessary, as they are all in the same style.

"The group of Laocoon, animated with the hopeless agony of the father and sons, is the work of Apollodorus, Athenodorus and Agesander of Rhodes. The style of this work, as well as the manner in which Pliny introduces it in his history, gives us reason to believe it was not ancient in his time, as your professor of painting has already observed."—*Lecture III., Grecian Sculpture.*

This is *all* that is said of the Laocoon. The descriptions of the colossal statues of Zeus and of Pallas by Pheidias, are as matter-of-fact as possible, concluding with the information, which makes the reader pause in doubt, and reflect on the dry account he has gone through, that the former "was justly esteemed one of the seven wonders of the world !" In the Lecture on Science, (p. 122,) our author says that this Zeus of Pheidias " was awful as when his rod shook the " poles, but benignant as when he smiled on his daughter " Venus, according to Homer's description." By such means as these modern books are made, and if not at all fruitful, are easily multiplied. The Lecture on Beauty is a regular " dead weight," as cold as a dead body, as hard " as any stone." The affections and passions are treated as the dullest companions we have. But, soon again we are indulged with a critical description of the Apollo Belvidere.

"The energetic Apollo Alexicacos, or the driver-away of evil, commonly called Belvidere, is 'severe in youthful beauty ;' he supplies Homer's description to the sight, his golden locks are agitated, his countenance is indignant, the quiver is hanging on his shoulder, and he steps forward in the discharge of his arrow."—*Lecture V., Beauty,* p. 149.

" Can such things be, and overcome us like a summer-cloud, without our special wonder ? " But mark another novelty :

"Venus, the example and patroness of beauty, appears more frequently in poetic numbers and rapturous description, than any other heathen divinity. She was the delighting and frequent theme of Homer, Hesiod, Sappho, Apollonius Rhodius, Virgil, and indeed most of the ancient poets." —*Lecture V., Beauty,* p. 154.

Really this is very like the Schoolmaster walking abroad among the Arts; and when the writer says " it would be end- " less to enumerate the foreign divinities of Syria, Egypt, " Arabia, Persia, Africa, Spain, Gaul, Germany and Britain, " which, during the Roman power, received Greek and Roman " forms and personifications; and if this were done we could " learn nothing novel from it, in relation to our present sub- " ject; " we are obliged to declare that this is precisely the case with regard to his account of those of Egypt and Greece, and congratulate ourselves on being spared.

These are rather heavy accusations, and perhaps require one more proof.

"Juno is the first of the goddesses, as sister and wife of Jupiter: she possesses the highest degree of beauty; her character is lofty and imperial.

" Minerva is sometimes seen as the patroness of peaceful arts, in attitude highly dignified, yet simple; clothed in full drapery, and holding an olive-branch; but she is most frequently seen armed, in her four-crested helmet and ægis bearing the terrors of Medusa's head, holding her spear and shield, as the virgin-goddess of war. In both characters she is the representative of wisdom."—*Lecture V., Beauty*, p. 153.

A small medal, probably of ancient origin, is now before us, representing in *bas relief* the figure of a goddess seated, with rather a commanding, though perhaps formal air, upon a fragment of rock on the sea shore. A Grecian helmet and crest is upon her head, and in her left hand she gracefully, yet firmly, sustains a Neptunian trident of the same kind as that described by Homer, Hesiod, Virgil, Ovid and other ancient poets. In some of these medals there is a variation of the design by a different position of the trident. Her right hand, which is extended, holds a sprig of myrtle or olive, emblematic of amity and union with distant shores ; a very small ship, where the medal is in fine preservation, being just perceptible in the horizon. A shield is behind the figure, upon which it partly rests. The drapery in front of the sea is acted upon by the wind, so that its principal folds are thrown behind, where it falls in diagonal curves much too sharp and regular to be graceful. The reverse of the medal presents a head in an indifferent and precarious state of preservation, and circled with a wreath of laurel, as though the individual were eminent for deeds of genius or virtue. The expression of the

face, however, is characteristic of physical qualities only. The throat is very full; the hair arranged with evident care and art; but the forehead is deficient. A few Roman letters, tolerably legible, and of a mythological tendency, surround the edge of the medal. " But whence is this?"

The above " critical account," though no studied imitation of Flaxman's style of writing, we venture to think resembles the " spirit of the original," and refer the reader to his book in attestation. He speaks of the antiques as we speak of this medal.—It is the description of an English halfpenny.

The concluding paragraphs of the Lecture on Beauty are as full of the sentiment of the subject as the rest. " The " foot," says the learned lecturer, " is about a head and a half- " nose in length; the breadth in a straight line across the up- " per joint of the little toe being one third, or a nose and a half." —p. 157. The axiom here involved premises that every nose shall be of the same length as a Standard Nose to measure from, so that the diversities of human countenance and character are totally merged in the *rule*, and graduated to a comprehensive monotony. This work, however, contains many other axioms less open to dispute. Here is one.

" In both male and female the great toe is large in comparison with the others, and separated from them by a distinct space."—p. 158.

It is gratifying to be able to conclude our account with one extract which contains both practical good sense, and a sound view of the free and incommunicable spirit of Art.

"All rules, all critical discourses, can but awaken the intelligence and stimulate the will with advice and directions for a beginning of that which is to be done. Every painter and sculptor feels conviction that a considerable portion of science is requisite to the productions of liberal art; but he will be equally convinced that *whatever is produced from principles and rules only, added to the most exquisite manual labour, is no more than a mechanical work!* Sentiment is the life and soul of fine art! Without, it is all a dead letter! Sentiment gives a sterling value, an irresistible charm, to the rudest imagery or most unpractised scrawl."—*Lect. VI.*, p. 192, 194.

In reading the above we endeavour to forget the author's previous acceptation of the term " sentiment," and adopt its more appropriate and obvious meaning. Flaxman found it much more easy to express his feeling of grace and beauty in marble, than in words—so wonderful is Nature and Art. Nor let it be supposed because the lustre of a man's name in

one of the high paths of genius shall often induce himself and the world to adopt a mistaken estimate of his powers in another, that a just and salutary exposition of the fallacy can militate in the least against that truth which pronounces him an honour to his species and a benefactor to his country.

Milman's "Comparative Estimate of Sculpture and Painting" is a philosophical production, manifesting a true appreciation of their respective powers, and of the object and end of both. He argues from general effects, not single instances (as artists invariably do), and traces these effects " up to the elements of the pleasure they impart." The book is full of valuable matter in information, analysis and suggestive speculation. His line of argument in showing why the genius of the ancients was for sculpture, as that of the moderns for painting, is profound and convincing. The mind of the Grecian, he observes, was like his atmosphere, all light; that of the Christian resembled our variable northern sky—an interchange of light and shade. The Greek mythology personified every important effect in nature, and found therein a solution and a satisfaction. Christianity meditates on the dark and mysterious—eternity—the nature of the soul—its destiny in a future state. When the Greek wished to understand Deity, he embodied it in a human form of beauty or of power, and hence an Apollo, a Heracles, or Colossus. If the Christian has to a certain degree adopted human personifications, there is still the omnipotent, immeasurable and incomprehensible God to confound and overwhelm his imagination. Sculpture requires the definite and decisive, and is admirably adapted to the Olympian *dramatis personæ* of Homer and Virgil; painting with its bright glimpses and dark concealments is more capable of expressing the vague, vast and intermediate, as in the terrible suggestions of Dante and Milton. Sculpture fills and satisfies the imagination which grasps it as a whole; painting excites the imagination beyond what it represents, as far as the powers of the spectator can bear him onward. But both painting and sculpture require " strong imagination and deep " feelings, without which no one can become a great artist, or " a great poet, or indeed a great judge of the arts and of " poetry." This work of Mr. Milman's is comprised in very few pages, but contains the essence of many fine volumes.

It is thus that books should be written. The method is much
more likely to be useful to students than the one adopted by
Sir R. Westmacott and others, who content themselves with
the learned display of historical and professional knowledge
of what has been done in the world of Art, but take little
pains to communicate the rudiments or principles of genius
and science, whereby such wonders have been evolved. Ho-
garth speaks of "ingenious gentlemen," who amuse their
readers or hearers with amazing encomiums on deceased art-
ists and their productions, "wherein they are continually
discoursing of effects, instead of developing causes." Some
of the addresses, however, which have been delivered from
the "high chair" of the Royal Academy have contained no-
thing whatever besides the former, and even *that* upon the
most partial and superficial scale.

As a philosophical writer on Art, nobody will expect much
of the courtly Sir Thomas Lawrence, though much profes-
sional advantage to the student might have been anticipated
from so refined and elegant an artist. His public Addresses,
however, are mere vapid gentilities and graceful nonentities,
of which we should not pause to take any further notice, but
that the only tangible thing they contain, though borrowed,
serves to perpetuate mischief.

"The rising school of England ought to do much, for it proceeds with
great advantages. *It has the soundest theory for its instruction,* the bright-
est example for its practice, and the history of past greatness for its ex-
citement. * * * * The elevated philosophy of Sir Joshua Reynolds, in
whose golden precepts, which are now acknowledged as canons of univer-
versal taste," &c.—*William's Life of Sir T. Lawrence.*

Our readers have by this time settled the point in their
own minds as to these "golden precepts," and we have
merely quoted the foregoing to show the extent of the influ-
ence. "It is singular," adds Sir Thomas, "that the judge-
" ment of Sir Joshua should have been impugned only on
" those opinions upon Art which seem to have been the most
" deliberately formed, and were enforced by him with parental
" zeal as his last remembrance to this Academy." Fatal de-
liberations!—we never questioned the sincerely good inten-
tions of Sir Joshua, but a more fatal bequest Pandora's box

never contained, nor any so dangerous; for there was hope at the bottom of her lamentable present.

" There may be new combinations, new excellencies, new paths, new powers ; *there can be no new principles in Art.*"—*Lawrence.*

As it is evidently meant that there can be no new principles, since Sir Joshua " laid down the law," we might deny the truth of the other parts of the foregoing sentence. How should new powers be developed, new paths explored, by men who are to have " no confidence in their own genius ?" Sir Thomas informs us (accordingly), that there is " a sufficient " proof of the sincerity of Sir Joshua's admiration of Michael " Angelo, in the actions of some of his *finest* groups *having been* " *taken from him.*" A very peculiar proof indeed, and expressed with all the amusing *naïveté* of one who was accustomed to prove his own admiration in the same way, and without acknowledgment, as the exhibition after his death of his collection of Michael Angelo's *Sketches* clearly attested. But why he should express an admiration for West, except as a form of courtesy due to a deceased President of the Royal Academy, it is not so easy to conjecture. With respect, however, to the finishing of the parts in any picture—of which Sir Thomas must be allowed an excellent judge—he has this passage :

" The history of the greatest masters is but one. The noblest work that perhaps was ever yet projected, the loftiest in conception, and executed with as unequalled breadth, is the ceiling of Michael Angelo : the miniatures of Julio Clovio are not more finished than his studies."—*Lawrence.*

Many passages in the conversation and correspondence of Sir Thomas Lawrence place him higher as a writer on art than anything contained in his Addresses to the students. His verses also display an elegant ease, and are pleasing to read. It is not necessary to give any specimen of them, especially as we are about to quote from an elaborate work of high purposes in poetry as well as painting.

The present respected President of the Royal Academy published, some twelve years ago, two works in a poetical form, both of which produced a great sensation at the time. They are of the same class-interest as Darwin's " Botanic Garden," and " Loves of the Plants," or, as Falconer's " Ship-

wreck ;" but in execution, the poetical department of Sir M.
A. Shee's volumes is without parallel. First, however, we
must observe that the Notes, which constitute the larger por-
tion of both works, are characterized by much good sound
sense and excellent advice to the students, although, toge-
ther with his prefaces, they are often verbose, tautological
and laboured imitations of the antithetical balance-sentences
of Johnson ; open also to sundry objections on the score of
criticism. Thus: he considers Wilson a finer landscape
painter than Claude; and after a pretty handsome acknow-
ledgment of the genius of Hogarth, he says " his place has
been ably supplied by an artist now living"—whereupon he in-
troduces Mr. Smirke. He says that Gainsborough's rural sub-
jects " raise him to a competition with Murillo !" How this
can possibly be effected we cannot possibly discern. Rubens
is also placed as the third great painter, above Leonardo da
Vinci and Titian. If Rubens, by his unsurpassed designs
and colouring, and his unrivalled mastery of execution, may
be considered as the third great painter, we certainly do not
consider him the third great Artist, because his subjects never
manifest the same intellectual and intense power that we find
in Da Vinci, Titian, and several others. The writer's estimate,
however, of the relative merits of Raphael and Michael An-
gelo seems to us very good, clearly expressed and convincing.
Nor can we pass over his logical refutation of Dr. Johnson's
definition of genius, and his highly creditable opposition to
the golden precepts of Sir Joshua, which he considers to be
" encouraging imbecility to persist in fruitless toil, and dis-
" crediting the influence of genius by asserting the omnipo-
" tence of industry."

" It may be safely assumed that all minds are not equally qualified to
excel in the fine arts. Why two students, with respect to opportunity
and application, circumstanced as nearly alike as the nature of human af-
fairs will permit, shall make an unequal progress ; why the one shall
soar to celebrity, while the other sinks to insignificance ;—it is perhaps
fruitless to inquire ; the fact is however sufficiently impressed upon us by
every day's experience : and whatever that quality may be which we de-
nominate genius, in no department of human exertion is its presence more
conspicuous, or its absence more fatal, than in painting."—*Elements of
Art*, p. 9.

Sir Martin's earnest appeals to the Muse in the cause of art-

ists and of art, are not altogether original in style, but never-theless the perfection of that style. He considers poetry as the " *verba ardentia,*" and the " *os magna sonaturum,*" and through the medium of this grand diapason, he delivers him-self of the oracle within, with numbers not unmeet.

> " The Muse attempts—with beating bosom springs,
> And dares adventurous on didactic wings."
>
> *Rhymes on Art, part I.*

The poet now points an imaginary finger towards Somerset House.

> " In yonder pile, by royal bounty placed,
> The Graphic Muse maintains the throne of Taste.
> * * * * * *
> Nor deem in soft beseeching tone the Muse
> From kindness courts what candour might refuse."

The independence and modesty of talent are celebrated, and the path of fame is shown to be as arduous as its sum-mit is elevated.

> "The blushing Muse judicious Taste arrays,
> Nor lets the rainbow on her bosom blaze.
> * * * * * *
> To gain the immortal wreath of art requires
> Whate'er of worth, or Muse or Grace inspires."

It is very true. Alluding to the well-meant and well-di-rected industry of those whom Nature never intended should be Artists, the poet justly observes that many,—

> " In evil moment to the Muse aspire,
> Degrade the pencil and abuse the lyre;
> Persisting toil, by no one talent graced,
> And rot like fungi on the fields of Taste."

It is most true. Nor is the public attention sufficiently alive to the claims of the higher orders of human ability.

> " Pursuits which on the vulgar world look down,
> And lead to life immortal in renown,
> Neglected, slighted, rue the tasteless hour
> When every Muse laments her lessening power."

The foregoing is perfectly expressed. We have not far to look for the painful instances. Well, alas! may the Muse lament when such is the case. When infirmity becomes po-pular, real power must be content to abide its time.

> "Each weeping Grace, her shrine deserted views,
> And calls for vengeance on th' indignant Muse,
> While Cupid trembling flies, &c.
>
> * * * * * *
>
> Each Muse desponding strikes her lyre in vain;
> She finds no ear at leisure for her strain."

It is quite true.

> "Will no warm patriot take the Muses' part,
> And rouse his country?" &c.

We deeply regret to say, we are of opinion that there is no patriot sufficiently warm to do so with permanent efficacy. One noble-spirited gentleman, indeed—may we be permitted to mention the name of Captain Polhill—has made several attempts, aided by a celebrated tyroglyphusian taster and purveyor; but the country is not yet roused. "Let us hope "however," to use the words of Sir Martin, "that the children "of Taste, like the children of Israel, will, ere long, find an "establishment in the Canaan of public munificence; that "some enlightened Moses will arise to lead them to the pro- "mised land of patronage and protection."

Sir Martin's chief strength lies in denunciation and invective, which he rather inconsistently directs against those "unpatriotic connoisseurs" who join in the lamentation, that the Muse's power is "lessening" and the "shrines deserted."

> "Hear him, ye powers of ridicule! deplore
> The Arts extinguish'd, and the Muse no more."

But if her power be lessening, as the poet previously observed, and "dwindling to the shortest span," she might just as well be dead—better, we think. Sir Martin's poetical tributes are, however, more inviting themes.

> "The cottage group their Gainsborough bemoan,
> And with the Muses' sorrows mix their own."

The next is to Raphael,

> "By nature's hand with liberal bounty graced,
> And proudly fashion'd for the throne of Taste."

And this to Michael Angelo.

> "Immortal spirit! lo! her virgin lays
> The Muse to thee an humble tribute pays—
> A Muse unknown," &c.

It is most true. The next is to Apollo.

> " Bright as on Pindus, crown'd by all the *Nine*,
> Behold Apollo, Pythian victor, shine !
> With holy zeal in Delphic splendour placed,
> And still revered—an oracle of Taste."

But the "lessening power" is not to be remedied by oracles of taste; and until it arise in its full dimensions, the reverence is, alas! little better than a mockery. The first Canto of the "Elements of Art" opens with these striking lines.

> "Tho' weak of wing, and scarce above the ground,
> Her former flight, the Muse some favour found ;
> Her cause attracted where her skill had fail'd ;
> The painter's, not the poet's art prevail'd.
> But now the theme to still *more* humble strains
> *Imperious* calls. * * *
> * * * * * * *
> Yet may the Muse, tho' still her course she trace,
> In technic trammels and didactic pace,
> Collect some flowrets as she plods along,
> Should Taste propitious smile upon her song."

Of this there can exist no manner of doubt. We have met with poems something like these before, but we were not aware until recently that any such were extant in their entire form. It would appear, however, that the class which constituted their readers were numerous.

> " And you! for whom the trembling Muse essays
> Her feeble voice and dares didactic lays ;
> Ye sons of Taste ! "

The poet's compliments to those whom he considers the heads of this class, are expressed with Popian grace of manner.

> " Nor venerable Boydell, thou refuse
> This passing tribute from no venal Muse."

Through such instrumentality, the Members of the Royal Academy may flourish :

> " But now, no longer heedless we refuse
> The proffer'd garland of the graphic," &c.

Nevertheless, it is becoming to do everything as perfectly as possible ; because,—

> " Transcendent merit may defects excuse
> That find no mercy in an humbler," &c.

And we should be careful not to mistake our *forte*, and

fancy that words will stand for ideas, and the mere sound for
the substance.

> " Such is the common lot of all who choose
> From life's dull track to wander with the," &c.

Perhaps not of all, but " instances have been known." Very
commonly the verse-spinner as well as,—

> " The Painter thus a bounded prospect views
> And clouds in error his contracted," &c.

Thus also may our philosophical bard remark of the lover
in general, be the object what it may, who by some similar
blunder in his self-estimate, loses,—

> " Whate'er of Love's elysium Fancy views,
> Or Heaven unfolds in vision to the," &c.

We have now presented our readers with ample means of
judging for himself concerning the " Rhymes on Art " and
the " Elements of Art," by Sir Martin Archer Shee, P.R.A.
In the second publication the term of " Elements " was adopt-
ed in the place of " Rhymes," as the author informs us,
" out of respect to those liberal critics of the former vo-
" lume, who judged so favourably of its merits as to think it
" disparaged by the title." The extracts we have made are all
strictly authentic. Should the least doubt exist as to the ac-
curacy of the impression conveyed, a reference to any three
pages in any part of the books will dispel it forthwith. Owing
to the high tide of prose Notes, rising up beneath the Cyn-
thian influence of the verse, only an average of ten or twelve
lines flow through each page ; still in nearly every page will
taste and the muse be found, or grace, and perhaps Britan-
nia,—so deeply is the author imbued with his subject, and
so earnest is he in his object. Both the works were popu-
lar in their day. They brought the author into celebrity ;
and his subsequent election to the Presidency of the Royal
Academy, in preference to all other painters, was mainly at-
tributable to the high opinion conceived of his literary attain-
ments.

Among all the artists who have written on the present sub-
ject, and we may also include almost every unprofessional
writer, no one stands so conspicuous for the graphic energy
of his style as Fuseli. The torrent of his enthusiasm carries

us away with him, and it is not until we come suddenly
among impassable rocks and shoals, or find ourselves getting
into a vortex, that we recollect the banks of *terra firma* from
whence we started, and which we in vain look back to dis-
cover. His lecturing style has more of grand sound than
fixed substance; not that his mind was wanting in the grand-
est conceptions of his Art, but either he had never system-
atized his ideas as to the means of attaining excellence, or else
had not the power of expressing them in words. Ideas crowded
upon him, and he remunerated himself for his inability to
develop them all in due proportions and places, by a fervid
impetuosity in the startling display of a few. When he can-
not prove a proposition he turns it into a stupendous image;
when the grounds of his argument fall beneath the vigour of
his incantation, he suddenly raises up a terrible shadow of
the imagined archetype, behind which he sinks, and leaves
you to your contemplations. While you are expecting an
analysis and exposition of causes, the desperate Lecturer rushes
abruptly away into the gloom, and re-appears, dragging for-
ward a struggling simile, gleaming and glaring with new-born
fires as from a Promethean forge. He is rich in apt illustra-
tions, derived from an extensive acquaintance with poetry in
all its forms. His criticism is generally in a high and eloquent
vein; often discriminating and just, never dull or common-
place. His philosophy of Art was not defined as a whole in
his mind; his theories were the obedient creatures of his un-
governed imagination and gigantic impulses. He was the
antithesis of Sir Joshua in all things. And yet he coincides
once or twice "in a way" with his theories.

"To compare Reynolds with his predecessors would equally disgrace
our judgment and impeach our gratitude. His volumes can never be
consulted without profit, and should never be quitted by the student's
hand, but to embody by exercise the precepts he gives, and the means he
points out."—*Introd. to Part II.*

The first sentence is not a little equivocal. His definition
of genius, however, is very good, and sets the matter at rest.

"By genius I mean that power which enlarges the circle of human
knowledge; which discovers new materials of nature, or combines the
known with novelty."

So much for Fuseli's and the "golden precepts." But

when we see so original a genius unable to escape entirely from the influence—as far as words are concerned—we may judge how much greater the influence has been among less positive characters and powers. In his edition of " Pilkington," Fuseli directly opposes the philosophy of Reynolds ; wherefore his admirably discriminating critique on the genius and talent of Sir Joshua has been *carefully expunged* from the subsequent editions of " Pilkington," and the old one-sided heap of indiscriminate panegyric adopted in its place. It is of no use for artists, or any body else, to have recourse to these manœuvres to establish their opinions and dogmas ; for the truth will out some day or other, in spite of all efforts to supersede discussion by choaking and burying all fair analysis. The student will derive much benefit from studying Fuseli's writings, were it only from the energy and impulse they are capable of exciting. As to general instructiveness, we can only say, that particular directions which he occasionally gives prove how exceedingly valuable his Lectures would have been, had he more frequently restrained his passion for wandering into wide-spreading heaths, rife with high discursive themes, instead of waiting to grasp a given object of importance, and reduce it to demonstration.

Of a calm and more philosophic tone than Fuseli, but equally without order or polarity in his ideas, the writings of Northcote extend over a larger surface than those of most other artists. They contain much choice information, anecdote, good criticism and reflection ; are often wandering and one-sided in their views ; and sometimes exaggerated and inconsistent. He says that Sir Joshua's Lectures " are replete with the soundest instructions," to which in a professional or practical sense, we immediately assent,—with certain exceptions :— when, however, Northcote adds, that in these same Lectures Sir Joshua " treats his favorite art with the *depth of a philosopher,*" we turn to the essay " On Originality " where Mr. Northcote gives out opinions of a very adverse philosophy.

" A true criterion of talent is alone to be formed from the novelty, the originality, which is to be found in any work of art. As this is one of the constitutional marks of a powerful mind which views nature from its own sensation or feeling, and an indispensable requisite in every work of genius, originality becomes the best test of merit."—*Northcote on Originality.*

Many passages in the writings of Mr. Northcote are very valuable; and it is evident that had he given more time to literature, and less quantity, he would have ranked much higher. "Northcote's Conversations," edited by Hazlitt, is one of the most delightful books that ever were published. The title however is an unfair division of the claims of authorship.

The number of English writers on art is far greater than would be supposed. After carefully reading all the works enumerated and suggested at the commencement of this article, we found it necessary to examine thrice the number more; indeed they seemed to "grow with our growth." As to the travelling critics, anecdote-mongers and writers of Catalogues Raisonnées and Unreasonable, "their name is Legion." They commonly display no more knowledge of the general or particular subjects of Art than will be found in any sixpenny catalogue of any exhibition. We find no small pleasure in naming such exceptions as the works published by the Rev. Mr. James, Mr. Ottley and Mr. Patmore, for their high-toned disquisitions; and the Catalogue of certain pictures in the National Gallery, by Mr. John Landseer; but these are rare exceptions. With respect to the latter, indeed, we are bound to say,—without at all coinciding with several of his opinions and decisions as to *expression*,—that there is no book in our language devoted to descriptions, explanations and criticisms on pictures, which manifests so careful and elaborate a research, so thorough a knowledge of the subjects concerning which it treats, or so much of the true spirit of Art with so much professional discrimination. If he sometimes judges wrongly, he always places you in possession of every communicable means to get at the truth. We make no extract because he gives us no broad principles to contest, and his critical elaborations cannot be estimated, except as wholes, for which we cannot afford space.

It may be expected by the limited number of patient readers existing in the world, that we should say something of the writings of Carey, Prince Hoare, Ollier, Duppa, Sir R. Colt Hoare, &c., because they are in a good spirit; and of those by F. Webb, Mesmes, Holwell Carr, Payne Knight, &c., because they are in a pernicious, or contemptible spirit; but we can afford no space for anything which does not present

large and prominent features, representing influential classes which excite our sympathies, challenge our analysis, or call forth our opposition. We therefore pass on to a brief notice of the Dictionaries, Histories, Biographies, Memoirs and Anecdotes.

Were it our business to dwell upon the historical or anecdotal part of our subject, we should have much to say of the valuable and laborious research, (it does not contain much criticism, except in the admirable account of Hogarth,) displayed in the well-known work "collected by Vertue, digested and published by Horace Walpole ; with considerable additions by the Rev. J. Dallaway;" nor should we, of course, omit the excellently condensed volume by Mrs. Callcott. Our object, however, is to lay before the reader a full exposition of the lectures for *instruction*, and the *criticism* and *philosophy* of Art which have been put forth by the writers of our own country.

Among all the dictionaries, biographies, &c., the fine work by the Rev. M. Pilkington, with the still finer additions made by Fuseli in the edition superintended by him, stands pre-eminent. There is an " appropriation" of this work, edited by Matthew Pilkington, which seems to have " shelfed " the original. It is partly a transcript, partly an abstract, sometimes an abridgement, and occasionally contains additional matter. The arrangement in the original is very tiresome and confusing; the other has greatly improved it : still, with all its faults, we prefer the original, which is full of the finest criticisms and rich illustrations of Fuseli. Many entire articles are written by him, and he has added copious and valuable notes. It is a most instructive and delightful work. The best things in Fuseli's Lectures will also be found here ; while some of his ablest criticisms have been cut away from the latter edition. Next to the old " Pilkington," though on a limited scale, we should place the critical biographies of Mr. Allan Cunningham. We give him great praise for the general discrimination, soundness, precision, fulness and fairness with which he has executed his task individually. To the choice of several of these individuals we demur. He entitles his work as " The Lives of *the Most Eminent* British Painters, Sculptors and Architects." We are consequently surprised at some of

the admissions and exclusions. The criticisms, though without any profound or strikingly new observations, are for the most part quite satisfactory as far as they go ; and we would especially refer to the remarks on Flaxman and Sir Joshua Reynolds. The justness of Mr. Cunningham's critical estimate of the latter has given great offence to many members of the Royal Academy. After the author's death, some editor will doubtless expunge it.

In the Biographical and Critical Dictionary, by Michael Bryan, there is nothing requiring particular notice in the way of criticism. The only peculiarity in the work, is in the "Account of the Painters of Antiquity," which, if they are not apocryphal, will rather militate against the theory put forth by Professor Milman in his "Comparative Estimate of Painting and Sculpture."* The two Biographical Explanatory and Anecdotal works by Mr. Elmes, are good professional and technical books of reference, calculated to be proportionately useful. Gould's Dictionary is a very unprofessional work, serviceable also as the most portable book of reference, wherein may be found all the gossip of the Schools, together with all which pertains to the private life of artists. Its philosophy and criticism are made up of the conflicting opinions of artists, or their most unanimous errors. Mr. Gould therefore very often gives opposite opinions on the same subject, and quoting the great authorities for each, leaves you, with an air of dry humour, to shift for yourself. The arrangement of names in the first edition was very faulty; in the second it is improved : but the omissions are unpardonable because wilful. Before the second edition was printed, the publisher, with the compiler's ready acquiescence, forwarded the proof sheets to a friend for revision. They were returned with sundry objections to the equivocal philosophy, and with a list of omitted names. But the "testy old gentleman" took offence at the intended service, and consequently his dictionary appeared without the names of many eminent painters, sculptors, engravers, &c., although his pages overflow with such matter as the presents of rings, canes and

* Not that this will overturn his theory; since scriptural subjects and characters are constantly painted by the moderns, though rarely sculptured. Pictures of Madonnas are common in our exhibitions: a statue of Jesus Christ is rarely attempted.

snuff-boxes to Sir Thomas Lawrence; the eligible marriages
that occurred in his family; and the rank, fashion and ex-
pense that attended his funeral ceremonies.

We commenced our task by an exposition of the causes of
those antagonistic opinions which have commonly character-
ized the professional and unprofessional writers on Art (mean-
ing the best intellects on both sides), and we have proceeded
through the sufficiently formidable library of their respective
works, displaying both the spirit and most characteristic mat-
ter of their contents. It appears, we think beyond question,
that there are faults on each side, not easily to be remedied
in any case; but *never* to be remedied until both parties be-
come reconciled on the common ground of a profound philo-
sophy of Art. The artist must lend a serious ear to those who
are competent to discourse of the highest aim and end of Art;
and the intellectual amateur must confess and endeavour to
repair his ignorance of the means of attainment. If, instead
of this, the latter has habitually manifested too much con-
fidence in his abstract judgment, the artist has always treated
every unfavourable criticism with the most uncompromising
contempt and indignation, as though it emanated from the
inflated jaws of a plague-wind. Hence those artists who
have brandished the pen against the unorthodox, unprofes-
sional critics, (among these defenders of the creed and craft
we may mention Reynolds, Barry, Shee, J. Landseer, Hay-
don and others,) have considered the cognomen of *dillettante,*
virtuoso, or *connoisseur,* as necessarily identical with blindness
and malevolence, inflated folly, and the prime essence of em-
pyricism. Mr. Haydon is the most communicative on the
subject, and we shall therefore let him be spokesman for the
rest.

"No man ever leaves off from what they have written, but with the dark
starts of the nightmare, a distaste for beauty, a doubt of truth, an indiffer-
ence to virtue, and a confusion about religion; but most of all a pang,
and a deep one, to see the mistakes Nature made in giving a portion of
capacity to beings of such heartless propensities."—*On the Judgment of*
Connoisseurs.

In this eloquent attack upon the blunders of Nature, and
summary of professional feelings, entitled "The Judgment of
Connoisseurs compared with that of Professional Men," we

discover that the stupidity of Mr. Payne Knight concerning the Elgin Marbles, " roused " Mr. Haydon " to these reflections." Because Payne Knight said that the finest thing among the Elgin Marbles was the black-beetle, all unprofessional critics are therefore considered as Payne Knights, and the exhausted artist at length ceases with a furious peroration about "blasts of Fame," "blowing of their grandeur," "roaring and swelling," " ages yet unborn," " thunder and harmony," &c. Surely the lowest order of empirics are not worth so much powder! Nor do the Elgin Marbles need it.

That it would be easy to find ample instances among the pretended *cognoscenti* and self-styled critics, to justify the lowest opinions of their capacity, is as plain as, that by groping in the mire we should soil our hands. But such a proceeding would by no means prove that the flower of an aloe was the substance of dirt. The rarity of the flower of criticism and the constancy of its thorns, is not an argument against its lofty purity when genius honestly measures genius. Let us place the following brief specimens in juxtaposition with Mr. Haydon's portraits in distemper, just quoted.

Hogarth's Rake's Progress.

" The expression in the face of his broken-down rake in the last plate but one of the *Rake's Progress.* * * * Here all is easy, natural, undistorted ; but withal what a mass of woe is here accumulated !—the long history of a mis-spent life is compressed into the countenance as plainly as the series of plates before had told it ; here is no attempt at Gorgonian looks which are to freeze the beholder ; no grinning at the antique bed-posts, no face-making, or consciousness of the presence of spectators in or out of the picture ; but grief kept to a man's self ; a face retiring from notice with the shame which great anguish sometimes brings upon it,—a final leave taken of hope,—the coming on of vacancy and stupefaction,—a beginning alienation of mind looking like tranquillity."—*C. Lamb, on Hogarth.*

Claude's Landscapes.

" They are perfect abstractions of the visible images of things ; they speak the visible language of nature truly. They resemble a mirror or a microscope. To the eye only they are more perfect than any other landscapes that ever were or will be painted ; they give more of nature, as cognizable by one sense alone; but they lay an equal stress on all visible impressions ; they do not interpret one sense by another ; they do not distinguish the character of different objects as we are taught, and can only be taught, to distinguish them, by their effect on the different senses. That is, his eye wanted imagination : it did not strongly sympathize with his other faculties. He saw the atmosphere, but he did not feel it. He

painted the trunk of a tree, or a rock in the fore-ground, as smooth,—with as complete an abstraction of the gross, tangible impression, as any other part of the picture: his trees are perfectly beautiful, but quite immoveable; they have a look of enchantment. In short, his landscapes are unequalled imitations of nature released from its subjection to the elements,—as if all objects were become a delightful fairy vision, and the eye had rarefied and refined away the other senses."—*Hazlitt, On Gusto.*

Expression in the Antique Gods.

" Exhibiting the mild serenity of a being superior to the passions of mankind, as shadowing out a state of existence in which the will possesses the most perfect freedom and activity, without the exertion of the bodily frame."—*Bell's Anatomy of Expression.*

Titian's Bacchus and Ariadne.

" Precipitous, with his reeling Satyrs round about him, re-peopling and re-illuming suddenly the waste places, drunk with a new fury beyond the grape, Bacchus, born in fire, fire-like flings himself at the Cretan. This is the time present. With this telling of the story—an artist, and no ordinary one, might remain richly proud. Guido, in his harmonious version of it, saw no further. But from the depths of the imaginative spirit, Titian has recalled past time, and laid it contributory with the present, to one simultaneous effect. With the desert all ringing with the mad cymbals of his followers, made lucid with the presence and new offers of a god, as if unconscious of Bacchus, or but idly casting her eyes as upon some , unconcerning pageant,—her soul undistracted from Theseus,—Ariadne is still pacing the solitary shore, in as much heart-silence, and in almost the same local solitude with which she awoke at day-break to catch the forlorn last glances of the sail that bore away the Athenian. Here are two points miraculously co-uniting; fierce society, with the feeling of solitude still absolute; noon-day revelations, with the accidents of the dull grey dawn unquenched and lingering; the *present* Bacchus, with the *past* Ariadne; two stories, with double time; separate, and harmonizing."—*Lamb's Essays.*

We cannot entertain the opinion that such critics are only worthy of contempt; or that such criticism, when placed by the side of technical disquisitions on design, colouring and anatomy, is so wide of the main question at issue as artists would have us believe. Those who think differently have only to place a mere professional criticism beside them, in order to discover which is the more comprehensive. The best criticisms of artists, those of Fuseli, (no criticisms are finer, few half so fine, as his best,) Barry, Opie, Reynolds, J. Landseer, &c., take a similar untechnical tone: directly the inherent power of the subject sublimates the feelings and intellect, and thus places them above their subject, instead of below, in the

laboratory. Some few artists have occasionally given unprofessional hands a friendly shake, upon the common ground of intelligence and mutual sympathy as to aims and results. Hogarth, in his jaunty way, sets off in his Analysis of Beauty, by declaring that he wishes people to see with *their own eyes*, and that he has more hopes of giving a true idea of his meaning to unprofessional folks, than to artists, "whose thoughts have been entirely and continually employed and encumbered with considering and retaining the ' manners ' in which pictures are painted." Jonathan Richardson, whose writings gave a strong impulse to those who were the fathers of the English School of Art, is equally explicit in his opinion, that to judge of pictures a man need not be a regular artist. In his curious old work, entitled " Discourses on the Science of the Connoisseur," he takes a very different view of the question from our more modern artists; and instead of holding forth on the tools and technics of art, and inculcating the necessity of professional knowledge and handicraft, he prefers to speak of the real end of painting, which he says is that of elevating and improving nature, and thus communicating valuable ideas; and that a connoisseur, in order to be competent to the highest subjects, must be acquainted with the nature and varied character of human passions, and the visible manner in which they are manifested ; he must have delicacy of eye, a masculine judgment, &c. This quaint old book, full of good feeling and sound philosophy,—though rambling with an unmethodical sequence of arguments, that sometimes get the author into equally amusing and irrelative perplexities,—was published in 1719. We need hardly observe how much it was in advance of his time, seeing that the present time has not yet arrived, with any unanimity, at those fixed and deep-rooted principles of Art which he was the first to inculcate among the rising artists of this country.

The only class of works connected with our subject, which remain unnoticed, are the remarks of Mr. Foggo and several others, touching the value of the Royal Academy as a national establishment and School of Art ; and the enquiries of Barry, Carey, Hazlitt and Westmacott, into the causes which impede the progress of Art. It must be apparent that such questions may find a partial solution in the preceding pages ; and that

which remains does not form any portion of our present design. The full solution must be sought in the laws which govern the mental faculties; in the causes which impede the progress of general intelligence, and of social, religious, moral and political institutions; and in the philosophy and works of the Artist as modified by, and influencing in turn, those institutions in the several phases of their progression.

"Royal Academy"

Athenaeum (May 12, 1838), 346–47; (May 19, 1838), 362–64; (May 26, 1838), 378

ROYAL ACADEMY.

We are not aware that threescore and ten years is the allotted term of existence for incorporated bodies, as well as the human race; yet it is impossible to deny that the Royal Academy, in the present, its seventieth exhibition, shows far fewer signs of progress or promise than might be reasonably expected from any like institution in vigorous and flourishing health. Not one new name of merit is added to the catalogue; and, with few exceptions, the artists to whom we have been accustomed to turn for our chiefest pleasure, have fallen below their usual standard.

Let us begin, however, with one of the exceptions, considering Mr. M'Clise as such, for the sake of No. 137, *Salvator Rosa painting his friend Masaniello.* This is unquestionably our favourite of its artist's works: it possesses all his vivacity, all his force, all his sense of the picturesque, but without any of the extravagance which too often mingles with them to their disfigurement—all his decision of form, without that harsh edginess which makes the greater part of his figures and draperies appear as if cut out of wood or metal; it is, moreover, coloured with far more harmony than most of his pictures. Mr. M'Clise's Salvator has twice the manliness, and genius, and *air gaillard* of Mr. Cattermole's. Though, by a certain sweetness of expression, proving him a *preux chevalier* —that is, tender as well as brave—we may divine that the artist is not insensible to the presence of the beautiful girl leaning upon his shoulder, and proudly admiring him the while he considers his subject,—his thoughts are obviously concentrated, with all the ardour and energy of young genius, upon the fisherman. The latter stands in the full light of the window, with his eyes cast down, and his arms folded, in a simple attitude, just as he might have stood on the beach waiting for his boat, or listening carelessly to his comrades' barcarolle ;—yet wearing on his brow, and around his lip, a gravity and a shrewdness which ennoble the features of their unconscious possessor ; and which tell of days when boat and barcarolle could be left for sterner cares, without regret or reluctance. The lady is worthy to form the third figure in such a group—the radiant and intense gaze which she bends upon her lover, sends light and fascination out of the picture. In other works exhibited this year by Mr. M'Clise, he has displayed his usual cleverness with his usual defects; and the latter are posi-

tively exaggerated in his *Merry Christmas in the Baron's Hall* (512) ; where we are distracted by some hundred figures thrown into every variety of attitude —by some hundreds of faces, two-thirds of which are open-mouthed, or distorted with laughter ; while their owners, with the Lord of Misrule at their head, keep up noisily the hearty sports and quaint customs belonging to the season. But if we find the general arrangement of the figures, and the separate expression of the faces, objectionable, from the utter absence of relief and repose,—the want of *oscuro* as well as of *chiaro* in the composition,—what are we to say of the riotousness of the colouring, in which every harsh and brilliant hue has been exhausted—thrown together without reason or harmony, like the black and red and yellow on a court card, or the motley patches in a Harlequin's coat ? The flesh, too, approaches in texture to the alabaster of the child's doll. In short, we have rarely seen such a chance-medley of genius, bad taste, and mannerism in the same space. Our remarks upon Mr. M'Clise's colouring will apply, in all their fulness, to his *Olivia and Sophia fitting out Moses for the Fair* (277)—a clever little picture ; but where the Vicar's daughters are far too modish in their prettiness, no less than in their attire, for the maidens of Goldsmith's novel. Besides these, he has exhibited two full-length figures, (301) *A Wood-ranger with a Brace of Capercailie*—a picture full of life, but chargeable with the superabundance of spirit just objected to : for the dead birds themselves, by their ruffled and chequered feathers, are made to do their part in destroying the repose of the work. No. 308, *A Page with a Brace of Pheasants,* though a weaker subject, is, of the two, far more pleasing.

After being in thought once again wearied and gratified, at the same time, by these pictures, we turn with a peculiar satisfaction to remember the works exhibited this year by Mr. Etty, who well maintains his high reputation. It is true that his excellence is sensual rather than spiritual—that he deals more fondly and familiarly with luscious forms and gorgeous complexions, and deep voluptuous eyes, and profuse hair (for an ornament, not a veil) than with the deeper and purer beauty of intellect and contemplation ; but there is a rich and fascinating poetry in many of his compositions—a luxurious harmony in his colouring, which refreshes at the same time that it feasts the eye. In *The Bivouac of Cupid and his Company* (16), though the urchin himself wants wit and beauty, and though the nymph who supports him is worse than carelessly drawn, there is another fair companion,—the one, we mean, with a scarlet drapery round her knees, who is plucking the grapes from among the profuse tracery of vine leaves, which hangs close above her head,—of a beauty sufficiently excellent to make us forget faults fifty times as glaring. This little picture is a perfect study for the apposition and management of colour. Another charming work is the music party in *Il Duetto* (112). Then there is a Nymph (490) resting upon her hands her drowsy forehead and poppy-bound black hair—steeped, as it were, in rich dreams—whom we must not forget. *The Converted Jew* (420) is in a graver manner:—a head, in its intelligence, no less than in its colouring, grand enough to make us wish that its artist would vary his

Anacreontic subjects more frequently. Mr. Etty
exhibits another picture, *The Prodigal Son* (46),
which must be praised, like the last, for its truth of
expression, no less than for the admirable manner in
which it is painted. A companion to it was, if we
recollect right, exhibited at the British Institution
some three years ago.

The mention of this scriptural subject reminds us
that we have not given the most ambitious picture in
the rooms, Mr. Hilton's *Murder of the Innocents* (193),
the place of honour in our notice. This, indeed, is one
of the only three historical pictures of high pretension
in the present exhibition. Mr. Hilton has singled out
one group from the scene of tyrannous massacre—a
woman who, pressed upon by a brawny soldier, is
holding her infant over the edge of a parapet, while
a pair of grim hands, rising from the depth beneath,
tell us, that her frenzied strength is put forth in vain.
Pain, terror, and agony are accumulated in her coun-
tenance, to the utter exclusion of tenderness—a
higher conception would, we think, have allowed
the latter to have been manifested—thus, at once,
heightening by contrast the despair of the moment,
and redeeming the picture from being chargeable
with pure unmitigated horror. The female figure,
however, is boldly drawn—thrown forward as it
were, out of the picture—and there is much force
in her brutal oppressor; the background is skil-
fully filled by a group of people, among whom
also the work of butchery and resistance is going on.
There is always thought and consideration in Mr.
Hilton's works, and the present one ranks far higher
than its neighbour—*The Reproof*(158), in which Mr.
Uwins has represented,—we cannot say successfully,
—Jesus and the Woman taken in Adultery. The
third picture to which we alluded is a *Madonna and
Child* (452), by Mr. Dyce, in which the placid forms
of the deathless ancients are imitated with success,
but their spirit (the spirit we are inclined to believe
of an age past not to return) is not present.

If Mr. Hilton's work belongs to the highest
branch of art, Sir David Wilkie has produced the pic-
ture which is the object of most general attraction:
this is *The Queen holding her first Council*(60). Where
so many unmarked physiognomies, and formal dresses
must, of necessity, be grouped together, and grouped
according to a certain prescribed arrangement—the
artist, be he who he may, runs a dangerous risk :—
add to this, that we are inclined to hold with those
maintaining that the painter of the ' Rent Day' and
' The Will,' has exceeded his mission when he passes
the boundaries of the familiar and domestic. But
the true merit of this work will be best felt by
comparing it with others of like subject and pre-
tension :—and whether we remember ' The Death
of the Earl of Chatham,' now to be seen in the adja-
cent National Gallery, or recall the acres of fresh-
painted canvas which disfigure the *Galeries Histo-
riques* at Versailles, we cannot but own that, with
many faults, Sir David, even when he is weakest,
approaches many of his predecessors, and surpasses
most of his contemporaries. The great interest
of the composition is of course concentrated in the
young girlish figure, who has assembled her counsel-
lors that she may put her hand and seal to her first
declaration. In her attitude and countenance, with-

out in the least forsaking simplicity, or adding to
nature that which it possesses not—the painter has,
in good measure, expressed that modest firmness,
that gentle confidence, that deep sense of responsi-
bility, which made the interview he has commemo-
rated so affecting and impressive to all concerned in
it. The likeness of her Majesty is a fair one—some
of the other portraits are of a more exact fidelity—
but there is a certain mannerism in their treatment
more easily to be felt than described, which gives a
needless monotony to the work, and the colouring is
pervaded by the particular tints and tones which Sir
David, by his constancy in reproducing and com-
bining them, would seem to consider as essential to
the historical style. We were much more pleased
with another picture by him, *The Bride at her Toilet
on the day of her Wedding* (201), though the subject
be of inferior and commoner interest: one of those
scenes three parts gay, one part melancholy, which
will come home to the personal experience of every
bystander. The girl at her toilet is far prettier than
most of Wilkie's young beauties; the white satin
robe, the significant orange-flowers, and the veil—
which is in the act of being adjusted by an old
familiar attendant—set off her loveliness without
overpowering it. And there is a natural and beau-
tiful touch of sentiment, in the glance which she
casts beyond her bridal screen, and past the fond
ancient nurse (a nurse after the pattern of Juliet's)
towards her mother—a lady still possessing the re-
mains of great comeliness—in whose features pride
at the marriage of her darling, and grief at her an-
ticipations of the vacant chair and the departed
voice, and the empty couch, are struggling naturally ;
making thereby a mixture sad, but not wholly desti-
tute of humour. The other figures and accessories
aid no less truthfully in the narration of the story.
Sir David Wilkie has also sent portraits, of which
we may speak when we come to that department of
the exhibition.

Mr. Turner is in all his force this year, as
usual—showering upon his canvas splendid masses
of architecture, far distant backgrounds ; and figures
whereby the commandment is assuredly not broken
—and presenting all these objects through such
a medium of yellow, and scarlet, and orange, and
azure-blue, as only lives in his own fancy and
the toleration of his admirers, who have followed
his genius till they have passed, unknowingly, the
bounds between magnificence and tawdriness. His
first landscape is *Phryne going to the Public Bath
as Venus* (31), in which the wanton lady is posi-
tively lost among a crowd of flame-coloured fol-
lowers—and these, again, show tame beneath such
a golden tree as never grew save in the gardens of
the Hesperides. The next is *Modern Italy—the
Pifferari*(57), a composition, in which the Campagna-
like background, with its curling smoke of scattered
fires, and its heaps of ruin, offers a resting-place to
the eye, fatigued by an accumulation of gorgeous
and picturesque objects in the foreground ; but
Phryne and the *Pifferari* are chaste and homely in
their colouring, and exquisite and precise in their
finish, compared with (192)—*Ancient Italy—Ovid
banished from Rome*, by the same hand—in which
the steadiest gaze can but snatch a vision of towers

and temples, rising, as it were, behind the brilliant fumes from an enchanted censer. We would fain escape intolerance and narrowness, but even the imagination of all these gorgeous monstrosities has lost its marvel and its charm for us. We have seen so much of the sorcerer, as to cease to be startled by the " shadows of power" he raises, and to dwell with impatience upon the conjuration (not to call it trick) which produces results so supernatural, but withal so monstrous. It is grievous to us to think of talent, so mighty and so poetical, running riot into such frenzies ; the more grievous, as, we fear, it is now past recall.

One picture more we will mention, that we may close our notice with praise,—this is the *Osteria di Campagna, between Rome and Ancona* (386), by Mr. Cope. The humours of this resting-place for travellers—where English magnificos, and German *burschen*, and travelling friars, and wandering minstrels, are assembled—are touched with a firm but a fine hand : the work is eminently picturesque, without nature being strained one hair's breadth. We know not whether to prefer the little lady, charmed by the music of the vagabonds, and looking at the dark-eyed child who approaches her for reward, with a sweet but grave curiosity, or the pair who are making the melody,—the woman with her piquant gipsy-like head-dress (we know the very tune she is singing), and the man who stands behind her, with eyes upraised, poor and profligate though he seem, having, in his look and figure, an echo of the improvisatore and artist of ancient Italy. Then there are, in the background, the fair-haired jovial troop of Teutonic pedestrians, in their comfortable *blouses*, with their eternal pipes, jingling their glasses in noisy good fellowship,—but it may be, in their freedom of untrimmed beards and familiar speeches, no less affected and theatrical than the English youth, who stares about him lack-a-daisically through his glass—and who, though true to nature, intrudes disagreeably upon the scene. We returned to this delightful picture more than once. Mr. Cope need but advance a little further, to become one of the most distinguished ornaments of modern British art.

We have now to notice a picture which has been spoken of as forming one of the most attractive features of the exhibition,—this is the *Seven Ages*, by Mr. Mulready (122). Here is displayed, in one group, the progress of human life, as epitomized by Shakespeare. The scene is the court-yard of an ancient but not decayed mansion,—the time may be that period which is immortal in our annals, if only as having given birth to ' As You Like it'—to the "thousand needless similies" of the melancholy Jaques. The personages it is needless to enumerate, from the infant upward to the toothless dotard wheeled abroad—but hardly able to feel, yet less to enjoy the bland air and the cheerful sunshine. It was a happy thought to assemble all these familiar types of humanity, and Mr. Mulready deserves much praise for the spirit with which he has traced out their several characters—for the gracefulness given to the love-sick youth, who leans up (something too publicly, however) against the balcony, whence his mistress listens to his wooing,—for the chubby sullenness in every pore of the " shining morning face" of the

school-boy,—for the placid self-complacency of the justice, who is well nigh as sumptuous in his sleekness, as one of Rembrandt's fur-capped burgomasters,—for the querulous feebleness of the " lean and slippered pantaloon," who peers at the ancient man, again a babe, in helplessness, but, alas! not in promise ; and while he peers, forgets how narrow a hair-line separates age from impotence. All these several characters, we repeat, are happily distinguished, and some of the accessory heads and figures appear to us admirable. Among the former, is that of the justice's clerk, following at his heels with a clasped book, and who has been conceived with some glimmering of Chaucer's spirit ;—among the latter, the brawny porter, drinking in the foreground, contrasted strikingly with the oldest man, at whose feet he crouches, in his abundance of muscle, and appetite, and strength. Yet, with all these excellencies, one is wanting to the picture,—that art in the arrangement of the figures, which should make them be felt as essential to a main purpose by taking a part in its action, and not as fulfilling the complement of personages required by Shakespeare's description. There is, to our apprehension, a want of clearness in the episode which groups the soldier and the whining owner of the satchel ; and we have already adverted to the unnatural publicity with which the Romeo in the pink doublet is performing the sweet labour of his courtship. So much, however, in this picture is admirable, that we studied it long, to endeavour to attain the painter's idea on the above points; and we turned away, sorry to admit the conviction that he himself has not grasped it steadily. The work is exhibited in a very unfinished state, many of its details having been recently effaced.

Mr. Leslie—of late a sparing exhibitor—has this year sent only one picture (185), which is akin to the one just noticed. It is an imaginary scene from the ' Merry Wives of Windsor,' where the personages of the play are supposed to be assembled round the table of Master Page. Here, as in Mr. Mulready's picture, with much cleverness, there is wanting that clearness and intelligibility, which—prosaic qualities though they be—are essential to the perfection of every work of art, even though it belong to the high fantastic school. There is no mistaking Falstaff, it is true, though his jolly features look rueful, and he ogles *both* Mrs. Page and Mrs. Ford, as if a foreknowledge of his ride to Datchet Mead in the buck-basket, mingled itself with his bombastic act of homage. The " wives" are more happily rendered than is customary, simply because Mr. Leslie has read his author aright, and made them fair (not fat), but " forty," withal—and clad in matronly fashion, instead of being young brides, fluttering in lace and feathers. The incomparable Master Slender wears an expression of smug—not lack-a-daisical fatuity, which is not exactly his property ; and Anne Page, with her round face, and her black hair neatly strained back from her forehead, resembles a beauty of the Celestial Empire, rather than a faëry of Windsor Chace and Herne's Oak. Surely the real Anne had the blue, laughing eyes, and auburn ringlets of a true nut-brown maid. The other personages are less happily designed. If Master Fenton be that gallant in peaked

shoes, who sits with his back to us, and is pledging the bashful Master Slender, he is too old and too mannish for his part. It is hard, however,—perhaps impossible,—for any painter to satisfy the reader of Shakespeare, for every student possesses his own ideal. Mr. Leslie's picture is, as usual, somewhat crude in its colouring, with a tendency to earthy redness in the flesh tints.

We must now speak of the half-dozen excellent contributions of Mr. Edwin Landseer. Excellent as they are, however,—pervaded, as usual, and that almost poetically—by a spirit in their animal, and a grace in their human nature, we are not sure that they equal some former works by the same admirable artist. The largest picture (21), is an Alpine scene; the antlered prey has plunged headlong down a chasm in the rocks, and been followed by the eager hound. There both lie, to all appearance dead,—and the hunter, equally zealous to secure his game, and not to lose his faithful companion, has been lowered by ropes to the spot. Here is no want of precision in the picture-narrative; the failure—if failure there be—is in the want of force and precision in the huntsman's figure, and in a certain *mildewiness* (we are obliged to coin our word,) in the general tone of colouring. Both may be consequent upon Mr. Landseer's success and constant practice in such gentler subjects as the *Portraits of the Marquis of Stafford and the Lady Evelyn Gower* (49)—a little lord and lady decking and playing with their favourite fawn and dog, who are hardly less high-born and thorough-bred,—or as the portrait of *Lady Fitzharris* (147), who reclines before an open window, wrapped (though it be not winter) in a soft-furred cloak ;— her head half sunk in a rich scarlet cushion, with a lap-dog sitting comfortably on her knee, the while she imagines herself busied with a few scarcely visible fragments of muslin ; the prettiest incarnation of the *dolce far niente* one could hope to find after a summer day's search ! Our remarks do not apply to Mr. Landseer's animals—vide his *Portraits of Her Majesty's favourite Dogs and Parrot* (90), or the superb, sagacious *Newfoundland Dog* (462). We are bound to mention his one other picture (369), a fight between "two antlered monarchs of the waste," in presence of the whole herd, that we may once again give him due praise for being, beyond most of his contemporaries, imbued with the spirit of Highland scenery.

The Decameron school of painters—those, we mean, to whom Chivalry, and Romance, and southern life supply their favourite inspirations—exhibit, this year, many creditable works. The first in the catalogue is *Lisa Piccini*, by Mr. Hollins (33). This was a lady of "surpassing beauty and modesty," who, pining for Pietro, King of Arragon, sent one Minuccio d'Arezzo, a musician, to the king, to disclose her passion. The courteous monarch heard, and straightway despatched the messenger to console the lady ; and the painter has drawn her extended on a couch, drinking in the minstrel's melody with intense pleasure,—all the more intense, inasmuch as it is in part restrained by her modesty. In her features, which bear traces of lonely vigils and melancholy thoughts, the "surpassing beauty" described by Boccaccio is hardly reached. She bears, moreover, a strong, but not

a flattering, family likeness to the Greek girl, painted by the same artist many years ago; but her attitude is graceful,—instinct with passionate languor. Her dress, too, must not be forgotten, as being rich and harmonious in its colours ; and so carefully have these been studied, that we are surprised Mr. Hollins could do nothing better for her couch of meditation, than cover it with a tight scarlet cloth—making it prominent at once by its poverty and gaudiness. In a circuit of the room, the next picture of this class which arrests the eye is Mr. Eastlake's *Gaston de Foix* (109) taking leave of his ladye-love, on the eve of the fight of Ravenna. The warriors are holding a revel *al fresco ;* and in the background, among the avenues and thickets of a rich garden, are groups reposing or in conversation, charming enough, without much disparagement to them, to remind us of Watteau. We have much praise for both the champion and the lady. He bends over her with a pensiveness in which there mingles a presage that he is bidding her farewell for ever, while she looks up in his face tearfully, but resignedly,—the man softened by his tenderness, the woman strengthened by her proud love, till the disparity between sex and courage is levelled. This seems, to us, most poetically rendered. The colouring is feeble, but not sickly. Mr. Severn is the other artist to be included in this paragraph concerning our romance-painters. We should have spoken of him earlier as an aspirant to the triumph of religious art, on the strength of his *Infant of the Apocalypse saved from the Dragon* (35), had not that sketch (for it is but a sketch) been long since searchingly described and discussed in a letter from Rome (*Athen.* 1834, p. 257). We shall therefore pass at once to his *First Crusaders in Sight of Jerusalem* (252), a work of great merit. The picturesque band have halted on an eminence, from whence their conductor, Peter the Hermit, points to the domes and the minarets of the Holy City, lit up by the setting sun,—a symbolical glory,—while gleaming eyes, and attitudes bespeaking eager and courageous devotion, testify that his eloquence will not pass away, without bearing a fruit of knightly deeds. It was well done of the painter to kindle the features of young and old with this inward enthusiasm, no less than with the outward glow from Heaven ; but was it equally well done to arrange that so many heads should be turned away from the entrancing spectacle ? We think not. The one feeling of devotion and bravery would have given more unity, even in the direction of attitude, to the act of worship ; and the monotony which might, in another case, offend the artist's eye, wou ld have added intensity to his embodiment of the se ntiment of his subject. Mr. Severn exhibits another picture, *The Finale of a Venetian Masque at the S immer's Dawn* (400), which is full of romance and e legance. Each one of those masqued beauties who st cam out, in gorgeous and varied apparel, from the fantastic portico of the *palazzo*—lit from behind by the glow of a thousand lamps, not yet extinguished, from the front, by the fresh day of a summer's morning— has her own love story which we could tell, time and patience permitting. One beauty leaning from the balcony bids sweet farewell to her cavalier—another, more archly, peeps out from a gondola to bestow upon

her *innamorato* a token flower at parting—while her sister, more wearied, or, it may be, less fortunate, has already fallen asleep. Nor must we forget the Greek lady with a lute, who has yet a canzonet left to beguile the insipid way homeward, or the tall figure behind the gondola,—a thorough *caballero ;*—but we must stop ; and, as we cannot descant further upon the details of the picture, we will not discuss its colouring, which, with the most judicious aim on the part of the artist, appears to us to have fallen short of his intentions.

We have less to say concerning Mr. Allan's *Slave Market, Constantinople* (156), than might seem due to a picture which has obviously been so carefully studied. But there is a want of *geniality*, which makes itself felt, and sobers our admiration. The marbly texture noticeable in the African and Arabian complexion, pervades the whole picture—the draperies—the very minarets of the Noor Osmanlie in the background. Our remarks will apply to two pictures by Mr. C. Landseer—we mean, *A Parting Benediction* (326), and *Queen Berengaria supplicating Richard 1. for the Life of Sir Kenneth* (350), where, however, the heads are very true in expression to Sir Walter's description ; and the monarch, prostrated, but not conquered, by his sore illness, looks not only lion-hearted, but also giant-armed. It is, perhaps, too wild and general a speculation to be soberly recorded ; but we would observe, that though the judgment may be satisfied by accuracy of form and propriety of sentiment ; harmony, if not richness of colouring—a texture bespeaking an easy, not a mechanical hand, are required to captivate the interest. We have, at least, fancied as much, while examining certain works of the French school. As we have spoken incidentally of our neighbours, we may here express our regret that the picture by Delaroche,—now, we believe, in the possession of Lord Francis Egerton,—is not exhibited, as was anticipated. Opportunities for the public generally to compare our own performances in art with those of our continental brethren might do good service, and awaken a beneficial rivalry.

There remains yet a picture or two to be mentioned, ere we descend to a more familiar class of subjects. One of these is *The Prophet Ezekiel* (40), by Mr. Hart, a head which is excellent for the power and brilliancy with which it is treated—a worthy companion to the Israelitish head, by Etty, mentioned a week ago. Mr. Uwins's *Brother and Sister* (421), two young children at prayer, are in his best manner; his *Top of a Style* (145)—the head of a girl, dressed as if by a *coiffeur*, with a gorgeous wreath of the garden convolvulus—is in his worst. Mr. Patten has a large picture of *The Passions* (270), in which there is much to praise. We are glad to trace in him the least disposition to extend his companionship beyond the Bacchantes and the Dryades, whose society he has chiefly affected. We must close this division of our labours, by congratulating Mr. Simson on his *Cimabue and Giotto* (434), another episode from the lives of the painters in addition to those already treated by our artists. There is intelligence and poetry in this composition. The genius in embryo, crouched among his " silly

sheep," above the rude sketch he has drawn, meets the calm benevolent regard of the elder painter with eyes in which shrewdness and consciousness are happily blended. Their owner, we see, possesses wherewithal to take the world by storm, though, as yet, he does not manifest that unscrupulous fearlessness in pursuit of his art which gave occasion to the legend of his after career, wherein he is denounced as having emulated Parrhasius, by crucifying a living model `n his eagerness to represent the tremendous agonies of the Passion. *Messer* Cimabue also, and his companions, are most happily imagined ; the colouring, like that of the *Camaldolese Monk showing the Relics* (163), by the same artist, is forcible, without harshness.

We have yet to speak of the pictures of familiar life, the landscapes, portraits, drawings, and sculptures.

WE must compress our concluding notice of this Exhibition into the smallest possible space. It is true that its more important features have been discussed ; and that any attempt to descant upon landscapes, representations of familiar life, or portraits of right honourable lords, ermined judges, or the beauties of the present reign, even as slightly as has been attempted in the case of pictures previously mentioned, would lead into needless prolixity and tediousness. One of the best compositions of its kind in the Exhibition, is Mr. Knight's *Saint's Day* (323),—a representation of a holiday kept at an alms-house for women. The ancient inmates, dressed up in their best clothes, have arranged themselves in readiness to receive the offerings of the charitable: and, perhaps, the character of English old age has never been more successfully caught, than in the group of gossips to the left of the picture ; while the young widow, with her children clinging about her, who stands in the full centre light, is no less natural and no less national. The details, too, demand praise, for the care, fidelity, and picturesque effect, with which they have been arranged : we have seldom seen a work, betokening so much care, more strictly clear of the slightest affectation. Mr. Knight delights in a rich and embrowned tone of colouring ; and hence it is that we find a trifle too much fire-(not day)-light in the picture. A like excess of warmth may be objected to his otherwise excellent and spirited portrait of the *Rev. W. Harness* (10). Far lower down on the scale—because far nearer to caricature—yet still clever,—is a little picture by Mr. Woodward, *The Happy Meeting* (206), in which contrast has been the uppermost idea with the artist, who has sought and produced an effect, by opposing the well-fed farmer and his wife, pillion-borne behind him—to the lean couple, and the white to the black horse. Nay, the very dogs, in colour, attitude, and expression, are made to take part in the simple, yet effective artifice : there is, however, a good deal of humour, in detail, in the separate heads. In the absence of Mr. Collins, Mr. Witherington is, perhaps, the best substitute that we could hope to meet. He is here, as usual, with rural scenes, made cheerful by the presence of rural children ; but the still and the speaking life have each, more or less, undergone the

smoothing process, by which their excellence is impaired.

And now, unless we were to linger with a protest before certain pictures by Mr. Ward, (inquiring, in a parenthesis, how and where he has come by the curiously bad mottos with which his works are graced in the Catalogue,) we must speak at once of the landscapes. Twenty words will almost suffice us, there being very little *to discover* in this department of art on the present occasion. Mr. Stanfield has been chary of his works this year; but those who would admire a choice specimen of his delightful talent, cannot do better than pause before No. 207, an Italian composition,—excellent in the management of its sky and water, and the fragment of rich ruined architecture in the foreground, round which a few figures and boats are grouped with most picturesque skill. Sir A. Calcott has also resorted to Italy for his chiefest inspirations this year, as Nos. 9, 15, and 67 of the Catalogue will show. It must be admitted, that in none of these has the master hand equalled its previous efforts. The artist has aimed to reach a classic chasteness, both of composition and colouring, but has stopped short of it; and is chargeable (for a wonder) with feebleness and formality. In three large landscapes, (Nos. 80, 214, and 269,) excellent as they are, Mr. Lee has only repeated himself,—repeated the cool uplands, and masses of summer foliage and louring skies, in which alone he sees Nature. The second of these—a park scene after a storm—is our favourite, as being less literal and more poetical than its fellows. Mr. Stark's *Scene near Henley* (484), belongs to the same school, and is hardly less excellent. We have still to enumerate Mr. Creswick's *Wayside Inn* (558), the best of those avenue scenes, which are treated by him so happily—Mr. T. S. Cooper's *Halt on the Fells* (385), one of his most admirable cattle pieces—Mr. Pyne's *Nightingale Valley* (239), and a landscape (340) by Mr. J. J. Chalon, in which it appears to us that he has attempted, perhaps without knowing it, to work upon Constable's principles. We are sorry that, with respect to *Granada* (296), by Mr. Roberts, we cannot speak as we desire of a favourite artist. The work, with its bird's-eye horizon, and its conventional colouring and execution, is little better than a cleverly painted stage scene.

It remains to mention the portraits: and this is not easy. The place of Sir Thomas Lawrence is as far from being filled as ever. The foremost of our artists, in attempting this branch of his craft, counterbalances the undoubted power and cleverness of such works as his full-length of *Daniel O'Connell* (200), by the affectation and false colouring displayed in more delicate subjects—vide *Mrs. Maberley* (275), also by Sir David Wilkie. Willing as we are to give all due honour to Phillips, and Pickersgill, and Shee, and Briggs, and Wood, and Say, and Eddis, and Laurence, each of whom exhibits works rather above than below his recognized standard of excellence, we are still compelled to confess that none of them rise above mediocrity. In saying this, we run the risk of being denounced as belonging to that race who are always praising the days gone by, in the splenetic resolution of not being satisfied with anything in

possession;—and yet, whether we consider the Catalogue in mass or in detail, such is our inevitable conclusion. The name of Mr. Geddes should be added to the above list; but, being a stranger, we mention it alone. There is also a pair of heads, coming under the class of ideal portraiture,—we mean the two ladies in the opera-box (242), by Mr. Rothwell, which, for their grace of attitude and pearly delicacy of colour, claim notice; but the work is little more than a sketch. A large full-length portrait hangs above them,—*Miss Cochrane* (243), by M. Dubufe, —the consideration of which did its part in restoring us to a better contentment with our own artists, so much of the *mode*, and so little of the young girl, have been displayed in it by the Parisian beauty-painter.

The last word of the foregoing paragraph, introduces us pertinently to the drawings and miniatures. Among them, Mr. Chalon is, as usual, paramount. No one can administer flattery so delicately, or so judiciously dispense with it, in proportion as his subject is homely or fair; nor throw such an artistic air over those modes of the toilette, which vary from week to week, as Fate and Madame Devy ordain. He has eight drawings, including Her Majesty, in a domestic dress, Her Royal Highness the Duchess of Kent, the Lady Wilhelmina Stanhope (triumphant in the magnificence of Court plumes), and the Duchess of Sutherland. Mr. Chalon's later drawings, however, manifest a tendency towards coarseness of execution, of which he will do well to remind himself. Sir W. Newton, and Messrs. Ross, Rochard, and Lover, have each sent miniatures: the last artist has not been happy in his portrait of *Thalberg* (798), but he makes up for it in his *Mustafa* (1004)—a study in which may be found a largeness of hand and richness of colouring too rare in miniatures. It would seem, however, as if both qualities were increasingly sought for, for there are some half a dozen miniatures by a Mr. Thorburn (the name is new to us), which are full of power and promise in these respects: we must instance the *Countess of Craven* (977), and *Lord Henry Cholmondeley* (1005). Miss Gillies has improved since last year: her miniature of *Mrs. Bridgman* (787), though a trifle too sibylline, is excellent, and free, in a great measure, from the exaggerated contrasts of light and shade which were most noticeable in her former works. The subject, indeed, is a favourite one with Miss Gillies, having supplied, if we mistake not, the model to her four striking designs of the Daughter of Zion, which we omitted to notice, with deserved praise, in our notes upon the Exhibition of the Society of British Artists.

In the Model Room, among many clever and careful drawings, one of the most interesting—certainly the most elaborate—is Mr. Cockerell's *Tribute to the Memory of Sir C. Wren* (1111), in which the principal works of that pride of English architects are judiciously grouped and exhibited in a bird's-eye view.

It is grievous that, to close our notice with a reference to the Sculptures, one scanty paragraph should be sufficient. Sir Francis Chantrey has not deigned to send even a bust. Mr. Baily exhibits but three works, two of which are sketches: one, how-

ever, wrought in marble, is his *Guardian Angels* (1264), a monumental bas-relief, in which there is much purity and elegance to be commended. By way, however, of making his figures aerial, the artist has *melted them* too much into the tablet on which they are presented. The most charming statue in the collection is the *Narcissus* (1255) of Mr. Gibson. The boy, who hangs over the mirror in a languid attitude, yet with a fixed gaze, is steeped (our word is not too strong) in voluptuous self-admiration. Next to this, perhaps, in merit, will come the Nymph by Bienaimé (1253): her name, however, is misapplied, for she possesses not the holy and unconscious beauty of Innocence. There are other statues of some pretension; but few that would abide close criticism. One of the happiest things in the whole room, is the *Paolo and Francesca* (1276), an alto-relievo in marble by Mr. Westmacott, Jun. The deep mutual passion, and deeper sadness, of the two lovers, the one supporting the other as they float downward, is beautifully rendered—the intense abandonment of love and sorrow manifested, but without excess or distortion. This gentleman also exhibits a very pretty companion to his 'Blue Bell' in *The Butterfly* (1288), which would have been our favourite, had it been the first of the two. With this we may mention Mr. Lough's *Boy bestriding a Dolphin* (1274) —the urchin is a veritable Triton; and his exploit has been cast with a fancy at once daring and delicate. Among the busts, that of *The Queen* (1252), by Mr. Weekes, stands first in the catalogue: the likeness is happy, and there is much grace in its general treatment: the drapery, however, is chargeable with pettiness in its arrangement. The best work of this class appears to us to be Mr. Moore's bust of *Charles Phillips, Esq.* (1372), in which there is a noble breadth and boldness of treatment, which cannot be too highly praised, associated as they are with the most perfect finish.

Anna Jameson

"The Exhibition of
the Royal Academy.
English Art and Artists"

Monthly Chronicle (June 1838), 348–55

THE EXHIBITION OF THE ROYAL ACADEMY.

ENGLISH ART AND ARTISTS.

" As I speak to myself," writes Sir Walter Scott, in his private diary, " I may say that a painting, to be excellent, should have something to say to the mind of a man like myself, well educated and susceptible of those feelings which any thing strongly recalling natural emotions is likely to inspire."

True,—but while we despise merely technical criticism and mechanical merit as much as Sir Walter himself, we must observe that a picture, to fulfil its purpose as a work of art, must gratify the imagination and satisfy the judgment, as well as appeal to our senses and our natural emotions. True it is, that he who can criticise the hem of a robe, yet remain insensible to the beauty and the significance of a great design, is, as Sir Walter says, " a poor creature." True it is, that the artist who makes us, while gazing on his work, forget the means in the end, is the great artist ; and the critic who forgets the end in the means, a poor critic. But it is also true that the critic, who in the end forgets or understands not the means through which it has been attained, is an unjust and ungenerous critic — and his pleasure, merely as an amateur, imperfect. It is with the wish of enlarging the sphere of enjoyment for those who, without being connoisseurs in painting, derive a real pleasure and pride from our national exhibition, that we have thrown together a few remarks on the peculiar characteristics of some of our English painters, without attempting to notice all those that might deserve notice, or pretending to give a catalogue *raisonné* of their pictures. We have heard this Exhibition (of 1838) called " *very tolerable*" by very competent judges. Now in most cases, particularly as respects ART, " very tolerable," and " not to be endured," are absolutely synonymous phrases ; but we must allow that here is an exception: a *tolerable* exhibition of the National Academy of England, is (to borrow another Shaksperian phrase) " a thing to thank God on." For let us consider for a moment of what this exhibition consists. Here are seven hundred and fifty artists, who have sent in thirteen hundred and eighty-two works of art, — all, with perhaps a few exceptions, painted within a year : if, in such a mass, the presence of *one* work of surpassing genius were enough in the eye of the critic to redeem a whole Gomorrah of mediocrity, shall we not be more than tolerant — shall we not be thankful where there are half a dozen such ?

Looking round the rooms of the Academy, we are obliged to acquiesce in the reiterated complaint, that the English school is poor in the grandest department of art, and that there are no historical pictures of a high class ; but we are persuaded that this is not from the want of talent, but from the want of patronage : let there be a call for this style of painting, and it will appear so, — what the age wants, it produces. " The darkest despotisms on the Continent," says Coleridge, " have done more for the growth and elevation of the Fine Arts than the English government: in this country there is no general reverence for art." And it is because hitherto the public sympathy would not have gone along with the government in the patronage of high art that we have it not to boast of. The last English sovereign who had a real taste for painting and patronised it on a magnificent scale was Charles I. George IV. was, indeed, flattered during his life as a patron of art, but his taste was contemptible. At the very time that

he was building his nondescript palace at Brighton, and covering its walls with monstrous Chinese abortions, the Crown Prince of Bavaria, out of the savings of his private fortune, was erecting that magnificent temple of art, the Glyphothek, at Munich. It remains for our young queen, Victoria, to make her reign a new and a glorious era in the annals of English art: her means are limited, as is her sovereign power; for in this, as in all things, she must have the accordance of her government and the sympathy of her people; but, idolized as she is, her individual tastes and wishes will have no slight influence. In our new House of Parliament we hope to see the worm-eaten tapestries of Elizabeth's time replaced by noble paintings; and all our national triumphs in arts and arms glowing from the peopled walls, and all our best artists in each department emulous to have their names inscribed in the list of decorators. This we hope to see achieved under the auspices of Queen Victoria: and now, instead of dwelling longer on our hopes, let us turn to those who must assist in realising them.

There are three pictures in the Exhibition which come under the denomination of Historical painting. Hilton has a group from the Slaughter of the Innocents, which is very finely painted ; there is some novelty, too, in the treatment of the subject, but none in the sentiment. A distracted mother is trying to save her infant from the grasp of a ruffian soldier ; she is leaning over a parapet, and while she repels the assassin with one hand, with the other she drops her child into the arms of a person beneath, whose two hands extended upwards are alone seen : there is much fine and skilful drawing in the mother and the child; the soldier is rather exaggerated. Those whom Herod employed to execute his command neither shared his secret terrors, nor his insane fury: they were slayers by command in cool blood, and performing an office so unnatural and abhorrent, that, unless they were demons incarnate, some touch of relenting and remorseful pity *must* have come over them. Often as this subject has been treated, and through every variety of feeling, from the tender pathos of Guido to the disgusting ferocity of Rubens, this modification of the sentiment has not, we believe, occurred to any artist: it would give the moral relief which would at once soften the horror and add to the impressiveness of this frightful tragedy — almost too frightful for painting.

Uwins has a picture of the Woman taken in Adultery, parts of which are finely treated and richly coloured : the head of the woman is very beautiful, that of our Saviour a failure.

When a painter takes for his subject a fact of universal or national interest and embodies it on his canvass, we are bound to consider it as an historical picture, " *ce que nous voyons aujourd'hui, sera de l'Histoire un jour.*" Wilkie's picture of Queen Victoria presiding at her first Privy Council is, therefore, an historical picture, but it is not historically, nor even poetically treated ; it is a mere group of portraits. The artist has had to paint a real and a recent scene, fresh in the recollection of those present, and no doubt has had extraordinary difficulties to contend with, not only in the monotonous costume, schooled attitudes, and conventional deportment of modern existence, but by the suggestions of individual *amour propre*, and so forth. We make these allowances, still the picture does not please us : it has passages of such beauty as Wilkie only could paint, and gross and palpable negligences, such as Wilkie alone would hazard before the public: many of the heads are exquisitely painted, particularly that of the Duke of Sussex. That of Lord Lansdowne has the benevolence, but not the thoughtfulness nor the power of his countenance. Lord John Russell is very like : — the King of Hanover, hatefully so ; and he and the Archbishop of Canterbury are too

"amicably close." The tone of the picture is rather cold and monotonous, and there is a want of concentration of effect; it ought to be round the young queen; but here the artist, in seeking to give the characteristic simplicity, has failed in some important points. There was certainly no occasion to give to Victoria the picturesque dignity of a Maria Theresa, or the imperious airs of an Elizabeth; but she sits on the edge of her chair like a timid country girl, and holds her "most gracious declaration" as if it were a petition for mercy. On the whole this picture falls below our expectations, and below the capabilities of the subject: it has every appearance in conception and execution of too much hurry. We are sorry to say all this, but it is the truth.

When an artist takes a passage from a known poet, or a scene out of our daily existence, and treats it in such a manner as to give it a dramatic interest appealing to the fancy and the natural emotions, we may call it poetical painting, a higher species of what the French call *tableaux de genre*, but below history. In this department, the English school has always been rich, and the present exhibition contains some splendid specimens.

And first, we must mention Mulready's picture (122.), which he calls "All the World's a Stage," but this we think a misnomer: looking to the treatment of the subject it should be rather "The Seven Ages of Man."

It is of course taken from the famous passage in Shakspeare, but treated with an originality, a feeling, a power worthy of the poet: higher general praise we cannot give; but this most charming picture deserves more particular remark than we have time to bestow: the different phases of our human existence are here combined into one harmonious whole with exquisite felicity. There is something quite Raffaellesque in the turn of the head and neck of the young girl, who, while she watches the lover and his mistress at the window, rests her hand on the shoulder of the old grandsire lost in second childishness: and nothing, we think, in the finish of the Dutch school ever exceeded the painting of the head and hands of this last figure. What a beautiful moral touch, too, is in that lean and slippered pantaloon, lifting his cap in reverence to one yet nearer than himself to the verge of the grave! But we must not trust ourselves to particularise farther: every group tells its own story, and is connected with the rest; the pervading subject and sentiment are carried far into the back-ground, where groups of soldiers, children, old beggars, youths and maidens, repeat in every variety of form the same changeful aspects of our human life. There is a fine harmonious tone of colour prevailing throughout, while the careful finish of the extremities, the breadth and the delicacy of the handling, are worthy of all praise. It is perhaps hypercriticism to add, that parts of the back-ground are rather flimsy and inaccurate, more so than the distance and aerial effect require.

Though Edwin Landseer generally takes his subjects from our everyday existence, from domestic or country life, he is a *poet painter* in the true sense of the word; he is a proof, if any such were wanting, how closely pure real nature is allied to the pure ideal. With him every object, however mean, is pervaded with character and sentiment, and becomes suggestive of thoughts "that do often lie too deep for tears." The man is not only a poet — he is a magician: it is not only what he does; the manner in which he does it is miraculous. He does not paint—he creates; every stroke of his pencil tells, and appears unerring in its delicacy, its facility, its firmness; he has a different touch for every different texture: never perhaps was so much mechanical dexterity in the use of his means united with so much poetical feeling and refinement and power in the choice and treatment of his subjects. He is our *national* painter — national in the turn of his mind, in his habits of thought, in his pursuits and sympathies as an artist: peculiarly

national in the quaint yet earnest significance of his humour: he is home-bred — English — owing nothing to foreign inspiration or education. He has been no worshipper of admired idols, however worthy of admiration — still less an imitator. To Nature only he has looked — her he has worshipped — to her he has bowed down; and richly has she rewarded him with full measure of her power and her tenderness! To him, as to a lover, she has revealed herself through all conventional disguises, and exists to him in the drawing-rooms of York House or Woburn Abbey as visibly as among the deer-stalkers in the Highlands. Not less admirable than his wonderful talent is his good sense — the plain simplicity of mind with which he measures his own power and follows the bent of his own peculiar genius. His progress has been steady from the first. We believe him capable of painting a great historical picture of national interest; but he will not *yet*, nor hastily undertake it; and when he does, he will meditate his subject till he has filled his mind with it, and then throw it upon his canvass like a single projection of the imagination. His style of colouring is clear and animated; he is fond of daylight effects and bright contrasts. We recollect to have seen him on some occasions rather crude, and his flesh-tints chalky and wanting in gradation; but every year these faults have been less and less perceptible. We regard him as decidedly the finest painter in his own department in all Europe — the boast of our English School of Art — of his brother artists the delight, the wonder, the despair.

Having said thus much of Landseer's general and characteristic merits, we have the less time to give to the beauties of particular pictures. He has six in the present exhibition: — (No. 49.) The Duke of Sutherland's Children, grouped with dogs and deer, is full of picturesque elegance; and what an exquisite little bit of aristocratic refinement and repose is the small portrait of Lady Fitzharris, embroidering at her window! It is pleasant to know that any thing so fair exists to represent the blood of the Tankervilles and the De Grammonts; but this picture does not require a name to lend it interest: one may stand before it and dream a whole romance. The pensive drooping of the beautiful head and long dark eyelashes, and the affectionate expression in the eye of her little dog as it looks up anxiously in her face, are very perfect. In the portrait of a majestic Newfoundland dog watching from the shore the return of his master's boat, the transparent heaving of the water round the stone-work is as finely painted as the dog. The group of the queen's favourite dogs and parrot is quite dramatic and significant; the beautiful little pet is lying in state on a velvet stool, and the two noble staghounds are in attendance like lords in waiting — the whole painted to admiration. The fine large group of deer and dogs fallen down the ravine tells its own story.

Wilkie has a very charming picture (201.), "The Bride at her Toilet," which we much prefer to his large picture. Wilkie and Landseer excel in what the Greeks called the "drama of painting;" and this is quite a little bit of elegant sentimental comedy: the heads are exquisite, the details rather careless, and the effect misty.

Etty has no large historical picture this year; but he has seven small pictures, marked by all his peculiar merits and defects — masterly drawing, poetical composition, splendid colouring; yet ever accompanied by a certain coarseness in feeling — form and colour too often prevailing over the sentiment, the material and the sensual over the spiritual and the ideal, — great heaviness and opacity in his *chiaro-oscuro*, and want of keeping in his distances: these are characteristic of all his pictures. But Etty is a very fine painter, and does brave things: we have reason to be proud of him. He would paint better on a large than a small scale; and yet his smallest picture

is the one we covet most. — (97.) The Bacchante and Boy dancing; the tipsy abandonment of the female and the elastic grace of the boy are very much in the *antique* spirit.

Uwins, one of our most charming colourists, has four pictures, besides the one already mentioned. No. 12. (The Favourite Shepherd) is a brilliant little gem, both in colour and composition.

What shall be said of M'Clise? — a young painter who has not yet realised the hopes formed of him, but who will do so yet if he lives and studies; at present his genius seems to be overborne by his exuberant animal spirits, his Irish temperament, and his self-complacency. With a perverse prodigality of fancy, he crowds into one of his half-finished compositions the materials for half a dozen pictures; in No. 512. for example, there are about 120 heads, of which some are admirable, and others gross caricatures. He scatters his effects all over his canvass with a total neglect of harmony; and while in every part of his picture there is something to admire, the whole is fatiguing and intolerable; his fertility, spirit, invention, and sentiment are as wonderful as his glaring lights : his crude colour, his hard drawing, his unpardonable carelessless are provoking and insufferable. It is worth while to be in a rage with M'Clise, for he has in him all the power, all the material of a great genius and a great painter. He has this year six pictures. We prefer The Wood Ranger and The Page with Game (Nos. 301. and 308.), which appear to be painted for the panels of a room, and are well fitted for such a destination. They are admirable, and full of spirit both in design and colour.

Comparisons are odious, else we should feel inclined to contrast with M'Clise an artist who is his opposite in all respects — we mean Knight, a man who is making slow but sure and steady progress towards the highest rank in English art. His picture (No. 323.) he calls the Saints' Day; the old women of an alms house celebrating a yearly festival. The subject is simple, taken from common, and even low life, but dignified by the poetical sentiment and moral feeling with which it is treated; it is moreover very carefully and beautifully painted in a fine rich tone of colour. It is very pleasant to stand before this picture and listen to the observations made on it; that it so speaks to every heart is one very decisive proof of its merit.

Eastlake, one of our most charming and classical painters, has only one picture this year, but then it is a gem—(No. 107.) Gaston de Foix parting from his Mistress before the Battle of Ravenna, in which he was killed at the age of twenty-three: a presentiment of his fate overshadows the brow of the young hero. Nothing can be more exquisite than the refined and delicate beauty of the female, — one of those Italian faces, all countenance and sentiment, like some of Giorgione's; — like Lady Harriet d'Orsay. She has been singing a farewell love ditty, but the mandolin has fallen from her hand, and she is looking up with anxious tenderness to her lover's face. The careful, faithful, yet unobtrusive finish, in every; part of this lovely picture, the transparent depth and richness of the colour, are quite admirable: the landscape and the group in the back-ground are beautifully painted — like Watteau.

Another painter, whose long residence in Italy has imbued him with a deep sympathetic feeling for Italian art, is Severn, in whose arms, it may be remembered, poor Keats died at Rome. He has four pictures in the exhibition. The Breaking-up of a Ball at Venice (No. 400.) is very Venetian in the sentiment and tone of colour ; and Ariel, " on the bat's back do I fly," a most covetable little picture, also painted with great delicacy and richness, as well as fancy,—in the deep golden Venetian tone. We must not pass over a picture (No. 386.) by Cope, an artist whose name we are almost

ashamed to confess is quite new to us—The Osteria di Campagna, an inte-
rior of a country inn in Italy, very dramatically treated, with much cha-
racter and truth, and painted in a rich and lively tone of colour.

Allan of Edinburgh has one picture — (No. 156.) The Slave Market at
Constantinople. This picture, though very striking, very finely composed,
and in general very beautifully painted, is not, we think, quite equal to some
of Allan's former pictures. The colouring appears to us a little crude; the
sky is not that of a southern clime; it is of a cold raw blue, wanting trans-
parency; and the aerial effects in the back-ground do not satisfy us: the
family group in the fore-ground is very beautiful, and appeals, as Scott
would say, to our "natural emotions" with a most touching, almost too pain-
ful, effect.

Leslie is the painter of romance, and in general distinguished by his
elegant fancy in conception, the flowing grace of his design, and the sweet-
ness of his colouring. He has given us one picture (No. 185.) again from
" The Merry Wives of Windsor." We say *again*, because we think it must be
the seventh or eighth picture from the same play; of which, however, we
are so far from complaining, that it might still furnish out subjects for as many
more. This picture is not equal to some of Leslie's fromer productions,
though full of talent, and in parts as finely painted as ever. The figures of
the two Merry Wives are very good, and well discriminated; so is that of
Falstaff; so is that of Cavalero Slender; but we do not like Anne Page:
there is a certain finesse and archness, mingled with maidenish grace and
delicacy in Shakspeare's delineation, of which there is no indication here. We
think, on the whole, that there is less mellowness of tone and delicacy of touch
in this picture, than we are accustomed to seek and to find in Leslie's works.

Charles Landseer has made a step forward since we last met him here,
and has two pictures of a higher class and more finely felt and painted than
any we have yet seen from his pencil. We prefer the " Parting Benedic-
tion," in which a young knight armed for battle is kneeling at the feet of
his mistress, and receives her last adieu and the blessing of a ghostly father.
In the back-ground, his squire is feeling the temper of a sword. In the
pendant, Richard I. and Berengaria, there is fine painting, but the female
figures in the back-ground want character and refinement: we can guess,
but would hardly venture to pronounce, for whom they are intended.

Mr. Howard and Mr. Ward, being Royal Academicians of long standing,
must be duly noticed — it would be rudeness to pass them over in their own
house. Howard has in his day painted some sweet pictures, by which we
hope he will be remembered, and not by the *fades* common-places of my-
thology and allegory, with which he has favoured us this year. And what
shall be said of Ward—a man who in his time has done really fine things?
is he quite mad? His pictures this year, of which there are eight, are the
most perversely atrocious things which we have seen for this long time. It
really required Ward's undoubted talent to attain to that excellence of bad-
ness, but more than his talent to be forgiven such crazy sins against good
taste and good feeling. One of Mr. Ward's pictures illustrates, or rather is
illustrated by, the following lines: —

> " Wider still, and wider, deep-mouth'd caverns
> Ope their ponderous jaws — join as
> In the charnel-house to nurture sin!
> Blast the fair forms of nature —
> Puff fungi poison, with deadly nightshade,
> Thistle, hemlock, wolf's-bane, and adder's tongue,
> Spawn in darkness, night orgie distillations,
> Cur-cast, indigest, surcharged with folly," &c.

We almost suspect Mr. Ward to be himself the author of this illustrious
doggrel, which is enough to choke one in the utterance : at all events, the
painting is worthy of the poetry, and the poetry of the painting : higher
praise we cannot bestow.

Turner was once the pride — the glory of our English school of landscape;
but he, too, has turned Bedlamite. Since he has been afflicted with this
incurable prismatic madness, we have avoided speaking of him ; and would
so now, but that his great name, and more, his great genius, mislead some
people, who think that what Turner does *must* be fine. Will Turner or his
admirers tell us that this is Nature ? if not Nature, what is it ? We know
" that Nature never did betray the heart that loved her ;" and it is because
Mr. Turner loved Nature with his imagination, and not with his heart, that
he has thus gone mad over her perfections, and violates with his harsh, auda-
cious crudities the sanctity of her sweet earnestness. Thinking of what
Turner *once* could do, we wonder and we sigh ; and if we were thereto given,
we should feel inclined to swear. No more — his pictures put our eyes out.

Turn we to Callcott, the true poet of classic landscape painting : he has
five pictures in the exhibition, three of which are Italian compositions, —
one from the Rhine and one sea-piece — all exquisite. If we might pre-
sume to criticise an artist of such perfect taste, we should say, that a little
more strength in his fore-grounds, and a little more transparency and move-
ment in his water would be an improvement. In this last particular he
must yield to Stanfield, another of our fine landscape painters, whose trans-
lucent waves and crystal depths look as though they would part at the touch.

If in Callcott we boast our English Claude, we have an English Hob-
bima in Lee, the most delicious painter of English domestic landscape now
living. What lightness, yet richness, in his foliage ! What coolness in
his verdure ! What a home-felt tranquillity brooding over his woodland
and heath scenery ! He has three pictures (80. 214. and 269.). In the "Effects
of a Storm," the middle distance is most admirably felt and painted : it is
perfect nature in all her truth and simplicity.

Another beautiful little bit of landscape is a Moonlight Dell (527.), by
O'Connor ; — nor must we pass over the Alhambra, by Roberts ; a deli-
cious little picture by Pyne (239.) ; a clever landscape by J. Chalon ;
another by Reinagle (48.) ; but these and others will strike every visitor.
We come, at length, to the Portraits.

We are proud of our English school of portraiture, and with reason : we
may be so while we can show the works of Reynolds, Hopner, Romney, and
Lawrence ; but with many admirable artists in this department, we have
not one living painter who can supply their loss, and be placed by common
consent in the vacant throne of Lawrence. The president's chair is not
that throne — we say it with all respect for the accomplished man who fills
it. Phillips is elegant ; Pickersgill, a fine, spirited colourist ; Briggs, a
manly painter of strong likenesses ; Rothwell, full of sentiment and refine-
ment ; Watson Gordon, Say, Mrs. Carpenter, Mrs. Robertson — all good ;
but take them altogether, and throw Wilkie as a portrait painter into the
bargain, they would not make a Lawrence, still less a Reynolds: some-
thing were wanting still.

The finest female portraits (and they are always a test of the artist's
skill) are Phillips's portrait of Mrs. Spottiswoode, which is very brilliantly
painted, and the rich landscape back-ground worthy of Hopner ; and
the portrait of Mrs. Heneage, by Mrs. Robertson, most charming from
its unaffected, lady-like grace, the easy flow of the drawing, and the rich
but delicate tone of colour, which is in harmony with the subject.

Pickersgill not only excels — he too often *exceeds* in colour, so as to

overcharge his pictures; and he is, besides, rather coarse in sentiment. His portrait of Mrs. Holland Archers (20.) is, however, very fine— the hands particularly. Rothwell has two charming female heads — (242.), which he calls A Remembrance; and Briggs's female portrait (265.) is very faithful and life-like, but deficient in grace, and heavy in colour. His men are much better.

Wilkie's full-length of O'Connell is very fine and characteristic, and a good likeness; as a picture, perhaps, a little too dark in the general effect.

Those of Mrs. Carpenter's pictures, which are hung within view, are, as usual, very elegant, particularly Miss Bailey.

Knight, whose large picture we have already mentioned, has two or three very fine portraits; that of Mr. Harness (No. 10.) is a very charming picture, besides being a good likeness of a most amiable man.

We come now to the Drawings and Miniatures.

Our lady artists (of whom we count near forty in the catalogue) shine this year. Of Mrs. Robertson we must observe, that her miniatures are among the very few we have seen which would bear magnifying, — uniting great freedom of style and excellent drawing with very delicate finish. There is a fine free drawing, richly coloured, by Miss Heaphy (No. 770.); and by Miss Cole and the two Miss Sharpes some very sweet portrait drawings. Newton and Thorburn have some fascinating miniatures; so has Samuel Lover, the well-known author of the charming Irish ballads, whose versatility of talent is as remarkable as his genius.

There is in this room a slight drawing by Wilkie, in black and white chalk — worth any money — if money could purchase it.

Alfred Chalon has eight drawings. Of him we must needs say, as Catalani said of Sontag, — " Il est le meilleur dans son genre, mais son genre n'est pas le meilleur." He is without a rival — without an equal in his own department; that of conventional elegance and artificial grace. As a painter of fair aristocratic girls, in blonde and ringlets — Lady Carolines and Lady Georgianas, and their dowager mammas, *un peu passées*, but lovely still, by favour of Chalon's airy pencil, and the most finished toilette — there is nothing like him. The drawing of our fair young Queen has much character and simplicity; it is intended, we suppose, as a pendant and contrast to the other drawing of her in her robes of state, also by Chalon, but not in the exhibiton. The Duchess of Sutherland is supremely elegant and duchess-like.

The Sculpture, generally poor, is this year poorer than ever. Chantrey does not exhibit. The best statue is the Narcissus, by Gibson; the best bust that of Mr. Travers, the celebrated surgeon, by Behnes. There is a bust of the Queen, by Weekes, which is one of the truest likenesses we have seen.

But the subject of English sculpture requires far more serious consideration and more time and space than we have now to bestow, — it must be matter for another essay. And having now led you, gentle and patient reader, round the walls of our National Academy, what think you? Is it a tolerable exhibition, or is it not? Do we find her the material on which to build great exulting prophecies of what may yet be performed by our English artists, when themes grand enough, and space wide enough, are allotted to them, — when they can command not only the patronage of the great, but the sympathy of the people? Look around, and say —

> " What consolation may be gained from Hope?
> If not, what resolution from Despair?"

W.M. Thackeray

"Strictures on Pictures"

Fraser's Magazine 17 (June 1838), 758–64

STRICTURES ON PICTURES.

A LETTER FROM MICHAEL ANGELO TITMARSH, ESQ. TO MONSIEUR ANATOLE
VICTOR ISIDOR HYACINTHE ACHILLE HERCULE DE BRICABRAC, PEINTRE
D'HISTOIRE, RUE MOUFFETARD, À PARIS.

Lord's Hotel, New Street, Covent Garden,
Tuesday, 15th May.

I PROPOSE to be both learned and pleasant in my remarks upon the exhibitions here; for I know, my dear Bricabrac, that it is your intention to translate this letter into French, for the benefit of some of your countrymen, who are anxious about the progress of the fine arts—when I say some, I mean all, for, thanks to your government patronage, your magnificent public galleries, and, above all, your delicious sky and sunshine, there is not a scavenger in your nation who has not a feeling for the beauty of Nature, which is, my dear Anatole, neither more nor less than Art.

You know nothing about art in this country—almost as little as we know of French art. One Gustave Planche, who makes visits to London, and writes accounts of pictures in your reviews, is, believe me, an impostor. I do not mean a private impostor, for I know not whether Planche is a real or assumed name, but simply a quack on matters of art. Depend on it, my dear young friend, that there is nobody like Titmarsh: you will learn more about the arts in England from this letter, than from any thing in or out of print.

Well, then, every year, at the commencement of this blessed month of May, wide open the doors of three picture galleries, in which figure all the works of genius which our brother artists have produced during the whole year. I wish you could see my historical picture of "Heliogabalus in the ruins of Carthage," or the full-length of "Sir Samuel Hicks and his Lady," —sitting in a garden light, Lady H. reading the *Book of Beauty*, Sir Samuel catching a butterfly, which is settling on a flower-pot. This, however, is all egotism. I am not going to speak of *my* works, which are pretty well known in Paris already, as I flatter myself, but of other artists—some of them men of merit—as well as myself.

Let us commence, then, with the commencement—the Royal Academy. That is held in one wing of a little building like a gin-shop, which is near St. Martin's Church. In the other wing is our National Gallery. As for the building, you must not take *that* as a specimen of our skill in the fine arts; come down the Seven Dials, and I will shew you many modern structures, of which the architect deserves far higher credit.

But, bad as the place is—a pigmy abortion, in lieu of a noble monument to the greatest school of painting in the greatest country of the modern world (you may be angry, but I'm right in *both* cases)—bad as the outside is, the interior, it must be confessed, is marvellously pretty, and convenient for the reception and exhibition of the pictures it will hold. Since the old pictures have got their new gallery, and their new scouring, one hardly knows them. O, Ferdinand, Ferdinand, that *is* a treat, that National Gallery, and no mistake! I shall write to you fourteen or fifteen long letters about it some day or other. The apartment devoted to the Academy exhibition is equally commodious: a small room for miniatures and aquarelles, another for architectural drawings, and three saloons for pictures—all very small, but well lighted and neat; no interminable passage, like your five hundred yards at the Louvre, with a slippery floor, and tiresome straggling cross-lights. Let us buy a catalogue, and walk straight into the gallery, however;—we have been a long time talking, "*de omnibus rebus*," at the door.

Look, my dear Isidor, at the first names in the Catalogue, and thank your stars for being in such good company. Bless us and save us, what a power of knights is here!
Sir William Beechey.
Sir Martin Shee.
Sir David Wilkie.
Sir Augustus Callcott.
Sir W. J. Newton.
Sir Geoffrey Wyattville.

Sir Francis Chantrey.

Sir Richard Westmacott.

Sir Michael Angelo Titmarsh — not yet, that is; but I shall be, in course, when our little liege lady — Heaven bless her! — has seen my portrait of Sir Sam and Lady Hicks.

If all these gentlemen in the list of Academicians and Associates are to have titles of some sort or other, I should propose —

1. Baron Briggs. (At the very least, he is out and out the best portrait-painter of the set.)

2. Daniel, Prince Maclise. (His royal highness's pictures place him very near to the throne indeed.)

3. Edwin, Earl of Landseer.

4. The Lord Charles Landseer.

5. The Duke of Etty.

6. Archbishop Eastlake.

7. His Majesty KING MULREADY.

King Mulready, I repeat, in double capitals; for, if this man has not the crowning picture of the exhibition, I am no better than a Dutchman. His picture represents the "Seven Ages," as described by a poet whom you have heard of—one Shakspeare, a Warwickshire man: and there they are, all together; the portly justice, and the quarrelsome soldier; the lover leaning apart, and whispering sweet things in his pretty mistress's ear; the baby hanging on her gentle mother's bosom; the school-boy, rosy and lazy; the old man, crabbed and stingy; and the old, old man of all, sans teeth, sans eyes, sans ears, sans every thing — but why describe them? You will find the thing better done in Shakspeare, or possibly translated by some of your Frenchmen. I can't say much about the drawing of this picture, for here and there are some queer-looking limbs; but — oh, Anatole! — the intention is godlike. Not one of those figures but has a grace and a soul of his own: no conventional copies of the stony antique; no distorted caricatures, like those of your "classiques," David, Girodet, and Co. (the impostors!) — but such expressions as a great poet would draw, who thinks profoundly and truly, and never forgets (he could not if he would) grace and beauty withal. The colour and manner of this noble picture are neither of the Venetian school, nor the Florentine, nor the English, but of the Mulready school. Ah! my dear Floridor! I wish that you and I, ere we die, may have erected such a beautiful monument to hallow and perpetuate our names. Our children — my boy, Sebastian Piombo Titmarsh, will see this picture in his old age, hanging by the side of the Raffaelles in our National Gallery. I sometimes fancy, in the presence of such works of genius as this, that my picture of Sir Sam and Lady Hicks is but a magnificent error after all, and that it will die away, and be forgotten.

To this, then, of the whole gallery, I accord the palm, and cannot refrain from making a little sketch, illustrative of my feelings.

Titmarsh placing the laurel-wreath on the brows of Mulready.

I have done every thing, you see, very accurately, except Mr. Mulready's face; for, to say truth, I never saw that gentleman, and have no idea of his personal appearance.

Near to "All the world's a stage" is a charming picture, by Archbishop Eastlake; so denominated by me, be-

cause the rank is very respectable, and because there is a certain purity and religious feeling in all Mr. Eastlake does, which eminently entitles him to the honours of the prelacy. In this picture, Gaston de Foix (he, whom Titian painted, his mistress buckling on his armour) is parting from his mistress. A fair, peaceful garden, is round about them; and here his lady sits and clings to him, as though she would cling for ever. But, look! yonder stands the page, and the horse pawing; and, beyond the wall which binds the quiet garden and flowers, you see the spears and pennons of knights, the banners of King Louis and De Foix, "the thunderbolt of Italy." Long shining rows of steel-clad men are marching stately by; and with them must ride Count Gaston — to conquer and die at Ravenna. You can read his history, my dear friend, in Lacretelle, or Brantôme; only, perhaps, not so well expressed as it has just been by me.

Yonder is Sir David Wilkie's grand picture—" Queen Victoria holding her first council." A marvellous painting, in which one admires the exquisite richness of the colour, the breadth of light and shadow, the graceful dignity and beauty of the principal figure, and the extraordinary skill with which all the figures have been grouped, so as to produce a grand and simple effect. What can one say more, but admire the artist who has made, out of such unpoetical materials as a table of red cloth, and fifty unoccupied middle-aged gentlemen, a beautiful and interesting picture? Sir David has a charming portrait, too, of Mrs. Maberly, in dark crimson velvet, and delicate white hat and feathers: a marvel of colour, though somewhat askew in the drawing.

The Earl of Landseer's best picture, to my thinking, is that which represents her majesty's favourite dogs and parrot. He has, in painting, an absolute mastery over

<div style="text-align:center">

Κυνεσσιν

Οιωνοισι τε πασι ;

</div>

that is, he can paint all manner of birds and beasts as nobody else can. To tell you a secret, I do not think he understands how to paint the great beast, man, quite so well; or, at least, to do what is the highest quality of an

artist, to place *a soal* under the ribs as he draws them. They are, if you like, the most dexterous pictures that ever were painted, but not *great* pictures. I would much rather look at yonder rough Leslie than at all the wonderful painting of parrots or greyhounds, though done to a hair or a feather.

Leslie is the only man in this country who translates Shakspeare into form and colour. Old Shallow and Sir Hugh, Slender and his man Simple, pretty Anne Page and the Merry Wives of Windsor, are here joking with the fat knight; who, with a monstrous gravity and profound brazen humour, is narrating some tale of his feats with the wild Prince and Poins. Master Brooke is offering a tankard to Master Slender, who will not drink, forsooth.

This picture is executed with the utmost simplicity, and almost rudeness; but is charming, from its great truth of effect and expression. Wilkie's pictures (in his latter style) seem to begin where Leslie's end ; the former's men and women look as if *the bodies had been taken out of them*, and only the surface left. Lovely as the queen's figure is, for instance, it looks like a spirit, and not a woman ; one may almost see through her into the waistcoat of Lord Lansdowne, and so on through the rest of the transparent heroes and statesmen of the company.

Opposite the queen is another charming performance of Sir David —a bride dressing, amidst a rout of bridesmaids and relations. Some are crying, some are smiling, some are pinning her gown ; a back door is open, and a golden sun shines into a room which contains a venerable looking bed and tester, probably that in which the dear girl is to—but *parlons d'autres choses.* The colour of this picture is delicious, and the effect faultless: Sir David does every thing for a picture now-a-days but the *drawing.* Who knows? Perhaps it is as well left out.

Look yonder, down to the ground, and admire a most beautiful fantastic Ariel.

<div style="text-align:center">

" On the bat's back do I fly,
After sunset merrily."

</div>

Merry Ariel lies at his ease, and whips with gorgeous peacock's feather his courser, flapping lazy through the golden

evening sky. This exquisite little picture is the work of Mr. Severn, an artist who has educated his taste and his hand in the early Roman school. He has not the dash and dexterity of the latter which belongs to some of our painters, but he possesses that solemn earnestness and simplicity of mind and purpose which makes a religion of art, and seems to be accorded only to a few in our profession. I have heard a pious pupil of Mr. Ingres (the head of your academy at Rome) aver stoutly, that, in matters of art, Titian was anti-Christ, and Rubens, Martin Luther. They came with their brilliant colours, and dashing worldly notions, upsetting that beautiful system of faith in which art had lived hitherto. Portraits of saints and martyrs, with pure eyes turned heavenward; and (as all true sanctity will), making those pure who came within their reach, now gave way to wicked likenesses of men of blood, or dangerous, devilish, sensual portraits of tempting women. Before Titian, a picture was the labour of years. Why did this reformer ever come among us, and shew how it might be done in a day? He drove the good angels away from painters' easels, and called down a host of voluptuous spirits instead, who ever since have held the mastery there.

Only a few artists of our country (none in yours, where the so-called Catholic school is a mere theatrical folly), and some among the Germans, have kept to the true faith, and eschewed the temptations of Titian and his like. Mr. Eastlake is one of these. Who does not recollect his portrait of Miss Bury? Not a simple woman — the lovely daughter of the authoress of *Love, Flirtation*, and other remarkable works — but a glorified saint. Who does not remember his Saint Sebastian; his body bare, his eyes cast melancholy down; his limbs, as yet untouched by the arrows of his persecutors, tied to the fatal tree? Those two pictures of Mr. Eastlake would merit to hang in a gallery where there were only Raffaelles besides. Mr. Severn is another of the school. I don't know what hidden and indefinable charm there is in his simple pictures; but I never can look at them without a certain emotion of awe—with that thrill of the heart with which one hears country children sing the Old

Hundredth, for instance. The singers are rude, perhaps, and the voices shrill; but the melody is still pure and godlike. Some such majestic and pious harmony is there in these pictures of Mr. Severn. Mr. Mulready's mind has lately gained this same kind of inspiration. I know no one else who possesses it, except, perhaps, myself. Without flattery, I may say, that my picture of " Heliogabalus at Carthage" is *not* in the popular taste, and has about it some faint odour of celestial incense.

Do not, my dear Anatole, consider me too great an ass for persisting upon this point, and exemplifying Mr. Severn's picture of the " Crusaders catching a first view of Jerusalem" as an instance. Godfrey and Tancred, Raymond and Ademar, Beamond and Rinaldo, with Peter and the Christian host, behold at length the day dawning.

" E quando il sol gli aridi campi fiede
 Con raggi assai ferventi, e in alto
 sorge;
Ecco apparir Gerusalem si vede,
 Ecco additar Gerusalem si scorge,
 Ecco da mille voci unitamente
 Gerusalemme salutar si sente !"

Well, Godfrey and Tancred, Peter, and the rest, look like little wooden dolls; and as for the horses belonging to the crusading cavalry, I have seen better in gingerbread. But, what then? There is a higher ingredient in beauty than mere form; a skilful hand is only the second artistical quality, worthless, my Anatole, without the first, which is *a great heart*. This picture is beautiful, in spite of its defects, as many women are. Mrs. Titmarsh is beautiful, though she weighs nineteen stone.

Being on the subject of religious pictures, what shall I say of Mr. Ward's? Any thing so mysteriously hideous was never seen before now; they are worse than all the horrors in your Spanish Gallery at Paris. As Eastlake's are of the Catholic, these may be called of the Muggletonian, school of art; monstrous, livid, and dreadful, as the dreams of a man in the scarlet fever. I would much sooner buy a bottled baby with two heads as a pleasing ornament for my cabinet; and should be afraid to sit alone in a room with " ignorance, envy, and jealousy filling the throat, and widen-

ing the mouth of calumny endeavouring to bear down truth!"

Mr. Maclise's picture of "Christmas" you will find excellently described in the May Number of a periodical of much celebrity among us, called *Fraser's Magazine*. Since the circulation of that miscellany is almost as extensive in Paris as in London, it is needless in this letter to go over beaten ground, and speak at length of the plot of this remarkable picture. There are five hundred merry figures painted on this canvass, gobbling, singing, kissing, carousing. A line of jolly serving men troop down the hall stairs, and bear the boar's head in procession up to the dais, where sits the good old English gentleman, and his guests and family; a set of mummers and vassals are crowded round a table gorging beef and wassail; a bevy of blooming girls and young men are huddled in a circle, and play at hunt the slipper. Of course, there are plenty of stories told at the huge hall fire, and kissing under the glistening mistletoe-bough. But I wish you could see the wonderful accuracy with which all these figures are drawn, and the extraordinary skill with which the artist has managed to throw into a hundred different faces a hundred different characters and individualities of joy. Every one of these little people are smiling, but each has his own particular smile. As for the colouring of the picture, it is, between ourselves, atrocious; but a man cannot have all the merits at once. Mr. Maclise has for his share humour such as few painters ever possessed, and a power of drawing such as never was possessed by *any other*; no, not by one, from Albert Dürer downwards. His scene from the *Vicar of Wakefield* is equally charming. Moses's shining, grinning face; the little man in red who stands on tiptoe, and painfully scrawls his copy; and the youngest of the family of the Primroses, who learns his letters on his father's knee, are perfect in design and expression. What might not this man do, if he would read and meditate a little, and profit by the works of men whose taste and education were superior to his own.

Mr. Charles Landseer has two *tableaux de genre*, which possess very great merit. His characters are a little too timid, perhaps, as Mr. Maclise's

are too bold; but the figures are beautifully drawn, the colouring and effect excellent, and the accessories painted with great faithfulness and skill. "The Parting Benison" is, perhaps, the most interesting picture of the two.

And now we arrive at Mr. Etty, whose rich luscious pencil has covered a hundred glowing canvasses, which every painter must love. I don't know whether the Duke has this year produced any thing which one might have expected from a man of his rank and consequence. He is, like great men, lazy, or indifferent, perhaps, about public approbation; and also, like great men, somewhat too luxurious and fond of pleasure. For instance, here is a picture of a sleepy nymph, most richly painted; but tipsy looking, coarse, and so naked, as to be unfit for appearance among respectable people at an exhibition. You will understand what I mean. There are some figures, without a rag to cover them, which look modest and decent for all that; and others, which may be clothed to the chin, and yet are not fit for modest eyes to gaze on. *Verbum sat* — this naughty "Somnolency" ought to go to sleep in her night-gown.

But here is a far nobler painting,— the prodigal kneeling down lonely in the stormy evening, and praying to Heaven for pardon. It is a grand and touching picture; and looks as large as if the three-foot canvass had been twenty. His wan, wretched figure, and clasped hands, are lighted up by the sunset; the clouds are livid and heavy; and the wind is howling over the solitary common, and numbing the chill limbs of the poor wanderer. A goat and a boar are looking at him, with horrid obscene eyes. They are the demons of Lust and Gluttony, which have brought him to this sad pass. And there seems no hope, no succour, no Ear for the prayer of this wretched, way-worn, miserable man, who kneels there alone, shuddering. Only above, in the gusty blue sky, you see a glistening, peaceful, silver star, which points to home and hope, as clearly as if the little star were a sign-post, and home at the very next turn of the road.

Away, then, O conscience-stricken prodigal! and you shall find a good father, who loves you; and an elder brother, who hates you — but never mind that; and a dear, kind, stout,

old mother, who liked you twice as
well as the elder, for all his goodness
and psalm-singing, and has a tear and
a prayer for you night and morning;
and a pair of gentle sisters, may be;
and a poor young thing down in the
village, who has never forgotten your
walks in the quiet nut-woods, and the
birds' nests you brought her, and the
big boy you thrashed, because he broke
the eggs: he is squire now, the big boy,
and would marry her, but she will not
have him — not she! — her thoughts
are with her dark-eyed, bold-browed,
devil-me-care playmate, who swore she
should be his little wife — and then
went to college — and then came back
sick and changed — and then got into
debt — and then —— But never mind,
man! down to her at once. She will
pretend to be cold at first, and then
shiver and turn red and deadly pale;
and then she tumbles into your arms,
with a gush of sweet tears, and a pair
of rainbows in her soft eyes, welcoming
the sunshine back to her bosom again.
To her, man! — never fear, miss!
Hug him, and kiss him, as though
you would draw the heart from his
lips.

When she has done, the poor thing
falls stone-pale and sobbing on young
Prodigal's shoulder; and he carries
her, quite gently, to that old bench
where he carved her name fourteen
years ago, and steals his arm round
her waist, and kisses her hand, and
soothes her. Then comes out the poor
widow, her mother, who is pale and
tearful too, and tries to look cold and
unconcerned. She kisses her daughter,
and leads her trembling into the house.
" You will come to us to-morrow,
Tom ?" says she, as she takes his hand
at the gate.

To-morrow! To be sure he will;
and this very night, too, after supper
with the old people. (Young Squire
Prodigal never sups; and has found
out that he must ride into town, to ar-
range about a missionary meeting with
the Rev. Dr. Slackjaw.) To be sure,
Tom Prodigal will go: the moon will
be up, and who knows but Lucy may
be looking at it about twelve o'clock.
At one, back trots the young squire,
and he sees two people whispering at
a window; and he gives something
very like a curse, as he digs into the
ribs of his mare, and canters, clatter-
ing, down the silent road.

Yes — but, in the meantime, there is
the old housekeeper, with " Lord bless
us!" and " Heaven save us!" and
" Who'd have thought ever again to
see his dear face ? And master to for-
get it all, who swore so dreadful that
he would never see him! — as for
missis, she always loved him." There,
I say, is the old housekeeper, logging
the fire, airing the sheets, and flapping
the featherbeds — for Master Tom's
room has never been used this many a
day; and the young ladies have got
some flowers for his chimney-piece,
and put back his mother's portrait,
which they have had in their room
ever since he went away and forgot it,
wo is me! And old John, the butler,
coachman, footman, valet, factotum,
consults with master about supper.

" What can we have ?" says master;
" all the shops are shut, and there's
nothing in the house."

John. " No, no more there isn't;
only Guernsey's calf. Butcher kill'd'n
yesterday, as your honour knowth."

Master. " Come, John, a calf's
enough. Tell the cook to *send us up
that.*"

And he gives a hoarse haw! haw! at
his wit; and Mrs. Prodigal smiles too,
and says, " Ah, Tom Prodigal, you
were always a merry fellow!"

Well, John Footman carries down
the message to cook, who is a country
wench, and takes people at their word;
and what do you think she sends up ?

Top Dish.

Fillet of veal, and bacon on the side-
table.

Bottom Dish.

Roast ribs of veal.

In the Middle.

Calves'-head soup (à la tortue).
Veal broth.

Between.

Boiled knuckle of veal, and parsley
sauce.
Stewed veal, with brown sauce and
forced meat balls.

Entre-mets.

Veal olives (for sauce, see stewed veal).
Veal cutlets (panées, sauce piquante).
Ditto (en papillote).
Scotch collops.
Fricandeau of veal (piqué au lard à la
chicorée).
Minced veal.
Blanquet of veal.

Second Course.
Curry of calves'-head.
Sweet breads.
Calves'-foot jelly.

See, my dear Anatole, what a world of thought can be conjured up out of a few inches of painted canvass.

And now we come to the great and crowning picture of the exhibition, my own historical piece, namely, " Heliogabalus in the Ruins of Carthage." In this grand and finished perform ——

 * * * *

 * * * *

*** Mr. Titmarsh's letter stops, unfortunately, here. We found it, at midnight the 15th–16th May, in a gutter of St. Martin's Lane, whence a young gentleman had been just removed by the police. It is to be presumed that intoxication could be his only cause for choosing such a sleeping place, at such an hour; and it had probably commenced as he was writing the above fragment. We made inquiries at Lord's Coffee House, of Mr. Moth (who, from being the active and experienced headwaiter, is now the obliging landlord of that establishment), and were told that a gentleman unknown had dined there at three, and had been ceaselessly occupied in writing and drinking until a quarter to twelve, when he abruptly left the house. Mr. Moth regretted to add, that the stranger had neglected to pay for thirteen glasses of gin and water, half a pint of porter, a bottle of soda-water, and a plate of ham-sandwiches, which he had consumed in the course of the day.

We have paid Mr. Moth (whose very moderate charges, and excellent stock of wines and spirits, cannot be too highly commended), and shall gladly hand over to Mr. Titmarsh the remaining sum which is his due. Has he any more of his rhapsody ?—O. Y.

Review of
B.R. Haydon and William Hazlitt,
Painting and the Fine Arts

Athenaeum (July 14, 1838), 482–84; (July 21, 1838), 510–12;
(July 28, 1838), 526–28

Painting and the Fine Arts. By B. R. Haydon, Esq., and W. Hazlitt, Esq. Edinburgh, Black.

We have ever entertained the idea that where anything great, in almost any department, is to be done, Englishmen can do it; and of all rival peoples do it best, and do it first, if they but *will* to do it. We would make few reservations, and those only in departments which scarce admit of greatness: Englishmen cannot cook or cut six as well as Frenchmen, nor fiddle or sol-fa perhaps as well as Italians, nor carve ivory into lacework or put together flea-coaches, like joiner grub, as well as the Germans. Regard also must be had to uncontrollable circumstances: no one can expect England to teem with first-rate fresco-painters any more than Bohemia with first-rate ship-builders, because there are natural preventives to both pursuits; neither can our country ever hope to distinguish herself in rhythmic improvisation more than in *lacryma Christi,* her language and her climate being as uncongenial to the one as the other. Yet it is wonderful what England has done, with Nature, almighty goddess, against her: an insulated position would seem to render military renown impossible, cutting her off from the perpetual experience, exercise and emulation that ensure it; despite of which she has produced the greatest generals, save one, of modern times,† and gained the most extraordinary land-battles. To the same point might be adduced her poetic triumphs: for rich in homestead scenery as she is, albeit luxuriant in golden crops and meadowy verdure, how should her general flatness, her monotonous surface, have given birth to the sublimest, wildest, most imaginative, varied, and picturesque of all poetry—Shakespeare's? to Milton's, the next in loftiness, boldness, perhaps of still more colossal features and vastitude of character. English poets altogether may be pronounced imaginative and picturesque much beyond their rivals of other countries—endeavouring to carry these attributes still farther seems only to have driven our German brethren upon the bizarre, the brainsick, and the exaggerated. Shakespeare and Milton in particular appear, from their aspiring gigantic style, to have trod a parent-country of Alps or of Andes, where cloudcapt pinnacles, unfathomable chasms, precipices cleft through the hearts of mountains, torrents pouring forth freshwater seas, valleys lost in their immense perspectives, forest

† It is singular enough that the three greatest generals—Napoleon, Marlborough, and Wellington, should have been all islanders.

wildernesses, boundless savannahs, all the enormous contours of a dilated Nature, had filled their minds with the grand, the magnificent, the tremendous, and given them their Titan-like ambition of dealing with the hugest things, and ever mounting towards the empyrean. We are told too of our raw northern clime, that we live half the year under a cavern of pitchy weather, —and therefore, as learned foreigners depone, must our artistic spirit, however fervent, be frozen in the heart, and all our sighs for pictorial pre-eminence be choked by the fogs; that if we will paint, our scenery must consist of snow-storms and deluges, our figures be stiff as icicles, and our colours, taking their tint from our misty atmosphere, must be as dim, as rueful, and as frigid. Well! what says fact to this ingenious piece of ratiocination? Nothing less than that England has produced the very best painters of the modern world,—nay, up to this moment, the only painters who can rank with those of the Middle Age; and moreover that their forte, their peculiar excellence, and indeed their sole pre-eminent merit is—colour. No lark loves to lose himself in the lustre of the sun more than an English painter in the glory of colour: no bee loves a flower-bed half so much as an English artist a picture in which one brilliant tint is but foil to a brighter near it. True, our national school cannot compete with the Old Masters: can the modern French, German, or Italian either? In Sculpture, we admit, England does not stand first: yet *Flaxman* alone raises her to the first line. For Architecture, whom can the whole modern continent pit against *Wren;* even with all the defects of his low-classic style, even with all the advantages accruing to the *Schinkels* and *Von Klenzes* from a re-discovered Athens, residence in Greece, and revival of Greek principles?

Where Nature has been for, not against her, England has progressed like a ship before wind and tide: witness her maritime deeds and power, by which this speck of earth has colonized half a continent, subdued an empire that swamped the might of Alexander, and made every other flag but a pale and wavering stripe beside her pendant: witness her manufactures, her mechanical operations, which however humble in their origin and object, ministering only to our basest wants as miserable earth-creatures, she has carried on with such a boldness and success as makes, it may be said, the human race her dependent for its comforts, with such a magnificence of spirit that merchandise in her hands assumes a kind of royalty. To complete our brief, most stinted sketch, where Nature has been neutral, her own force of mind and character have borne this country into the van of human progress: for example, in mathematical and physical science, Newton has been the all-

245

enlightening Sun, his *Principia* as it were a secular revelation, unravelling the hidden System of the World; whilst the works of Lord Verulam have opened the interminable vista where Inquiry may be seen advancing, at the head of a train gathered from all countries, towards the Temple of Universal Knowledge. In Ethics, in Theology, England reckons some of the brightest names; in the minor sciences and arts many illustrious. At present, perhaps her mind is too much spread not to be superficial, but this, let us hope, may be a transition state—with her Saxon bone and her Norman blood she should outstrip all competitors on all paths; she would did she only *will*.

Nationality, of that foolish and fulsome kind, quite distinct from pure patriotic feeling, which be-swaddles the Patron-Goddess with triumphant wreaths, like the Dancing Bush on May-day—which will set up Racine as a Sophocles, Lincoln-Fens as an Arabia Felix, the Ayrshire Ploughman as a pastoral Apollo, or Andrew Jackson as Julius Cæsar the second,—nationality of this sort can scarce be thought to have actuated us in the above tribute of praise to our mother-land. We, almost alone, often come forth complainants against her, questioning her supremacy on certain points, demonstrating her inferiority on others, venturing with unpolished lips and no honied tongue to tell her when the wisdom of her conduct seems dubious—sooth to say, now and then forgetting all filial reverence to pour out our ounce-vials of wrath upon her greensick taste for the garbage of literature, her materialist spirit, her idolatrous worship of the *Golden Calf*, her poor and petty ambition in the Fine Arts, with other peccadillos too numerous for mention. As regards Painting especially, we have permitted the annual flowers of panegyric to bestrew her Exhibitions, because our artists, like the green birds of Paradise, would expire unless fed upon fragrance; but we have whispered at times very unflattering secrets into her ear, and somewhat less sweet than frankincense. It is not many years ago that certain pinks of artistic perfection professed themselves cruelly frost-bitten by our rather temperate praise, and wagged their heads against us because we did not proclaim these slips and suckers from the Academy *hortus siccus* as budding Raffaels and Buonarottis. Let us refer also to our articles on ' Lessing's Laocoon,' ' Brown's Leonardo da Vinci,' ' Rio's Christian Art,' together with various scattered notices of German and French paintings, for proof that we are far from blind to the defects of our English school, but can look with Equity's iron eyes upon it and its continental antagonists. The volume before us may furnish another occasion to show how very possible it is to be unprejudiced and impartial, yet a good Englishman.

In all strictures on contemporaneous art there is this regretable circumstance, that mere mention of name often amounts to assassination of character: were we candid as idiotcy itself, or as loose of tongue as tipsy senility, a feeling for the dependents on public applause must teach us to point our remarks rather at qualities in the abstract than in the artist himself; though sometimes to do so will be neither possible nor proper. We came into the world of literature with the smiling assurance that our blows had only to be well meant to be well taken, and had not the least idea they would prove far more agreeable if deadened through a curtain: brief experience however set our cherubin simplicity right, and we no longer volunteer open flagellation in the vain thought of earning the patient's eternal gratitude by a wholesome discipline administered *con amore*. It is true, the dead are allowed fair subjects for dissection; they may be scarified and mangled at pleasure. Reynolds undergoes with perfect justice drawing and quartering, as in Mr. Hazlitt's treatise, while R.A. Esquire (who can defend himself) shall not suffer one scratch from the demon claw of criticism—till we have him pinioned between six deal boards at our feet. Such being the statute graven upon the Broad Stone of Honour, we are bound to observe it, whether penetrated with a sense of its exact propriety or not.

Amongst modern schools of painting the English has had, till of late, no rivals. If we take the next back-period to the present, Greuze and Joseph Vernet are the only continental names of much note, and they are extinguished in the superior lustre surrounding those of their English cotemporaries, — Reynolds, Wilson, Gainsborough, and Hogarth,—we cannot admit Battoni, Mengs, Appiani, &c. as original artists, nor even able imitators; Watteau belongs to the seventeenth century, and old masters. In the present period, until within these few years, the Italian, the German, the Flemish styles were little else than coarse or faint aspects of the French, and this was all but hideous. No artists such as Lawrence, Turner, Wilkie (we speak of the latter two in their first best style),—Morland, Stothard, and others might perhaps be added, —gave at once a new, brilliant, and beautiful phase to painting, which may yield place to a different, but will anon come round into sight and admiration again. Single meritorious pictures, *Gericault's* ' Wreck of the Medusa,' *Gerard's* ' Thetis,' may have been produced, but no class of works, like the British, had raised any continental school into splendid and Catholic notoriety—Lawrence was always honoured in France, *David* detested here. A host of excellent English colourists, portraitists, fancy-painters proved our right to the crown pictorial very much more legitimate than the Italian claims upon that of

Sculpture through Canova's single pretensions. After this meed of praise due to our country, comes the grievous qualification; underneath her chaplet of roses lurks one thorn which must pain the blushing conqueress in the midst of her triumph. Let us be honest as well as patriotic, and own the true secret of her pre-eminence thought chasten our pride. If England has outgone as yet all modern competition in painting, it is simply because she has chosen the lowest, least difficult path to fame,—portraits, landscapes, cabin scenes, and cabinet pictures. *Colour* also forms her transcendant distinction—colour, the humblest of all the excellencies : on the scale of artistic merits the nearest to contempt, however many degrees above it. Thus, though she wears her plume with ineffable grace, and tosses it with most superior air, she must not forget that sovran art has nobler adornments than a garish feather. Certainly, nice little rambles round the base are preferable to giddy-pated ascents of the pinnacles : as a work of art Wilkie's ' Blind Fiddler' far excels Gerard's 'Belisarius,' a leash of wolf-dogs by Landseer all the Brutuses and Leonidases of David, whilst Etty's ' Judgment of Paris,' or even one pure pearly-toned gem by Eastlake, is worth all the cold classicalities of Camuccini or the bombastic frescos of Benvenuti. But, on the other hand, if any dawn of success in the historical line break out elsewhere, it will much diminish the lustre of our reputation in lower departments ; and if this dawn shall spread into a full daylight, our stars of the first magnitude will be extinguished altogether. Now what is the fact which every observant traveller of natural taste, and unbesotted by fuming patriotism, must acknowledge?—That with France and Germany historic painting *has* succeeded of later years, to a pitch most ominous for our future pre-eminence in the world of art. Bare mention of two names—Delaroche and Overbeck—might suffice to prove this ; but we may subjoin those of Schnorr, Veit, Cornelius, Hess, Bendemann, Vogel, Schaeffer, Schwanthaler,* Zimmerman, Wach. These men have at length been able by their united efforts to lay that corner-stone of art's second temple—solid design—and to strike out a sagacious plan for the superstructure. Whether they or their aftercomers will have genius and good-fortune enough to rear a monument as perfect and enduring as its idea is aspiring, remains to be determined by that potent solver of problems, Time : if they have *not*, our own little system was the wisest. We state this doubt because, though foreign artists draw well, they are not as yet impeccable draughtsmen ; their style when classic tends to the *statuesque*,

when heroic to the theatric, when natural to the ignoble, when simple to the mimic-antique.

Besides, though some of them *paint* well, and most understand sufficiently composition, clair-obscure, with the details of mechanism, their colour is not indifferent like Raffael's, but abominable—it makes the skin creep—gives the shudders—has the Gorgon charm about it, to petrify, and no other. This we mean as its general complexion, almost universal ; the works of Overbeck which transcend all the rest in merits, transcend them too in miserable colour ; so attractive on the plate, they are, when more than mere chiaro-scuros, revolting on the canvas. *M. Decamp* goes for a good colourist, but then he is not a historic painter ; the productions we have seen of all the other prime artists, except *A. Schaeffer*, are dry, hard, frigid, and harsh,—to a degree perhaps no less irreconcileable with the re-edification of art's temple than weak draughtsmanship. For though fine colour may not be a *sine qua non*, frightful will ever be a *qua non* of excellent painting. Herein lies our hope of continued pre-eminence ; English artists have a decided power over pictorial composition, apart from linear,—a power to extract beautiful and sublime effects from the various paints, tints, or tones harmonized and worked up together. This faculty is so strong in our countrymen that we have thought it possible at the Louvre, which affords a kind of public atelier where students from all nations congregate, to distinguish an English painter among foreigners by the *laying of his palette ;* it resembles a bouquet of bright flower-buds arranged with instinctive harmony, while the Frenchman or German sticks his little muddy heaps like dirt-pies about the board pele-mele, as if he were rather scraping defilement off the canvas than putting embellishment on. To be sure, foreigners may learn to colour well before our artists learn to design well, but perhaps the latter being more mechanical is more acquirable than the former. From a pretty extended inspection of continental works we are somewhat of opinion that both the French and Germans have an eye for colour naturally defective, which may require ages of practice to make habitually good. One or two exceptions, such as Claude and Dürer* do not disprove this hypothesis: old German (Alt-Deutsch, distinct from Flemish,) pictures are generally of a meagre, white, and crude reddish tone, of poor impasto, and court-card composition as to colours; the old French masters, Vouet, Le Sueur, N. Poussin, Le Brun, &c., had a still duller sense of the lustrous, the mellow, the beautiful modulation of tints, and what may be

* This artist. though properly a sculptor, has designed many of the best works in the *Königs-bau* at Munich. Also, for M. Delaroche's best productions we must refer to other than those now before the British public.

* Neither, by the bye, nor Holbein, can be considered a rich or great colourist, notwithstanding Claude's magic in aerial perspective. Watteau is the Rubens of French colourists—a petit maitre Rubens.

called the spiritual mechanism of colouring. Italy, Spain, Holland, England, Flanders at two periods (of Van Eyck and of Rubens) seem the peculiar favourites of Iris, gifted with chromatic power, with delicate sense and relish for optical luxuries above other nations—Greece no doubt was a pure epicurean in this line also. China seems to have much taste for colour.

Now although Englishmen have never yet displayed power in draughtsmanship, they have given no positive proof of an eye for form naturally erroneous,—their *feeling* for the true line is often correct, and perhaps ill-developed from want of right principles, good patterns, or sufficient practice alone. But indeed, if they possess the Elgin Marbles much longer without imbibing the ambition to model and design well, it will demonstrate them defective in taste for this excellence, and therefore altogether impotent to succeed in the highest walk of art—the historical. Titian, Rubens, Correggio learned to draw well,† or we should never have had the 'San Pietro Martire,' the 'Descent of the Cross,' and the Cupola of Parma; but they must have learned to draw better, or, with all the genius of Michaelangelo, they could never have painted the Vatican Chambers and the Sistine. Let us repeat this important maxim : that much of the pretty, the fanciful, and even the gorgeous, may be attained without great power of anatomical design ; but that it is indispensable towards producing supreme works of art, and the nation which chooses to neglect it can no more accomplish aught beyond the subordinate than catch leviathan in a lady's reticule or pull the sun out of heaven with a silken halter. We pronounce it thus essential, because the highest aim of art is to represent the highest modes of human (or human-like) action and passion by the varied modifications of aspect and attitude, nor can this be done without complete knowledge of the human figure, and power to delineate it at will. Correggio, it is known, besides his studies in the severe style of Mantegna, served a friendly apprenticeship to Begarelli, the sculptor, modelling clay-figures under or along with him ; Michaelangelo alone could reprehend Titian as an indifferent draughtsman, for the rigid school of Bellini must have exacted attention to design, and Titian himself proved its necessity by re-cultivating it express when about his 'Peter Martyr.' None but the superficial could assert these two masters ignorant of drawing, because they preferred to dispense themselves from its practice

in favour of chiaro-scuro or colouring ; it were far more just to say that neither had especial genius for design, and what was the consequence ? Neither shone forth a supreme delineator of human action and passion, neither a supreme historic painter ! What is the Parmesan Cupola to the Sistine Vault, or the Peter Martyr to the Heliodorus?

We must return to this subject in another article.

Painting and the Fine Arts. By B. R. Haydon, Esq., and W. Hazlitt, Esq.
[Second Notice.]
Quarterly Review. No. CXXIII. Art. IV.

WHILE drawing up the present observations we were rejoiced to find a subject upon which the *Athenæum* has long laboured to fix public attention, taken up by the *Quarterly Review.* Oracles in this country pass for no more than the murmurs of a wild pigeon unless spoken from the tripod. In a review of Dr. Waagen's and Messrs. Haydon and Hazlitt's treatises, the *Quarterly* repeats our obnoxious statement, that English Art is now at a very low ebb—seconds our complaints so often lodged against the meretricious flagrancies of a debauched school, its "want of truth and repose, glare of contrasted colours, struggle for effect"—and moreover hints what we have ventured broadly, incessantly to affirm, that the root of these evils, the cause of said low condition, can be nothing else than unacquaintanceship with the prime and main mover, the purifier and elevater of art—the empowerer of artists—*Design.* It is true, the writer limits his allusions to our ill success in *historic* painting ; but a little reflection would have shown him that impotent design must necessarily keep a limner upon the surface of *all* excellence which lies deeper than florid effect and general character. Could Wilkie have made certain sixpenny spots of canvas speak so much eloquent humour and feeling without considerable craft of design, now (as the reviewer admits) weakened amid wastes of oil, like the vigour of a dead hand washed to a jelly in the sea? What renders a glittering group by Turner such an *olla podrida* of bright colours, but that he does not (peradventure cannot) design and define the forms? Compare them with those in the 'Resurrection of the Blest,' by Rubens, at Munich, and perceive how much genuine value brilliancy

† This phrase has two meanings, very dissimilar, often confounded, yet of momentous difference ; power to draw

well is the power to delineate forms, either of a pure type —or of a type known, but convenient—with accuracy and facility. *That* was possessed by the Greeks, by Raffael likewise in some measure ; *this* by Michaelangelo and the

three artists just quoted. Even Rubens drew well after his way, embodying his conceptions, such as they were, with great ease and exactness. Battoni, though his type was purer, drew far less well, not having equal mastership over his pencil. Few English artists can do more than dab neatly instead of draw ; and this feebleness is called *freedom !*

itself acquires through tolerable drawing. Lawrence's ladylike portraits are feeble from a double cause,—feebleness of hand as well as feebleness of mind. Reynolds caught the general air with miraculous dexterity, impressed it with great general truth, but he could no more have painted that living head called ·Gevartius by Vandyck, or the *Julius* (at Florence, by Raffael, than carved Diana's face upon the moon with a fruit-knife, owing to his small knowledge of design. In short, for want of this power an artist is driven upon makeshifts, subterfuges, superficialism, dazzling legerdemain, tricky adroitness, and dishonest workmanship; nor can he either develope his full will, or make the pictures of his mind visible: his pencil may be said only to *stutter* over the subject it would express, failing to reach that articulate fluency which involves the profound charm, the perfection of Painting, as well as Music. This, however, is but the proximate cause whose existence kept English Art so long in the background, and still keeps it on a low one,—portraiture, cabin scenes, fancy bits, and kaleidoscope effects of colour. The reviewer specifies other causes deemed original and efficient: one being, that "England, in its habits, its people, its faces, its costume, is essentially *unpicturesque*." This seems a cause predestinative enough: can we allow it much force? How happens English poetry to be so picturesque? How happens it that the English school of painting *is* essentially picturesque, characteristically such, compared to the classic or pseudo-classic school of modern France and the continent? How happens it that from the most picturesque part of the empire—Scotland, with its lakes and precipices, bonnets, trews, and tartans, its peculiar customs and primitive people, precisely the least picturesque painters come? Scarce a more practical artist than Wilkie, certes not one more visionary than Turner. Is Allan more picturesque than Martin? Has then this alleged cause so much indeed to do with the matter? We admit the reasoning very plausible, but look at the result! Perhaps "unpicturesque" may mean here what it usually means the reverse of—unclassic or unhistorical; so we infer from the reviewer's next sentence, that English eyes "are not familiarized with forms and combinations such as *historical* painting requires." But how has this affected a sister art? Notwithstanding the want of these forms and combinations, is Inigo Jones's *architecture* less classic than De Lorme's, or Wren's than Palladio's? Is the New Post Office less classic than the *Bourse* of Paris, or the Bank than the Theatre Carlo Felice at Genoa? Again: Prussian eyes, we think, will be conceded as little familiar with those forms and combinations as English; no country can well be more deficient than Prussia in objects, animate and inanimate,

either picturesque or classic; yet the architecture of Potzdam is as classic as that of cotemporaneous Rome, and the Berlin Museum as much so at least as the *Madeleine*, Brandenburg Thor as *L'Arc de l'Etoile*. We should be loth to deem historical painting out of the English pale because our compatriots neither walk about with Etruscan pitchers on their heads or Grecian noses. Surely our painters might as well import and imitate classic examples, as our architects— wherefore should not Haydon furnish his mind from Greece as well as Cockerell, or Hilton as Sir Robert Smirke? Bavaria has cultivated the historic department of painting with eminent success—France with considerable: yet are German "faces" so very classical, or is the French physiognomy such a model of pure, regular outline and sublime chastened expressiveness? We may grant our national countenances have too much of the bull-dog in them; but do those resembling fallow wild-cats and freckled apes come nearer the heroic character? English costume could not be more unpictorial; save in the lower rank, however, this is as true of the continent; and how seldom are Norman high-starched steeple caps or Bavarian fur-bonnets introduced into historical pictures? As for Gothic history-pieces (which perhaps ought to be the chief aim of modern historic art), we stand on a par of advantages with other peoples. Nor does it seem that English habits should prove so deadly, though indeed somewhat obstructive, to the higher style of painting: they are, it is true, very matter-of-fact and practical, imbued overmuch, as we have elsewhere lamented, with a money-scraping, materialist spirit; nevertheless, if our countrymen have the *genius*, why should it all evaporate in steam, or consume itself in generating gases, when the different nations most distinguished for Art were, every one of them, practical and commercial to the extremest pitch then known? The Athenians, Rhodians, Florentines, Pisans, Venetians, Flemings, Dutch. Many more instances might be added. The historical genius of Van Eyck and Memling was not smothered beneath Flemish woolbags; Rubens could find patronage from the same community of clothworkers, and turn their buxom blouselindas, with the fat of the land teeming over their tuckers, to his purposes as models for great pictures—glorious enormities, call them what else you please. Where genius exists, these "habits" called stumbling-blocks become mounting-stones: they augment its noble rage, as rocks the fury of rivers. At least, if we concede our practical habits efficient to delay the evolution of genius, render the birth difficult, but not to strangle it altogether or keep it a blind fetus in the womb, more can scarce be required from us: we cannot allow more force to this excuse for English supineness as to historical

painting. Essayists may do far better than press the impossible on their countrymen's genius, for instance, resuscitation of the Drama, when the fire of its life is out, and could find no fuel in our present manners; little worse, however, can be done, than, by confounding the difficult with the impossible, to deter genius from experimentation where there remains a hope of success not altogether forlorn, where but a few faint efforts have been made, and where the object, if seized, would well repay large sacrifices.

Against other alleged causes, the reviewer deploys his artillery of ridicule in great force: to wit, against Mr. Haydon's position that the Royal Academy, and against Mr. Stanley the auctioneer's evidence before the House of Commons, that " want of encouragement and taste" in our mock-Mæcenases, keeps down historical painting. A short way with the former nuisance, if such, he avers would be to demolish the Academy: but perhaps to demolish its *rotten parts* were preferable. We cannot suppress a notion, that within those precincts there is a hot-bed or *two of very rank abuses: the *Quarterly* itself gives a gentle lashing to a malpractice there, which well deserves a Russian administration of the *knout*—viz. repaintment, by certain members, of their works hung up for exhibition, so as to kill all other pictures around them. This privilege is not only disgraceful and dishonourable, but is sure to induce a strumpet style of colouring, as well as a hasty-fisted botchwork, no more to be called sound painting, than the tarring a boat-bottom. We trust this odious privilege will soon yield to the universal anathema against it. In our humble opinion likewise, the Academy might do much towards the elevation of English art, by establishing a stricter quarantine against the great plague of portraits, rather than turn itself into a sort of panorama for exhibiting all the physiognomies of the kingdom in rotation. Still farther might that end be promoted, we suggest, by awarding the space thus gained to works of sedulous design, even though at first little attractive; and by affording, in the School of Design under their roof, special encouragement, with all liberal means and helps so profusely furnished abroad, to good draughtsmanship, which is the very pith of historic art. No doubt, exhibition-goers would complain the first season or two—one, that a dry-boned academical figure displaced his grandfather the Judge; another, that a truculent Black Prince has thrust out her gentle Hussar— the receipts may come a few shillings short, and newspaper small wit superabound—but all would at length re-adjust itself. How is the public to acquire a relish for good design without seeing it—seeing it often? Why should it not prefer rich colour to wretched draughtsmanship, or even bad portraits of withered fashionables and

purple-nosed cits, to worse heads of the saints and angels themselves? At a word, will the Academy make any exertion, any sacrifice,—become a pilot to public taste, or continue a pander?

With respect to the other cause alleged, our droll contemporary proposes, as a refutation, to "raise Michaelangelos by annual grant from the Exchequer." We love a good jest, and can accept wit in lieu of wisdom, if the latter be scarce; but we would rather have both,—and they are quite compatible. If a witticism had been cracked on the other side, to prove that Michaelangelos could be raised by *no other means* than annual grant of public patronage (the same thing as from the Exchequer), we should have felt still more pleased; for such is the truth. Were all the way to art's summit paven with ingots and hedged with clustering emeralds, there might not be an Englishman able to reach it through want of requisite genius: but Michaelangelo himself would never have reached it, for all his genius, without public grant of some kind, in hand or hope,— money, fame, grade, consideration, all which come under patronage. So that "want of public encouragement and taste" must be fatal to art— to everything—although, that the presence of these must, reversely, raise great artists, is a mere wit's conclusion. In good sooth, Mr. *Auctioneer* knows somewhat more about this matter than Mr. *Quip* of the *Quarterly!*

We will not discuss the several remaining causes, but we will endeavour to sum them. First, the distance of England from Italy, the centre of civilization, in the Middle Ages: second, the climate, unfriendly to fresco, which gives largeness of style: third, the Reformation inimical to religious pictures, which give dignity to art: fourth, the small apartments, and few state rooms, of English mansions: fifth, the national chariness about exposure of forms, which likewise are held by some as no good models.† To these familiar causes we will add others less apparent. Close intimacy with the Dutch and Flemish, who, when we did commence art, gave us our still existing taste for cabinet and high-coloured pictures. The wealth, political power, and that excessive pride always distinguishing a democratic noblesse, such as the Venetian, Florentine under the Medici, and English after the great Rebellion,—all which qualities tend to the over-patronage of portraiture—have introduced it here to the utter degradation of art. Hence it was that Ghirlandajo, and other creatures of Lorenzo, filled their compositions, sacred as well as secular, with Medici likenesses; that Titian and Paul Veronese delineated so many doges,

† Mr. Haydon asserts them as good as Greek (p. 87), and brings Cicero to prove the plainness of the Athenians.

proveditori, and magnificos, in their large works; and that all the Venetian painters gave themselves up so much to portrait, while the Roman, Bolognese, Lombard, and French schools, sought rather to conceal the living model under the ideal. Portraiture, indeed, latterly became more frequent everywhere; church demand upon art ceased, in a great measure, after so long a supply, and the middle classes had acquired eminence and opulence enough to set up as patrons also. Just about the period when the rays of refinement had reached from Italy to England, portrait-painting was at its fever-height throughout Europe; Holbein, Velasquez, Vandyck, were inflamed by it, and inflamed it: English wealth secured two of these artists successively, a democratic noblesse fostered the branch of art which set forth their self-importance, an opulent middle order emulates them in the same system of egotistical patronage;— and so this circumstance united with the rest to stamp us a portrait-loving people. Lely, Kneller, Reynolds, Lawrence, have been our most favoured artists: a historical painter finds no more grace among us, than a missionary among the oran-otans: nay, the few historical pictures by West and Haydon had chief interest with us on account of their portraits—Miss Stephens the singer, Mr. Young the tragedian, &c.!—we doubt if Harlowe's 'Trial of Queen Katharine' would fasten one eye upon it out of each hundred, but that it pourtrays the family of the Kembles! Again; Rubens made every nation within his reach a lover of gorgeous hues— Flanders, Spain, England, — except France, which Flora herself could not inspire with a taste for colour. Rubens and Vandyck gave English art its tendency to rich colouring, and the power which Reynolds threw into this province, confirmed its sway over the kingdom.

Two causes more must be mentioned why English art remains on the low ground thus primitively taken: and we trust our frankness in stating them may not get the name of irreverence. First then: English art is submitted to the public through *Exhibitions*, and so falls to the level of miscellaneous, instead of rising to the height of select judgment. Princes, with their retinue of court poets, literary prompters, prelatical connoisseurs, and philosophic parasites, are no longer the committee of taste, which awards fastidious praise, censure, patronage.* Almost the whole people may be said to have resolved itself into

such a committee; and the middle class, by its superior aggregate wealth, is now chief patron of art,—by its voice uttered in journals and exhibition-rooms is the oracle of criticism which artists must consult if they mean to prosper. What follows? Why, that the vast majority of works are made to suit medium taste, and wealth, and tenements; pretty, petty things, which display domestic scenes, "bits" of nature, or colour, or effect, portraits of dear nonentities, my daughter or my lap-dog, my grandmamma or my mistress—often most creditable to our feelings, most useful towards their gratification and cherishment, but fatal to an exalted character in the Fine Arts. Popular opinion is on no subject more fallible than on this, because purified judgment can only result from an experience too long and an education too refined for the many to attain. Not that we would, if able, interdict Exhibitions or public patronage; peradventure they are, under existing circumstances, the sole possible support of art: we do no more than state their tendency, which is to fritter artistic power, and lower artistic aim, turn exhibition-rooms into bazaars for cheap ornamental chattels, and the pursuit itself into a manufacture of glittering toys for old children.† Middle-class domination, with all its merits, has beyond doubt this deleterious effect. Under the same head may be ranged the possession of so many ancient pictures, embellishing, almost encumbering, our aristocratic residences; little room is left for English works of magnitude, and still less taste for them by the side of such masterpieces. The miserable selfishness and jealous illiberality which these treasures are shut up from public approach, prevents, to a great degree, the beneficial action they would otherwise have in raising the common standard of criticism.

Now let us suggest the last cause to which the low condition of British art is ascribable: illiterateness of our artists. There are, we admit, some exceptions to this general charge; moreover, we shall be as prompt to palliate as allege it; but the fact we feel bound in duty and justice to proclaim—our artists, as a class, are men of altogether neglected education.‡ It were ludicrous to ask where is the philosopher, or mathe-

* We confess the "select judgment" lately exercised upon certain public Statues, and the fitness of certain artists to undertake them, might be quoted against our position; but from the long prevalence of ignorance and bad taste throughout all orders in England, even the highest can scarce give an opinion as to Art that does not deserve the jeer of the universe. Our leading connoisseurs only open their mouths at a committee to cry—*Oyez!* what imbecilities and false oracles it is our pleasure to put forth in the year of our Lord 1838, *Oyez! Oyez!*

† Let us here cite the name of a great artist, Wilkie, who has accommodated himself, voluntarily or necessarily, to the public goût for portraits, and garish sketchwork.

‡ As a late sample: in the present R.A. Exhibition is an otherwise very clever picture, setting forth the well-known story of Giotto, when a shepherd boy: straight above his head rises the Palazzo Vecchio of Florence, which *he himself* built long after; beside him swells the famous Dome of Brunelleschi, who lived a century later; and yet worse, on a gateway such as Florence never had, lie two of the *Medici statues by Michaelangelo!* We suppress other errors: in fact, the artist seems to have accumulated upon this small canvas at least as many proofs of his ignorance as his talent. Apropos of Giotto: it was our misery to hear an English artist, of some repute and long experience, ask a German brother-artist, when showing us his sketches from the antique frescos of Italy, " if Giotto were *one of the old painters?*"

matician, or profound linguist, among them?
Indeed, so unacquainted are they even with the
nobleness of their own Art, that it is probable
they will demand of us—what has philosophy, or
abstract science, or deep erudition, to do in the
matter? Without doubt, when art was highest,
the great number of its disciples were mere
artists and no more; but very many were also
of gentle blood as well as minds ennobled by
knowledge; some—and these the perfectionaters
of their craft—were amongst the brightest lumi-
naries which shone in the Middle Ages. Leo-
nardo da Vinci was a veritable Crichton; Michael-
angelo a geometer, scholar, and poet. Raffael
must have been a well-instructed, though, per-
haps, self-educated man; at least, his works so
full of biblical, and mythologic, and classic lore,
prove the necessity for such acquirements where-
with to furnish forth supreme art. Inferior
spirits followed in the wake of these guides; nor
could painting and sculpture ever have reached
their ancient perfection, had they employed heads
as imaginative from nature as need be, unless
enlightened too. With us moderns, the case is
still stronger: our artists need all, and perchance
more than all the aid that mental cultivation can
afford them, to fertilize their minds, purify their
tastes, exalt their ideas of what art should be,
and enlarge the grasp of their faculties as much
as the scope of their ambition. But no!—an
odd Waverley novel, or canto of Don Juan,
Richard the Third learned at the playhouse, a
maudlin magazine article, and perhaps a daily
newspaper—these make up the fund of literature
from which our artists derive their mental culti-
vation! What has a painter to do with books,
except now and then to embellish them? Those
may read who must write: let *him* study the
vast unlettered volume of Nature! Thus he re-
mains lifelong depending on his single mind,
which burrows for ever in its own barrenness;
thus he remains ignorant of those grand prin-
ciples, the fruit of protracted, painful, multi-
farious, co-operative researches and reflections,
those philosophical *interiora rerum*, that alone
give dignity to his art, distinguishing it far above
a mere elegant handicraft, or clever trick with
pigments and varnishes to perform pretty illu-
sions on the eye-sight; thus he remains in sim-
pering complacency at his neat little transcripts
from Nature's volume aforesaid, while they catch
but the vulgar sense of it, nor ever detect the
sublime mythos it conveys, because he will use
no interpreter of it but his own insufficiency.
Much excuse for this, we grant, should be made.
The chief fault lies with our democratic nobility
and gentry above mentioned: having been so
long the omnipotent faction of the realm, they
look down with sovereign scorn upon the strug-
glers for mere existence,—especially those who
are called *gentlemen* as well as themselves—

authors, artists, &c.; being so near akin likewise
to the middle classes, by means of their mer-
cenary marriages, and commercial dabblings,
and frequent origin from the bar, the warehouse,
the camp,—they must assert their superior rank
by their hauteur, and their disconnexion by
horror of contact with those beneath them.
Genius, which is God's patent of aristocracy,
begins now indeed to measure itself against birth,
which is man's; but prejudice and poorness of
spirit still to a great extent govern public opi-
nion on this subject; besides that the pursuits of
Art, being in some measure mechanical, are so
far forth degraded beneath those occupations
which may be called purely mental. Hence the
artistic profession devolves upon a lower class, a
less educated. University men, for example, we
believe seldom enter it; and persons, wheresoever
instructed, if they have genius as well as erudi-
tion, will not often devote them, like Da Vinci
and Buonarotti, to exalt what is held in such
humble esteem. *Honos alit artes.* Yet without
leaders of that high intellectual, philosophic, and
accomplished character, the fraternity of artists
can never rank much above a guild of artizans.
Another palliation may be found in that politico-
economic mania of our age for the division of
labour: we have lost the skill, or the will, to
develope the whole sum of powers called Man
co-ordinately; if a boy exhibit genius with his
pencil, he is sent to the school of design, and to
no other—the Royal Academy and the painting-
room leave him small leisure to "throw away"
on books—Cambridge and Oxford are as much
out of his perspective as the groves of Academus
and the college of Brahma. How should he be
other than illiterate? Again: the belief that
supreme art consists in a sort of splendid blotch-
work, off-hand effects, or at most of brilliant
fancy-pieces, and a power to bespread canvas with
deep, rank composts of colour—for all which a
good eye and ready hand are alone sufficient—
disposes artists to consider education superfluous,
and classic taste rather an injurious acquisition.
But this is more an effect than a cause of igno-
rance.

With the treatise of Mr. Haydon before us,
and a pre-knowledge of his literary attainments,
his name can have suggested the above remarks
by contrast alone. Some eruptions of his rhe-
toric must, we imagine, look strange in the de-
corous pages of the 'Encyclopædia Britannica,'
and will no doubt startle the propriety of its
grave perusers; but all his sentiments betray a
keen appreciator of his art, a skilful theorist no
less than practician, book-read, and, what is
better, well-educated *ab intra*—that he has
neither thought, nor swallowed print, at random.
We might, perhaps, find something beside "ninth-
parts of a hair" to cavil with him on,—not many
essential principles.

Next week we propose discussing the merits of Mr. Hazlitt's essay, as it more regards English Art, and has obtained the particular approbation of the *Quarterly*. An essay upon Arts and Artists, which we have just seen in the last number of the *Edinburgh*, may also demand some notice.

Painting and the Fine Arts. By B. R. Haydon, Esq., and W. Hazlitt, Esq.
Quarterly Review. Art. IV. No. 123.
Edinburgh Review. Art. VI. No. 136.

[Concluding Notice.]

OUR last notice bestowed on Mr. Haydon unalloyed encomium;—would we might continue to indulge the same vein; but Jove denies half our prayer! Mr. Hazlitt is a sparkling, imaginative writer; but when he speaks on art, his enthusiasm strikes us as too much cooked—paradox seems his dear delight as affording stimulus to his ingenuity, and a heart-spring of hatred to have been his exhaustless Hippocrené. Hence we can seldom depend on his verdicts, however argute or energetic; indeed, are as little convinced by them as we should be by the refinements of Sphinx or the bellowings of Megæra. Mr. Haydon denounces his publication of Northcote's book about Reynolds in very unmeasured terms; we trust it was rather a discharge of ill-humour, or a result of prejudice, than "a deep scheme of malignant defamation." However, our concern here is not with his motives, but his opinions—and with his opinions only, because they may affect English Art, the more so as they are now pushed forward, and backed up, and panegyrized, by the liberal *Quarterly*. Hazlitt was never meant for a tutelar genius of painting. He attacks Reynolds's doctrine of the *Ideal* with the vivacity of an ichneumon fallen upon a crocodile's egg, as if, like Pandora's box, it contained all evils. What the mote was that troubled his mind's eye while reading the 'Discourses,' we cannot say; it is plain he took a most erroneous view of them, or at least presents it. For instance, he states as Sir Joshua's chief maxim that "details should be neglected." A monstrous exaggeration of the fact, which would only become the genius of a news-crier. Sir Joshua's maxim is, that general character should not be neglected *in favour* of details. His context proves it was *petty* details he opposed, and ostentatious minutiæ. Again, Mr. Hazlitt pleases to make him say that "the perfection of portrait painting consists in giving the general idea or character without the individual peculiarities:" how different from what Sir Joshua does say, that "the excellence of portrait painting depends *more* upon the general effect than on the exact ex-

pression of the peculiarities, or minute discrimination of the parts." So far from recommending to oust peculiarities altogether, he adds they may be "reduced to classes," and have "large ideas" founded upon them; likewise "single features may be laboured to any degree thought proper." Perhaps the beam which stuck in our critic's eyeball was, that Sir Joshua's principles went to consecrate the inane style of Lely and Kneller, whilst they really go to condemn the microscopic manner of such limners as Battoni, and the Dutch love for ale-house nature, mean personal appurtenances, for degrading historical characters into portraits of their own Change-alley heroes, for imitating historical scenes from their own huggermugger localities. Is it not rather strange Mr. Hazlitt should exalt Sir Joshua's pictures—remark the "striking similarity" between his practice and his doctrine—yet set out forthwith to prove the latter absurd, as well as destructive of all excellence? This discrepance alone, we think, might have made the most blind-minded shake off the film of prejudice or self-mystification.

But where does Reynolds propound that "the great style in art, and the most perfect imitation of nature, consists in avoiding the details and peculiarities of particular objects,"—propound it as a "sweeping principle," applicable to portrait, history, and landscape? Nowhere, save in his criticiser's extracts. Sir Joshua makes special and sagacious distinction between portrait and the two other branches of painting: besides what we have quoted above, he says, that though when a painter wishes to idealize a resemblance, all the "minute breaks and peculiarities in the face and temporary fashions in the dress must be omitted," yet, if he desire to individualize it, or give an exact resemblance, more will be lost than gained by such a process—it will be "very difficult to ennoble the character but at the expense of the likeness." Is this a *sweeping* prohibition of peculiarities? We recommend critics to read these Discourses with more diligence, if they wish to give a plausible misrepresentation of them; Mr. Hazlitt, we are convinced, had as little clear recollection of them as of his reveries in the cradle. Even to Landscape, Reynolds allows considerable latitude, enjoining "anatomical" studies of all the particulars, and praising Titian for his distinctions, marked yet not too minute, between varieties of trees, plants, and weeds,—does this look like excommunication of peculiarities? No!—the Discourses contain errors, but it is unlucky to have pointed out sound truths as samples of them! Neither respecting history itself has Reynolds put forth the unqualified principle abovesaid: he shows, in perspicuous expansion of his doctrine, that such peculiarities and details are to be avoided which

debase the art into dogged imitation, or the subject into commonplace life—"accidental deficiencies, excrescences, and deformities of things" —"trifling and artful play of little lights"— fashions, local customs, showy patterns, and minute discriminations of stuffs—parade of mechanism and "subordinate assiduity"—servile mimicries of nature, &c. His other doctrines are in like manner quite misconceived. He does not say that Ideal or Central Forms are to be produced by "indefinite," but *definite* abstraction—not by a "voluntary fiction of the brain," but by "long laborious comparison of the most beautiful forms in nature." Take any living model, even the most beautiful, it will have some defect; the forehead a little too low, or high, or narrow, or sloping, the eyes too small or the mouth too big, the chest too sunk or the abdomen too prominent; it will have peradventure knock-knees, craggy ancles, or splay feet. Take other models which have other defects, but not these; combine all the separate perfections of these forms, and you obtain one perfect form; this is the *Ideal*, so called because it does not exist in nature. Or: abstract the defect, the too little or the too much, from each trait, feature, muscle, member, and you obtain the perfect form, which is called the Central, as it lies midway between that same too much and too little. Here is the doctrine of Reynolds so hissed against and hooted by Mr. Hazlitt! What is it but the old Greek doctrine, exemplified in the story of the five Nymphs who contributed their charms to form a Venus? What but the practice of Phidias and the best artists of Greece, as declared by Proclus, Cicero, and the writers of antiquity? What but the practice of Raffael himself, as expressed in his well-known letter to Castiglione: not finding, he says, mere nature perfect enough, "io mi servo di *certa idea che mi viene alla mente*"? What but the system praised by Barry, which Hazlitt's tirade, with suicidal effect, quotes against Sir Joshua: that observant traveller describes Raffael as having copied all the heads of certain frescos "from particular characters, *nearly* proper for" what he wanted them; only *adding or taking away* in little parts, features, &c. what answered his purpose; conceiving, while he had the heads before him, *ideal* characters and expressions, which he adapts these features and peculiarities to." What is this but seeking out central form, and abstracting, and idealizing? True, Raffael did not push the system so far as the Greeks did, and therein lies his inferiority. He was rather too fond of thrusting his Fornarinas, and Pippis, and Popes into sacred pictures, thereby often no little degrading the latter to profane ephemeral purposes, giving them a prosaic instead of a poetic air, and confusing their historical harmony. But his best figures are fine nature *plus* ideal characters and ex-

pressions—all that Reynolds requires and Phidias gives. For the Elgin Marbles have not, as Mr. Hazlitt affirms, "all the ease, the simplicity, and variety of *individual* nature," but of *select* nature; they are not "precisely like casts taken from life." A cast taken from Frank Bothwell, cap and feather of the Guards, would present us with a head somewhat too large, or a nose somewhat askew (as every individual nose is), or a faulty formation somewhere: the Theseus has a head of the central size, a nose in the middle of his face, and every part of just developement. Frank Lothwell, yea Coriolanus himself, would recline with something less than the temperate majesty, the unobtrusive yet tremendous grandeur of that godlike statue. Compare the reclining Fate with a cast of Sarah Siddons sitting her best—we fear the comparative anatomist, the admirer of individualities, would have to exclaim at the sight—"alas! poor human nature!" The Elgin Marbles are indeed true to nature, but if they are no more, what use in them? Why not attend the Swimming Baths, or Bruising Matches, or Whipping-posts, if you only desire to see Nature? Why look at nature in dead stone when you have her in warm live flesh at your elbow? Hazlitt tells us the head of Antinous is finer than that of the Belvedere Apollo, by way of recommending the individual above the ideal: let gross voluptuous beauty be conceded finer than "supercilious": who can prove the Antinous head a mere portrait, and not the idealized resemblance of Adrian's minion, in his well-known character of *Bacchus?* Such idealism it is, and so what becomes of the argument!

But with all the clevernesses, brilliant thoughts, picturesque images, and glimpses of truth, in this Encyclopædia article, we are compelled to pronounce it on the whole a maze of mistakes and mis-statements. As a proof how little the author was capable of handling his subject, behold the definition he propounds of the Great Style, after such efforts to quash that of Reynolds: "grandeur does not consist in omitting parts, but in connecting all the parts into a whole, and in giving their combined and varied action: abstract truth, or ideal perfection, does not consist in rejecting the peculiarities of form, but in rejecting all those which are not consistent with the character intended to be given, and in following up the same general ideas of softness, voluptuousness, strength, activity, or any combination of these, through every ramification of the frame." We shall thank any one who extracts the square-root of this hotchpotch, and tells us the clear value. So every piece of work which is consistent with its character however mean and vulgar, which follows out its general idea however petty and poor—belongs to the grand style, realizes ideal perfection? Gerard Dow's "Cabbage-seller," and his "Brass-pot

Scourer," are samples of the great style! Surely they keep up their characters and follow out their general ideas! The famous anatomical Wax-works at Florence must, in this case, be the very sublimest models of artistic perfection since the days of Prometheus, for they give every ramification of nature to a tittle! Nay, by this definition, the cast of a flea-catching Monkey surpasses the *Moses* of Michaelangelo himself in ideal grandeur! Curious that the above definition should not contain one essential mark of the great style, or teach us how to recognize or how to attain it: the *Drunken Faun* becomes as grand as the Phidian *Dioscuros* of Monte Cavallo, and Alderman Carbuncle's image in the glass is nearer ideal perfection than Sir Joshua's *Lord Heathfield*, because there all the ramifications are followed up, here suppressed! But let us have another specimen of that artistic enlightenment which the *Quarterly* deems this careless treatise so calculated to introduce: defining a *historical* portrait, the author says—it " means the representation of the individual under one consistent probable and striking view, or showing the different features, muscles, &c. in one action, and modified by one principle." Why then a faithful portrait of Cribb, the pugilist, giving a "floorer," is historical! *Every* well-modelled, consistent portrait, under a striking view, though as individual as pimples, a hare lip, and a squint could make it, is historical! Observe the adroitness with which all that distinguishes a historical from a common portrait has been omitted in this definition: we entreat the reader to consult Sir Joshua's, if they wish to see the difference between a mind that could and that could not philosophically grasp the subject.

For the talents of Mr. Hazlitt we feel a suitable respect, and should have dismissed his tract after due praise of its vivid thoughts and expressions, but that the brilliant axe it lays to the root of Art required to be turned aside. This was the more needful, as what we cannot help calling a most ill-judged eulogium in the last *Quarterly Review* seems to authorize that destructive attempt—endeavouring to disseminate the pestilence of erroneous principles, instead of stopping it. So little has been written or reflected about the Theory of Art in this kingdom, that our best critics give proof of nescience from day to day, which would make a tolerable German connoisseur turn white with astonishment. For ourselves, we only know enough to blush at the common ignorance of Englishmen on the subject. Yes, one thing more we know: the cause of Mr. Hazlitt's and our contemporary's error. They perceived that English painters—misinterpreting or misapplying the ideal doctrine of Reynolds—misled by his practice—have fallen into a vague, slattern, truthless, factitious style —one of brilliant show, beautiful smutching,

surface-work and sketch-work—nature itself either dabbed out of the canvas, or dabbed in : hence that doctrine is condemned instead of its abuse, as if we should condemn the brightness of the sun because trick-players chose to set our tails a-fire with burning-glasses. Had this abuse of the Ideal—Sir Joshua's own too sketchy and toss-off manner, perhaps less from choice than feeble draughtsmanship—been pointed out, the proper use illustrated and enjoined, some benefit to English Art might have accrued ; but crying down the ultra-ideal, and crying up the ultra-natural, is precisely of kindred wisdom with that of saving one's-self from Scylla by slipping into Charybdis. Let English painters be assured they cannot find anywhere, in the same compass, a solider " globe of precepts" on their art, than Reynolds's treatise, nor an emptier bubble than Hazlitt's; but they must study the former, and understand it, and imbue their practice with its genuine spirit—or they might as well follow any ignis fatuus theory that muddled wits have engendered. Some few higher principles than appear in the ' Discourses' may be revealed elsewhere, none lower can ever be canonical. If painters wish to attain sound practice, we cannot commend Sir Joshua's pictures nor his process as a guide, but rather as a beacon to warn off. However admirable both his theoretical and practical works are, the grand deficiency in both is the same—neglect of design. Upon this qualification Sir Joshua insists little, exemplifies it less. We venture to affirm, that what English Art needs to render it perfect—even as an Ornamental style—is good design. We repeat it, as the ancient orator did his maxim; of perfection in art there are three chief secrets—*design, design, design!* Without this, Painting at best will remain among us a gorgeous Superficiality—no more.

But wherefore should we have called artists over the brimstone coals of criticism, on account of ignorance, and narrow-mindedness, and pitiful ambition? Behold what our two grand Digests of all knowledge and illumination—the *Quarterly* and the *Edinburgh*— have brought forth this month : these receivers made to catch the sublimed extract and distilled essence of good taste evaporating from the brain of all our choice spirits ! What have these literary nose-leaders of the nation done for its advancement in connoisseurship? One of them tweaks it towards Hazlitt as the sign-post which points out, with infallibility's ruddled right hand, the royal road to the Triumphal Arch of Painting. We have above started some few suspicions that the great mystagogue, who is supposed to spread open such a splendid perspective, may prove but the St. Peter to a fool's paradise ! Alas ! how the mighty are fallen ! Here, likewise, the *Edinburgh*, that once had the whole

world of literature as a tail, comes now in the rear of a foreign cognoscente, and from him snuffs all its inspiration! The review of Dr. Waagen's ' Arts and Artists' is little more than a bald abstract of that work's most commonplace portion, without an original idea of a maravedi value; having sufficient unacquaintanceship with the subject, to ensure, one would think, as smart a sketch as the *Quarterly's*, yet being as dull as if it were ever so learned. Not that we hoped to find any English pericranium knowledge-logged on the matter, like many a German; but we did expect some evidences of higher gusto in art, more Apician discrimination about it, from our two daintiest of periodicals. How vitiated must the public palate be, when so blunt a sense is evinced by the " nose of haut-gout, and the tip of taste." But what particular glory to march forth the "fattest hogs of Epicurus' stye," with snout between the hoofs, and looks commercing with the mire, where it is only a swinish multitude that gives you precedence? Small wonder, indeed, if the lower press vent day after day such ineptitudes upon art, when our " mighty *Totty-potty-moys*" of criticism utter nonsense by the flood. Hear our Committees of Taste, and cognoscente speeches on artistic occasions! Flagrant errors in fact, appalling absurdities in doctrine! One gentleman who professes (very superfluously) he knows nought about sculpture, nevertheless girds up his loins to make affidavit that a certain bronze distortion, tripudiating on a pedestal, as awkwardly as a cripple jerks out crooked legs and crutches in a Highland Fling, is the perfection of caballine elegance! Another topping dilletante declares *portraiture* the summit of art,— recommends Royal Academicians to paint ephemeral physiognomies as the best way of making themselves immortal—of raising an endurable monument (like the Tartar trophies of *skulls*) to the renown of their nation—and in the plenitude of his ignorance takes a dictatorship upon him, when the least knowledge of himself or of art would teach him to conceal himself among the common slingers and archers of criticism. After all, though emptiness and presumption can never be laudable, it is natural enough they should place themselves as directors at the head of a public that follows them as two pillars of light in the utter depth of its own darkness : where the flock are geese, what do we expect to find stalking with imperious gabble before them— golden eagles, or ganders? The great slug which trails itself over the garden of Art, if unable to see its way, must put forth blind horns to feel it.

But the most deplorable, most decisive proofs of this country's degradation in pictorial knowledge and taste, are the abovesaid articles, just published by our two chief Reviews : these may be considered the standards and highest exponents of popular information and feeling upon art—to which particular excellence will always remain proportionable. We can augur no bright futurity for it, when the low-grounded mystified doctrine of a random essayist, playing at hoodman's-blind with his theme, is exalted by the *Quarterly* as a starry way to the zenith of perfection; and a few glimpses of criticism, caught from a tour book, are given by the *Edinburgh* as the whole effulgence of its illumination on the matter. We can augur no bright futurity for art in these kingdoms, while it is committed to the hands of *any* critics, or connoisseurs, or professors, who are such and nothing more : it must engage the interest of our loftiest poets and philosophers ere it can become illustrious. German professors own, with profound gratitude, that art has attained its present height among them—all its hope of future success—from the theoretic instructions of a *Lessing*, a *Goethe*, a *Tieck*, and other writers, who have irradiated, by their genius, a province so close to the poetical empyrean. Which of our great authors contributes a theory, nay a principle, that a sagacious professor would not keep in his sleeve to laugh at as preposterous or impracticable? What deluge of enlightenment did Scott pour out upon the grand mysteries of painting? Into what sublime mould did Coleridge cast the minds of the artistic generations around him? Byron's most splendid ideas about art would have illumined its pinnacles as permanently and profitably as so many flashes of lightning the peaks of the Lunar Mountains. With respect to English authors now alive, we shall but allege our belief that not one of them is able to write a *l'Envoy* to Winkelman, or a preface to the ' Laocoon,' or a paper for the *Kunstblatt*—to induct a tyro into the pure elements of artistic poetry, far from imbuing a professor with the essence. Yet until our intellectualists see the Fine Arts worth their thought, their abstract cultivation, their patronage, and their promotion by disert eloquence written and oral, those arts can never rise much above their present state of a genteel handicraft—can never afford professors much beyond a respectable pursuit as *esquire* artisans, nor the public aught nobler than an elegant relief from ennui, or means of titillating the retina with gaudy phantasmagoria; while the souls of both remain as uncherished and undeveloped by these superficial occupations, as reptiles shut up in the hearts of rocks are by the lichens outside them. We have done.

Edward Chatfield

"Poetic Painting and Sculpture"

New Monthly Magazine 55 (February 1839), 196–205

POETIC PAINTING AND SCULPTURE.

" Our poesy is as a gum which oozes
From whence 'tis nourished."

THE word Poetry, may be made to take so wide a range in its signi-
fication, that it is necessary to be as definite as possible, when applying
the term to works of art; we therefore beg to be understood, as re-
ferring principally to a certain imaginative temperament in the artist,
which raises his work beyond a close imitation of life, distinguishing it
from mere skilful mechanism, and the various principles of taste, which
are transferable from master to pupil, and whose diversity forms and
divides the schools. Thus, a taste for colour, composition, and effect of
light and shade, may be exhibited in pictures of exceeding beauty; yet
those pictures, in their subjects and treatment, may rather delight the
eye as accurate delineations of nature, than excite the fancy particu-
larly, or come within the circle of what is generally called poetic.
Imagination is stimulated by the study of Nature, but its inbred and
independent character is imparted to every object it moulds or colours,

" And gives to every power a double power,
Above their functions and their offices—
It adds a precious seeing to the eye."

The greatest works of painter or sculptor with which we are ac-
quainted, are indebted, for the halo of glory which surrounds them, to
this intellectual attribute. Let the connoisseur rave as he will about
what he calls *texture* and *touch*, there is nothing to be compared to the
delight afforded to the mind by an elevated style of art, which places
all the means used in a subordinate position, and produces in the
thoughts an ecstasy, associated with the best and loftiest emotions, of
which human beings are capable.* At the same time, we admit the
necessity of an accompanying feeling and taste for those minor accom-
plishments, and an artist-like execution of them, otherwise the pleasure
of the amateur is likely to be qualified with a portion of disappoint-
ment as considerable as that of a musician would be, who listened to a
composition of Handel, performed by an unpractised hand.

So nice a balance is required of the various faculties which make up
the mind of a really great artist—the combination of enlarged imagi-
native powers, and a dexterous, industrious, and tasteful application of
the materials, being the grand desideratum—that it is not surprising so
few genuine poetical painters and sculptors have existed. It happens,
not unfrequently, with a prodigal imagination, revelling in the undisci-
plined exercise of its capabilities—wild above rule and art—to be
carried with impulsive energy beyond all reasonable limits. So long

* An eminent living writer and poet, but neither artist nor connoisseur, was present
with us at a private exhibition of some very fine copies, from Michael Angelo's Pro-
phets and Sibyls. Every person in the room seemed struck with awe at the extreme
majesty of the figures ; but he sat apart, and actually cried with the emotions produced
by the sublime of painting. How noble a thing is art in this exalted aspect ! we envy
not the man who laughs at, or who cannot understand all this. He may exclaim in
mockery, what a noble thing to cry at a picture ! cannot he go deeper than this ? The
living and the dead are but as pictures.

as the fancy and the implements are at work, it matters little what is the subject, according to the notions of this kind of enthusiast. What will the reader think of a painter representing the *Blessed Virgin perform-ing a dance with the Prince of Darkness*, or of another delineating the *Ghost of a Flea?* These are instances of imagination run to seed. Some there are, or have been rather (the present generation of artists being remarkable for sobriety of fancy), still forgetting propriety of subject, who plunge into an element adapted only to the appliances and means of the writer, and become unintelligible or offensive to the sense, through which the artist must ever appeal to the mind. From this Limbo, wherein the unsound conceit is imparadised, to the highest Heaven of invention, the path is marked by numerous degrees—a hundred mirrors, each stained with its peculiar colour, and all held up to nature, dazzle and perplex the taste they should instruct and guide. The fantastic, the eccentric, the grotesque, the unnatural, the horrible, may all put in their claims to the title of Poetic, and some portion of the true Hippocrene may mingle with all; but a matured taste rejects from any affinity with the genuine fountain of the Muses, whatsoever is inconsistent with fine sense or propriety of character.

FUSELI's pictures will occur to the recollection of the visitors of the Somerset House Exhibition some years ago, as illustrating a kind of nightmare of the heat-oppressed brain, rather than the healthy inspira-tion of the poet—there was a strange mixture in them of the ludicrous and the terrible—evidence of a wild and powerful fancy created a respect, which was marred by the eccentric mode of its operation. The capacity of FUSELI was too great to allow him to fail in depicting poetical subjects of the highest kind—his designs from Milton, for ex-ample—even something of the sublime occasionally gleamed from his pencil; but his impatient spirit spurned the control, which a refined taste would have imposed upon his wilful manner. All his learning (and he was no mean scholar), all his knowledge of the finest art, were insufficient to restrain his love of the preternatural—his relish of the terrible, within bounds. His figures look not like the inhabitants of the earth, nor seem aught that man may question—their gestures are the contortions of dumb fiends, an ominous forefinger violently points some deadly purpose. If a voluptuously-formed woman is designed, a goblin-knight hovers about, pursues—torments her. The simple sor-row feeding on the damask cheek, had no charm in itself for an imagi-nation, which revelled in the most appalling scenes of Dante—beauty was only valued as it might set off surrounding terrors—it was a light which served but to discover sights of woe.—" Nature put him out," was the painter's apology for not consulting her more frequently than he did; his mind shrunk from her simplicity, as the Devil is said to eschew the touch of holy water—his conceptions expanded in propor-tion as they receded from familiar life, and seemed at home in an ideal world; but it was a world of grimace rather than of beauty. Nothing in Fuseli's pictures was adapted to the taste of the connoisseur; a few finely-imagined designs, therefore, are all that remain on the memory to warrant their admission to our Gallery of Poetic Art. Such are the *Lycidas, Uriel watching the flight of Satan, The Lazar House*, and nearly all the illustrations of Milton.

It is melancholy to think what the SHAKSPEARE GALLERY might have been, or should have been, and what it was. Scarcely one picture

was executed in a spirit akin to that of the great poet ; nor is it reason-
able to expect, out of a collection containing between one and two hun-
dred subjects, from the hands of nearly thirty artists, much of the
right leaven ; but the set of illustrations was remarkably deficient in
imagination, originality of character, and in those essential qualities which
pictorial merit which compensate to the eye for any loss to the fancy.
The designs of SMIRKE, form a great exception, it is true, but their sub-
jects are chiefly of a comic nature. Mr. Boydell, the spirited projector
of this gallery, says, in his preface to the catalogue, printed May 1,
1789, " Though I believe it will be readily admitted, that no subjects
seem so proper to form an English school of historical painting, as the
scenes of the immortal Shakspeare ; yet it must be always remembered
that he possessed powers which no pencil can reach, &c. It must not
then be expected, the art of the painter can ever equal the sublimity of
our poet. The strength of Michael Angelo, united to the grace of
Raphael, would here have laboured in vain. It is therefore hoped, that
the spectator will view these pictures with this regard, and not allow his
imagination, warmed by the magic powers of the poet, to expect from
painting what painting cannot perform." The worthy alderman should
have confined his apology to the pictures in his catalogue, which, for
the most part, certainly stood in need of it ; and not have troubled
himself to extend his excuse to the art itself. Painting or sculpture
require no vindication upon such grounds. They possess poets of their
own, whose works are sufficiently vivid with poetic fire, to kindle the
imagination, which, it is advised, the spectator of the Shakspeare gal-
lery should keep as cool as possible. It is sorry work for art, when
there is much to forgive. If it be not triumphant, it is worthless.
 The only men of genius, in the list of Alderman Boydell's selection,
are BARRY, STOTHARD, OPIE, REYNOLDS, ROMNEY, FUSELI, and
SMIRKE above mentioned ; that is, seven out of eight-and-thirty !
Nor can it be declared the powers of these are altogether of a Shak-
spearian kind. Of BARRY it has been truly said he possessed a grasp
of mind, and this grasp represents the poetical quality of his pictures,
as far as intention or design goes—it is clearly evident from his works,
he was an original and profound thinker ; but the eye seeks in them
vainly for some charm, either of form, expression, or colour, by which it
associates the design of the artist with the beauty or grandeur of na-
ture in its external aspect. We are also occasionally shocked by ab-
surdities, such as the unlooked-for appearance of Dr. Burney, " accou-
tred as he was " in cocked-hat, wig, &c., plunging among the river
nymphs,

" In the waters which flow by Somerset House,"

or by an assembly of painters seated at their easels in the clouds. It
is true, the " old masters " gave their angels violins to play upon ; but
however *outré* this taking scripture at its word, on the part of the pain-
ters, may be to our reformed notions, it was in perfect keeping with the
faith of the Roman Church, and the taste for allegory of the fifteenth
century. Barry's contribution to the Shakspeare gallery, taken from
CYMBELINE, where Iachimo issues from the trunk, is finely conceived.
If Sir Joshua had painted the Imogen, we might have had nothing to
wish for. STOTHARD was undoubtedly poetical—grace, sweetness, sim-
plicity, refined taste, female beauty, all his own, yet reminding us of

the antique, must accord, more or less, with judicious selections from our great dramatic poet. The elegant invention of this distinguished artist was exercised upon three subjects only, from Shakspeare, and those not best adapted for the display of his peculiar style ; whilst others, filled canvass after canvass, and occupied with their mawkish productions three-fourths of a collection intended to illustrate the greatest poet of England, and to exhibit the strength of British art. REYNOLDS, genius as he was, could not adapt his extraordinary and beautiful skill, as a painter, to the text of our poet. The impulse which guided him to such truth of character, and startling reality, when painting from nature, his constant custom, forsook him when his mind was left to roam about the ideal world, in search of abstract personation. He wanted a SIDDONS seated before him on his throne to inspire, to elevate his touch to the poetry of art ; and with a sitter whose characteristics he was scrupulous to seize, whether that sitter were Goldsmith or Burke, a charming woman or a dear little child, he became a poet himself—exquisite in taste, delicious in colour unequalled in the vivid effect of individual nature.

The *Death of Dido* is one of the most splendid pictures in existence ; but its ideality lies in the distribution of light and richness of colour rather than in expression and character. *Cymon and Iphigenia* is miraculously fine : here again, the fascination is involved in the brilliant colouring of the fair maid's naked form, reposing beneath a wide-spreading beech-tree—a living soul seems to breathe through the glowing skin ; perfect harmony lulls the mind to a state of placid satisfaction ; the sun's rays struggle through the trees, as if to gaze with Cymon, but they are less bright than Iphigenia—what a gallant poet was Sir Joshua ! OPIE threw a strength of character and a breadth into his pictures, which might well illustrate some of the heated encounters in the historical plays. ROMNEY's *Infant Shakspeare, attended by Nature and the Passions*, contains much grandeur of design, and a feeling for beauty. NORTHCOTE's *Burial of the Princes in the Tower, from Richard III.*, is well known, and has been deservedly extolled.

The public, as ignorant of the profound beauties of Shakspeare, as of the highest capabilities of art, might have been satisfied with this pictorial elucidation of the poet's conceptions. Many of the painters, now totally forgotten, were then in the full bloom of fashionable patronage, and no doubt were considered by many quite competent to the task assigned them of doing justice to Shakspeare. Some of the most talented in the second class o. artists were encumbered by their study of the various schools of Italian art, and venerating Raphael and Michael Angelo, more than they respected nature, were infatuated by the ambition of reviving a style of art, which was valuable only if accompanied by the genius which invented it. They fashioned the body anew, but were unable to restore the soul. In the pictures of men of genius we see something great or lovely we cannot find elsewhere ; the inferior works contain only a degenerated variety of the indigenous flower.

Invention is of no school, Academies can neither create nor destroy its finely-touched quality, and wherever it appears, wonder and delight rise to do it honour—a host of admirers, a swarm of imitators follow in its wake. The homage literally paid to CIMABUE, when he revived painting, and when the picture he first produced at Florence was carried from his house in procession to the Church of the Virgin, attended

by a band of performers on musical instruments, and amidst the loudest applauses of the citizens, is bestowed, in various degrees and diversity of manner, upon novelty of every kind. If the landscapes of CLAUDE, SALVATOR, of TITIAN, REMBRANDT, and the POUSSINS, may be termed poetic—and who would withhold from them the beautiful epithet?—what phrase shall be applied to the ambitious and magnificent works of some of the landscape-painters of our own times and country? "One pursues the vast alone:" a daring ingenuity propels mechanism and science into the world of ideality—a gigantic conception is built up of infinitesimal particles—the fancy wanders uncontrolled amidst interminable architectural piles of poetic perspective, immeasurably multiplied and stretched to infinity—palace rises above palace, whose marble floor contains a city's entire population, whose golden roofs and battlements pierce beyond the highest of heaven's clouds:

> " Not Babylon,
> Nor great Alcairo such magnificence
> Equall'd in all their glory, to inshrine
> Belus or Serapis their gods, or seat
> Their kings, when Egypt with Assyria strove
> In wealth and luxury."

Innumerable touches of sparkling light, and splendid colour, express the movement of an army, the panic of Belshazzar's court, or the annihilation of a world. A sulphurous light indicates the immediate presence of an avenging or a protecting God, to smite Nineveh, or to aid Joshua by a miracle. Wonder-exciting, novel, comprehensive in design, minute and exact in detail, a series of biblical pictures appealed at once to the imagination, and the religious faith of the British public. Poetry in art was identified with the marvellous—the simplicity of nature was for the time superseded by the illusion of scenic splendour, as better illustrating the text of scripture, and the inventive powers of the fancy.

Much true poetic feeling, revealing itself in beautifully-painted landscape of a solemn tone of colouring, appropriate to subjects of awful sentiment, has been shown to us in the works of DANBY, being equally elevated in design with those alluded to above, and less equivocal in their claims upon the admiration of the connoisseur. Such are the grand pictures exhibited at the Academy, of *The Destruction of Pharaoh's Host in the passage of the Red Sea, The Opening of the Sixth Seal*, from Revelations, and *Sunset after a Wreck at Sea*.

A third, a still mightier master of the magical powers of landscape, whose genius disdains shadow as a source of excitement, radiates before the eye in a universal spread of sunshine. The sentiment of historical or poetical subject is unfolded by the visionary charm of atmospherical colour. Thus, in the large picture, which may be considered a *chef-d'œuvre* of the artist,* *The Decline of the Carthaginian Empire*, the splendour, the luxury, the sinking grandeur of Carthage, are finely expressed by the brilliancy of the setting sun, which gilds with a transient lustre the architectural glories of the city, and beautifully illustrates the moral state of an enervated race. CLAUDE himself, in his most classic compositions, has not surpassed the great

* This picture was exhibited at the Academy, in 1817. Will Mr. Turner test his reputation by that year's produce, or by his freaks of fancy in the last exhibition?

qualities of this picture. Our distinguished academician is not always
so happy in the elucidation of his subject, *Ulysses deriding Polyphe-
mus*, by any other name, would look as sweet. The mind is directed
to a subject replete with materials of the most romantic character.
The islands of the Cyclops, where

——— " stretched beside the hoary ocean lie
Green meadows moist, where vines would never fail."
The foreground
——— "fast by the sea,
A cavern lofty, and dark-browed above
With laurels :
——— fenced with stones from quarries hewn,
With spiry firs and oaks of ample bough."
Polyphemus,
——— "a giant vast, hideous in form,
Far less resembling man, by bread sustained,
Than some huge mountain-summit."

All these particulars, which the fine spinning brain of the poet had
so carefully turned into shape, and given a local habitation, the caprici-
ous painter has dissolved again into thin air, an insubstantial pageant. A
purple mist envelops rock, ship, and man.

"The eastern gate, all fiery red,
Opening on Neptune with fair blessed beams,
Turns into yellow gold his salt-green streams."

An artist who takes such liberties with the poets, is not likely to be
over scrupulous, when commissioned to paint views of gentlemen's
houses. Sufficiently puzzled have been the matter-of-fact ideas, of
various wealthy landed proprietors, when beholding this painter's ver-
sion of their mansions and parks. The removal of a clump of trees, or of
a building from its exact position, is an employment of little difficulty
and less compunction with the artist. He considers it rather a virtue
to change those relative situations, which appear criminal in the eye of
taste. An accusation is preferred against the fanciful painter that he
perverts the truth. Truth, however, in this respect, as well as in sub-
jects more ethical, chameleon-like shifts her aspect, appearing to the
organs of one man coloured in bridal splendour, and in the eyes of
another, attired in modest green or monotonous gray. " That picture
is very beautiful," said an acquaintance of the artist to him, regarding
one of his works, " I only wish it was more like nature."—" Do you
not wish nature was more like this?" replied the other. Such is one of
the most original and poetic of living landscape-painters. Showering
from his palette golden dust in the eyes of connoisseurs, as if to
dazzle and confound—charming the fancy, delighting the eye by a
lavish display of colour, the clearest brilliancy of light. Now sweet
and harmonious, now meretricious, now delicate, now coarse, at once
magnificent and absurd. Subject, propriety of detail, minute distinc-
tion of form must submit to the deluging influence of his fancy. How-
ever precise may be the first outline, the last operation appears the
abandonment of all discretion—with the knife, with the brush, or the
hand, tints are spread, light heaped upon light, colours opposed or
harmonized, as if chance or magic effected their consummation—or the
uncertain flowing of the material waited the watching eye of its master,
to be struck with sudden meaning and tasteful order springing from confu-

sion. That his style is dashed with vicious qualities, there can be no doubt, but not to these is the charm due, which is acknowledged by all persons of finished taste and knowledge of art. If nature would disclaim the whole possession, she would assert her right to the finest portions of his style—to the breadth which is her own teaching, to the purity of tint and dazzling splendour ; nor would she resign her share of the poetic character of his works, for an effect is not necessarily unnatural, because it is uncommon, nor need colouring be false, in order to be brilliant. The decision must rest with those who possess in the highest degree knowledge of art and an imaginative temperament, taste and an eye for nature. It is no small compliment to the powers of this eminent man, that frequently, when an unusual loveliness and visionary beauty invests an actual scene of rock, wood, and water, or architectural composition, an involuntary exclamation bursts from the lips of the beholder of " How like Turner ! "

Colour, as an art, bears the same relation to the eye as music to the ear. The word harmony is applied to both—the perfection of each depends upon the same sensibility of mind and exquisite touching of the faculty. This may be understood by the amateur of music, however indifferent he may be to that which meets his eye, if he will conceive for a moment the same sentiments may be produced, an equal degree of delight and elevation of feeling, by a certain combination of tints with that which he may experience from fine musical compositions. What would Paganini think of a person incapable of distinguishing between A flat and D sharp ? or what would ETTY say of another who should be unable to distinguish the colour of his own coat ? Would they not both consider in such cases " wisdom at one entrance quite shut out ?"—

> " Offspring of holy light !
> Bright effluence of bright essence !"

Colour confers a new beauty and glory upon art—a new blessing to the eye—a fresh impulse to the imagination. Nature, so prodigal of this charming property, unfolds in its display to the artist, with the principles of harmony, the characteristics of joy and love—of pathos and the sublime. Thanks and honour to the painters for the music, the poetry of colour !—To TITIAN and REMBRANDT, for their richness and organ-like depth of tone — for their golden solemnity, delicious harmony, warmth, and brilliancy !—To PAOLO VERONESE, for his airy gaiety, silvery skies, and beautiful balance of local tints !—To REUBENS, for his peach-like bloom, his vivacity and splendour, pearly moisture, exuberance, and lavish expenditure of his palette's treasures !—And last, not least, to our dear Sir Joshua, for his strawberries and cream !*

No painter ever possessed a stronger passion for colour than REUBENS —his delights were, indeed, dying—" dolphin-like "—they sport above the deep element wherein the minds of more solemn thinkers germinate —not to be controlled by the subduing spell of the pathetic or the awful, his subject was lifted into the ideal world by the charms of a thousand hues ; and with the fancy of a poet he expounded from his palette the mystery and beauty of the chromatic language. His pictures swarm with beings " that in the colours of the rainbow live and play i'

* An eminent critic on art has said, in allusion to Reynolds's colouring of the flesh, he painted as if he had dipped his brush in strawberries and cream !

the plighted clouds "—bursting with life, motion, and vigour—teeming with the wanton growth of primeval nature—radiant as sunrise, juicy as fruit " ripe for use." What a picture is the Silenus! How very drunk is the white-bearded gorbellied preceptor of Bacchus! how brimful of rustic mischief and fun the group of fauns shouldering him along! A wild and beautiful girl squeezes a bunch of grapes over the rubicund huge hill of flesh; the glittering drops slip down his hairy breast like dew over the hide of a boar.

A scene occurs to us at this moment as described by Shakspeare, from whom, indeed, extracts might be made illustrating the various tastes of all the painters, which brings so vividly before the mind's eye the unrestrained style of Reubens, that we cannot help quoting it, particularly as, not being a passage from his plays, it may come fresh to the generality of readers. The subject is Venus meeting the boar which had just killed Adonis :—

> " And with that word she spy'd the hunted boar,
> Whose frothy mouth bepainted all with red,
> Like milk and blood being mingled both together;
> A second fear through all her sinews spread,
> Which madly hurries her she knows not whither.
>
> " Here, kennel'd in a brake, she finds a hound,
> And asks the weary caitiff for his master ;
> And there another, licking of his wound,
> 'Gainst venomed sores the only sovereign plaster ;
> And here she meets another, sadly scowling,
> To whom she speaks, and he replies with howling.
>
> " When he had ceased his ill-resounding noise,
> Another flap-mouth'd mourner, black and grim,
> Against the welkin volleys out his voice ;
> Another and another answer him,
> Clapping their proud tails to the ground below,
> Shaking their scratcht ears, bleeding as they go."

In the same era were produced a sculptor and architect, a painter and a poet, so mighty in their genius, so nicely balanced their various powers, it seems that nature, in giving SHAKSPEARE to England, had wished to preserve her impartiality, by bestowing upon Italy MICHAEL ANGELO and RAPHAEL. The poetic mind was at once poured in its brightest splendour through the medium of the arts, literature, and the stage. The poetry of art towered to its meridian in the ceiling of the Sistine chapel. It triumphed when the painter of the Prophets and Sibyls triumphed over the low envy of Bramante, and the impatient Pope and crowd of cognoscenti rushed through the dust caused by the removal of the scaffolding, and gazed with wondering eyes upon the greatest achievement known of the mind and hand of an artist. The intellectual greatness of art also triumphs in the Vatican, where the angelic genius of Raphael, whose name is familiar as a household word in lands far removed from the scene of his labours, presides in princely dignity the acknowledged sovereign of the pictorial world. It is hard to pass such high examples of the poetic in art with brevity ; yet is it unnecessary, at this time of day, to attempt to add to the many and fine things which have been written and spoken upon the characteristics of M. Angelo and of Raphael. The imaginative temperament of their genius is visible even in the most indifferent copies of their works—it has formed

the inspiration of successive generations of artists, some of whom have built thereon a temporary, and some a lasting reputation for themselves. From these instances, one great principle may be learned—taught also by our Shakspeare and Milton—viz., no restriction is imposed upon the imagination by the study and imitation of nature—for ideality is but a splendid folly without such poise. The dilated contour of M. Angelo impresses greatness of style upon an anatomized limb—the most trifling sketch illustrative of the elements of knowledge shows indications of the winged mind which expands every fibre when it unfolds its entire breadth. Grandeur was the element of Michael Angelo—grace that of Raphael. The last exhibits more beauty, more variety, more dramatic power; it is enough that Michael is sublime. Yet there is beauty, awful beauty, in the Delphic Sibyl, and the Prophets are as various in character as the similarity of their occupations will allow. It is curious that a work which the greatest sculptor undertook so reluctantly, and would have altogether avoided upon the plea of never having painted in fresco, should prove so glorious for his reputation, so overpowering to his enemies. It is also a curious fact, that during the pontificate succeeding the death of Julius II., the great patron of M. Angelo, the latter was employed in doing nothing more than in superintending the quarries of Carrara. Had Leo X. been the sole patron of our artist, into what mean channels might not his imagination have been forced! How many mute, inglorious Miltons, may be at this moment writing leading articles in daily and weekly newspapers!

The arts might have remained at the point in which they were left in Asia and Egypt, had not the Greeks discovered this ideal beauty and expression of character, so conspicuous in their sculpture. From the first advance beyond the earliest efforts known to us, made by Dædalus, to the time of Phidias, a period of nearly four hundred years, art in Greece had progressively advanced towards that ideal beauty through all the stages of emblematic representation. At length a marvellous light burst full upon it—a divine revelation seemed to descend and chase the darkness of error. The enlightened artist dispensed with all that was not consonant to nature, and assembled whatever was found most perfect in that nature itself. The gods were made after the image of man, freed from all brutality; and divine character was mirrored in human proportions. By these beautiful examples of form, grace, and expression, the taste of all succeeding ages has been modified:—

" In form and moving, how express and admirable!
In action, how like an angel!"
" The beauty of the world!
How this grace speaks his own standing!
What a mental power
This eye shoots forth! How big imagination
Moves in this lip! To the dumbness of the gesture
One might interpret."
" Hyperion's curls—the front of Jove himself," &c.

In associating the foregoing extracts with the abstract of man's form, it is impossible to avoid applying them to the antique. Taken apart, they are like so many grand fragments of an age which produced the Jupiter and Apollo—they contain no allusion to colour, which is an additional reason for affixing them to poetic sculpture.

The taste which excludes the imitation of colour in an art devoted to form, which deprives the eye of its flash, the hair of its texture, seems, to our notions, more refined than that which would paint the marble statue and fill the sockets of the eyes with precious stones. If such aping of nature were desirable, Madame Tussaud might rival Canova. It is the privilege of sculpture, in its most dignified character, to recede from the familiarity of rigid imitation. We recognise the characteristics of the human being in the statue which yet appears not of the earth. There is in its aspect

> " Elysian beauty, melancholy grace,
> Brought from a pensive, though a happy place."

The mortal clay has put on immortality ; the frail flesh is translated to unchanging stone ; the voluptuous is refined ; the heroic is sublimated ; the grand is hallowed. A comprehensive perception triumphs over trivial imitation. One great attribute of nature is sacrificed to achieve the perfection of another, and the absence of colour is the poetry of form.

Whatsoever is most elevated in the contemplations of the mind, will meet with support by its adhesion to all which is greatest in art. Nothing is so mean in nature, which ideality may not mould to a fine purpose—nothing is so great in art, that its germ cannot be found in nature. Imitation begins, imagination completes. Deprive art of its poetry, you kill its soul ; enrich it by the co-operating powers of invention, the sphere in which it may act is immense, the progress it may make is illimitable. Imagination is an exquisite, yet a dangerous faculty : allied to folly, its power is madness ; to reason, taste ; to vice, deception ; to knowledge truth ; to genius, inspiration. Its retrospective glance refreshes the desolate regions of antiquity ; the millions who have died, are uplifted from the dust, and on the present is thrown the refracted splendour of the past. Ignorance has misapplied, knowledge has directed its miraculous light. To this age—to the future, may belong the honour or the disgrace of uniting with or separating from the graces of the imagination, increase of knowledge, enlarged science, improved mechanism. That the spirit of poetry will ever be entirely banished from the earth, whilst ideality remains a part of the human mind, is impossible. Without the aid of the mightiest powers of this quality art will never be great as of old, will never rise to dignity, to consummate beauty, or include the sublime as a moral agent. The ground of its exercise must be shifted, the subjects, the stimulants, must differ from those of a bygone age. The insatiable thirst for novelty, the ever-active propensities for wonder and delight, exact from genius, wherever it may appear, new exertions of the imagination, phases of its glittering orb hitherto unbeheld.

The subject entered upon in this essay, admits of amplification more extensive than the limits afforded by the present publication will allow. It has been necessarily compressed, and many illustrious names* and works consequently omitted. The ground has been broken only, but the writer has in store a fund of materials for a renewal of the theme, should it be required. ECHION.

* The American painter ALLSTON, who exhibited at the Academy formerly, displayed a fine poetic feeling in pictures. The *Jacob's Dream* and *Uriel* will not be forgotten by those who have seen them,

"The Royal Academy.
The Seventy-first Exhibition. 1839"

Art-Union 1 (May 1839), 65–71

THE ROYAL ACADEMY.
THE SEVENTY-FIRST EXHIBITION.
1839.

FOR nearly three quarters of a century "THE ROYAL ACADEMY" has presided over the Fine Arts of Great Britain. In the year 1839, we are not called upon to explain the circumstances out of which it arose, the earlier struggles against which it had to contend, or the objects for the promotion of which it was expressly chartered. The public have been supplied with abundant information upon this topic, both from friends and enemies—but most largely, if not most liberally, from enemies. As, however, this is the first opportunity we have had of expressing our sentiments on the subject, we shall not consider ourselves "out of order" if we occupy some space in contributing to the materials which already exist for ascertaining the merits or demerits of an Institution, the only one in the kingdom, representing the Arts, incorporated by Royal Charter. We are, indeed, anxious to do so; because, notwithstanding that so much has been said and written,—that a close and searching parliamentary scrutiny has gone through its books—that its officers have been examined before a committee of the house,—that every tittle of evidence against it has been raked up from every quarter,—that its opponents have given private lessons for the instruction of its prominent and influential adversaries,—that, in short, prodigious efforts have been made to excite popular prejudice to its injury, and that such efforts have notoriously failed;— occasional attempts are still made to lower it in public estimation, to show that its original formation was impolitic, that its existing arrangements are unjust, and that it influences the Arts of the Kingdom, not for their benefit, but to their injury. Within the last few weeks, two or three pamphlets, taking more or less this unjustifiable view, have been laid before us,—one, being the report of "A Society for obtaining free access to Public Monuments, &c.;" another "A Letter to Sir Martin Archer Shee," by the Secretary of the Art Union of London,—a gentleman of considerable attainments and desirous of being a fair and honourable opponent, but who has adopted some of the notions we consider erroneous. In the first-named publication, hints are conveyed that Parliament will be again called upon to interfere in the affairs of a society with which it has no more to do than with the rights and privileges of any private gentleman. Moreover, no fewer than five letters have been transmitted to us, expecting, and in one case insisting, that we should appear in the ranks of its enemies. For these reasons we conceive ourselves bound to express our opinions fully, freely, and without reserve. We know that we shall receive no thanks from the Academy for so doing. That body has always most unwisely, if not absurdly, professed indifference to the comments of the Public Press; they have made enemies of many who might have been friends—or, at least, have remained neutral; and have seemed rather to court than avoid the hostility of those who direct the opinions of thousands. In their desire to shun the semblance of walking through by-ways to public favour, they have gone to the opposite extreme, and have seemed to treat with contumely those who, after all, are the only channels by which public favour can be dispensed. Much of the bitterness manifested towards them may be traced to this source. We are, therefore, perfectly aware that our task of defending the Royal Academy will be without thanks—but we shall discharge our duty none the less. We have no partialities to mislead us on the one hand, nor have we prejudices to overcome on the other. We desire, by every means in our power, to aid in establishing the Royal Academy in public confidence; because, by so doing, we advance the interests of British art, of which they are the appointed guardians; and, because, we entirely and conscientiously believe that no body enjoying "a monopoly" has ever used power so little for their own objects, or so much to forward the great design for which they were incorporated.

The circumstance we have referred to, while it has left the Academy open to attack, has prevented the public from ascertaining on what it rests for defence; consequently there is still a great degree of ignorance abroad, in reference both to what it does and what it does not; and sins, both of omission and commission, are perpetually laid to its charge. It is a common opinion that to some extent at least, it is maintained by the Nation; and that its funds are expended by the members only upon themselves. The President has, indeed, put forth two or three pamphlets to set these points at rest; but he knows how difficult it is to induce the general perusal of publications of the kind. We speak what we know, when we assert that many who ought to be better informed believe the Royal Academy to derive funds from Government, and to devote these funds only to their own purposes. Can it be matter of surprise that this impression prevails, when we hear a member of parliament at a public meeting saying what is tantamount to the former, and infers the latter?

Mr Hume has laboured—and, perhaps, effectually —so to confuse facts regarding it, as to render it difficult for the truth to circulate. The hon. gentleman is, if we may so express ourselves, *constitutionally* ignorant of all that appertains to art; we doubt if he can distinguish the style of Howard from that of Etty, or indeed if he has ever heard, so as to notice, the name of either; but he has placed himself forward as the leader of certain "discontented and repining spirits," endeavoured to give a political taint to its Charter; to rouse a spirit of animosity against it; and to remodel it, in accordance with the suggestions he receives from persons interested in its destruction.

We conceive, therefore, we shall discharge our duty to the public, if we put them in possession of the true facts upon which the Royal Academy rests

its claim to the support it has so long received—the only support, indeed, it has ever asked for, or wished for; but not the only support it ought to have obtained; for we hold it to be discreditable to our national character that no grant of public money has ever issued from the Exchequer to encourage and improve the arts of Great Britain.

First, then, as to its funds : the Public has never been called upon to support the Academy ; it receives nothing from Government, except the loan of a suite of rooms. These rooms are now part of the National Gallery ; but they belong to the Academy as justly as if they had been purchased and paid for. Their original residence they received as a gift from George III—such residence being, at the time he gave it, his Majesty's private property. And when, subsequently, he disposed of that property to the Nation, he expressly stipulated that apartments in lieu thereof, should be fitted up for, and appropriated to, the Academy in Somerset House. Their removal from Somerset House to Trafalgar square may have been beneficial to the members, but the transfer was also a public convenience. The apartments they formerly occupied they have resigned to the Crown. Its income is derived solely from its annual exhibitions ; the sum thus collected is disbursed in payments for the maintenance of the schools, in salaries to professors, keeper, librarian, and secretary, and the necessary servants ; for the delivery of lectures ; for the prizes distributed every year ; in maintaining a student on the continent ; and, above all, in supporting decayed artists, their widows, and children—not the widows and children of members only ; large sums have been distributed among those whose only claim upon it, was that they or their progenitors had been meritorious labourers in the profession. A sum of 300,000*l.* has been raised by the Academy, since its foundation, from one only source—its annual exhibition. For nearly half a century, there was no other institution for educating artists ; no other " charity " to which distressed artists could apply for relief; and both projects were largely accomplished without a call having ever been made upon the Country to assist in forwarding objects in which the country was deeply interested ;—England being, we believe, the only civilized nation of the world which has never granted money from the public coffers to accomplish a purpose not deemed alone desirable, not alone honourable, but necessary ; necessary to extend its fame, to improve its citizens, and to uphold its intellectual rank.

Serious objections are made, first, to limiting the number of members; next, to the manner in which they are elected ; next, to its mode of government, and next, that the best candidates are not always chosen. Probably, as artists have so largely increased of late years, it might be now desirable to add to the body. We say probably ; for it is at least problematical. The distinction would be less coveted and, consequently, less *laboured* for, if it were of much easier attainment ; and it has been rarely found that a painter of high merit has had to wait very long before he " took honours." The society now consists of forty; if ten were added to it, there may be, at this precise moment, ten

justly entitled to the promotion ; but there have been several years when it would have been very difficult to find so many who unquestionably deserved it ; and to select from among such as were below the line of mediocrity, would have been an onerous and painful task, and have given universal offence to the excluded—among whom there might have been dozens with pretensions quite as lofty.

The recognition of Associates is also objected to as a distinction degrading rather than elevating ; but this objection will, we think, have little weight when it is borne in mind that they are, in point of fact, simply in the position of candidates for admission—a formality absolutely essential in all public bodies ; and without which it would be impossible for a society to know with accuracy where to recruit its ranks. The Engravers complain, with some show of justice, that they are incompetent for promotion ; but upon this topic there is a strong difference of opinion among engravers themselves ; and certainly they are so very numerous that to select a few from them might be invidious, and prevent their doing that which they are now about to do—forming a Chartered Institute of their own. It should also be recollected—as a consideration of some value—that engravers have abundant opportunities of exhibiting their works. Every street of the metropolis enables the public to become familiar with their style and merits—an advantage which the painter cannot have. The subject is, however, one which involves so many points, that we cannot at present think of discussing it.

The Academy is governed by a President and a council of eight, who are chosen annually. There have been four presidents—Reynolds, West, Lawrence, and Shee. No complaints have been made against either the policy or practice of the three first of them ; and if it has been considered that when the last vacancy was filled up the Academecians might have chosen a Painter of higher attainments in art, it was the universal opinion that no one could have been selected better fitted to represent the body in all cases where conciliatory courtesy, scholarship, habits of business, zeal for his profession, and high and upright character, were deemed requisite. Sir Martin Archer Shee has given abundant proof that his brethren, in appointing him, made a most wise and prudent choice. When there is a vacancy in the Academy, the whole body elects to it, and the elections are by ballot. It is obviously the *interest* of the institution to select from among the candidates the artist who is most distinguished, inasmuch as its funds being dependent solely on the attractions of its exhibition, it is essential to secure the co-operation of the most approved and popular painter. That they have done so within the last five or six years is admitted on all hands. Who among the candidates for election as associates have been more " approved and popular " than the eight elected during that period—Maclise, Hart, Knight, Patten, C. Landseer, Ross, Roberts, Westmacott ; or, who among the associates have been more worthy than Gibson, Stanfield, Uwins, Wyon, Lee, Briggs and Allan ? It is certain that, with one or two

exceptions, and these from circumstances easy of explanation – the leading one being that a long-ago pique prevented the artists from " putting down their names " as candidates for admission—no artist of high and acknowledged ability has been passed over to make room for one less esteemed, or less deserving.

Some years ago a frequent complaint was made, that gross favouritism was shown in " hanging " the pictures ; and beyond doubt occasionally a meritorious work was fixed either too high or too low, while one of a less worthy character was placed on a level with the eye. Such instances, however, were rare ; they were loudly commented upon when they did occur ; while but little notice was taken of the fact, that many painters, perfectly unknown and without influence, had stations assigned to them which they would themselves have chosen if called upon to do so. We might mention many cases in point ; but our safest course is to draw attention to those supplied by the exhibition of this year. " On the line " the visitor will perceive paintings, all of large size—we do not take into account those of smaller dimensions — by Douglas Cowper, John Wilson, jun., J. Hollins, J. Severn, T. Woodward, A. D. Cooper, R. Redgrave, R. S. Lauder, J. Renton, T. Creswick, G. Lance, W. Simson, J. Wood, A. Fraser, F. Grant, H. O'Neil, F. P. Stephanoff, H. P. Parker, and several others ; while above and below " the line " are many works by members and associates.

In the earlier part of these remarks we made reference to two publications, having for their common object certain changes in the character and constitution of the Royal Academy. The one which bears the signature of the Secretary of a " Society for obtaining free access to Public Monuments," is unfair and disingenuous. His design is to confound the Academy with the Tower and Westminster Abbey—the property of the Nation ;—although, as we have shown, and as he cannot but know, the right which may be admitted as regards the one cannot be contended for with respect to the other. We are by no means satisfied that, even if the Academy consented to give up its only source of income — to dismiss its lecturers, to recall its students, and to shut the doors against all applicants for charity—that any real benefit would result to the community at large. It is not however designed, we imagine, to go quite so far ; but that, according to the milder construction of Mr Edwardes, the public should be admitted free " during a certain period." Now we believe there are very few of " the people" unable to pay one shilling once a-year, who care to examine works of art ; the tax is so trifling as to be no grievance ; and we venture to assert, that, if the rooms were thrown open " for a certain period," all who had decent habits and feelings would prefer to visit it—paying their shillings—to the sort of beggarly admission against which independence revolts. Such would not be the case, if the right of entrance-free were *universally* conceded ; but such it would assuredly be, if such right were only " for a certain period." Either the gallery would be empty on such occasions, or it would be filled

with half-brutalized gazers, who could receive neither instruction nor enjoyment from the sight. John Bull has an honest pride of his own, and does not like to be distinguished from the more substantial citizen, as the man who is to get his treat for nothing. We contend then, that unless admission were made free to all without distinction, and for the whole period of the exhibition, no good could arise to any ; and we argue, farther, that if this principle were applied to the Royal Academy, it ought to be applied to every other exhibition—talking singing-birds, dioramas, wonderful giants, Polytechnic Institutions, and what not. The project of the " Society" has, we are aware, been partially acted upon—we have noticed the cases of Edinburgh and Newcastle—but free admission has been only given to public bodies, such as Mechanics' Institutes, and in no instance that we know to the public generally. The fact is, that the Secretary and " the Society" both appear to be less stimulated by a desire to contribute to the enjoyments of " the people" than to attack the Royal Academy, with a view to humbling it, and placing it in a disadvantageous position before the public. The assertion, that it " retards the progress of taste and civilization," is meant to imply more than that it refuses to dispense with its shilling fee, and is one of the modes by which it is sought to disseminate prejudice against it. The pamphlet which Mr Edwardes, the Secretary to the " Art-Union of London," has printed " for private circulation," has been written with a very different feeling. He is at least a generous opponent, and *aims* to be a just one. His principal project for removing complaints and renovating its constitution, is to place the management of the " Exhibition" in the hands of an " elective" body, chosen by the whole of the exhibitors, of a certain standing. How many are to compose the body he does not inform us ; whether the members of the Academy, being " exhibitors," are eligible to be included in it ; neither does he enlighten us as to what he means by " a certain standing ;"—whether such men as we see, for the first time this year, climbing suddenly to the topmost branch of the tree, are to be excluded from it ; how the election is to take place ; whether the elected are to have any acknowledged head to guide them ; and if not, who is to arbitrate in case of squabbles, and decide in the event of differences irreconcileable ; whether " most votes are to carry it ;" and if so, whether the votes are to be taken when all the hangers are present, or when only one hanger is by ; whether they are to be responsible or irresponsible, and if the former, to whom ; whether they are to be known or unknown to the public ; whether they are, or are not, to be paid for some three weeks of incessant, irksome, and thankless labour ; whether each person elected is to be *compelled* to act " will he nill he ;" and when all is done, which of the hangers an ill-used artist is to call to account for undertaking a task he was not forced to undertake as a part of his duty. In short, a more visionary scheme was never, we think, proposed ; it is so obviously absurd that we marvel a gentleman of taste and ability could seriously propose it and consider his proposition as " at once just,

practicable, and perfectly safe, as regards all existing interests." Yet this is Mr Edwardes' panacea for all the evils which beset the Royal Academy. With how much greater pleasure do we transcribe from his pamphlet the following passage :—"Far from entertaining any sentiment of hostility to the Royal Academy, I can view it with no feelings save those of gratitude for the past and of confident hope for the future. That it greatly needs alteiation in some of its features, I regard as but the inevitable result of social progress; nor can I at all understand that new and mysterious doctrine of "free trade in Art," which, contrary to all experience, proposes to advance the Fine Arts by depriving artists of the most important of the meagre honours they at present enjoy, and by destroying that school which has, at least, trained a very considerable proportion of the best artists who have at any time adorned our country."

"Some of its features" may, no doubt, be improved, — there may be many matters worthy of consideration with a view to change ;—we have no doubt they have received it ; but, after all, they are very minor in their nature and their consequences.

We hope that this article may not be misunderstood ; we have nothing to hope or to fear from the Royal Academy. As we have intimated, they affect indifference to the opinions of the public press; it is the only society which extends no privilege to its conductors, forgetting altogether that what *must* be done ought to be done well—that to do it well all reasonable facilities should be given, and that to examine their Exhibition, in the midst of a dense crowd, is wearisome, disheartening, and unfavourable, both to the critic and the criticised. Our opinions are put forth in the conscientious discharge of our duty. We have already, occupied a larger space than we can well spare ; but we think the public will scarcely complain that a Journal, asking its confidence and labouring to deserve it, should endeavour to place in a just and favourable light an Institution which, for nearly two-thirds of a century, has sustained, improved, and advanced the arts of Great Britain—almost alone and altogether unassisted. Without going the lengths of Lord Shaftesbury and the scholars of his training, and pronouncing that "taste and the moral sense are one," and that an appreciation of The Beautiful is the sure associate of Virtue, who can doubt that, to cultivate a feeling for the graceful and refined—to familiarize the mind to what is TRUE in Nature and in her copyists—to stir the heart and the fancy by depicting the pathetic and the humorous—to excite honourable ambition and emulation by presenting forcible records of national glory—to stimulate exertion in the highways that lead to fame, by continually placing before the aspirant examples of its achievement—are so many effectual modes of education, so many aids in forwarding the great cause of humanity—so many objects, in the strongest and best sense of the term, "NATIONAL!"

We have now to introduce our readers to THE EXHIBITION for the year 1839—the Seventy-first Exhibition of the Royal Academy. We do not hesitate to say that it is altogether SATISFACTORY.

It contains few pictures of an absorbing character ; there are none, perhaps, on which the eye fixes and the mind dwells, to the exclusion of all others ; but there is abundant proof of a safe and sure progress in our British artists. We are at once conscious that a more *general* excellence prevails, that a meretricious character is rapidly disappearing, and that our students have learnt to know that Genius cannot succeed without the help of Thought and Industry. We look around the walls, and we are at once struck with the change that has taken place within a few years ; the white garish hues have given way to a deeper and sterner tone of colour. On examining, we ascertain the cause of this :—our artists have laboured, have studied, have reasoned, and reflected ; opportunities for acquiring KNOWLEDGE have been placed within their reach, and they have been seized and applied to purpose. While there is no falling off in the great masters, there are proofs of excellence in the younger spirits they have taught. No three years put together of the last century have produced so many high class pictures by exhibitors hitherto unknown or not known very advantageously. The Exhibition of 1839 is therefore the most "satisfactory" which this country has yet witnessed ; because it affords evidence, not only of existing talent of the highest order, but of improvement, not to be mistaken, in the junior members of the profession ; we say this without the fear of contradiction by any who will go carefully, and in a fair spirit, through the rooms. We cannot expect our views will be those of persons who glance along the walls, stroll about for an hour, find that Mr This has not outdone himself, and that Mr That has not surpassed his former efforts, and depart with a murmur that the collection is "an average one." Such is not the way in which it should be judged, but we lament to say that so it has been judged ; and thus our national character is lowered by the very persons who should uphold it. This is cause far more for sorrow than for anger. Our judges decide, but will not examine—sentence, but will not hear.

We have but one circumstance to regret connected with the Exhibition ;—it contains no work of Hilton's, beyond question the greatest historic painter, not of the country, but of the age. Can it be possible that the artist has had no "commission" during the past year, and that he is "weary of well doing" in the absence of adequate recompence ? If so, how sadly must our national pride dwindle ; if dogs and horses, foolish faces, and brute beasts, are painted "to order" and make their producers rich, shall we boast, therefore, that we, as a people, know how to estimate art, and covet the distinction of acknowledged excellence ? Where be our wealthy nobles, our rich merchants, our princely traders? What are our public, our "national," institutions about? We trust that our apprehension is erroneous, and that we must attribute the absence of Mr Hilton from these walls to any cause but the want of encouragement. We are almost selfish enough to hope that it has arisen from illness, and that we may find some cause more tolerable than that of our national dishonour. Callcott is also an absentee—so is Chantrey—so is Stanfield—so is Roberts ; and although there are many valuable contributors among the younger

aspirants, they cannot make sufficient amends for the loss of these five. It is understood that the accomplished lady of Sir Augustus Callcott has been so dangerously ill that his mind has not been of late turned to his profession. Mr Stanfield has but recently returned from a long tour in Italy; and Mr Roberts is travelling in the East. Why Sir Francis Chantrey has not added to the exhibition we cannot conceive. He is sadly missed from the sculpture room.

THE EAST ROOM.

No. 5. ' Portrait of Lady Mordaunt;' Mrs Carpenter. One of the most gracefully managed and ably painted portraits in the collection. The lady is stately and beautiful, and the artist has deemed it unnecessary to associate with her fair [form those extraneous " aids " which are so frequently considered advantageous to a picture. There is nothing but the portrait, and a sober back ground; no glaring red or gaudy green curtain has been introduced, hanging from an awkward pillar, or a budding tree. There is a degree of classic simplicity in the arrangement;—it is painted with great skill, and manifests a thorough knowledge of the capabilities of art in dealing with subjects not always calculated for it. We may take an early opportunity of entering our protest against the silly and groundless objections so frequently urged against portrait-painting. Leaving out of sight the gratification it so largely produces, the beneficial examples of which it is so fertile, and its enviable privilege of perpetuating the memories of the great and good, or the merely beloved—as a branch of art it is entitled to the highest respect and admiration. To produce a fine and effective portrait, is perhaps, the most difficult task in the whole range of the profession. Ten fail for one who succeeds. It requires qualities rarely combined, and such as have been obtained only by persons of the very highest genius. Among the richest and most prized productions of the old masters, portraits hold a very foremost rank, considered merely in reference to their character and value as works of art.

No. 6. ' Scene from the Burletta of Midas;' D. Maclise, A.R.A. Sileno is described as introducing the disguised Apollo to his wife and daughters. The old woman greets him with abuse, the young girls murmur their delight—" so modest, so genteel "—while Apollo sings,

" Pray goody please to moderate."

And this is certainly an exquisite picture, full of point and character; the scolding looks of the mother, the archness of her daughters, and the vexation expressed by Sileno, are capitally expressed. The minor details are all admirably made out. The colouring is no doubt too slight, and, perhaps, cold; but with the conception of the work, and its arrangement, no fault can be found. There is no question but that the next member of the Royal Academy will be Daniel Maclise. He is still a young man—his years, we imagine, are under thirty—and he has established his position as a leading artist of the age. From one who has already done so much, how

much more may be expected ! His course has been one of progressive excellence.

No. 13. ' River Scene, Devonshire ;' F. R. Lee, R.A. An excellent landscape, truly and characteristically English. A humble cottage nestles under lofty trees ; at the foot of it rushes a miniature cataract, down which some peasants are labouring to drag the trunk of a huge century-old denizen of the forest. The picture is somewhat broken into bits ; it seems to want a concentration of light, but it is well designed, and executed with considerable vigour. The artist is always bold in the use of green colour, but we think never injudiciously so.

No. 20. ' The Broken Heart !' J. P. Knight, A.R.A. A very touching picture of a deeply touching scene. The young girl is dying—dying of that disease for which there is no cure. Her weeping sister looks sadly and hopelessly on her—she knows her secret ; her parents are seeking consolation from the Bible, but the mother's thoughts are away from the sacred book and with her stricken child, to whom she turns her mournful gaze; even the little dog sympathizes with the sorrow he cannot dispel. The principal figure is admirably, though disagreeably, true—the wasted form, the woe-worn features, the wandering mind of the poor maiden, are full of pathos. " Is she thinking of her faithless lover, or of the church-yard," where she will soon soundly sleep ? The hands are of a livid hue—not white and bloodless, as they should be, but of an unnatural blue tint, as if they had caught their shadow from the drapery thrown around her limbs. Altogether, the picture is not one we should like to look upon often—an evil for which its good qualities do not compensate.

No. 41. ' Card Players ;' F. Goodall. A well composed and cleverly painted picture, representing the interior of a Normandy cabaret, with a group of French soldiers playing cards. The children, who play a pleasanter game round the tables' feet, are finely pictured.

No. 43. ' The Fighting " Temeraire" tugged to her last berth, to be broken up ;' J. M. W. Turner, R.A. This is, perhaps, the most wonderful of all the works of the greatest master of the age; a picture which justifies the warmest enthusiasm :—the most fervent praise of which cannot incur the charge of exaggeration. We pity those, if there be such, who cannot enjoy it as we have done. It is a painted " ode," as fine and forcible as ever came from the pen of poet; it will live in the memory associated with the noblest productions of those who have made themselves immortal by picturing with words. The venerable victor in a hundred fights is tugged to his rest by a paltry steam-boat, upon whom he looks down with powerless contempt :—the old bulwark of a nation governed and guided by the mean thing that is to take his place ! On one side is the setting sun—emblem of the aged ship—its glory tinging the clouds with brilliancy, but with little warmth ; while on the other is the young moon—type of the petty steamer—about to assume its station in the sky. The picture is, indeed, a nobly composed poem,—one to which the pen of genius can add nothing in the way of illustration.

No. 45. ' Forbidden Fruit ;' R. Farrier. A set of mischievous urchins are stealing apples. The story

is well told, but the colouring is cold and chalky, and does not afford proof that the artist is improving. His "thoughts" are better than his powers of execution. It is, we fear, because he neither studies nor labours as he ought to do.

No. 49. 'The Rencontre ;' W. F. Witherington, A.R.A. The rencontre takes place between the protector of a flock of goslings and a troublesome cur, who is striving to attack them, yelping and running round the pond which he fears to enter. The group of children, enjoying the fun, is painted with considerable care, and evinces much talent. The pictures of this artist are always pleasant, though not of a high order. He selects his subjects well.

No. 57. 'Who can this be?' C. R. Leslie, R.A. A title Mr Leslie has given to a work of the highest merit in design ; if he could colour as he conceives, he would be unrivalled in his age. A fair young dame of the olden time is leaning on the arm of an " approved good senior," to whom a gallant approaches and bows low. That he is the admirer, perchance the lover, of the gentle maiden, who can doubt ? This picture and its " companion" are the property of a gentleman—at once largely liberal and unobtrusive—who, in a quiet nook at Blackheath, has collected some of the rarest treasures of British art, and who has done more, in his own gentle and generous manner, to advance its true interests than half the magnates of the land ; a gentleman whose name every lover of art, except himself, delights to hear mentioned, and whose retiring habits unfortunately prevent the advantages that might arise from the influence of his example. These pictures of Leslie are worthy to be added to the choicest, if not the most extensive, collection in the kingdom. The artists labour for him *con amore* ; so highly is he esteemed, that he is sure to possess their best works.

No. 58. 'The Pride of the Village ;' J. C. Horsley. The same subject that Mr Knight has selected, but, of course, differently treated, and certainly not of inferior merit. The dying maiden leans on the shoulder of her sad mother. Her face is exquisitely painted ; it tells the mournful story of her life. Mr Horsley is among the young artists of the day who are rapidly rising to eminence.

No. 60. ' Portrait of the Earl of Aberdeen ;' Sir M. A. Shee, P.R.A. A finely painted portrait, by the President of the Academy ; a striking likeness of the noble lord, and an agreeable one ; just such a one indeed as we desire to see of men to whom the nation is indebted ; without exaggeration, without undesirable aid from fancy, and yet pleasantly preserving the features and exhibiting "the man."

No. 61. ' Sir David Baird discovering the Body of the Sultan Tippoo Saib, after having captured Seringapatam, on the 4th of May, 1799 ;' Sir D. Wilkie, R.A. What shall we say of this picture ? What but that we lament the expenditure of so much time to so little purpose, by an artist whose every scrap of covered paper is of value. It is not a work of the grand class ; it will add nothing to the fame of the great painter. In parts it is undoubtedly admirable, but as a whole it is A DISAPPOINTMENT. The principal figure is undignified ; we have seen bad actors often assume the position,

a sort of " My name is Norval" attitude, uneasy and ungraceful. The highlander and the figures in the foreground are unquestionably good and effective ; but where all cannot be praised there is much to blame in an artist whom the voice of society and the suffrages of his professional brethren have placed on the highest pinnacle of fame. We feel grieved when we consider what we have lost ; how many delicious pictures this large canvass has cheated the world of ; we shall be joined by tens of thousands when we entreat Sir David to leave these matters for weaker men, and paint again the scenes and characters which have made his name immortal, and that come home to the hearts of all who worship nature and appreciate art. We would not be understood as considering this work an inferior one —-it is inferior only because it is the production of Wilkie's pencil. It is beyond question the best in the Academy ; but this is not sufficient praise to satisfy us. It has been painted for the brave general's widow.

No. 66. ' Ancient Rome ;' J. M. W. Turner, R.A. Another of Turner's gorgeous works ;—a reckless example of colour, but admirable in conception, and brilliant in execution. The critics who protest against his using too much yellow, will this year have to complain of his dealing too much in red. As usual, he has introduced " a story" into his picture ; he describes " Agrippina landing with the ashes of Germanicus," and has summoned his fancy to restore the ancient glories of the eternal city ; to present to the spectators its triumphs of art, and the acts and persons by which and whom it was made immortal.

No. 69. ' The Princess Mary of Cambridge ;' E. Landseer, R.A. One of Mr Landseer's happiest pictures ; a sweet child giving lessons to a superb Newfoundland dog ; but it seems to us that the dog is exaggerated, or that the child is " small for her years." It is finely and carefully painted, and worthy of an artist whose works are " famous " all over the world.

No. 70. ' Modern Rome ;' J. M. W. Turner, R.A. A fine and forcible contrast to No. 66. The glory has departed. The eternal city, with its splendours—its stupendous temples, and its great men—all have become a mockery and a scorn. The plough has gone over its grandeurs, and weeds have grown in its high places.

No. 81. ' Portrait of his Grace the Duke of Somerset ;' H. W. Pickersgill, R.A. A masterly portrait ; painted with exceeding care, finished to a high degree of excellence, and composed with a view to quiet dignity of attitude and expression. It is undoubtedly the produce of much thought ; not the less certain, because it is not at once obvious ; and it has been wrought upon with great labour and minute attention to all its necessary details.

No. 82. ' Who can this be from ;' C. R. Leslie, R.A. This picture is a companion to that we have already referred to. It is a most delightful work, although somewhat cold and "chalky ;" a defect which is the more apparent because it is placed near paintings of very brilliant colour. The fair maiden has been sent a letter by her "bowing" lover ; which she hesitates at receiving. The contrast

between the aristocratic lady and the homely serving wench, who conveys the epistle, is capitally given.

Nos. 83 and 84. ' A Wedding of Contadini,' and ' A newly-made Nun taking leave of her Family ;' T. Uwins, R.A. Two cabinet pictures, full of character and expression, and telling interesting and pathetic "stories." They are both elaborately finished, as cabinet pictures ought to be ; for that which must necessarily be placed, in consequence of its size, near the eye, should be more highly wrought than that which is designed to be placed at a distance from it.

No. 90. ' Poor Travellers at the door of a Capuchin Convent, near Vico, Bay of Naples ;' W. Collins, R.A. The most attractive of the three pictures which Mr Collins this year exhibits as the results of his long continental tour ; and which will, we think, be generally considered as the most agreeable and interesting of the whole Gallery. "He travels to good purpose who takes notes." Mr Collins has added largely to his stock of knowledge—previously extensive ; and has undoubtedly improved his mind by cultivating acquaintance with Nature in lands other than his own. His paintings have a stronger, deeper, and firmer tone. At one time, we thought he used his colours too sparingly, as if he grudged to lay them on. He has got rid of this defect. What truth there is in this composition, what happy arrangement, what delicacy of effect, what skill in grouping, what perfect harmony of colour! every part is excellent. A group of beggars are at the door of a way-side convent ; they are completely Italian ; in the distance is the Bay of Naples.

No. 98. ' A posthumous Portrait of the Earl of Egremont ;' T. Phillips, R.A. A finely painted portrait of one of the " noblest men that ever lived in the tide of time ;"—a noble of nature as well as of the land—one whose memory is treasured by thousands whose aching hearts he healed. If he anticipated, during his life, but a tithe of the gratitude he excited for the blessings he bestowed, his feelings may well be envied.

No. 99. ' Francfort-sur-le-Mein ;' G. Jones, R.A. A fine example of an artist who is always excellent, whether he copies an old building, describes a battle, or embodies the creation of some classic poet. No painter more happily combines the real with the poetical—the actual with the imaginative.

No. 102. ' Glendalough ;' T. Creswick. One of the most wonderful scenes in nature : the

"Lake whose gloomy shore
Sky-lark never warbles o'er."

Mr Creswick has succeeded in giving an accurate idea of its lonely grandeur.

No. 103. 'Christ Blessing Little Children ;' C. L. Eastlake, R.A. This is perhaps the most faultless picture in the exhibition ; is most honourable to the British school ; and one indeed of which the age and country may be justly proud. We do not apprehend a single dissenting opinion. It is impossible for any one to look upon it without being at once struck by its high merit, or to examine it without arriving at the conclusion we have drawn. The composition is perfect ; the colouring admirable ; and the incident it represents is touching in the extreme. The countenance of the Saviour is at once humble and dignified. He is the FRIEND of the " little children," whom he intreats, and not commands, to be " suffered to come unto Him." How finely does it contrast with that of the disciple He " rebukes." We have in this work evidence of the most refined intellect, as well as of intimate and matured knowledge of the capabilities of art. The subject has been studied deeply ; the picture is not large ; and we venture to assert that as much time was given to the consideration as to the execution of it. The example should be followed. It is an error to think that genius works by " fits and starts." Patience and industry are the only sure guides to enduring fame.

No. 109. ' Constancy ;' J. R. Herbert. A clever picture ; the subject of which is very touching. A fair young woman has " outwatched the drowsy sentinel," and conveys bread and wine to a prisoner through the barred window of his cell.

No. 119. ' Young Neapolitans returning from the Festa of St Antonio ;' T. Uwins, R.A. A delicious picture ; a group of beautiful girls, almost children ; the expression of the countenance of the leading figure is surpassingly lovely. The work is, indeed, one of the highest merit. It is, we believe, to be added to the gallery of Mr Wells, of Redleaf— a destination worthy of it.

No. 124. ' The Second Adventure of Gil Blas ;' D. Maclise, A.R.A. The youth " meets with a knowing one, who sups at his expense, and repays him with flattery." The story is admirably told ; the simple and silly enjoyment of Gil Blas, the cunning confidence of the " knowing one"—the rogue and the victim—the sly humour of the host, and the half participation of the hostess, are given with prodigious effect. The colouring is hard and mannered —an error he need not fall into ; for it is not so apparent in his great work, to which we shall presently refer. The composition is excellent, and the drawing admirable. No artist has ever more perfectly caught the meaning and intention of an author. The humour is not broad or coarse. It would have satisfied, and certainly gratified, Le Sage himself. We understand the Queen has purchased this picture ; and for so doing beg to thank her on the part of the nation.

No. 125. ' Sancho Panza ;' C. R. Leslie, R.A. A capital work ; the embodied idea of the Prince of Baratara, when cheated of his meals by the mandate of the physician.

No. 129. ' The Sonnet ;' W. Mulready, R.A. A bit of true character that will tell with all who have been lovers. The youth is fiddling with his shoe-tye, but casting upwards a sly look, to ascertain what effect his lines produce upon the merry maid who reads them. His face is hidden, but we can guess his feelings, when he finds her placing her hand before her lips to suppress her laughter. It is admirably painted ; but we venture to object to the lavish use of light-green to which the artist has, of late, resorted.

No. 138. ' Rising of the Pleiades ;' H. Howard, R.A. We regret that we cannot like this picture ; and wish that Mr Howard would draw less upon

fancy and more upon fact. To us it brings but a poor idea of the " Atlantic sisters" rising to " join the starry host of Heaven." They are heavy figures, with heavy draperies. The picture is coldly coloured and tamely conceived.

No. 142. 'Market Girls;' J. Inskipp. If this be not one of the admirable artist's best works, it is, at least, a work of high merit. It is true to nature. We lament that others have not seen the pictures of Mr Inskipp with our eyes. There is not one of them advantageously placed. He is worthy of a better station than he has received ; and he is almost the only exhibitor to whom the observation can apply.

No. 143. ' Open your Mouth and shut your Eyes;' W. Mulready, R.A. Another of his delicious subjects. The lovely little girl who "opens her mouth and shuts her eyes," is beautifully painted.

No. 144. ' Dulcinea del Toboso;' C. R. Leslie, R.A. This is a misnomer. It is not a portrait of the inamorato of Don Quixote; although a very carefully painted picture of a buxom country wench.

No. 145. 'Tethered Rams,' scene in Scotland ; E. Landseer, R.A. A fine picture of a peculiar character ; with little of what the general observer will consider interesting ; but of large value as a work of art. It is elaborately finished—as if the artist had determined to do his best.

No. 154. 'Grace before Meat;' Sir D. Wilkie, R.A. Sir David has selected for illustration some pleasing lines by the Countess of Blessington. They describe a family about to " ask a blessing" on their noon-day meal. The great artist is " at home " here. He has had to paint village character. It is unquestionably too low in tone ; the flesh more especially ; but the treatment of the subject, the arrangement of the group, the expression of the various countenances, are all admirable.

No. 159. ' La Svegliarina;' C. L. Eastlake, R.A. A charming picture of the highest character and class. It is exquisitely composed and beautifully executed—a perfect "gem" indeed ; and one that will be singled out for admiration by all who have taste and feeling.

No. 164. 'Portrait of the Hon. Mount Stuart Elphinstone;' H. W. Pickersgill, R.A. This portrait has been painted for the Oriental Club : whose room it is to ornament. It is an able work, and honourable to the artist's acknowledged and appreciated talents.

No. 165. 'Flora Mac Ivor;' T. Phillips, R.A. The portrait of a melancholy lady ; but in no way recalling to our minds that which was drawn by the pen of Sir Walter Scott.

No. 173. ' Battle of Lewes;' A. Cooper, R.A. A confused mass of mingled horse and foot; not so confused as to convey the idea of a bloody struggle on the war-field, but unhappily suggesting the notion that the artist did not know how to arrange the materials necessary to depict the scene he desired to describe. Mr Cooper is a good animal painter—was at one time among our best in that class of art, although of late years several have far surpassed him—his name-sake more especially ; but he understands horses better than men.

No. 174. 'Scene on the Thames;' W. A. Knell. A good picture, though somewhat coldly coloured ; a defect into which the artist has fallen in consequence of his design to preserve the character of a sombre and cloudy day. There is in this work, however, that which holds out a hope of better things from his pencil.

No. 180. ' Neapolitans dancing the Tarantella ;' T. Uwins, R.A. Another of Mr Uwins' good and true portraitures of Italian character and costume.

No. 186. ' Portrait of his Grace the Duke of Wellington ;' J. Simpson. A likeness, though not an agreeable likeness, of a man the nation loves. It is strange that, though his Grace has been painted nearly a hundred times, he has received justice from no one but Sir Thomas Lawrence.

No. 187. ' Edward and Eleanor :' S. A. Hart, A.R.A. This picture represents the well-known incident of Eleanor sucking the poison from her husband's wound. It is a disagreeable subject ; and the artist has not lessened its unpleasing character, although he has displayed some skill in dealing with it as a work of art.

No. 195. ' Diana and Endymion ;' W. Etty, R.A. Mr Etty is not conspicuous in this exhibition, as he ought to be. His powers are of the very highest order, and though he is seldom happy in the selection of his subjects, he has qualities which make some amends for his defects. With most amazing genius, with industry, perhaps, unparalleled, with a thorough knowledge of all the " machinery" of his profession, he is rarely successful with the mass, simply because he aims to satisfy the judgment rather than to touch the heart. Now this, we submit, is neither politic nor just. It is the noblest privilege of art to inform and gratify universally ; to make the more elevated class of subjects familiar and easily understood, and not so to paint as to be "caviare to the general." We are not of those who raise a silly and impure outcry against his painting the ' Human form Divine ;' but we join with those who protest against his so continually selecting themes that excite no sympathy and rouse no generous emotion. His powers are great, his capabilities greater, and we, therefore, the more deeply grieve at finding him very frequently doing as little good for manhood as the priest who preaches his sermon in Latin.

No. 202. ' Portrait of the Earl of Yarborough ;' H. P. Briggs, R.A. A finely painted portrait, sound and true ; composed with skill, and executed with power. Mr Briggs is among the few portrait painters of undoubted excellence. Notwithstanding the encouragement which this branch of art has received, it has strangely deteriorated during the half century gone by; and though there be some of considerable ability, there are none of the highest and most unquestionable genius.

No. 203. 'Scenery in Woburn Park;' F. R. Lee, R.A. The foliage is well and firmly painted, and the cattle admirably so. The scene is of a simple character, a glade in a noble park, but the artist has contrived to make it very interesting.

No. 204. ' A Protestant Preacher ;' H. Scheffer. This picture is of the highest merit. It is of rather too low a tone for exhibition in a public gallery,

where the chances are that it must stand beside some glaring work. The artist is, we believe, a Belgian, certainly a stranger, and we regret that his painting was not placed "upon the line" instead of beneath it. The heads of the group are admirably painted. The figure of the man with his face hidden by his hands on the right of the preacher, is very fine. The whole is carefully and ably wrought; and if, as we fear, it will not find many admirers, it is because the public is not yet prepared to welcome works of the class. Many of our English students may take lessons from him. He has precisely what they want. The picture tells the story of the protestants, who, like the covenanters of Scotland, were compelled, after the revocation of the edict of Nantes, to worship God, according to the dictates of their consciences, in places not liable to intrusion.

No. 210. 'The Bay of Naples;' T. Uwins, R.A. A long and narrow picture, painted, we understand, for the Marquis of Lansdowne, to fill a pannel in his most costly and tastefully arranged room. It describes a group of peasants "going to the villa Reale, on the morning of the festa of the Pie de Grotta." It is an exquisite work both in design and execution; chaste and classical in composition, and finished with exceeding accuracy and care.

No. 211. 'A Scene near Subiaco, Roman States;' W. Collins, R.A. Another of Collins's exquisite Italian pictures. A market woman is on her way through a mountain pass; her children meet the monk who is begging for his convent; each drops a mite into the treasury.

No. 212. 'Portrait of the Countess of Dunraven and her youngest Son;' T. Phillips, R.A. We notice this work to express our regret that an artist, of such undoubted ability, and who holds the very foremost rank in his profession, should so far outrage good taste as to hang a glaring red curtain among the trees of the landscape in his back ground:—

"Not that the thing is either rich or rare—
One wonders how the d— it got there."

No. 221. 'Calvin on his Death-bed;' G. Hornung. Another contribution by a foreigner, and one which we also regret to find not "upon the line." We fear our academy will have incurred the reproach of acting ungenerously to strangers, and deeply lament that even the suspicion of it should appear to be justified. This work deserved one of the best places in the room. It is of unquestionable merit; it is elaborately wrought; too much so, perhaps, — for the labour bestowed upon it is too apparent. The arrangement is good. It would have been greatly benefited by the introduction of youth with age ; which would not, we think, have disturbed the solemn scene. Its execution is marvellous. The heads are powerfully expressive in character. If it stood alone, and without the confusion incident to an exhibition, it would excite the profoundest awe. The subject is 'the Death of Calvin.' The great reformer is giving his parting instructions to the council and pastors of Geneva, assembled round his death-bed. Its interest is increased by the fact, that the painter not only consulted the best authorities for the likenesses of the persons he has intro-

duced, but has copied from "the originals" which belonged to Calvin, the arm chair, the bible, &c. which appear in the room.

No. 222. 'Corsican, Russian, and Fallow Deer;' E. Landseer, R.A. Mr Landseer has made a fine picture, and grouped his "sitters" well together, but we must be allowed to ask him how, when, and where, it chanced that deer, of habits so opposite, herded together without fighting?

No. 227. 'The Widow;' W. Allan, R.A. A picture beautifully painted and full of deep pathos; telling a sad and powerful story; the chief mourner is not a new-made widow, for the grass has grown over her husband's grave. The child, however, is young, too young to comprehend his loss ; the dog feels it more acutely. Mr Allan is an artist of the highest genius. His own country, Scotland, is justly proud of him, and he has for many years taken a prominent station in the exhibition of the academy, of which he is a member. He has not this year done much for us, but what he has done, he has done well.

No. 235. 'Portrait of Miss Eliza Peel with Fido;' E. Landseer, R.A. This is, to our minds, the happiest of all Mr Landseer's pictures in the present exhibition. It is perfectly delicious. A lovely little maid petting her dog—nothing more. The artist has had no loftier task than to copy simple, beautiful, and artless Nature; he has done this, knowing that to do so was worthy of his genius.

No. 241. 'Pluto carrying off Proserpine;' W. Etty, R.A. Always excepting the selection of the subject, this is a picture of surpassing merit. The Proserpine is admirable in form and colour; but the finest part of the picture is the water nymph in the fore ground.

No. 242. 'Portrait of Alderman Lucas;' Sir D. Wilkie, R.A. Lucky Alderman, to obtain immortality at such small cost. We have never seen the worthy citizen, and know not if it resemble him; if it does, he must be a kindly and a pleasant gentleman—one with whom a hungry critic would like to dine. Who, after this fine work, can doubt the ability of Sir David to paint portraits, however much we may regret the inclination, or the temptation, of the great artist so to do.

MIDDLE ROOM.

No. 264. 'Rhyme of the Ancient Mariners;' J. Severn. This is a production of amazing power; "a wild and singular" production, such as an attempt to realize the dream of Coleridge ought to be. It has all the awful and terrible character of the poet, yet with added imagination on the part of the painter. The one is worthy of the other. Unhappily, the artist has deemed it necessary to introduce the albatross—an awkward and unpictorial introduction it is, the meaning of which, in the poem, we never could comprehend. and we remember once hinting to Coleridge—"that old man eloquent"—our desire to be enlightened on the subject. The answer was—a long speech, full of music; lulling and charming as the fall of a rivulet over rocks on a sunny day in spring; but informing us, therefore, none the more. The painter might have omitted it altogether, or, at least, have

made it less obtrusive. As it is, it looks, alas! for the simile, like a slaughtered goose.

No. 275. ' Margaret alone at her Spinning Wheel ;' J. Hollins. A character—*the* character—from Goethe's ' Faust ;' finely expressing the sorrow which arises from "hope deferred." Arranged with skill, and painted with considerable talent.

No. 288. 'Portrait of a Lady ;' R. Rothwell. A portrait of exceeding beauty ; not only as regards the subject, but the manner in which it has been copied on the canvass. The flesh is all but real ; the hands are almost absolute life. Mr Rothwell has three other pictures in the collection ; they are of high merit ; in some respects, he surpasses all his competitors in this department of the art ; in a keen perception of the beautiful none exceed him. A little more care for the "soundness" of his work ; a deeper tone, and greater labour to produce a vigorous effect, and he would be unrivalled. Grace need not absorb all the other qualities we look for in a work of art—and cannot compensate for their absence. Something is wanting in all his works ; he should study the old Flemish rather than the Italian masters. They lack bone and muscle.

No. 293. 'Robin Hood ;' D. Maclise, R.A. " The cynosure of wondering eyes" is this picture, by Daniel Maclise. It is unquestionably the leading attraction of the exhibition ; those who would see it must rise betimes. The artist has been prodigal of his talent, but penurious of his time. It is an outbreak of genius—genius self-dependent ; one that might have been conceived in an hour ; but the execution of which should have occupied a year. It has faults undoubtedly, but its merits are of the highest order. It is too much broken and diffused ; the eye seeks some object to rest upon, and if it find any, it is that which it ought not to find—the heap of gold and silver in the corner. The portrait of Richard is ungraceful and undignified—a man, such as he was, even in his gayest moments could have sacrificed neither dignity nor grace. His laugh is not the hearty laugh of a joyous soldier ; but an absolute and hideous grin. But these are as spots in the sun. How delicious is this picture of Allan-a-dale ; how glorious this of Friar Tuck ; how capital this of Maid Marian; how famous this of the jovial captain of the merry men all ; how admirable are the minor details ; how finely all has been imagined ; how skilfully all has been executed ! A little more labour—more thought was scarcely requisite—and this work would have been perfect.

No. 295. 'Portrait of Bettina Brentano ;' T. Von Holst. A vigorously arranged and admirably painted picture ; one that bears the stamp of unquestionable genius ; and far less exaggerated than the works of this artist usually are. His imagination too frequently runs riot. He has more fancy with less judgment than many of his competitors; unhappily, he cherishes most that which should be controlled, and neglects that which he ought to cultivate.

No. 301. 'Portrait of the author of the city of the Sultan ;' H. W. Pickersgill, R.A. A fancy portrait of Miss Pardoe ; but a picture that does not please us—why, we can scarcely say.

No. 309. ' The Fox Hunters' Funeral ;' T. Woodward. A picture of considerable merit ; the dogs are as absolute mourners as the old huntsman. It is arranged and painted with great skill.

No. 315. ' The Four Rivals ;' the Rev. J. O. W. This is by an amateur ; and one of which many of the best members of the profession might be proud. It is sweetly composed ; telling a touching and pathetic story, and coloured as if by a veteran in art.

No. 325. 'Charles Brett, Esq. with his horse Toby ;' A. D. Cooper. Portraits made poetical ; a skilfully arranged and ably painted work, one which entitles the artist to be placed high on the list of candidates for first places,

No 327. The Pillaging of a Jews' House, in the reign of Richard I ;' C. Landseer, A.R.A. Mr Landseer has within the last three or four years, made rapid strides in his profession. This picture secures his claim to be considered foremost among the aspirants for promotion. It abounds in proofs of true talent. It has its faults. The principal figure, the Jew, has an expression he could not have had ; and the maiden and her lover are flung awkwardly on the floor. He has made the characters in the back ground as important as those in the fore ground—a great mistake, for the eye wanders too much among them ; and he has introduced two or three painful and useless episodes which take from the interest of the " story." Its merits are, however, more than ample to compensate for its defects. It is a fine and able work, and " leads" at the exhibition.

No. 328. ' The Hon. Mrs Saunderson and Child ;' F. R. Say. A well painted portrait. Mr Say is conspicuous among the younger candidates for fame in this department of the art.

No. 346. ' Portrait of Sir Robert Harry Inglis, Bart, M.P. ;' Sir M. A. Shee, P.R.A. A striking likeness ; and an admirably wrought picture.

No. 351. ' Van Amburgh and his animals ;' E. Landseer R.A. The task of perpetuating a record of the stage's degradation in the nineteenth century was an unworthy one. Mr Landseer cannot easily fail in anything he undertakes, and the merit so conspicuous in some parts of this picture makes us the more regret that he was ever " commanded" to paint it. On the whole, however, it is by no means a successful one—the artist has laboured in chains. The lion looks well pleased, and, at the same time, astonished at his promotion. The great brute-tamer exhibits the bloody cuts upon his neck and arms, with evident pride and satisfaction, as so many honourable scars. While the John and Jenny Bulls peep through the grating with wonder and delight. This is a " national" work—a commission from the Queen of Great Britain. As loyal subjects, having, we trust, a tinge of that old and honourable chivalry which makes personal all that concerns the crown, we lament deeply that this subject should have been selected—and placed in the hands of a painter whose name must be hereafter a part of British history.

No. 360. ' Pluto carrying off Proserpine ;' J. M. W. Turner, R.A. A gorgeous piece of wild imagining—abounding in proofs of genius—genius

suffered to pursue its own unrestrained course. This picture, more than any other by the great master, gives us hints of the perishable nature of his materials. It seems as if part of it must peel off before the exhibition closes; we could almost fancy that portions of it have been painted in distemper.

No. 360, 'Portrait;' D. Cowper. A pleasantly conceived and very ably executed picture of an arch and merry-hearted lass—the 'Kate Kearney' of the ballad, in whose smile there is danger.

No. 363. 'Foot Ball;' T. Webster. This is unquestionably the best work that Mr Webster has produced. Its merits are of the very highest order. It is well grouped and carefully finished; especially good are the figures of the boy lifting up his knee and, in his agony, catching hold of the hair of his neighbour, the boy who is bonneted, and the boy kneeling in the fore ground, who has had, but not made, "a palpable hit." The whole scene is capital—the eager urchins rush forward in the very spirit of rivalry; each ardently struggles to get "the ball at his foot," as he will do for more important purposes in after life. It is an excellent picture; and establishes Mr Webster in the high position at which he has long been aiming, and towards which he has gradually and safely progressed.

No. 366. 'Naples; young Lazzaroni playing the Game of Arravoglio;' W. Collins, R.A. We have here an example of the manner in which Italian boys play their games. It forms a striking contrast to that we have just noticed; we doubt if the lads of the sunny south are more hearty and merry than our young Islanders. It is a capital picture, beautifully coloured, excepting perhaps the town, which seems too dark in hue, giving one little idea of the brilliancy and whiteness of the houses.

No. 377. 'Quentin Matsys, the Blacksmith of Antwerp;' R. Redgrave. This picture—by a new candidate for fame, and one who has suddenly achieved it—tells the old story of the youth who loved a maiden, whose father refused to give her to any one but a painter. Love, who works wonders, taught the art; the blacksmith became an artist, produced the famous picture of the Misers, won the old man's heart and the young maid's hand. Mr Redgrave has selected the moment when the work is exhibited; and the delighted father gazes upon it with wonder and admiration. The expression in the countenance of the girl—fit bride for an artist—is exceedingly happy; not so, we think, is that of her lover, it is more a sly leer than the deep, anxious, hoping or confiding, gaze of one whose fate is to be decided by the chances of a moment—one whose heart and soul have been staked upon it. The picture, however, abounds in proofs of true talent; and Mr Redgrave may assure himself that he will be one of the many—for they are many—this year marked out for promotion.

No. 382. 'Tulford Park;' F. R. Lee, R.A. A sound landscape; the still life especially excellent.

No. 389. ' Lady Jane Grey at the place of her Execution ;' S. A. Hart, A.R.A. This is the largest picture in the Exhibition; we regret that we cannot consider its merits commensurate with its extent. The subject is ill arranged; the characters are placed, in-deed, as if settled in positions for the stage, and have a stiff and formal character, as if there only for display. The colours are glaring, and laid on with a heavy hand. The eye is not directed to the leading figure, but fixes rather upon the red beef-eater, who pokes upward his ungainly figure. The masked executioner is hideous to a degree. The countenance of the hapless queen is not that which it should be—resignation without hope, or rather with hope beyond the reach of her enemies. An unhealthy tone pervades it throughout; and sure we are, that those who anticipated an historical painting of the higher class, will be grievously disappointed.

No. 394. ' Othello relating his Adventures ;' D. Cowper. On the whole, we consider this picture the most satisfactory of the many meritorious productions exhibited this year by junior candidates for distinction. We met the artist's name, for the first time, a few months ago, at the British Institution; his productions there, though very inferior to this, justified us in anticipating that he would ere long occupy a much higher position. He has not disappointed us. The subject has been conceived with much ability. The three figures are skilfully disposed: they have precisely the expression we can fancy the great poet intended them to have; the form and countenance of Desdemona are especially beautiful; she is just the young girl who might love the Moor " for the dangers he had passed"—artless, tender, and confiding; and he is exactly one who might adore her " that she did pity them." It is carefully and vigorously coloured; and is altogether a production honourable to British art—one of the many proofs of its sure and certain progress.

No. 409. ' The Brides of Venice ;' J. R. Herbert. A clever and, we believe, a faithful representation of a gorgeous scene, peculiar to the ocean queen, —a queen that has long been without a crown.

> " For as the custom was,
> The noblest sons and daughters of the state,
> Whose names are written in the book of gold,
> Were on that day to solemnize their nuptials."

It is a finely conceived and arranged picture, blotted by slovenly painted water, but carefully wrought upon in all its other details. Mr Herbert possesses very considerable talent, and he exerts it in association with reflection and diligence.

No. 414. ' The Graces ;' G. Patten, A.R.A. This is an agreeable picture, but will please the eye more than the judgment. The drawing is incorrect, the flesh too white, and the grouping " inharmonious." How rarely is it that we find the graces gracefully portrayed.

No. 421. 'Mohammed Hafiz ;' J. P. Knight, A.R.A. A vigorously painted portrait, preserving a strong and marked character.

WEST ROOM.

No. 427. ' The Conspiracy of the Pazzi, or the attempted Assassination of Lorenzo de Medici ;' W. Fisk. A picture which occupies a large and prominent place; but the merit of which is at best apocryphal. It is, to our minds, a confused mass of awkward and ungainly figures; the assassins are stabbing as if they themselves desired to be stabbed; and, of course, they are stabbed accordingly.

It is clear that the conspirators were a set of bunglers, and that "the Medici" might have been as much afraid of a troop of mummers with daggers of lath. The only individual of the party who understands his business is the priest, praying to a crucifix, in the background.

No. 428. 'The Bride of Lammermuir;' R. S. Lauder. We believe this artist has been distinguished in Scotland, and that he is of matured experience in art. His name is, however, new in London. If he be young in years, there can be no doubt that he gives as safe promise of excellence as any other artist of our day. This picture is of the highest merit; it is admirable in all its parts; — fine in conception, skilful in arrangement, and vigorous in execution. Every portion of it has been deeply studied: THOUGHT is manifest even in the minutest details. The countenances of the broken-hearted maiden and her crushed lover, are full of that woe-worn character which the great writer could not bring so forcibly before us. He has selected the moment when Lucy Ashton "drops the pen," and the master of Ravenswood enters. All the other persons of the picture are conceived with amazing accuracy, and painted with great power—the mother, the father, the brother, and the "accepted" suitor of the sad lady. The work is most creditable to the Exhibition and to British art."

No. 441. 'Sweet Summer-time;' T. Creswick. A youth and maiden making love under the shadow of the beech trees. They are dressed in the costume of Queen Anne. Too much space has, perhaps, been given to the foliage, but the work is one of the pleasantest and most attractive in the Exhibition: the artist has aimed less than he has done of late to make a pretty picture, has "ambitioned" a higher effort, and has succeeded. There can be no doubt that he will soon be "put in authority" over art.

No. 454. 'The Flemish Mother;' C. W. Cope. This, although a clever work, does not realize the expectations we formed from Mr Cope's display in the British Gallery.

No. 455. 'Captain Rolando shewing Gil Blas the Treasures of the Cave;' G. Lance. The still life, as our readers well know, is admirable, wonderful indeed; but we are not compelled to limit our praise to this peculiarity in the picture. The two figures are well and boldly painted.

No. 460. 'The Lady Maycress of York;' W. Etty, R.A. A picture which an artist may paint—*must* paint is, perhaps, the better word—but it is one which he ought not to exhibit. It can do him no possible service.

No. 463. 'Cicero at his Villa;' J. M. W. Turner, R.A. Another of Turner's examples of revelling with colour, and picturing the dreams of his fancy.

No. 469. 'Le Chapeau de Brigand;' T. Uwins, R.A. A most delicious picture; a pretty and merry child having robbed the lay figure of the artist, was detected with the spoils upon her person. The chance was a fortunate one for the painter. There are many who will prefer this to any of his other works. It is a noble example of colour.

No. 471. 'St Dunstan separating Edwy and El-giva;' W. Dyce. This picture, at the first glance, seem-

ed crude and hard, and uninviting; it had something however which tempted us to look again, and to inspect it more closely. It is certainly the production of a man of deep and matured knowledge of art; one who, perhaps, too much scorns the modern notions of refinement. He is Gothic in his style, and probably in his mind, and has evidently taken for his models the sterner of the old masters. Those who look only to complain, will think that he has thrown over lay figures draperies soaked in water, and so copied them; if they examine more carefully they will, however, find abundant proofs of thought and study. He does not paint to become popular—he is not disposed to woo the suffrages of the mass. In conception, and in arrangement, his views are just and sound; the execution he either does not care for, or he has adopted ideas peculiarly his own; and we venture to affirm that it would be difficult to persuade him that his course is not a wise one.

No. 474. 'Cimabue and Giotto;' E. M. Ward, R.A. A clever picture, but with too much of the coldness which so frequently arises from studying in Italy.

No. 502. 'Eton College;' J. B. Pyne. An admirably painted landscape; too white perhaps; a fault which this excellent artist will do well to guard against. He has qualities of a high class; few excel him in giving distance, and his groups are always skilfully and gracefully introduced.

No. 503. 'Portrait of Master Donne;' Sir D. Wilkie, R.A. This will be considered too slight, and be treated more as a sketch than as a finished picture. It is, however, chaste and quiet, and one that cannot fail to obtain many admirers.

No. 505. 'Olivia's Return to her Parents;' R. Redgrave. A clever and touching picture, not equal, we think, to the one we have noticed by the same pencil. Sophy meets Olivia at the cottage-door; Moses is peering in before them, while the vicar and Mrs Primrose, sit by the fire-side, reading the Bible, from which the good old man is drawing lessons of mercy to the repentant sinner.

No. 506. 'Ferry on the Thames;' J. Stark. A good and sound copy of a truly English scene. No artist can paint such a scene better. Mr Stark has but little imagination—too little, it may be, for the "public at large;" but no one has a purer eye for nature, or greater power in transferring her charms to his canvass. This work may, in some respects, vie with the most favoured of the whole Exhibition.

No. 519. 'Columbus asking bread and water for his child at the door of the Convent of Santa Maria de Rabida;' W. Simson. Mr Simson is rapidly acquiring a name. This work is one of undoubted merit, and if others of the younger aspirants have gone beyond him, as they certainly have, he has at least sustained here the reputation he made at the British Gallery.

No. 524. 'The Invocation to Sabrina;' J. Wood. Mr Wood exhibits several good portraits. This attempt to embody the character and incident of the poet will not justify high praise. He has committed a striking error; though Sabrina fair is sitting "under the glassy, cool, translucent wave," it by no means follows that she ought to have the

hue of the waters, or that her form, as seen through them, should be green.

No. 538. ' A Scene from Parnell's Hermit;' A. Frazer. One of the best pictures in the Exhibition; full of point and character, though unfortunately a dull and listless tone of colouring pervades it.

No. 545. 'The Melton Hunt;' F. Grant. This work is the epic of its class. None of what are usually termed "sporting pictures," of which the last century has been so fertile, are for a moment to be compared with it. Mr Grant is an admirable artist, and he perfectly understands that of which we know nothing—the mystery of horses, hounds, and huntsmen; and all matters thereunto appertaining. This subject contains no fewer than thirty-six portraits, including a large proportion of the aristocratic Nimrods of the day. It has been, we understand, purchased by the Duke of Wellington.

No. 546. 'May-Day at Finglas, Dublin;' H. MacManus. This is the only purely Irish subject we find in the Exhibition. It is full of life and character, and affords a capital notion of the peculiarities of our light-hearted and light-headed neighbours. It is painted with considerable skill, and is altogether a work of more than ordinary promise.

No. 551. '[Portrait of the Hon. Mrs Blackwood :' F. Stone. A full-length portrait of a very lovely and accomplished woman, one of three sisters, whom nature has largely endowed.—Mrs Norton, Lady Seymour, and Mrs Blackwood; the grand-daughters of Sheridan, upon at least one of whom the mantle of his genius has descended, Mr Stone has copied her face, form, and countenance with accuracy; and has consequently produced a charming picture. It is simple and graceful; the painter has not conceived it necessary to borrow aught of ornament. It has a fine firm tone of colour, which must place Mr Stone in a foremost station among the portrait painters of the age.

No. 561. 'The Watering place;' J. Wilson, jun. We have prophesied this young man's success on two occasions already. His pictures at the British Gallery, and those at the Society of British Artists, might have justified the most casual observer in anticipating it for him. He has attained it more rapidly even than we expected, Few modern pictures surpass this. He has caught the spirit of his father, one of the best of our true English landscape painters; and has even now reached the goal at which his excellent teacher has been so long aiming. This work is simple in composition, and exceedingly well coloured. It is easy to be prophets of the past. We shall now find critics enough to augur his prosperity.

No. 579. 'Scene on a Farm, East Kent;' T. S. Cooper. A noble work; without a competitor in its class of art. The cattle are admirably drawn, and as admirably coloured; the picture is injured by the whiteness of the trunk of the tree, which is not natural where green leaves flourish on the branches.

No. 580. 'Sancho, Governor of Barataria;' F. P. Stephanoff. We rejoice to find the excellent artist in his vigour; there are qualities in this picture unsurpassed by any in the Exhibition. It is full of humour—humour in no degree exaggerated. The grouping and arrangement are decidedly good, and the whole is minutely and delicately finished.

We have never seen Sancho better described; the expression of his countenance, as he sees another tempting dish vanish before the wand of the remorseless physician is inimitable.

"Royal Academy"

Athenaeum (May 11, 1839), 356–57; (May 25, 1839), 396–97; (June 1, 1839), 418

As an exhibition of cabinet pictures, the display this year ranks higher than usual. But as to works of art, as to evidence of lofty aspirations, it is singularly poor. A large composition by Sir David Wilkie, in commemoration of Sir David Baird; another from earlier English history, the Execution of Lady Jane Grey, by Mr. Hart; and a third from the earliest times of Edwy and Elgiva, by Mr. Dyce, are the most ambitious gallery pictures in the rooms: and not one of the three possessing merit sufficiently unquestionable and pre-eminent, to command a like prominence in our critical notice. We regret to miss Calcott and Stanfield, though the latter be gathering new inspirations in Italy; and Roberts, though he be feasting his eyes, and filling his sketch-book among the palms and pyramids of the Nile, and the magicians of Cairo: but Collins makes his appearance again, having broken ground hitherto new to him — and some of our younger and less celebrated artists have done themselves great credit: still, be it remembered, *but* in cabinet pictures.

Captious visitors, not admitting the great Wilkie to such a post of honour, have complained of the exhibition as being this year without ' The Picture.' But with us this want is satisfied, as far as we have any hope of seeing it satisfied in the present state of English art, by No. 103, Mr. Eastlake's *Christ blessing little Children.* Liable though this be in some measure to the reproach of prettiness, and a predominance of the domestic over the devotional spirit, to which we have elsewhere adverted as a national characteristic in art, the painter has still seen something more than the beauty of childhood in his subject,—he has been visited by a vision of the "beauty of holiness." Traces of this are apparent, not so much in the principal as in the accessory portions of the work—that is, not so much in the head of the Redeemer, which, though sweet and gentle, has too much of unsubstantial delicacy, for Him who could also rebuke the Scribes and Pharisees, and scourge the money-changers forth from the temple; —not so much in the babe who nestles up close to him, or the kneeling mother at his feet, graceful as is her attitude, and pure almost to sanctity her raiment;—not so much in the young child, who sits still nearer the foreground, looking upward to the friend of little children,—as in traits and attitudes, which, from their being less prominent, may possibly be less remarked. To ourselves, the most exquisite things in the picture are the half-seen head, and the clasped hands of one of the two children in brown garments at the right; above these again, and more in the centre, the second female head is our favourite. The colouring of the picture is beautifully delicate, perhaps almost too delicate ;—another little picture of a mother and a naked child, *La Svegliarina* (159), also by Mr. Eastlake, is yet more so,—with much tenderness and elegance of conception and attitude.

Very near Mr. Eastlake's Christ, hangs a picture, according to its order, no less clever: but as positive a contrast in subject and in manner, as the great room could present. This is a scene from Gil Blas (124)—"his second adventure done into oil," by Mr. M'Clise. Poor Gil has fallen into bad company— the braggadocio who clutches him so lovingly on his shoulder, the while he forks up his eggs and tosses down his wine, with an impromptu *sauce piquante* of flattery, all at the raw youth's cost,—has a fatally good understanding with the unctuous, knavish fellow in the door-way—nay, even the Maritornes with the fish on the platter at the foot of the table, who might have rouged herself to amuse the well-looking stripling (for never had Spanish maiden such brilliant cheeks,) eyes the boy with a malicious smile for which also he is to pay dear. Poor Gil Blas!—pitiable indeed were his case, did we not see, or fancy we see, in spite of his sleekly-curled hair, and modest attitude,—a certain curl on his lip beneath its down, a certain twinkle in his eye with all its *credulity* —which portend that one day he will turn out as notable a picaroon as the best of that merry party, and in his turn prove as fatal to Gils yet unfledged, who shall fall into his way. The picture is finished with all Mr. M'Clise's well-known accuracy of detail: and without that harshness of colour to which we have been obliged to object. This, however, is unpleasingly evident in his otherwise capital *Scene from Midas*, No. 6. Mr. M'Clise's largest work, *Robin Hood* (No. 293), is one of those things in which he is unapproached, and, let us add, the least fatiguing of all the *row*-pictures by which he has so indefeasibly proved his nationality. It is the entertainment given by the bold outlaw to the jovial monarch. There sits Richard, thoroughly at his ease among these lawless knaves, bronzed with the sun of the Saracen, and showing a case of teeth calculated to make formidable inroad into any Clerk of Copmanhurst's party, the while he bestows a smile (rather Irish than English, however, for there is *blarney* in it) upon Maid Marian—who, decked in her best forest bravery, and perched beneath a natural arbour of honeysuckles twining round the roots of a Sherwood Oak, dares to return a glance arch enough to allure a sovereign, were he even as well experienced in all the witcheries of Heathenesse as Richard's opponent, the Soldan himself. We do not like Robin Hood's figure ; there is too much of the clown's frolic in the *fling* with which he drinks Lion-heart's health, for one who had to overawe and control such an irreverent priest as Friar Tuck, who sprawls on the opposite side, reckless, in the plentitude of good cheer, that Royalty is in presence—and such a burly giant as " Little Johan," who pillars up the left extremity of the picture; so little oppressed—this Milo of Watling Street—by the load of the two " pryme fallowe bucke" he is bringing in to the banquet, that he is quite able to take note of his chief's worship-

ful guest, with the giant's scowl of dull curiosity. It would not be difficult, in enumerating the other items which make up this clever picture, to run a paragraph to the length of Robin Hood's Garland, inasmuch as clever heads, and figures full of life and motion, are here in number enough to stock a dozen canvasses. Not far from it hangs a female portrait (No. 320), also by Mr. M'Clise, how totally different in style, but still how admirable! It is an elderly lady, (the artist's mother, we were told,) clad in the formal and decent costume which befits the respectability of age : in its plain, but not coarse homeliness and fidelity, coming very close to the good works of the Flemish school—and worth an Academy full of the over-dressed affectations, which crowd the walls far too profusely.

The great Wilkie (No. 65), *Sir David Baird discovering the Body of Sultan Tippoo Saib*, has already been adverted to as a disappointing picture. There are not many instances in which modern painting, as the chronicler of military achievement, has produced any work of high artistic interest—witness the acres of battles at Versailles—witness the ghastly extravagancies devoted to Napoleon's Russian campaign in the Louvre. But, besides this general difficulty of subject, Wilkie's acknowledged mannerism, when the great historical style is attempted by him, detracts yet further from the success of his present work, picturesquely arranged though it be. Baird is descending a low flight of steps, with the Killedar of the fortress on one side, and on the other a Highland soldier, who throws from his torch a light upon the prostrate, half-naked figure of the Terror of the East, lying with a confused heap of spoils, garments, and arms, around him. Here, besides the contrasts of complexion, costume, and attitude, there was fine scope for a striking effect of light ; but this has been missed,—the whole is melancholy and livid in tone ; and thus, in spite of some single heads painted with a rare fidelity, and a general exactness of detail warranting the truth of the anecdote of the biscuit,* and that clearness in telling his story, in which Wilkie is always so excellent, the work would hardly arrest the passing visitor, were it not for its commanding position and the magical name in the catalogue. In his *Grace before Meat* (No. 154), Sir David is himself (or David without the *Sir*) again. Four years ago (*Athen.* No. 396), we had to report upon a picture in the Exhibition of Ancient Masters precisely identical in subject ; then, taking occasion to notice the mixture of pathos and misery, which the artist (Jan Steen) had contrived to throw into this homely act of thanksgiving. Here we have all the Dutchman's feeling,—witness the faces of the venerable dame, a true " auld wife," perfectly able

* The anecdote runs thus :—Wilkie was one morning visited in his studio by a brother artist of high excellence, who came to look at some picture then in progress. The two chatted pleasantly for awhile, till the guest was suddenly startled by a violent exclamation of complaint and reproach. Unconsciously, while he had been examining the picture, he had broken up a biscuit which had lain on a table hard by, and "the biscuit," said his host, "was a very peculiar biscuit, which he had picked out from among some hundreds in a baker's shop, to serve as model for one he wanted to paint."

to "knap doctrine" with any minister whatsoever, —of the mother endeavouring, by clasping her baby's little unwilling hands, to teach it reverence with speech,—of the eager little children at the end of the board,—of the lassie, their eldest sister, one of Wilkie's very best peasant girls,—and of the head of the house, who lifts his bonnet reverently as he pronounces the holy words; but there is not the poverty which made Jan's picture, in some sort painful. The family are a " sponsible" family —the board is comfortably, if not luxuriously, spread —and the thankfulness is not enhanced and quickened by the poignancy of hunger. Sir David, besides these pictures, exhibits certain Portraits, in which he is more than usually unfortunate.

Still continuing in the great room, we must next speak of two works by Mr. Etty—the most characteristic specimens of his recent manner we can call to mind. What that manner is, every exhibition haunter well knows, and therefore we need not once again dwell upon the mixture of sensuality with poetry in his conceptions, of crude contrast with great richness in his management of colouring. The first is *Diana and Endymion* (195). The goddess— the form of her own crescent being given to her by the attitude with which she stoops from heaven

> To catch the young Endymion fast asleep—

and by the veil of dews which tempers, but does not hide her dazzling beauty—bends a liquid and enamoured gaze upon the yellow-haired boy, who sleeps, his faithful hound by his side, as calmly as if no gleams of divinity were flashing so close above his slumber. But *Pluto carrying off Proserpine* (241) is a yet more remarkable work, though in places little more than a sketch. We know of no modern painter beside, who could produce such

> A gorgeous masque of pageantry and fear.

There is a violent unwillingness in the struggling figure of the queen elect of Erebus, telling rather of force than of seduction, and therefore tending too strongly towards melo-drama ; and Pluto, drunk with delight at embracing so sumptuous a load in his brawny arms, has too much of Caliban's leer when mocking Prospero ; but there is, to our thinking, an exquisite touch of poetry—the contrast between the nymph and the demon,—in the grace with which her long, waving yellow tresses are thrown with a floating grace over his swart locks. Something of a like antagonism is maintained by the torch-bearing Cupid, fluttering almost within reach of the breath of the coal-black steeds, whose hoofs are, in another instant, to cleave a downward passage for the ravisher to his infernal bridal bed. Mr. Etty has lavished all his best care upon the surprised companions of the devoted Proserpine : one lets drop a lapful of gorgeous flowers—another, gathering her drapery, flies, alarming the echoes of Enna's vale as she goes— while Cyane and a companion falling to the ground in their gentler sorrow, are dissolving in tears, green reeds and clear waters already gathering round them. These two recumbent nymphs would, of themselves, make a most enticing cabinet picture. Mr. Etty is too wholly steeped in dreams of classic beauty, to have any success when he touches the work-day world of modern portraiture: witness his *Lady Mayoress of York* (460), a ghastly, leering woman,

with the head-tire of an opera dancer, and the complexion of Inez de Castro on the day of her fearful coronation.

Mr. Turner has also treated the Rape of Proserpine in one of the best of his grand landscapes (360)—best, because most finished, and because the lurid hues of the southern sunset, and the flame-coloured richness of foreground vegetation, which he must now scatter over his canvas, be the occasion what it will, befit the scene and the story. There are two landscapes in the great room, of *Ancient Rome* (66) and *Modern Rome* (70), which are in his maddest manner: the frenzy, which was splendid when it was unexpected, becomes tiresome and mechanical when it is so remorselessly iterated. It has not forsaken the painter, even when engaged on such a subject as (43) the "*Fighting Temeraire*, tugged to her last berth to be broken up." A sort of sacrificial solemnity is given to the scene, by the blood-red light cast upon the waters by the round descending sun, and by the paler gleam from the faint rising crescent moon, which silvers the majestic hull, and the towering masts, and the taper spars of the doomed vessel, gliding in the wake of the steamboat—which latter (still following this fanciful mode of interpretation) almost gives to the picture the expression of such malignant alacrity as might befit an executioner. If this be bathos, Mr. Turner is to blame, not ourselves: the poetry of his picture having strongly impressed us.

ROYAL ACADEMY.

WE resume our notes at the entrance of the great room, for the purpose of comparing Mr. Knight's *Broken Heart* (20) with Mr. J.C. Horsley's *Pride of the Village* (58)—two versions of the same passage, from one of Washington Irving's sentimental sketches. All the ghastliness of death is to be found in Mr. Knight's composition, but without that graceful and delicate veil which the American has thrown over it. The forsaken girl is sitting alone, propped in her chair, and warmly wrapt, though on a summer's day, (in Mr. Horsley's picture, she is leaning against her mother's shoulder,) with quiet despair and death in every trait of her wan countenance. Before the window, her parents are seated, side by side, endeavouring to derive comfort and resignation from the open Bible before them: while between the two stands a rosy country girl—the blemish of the composition, because her attitude and dress form the exceptional conventionalism in a work otherwise remarkable for its homely fidelity. As regards its colouring, Mr. Knight's picture wants air: it has a certain dinginess of tone, which makes it less pleasing to the eye than Mr. Horsley's, though in its literal truth it has the advantage. In the picture of the younger artist, there is great sweetness in the countenance of the dying girl, but, both from her air and the cast of her beauty, she might be the Pride of the Hall, rather than of the Village. The sorrow, too, of her mother is tempered by a refinement belonging rather to the American sketch-book than to the English cottage; but the arrangement of the figures, the management of the light, and the care with which all the accessories have been studied, make it a work pleasing, and creditable to the taste of its painter.

We must return for one moment to Mr. Knight, to mention favourably his *Mohammed Hafiz* (421)—a turbaned Arab head, painted with force and richness.

Mr. Leslie has four cabinet pictures in the great room. Two of these (57 and 82) belong to the class of pretty insipidities, being devoted to love passages slily maintained between gentlemen and ladies, tricked out in stage magnificence, neither party the least in earnest, or in the least resembling personages of any age, court, or country whatsoever. We might lament as we asked, where is Mr. Leslie's racy humour? where his feeling for the beauty of youth, and health, and cheerfulness?—if two single heads, *Sancho Panza* (125) and *Dulcinea del Toboso* (144), did not furnish us as pleasant a reply as we could desire. The first exhibits the sententious governor of Barataria balked at his repast by the intrusive hand of the physician, who waves from before him all the appetizing viands he had been contemplating with such relish; the second, —not as the goddess of the Don's magnificent fantasy, but in her real guise as the peasant girl who rode to mass or market on "her pied belfry," arranging her hair, not to tempt bold knights to gentle deeds, but to insure the more equal and substantial wooing of the chosen Gil or Juan. We are sorry to observe, that Mr. Leslie's scarlet fancy in flesh-colouring is rather on the increase :—let him carry it a little further, and the critic must needs talk of the geraniums, not the roses, on the cheeks of his maidens.

We announced last week the return of Mr. Collins. He has brought back a portfolio, filled with sketches of Italian figures and Italian landscape features, as the pictures numbered 90, 211, 366, agreeably attest; but he has not brought back with him the sun and the sky of Italy. The grey atmosphere of the north is over all the three pictures, excellent though they be in the character and costume of these wayfarers and children. Mr. Uwins, whose Italian scenes are always acceptable, runs into the opposite extreme ; see his peasants *Gathering Oranges, Capo di Monte* (166), his *Neapolitan Peasants dancing the Tarantella* (180), and yet most, his *Bay of Naples* (210), which hangs, as if to provoke contrast, close to one of Mr. Collins's green-grey Italian landscapes. In his *Young Neapolitans returning from the Festa of St. Antonio* (119), Mr. Uwins reproduces his favourite cherubic type of childish beauty and innocence, which has, however, now lost the charm of novelty. A head, far prettier, though still something affected, is that of the child (469), the *Chapeau de Brigand*—a merry little elf, who has entered the artist's *studio* in his absence, and decked herself, at the expense of his lay-figure, with hat, scarf, and feather.

Mr. E. Landseer's pictures, excepting perhaps his *Corsican, Russian, and Fallow Deer* (222), in which there is an admirable open-air freshness, are universally admitted to be less excellent than those which he has exhibited in former years. One of them, *Van Amburgh and his Animals* (351), though all justice is done to the subject, is, to our thinking, as the real exhibition was, repulsive rather than pleasing —at best, a waste of talent.

Besides the great historical picture by Mr. Hart, mentioned in our former notice, he exhibits a smaller composition (187), of some pretension. It is Eleanor

sucking the poison from the wound of her husband, whose assassination had been attempted by a fanatic Mohammedan—an incident from the days of the Crusades, which suggested to Sir Walter Scott one of the most vivid scenes in his ' Talisman.' With great richness of colour and costume, and attention to variety in its disposition, this picture is, at best, but a gay failure. Edward droops on his couch too sentimentally for one so stalwart ; his wife, while applying her lips to his arm, looks up in his face with a countenance of mistrust rather than of love ; and in attempting to paint her Saxon beauty, the artist has made her a Saxon milkmaid ; while the countenance of the turbaned and bearded physician holding up the flask of balsam behind the monarch's couch, (a far-off reflection of one of Rembrandt's old men,) is distorted rather than quickened by speculation. We passed from this picture—which is as agreeable to the eye, but almost as unsatisfactory to the mind, as a painted bunch of tulips—to another, than which a stronger contrast could not be found ; we mean (204) M. H. Scheffer's *Protestant Preacher during the Dragonades ;* one of the most remarkable works in the exhibition, and, as such, surely deserving a better position than it occupies ; whether for its merit, or from the courteous reception due to its foreign parentage. M. Scheffer is as self-denying in all the vanities of rich colour, as Mr. Hart is extravagant. A sad and sombre tone, it is true, best befits the character of his subject : but, beyond this reasonable pertinence, his picture looks hard, and flat, and faded, among its more genially-painted neighbours ; and thus (and from the unpleasantly low place it occupies) it may possibly be passed over, by more than one casual visitor. But it deserves attentive and respectful consideration, if character, and intelligence, and unexaggerated truth are claims which go for anything. The preacher stands with his back to the spectator, and his profile ·is so deeply shaded that we can but divine what the play of his features must be, from the influence which his impressive countenance, and his yet more impressive words are exercising upon his small congregation. Never was attention better pourtrayed : the soldier in his buff coat, the mother with the child at her breast, the maiden, though at an age when what is stern and solemn is generally superficial in its effect, are all fixing their hearts with an earnest assent and reliance upon the preacher's discourse : and that he is telling them how "faithfulness in death shall be recompensed by the crown of life," might be surely divined from their pale countenances and their mourning garb, which tell of persecution, and bereavement, and suffering. It is the predominance of the intellectual over the material—of character over colouring—in this picture, which makes us strongly recommend it, to our artists as well as our amateurs, in contrast with Mr. Hart's clever piece of colour.

If there be any among our rising painters in whose direction Stothard's mantle may have fallen, Mr. Herbert, we think, is the man. A small picture, *Constancy*, (109) displays a lady, leaning up against the dungeon-grate which confines her lover, and passing food to him through the bars ; in the grace of her figure, and the delicacy of her expression, reminding us of those whom the Decameron painter

loved to draw. The advantage of correctness, how- ever, is on Mr. Herbert's side, and there is nothing of imitation to be charged upon him : the spirit, only, is the same : possibly the result of a like organization, and a like preference in the manner of study. But the comparison, which is one of pleasant augury, will, we think, be yet further justified by Mr. Herbert's *Brides of Venice* (409), which is treated with a picturesque· subtlety, winning largely upon the gazer, who, at first, may conceive the picture chargeable with formality. The barge, containing the Venetian maidens, robed in white and decked with their most gorgeous jewellery, occupies the centre of the picture ; winding down the canal towards the distance is the Bucentaur, followed by a barque filled with ecclesiastics, while the prow of a gondola in the foreground, one or two rowing figures, and one or two parties of spectators advancing, though with no harsh prominence, into the picture, carry on the idea of the procession, and give the fancy most pleasant occupation. There is a slight tendency towards the straight lines of monumental sculpture in Mr. Herbert's female figures, especially remarkable among the " Brides," which we observe, fearing that it may become a manner with him ; but that he can cast his figures into attitudes of any required boldness, the gaily-vested gondoliers in the foreground sufficiently attest—while we cannot but instance the little serious child, to the right of the picture, who waves his baby gonfalon as importantly as if the pageant could not go on without his presence,—as a proof that Mr. Herbert, besides the general idea of grace, possesses that delicate insight into nature, which may lead him on to works far superior to the one under admiration. From speaking of a painter in whose work his Italian studies have left traces more than usually clear, it is but natural that we pass to Mr. Severn —another artist of like sympathies ; but whose *Rhyme of the Ancient Mariner* (264) proves him to be possessed of the more exuberant imagination. This picture was so fully discussed (*Athenæum*, No. 336) in a letter from our Roman correspondent, that it is needless to return to the subject. We like far less Mr. Severn's *Rienzi* (281), for manner is therein pushed to ·an obtrusive point—there is a dryness of outline, and a hot flatness of colour, due compensation for which is not forthcoming either in the general composition of the picture or in its individual heads and figures. Rienzi himself was not a very graceful actor of melo-drama, if we are to accept Mr. Severn's vision of him.

With a few productions, illustrating picturesque incidents connected with art, poetry, and romance, we shall close this section of our labours. The first is the *Quentin Matsys* (377), by Mr. Redgrave ; the point of time chosen being the moment when the ex-blacksmith, whom love has made a painter, withdraws the curtain from his inimitable "Misers," to claim the promised guerdon from the hands of the old artist, whose daughter, the while he gazes, lingers agitated behind his chair. In this picture, the lover's part is the worst filled, the old man's the best. He gloats with a professional curiosity and eagerness upon the work exhibited to his inspection—thinking rather of tone and contour, and detail and balance of

colour, than the miracle which has converted the Romeo of the anvil into the Romeo of the palette, forgetting that there is one behind him, playing with her gold chain to beguile her pretty impatience, till the moment when he must give his consent. This old painter's figure gives good promise for Mr. Redgrave. In his *Olivia's Return to her Parents* (506), from the Vicar of Wakefield, though he has entered into his characters with a close appreciation of their beautiful simplicity—witness the repentant Olivia and the sympathetic Sophia, marshalled by the innocent Moses, who screens a blush with his three-cornered hat, while he announces their entrance—witness the compassionate child at the fireside, who kneels to the strict owner of the crimson paduasoy, to induce her to forgive her erring daughter:—he has taken too great liberties with his author, in making Dr. Primrose sit demurely beside his inflexible wife, while such a scene is going on. We are bound to note the fault, because Mr. Redgrave is an aspirant, and not an unsuccessful one, to the merits which belong to nature faithfully pourtrayed, and an incident graphically narrated. A picture of the same order, though a degree higher in its class of subject, is Mr. Cowper's *Othello relating his Adventures* (394). Here again we have a composition of three figures: here again the *Brabantio* of the group—"the old man," whose daughter the impassioned Moor seduces by his tales of hair-breadth 'scapes, is the most happily rendered,—the gravity, the deliberate attention, and something of the mistrust of age, being blended in his features, and in the composed but not relaxed attitude of the white-haired patrician, as he listens, supporting the fair-haired girl who clings to him:—eye, and ear, and heart, being all given to the narrator, and given past recall. Othello is, perhaps, too young, too much of a gallant. Nevertheless the picture is one of good promise, and very delicately painted. With a passing mention of Mr. Lauder's *Bride of Lammermuir* (428), in which like accuracy in story-telling is spoilt by defects of manner, and a sickly greenish tone of colouring ; and Mr. Lance's *Captain Rolando showing to Gil Blas the treasures of the Cave* (455), in which the spoils are set forth with an expensive gorgeousness, for which the two figures, though not positively defective, pay, inasmuch as they are *outglared* thereby,—we shall conclude our notice with Mr. Simson's *Columbus at the Convent of Santa Maria de Rabida* (519), a work of the picturesque-narrative class, in which clever composition, and agreeable contour, are in some measure neutralized by a want of careful thought and directness of purpose on the part of the artist. Columbus looks too cheerful and prosperous, his child too fresh, too little travel-worn ; while Friar Juan, whose casual arrival at the moment when the future discoverer of America was asking alms, produced such magnificent results, owns a head " without speculation." We must here pause for the present.

ROYAL ACADEMY.
[Concluding Notice.]

On returning yet once more to this Exhibition, we must specify a picture or two unmentioned in our former notices, but not therefore less worthy of "honourable construction." Foremost among these,

are the tiny pair of contributions by Mr. Mulready, *The Sonnet* (129) and the children playing at bob-cherry (143), both of which, though the tone of colouring is needlessly factitious, are greatly to be admired for the management of their lights, the natural ease with which their figures are grouped, and the delicate care bestowed upon their finish. Near them hangs Mr. Howard's *Rising of the Pleiades* (138), a work which must not be passed over, though, like the same artist's *Portrait* (153), it be merely a repetition of shapes of grace and beauty, which he has perpetuated more successfully in earlier works. Nor must Mr. Phillips's *Flora M'Ivor* (165) be forgotten : an ideal portrait of Scott's heroine, sitting alone, in the desolation of her bereavement, on the morning of her brother's execution. All these, however,—let civility be stretched as far as we will,—come but into the category of elegant insipidities. What a contrast between them and the harsh, stern, but expressive character, and the metallic execution of such a work as Mr. Hornung's *Calvin on his Death-bed!* (221) a composition of great vigour, only failing to produce a powerful effect, from the infelicitous and muddy tone of its colouring, which is at once thick and harsh : this fault is yet more largely chargeable upon Mr. Hornung's little *Catherine de Medicis* (364).— In the Middle Room we have to add to our notice Mr. Hollins's *Margaret alone at her spinning-wheel* (275) ; a pale, pensive, repentant girl,—but without the touching simplicity which breathes through Goethe's poetry, or the passion which Schubert has so intensely rendered in music, and, therefore, assuredly not the Margaret of Faust. There, too, hangs Mr. C. Landseer's *Pillaging of a Jew's house in the reign of Richard the First*, the best of his pictures on similar subjects—the chances of rude warfare seeming all but to monopolize his attention. We can only enumerate Mr. Patten's *Graces* (414) and Mr. Fraser's *Scene from Parnell's Hermit* (538), as fair specimens of each artist, and add a few words on the landscapes, portraits and drawings exhibited.

In the first department Mr. Lee unquestionably "bears the bell," in right of the works numbered 13, 203 (a rich opening in Woburn Park, with cattle gathered under the cool shade of ancient trees), and 382 (a similar subject, yet more faithfully executed). Mr. Lee is more cheerful in his air-tints this year than usual: fewer rainy gray clouds wander across his skies, than those which in former exhibitions have given his excellent landscapes a certain mannerism. But though the merit and number of his works entitle him to the first place, Mr. Creswick's *Sweet Summer-time* (441,) is admirable enough, in its own peculiar manner, to justify any one disposed to enter a protest on its behalf. It is a wood scene, or, to speak more precisely, a vista among such tall trees as are to be found in a nobleman's pleasure ground : a delicious air and coolness and depth of green shadow, being cast by their lofty and feathered boughs, which the eye loves to penetrate, while the Celadon and Amelia couched upon the smooth lawn in the foreground, are not the less fitted to the place, for being habited according to the fashions of Ranelagh rather than Arcadia. After having mentioned Mr. Witherington's *Rencontre* (49), which shows us a break in

a wood less trim than Mr. Creswick's, and peopled by figures less sentimental—namely, village children; and commended Mr. Wilson, Jun.'s *Watering Place* (551), and Mr. T. S. Cooper's *Scene on a Farm, East Kent* (579), as clever cattle pieces—we take leave of the landscapes,—our paragraph, truth to say, amounting to little better than to a confession of monotony—if not of absolute poverty.

Little more encouraging or satisfactory is the show of portraiture this year—those exhibited, making up

—in number what they want in weight.

It is true that there is no lack of clever works by Pickersgill, and Briggs, and Phillips, and Sir Martin Shee, and Lucas, nor of delicate ladies delicately painted by Rothwell, and Say, and Mrs. Carpenter—but no one individual work stands out prominently amid this assemblage of mediocrities. Though we remember well all his faults, we cannot but feel that the place of Lawrence is still a barren void. Among the drawings and miniatures, the chief exhibitors of former years remain the chiefs still. Chalon reigns supreme in his knowledge of the newest French modes, and in the employment of that judicious quantity of flattery which makes all plain faces comely, still leaving them a character and a verisimilitude. Among the miniatures, a breadth of effect seems to be increasingly studied, at the expense of the old preternatural porcelain smoothness of finish: *vide* Mr. Thorburn's *Walter Farrier* (817), and Miss Gillies's portrait of *Miss Helen Faucit* (884) as the heroine of Sir E. L. Bulwer's 'Richelieu;' in her companion likeness of Mr. Macready as the Cardinal (918), the proportions are wrong, the features being exaggerated, and the face contracted. Mr. Collen exhibits a curious *Study from Nature—Extatic Delirium* (890), which, as being, if we mistake not, a portrait from one of Dr. Elliotson's subjects, will excite interest among the advocates of Animal Magnetism. We miss Mr. Lover's clever and characteristic miniatures,—the only finished work of its class exhibited by him this year (877), being by no means his happiest effort.

And now—pausing one moment in the Architectural Room to notice Mr. O. Jones's *View of the Alcove in the Hall of the Two Sisters in the Alhambra* (1177), as one of the most magnificent displays of gorgeous colour and elaborate tracing we ever saw— we may descend among the sculptures; would we might call them, in right of their excellence, the Graces or the Virtues in marble! But the show is even more poverty-stricken than usual—Mr. Gibson's *Venus* (1303) elsewhere mentioned in our columns, being excepted. Mr. Baily, it is true, exhibits his colossal statue of Telford—a fine vigorous work— (1296), and a pair of half-length figures of children (1300), in which Nature and Affectation keep up a tolerably equally-balanced warfare. Sir R. Westmacott has a beautiful sleeping baby (1302), which puts to shame sundry other designs of the same class scattered up and down the Sculpture closet; Mr. Gibson, a too affected bas-relief of *Venus and Cupid* (1298), Mr. R. T. Wyatt, a graceful *Hebe* (1301); and Messrs. Moore and Westmacott, Jun., and Lough, some clever busts; but, beyond these, there is little to tempt the gazer. Let us hope that we shall, in this chapter of art, as in every other, fare better next year.

W.M. Thackeray

"A Second Lecture on the Fine Arts, by Michael Angelo Titmarsh, Esq."

Fraser's Magazine 19 (June 1839), 743–50

A SECOND LECTURE ON THE FINE ARTS, BY MICHAEL ANGELO TITMARSH, ESQ.

THE EXHIBITIONS.

Jack Straw's Castle, Hampstead.

MY DEAR BRICABRAC,—You, of course, remember the letter on the subject of our exhibitions which I addressed to you this time last year. As you are now lying at the Hôtel Dieu, wounded during the late unsuccessful *émeute* (which I think, my dear friend, is the seventeenth you have been engaged in), and as the letter which I wrote last year was received with unbounded applause by the people here, and caused a sale of three or four editions of this Magazine, I cannot surely, my dear Bricabrac, do better than send you another sheet or two, which may console you under your present bereavement, and at the same time amuse the British public, who now know their friend Titmarsh as well as you in France know that little scamp Thiers.

Well, then, from Jack Straw's Castle, an hotel on Hampstead's breezy heath, which Keats, Wordsworth, Leigh Hunt, F. W. N. Bayly, and others of our choicest spirits, have often patronised, and a heath of which every pool, bramble, furze-bush-with-clothes-hanging-on-it-to-dry, steep, stock, stone, tree, lodging-house, and distant gloomy background of London city, or bright green stretch of sunshiny Hertfordshire meadows, has been depicted by our noble English landscape painter, Constable, in his own Constabulary way — at Jack Straw's Castle, I say, where I at this present moment am located (not that it matters in the least, but the world is always interested to know where men of genius are accustomed to disport themselves), I cannot do better than look over the heap of picture-gallery-catalogues which I brought with me from London, and communicate to you, my friend in Paris, my remarks thereon.

A man, with five shillings to spare, may at this present moment half kill himself with pleasure in London town, and in the neighbourhood of Pall Mall, by going from one picture gallery to another, and examining the beauties and absurdities which are to be found in each. There is first the National Gallery (entrance, nothing), in one wing of the little gin-shop of a building so styled near St. Martin's Church; in another wing is the exhibition of the Royal Academy (entrance, one shilling; catalogue, one ditto). After having seen this, you come to the Water-Colour Exhibition in Pall Mall East; then to the gallery in Suffolk Street; and, finally, to the New Water-Colour Society in Pall Mall,—a pretty room, which formerly used to be a gambling-house, where many a bout of seven's-the-main, and iced champagne, has been had by the dissipated in former days. All these collections (all the modern ones, that is) deserve to be noticed, and contain a deal of good, bad, and indifferent wares, as is the way with all other institutions in this wicked world.

Commençons donc avec le commencement—with the Exhibition of the Royal Academy, which consists, as every body knows, of thirty-eight knight and esquire academicians, and nineteen simple and ungenteel associates, who have not so much as a shabby Mister before their names. I recollect last year facetiously ranging these gentlemen in rank, according to what I conceived to be their merits,—King Mulready, Prince Maclise, Lord Landseer, Archbishop Eastlake (according to the best of my memory, for Jack Straw, strange to say, does not take in *Fraser's Magazine*), and so on. At present, a great number of new comers, now associates even, ought to be elevated to these aristocratic dignities; and, perhaps, the order ought to be somewhat changed. There are many more good pictures (here and elsewhere) than there were last year. A great stride has been taken in matters of art, my dear friend. The young painters are stepping forward. Let the old fogies look to it; let the old Academic Olympians beware, for there are fellows among the rising race who bid fair to oust them from sovereignty. They have not yet arrived at the throne, to be sure, but they are near it. The lads are not so good as the best of the academicians; but many of the academicians are infinitely worse than the lads, and are old, stupid, and cannot improve, as the younger and more active painters will.

If you are particularly anxious to

know what is the best picture in the room, not the biggest (Sir David Wilkie's is the biggest, and exactly contrary to the best), I must request you to turn your attention to a noble river-piece by J. W. M. Turner, Esq. R.A., " The fighting Téméraire "— as grand a painting as ever figured on the walls of any academy, or came from the easel of any painter. The old Téméraire is dragged to her last home by a little, spiteful, diabolical steamer. A mighty red sun, amidst a host of flaring clouds, sinks to rest on one side of the picture, and illumines a river that seems interminable, and a countless navy that fades away into such a wonderful distance as never was painted before. The little demon of a steamer is belching out a volume (why do I say a volume? not a hundred volumes could express it) of foul, lurid, red-hot, malignant smoke, paddling furiously, and lashing up the water round about it ; while behind it (a cold gray moon looking down on it), slow, sad, and majestic, follows the brave old ship, with death, as it were, written on her. I think, my dear Bricabrac (although, to be sure, your nation would be somewhat offended by such a collection of trophies), that we ought not, in common gratitude, to sacrifice entirely these noble old champions of ours, but that we should have somewhere a museum of their skeletons, which our children might visit, and think of the brave deeds which were done in them. The bones of the Agamemnon and the Captain, the Vanguard, the Culloden, and the Victory, ought to be sacred relics, for Englishmen to worship almost. Think of them when alive, and braving the battle and the breeze, they carried Nelson and his heroes victorious by the Cape of St. Vincent, in the dark waters of Aboukir, and through the fatal conflict of Trafalgar. All these things, my dear Bricabrac, are, you will say, absurd, and not to the purpose. Be it so : but Bow-bellites as we are, we Cockneys feel our hearts leap up when we recall them to memory ; and every clerk in Threadneedle Street feels the strength of a Nelson, when he thinks of the mighty actions performed by him.

It is absurd, you will say (and with a great deal of reason), for Titmarsh, or any other Briton, to grow so politically enthusiastic about a four-foot canvass, representing a ship, a steamer, a river, and a sunset. But herein surely

lies the power of the great artist. He makes you see and think of a great deal more than the objects before you ; he knows how to soothe or to intoxicate, to fire or to depress, by a few notes, or forms, or colours, of which we cannot trace the effect to the source, but only acknowledge the power. I recollect, some years ago, at the theatre at Weimar, hearing Beethoven's " Battle of Vittoria," in which, amidst a storm of glorious music, the air of " God save the King " was introduced. The very instant it began, every Englishman in the house was bolt upright, and so stood reverently until the air was played out. Why so ? From some such thrill of excitement as makes us glow and rejoice over Mr. Turner and his " Fighting Téméraire ;" which I am sure, when the art of translating colours into music or poetry shall be discovered, will be found to be a magnificent national ode or piece of music.

I must tell you, however, that Mr. Turner's performances are for the most part quite incomprehensible to me ; and that his other pictures, which he is pleased to call " Cicero at his Villa," " Agrippina with the ashes of Germanicus," " Pluto carrying off Proserpina," or what you will, are not a whit more natural, or less mad, than they used to be in former years, since he has forsaken nature, or attempted (like your French barbers) to embellish it. *On n'embellit pas la nature,* my dear Bricabrac ; one may make pert caricatures of it, or mad exaggerations, like Mr. Turner in his fancy pieces. O ye gods! why will he not stick to copying her majestical countenance, instead of daubing it with some absurd antics and fard of her own ? Fancy pea-green skies, crimson-lake trees, and orange and purple grass — fancy cataracts, rainbows, suns, moons, and thunderbolts — shake them well up, with a quantity of gamboge, and you will have an idea of a fancy picture by Turner. It is worth a shilling alone to go and see " Pluto and Proserpina." Such a landscape ! such figures ! such a little red-hot coal-scuttle of a chariot ! As Nat Lee sings —

" Methought I saw a hieroglyphic bat
Skim o'er the surface of a slipshod hat ;
While, to increase the tumult of the skies,
A damned potato o'er the whirlwind flies."

If you can understand these lines, you can understand one of Turner's landscapes ; and I recommend them to

him, as a pretty subject for a piece for next year.

Etty has a picture on the same subject as Turner's, " Pluto carrying off Proserpina ;" and if one may complain that in the latter the figures are not indicated, one cannot at least lay this fault to Mr. Etty's door. His figures *are* drawn, and a deuced deal *too much* drawn. A great, large curtain of fig-leaves should be hung over every one of this artist's pictures, and the world should pass on, content to know that there are some glorious colours painted beneath. His colour, indeed, is sublime : I doubt if Titian ever knew how to paint flesh better — but his taste ! Not David nor Girodet ever offended propriety so — scarcely even Peter Paul himself, by whose side, as a colourist and a magnificent heroic painter, Mr. Etty is sometimes worthy to stand. I wish he would take Ariosto in hand, and give us a series of designs from him. His hand would be the very one for those deep luscious landscapes, and fiery scenes of love and battle. Besides " Proserpine," Mr. Etty has two more pictures, " Endymion," with a dirty, affected, beautiful, slatternly Diana, and a portrait of the " Lady-Mayoress of York ;" which is a curiosity in its way. The line of her ladyship's eyes and mouth (it is a front face) are made to meet at a point in a marabon feather which she wears in her turban, and close to her cheekbone ; while the expression of the whole countenance is so fierce, that you would imagine it a Lady Macbeth, and not a lady-mayoress. The picture has, nevertheless, some very fine painting about it — as which of Mr. Etty's pieces has not ?

The artists say there is very fine painting, too, in Sir David Wilkie's great " Sir David Baird ;" for my part, I think very little. You see a great quantity of brown paint ; in this is a great flashing of torches, feathers, and bayonets. You see in the foreground, huddled up in a rich heap of corpses and drapery, Tippoo Sahib ; and swaggering over him on a step, waving a sword for no earthly purpose, and wearing a red jacket and buckskins, 'the figure of Sir David Baird. The picture is poor, feeble, theatrical ; and I would just as soon have Mr. Hart's great canvass of " Lady Jane Gray " (which is worth exactly twopence halfpenny) as Sir David's poor picture of " Seringapatam." Some of Sir David's portraits are worse even than his historical compositions — they seem to be painted with snuff and tallow grease : the faces are merely indicated, and without individuality ; the forms only half-drawn, and almost always wrong. What has come to the hand that painted " The Blind Fiddler " and " The Chelsea Pensioners ?" Who would have thought that such a portrait as that of " Master Robert Donne," or the composition entitled " The Grandfather," could ever have come from the author of " The Rent-Day " and " The Reading of the Will ?" If it be but a contrast to this feeble, flimsy, transparent figure of Master Donne, the spectator cannot do better than cast his eyes upwards, and look at Mr. Linnell's excellent portrait of " Mr. Robert Peel." It is real, substantial nature, carefully and honestly painted, and without any flashy tricks of art. It may seem ungracious in " us youth " thus to fall foul of our betters ; but if Sir David has taught us to like good pictures, by painting them formerly, we cannot help criticising if he paints bad ones now : and bad they most surely are.

From the censure, however, must be excepted the picture of " Grace before Meat," which, a little misty and feeble, perhaps, in drawing and substance, in colour, feeling, composition, and expression, is exquisite. The eye loves to repose upon this picture, and the heart to brood over it afterwards. When, as I said before, lines and colours come to be translated into sounds, this picture, I have no doubt, will turn out to be a sweet and touching hymn-tune, with rude notes of cheerful voices, and peal of soft, melodious organ, such as one hears stealing over the meadows on sunshiny Sabbath-days, while waves under cloudless blue the peaceful golden corn. Some such feeling of exquisite pleasure and content is to be had, too, from Mr. Eastlake's picture of " Our Lord and the little Children." You never saw such tender white faces, and solemn eyes, and sweet forms of mothers round their little ones bending gracefully. These pictures come straight to the heart, and then all criticism and calculation vanishes at once, — for the artist has attained his great end, which is, to strike far deeper than the sight ; and we have no business to quarrel about defects in form and colour, which are but little parts of the great painter's skill.

Look, for instance, at another piece

of Mr. Eastlake's, called, somewhat affectedly, " La Svegliarina." The defects of the painter, which one does not condescend to notice when he is filled with a great idea, become visible instantly when he is only occupied with a small one ; and you see that the hand is too scrupulous and finikin, the drawing weak, the flesh chalky, and unreal. The very same objections exist to the other picture, but the subject and the genius overcome them.

Passing from Mr. Eastlake's pictures to those of a greater genius, though in a different line,—look at Mr. Leslie's little pieces. Can any thing be more simple—almost rude—than their manner, and more complete in their effect upon the spectator ? The very soul of comedy is in them ; there is no coarseness, no exaggeration ; but they gladden the eye, and the merriment which they excite cannot possibly be more pure, gentlemanlike, or delightful. Mr. Maclise has humour, too, and vast powers of expressing it ; but whisky is not more different from rich burgundy than his fun from Mr. Leslie's. To our thinking, Leslie's little head of " Sancho" is worth the whole picture from *Gil Blas*, which hangs by it. In point of workmanship, this is, perhaps, the best picture that Mr. Maclise ever painted ; the colour is far better than that usually employed by him, and the representation of objects carried to such an extent as we do believe was never reached before. There is a poached egg, which one could swallow ; a trout, that beats all the trout that was ever seen ; a copper pan, scoured so clean that you might see your face in it ; a green blind, through which the sun comes ; and a wall, with the sun shining on it, that De Hooghe could not surpass. This young man has the greatest power of hand that was ever had, perhaps, by any painter in any time or country. What does he want ? Polish, I think ; thought, and cultivation. His great picture of " King Richard and Robin Hood" is a wonder of dexterity of hand ; but coarse, I think, and inefficient in humour. His models repeat themselves too continually. Allen à Dale, the harper, is the very counterpart of Gil Blas ; and Robin Hood is only Apollo with whiskers : the same grin, the same display of grinders,—the same coarse, luscious mouth, belongs to both. In the large picture, every body grins, and shews his whole *ratelier ;* and you

look at them, and say, " These people seem all very jolly." Leslie's characters do not laugh themselves, but they make *you* laugh ; and this is where the experienced American artist beats the dashing young Irish one. We shall say nothing of the colour of Mr. Maclise's large picture ; some part appears to us to be excellent, and the whole piece, as far as execution goes, is worthy of his amazing talents, and high reputation. Mr. Maclise has but one portrait ; it is, perhaps, the best in the exhibition : sober in colour, wonderful for truth, effect, and power of drawing.

In speaking of portraits, there is never much to say ; and they are fewer, and for the most part more indifferent, than usual. Mr. Pickersgill has a good one, a gentleman in a green chair ; and one or two outrageously bad. Mr. Phillips's " Doctor Sheppard" is a finely painted head and picture ; his lady, Dunraven, and her son, as poor, ill-drawn, and ill-coloured a performance as can possibly be. Mr. Wood has a pretty head ; Mr. Stone a good portrait of a very noble-looking lady, the Hon. Mrs. Blackwood ; Mr. Bewick a good one ; and there are, of course, many others whose names might be mentioned with praise or censure, but whom we will, if you please, pass over altogether.

The great advance of the year is in the small historical compositions, of which there are many that deserve honourable mention. Redgrave's " Return of Olivia to the Vicar" has some very pretty painting and feeling in it ; " Quentin Matsys," by the same artist, is tolerably good. D. Cowper's " Othello relating his Adventures," really beautiful ; as is Cope's " Belgian Family." All these are painted with grace, feeling, and delicacy ; as is E. M. Ward's " Cimabue and Giotto" (there is in Tiepolo's etchings the selfsame composition, by the way) ; and Herbert's elegant picture of the " Brides of Venice." Mr. Severn's composition from the *Ancient Mariner* is a noble performance ; and the figure of the angel with raised arm awful and beautiful too. It does good to see such figures in pictures as those and the above, invented and drawn,—for they belong, as we take it, to the best school of art, of which one is glad to see the daily spread among our young painters. Mr. Charles Landseer's " Pillage of a Jew's House" is a very well and

carefully painted picture, containing a great many figures, and good points; but we are not going to praise it: it wants vigour, to our taste, and what you call *actualité*. The people stretch their arms and turn their eyes the proper way, but as if they were in a tableau, and paid for standing there: one longs to see them all in motion, and naturally employed.

I feel, I confess, a kind of delight in finding out Mr. Edwin Landseer in a bad picture; for the man paints so wonderfully well, that one is angry that he does not paint better, which he might with half his talent, and without half his facility. "Van Amburgh and the Lions" *is* a bad picture, and no mistake; dexterous, of course, but flat and washy: the drawing even of the animals is careless; that of the man bad, though the head is very like, and very smartly painted. Then there are other dog-and-man portraits; "Miss Peel with Fido," for instance. Fido is wonderful, and so are the spunges, and hair-brushes, and looking-glass, prepared for the dog's bath; and the drawing of the child's face, as far as the lines and expression go, is very good; but the face is covered with flesh-coloured paint, and not flesh, and the child looks like a wonderful doll, or imitation child, and not a real young lady, daughter of a gentleman who was prime minister last week (by the bye, my dear Bricabrac, did you ever read of such a pretty Whig game as that, and such a nice *coup d'état?*). There, again, is the beautiful little Princess of Cambridge, with a dog, and a piece of biscuit: the dog and the biscuit are just perfection; but the princess is no such thing,—only a beautiful apology for a princess, like that which Princess Penelope *didn't* send the other day to the lord-mayor of London.

We have to thank you (and not our Academy, which has hung the picture in a most scurvy way) for Mr. Scheffer's "Prêche Protestante." This fine composition has been thrust down on the ground, and trampled under foot, as it were, by a great number of worthless academics; but it merits one of the very best places in the gallery; and I mention it to hint an idea to your worship, which only could come from a great mind like that of Titmarsh,—to have, namely, some day, a great European congress of paintings, which might be exhibited at one place,—

Paris, say, as the most central; or, better still, travel about, under the care of trusty superintendents, as they might, without fear of injury. I think such a circuit would do much to make the brethren known to one another, and we should hear quickly of much manly emulation, and stout training for the contest. If you will mention this to Louis Philippe the next time you see that *roi citoyen* (mention it soon,—for, egad! the next *émeute* may be successful; and who knows when it will happen?)—if you will mention this at the Tuileries, *we* will take care of St. James's; for I suppose that you know, in spite of the Whigs, her most sacred majesty reads every word of *Fraser's Magazine*, and will be as sure to see this on the first of next month, as Lord Melbourne will be to dine with her on that day.

But let us return to our muttons. I think there are few more of the oil pictures about which it is necessary to speak; and besides them, there are a host of miniatures, difficult to expatiate upon, but pleasing to behold. There are Chalon's ogling beauties, half-a-dozen of them; and the skill with which their silks and satins are dashed in by the painter is a marvel to the beholder. There are Ross's heads, that to be seen must be seen through a microscope. There is Saunders, who runs the best of the miniature men very hard; and Thorburn, with Newton, Robertson, Rochard, and a host of others: and, finally, there is the sculpture-room, containing many pieces of clay and marble, and, to my notions, but two good things, a sleeping child (ridiculously called the Lady Susan Somebody), by Westmacott; and the bust of Miss Stuart, by Macdonald: never was any thing on earth more exquisitely lovely.

These things seen, take your stick from the porter at the hall door, cut it, and go to fresh picture-galleries; but ere you go, just by way of contrast, and to soothe your mind after the glare and bustle of the modern collection, take half an hour's repose in the National Gallery; where, before the "Bacchus and Ariadne," you may see what the magic of colour is; before "Christ and Lazarus" what is majestic, solemn, grace, and awful beauty; and before the new "St. Catharine" what is the real divinity of art. O, Eastlake and Turner!—O, Maclise and

Mulready ! you are all very nice men ; but what are you to the men of old ?

* * * *

Issuing then from the National Gallery—you may step over to Farrance's by the way, if you like, and sip an ice, or bolt a couple of dozen forcedmeatballs in a basin of mock-turtle-soup — issuing, I say, from the National Gallery, and after refreshing yourself or not, as your purse or appetite permits, you arrive speedily at the Water-Colour Exhibition, and cannot do better than enter. I know nothing more cheerful or sparkling than the first *coup d'œil* of this little gallery. In the first place, you never can enter it without finding four or five pretty women, that's a fact ; pretty women with pretty pink bonnets peeping at pretty pictures, and with sweet whispers vowing that Mrs. Seyffarth is a dear, delicious painter, and that her style is " so soft;" and that Miss Sharpe paints every bit as well as her sister; and that Mr. Jean Paul Frederick Richter draws the loveliest things, to be sure, that ever were seen. Well, very likely the ladies are right, and it would be unpolite to argue the matter; but I wish Mrs. Seyffarth's gentlemen and ladies were not so dreadfully handsome, with such white pillars of necks, such long eyes and lashes, and such dabs of carmine at the mouth and nostrils. I wish Miss Sharpe would not paint Scripture subjects, and Mr. Richter great goggle-eyed, red-cheeked, simpering wenches, whose ogling has become odious from its repetition. However, the ladies like it, and, of course, must have their way.

If you want to see *real* nature, now, real expression, real startling home poetry, look at every one of Hunt's heads. Hogarth never painted any thing better than these figures, taken singly. That man rushing away frightened from the beer-barrel, is a noble head of terror; that Miss Jemima Crow, whose whole body is a grin, regards you with an ogle that all the race of Richters could never hope to imitate. Look at yonder card-players; they have a penny pack of the devil's books, and one has just laid down the king of trumps! I defy you to look at him without laughing, or to examine the wondrous puzzled face of his adversary without longing to hug the greasy rogue. Come hither, Mr. Maclise, and see what genuine comedy

is ; you who can paint better than all the Hunts and Leslies, and yet not near so well. If I were the Duke of Devonshire, I would have a couple of Hunts in every room in all my houses; if I had the blue-devils (and even their graces are, I suppose, occasionally so troubled), I would but cast my eyes upon these grand, good-humoured pictures, and defy care. Who does not recollect " Before and After the Mutton Pie," the two pictures of that wondrous boy? Where Mr. Hunt finds his models, I cannot tell; they are the very flower of the British youth; each of them is as good as " Sancho ;" blessed is he that has his portfolio full of them.

There is no need to mention to you the charming landscapes of Cox, Copley Fielding, De Wint, Gastineau, and the rest. A new painter, somewhat in the style of Harding, is Mr. Callow; and better, I think, than his master or original, whose colours are too gaudy to my taste, and effects too glaringly theatrical.

Mr. Cattermole has, among others, two very fine drawings; a large one, the most finished and the best coloured of any which have been exhibited by this fine artist; and a smaller one, " The Portrait," which is charming. The portrait is that of Jane Seymour or Anne Boleyn ; and Henry the VIIIth is the person examining it, with the cardinal at his side, the painter before him, and one or two attendants. The picture seems to me a perfect masterpiece, very simply coloured and composed, but delicious in effect and tone, and telling the story to a wonder. It is much more gratifying, I think, to let a painter tell his own story in this way, than to bind him down to a scene of Ivanhoe or Uncle Toby ; or worse still, to an illustration of some wretched story in some wretched fribble Annual. Wo to the painter who falls into the hands of Mr. Charles Heath (I speak, of course, not of Mr. Heath personally, but in a Pickwickian sense — of Mr. Heath the Annual-monger); he ruins the young artist, sucks his brains out, emasculates his genius so as to make it fit company for the purchasers of Annuals. Take, for instance, that unfortunate young man, Mr. Corbould, who gave great promise two years since, painted a pretty picture last year, and now—he has been in the hands of the Annual-mongers, and has left wellnigh all his

vigour behind him. Numerous Zuleik-has and Lalla Rookhs, which are hanging about the walls of the Academy and the New Water-Colour Gallery, give lamentable proofs of this : such handsome Turks and leering sultanas; such Moors, with straight noses and pretty curled beards ! Away, Mr. Corbould ! away while it is yet time, out of the hands of these sickly, heartless Annual-syrens! and ten years hence, when you have painted a good, vigorous, healthy picture, bestow the tear of gratitude upon Titmarsh, who tore you from the lap of your crimson-silk-and-gilt-edged Armida.

Mr. Cattermole has a couple, we will not say of imitators, but of friends, who admire his works very much; these are, Mr. Nash and Mr. Lake Price; the former paints furniture and old houses, the latter old houses and furniture, and both very pretty. No harm can be said of these miniature scene-painters; on the contrary, Mr. Price's "Gallery at Hardwicke" is really remarkably dexterous; and the chairs, tables, curtains, and pictures, are nicked off with extraordinary neatness and sharpness — and then ? why then, no more is to be said. Cobalt, sepia, and a sable pencil, will do a deal of work, to be sure ; and very pretty it is, too, when done; and as for finding fault with it, that nobody will and can ; but an artist wants something more than sepia, cobalt, and sable pencils, and the knowledge how to use them. What do you think, my dear Bricabrac of a little *genius?—that's* the picture-painter, depend on it.

Being on the subject of water-colours, we may as well step into the New Water-Colour Exhibition : not so good as the old, but very good. You will see here a large drawing by Mr. Corbould of a tournament, which will shew at once how clever that young artist is, and how weak and *manière.* You will see some charming unaffected English landscapes by Mr. Sims; and a capital Spanish Girl by Hicks, of which the flesh-painting cannot be too much approved. It is done without the heavy white, with which water-colour artists are now wont to belabour their pictures; and is, therefore, frankly and clearly painted, as all transparent water-colour drawing must be. The same praise of clearness, boldness, and depth of tone must be given to Mr. Absolon, who uses no white, and only just so

much stippling as is necessary; his picture has the force of oil, and we should be glad to see his manner more followed.

Mr. Haghe's " Town Hall of Courtray" has attracted, and deservedly, a great deal of notice. It is a very fine and masterly architectural drawing, rich and sombre in effect, the figures introduced being very nearly as good as the rest of the picture. Mr. Haghe, we suppose, will be called to the upper house of water-colour painters, who might well be anxious to receive into their ranks many persons belonging to the new society. We hope, however, the latter will be faithful to themselves ; there is plenty of room for two galleries, and the public must, ere long, learn to appreciate the merits of the new one. Having spoken a word in favour of Mr. Johnston's pleasing and quaintly-coloured South American sketches, we have but to bend our steps to Suffolk Street, and draw this discourse to a close.

Here is a very fine picture, indeed, by Mr. Hurlstone, " Olympia attacked by Bourbon's Soldiers in Saint Peter's, and flying to the Cross." Seen from the further room, this picture is grand in effect and colour, and the rush of the armed men towards the girl, finely and vigorously expressed. The head of Olympia has been called too calm by the critics; it seems to me most beautiful, and the action of the figure springing forward and flinging its arms round the cross, nobly conceived and executed. There is a good deal of fine Titianic painting in the soldiers' figures (Oh, that Mr. Hurlstone would throw away his lamp-black !), and the background of the church is fine, vast, and gloomy. This is the best historical picture to be seen any where this year ; perhaps the worst is the one which stands at the other end of the room, and which strikes upon the eye as if it were an immense water-colour sketch, of a feeble picture by President West. Speaking of historical paintings, I forgot to mention a large and fine picture by Mr. Dyce, the " Separation of Edwy and Elgiva ;" somewhat crude and odd in colour, with a good deal of exaggeration in the countenances of the figures, but having grandeur in it, and unmistakeable genius ; there is a figure of an old woman seated, which would pass muster very well in a group of Sebastian Piombo.

. A capitally painted head by Mr. Stone, called the " Sword-bearer," almost as fresh, bright, and vigorous as a Vandyke, is the portrait, we believe, of a brother-artist, the clever actor Mr. M'Ian. The latter's picture of " Sir Tristram in the Cave " deserves especial remark and praise; and is really as fine a dramatic composition as one will often see. The figures of the knight and the lady asleep in the foreground, are novel, striking, and beautifully easy. The advance of the old king, who comes upon the lovers; the look of the hideous dwarf, who finds them out; and behind, the line of spears that are seen glancing over the rocks, and indicating the march of the unseen troops, are all very well conceived and arranged. The piece deserves engraving; it is wild, poetic, and original. To how many pictures, now-a-days, can one apply the two last terms?

There are some more new pictures, in the midst of a great quantity of trash, that deserve notice. Mr. D. Cowper is always good; Mr. Stewart's " Grandfather " contains two excellent likenesses, and is a pleasing little picture. Mr. Hurlstone's " Italian Boy," and " Girl with a Dog," are excellent; and, in this pleasant mood, for fear of falling into an angry fit on coming to look further into the gallery, it will be as well to conclude. Wishing many remembrances to Mrs. Bricabrac, and better luck to you in the next *émeute*, I beg here to bid you farewell, and entreat you to accept the assurances of my distinguished consideration.

M. A. T.

from

"The Royal Academy.
The Exhibition — 1840"

Art-Union 2 (May 1840), 73 – 78

THE ROYAL ACADEMY.

THE EXHIBITION—1840.

The seventy-second Exhibition of the ROYAL ACADEMY was opened on Monday the 4th of May. It contains 1240 works; and it is understood that 900 have been rejected — " rejected" is not the word, however, for it is certain that a large proportion of them were returned, not because they were deficient in merit, but because our great National Gallery was not large enough to contain them.

It is disgraceful to this country, that while scandalously extravagant of the public money in matters that benefit the public nothing, we should have been niggards in all that tends to improve it; the building in Trafalgar-square will long continue a monument of bad taste and false economy; and justify the sneer and chuckle of the foreigner, when he classes the intellectual might of the Englishman as many degrees lower than his physical strength. Still, as the mass of brick and mortar, divided into "rooms" is there, let us make the best of it; until Sir Robert Peel is in a condition to fulfil his implied promise, when in his place in the House of Commons, on the 30th of July last, he said :—

" He did hope to see the day when this country would be rich enough to build for itself a depository for the Arts, worthy of the British nation. He did hope to see the day when, in the most favoured part of Hyde Park, he should witness the erection of a magnificent building devoted to subjects of art; not for the accommodation of the sovereign; but for the accommodation and delight of the universal people of this country, for their amusement, for their intellectual refinement, and for their improvement in the arts generally."

It may be our duty hereafter to remind the right honourable baronet of this " hope," and possibly to call upon him for a grant " for the accommodation and delight of the universal people of this country," equal at least to that which has been issued from the Exchequer to repair stables at Windsor.

But as we have the building, and must use it, let us see if it be made as available as it may be made. What is to prevent our removing the pictures in the national collection, or boarding them in, for a period of three months, while the exhibition of the Royal Academy continues open? We have the example of the French to quote as a precedent. Such is the course invariably adopted at the Louvre. If this plan were acted upon—and there is not, we think, a rational objection to it—the 900 works returned to the artists would have been seen by the public; better places obtained for many that are now grievously treated; and the public have a still richer treat provided for them; while there would be infinitely less pushing and crushing through the narrow apartments. The advantage of this arrangement is so obvious, and we cannot anticipate an argument against it, that we earnestly advise the artists to draw up, previous to next May, a memorial to the Lords of the Treasury, which, backed as we take for granted it would be by the Royal Academy— would we feel assured be followed by giving up the whole of the structure for the time required.

Nine hundred pictures have, it seems, been returned to the studios of the artists; the question whether the " accepted" are all of a better order than the " rejected," will very naturally be asked. If the visitor believes, while looking on some of the objects placed, that they are of higher merit than those returned, he will marvel greatly how such an immense number of bad works could have been produced; and it is therefore our duty to state plainly and emphatically, that the arts are not so low as this judgment would lead the casual spectator to believe them. We "speak what we do know," when we assert that many of those sent back are infinitely superior to many of those that are exhibited. We are willing to make due allowances for this sin of omission rather than of commission; but we presume to enter our protest against the rejection of works by artists, where only one is sent, and to the exclusion of all the works when more than one have been forwarded, unless such works be of a character utterly worthless. We could name several so circumstanced, who have, this year, to endure the deep mortification and severe injury of finding themselves unnamed in the catalogue. The hangers, this year, have been thoughtless, to say the least; they seem not to have paused to think over the pangs they were inflicting, for sure we are if they had seen the sad countenances— betokening aching hearts—of several who came in our way on the morning of the 4th; when, peering anxiously into the catalogues they found their names omitted, they would have felt what deep responsibility they had incurred, and have given much to recall the judgment that made many homes cheerless, if not desolate. This we maintain was unnecessary ;—among the minor artists there are many who have four, five, or six pictures hung; half the number would have sufficed—for their comfort, perhaps, and certainly for their fame; and, thus, room might have been made for one by each of the artists who were altogether excluded. In the case of the Royal Academy the evil is especially great; for it is the last exhibition of the year; and the painter has no chance of showing his picture elsewhere; it cannot be argued that he may console himself with the notion that another year may be more propitious; for he hopes to improve, and will not think of subjecting a rejected work to

the hazard of another repulse. His year's labour has gone comparatively for nothing.

Our readers would not complain of our having dwelt so long on this topic, if they knew as we know, the frightful suffering of mind which many able and promising artists have had to endure in consequence of this needless, and we must add careless, system of entire exclusion.

The general impression is that the present EXHIBITION surpasses any of its predecessors; we bow to an opinion so widely expressed; but if we venture to think for ourselves, we cannot consider it so satisfactory as that of last year. There does not seem, to us, the same evidence of improvement in junior professors; and but one or two "new men" have startled us into admiration. It contains, however, a vast number of noble and beautiful works; and undoubtedly maintains the high position which this country occupies in art.

SIR DAVID WILKIE, R.A., contributes eight pictures—No. 62, 'Portrait of the Queen;' No. 110, 'Portrait of Viscount Arbuthnot;' No. 132, 'Portrait of Mrs. Ferguson of Raith;' and No. 276, 'the Hookabadar;' in these portraits there is abundant evidence of power and masterly skill in the executive of art; and in some respects, as in Nos. 132 and 276, there are qualities of the rarest excellence; such as none of our portrait painters can approach. Nevertheless we must be permitted more to covet the possession of the little cabinet sketch, No. 112, 'From the Gentle Shepherd,' than either of these elaborate displays of much labour and little gain. The best of his productions is, perhaps, No. 48, 'Benvenuto Cellini presenting for approval to Pope Paul III. a silver censer of his own workmanship.' It is in all respects the finished work of a master; few who look upon it, will regret even Sir David's departure from the path he pursued at the commencement of his career. There is no exaggeration in this picture; the eager joy of the receiver and the calm consciousness of genius in the giver, are happily and most naturally pourtrayed. The work is carefully executed; the artist has laboured as if he was achieving, and not merely sustaining fame. An interesting and attractive picture is No. 252, 'The Irish Whiskey Still;' but it is not Irish. The originals may have been seen in Spain; but Ireland knows them not. Who ever saw a son of the sod with pink inexpressibles? Who ever encountered a peasant with a neatly trimmed moustache, in lieu of a grizzly beard? Where could these elegant and graceful jars and bottles have been conveyed from? Indeed, there is hardly a single touch on the canvass that conveys to us the remotest notion of aught appertaining to the island of saints. It is a fine picture of a whiskey still—but still it is not Irish. There are parts of it so especially beautiful, as to be unsurpassed in modern art; the little naked child is exquisite. This, too, is

very elaborately wrought—it manifests nothing approaching to indifference as to finish. It is a valuable lesson—that which teaches how essential to genius is industry.

I. M. W. TURNER, R.A. It is to be lamented by all who love art and desire to extend its influence, that Mr. Turner sports with his pencil as if his sole ambition was to show the freaks and follies a great mind may perpetrate with impunity; unfortunately, in his wildest caprices there is so much evidence of genius of the very highest order, that the observer is far more disposed to weep over, than laugh at, power misapplied and time mispent. Who can contemplate such absurdities as we encounter in No. 419, 'Rockets and Blue Lights,'—unless indeed he consider that the artist meant the title and the subject as a sarcasm upon the style? Who will not grieve at the talent wasted upon the gross outrage on nature, No. 203, 'Slavers throwing overboard the dead and dying,' the leading object in which is a long black leg surrounded by a shoal of rainbow-hued "John Dorys," seen more clearly through the ocean surface than flies in amber. If Mr. Turner will persevere in painting, so that no possible advantage or enjoyment can be derived from his works, he must expect that universal censure which, although it may be non-effective in turning him from the evil of his ways, may at all events deter others from following his pernicious example. The young too often mistake notoriety for popularity. Mr. Turner lives on his past reputation; for although high capability may be perceived in the midst of a mass of absurdities in these, his productions, it reminds us more of the occasional outbreaks of the madman, who says wonderful things between the fits that place him on a level with creatures upon whom reason never had been bestowed.

C. L. EASTLAKE, R.A. This accomplished painter contributes but one picture. No. 61, 'The Salutation of the aged Friar.' It is of the very highest merit; exquisite in composition and admirable in execution. The grace and beauty of the fair girls of Italy, who "salute" the aged friar, the boy who is about to kiss his hand, are points touching in the extreme; the production is one that cannot fail to produce pleasure; those who may not be able to appreciate its character as an example of art, will, at all events, feel the sweet story it tells, and enjoy it as a refreshing transcript of true nature. It is, on the whole, the favourite of the year; and it is impossible for language to overpraise it.

DANIEL MACLISE, R.A. Maclise has shown himself worthy of the distinction conferred upon him. No. 174, 'The Banquet Scene in Macbeth,' is even a step in advance; a work of wonderful merit. The Scottish tyrant is described at the moment when the Ghost appears and sits in **the seat appointed for the living Banquo**; his **horror at the apparition is depicted with amaz-**

ing force; the muscles of the hands tell it no less than the features of the face. La ty Macbeth is addressing the astonished and alarmed guests—" Sit, worthy friends; my lord is often thus." The guests, in number about seventy, are all distinctly made out; yet there is no sameness either in countenance, expression, or attitude. The triumph of the picture, however, is the figure of the blood-boltered Banquo. It is indicated rather than painted; the human form is there, darkly shadowed forth; indistinct, but more terrible from its indistinctness. The imagination has full scope; art has never more nearly conveyed the reality of an appalling scene. The accessaries too have been all carefully considered, from the jewelled crown of the usurper to the draught of red wine flung upon the floor. It is a noble picture; and we trust will find its way into the choicest of our British galleries. Of another class, but of equal merit, is No. 381, 'The cross-gartered Malvolio playing off his antics before the Lady Olivia and the maid Maria.' It is painted with singular delicacy. No. 214, ' Gil Blas selecting his dress of " blue velvet, embroidered with gold,"' is a rich example of humour, without coarseness or exaggeration. Nothing can be finer than the contrast between the bedizened youth and the tailor's apprentices,—one of whom holds the looking-glass.

C. STANFIELD, R.A. Mr. Stanfield is an extensive and valuable contributor; several of his pictures are of a large size; and all of them of great merit. The first, No. 13, 'Citara, in the Gulf of Salerno,' is a fine and interesting work, but too much broken up, and certainly deficient in harmony. No. 148, 'Ancona;' No. 155, ' Salerno;' No. 271, ' St. Georgio Maggiore;' No. 343, 'Avignon; No. 470, 'On the coast, near St. Malo;' and No. 476, 'Amalfi,' are, all, landscapes of a high order of merit; but it seems to us that the accomplished painter is contracting a hardness of style.

EDWIN LANDSEER, R.A. The artist has this year limited his powers almost exclusively to portraits—his sitters being, as usual, the dogs of the aristocracy; he has not exercised his mind in the production of any work requiring invention, thought, or study; and we lament to record a consequent waste of his strength. No. 120, ' Horses taken in to bait,' is the only one that relieves us from the Pompeys and Pontos— big and little. It is a delicious work, with far more of fact than of fancy; but so sweetly and gracefully composed, that the character of a mere stable, with the stable-requisites only introduced, has somewhat of the air and aspect of a baronial hall. No. 139, ' The Macaw, Lovebirds, Terrier and Spaniel Puppies belonging to her Majesty,' pleases us far less; it is comparatively raw and cold; and if *true*, the Court atmosphere must be favourable to friendship; for the terrier is fearless of the macaw's beak; and the love-birds are sporting under his very nose.

No. 149, ' The Lion Dog from Malta,' is little more to our taste; No. 311, ' Laying down the Law,' is a most amusing picture—bordering somewhat on caricature; a white poodle represents the grave judge, and dogs of every degree the barristers on either side; while a sharp crabbed terrier stands in the place of the attorney. No. 278, 'Lion and Dash, the property of his Grace the Duke of Beaufort,' is by far the ablest, best, and most interesting of the works this year exhibited by Mr. Landseer. Here we have all " the force of contrast," a dog of the finest and noblest character, with a tiny pet, scarce bigger than the head of the huge animal its protector. Modern art has produced nothing of the class, so near perfection.

R. REDGRAVE. No. 10, ' The Reduced Gentleman's Daughter,' is a most touching and effective picture; very eloquent in composition, and finished with exceeding care and ability. Parts of the drapery of " the lady" are as fine, in execution, as aught in the gallery; and all the accessaries are highly wrought. The young girl in black, who bears, with a half proud and half petitioning look, the gaze and banter of the insolent persons from whom she seeks employment, is a portrait as impressive as art can produce. No. 334, ' The Wonderful Cure by Paracelsus' pleases us by no means so well. The subject is not happily chosen; the singular life of Paracelsus might have supplied the artist with matter far worthier of his pencil; we recommend him to read Mr. Browning's poem, which exhibits the great medical reformer in a truer and more honourable light than that of a quack.

CHARLES LANDSEER, A.R.A. The two works exhibited by Mr. C. Landseer possess considerable merit, and afford proof of a desire not to be satisfied with copying the mere surface of things. No. 33, ' The Tired Huntsman,' is a fine and most agreeable composition; highly wrought withal, and finished with due care and consideration. The hounds are worthy of his brother, and the huntsman's wife, of himself. No. 21, ' Nell Gwynne' is also a good picture; but " the gay wits and men of fashion" who gaze upon " the handsome orange-girl," are too staid and sober; and one of them is stern and gloomy enough to be a Covenanter in disguise.

W. MULREADY, R.A. It is impossible to praise too highly the works of Mr. Mulready. No. 116, 'Fair time,' is in his old manner, full of point and humour; but certainly inferior, both in character and execution to the other two—for he exhibits three. ' First Love,' No. 133, is a delicious composition; a youth is whispering into the ear of as fair a maiden as was ever born of woman; she is too young to comprehend the meaning of the love-words that call the flush into her cheek and brow; the morning of their years and hopes is made to contrast happily with the rich sunlight of a departing day; and just at the moment when some

answer must be made, forth rushes from the cottage the girl's mother and a noisy boy, with a summons to the supper-table. It is a sweet story sweetly told; and negatives the assertion that a painter can preserve but one incident in a tale; what a volume of thought is produced by this single passage in a life! Of a character still more charming is No. 99, to which the painter has given the unworthy title of 'An Interior;' an artist is resting from his labours, his framed picture is on the easel, his young wife sits by his side, and their babe is sleeping near them. The hand of genius is perhaps more visible here than in any part of the exhibition. A more exquisite gem the age has not produced.

A. E. CHALON, R.A. Immediately above ' the Interior,'—so graceful, pure, and natural in conception, and so perfect in execution—is a painting by Mr. Chalon, which ought not to have been hung on the walls of the Royal Academy. Its merits as a work of art are of a mediocre order; but the subject is repulsive to a degree; a modest woman will turn from it; there is no mistaking the character of the dame who exhibits her red leg to the gaze of the man who sits on the steps beneath her. The artist has taken care that his meaning shall not be mistaken, by explaining it in a motto, although he leaves a blank which the spectator may, if he pleases, fill up. The motto is not, indeed, an English one—but there are very few young ladies who cannot read French. This sort of taste is still foreign to our exhibitions; long may it continue so; may this be the first and last time we shall have to notice on the walls of the Royal Academy a picture that could hardly be gazed at deliberately by a person of character in the lowest ally of the metropolis! We raise our voices against it in good time. Possibly it may yet be removed from the room and the catalogue.

T. UWINS, R.A. All the contributions of Mr. Uwins are of Italian scenery and character; a circumstance we cannot but regret; our own English homes afford worthy subjects for his graceful and powerful pencil. They are all, however, of high merit; he has a fine and true eye for the beautiful in nature; and is a master of his art. Nos. 89 and 92, are two cabinet pictures, the one representing a Neapolitan youth decorating the hair of his inamorato, the other ' the Loggia of a Vine-dresser's Cottage.' The largest is No. 266, 'A group of Mountaineers returning from the Festa of Monte Vergine.' They are on their way home, having made their offerings, and " the mountains echo the sounds of 'joy and gladness." In the train is an Asiatic convert blowing the conch with as much fervour, " as if he had been a devout Catholic all his life." The grouping is good; the characters are finely expressed; in pourtraying female beauty few painters surpass Mr. Uwins, and he has here introduced it most happily. It is carefully finished throughout, and must be

regarded as one of the most admirable works in the collection. No. 416, ' Fioretta,' is the portrait of a merry maiden "innocent as gay," adorned with wreathed flowers, which she has flung most gracefully over her shoulders—a pleasant thought skilfully communicated. The artist also exhibits a water colour drawing, No. 599, ' From the Merchant of Venice,' it is a rich example of colour, and worthy of his pencil.

A. COOPER, R.A. A picture placed in the position occupied by No. 124, it is impossible to pass without notice. It professes to represent ' Richard Cœur de Lion reviewing the Crusaders in Palestine,' but illustrates that passage in Sir Walter Scott, which describes the attack of the hound, Roswal, on the traitor Conrade. A more complete failure as a work of art is not in the exhibition, above the eye or below it; the heroes of the drama have neither the gait of Christian, Infidel, or Jew; so miserable a set of mortals never yet degraded humanity, wearing the garb of gallant knights. Mr. Cooper may paint horses; but his attempts at higher objects are melancholy to a degree.

W. COLLINS, R.A. The works of Mr. Collins are sure attractions; and, what is more, they never disappoint. No. 115, is 'A Scene near Tivoli.' An Italian mother playing on her mandolin, and singing her evening song to the Virgin, while her boy rests by her side. No. 256, 'The Passing Welcome,' represents a group of peasants receiving gifts from a group of maidens on the parapet of a palace garden. Both works are exquisite in conception, and admirable in all their details. But Mr. Collins has essayed a new style; the most graceful of all the painters of our cottage homes has not only quitted the green fields and lanes of Merry England, to shelter under ripe vineyards, and watch Italian peasants at their festas—he has actually become a painter of history; and already selected the most ambitious subject he could take from the grandest of all ₅sources. No. 74, ' Our Saviour with the Doctors in the Temple,' is a picture of high merit undoubtedly; it may not be all his own—at least the spectator will be reminded of features made familiar to him by the old masters; but as a first effort in a new path its effect is startling. It is such a work only as a man of unquestionable genius could produce; but we doubt greatly if it will delight as much as do his ' Peasants of Italy;' and we question if these, again, yield the pleasant sensations obtained from his pictures of our own hamlets or coasts.

SIR A. W. CALLCOTT, R.A. This artist also has walked out of his accustomed path; but we can neither rejoice for him nor for ourselves that he has done so. We miss the almost divine copies of nature, he has for so many years presented to us; and are badly compensated for our loss by the huge picture, No. 125, ' Milton dictating to his Daughters;' the figures being nearly as large as life. There is, indeed, ample

evidence of high ability, but not sufficient to induce the hope that the painter will continue in a course that cannot be advantageous to him or satisfactory to his numerous admirers.

W. BOXALL. There are few pictures in the exhibition so perfect as No. 56, ' Hope,' from the pencil of Mr. Boxall—an artist who has suffered us almost to forget he is in existence. It is a noble composition, of the very highest class ; alike unserved and unimpaired by association with any object, the grand and solitary figure sits alone ; it is the conception of a master mind, and is unquestionably the result of matured thought and continued labour. It has all the spirit as well as the simplicity of the ancient days ; and will bear the test of the severest criticism the devotees of the old masters may apply to it.

W. ALLAN, R.A. No. 136, ' Prince Charles Edward in adversity.' The picture commemorates one of the events connected with the marvellous escapes of the Pretender. He is dandling a bibe in the home of one of his faithful followers. The story is effectively told ; the accessaries are well made out ; but the countenance of the prince has an expression almost amounting to silliness. No. 242, ' The Orphan and his Bird,' is a more true and touching picture of adversity—a boy kneeling alone amid the solitude of nature, and gazing, heart-broken, on his dead bird. It is a beautiful illustration of one of Dickens' most pathetic episodes.

W. ETTY, R.A. No. 26, ' Andromeda—Perseus coming to her rescue.' A fine example of the artist's power in painting the human form and copying the true tints of nature ; the spectator will wish, however, that Perseus had deferred his " coming" yet awhile, for the figure in no degree serves the picture. No. 30, ' Mars, Venus, and attendant derobing her mistress for the Bath.' The god of war is, we presume, sleeping—or he ought to be. The dark skin of a negro girl contrasts happily with the brilliant tints of the goddess omnipotent. It is a nobly painted work. No. 230, ' A subject from the Parable of the Ten Virgins.' The execution of this work is admirable ; but the dignity of the subject is, we think, impaired by placing the 'Saviour' and the ' Wise Virgins,' in a sort of opera-box above the gate. The foolish ones upon whom " the door has been shut" are strongly expressive of deep grief and vain remorse.

W. DYCE. No. 197, ' Titian and Irene da Spilembergo.' There are few works by the older masters, and none by the younger members of the profession, that surpass this happily conceived and admirably executed picture. Its merits are such as certainly to secure the admission of the accomplished artist into the Academy whenever an election shall take place ; inasmuch, as he has shown that his ability to execute equals his power to conceive. The figure of the young and lovely girl who takes lessons in art, in the presence of nature, from the aged

painter to whom she is a study, may be, perhaps, liable to the objection that it is too much " attitudinized ;" but that of the great teacher is perfect. The back-ground, too, is exquisitely painted. The work is of the true school of art ; we trust that the recompense the painter will receive may be such as to encourage others to tread in the same path.

H. HOWARD, R.A. No. 95, ' Proserpina' is scarcely worthy of Mr. Howard. The subject was not calculated for his pencil. The fair Proserpine resembles a dressed doll ; and " Peerless Diana," and the affrighted nymphs who occupy "the field of Enna" are aught but deities.

L. BIARD. No. 441, ' The Slave Trade.' This picture is not only creditable to the French school, but confers an honour upon painting in general, and places it on a par with the greatest efforts of poetry and eloquence. While our artists are employing their pencils in representing the tom-fooleries of men and dogs, Mr. Biard places himself in the ranks with Clarkson, Wilberforce, and Brougham, and rouses within the breasts of the spectators a virtuous indignation against the cruelties inflicted upon our fellow-men in this accursed traffic. In the centre is stretched out on the ground a model of a man in muscular strength, whose age a human brute is examining by forcing open his mouth ; while sitting on the body, a slave-agent (grown grey in the service) is announcing to the merchant the health and firmness of the unfortunate object of their purchase ; one of his own species explains by his fingers the price of the prisoner ; while another, with a gun on his shoulder, looks down upon him with a malicious grin of satisfaction : on her knees is a young female, perhaps his wife, undergoing the torture of being branded on the back with a red-hot iron ; she turns with a cry of agony to the villain, who is coolly smoking his cigar ; while another in the garb also of a sailor, holds the irons in which their heads and hands are placed on shipboard. " Thank God !" exclaimed one of the crowd, as we were examining the picture, " these are not English sailors." No ; we replied, but it is for the English that these wretches make slaves. We felt that the artist had made the " galled jade wince ; lower down on the beach is a mother wailing over her infant, while those already on board are taking a last look of their country, in spite of a black wretch, who is driving them down into the hold with a cat-o'-nine-tails. On the right hand in the background, are a gang fastened to a log laid along their shoulders, waiting their turn for inspection ; while the sky, red and lurid, is in unison with the scene. It is a painful subject ; one that cannot be examined without a shudder ; but the most emphatic moral lessons are so conveyed. The execution of the picture is of a high order ; many of our English painters will do well to study its deep tone and character ; it will humble while it will teach some

of them who find themes of art in the nicknackeries of life and character, and lay on their colours so that it would seem a breath might blow them off the canvass.

T. CRESWICK. No. 215, 'A Saw-pit;' No. 273, 'The Bye road; and No. 7 (in the Octagon Room), 'The Ford,' are three delicious landscapes; having perhaps an undue preponderance of that English green, which a few months' travel on the continent might convert into hues more akin to nature. Mr. Creswick is unequalled for grace and delicacy; we look to more matured study, and especially in new schools, for that vigour and force which may give to his works greater effect.

T. WEBSTER. No. 328, 'Punch,' is beyond question one of the best, as well as most attractive works in the exhibition: it is admirably painted; no part of it has been slighted; there is nothing of that dashing for effect, which more frequently indicates idleness than genius. The artist has carefully studied, and then laboured to finish every portion of his design. The picture is full of character; varied to the utmost, yet never bordering on the grotesque. There are a score of incidents, yet no one of them is hurtful to another. The young and old are as happy as simple amusement can make them—all but the widowed and orphaned group that wait the coming of the waggon, and have no heart for laughter. This episode is most judiciously introduced; it gives *weight* to the picture, and produces that satisfaction which is invariably produced by skilful contrast—CONTRAST being a word which our English artists too frequently omit from their vocabulary. In Mr. Webster's one, we have a dozen pictures; the school in the background is delightful; the little urchins "just let loose," running eagerly to be at the point of attraction; the wonder the one expresses; the alarm felt by the other; and the curiosity of the young rogue who peeps under the blanket; the aged, ailing man, who comes to look and laugh; the baker's lad who lingers on his errand; in short, the work is full of matter, all good, all affective, and all true. It is a volume that may be read with excessive delight.

A. W. ELMORE. No. 415, 'The Martyrdom of Thomas à Becket.' This is the ambitious effort of a young man; and one that is eminently successful. There is merit even in the attempt; and comparative failure would not have been discreditable. There are too few of our artists daring enough to venture out of the beaten path—who will aim to be something or resolve to be nothing. For the one who will hazard all, there are scores who will incur no risk; content with that mediocrity which gives little trouble and no anxiety. Productions such as this, that make the heart of the painters beat with hope or throb with apprehension, should be especially cared for by the Royal Academy; they are wrought with little chance of profit; and, very often, to buy the canvass, the artist

starves. Mr. Elmore has produced a noble work, giving evidence of power as well as labour; of judgment as well as thought. We cannot doubt that a career, so propitiously commenced will be honoured and distinguished; and, as we understand, he is about to voyage to Italy, we anticipate for him ere long a proud position among the artists of his country.

D. ROBERTS, A. Mr. Roberts contributes largely from his treasure-store gathered in the rich east. No. 190, 'The Greek Church of the Holy Nativity at Bethlehem;' No. 220, 'A Gate and Mosque at Cairo;' No. 292, 'The Dromos, or outer gate of the Great Temple at Edfou, in Upper Egypt;' No. 501, 'Statue of the Memnon on the Plain of Thebes;' and No. 944, 'Remains of the Portico of the Lesser Temple, at Baalbec,'—are all pictures of high merit, and of great interest, as introducing us to scenes comparatively new to art. The first-named is a gorgeous work; certainly equal in execution to anything the artist has ever produced; and in his own peculiar walk he has been, hitherto, unrivalled. 'The Statue of the Vocal Memnon' is, on the other hand, cold and tame.

J. R. HERBERT. No. 287, 'The Monastery in the 14th Century; Boar Hunters refreshed at the Gateway of St. Augustine, Canterbury.' A finer composition than this does not grace the walls of the exhibition; and, in parts, the execution is on a par with the conception. It is, however, evidently unfinished—a circumstance we must attribute to the severe illness of the artist prior to the opening of the Academy, and certainly neither to indolence nor indifference; we lament, however, that it is so; for many may imagine he has followed the too prevailing principle, and considered that labour is not necessary to perfection. Mr. Herbert has achieved a very high fame; and is too wise to incur the hazard of trifling it away. The picture will interest all who examine it; a knight and lady are waited upon by the good monks of the monastery—their hospitality belongs to history; with them departed the assurance that refreshment was ever ready for the wayfarer at the convent gate. The arrangements are skilful and judicious; and the minor portions evidence thought and care—they must be more highly wrought hereafter. He has undoubtedly sustained his previous reputation,—and will have surpassed it in the estimation of those who look more to the design than the completion of the picture.

J. C. HORSLEY. No. 288, 'Leaving the Ball.' The artist has not produced so touching or so effective a work as he did last year. This picture is comparatively common-place; a young soldier and a brilliant girl are passing down the steps of a mansion, about to enter their carriage; and near them, unnoticed, " a houseless shivering female lies." The incident is not an agreeable one; nor is it told so as to produce sympathy with suffering.

F. R. LEE, R.A. Mr. Lee exhibits several fine and highly finished landscapes—broadly painted and amazingly true to nature. He is not always, however, fortunate in his choice of subjects ; but frequently occupies large space with matter that might be advantageously compressed. In Nos. 364 and 374, this is apparent—in one of them the attention is exclusively directed to a herd of deer swimming across a narrow river ; and No. 316, a picture of some extent, contains nothing but dead game. In each and all there is ample proof of high power ; but an artist who commands so masterly a pencil should make art labour more beneficially in the cause of nature ; should make his canvass speak of her beauties to mankind. No. 185, ' Charcoal Burning ;' and No. 424, ' Taking up Trimmer Lines,' are far better—better, at least, in the sight of those who love to see a landscape free and unfettered. We fear he confines his study too much to a single or limited locality ; and does not seek far and wide for themes worthy to be copied.

E. V. RIPPINGILLE. No. 438, ' Brigands visited by their Friends and Manutengoli.' This picture has been sent from Rome ; and although it possesses considerable merit, it has all the coldness and hardness that too usually mark the works of our English painters when they visit Italy.

P. F. POOLE. No. 201, ' The Recruit.' This is a sweetly composed picture ; the production of a fine and natural mind. The colouring is weak and flimsy ; but sure we are that the artist is in the road to fame, and that a few months continual and careful study of the old masters will give him that power over his material, without which his taste and judgment will produce comparatively little effect. ' The Recruit' has met his sweetheart in a lonely lane : the intensity of her agony is finely expressed ; while the character of the thoughtless youth, still dressed in his peasant-garb, his decorated hat laid by his side, is also admirably depicted.

J. LINNELL. No. 403, ' Philip baptizing the Eunuch.' A work of the highest and best class ; excellent in composition, and with a depth of tone and vigour of touch, such as many of our English painters will do well to imitate. The artist exhibits also several portraits of very considerable merit.

T. S. COOPER. No. 472, ' Turning the Drove ;' and No. 33 (in the Octagon Room), ' In the Meadows of Fordwich,'—two admirable cattle pieces, with all the vigour and freshness of nature, literal copies of facts, and yet having the character of true pastoral poetry. There is nothing so good, of the class, in the exhibition.

H. GRITTEN, JUN. No. 36 (in the Octagon Room), ' Amiens, with the Cathedral, from the River Somme.' There are few landscapes in the collection that surpass this ; and none that give so sure a promise of future fame. We had occasion to notice the works of this young

painter in the British Institution ; we rejoice to find that he is realising the high expectations we have formed of him. He has a free and vigorous pencil ; and studies nature as attentively as she must be studied to arrive at excellence. The old buildings that overlook the bridge are of marvellous fidelity ; and the ferry-boat, with its assemblage of merchandize and passengers, adds greatly to the interest of the picture. We have rarely examined a production that so faithfully conveys the peculiar character of the scenery and people.

E. M. WARD. No. 22 (in the Octagon Room), ' Scene from King Lear.' A very noble work ; the production of matured thought as well as labour. It is grouped with great skill ; the figure of " poor Cordelia" is especially good ; and we have rarely, if ever, seen the unhappy king more satisfactorily represented. The artist has entered on the arduous and honourable career of an historical painter ; and sure we are that he will excel in it. He has evidently studied in the best school ; a little too much, perhaps, in Germany. Yet he has got rid of much of that hardness of outline, upon which we had to comment in noticing his picture last year.

F. STONE. No. 123, ' Scene from a Legend of Montrose.' The picture represents the scene in which Annot Lyle subdues the fierce temper of Allan M'Aulay—the young Earl of Monteith being by. It is a very graceful composition, and painted with considerable vigour ; there are indeed few more touching or more interesting works in the exhibition.

J. A. CASEY. ' The Captivity of Joan of Arc.' A work of considerable merit ; the production of an artist with whose name we are not familiar. The conception is good, the idea original, and it has been executed with much ability. The passage selected for illustration from the history of the ill-fated Maid of Orleans, whose murder has been so long a foul blot on English character, is that which describes her persecutors as having introduced armour into her chamber, after they had extorted from her a promise that she would never wear any dress but that of her sex. The device succeeded ; the doomed heroine found the temptation irresistible ; put on the armour ; and was condemned to the stake.

F. GRANT. No. 162. ' Equestrian Portrait of her Majesty, &c.' This is by no means a satisfactory work ; it is stiff, formal, and ungraceful ; and, as a composition, unworthy of the artist's high and deserved repute. How marked is the contrast between this and No. 508, beyond doubt the most admirable portrait in the exhibition ;—a painting of which the most famous of our old British artists might be greatly proud. It is so pure in composition, so completely uninfluenced and consequently unimpaired by any extraneous matter ; so true to nature ; so correct in drawing ; so exquisite in colour ; so perfect indeed, in all respects, that if it had been carried

a little farther in the execution, it might vie with many of the best of those that adorn the other wing of the building.

C. W. COPE. No. 484. 'Altar-piece for St. George's Church, Leeds.' This is the largest picture in the exhibition; we regret we cannot speak of it in terms of entire praise; because the effort is an honourable one, and demands that encouragement without which the lofter departments of the arts can never flourish. Moreover it is to be placed in a church—and it is certain that if historical painting is yet destined to prosper in Great Britain, it can only be by depositing works of arts in our churches and other public buildings, where justice is to be awarded, virtue inculcated, or charity practised and taught. Mr. Cope did not, we think, select his subject well or wisely. It is a fiction, and unnecessarily so, for "the Book" supplied him with realities far more effective. A group of sinners assemble at the foot of a tall cross; the cross at once disturbs our notions of truth, for it is without actual character—long and thin, and, if we may so apply the term, unnatural. The figure of the Saviour in the clouds has little of dignity: it is to our mind heavy and ungraceful, and the position in which the artist has placed it, is not an apt illustration of the text, "He ever liveth to make intercession for us." The Magdalen, embracing the cross, is finely conceived and finished; but in spite of our desire to do so, we are unable to be satisfied with the other figures introduced. The canvass was too huge for the amount of thought and labour bestowed upon it. Nos. 198 and 204 are infinitely smaller, and we think more meritorious works; the one represents an aged man supported by the arm of his fair daughter; the other a touching group, characteristic of Charity.

G. RICHMOND. No. 16 (Octagon Room), 'Our Saviour and two Disciples.' The subject has been ably treated, and is painted with considerable power. The two disciples "that went to Emmaus," are happily contrasted with the Saviour—their comparatively common place character with the divinity of their master.

R. S. LAUDER. No. 5 (Octagon Room), 'The Glee Maiden;' No. 34, 'Scene from Romeo and Juliet.' Mr. Lauder does not, in these works, sustain the reputation he achieved in the exhibition last year. They are by no means without merit; but have neither the careful composition, nor the high finish of his picture from "the Bride of Lammermoor."

J. WILSON, Jun. No. 26 (Octagon Room), 'Noon Day.' Although this picture is very disadvantageously placed—and we make due allowance for the depressing circumstance — we cannot consider it as sustaining the young artist's fame. He has been seduced into the notion that he might produce greater effects by crowding his canvass; and departing from the simple path in which he has heretofore followed nature. A failure it is not; it has suf-

ficient proof of genius; with infinitely less EFFORT he would have painted a far better work.

F. P. STEPHANOFF. No. 1 (Octagon Room), 'The last Sigh of the Moor.' The picture is interesting, and manifests much ability. There is, however, far less of that grief in the party "assembled to take a farewell gaze of their beloved city," than we might reasonably have expected; and the depicting of which would have been essentially useful to the painter.

W. SIMSON. No. 11 (Octagon Room), 'Titian in his Study;' No. 404, 'Gil Blas introducing himself to Laura, as his master Don Mattias de Silva.' Two well composed and highly finished works, but of scarcely sufficient importance to increase or even uphold the well earned fame of the artist. He is one to whom we look for some great undertaking that shall be honourable to the country and the arts.

T. SULLY. No. 483, 'Portrait of her Most Gracious Majesty.' With the fine engraving from this picture the public are familiar. It is elegant and graceful, and we think a good likeness, notwithstanding the small resemblance it bears to so many other copies of the most gracious countenance of the Queen. The red curtain greatly impairs its harmony; how much better would have been a quiet back-ground.

W. MULLER. No. 207, 'Athens, from the Road to Marathon;' No. 12 (Octagon Room), 'Ruins at Gornou, Egypt.' Mr. Muller sustains his reputation to the full; both these works are of admirable character; they bear the stamp of truth; and while they betoken a free and vigorous pencil, they afford evidence of thought and careful study.

J. UWINS. No. 29, 'Capuchin Convent at Amalfi;' No. 189, 'Terrace of the Capuchin Convent, Bay of Naples.' We heartily congratulate this young painter on his progressive improvement. We cannot doubt that he has laboured hard throughout the year; the reward of his industry will be the universal satisfaction his pictures cannot fail to produce. There is now nothing stiff or constrained in his work; it is evident that he feels at ease, and uses his pencil with freedom. The exhibition does not afford us an example of surer and safer progress. The subjects, too, are well chosen; strongly characteristic of Neapolitan scenery, and highly picturesque.

J. MARTIN. No. 393, 'The Eve of the Deluge;' No. 509, 'The Assuaging of the Waters.' Two pictures of large size, to which due honour has been done by the Royal Academy; they are placed on the line. Of their merit as compositions there can be no question: Mr. Martin paints poetry. 'The Eve of the Deluge' represents Methusaleh, "full of years," comparing the signs in the heavens with those "written" testimonies which foretold the mighty overthrow, when the gates of heaven should be opened. He is on a lofty mountain, surrounded by his kindred; while, in the valleys beneath—

in the pleasant places of the earth—the thought-less multitude are revelling and rejoicing. 'The Assuaging of the Waters' is a fine conception. The raven who, finding his prey, returned not to the Ark, is a new, but natural, reading of the story; yet, to the general observer, the picture is deficient in interest. The imagination may wander, beneath those heaving waters, to fresh fields and pastures; to the mighty wreck, out of which Earth is formed; but, in the Exhibition, the grand effect of the loneliness, which is its distinctive feature, is destroyed, and far too much light is thrown upon the glittering waters. The colouring in both is cold: time will greatly improve them.

T. DUNCAN. No. 482, 'Prince Charles Edward, and the Highlanders, entering Edinburgh after the Battle of Preston.' This is among the most striking pictures in the collection; the figures are multiplied to confusion; the eye is fixed upon no particular object; occasionally we are reminded too forcibly of the manner of the great Scottish artist; and two or three errors, of minor importance, but still important, have been committed. In this age of improvement in matters of information relating to costume, what is the reason that Mr. Duncan should have taken such unaccountable liberties in representing the highland characters in wrong tartans? For instance, Clanranald is painted in red, when that clan have invariably worn green. Lochiel, too, is painted in red, which should have been as green as Fluellyn's leek. James Macgregor is shown leaning on the cannon with a modern imitation of tartan—certainly not the Macgregors. Then the Prince himself is adorned with a new invention called "Victoria tartan." Why should he not have been painted in the garb he actually wore—in the Stuart's tartan? The axe in the miller's hand is much too small. But the work has merits of a very high order, to compensate for these defects. It is conceived in a bold spirit, realizes our imagination of the exciting scene, is full of interesting episodes, and may bear an hour's inspection without wearying the spectator. The execution, too, is highly creditable; the artist felt he was engaged upon a work that must make or mar his fortunes, and he has laboured with a consciousness that no effect was to be lost that was to be obtained by industry.

W. D. KENNEDY. No. 487, 'The Lay of the Last Minstrel.' There are high qualities in this work; the drawing is good, the composition fine, and the colouring judicious; but the painter has fallen into the error of giving new faces in association with ancient draperies; there is a sad want of harmony between the dresses and the countenances, which induces a suspicion that the artist tempted his friends to sit for their portraits. There is, also, a degree of affectation in making Scott the aged minstrel, and giving to him a most weakly expression. The painter has not been happy in depicting the grace or

beauty of his females—although many of his men are admirably placed and drawn.

F. GOODALL. No. 12, 'Leaving Church.' This young artist must take care. It is easier to gain a reputation than to keep it. 'Leaving Church' is clever in design and execution; but certainly not superior to the works he exhibited last year. In art, at his age, there is no standing still; he who does not progress, must be said to retrograde.

J. P. KNIGHT, A. No. 82, 'Melody.' A very agreeable and a good picture; although not, perhaps, of value sufficient to maintain Mr. Knight in the position he has obtained; a group of cottagers are listening to a rustic musician playing on the clarionet. The artist exhibits several excellent portraits,—that of the Marquis of Anglesey is painted with much ability, and is a striking likeness of the veteran.

N. I. CROWLEY, R.H.A. No. 87, 'The Wedding Ring.' There are five works by Mr. Crowley. They are clever productions, each and all; but a little more study of the simple and natural will greatly benefit the artist: we notice, with regret, an evident straining after effect, amounting almost to affectation; a fault we are less inclined to overlook, where there is so much natural talent.

A. JOHNSTON. No. 72, 'Scene from the Gentle Shepherd.' A sweet composition, but "flimsily" coloured. A firmer hand to produce a little more depth of tone would have made this one of the best pictures in the exhibition.

MRS. M'IAN. No. 94, 'Katty Macane's Darlint.' We regret that this is the only work exhibited by the accomplished artist, who has taken a high position among professors of the gentler sex. It is a very agreeable picture; illustrating a scene in Mrs. S. C. Hall's novel of "Marian; or, a Young Maid's Fortunes."

MRS. ARNOLD. No. 255, 'View of Mountains in Denbighshire.' A vigorous landscape, and entirely true to nature. There are few of our landscape painters whose pencil has greater force or accuracy. The lady is not always happy in her selection of subjects; and aims more to satisfy the connoisseur than the mass: we never examine one of her productions without pleasure and satisfaction.

A. GEDDES, A. No. 369, 'A Spanish Girl.' Mr. Geddes exhibits several portraits of high merit; but this is a work of a more extensively interesting character. It may be classed among the best in the exhibition: there is fine feeling in the arrangement, and great power in the execution.

G. PATTEN, A. No. 173, 'Portrait of his Royal Highness Prince Albert.' The most interesting and attractive of Mr. Patten's works is, of course, the portrait of the Prince "in his robes of the Order of the Garter." It is a striking likeness, and the composition is of a high order, but it is more than probable that it

was hurried to a completion; and that, when
the artist has bestowed more time upon it, it
will be of far higher excellence as a work of art.

R. DADD. 'Alfred the Great, disguised as a
Peasant, reflecting on the misfortunes of his
Country.' There is much in this picture that
gives promise that the artist will attain a high
rank in his profession. The colouring is, per-
haps, raw, but there is a fine character in the
composition, and proofs of a reflective mind.

H. J. BODDINGTON. No. 440, 'The Village
Farriers.' There are few more agreeable or
better painted pictures than this in the exhibi-
tion. It is the work of an elegant and observant
mind ; of one who has studied under the influ-
ence of nature, and whose pencil has the free-
dom of a master. The little group in the fore-
ground is exquisitely managed ; the foliage is
true ; and the cottage, with its smithy, are highly
wrought, and yet with freedom.

MRS. W. CARPENTER. No. 156, 'Portrait of
Mrs. Constable.' The accomplished lady has,
this year, permitted no scope to her fancy. In
the portraits she exhibits there is, however, am-
ple evidence of that fine feeling and intimate
knowledge of art which have given to her name
prominence in the list of candidates for the high-
est honours the profession can bestow.

SIR M. A. SHEE, P.R.A. The six portraits
exhibited by the President are all of a valuable
order. They manifest no effort at display ; no
striving after meritricious aids ; they are tho-
roughly and essentially English ; good and
graceful copies of the originals ; *mere* portraits,
indeed, they are all ; but far more interesting to
those who will possess them than they would be
if the artist had sought the help of fiction, and
wrought more for an exhibition-room than for a
drawing-room. If the painter supplies us with no
proof of imagination in his painted works, he gives
us ample evidence of good taste—and of that
TRUTH, which is, to our minds, the only founda-
tion of excellence in a department of the arts in
which he is the leading professor, and which we
hope will long continue to flourish in England,
in spite of the depreciating tone in which so
many critics treat it. No. 308 may be referred
to as one of the finest and most satisfactory por-
traits in the collection.

Of the portraits generally, it is but justice to
speak in high terms ; they are such as fully to
sustain the reputations of Mr. Pickersgill, Mr.
Phillips, Mr. Briggs, Mr. Say, Mr. Faulkner, and
Mr. Watson Gordon.

W.M. Thackeray

"A Pictorial Rhapsody
by Michael Angelo Titmarsh"

Fraser's Magazine 21 (June 1840), 720–32

MY DEAR YORKE,—Do you remember the orders which you gave me at the close of our dinner last week at the Clarendon?—that dinner which you always provide upon my arrival in town from my country-seat; knowing full well that Titmarsh before he works must dine, and when he dines must dine well? Do you, I say, remember the remarks which you addressed to me? Probably not; for that third bottle of Clos-Vougeot had evidently done your business, and you were too tipsy, even to pay the bill.

Well, let bills be bills, and what care we? There is Mr. James Fraser, our employer, master, publisher, purse-bearer, and friend, who has such a pleasure in paying that it is a pity to balk him; and I never saw a man look more happy than he when he lugged out four five-pound notes to pay for that dinner of ours. What a scene it was! You asleep with your head in a dish of melted raspberry-ice; Mr. Fraser calm, beneficent, majestic, counting out the thirteens to the waiters; the Doctor and Mr. John Abraham Heraud, singing, "Suoni la tromba intrepida," each clutching the other's hand, and waving a punch-ladle or a desert-knife in the unemployed paw, and the rest of us joining in chorus when they came to "gridando liberta."—But I am wandering from the point: the address which you delivered to me on drinking my health was in substance this:

"Mr. Michael Angelo Titmarsh, the splendid feast of which you have partaken, and the celebrated company of individuals whom you see around you, will shew you in what estimation myself and Mr. Fraser hold your talents,—not that the latter point is of any consequence, as I am the sole editor of the Magazine. Sir, you have been called to the metropolis from a very distant part of the country, your coach-hire and personal expenses have been defrayed, you have been provided with a suit of clothes that *ought* to become you, for they have been for at least six months the wonder of the town while exhibited on my own person; and you may well fancy that all these charges have not been incurred on our parts, without an expectation of some corresponding return from you. You are a devilish bad painter, sir; but never mind, Hazlitt was another, and old Peter Pindar was a miserable dauber; Mr. Alexander Pope, who wrote several pretty poems, was always busy with brush and palette, and made sad work of them. You, then, in common with these before-named illustrations, as my friend, Lady Morgan, calls them [Sir Charles returned thanks], are a wretched artist; but a tolerable critic — nay, a good critic — nay, let me say to your face, the best critic, the clearest, the soundest, the gayest, the most eloquent, the most pathetic, and, above all, the most honest critic in matters of art that is to be found in her majesty's dominions. And, therefore, Mr. Titmarsh, for we must give the deuce his due, you have been brought from your cottage near John O'Groat's or Land's End,—I forget which,—therefore you have been summoned to London at the present season.

"Sir, there are at this moment no less than five public exhibitions of pictures in the metropolis; and it will be your duty carefully to examine every one of them during your residence here, and bring us a full and accurate report upon all the pieces exhibited which are remarkable for goodness, badness, or mediocrity."

I here got up; and, laying my hand on my satin waistcoat, looked up to heaven, and said, "Sir, I ——"

"Sit down, sir, and keep your eternal wagging jaws quiet! Waiter! whenever that person attempts to speak, have the goodness to fill his mouth with olives or a damson cheese.—To proceed. Sir, and you, gentlemen, and you, O intelligent public of Great Britain! (for I know that every word I say is in some way carried to you) you must all be aware, I say, how wickedly,—how foully, basely, meanly—how, in a word, with-every-deteriorating-adverb that ends in *ly*—in *ly*, gentlemen [here Mr. Yorke looked round, and myself and Mr. Fraser, rather alarmed lest we should have let slip a pun, began to raise a low, faint laugh]—you. have all of you seen how the world has been imposed upon by persons calling themselves critics, who, in daily, weekly, monthly prints, protrude their nonsense

upon the town. What are these men? Are they educated to be painters?—
No! Have they a taste for painting?—No! I know of newspapers in this town,
gentlemen, which send their reporters indifferently to a police-office or a picture-
gallery, and expect them to describe Correggio or a fire in Fleet Street with
equal fidelity. And, alas! it must be confessed that our matter-of-fact public
of England is itself but a dull appreciator of the arts, and is too easily persuaded
by the dull critics who lay down their stupid laws.

" But we cannot expect, Mr. Titmarsh, to do any good to our beloved public
by telling them merely that their instructors are impostors. Abuse is no argu-
ment, foul words admit of no pretence (you may have remarked that I never use
them myself, but always employ the arts of gentlemanly persuasion), and we
must endeavour to create a reform amongst the nations by simply preaching a
purer and higher doctrine. Go you among the picture-galleries, as you have
done in former years, and prattle on at your best rate ; don't philosophise, or
define, or talk big, for I will cut out every line of such stuff, but speak in a
simple, natural way,—without fear, and without favour.

" Mark that latter word ' favour ' well ; for you are a great deal too tender
in your nature, and too profuse of compliments. Favour, sir, is the curse of the
critical trade ; and you will observe how a spirit of *camaraderie* and partisanship
prevails in matters of art especially. The picture-critics, as I have remarked,
are eminently dull — dull and loud ; perfectly ignorant upon all subjects con-
nected with art, never able to guess at the name of an artist without a catalogue
and a number, quite unknowing whether a picture be well or ill drawn, well or
ill painted : they must prate, nevertheless, about light and shade, warm and cool
colour, keeping, chiaroscuro, and such other terms, from the Painters' Cant
Dictionary, as they hear bandied about among the brethren of the brush.

" You will observe that such a critic has ordinarily his one or two idols that he
worships ; the one or two painters, namely, into whose studios he has free access,
and from whose opinions he forms his own. There is Dash, for instance, of the Star
newspaper ; now and anon you hear him discourse of the fine arts, and you may
take your affidavit that he has just issued from Blank's *atelier* : all Blank's
opinions he utters — utters and garbles, of course ; all his likings are founded on
Blank's dicta, and all his dislikings : 'tis probable that Blank has a rival, one
Asterisk, living over the way. In Dash's eye Asterisk is the lowest of creatures.
At every fresh exhibition you read how ' Mr. Blank has transcended his already
transcendant reputation ;' ' Myriads are thronging round his glorious can-
vasses ;' ' Billions have been trampled to death while rushing to examine his
grand portrait of Lady Smigsmag ;' ' His picture of Sir Claude Calipash is a
gorgeous representation of aldermanic dignity, and high chivalric grace!' As
for Asterisk, you are told, ' Mr. Asterisk has two or three pictures — pretty, but
weak, repetitions of his old faces and subjects in his old namby-pamby style.
The committee, we hear, rejected most of his pictures : the committee are very
compassionate. How *dared* they reject Mr. Blank's stupendous historical picture
of So-and-so?'"

[Here, my dear sir, I am sorry to say that there was a general snore heard
from the guests round the table, which rather disturbed the flow of your rhetoric.
You swallowed down two or three pints of burgundy, however, and continued.]

" But I must conclude. Michael Angelo Titmarsh, you know your duty.
You are an honest man (loud cheers, the people had awakened during the
pause). You must go forth determined to tell the truth, the whole truth, and
nothing but the truth ; as far as you, a fallible creature (cries of ' No, no !') know
it. If you see a good picture, were it the work of your bitterest enemy — and
you have hundreds — praise it."

" I will," gasped I.

" Hold your tongue, sir, and don't be interrupting me with your perpetual
orations ! If you see a bad picture, were it the work of your dearest associate,
your brother, the friend of your bosom, your benefactor — cut, slash, slaughter
him without mercy. Strip off humbug, sir, though it cover your best boon-
companion. Praise merit, though it belong to your fiercest foe, your rival in the
affections of your mistress, the man from whom you have borrowed money, or
taken a beating in private !"

" Mr. Yorke," said I, clenching my fists and starting up, " this passes

endurance, were you not intox ——;" but two waiters here seized and held me down, luckily for you.

"Peace, Titmarsh (said you); 'twas but raillery. Be honest, my friend, is all that I would say; and if you write a decent article on the Exhibitions, Mr. Fraser will pay you handsomely for your trouble; and, in order that you may have every facility for visiting the picture-galleries, I myself will give you a small sum in hand. Here are ten shillings. Five Exhibitions, five shillings; catalogues, four. You will have twelve pence for yourself, to take refreshments in the intervals."

I held out my hand, for my anger had quite disappeared.

"Mr. Fraser," said you, "give the fellow half a sovereign; and, for Heaven's sake, teach him to be silent when a gentleman is speaking!"

What passed subsequently need not be stated here, but the above account of your speech is a pretty correct one; and, in pursuance of your orders, I busied myself with the Exhibitions on the following day. The result of my labours will be found in the accompanying report. I have the honour, sir, of laying it at your feet, and of subscribing myself,

<div style="text-align:center">

With the profoundest respect and devotion,
Sir,
Your very faithful and obedient Servant,
MICHAEL ANGELO TITMARSH.
</div>

Moreland's Coffee-House,
Dean Street, Soho.

<div style="text-align:center">

ΡΑΨΩΔΙΑ ἢ ΓΡΑΜΜΑ Α'.

The Royal Academy.
</div>

HAD the author of the following paragraphs the pen of a Sir Walter Scott or a Lady Morgan, he would write something excessively brilliant and witty about the first day of the Exhibition, and of the company which crowd the rooms upon that occasion. On Friday the queen comes (Heaven bless her majesty!) attended by her courtiers and train; and deigns, with royal eyes, to examine the works of her Royal Academicians. Her, as we are given to understand, the President receives, bowing profoundly, awe-stricken; his gold chain dangles from his presidential bosom, and sweet smiles of respectful courtesy light up his venerable face. Walking by her majesty's side, he explains to her the wonders of the show. "That, may it please your majesty, is a picture representing yourself, painted by the good knight, Sir Francis Wilkie: deign to remark how the robes seem as if they were cut out of British oak, and the figure is as wooden as the figure-head of one of your majesty's men-of-war. Opposite is your majesty's royal consort, by Mr. Patten. We have the honour to possess two more pairs of Pattens in this Academy—ha, ha! Round about you will see some of my own poor works of art. Yonder is Mr. Landseer's portrait of your majesty's own cockatoo, with a brace of Havadavats. Please your royal highness to look at the bit of biscuit; no baker could have done

it more natural. Fair maid of honour, look at that lump of sugar; couldn't one take an affidavit, now, that it cost eleven pence a-pound? Isn't it sweet? I know only one thing sweeter, and that's your ladyship's lovely face!"

In such lively conversation might we fancy a bland president discoursing. The queen should make august replies; the lovely, smiling maids of honour should utter remarks becoming their innocence and station (turning away very red from that corner of the apartment where hang certain Venuses and Andromedas, painted by William Etty, Esquire); the gallant prince, a lordly, handsome, gallant gentleman, with a slight foreign accent, should curl the dark mustache that adorns his comely lip, and say, "Potztausend! but dat bigtute of First Loaf by Herr von Mulready ist wunder schön!" and courtly chamberlains, prim gold-sticks, and sly polonaises of the court, should take their due share in the gay scene, and deliver their portions of the dialogue of the little drama.

All this, I say, might be done in a very sprightly, neat way, were poor Titmarsh an Ainsworth or a Lady Morgan; and the scene might be ended smartly with the knighting of one of the Academicians by her majesty on the spot. As thus:—"The royal party had stood for three-and-twenty minutes in mute admiration before that tremendous picture by Mr. Maclise, representing the banquet in

the hall of Dunsinane. ' Gory shadow of Banquo,' said Lady Almeria to Lady Wilhelmina, ' how hideous thou art !' ' Hideous! hideous yourself, marry !' replied the arch and lovely Wilhelmina. ' By my halidome!' whispered the seneschal to the venerable prime minister, Lord Melborough —' by cock and pie, sir count, but it seems me that yon Scottish kerne, Macbeth, hath a shrewd look of terror !' ' And a marvellous unkempt beard,' answered the earl; ' and a huge mouth gaping wide for very terror, and a hand palsied with fear.' ' Hoot awa, mon !' cried an old Scots general, ' but the chield's Macbeth (I'm descanded from him leeneally in the saxty-ninth generation), knew hoo to wield a gude claymore !' ' His hand looks as if it had dropped a hot potato !' whispered a roguish page, and the little knave's remark caused a titter to run through the courtly circle, and brought a smile upon the cheek of the President of the Academy; who, sooth to say, had been twiddling his chain of office between his finger and thumb, somewhat jealous of the praise bestowed upon his young rival.

" ' My lord of Wellington,' said her majesty, ' lend me your sword.' The veteran, smiling, drew forth that trenchant sabre,—that spotless blade of battle that had flashed victorious on the plains of far Assaye, in the breach of storm-girt Badajoz, in the mighty and supreme combat of Waterloo ! A tear stood in the hero's eye as he fell on his gartered knee; and, holding the blade between his finger and thumb, he presented the hilt to his liege lady. ' Take it, madam,' said he ; ' sheathe it in this old breast, if you will, for my heart and sword are my sovereign's. Take it, madam, and be not angry if there is blood upon the steel—'tis the blood of the enemies of my country !' The queen took it; and, as the young and delicate creature waved that tremendous war-sword, a gentleman near her remarked, that surely never lighted on the earth a more delightful vision. ' Where is Mr. Maclise ?' said her majesty. The blushing painter stepped forward. ' Kneel! kneel !' whispered fifty voices ; and frightened, he did as they ordered him. ' Sure she's not going to cut my head off ?' he cried to the good knights, Sir Augustus Callcott and Sir Isaac Newton, who were standing. ' Your name,

sir ?' said the Ladye of England. ' Sure you know it's Maclise !' cried the son of Erin. ' Your Christian name ?' shrieked Sir Martin Shee, in agony. ' Christian name, is it ? Oh, then it's Daniel Malcolm, your majesty, and much at your service !' She waved the sword majestically over his head, and said, ' Rise up, Sir Malcolm Maclise !'

* * * * *

" The ceremony was concluded, the brilliant *cortége* moved away, the royal caroches received the illustrious party, the heralds cried, ' Largesse, Largesse !' and flung silver pennies among the shouting crowds in Trafalgar Square ; and when the last man-at-arms that accompanied the royal train had disappeared, the loud *vivas* of the crowd were heard no more, the shrill song of the silver clarions had died away, his brother painters congratulated the newly-dubbed chevalier, and retired to partake of a slight collation of bread and cheese and porter in the keeper's apartments."

Were we, I say, inclined to be romantic, did we dare to be imaginative, such a scene might be depicted with considerable effect ; but, as it is, we must not allow poor fancy to get the better of reason, and declare that to write any thing of the sort would be perfectly uncalled for and absurd. Let it simply be stated that, on the Friday, her majesty comes and goes. On the Saturday the Academicians have a private view for the great personages; the lords of the empire and their ladies, the editors of the newspapers and their friends ; and, after they have seen as much as possible, about seven o'clock the Academicians give a grand feed to their friends and patrons.

In the arrangement of this banquet, let us say roundly that Messieurs de l'Académie are vastly too aristocratic. Why were *we* not asked ? The dinner is said to be done by Gunter ; and, though the soup and fish are notoriously cold and uncomfortable, we are by no means squeamish, and would pass over this gross piece of neglect. We long, too, to hear a bishop say grace, and to sit cheek by jowl with a duke or two. Besides, we could make some return; a good joke is worth a plate full of turtle; a smart, brisk pun is quite as valuable as a bottle of champagne ; a neat anecdote deserves a slice of venison, with plenty of fat

and curranty jelly, and so on. On such principles of barter we might be disposed to treat. But a plague on this ribaldry and beating about the bush! let us leave the plates, and come at once to the pictures.

* * * * *

Once or twice before, in the columns of this Magazine, we have imparted to the public our notions about Greek art, and its manifold deadly errors. The contemplation of such specimens of it as we possess hath always, to tell the truth, left us in a state of unpleasant wonderment and perplexity. It carries corporeal beauty to a pitch of painful perfection, and deifies the body and bones truly; but, by dint of sheer beauty, it leaves humanity altogether inhuman — quite heartless and passionless. Look at Apollo the divine: there is no blood in his marble veins, no warmth in his bosom, no fire or speculation in his dull, awful eyes. Laocoon writhes and twists in an anguish that never can, in the breast of any spectator, create the smallest degree of pity. Diana,

> " La chasseresse
> Blanche, au sein virginal,
> Qui presse
> Quelque cerf matinal," *

may run from this till doomsday; and we feel no desire to join the cold, passionless huntress in her ghostly chase. Such monsters of beauty are quite out of the reach of human sympathy: they were purposely (by the poor benighted heathens who followed this error, and strove to make their error as grand as possible) placed beyond it. They seemed to think that human joy and sorrow, passion and love, were mean and contemptible in themselves. Their gods were to be calm, and share in no such feelings. How much grander is the character of the Christian school, which teaches that love is the most beautiful of all things, and the first and highest element of beauty in art!

I don't know, madam, whether I make myself clearly understood in saying so much; but if you will have the kindness to look at a certain little picture by Mr. Eastlake in this gallery, you will see to what the observation applies, and that out of a homely subject, and a few simple figures not at all wonderful for excessive beauty or

grandeur, the artist can make something infinitely more beautiful than Mediccan Venuses, and sublimer than Pythian Apollos. Happy are you, Charles Lock Eastlake, Esquire, R.A.! I think you have in your breast some of that sacred fire that lighted the bosom of Raphael Sanctius, Esquire, of Urbino, he being a young man,—a holy kind of Sabbath repose — a calm that comes not of feeling, but of the overflowing of it — a tender, yearning sympathy and love for God's beautiful world and creatures. Impelled by such a delightful sentiment, the gentle spirit of him in whom it dwells (like the angels of old, who first taught us to receive the doctrine that love was the key to the world) breathes always peace on earth and good-will towards men. And though the privilege of enjoying this happy frame of mind is accorded to the humblest as well as the most gifted genius, yet the latter must remember that the intellect can exercise itself in no higher way than in the practice of this kind of adoration and gratitude. The great artist who is the priest of nature is consecrated especially to this service of praise; and though it may have no direct relation to religious subjects, the view of a picture of the highest order does always, like the view of stars in a calm night, or a fair quiet landscape in sunshine, fill the mind with an inexpressible content and gratitude towards the Maker who has created such beautiful things for our use.

And as the poet has told us how, not out of a wide landscape merely, or a sublime expanse of glittering stars, but of any very humble thing, we may gather the same delightful reflections (as out of a small flower, that brings us " thoughts that do often lie too deep for tears ")—in like manner we do not want grand pictures and elaborate yards of canvass so to affect us, as the lover of drawing must have felt in looking at the Raphael designs lately exhibited in London. These were little faint scraps, mostly from the artist's pencil — small groups, unfinished single figures, just indicated; but the divine elements of beauty were as strong in them as in the grandest pieces: and there were many little sketches, not half an inch high, which charmed and affected one like the violet did Wordsworth; and left one in that unspeakable, compla-

* **Alfred de Musset,**

cent, grateful condition, which, as I have been endeavouring to state, is the highest aim of the art.

And if I might be allowed to give a hint to amateurs concerning pictures and their merit, I would say look to have your *heart* touched by them. The best paintings address themselves to the best feelings of it ; and a great many very clever pictures do not touch it at all. Skill and handling are great parts of a painter's trade, but heart is the first : this is God's direct gift to him, and cannot be got in any academy, or under any master. Look about, therefore, for pictures, be they large or small, finished well or ill, landscapes, portraits, figure-pieces, pen-and-ink sketches, or what not, that contain sentiment and great ideas. He who possesses these will be sure to express them more or less well. Never mind about the manner. He who possesses them not may draw and colour to perfection, and yet be no artist. As for telling you what sentiment is, and what it is not, wherein lies the secret of the sublime, there, madam, we must stop altogether; only if, after reading Burke *On the Sublime,* you will find yourself exactly as wise as you were before. I cannot tell why a landscape by Claude or Constable should be more beautiful—it is certainly not more dexterous—than a landscape by Mr. —— or Mr. ——. I cannot tell why Raphael should be superior to Mr. Benjamin Haydon (a fact which one person in the world may be perhaps inclined to doubt) ; or why Vedrai Carino, in "Don Juan," should be more charming to me than "Suoni la tromba," before mentioned. The latter has twice as much drumming, trumpeting, and thundering in it. All these points are quite undefinable and inexplicable (I never read a metaphysical account of them that did not seem sheer dulness and nonsense); but we can have no doubt about them. And thus we come to Charles Lock Eastlake, Esquire, from whom we started about a page since ; during which we have laid down, first, that sentiment is the first quality of a picture; second, that to say whether this sentiment exists or no rests with the individual entirely, the sentiment not being capable of any sort of definition. Charles Lock Eastlake, Esquire, possesses, to my thinking, this undefinable arch-quality of sentiment to a very high degree. And,

besides him, let us mention William Mulready, Esquire, Cope, Boxall, Redgrave, Herbert (the two latter don't shew so much of it this year as formerly), and Richmond.

Mr. Eastlake's picture is as pure as a Sabbath-hymn sung by the voices of children. He has taken a very simple subject—hardly any subject at all ; but such suggestive points are the best, perhaps, that a painter can take ; for with the illustration of a given subject out of a history or romance, when one has seen it, one has commonly seen all, whereas such a piece as this, which Mr. Eastlake calls "The Salutation of the Aged Friar," brings the spectator to a delightful peaceful state of mind, and gives him matter to ponder upon long after. The story of this piece is simply this :—A group of innocent, happy-looking Italian peasants are approaching a couple of friars; a boy has stepped forward with a little flower, which he presents to the elder of these, and the old monk is giving him his blessing.

Now, it would be very easy to find fault with this picture, and complain of excessive redness in the shadows, excessive whiteness in the linen, of repetition in the faces—the smallest child is the very counterpart of one in the "Christ and the Little Children" by the same artist last year—the women are not only copies of women before painted by Mr. Eastlake, but absolutely copies of one another; the drawing lacks vigour, the flesh-tints variety, (they seem to be produced, by the most careful stippling, with a brilliant composition of lake and burnt sienna, cooled off as they come to the edges with a little blue.) But though, in the writer's judgment, there are in the picture every one of these faults, the merits of the performance incomparably exceed them, and these are of the purely sentimental and intellectual kind. What a tender grace and purity in the female heads ! If Mr. Eastlake repeats his model often, at least he has been very lucky in finding or making her : indeed, I don't know in any painter, ancient or modern, such a charming character of female beauty. The countenances of the monks are full of unction ; the children, with their mild-beaming eyes, are fresh with recollections of heaven. There is no affectation of middle-age mannerism, such as silly Germans and silly French-

men are wont to call Catholic art; and the picture is truly Catholic in consequence, having about it what the hymn calls " solemn mirth," and giving the spectator the utmost possible pleasure in viewing it. Now, if we might suggest to Mr. Lane, the lithographer, how he might confer a vast benefit upon the public, we would entreat him to make several large copies of pictures of this class, executing them with that admirable grace and fidelity which are the characteristics of all his copies. Let these be coloured accurately, as they might be, at a small charge, and poor people for a few guineas might speedily make for themselves delightful picture-galleries. The colour adds amazingly to the charm of these pictures, and attracts the eye to them. And they are such placid, pious companions for a man's study, that the continual presence of them could not fail to purify his taste and his heart.

I am not here arguing, let it be remembered, that Mr. Eastlake is absolute perfection; and will concede to those who find fault with him that his works are deficient in power, however remarkable for grace. Be it so. But, then, let us admire his skill in choosing such subjects as are best suited to his style of thinking, and least likely to shew his faults. In the pieces ordinarily painted by him, grace and tender feeling are the chief requisites; and I don't recollect a work of his in which he has aimed at other qualities. One more picture besides the old Friar has Mr. Eastlake, a portrait of that beautiful Miss Bury, whom our readers must recollect in the old house, in a black mantle, a red gown, with long golden hair waving over her shoulders, and a lily in her hand. The picture was engraved afterwards in one of the Annuals; and was one of the most delightful works that ever came from Mr. Eastlake's pencil. I can't say as much for the present portrait: the picture wants relief, and is very odd and heavy in colour. The handsome lady looks as if she wanted her stays. O beautiful lily-bearer of six years since! you should not have appeared like a mortal after having once shone upon us as an angel.

And now we are come to the man whom we delight to honour, Mr. Mulready, who has three pictures in the Exhibition that are all charming in their

way. The first (" Fair Time," 116) was painted, it is said, more than a score of years since; and the observer may look into it with some payment for his curiosity, for it contains specimens of the artist's old and new manner. The picture in its first state is somewhat in the Wilkie style of that day (O for the Wilkie style of that day!), having many greys, and imitating closely the Dutchmen. Since then the painter has been touching up the figures in the foreground with his new and favourite lurid orange-colour; and you may see how this is stippled in upon the faces and hands, and borrow, perhaps, a hint or two regarding the Mulreadian secret.

What is the meaning of this strange colour?— these glowing, burning crimsons, and intense blues, and greens more green than the first budding leaves of spring, or the mignonnette-pots in a Cockney's window at Brixton. But don't fancy that we are joking or about to joke at Mr. Mulready. These gaudy prismatic colours are wonderfully captivating to the eye; and, amidst a host of pictures, it cannot fail to settle on a Mulready in preference to all. But, for consistency's sake, a protest must be put in against the colour; it is pleasant, but wrong; we never saw it in nature—not even when looking through an orange-coloured glass. This point being settled, then, and our minds eased, let us look at the design and conception of " First Love;" and pray, sir, where in the whole works of modern artists will you find any thing more exquisitely beautiful? I don't know what that young fellow, so solemn, so tender, is whispering into the ear of that dear girl (she is only fifteen now, but, *sapristie*, how beautiful she will be about three years hence!), who is folding a pair of slim arms round a little baby, and making believe to nurse it, as they three are standing one glowing summer day under some trees by a stile. I don't know, I say, what they are saying; nor, if I could hear, would I tell —'tis a secret, madam. Recollect the words that the captain whispered in your ear that afternoon in the shrubbery. Your heart throbs, your cheek flushes; the sweet sound of those words tells clear upon your ear, and you say, " Oh, Mr. Titmarsh, how *can* you?" Be not afraid, madam —never, never will I peach; but sing, in the

words of a poet who is occasionally quoted in the House of Commons —

" Est et fideli tuta silentio
Merces. Vetabo qui Cereris sacrum
 Vulgarit arcanæ, sub iisdem
 Sit trabibus, fragilemve mecum
 Solvat phaselum."

Which may be interpreted (with the slight alteration of the name of Ceres for that of a much more agreeable goddess)—

Be happy, and thy counsel keep,
 'Tis thus the bard adviseth thee ;
Remember that the silent lip
 In silence shall rewarded be.
And fly the wretch who dares to strip
 Love of its sacred mystery.

My loyal legs I would not stretch
 Beneath the same mahogany ;
Nor trust myself in Chelsea Reach,
 In punt or skiff, with such as he.
The villain who would kiss and peach,
 I hold him for mine enemy !

But, to return to our muttons, I would not give a fig for the taste of the individual who does not see the exquisite beauty of this little group. Our artist has more passion than the before-lauded Mr. Eastlake, but quite as much delicacy and tenderness ; and they seem to me to possess the poetry of picture-making more than any other of their brethren.

By the way, what is this insane yell that has been raised throughout the public press about Mr. Mulready's other performance, the postage cover, and why are the sages so bitter against it ? The *Times* says it is disgraceful and ludicrous ; the elegant writers of the *Weekly Dispatch* vow it is ludicrous and disgraceful ; the same sweet song is echoed by papers, Radical and Conservative, in London and the provinces, all the literary gentlemen being alive, and smarting under this insult to the arts of the country. Honest gentlemen of the press, be not so thin-skinned ! Take my word for it, there is no cause for such vehement anger — no good opportunity here for you to shew off that exquisite knowledge of the fine arts for which you are so celebrated throughout the world. Gentlemen, the drawing of which you complain is *not* bad. The commonest engravers, who would be ashamed to produce such a design, will tell you, if they know any thing of their business, that they could not make a better in a hurry. Every man

who knows what drawing is will acknowledge that some of these little groups are charmingly drawn ; and I will trouble your commonest engravers to design the Chinese group, the American, or the West Indian, in a manner more graceful and more characteristic than that of the much-bespattered post envelope.

I am not holding up the whole affair as a masterpiece — *pas si bête*. The " triumphant hallegory of Britannia ruling the waves," as Mathews used to call it, is a little stale, certainly, nowadays ; but what would you have ? How is the sublime to be elicited from such a subject ? Let some of the common engravers, in their leisure moments, since the thing is so easy, make a better design, or the literary men who are so indignant invent one. The government, no doubt, is not bound heart and soul to Mr. Mulready, and is willing to hear reason. *Fiat justitia, ruat cælum* : though all the world shall turn on thee, O government, in this instance Titmarsh shall stand by thee — ay, and without any hope of reward. To be sure, if my Lord Normanby absolutely insists — but that is neither here nor there. I repeat, the Post Office envelope is not bad, *quoad* design. That very lion, which some of the men of the press (the Daniels !) have been crying out about, is finely, carefully, and characteristically sketched ; those elephants I am sure were closely studied, before the artist in a few lines laid them down on his wood-block ; and as for the persons who are to imitate the engraving so exactly, let them try. It has been done by the best wood-engraver in Europe. Ask any man in the profession if Mr. Thompson is not at the head of it ? He has bestowed on it a vast deal of time, and skill, and labour ; and all who know the difficulties of wood-engraving — of outline wood-engraving — and of rendering faithfully a design so very minute as this, will smile at the sages who declare that all the world could forge it. There was one provincial paper which declared, in a style peculiarly elegant, that a man " with a block of wood and a *bread-and-cheese* knife could easily imitate the envelope ;" which remark, for its profound truth and sagacity, the London journals copied. For shame, gentlemen ! Do you think you shew your knowledge by adopting such opinions as these,

or prove your taste by clothing yourselves in the second-hand garments of the rustic who talks about bread and cheese? Try, Tyrotomos, upon whatever block thou choosest to practise; or be wise, and with appropriate bread-and-cheese knife cut only bread and cheese. Of bread, white and brown, of cheese, old, new, mouldy, toasted, the writer of the *Double-Gloster Journal*, the *Stilton Examiner*, the *Cheddar Champion*, and *North Wiltshire Intelligencer*, may possibly be a competent critic, and (with mouth replete with the delicious condiment) may no doubt eloquently speak. But let us be cautious before we agree to and admiringly adopt his opinions upon matters of art. Mr. Thompson is the first wood-engraver in our country — Mr. Mulready one of the best painters in our or any school: it is hard that such men are to be assailed in such language, and by such a critic!

This artist's picture of an interior is remarkable for the same exaggerated colour, and for the same excellences. The landscape seen from the window is beautifully solemn, and very finely painted, in the clear bright manner of Van Dyck and Cranach, and the early German school.

Mr. Richmond's picture of " Our Lord after the Resurrection " deserves a much better place than it has in the little, dingy, newly-discovered octagon closet; and leaves us to regret that he should occupy himself so much with water-colour portraits, and so little with compositions in oil. This picture is beautifully conceived, and very finely and carefully drawn and painted. One of the apostles is copied from Raphael, and the more is the pity: a man who could execute two such grand figures as the other two in the picture need surely borrow from no one. A water-colour group, by the same artist (547. " The Children of Colonel Lindsay"), contains two charming figures of a young lady and a little boy, painted with great care and precision of design and colour, with great purity of sentiment, and without the least affectation. Let our aristocracy send their wives and children (the handsomest wives and children in the world) to be painted by this gentleman, and those who are like him. Miss Lindsay, with her plain red dress and modest looks, is surely a thousand times more captivating than those dangerous smiling

Delilahs in her neighbourhood, whom Mr. Chalon has painted. We must not be understood to undervalue this latter gentleman however; his drawings are miracles of dexterity; every year they seem to be more skilful and more brilliant. Such satins and lace, such diamond rings and charming little lap-dogs, were never painted before,— not by Watteau, the first master of the *genre*,—and Lancret, who was scarcely his inferior. A miniature on ivory by Mr. Chalon, among the thousand prim, pretty little pictures of the same class which all the ladies crowd about, is remarkable for its brilliancy of colour and charming freedom of handling; as. is an oil sketch of masquerading figures, by the same painter, for the curious coarseness of the painting.

Before we leave the high-class pictures, we must mention Mr. Boxall's beautiful " Hope," which is exquisitely refined and delicate in sentiment, colour, and execution. Placed close beneath one of Turner's magnificent tornadoes of colour, it loses none of its own beauty. As Uhland writes of a certain king and queen who are seated in state side by side,—

" Der *Turner* furchtbar prächtig wie
 blut'ger Nordlichtschein
Der *Boxall* süss und milde als blickte
 Vollmond drein."

Which signifies in English, that

As beams the moon so gentle near the
 sun, that blood-red burner,
So shineth William Boxall by Joseph
 Mallerd Turner.

In another part of the room, and contrasting their quiet grace in the same way with Mr. Turner's glaring colours, are a couple of delightful pictures by Mr. Cope, with mottoes that will explain their subjects. " Help thy father in his age, and despise him not when thou art in thy full strength;" and " Reject not the affliction of the afflicted, neither turn away thy face from a poor man." The latter of these pictures is especially beautiful, and the figure of the female charity as graceful and delicate as may be. I wish I could say a great deal in praise of Mr. Cope's large altar-piece: it is a very meritorious performance; but here praise stops, and such praise is worth exactly nothing. A large picture must either be splendid, or else naught. This "Crucifixion" has a great deal of

vigour, feeling, grace ; BUT,— the but is fatal ; all minor praises are drowned in it. Recollect, however, Mr. Cope, that Titmarsh, who writes this, is only giving his private opinion ; that he is mortal ; that it is barely possible that he should be in the wrong ; and with this confession, which I am compelled (for fear you might overlook the circumstance) to make, you will, I dare say, console yourself, and do well. But men must gird themselves, and go through long trainings, before they can execute such gigantic works as altar-pieces. Handel, doubtless, wrote many little pleasing melodies before he pealed out the " Hallelujah " chorus ; and so painters will do well to try their powers, and, if possible, measure and understand them, before they use them. There is Mr. Hart, for instance, who took in an evil hour to the making of great pictures : in the present Exhibition is a decently small one ; but the artist has overstretched himself in the former attempts : as one hears of gentlemen on the rack, the limbs are stretched one or two inches by the process, and the patient comes away by so much the taller ; but he can't *walk* near so well as before, and all his strength is stretched out of him.

Let this be a solemn hint to a clever young painter, Mr. Elmore, who has painted a clever picture of " The Murder of Saint Thomas à Becket," for Mr. Daniel O'Connell. Come off your rack, Mr. Elmore, or you will hurt yourself. Much better is it to paint small subjects, for some time at least. " Non cuivis contigit adire Corinthum," as the proverb says ; but there is a number of pleasant villages in this world beside, where we may snugly take up our quarters. By the way, what is the meaning of Tom à Becket's black cassock under his canonicals ? Would John Tuam celebrate mass in such a dress ? A painter should be as careful about his costumes as an historian about his dates, or he plays the deuce with his composition.

Now, in this matter of costume, nobody can be more scrupulous than Mr. Charles Landseer, whose picture of Nell Gwynn is painted with admirable effect, and honest scrupulousness. It is very good in colour, very gay in spirits (perhaps too refined,— for Nelly never was such a hypocrite as to look as modest as that); but the gentlemen and ladies do not look as if they were accustomed to their dresses, for all their correctness, and had put them on for the first time. Indeed, this is a very small fault, and the merits of the picture are very great : every one of the accessories is curiously well painted,— some of the figures very spirited (the drawer is excellent) ; and the picture one of the most agreeable in the whole gallery. Mr. Redgrave has another costume picture, of a rather old subject, from *The Rambler*. A poor girl comes to be companion to Mr. and Mrs. Courtly, who are at piquet ; their servants are bringing in tea, and the master and mistress are looking at the new-comer with a great deal of easy scorn. The poor girl is charming; Mrs. Courtly not quite genteel, but with a wonderful quilted petticoat ; Courtly looks as if he were not accustomed to his clothes ; the servants are very good ; and as for the properties, as they would be called on the stage, these are almost too good-painted, with a daguerréotypical minuteness, that gives this and Mr. Redgrave's other picture of " Paracelsus " a finnikin air, if we may use such a disrespectful term. Both performances, however, contain very high merit of expression and sentiment ; and are of such a character as we seldom saw in our schools twenty years ago.

There is a large picture by a Scotch artist, Mr. Duncan, representing " The Entry of Charles Edward into Edinburgh," which runs a little into caricature, but contains a vast deal of character and merit ; and which, above all, in the article of costume, shews much study and taste. Mr. Duncan seems to have formed his style upon Mr. Allan and Mr. Wilkie — I beg his pardon — Sir David. The former has a pleasing brown picture likewise on the subject of the Pretender. The latter's maid of Saragossa and Spaniard at the gun, any one may see habited as Irish peasants superintending " A Whisky Still," in the middle room, No 252.

This picture, I say, any one may see and admire who pleases : to me it seems all rags, and duds, and a strange, straggling, misty composition. There are fine things, of course ; for how can Sir David help to paint fine things ? In the " Benvenuto " there is superb colour, with a rich management of lakes especially, which has been borrowed from no master that we know of. The

queen is as bad a likeness and picture as we have seen for many a day. " Mrs. Ferguson, of Raith," a magnificent picture indeed, as grand in effect as a Rubens or Titian, and having a style of its own. The little sketch from Allan Ramsay is delightful; and the nobleman and hounds (with the exception of his own clumsy vermilion robe), as fine as the fellow-sized portrait mentioned before. Allan Ramsay has given a pretty subject, and brought us a pretty picture from another painter, Mr. A. Johnston, who has illustrated those pleasant quaint lines,—

" Last morning I was gay, and early out ;
Upon a dike I leaned, glow'ring about.
I saw my Meg come linkan o'er the lea ;
I saw my Meg, but Meggy saw na me."

And here let us mention with praise two small pictures in a style somewhat similar,—" The Recruit," and " Herman and Dorothea," by Mr. Poole. The former of these little pieces is very touching and beautiful. There is among the present exhibitioners no lack of this kind of talent; and we could point out many pictures that are equally remarkable for grace and agreeable feeling. Mr. Stone's " Annot Lyle" should not be passed over,— a pretty picture, very well painted ; the female head of great beauty and expression.

Now, if we want to praise performances shewing a great deal of power and vigour, rather than grace and delicacy, there are Mr. Etty's " Andromeda" and " Venus." In the former, the dim figure of advancing Perseus galloping on his airy charger is very fine and ghostly ; in the latter, the body of the Venus, and indeed the whole picture, is a perfect miracle of colour. Titian may have painted Italian flesh equally well; but he never, I think, could surpass the skill of Mr. Etty. The trunk of this voluptuous Venus is the most astonishing representation of beautiful English flesh and blood, painted in the grandest and broadest style. It is said that the Academy at Edinburgh has a room full of Etty's pictures : they could not do better in England than follow the example ; but perhaps the paintings had better be kept *for the Academy only*,—for the *profanum vulgus* are scarcely fitted to comprehend their peculiar beauties. A prettily drawn, graceful, nude figure, is " Bathsheba,"

by Mr. Fisher, of the street and city of Cork.

The other great man of Cork is Daniel Maclise by name ; and if in the riot of fancy he hath by playful Titmarsh been raised to the honour of knighthood, it is certain that here Titmarsh is a true prophet, and that the sovereign will so elevate him, one day or other, to sit with other cavaliers at the Academic round table. As for his pictures,—why as for his pictures, madam, these are to be carefully reviewed in the next number of this Magazine ; for the present notice has noticed scarcely any body, and yet stretched to an inordinate length. " Macbeth" is not to be hurried off under six pages ; and, for this June number, Mr. Fraser vows that he has no such room to spare.

We have said how Mr. Turner's pictures blaze about the rooms : it is not a little curious to hear how artists and the public differ in their judgments concerning them ; the enthusiastic wonder of the first-named, the blank surprise and incredulity of the latter. " The new moon ; or, I've lost my boat : you shan't have your hoop," is the ingenious title of one,— a very beautiful picture, too, of a long shining sea-sand, lighted from the upper part of the canvass by the above-named luminary of night, and from the left-hand corner by a wonderful wary boy in a red jacket—the best painted figure that we ever knew painted by Joseph Mallerd Turner, Esquire.

He and Mr. Ward vie with each other in mottoes for their pictures. Ward's epigraph to the S——'s nest is wondrous poetic.

277. The S——'s Nest. S. Ward, R. A.

" Say they that happiness lives with the
 great,
On gorgeous trappings mixt with pomp
 and state?
More frequent found upon the simple
 plain,
In poorest garb, with Julia, Jess, or
 Jane ;
In sport or slumber, as it likes her best,
Where'er she *lays* she finds it a S——'s
 nest,"

Ay, and a S——'s eggs, too, as one would fancy, were great geniuses not above grammar. Mark the line, too,

" On gorgeous trappings mixt with pomp
 and state,"

and construe the whole of this sensible passage.

Not less sublime is Mr. Ward's fellow academician.

230. " Slavers throwing overboard the Dead and Dying: Typhon coming on." J. M. W. Turner, R. A.

" Aloft all hands, strike the topmasts and
belay !
Yon angry setting sun and fierce-edged
clouds
Declare the Typhon's coming.
Before it sweeps your decks, throw over-
board
The dead and dying,—ne'er heed their
chains.
Hope, Hope, fallacious Hope !
Where is thy market now ?"
MS. Fallacies of Hope.

Fallacies of Hope, indeed : to a pretty mart has she brought her pigs! How should Hope be hooked on to the slaver? By the anchor, to be sure, which accounts for it. As for the picture, the R.A.'S rays are indeed terrific ; and the slaver throwing its cargo overboard is the most tremendous piece of colour that ever was seen.; it sets the corner of the room in which it hangs into a flame. Is the picture sublime or ridiculous? Indeed I don't know which. Rocks of gamboge are marked down upon the canvass ; flakes of white laid on with a trowel; bladders of vermilion madly spirted here and there. Yonder is the slaver rocking in the midst of a flashing foam of white-lead. The sun glares down upon a horrible sea of emerald and purple, into which chocolate-coloured slaves are plunged, and chains that will not sink ; and round these are floundering such a race of fishes as never was seen since the *sæculum Pyrrhæ ;* gasping dolphins redder than the reddest herrings ; horrid spreading polypi, like huge, slimy, poached eggs, in which hapless niggers plunge and disappear. Ye gods, what a " middle passage !" How Mr. Fowell Buxton must shudder! What would they say to this in Exeter Hall ? If Wilberforce's statue down stairs were to be confronted with this picture, the stony old gentleman would spring off his chair, and fly away in terror !

And here, as we are speaking of the slave-trade, let us say a word in welcome to a French artist, Monsieur Biard, and his admirable picture. Let the friends of the negro forthwith buy this canvass, and cause a plate to be taken from it. It is the best, most striking, most pathetic lecture against the trade that ever was delivered. The picture is as fine as Hogarth; and the artist, who, as we have heard, right or wrong, has only of late years adopted the profession of painting, and was formerly in the French navy, has evidently drawn a great deal of his materials from life and personal observation. The scene is laid upon the African coast. King Tom or King Boy has come with troops of slaves down the Quorra, and sits in the midst of his chiefs and mistresses (one a fair creature, not much darker than a copper tea-kettle), bargaining with a French dealer. What a horrible callous brutality there is in the scoundrel's face, as he lolls over his greasy ledger, and makes his calculations. A number of his crew are about him ; their boats close at hand, in which they are stowing their cargo. See the poor wretches, men and women, collared together, drooping down. There is one poor thing, just parted from her child. On the ground in front lies a stalwart negro ; one connoisseur is handling his chest, to try his wind ; another has opened his mouth, and examines his teeth, to know his age and soundness. Yonder is a poor woman kneeling before one of the Frenchmen ; her shoulder is fizzing under the hot iron with which he brands her ; she is looking up, shuddering and wild, yet quite mild and patient : it breaks your heart to look at her. I never saw any thing so exquisitely pathetic as that face. God bless you, Monsieur Biard, for painting it ! It stirs the heart more than a hundred thousand tracts, reports, or sermons : it must convert every man who has seen it. You British government, who have given twenty millions towards the good end of freeing this hapless people, give yet a couple of thousand more to the French painter, and don't let his work go out of the country, now that it is here. Let it hang along with the Hogarths in the National Gallery ; it is as good as the best of them. Or, there is Mr. Thomas Babington Macaulay, who has a family interest in the matter, and does not know how to spend all the money he brought home from India ; let the right honourable gentleman look to it. Down with your dust, right honourable sir; give Monsieur Biard a couple of thousand for his picture of the negroes, and it will be the best black act you ever did in your life ; and don't go for to be angry at the sug-

gestion, or fancy we are taking liberties. What is said is said from one public man to another, in a Pickwickian sense, *de puissance en puissance,*— from Titmarsh, in his critical *cathedra,* to your father's eminent son, rich with the spoils of Ind, and wielding the bolts of war.

What a marvellous power is this of the painter's! how each great man can excite us at his will! what a weapon he has, if he knows how to wield it! Look for a while at Mr. Etty's pictures, and away you rush, your "eyes on fire," drunken with the luscious colours that are poured out for you on the liberal canvass, and warm with the sight of the beautiful syrens that appear on it. You fly from this (and full time too), and plunge into a green, shady landscape of Lee or Creswick, and follow a quiet stream babbling beneath whispering trees, and chequered with cool shade and golden sunshine; or you set the world — nay, the Thames and the ocean — on fire with that incendiary Turner; or you laugh with honest, kind-hearted Webster, and his troops of merry children; or you fall a weeping with Monsieur Biard for his poor blacks; or you go and consult the priests of the place, Eastlake, Mulready, Boxall, Cope, and the like, and straightway your mind is carried off in an ecstasy,— happy, thrilling hymns sound in your ears melodious,— sweet thankfulness fills your bosom. How much instruction and happiness have we gained from these men, and how grateful should we be to them!

It is well that Mr. Titmarsh stopped here, and I shall take special care to examine any further remarks which he may think fit to send. Four-fifths of this would have been cancelled, had the printed sheets fallen sooner into our hands. The story about the Clarendon is an absurd fiction; no dinner ever took place there. I never fell asleep in a plate of raspberry ice; and though I certainly did recommend this person to do justice by the painters, making him a speech to that effect, my opinions were infinitely better expressed, and I would repeat them, were it not so late in the month.—O. Y.

"Reflections Arising Out of the Late 'Exhibition'"

Art-Union 2 (August 1840), 126–27

REFLECTIONS ARISING OUT OF THE LATE " EXHIBITION."

In some respects, as to individual ability, we think we remember exhibitions of the Royal Academy that have given infinitely more satisfaction than that which has just closed; but the general feeling, both among artists and the public, seems to be that, taking it altogether, it was one of the best that has been seen for many years. The particular exceptions to which we refer will have struck every observing frequenter of the Academy, and the defaulters—so by their own free will, and with " malice prepense"—if they happen to have joined the company in the exhibitions-rooms, may doubtless have had their ears greeted by their lamentations and regrets which have pretty freely been expressed upon the subject. We are not ungrateful for what these worthies have effected, and thank them sincerely for the honour gained through them to the art of our country, but they are of the past rather than the present; they no longer choose to meet us in their strength; and we confess that, in common with many, we deeply lament it.

But in spite of these gentlemen who have relinquished their admitted power to look after a vague uncertainty of laurels; in spite of their submitting to have their lock of Samson shorn, the exhibition of the present year must be admitted to be one of very great interest, and the attempt to trace the causes through which it has gained this general commendation may not be without its use.

A change in taste has, for the last few years, gradually been coming over us. Whether the loss of Lawrence diverted the attention from portrait, or when his own personal influence had ceased, a comparison of his works with those of preceding schools opened people's eyes to what, with all his great merits, was false or meritricious in his style; or whether subjects of mere individual interest became fatiguing and monotonous, and the " nothing-but-portrait" cry had, at last, its effect in forcing artists to endeavour to produce matter of another sort, we cannot pretend to say; but it is undeniable that season after season, for some years, has shown a most remarkable increase in the interest taken in that branch of art called *subject* painting.

It has always been urged, that historical art has not been practised in this country, simply because there never has been any demand for it; and that the want of encouragement has led to its failure, or rather to its neglect by artists. If this argument is allowed all the force it is intended to have, it should follow, *pari ratione*, that where there is great encouragement, success will be the consequence. It may be worth while to inquire how far this is the case. The constant exclamation at each exhibition for many years within our remembrance has been, that " the number of portraits is overpowering;" and certainly there never was at any time such demand for portrait painting as during the last seventy or eighty years; so that want of encouragement in that branch of art cannot be complained of with any truth or justice. Has that demand and encouragement improved our school of portrait painting? In that period, be it remembered, have lived Reynolds, Gainsborough, Romney, Opie, Hoppner, Owen, and Lawrence; and the latter, especially, had more employment on his hands than any conscientious painter ought to undertake. Has the English school of *portrait* painting gone on progressively improving from the first of these great names to the last? We should say it has *not*. As, then, the most liberal encouragement in any particular branch of art—meaning here extent of commissions and prices paid—does not, as has been shown, singly and alone, lead, as a *matter of course*, to excellence in that branch, it is not unreasonable to suppose it may and must depend also upon other circumstances. The chief of these is perhaps the existence of a *corresponding* feeling between the artist and the public; some bond of union, however slight, to link his efforts with their sympathy and understanding. It has very properly been said, that artists should endeavour rather to lead or direct the public taste than bow to any prevailing fashion. Art should doubtless be the teacher and illustrator of all that is good; but it not unfrequently happens, not in art only, that the good which might be done is not effected, because the conditions on which its attainment depends are not sufficiently taken into consideration. Now it seems to us, speaking, however, with great deference, that it may be of the greatest importance to artists and to art, to watch the direction of the public mind, and having ascertained its general bias, to endeavour to turn it to advantage, not by pandering to its bad tendencies, but by offering such subjects to it (treated, however, in an *elevating* manner) as are likely to find some correspondence, or to be in some degree in harmony with it; and thus by degrees lead it to contemplate and to appreciate what is excellent, when opposed to, or contrasted with, what is bad. It will not be wise to feel disappointment that *all* the good it is desired to effect cannot be attained at once. As great an error has been committed by many zealous and able advocates of high historical art, by supposing that excellence will follow immediately upon encouragement, or patronage being extended to it, as that, if attained, it could be appreciated as suddenly by the public; but, by accustoming the public to see

subject art—if the term may be used—and exciting its interests and sympathies in the objects represented, a new or dormant feeling may be awakened, which it is fair to hope may ripen, by gradual advancement, into a desire to see productions of the most elevated character.

That a preference for subject pictures is springing up, and has, indeed, rapidly increased, no one who has watched the progress of art will for a moment deny; and the effect of attracting the public attention, already predisposed to the influence, has reacted most beneficially upon the artists themselves; for that which was at first done as a mere experiment, (it may even be said attempted wildly and almost hopelessly) may now, if well done, be pursued for its certain advantages. Where the public now takes an interest it will eventually extend its patronage. Indeed, the fact of its doing so already is proved by the sales at all exhibitions during the last two or three years. Two other circumstances may be adverted to in connection with the subject, which go to support the views here taken. First, the diminution in the average numbers of mere portraits (including animals) in a given number of oil paintings for exhibition at the Royal Academy in each of the last ten years: and secondly, in the class of artists who have been elected into the academy for the last five or six years, to fill up vacancies in the lists of academicians or associates.

With these facts, and this hope of encouragement opening before them, it is hardly necessary to show how incumbent it is upon our artists to qualify themselves to take advantage of it, and to supply such works as shall improve the public taste, and the disposition that begins to display itself in favour of such productions. An acquaintance with the finest productions of ancient art, and the immortal works of the great Greek and Latin poets, will be the best foundation for a pure and classical feeling, both for form and the manner of treating a subject. With these safeguards there will be no danger of the painter or the sculptor running into the mean and miserable, or of his mistaking the vulgar for the natural; of believing, or pretending to believe, that all that nature offers is fit for the pencil or the chisel.

One of the points that requires the most consideration, is the *choice* of subject. Much more depends upon this than artists are sometimes disposed to admit. It will not be relevant here to discuss the question whether or not it is to be deplored, but we think it will be allowed that but little interest is now excited by subjects taken from fabulous, heroic, or even accredited history of very ancient times. The day is gone by when the sympathies could be awakened for personages only known to scholars, through Greek and Roman writers, or to the only commonly educated of the multitude through the compilations of Natalis Comes, or Dr. Lemprière. Fine drawing, skilful arrangement, rich colouring, appropriate character and expression, will always please, and will draw commendation from critics; but the great secret of success is to be found in another direction. Sympathy must be gained—sensibility must be excited—and the observer be made to identify himself with the subject, which can hardly be expected, when he is called upon to weep with Hecuba, or to rage with Achilles.

Let us remember that Michel Angelo, Raffaelle, and Titian did not usually choose such subjects, but, working *with* their age, selected those, chiefly from Holy Writ, which, according with the feeling of the time, appealed to general sympathies. Their works are still the admired of all who have hearts to feel; while those artists of a more modern school, who have ransacked the Greek and Roman historians and poets, have shown, as well by their own weakness, as by the want of what is interesting in their subjects, how utterly impotent they are to excite any lasting impression, or to advance the cause they desire to support. They do no more for art than the affectation which prevailed in the thirteenth and fourteenth centuries of writing in Latin did for Literature. Even Petrarch and Boccaccio prided themselves on their imitation of a dead language, while their own was, for want of nurture and cultivation, in the lowest state. Happily, however, they lived to regenerate it. No one reads their Latin, *for* the Latin; while they are hailed almost as the founders of their own Italian literature. While, however, a sort of protest is thus entered against a habit of choosing subjects from the ancient mythology, and more remote history, simply because they do not appeal sufficiently to our sympathies—the grand object at which the painter and the poet should aim—we must at the same time clear ourselves from the suspicion of admiring or advocating the treatment of *common* every day scenes, exhibiting either the meannesses and vulgarities of low, or the equally objectionable littlenesses, speaking *artistically*, of more polite life. Subjects of affecting interest, of deep expression, of great beauty, and often conveying a fine moral, are to be found without degrading the pencil to common-place. The object of art is not to gratify the taste of tinkers and cobblers; but there are minds in various states of advancement, and by attracting the attention of that class which may be uneducated, and perhaps even coarse and vulgar, even they may be improved, and, by degrees, acquire a relish for that which is beyond the usual range of their observation and preference.

To say what subjects should be chosen by those who object not to work in this field, would be to assume more than is consistent with our present object, or indeed with propriety. Artists alone can choose, properly, for themselves; and then the heart and the hand work together. But, it may be observed, that, independently

of the sacred writings, the modern poets and historians of all countries that boast a literature, are now read very generally, and they offer in abundance subjects that fulfil all the conditions which we have adverted to as essential to the success, in this day, of this class of art. The admirer of the grave, of the pathetic, or the gay —, the classical designer, or the playful and sparkling colourist—may all be provided from the abundant spring of more modern observation, incentive, and story; and infinitely more good to art will be effected by showing how those subjects with which so many are acquainted may be illustrated, than can ever be produced by the taste which some, well meaning, but ill judging, have attempted to force by only admitting into the circle of *legitimate* historical design, the but half understood subjects which are picked out of the writings of even the greatest geniuses of antiquity.

Some observations made in the course of these remarks might possibly lead to the belief that it is intended to underrate the value and importance of portrait-painting—such intention is unequivocally disclaimed. The outcry that has sometimes been raised that it is encouraged and *patronised* (a word, by the way, we strongly object to as applied to artists and men *of mind*), to gratify individual vanity and conceit, is both unfounded in fact, and foolish. Very few persons, comparatively, have their likenesses taken of themselves; or, if of themselves, *for* themselves. They are either preserved as records of affection, keepsakes of domestic love and kindly feeling, or to do honour to distinguished merit. Walpole used to say that good portraits were the only real historical pictures; and, in one sense, he said truly. Burke, in one of his letters to Barry, who had sneered at this branch of the art, says, " That portrait painting, which few affect to despise, is the best school that an artist can study in, provided he study it, as every man of genius will do, with a philosophic eye, not merely to copy the face before him, but to learn the character of it, with a view to employ, in more important works, what is good of it, and to reject what is not." When it is remembered whom (and *how!*) Titian, Raffaelle, Georgione, Rembrandt, Vandyke, and, let us add, our Reynolds, Gainsborough, and Lawrence, painted, no unworthy reflection will ever be cast on an art in which such glory has been achieved.

Without disparaging any, all that we aim at is to advance that class of art which we sincerely believe is capable of inducing a really sound and healthful revolution in taste and feeling; and it is also our sincere belief that the time is arrived when the artist will be met half-way in his desire to gain a standing for that branch of art which will effect so desirable an end. The lamentation that there is no feeling for historical design will then, by degrees, be changed into gratulation that the highest walks of art

may be trod without subjecting the artist to poverty and neglect; and from these comparatively small beginnings, this country, already pre-eminent in art in all that belongs to colour and effect, may yet boast also a noble school of design.

The hints we have here thrown out we must leave to work their way; it is more than probable, that we shall hereafter again take up the matter—that part of it, more especially, which has reference to the artist's choice of subjects.

from

"The Royal Academy.
The Exhibition — 1841.
The Seventy-third"

Art-Union 3 (May 1841), 75 – 79

THE ROYAL ACADEMY.

THE EXHIBITION—1841.

THE SEVENTY-THIRD.

THE Exhibition of the year 1841—the seventy-third since the foundation of the Royal Academy—is calculated to give very general satisfaction; for although there are few pictures of commanding merit, there is ample evidence of improvement in a large proportion of the Exhibitors. The collection is to be viewed in reference to the absence of three leading British Artists—Wilkie, Callcott, and Landseer : and in forming an estimate of its relative value, we are bound to consider what it would have been if there were added to it about twenty pictures of the highest class. So tested, it will be, undoubtedly, characterized as an advance upon its predecessors.

As usual, some serious complaints have been urged against the "Hanging Committee:" this evil will inevitably arise—to give universal content being utterly out of the question. Making, however, all due allowance for difficulties that cannot fail to exist, we must admit that some artists have good right to enter an appeal against the decision of their judges. In the Miniature-Room, quite out of sight, there are seven or eight excellent works, by painters who do not begin their career to-day, but who have already achieved professional distinction; in the room for "Architecture" there are four or five of very considerable merit, by men not many degrees below the most celebrated members of the academy; and in the "Octagon Room" several of the most admirable pictures in the whole assemblage have been doomed to a close atmosphere, and a "dim, uncertain light." We can point out at least a dozen productions, to remove which we feel assured the Artists who produced them would sacrifice the full value of the time employed in their creation. While we perceive along "*the line*" many an example of mediocre painting, we find, on and near this post of honour, pictures which, whether meritorious or not, would have been sufficiently well seen in higher places—places now, by a strange contrariety of fortune, error of judgment, or shameful negligence, adjudicated to carefully-executed works of a higher character, and whose delicate finish and smaller parts indicate the necessity of a nearer view. Nothing can justify this; if they cannot be better placed let them

be excluded. When a picture is ill-hung, the hanger places upon it the daily ban of a damnatory criticism, far more injurious and depressing than any the pen can produce—the effect of which may pass speedily away, or be negatived by a kinder or sounder judgment. The remark especially applies to the Royal Academy — arbiters of the fate, for a season at least, of all up-rising men; and whose decision will be considered as final by thousands who know no better, or who distrust their own opinions.

We have, as in duty bound to do, given this troublesome, painful, and embarrassing subject our best attention; and sure we are, that the evil cannot be remedied until in an exhibition-hall there are NO BAD PLACES; none, that is to say, where a picture cannot be fairly examined, and its merits or demerits fully ascertained; so that neither undue eminence nor injurious depression be given to any artist by the caprice, or biassed feeling, or wrong judgment, of any tribunal. This can be done effectually only by providing rooms spacious enough to accommodate all applicants; or until this advantage is obtained, by placing such works alone as can be placed where they will benefit and not injure the producer. The object of the painter in exhibiting his work is that it may be SEEN : it is small recompense to him to perceive his name in the catalogue, and be honoured with a free ticket of admission; his hopes of a year—perhaps of a life—are blasted if his friends and the public are insidiously led to form the idea that he is held in small estimation by his brother artists—by those who are considered the best judges as to the rank he ought to hold. In every point of view, it is prejudicial, if it be not ruinous, to a painter to have his picture hung where it is stamped with the baleful mark of inferiority : be it ever so mediocre, the great mass of examiners will be sure to think it worse than it really is; and instead of the exhibition being to him a step forward, it is a thrust backward; he will have more difficulty than he previously had to make his way to public favour. Now, if we state the case fairly, this is a manifest injustice, gratuitously inflicted; for no association can be so circumstanced as to be compelled, against their better feelings, to do the injury. In no gallery, that at present exists, is there space to exhibit favourably *all* the works that are sent to be exhibited; but we submit, that it is far wiser and more generous to *exclude* those that can be only placed disadvantageously. But is not the real and practicable remedy sufficiently obvious? If a cotton-spinner's trade increases beyond the limits of his building, what does he do? He either enlarges his premises, or builds to an extent commensurate with his wants. We have not the remotest doubt, that if the Royal Academy will bestir themselves they may either obtain the whole of "the National Gallery"—for a season, or altogether — or obtain funds

for erecting a structure worthy of the country, and of such a size as shall completely answer the purpose for which it will be intended. If the country will not do this for the Arts, the Artists themselves must — *and they can!* It should be remembered, that although the profession—like every other profession—has increased at least fourfold during the present century, the accommodation is very nearly what it was thirty years ago ; for we much doubt whether the number of square feet allotted to artists in the National Gallery is greater than it was in old Somerset House. In this age there is no standing still; if we do not advance of our own accord we shall be driven onwards. We earnestly hope the Royal Academy will be more active than it has been, so as to think and act for an altered state of things. They have the confidence of the country ; to a very large extent the confidence of the profession—and they deserve both ; but it is impossible not to know that a time is at hand when they will be called upon to do more than they have hitherto done. Their means must be less circumscribed ; but their proneness to avoid the movement must be less liable to suspicion.

For our own parts, we shall not cease to agitate upon this all-important matter—THE ABSOLUTE NECESSITY FOR PROVIDING A SPACE SUFFICIENT TO EXHIBIT PROPERLY EVERY PICTURE THAT OUGHT TO BE EXHIBITED ; AND THAT NO WORK SHALL BE HUNG WHERE THE HANGING OF IT IS INJURIOUS TO THE PAINTER.

Let the members of the Royal Academy, or any portion of them, WILL that this shall be done, and it will be done as surely as that day will follow night.

John Eagles

"Exhibitions —
Royal Academy and British Institution"

Blackwood's Edinburgh Magazine 50 (September 1841), 340–51

It is somewhat late to make remarks upon the annual exhibition of our Royal Academy, after it has been fairly and unfairly pelted and buffeted by admiring and pugnacious critics. " The latter end of a fray, and the beginning of a feast." That we have taken the latter end of both, may argue us " dull fighters, and not keen guests." It is the bill of fare makes the keen guest; we therefore, not having been always pleased with the catering of one house of entertainment, defer our visit till the rival restaurateur open house, that, if our taste be disappointed in the one, we may seek gratification in the other. The Royal Academy and the Institution in Pall-Mall exhibit, at the same time, the old and modern art. There is great advantage in this, both to professional artists, and admirers and patrons of art; but if we make our object comparison, it is but fair to remember that the works of modern art are on their trial, can scarcely be said to be selected, while those of elder art are those that have generally, from their approved excellence, survived the havoc of time, criticism, and the cleaner. We suspect that modern works will not come so well out of the hands of the latter (the cleaner) as the old, until our artists adopt a better method than the use of varnishes and megillups furnish them. This is a subject very important indeed, and rendered more so by the efforts made to enforce an evil practice in the publication of Merimée, translated by Mr Sarsfield Taylor, and published under an indiscreet sanction of the Royal Academy, and which was reviewed in Maga of June 1839; but as it does not at present come within our scope, we shall not here discuss it.

We doubt if, on the whole, this year's exhibition is an improvement on the last. Mere vulgarity is certainly disappearing. Insipidity, however, not works of sentiment and thought, fill too large a space. For whom are all these things of no meaning, which crowd the walls, painted, is a question we annually ask ourselves? That the painter should be pleased with his own manual dexterity, and mere power of representing objects, if he be uncultivated for higher aim, is not surprising; but that the public should be pleased with such works, does excite our wonder. It surely argues no good public taste, when the eye seeks a gratification unconnected with intellectual and moral feeling. We know the love of imitation is strong; but in the works we speak of, *that* is often faintest and least exact, where most required. It is curious, too, that even in imitation the truest does not always please most. The nice touches of absolute truth have never been noticed by the entirely uncultivated, and are therefore not only not recognised by them, but too visibly interposed, and draw attention as to things to be learned, and extraneous to usual observation. It is strange, too, that what the eye sees and must see in nature, and would see in the picture, were it so placed as to be an illusion, and taken for nature, it does not see when the consciousness of looking at a picture is admitted. This would be incredible, were it not daily brought to the proof. All understand a panorama, but all would not understand the parts taken separately. The light and shade that makes the whole more perfect, even in illusion, tend to confuse in the picture. When Queen Elizabeth required to be painted without shadow, she showed she had been offended in picture with that which she could not understand. We remember an instance of the same kind :—An old lady sat for her portrait. It was admirably painted, so that, with a little trickery and management of light, and hiding the frame, there is no doubt but that her domestics might have addressed the picture as their real mistress; yet at length, when the portrait was quite finished, and they were admitted to see it, knowing they were to see a picture, the oldest and most confidential servant was offended, and remarked that her mistress had not that black and blue mark by the side of the nose. It was no affectation in the good woman. Light and shadow had sported before her all her life unnoticed. The " gentleman without a shadow" would never have startled

her imagination. It is not then the most true to nature, that is the most striking. When Partridge thought the man who acted the king was the true actor, he showed, that in all representation the vulgar mind rather requires exaggeration than truth, and such exaggeration as shall overwhelm the delicate touches of nature, which would perhaps be only in the way. The cultivation of the eye is as necessary to art, as of the ear to music. The art is not wanted for daily use in this bustling world, nor is poetry nor any high reach of intellect. But the nerves of all our organs, our outward senses, do reach to the inner mind; but the mind must by intellectual cultivation, or an intuitive and rare gift, be enabled to play upon these instruments. So that we are indeed wonderfully made, that we may never lay ourselves down, and cover ourselves with the rust of idleness; but after we have exercised successfully the faculties necessary for our subsistence, those of highest power remain to be cultivated, and the means of enjoyment infinitely enlarged. Perfect taste is the enjoyment of perfected beings. We are afraid we are more than on the borders of dull truism; but we cannot come to the " why and wherefore" of things otherwise. Apply what has been said to our national taste and practice, as artists or admirers. What is the character of things exhibited?—here you have the aim of the artist; what is the character of things admired, encouraged, and purchased?—here you have the public taste. How far the one depends upon the other, may be a question for philosophical enquiry, and' not unworthy attention. It may be more than an object of curiosity to trace to causes, facts in the history of taste, or, if you please, of art; we say taste, because it comprehends the world to be pleased as well as the artists who are to please;—how it is that works unvalued in their own age, in a subsequent age are every thing—how it is that the most valued become worthless. Are we sure that the present estimation of the works of other days, of the great masters as they are called, is on a correct scale? for even here there is no steady certainty. Whoever has lived twenty years in the world of art, must have noticed the variation of the scale; and then comes a still more curious enquiry—are modern works received into favour for and upon the same principles of taste, which have given their value to the old? or if not, can there be *opposing principles* of taste? And then, from what cause or happy combination of causes is it, that in any age the genius of the artist, the painter, maker, worker, the ποιητης, shall have been in perfect union and sympathy with the public requirement? Is there always an accordance between a people and the state of art among them? If so, how is it that the works of one age so admirably suit another, in which no such works originate? And as to the present age, were the works which have been recognised as the excellence of former days, reproduced as originals among us, would they be acknowledged to be what they are? The history of the world of events has been written, fabulously and truly, with great learning and research; but the history of the world intellectual and moral, of nations separate from warfares and dynasties, is yet a desideratum—the history of taste. However, these subjects may remain for philosophical enquiry—it may not be unfair to infer so much, that, whatever art shall have for ages engaged the attention, and more than that, the affections of mankind, it shall have left in its progress some certain principles, a deviation from which always produces deterioration. Advancement, indeed, may bring forth other principles, for many may be admitted; but it may be safely asserted, that it can bring forth nothing in contradiction, and that when such are attempted to be laid down, the consequence is any thing but advancement, if that word be taken in its good sense. These are then principles of taste— they are based on feeling, and nature; it is only practically and in combination they are intricate—in themselves they are simple, and perhaps fewer than may be at first view imagined. No one doubts that there are principles of taste: in Homer the epic—in Æschylus, Sophocles, Euripides, and above all, our own Shakspeare, dramatic ;—how to bring forth and sport with every passion of nature, from the deepest pathos to the lightest wit— from Æschylus to Aristophanes. There are in these, however occasionally obscured and hurt, sure prin-

ciples of taste, So in what we term more especially the arts—there are sure principles in ancient sculpture, and in painting in the works of the 15th and 16th centuries. Are these principles sufficiently and practically established? Are the rules which they lend to the mechanism of the art, and to the modes of expression, enforced by the precepts or examples of our academicians? Is there, in fact, sufficient learning in our school— learning as to the nature of poetical conception, in design, in composition, in chiaro-scuro, and in colour? We doubt if painting has been yet clearly established as an art upon its principles, and rules laid down from which there can be no deviation with impunity. If it be said that such would cramp genius, we assert that, by enlarging its means, they would increase its power; and we would point to the known learning and deep studies of the most eminent masters, who were not only painters, but sculptors and architects, and well versed in poetry, science, and all philosophy. And, on the other hand, we would point to the vagaries of men of unrestrained and untutored talents, which too often make even genius ridiculous, and the want of it contemptible. The motto to the catalogue of the Academy Exhibition for this year, seems to offer defiance to criticism, and refers to nature—" Opinionum commenta delet dies; judicia naturæ confirmat." Time, indeed, may set aside criticism, and confirm the edicts of nature; but it is rather a bold assumption, yet it would seem implied, that the works of the exhibitors will bear the test of nature. That there are very strange, shall we say deviations from or defiances of nature, and that from the hands of artists whose authority is potent and of dangerous sanction, is a matter of great regret among persons of any experienced taste; if the " commenta opinionum" of such persons be endeavoured to be set aside by the reference to nature in the quotation, the motto bears an audacity with it that promises only a perseverance in evil. We protest against practices in defiance of nature and all hitherto conceived principles of art, discoverable in the best works of the best times. That contradictories cannot be both true, is the rule of reason. If, therefore, called upon to condemn the practice

of those masters whose excellence the opinion of ages, the admiration of the universal world, have established, or the vagaries, at once extravagant and insipid, set up in opposition and contradiction, we think it no arrogance to decide against the pretensions of modern innovators. There is no so great defaulter in this respect, in his branch of art, as Mr Turner. There is not a picture of his in this year's exhibition, that is not more than ridiculous. There are, however, admirers who, when told that his works are unlike nature—boldly say, " So much the worse for nature: it would be better for nature if she were like Turner." This is certainly taking the bull by the horns, and to this no answer can be given. It is painful to refer to particular pictures—and they are all nearly alike absurd : but what can be said of No. 176, " Schloss Rosenau, seat of H. R. H. Prince Albert of Coburg, near Coburg, Germany," but that it may have a " name," but can have no " local habitation"—or of No. 277, " Depositing of John Bellini's Three Pictures in la Chiesa Redentore, Venice," that could only please a child whose taste is for gilt gingerbread ! Can any thing be more laughable, in spite of regrets, than No. 542, " Glaucus and Scylla?"— where the miserable doll Cupids are stripping off poor Scylla's clothes; yet there is no chance of indecent exposure, for there is certainly no flesh under them. No. 532, " Dawn of Christianity," (Flight into Egypt,) is really quite horrible, and happily unintelligible without the description. As to the passage into Egypt, it is long before you can distinguish a figure ; Egypt is taken literally for the " fiery furnace," and it is out of the frying-pan into the fire. And this is meant for the poetry of painting, and what a composition !—and that " Old Dragon" dwindled into a very pretty playful common snake. It is by far too bad ! Mr Stansfield's pictures this year are very perfect of their kind; they show an increase of force; the finest perhaps is No. 9, " Castello d'Ischias from the Mole." The motion of the water is remarkably good. We cannot but again notice his conventional colouring—the mud drab for lights, and blue for shadows, and strong and unnatural browns, to throw parts into greater distance. Surely

his pictures, which do not pretend to be any thing but views, would be greatly improved by attention to local colour. We cannot believe that all places on this earth are built up of drab clay. Mr Stansfield is at the head of our view-painters. He may confine himself too much to scenes of one character. We are persuaded he has a power for a greater variety, and for scenes of greater loveliness. He has chosen what has almost exclusively been termed picturesque, and manages all with so much art and dexterity, that in admiring the skill of the artist, we excuse the poverty of the subject. We do not mean by poverty subjects without artistical composition, but subjects which of themselves would in nature give little pleasure, excepting it be in reference to his manner of treating them. It is a peculiar style, and the view-taste a peculiar fancy—for it in nine cases out of ten, perpetuates the remembrance of places one enters with pain, and is glad to escape from as soon as possible. What must the inhabitants of all the tumbledown places on the Rhine and the Rhone think of us, our scenery, our buildings, and our taste, when they learn that representations of their beggarly edifices and their abominable outskirts form the chief ornaments of our Royal Exhibition? If this be a new style, there is no need to quarrel with it; but the artists so employed must not call themselves landscape painters. Claude and Gaspar, it is true, introduced towns and hamlets, but quite subordinate to a general and pervading pastoral feeling—remarkably so with the latter. He understood well how to mingle the repose of nature with the activity of life—an activity that never lost sight of enjoyment, and was therefore perfectly consistent with pastoral repose. It was in deep glens, amidst rocks and waterfalls, that he delighted to study—every picture of his encloses a pastoral world, (pastoral in its admitted sense, not as of rustic labour and toil,) with homes that seem nature-built out of the very rocks, that all may partake of one feeling—the shelter, the bounty, and the beauty of nature. Often have we lamented, and still lament, that this sentiment of nature has been abandoned by art. The view has taken place of the poetical landscape. Surely there may be room for genius in that

walk, without imitating either Gaspar, Poussin, Claude, or Salvator Rosa. It is one, however, in which English painters have ever been lamentably deficient. Those who have attempted it have, for the most part, failed; have either taken up a sort of mock-classical, or dropped into unmeaning vulgarity. Let the landscape painter, before he puts his subject on his canvass, ask himself if the scene he is about to represent be such as he would delight to dwell in, or for any length of time to contemplate, for any feeling it is to convey. It is not a dead tree and a muddy pool that make a landscape, nor is it much mended by the affected sublimity of a geological survey. Nor, in respect to architecture, are our views always in good taste. The low and the mean, the decayed and poverty-striken, are often thought to be the only picturesque, as if *picture* must indulge vile associations. Let not art take habitat in "rotten rows," nor vainly imagine that the eye should seek delight where the foot would not willingly tread—the purlieus of misery and vice. All the pictorial charms of light, and shade, and colour, are to be found in subjects which shall not degrade them. There is no lack of architecture, that elevates instead of depressing the mind, both by its grandeur of design, the work of genius, and by the associations it calls up. In a word, in every branch let what is low and mean be discarded, however it may tempt the artist under the idea of the picturesque. We mean not to exclude common scenes and common life, whenever they offer propriety throughout of action and sentiment, with such touch of nature as "makes the whole world kin." "Nihil humani a me alienum puto," means not every thing mankind do, but what is done with a certain propriety of feeling. It is with this view of discarding vulgarities, that we again congratulate the public and exhibitors upon a most decided advance in the "Elegant Familiar." Thanks are chiefly due, on this account, to Redgrave, Maclise, and Lauder. Redgrave's "Sir Roger de Coverley's Courtship," No. 287, is perfect. The finish is beautiful and most appropriate. It is admirably coloured; the characters most truly conceived; nothing can be finer than the modesty and simplicity of the knight. His

total ignorance of the widow's aim, and admiration at her discourse upon love and honour, " which he verily believed was as learned as the best philosopher in Europe could possibly make," are fully expressed. The confidant is not quite good, not quite worthy the widow. This is the best of his pictures in the exhibition ; there are two others very good, No. 206, " The Castle-builder"—" Never reckon your chickens before they are hatched," and No. 498, " The Vicar of Wakefield finding his lost daughter at the inn." The feeling in the latter is very true ; but it may be a doubt if the vicar is quite the character. Mr Redgrave has fully answered the expectation he raised last year. His characters have such particular truth, and the work and feeling so well go together, that it must be difficult ever to forget his pictures. They will one day be inestimable. Mr Maclise has exhibited this year four pictures—No. 33, " The Irish Girl, ' No. 124, " The Sleeping Beauty," No. 265, " Lady in a Hindoo dress," and No. 313, " Hunt the Slipper at Neighbour Flamborough's—unexpected visit of the fine ladies." These are all highly finished, and full of subject, and, excepting in colour, admirable, though in this respect we think Mr Maclise improved. His power of drawing is very great—he is afraid of no attitude or difficulty of foreshortening, yet his power does not obtrude too ambitiously. Mr Maclise has shown that his fancy is exuberant in the purest fiction, as well as in that which has a more strict reference to everyday truth. The difficulty of such a work as the " Sleeping Beauty," may best be conceived by the exposition of the subject in the catalogue ; the picture, however, tells its own tale : —" So the princess, having fallen into a deep sleep for a hundred years, was placed in the finest apartment in the palace, on a bed embroidered with gold and silver, &c. So the fairy touched with her wand all that was in the palace. Maids of honour, gentlemen ushers, grooms of the bedchamber, lords in waiting, waiting women, governesses, stewards, cooks, scullions, guards, porters, pages, footmen, &c., even little Bichon, the princess's favourite lapdog, who lay on the bed by her side, all fell fast asleep, &c. At the expiration of a hundred years,

the prince arrived. He approached the castle by a long avenue ; he crossed a large court-yard paved with marble ; he ascended the staircase, entered the guard-room where the guards were snoring away most lustily ; he passed through several rows of ladies and gentlemen, some sitting, some standing, but all asleep. At length he came to an apartment gilded all over with gold, and saw on a magnificent bed, the curtains of which were opened all round, a princess more beautiful than any thing he had ever beheld," &c. This multitudinous sleep, if the expression may be allowed, is no less in the picture than its recital—and all the gorgeous beauty, with one fair princess superlatively beautiful, is perfectly represented ; nor is the more fanciful, the fairy part, less sufficiently told. There is but one thing that offends, and that the less because the subject will admit of a fairy light, and not quite true—but little is required. The princess and all her attendants are not sufficiently " heirs of flesh and blood"—are too much of the texture of all around them—and too strong of white lead. This whiteness, which is equally observable in " Hunt the Slipper," is probably from a notion that time will subdue it—a false notion, we think, under which other artists have laboured, and laboured in vain. For time, if it subdues, will not substitute colour ; and we think Mr Maclise mistaken, if he supposes that, a hundred years hence, his picture of the Sleeping Beauty will awake into a greater bloom and freshness. At present, it may keep up the expectation, but in a hundred years it will " be all one," and not another in that respect—or, if it change, it will not be for the better. The story at Farmer Flamborough's is as well told—the natural unrestrained joyousness of the artless family. is well contrasted with, and as yet not actually disturbed by, the presence of Lady Blarney and Miss Carolina Wilhelmina Amelia Skeggs, who are seen entering by a door, at the extreme side of the picture. The ladies are affected and fine enough, perhaps a little too old. His other pictures have less subject and less meaning. There is something not quite pleasing in the hardness of Mr Maclise's style : we should be glad to see a little more attention to general colour—there is too metallic a cast ; it may give force, but

it is not necessary to it. It is a pity
his genius should in any degree be
subservient to mannerism.

It is with very great pleasure we
notice Mr Lauder's No. 539, " The
Trial of Effie Deans."—"A deep groan
passed through the court; it was
echoed by one deeper and more agon-
ized from the unfortunate father. The
hope to which, unconsciously and in
spite of himself, he had still secretly
clung, had now dissolved, and the ve-
nerable old man fell forward senseless
on the floor of the court-house, with
his head at the foot of his terrified
daughter. The unfortunate prisoner,
with impotent passion, strove with the
guards between whom she was placed."
—*Heart of Mid-Lothian.* Such is the
deeply pathetic incident that Mr Lau-
der has chosen; and not for a moment,
in all his elaborate work, has he for-
gotten the sentiment. It is the most
powerfully painted picture in this
year's exhibition; by powerfully paint-
ed, we mean the most successfully
daring as to the absolute delusion of
light, and effect of reality. In this
respect, it is dioramic, and as such,
may possibly meet with censure from
many who think historic art ought
to have no such aim—that it should
not descend to such particular and
strongly defined representation of de-
tail—that there is too much actual
truth. But we think a little consider-
ation of the subject painted will make
that a merit of the painter which
might be too hastily considered a
defect. Whoever has been present
at such harrowing scenes as the
trial of Effie Deans, has borne away
with him, fixed upon his memory,
and connected with the event in no
other way than accidentally, some
visual object or objects which he
can never after separate. There is
an effort in the mind, under the most
trying circumstances, to find relief
from the external senses—and the or-
gans of the eye do their part with
wonderful fidelity. In such cases,
there is ever in the mind, with the
event, a most distinct remembrance of
accompanying things; and when, as
in the instance we are speaking of,
they are of a character more strongly
in contrast with the peculiar charm
with which the sufferer is invested, it
becomes the duty and great merit of
the poet and painter to give them the
most absolute distinctness. Sir Wal-
ter Scott was no inefficient master of
this art, and Mr Lauder must have
felt and noted it with great judgment.
What are the objects thus brought
out—the very iron, the bars of stern
justice, are seen in themselves and their
shadows, objects that show the busi-
ness of law, that horrid detail, from
which innocence cannot escape, pro-
ceeding like unrelenting destiny. The
magical illusion of light upon the two
barristers, standing out as they do
boldly from the background, (which
shows behind them that their work is
done, and that the merciless business
of consignment of the law is at work,)
yet, by their position and look, direct
the eye to the beautiful and energetic
sufferer. There is not a countenance
that is not full of character. This for-
cible delineation and notice of objects
which we have immediately remark-
ed, has not been forgotten by another
great master of pathos. Mr Dickens
has made good use of it in his trial of
the Jew Fagan—the mind of the crimi-
nal is there strangely employed upon
some visual objects. It is nature—
and whether it be told in language or
in paint, will ever be effective. Mr
Lauder is an artist of very great power;
in representation of character and pa-
thos, he is inferior to none.

" Ubi *plura nitent,* non ego paucis
Offendar maculis."

We will not, therefore, disturb the
impression the picture has left, by no-
tice of unimportant and minute ble-
mishes.

We have at other times ventured
to criticise Mr Lee somewhat freely.
We love landscape, and this is Mr Lee's
walk: we earnestly desire to rescue
him, and that he should rescue art,
from *views,* even though they be of his
favourite Devonshire scenery. He is
a painter of great ability, and more
may be expected from him than his
pencil has yet realized. His large pic-
ture, (No. 300,) " Highland scenery,"
is the best that he has yet exhibited.
It is true to nature, vigorously con-
ceived and executed, and well colour-
ed, excepting in the drab tongue of
land to the right, from which arise the
bare trees. Here is a little art of his
conventional colouring, and from the
school of Landseer and Stansfield,
which does harm to the whole picture.
Not only is it unnatural for the scene,
for it is mud, whereas the lake is clear

—but it injures the solemnity and grandeur by the idea it conveys of shallowness, nor is it quite consistent with the rush of water immediately succeeding. His " Cottage from Nature," (No. 148,) is a failure, very, very poor ;—the poverty of his 201, " Devonshire Scenery," is still more remarkable, in which nature is certainly treated as a dirty drab. His " Inverlochy Castle and part of Ben Nevis," (No. 372,) makes amends—why are painters so unequal to themselves ? His " Highland Scenery " of mountain, cloud, and water, in poetical accordance, must be the test by which to try himself, and from which he is to advance more boldly into more extensive regions of fancy. It *is* possible for artists to sketch too much from nature, especially when the sketches are of scenes to paint, to the neglect of parts which a knowledge of composition is to unite, and with which, in combination, it is the gift of genius to create. The real learning of art lies in a thorough knowledge of composition ; we may as well expect the music of Handel complete in the chance sounds of nature, as a perfect composition in natural scenery. We know this will be considered heterodox in art—but painting is art, and genius is to mould the elements that nature gives. Thomson felt this when he called Poussin learned—

" Or savage Rosa dash'd, or learned Poussin drew."

We were sorry to find nothing to call forth admiration this year from the hands of Mr Uwins. Neither his Lear nor his Cordelia, in No. 166, at all come up to the characters. We remember his " Fioretta," and regret that he should waste his time upon unmeaning processions, eternal repetitions not worth repeating, where crude blues and reds vie which shall first put out the eyes of the spectator. And what are they ? what interest can they create ? It is sheer poverty tricked up too gaily. We cannot compliment him on No. 291, " The Bay of Naples on the 4th of June—various groups returning from the Festa of St Antonio." Nor upon No. 622, " Children returning from the Festa of St Antonio, and chanting a hymn in praise of the Saint." Would that the whole kalendar of his festas was burned, and that he would try his hand on something better, something that shall convey sense and meaning ! He has made them red hot enough, and deluged them with ultramarine to cool them down again. Mr Uwins, the painter of Fioretta, has too much talent to be the worker of but one idea, and that not a good one. Some indiscreet praise has perhaps made him think that good which his better judgment should tell him is bad; and he perseveres under a false impression. This hot and cold extravagance unfortunately begets followers—or we should not have such a performance as No. 609, P. F. Poole, " By the waters of Babylon there we sat down; yea, we wept when we remembered Zion." Personages should be coppered to sit down in such a burning scene, and coppered they are. Poor creatures !— water there could not be where all is red-hot. It is after the fashion of Nebuchadnezzar ; fiery furnace, heated seven times hotter than it was wont. The weeping maidens must soon be reduced to cinders.

" Their scalding tears in crimson streaks,
Hiss down their copper-colour'd cheeks."

We have not a better colourist than Mr Etty, and his compositions are in general very good. No. 136, the " Repentant Prodigal's Return to his Father," fully keeps up his high reputation. The feeling and expression of the father and son are extremely good ; fully speaking the language of penitence and affection. " And the son said unto him, Father, I have sinned against heaven and in thy sight, and am no more worthy to be called thy son." Mr Etty has violated the unities in telling his story ; in this he has recurred to the practice of the early embellishers. Formerly, with any other view, he would not have introduced the dancing group in the background. They would hardly have followed the Prodigal into his father's house ; and it is quite out of character that they should have followed him at all, in his misery and poverty. Perhaps the Prodigal is scarcely enough emaciated.—His No. 206, we do not much admire. It is an old subject, and not treated with much variety. We are disposed to ask if there be a play on the words " To arms, to arms" intended. For there is a choice of *arms* for the warrior, warlike and feminine. Mr Roberts

has not in any respect varied his style. His pictures have great breadth and effect; does he not somewhat injure them by his figures? which are nevertheless very good; but as they are in such vivid contrast with the whole colouring, it requires great management to keep his groups from being spotty, and attracting too much attention. Good as they are, we have often wished to see at least half of them painted out, or in some way better connected; as it is, the eye jumps from one to the other. His subjects are very imposing, and at first we thought his pictures were most true; but when we see Jerusalem, Dendera, Ruins of Baalbec, all precisely of the same colour and texture, we suspect his manner is not quite true. Nor do we think the " French polish " which is laid over the old ruins invariably, either pleasing to the eye or improving the grandeur of the design. A more dry manner, at least partially if not generally, would perhaps be actually more powerful. Even in his fine picture, the " Portico of the Temple of Dendera," there would be more solemnity if the shadows were less transparent: deep architectural shadows appear to our eyes semi-opaque: when the transparency amounts to a stain or mere wash of varnish, the *mystery*, which in such subjects is all in all, is very much injured.

Mr C. Landseer tells his story well, and paints with breadth, and power, and clearness of colour. His " Temptation of Andrew Marvel," a good anecdote, is painted with his usual propriety of effect and colour. Are there not too many witnesses to the bribe? Art is but misapplied in Leslie's " Fairlop Fair," yet it is well painted in parts; the texture is very bad. Mr T. Creswick is advancing. His No. 181, " A Rocky Stream," is very clever. He is a little too minute in his penciling. Nature is so, it may be said;—true, but nature hides more than half her work. It is only a little bit, here and there, of minute work that is thrust out to show her riches, just as touches of exquisitely fine lace-work edge the masses of drapery of the stateliest pride. Minute work, if there be too much of it, is displeasing, fatigues the eye and the mind, which never loves to dwell upon labour. We look upon the " Peacemaker," No. 195, W. Collins, R. A., as a specimen of detestable colouring. We must not omit to notice an attempt at poetical or historical landscape, No. 329, " Mercury and Argus," A. Geddes, A. It is poetical and promising. The colouring is better than the composition, which, in fact, is too simple to merit the name of composition; not that it is bad as far as it goes, but a few stems of trees are not enough for such a subject. We are glad to see this beginning, and hope Mr Geddes will try his powers more decidedly in that line. Though the style of art be not to our taste, we must acknowledge the merit of No. 422, " Poor-Law Guardians," C. W. Cope. It is very good; every figure seems to have been taken from nature. If viewed as a satire, which it is to be presumed is the intention of the artist, is there not a something more wanted? Is it sufficiently biting? No. 410, " Pirates of Istria bearing off the Brides of Venice from the cathedral of Olivolo." This is admirably painted, and has great force; and, what is a rare thing in our Academy exhibitions, variety of colours without distraction. Mr J. R. Herbert has looked at the old masters, particularly of Venice and Lombardy, with advantage. The public have reason to expect much from him. In the west room was a picture, from which at first we turned away in disgust, the colouring is so offensive, as well as some other parts in its management; but being large, it attracted the eye, and we each time felt something which forced us, in spite of its general disagreeableness, to return to it; and we did return often. It is No. 420, " Lawrence's Death," V. Dartignenare. Who Lawrence is we know not, but it is most pathetic in expression. It is of a young woman on her death-bed, dead or dying, and holding to her bosom the one hand of, as we presume, her lover; who, with his face averted, and in deep shade, seems overwhelmed with sorrow. Bad as the colouring is, the face, drapery of bed, &c., all being of one colour, it is very painfully powerful. It is a history of love and misery not ended, for there is a survivor; and love in the dead or dying, it is uncertain which, seems even to be still dominant. It reminded us of the touching lines of the poet, than which we know no passage more simply affecting—

" Et tandem suprema mihi cum venerit
hora,
Te teneam moriens deficiente manu."

The hand in death has still its grasp
of love.

Mr Martin has two pictures that
are a contrast to each other—one dark,
the other light—No. 428, " Celestial
City and River of Bliss."

" The Author of all being,
Fountain of light, thyself invisible
Amidst the glorious brightness where thou
sitt'st
Throned inaccessible."
" Immortal amaranth !
To heaven removed, where first it grew,
there grows,
And flowers aloft, shading the fount of life ;
And where the river of bliss, through
midst of Heaven,
Rolls o'er Elysian flowers her amber
stream ;
With these that never fade, the spirits elect
Bind their resplendent locks, unwreathed
with leaves.
These blissful bowers
Of amaranthine shades, fountain or
spring,
By the waters of life
They sat
In fellowship of joy."
Paradise Lost, b. iii. 11.

Now, taking all together enclosed by
the poet in these passages, is there a
subject for a picture ; and if so, what
should be its character ? " The glo-
rious light, or the blissful bowers of
amaranthine shades?" — or which
should predominate? The poet is
rapid in his imaginative conceptions ;
dares not dwell upon the " Fountain
of Light ;" but, as it were, with closed
eyes adores " Thyself invisible," and
passes on to the occupation of saints
in blissful bowers, the spirits elect.
The painter attempts too bodily what
the poet hurries over as celestial
ground, unfit for mortal foot. There
remains, then, nothing but the sublime
repose. Is it in the picture? Any
thing but that. It is of all distrac-
tions—of blue, and yellow, and white;
with greater distraction of a multipli-
city of minute parts, all, with slight
variation, resembling each other. You
may conceive yourself suddenly trans-
ported to a land lying *sub iniquo sole,*
where you would be in expectation of
instant ophthalmia, and, if it only in-
flicted the loss of sight, have little to
regret ; but as to bower and shade,

they seem quite out of Mr Martin's
desires. We want *eye-preservers* in
the Academy in more senses than one.
The wretch who has practically poked
out the eyes from pictures, may have
had his revenge for the academical
putting out of his own ; but he has
selected with indiscriminate malevo-
lence. Having thus criticized Mr
Martin's " Celestial City," we have
much more sincere pleasure in referring
to his No. 570—" Pandemonium."

" Anon, out of the earth, a fabric huge
Rose like an exhalation, with the sound
Of dulcet symphonies and voices sweet,
Built like a temple, where pilasters round
Were set, and Doric pillars overlaid
With golden architrave; nor did there
want
Cornice or frieze, with bossy sculptures
graven."
Paradise Lost, b. i.

There is a simple and awful grandeur
in this picture, that evinces no common
genius. It is a preternatural and
gloomy light, that even the rising fires
cannot subdue. The long unbroken
lines confer a continuity of awful
greatness. It is, indeed, a very Pan-
demonium, with its mob of hellish re-
formers. We shrink from it instinct-
ively, and remember the Reform
burners of Bristol.

We were nearly overlooking a pic-
ture of great merit and of much fancy,
from its general modest unpretend-
ing hue. Yet it is a subject many a
painter would have treated gaudily,
and obtruded on the eye with forced
colours and forced effect.

No. 207, " Titania sleeping." R.
Dodd.

" There s'eeps Titania, sometime of the
night,
Lull'd in these flowers with dances and de-
light."

Mr Dodd has most poetically con-
ceived the subject, and not forgotten
the earliest learned mystery of fairy-
land—that fairies *hide* themselves—
seen only by the gifted, and by them
with half-shut eyes, between twi-
light and starlight. He has well pre-
served the fairy scale and measure-
ment—and the enclosure of flowers is
quite beautiful, and the outer *fiend*-
frame shows a creative fancy. It is
very highly finished—a really beauti-
ful picture—one we fear misplaced ;
the glare around will scarcely allow
the mind sufficient abstraction fully to

enjoy so imaginative a picture. We do not pass over Mr Eastlake's fine picture, his only contribution, universally admired, from any reluctance to offer our meed of praise; but it was so difficult of access that we fairly confess that we are not qualified to speak of it as we should. He is at all times a painter of sweetness and tenderness, of a delicacy and softness, both in colour and execution, that sometimes, perhaps, detracts a little from a due force. This we say not in reference to the present work, but because we believe Mr Eastlake not disinclined to hear remarks, and to think upon them; to weigh them in the nice balance which judgment adjusts for genius.

Why has not Mr Danby something more important than his " Sculptor's Triumph," or his " Enchanted Castle?"—the latter by far the best, though not so elaborate a picture as the " Triumph," which wants some leading feature; there are too many straight lines; the parts do not necessarily connect themselves with each other, to make the design a whole. It is, too, better finished than coloured. The " Enchanted Castle" looks poetry; but, perhaps from the position, not quite clear and luminous. We remember last year Mr Danby's fine picture of the " Deluge," which was not in the Academy, and feel disappointed.

And here we close our remarks on the Academy Exhibition, aware that too much has been overlooked, even in so short an account. But we cannot help it. We contend that the display is too great; that one-third of the number of pictures would make a better and more pleasing exhibition. The very gilt of upwards of twelve hundred frames, to say nothing of the pictures, is enough to put out the eyes and distract the judgment. But the piling up, pyramidically, picture upon picture, where neither their merits nor demerits can be seen, is a practice most vile, injurious to artists, and we really think no small insult to the public. Let the upper tier, at least, be henceforth dispensed with, that innocent artists may not be uplifted to such unenviable a distinction.

If we complain of the great number of works in the Academy Exhibition, the very circumstance that the British Institution contains, large and small, but 220, is greatly in its favour. We are here reminded of the passage of Time; for those whom we remember as living artists are taking their places among the old; yet they enter, as it were, with a modest step, keep together, and take positions somewhat at a distance. And we are compelled to say that this selection from their works justifies their position. We remember to have seen many of Stothard's designs for the *Novelist's Magazine* in water colours, exquisitely beautiful, and were sorry to see his paintings, which do not indicate the genius so conspicuous in his careful drawings. In painting, his style was peculiar; and we suspect his pictures have suffered from the use of mastic varnish. But there is a want of freshness in them. The most pleasing is No. 172, " A Fête Champêtre.' It is a subject, in the landscape, of solemn repose; and, if but one group of figures had been allowed to remain, the effect would have been very good. Whenever he introduced much landscape, he was too apt to separate his figures into distinct groups. We are not here criticizing Stothard but as a painter, a colourist; as to the making up his picture as a whole, many of his designs are very beautiful, and full of genius.

There are some very good and some very inferior pictures by Sir Joshua Reynolds. No. 117, " Kitty Fisher," though, comparatively speaking, a slight, and even faint picture, leaves a stronger, a more vivid impression than any other in the room from his pencil: it might be called the weakest and the strongest, it is so perfectly one in its simplicity; nothing being in it but what completes the idea, and nothing being wanting, we are satisfied. It is just one of those things upon which, when nominally unfinished, unwrought on by any glazings and force of colour, we should have deprecated another touch of the pencil. It is quite life: we want nothing, and look for nothing more: the apparent ease and simplicity with which it is painted, are strictly in accordance with the subject. Another of Sir Joshua's has a strange fascination—the portrait of Sterne. His look is quite searching. It is very finely painted. The intellectual wit is quite alive—it conveys the idea of a double action; keen outward observation, and the creation of wit from within. Who is there

that will not dwell long on the features of the author of *Tristram Shandy*?

It is with pain we saw the Gainsboroughs and Wilsons. They are all bad. Wilson was a landscape painter; but in what respect? In his colouring, and that he did not offend by the vulgarity in composition then so common; so that we are inclined to pass him off for understanding more of composition than he did. He seldom ventures upon much complication of subject. He was in that respect content with little, which little he often managed with great effect, and with great feeling for colour. But he knew little of form, and nothing of composition as an art. Look at any of his well-known prints, where the colour and strong effect do not bear them out—and see how poor he is. Here is his " Niobe" with the bridge, for instance. The landscape partakes of neither the vengeance of the offended deity, nor of sympathy and suffering with his victims. The great tree is a vulgar hedge-row commonplace sort of thing, and the rocks are like loaves, one directly above the other, just in the lines they should have avoided. Still he was a landscape painter, and had a bold genius too; but it lay not in composition. If we so pronounce of Wilson, what shall we say of Gainsborough, but that he knew still less than Wilson, and could not conceal his defects by the charms of which Wilson was master. We have seen some small landscapes by Gainsborough that were very pleasing, but never one of any size. He was too good a painter not to hit off a bit from nature with truth and beauty; and, if the subject happened to be good, a matter of chance, it was well; but when he attempted a composition, whether in his affected grander style, or the more common, they were equally poor, if not equally vulgar. And in these he seems to have lost his powers as a colourist. But as a portrait painter, who could vie with Gainsborough, in uniting identity of character with great pictorial management? Not even Sir Joshua—and certainly no one else. We can say nothing, then, in favour of the landscapes of Gainsborough and Wilson in the Institution. In these remarks upon these eminent painters, we shall be thought all in the wrong; but will any one venture to refer us to their works in the National Gallery, the depository of their supposed treasures, to the " Niobe," or the detestable vulgarity called the " Market Cart?"

The Canalettis are curiously unequal. No. 93, the " Capitol, Rome," is strikingly beautiful—a perfect contrast to the dingy, damaged-looking pictures he painted in England, such as his Whitehall, No. 95. The management of the view of the Capitol is most skilful — atmosphere pervades every part of it. The variation of colouring in the masses is but slight. Greys pervade, and wonderful force is given by throwing his stronger drawing and stronger colouring in the figures, and upon the shadows. The coach at the steps tells wondrously. This is a very fine specimen of Canaletti, and painted with great care and neatness, excepting where force is required. No. 84, The " View in Dresden," is, we believe, by his brother. It has great freshness and vigour—the ground and the buildings too much of a colour. The Vernet, No. 220, " A storm on the coast of Italy," is not a very good specimen of that pleasing painter; it has evidently changed in colour.

It is time to look a little at the old masters, and we regret our space will not allow us to say much. We doubt very much the one made most conspicuous by silk curtaining; a silly practice. A picture should speak for itself, without the recommendation of the upholsterer—and so to set off a Raffaelle, and that an unfinished picture, by a trickery that makes it look more unfinished, is absurd and deteriorating. The picture, No. 7, " The Holy Family," is in fact but little more than sketched in. If we could be assured of its being a genuine Raffaelle, we should be pleased by seeing his manner of working. Whoever painted this, it seems to have been his practice to have outlined with pen and ink, then to have filled up to the outline his background, with a very odd mixture—a coarse black paint—then to have worked upon the heads and extremities of the figures. But what authority is there for this being by Raffaelle?—the heads have not his chaste sweetness and mild dignity—and can the very uncertain outlines be by Raffaelle's *certain* hand? Was not Raffaelle's handling clean and continuous in his drawing? but here it is too much of the un-

meaning flourish—a sort of thunder and lightning run of the pen, or whatever else he used. We would not swear to Raffaelle's handwriting there. There was, however, a very beautiful Raffaelle, that grew more and more into our admiration. On viewing it at first, it seemed a little hard, from that *clean* outline a little showing, as if it had come through. The more we looked, however, the less we saw it ; it was overpowered by the great and sweet character of the whole. This picture had been removed when we saw the exhibition lighted up at night. No. 19, " The Magdalen," Domenichino—is certainly most beautiful ; it is the picture engraved by Schiavonetti for Forster's gallery. The sentiment is very fine, and painted with such force and breadth, as to render it very powerful. It is not throughout painted with the finished care of the master, which is mostly observable in the lower drapery ; perhaps the glazings have suffered generally in the cleaning. It sold for L.600, a price which ought to have ensured it for the National Gallery. And while upon this subject, (the National Gallery,) we must express our regret that another picture in this collection was not purchased for the public—" The School," by Jan Steen. It is not of the class of pictures to our individual taste, but it is unique ; there is none so good of the master, and it is a very fine picture too, full of nature and truth. Every attitude and feeling that schools exhibit may be found here—and it surely is a picture which, from its subject coming home to every one's memory and feelings, would give more pleasure to ninth-tenths of the persons who visit the National Gallery, than would the finer productions of the Italian schools. What a wonderful portrait painter was Van Helst ! The " Portrait of Madam Wouverman," No. 68, is the triumph of art over nature ; for it is a fascinating portrait of a very ordinary, not to say ugly

woman. Yet we would not wish a feature beautified. It is only inferior to a Rembrandt—and indeed it is very like one. There are some good Rembrandts. No. 71, " The Portrait of Cornelius Van Hooft, the translator of Homer into Dutch," is full of solemn thought, with which the tone and colour are in perfect harmony. What a contrast is it to the fluster of Rubens, " The meeting of Abraham and Melchizedek ?" How seldom do we receive pleasure from Rubens, and perhaps the less when we are forced to admire ! How strange it was that he should have delighted in subjects rather of show than of sentiment ! They are well adapted for the vestibule in the temple of art, but seldom deserve to be admitted within the temple's more sacred recess. But we must stop short, or we could write much upon the peculiarities of this great and singular master ; and perhaps should be bold enough to endeavour to show his deficiency as a colourist, and the false principles even in this branch of the art, upon which his pictures are very commonly painted. This is a very imperfect review of the Institution this year ; but it will more than suffice in the opinion of many, whose habitual taste will be shocked at the heterodoxy of some of our remarks. There is one other picture, however, which we must not omit to mention—the Van Eyck. Much has been said of late of vehicles, and of Van Eyck's supposed invention of painting in oil. This production, therefore, demanded great attention. It is wonderfully luminous, more so indeed than any picture in the rooms ; and the finish is quite wonderful. Strange and stiff enough it is, and odd in form and design—but the painting, the texture, for which we look at it, is surpassingly beautiful. The metallic lamp and the clogs are specimens of most exquisite and elaborate work—the metal and the wood are perfect imitations.

John Eagles

"The Natural in Art"

Blackwood's Edinburgh Magazine 51 (April 1842), 435–44

ON the discussions of art there is no greater obstacle to the setting forth principles, than the unsettled terms nature and natural. They are indeed the limits of art, beyond which there can be no legitimate exercise; but the boundaries remove themselves out of sight, or contract themselves within the smallest space, according to the fancy, perhaps we should say the genius, of the disputants. To those of the contracting system, the art is considered as nearly entirely imitative of external visible nature, with a power (scarcely of creating) of combining, of putting together things that are, exactly and no other way than as they may be, and have been, though not so seen, perhaps, at the moment of any incident to be represented. Others, again, by nature, admit whatever the mind, in its most sane, healthy, imaginative, comprehensive state, can conceive. As we believe the latter is the highest and best sense in which nature, as applied to art, is to be understood, so do we believe it is the truest. It is the highest, because it is the most creative; it is the truest, because, with regard to its general reception, it carries with it a spell not to be denied, enforcing a general credence, if not conviction. In the best and healthiest state of the most discursive imagination, there is an intuitive knowledge, instantly forming a judgment and decision, as to that particle of the natural, in even the least imaginative minds, which will unite itself, as by a chemical affinity and attraction, to the natural portion in the created and fanciful, and by that amalgamation make all be, or at least appear, as natural. The true creator never loses sight of this—the judgment is ever with him; he decides by it, and this judgment, presiding over creative power, constitutes genius. Genius, then, or art—for consummate art is genius—not only has the power of creating a world for itself, but of creating in the minds of spectators and hearers a belief in its existence. It is very strange that this should be so generally felt; and it can scarcely be unacknowledged with regard to poetry, particularly the drama, and yet be denied in reference to the art of painting. Because painting is the visible art, it must, with some, be merely the imitation of things seen;

whereas poetry and music are, in the same sense, imitative as painting, and in no other—unless, indeed, we speak of the lowest kind of painting, that deadweight fastened to art by an indissoluble chain, but which was never intended to keep it from rising. It should rather be the ballast, to keep steady the aeronaut in his upward course. Let us exemplify this power of genius by its effects in poetry, and then let the fair inference be drawn, " Ut poesis pictura," as well as " Ut pictura poesis." Let there be to both arts the " Quidlibet audendi æqua potestas." Try the power by Shakspeare's most imaginative plays—the " Tempest" and " Midsummer Night's Dream." In both these plays we have a new creation—new beings such as none ever saw, and such as none ever believed to exist until they saw these plays acted, or read them. We say such as none ever believed to exist, because we must not deceive ourselves, and take advantage of the wonderful power of that belief created in us by the poet, to fancy we have imagined such beings. We never did—the exact creations of Shakspeare, *his* Caliban and *his* fairies, had no prototypes in our belief; but we have naturally a vague particle of belief, which instantly seizes upon and appropriates the creation. There is nothing more natural than the fear and feeling of the preternatural. Shakspeare worked upon this nature, and spun and wove from the tangled, unformed materials in the human bosom, the fairest and most hideous creatures— not simply the two, the fairest and foulest, but many and infinitely varied in their characters. Caliban and Puck are not less distinct than Ariel, and Oberon, and Titania. And how different are their provinces!—how unlike their powers over the elements, the air, the earth, and the sea! Now where, in external nature, do we get all this? It is purely creation, and shows the illimitable province of art. The world, then, from which art is to *make* its pictures, is not only the external visible world of nature, but the world of imaginative nature, a portion of which is inherent in all mankind, and which makes them love and fear, in cases of their own predilection or terror, a little beyond reason, but not

a little beyond truth, for the very nature is truth. If it be in the nature of our minds that thought should travel and shift its ground, with instant and wonderful rapidity, from east to west, and yet then not be bounded by the limits of the world, may not art in this imitate nature, or rather take advantage of this ubiquity of fancy's nature, and, with nice arrangement and rapid delusion, hurry us over space and time, and place us when and where it pleases, without violence, as the drama does in its shifting scenes, and as Shakspeare has done in his " Winter's Tale?" Be it well or ill done, is the only question. If with a judgment and power, it is the work of genius ; lacking that judgment, we make a mock of and deride the attempt, and point to it as a palpable cheat. In the theatre we hiss the poor actor—we should condemn the author. Is not Burns's " Tam O'Shanter" a pure creation? Here, too, we have fairy creatures of another " kith and kin ;" and do not let any one fancy that, before reading Burns, he has had any knowledge of them. The poet spun them out of that common material which was in his and every one's mind ; and as the thread is drawn out in the poet's mind, so, by his electric power, is it drawn out in all, and the same forms created, and being created thus within every mind, it is felt and acknowledged to be natural. And in this of Burns, there is another natural instinct called into play—the humorous ; so that, however dressed or undressed in its vagaries, the phantasma is still natural, still in itself a truth. The forms " of things unknown"—unknown till called into existence from the dormant materials of general nature, by the head of genius—thereby acquire henceforth a local habitation and a name. And thus it is that genius confers an everlasting benefit upon mankind, present and to come, continually enriching it, creating treasures for every one's enjoyment—doing that out of the mind which cannot be done out of the material world, adding to that which was ; for, if with matter, there is not since the creation of world one atom more than there was at first, it is the very contrary with the world of thought, of intellectual invention, of mind, which is continually enlarging, multiplying itself, becoming more. Nay, the painting it takes possession of matter, gives to it thought, and makes a new thing of it. That it may

not appear we are arguing without an adversary, it may be as well here to give some account of a discussion we had with a professed lover of the natural, and which originated in a conversation on " schools of design." We will put it in the form of a dialogue, if not according to the exact words, correct as to the substance of what was said. We will designate our opponent NATURALIST, ourselves IDEALIST :—

NAT. The advantages of studying from nature alone, will be manifest in the truth that will be in every department of art. In our ornamental manufactures, you will see nothing represented that *is* not.

IDE. And that you consider a great advantage ; and are you not confounding two things a little incompatible with each other—art and manufacture?

NAT. No, I consider them one ; there may be higher excellences in some departments of art than others, but I consider ornamental manufactures a department of art ; and it is because you have seen such bad things in patterns, that you would separate them. Art altogether arises out of the love of ornament.

IDE. Yes ; and, like a magnificent river, may rise from a very insignificant source. You may sport and play at the fountain-head what petty gambols you please ; kick it with your feet and splash it with your hands, like wanton children ;—but further on it will become deep and resistless, and though people build their pleasant villas upon its banks, they do so not without a fear of its power, and carefully fence themselves against its inundations. So art, if you will still call it so, while it is confined to the narrow and shallow ornament, is a thing of mere sport, may have rules of its own play ; but when this art in its progress enters upon the territories of thought, of mind, it takes another name and character—it is genius—is grand and fearful, of every beauty. It commands—but we shall get out of our depth. Sufficient difference is shown to justify us in separating them : so that, when we speak of art, we will only speak of it, as the higher quality, wherein it is invariably in the province of mind.

NAT. I will not quarrel with your distinction, if you will make the exact study of nature the necessary foundation of both.

IDE. If we can first agree what is nature. I fear, in your sense of it, we shall not agree; for I think you are adverse to the representation of any thing and every thing in higher art and design in manufactures, that has not the exact delineation and character of some visible, palpable thing.

NAT. Yes, I have an aversion to vagaries—my sense of truth is shocked.

IDE. Your sense of truth need not be shocked. You have limited yourself to a particular truth, and finding not that, look not for the truth that may be.

NAT. I do not understand you.

IDE. Well, then, put it thus: we do not always think in syllogisms. Fancy hurries away the mind frequently, so that we cannot connect thought with thought; we run into unrestricted "vagaries" as you term them, and refresh ourselves in the freedom of undefining idleness. This is a character of our minds; and in art, whatever accords with that is *a* truth; force upon that mood an exact similitude, and in your attempt to establish perhaps the minor truth, you have destroyed the greater. Let us exemplify it by the vagueness of some *ad libitum* movements in music, that delight from the very scope they give to this idle indulgence. The artist, the musician, nay, even the manufacturer of ornamental design, that shall succeed in drawing you into this vein, does so by touching a chord of truth existent within you—of nature, if you please; for in the sense we now speak of truth, it is one with nature.

NAT. There may be something in your view, but it is new to me, and I must consider it. I fear it will not bear the test of strict examination. Your argument would, I suspect, admit impossibilities as legitimate subjects of art.

IDE. I do not see why art should not employ itself about impossibilities, if there be the genius to make them credible. For genius has

" Exhausted worlds, and then created new."

NAT. That is the creation I fear: surely where there is so much of beauty in the world that is, an inexhaustible source, would it not be better first to work in that mine?

IDE. It is very good to do so, I will not say it is better, if you mean to confine the operator to that mine; every mine should be worked, and some workmen have an irresistible impulse to try new, and if they dig out treasures we ought to be satisfied.

NAT. You are losing the thread of the discussion. Now, look at that frame to your pier-glass, it has been offending me this hour, and attracts my attention to its absurdity. This is, I believe, of the taste that is attempted to be revived, the ornamental of the time of Louis the XIV. Can any thing be more silly deformity? You have flowing lines that, as far as I can judge, mean nothing, for they are neither stem, leafage, nor feather; and how ridiculously is the upper involution terminated in what is meant, I suppose, to be a dragon's head, with the dress of a fury! Yet never was there, never could there be such a creature, or part of a creature. You will not pretend to call this abortive absurdity a truth?

IDE. Yes, I do—the sort of truth just referred to. It is the very unlikeness makes the vagary; the impossible metamorphosis, with its easy flowing infinity of lines, that draw away the strict judgment into a maze of wonder, from which it cannot and would not escape; this impossible, which is made half credible in the dream-like condition it engenders, I would term the " magic of ornament;" and indeed, in my pleasure, I am almost disposed to retract the distinction I have made between art and design in manufacture; at least, it draws me away further from your view of exact representation. How could you alter it? imagine instead of it a sheep, for it is its opposite, a cow, and, if you please, the maid milking it, carved according to most exact life; you might admire the thing, but it would be turned out of this room.

NAT. And why, for I really think it would be an alteration for the better?

IDE. The why is, that I do not want the fatigue of comparison with the reality, where ornament, not picture, is intended; and while in this room I would shut out the farm-yard and all its pigs and sheep, delvers and diggers.

NAT. Now you turn from sober argument to wit, and throw an air of vulgarity into the representation, that need not be a part of it. Why not represent things in themselves more elegant; flowers, for instance, and fruit: you know the value of Gibbon's carving?

IDE. Gibbon's work is beautiful in-

deed, and he knew well how to manage his lights and shadows, to give boldness and delicacy too where required : you have brought a giant in that line of art to combat for you ; but I will pit the dragonat against him ; and in all that ideality, I can fancy that though he cuts off one head, another will peep out from some of the involutions of lines, and soon thrust out the perfect head, and hiss *secundum artem.* Besides, the whole thing is delightfully fantastic, and the depths and hollows and maziness of the lines are all of ornamental magic, to be converted *ad libitum* to any magical meaning : and, strange to say, fancy will do what comparison will not, and invest with life, understanding, and meaning, and purpose, those, to your view, unmeaning lines, more readily than the nicer judgment will admit those living qualities in things meant to be exact similitudes. We are ready to deny what is arrogantly assumed. " Are those pictures like the lions ?" said the boy to the showman. "Like !" quoth he, " so much so, that you would not know one from the other." " Then," said the boy, " I will save my money." He had nothing left him to wonder at. Had the dragon been really like any thing, we should never wonder ; now, you may look yourself into a maze of wild metamorphosis, and find truth and impossibility linked together to give you pleasure.

NAT. You really magnify the ornamental greatly—you surprise me ; I should have thought you would have reserved all your ideality for the higher art—picture ; but now, I find that, if imagination be the test of genius, there must be more of it in ornamental design.

IDE. No, by no means, I do not even intimate so much. Pictures have more distinct, more defined objects ; their ideality is of a precise purpose, and must be united at the same time more closely to the exactness of nature, while they have an aim above it. Design in ornamental is best where little is done ; in picture, where much. The mind must be in the picture—in the other, the mind is in yourself—if mind it should be called, —rather say fancy, which the character of ornament surely enables you to indulge in.

NAT. Now, then, I am glad to find you are coming round to my opinion. In art, then, in picture, you will at least call the artist to a strict account of the natural in his works— you will make him study nature, and nature alone, in all forms, particularly the human figure, the most beautiful of forms. Let us confine ourselves to picture, I will consider "schools of design" for our manufactures at another time. Let us have exact drawing from real things, and exact colouring too, perfect nature in the arts, meaning picture-painting ; for where, as you say, there must be a more definite object, there must be nothing but precise truth.

IDE. But you forget this was agreed, if you would define precise truth correctly, and thus it is we argue in a circle ; for as I expected, or as such was my meaning, precise truth may be more than the first visible and obvious truth. Exemplify it thus by a truly ideal painter in one respect, and not at all so in another—Rembrandt. Often, in telling his story, his object is mystery, his figures may be ill-drawn, ill-conceived ; no matter, he wishes not to draw you to them as to beautiful objects, but they tell as parts to throw into light and shade, and on which to vary his colour, so that you think not of them, but of the mystery—that is his object, he is *true* to that. His work, therefore, establishes the truth of mystery, to which he has occupied the minor truths—minor with him with regard to his object, though every thing in another painter of another aim. So you will see here, by your precise truth, perhaps you did not mean to include this ideal truth.

NAT. But do you not think Rembrandt's pictures would be better, if, in addition, there was the beautiful and correct drawing of the figure?

IDE. I fear to incur the charge of inculcating bad taste, but if compelled to decide, I must say—no. Perfect music may not be without a sacrifice to discord. A Venus and Apollo in their utmost beauty would offend in one of Rembrandt's deep mysteries— they would divide his subject. Where they are, they must have absolute dominion.

NAT. Well, there may be something in that—but you are flying from the purpose. I am not of a new opinion—the controversy is an old one. The Caracci first set up the school of naturalists. They saw in nature all that was wanted in art.

IDE. In obvious nature, did they ?

They presumed to do so, but in their better works stepped beyond the limits they professed to confine themselves within; and their predilection has even made their high fame and name of uncertain duration. The fame of the Caracci is not rising. But were not Correggio and Raffaelle naturalists? Certainly they were, and idealists too—the great painter must be both; but I doubt if you do not, in referring to that controversy, some-what leave your own ground. You widen the discussion. You forget, too, that your Caracci painted tritons, and sea gods, and wood nymphs, dryads and hama-dryads, which they did not find in their academies—and, where they made them too human, they lacked genius, and were shack-led. The fact is, the art is universal; too wide is the field for these limits. We agree perfectly, if you assert that nature should be studied intensely, and with utmost accuracy; but when na-ture's forms leave you, that is exter-nal, shrink not from the ideal daring.

NAT. It is not that nature's forms leave you, but you leave them; and the examples you give, though from the naturalists the Caracci, are to my view absurdities. Who ever saw, or in a sane state imagined, tritons and mermaids, and *id genus omne?*—the im-possibility of their existence is shock-ing. There cannot be physically, anatomically, such a being as half-man half-fish: our actual knowledge rises up against the fabrication, and proclaims the cheat.

IDE. Not so fast—you assume too much; who ever saw is one thing, but who ever, in a sane state, imagin-ed is another thing. I will tell you the sanest who imagined he saw

" A mermaid on a dolphin's back."

Nay, the all-sane Shakspeare not only imagined he saw, but called the tes-timony of another sense; he heard her
" Uttering such dulcet and harmonious breath,
That the rude sea grew civil at her song,"

You must not pass over the last line, the idea beyond the visible nature, giving, endowing with the anatomy of brain, and feeling, and sense of civili-ty too, that which hath none. Nay more, the very stars are mad to hear the music—
" And certain stars shot madly from their spheres,
To hear the sea-maid's music,"

So that you perceive that not only did

Shakspeare imagine the mermaid, but gave the sea and the stars life, and un-derstanding, and delight to hear her. I see you yield—be sure that, if you bring poetry into the argument, you are lost; for the art is poetry, only for words it uses forms and colours.

NAT. No, not quite the same—words hurry over the absurdities, but paint-ing fixes them.

IDE. Painting only fixes what it se-lects, so that it must bear the blame, or assume the merit.

NAT. Even in poetry does not Ho-race decry the practice of imagining impossible conjunctions?

IDE. Certainly he does not—he only condemns the incongruous in character—the tigers and lambs—*non ut placidis coeant immitia.* The monster he called his friends to deride, was indeed an absurd jumble of odds and ends, that never could be imagin-ed to be one being. The horse's neck, and the woman's head, and what be-side?

NAT. You will not defend a Cen-taur, that worst of impossibilities; would any painter of sense now-a-days perpetrate such a subject?

IDE. Why not? I have seen a very beautiful picture, by Rubens, of the Centaur Nessus—the wounded Nes-sus; nor did Rubens think it a vile perpetration to paint the half-bull half-fish monster, rushing from the sea to destroy the chaste Hippolytus; nor do I think you would, upon re-flection, disdain the beast; but Cen-taurs surely are a poetical conception, and of admitted, recognised fable.

NAT. Poetry run mad, and paint-ing too, that adopts the fable. Do let me show you the absurdity. Here is a creature with two stomachs, the hu-man and equine, and one mouth to maintain them both—the one body lives on hay, the other on flesh, and there cannot be, physically speaking, any union or communication between them. Is it possible to look at a pic-ture of a Centaur, and not see and laugh at the folly or ignorance of the artist?

IDE. Well, you have put a very strong case—you have put the dissec-tion of your own natural in a very striking, startling way; but if, not-withstanding that, I can make out a case for the Centaurs, the greater will be the triumph of art.

NAT. Admitted.

IDE. We hear a great deal of igno-rance—it may be asked if knowledge,

too, does not produce its morbid disease ; and, be not offended, it may happen that your imagination is infected by it ; and as one in the jaundice sees all things of one hue, so one under the knowledge of disease, may see, by too scrutinizing a view, through the beauty-covering to the bones and sinews, and anatomize a Venus. It has been said, happy is he that does not know he has a stomach ; we may say, doubly unhappy is he who, in looking at a picture of a Centaur, should discover that he has two. You are disenchanted by your knowledge, it has deadened your imagination. You would be incredulous of any fruit but pippins, in the fabulous Hesperides. You would bark in return at all Cerberus's heads, and pass on, never believing that you would meet the ghost of Achilles in the Elysian fields, and converse with him on glory. The waking dream of poetry must not be for you. You must always pass condemnation on our best poets and painters, if you cannot so master your mind as to throw it into a belief. What to you would be Titian's Bacchus and Ariadne, and the young Satyr-god dragging the captured head? What Raffaelle's Archangel treading upon the Great Enemy ? Would you not see the impossibility of make and muscle to support his wings, as you do that of the two-bodied Centaur? Poor Ovid! and all the poets and painters that have followed him, you would burn all their metamorphoses. The beautiful Circe, too, you will not acknowledge a swine of her making. You can pass with an unpalpitating heart between Scylla and Charybdis. But you are not to be envied. The fact is, in the better half of poetry we are not called upon to know but to believe—to believe even against knowledge ; a belief that borrows more from our feelings, and perhaps our better ones, than from our understandings. You cannot love truly with this ever-vigilant, prying knowledge, for to do so you must take something for granted, and borrow a few fascinations from imagination. So, my good friend, if you go on at this rate, you will strip yourself bare indeed ; you will have no confidence in hidden virtues. Go not to a theatre, for if the fit lasts, you will see nothing but the actors ; you will not shed a tear over Lear and Cordelia, for you will know they are but mimes. Nay, you must hourly call yourself to task for the very language you use, lest you deal in hyperbole, in trope and figure. Now tell me, is not all this abandonment against your nature? you have really not considered the subject sufficiently. Are you prepared to give up all that is shown, from the drift of your arguments, you must give up ? Knowledge makes even charity cold ; you had better give your pence to a good actor than discover every cheat. But be consistent ; burn every work of imagination that demands of you a prior belief, (and you shall have a small library,) or admit even Centaurs within the pale of credibility.

NAT. You have lectured me finely, and have said as much for your Centaurs as can be said.

IDE. By no means. There is much more to be said—the better half is unsaid ; for even courts of justice bow to precedent—there is authority in their favour. Do you really forget the great statuary—the noble battle of the Lapithæ and Centaurs ? even, you see, in hard solid marble has the great idea been perpetuated. But I will give you an example in painting. Let us look for Lucian's description of the copy of a picture by Zeuxis, which he saw at Athens, of a female Centaur. Here it is—Eιχονα της ειχονος.

NAT. And, with the original, hand down the translation. Franklin's, I see?

IDE. I shall read it.

NAT. By all means.

IDE. Thus, then, saith Lucian:—" I will tell you a story of Zeuxis. That famous painter seldom chose to handle trite and common subjects, such as heroes, gods, and battles; but always endeavoured to strike out something new, and exerted all his art and skill upon it. Among other things he painted a female Centaur, with two young ones. There is an exact copy of it now at Athens; the original was said to have been sent into Italy by Sylla, the Roman general, and lost at sea with the whole cargo, somewhere, I believe, near Malta. The copy, however, I have seen, and will describe to you; not that I pretend to be a judge of pictures, but because when I saw it, in a painter's collection there, it made a strong impression on me, and I perfectly recollect every part of it. The Centaur is lying down on a smooth turf ; that part which represents a mare is stretched on the ground, with the hind feet extended backwards. The fore feet"—(Stay a moment, the good Dr Franklin has omitted to trans-

late—" το δε γυναικειον οσον αυτης, ηρεμαεπεγηγερται,και επ' αγκωνος εστιν. But that which is woman is gently raised, and reclines upon the elbow." Why did he omit it? Did he think it contradicted, by the action of holding her young? But to proceed)—" The fore feet not reaching out as if she lay on her side, but one of them as kneeling, with the hoof bent under, the other raised up, and trampling on the grass, like a horse prepared to leap." (That won't do, Dr Franklin—και τα εδαφους αντιλαμβανε]αι, οιοι εισιν ιπποι πειρωμενοι αναπηδαν — holding the ground, as horses do that try to rise up, to leap up, if you please, when lying down. But to proceed)—" She holds one of the young ones in her arms, and suckles it like a child at her woman's breast, and the other at her dugs like a colt. In the further part of the picture is seen a male Centaur, as watching from a place of observation, supposed to be the father," (supposed to be the father! for shame, Dr Franklin, who would doubt?—no supposition at all ; Lucian says, thinking of the subject, the female Centaur—ανηρ εκεινης δηλαδη της τα βρεφη αμφοτερωθεν τιθηνυμενης—" The husband of her thus in both ways, nursing her young.") " He (the husband, and, of course, the father) is behind, and discovers only the horse part of the figure, and appears smiling, (smiling, γελων: Centaurs don't smile, more likely uttering a good horse laugh, and επικυπτει γελων, describes an action. But thus let it be smiling)—showing a lion's cub, which he lifts up as if to frighten the young ones in sport. With regard to correctness in drawing, the colouring, light and shade, symmetry, proportion, and other beauties of this picture, as I am not a sufficient judge of the art, I leave it to painters, whose business it is to explain and illustrate them. What I principally admire in Zeuxis, is his showing so much variety, and all the riches of his art, in the management of one subject, representing a man so fierce and terrible, the hair so nobly disheveled, rough and flowing over the shoulders where it joins the horse, and the countenance, though smiling, amazingly wild and savage. The female Centaur is a most beautiful mare of Thessalian breed, such as had been never ridden or tamed. All the upper part resembling a very handsome woman, except the ears, which are like a satyrs: that part of the figure, where the body

of the woman joins to that of the horse, incorporating as it were insensibly, and by slow degrees, so that you can scarce mark the transition, *deceiving the sight most agreeably.* The ferocity that appears in the young ones, is moreover admirably expressed ; as well as the childish innocence in their countenances when they look towards the young lion, clinging at the same time to the breast, and getting as close as possible to their mother." Does not this description reconcile you to the Centaurs even more than the Phygaleian marbles? How admirably does Lucian criticise the picture, feeling every beauty ! The Hippo-Centaur, looking on at his infants, and holding up the lion's cub to frighten them—his βλεμμα καιτοι γελωντος θηριωδες ολον, και ορειον τι, και ανημερον. The look, all wild and savage, of the laughing mountain man-beast. How well the man is defined, and the brute! How beautiful the female, and how well the human body blends with that of the horse η μιξις, και η αρμογη των σωματωνκαθ' ο'συναπτεται, και συνδειται τω γυναικειω το ιππικον, ηρεμα και ουκ αθροως μεταβαινασα, και εκ προσαγωγης τρεπομενη, λανθανει την οψιν εκ θατερα εις το ετερον υπαγομενη. Lucian, and of course Zeuxis, you perceive, saw, as well as you and all other naturalists, the impossibility of the junction of the two bodies, and directs your attention to the wonderful art with which you are cheated into a belief of it. Lucian claims as a merit what you would make an objection. How nicely he notices, particularly as being most wonderful in effect, the expression of the infants at the breast, still feeding, but looking παιδικως μαλα προς τον σκυμνον του λεοντος, which the father is holding up to terrify them, and to observe the effects. Does not all this variety, the infants, and the incident of the lion's cub, avert your attention from any impossibility? —and how artfully managed? Zeuxis, Lucian tells us, was disgusted that the novelty of the subject only was admired, and not his mode of treating it. τον πηλον της τεχνης επαινουσι. The mud, the dirt, of the art they only admire—the dregs says Franklin. Lucian winds up both with a notice worth your attention. " All else but the novelty did Zeuxis in vain ; yet not in vain, for you are judges of painting, and see every thing with a knowledge of art, provided it be worthy an exhibition"—which we think

Franklin mistranslates. " I hope my productions will be worthy your approbation." " γραφικοι γαρ ὑμεις και μετα τεχνης ἑκαστα ὁρατε, ειη μονον ἀξια τα θεατρα δεικνυειν." An excellent mottoto be placed over the door of a national gallery. Franklin has some whimsical notes—"Zeuxis," says he, " if we may credit our author, must have been the Stubbs of antiquity."

NAT. The description is at any rate beautiful, and I know you will take advantage of that admission, and say the description is the picture; so I must yield myself up, at least for the present, to believe any thing to be natural.

IDE. That is more than I ask ;—but come, Lucian had a sane judgment, loved pictures, and has given descriptions of a few—shall we look into them ?—you will be called to believe more impossibilities. We will take his dialogue of Zephyrus and Notus — his picture; and Paul Veronese never painted better. " *Zephyrus.* Europa wandered to the sea-shore, to divert herself with her companions, when Jupiter, putting on the form of a bull, came and sported with them. Most beautiful did he appear, for he was milk-white, his countenance mild and gentle, and his horns turned back in the most graceful manner ; he leaped and played about the shore, and lowed so delightfully, that Europa ventured to get upon him. Jupiter immediately ran off with her as fast as possible into the sea, and swam away. She was frightened out of her wits ; with one hand laid hold of his horn that she might not fall off, and with the other took up her robes that were tossed about by the wind." "*Notus.* It must have been a charming sight, Zephyrus, to see Jupiter swimming and carrying his beloved." " *Zephyrus.* But what followed was still more delightful. The sea became placid, and, lulled as it were into tranquillity, resembled a smooth and unruffled plain ; we, as silent spectators only, accompanied them. The loves, hovering round them, and sometimes just touching the waves with their feet, bore lighted torches, and sung hymeneals. The nereids, half-naked, rising from the water, rode on the backs of dolphins, and joined in the chorus of applause. The tritons and sea nymphs, all that the element could produce of grace or beauty, sported and sung around. Neptune himself, ascending his chariot with Amphitrite, led the way rejoicing, and

was bridesman to his happy brother. Above all, two tritons carrying Venus reclining in her shell, and scattering flowers of every kind in the way before the bride : thus they proceeded from Phœnicia quite to Crete. When they arrived at the island, Jupiter appeared no longer in the form of a bull ; but, in his own, taking Europa by the hand, led her blushing and with downcast eyes into the Dictæan cave. We returned to the sea ; and, according to our several departments, moved the waves of it." "*Notus*. Happy, thrice happy art thou, Zephyrus, to have seen such a sight, whilst I was employed in looking at griffins, elephants, and blacks." Here are pictures that many have painted after this description, in words and colours, and not the least worthy the fascinating Ariosto. There is, by-the-by, a pretty little Greek idyll taken from this tale of Europa, that Gibson the sculptor would make much of. It is of Cupid turned ploughman, and, while sowing, he sees and knows Jupiter in his bull form, looks back and threatens him, that if he doesn't mind what he is about, he will put his neck in the yoke. Is not this a subject for sculpture, the god-bull, what a form—and the arch-god love ?"

But you remember Lucian's picture of Luna and Endymion, in the dialogue between Venus and Luna. The Greek is all gentleness of most moonlight sleep, and silver-shaded light.

" You think Endymion then, said Venus, beautiful ?

" Oh yes, particularly when ὑποβαλομενος ἐπι της πετρας την χλαμυδα, καθευδη, τη λαιᾳ μεν ἔχων τα ἀκοντια, ἤδη ἐκ της χειρος ὑπορεοντα, ἡ δεξια δε περι την κεφαλην ἐς το ἀνω ἐπικεκλασμενη ἐπιτρεπει, τῳ προσωπῳ περικειμενη. ὁδε ὑπο του ὑπνου λελυμενος ἀναπνει το ἀμβροσιον ἐκεινο ἀσθμα. Τοτε τοινυν ἐγω ἀψοφητι κατιασα ἐπ' ἀκρων των δακτυλων βεβηκυια, ὡς και μη ἀνεγρομενος ἐκταραχθυιη—οἰσθα.

Franklin thus.—" *Luna*—To me, I confess he appears charming, especially when, throwing his garment on the rock, he goes to sleep, his arrows in his left hand, that seem dropping from him, (no 'that seem,' there is no seem at all—already now slipping out of his hand, yet that has not the beauty of ὑπορεοντα,) and his right supporting his head, and giving new lustre to his beautiful face. His breath, as he sleeps, is sweeter than ambrosia. (Oh! Franklin, Franklin! It is ' he, dissolved in sleep, breathes out that ambrosial

breathing.') Then come I down, as softly as possible, and treading on my tip-toes that I may not wake and disturb him. You know the rest, in short, I am dying for love of him." The latter part, in particular, is vilely translated. The Greek has the very softness and caution of the gentlest footing. Albano painted this, and sweetly. It was soft moonlight, and sleep, and love, and Dian's beauty.

NAT. But this is Lucian's picture of words, not his description of a picture actually painted.

IDE. True—and if you are not tired of Lucian, we will turn to his description of a picture, which he says he saw in Italy, ἐστιν εἰκων ἐν 'Ιταλια καγω εἰδον. The picture is by Ætion—the marriage of Roxana and Alexander. Raffaelle was so pleased with this description, that he painted a picture of it, which was hung in his own room. The only alteration made by Raffaelle being, that he transferred the scene from an inner chamber to a camp. Lucian's description is perfectly graphic παγκαλον τι χρημα παρθενον εἰς γην ὁρωσα.

Such was the perfection of the picture, that Proxenidas, the chief judge, was charmed with it to such a degree, that he gave Ætion, who was a stranger, his daughter in marriage.

"The scene," says Lucian, "is a handsome inner chamber, with a nuptial bed in it, on which Roxana, a most beautiful virgin, is reclining, with her eyes fixed on the ground, as ashamed of looking up to Alexander, who stands by her. She is attended by several smiling cupids, one of whom is behind, lifting up her veil, and discovering her beauties to the bridegroom; whilst another, in the character of a slave, pulls off her slipper, that she may lie down; another lays hold on Alexander's robe, and seems drawing him, with all his strength, towards the bride. He has a garland in his hand, which he offers to her. Hephæstion stands close to him with a torch in his hand, and leaning on a beautiful youth, whom I take to be Hymen, though there is no name inscribed over him. In another part of the picture are a number of cupids sporting with Alexander's armour, two of them—like porters sweating under a burthen—carrying a spear, with two more at a little distance, one lying upon his shield, and borne, like a king in triumph, by several who take hold of the handles of it, whilst

the other gets into his coat-of-mail, and conceals himself, as if with a design to frighten the rest if they come that way; nor are these sports without design, as the artist meant by them to point out the hero's passion for war, and to show that how much soever he might be in love with Roxana, he had not forgot his arms. The picture, it may be observed, had something nuptial in it, which might recommend Ætion to the daughter of Proxenidas, as the marriage of Alexander was a type of his own, and the hero, whose wedding was represented, a kind of bridesman to the painter, who went away equally happy." This of Franklin's is not the most elegant translation; but does it serve to reconcile you to the machinery of cupids, which, unless you have advanced, are a step or two beyond your limits of the natural?

NAT. I see you are determined to decide for me; but has not this same Lucian a description of a portrait, and a defence of the flattery, in which there is no such cupid machinery?

IDE. "The Portrait," which is so much the work for the painter that the translator "humbly inscribed the translation to his friend the great portrait painter of England, Sir Joshua Reynolds." But are you quite correct as to the machinery? It is not a description, but directions how to paint it; and all art, all beauty, all wisdom, gods, goddesses, the most noted philosophers, and most fascinating of woman kind, are called upon to contribute, even Dædalus and his wings, which, by-the-by, offers the translator an opportunity of a far grosser flattery than could be charged against his original, and is certainly a specimen of the bathos. Thus, in a note on Dædalus's wings, he says :—"This is to the last degree elegant; the whole description is, indeed, inimitable. It is perhaps impossible for an English reader at the present juncture, to read the latter part of it without applying it to the best of women, our own amiable and beneficent Queen Charlotte." The passage that called out this nonsense runs, "and thus she also gains universal admiration, for all wish those wings may ever remain unhurt which scatter blessings on every side of them ;" and by this, you, my friend Naturalist, will learn two things—that "The Portrait" does refer to things a little out of your nature, and that flattery will never want

an avenue to enter in at. And you may perhaps add, that what was impossible for an English reader at one juncture, is very possible at another; and thus you may be led to question some other of your impossibilities.

NAT. You certainly do not consider any conceptions good and worthy of representation, but those of a sound mind. For that, sanity is necessary to genius. Yet you must admit—for, as a strong case, I return to the Centaurs—that the conception of these monsters arose from terror, which is not the sane state of the mind. It is a state in which we see things not as they are. The enemy that first made their appearance descending from the hills on horseback, in the terror caused by the strangeness of the object, were taken, man and horse, for one creature. Here fear set aside reason; and it is surely doubly absurd to perpetuate, when reason returns, what could only be conceived in the absence of reason.

IDE. Well, we will say that terror was the parent of the idea; but I cannot admit that terror is not a sane state of the mind; it is the very condition of human nature to be subject to terror—moreover, it is enough for my purpose in the argument to show that it is natural. To express the ideas that the mind naturally under any circumstances conceives, is legitimate to the province of poetry and painting. Nor are you prepared to say that the mind in a state not sane, may not conceive ideas grand and beautiful, and such as might find a ready reception in all minds, and create for themselves a sufficient belief. But mark how some action given to the creature, shall bring forward the power and grandeur of it, so as at once to take out of you the conceit of your knowledge, that the creature never could be. You see it has life and motion, and you question no further.

" Ceu duo Nubigenæ cum vertice montis
 ab alto
Descendunt Centauri; Homolen Othryn-
 que nivalem
Linquentes cursu rapido : dat euntibus
 ingens,
Sylva locum, et magno cedunt virgulta
 fragore."—*Virgil.*

Here you see two cloud-born creatures, from the brow of a lofty hill, descend. You know not what—you wonder, are amazed—are prepared for something extra-human, and the next word tells you they are Centaurs. Then you see them in their rapid course—too rapid to allow you to scrutinize their forms—quitting Homole and the snowy Othrys, they enter the woods, the woods give way as they pass, and you hear nothing but the crash of branch and leafage. Away they fly. The vision has passed; but the remembrance of it never: and will you coolly turn round, and swear you could have seen nothing, for the creatures must have had each two stomachs, and think it an impossibility? We are all apt to yield a more ready belief to fancy, than you give even yourself the credit for doing. It is natural—we begin it with infancy, and if we lose the power, it is only in a morbid state of knowledge. Some are fearful we shall believe too much in works of fancy—you too little for enjoyment. Bottom thought that Snug, the joiner, should show half his face through his lion's mane, and advertise himself to the ladies as a man, as other men are, for " there is not a more fearful wild-fowl than your lion living." After all, it is better to give a little credit to fancy, one's own or of others, than to stick and flounder in the mire of what we choose to term realities. It is a pleasant refuge, sometimes, from the damp dispiriting streets and alleys, and vexatious business of every-day life, to go off with fancy to the woods and wilds, to the sea and to the rivers, that are not within geographical limit, to see the pastimes of Silenus and his satyrs, wood nymphs and water-nymphs; to hear, as Wordsworth says in one of his sonnets, old Triton wind his wreathed horn; and see Proteus coming from the sea and gathering his phocæ around him. Keep your fancy healthy whatever you do, and do not take every waking dream for a symptom of disease. We are, as I think Wordsworth says, too much of the world, and the world is too much with us. Come and race with that wild Bacchante, that on a Centaur's back is goading him on with a thyrsus. Do you doubt its reality, because you see it is a copy from a picture from Pompeii or Herculaneum? Then you will be happier in your dream if you can keep up the chase, and even when you wake, believe it to be one of the truths of nature. " For so to interpose a little ease, let our frail thoughts dally with false surmise."

NAT. Farewell then, you have more than half brought on somnambulism, for I feel myself sleepy.

W.M. Thackeray

"An Exhibition Gossip.
By Michael Angelo Titmarsh.
In a Letter to Monsieur Guillaume, Peintre"

Ainsworth's Magazine 1 (June 1842), 319–22

AN EXHIBITION GOSSIP.

BY MICHAEL ANGELO TITMARSH.

IN A LETTER TO MONSIEUR GUILLAUME, PEINTRE,

A son Atelier, Rue de Monsieur, Faubourg St. Germain, Paris.

DEAR GUILLAUME,—Some of the dullest chapters that ever were written in this world—viz., those on the History of Modern Europe, by Russell, begin with an address to some imaginary young friend, to whom the Doctor is supposed to communicate his knowledge. "Dear John," begins he, quite affectionately, "I take up my pen to state that the last of the Carloviagians"—or, "Dear John, I am happy to inform you, that the aspect of Europe on the accession of Henry VIII. was so and so." In the same manner, and in your famous "*Lettres à Sophie*," the history of the heathen gods and goddesses is communicated to some possible young lady ; and this simple plan has, no doubt, been adopted because the authors wished to convey their information with the utmost simplicity possible, and in a free, easy, honest, confidential sort of a way.

This, (as usual,) dear Guillaume, has nothing to do with the subject in hand ; but I have ventured to place a little gossip concerning the Exhibition, under an envelop inscribed with your respectable name, because I have no right to adopt the editorial *we*, and so implicate a host of illustrious authors, who give their names and aid to Mr. Ainsworth's Magazine, in opinions that are very likely not worth sixpence ; and because that simple upright I, which often seems egotistical and presuming, is, I fancy, less affected and pert than "we" often is. "I," is merely an individual ; whereas, "we," is clearly somebody else. "I," merely expresses an opinion ; whereas, "we," at once lays down the law.

Pardon, then, the continued use of the personal pronoun, as I am sure, my dear friend, you will ; because as you do not understand a word of English, how possibly can you quarrel with my style?

We have often had great battles together on the subject of our respective schools of art ; and having seen the two Exhibitions, I am glad to be able to say that ours is the best *this* year, at least, though, perhaps, for many years past you have had the superiority. We have more good pictures in our 1400, than you in your 3000 ; among the good, we have more *very* good, than you have this year, (none nobler and better than the drawings of M. Decamps) ; and though there are no such large canvases and ambitious subjects as cover the walls of your salon, I think our painters have more first-class pictures in their humble way.

They wisely, I think, avoid those great historical "parades" which cover so much space in the Louvre. A young man has sometimes a fit of what is called "historical painting ;" comes out with a great canvas, disposed in the regular six-feet heroical order ; and having probably half ruined himself in the painting of his piece, which nobody (let us be thankful for it !) buys, curses the decayed state of taste in the country, and falls to portrait-painting, or takes small natural subjects, in which the world can sympathize, and with which he is best able to grapple. We have no government museums like yours to furnish ;—no galleries in chief towns of departments to adorn ;—no painted chapels, requiring fresh supplies of saints and martyrs, which your artists do to order. Art is a matter of private enterprise here, like everything else : and our painters must suit the small rooms of their customers, and supply them with such subjects as are likely to please them. If you were to make me a present of half a cartoon, or a prophet by Michael Angelo, or a Spanish martyrdom, I would turn the picture against the wall. Such great things are only good for great edifices, and to be seen occasionally ;—we want pleasant pictures, that we can live with—something that shall be lively, pleasing or tender, or sublime, if you will, but only of a moderate-sized sublimity. Confess, if you had to live in a huge room with the Last Judgment at one end of it, and the Death of Ananias at the other, would not you be afraid to remain alone—or, at any rate, long for a comfortable bare wall ? The world produces, now and then, one of the great daring geniuses who make those tremendous works of art ; but they come only seldom—and Heaven be thanked for it ! We have had one in our country—John Milton by name. Honestly confess now, was there not a fervour in your youth when you had a plan of an epic, or, at least, of an heroic Michael-Angelesque picture? The sublime rage fades as one grows older and cooler ; and so the good, sensible, honest English painters, for the most part, content themselves with doing no more than they can.

But though we have no heroical canvases, it is not to be inferred that we do not cultivate a humbler sort of high art ; and you painters of religious subjects know, from the very subjects which you are called upon to draw, that humility may be even more sublime than greatness. For instance, there is in almost everything Mr. Eastlake does (in spite of a little feebleness of hand and primness of mannerism), a purity which is to us quite angelical, so that we can't look at one of his pictures without being touched and purified by it. Mr. Mulready has an art, too, which is not inferior, and though he commonly takes, like the before-mentioned gentleman, some very simple, homely subject to illus-

trate, manages to affect and delight one, as much as painter can. Mr. Mulready calls his picture, " The Ford;" Mr. Eastlake styles his, " Sisters." The " Sisters" are two young ladies looking over a balcony; " The Ford" is a stream, through which some boys are carrying a girl: and how is a critic to describe the beauty in such subjects as these? It would be easy to say these pictures are exquisitely drawn, beautifully coloured, and so forth; but that is not the reason of their beauty: on the contrary, any man who has a mind may find fault with the drawing and colouring of both. Well, there is a charm about them seemingly independent of drawing and colouring; and what is it? There's no foot rule that I know of to measure it; and the very wisest lecturer on art might define and define, and be not a whit nearer the truth. I can't tell you why I like to hear a blackbird sing; it is certainly not so clever as a piping bullfinch.

I always begin with the works of these gentlemen, and look at them oftenest and longest; but that is only a simple expression of individual taste, and by no means an attempt at laying down the law, upon a subject which is quite out of the limits of all legislation. A better critic might possibly, (I say " possibly," not as regards the correctness of my own opinion, but the unquestionable merit of the two admirable artists above named;) another critic will possibly have other objects for admiration, and if such a person were to say, Pause—before you award preeminence to this artist or that, pause—for instance, look at those two Leslies, can anything in point of *esprit* and feeling surpass them?— indeed the other critic would give very sound advice. Nothing can be finer than the comedy of the Scene from Twelfth Night, more joyous, frank, manly, laughter-moving;— or more tender, and grave, and naïf, than the picture of Queen Catherine and her attendant. The great beauty of these pieces is the total absence of affectation. The figures are in perfectly quiet, simple positions, looking as if they were not the least aware of the spectator's presence, (a rare quality in pictures, as I think, of which little dramas, the actors, like those upon the living stage, have a great love of " striking an attitude," and are always on the look-out for the applause of the lookers-on,) whereas Mr. Leslie's excellent little troop of comedians know their art so perfectly, that it becomes the very image of nature, and the best nature, too. Some painters (skilled in the depicting of such knicknacks) overpower their pieces with " properties"—guitars, old armours, flower-jugs, curtains, and what not. The very chairs and tables in the picture of Queen Catherine have a noble, simple arrangement about them; they look sad and stately, and cast great dreary shadows—they will lighten up a little, doubtless, when the girl begins to sing.

You and I have been in the habit of accusing one of the cleverest painters of the country of want of poetry: no other than Mr. Edwin Landseer, who, with his marvellous power of hand, a sort of aristocrat among painters, has seemed to say—I care for my dog and my gun; I'm an English country gentleman, and poetry is beneath me. He has made us laugh sometimes, when he is in the mood, with his admirable humour, but has held off as it were from poetic subjects, as a man would do who was addressing himself in a fine ball-room to a party of fine people, who would stare if any such subjects were broached. I don't care to own that in former years those dogs, those birds, deer, wild-ducks, and so forth, were painted to such a pitch of desperate perfection, as to make me quite angry—elegant, beautiful, well-appointed, perfect models for grace and manner; they were like some of our English dandies that one sees, and who never can be brought to pass the limits of a certain polite smile, and decorous, sensible insipidity. The more one sees them, the more vexed one grows, for, be hanged to them, there is no earthly fault to find with them. This, to be sure, is begging the question, and you may not be disposed to allow either the correctness of the simile, or that dandies are insipid, or that field-sports, or pictures thereof, can possibly be tedious; but, at any rate, it is a comfort to see that a man of genius who is a poet *will* be one sometimes, and here are a couple of noble poetical pieces from Mr. Landseer's pencil. The " Otter and Trout" has something awful about it; the hunted stag, panting through the water and startling up the wild-fowl, is a beautiful and touching poem. Oh, that these two pictures, and a few more of different English artists, could be carried across the Channel—say when Mr. Partridge's portrait of the Queen goes, to act as a counterpoise to that work !

A few Etties might likewise be put into the same box, and a few delightful golden land-scapes of Callcott. To these I would add Mr. Maclise's " Hamlet," about whose faults and merits there have been some loud controversies; but in every Exhibition for the last five years, if you saw a crowd before a picture, it was sure to be before his; and with all the faults people found, no one could go away without a sort of wonder at the prodigious talent of this gentleman. Sometimes it was mere wonder; in the present Exhibition it is wonder and pleasure too; and his picture of Hamlet is by far the best, to my thinking, that the artist has ever produced. If, for the credit of Old England, (and I hereby humbly beg Mr. Maclise to listen to the suggestion,) it could be transported to the walls of your salon, it would shew French artists, who are accustomed to sneer at the drawing of the English school, that we have a man whose power of drawing is greater than that of any artist among you,—of any artist that ever lived, I should like to venture to say. An artist,

possessing this vast power of hand, often wastes it—as Paganini did, for instance—in capriccios, and extravagances, and brilliant feats of skill, as if defying the world to come aud cope with him. The picture of the play in " Hamlet" is a great deal more, and is a noble poetic delineation of the awful story. Here I am obliged to repeat, for the tenth time in this letter, how vain it is to attempt to describe such works by means of pen and ink. Fancy Hamlet, ungartered, lying on the ground, looking into the very soul of King Claudius, who writhes under the play of Gonzago. Fancy the Queen, perplexed and sad, (she does not know of the murder,) and poor Ophelia, and Polonius, with his staff, pottering over the tragedy; and Horatio, and all sorts of knights and ladies, looking wondering on. Fancy, in the little theatre, the king asleep; a lamp in front casts a huge forked fantastic shadow over the scene—a shadow that looks like a horrible devil in the background that is grinning and aping the murder. Fancy ghastly flickering tapestries of Cain and Abel on the walls, and all this painted with the utmost force, truth, and dexterity—fancy all this, and then you will have not the least idea of one of the most startling, wonderful pictures that the English school has ever produced.

Mr. Maclise may be said to be at the head of the young men; and though you and I, my dear Guillaume, are both old, and while others are perpetually deploring the past, I think it is a consolation to see that the present is better, and to argue that the future will be better still. You did not give up David without a pang, and still think Baron Gérard a very wonderful fellow. I can remember once, when Westall seemed really worth lookinr at, when a huge black exaggeration of Northcote or Opie struck me as mighty fine, and Mr. West seemed a most worthy President of our Academy. Confess now that the race who succeeded them did better than they; and indeed the young men, if I may be permitted to hint such a thing, do better still—not better than individuals—for Eastlake, Mulready, Etty, Leslie, are exhibitors of twenty years' standing, and the young men may live a thousand years and never surpass them; but a finer taste is more general among them than existed some thirty years back, and a purer, humbler, truer love of nature. Have you seen the " Deserted Village" of the " Etching Club?" What charming feeling and purity is there among most of the designs of these young painters, and what a credit are they to the English school!

The designers of the "Etching Club" seem to form a little knot or circle among themselves; and though the names of Cope, Redgrave, Herbert, Stone, have hardly reached you as yet in France, they will be heard of some day even there, where your clever people, who can appreciate all sorts of art, will not fail to admire the quiet, thoughtful, pious, delicate feeling which characterizes the works of this charming little school. All Mr. Cope's pictures, though somewhat feeble in hand, are beautifully tender and graceful. " The Hawthorn-bush, with seats beneath the shade, for talking age and whispering lovers made," is a beautiful picture for colour, sentiment, and composition. The old people, properly garrulous, talking of old times, or the crops, or the Doctor's sermon; the lovers—a charming pair—loving with all their souls, kind, hearty, and tender. The Schoolmaster of one of his other pictures is an excellent awful portrait of Goldsmith's pedagogue. Mr. Redgrave's " Cinderella" is very pleasant, his landscape beautiful. Mr. Stone's " Advice" is full of tender sentiment, and contains some frank, excellent painting; but how vapid all such comments appear, and how can you, on the banks of the Seine, understand from these sort of vague, unsatisfactory praises, what are the merits or demerits of the pieces spoken about!

We have here a delightful, *naïf* artist, Mr. Webster by name, who has taken little boys under his protection, and paints them in the most charming comic way—in that best sort of comedy, which makes one doubt whether to laugh or to cry. His largest picture this year represents two boys bound for school. Breakfast is hurried over, (a horrid early breakfast;) the trunk is packed; papa is pulling on his boots; there is the coach coming down the hill, and the guard blowing his pitiless horn. All the little girls are gathered round their brothers: the elder is munching a biscuit, and determined to be a man; but the younger, whom the little sister of all has got hold of by the hand, can't bear the parting, and is crying his eyes out.

I quarrel with Mr. Webster for making one laugh at the boy, and giving him a comic face. I say no man who has experienced it, has a right to laugh at such a sorrow. Did you ever, in France, look out for the diligence that was to take you to school, and hear a fatal conducteur blowing his horn as you waited by the hill side — as you waited with the poor mother, turning her eyes away—and slowly got off the old pony, which you were not to see for six months—for a century—for a thousand miserable years again? Oh, that first night at school! those bitter, bitter tears at night, as you lay awake in the silence, poor little lonely boy, yearning after love and home. Life has sorrows enough, God knows, but, I swear, none like that! I was thinking about all this as I looked at Mr. Webster's picture, and behold it turned itself into an avenue of lime-trees, and a certain old stile that led to a stubble-field; and it was evening, about the 14th of September, and after dinner, (how that *last* glass of wine used to choke and burn in the throat!) and presently,

a mile off, you heard, horribly distinct, the whirring of the well-known Defiance coach wheels. It was up in a moment—the trunk on the roof; and—bah! from that day I can't bear to see mothers and children parting.

This, to be sure, is beside the subject ; but pray let Mr. Webster change the face of his boy.

Letters (except from young ladies to one another) are not allowed to go beyond a certain decent length ; hence, though I may have a fancy to speak to you of many score of other good pictures, out of the fourteen hundred here exhibited, there are numbers which we must pass over without any notice whatever. It is hard to pass by Mr. Richmond's beautiful water-colour figures, without a word concerning them ; or Mr. Charles Landseer's capital picture of "Ladies and Cavaliers;" or not to have at least half a page to spare, in order to make an onslaught upon Mr. Chalon and his ogling beauties: he has a portrait of Mdlle. Rachel, quite curious for its cleverness and unlikeness, and one of the most chaste and refined of our actresses, Mrs. Charles Kean, who is represented as a killing coquette ; and so Mr. Kean may be thankful that the portrait does not in the least resemble his lady.

There is scarce any need to say that the oil portrait-painters maintain their usual reputation and excellence : Mr. Briggs, Mr. Pickersgill, Mr. Grant, shew some excellent canvases: the latter's ladies are beautiful, and his "Lord Cardigan" a fine painting and portrait ; Mr. Briggs' "Archbishop" is a noble head and picture ; Mr. Pickersgill has, among others, a full-length of a Navy Captain, very fine ; Mr. Linnell's portraits are very fine ; and Mr. S. Lawrence has one (the Attorney General), excellently drawn, and fine in character. This year's picture of her Majesty is intended for *your* Majesty, Louis Philippe—perhaps the French court might have had a more favourable representation of the Queen. There is only one "Duke of Wellington" that I have remarked—(indeed it must be a weary task to the good-natured and simple old nobleman to give up to artists the use of his brave face, as he is so often called upon to do)—at present he appears in a group of red-coated brethren in arms, called the "Heroes of Waterloo." The picture, from the quantity of requisite vermilion, was most difficult to treat, but is cleverly managed, and the likeness very good. All the warriors assembled are smiling, to a man ; and in the back-ground is a picture of Napoleon, who is smiling too—and this is surely too great a stretch of good nature.

What can I say of the Napoleon of Mr. Turner ? called (with frightful satire) the "Exile and the *Rock-limpet.*" He stands in the midst of a scarlet tornado, looking at least forty feet high.

Ah! says the mysterious poet, from whom Mr. Turner loves to quote,—

> "Ah! thy tent-formed shell is like
> The soldier's nightly bivouac, alone
> Amidst a sea of blood ————
> ————*but you can join your comrades.*"
> FALLACIES OF HOPE.

These remarkable lines entirely explain the meaning of the picture ; another piece is described by lines from the same poem, in a metre more regular :—

> "The midnight-torch gleam'd o'er the steamer's side
> And *merit's corse* was yielded to the tide."

When the pictures are re-hung, as sometimes I believe is the case, it might perhaps be as well to turn these upside down, and see how they would look *then;* the Campo Santo of Venice, when examined closely, is scarcely less mysterious; at a little distance, however, it is a most brilliant, airy, and beautiful picture. O for the old days, before Mr. Turner had lighted on "The Fallacies," and could see like other people!

Other landscape-painters, not so romantic, are, as usual, excellent. You know Mr. Stanfield and Mr. Roberts, in France, as well as we do: I wish one day you could see the hearty, fresh English landscapes of Lee and Creswick, where you can almost see the dew on the fresh grass, and trace the ripple of the water, and the whispering in the foliage of the cool, wholesome wind.

* * * *

There is not an inch more room in the paper; and a great deal that was to be said about the Water-colour Societies and Suffolk-street must remain unsaid for ever and ever. But I wish you could see a drawing by Miss Setchel, in the Junior Water-colour Society, and a dozen by Mr. Absolon, which are delightful in grace and expression, and in tender, pathetic humour.

"Exhibition of the Ancient Masters"

Athenaeum (June 11, 1842), 530; (June 18, 1842), 547–49; (June 25, 1842), 565–67; (July 2, 1842), 584–86

EXHIBITION OF THE ANCIENT MASTERS.

LET England put a simple question to all Europe. Let her receive a candid answer. She has been able to exhibit, without presumption, without national prejudice or egotism, SIX series of Modern Works among those of the Ancient Masters—viz. the works of *Reynolds, Hogarth, Wilson, Gainsborough, Lawrence,* and *Wilkie.* What other kingdom could have done the same?—we mean with a right which the rest of Europe would have admitted. Could France, on the strength of her two series— *Vernet's* landscapes and *Greuze's* figure-pieces? For if she push forward the works of *David, Géricault, Girard, Gros,* &c. into this rank, we must bring up those of *Barry, Morland, Northcote, Stothard, Hilton,* and numberless others, into line also. Could Italy, on the strength of *Appiani's* productions and *Battoni's,* or rather the weakness? Could Germany? She has but one such series—*Mengs's*—and of that she herself would consider an exhibition as an exposure. *Fuseli's* works are Swiss if not English; or even granting them German, there is scarce a single good picture among so many grandiose designs. We have often been taxed with an unpatriotic prepossession in favour of foreign art; we have always maintained the superiority of *living* continental painters, as respects elevated aims, enlarged principles, powers well nurtured, and productions of a nobler, purer cast, though less noble and pure, peradventure, than they think them; we cannot, therefore, be deemed partial to our own countrymen on the present question, when we decide it for them against all Europe. No other people could dare to exhibit side by side with the Old Masters one half so many New as the British, without such a contrast rendering their presumption flagrant and ludicrous and repulsive. Of course we do not include among new masters thus exhibitable, those yet above ground; were *they* compared together, the trumpet we have just blown so loud in Great Britain's praise we should have to fill with a very long sigh! But we need not become sentimental at present: let us, like the schoolboy, who, whatever dismal times await him, pours his pensive soul through a pennywhistle,—let us take little thought of the future; let us hope that ere the *Overbecks* and the *Delaroches* depart this life, some British painters will enable their country to stand the brunt of another contest against all Europe, and enable us to blazon her triumph then as we do now.

The present Exhibition consists of one hundred and thirty pictures, sketches, and drawings, by Wilkie, with about sixty productions by the Old Masters. Although the latter are deposited in the last Room, we shall give our notices of them the precedence, because they may be dispatched at once. The pictures properly called Ancient do not comprise a single one of renown, nor any deserving it. That which has most pretension to name, is ' Job and his Friends,' by *Salvator Rosa,* No. 186. This work neither amazes nor delights, whilst a Salvator often does both, and almost always the first. It seems to be, however, in bad condition, which may account for the obscurement of its beauties, displaying as few as Job's own spotted person, and looking altogether as neglected as if it had been in the care of his Friends. Salvator's rough, earthen impasto harmonized well with such a subject, but still better with ' Diogenes,' No. 191, his favourite philosopher and exemplar of cynical satire. A much more attractive work we consider ' The Virgin presenting the Infant Saviour to a female Saint,' by *Paul Veronese,* No. 183. Here we find lustrous, translucent colour, colour we can look into, as into an inch-deep plate of emerald or other pure-bodied precious stone, though the surface of paint lies as thin as a double veil upon the canvas. Here is at least Veronese's rich style of colouring and fleshy modelling, in the cherubic messenger for example. A small ' Boar-hunt,' by *Rubens,* No. 190, rather light of tone, whilst the Veronese is mellow, bespeaks its different climate, like a Northern blonde beside an Italian brunette; ruddiness of complexion may be said to characterize Rubens's pictures, no less than his countrywomen; this brilliant thing is a *Helen Forman* of pictorial beauties. The extreme hastiness in the design evinces rather a sketch than a picture, but that very hastiness in the workmanship has a wonderful congruence with the subject; we imagine ourselves to see the wild boar rushing across, and to hear the wind whistle as dogs and hunters drive pell-mell through it. ' Environs of Dresden,' by *Canaletto,* Nos. 192 & 142, which make that dull-grey, dull-flat city look far more bright and ethereal than ever we saw it even of a summer-noon, when the city of Cimmeria would glitter. ' Interior of a Dutch Church,' by *Cuyp,* No. 181, full of sunshine, but having a hard effect, which sunshine never could produce, shut up in the well of a church, were its walls rock-crystal. ' An Exterior of a Flemish House,' by *De Hooge,* No. 187: sunshine yet more brilliant, sunshine condensed as it were at the bottom of a parabolic reflector, and nevertheless without *any* harsh glare or *edginess* where it breaks upon rectilineal objects. Some excellent ' Landscapes' by *Ruysdael,* Nos. 179, 174, 141, which bring the art itself so far forth to perfection, if their monotony of theme and detail display little mind not technical. A ' Madonna' by *Sassoferrato,* No. 173, very blue and very white as usual; the frequent repetition of this model proves its merit, or at least its repute. A ' Last Supper' by *ditto,* No. 180, imitated from Da Vinci's, shows how apt dulness is to become insipid when fain to be impressively simple like genius. ' Heads,' by *Titian,* No. 169; of a fine character and forcible execution, were they heads of Red Men by Mr. Catlin; we see nothing Titianesque about them. No. 155, ' Adonis going to the Chase,' is another so-called Titian, and is another *replica* by whatever hand of his famous original, said, like the Irish bird, to be in two places at the same time—our National Gallery and Madrid. ' St. Peter repentant,' by *Vandyk,* No.

158, a most expressive and powerful head, with that taint of the vulgar which infects all the historical works of this artist, while his portraits are so dignified. A large 'Family Portrait-piece,' No. 153, by him gives the broad-faced Bolingbrokes an air of nobleness that might have become the regal house instead of the St. Johns. This picture betrays no great respect for his customer by the finishing. 'Landscape,' by *Gaspar Poussin*, No. 154; not one of the common "bottle-green" Gaspars which we mentioned lately as glutting the picture-market, but a selecter specimen. Storm always arouses Poussin's spirit, which rides it like a god: here is a fine dark rain-burst, making the sun-tipt river beneath it foam with double whiteness ; a figure in the clouds, on pretence of rendering the landscape "historical," is put there for a purpose purely and skilfully pictorial—it enhances the sublime effect like Virgil's Jupiter brought to improve a tempest-scene just described—"Ipse pater, media nimborum in nocte," &c. *Carlo Dolce's* 'Daughter of Herodias with the head of St. John,' No. 150, has his usual merits and faults, effeminate pathos, over smoothness, and chess-board distribution of light and shade. Did Salomé look sentimental when she danced in with her trophy upon a charger? The best works here are small ones by *Ostade, Teniers,* and *Jan Steen*, but we shall postpone our particular opinions about them till next week, as serving to illustrate the works of Wilkie. We keep silence till then, also, about *Gainsborough* and *Reynolds*, for the same reason, and because these two painters are more properly modern. A 'Swine-herd,' by *Karel du Jardin*, No. 147, is beautiful, maugre its subject; but Karel could elevate pig-pieces into idyllics, *Morland* could only render them exact transcripts of the sty. Two oil-miniatures by *William Mieris*, Nos. 152 and 156, look as smooth as if painted on tan-coloured kidskin ; elaborateness and delicate handling could not go much farther in Gerard Dow.

EXHIBITION OF ANCIENT MASTERS.
WILKIE'S WORKS.
[Second Notice.]

THOUGH at this time last year we said, let there be an exhibition of Wilkie's works, and there is one, we do not claim an *Athenæum Testimonial* from the public, for our successful plea on its behalf. Doubtless the event has taken place rather in accordance with our wishes than obedience to our suggestions. Indeed, what we did suggest has not had the effect we might have reasonably anticipated—viz. that a "*complete* series" of Sir David Wilkie's works should be exhibited. Any series, we knew, must prove both interesting and instructive, but the whole number of links necessary to its completeness would have enhanced that value little less than the full complement of wedge-stones would increase the beauty and utility of a bridge. We will not liken the proprietors of Wilkies to Heathen Gods, who felt great pleasure in conceding just half their supplicant's prayer, and yet more in refusing the rest. We will not do so, because it is our duty to distinguish between holders and withholders of pictures, the latter of whom— nay, even a single hard-fisted "Sir Gripus" among

them—might alone defeat the generous object of the majority. Some such churl in soul might have *eight or nine* pictures by Wilkie, but had he three ears might shut them against every request on the subject, or rather open them as wide as Macbeth, yet still hug his treasure the closer. If there be such a personage, we need affix no stigma upon him ; he brands himself an Illiberal, by having put his name down in the catalogue of possessors and not in that of exhibitors. Whatever has occasioned the deficiency, almost half a room remains unfilled at the Institution this year, except with slight imperfect sketches, water-drawings, chalks, &c. Nevertheless, most of Wilkie's best pictures have been got together, and the wonder is, that an artist who painted so many of his works in a cabinet size, and with so much care, and whose death was somewhat premature, should enable us, after all deductions, to class this among the greatest Collections, for magnitude and merit, which England or Europe has, or could have exhibited, consisting in pictures by a single Modern Master.

De mortuis nil nisi bonum is a misprision of treason against the majesty of Truth : it is a telling of silent lies. To speak nought but good about the *living* were a far more benevolent maxim, though philanthropists rather recommend bestowal of that charity upon those who no longer can feel it. Perhaps, however, the maxim was made for the benefit of private, obscure characters, about whom nought need be said at all, and therefore any unfavourable mention would be gratuitous malice, which might tarnish their domestic repute, and do little general service. Peace to those still, who never made any noise in their lives ! But Wilkie stood forth among the van of men : his name rebounded from zenith to nadir of the intellectual world : he does not appeal *to* the compassion of Criticism, but *against* it. Spare weakness and Westall—genius and Wilkie cry, Have *no* mercy upon us ! The paladin who challenged the giant would as soon he wept millstones as tears when about to strike. Wilkie demands just, not indulgent, criticism ; he does not deprecate rigour, he defies it. This is the sort of genius we like to deal with ; which we can praise highly, yet heartily, and which, imbued as it is by the spirit of immortal life, we can anatomize to the heart's core, without killing or even without injuring. If we have to find fault at times, for the sake of Art, let that great end be recollected, and if our encomiums are seldom extravagant, that superlatives never have much of the positive in their vagueness.

Wilkie's artistic life divides itself into several periods distinguished by his different styles of painting. They will be more or less numerous proportionable to the strength of the critical microscope with which they are examined. Not professing to use one of very high power, we can yet reckon *eight* or *ten* fairly and clearly demarcated from each other. It is true, a picture will sometimes start up beyond its own district, like a part of Durham in Northumberland, or belong to many districts at once, like the Shire Oak ; this period of our artist's professional life may, perhaps, now and then reflect one that has past, as some greybeards can temporarily grind themselves young in the back-revolving mill of a strong memory, moved

by a strong imagination; but such exceptions need not disturb our general arrangement. We, however, recollect no painter, modern or ancient, comparable to Wilkie for unsteadiness of style. Raffael, with his four manners, is a stereotype painter beside him. His methods exhibit a perpetual flux and reflux and conflux of directing principles; now an imitator of Ostade, now of Teniers, now of Correggio, now of Murillo, &c.; here resolute to copy Nature alone, there employed on the beautiful artificialities of chiaroscuro, there again almost losing himself amidst splendid colours; his mechanism at first contracted to a miniature treatment, afterwards dilated to a breadth proper for the mightiest frescos; finished, sketchy— laborious, careless—solid, superficial; furthermore, uniting these various principles in various proportions, re-adopting rejected ones, and ending with scarce a principle left which had marked its commencement. Every artist has altered his style, somewhat, once or oftener, in the course of his practice—save *Michaelangelo*, perhaps, who, at his outset, chose the loftiest style, and maintained it with no palpable variation to the last; but Wilkie is seldom the same for two successive pictures, until he falls into decided mannerism during his latter years. This Proteus-like character of our artist many would ascribe to caprice or versatility, as their prejudices may be, and his imitations to feeble original powers, or a grasping after all excellence; we should rather say that the source of both was an inborn explorative genius, driven forward, also, by circumstances which obliged it to educate itself. Wilkie we must look upon as a self-taught painter; his earliest, bad, pictures alone betray any academical teaching; he had to seek a style, and those which offered themselves first, in a kingdom not overstocked with ancient master-pieces, he might subsequently find or think were neither the best, nor, even if so, unimproveable. Had the Scottish boy been at a good mountain-school, like young Raffael, at Perugino's, he would have set out from a good manner, that he needed never have striven to forget, or replace by a different, or modify beyond what its own principles admitted for its improvement. Something, however, must be attributed to his natural explorativeness, as self-education has been forced upon other artists, who yet kept the first style they adopted, like their school-taught brethren. Wilkie's superficial and mannered styles the public must impute to itself: it would not give remunerating prices for thoroughly-thought and honestly-wrought works, so it compelled the production of half-studied pictures, slighted off the easel in a scene-shifter's spirit, and maintained because done out of hand, not from ever-diversified Nature's models, each with its characteristic distinction; the popular taste relished such things, and Wilkie—alas! that we must say so—pandared to it.

In his first style is No. 114, 'Subject from Burns's Poem of the Vision,' where a Scottish Muse, Coila, crowns her favourite Bard—

" And wear thou this," she solemn said,
And bound the holly round my head:
The polished leaves and berries red
Did rustling play,
And like a passing thought she fled
In light away.

We should have said this picture (date 1802) belonged to Wilkie's first *period*, for style it has none. Its merits are akin to those recorded of Liston's first attempt on the stage, being intendedly tragic and unconsciously mock-heroic. Coila is not

A tight, outlandish, hizzie braw,

but a loose and lank corpse stept from an upright coffin, in her tartan last dress,—outlandish enough. The painter does not translate the poet into colours:

A hair-brained, sentimental trace
Was strongly marked in her face;
A wildly-witty, rustic grace
Shone full upon her.

It is singular that with so much congenial humour, Wilkie even at this age should not have entered more into the spirit of Burns, whose portrait, however, he seizes better than his poetic conception. Scottish patriotism, we believe, would exonerate him from having painted this wretched picture; but, unluckily, *David Wilkie* is discernible, half obliterated, upon it.

No. 33, a 'Scene from the Gentle Shepherd,' we may set down to the same period, though later, as it promises somewhat, while No. 114 promises nothing. How paradoxical, to see this very mawkishness of character in No. 35, 'The new Coat,' five years afterwards, that year which produced ' The Blind Fiddler,' Wilkie's master-piece ! We could suspect a wrong date (1807) were Catalogues not proverbially infallible.

No. 128, 'The Recruiting Party,' represents a new period and style,—the first style which deserves to be called one (date 1805). There is some humour and character about it, especially in the tall Irish *Lismahago* of a soldier, whose limbs hang together as if they were only meant to be lost on the battle field, and whose reckless physiognomy betokens one who would scarce remember if ever he had more than were left him. The Dog smelling suspiciously at him is a sly satire against the Sister Isle. The workmanship looks like an imitation of those Dutch imitations of Teniers which enlarge and enfeeble his composition.

No. 118, 'Sunday Morning.' Same date as the last, 1805, but approaches much nearer the true Wilkie style in subject,—comic rural drama, and characteristical detail,—even in the mechanism itself; which latter, though still without force of tone or colour, cannot be called vacant, condensing the composition at least, whilst renouncing the Teniers model for a costume, outline, and expression that afterwards grew into perfect distinctiveness and originality. All these works are so well known from prints, as to make superfluous any dissertations on their moral or mental qualities. The little boy who is having his toilette made with such a rough hand for him, must be familiar to most persons, whether amateurs or not: he would join the Unco' Guid, we dare swear, to probibit servant-girls *scouring* on Sunday.

No. 124, 'Alfred in the Neatherd's Cottage,' 1806. This belongs to the second period and style, according to our classification. There is the same weak enlargement of outline as in the last-mentioned work, the same flatness of effect, and vapidity of colour. It displays similar merits, too, but with a considerable accession of faultiness: the clowns are

most clownish, the Scolding Wife expresses commonplace anger well, yet the principal character, Alfred, has, like one of Pope's women, no character at all. To be simple it is not enough to be insipid, nor are a long bow and a carving-knife enough to suggest the meditative Conqueror of the Danes, the self-destined Liberator of his country: Brutus curls and a Roman nose no more make a heroic bust than huge limbs a moral Colossus, already heaven-entitled Alfred the Great. Wilkie's low subjects are never low-minded, this sublime one is: Hogarth was often coarse, sometimes disgustful, and almost sure to misconceive a grand subject, like ' Sophonisba;' but he could as little be mean as feeble or dull. We cannot admit in excuse that our artist had here gone beyond his strength ; he had gone out of his element, or rather had scarce yet got into it. His first essays, we have said, were serious.

'The Village Politicians,' date 1806. This is said to be the first picture Wilkie exhibited at the Royal Academy. It returns to the style of ' Sunday Morning,' but shows a prodigious advance in that style, and may stand as the first decided Wilkie picture, the first which bespeaks a painter to make an era, the first of his best manner, or at all events of his most characteristic and original. It is deeply stamped with the impress of his peculiar genius, although the colours have faded, and were perhaps never very forcible. Here are his natural yet striking selection of circumstances, his power to individualize and vary characters, his humour less rich than Hogarth's, but more chastened, his well-studied details, his careful manipulation. Some faults might be pointed out, which he afterwards learnt to avoid: the composition wants union, and its right-hand half is superfluous ; the group round the table is, in fact, the whole true picture, all the rest being irrelevant. Hogarth's episodes, on the contrary, are not excrescences, but integral parts of his poem, *within* it, not beside it. Wilkie's second, or fire-side group, would also, if omitted, omit whatever of *Teniers* remains to destroy the unity of manner.

No. 55, ' The Rent Day.' Here Wilkie is all himself, and in no part either a Dutch, Spanish, or Italian, but a wholly original and national painter. This, his *fourth* style, is, we think, his best, and this specimen among its best examples. The vigour of the hues has somewhat declined, but none of the graphic spirit has evaporated. The mere mechanism may be capable of improvement ; would that, by adherence to this single mode, it had been improved unto perfection ! for this we say again is the style more full of Wilkie, more his own, more his country's own, than any other he adopted. It elicits all his genuine powers, while it limits him to them, yet affords them the largest scope wherein to develope themselves with the greatest luxuriance. Rural comedy and tragedy, in the language of colours, are his element: —the changes and chances, the manners, the foibles, the virtues, the errors, of Peasant Life, dramatized in silent poetry—cottage scenes, characters, pleasures and pains, solemn or serious or ludicrous occurrences —these are his true province, nay, his dominion. Here he reigned, and like a god, quite alone. High as Wilkie stands, how much higher would he have risen, had he never aimed to soar above this style ! The Rent Day is well composed: it tells itself all

along the canvas : we see the rent demanded—disputed—ready to be paid—preparing to be paid— uncertain to be paid—paid a full hour ago, for here are the first-come tenants set down at the well-satisfied landlord's hospitable board. Raffael could not have represented the scene with more dramatic truth and completeness : he could not have given his characters more reality and individuality, nor idealized them within those bounds more happily. There, by the pay-table, stands that marvellous impersonation of laborious ,Old Age, dreaming, as he stands, through sheer dotage, yet keeping the one habitual recollection before his mind's half-closed eye—rent, rent, rent,— his whole train of ideas, his whole intellectual essence: though the tree has begun to die at the top, still its upright trunk betokens what a stubborn Son of the Clod sustains itself yet by the very ruggedness of its bark. This figure we think Wilkie never surpassed, perhaps never equalled. Next him is a beautiful sitting group, a mother and two children, sweetly coloured, the infant's carelessness finely contrasted with the matron's thoughtful brow, and the general solicitude around. Our artist's turn for that good-humoured satire which " plays about the heart-strings," is seen in the voracious guest, swallowing back as much as he can of the rent, filling his chaps like a pelican, with more than he can possibly eat at once ! Our admiration of this picture has no bounds, on every score except its mechanism, which nevertheless, we admire too, though rather imperfect. ' Reading the Will,' a work now at Munich, is, to the best of our remembrance, painted much after the Rent Day pattern, but without its dryness, without its sharpness. Yet that was painted thirteen years later, this being signed 1807. But Wilkie, instead of continuing the same style through this period, had cultivated several. Hence his little improvement in it, beyond what he so early made.

No. 129, ' Portraits of the late Rev. David Wilkie, Minister of Cults, and of Mrs. Wilkie, the parents of Sir David Wilkie,' is a miniature oil-work belonging also to the last year, 1807, and the last style. Earnestness, good faith, excellence deeply-endeavoured after, distinguish its workmanship ; no attempt to palm upon the spectator slightness for ease, or blind his judgment with a blaze of gorgeous colours. But it is somewhat hard in the outline, and timid. Wilkie's father seems just the man to have written (as he did) a ' Theory of Interest, Simple and Compound, derived from First Principles, and applied to Annuities of all Descriptions ;' while his gentler parent has the soft, blue-gray, beaming eye, which we should guess would have looked more enlightenedly and enlargedly on her son's juvenile productions, which betrayed his imaginative tendencies. No. 130, ' Portrait of the Lady Margaret Fitzgerald,' 1807, with all the artistic merit, but without the interestingness, of its companion just mentioned.

No. 31, ' The Jew's Harp,' 1807. Freer and apparently more off-hand than the above ; if less laboured, perhaps a subject less worth much outlay of time and toil. Attention in the group is, however, very well graduated ; the child scrambles at the music, the maiden listens with absorbed composure, and the dog between them attends most intensely— to her countenance alone ! Wilkie, as a native of a pastoral land, was fond of dogs, and fond of introduc-

ing them in his pictures, which he ever does with the effectiveness of human characters, and often with far more.

We must postpone till next week the rest of our remarks upon this important Exhibition.

EXHIBITION OF ANCIENT MASTERS.
WILKIE'S WORKS.
[Concluding Notice.]

WE can remember no subject upon which there is not far more folly than sense talked and written, or, if such a subject exist, it is one very seldom discussed by the world in general. Painting must therefore be content with the common lot, indeed a yet worse, as even sensible persons seem to think Fine Art a good outlet for their weaker effusions, and dunces for their wisest, not less ridiculous. How puerile does the father of two families become when he balbutiates about—gusto, hand of the master, divine pencils, &c.—cries up extravaganzas that convey no idea at all as the truly ideal, and commonplace as the amazingly natural! If senator and sage do so, what should we expect from those amateurs whose understandings are ever in the cradle? Nay, we must acknowledge too that profoundest critics, amidst their profoundest researches, perhaps by reason of them, oftentimes go still farther astray, because the best divers get most out of their depths. For such investigators, Falsehood lies at the bottom of the well rather than Truth. As the ancients said, there was nothing so absurd in philosophy which some philosopher did not maintain, we may assert the same of connoissance and connoisseurs. One held *Michaelangelo* no painter, a second that all but Southern climates freeze the mercury in a painter's imagination; and a deal of like perilous stuff, that weighed upon their brains, were those oppressed with it able to discharge through the vent which a fantastical *Virtù* afforded. For a more familiar example, has not enough confusion been introduced lately by over-nice distinctions between *Raffael's* several "manners"? Some critics divide them into so many that none of them remain visible. To what end this super-serviceable refinement? Getting at the root, indeed, but getting away from the fruit—that must be got in a different direction! Nevertheless, beyond doubt, neither Raffael nor any other artist is thoroughly understood till his various styles, if he have them clear and characteristic, are analyzed and appreciated. Who can say he understands *Titian*, if he knows nothing of that painter's elaborate, severer style? Is *Rembrandt* understood by any one who has only seen his pictures in the more popular manner, which has as if they had been struck off at a blacksmith's forge—splendour surrounded with darkness? On the same principle, we hold a comparative analysis of *Wilkie's* numerous distinct styles an essential condition to the right understanding of his merits. It lays open their inmost nature, fathoms their fullest depth, measures their whole expansion. But furthermore, it serves to illustrate the artist's personal disposition, is a sort of biography within a biography, giving the life of his mind, recounting its actions, pursuits, progress, and vicissitudes—the very life of his life—for in such abstract circumstances has

every great painter his chief moral being, and when he depicts characters on his canvas, pourtray them with what vividness he will, he yet more faithfully though unwittingly pourtrays his own.

Our last notice led us to Wilkie's *fourth* style, of which we cited the 'Rent Day' as an admirable specimen, along with other collateral examples. In the same constellation we shall now range many stars besides, of the first magnitude, rating their size astronomically by their superior gloriousness. But even these master-pieces differ among themselves, as do those stars, whilst all exhibit the most wonderful handiwork of their creator. Were we not anxious to give large and general views no less than precise ones, we might distinguish in this fourth class three several manners; which, however, we shall describe as modifications of the fourth style, instead of variations from it. No. 48, 'The Card Players,' is a work very remarkable for crystalline purity of aërial perspective; its gray lustre has the intenseness of whitest light; when looking at it, we seem to inhale some vivific gas, which makes us see with a clearness almost painful. The effect, if not hard, we feel to be somewhat harsh. Yet, as we said, in general tone it is subdued; that beautiful silver-gray tint was never exceeded by Teniers—none but an aquatic people, by the bye, like the Dutch and English, could give those soft cerulean hues, or perhaps reach the perfection of neutral colouring: ocean and its pale bright progeny so often brought before the eyes, educated through them the taste of a *Teniers*, a *Backhuysen*, a *Vandervelde*, a *Terburg*, an *Ostade*, &c., and at times inspired a *Wilkie*. This picture displays a strength of expression proportionable to that of the colour: each personage not only tells you his character, but tells you it as if he were painted, like Rumour, with tongues all over. Perhaps the victorious Butcher may look a little too butcherly: he is every inch a butcher, from the top of his red nightcap to the toe of his other self, his Dog. The good-humoured Clown opposite him, a pendant yet a perfect contrast, has nothing of his fire-eyed hilarity which could turn at once to rage if their success was reversed, but unable to contain himself, oozy vessel as he is! lets all the simpleton burst out amidst a flood of laughter—though he would fain triumph aside behind his cards. Unskilful he to steal a kiss through a cottage-lattice by moonlight; his smack upon the maiden's lips would be a kind of small thunderclap—it would "cry sleep no more, to all the house," bringing forth Gammer in a patched quilt, and Gaffer perhaps without one,—so powerless would the poor rogue be to enjoy with any discretion such intoxicative plunder. He is an epitome of that numerous class called "Honest Johns," whose honesty arises from their want of wit to dissemble. Again: dramatic painters, like Raffael and Wilkie, seldom turn away the faces of their personages, as mere colourists often do, because expression is thereby sacrificed: yet here a Card-player who has lost, presents his huge, rough-squared, high-shouldered back, which has written upon it—the exact man to be puzzled, perplext, nonplust—plainer than his character was ever graved on his tombstone. His partner's full face, dark and long in itself, darker and longer in its chapfallen state, but reflective and

calculating as the parish tax-gatherer's, bespeaks a desperate character at cards. *Hic niger est :* he will have his " revenge ;" beware ye singers of simple *Te Deums,* there is a sword in the sharpness of that countenance threatens deadly doings still !—Verily, a whole volume like the ' Characters of Theophrastus' might be translated into the vernacular from Wilkie's pictures belonging or appertaining to the deep-minded fourth style, the pregnant, the suggestive. Under this head come these subjoined.

No. 34, ' The Cut Finger,' dated 1809, a year after the last. It exhibits the same lucid colouring and vigorous touch, though not to the same degree. There is, however, no palpable reminiscence of Teniers about it, as there is still about its predecessor ; Wilkie has become national again. The characters are well drawn, representing one of those scenes from that real tragi-comedy—Life :—one of those scenes which show how trivial, how ludicrous to a man appear the afflictions so very doleful to a boy, and therefore how heartily angels may *smile* at the deepest sorrows of men, whose patriarchs themselves are but children by comparison with immortal beings. We do not think Wilkie meant to draw this moral, neither does his picture suggest, while admitting it ; our penetration never was of the kind to discern all the arts and sciences in Homer, or all the virtues of medicinal substances in tar-water : nevertheless, a work is good for little that will only induce the spectator's thoughts to go as far as itself. Wilkie had here even a more trite subject than usual with him, and of little scope. In no point can this production be said to excel his ' Card-players,'—or equal it, except in perfect observance of nature and truth. The clumsy-looking hoddy-doddy of a boy is just the awkward urchin to cut his finger, and the soft-headed oaf to blubber with helpless terror about it. A finished Sketch, No. 73, may be almost considered a duplicate of the picture.

No. 16, ' The Sick Chamber,' painted in 1808. Another production like the last two, but the workmanship a grade beneath that of the second, far beneath that of the first. It has a timid look ; perhaps may have been an earlier attempt of this kind. We have no abstract dislike to the subject represented, for albeit a sick chamber with its associations is somewhat unsavory cud to the mental palate, yet it may prove sweet if the artist can give it a relish of genius : without this ingredient many a picture representing red-cheeked health amidst a landscape, one broad laugh of gaudiest flowers and garish sunlight, has made us sick and sorrowful to look at it. Wilkie does not disguise the wormwood in ambrosia enough on this occasion. Nothing can be more natural we own than his delineation ; it is *too* natura —almost commonplace. We are little charmed with the characters, though they be appropriate and expressive ; they strike us as rather *too* much literalized—a better extreme than if they were too much idealized, but a bad one still. What wonder ? the son of a god could not keep the golden mean, even when it was a zodiac—pointed out to him, and its whole breadth a blaze of brightest stars to illumine his discernment ! How should the son of a Fifeshire parish-priest keep the hair-broad, or hair-narrow, mean betwixt over-literality and over-ideality ? 'Tis

a great matter that he hit it so often, for the landmarks left on the path by all philosophers since Pythagoras inclusive, are as perishable as Poucet's crumbs. We have an example in this picture compared with the last of our painter's attention to his animal characters : here the patient's affectionate little dog sits gazing at her while the physician feels her pulse, sits here as intensely still as if anxious to hear the throb go on :—in the ' Cut Finger' a cat sits also amidst the group, yet with characteristic selfishness dozes under the very blood-drops from her human playmate, and purrs her own lullaby, most content, while he bellows out his pain beside her. Grimalkin is no great pet of ours, but, as such an illustration of character and assistant to the scene, we hardly value her less than sympathetic little *Fidelio* above mentioned.

In concluding upon Wilkie's fourth style we must not omit to enumerate ' The Blind Fiddler,' which is a rival of the ' Rent Day,' and some judges think the painter's masterpiece. Yet it was painted before its rival, amongst his very earliest independent works, and little after the ' Village Politicians,' quoted by us last paper as a representative of his *third* style, because still retaining a Teniers feature or two, and its mechanism being irresolute and somewhat deficient of the fullest perfection. Both these pictures are dated 1806, though the ' Blind Fiddler' generally passes, no doubt from its great excellence, for a production of 1807, contemporaneous with the ' Rent Day.' It however has an air of the Dutch school, while this latter work breathes fresh and pure throughout of Great Britain. That may well be called an " air" indeed, for it is not at all palpable ; it is felt rather than seen. A connoisseur immediately detects the spirit of Teniers moving over the face of this picture, but would prove a blind fiddler himself did he attempt to catch the fugitive, and measure it between the tips of the wings. Suffice it that such air exists : it thus serves as a point of contact where the fourth style borders on the third. Almost all Wilkie's productions are transitional to a certain degree ; his mind was ever in a transit from good to better or better to good, from old to new or new to old—his genius alone, if not uniform, was constant. The National Gallery picture being familiar to our readers, we hope they need no enlightenment upon its obvious merits. After all that can be said, the *un*-artistic beauties are those most important to a work of art, and with regard to them, native taste is just as competent a judge as connoisseurship, at least if duly improved by culture and experience. We shall not say—here we have a blind fiddler fiddling to a fiddle-loving family, the whole of this bill, and nothing but this bill ; we have much better —a scene composed (like the portrait of Helen from five human Graces) from many natural models which Cottage Life set before our keen observer, models whose various suitable qualities he so well knew how to select and harmonize and enhance. The composition is *pyramidal,*—a beginner's grand secret and absolute law,—his eleventh article of the decalogue ! Wilkie's colouring, though very quiet and subdued, was never, we think, in any work sweeter. The mechanism shows great care, not minute labour, a fondness for his task—over which he no doubt, like

the bee, "that at her flowery work doth sing," hummed with great satisfaction. It was care well repaid by Fame, if otherwise by Sir George Beaumont. The painter too soon learned to think her goddess-ship a poor Paymistress !‡

Wilkie's next style distinguishes itself from the last by more of colour and less of character, by attention to groups rather than individuals, by a waving outline substituted for a straighter and severer, by a softer touch and oilier surface, generally by an emulation of *Ostade* instead of *Teniers*. We conjecture also, that about this time began the painter's enthusiasm for *Correggio*, who revived and rendered popular the principle of sinuosity, which *Michaelangelo* had introduced into modern draughtsmanship, pictorial as well as sculptural, and which *Hogarth* long afterwards thought he discovered, while his extravagant panegyrics beyond doubt sunk it again. No. 15, ' Blindman's Buff,' seems to warrant our distinctions above-taken, and with several kindred, contemporaneous pictures, to demarcate a *fifth* characteristic style. Its period, we would say, extends between the years 1809 and 1812, when the sketch for ' The Village Festival,' No. 24, and ' Blindman's Buff' were respectively painted. In this latter work, the undulous contours of Correggio are very apparent ; even the mechanism has his smoothness and mellowness. Ostade, it is true, was a morbid colourist likewise, as may be seen by No. 157, ' The Flemish Ball,' though a specimen much less warm and rich of tone than usual, perhaps too little so. But Ostade's peculiar *hotness* in prominent points and features appears, as a Queen Anne's poet would say, to have " fired the imagination" of Wilkie : see for example that droll figure, the inimitable Toss-pot, the personified Hiccup, of the ' Village Festival,' or that other ruby-nosed rollicker of No. 20, ' Ransacking the Wardrobe.' Our artist indeed shades off the fierce red into a (*sfumato*) suffused glow, resembling the ripe side of a peach seen through its down, which softens and covers it like a vapour. Few points are thus forced in ' Blindman's Buff,' though some have a strawberry vividness and juiciness—the principal Maiden's bust for instance. Nothing can be sweeter than the general colour ; this is the mellowest of all Wilkie's pictures, if not so rich or brilliant as the 'Village Festival.' Its defects seem, first a want of vigour and relief ; but being hung too near the 'Chelsea Pensioners,' a very powerful work, the contrast may exaggerate that appearance : second, a waste of background, which, with their slender winding forms, gives a *worm-like* pettiness to the figures. Those of the ' Village Festival' are small, but its rear is better filled with picturesque cottage-roofs and foliage. Ostade loves to assemble many little people, without however leaving his canvas round them as idle

‡ Apropos of this National Gallery picture : we observe with regret and amazement that both it and its companion there, ' The Village Festival,' are in a state little creditable to the painter or to the cleaner—it betokens either bad original workmanship, or vile after-meddling. Who is the real delinquent ? Both pictures have got a coat of varnish or some desiccative compost, which has shrivelled up the paint beneath, till the *white ground* itself appears through the numerous fissures, and ere long will scale or curl off like bark from a beech, unless the evil be remedied. Remedied ?—we fear it is irremediable !

as a common : he does not, we grant, always group them well, which may be seen if we compare the ' Flemish Ball' above-said in reference to its lines, so unpleasantly jumbled, with any specimen of our painter's fifth style, beyond all ' Blindman's Buff,' so naturally yet adroitly, beautifully, and gracefully composed. Character is here not much developed, we mean that its peculiarities—those which single out persons or specialize habits—are not much sought after, for each individual expresses his or her present feelings at least, clearly enough. Consequent upon this minor solicitude about character, several faces are dispensed with, and expression is limited to the attitudes —one creeping from the foreground, is quite *Correggiesque* for its able foreshortenment. *Raffael's Elymas* was perhaps foster-father to Wilkie's blinded man, who however seems to *feel* the air more cautiously and searchingly : indeed we think this figure has most appropriateness of the two, because, as we ventured to say (*Athenæum*, No. 534, ' Cartoons'), a person struck blind is struck of a heap, and does not begin at once to grope forwards like the Sorcerer. But if we thus, even in one particular of a particular figure, give our rural dramatist higher praise than the Shakspeare of Painting, readers will imagine us either his countrymen or blasphemers against the latter.

EXHIBITION OF ANCIENT MASTERS.
WILKIE'S WORKS.
[Concluding Notice.]

IN this paper we propose to conclude our concluding notice. A volume might, and should be, written on the works of Wilkie, who was emphatically a Painter for the People : but to such a volume we can furnish no more than a possible outline, an imperfect table of contents—our previous suggestions, and these final ones, both which would form at best a mere nucleus within the orb of illustrative criticism required by a theme so national. Little has been said upon it as yet beyond what " Wonder with a foolish face of praise" may have uttered ; the inner principles producing the outward effects, the elements constituting Wilkie's artistic power, are known to very few persons, though imagined obvious to every one. Many admirers think they explain all in the rapturous ejaculation that Nature alone was his Art, a popular notion about as correct as its opposite, that Art alone was his Nature. The truth perhaps is, that the most natural among his creations are likewise the most artistic, and that after Reynolds, Wilkie was the most of an artist among our six great Modern Painters. Hogarth, Wilson, Gainsborough, wrought much, it may be said, at random, following their own fine wild wills, without observing any philosophical law of procedure—on which, nevertheless, perfect art, as art, must found itself : Lawrence cultivated in his practice but the one pervading principle, delicacy of treatment, which he carried to its utmost. Both Reynolds and Wilkie sought out all the deepest, subtlest arcana of their profession, and adopted all those compatible with their subjects. This was the right catholic spirit, if their aim was to become supereminent painters ; nay, even if it

was to become supereminent poets on canvas. How
many of Hogarth's painted poems want their due
vigour from his defective masterdom over the pencil.
How inferior oftentimes compared with his engravings,
because of his rough dexterity at the burin. When
Wilkie laid aside the sound, recognized principles of
art, he became, paradox as it may seem, not more
natural, but more artificial; for example, in his later
productions, which are as mannered and affected as
his earlier are spontaneous and simple. He appears
to have had even less than Reynolds a substantive,
self-dependent genius, except that also be a species
of it,—a genius able to stand up uncrushed amidst
its multitudinous acquisitions from without, and main-
tain its dominant character through all its imitative
efforts, which would destroy the identity of a mind
not so original. Had Milton no substantive, self-
dependent genius, because he made use of classic and
Italian models towards its improvement? Wilkie
may have resembled his countryman Walter Scott,
who borrowed assistance upon every hand, rather
than his countryman Burns, who borrowed little any-
where; yet the buttresses, far-from overlaying the
tower, only rendered it firmer on its own foundations.
At the same time we do not rank Wilkie for this
reason above Hogarth more than Scott above Burns,
but in truth about equally beneath him.

With respect to Wilkie's *fifth* style, of which our
last notice cited the chief examples, 'Blindman's
Buff,' and 'The Village Festival,' few other remarks
need be added. His presentation picture to the
Royal Academy, called 'Digging for Rats,' dated
1811, evinces those qualities we set down as dis-
tinctive of this period—curvilinear outline, skilful
agroupment, appropriateness without peculiar indi-
vidualization of character; its touch smooth, its
colour mellow and unctuous;—but its condition be-
speaks the care of a Public Body for public property
under their guardianship, being "as dull, as dead in
look, as woe-begone," as if it had come from the
vaults of St. Martin's Church, not of their Establish-
ment hard by. We have mentioned 'Ransacking
the Wardrobe,' 1810. By the bye, these dates rather
mark the mere execution of the pictures than their
conception, which latter determines their epoch and
style. Thus 'Blindman's Buff,' though painted in
1812, was premeditated at least a year before, as is
plain from the admirable Sketch No. 8, signed 1811:
thus likewise the 'Village Festival,' exhibited in 1812,
having been sketched in 1809. The date on No. 24,
proves that this style followed its predecessor earlier
than would seem, and so illustrates the restless activity
and ambitious explorativeness of our artist's mind.
No. 32, 'The Bagpiper,' dated 1811, is individualized
with a spirit and knowledge of human nature credit-
able even to the fourth style: he bears his little round
felt hat as proud and high as the God of Music his
laurel, yea, or his radiant crown; and it is plain by
his attitude he thinks the skirl of his chanter should
awaken all Scotland from death's sleep itself, like a
particular last trumpet blown on Ben Nevis—verily,
there is deep character, too, in the bold cock-grouse
glance of his eye and the hardiness of his heather-
coloured complexion. Yet though painted with great
brilliance and a tasteful care, we prefer relatively to
its mechanism, 'John Norman, Blacksmith of the
Village of Cults,' No. 37, a less artificial, but more

artistic, production: date 1813. Here both touch
and tint betoken character as well as the traits; if
his features look hammered out and filed, the tints
seem welded after a coarse, strong fashion; the touches
are dexterous smutches, the general tone is a cool
iron-grey,—everything denotes the toil-worn Son of
the Anvil, who half washes his brow at supper-time
in his ferruginous trough-water: he is Blacksmith to
the very blearness of his eyelid, which smoke and
coal-dust have tormented. This work, however,
comes under Wilkie's *seventh* or Mixed Manner.

The *sixth* style demands particular consideration.
It returns *per saltum* over the fifth to the fourth,
subordinating agroupment and sedulously prosecuting
developement of character, eschewing small propor-
tions,—indeed, enlarging its figures to a yet unusual
size,—and relinquishing the apple-blossom com-
plexions, the nosegay assemblages of tints, for quieter
and more uniform colours. The rectilineal outline is
also readopted in great part, the curvilinear only not
abandoned. But our artist appears to have had as his
chief object all through this sixth style, the *principle
of illumination*, which may be accounted its demar-
cator. He brings "the sun into the room"; he satu-
rates with sunlight every object which has any affinity
for it. The reigning tone of his pictures is a sweet,
soft, luminous yellow; the local hues are most often
gay and brightsome, even when the scenes depicted
are mournful. No. 44, 'Distraining for Rent,' will
exemplify these several positions, and we think so far
verify them. 'Rent-day' itself does not dramatize
the subject better, nor distinguish its *dramatis per-
sonæ* one from another by more characteristic and
appropriate qualities. There is that perfect pattern
of scolding queans, the toothless dame, who has got
a freer vent for her shrill eloquence, her hard-grey
eye spitting forth and sparkling with fire like a stone-
coal that burns unconsumed: shrewish to her own
good man, crabbed and cross to her own children,
what must she be to a Bailiff? There is the Dog
under its unfortunate master's chair, a suppressed
growl from the tip of its nose to the bottom of its
chest,—second only to the sceptical Dog in the
'Blind Fiddler,' perplext beyond measure at the
family's endurance of such a disreputable stranger.
Though 'Distraining for Rent' be no cheerful subject,
a sheet of latent sunlight gleams throughout the whole
composition: it spreads evenly, with not one strong
contrast from end to end, with a quietude of *chiar-
oscuro* like that produced by the subtle, undulant
modelling in a Greek marble. It resembles the
uniform glow of a *Cuyp* landscape transferred to an
interior. But *De Hooghe's* condensing power, which
makes his pictures look like corners of a hot-house,
perhaps kindled our painter's ambition. Nos. 25
and 62, 'The Errand Boy' and 'The China-menders,'
have quite De Hooghe's air of *outside* interiors, (for
even his exteriors seem built up or shut in—*closes*,
let us call them,) but still imitate them with an ori-
ginality, tempering their fervid lustre by the impal-
pable mistiness that gives a cooler tone to our atmo-
sphere. These pictures were among the last of this
style; both are referred to 1818, three years later
than the first-cited work. No. 43, 'The Breakfast,'
1817, presents as cheerful a parlour as those two
self-pampering domestic Epicures, the old lady and
gentleman, could desire to sun themselves in, and

comfort their frigid constitutions with the warm South, besides hot tea and toast and a heaped fire. The submissive *Reader-out* at table, who seems to be on his P's and Q's, and the more independent Maid-servant, who could be smart if not saucy, for all her sweetness of complexion, are admirable contrasts to each other, and to their superiors. Wilkie was a shrewd hand at old women of both sexes ; the Mis-tress's character here is written at full in the lines of her countenance; she is evidently a martinette in tea-making, and most punctilious about all matters which concern her personal welfare. We have no time to enlarge further on this work, nor to discuss, as we would wish, the merits of its companions. No. 50, 'The Pedlar,' has a primitive look, yet dates itself 1815* : its light and shade relieve, yet do not force, each other ; the characters are likewise natural, and vivid without being over-expressive,—save one per-haps, the girl who holds up a muslin pattern less to examine it herself, than to make us remark she exa-mines it. This *playing to the spectator* is always a fault, and too frequent with Wilkie. We shall have more of it anon. No. 47, 'Duncan Gray,' 1814, and 'The Letter of Introduction,' 1813, come under the sixth style, but do not close its period. We have a small folio written about each on our cerebral membrane, yet want time even to copy it on paper for printing, as we purposed. In brief, we prefer ' Duncan,' tried by its mental worth, and the ' Letter' by its mechanical (to make a popular distinction), although within the limit of so confined a subject this last work compresses much excellent meaning. Cau-tion never looked from beneath more inquisitorial brows, or endeavoured with more circumspect side-glances to spell and put together, than he does who compares the letter and the letter-bearer : his very attitude gives that moiety of 'a cold shoulder which your man-of-the-world bestows upon all humble ap-plicants. Again we must signalize the Dog, who snuffs in such a suspicious way, that he almost seems to sneer at the stranger. This is extracting the quintessence itself from Nature. But we must on. There are some other pictures to be classed under the sixth style,—e. g. ' Guess my Name,' 1821 ; No. 19, ' The Rabbit on the Wall,' 1816† ; No. 27, ' The Newsmongers,' 1821, &c. But these and their above-mentioned class-fellows present, nevertheless, distinct phases of the painter's mind ; these exhibit the principle of *artificial* illumination, those of *natural* illumination, reflected by *Correggio* and by *De Hooghe* severally. ' Guess my Name' and the ' Rabbit' imi-tate the *Notte* principle, which spreads light from a centre over a spherical circumference of objects grow-ing dimmer as more distant ; the ' Newsmongers' proceeds on this principle reversed, and still Correg-giesque, which spreads shadow from a centre, and lets it lose itself amidst the surrounding light with gradual diminution. It is no valid objection that Wilkie had never seen the *Notte ;* he saw copies or prints of it, just as he saw some work of *Ostade* at

second-hand, which was quite enough to inspire and instruct his sympathetic taste. *Thorwaldsen* never had seen the Elgin frieze itself when he sculptured his ' Triumph of Alexander.'

No. 14, ' The Chelsea Pensioners,' 1822. This is esteemed Wilkie's greatest work by many critics, especially artists. And it has many claims to that high distinction. Its general effect is powerful, its detail most varied, teeming over with mental riches. Certain of the characters are unsurpassed for graphic truth of delineation, and for exquisite painting : the groups are fine pictures by themselves ; the subject would be intelligible to an idiot, as far as that it was news of a victory, and to every one besides but an absolute ignoramus, that it was Dispatches from Waterloo ; so well seized, and selected, and set forth, are the circumstances. We admire its numberless shining points, which would trouble us little less to catalogue than the fixed stars, for the more intimately they are observed the more infinite do they seem. Yet, and after all that can be said or sung in its praise, we doubt if it be Wilkie's *chef-d'œuvre.* It has tre-mendous faults to balance its transcendant merits. We do not know one of Wilkie's good pictures which congregates, and exaggerates, so many of his defects, and metamorphoses so many of his beauties into blemishes. It strikes us as the most artificial among these productions ; even its most natural objects have an air of the *prepense* about them—it is *composed* rather than inspired. Nevertheless, its composition, though skilful pictorially, we think poetically erro-neous ; it seems painted piecemeal, and, by dispersing the masses to people corners, diminishes the unity of action : such dispatches read, for the first time (which the reader's face certifies with marvellous expressive-ness), would make but one group of all listeners, while here much fewer collect round the centre of attraction than stand away from it—some to hear a bagpipe in preference, some to eat oysters in the dog-days ! Shakspeare would not have done this, had Shakspeare been the painter. It never did, nor could have, happened, unless Chelsea Hospital were a Porch of military stoics. Again, we think illumination is pushed somewhat too far—into glare, or at least un-mellow brilliance. Wilkie was a feeble draughtsman, yet generally exhibits the next power to it—adroit-ness in concealing his defect : here it becomes almost ostentatious,—several figures are not only ill-drawn, but solicit us to observe that they are so,—for ex-ample, the long-armed Blackamoor, the spindle-shanked Life Guard, the distorted Dragoon and his long-limbed Lady, &c. We should also wish that the picture had less the air of a *tableau vivant*, the cha-racters less importunacy of attitude and expression, hungering for the spectator's notice and applause : this is what we called " playing to the public :"—look at ' Blindman's Buff,' how natural and genuine the enjoyment, how the personages all play *to themselves*, for the game's sake, and not for *your* gratification,— they are unconscious of your presence ! We can neither find nor fancy a fault in the old Pensioner, venerable still despite his dotardism and his muddled condition : he is perhaps the most graphic among Wilkie's figures, perhaps the clearest portrait of cha-racter : if we rank him beneath the aged Peasant of ' Rent Day,' we do so because he seems less a crea-tion, a mere individual, while the other epitomizes a

* Several dates in the Catalogue are erroneous, even when they appear written plainly on the pictures themselves ! Such oversights render almost dis-serviceable a compilation that will be appealed to as an authority, published under the auspices of the British Institution.

† Vide *Athenæum*, No. 769, p. 458, for a description.

whole species; this is Old Jack Such-a-one, that is toil-worn Rural Senility. If, notwithstanding its superior mechanism, or at least effectiveness, we rank the present picture itself beneath ' Rent Day,' it is because, though both subjects are common occurrences, the latter would occur less to a painter's mind, and evinces therefore a higher invention, besides having a moral dignity throughout all its homeliness of subject, which the ' Chelsea Pensioners' cannot arrogate. To conclude, we are much mistaken or ' Rent Day' will prove far the sounder painting, and will remain a monument when its rival has become a ruin. The lime-like substance which gives the latter its present brilliancy *will burn it up*. We regret to add, that a similar fate threatens many another besides this noble picture by our explorative, or not altogether conscientious, artist. One half his works have the *dry-rot* upon them now, and some will drop into dusty nothing before their purchasers. To obtain effect, or facility, he made use of a *white* in his later works that poisoned them—that was powdered arsenic to their constitution! No. 40*, ' Not at Home,' painted but nine years, is already a *pot-pourri*—a festering compost of rich, rank colours. Had we no other reason, this were enough to make us lament that Wilkie ever relinquished his earlier, careful, severe manner.

No. 20, ' The Penny Wedding,' 1820. A Dutch *Kirmesse* translated into Scottish characters ; Teniers's spirit walks among them again, after having been laid in the river of Lethe for so long an interval. We do not make the remark dispraisingly, but as a psychological fact, a point of artistic and of historic interest, like Raffael's recurrence unawares to Perugino's design at a late period. The work before us agrees with Wilkie's sixth style in most particulars, except its diminutive figures. It has, however, some singularities. The illumination is bright, but broken up, and its tone a disagreeable tawny. Decomposition has set in here also—the tints are corrupted, decayed, or fled altogether—leaving several faces disfeatured like mummies, lips melted into one, and cheeks yellow or bloomless. Out upon the quick-lime that did this ! Yet many admirable portions remain. The auld wives, as usual, bear off the bell. One, occupied in that kind of stationary dancing practised by common people, who lift their legs as a steam-engine its pump-rods parallel to each other, always from the same spots, is laughter for a twelvemonth:— her visage so full of self-complaisance, her clumsiness so buoyant with good humour ! The attitudinarian next her would cure a cynic of the spleen, to see his capricoles, far more risible by their efforts at grace than a theatrical clown could render his by forced distortions. This whole group strikes us as perfect in composition. The Girl putting on her shoe is an elegant version of a very rustic action.

Wilkie's *fourth, fifth,* and *sixth* styles, contain his best pictures. ' Reading the Will,' exhibited in 1820, is amongst them; as a composition it belongs to a much earlier period, that of ' Rent Day,' but if we remember right, does not regain much primitive excellence of workmanship. We saw it at Munich some five years since.

Our task, and the reader's, is almost done. We shall pass over, without numbering, Wilkie's *Spanish* or *Italian* style, of which ' The Maid of Saragossa,'

1828, the three ' Guerilla' scenes, 1828 and 1830, ' Columbus,' 1835, are samples ; and his *Oriental* style, exemplified by ' The Hookabardar,' 1841, and the ' Turkish Letter-Writer,' 1840 ; all, to our judgment, feebly imagined, ill drawn, and worse painted, save here and there a rich blotch of colour or a tasteful " bit of the naked." We shall likewise not stop to discuss his intermediate style, preferable, though still deplorable, which we would entitle his *Mannered* style; from its predominant affectation, bizarre originality both of idea and execution, false sentiment, and fantastic costume. No. 12, ' The Fortune-teller,' 1837, is a favourable specimen. It outrages both the truth of Nature and of History, representing Josephine, the simple-hearted Creolian Empress that was to be, as a pale-faced English fashionable, yet does not want elegance or expression or delicate colouring after their kind. No. 40, ' Cellini and the Pope,' marked 1840, exhibits a very well-painted Apostolic *Virtuoso*, and a wretched apology for the spiritual artist and vivacious self-biographer. We cannot laud No. 84, ' The White Boy's Cabin,' 1836, a piece of sickly romance, as untruthful in costume as capricious in mechanism. Wilkie's mannered style distinguishes itself by a certain *streakiness* of touch, that he either mistook himself, or thought the world would mistake, for freedom. His pictures often look as if they had been rained upon, and that their tints ran down their surfaces, like drops down a window after a heavy shower.

If from Wilkie's explorativeness, or unsteadiness, he has not bequeathed us perfection in any one style, we must be content with the varied nature of our heritage ; we must accept the dross and virgin ore together, when even the former has its value. Besides the three styles just named, but not numbered, let us specify a tenth, designating it as the *Seventh*, or *Mixed* style, because it comprises several good pictures, on which he employed two or more at once of his previous manners, and oftentimes a new transitory method also. No. 42, ' The Parish Beadle,' 1823, a work of powerful black-and-white effect : this chiaroscuro in masses is a very simple thing compared to the chiaroscuro in detail, that keeps all figures and forms distinct from each other by a skilful system of reliefs, yet connects them by neutral gradations into a whole. What miracle-workers the Dutchmen were, as chiaroscurists of the latter description ! How far above Wilkie's best attempt is No. 163, ' Dutch Boors,' which is *not* Teniers's best, or No. 159, ' An Interior'; or even *Jan Steen's* ' Itinerant Musicians,' No. 145, more remarkable for burlesque, broad humour, than mellow treatment. But several faces in the ' Parish Beadle' are admirably painted, with Correggio's globular contours and smooth enamelled skins well imitated : the personages need no labels out of their mouths, or windows in their breasts, to let us see what they are saying and thinking ;—character abounds, the shrill Virago, the weather-beaten Picaroon, authoritative Beadle, awe-stricken dog, and monkey subdued from restless vigilance into quiet contemplation upon the changes and chances of human life, &c. No. 61, ' The Highland Family,' 1824, has similar impasto, but less effect, and altogether much less merit. No. 1, ' George the Fourth's entrance into Holyrood Palace,' 1829 : the King's face delicately painted, and one or two other " bits"

very clever ; for the rest—leather and prunella !
No. 10, 'John Knox Preaching': like the last, half
obliterated, though but ten years old—the back-
ground figures a mere puddle of varicolor paints—a
Spanish blister ! We scarce regret it—Wilkie's his-
torical attempts were sad perversions of his powers.
There is a comic side to Knox's most serious cha-
racter, which Scott, as a painter, might have seized :
Wilkie's hero of the Northern Reformation brings to
mind Hogarth's Methodist preacher, who splits the
pulpit canopy with the force of his vulgar elocution,
and would have made religion ridiculous in his person
to a rational people like our neighbours. See *Athen.*
No. 758, for further remarks on Wilkie's different
conceptions of this subject ; and on his 'School,' an
unfinished picture, which combines the rural drama-
tism of his earlier styles with the Correggiesque con-
tour and surface, and with the mannered character
of his later mechanism likewise. We can say little
decisive respecting a work exhibited two seasons since,
'The Whiskey Still' ; as well as we remember, it is
similar in general spirit to the 'School,' but does not
perform all the last-cited production's promises.
No. 51, 'Queen Mary's departure from Lochleven,'
1837, a specimen of hollow *chiaroscuro.*

Wilkie's Portraits are admitted failures, yet would
be triumphs for many an artist known by nothing
superior. Fine portraiture, however, if not above his
reach, was out of it : those two very subordinate spe-
cimens by *Reynolds,* Nos. 167 and 176, exhibit the
real principles of this peculiar art better than 'Mrs.
Maberly,' No. 109, and all her companions, though
her likeness has a charm we failed to discover in the
celebrated 'Lady Lyndhurst,' No. 58.

One moment and sentence must suffice to record
our admiration of No. 171, 'A Cottage Girl,' and
No. 175, 'A Sea Shore,' by *Gainsborough.* We
hoped that leisure would have permitted us to insti-
tute a comparison between the genius in them, and
in the Wilkies, in the earlier and later Schools of
British Art ; but we are glad, on reflection, to sup-
press such a piece of criticism.

"The British Institution.
Exhibition of the Works of
the Late Sir David Wilkie, R.A."

Art-Union 4 (July 1842), 159–60

THE BRITISH INSTITUTION.

EXHIBITION OF THE WORKS OF THE LATE SIR
DAVID WILKIE, R.A.

This is to the public the most interesting, and
to artists the most profitable exhibition that has
for years been submitted to them; indeed, since
the works of Reynolds and Lawrence were collected
and simultaneously shown, we remember no simi-
lar exhibition equal in attraction. We find here
works from the earliest to the latest period of Wil-
kie's career, wherein we trace not his progress to
excellence—for he attained to it at once—but those
changes in his method of working, which, although
the result of greater confidence, were not produc-
tive of improved effect; as also a radical change in
his style of subject, effected with an ardent wish to
base his fame upon something morally higher than
domestic painting. Most of his famous pictures
now hang on the walls of the British Institution
(with the exception of those in the national col-
lection, and one or two others); an exhibition
which, in a late number of the ART-UNION, we
expressed a hope to see, before, we believe, it was
determined upon by the governors of the Institu-
tion. The world is familiarized with every one of
these compositions by means of engraving; but
this is not enough to the artist, whose inquiries
extend to colour, handling, &c., and the many
niceties which they involve; nor to the lover of
Art is the mere sight of these extensively circu-
lated prints enough, for we cannot well conceive
one who, possessing an engraving from any par-
ticular picture, would not embrace a convenient
opportunity of examining the original. Such rea-
sons alone will render this a memorable exhibi-
tion. We have of late seen much of Wilkie in
every style which he practised; and all must con-
cur with us in the opinion, that had he not in
earlier times produced better pictures than those of
which he was more recently the author, never
had he achieved the high place he occupied in the
consideration of the world.

This assemblage affords an opportunity of col-
lating the works of all the periods of one of the
most celebrated men that ever practised painting
—an occasion which, with all its attendant cir-
cumstances, has never been surpassed in interest
to those who appreciate such qualities as those
whereby Wilkie rose to eminence.

In saying that Wilkie attained at once to ex-
cellence, we mean not, be it understood, that he
did not graduate from bad to better and thence
again to perfection, but we mean that his advance
had in it none of the halting of ordinary progresses
to excellence. His earliest picture in the present
exhibition bears date 1802, and is a production as
indifferent as might be expected of him at that time.
We cannot, in these pictures, recognise a variety
of *styles* : a style requires to be confined by more
than one picture painted in a particular taste.
There were but two great epochs in Wilkie's pro-
fessional career, in the former of these he was
great and alone, and it was then that he secured
such a hold of the affections of his countrymen,
that although he forsook himself, their love yet
abode with him, and they themselves knew not its
strength until death divided him from them. As
the tribes of old forsook their own salvation so he
forsook himself, and like them set up unto himself
idols of wood. We may, changing the time, apply

to him the stern truth of Cicero, "tanti fuit aliis
quanti sibi fuit;" but although he thus, like the
shadow in the Persian fable, passed by his own
substance, he was yet followed for what he had
done. When he had produced even some of his
best pictures, his experience in oil painting was
comparatively nothing; we find him, therefore,
in his early works casting about and feeling for
the best methods of expression; he certainly found
it, but like all true genius he was never satisfied
with his own work. Some of his first pictures
have a strong leaning to the Dutch style, yet they
all differ, and succeed each other in the manner of
some modern novels, as "Hardness, by the Author
of Softness," and *vice versa*. Take the exhibition,
however, as a whole, there is no modern school of
Art that can muster a similar collection with even
one picture comparable to some of these. A
chapter were necessary to do justice to each of
Wilkie's famous productions—they are so well-
known that we attempt, in the little space we can
devote to them, to do little more than enumerate
them.

No. 1. 'King George the Fourth's Entrance to
his Palace of Holyrood House, the 15th of Au-
gust, 1822,' painted in 1830; her Majesty. This
picture partakes much of the latter method of the
artist, but is by no means so free and so abun-
dantly glazed as subsequent works. It contains a
multitude of figures, but all subservient to that of
the King, who wears a military uniform. The
keys of the Palace are presented by the Duke of
Hamilton, first peer of Scotland; and on the right
of the King is the Duke of Montrose, Lord-
Chamberlain, pointing to the entrance of the
Palace, where is stationed the Duke of Argyll in
his family tartan, as Hereditary Keeper of the
Household. Behind the last is the crown of
Robert the Bruce, borne by Sir Alexander Keith;
and on the left of the picture are the Earl of
Hopetoun, near to whom is Sir Walter Scott in
the character of historian, or bard. The likenesses
are striking to a degree, and the Duke of Argyll,
wearing the tartan of his clan and the ensigns of
chieftainship, is a most noble figure : the Highland
garb sits well upon him, and seems not to have
been assumed merely for the nonce.

No. 2. 'The Siege of Saragossa,' painted in
1828; her Majesty. Better known as 'The Maid
of Saragossa,' and familiar to the art-loving pub-
lic through the engraving. Many conflicting opi-
nions have been pronounced on this picture, but
we cannot concur in those which would depreciate
its merit in any marked degree. 'The Maid of
Saragossa' was not beautiful, but, like Waverley
before his aunt Rachel, resolved that he should see
the world, Wilkie also has endued *his* heroine with
grace and beauty, and very properly so; indeed,
he seems to have filled his mind with the spirit of
the lines, beginning—

" Ye who shall marvel when you hear her tale,
Oh, had you known her in her softer hour," &c.

The picture declares a decided and successful
effort to break away from the domestic style of the
heads prevalent in other works. The movement and
passion of the figures—the instant so well defined
that the spectator awaits breathlessly the report of
the gun, and other important matters—sink into
nullity all subordinate faults.

No. 4. 'Her Majesty Queen Victoria,' painted
1841; Sir Charles Forbes. This is a full-length
portrait, a style of Art which Wilkie's friends

wish he had never adopted. It is embrowned with that fatal glaze which seems to send all these portraits into their own backgrounds.

No. 9. 'Her Majesty Queen Victoria at her First Council,' painted 1839; her Majesty. This picture must be so fresh in the public remembrance as to require no particular description; it is, however, remarkable, that wherever we find, in these works, portraits constituting anything like a subject, they are always better painted than if the same heads had formed individual portraits. We should have liked to have heard this anomaly accounted for from the lips of Wilkie himself.

No. 10. 'John Knox Preaching,' 1832; Right Honourable Sir Robert Peel, Bart., M.P. We are glad of having had such an opportunity of examining this picture as is here afforded. It will, at once, strike the spectator that in the engraving there is a higher light thrown on the Queen than is found in the original, even allowing for the sinking of colour, &c. The glazing matter lies in welds on some parts of the surface, and many of the background heads are flattened into the canvass by it. In painting this picture, Wilkie seems to have been actuated by a determination to show that, although he painted domestic scenes, he was not unfitted for a higher walk; there is everywhere evidence in the work that he felt himself driven to this in what he, perhaps, deemed self-justification. Like all things which are good it has its declaimers, but these are not to be heeded; every competent judgment must admit it to rank with the very best of its kind.

No. 11. 'The Penny Wedding,' 1818; her Majesty. This is the most remarkable of the last pictures painted by Wilkie in his really characteristic manner: all his celebrated works, 'The Blind Fiddler,' 'Distraining for Rent,' 'The Rent-day,' &c. &c., preceded this production. The shadowed parts of the work are not so transparent as the same in earlier works, but it is, notwithstanding, a first-class specimen of the master.

No. 14. 'Chelsea Pensioners reading the Gazette of the Battle of Waterloo,' 1822; Duke of Wellington, K.G. It is curious to observe how faithfully the *locale* is described in this picture. It is the entrance to the Hospital as it is now, and as it was twenty years ago: there is no change save in some of the actors themselves, who have retired for ever from that and every other stage, for the figures assure us that Wilkie peopled his canvass, in a great measure, from Chelsea. This picture is brilliant and will remain so as long as it hangs together: it contains some of the most expressive heads that were ever designed by an inspired pencil.

No. 15. 'Blind Man's Buff,' 1812; her Majesty. Another of the famous series whereon the great name of the author rests; the picture is in admirable preservation and is distinguished by all the care and nicety of his finest works.

No. 16. 'The Sick Chamber,' 1808; F. G. Moon, Esq. This composition may not be so well-known as many others of the same and a later period; it is, however, second to none in the pathos of its narrative.

No. 19. 'The Rabbit on the Wall,' 1816; T. B. Brown, Esq. This picture has lately been purchased at a high price; and if such declaration of its value be compared with the prices of others

of the artist's works lately disposed of, it will sufficiently show that the public taste is just in the estimation of them.

No. 25. 'The Errand Boy,' 1818; Sir John Swinburne, Bart. The subject will be remembered as a boy mounted on a very *Morlandisch* pony; and having arrived at his destination, is about to draw from his pocket the note which two female figures are waiting at the door to receive from him.

No. 26. 'Death of the Red Deer,' 1821; Miss Rogers. The fat buck is extended on the ground, while the piper (for the scene is in the Highlands) celebrates "the death" with the accustomed triumphal music.

No. 27. 'The Newsmongers,' 1821; Robert Vernon, Esq. This picture was engraved for one of the Annuals, as were many other of Wilkie's minor works: it consists of a group listening to one of the party reading a newspaper.

No. 28. 'Portrait of Sir Peter Laurie;' Sir Peter Laurie. A three-quarter portrait; the likeness is perfect and the head is among the best of this class ever painted by Wilkie.

No. 31. 'The Jew's Harp,' 1807; William Wells, Esq. A small picture containing only three figures, and in parts somewhat more free than other works of its time. The earnestness of the player is admirably expressed.

No. 32. 'The Bagpiper,' 1812; Robert Vernon, Esq, A single figure, who, unlike most of his calling, wears a hat; but it is sufficiently evident that it is a study from the life, and coloured in a manner as masterly as anything the author ever painted.

No. 33. 'Scene from the Gentle Shepherd;' Thomas Wilkie, Esq. Every figure in the composition is a study from rustic life; but if the artist reach not the sentiment of the poet, he is doubly at fault, since the most common-place incidents described in poetry, come to him with a double refinement. We know of few painters of celebrity less fitted for poetical painting than Wilkie; yet we ought not to speak thus of him individually; for where is there a painter who has not, at some period of his career, attempted a style of Art in which he was in every way unfitted to succeed?

No. 34. 'The Cut Finger,' 1809; W. H. Whitbread, Esq. The flesh shadows in this picture are much more red than we find them in other pictures; and the head of the child is too large; other parts of the composition are sufficiently Wilkie-like.

No. 35. 'The New Coat,' 1807; M. Stodart, Esq. Of the three figures composing this work, the tailor is the most intelligent; indeed, the head is forcible to a degree. The student looks as if he had been baited into dulness by examination—he is at any rate a dull craft, a heavy sailer over the text of Sophocles.

No. 40. 'Benvenuto Cellini and the Pope,' 1841; Henry Rice, Esq. This is one of Wilkie's larger pictures; all of which that contain a display of drapery will remind the spectator of Rubens' method of dealing with this part of his compositions. Cellini is presenting to the Pope one of his highly-wrought vases.

No. 42. 'The Parish Beadle,' 1823; Lord Colborne. Most of the figures in this picture are in little, precisely what so many of the portraits of this distinguished artist are in large. The manner

of the work is so different from those of a better period, that it might be pronounced a bad foreign imitation. The shadows are black and opaque, and, but for some of Wilkie's own children, scarcely should we recognise the authorship.

No. 43. 'The Breakfast,' 1817; Duke of Sutherland, K.G. A much more luminous production than the preceding, consisting of four figures—an elderly couple, a visitor, and servant, all incomparably made out, especially the old lady, who is superintending the making of the tea.

No. 44. 'Distraining for Rent,' 1815; W.Wells, Esq. Certainly one of the most valuable of Sir David Wilkie's works. No language can excel the perspicuity with which the story of distress is told; for every figure is in unison with the whole. This work is so well known through the engraving, that no description is here necessary.

No. 45. ' George the Fourth in Highland Costume,' 1832; Duke of Wellington, K.G.; and No. 46, ' His Royal Highness the Duke of Sussex in Highland Costume,' 1836; her Majesty—are two of the best of the full-length portraits.

No. 47. 'Duncan Grey,' 1814; J. Sheepshanks, Esq. It is to be regretted that Wilkie did not further cultivate this tone of sentiment; for nothing that has ever been painted comes home to the heart with a force equal to this. Throughout these works the narrative is generally aided by action, but here the auxiliary is thrown aside, and the argument is detailed in language intelligible to the most obtuse sense. The distinctive expressions of persuasion, obduracy, and disappointment, place the artist, albeit his picture is neither heroic nor historical, upon a rank with all those who have best succeeded in painting the emotions.

No. 48. ' The Card Players,' 1808; Charles Bredel, Esq. The background is beautifully liquid and transparent, in contrast to which the figures come out somewhat hard. The laugh of the man who holds the best cards is more rigid in the picture than in the engraving.

No. 49. ' Guess my Name,' 1821; Frederick Perkins, Esq. A marked difference is here observable between this and the preceding picture. ' The Chelsea Pensioners' was in progress about this time, but the styles of work in those two pictures bear no relation to each other.

No. 50. ' The Pedler,' 1814; Miss Baillie. The pedler has asked too much for a gown-piece which he is displaying; and the angry remonstrance of the housewives, met by his look of deprecation, is equal to the best things of the artist.

No. 51. ' Queen Mary Escaping from Lochleven Castle,' 1837; E. R. Tunno, Esq. This picture pronounces itself at once one of Wilkie's latter works. There is somewhat too much ceremony for an escape.

No. 55. 'The Rent-day,' 1807; Countess of Mulgrave. An error in the composition of this famous picture is, that the grouping is not sufficiently rounded. All the figures are placed nearly upon one plane. Like the early and simply-painted pictures of the collection, it remains in a fine state of preservation, and must ever maintain the high place it holds in the public estimation. It is true that, like the oysters in the ' Chelsea Pensioners,' it contains contradictions, as some of the tenants wear great-coats and cloaks, while another is exhausted by a harassing cough, all of which would argue that they are paying the Christmas rent; but, on the other hand, the wine is subjected to

the process of cooling, a circumstance which points out that it is the Midsummer quarter. These, however, are incidents which, although frequently noticed, are beneath the serious observation of the critic, since they in nowise compromise the value of the picture.

No. 61. ' The Highland Family,' 1824; Earl of Essex. This composition is even more distant in style than in years from the bright and beautiful works, ' The Penny Wedding,' ' Blindman's Buff,' &c. The family consists of a Highlander, his wife, and child; but the " gudeman" looks out of place, being too well dressed for the cottage he inhabits; the " gudewife," too, looks more than the mistress of the chattels about her; in short, the pair seem to be persons of a higher rank rusticating for amusement. Everything in the composition is kept in shadow, the tones of which are of that heavy and opaque character seen in too many otherwise beautiful productions.

From No. 64 to No. 107 inclusive are preparatory studies, sketches, and unfinished pictures, many of which we recognise as having been disposed of at the recent sale by Messrs. Christie and Manson, as the ' Head of Talleyrand,' the ' Encampment of the Sheik and Arabs,' ' Samuel and Eli,' the ' Turkish Letter Writer,' &c., &c., besides other sketches executed at many periods of the artist's life. Of these one only is a finished oil picture, No. 84, 'The Whiteboy's Cabin,' 1836; Robert Vernon, Esq. It is a large picture, composed of three figures, and painted for distant effect. The subject is one which would have been adapted for a picture for the early series; but how differently would Wilkie have then painted it! The whiteboy is sleeping, while his wife and another female seem to be watching in apprehension of his being apprehended. This production, which, in its kind, is a return to the style of subject which won for the author his high reputation, we cannot help comparing with the works in that style. The cabin and its still-life contents are as they must have been then; the treatment is changed only in light and colour, and the change is not an improvement; but the place, as a whole, is a cabin of the meanest standard—a hovel. Thus we find the quality of interior sunk, while that of the figures is so much raised, that they assort but ill in character with the scene of action. Had this picture been painted a quarter of a century earlier, the figures would have been to the purpose; as it is, they are inconsistently dramatic. Yet the picture is a masterpiece, but not as a Wilkie. The foreshortening of the whispering figure cannot be excelled.

No. 109. ' Portrait of Mrs. Moberley.' Among the larger portraits by Sir David Wilkie, the colouring of this approaches the life as nearly as any we have seen. In many of the female portraits of the collection we find half the faces lost in broad shadows, a most infelicitous manner of painting ladies; but here the face is in a full light, whereby the picture is advantaged far beyond others of its class, but is yet, in other respects, far from ranking as a superior portrait.

No. 115. ' Digging for Rats,' 1811; the Royal Academy. This, we believe, was the presentation picture to the Academy, and although consisting of few figures, and simple in composition, is, perhaps, the finest of its immediate class ever painted. Some urchins, aided by a couple of terriers, are engaged in hunting rats, and the exemplification of

eagerness and impatience, as well on the part of the canine as the human kind, is beyond all praise. The background is in clear shadow, and the colouring of the figures is rich and harmonious.

No. 114. ' Subject from Burns' Poem of the Vision,' 1802 ; James Wardrop, Esq. As a work of Art this production is of no value ; it is only to be estimated from associations, and as an early effort of a subsequently great artist. From the youth and inexperience of Wilkie at the time of his painting this picture, we do not consider it open to remark.

No. 118. ' Sunday Morning,' 1805 ; Countess of Mulgrave. The subject is the preparation for church ; the washing of the children, &c. ; a home scene so familiarized to young Wilkie that he has rendered it with the utmost fidelity ; but the work is like those of others of the same period ; some of the heads are too large.

No. 118. ' Village Politicians.' One of the most celebrated of these compositions ; but it is to be regretted that it is not in such good preservation as many others equally famous. Anything as forcible as the noisy and emphatic earnestness of the group round the table has never been seen in any work of Art, either prior or subsequent to this ; but the colour in comparison with that of ' Digging for Rats,' is somewhat hard and dry. The detail throughout is elaborated to the utmost nicety.

No. 121. ' The Cotters' Saturday Night, 1837 ;' G. F. Moon, Esq. Another of those subjects which, in earlier years, would have been treated in a manner entirely different. The figures and circumstances are wrought to some grades higher than the images which the verse of Burns calls up ;

but from all similar subjects latterly painted by Wilkie, the natural truth and force have been refined away : this we can term nothing but a disease caught by the artist of society, the symptoms of which were most markedly shown in his works ; he was looking continually upwards, and seemed to forget the phases of simpler nature. The candle-light effect is admirably painted, although the whole has been flooded with a brown glaze.

No. 124. ' Alfred in the Neatherd's Hut, with portrait of Sir David Wilkie in the background,' 1806 ; Sir Thomas Baring, Bart. The texture of this is different from that of any other of these works we have had an opportunity of examining, from its being painted on a ticken. Alfred is the most remarkable figure in the composition, which is by no means equal to the domestic histories.

No. 125. ' Landscape with Sheepwashing,' 1817 ; Sir Thomas Baring, Bart. Remarkable as the largest landscape Wilkie ever painted. The scene is a composition, if we may judge from the circumstance of its having been modified from the preparatory sketch which hangs near it. It is a solid and sensible picture, valuable in its solitary state as the production of a man unrivalled in another walk of Art.

No. 128. ' The Recruiting Party,' 1805 ; Wynn Ellis, Esq., M.P. This is one of the most Dutch-looking pictures in the collection, and very unlike the ' Village Politicians,' and other pictures that were executed about the same time. It is free in touch, and unambitious in sentiment ; indeed, there is an entire want of that narrative which distinguishes even the earliest of these productions.

In addition to the works of the late Sir David Wilkie, there were exhibited others by celebrated artists, to a few of the titles only of which we can afford space. These are—' A Fête Champêtre,' by Watteau ; ' Adonis going to the Chase,' Titian ; ' Interior,' Teniers ; ' Dutch Boors,' Teniers ; ' Portrait of Mrs. Robinson,' Sir Joshua Reynolds ; ' A Cottage Girl,' Gainsborough ; ' Portraits of John Bellenden Ker and his brother Henry Gawler,' Sir Joshua Reynolds.

Beautiful, however, as are some of these and others that hang upon the walls, the great charm of the exhibition is centred in the works of Wilkie ; and we congratulate the public and the profession on this opportunity of seeing thus assembled the works of a man who has enjoyed, during his life, a more extended and unaffected popularity than any other artist, whatever may have been his distinction in his avocation.

from

John Eagles

"Exhibitions — Royal Academy"

Blackwood's Edinburgh Magazine 52 (July 1842), 23–34

THE Royal Academy have chosen a motto from Symmachus for their catalogue this year that may be of ambiguous sense—" Omne quod in cursu est viget." There are movements in a circle, movements retrogressive as progressive. The vitality shown in the course, the movement, is not always healthy, not always indicative of vigour. A foundered post-horse cannot keep on his legs at a quiet pace—you must spur him to the full trot or the gallop. A spent ball too, *viget*, yet is nevertheless a spent ball, progressing to a dead stop apparently leisurely enough, yet deadly to encounter. A newly recruited soldier in one of our battles, not being in the thick of the fray, saw one of these spent cannon-balls hesitatingly and slowly rolling onwards near the ranks, and to make sport, ran out to stop it as he would a cricket-ball, but it killed him on the spot. " Omne quod in cursu est viget," was to him an epitaph. We do not see any very just application of the line to the academicians and their works. We cannot suspect them of the extreme modesty, that they should say in it, " You see we keep moving, therefore are not defunct." And yet it is more than possible that they may have some " spent balls" among them ; and some who, like the post-horse, exhibit their vitality in rapid and eccentric motions, with which public taste cannot keep pace. " Symmachus" here then is not a good " ally," as the name would import, and is rather ready to trip up the heels of friend or foe. For our part, we do most sincerely wish that our academicians would go on at a more sober pace, and not endeavour to outrun each other at all, oftentimes outrunning thereby all judgment, both their own and the world's. And while in the wishing trim we may add, that we should be better pleased if they did not admit so many candidates in the race, though many of them do happen to come with flaunty colours and ribbons flying. One thousand four hundred and nine works of art in *one* exhibition is a fearful number, perhaps enough to bring the arts into disrepute. And then we are told of hundreds upon hundreds rejected ; and yet a general cry is raised for patronage. That is well enough, for it must require a great deal of patronage to take off this stock on hand ; but then with this cry for patronage, there is a concurrent attempt to raise, not art, but artists by the thousands ; so that if we " progress," and our English school " of design " viget, an income tax will not provide *all* with a crust and porter. It may be very much doubted if the multiplication of artists is the advancement of art. It encourages a taste for mediocrity, even intentional mediocrity ; it sets before the public eye too conspicuously minor fascinations, till it is content to look no higher, and to leave the mind unfed. We wish, therefore, it were a rule to select the best pictures, best in their moral effect and dignity, to an amount not exceeding one hundred; and surely it would be very difficult to find, at any one exhibition, such a number, worthy to bear and carry with them in the world's opinion the stamp of the " English school." It is not intended by these remarks that pictures of lower class should not be exhibited ; they should have their appropriate " show rooms ;" but we would have our Royal Academy come forth with the sanction of genius, and " honoris causâ" the implied mark of distinction for every production it exhibits. We might then have an " English school." If the academy, however, will still go on upon the multiplying scale, we should like to see a new establishment arise upon this limiting foundation, persuaded that it would create ten times the interest of any other exhibition, and hold forth a noble object of emulation. We want to make not many painters, but great painters ; noble rewards, not frittered and minute distributions. We should not care if half the artists we already have, and who have merit and dexterity of execution, were sent taylored to-morrow. We are overwhelmed with mediocrity of talent—with works you cannot deny to be good in their kind, but of a bad kind, without meaning, or any meaning that the mind will burden itself to remember. We paint all things, where few are worthy. Our great academical exhibition wants *a* character. It has nothing great and important wherewith to designate it. We happened, before we had visited the Exhibition, to ask a foreigner of great acknowledged taste and distinction, what he

thought of it. His reply struck us as not to the honour of our country. We felt a sting, which was probably not meant to wound. He said, " there are some exquisitely-painted dogs." Is then, thought we, in our jealousy, the great depository of British Art little better than a kennel! Yet we do not depreciate the great artist, for great he is, and immortal will be his name and his works, who thus seemed to characterize our school: on the contrary, " upon view," we were almost reconciled to the remark, so eminently excellent are the works of Landseer, and at no exhibition that we remember, more so than at this. He is, in fact, not only our most fine workman, but perhaps our most poetical painter. He is, as the wisest fabulists were in literature, moral and historical, instructing and delighting all, men, women, and children, by other creatures than of their own kith and kin, yet demanding a universal sympathy, and obtaining it easily. Having thus spoken our sentiments concerning this admirable painter, we may still regret that there should be little in other walks of art, of comparative excellence, by which our English school might be worthily distinguished. And yet it cannot be denied that there are works of pretension and great merit, and of sufficiently new cast to help to a designation—they are, however, too few, stand alone, and perhaps, we may add, fall short of the perfection which is aimed at, and which is so nearly attained. We allude chiefly to the works of Maclise. He dares to tell the whole of a story, some will say, do say, theatrically—that we consider no dispraise. It is the business of the dramatist to make good pictures, and whether it be done by the players or the painter, what matter, so they be effective, and the story worth telling; and how shall they be better told than as the author intended they should be represented? The boards of the theatre and the canvass are the same thing—the eye is to behold, and the mind is to be moved. Nor is there a lack of originality in Mr Maclise; he knows how to assist, and by *his* art to bring out the whole conception of the poet; a conception not to be discovered as embodied, or capable of being embodied, in distinct words and in parts, but gathered from the feeling of the whole, and which to embody by another art, is no small test of genius. Whatever defects Mr Maclise may have, and we think he has many, they arise not from weakness—power is his chief quality; it even makes his faults more conspicuous; and we had rather see it so; for great and noble things may be struck off by it, and that which is now wrong, nay, false and bad, may find in him a tempering hand, and be made keep due place, and be converted into beauty. He fears no position of the human figure, his drawing is bold and true, and his grouping artistically, technically speaking, nearly perfect. If he chooses to make rules for himself, and to introduce more figures, and more evident episode than the old masters thought proper, he contrives not to lose the *entirely* of his subject in so doing, and so groups his figures, that, however many, they do not oppress us with a crowd, and he makes them appear essential to his story. We say not that this his rule is a good one. We wait to see what he will ultimately do with it, unwilling to admit limits and shackles unnecessarily upon genius. We believe we have spoken of the two artists that most people speak of who visit the academy this year, as giving, more than any others, or rather, we should say, tending to give, a character to our Exhibition; and therefore it is fair to give such notice of them, even before we come to make any remarks upon their particular works.

Upon the whole, we do not think this year's Exhibition any improvement upon the last. Some artists that should be greatest are inferior to themselves—far inferior; and some, so few or so unimportant are their pictures, may be scarcely considered exhibitors. Eastlake has but one picture, and that a small one, and might be overlooked from its very modesty and excellence; it is, however, exquisitely beautiful. We have lost Sir David Wilkie—for it would not be fair to his name and fame to view his pictures now exhibited as specimens of his power. Poor Sir David! his was a melancholy end, just when he was in the full hopes of realizing the fruits of his travail and his travel. Nor do we in the least sympathise with Mr Haydon in his ambiguous eulogium upon his friend, in thinking it a glorious death that a painter's bones should be committed to the

deep sea. Such a burial might be in keeping with the life and death of a sailor whose home that element is : but with the painter we associate the warm hearth, and comfortable fire gleaming upon his easel, and *conver-sazzione* on art. How apt are some people to exaggerate the pathetic, and think it fine, and fine feeling too, all the while being nothing more than ridiculous. Nor is exaggeration of the merits of an artist beneficial to his after fame ; the strained bow re-coils ; we are apt to undervalue when the cold fit comes. We were never of those who thought Sir David a giant in art, and have often criticised his works with some severity ; and see no reason why his death, which we lament, should excite a maudlin sym-pathy, or disarm criticism of truth. In this age we deal in complimentary superlatives, so that it is difficult to fix any in a true position. Sir David Wilkie was an admirable artist ; but neither in design, nor manner of treat-ing his subjects, was there conspicu-ous the " vivida vis ingenii." He ap-peared always to be cool, and to a great extent judicious, at his easel ; never hurried into an enthusiasm that should take with it his subject and the spectator. Good sense, talents, and unwearied labour, from an early age led him to a less faulty style of painting than we had before seen among us. He captivated by his finish and great truth of character. Nature was at once recognised ; and his arrangements were clear and art-istical. We always thought him very judicious in giving a proper space for his figures to act their parts in ; they did not crowd in upon the canvass ; nor leave too large a space " to let." In these respects he was highly bene-ficial to Art ; for after him, the unde-fined, ill-painted scenes of familiar life only disgusted. He brought this class of art into high respectability. If he was not a good colourist, he avoided offending by an unnecessary display, and this was characteristic of his judgment. He had not, however, a true and strong feeling for beauty. He would often introduce positive de-formity when the beautiful would have answered the purpose of his story quite as well. In his celebrated pic-ture of the " Blind Fiddler," we do not remember one graceful, mode-derately graceful, figure ; the boy with his mocking imitations is absolutely

hideous in his grimaces ; if compelled to have the picture before us, we c ı ld not resist the painting him out. In his " Rent Day," the figures are half of them deformed—the farmer at the table has a hump-back, or his shoulder is out. The " Blind-man's buff " is all hips and elbows, quite disagreeable to the eye when it has caught this pe-culiarity.

Now, we think it should be a max-im in art to deal as much as possible in beauty—never to introduce defor-mity, unless the subject demands it, and then to let the manner of treating it, or the attraction of other parts, take off the unpleasantness of it. And herein the painter will often be called upon to distinguish between infirmity and deformity. Raffaele's genius was very remarkably shown in his power over the necessity of his subject ; making beauty conspicuous as a whole, where some of the parts were neces-sarily otherwise. And even these, as we may term them, originally bad parts, how does he put upon them some mystery, or some divine opera-tion, to which the mind is so power-fully directed, that it too is absorbed in awe and expectation to dwell upon the defect as infirmity or deformity. So it is in the figures at the " Beauti-ful Gate," where beauty is throughout the picture ; and in the miserable cripple we fancy we see one ready to start up into strength and beauty, even such perfection of form as we see all around him. And such is the case in the demoniacal boy in " The Trans-figuration." There is the awfulness of a mystery beyond human means to comprehend, and the presence of a potent evil, above human, that the great subject of the Transfiguration can alone annihilate. Now, Sir Da-vid's early practice lying in the look-ing for and accurate delineation of *peculiarities* of character, was against his natural perception of the beautiful, if it was ever much in him. We have hitherto been speaking of his earlier style, upon which, after all, his fame will rest, for he did not succeed, with very few exceptions, (one of which was his " Benvenuto Cellini and the Pope,") in the attempt to incorporate with his own the manner of the Spa-nish and Italian painters. There was, too, a lack of prominent object in his story. It is not enough to say, this shall represent such and such an event; what power, what feeling, is the event

itself to tell? if it is nothing but pictorial device, and display of mechanical art, there is, after all, but a splendid poverty.

Painters often overwork themselves, and are, in consequence, subject to hallucinations. It has often been exemplified, and fictions built upon the malady: it deserves to be treated tenderly, for it arises from overlabour in the service of mankind. It is apt to seize upon some oddity, some misconception, wherein the eye has ceased to be true to the judgment, but strangely caters to the hallucination. In his later pictures, Sir David Wilkie's manner of representing hair must have arisen in some deception of this kind. It is even conspicuous in his head of Cellini; but the most remarkable instance of it was in the small portrait of a boy, some three or four years old, that every eye but his own thought the strangest thing imaginable. And latterly, in his portraits, the flesh was apt to be pinked up into innumerable little swellings, as if the subject were gouty. We are persuaded he required rest and recreation out of his art. This he had probably obtained; and had he lived, we should have seen these his eccentricities amended. The public, then, have great reason to regret his loss; he certainly advanced art, by removing indefinitiveness and inaccuracy, and substituting precision and clearness; so that honour will ever attend his name, and his country, Scotland, has, and ever will have, reason to be proud of him. But we would not so detract from the praise due to the artists who survive him, as some do, by lauding him as superlatively great, as if he were exclusively *the* English painter. Scotland may be justly proud, and more deeply grave; but with the presence of British art before us, we would say, with the author of Chevy Chase:—

"Now, God be with him, said our (queen,)
 Sith 'twill no better be;
I trust I have within my realme,
 Five hundred as good as hee."

Turner's eye must play him false, it cannot truly represent to his mind either his forms or colours—or his hallucination is great. There were a number of idolatrous admirers, who, for a long time, could not see his exhibited absurdities; but as there is every year some one thing worse than ever, by degrees the lovers fall off; and now we scarcely find one to say a good word for him. And yet, though there is perhaps a greater absurdity than ever in one picture—his "Buonaparte"—yet, on the whole, we do sincerely think Turner improved; there is more of the palpable and intelligible poetry, less obscured by the inconceivable jumble of colours; and, with the exception of the "Buonaparte," less of the blood-red, into which he delights to plunge his hand—a practice which might have entitled him to the address of the unknown author in the Rathologia:—

Ζωγράφων ὦλῷς,
Αἵματι μὴ χρῶσαι Φεισάμενος παλάμην.

We have a right to suppose that the dreams of a sick poet have a dash of his genius; so it is with Turner's dreamy performances; there are glimpses of bright conceptions in them, not indeed distinctly discernible, yet they may be so perhaps to himself. They are like the "Dissolving Views," which, when one subject is melting into another, and there are but half indications of forms, and a strange blending of blues and yellows and reds, offer something infinitely better, more grand, more imaginative than the distinct purpose of either view presents. We would therefore recommend the aspirant after Turner's style and fame, to a few nightly exhibitions of the "Dissolving Views" at the Polytechnic, and he can scarcely fail to obtain the secret of the whole method. And we should think, that Turner's pictures, to give eclat to the invention, should be called henceforth "Turner's Dissolving Views."

As usual, we have to lament the absence of landscape — composition landscape. There are but few that even pretend to be more than views. Nor has Mr Lee come up to the promise his last year's landscape gave. There is a new attempt by Creswick to represent some of the sweet scenes of *green* repose, of nature's river scenes, and to a great extent successful. A little composition, where nature has failed him, would have wonderfully improved some of these scenes. Mr Roberts's pictures are quite an exhibition of themselves, and, we doubt not, would look better without the accompaniment of works of a distracting nature. He has less, this year, of the French-polish; but we still think a little more strong roughness, or dryness, would be an improvement. His execution is admirable, and his effects happy.

It is said that we excel in portraits ; many in this exhibition are admirable ; yet would it not be very desirable that they should have a room to themselves? They sadly injure other pictures ; the masses of colours in them are so large, and often so vivid, that pictures of subject and of many parts are greatly injured by the juxtaposition. Surely the portraits themselves would look better separated ; and there would be a fairer field for composition, as thereby the merits of each artist would be better distinguished, and the candidates for a sitting would at one glance be able to judge what painter would be best suited to their individual likenesses.

It is somewhat singular that this country should have so few marine painters. How seldom do we see one picture that would remind us that Vanderveldt visited our coasts. The insignificant pieces of this kind that are occasionally exhibited, generally represent small vessels, a sea of no great character, and gaudy skies. How unlike Vanderveldt and Backhuyen! It is said that the French artists excel us in this line of art—a line which might have been considered particularly adapted to the feelings of Englishmen. Stansfield, indeed, paints coasts, and the waters that wash them, with considerable effect ; but his pictures are scarcely sea-pieces.

from

"The Royal Academy.
Seventy-fifth Exhibition. 1843"

Art-Union 5 (June 1843), 159–78

THE ROYAL ACADEMY.

SEVENTY-FIFTH EXHIBITION, 1843.

THE seventy-fifth Exhibition of the Royal Academy was opened to the public on the 8th of May; the opening having been postponed from the 1st, in consequence of the death of the Duke of Sussex. The anniversary dinner took place on the Saturday preceding; the "private view" on the day previous; and on the eventful Monday, the usual rush was made at the doors, the customary crowd being admitted, to see each other—and the pictures, if they could. The day of private view affords a fertile theme—for THE AUTHOR; it is sadly productive of sighs, heart-burnings, and blighted hopes; a description which should keep a long way within the boundary that divides truth from fiction, would seem a huge exaggeration to those who have not endured the pain of witnessing the many sad countenances, indicative of sad hearts, congregated within the walls of the Academy on its "opening day." Our business is merely with plain facts, and to condense them as far as possible, leaving to others the task of describing— a task that might obtain a large reward, if properly executed, by inducing some change in a system out of which arises vast personal and public evil. We cannot, however, pass by this very proper opportunity of commenting upon some matters of very deep interest and importance to the Royal Academy, to British artists generally, and to British Art. We shall do so—swayed only by the knowledge that we are called upon to discharge an unpleasing, but an imperative, duty.

It is notorious that the Royal Academy are compelled to return a large number of pictures to their producers—and why? Because they have not room to hang them. It is not pretended that these proffered works are of inferior character; the majority of them are productions by artists—one or two of whose works are placed, and whose claim to reception, on the ground of ability, is thus admitted. If, however, there be a large number of pictures annually rejected, there are others so placed that rejection would have been a boon. And why is this? Because the Royal Academy have not room to hang them where they may be seen to advantage. Far above the ken of naked eye, and below the level of a child's knees, are pictures of great merit; and one room, so decidedly bad as to be distinguished as " the condemned hole," is filled with works, scarcely one of which is inferior, and many of which confer honour upon the British School.¹ It is our duty to inquire if this evil be without a remedy. So long as it exists, a taint will remain upon the reputation of the Royal Academy; serious injuries will be inflicted upon unprivileged exhibitors; the national character for integrity and " fair-play " will admit of doubt, and the Arts will be kept back in spite of all the government patronage that may be exerted for their advancement. These may seem large deductions from limited premises. But a little reflection will show that this is, in reality, *the* source of *the* mischief; that if sufficient space were supplied, by which the claims of every candidate for fame might be fairly tested, the onward march of improvement would be most sure, most safe, most rapid. We should occupy many columns, if we were to urge, fitly, the various arguments by which this assertion is to be supported. Briefly they are these:—Nearly all young artists work in fetters; paint for possible positions, high or low; dare not hazard subjects that require size; colour for exhibition-effects; in fact, labour under the conviction that their destiny depends upon chance, caprice, pre-estimate, personal feeling— upon any circumstance, indeed, save the genuine desert of the offering sent in. We are far from admitting the necessity for such courses, or the justice of such suspicions; but it is beyond question, that they are very generally entertained, solely because the Royal Academy, if they hang them at all, are compelled, from want of room, to hang injuriously three out of four " contributed pictures."

We think the evil by no means without a remedy. It should be sought for and obtained by the Royal Academy; or *by the great body of Artists of Great Britain*, if the Royal Academy decline to make the efforts necessary for its removal. Unhappily it is the characteristic of all chartered and privileged Institutions to be tardy in the admission of changes, even after such changes are shown to be beneficial; and it may be that the Royal Academy will require what is called pressure from without. Great bodies are proverbially " hard to move." But the latter half of the nineteenth century must not be permitted to pass, like the early half, without an adequate effort on the part of the profession to keep pace with the general advance of mind, and to meet a state of things marvellously altered since laws for the government of the Royal Academy were enacted.

It is undeniable, that certain changes in the constitution of this body have been rendered essential by Time. We earnestly hope that when made—and that they will be made, no reflecting person can entertain a doubt—the " makers " will be *the members themselves.* That they will not postpone a solemn and imperative duty until it is too late, and the task has been confided to the hands of enemies, who may so confuse the valuable with the objectionable as to destroy the one while removing the other.

The venerable and excellent Institution may be safely and advantageously improved by those who are interested in its preservation.

Let it not be intrusted to those who may contemplate—not its renovation, but its destruction. [2]

Our principal purpose in these introductory remarks is to implore the Royal Academy not to consign to others the task of providing adequate means by which the contributions of artists to an Exhibition may be properly exhibited. There is no reason for the continuance of an evil which all deplore, or, at least affect to deplore, as a grievous injury to the Arts and the artists of this country. We say, without the fear of contradiction, that if the members of the Academy will stir in the matter, the object will be achieved without " AGITATION ;" and that, if they decline to move, it will be effected without THEM—in that case, not immediately, nor without agitation, but, very certainly, after a time, when representations have been made in proper quarters.

The necessity for improvement has become more evident to us after a recent visit to the Louvre, and a comparison of its QUARTER OF A MILE of gallery with the four or five miserable chambers into which the productions of our artists have been thrust. The number of works contributed to both exhibitions are nearly the same; the Louvre containing 1597, including sculpture, minatures, water-colour drawings, engravings, and lithographies; the apartments in Trafalgar-square 1530. These apartments are lined with frames containing canvass, literally from the floor to the ceiling ; while, at the Louvre, there is no single picture removed from the eye so far as to prevent its receiving just and fair estimation.

There is an old saying, " What can't be cured must be endured;" it would be idle, or worse than idle, to dwell upon evils that admit of no remedy. But, we repeat, the remedy is easy ; a practical remedy is suggested by one of, at least, a score of correspondents, who have addressed us on the subject. We print his letter in a note, although, upon some points, we dissent from it. [3] We for the present content ourselves with observing that the proposal of a FREE Exhibition is made thoughtlessly, and without reflection as to the various interests it involves. Under existing circumstances it is quite out of the question.

We have no doubt whatever, that if the Royal Academy will set themselves to the work of obtaining a gallery suited to the purposes of exhibition, and in all other respects worthy of the country, they will soon procure one. Until this object has been achieved, at least we may ask for additional room in the—so called—" National Gallery," in order that the British public may have some idea of the progress made by British artists. Three years ago, we threw out this suggestion for boarding over the remaining half of the " National Gallery " for two months, as they do at the Louvre, where, by the way, however, they only cover *a part* of the collection of the old masters. Sure we are that the English public would by no means complain of such an arrangement, when made aware of the immense advantages likely to result to the artists and the Arts of Great Britain. But such a plan can be contemplated only as a temporary plan. Ultimately, and before long, a PROPER BUILDING MUST BE ERECTED, EITHER FOR THE NATIONAL COLLECTION OR FOR THE ROYAL ACADEMY. In all probability it will be for the former ; leaving to the latter the structure—such as it is—in Trafalgar-square ; unless circumstances should arise by which the two shall be amalgamated ; and *the Nation shall become the fountain of honours in the Arts, and the national wealth the means of their advancement.*

Again, then, we presume to urge upon the Royal Academy the wisdom and justice and sound policy of not permitting another year to pass without removing a huge reproach from themselves and the country. True, there is space—or nearly space—enough to hang all the contributions of members and associates ;[4] and until the body is enlarged—which it surely will be ere many years elapse—so as to present a size proportionate to the vastly augmented body without, the Royal Academy will not, *for their own interests*, be called upon to make an effort—mighty in its after influence upon the Arts ; but for the sake of the great and numerous CLASS they represent, we earnestly hope the year 1843 will be the last year to witness an exhibition so humiliating and ruinous to the contributors, so prejudicial to the judgment or integrity of the Royal Academy, so injurious to the Arts, and so disgraceful to the country—merely because (after rejecting about 1000 works) there is WANT OF ROOM IN OUR NATIONAL GALLERY ! ! ! [5]

For the Royal Academy as a body, and for the members individually, we entertain sentiments of the highest respect. We repeat our conviction that no public Institution ever existed in any country more free from reproach, or less liable to the charge of wrongdoing. But there are periods in social life when (paradoxical as it may seem) to do no evil is to do much evil. Very recently a mighty move has been made that must produce immense effects upon the Arts. " The Government" on the one hand, and " the people" on the other, have been stirred from apathy into activity. The Royal Academy must not stand listlessly by, waiting for what may happen ; it must direct the rising waters where to flow, so that fertility and not disaster may follow.

Fortunate are those who can foresee a coming storm !

Again, we say, all veritable patriots, and all true lovers of the Arts, will hope to see changes, —rendered necessary by Time—effected by the members of the Royal Academy, not forced upon them.

We have submitted these remarks, not only because this terrible evil—this "WANT OF ROOM" —is a poor excuse for the perpetration of immense mischief, but because it enables us to account for errors in " hanging," which undoubt-

edly startle and confound those who have confidence in the judgment and integrity of the Royal Academy. [6]

Having said so much—and so discharged a duty by no means altogether pleasing—let us direct our attention to more agreeable views of the important matter. The present Exhibition, on the whole, affords ground for congratulation, although it presents no single •bject of general attraction, and the absence of some of the best members of the Academy is a serious disadvantage. Neither Callcott nor Mulready have contributed anything ; Edwin Landseer has done little. [7] Yet, on the whole, the collection manifests a decided improvement, a marked advance, more especially on the part of those with whom the hopes of the country mainly rest—the junior candidates for high places.

The general aspect of the Exhibition gave to us especial, and far more than usual, pleasure this year, inasmuch as our visit took place almost immediately after a visit to the Louvre. Nor was that pleasure diminished when minute examination and matured reflection had enabled us to institute comparisons between the great public "shows" of England and France. Making all due allowance for the fact, that the great artists of France are not (and, by the way, rarely have been) among the contributors, [8] we are by no means disposed to concede the palm of excellence to our continental brethren. The very opposite.

Setting apart a score or two of good works, about half-a-dozen very good works, and, it may be, two or three of a high order—the collection certainly does not rise above mediocrity ; and a vast proportion of them—of the 1597—would not possess sufficient merit to secure places even near the wall or on the ground of the Gallery in Trafalgar-square. The portraits are for the most part villainous ; the landscapes, with few exceptions, execrable ; the historical works, generally—big, and nothing more ; and the pictures *de genre*, usually as unlike nature and fact as paintings can well be. There is, indeed, in this gallery much to stimulate and nothing to discourage the artists of Great Britain. Yet to the former "the nation" has been very liberal ; for the latter "the nation" has, as yet, done literally nothing. OUR time is to come.

We do not apologize for the length of this introduction ; the topics it embraces are of vast magnitude and importance, and we are bound to discuss them freely and boldly, but also, as we hope we have done, with sufficient distrust of our own judgment, mingling reasonable hesitation in pushing forward our opinions with proper earnestness in our advocacy of those we consider right and just.

Let us now enter upon the main subject in hand.

The Catalogue, as we have intimated, [9] enumerates 1530 works, 144 of which are in sculpture ; and of which no fewer than 737 are classed among the miniature drawings and architectural models, medals, &c. Among these 737 there may be about 50 paintings—condemned works, hung just underneath the ceiling, above the lines of miniatures. In reality, therefore, the whole of the Exhibition does not contain more than 700 paintings—no very large number, after all, and certainly not sufficient to alarm those who have forced themselves into a fancy that every youth not born to fortune is destined to try for the achievement of one by his pencil.

No. 1. ' Welsh Mill on the Dolgarey,' W. MÜLLER. The native subjects of this artist are selected with a fine appreciation of the picturesque, insomuch as to approach the dramatic romance of landscape composition. His mind is essentially poetical, yet capable of devotion to the merest and simplest facts. His drawing of natural objects manifests careful thought and study ; and drawing, in trees, stones, and waterbrooks is too generally neglected as of small importance—a grievous mistake. The bed of the stream whereon the mill is situated forms the rocky and broken foreground,—laid in with a marked predilection for a cold and opaque gray colour, which prevails throughout, and which may operate to its disadvantage with those who merely give a transient glance at the picture. It is, however, true to nature—to Nature, who has a thousand varied dresses, and who may change them a thousand times between sunrise and sunset. The genius of Mr. Müller is discursive : no living artist is capable of attaining so much excellence in so many departments of the Arts ; but, as a landscape-painter, he may be assigned a very foremost rank—with certain peculiarities which the mass may not entirely comprehend, but which those who truly estimate genuine worth can thoroughly understand and appreciate.

No. 7. ' Portraits of Lady Mary Viner and Son,' J. LUCAS. The lady is seated in a high-backed chair holding her child. The work is extremely low in colour, but is to be valued as not being a dress portrait. The glimpse of sky striped alternately blue and yellow is a defect.

No. 8. ' Portrait of H. R. H. the Duke of Sussex,' SCHMIDT. The composition of the portrait is sufficiently orthodox, but the pose of the figure is highly objectionable ; the Duke being seated in a chair with his hands so disposed as to convey the idea of his being afraid of falling. The features have by no means the fulness that belonged to those of the Duke.

No. 9. ' Virgil's Bulls,'' J. WARD, R. A. This is an illustration of a passage in the third book in the Georgics, in which the bulls are described fighting—

" Illi alternantes multa vi prælia miscent
Vulneribus crebris.''

It is surprising that one justly celebrated as an animal painter should not have introduced Italian cattle into his picture in lieu of an Alderney and one of Lord Tankerville's breed. This brings us at once down from Virgil's cam-

panian hexametrical associations to the halting prose of our own farm-yards. The animals are powerfully drawn, they fight with fierce determination, but the cow is by no means the "pulchra juvenca" of the poet's verse. The background wants breadth, and the sky natural colour.

No. 10. 'Windsor Castle and Park from St. Leonard's,' AMATEUR. It is to be lamented that such a picture should find a place on these walls to the exclusion of some other which could scarely be rejected as being worse. It is painted in affectation of a taste acquired by copying works of the earlier schools of landscape art.

No. 11. 'Study for a Head of Christ,' M. MOORE. A head in profile painted in imitation of the early Italian manner, and toned down with warm colour until the whole is uniformly brown and adust. The expression is also inappropriate, for the artist, in casting about for intense humility, has fallen upon a vulgar and sinister character.

No. 12. 'The Bay of Naples,' W. LINTON. This picture has been painted with the utmost regard to identity; every object in the composition has been duly cared for and put in with great firmness of touch. It is, however, somewhat difficult to determine, from one or two incongruities, the kind of weather under which the view is presented to us.

No. 14. 'The Opening of the Wallhalla, 1842,'' J. M. W. TURNER, R.A. On a remote hill, rising above the winding river, is seated the Wallhalla, approached from the opposite bank by a bridge of many arches, to which leads, from the foreground, a sinuous route, thronged by thousands of figures moving onward to celebrate the opening of the famous temple. The sun is not in the picture, but on the right is poured downwards a flood of light, painted apparently with chrome yellow. The landscape is by no means generally eligible, but this is of no moment, the object of the artist being to paint light and atmosphere; and how far he may be successful, will be better shown half a century hence than now. The admirers of Mr. Turner say, indeed, that Time will restore to him the high fame of which Time has deprived him. Yet those who see this picture, and here make a first acquaintance with the artist, will find it difficult to believe he once painted pictures of chaste, delicate, and surpassing beauty, —as true to Nature as Nature is to herself. Criticism would be wasted on what appears to be executed without end, aim, or principle. The picture is a whirlpool, or a whirlwind of colours, neither referring to fact, nor appealing to the imagination; yet there are others in the exhibition more objectionable still.

No. 15. 'Her Majesty the Queen,' F. GRANT, A.R.A. This portait has been painted for the United Service Club. Her Majesty is seated, wears a diadem, and is habited in white satin; the likeness is good, and a pleasing expression has been given to the features. The work is characterized by elegant simplicity, and the utmost value has been accorded to those portions upon which the artist has most dwelt. Still the Queen has not yet been painted so as to do honour to the Art; and, even now, with this effort by Mr. Grant before us, we are reluctantly compelled to admit that all who have striven to picture her Majesty fall short of M Winterhalter. We are by no means willing to allow that we are unable to surpass it, but assuredly it remains to be done.

No. 23. 'Portrait of Mrs. Gage,' T. M. JOY. There is much personal grace in this figure; it is plainly habited, but the drapery is too much cut up.

No. 25. 'Scenery on the River Teign, Devonshire,' F. R. LEE, R.A. On the left of the picture is a mill, overshadowed by the fresh verdure of a knot of sheltering trees, beyond which the view opens, showing rising ground, painted in with colours somewhat cold and heavy. The stream flows over a bed interrupted by shelvings and blocks of stone, to each of the latter of which there is given an individuality so marked as to force them on the eye. The trees are inimitably painted; they are made out in a manner which gives them their full meed of richness and beauty.

No 27. 'Cottage Scene in Kent,' R. HILDER. Among the simplest materials of composition; a cottage and a tree; the latter constituting the picture, but finished with a huskiness of touch detrimental to that effect for which masses of foliage depend on each other.

No. 28. 'Peasant Boy and Girl,' A. MONTAGUE. The figures are seated on some broken ground, and, although looking as if sitting as models, are yet placed at ease with themselves. They are skilfully relieved by a background thrown in with more freedom and good feeling.

No. 30. 'The Graces—Psyche and Cupid, as the personification of Love burning the arrows of destruction, and trampling on the insignia of war,' W. ETTY, R.A. The title is followed in the catalogue by a long and embarrassing quotation from Lempriere, which the author of this picture reads very pleasantly. The Graces are presented, as usual—a brief chain of three beauteous links; near them is Psyche, plucking a rose; and on the other side Cupid, burning the arrows, &c. A glance at these figures enables the merest tyro at once to declare the particular excellence which the artist is most proud to have acknowledged. We find in them all the swelling and flowing tracery— all the play of line consonant with benignant inspiration; but this is only secondary to materiality, to which here everything yields. The roundness of the limbs—the warm *morbidezza* of the flesh—which has settled in, with the texture of the veritable cuticle, bring back the mind to earthly substances, how disposed soever to allegorize.

No. 31. 'A Peasant Girl,' E. M. EDDIS. The figure is standing looking out of the picture. The feet do not seem to have been

painted from such a model as we might suppose to be required for such a design; they are too large, marked like those of an adult, and also remarkable for want of symmetry. There is, however, a fine feeling manifested by the work, which compensates for minor defects.

No. 32. 'Portrait of the Rev. W. Pullen,' C. W. CLARKE. The head is forcibly put in, but it has so far the advantage of the figure that the latter looks too meagre, yet this may be the effect of the height at which it is seen.

No. 36. 'Portrait of N. G. Campbell, Esq.,' H. P. BRIGGS, R.A. This is a sporting portrait—by the way, now a very fashionable taste, and assorting well with the pride of humility prevalent in modern costume. The figure stands holding in the right hand a fishing-rod, and is brought forward by a dark unbroken background. The portrait is pleasing, although almost entirely painted with low browns and grays.

No. 37. 'Mazerbo and Lucello — Gulf of Venice,' C. STANFIELD, R.A. The effect of this picture is the broad and simple daylight so often observed in the works of this artist—the sky and water have the purity incidental to a tranquil scene, and the objects are real and substantial. On the right of the composition stands the remnant of a classical edifice, with steps descending to the water, which occupies the lower parts of the canvas; beyond this are seen some modern habitations, among which rise a cupola, and the square tower so common in domestic Italian architecture. The life of the picture consists of a few figures variously disposed: its great charm is its truth—solid and everlasting truth — pervading every passage of the work. The picture is one that will attract every visitor, and satisfy as well as delight all. It is, indeed, a noble work—a pride of the British School. Happy should we be to transfer it for a month or two to the Louvre, that our neighbours might see what—at all events in this way—we can do.

No. 38. 'Arabs Seeking Treasure,' W. MÜLLER. We are here shown, by torch-light, into one of the galleries of perhaps the pyramid of Cheops, where some of the dark men of the desert are unrolling a mummy in expectation of finding valuables which have been deposited with the body. At the end of a vista, formed by huge columns, is perceptible an opening, through which the moon is seen : the torch-light breaks most effectively on the near column, and is repeated, in different degrees of force, by the whole line. The work is excellent in design and execution, and singularly contrasts with the picture, by the same master-hand, to which we have already made reference.

No. 41. 'Portrait of Benjamin Travers, Esq., F.R.S.,' C. R. LESLIE, R.A. This is a small portrait, forcible and brilliant to a degree. It is everywhere distinguished by the utmost care and high finish. In the hand is a book, the white portion of which requires toning down, as being obtrusive.

No. 42. 'Recollection of a Scene by Sunset, near Piedmont,' R. R. REINAGLE, R.A. The eye is led up a rocky ravine to a distance too much cut up by hard contrasts. The dry and overheated mannerism of the picture wants the relief and qualification of cooler colour and fresher tone.

No. 44. 'The Bather,' W. ETTY, R.A. In this kind of subject the artist is pre-eminent. A female figure has just stepped into a pool of water, and is looking anxiously about her in apprehension of discovery. The usual living roundness and substance are given to the figure; but the right arm is unquestionably ill-drawn. The trees rising in straight lines behind the figure have a prejudicial effect; but the colour and manner of the foliage, if it may be so called, are of the utmost value to it. It is the practice of this artist, we believe, to paint more from nature than from memory, and the principle is an excellent one: it may lead to the substitution of individual for general form, but it is an effectual safeguard against mannerism, and all sorts of pictorial vices. The only danger to which the painter is liable may be avoided, by taking care not to paint too much from one model; it is safer and wiser to resort occasionally even to an inferior.

No. 45. 'Sailor—a Retriever, the property of Charles Brett, Esq.,' A. COOPER, R.A. The dog is black, carries a pheasant in his mouth, and is so well painted, that we look reluctantly beyond the animal to the sky, which is green and pink. We have before observed this singularity of hue in other works by this painter; but the mannerism becomes more and more conspicuous in later works.

No. 47. 'Spanish Lady,' T. VON HOLST. The figure is in profile, but the head is a little turned—the picture merits a lower place ; for, being so high, the carnation tones want clearness. The large dark flashing eye speaks of passion, and a heart open to impetus for good or evil. It is evidently a work of great merit; and not unworthy the reputation acquired by one of the most *full* painters of the age and country—a painter, whose surplus mind might be beneficially scattered among a score of more prosperous men.

No. 51. 'A Fruit Girl,' J. T. HOULTEN, Esq. This is the work of an amateur; and although placed high, there are yet many artists whose works have been rejected who would have been content to have seen a picture of theirs in its place. The picture is, in parts, well painted, but is overdone in affectation; because, if it be a portrait, why should the figure be circumstanced as a fruit-girl? and if a fruit-girl, why be charactered in a manner so superior to the vocation ?

No. 52. 'Portrait of J. H. Hippesley, Esq.,' H. P. BRIGGS, R.A. The figure is seated in a red chair, turning over the leaves of a folio. The composition exhibits lines in great diversity, managed most skilfully to contribute to the effect.

No. 53. 'Ruins in the Island of Philoe— Nubia,' D. ROBERTS, R.A. The aspect of this scene is that of intense heat, and for the beauty of the picture, it may be said to be too hot; but the work strikes the spectator as being an unqualified translation from nature, in a garb in which we are not in these climates accustomed to contemplate her. The shadows in the near parts of the work are clear, and beautifully united with the lights. The ruins are seen at a little distance, and round them flows the sullen and apathetic Nile mantled in the deep blue of the upper sky. This is a picture of a venerable solitude: it is true there are figures, but they have nothing to do with the ruins; they and the yet reluctant piles of stones are at the two extremities of a long series of ages.

No. 54. 'The Old Foot Road,' T. CRESWICK, A.R.A. A narrow path embowered by overhanging trees, and resembling the dry bed of a winter torrent. This picture is in that style whence the author has already reaped an abundant harvest of praise; but it may be observed that he now inclines to the "sere and yellow leaf," rather than the sunny freshness which charms all hearts, and comes home to all understandings. We do not mean to complain of this occasional change of style; on the contrary, we think it beneficial. It is a departure from the "jog-trot" that marks an active, thoughtful, and original mind.

No. 55. 'Christ Crowned with Thorns,' W. E. FROST. This picture is well managed for effect, and is marked by strong character; but the arms of the Saviour are those of an Athlete or a well-practised Discobolus. How frequently does a love of anatomical display lead to extravagance and inaccuracy!

No. 59. 'An Arcadian Landscape,' W. LINTON. The title of this composition would induce an expectation of a pure pastoral, which would scarcely be complete without some allusion to Pan, the presiding deity. We have, instead, buildings having about them much of the *procul negotiis* air. The composition is otherwise well designed, and effectively painted.

No. 60. 'The supposed Death of Imogen,' W. F. WITHERINGTON, R.A. This group consists of three figures hanging over the pallid and apparently dead Imogen. The subject is not the most interesting, but the artist has worked it out with peculiar force. It is not in style akin to the other works we have lately seen from the same source; there is, however, nothing lost by the change. The group is characterized by great firmness, and derives importance from the breadth of treatment prevalent in the background. It is painted with much clearness of colour, and firm execution. The figure of Imogen is very gracefully disposed, but with so little development of the female form, as to render the artifice of her disguise perfectly probable.

No. 61. 'Portrait of the Countess Bective,' H. W. PICKERSGILL, R.A. A full-length portrait, in which the figure is standing before a column and some low-toned foliage. It is graceful in design and arrangement, very highly wrought, and possessing claims to be distinguished among the best productions of its class. The satin dress is a positive study. The whole work affords evidence of industry, thought, and judgment properly directed.

No. 67. 'Dante, accompanied by Virgil in his Descent to the Inferno, recognises his three countrymen, Rusticucci, Aldobrandi, and Guido Guerra,' G. PATTEN, A. This is a magnificent subject for a picture—altogether a fitting exercise for the richest imagination. It is here brought forward as a large gallery picture. On the left of the composition stand Virgil and Dante: the rest of the space is devoted to the other three figures, who are amid the smoke and glare of the very hot sphere to which they are condemned. It would assuredly have been better to have treated this passage according to the spirit prevalent in almost every line of the poet, than to have presented them made up, like ourselves, of substantial thew and muscle. Virgil is also too much of this earth. In reply to Dante, in the first canto, he says, "Non Uom; uomo gia fui;" therefore Dante, in force and substance, should have stood distinct from the others. This is remembered and sufficiently shown by the poet himself, in a meeting between Virgil and Dante, and a multitude of spirits, who, on descrying them, hasten towards them to learn the news from the earth, but are much alarmed on seeing the shadow of Dante, themselves being immaterial, and casting no shadow. Again, Dante, with respect to his age, describes himself as

" Nel mezzo del cammin di nostra vita ;"

but he is here represented to us much older. Yet, the picture, the largest in the exhibition, is certainly by no means one of the least effective. Mr. Patten has made a great stride in his profession. The subject is perhaps not one of the best he might have chosen from the "Divina Commedia;" but it has been treated with great academic skill in what relates to form and character, and in colour and effect it is peculiarly striking and impressive. As a composition, we think it somewhat defective; the limbs cross each other at too many angles. But, when we compare this picture with Mr. Patten's 'Eve' of last year, we can only repeat that we think he has made a huge step in advance.

No. 68. 'Portrait of Mrs. Richard Lee Bevan,' T. PHILLIPS, R.A. The figure comes out before a garden background, and is strongly marked by substance and reality. The features are not strictly beautiful, but are characterized by much attractive sweetness. The arms are sharply cut by the frame, which has a very bad effect.

No. 69. 'War—a Sketch for a large Transparency, executed in 1815, on occasion of the Peace,' H. HOWARD, R.A. A fine conception, executed with a bold and decisive pencil, and in a depth of tone worthy of being transmitted

through a much better medium than that of a transparency. This sketch is a work of genuine Art; we prefer it by very many degrees to the artist's 'Nativity' opposite to it.

No. 70. 'Horses of Sir E. Filmer,' Bart., E. B. SPALDING. The group consists of a chestnut horse, a bay, and a pony, all drawn and painted with the utmost care and attention to obtain roundness and elasticity of limb. The field is coloured with exquisite taste; indeed a little more would make it a landscape independent of the animals.

No. 71. 'View of Shank Castle, on the River Line, Cumberland,' T. M. RICHARDSON, sen. The castle is a ruin seated on high ground in the distance, the bulk of the work consisting of the river and its wooded banks. The work declares the author to have studied nature long and ardently. It is the production of an accomplished mind; and in every part affords evidence of the consummate skill of a master.

No. 72. 'Portrait of a Roman Lady,' M. MOORE. This is a profile, brown, hard and dry to a degree, with respect to its painting; there is, however, about the head a character reminding us strongly of the profiles on ancient Roman coins.

No. 74. 'The Queen Receiving the Sacrament (the concluding part of the Ceremony of her Majesty's Coronation), on the 28th June, 1838,' C. R. LESLIE, R.A. The merits of this picture place it among the highest of its class; the artist has succeeded in wrapping the scene in a holy interest, powerfully supported by the deep and anxious attention settled upon the faces of all present. An appropriate effect is produced by a beam of light which descends towards the altar. The figures are remarkable for their ease and grace, and the likenesses are strikingly identical. It must be remembered that in the treatment of such subjects there are many difficulties to be surmounted. The whole arrangement is arbitrary; the business of the artist is to paint the actual fact, unheightened by imagination or pictorial artifice. Parts of this picture, assuredly, required no embellishment: the figures of the young Queen and her maids of honour are as graceful, ideal, and beautiful as the most poetic fancy could desire; we cannot say so much for some of the great dignities and strait-laced officials who figure in the ceremony, but they are equally essential to the occasion, and they are well discriminated.[10]

No. 75. 'Portrait of a Lady,' J. P. KNIGHT, A.R.A. This portrait is unexceptionable in style and colour; the head has been especially dwelt upon, although every part bears evidence of the utmost care.

No. 76. 'Peace,' H. HOWARD, R.A. This is a sketch, also for a large transparency executed in 1815 on occasion of the peace—it comprehends many figures, the principal of which is Peace. The allegory is well supported, and the composition would, upon a large scale, have an imposing effect.

No. 77. 'Carriage Horses, the property of the late Sir Francis Chantrey,' A. CORBOULD. The animals are faithfully drawn and unaffectedly painted, but too much has been attempted as respects the gloss of their coats, which resembles rather the bloom on fruit.

No. 78. 'Entrance to the Crypt, Rosslyn Chapel,' D. ROBERTS, R.A. One of the class of pictures called interiors, abounding with stone carving of a rich and florid character. The work is remarkable for the softness and transparency of its shadows, and the power displayed in painting the cross lights. The subject is bisected by a heavy column, a little beyond which are two figures who do not support the feelings generated by such a work.

No. 79. 'The Entombment of Christ,' W. ETTY, R.A. The group consists of the persons usually present; and, had the work no merit beyond, it is really valuable from its entire want of affectation, being the result of a solidity of purpose which many of our painters would substantially profit by imitating.

No. 80, 'Mrs. Smith Barry,' B. R. FAULKNER. One of those graceful portraits which always recur with pleasure to the memory. The lady is in a garden, two trees of which rise before her, much to the disadvantage of the general effect. The drapery is most beautifully modelled in, and the colour judiciously arranged.

No. 86. 'Portrait of the Rev. Sir H. Dukenfield, Bart., Vicar of St. Martin's,' Sir M. A. SHEE, P.R.A. The figure is in a black robe relieved by a red curtain; the head is most forcibly painted, and the pose is one of perfect ease.

No. 87. 'Lex Talionis: the Raid on the Reivers, or the Laird getting his ain again,' A. COOPER, R.A. This picture is allusive to the marauding habits of the borderers before the inhabitants of the debatable land had, like some of their own morasses, been taken into cultivation. The cattle of a landed proprietor have been driven off, and, as usual, secured in the peel-house or fastness of the reivers, upon which an attack has been made for their recovery—and attended with success, for they are now rapidly driven down the path leading to the peel-house. This is an excellent subject for an animal painter, and more might here have been made of it. The bullocks and horses in the foreground are painted with great skill, but the latter show too much breeding to have been the property of a border landlord of the seventeenth century. This work redeems the artist's reputation a little from the picture of race-horses in the adjoining room; it contains some attempt at composition and arrangement of colour, but the execution, as in most of Mr. Cooper's pictures, is lamentably poor and weak.

No. 88. 'The Lake of Nemi,' W. LINTON. The lake is the principal feature of the picture; it lies enclosed by banks of highly picturesque character. The whole is firmly and unaffectedly painted; the greens are very positive.

No. 89. 'View on the Thames near Wool-
wich,' R. Crosier. A small picture, present-
ing a view of the river, which is under the in-
fluence of a stiff breeze. The time is that of
high water, and vessels are seen taking advan-
tage of the flood.

No. 93. 'A Scene at Zurich, taken from the
Bridge,' S. J. Stump. We know not what could
have induced the selection of this subject, which
is marked by no one tolerable feature. On
each side of the picture are buildings mono-
tonously brown, and abounding in straight lines.
The distance is leaden, and the sky equally
dead.

No. 94. 'The World or the Cloister,' W. Col-
lins, R.A. We should have called it "To be,
or not to be;" and most certainly, "not to be"
was the issue. In the cloister of a nunnery are
seated three figures : two of the sisterhood, and
one who seems to have partaken of the pleasures
of the world even to satiety. Nothing can be
more perfectly characteristic than the air of the
two *religieuses*, who are earnest and urgent in
exhorting the other to the veil. The flaunting
attire of the latter contrasting with the sombre
weeds of the sisters supports the story most
effectively. The lady in blue has been disap-
pointed in the fidelity of her lover, or been
eclipsed at a ball; but, however annoyed for a
moment, "she won't be a Nun." The younger
" of the sisters" is a most exquisite portrait;
and the exterior of the Convent, with the land-
scape, is elaborately and beautifully painted.

No. 95. 'The Lady and Son of W. L. Chute,
Esq., M.P.,' F. R. Say. This picture is
most agreeably composed; the lady is seated on
a flowery bank, and a playful child leans upon
her shoulder. A happy subject and happily
treated.

No. 96. 'The Countess of Malmesbury,' J. G.
Middleton. The flesh-colour here looks yel-
low throughout; but this defect is counter-
balanced by many beauties, the chief whereof
lie in its simple and unassuming style.

No. 100. 'Portrait of the Hon. Ashley Pon-
sonby,' E. Landseer, R.A. The figure, that
of a young gentleman, is habited in crimson
velvet, mounted on a bay pony, and attended
by two dogs, one of the terrier and the other
of the beagle race, the willing companions of
his boy's sport, rabbit-hunting—which, by the
way, has been ample for him, being two brace
slung over the pony *en croupe.* Of these dogs
we shall say nothing, they can bark in their
own praise; nor of the pony will we speak fur-
ther than to observe that he looks one of the
best that ever went before a tail; yet of the
entire composition, a few words : it is at once a
picture and a portrait, a work of that class in
which no other school save our own succeeds.

No. 104. 'The Hop Garland,' W. F. Wither-
ington, R.A. Some children have been gather-
ing hops, and are now engaged in fitting "the
hop garland" to the head of one of their party.
The figures are round, free, and, above all,
sufficiently childish and natural. The colour

and texture are appropriate and masterly; in
short, it is a work of high merit.

No. 105. 'Portrait of Stewart Marjoribanks,
Esq., M.P.,' J. Linnell. This is a small
half-length, with the head beautifully high in
colour ; but yet, seductive though it be, this
richly Hesperidian hue is by no means natural,
as suffusing the entire face.

No. 107. 'Prince Arthur's Dream,' H. Le
Jeune. The subject is from the " Faerie
Queene," and about the execution and compo-
sition there is strong independence of manner,
declaring a genius intent upon taking a path of
its own. Two figures, one of which is Prince
Arthur, in a suit of ringed mail, are so disposed
in extended positions that the two heads in
shadow are presented in strong opposition to a
light sky ; the higher of the two as if

" Watching at the head of him that sleeps."

This is a very remarkable picture, and betokens
clearly a degree of progress in its author. We
are looking to him anxiously for great things.

No. 108. 'Hagar and Ishmael,' C. L. East-
lake, R.A. The back of Ishmael is turned to
the spectator, and Hagar is in the act of giving
him water from an earthen cruise which she
holds for him to drink from. The scene is the
desert, and near Ishmael lie a bow and quiver,
and upon the left of the quiver a fallen and
withered palm. Conscious of his power, the
author of this work has laid aside all meretricious
auxiliary : the figures are appointed with that
severe simplicity which best becomes a pure
and lofty style. The drawing and painting of
the back of the boy is beyond all praise : in
breadth, texture, and colour, this piece of
painting has never been excelled. An imita-
tion of this we recommend to those who insist
upon an offensive display of anatomy, and to
those who would paint Ishmael meagre and
bony. It may be objected that the skin of
the boy is too clear. This, assuredly, is not
consistent with truth, but it is a transcendent
licence, charming us into the spirit which has
suggested it : such mastery could not have been
shown with deeper tones. We never saw what
may be termed " breathless anxiety" so fully
depicted as in the face of Hagar—she is beauti-
ful ; but the beauty of the woman is lost in the
feeling of the mother. The features and atti-
tude express the intense passion of her agony
lest the draught should have come too
late. Few mothers can look upon this pic-
ture without tears. It is a source of deep
and general concern that so few of this
artist's works are publicly seen. Mr. Eastlake's
feeling evidently inclines to the earlier rather
than the later schools of Art. He amalgamates
his figures but little with his backgrounds, but
he obtains perspicuity by an inflexible breadth
of style. His works have a religious severity,
we had almost said sanctity of effect, which
reminds us strongly of the earlier schools of
Italy, and which no other artist of this age has
achieved. The moment you look upon his pic-
tures, you feel, as it were, in the presence of

power and genius, and entertain a distaste to whatever may immediately follow. The subjects which Mr. Eastlake suggests are worthy of a high ambition. His own mind is not frittered away in efforts to produce mere amusement; he is indeed a great teacher, whose pencil is richly eloquent, and whose eloquence is most effective in the cause of virtue and truth. For simple purity and veritable worth, without seeming effort, he stands at the head of modern Art.

No. 109. 'A Composition,' J. J. CHALON, R.A. Consisting of ruins, the banks of a river, and distant prospect of the sea; but the ruins are so numerous that they lose value in a mere irrelative composition.

No. 110. 'Meeting the Sun,' J. WARD, R.A. This is a brilliant morning effect; the life of the picture lies in two figures who, behind the plough, are "meeting the sun" in going over a ridge.

No. 112. 'Acis and Galatea,' R. JEFFRAY. Two figures, which have been profitably studied and exceedingly well painted, but the heads want character: they have been transferred without treatment from very commonplace models.

No. 113. 'Study from Nature, near Hayes, Kent,' W. T. WITHERINGTON, R.A. The truth of the title is everywhere borne out. It is a study of trees, and those not of the most picturesque character; hence the greater difficulty in attaching interest to them; yet they possess it in a high degree, being fresh, verdant, and with branches that would yield not only to the passing breeze, but even to the weight of the smallest bird.

No. 114. 'The Confession,' T. UWINS, R.A. This is a frequent subject among foreign artists, but we have never seen it more effectively dealt with than in the present production. An Italian woman is kneeling at the confessional, within which sits a monk; the latter is in deep shadow, which is thrown in with admirable depth and management.

No. 125. * * * * A. SOLOMON. An incident from Crabbe's poems—a source abundant in subject-matter to painters of English character. The courtship of Ditchem, the friend of Dawkins, is here described. The suitor is an elderly man, in a new red coat, telling the story of his love in a manner somewhat too broad and dramatic.

No. 126. 'Beatrice,' M. MOORE. There is nothing to tell us which of the heroines of the name this is intended for, or if it be brought forward at all as a heroine. It is a profile, apparently a portrait of a Roman woman, toned down to one uniform and unmitigated swarthy hue, and drawn in with all the sharpness and severity of the earlier period of Italian Art. It may be somewhat original in character; but at best it seems a mere *capriccio*.

No. 128. 'Sickness and Health,' T. WEBSTER, A.R.A. Before a cottage door two children are dancing to the music of a hand-organ, played by an Italian itinerant: this is the illustration of health; that of sickness is a girl seated by the door, and supported by pillows,—on her sad features plays a gleam of temporary pleasure at the performance of her sisters. The invalid child is touchingly painted; it is apparent that the general object is her amusement, and also that there is some anxiety to prevent her feeling this; a temporary glow suffuses her cheek, but her feeble and languid condition seems to pronounce her mortally stricken. The children are most successfully pictured, and the organ-boy is a perfect specimen of his class. Altogether, it is one of the most effective and interesting pictures in the collection, fully sustaining, if indeed it do not increase, the high reputation of this excellent artist.

No. 129. 'The Sun of Venice going to Sea,' J. M. W. TURNER, R.A. The title is accompanied by some lines, which do not aid us to any understanding of the treatment of the subject, as we are therein told that "soft the zephyrs blow a gale:"" the softness which marks the lines is scarcely carried into the picture. The 'Sun of Venice' is a fishing felucca, putting to sea amid the blaze of a sunny morning: she is a holiday-looking craft, and but ill fitted for a gale in any shape,—and less for one such as the oldest eyes of the United Service Club never saw. The water is a brilliant and highly transparent mixture of yellow and green, through which this boat is making her way to the open sea, and the towers of Venice rise in the background. The most celebrated painters have been said to be "before their time;" but the world has always, at some time or other, come up with them. The author of the 'Sun of Venice" is far out of sight; he leaves the world to turn round without him: at least in those of his works, of the light of which we have no glimmering, he cannot hope to be even overtaken by distant posterity; such extravagances all sensible people must condemn; nor

"is the winter of *our* discontent
Made glorious summer by this '*Sun of Venice*.'"

No. 130. 'Portrait of R. Benyon de Beauvois, Esq.,' H. P. BRIGGS. This portrait is painted for the Royal Berks Hospital. The figure is relieved by a red curtain; the attitude is that of marked attention, and the most prominent points of the work display the sterling and substantial manner of the artist.

No. 131. 'Portrait of E. H. Bailey, Esq., R.A.,' T. MOGFORD. An excellent and very agreeable likeness of the distinguished sculptor. The work is painted with much force and freedom, manifesting a firm and masterly hand. Altogether, it may be classed among the better portraits this year exhibited.

No. 136. 'Portrait of the Queen, in the Robes worn by her Majesty when delivering the Royal Speech, on the opening of the Session of Parliament,' Sir M. A. SHEE, P.R.A. The author of this work has availed himself of the supposed occasion in order to give a novel treatment as regards expression, and has succeeded. The figure is of course full length; the Queen holds

the speech in her left hand, and a tone of thought and anxiety has settled upon her brow as being about to pronounce it in the House of Lords. As a high work of Art, it is impossible to class it; neither can we be justified in describing it as a remarkably accurate likeness.

No. 137. 'The Actor's Reception of the Author,' D. Maclise, R.A. This is a gorgeous and pungent rehearsal of one of those scenes which occurred after Gil Blas had fallen among the players. It represents the author offering to Gil's mistress the acceptation of a part, with these words:—" Be so good, madam, as to accept of this part, which I take the liberty to offer." The composition consists of many figures, some sitting, others standing; for the reception takes place while the company are at table. For finish, laborious but successful study, intelligent and unwearied research, nice selection, and fit association of objects, and, above all, for expression, character, and imaginative power, this picture is unequalled in its class. In short, we know of no painter of any school who could produce a work to rival it in so many of the highest qualities of Art. The author has been lavish of the wealth of a very rich imagination, and lavish of his powers of realizing even the least significant points of his conceptions. The author enters, and bows very low, while the "magnificent" lady whom he addresses keeps her seat in contemptuous silence; the attention of all present is fixed upon the author in a manner at once to point the tale and confirm the unity of the composition. If there be a fault in this part of the picture, it is the evidence of power too much indulged; the expression is somewhat exaggerated: that is, the contempt of the players is too broad. Mr. Maclise's works are, as it were, other words for luxuriant inventions, especially when, as in the present instance, they lead to the exhibition of ladies, cavaliers, pages, and gay people of all sorts, laughing, quaffing, coquetting, and enjoying themselves. The poor author seems the only unhappy person in the group. The colouring of this picture is wholly deficient in depth and tone; but, as those are qualities which the painter does not appear to have aimed at, we may not condemn him for the absence of that which he had no intention to give. The sort of effect aimed at in colour by Mr. Maclise is that of hilarious cheerfulness; a quality, however, which, with adequate management, we think by no means inconsistent with a certain sobriety of tone. But let us avail ourselves of this opportunity—a more fitting one could not occur—to enter our solemn protest against the application of so much genius to such comparatively unworthy purposes. Maclise has been too much wasted upon " Gil Blas;" and a very large number of our artists are rushing to that book, and others like it, as to fountains at which large draughts should be taken. " Gil Blas" and the " Diable Boiteux" have indeed, of late years, been a kind of stock-books for British artists. But the high power of Maclise, at

least, should be addressed to loftier subjects— subjects the treatment of which might confer honour upon himself and add to national honour. Up to the present time he has scarcely grappled with a single real difficulty—a difficulty that demanded a mighty struggle, in which failure would have been terrible, but in which success would have been great glory. It is full time that he does so; that he opens the book of British history.

No. 140. 'Happy Moments,' G. Healey. A maiden sitting asleep near a window, into which a young man is looking. It is surprising that artists, with a certain amount of knowledge and power, should not exercise those acquisitions on subject-matter more tangible, since every abuse of sentiment cannot be merely ineffective but must be more or less ridiculous. In an ordinary way, a descriptive passage may be approached with some degree of success; while imaginative sentiment is intolerable save when comparatively perfect in treatment.

No. 141. 'Landscape, Herefordshire,' P. W. Elen. A small picture composed of a trout stream and trees, put together with good feeling. The colour is natural and unaffected.

No. 143. 'The Holy Man,' T. Uwins, R.A. There is, according to a quotation appended to the title, in every religious house in Italy, one of the brethren more religious than the rest, who is an object of particular reverence among the neighbouring peasantry, on account of his devoted sanctity. Such a person is the principal figure of this group. He is blessing those who are kissing his garments. The expression and manner of the Holy Man are deeply devotional, and altogether the passage is charmingly illustrated. It is, indeed, a delicious picture—full of touching pathos and sweet instruction.

No. 144. ' Dogana and Madonna della Salute, Venice,' J. M. W. Turner, R.A. This is the most intelligible of the pictures painted by this artist; yet here there are extravagances which reduce the work infinitely below the average of similar subjects exhibited in past years.

No. 145. 'Portrait of the Right Rev. the Bishop of Ely,' T. Phillips, R.A. The head of this prelate is precisely such a one as would tempt a lover of his Art to an extraordinary effort, and it may be said that in the present instance the subject has received justice. The figure is seated, and attired in episcopal robes.

No. 150. 'Portrait of a Lady,' J. P. Knight, A. A full-length portrait; the lady is habited in black satin, and seated. It is a work exhibiting a vast amount of power; the artist has neglected all those aids which are rather supplementary than contributive of real value. He has painted here a figure in a manner we would gladly see more extended.

No. 152. ' Summary Conviction under Martin's Act—Village School Exercises in " *Ass in presenti*," ' T. Woodward. This is, perhaps, a very facetious title, but we do not think it

helps the picture. "Ass," of course, is translatable enough; "in presenti" must mean "in the background." The picture is illustrative of the schoolboy sport of tormenting a donkey, which is interrupted by the παιδαγωγὸς, whose name is Martin, and who, in just wrath, is about to seize the ringleader by the ear. Parts of the picture are admirably painted, but we cannot patiently contemplate such an abuse of power.

No. 153. 'The Terrace,' F. CRESWICK, A.R.A. We. may presume we are again at Haddon, such is the quality of the old and good materials here presented—literally a terrace we would gladly ascend. It is one of a class of pictures to which the accomplished painter is indebted for his reputation. Although the subject be perhaps a little formal, yet the work is in the highest degree beautiful.

No. 154. ' Beauty and Sprite—the property of Miss Latham,' J. WARD, R.A. A white horse partially dappled, and a rough terrier, the former playfully following the latter : the background is a field. The horse is finely drawn, and his anatomy skilfully marked, there is also roundness in his limbs and elasticity in their play; but in the colour there is a somewhat of disagreeable rawness in the red touches about the head.

No. 155. ' Dante's Dream,' F. R. PICKERSGILL. A female figure dressing her hair, with a fountain for a mirror, and coming out before a dark woody background. There is nothing in the treatment of the subject to suggest its being painted from Dante's Dream in the seventh canto of the " Purgatory." The figure that appeared to him was Leah, daughter of Laban, and first wife of Jacob, and was intended by Dante to allegorize active life. There is nothing in the work appropriate to the source whence it is said to be taken; this commonplace and matter-of-fact treatment of such subjects is much to be deprecated. We regret this the more, because the artist promises well, and possesses much ability.

No. 164. ' Scene from the "Vicar of Wakefield,"' C. R. LESLIE, R.A. The family are intently listening to the discourse of the two ladies from town, who are voluble, if not eloquent, in praise of virtue : " Virtue, my dear Lady Blarney, virtue is worth any price, but where is that to be found?"—to which the sterling friend of the family, who sits by the fire, with his back turned to the company, appends his significant ejaculation, "Fudge !" much to the discomfort of the Vicar, who eyes him askance with evident disapprobation. The artist has, in this picture, adhered closely to the letter and the spirit of the story, for there is no more here than Goldsmith himself intended ; and, like his author, the artist centres his force in character. The scene is most effectively maintained : the ladies from town are the lions of the party, of whom all, but the malecontent by the fire, sit in awe. This is assuredly the real feeling wherewith to paint

from this very popular work ; but where shall we find other powers equivalent to genuine illustration like this ? No artist, living or dead, has ever so completely and thoroughly entered into the spirit, feeling, and meaning of an author, from whose written characters portraits are taken. Fancy excellent old Noll, with his young heart and genuine nature, rising out of the grave to look upon this copy from his creation ; sure we are he would have nothing to suggest, nothing to add, nothing to take away. It is so in all cases where a book furnishes Leslie with a subject. Pity it is that he cannot, or rather will not, colour as he conceives—study the natural when his palette rests on his fingers, as well as when he is studying the expression most fitting and most true.

No. 165. 'Italian Peasants,' E. V. RIPPINGILLE. At the bottom of some steps two female peasants are seated, busied in some light occupation, while a third is near carrying a child. There is in this small picture that severity of truth which rejects all qualification : the figures are put in in rigid imitation of nature and substance, and are consequently perfect portraits of Italian rustics. It is distinguished by a most careful finish, and great brilliancy of colour.

No. 168. 'A Festa Day,' T. UWINS, R.A. A family of some half-dozen Neapolitan peasants are keeping the *festa* under the grateful shade of a vine arbour, which is open to the seabreeze. The principal actors are a mother and her child, the former teaching the latter to dance the universal tarantella, while the father, grandmother, and others applaud the talent of the infant votaress of Terpsichore. This picture is throughout painted with the utmost purity ; it is beautiful in conception, and admirable in execution.

No. 169. ' In the Greenwood Shade,' W. ETTY, R.A. A female figure lying on a flowery bank, and with her a winged child, whom we must presume to be Cupid; the figures lie in shade, canopied over, as it were, with the boughs of trees. We can suppose this nothing more than an accidental study, wrought into a picture, and, like all such works—the *capita mortua* of the studio, devoid of that kind of meaning—the voice with which a picture speaks to the understanding.

No. 170. ' Una,' C. TAYLOR. A picture unfortunately placed, but apparently possessing very great excellence. It is the " familiar face " of the fair Una—seen often, but welcome ever. We shall look for other works of this artist, who, if we mistake not, is destined for distinction.

No. 171. ' Shakspere's Walk,' F. STACKPOOLE. A good and natural landscape, if we can judge fairly of the work.

No. 177. ' Portrait of Mrs. Charles Whitlaw, with her infant Son,' G. PATTEN, A. The lady is habited in black velvet, and disposed in an easy and conversational attitude : an excellence valuable in proportion as it is rare of attainment.

No. 178. ' Gil Blas in attendance on the Robbers in their subterranean abode,' J. J. CHALON, R.A. This is one of the most extraordinary experiments upon human forbearance that has ever come under our notice ; there is not one redeeming point of any value whereon to fix, in order to say anything in its favour. The subject has been seized, and this production wrung out of it in the intoxication of fancied power ; but it does not ascend to even mannerism ; the brush has scotched roughly on, reckless of everything that should constitute a picture, and not the least important of all—of reputation. The captain, Rolando, and his gallant band are supping beneath the rays shot from their iron lamp, and poor Gil (too bad for even a man who had fallen among thieves), their *minister poculorum*, is doing the *rapti Ganymedis honores.* The drawing is everywhere questionable ; the effect is *nil ;* and, in short, we find outraged the whole series of those decencies which render a picture at all presentable. It is difficult to divine under what views such a work can have been exhibited ; there is nothing in it to add to a reputation, but everything to detract from one : it is an experiment that no even established reputation could afford to risk.

No. 179. 'Portrait of Henry Angelo, Esq.,' C. R. LESLIE. A small three-quarter portrait, every part of which is kept, save the head, which is very brilliantly coloured, though with a too great prevalence of cold tints.

No. 182. ' The upper part of the river Teign, near Dartmoor,' F. R. LEE, R.A. The river flows between banks rising abruptly from the stream ; upon the right bank is a road, by the side of which is seen a gipsy encampment. The landscape is painted under a clouded sky, an effect to which this artist is so much attached that we rarely find his works present any other. The foreground is laid in with a full and luxuriant touch, and abounds with rich and appropriate colour ; but the background is in parts cold and heavy.

No. 183. ' Sir Roger de Coverley and the Spectator go hunting,' R. B. DAVIS. The scenery is here sketched apparently from nature ; the costume of the time is accurately preserved, and the buoyant eagerness of the hounds, who are rushing out, is expressed in a manner which must, we think, gladden the heart of a sportsman.

No. 190. ' Portrait of Admiral Sir Philip H. Calderwood Durham, G.C.B.,' J. WOOD. The figure is in full uniform, standing, and relieved by an appropriate background ; the head is not very happy in colour or expression, but the other portions of the picture have been accurately studied.

No. 191. 'Portrait of a Lady,' J. WATSON GORDON, A.R.A. This is one of the most graceful female portraits we have of late seen. The figure displays all the elegance and gentleness which characterize a gentlewoman. She is attired in white, and relieved by the utmost simplicity of management.

No. 192. ' The Castle of Ischia, Kingdom of Naples,' C. STANFIELD, R.A. The castle is seated upon a rock, which rises from the water like another St. Michel. The scene is tranquil ; the light under which it is presented is that of sober day, and the colour of the near objects is unequivocally local. The pure hues of the air and water in this work are equal to the best efforts of the artist ; the latter is beautifully cleared up by a piece of rock rising above the surface near the shore, an incident of such frequent occurrence in the rocks of this gentleman, that we cannot think it always so happily cast in nature. The most beautiful passage in this picture is the succession of small waves breaking on the sand ; the little crest of white rises from a slight swell invisible in deeper water, and is thrown perfectly limpid on the yellow sand, which is seen through the waves until concealed by depth.

No. 193. 'The Cotter's Saturday Night,' C. W. COPE. This is a popular subject, and one of amplitude sufficient for a work of high merit. The entire family of the cotter are, of course, present, and they are judiciously grouped, but the colour is entirely subdued by over-toning ; there is also a want of expression in the features, defects which reduce this work below the average of what we have been accustomed to see from the same hand.

No. 194. ' Scene in Wales,' R. M'KENNY. A small production composed of a lake with rocky shores and hills, so substantially and effectively painted as to look very like a faithful copy. It is unassuming and strikingly natural.

No. 197. The ' Nativity,' H. HOWARD, R.A. This picture is painted from Milton's hymn " On the Morning of Christ's Nativity," and supposes the Virgin holding the infant Jesus—

> " Whilst all about the courtly stable
> Bright harnessed angels sit,
> In order serviceable."

The angels occupy the upper part of the picture, and are so represented that, at a certain focus, they seem to throw the Virgin and child in the background. There are precedents for pictures like this, but there is no originality in painting by precedent. The work is at best a poor affair, creditable neither to the Exhibition nor the Academy.

No. 199. ' Crossing the Brook,' T. MOGFORD. A work in which much fancy and close observance of nature are combined with skilful execution.

No. 200. ' Portrait of Madame Eliza Forgeot,' T. M. JOY. A portrait of the highest class ;— we apply the term to its character, and not to its position.

No. 203. ' Portrait of the Right Hon. Viscountess Glentworth,' T. PHILLIPS, R.A. A portrait of the highest class. The head is exquisitely painted, and the utmost nicety prevails throughout the rest of the work ; the figure is relieved by foliage.

No. 204. ' A Windy Day, Sussex,' W. COLLINS, R.A. The composition is very similar to that of one of the series of etchings lately pub-

lished by this artist. It is a coast scene, with figures : a fisherman selling fish to a damsel, who has some difficulty to maintain her position, in consequence of the violence of the wind. There is great purity of colour in the picture, in every part of which the main purpose is supported. It assimilates with the olden style of this excellent artist—a style which we confess we prefer to that which his journey into Italy tempted him to adopt. Mr. Collins is essentially an English painter ; and in England he is, in a double sense, most at home.

No. 207. 'A Squall off Boulogne,' J. WILSON. Powerfully as this picture is painted, we cannot concur in the description it professes of a squall, which is here said to lie upon the water like a blasting cloud, while some small craft are preparing to meet its effects by taking in sail at the instant they are about to be enveloped in its dark volume ; in short, a boat like that, with the sails set, must be swamped in such a state of preparation for a squall. It would have been better to have shown the effect at greater distance than to have admitted such discrepancies.

No. 209. 'On the Conway, North Wales,' T. CRESWICK, A.R.A. A valuable subject, but not exactly of that kind with which this name is identified. The water flows to the foreground between banks covered with verdure, beyond which is distant rising ground.

No. 210. ' Gate of the Mosque of the Metwales, Grand Cairo,' D. ROBERTS, R.A. This is a street scene in the city of tombs. On the immediate right of the picture are houses with projecting latticed windows, such as are everywhere seen in the East ; and beyond these are the gates of the mosque, over which rise two lofty minars, with open galleries at intervals from the gates upwards. The pencil of this celebrated artist descends to the nicest *minutiæ*, where necessary, an example of which is here offered. The street is crowded with figures, camels, &c., in perfect keeping with the mauresque architecture.

No. 211. 'The Lord Wharncliffe, Lord President of the Council,' F. GRANT, A.R.A. The character of this work is studied simplicity—a method of treatment which assuredly confers on works of the kind a more lasting value than any other. The likeness is very striking ; a tone of thought is thrown into the features—a very apposite allusion to the position occupied by the noble lord.

No. 217. ' A Sultry Day—Naples,' W. COLLINS, R.A. A seashore view, comprehending in the near parts of the composition boats and the multifarious paraphernalia of fishermen. In shadow beneath a boat is a fair example of the delicious *far niente*, a man sleeping very much as if it was his " custom of an afternoon." A sultry day is an infinitely more difficult subject than a windy day, and we do not think the artist has so well succeeded with the former as the latter.

No. 218. ' Doctor Johnson perusing the Manuscript of the " Vicar of Wakefield," as the last resource for rescuing Goldsmith from the hands of the bailiffs,' E. M. WARD. This is a well-selected anecdote, admitting of much picturesque variety in grouping and character, of which the painter has availed himself very happily. The Doctor's expression is admirable, full of interest, anxiety, and critical *acumen*. Poor Goldy exhibits his natural *insouciance*, albeit a little disturbed by immediate circumstances. The landlady, we think, might have been made a little more old and ugly ; her expression, however, is sufficiently that of a virago ; and the bailiffs perform their duty with a quiet satisfaction naturally resulting from their benevolent employment. As a whole, very few artists have shown more judgment in selecting a subject, or better skill and knowledge in the treatment of it. The picture is, indeed, one of very great excellence, highly interesting in character, and executed with masterly ability.

No. 219. ' Gateway of the Great Temple at Baalbec,' D. ROBERTS, R.A. The gateway is constructed of marble, and is beautifully sculptured ; through it is seen a *façade* of rich architecture, and on the threshold appear those letters S.P.Q.R., a legend of freedom in Rome, but rivets of bondage abroad. Other inscriptions there are also : on the massive side pillars are written Irby, Mangles, Scheik Ibrim, Puckler Muskau, &c. &c. These we presume to be the ruins of the famous temple of the Sun, at least the gate, for the rest do not seem to be of the same character.

No. 220. 'The Father's Grave,' J. C. HORSLEY. A widow sitting with her son near the recent grave of her late husband—a passage from the book of life easily read by the humblest intelligence. A very charming picture, full of pathetic sentiment, and exceedingly well arranged. The face of the young widow is touchingly beautiful. This is a subject frequently brought forward with more or less success ; here it is treated with much ability, though not one whereupon a rich imagination would fix.

No. 222. ' Portrait of a Gentleman in the Highlands,' H. W. PHILLIPS. This is a small sporting portrait. The figure is seated on a stone, habited in shooting gear, and anxiously watching game. It comes off in strong relief against the sky, and forms altogether an agreeable picture.

No. 223. 'Portrait of the Bishop of London,' S. LANE. This is a small portrait, composed and painted with great taste. The identity is striking, although the bishop looks somewhat older than this portrait.

No. 232. 'Dinner-time in the Refectory of the Franciscan Convent of the Ogni Santi, at Florence,' S. A. HART, R.A. This mode of painting—in which an exact transcript is made of some particular scene, without the slightest attempt to generalize the effect by the principles of Art—may have, for the vulgar eye, a certain look of reality ; but the style is a poor one, and we think any artist of talent does but waste his time on such subjects. The only

value of the work consists in its faithful representation of a place which has no claim to pictorial interest. We hope we may hereafter see a more satisfactory issue of Mr. Hart's visit to Italy.

No. 233. 'Dead Fallow Deer,' W. BARRAUD. The animal lies in the foreground, having been shot by a sportsman who is again following the herd. Although this picture is well coloured there is about it an unpleasant smoothness, which gives it a quality of dryness.

No. 234. 'Portraits of three Greyhounds, the property of H.R.H. Prince Albert,' G. MORLEY. Two are black and one gray; they are on the outside of a paling, which is overtopped by trees, whence descends a deep shadow on the ground; the effect is not objectionable, but a more agreeable picture would have resulted from a lighter aspect.

No. 236. 'Enjoying the Breeze,' J. WARD, R.A. Cattle of various breeds are here grouped together, some of which may be supposed to be "enjoying the breeze." They are naturally disposed.

No. 237. 'The Cynosure of Neighbouring Eyes,' C. LANDSEER. A lady is here seated and reading a letter, while a cavalier leans at the open door with his eyes fixed upon her. There are many points to praise in the figures, and the circumstances of the composition, but the subject is by no means clear; hence is lost much of the real value of the picture.

MIDDLE ROOM.

No. 242. 'The Claims of St. Francis,' H. and W. BARRAUD. A picture of considerable size, comprehending many figures, horses, slain deer, &c.; those in the more immediate parts of the work are monks apparently requesting of a mounted gentleman, habited as of the period of about our Henry VIII., a share of his abundant day's sport, for on the ground lies many a fat carcase of antlered deer. The animals are generally well painted, but the components are too much scattered, and the grouping too much subdivided for good effect. There is also great poverty about the buildings which enclose the court-yard, and if the arm of the foreground monk were straightened, the hand would fall nearly to the knee.

No. 248. 'Portraits of Mrs. Burn Callander and Children,' R. S. LAUDER. This, as a portrait, is a work of the highest merit. The lady is drawn at full length; she stands with a child in her arms, while a beautiful boy is seated near her; the countenance is pale, and a cast of sadness is settled on the features, the impression of which the spectator cannot shake off even by dwelling upon the most prominent and more graceful beauties of the work. Although the sky is blue, it is so low in tone that the blue dress of the child in arms is somewhat staring, as being altogether unaccompanied; and the seated child is so posed that there is not a sufficient indication of the right leg.

No. 249. 'A Welsh Glen,' T. CRESWICK, A.R.A. This is an apparent misnomer, whatever may be the fact, the substance of the picture being a *stream* flowing between almost perpendicular rocky precipices, crowned with trees wearing the richest livery of summer. This is the style of picture wherein the power of this artist is most conspicuous: his monument, indeed, is of rocks and trees, and on both is his name deeply graven. The water here is subdued, and catches the shadows of objects with undiminished limpidity. It is a bright day beyond this close solitude, which but one speck of sunshine has reached, and that has fallen on the hard rocks. The truth and beauty of the work is not to be surpassed.

No. 250. 'Salvator Rosa sketching amongst the Brigands in the Mountains of Calabria,' R. C. J. LEWIS. This picture comprehends many figures, but they are thrown together without attention to a concentration of interest. Salvator is seated upon the left of the picture, the centre point of a group remarkable for rich and effective colouring; and entirely disjointed from this another group occupies the left of the composition. It may be that Salvator is sketching from this, but the composition would have been improved by a closer correlation. As for the figure of the "Savage Salvatore" himself, he was not so favoured by nature as we have him here. There are in the work traits of great beauty in colour and grouping, but the character of those near and around the great painter is too much of what we see at home to carry us in imagination to Calabria. The drawing is also defective, and the author of the work would have done better to have followed the style of composition adopted so closely after nature by Salvator himself.

No. 252. 'A Scene from Bombastes Furioso,' J. FRANKLIN. A work of much merit, full of point and character. The female figure is especially good and effective; the colouring is remarkably brilliant.

No. 253. 'In Windsor Great Park,' J. STARK. A group of oaks elaborately studied from nature. This is all the picture consists of, but so accurately drawn and fittingly painted are they that the eye is nowhere offended by the slightest impropriety. The picture, although small, surpasses any we have of late seen by the same hand; and that is saying much; for his contributions to the Royal Academy and the British Gallery have been universally liked, and have found greedy purchasers.

No. 254. 'Horses—the property of Sir George Farrant,' W. BARRAUD. The animals are two, a grey and a bay. The body and limbs of the former are well drawn and painted, but the head is too short and obtuse: this may be a characteristic of the horse, yet it is here too prominent. The turned neck of the other, also, is foreshortened in a manner productive of bad effect.

No. 255. 'Portraits of all the Horses and Jockeys engaged in the Derby Stakes, won by Little Wonder, the property of David Robertson, Esq.,' A. COOPER, R.A. This picture, for many cogent reasons, had better not have been exhibited: it can be interesting only to the jockeys who figure in it. Love of Art never prompts the execution of works like this, and when things of the kind are painted by commission, it should be remembered that such studies do not promote legitimate Art, and they ought, consequently, to give place to those that do. Several really valuable pictures might have been hung in the space occupied by this jockey picture. Assuredly, if Mr. Cooper had not been a member of the Royal Academy, he would not have had the face to ask that such a perpetration should be hung. It is a huge blot upon the exhibition. What will a foreigner say, who is not aware of circumstances, at seeing this disfigurement so honourably placed, and then entering the Octagon Room, where a work by another COOPER is doomed? He will not for a moment imagine that both are by the same hand; but he will be terribly puzzled to make out by what "accident" the two works dropt into their present places.

No. 257. 'The Little Roamer,' R. ROTHWELL. A child who has been gathering flowers, and is now resting against a bank. The assumed ease of her position has an appearance of awkwardness. The head is most forcibly painted, and the background is rich to a degree.

No. 262. 'Spring,' A. GEDDES, A.R.A. A large picture, presenting Spring in an allegorical impersonation—the subject taken from the first lines of Thomson's poem. A fair-haired and blue-eyed nymph is stepping from a descended cloud to the earth, already studded with the first flowers of the year. Save for especial purposes, allegory of this kind is less acceptable to public taste than any other department of Art. If Rubens were unequal to it, men of less pretension may be content to fail with him. In the present work it is not attempted to complete the description which the poet continues,—

"While music wakes around, veiled in a shower Of shadowing roses, on our plains descend."

We admit the difficulty of following the lines, but cannot help observing that so great is the charm of painting the figure, that the infatuation will keep us pinionless down to the substantive associations of our own earth. This work will do no service to the reputation of Mr. Geddes—a very unequal painter, sometimes remarkably good, at other times exceedingly bad.

No. 263. ' Prince Charles Edward asleep in one of his Hiding Places, after the Battle of Culloden, protected by Flora Macdonald and Highland Outlaws, who are alarmed on their Watch,' T. DUNCAN. In Art as in letters history has a subtle rival in its own romance ;

indeed, those passages of the annals of a nation called not improperly the romance of history, generally hold place in the memory to the exclusion of facts only chronicled to supply what would be otherwise a blank in the catalogue. The adventures of the Pretender have been a fertile theme of song and story in Scotland ever since "the '45"—they have also supplied painters with subject-matter of various complexions ; but no incident in the perils to which he was exposed has been so powerfully painted as that which forms the subject of this picture. It is a large and imposing work ; the scene is a cave, and extended on the ground lies Charles Edward ; near his head Flora Macdonald, expressing anxiety lest he should be wakened ; near the mouth of the cavern, and looking out of it, are the dark and wild figures of the Highland outlaws. The circumstance is rendered here precisely as it might have happened without impertinent exaggeration ; and no mean labour has been exerted in the acquisition of every effective propriety. The cavern is lighted by the dying embers of a recent fire, the light of which is broken in variously graduated force upon all the objects. This work is one of the most meritorious of its interesting class. It will fully establish the reputation of the artist. Mr. Duncan's name is comparatively new, but his picture is one of —we will not say the highest promise, but of actual performance. It combines in an unusual degree and in nearly equal excellence the qualities of composition, colouring, and chiar' oscuro. The effect of fire-light is given with surprising truth and brilliancy, but in such a manner as in no shape to interfere with the general effect of gloom, terror, and mystery which pervade the picture. It is frequently the case, when the attention of the artist has been greatly directed to picturesque arrangement, to see sentiment sacrificed to that object; but the two qualities have been united in this work with complete success. It is, we understand, about to be engraved by Mr. Ryall, for Mr. Hill, of Edinburgh, an indefatigable and enterprising publisher, to whom Scotland is already very largely indebted. [12]

No. 266. 'Fishborne Creek, Isle of Wight,' A. VICKERS. A small picture of ordinary materials, rendered pleasing by judicious treatment ; the water occupies the lowest part of the canvas, and diminishes to distance, closed in by a low and flat country. The work is, in parts, somewhat cold, but has otherwise great merit.

No. 270. ' Making the Most of their Pen'orth,' J. A. AGASSE. A very vulgar title to a weak and puerile subject—some children riding upon hired donkeys. To speak mildly, the production of this picture was an error inexplicable, and the hanging it an error unpardonable.

No. 271. 'The Gillie's Departure for the Moors,' A. COOPER, R.A. At the door of a cottage, amid bleak Highland scenery, stands a

gray pony and a Gillie, who is receiving the stirrup-cup from a woman at the door of the cottage. This is a small picture, executed with even less care than is usual with this artist.

No. 272. 'A Neapolitan Boy playing a tune on the Mandoline to his Inamorata,' T. UWINS, R.A. This is a small picture, light, and sketchy, and pleasing, though somewhat artificial in its composition; they are seated in a nook, shaded by the vine, he being at the feet of his mistress. In the remote distance we have a glimpse of the blue sea.

No. 279. 'Highland Cearnach defending a Pass,' R. R. M'IAN. This picture is worthy of a much lower place; indeed, at such a height, it is impossible to do it the justice it evidently merits. A group of Highlanders are busied, on the very crest of their native rocks, in arresting the progress of an enemy's advance below. They are remarkable for the determination with which they fight, having put in requisition missiles of every description, in as far as we can make out the composition, which powerfully illustrates one of those incidents peculiar to the history of the inhabitants of the northern hills and glens, appropriated and described by this artist with intense nationality of feeling.

No. 280. 'Naomi and her Daughters-in-Law,' E. U. EDDIS. This work derives its chief value from the chastity of its treatment. Naomi and her two daughters-in-law are presented without any accompaniment; but we have in them once more to complain of what our artists seem to be utterly heedless of—that is, national characteristic: we have here three Englishwomen figuring as Asiatics. However, the reluctant consent of Naomi, and the affectionate solicitation of Ruth, are impressively alluded to.

No. 281. 'The Ducal Palace and Columns of St. Mark, Venice,' C. STANFIELD. A view even more familiar than the most remarkable within or around our own metropolis; but it does not possess the interest which attaches to the sea-scenes of this gentleman, although of the highest order of its class. The Palace is upon the left, and the view traverses the façade and extends to the distance. The foreground is thronged with figures in every variety of costume.

No. 282. 'Morning at Lymington—the Isle of Wight in the Distance,' A. VICKERS. It is the highest merit in pictures like this, that their homely materials are so attired as to exercise the mind in immediate comparison between them and nature: this is a proof of their suggestive power. This work is very like the place it professes to picture; it is atmospheric, and faithful in perspective.

No. 284. 'Landscape and Cattle,' J. WILSON, jun. Three cows, a cowhouse, and other probabilities, thrown into a nook of pasturage. In the upper part of the picture a cloudy effect is well handled; but the ground wants breadth, being frittered and cut up in a manner unjust to the principal objects. Although a fine work,

and supplying evidence of great ability, it scarcely upholds the reputation of the young painter.

No. 287. 'Waterloo, 18th June, 1815, half-past seven o'clock p.m.,' Sir W. ALLAN, R.A., P.S.A. This picture has an interest far beyond ordinary battle-compositions; it affords, as nearly as can be afforded, a distinct view of the position and distribution of both armies on the occasion of the last grand effort of the French to force the British position, upon which occasion the advancing columns of the French reserve were cut down by the British batteries in front, and the deadly flanking fire of the brigades of Generals Adams and Maitland; the columns move onward, but only to augment the frightful carnage in front. This is the terrible moment here represented, that in which the utter fortunes of both sides were cast into the balance, and the result of which, announced with the words " *La garde recule*," threw a panic even to the rear of the French army. There are many things in the picture which it is difficult to reconcile. The ground has been carefully modelled in : Napoleon, with some staff officers, occupies the right foreground of the picture ; immediately in front of him are some of the French batteries, and the Imperial Guard is still marching past his position in column ; in the extreme left of the foreground the cuirassiers are engaged with a regiment of British light cavalry, the 23rd ; immediately in rear or on the right of whom are volumes of smoke issuing as if caused by a battery upon the spot. This we cannot account for, and if it can be reasonably accounted for, which we doubt, it leads, seen as it is, at least to erroneous suppositions. The person of the Duke of Wellington is clearly recognisable by the spectator, who is supposed to be standing near the Emperor. He is conspicuous in everything : the recognition must afford the utmost pride and pleasure to every spectator ; but presenting so fair a mark to the batteries in the foreground, his Grace would not assuredly have been overlooked by them. With respect to the frightful slaughter in progress at the head of the advanced columns, that of course is not to be accounted for by the batteries in front and the lines on the left; but there are no doubt other batteries aiding, which are not in the picture; yet, with the discrepancies we have noted, and others of minor import, it is perhaps the most valuable battle picture that has ever been painted, in consequence of the ncontrovertible truth of its main features, to lay no stress upon its great merits in execution.[13]

No. 288. 'The Hindoo Gentleman—Dwarkanauth Tagore,' F. R. SAY. An admirable subject for a pictorial portrait. This celebrated person is painted in the full costume of the Hindoo of condition: he is turbaned and shawled; and so successfully has the artist met the spirit of his subject, that he has not only left his work a meritorious portrait, but a valu-

able picture. The colouring is wonderfully brilliant. In this respect, indeed, it is beyond all question the most remarkable work in the Exhibition.[14]

No. 290. 'Scene in Kirkdale, Yorkshire,' J. RADFORD. This is apparently a landscape of much merit ; but it is so high as to preclude an examination of the manner of its detail.

No. 291. 'Griselda,' H. LE JEUNE. This subject is supplied by Chaucer, and its treatment is such as at once to declare the motive of the scene. The Marquis is mounted, and addresses Griselda, who is at the door holding an earthen cruise. There is some skilful drawing in the picture, and the artist is not afraid of bringing forward his outline : his figures, moreover, are distinguished by a substantial roundness and fulness, which clears them entirely from the back scene of the picture ; shadow is so far valuable, but in a simple daylight scene there is some affectation in throwing unreasonably the principal head into shadow.

No. 292. 'Reading the Scriptures,' C. W. COPE. This is a large picture, with large half-length figures. Such a method of treatment is inappropriate to the subject, which is of that class generally treated on smaller canvass. The work is overtoned,—thus producing an ungrateful muddiness throughout. The abilities of Mr. Cope are unquestionable ; but he evidently wants the tact to know how best to apply them.

No. 293. 'View on the Giudecca, Venice,' C. STANFIELD, R.A. A large upright picture with a circular top. The near objects on the right of the foreground are buildings and part of a church, whence the eye is led along the quay to objects in the distance. " Everybody " has painted the most remarkable views in Venice : this excellent work is composed of fragments ; yet in even this way the famous city cuts up well in the hands of an operator so skilful.

No. 297. 'Nuts to Crack,' W. CARPENTER, jun. A black boy feeding a mackaw with nuts ; both are profitable studies of colour, and the character of the boy has been admirably dealt with. The picture is indeed one of small pretensions ; but there are few better in the whole gallery. This young artist is on the safe and sure road to fame.

No. 298. 'The Pet Lamb—a Sketch in the Abruzzi,' T. UWINS, R.A. A girl is seated with the lamb near her ; a simple subject made out with a corresponding feeling. The manner is free and sketchy.

No. 300. 'Jessica,' W. DYCE. A head and bust—certainly as such most chastely dressed, but as certainly in no degree pointing to Jessica. The expression is not that of the daughter of Shylock. The head has much the character of Raffaelle, whose style seems to have been closely followed. The shoulders are enveloped in satin, which has been imitated with the most felicitous accuracy. It is a good work ; perhaps more than a good work ; yet insufficient to sustain the reputation of Mr.

Dyce, and making no claim whatever to original thought.

No. 301. 'A Woman playing on a Sistrum,' Miss E. COLE. This idea is very far-fetched, the sistrum being an instrument used in the rites of the ancient Egyptians. The sistrum therefore, associated with this lady in comparatively modern attire, is a practical anachronism. The figure is firmly painted and well drawn, and the work altogether manifests considerable ability.

No. 305. 'Portrait of Lady Oranmore,' S. WEST. A full-length portrait. The lady is seated, and attired in dark blue velvet, coloured with a deep and rich effect. The work is one of great excellence, and sustains the character of a very excellent portrait-painter.

No. 306. 'John Knox endeavouring to restrain the Violence of the People, who, excited by his Eloquence against the Church, destroyed the Altar, Missals, Images of Saints, &c., at Perth, 1559,' J. P. KNIGHT, A.R.A. Mr. Knight is one of the best colourists and most dexterous *executors* in the English school. There is a richness in his effects, a harmony in his colouring, and a fluency in his pencil, which, at a first glance, make his works exceedingly captivating ; but he should confine himself, we think, to pictures of a quiet and unobtrusive character ; for where energy and power are wanting, there is a deficiency in mental conception which becomes strongly evident in such a subject as the present. None of the figures seem in earnest. John Knox deports himself with a coolness as if he were covertly enjoying the mischief going on ; and it would be impossible to understand the action or *motive* of several of the other persons, except as we are informed by the Catalogue. There are sad disproportions too throughout the figures, in many of which the head, arms, and legs do not appear to belong to the same individuals. Art, however, has vast capabilities, and works, in which parts are portentously bad, are frequently redeemed by passages of equally conspicuous beauty; and whatever may be the faults of Mr. Knight's picture, there is so much that is excellent in it, that he must be a very sour critic indeed who does not look at it with more gratification than dislike.

No. 307. 'The Sisters—Children of the Hon. Col. and Mrs. Dawson Damer,' F. GRANT, A. One of these heads is a profile, the other is a front face. The heads exhibit surpassing power ; they are childish, winning, and admirable in texture ; but there is about the whole picture a degree of laxity to which we have not been accustomed in the works of this artist.

No. 309. 'The Virgin and Child,' W. COLLINS, R.A. The subject is here treated with a novelty not less attractive for its own sake than charming on account of the many beauties by

which it is distinguished. The title is accompanied by some lines from Milton's Nativity Hymn, but instead of the stable the artist has assumed the license of seating the Virgin within a rocky cavern, open to the sky, wherein we see Heaven's " youngest teemed star." The infant lies upon the knee of the Virgin, and is strongly lighted by a ray which descends upon him. The head of the Virgin is enveloped in a thin white veil, which we would gladly see painted out, as a nicety only tending to vitiate the effect. This picture is in the whole distinguished by a profound feeling which accords to this gentleman a high place among the painters of the poetry of scripture.

No. 311. ' A Weir on the Thames,' A. GILBERT. The scene is closed in by trees, which are crisply painted, but somewhat raw in colour. The water is not sufficiently broken, and is deficient of relief in colour.

No. 314. ' Horses—the property of William Wigram, Esq.,' E. LANDSEER, R.A. The animals are in a field, and brought up to the foreground to drink from a large iron pot. There is between them a strong generic difference, which has been respected in every line and touch. In examining the admirable texture of their coats, it is astonishing to see with how little effort this accomplished artist produces the necessary effects. The less of the two is placed nearest the spectator, and, though it is a plain creature to look at, it is round, warm, and heaving with life. This is not all the picture : there are also two magpies—one by the side of the horse, coquetting with a marrow-bone ; and it is evident that the horse considers the bird one of evil omen, for while drinking his eye is turned towards it, and his ears are thrown back. Of the magpie, one more word : we beg to differ from the artist with respect to his size ; for he is not a bird of nearly three times the magnitude of a horse's hoof.

No. 315. ' Sir Joshua Reynolds and his Friends,' M. CLAXTON. This is a large picture ; the subject is a *conversazione*, at which some of the most celebrated persons of the time of Reynolds are invited to assist. The force of the picture lies in a group on the right, of which Mrs. Siddons is the centre : the figures here compose well, but the heads might have been painted with more brilliancy. On the extreme right of the picture are Dr. Johnson, Goldsmith, and others, forming a group of themselves, without connexion with the others in the room, being indeed divided from them by a positive *hiatus*, formed by the excessively white and obtrusive fire-place. Many of the portraits are striking ; but it was ill-advised to put them in the positions in which they are familiar to us in Sir Joshua's pictures. The work would be improved in value by certain modifications. The subject is a valuable one ; we are sorry it has not been better dealt with.

No. 318. ' Expectation,' M. J. CROWLEY. Evidently portraits, and very skilfully managed ; painted with much care ; arranged with skill and judgment ; and eloquent of an interesting " story."

No. 322. ' Portraits of the late Mrs. Thompson, &c.,' J. P. DAVIS. A striking and interesting family group, composed with judgment, but defective in colour.

No. 325. ' Portrait of the Most Honourable the Marquis of Clanricarde, K.P.,' J. SIMPSON. The features are remarkable—they command attention to something serious already prefaced by the eye, and which is about to pass the threshold of the lips. Nothing, however, can in bad taste go beyond the very " clean " white waistcoat put upon the figure ; this ought to be taken off for many reasons.

No. 326. ' Portrait of Miss Ward,' G. PATTEN. Parts of this work, especially the arms, are exquisitely painted. The pose is somewhat uneasy, but we are aware of the difficulty of avoiding monotony, and being always successful in change.

No. 328 * * * F. DANBY. There is no title to this picture ; it is accompanied by a quotation from Wordsworth, although the substance of the story were evident enough without it. Two shipwrecked sailors have saved themselves by gaining the summit of a barren rock, the boundless sea is around them, and there is no hope of succour. The story is emphatically told, but there is a too prevalent redness in the picture. It is, however, a work of high promise.

No. 329. ' Dovedale, Derbyshire,' H. DAWSON. This is a large landscape, composed chiefly of the rocks rising on each side of the dale, at the bottom of which flows a rapid current. It resembles in feeling some of the pictures of Ruysdael, but on the whole is heavy, and little relieved by the patch of rich herbage in the foreground.

No. 330. ' A Grecian Sunset,' W. LINTON. A brilliant and Claude-like composition, apparently at a distance, for it is placed too high to admit of examination into detail.

No. 333. ' Portrait of a Gentleman, and favourite Bloodhound,' W. SIMSON. A three-quarter length, the figure standing and wearing a great-coat as if prepared to go out—marked by much of the power which distinguishes this gentleman's portraits generally.

No. 334. ' Lord Charles Scott, youngest Son of the Duke and Duchess of Buccleuch,' F. GRANT, A. A child holding a dog by a ribband : he is standing in a landscape very freely painted. The head of this little figure is brought forward with inconceivable force. The work is perhaps one of the most perfect in the exhibition ; but the " finery" given to the child is a little too prominent.

No. 335. ' Portrait of Sir W. Lubbock, Bart.' T. PHILLIPS, R.A. The expression of the countenance is agreeable and animated ; but this is a portrait which would scarcely arrest the attention of any save those to whom the subject is known.

No. 336. ' A British Man-of-War hard and fast on the Rocks,' J. C. SCHETKY. The vessel is on the Rocks, but not in such weather nor in such a sea as will justify her officers under trial by court martial. There is in the water a hardness destructive of motion and transparency, and the sky accompanying the scene should have worn a very different aspect.

No. 338. ' The Falcon,' C. DUKES. A gentleman and lady, in ancient costume, are here looking at a falcon on the hand of the former. The figures are defective in drawing and ungraceful in treatment. They have very much the appearance of having been supplied by a recent publication, illustrative of earlier costume. It is necessary that such works be consulted, but they are not intended to afford figures.

No. 339. ' Christ and the Woman of Samaria,' J. R. HERBERT, A. " And Jesus saith unto her ' I that speak unto thee am he.' " These words and their living utterance the author of this work has pictured in the features of the Saviour ; and their effect upon the woman is described as well with all the emotion that human nature can supply to Art, as with expression that surpasses language. Jesus is seated on the stones of the well, the woman stands opposite, and beyond the well are some palms to assist the effect. The former is attired in red and blue subdued, and the latter in simple and appropriate drapery. The exalted style of this work is comparable to that of any which in modern Art are held up as the nearest approaches to highest excellence. The Saviour is here painted with red hair,—we know not from what authority, other than inveterate habit, and for the sake of apparently harmonious colour. The woman is clad in the simple manner of some of the Arab tribes of the present time ; a sufficiently good authority—for the costume of some of these people is now much the same as it was two thousand years ago. This production will acquire for its author a very high consideration in his profession. It is less finished than it ought to be, and is marked by hastiness in its less prominent parts ; indeed, in the draperies of the principal figure we notice an absence of due labour, but the *feeling* that pervades the whole is exquisite, simple, pure, and true.

No. 340. ' River Scene—Morning,' J. TENNANT. This is a very favourite effect with this artist, and one which he paints with the utmost sweetness. Some cows are standing on a tongue of herbage relieved by the sheen of the passing water ; some trees occupy the left of the picture, whence we look into a distance melting into light and air. All this is beautiful ; but of the trees we have to observe they want softness, and that quality whereby they are made to yield to the wind. The grass and weeds are too hard and edgy ; they look as if they would not bend to the foot.

No. 341. ' A Lane in Holm Chase, South Devon,' S. R. PERCY. A green lane, shaded by towering trees, painted with a rich and full brush. Although there is much careful pencilling, there is yet a want of union in the masses, and a judicious toning, leaving much crudity in the colour. There is, withal, much in the manner that may be modified into excellence.

No. 342. ' The last Moment of Sunset,' F. DANBY, A. This is a continuation of the landscape Poussin, who could not have painted better the departing glories of the setting sun. A group of trees occupies the left of the picture. They are sunk in liquid shadow, and worked out with the finest feeling. The utmost tranquillity prevails, broken only by a cow crossing the water, which reflects the colour of the distant sky. This picture is the work of a mind imbued with the purest classical taste, and may be classed among the *chefs-d' œuvre* of the British school.

No. 343. ' Bruce about to receive the Sacrament on the Morning previous to the Battle of Bannockburn,' J. P. PHILLIP. A large work, comprehending many figures in military and clerical costume. Bruce is a powerful and martial figure ; kneels bareheaded, having given his helmet to a page near him, and is about to receive the cup from the officiating priest. Among the crowd by whom he is surrounded there are some women, and it may be asked, what they do in a field of battle? But it may be remembered it was a number of women, marched over a distant height, who assisted in the defeat of Edward's army by causing a panic. Many of the figures are extremely fine, and the scene, on the whole, is highly impressive. Bruce, by the way, wears plate armour : this is an anachronism. We regard the work as a work of right good promise. It affords evidence of thought and industry added to genius ; and is altogether honourable to its producer.

No. 349. ' Portrait of a Gentleman,' C. SMITH. This is a full-length portrait, the figure being seated. This is a work that does not tell well in an exhibition, from the singular lowness of the forehead, the deficiency of which gives to the countenance a forbidding expression, and even lowers the value of every item of the composition.

No. 358. ' The Wreck,' W. F. TOLDERVY. A vessel, having been cast ashore, is left by the tide : it is now night—the moon has risen ; and it is in its effect that the force of the picture lies. The moon, however, is too bright—it deteriorates the transparency of the night-air lying on the principal object.

No. 361. ' Jephtha's Daughter — the last Day of Mourning,' H. O'NEIL. The daughter of Jephtha and her companions are here represented bewailing in the wilderness ; it is, however, " the last day of mourning ; " in the distance, therefore, is seen an escort, prepared to convey them back, in order to the fulfilment of the vow. In composition, this work is somewhat artificial ; the

heads of the maidens rise in amphitheatrical array—the lower ones relieved by the upper, and the upper by the sky : it is also difficult to account for the manner in which they are supported; there is also too great a nicety of dress for women who have been two months bewailing in the mountains. Moreover, there is not a single one of the figures whom the mind will associate with ideas of Jewish maidens. Yet the beauties of the work are numerous and striking : every part has constituted a theme of deep thought to the artist. The heads are generally very beautiful, and the grief of the principal figure is expressed in a manner the most touching. The work will greatly augment the already high reputation of Mr. O'Neil; who has long promised to occupy a prominent station in his profession.

No. 362. 'Passing the Cross—Brittany, 'F. GOODALL. Some peasants are going to market, and in passing a *Calvaire* are seen acknowledging it : the men raising their hats, and the women crossing themselves ; one woman is kneeling in devotion at the foot of the cross. We have already remarked on the fidelity with which this artist paints the people of Normandy and Brittany, even to the prevalent national cast of countenance. The present work is in that respect equal to others that have preceded it ; but the colours are much more toned down than in those which have made a reputation so early. It is to be hoped this will not so increase as to sully the lustre and more than sweetness of his original style. The figures are mounted on the small rough nags so cheap and abundant in the country ; and the heads are put in with careful but broad finish ; and the faces wear an expression admirably adapted to the feeling of the subject.

No. 363. 'Shade and Darkness—the Evening of the Deluge,' J. M. W. TURNER, R.A. We presume to read this the *Eve* of the Deluge— yet it aids us but little to the meaning of the picture. In the Catalogue we find a quotation from "The Fallacies of Hope," which suggests an interpretation of some of the misty imagery with which the picture abounds. We are to suppose the last awful menace in the heavens —the ark floating in the distance—the scared birds wheeling and screaming in the air, and the beasts wading to the ark. There is nothing for an intelligent and reasonable mind to seize upon. The work is an extravaganza in Art, exemplifying the anti-climax from the sublime to the contemptible.[15]

No. 371. 'Portrait of a Lady and Child,' J. PARTRIDGE. The lady is drawn at full length and in black velvet : the head is much too small for the other personal proportions, and the child she holds is inanimate and doll-like.

No. 373. 'The Love Reverie,' D. MACNEE. A maiden seated on a bank, having a plaid over her shoulders, and habited otherwise in accordance. She is supposed to be visiting a spot she has frequented with her lover

who is absent. The figure is thrown out by the deep shadow of the bank ; the head is partially in shade, and the eyes are cast down, accompanied with an expression of sadness which says all recorded in the four lines of the quotation that follow the title. The figure has in every part been studied with success and truth.

No. 374. 'Landscape,' F. W. WATTS. Trees on the bank of a river, the water of which is cold and opaque; a like degree of heaviness prevails in other parts of the work, the best of which is the largest tree, though in the green so much white has been used, as to render it flat and ineffective.

No. 375. 'Chateau Gaillard, on the Seine,' C. R. STANLEY. This famous seat, we believe of the Bishops of Rouen, is seen in this view rising with its many towers on the right bank of the river. The place is represented with fidelity, but the colour of the picture seems faulty. The artist is always pleasing, agreeable, and true to nature ; and his pictures are distinguished for accuracy.

No. 376. * * * C. LANDSEER, A.
"The monks of Melrose made good kaill
On Fridays when they fasted ;
They neither wanted beef nor ale
As long as their neighbours' lasted."

We are here invited to what is termed, on the banks of the Tweed, "a kettle of fish"—that is to say, a "red fish," transported from the eddying current of that famous and romantic river into the seething whirl of a cauldron boiled with sticks upon the greensward. We are in sight of "bonny Melrose," and have fallen into excellent company—that of the Abbot, one or two of the brethren, and some sportsmen, whom we should, in the phrase of Burns, designate as of the "ram stam squad." The sportsmen had established themselves on the verdant grass, with a venison pasty and plenty of wine—Bordeaux, of course, that was the favourite beverage in those parts—when a descent of the brethren takes place, and they unceremoniously help themselves to the viands they like best. There is much ability manifested in this picture; so, indeed, there is in all the productions of the artist, although it rarely approaches genius. But we can scarcely consider this work as an advance; it is not, indeed, to our thinking, equal to his pictures produced some three or four years ago. We cannot but consider, therefore, that he is more indebted to his "luck" than to his merit for the out-of-proportion sum he received for the picture from the Art-Union subscriber, who was also more fortunate than deserving.

No. 377. 'The Sepulchre,' M. CLAXTON. A naked figure is here lying with the head supported on "the sepulchre;" but we cannot agree with the artist in his method of treating the subject. Such a display of the anatomy of the human form, with every appearance of attenuation from disease, is certainly revolting.

Apart from this objection, there is much excellent work in this picture.

No. 379. 'Portrait of a Gentleman,' R. ROTHWELL. The head is painted with that brilliancy which distinguishes the artist. The other parts are made out in a manner to support the principal light. It is perhaps one of the best male portraits in the collection.

No. 382. 'The Rival Pets—a portrait,' J. SANT. A lady, full length, habited in light satin. She is playing with a cockatoo, which sits upon her right arm. The figure is egregiously tall, being some eight or nine heads in height, and the character of the portrait is extravagant in its theatrical taste. The head is well painted, but the person is overdone in dress, and the whole work is marked by affectation.

No. 384. 'The Meeting of Hetty Hutter and Wah-ta-wah on the Banks of the Glimmer Glass,' A. D. COOPER. The subject is from the "Deer-Slayer," and the picture presents Hetty and the Indian woman seated among the rocks at the brink of the river, and near them a canoe drawn up clear of the current. Hetty is a damsel so coarse that she sinks in comparison with her Indian companion. There is not a sufficient intelligence between the figures; and the other parts of the picture want harmony.

No. 385. 'Light and Colour (Goëthe's theory)—the Morning after the Deluge, Moses writing the Book of Genesis,' J. M. W. TURNER. Each successive year brings forth some production by this once eminent artist more absurd than the preceding; to what his insane stars will ultimately lead him it is impossible to say. Amid a reduction of "Goëthe's theory," bright with all the unalloyed wealth of the palette, sits a figure in the clouds, from which a serpent is falling. Mr. Turner may fancy himself in a position to make any experiment he pleases upon the good nature of his friends—and we know full well that there are persons who would laud anything he did—but he is fast losing the suffrages of the sensible part of the community, who never themselves do anything without a reason, and expect others to be able to plead a sufficient cause for what they do. No vindication of such pictures as this can be brought forward, nor can the ardent admirers of such works say in what consists their real value. To the artist himself we would offer the advice given by *Falstaff* to *Pistol*, and entreat him to discourse to us like a man of this world.

No. 386. 'The Visit of the Village Pastor to a Reduced Family,' T. F. MARSHALL. There is much here that is well intended, but the whole is feeble in character and coarse in execution.

No. 388. 'Hayes Common, Kent—Study from Nature,' W. F. WITHERINGTON, R.A. Valuable for the success with which the perspective of the Common is given, but by no means comparable with the figure pictures of this artist.

No. 389. 'Flemish Courtship,' W. ETTY, R.A. This is a subject of a complexion very different from those generally treated by this gentleman. A *Flamande* is leaning on a copper water pitcher, and so receiving the proposal of her *Flamand*, a youth wearing a *bonnet rouge* on a head very picturesque. But the charm of this picture centres in the head of the woman, which is coquettishly set off by a high lace cap with long ears; her head is marked by an originality rarely met with.

No. 396. 'Portrait of Mrs. W. Jackson, Birkenhead,' T. H. ILLIDGE. A lady, drawn full length, in black velvet. There are few portraits in the Exhibition more *soundly* painted. The figure is gracefully, and without effort at attitude or affectation, introduced into a brilliant landscape, standing on the steps of a magnificent mansion, the lordly entrance to a baronial hall. The flesh-tones are remarkably true, and the dresses and draperies are admirably wrought. We have, indeed, seldom seen velvet more accurately copied. The work is calculated to do the painter much service, at a time when competition in a most profitable branch of the Arts is as eager and zealous as it is honourable.

No. 397. 'The Fortune-Hunter,' R. REDGRAVE, A.

"Neglects a love on pure affection built
For vain indifference, if but double-gilt."

The scene is in the hands of three persons, who enact to admiration the parts committed to them, as to the immediate business, though the detail of the narrative appears to us somewhat ambiguous. It would appear that the fortune-hunter pays a visit to a lady really attached to him, and at the same time addresses earnestly, and *sub rosá*, another possessed of more property. All this takes place in a room wherein the neglected one sits within a screen, on the other side of which she hears her faithless lover kissing the hand of her rival. Without the hint from the title, the scene must fall to the level of a simple love-affair, overheard from within the screen, for there is nothing to tell of the fortune-hunter. The figures are admirably drawn and dressed, and the painful agitation and uneasiness of the lady within the screen is inimitably set forth.

No. 398. 'Watering Cattle,' E. WILLIAMS. A wooded landscape, with water, cows, and a broken foreground. The trees are painted with great firmness of touch; but they are assuredly among the most difficult objects in nature to paint well, since imperfections in their structure are so obvious and offensive. There is a deficiency here of intermediate gradations, and the colour is crude.

No. 407. 'Portrait of Mrs. Gurwood,' A. MORTON. The lady is seated, and painted at half length. The execution of the head is of the highest order of this class of Art, but the

bust and person are *gigantesque*; and so conspicuous is the disproportion as to be a real defect.

No. 409. 'View in the Medway,' C. STANFIELD, R.A. Be it as it may, this view in our own land comes to the heart more warmly than even the sunniest prospects in classic Italy. The picture consists of nothing—nothing at all, except a few hulks, a boat, a brig, and the everfretting waters of the estuary; but with what surpassing beauty of effect are these simple elements combined! We are placed, as it were, upon the water; look into it and feel its motion. This is *ne plus ultra* of marine painting.

No. 410. 'A Scene from the Heart of Mid Lothian,' A. FRASER. The impersonations are those of Butler, old Deans, and his daughter, and the scene of the colloquy, the house of Douce Davie. It illustrates one of the passages of deep pathos so abundant in this novel; but the artist has recourse rather to action than to the countenance, for the expression of emotion. The composition of the picture is unobjectionable, and the light passing in at the window and falling on the figures contributes to their value; but there is in the whole an affectation of looseness of manner, and a contempt of colour, which detract considerably from the merit of the performance.

No. 412. 'Evening,' T. CRESWICK, A. In this work the artist has been less careful of finish than in other works on these walls; he here relaxes the stringent observances peculiar to his works, and we think detrimentally to the picture : but in effect it is equal to the best things he has ever done ; the near parts of the landscape are filled by a river and its banks, from the more distant of which rises a group of trees brought forward by the fading light of the western sky, for the sun has recently sunk below the horizon. It is in the foliage that we cannot well spare the touch, which, although individualizing the leaves has at the same time reconciled them in swaying masses of light and shadow; albeit, however different in execution, we acknowledge the sentiment of the work, which comes home in full force to all who have any perception of the beautiful in the varying phases of nature.

No. 413. 'Interior of an Irish Cottage,' N. CONDY. A very clever and accurate copy of one of the "bettermost" Irish cottages. The furniture and *et-ceteras* have been carefully considered and skilfully introduced.

No. 414. 'Low Water on the Coast near Scarborough,' A. CLINT. A beach view, with the cliffs occupying the right of the picture; this feature of the composition, with its irregularities, is carried into the distance with a fine perspective effect. The shore is shingly, and relieved by water left by the receding tide. There is breadth in the picture as a whole, but too much pains has been bestowed on strewing the foreground with pebbles and bowlders, which displease the eye as much as they would fret the foot. It is necessary to express this, but it should be done in a manner much less positive.

No. 415. 'Market Figures crossing a Ford,' F. R. LEE, R.A. An unqualified daylight scene wherein everything is represented with local colour. The life of the picture lies in a party fording a brook in their cart as returning from market. The water is crossed by a rude bridge, beyond which rise some lofty trees with leaves yet young in colour. Upon these trees the brush has fallen with a full and free touch, perfectly describing the manifold richness of leaf over leaf. In this valuable picture the best traits of the accomplished artist are discoverable; but in the water there is an apparent rapidity of current which would have justified its being a little more broken on the surface.

No. 416. 'Scene from Molière,' C. R. LESLIE, R.A. The scenes painted by this artist from the French drama possess the extraordinary merit of being real life pictures, rather than enacted colloquies. He translates the drama into actual life, while so many of our painters carry sober realities to the *outrance* of stage effect. This is the famous scene wherein M. Purgon leaves his patient to the merciless course of a list of evils, sufficient to destroy a frame of cast-iron. The figures are four, the principal of whom are the *malade* and his physician, who is quitting the room with the words, " J'ai à vous dire que je vous abandonne à votre mauvaise constitution, à l'intempérie de vos entrailles, à la féculence de vos humeurs." M. Purgon is an incomparable epigram in the characteristics of the peculiars of his class at the period supposed. He is exquisitely dressed, and the bitter denunciation of his look says more than is expressed in the text. He speaks, through Leslie, in a strain of irate emotion, more deep than through Molière. The eye, and the lip, and the bursting fury of the manner say more than the written words. The patient seems already overwhelmed by the catalogue of diseases to which he is resigned ; his look is powerfully deprecative of the doctor's wrath. Toinette stands behind his chair, and her phrase, " C'est fort bien fait," is outdone by her countenance ; indeed, the picture is one entirely of character, and in the spirit in which it is painted has been very rarely equalled, and never surpassed.

No. 417. 'The Children of Lord Clinton,' Mrs. J. ROBERTSON. We do not remember to have before observed a picture so large by this lady. It comprehends portraits of a numerous family of children, who are disposed with the best effect in a richly-furnished room. This is a work whereon very great labour has been bestowed, with the happiest results ; indeed, a work of such power as to challenge comparison with the best of its class. The various ages of the children are accompanied by most appropriate character—generally a remarkable deficiency in infantine portraiture.

WEST ROOM.

No. 423. 'Solomon Eagle exhorting the People to Repentance, during the Plague of the Year 1665,' P. F. POOLE. All who have been acquainted with the style of the author of this extraordinary work cannot help expressing astonishment at a vast and sudden display of power, for which they had not been prepared by any previous announcement. It is a large picture, in which is summed up, in epitome, all the horrors of the direst virulence of the pestilence. It refers immediately to Defoe: Solomon Eagle is, of course, the principal figure; he stands naked in the middle of the picture, preaching, with a pan of burning charcoal on his head. The expression of his countenance is carried beyond the maniacal, it is almost demoniacal, but it is tempered by relief from other parts of the figure, declaring the spirit to be vehemence of language and not violence of action. There is one circumstance, however, in the management of this figure injurious to the composition—he is preaching, not so much to those around him, as to the spectator; and is thus independent of the rest of the composition. The artist has read Defoe to good purpose, and somewhat too painfully followed him; his picture is, accordingly, brimful of the horrors of the time he has chosen to illustrate. The *locale* seems the door of a public-house, where are seated some of the reckless roysters, who betook themselves to the most desperate excesses even while their friends were dropping around them; one of these falls dead with the cards in his hand. On the right of the picture a corpse is let down from a window; and, on the left, a woman, raving mad, is rushing into the street, in almost a state of nudity; look where you may on the canvas, it is rife with allusion to the pestilence; in its beginning, its progress, its crisis, and results, nowhere is there any help save to a loathsome grave, and nowhere any consolation; for Eagle himself speaks rather of despair than hope. Of all who see this picture not one will call it beautiful, but all must acknowledge it a wonderful work of Art; it is one of those which sink deep into the memory—an unerring evidence in favour of works of Art. It is peculiar, we may say original, in style, but, on examination, we can detect, in the handling, the known manner of the artist. We cannot, at a moment, remember any other work similar in feeling and execution to compare with it, save the 'Wreck of the Medusa;' we can offer the artist no higher praise. The exhibition of this work forms, indeed, an epoch in the Arts. It is not too much to say that no work, produced in our time, has so *suddenly* arrested our admiration—so suddenly elevated its producer from a comparatively humble station to the very foremost rank in his profession. The picture is one for which we challenge competition, among all the schools of Europe. Mr. Poole must be hereafter classed among the great artists of the age and country.

No. 421. 'The Death,' R. ANSDELL. A noble stag has here been overtaken by the dogs just as he was about to take to the water; he is in a shallow, surrounded by the dogs, which are fastening on him. The picture is very large, cold in tone, and appears too much cut up for agreeable effect. Yet it is evidently *true;* the actual transcript of a veritable scene.

No. 422. 'Portraits of Mrs. H. J. Johnston and Child,' J. WOOD. The lady is dressed in maroon velvet, seated, and holds the child; both are substantial, round, and lifelike. It is a brilliant and unaffected work, the object of the artist having been substance and animation, and in this he has amply succeeded.

No. 425. 'Miss Herbert,' Mrs. J. ROBERTSON. This is a miniature in oil; one of those charming little works which have acquired for the lady a reputation so extensive. The figure is full length, and has just descended some stairs. The movement is graceful to the highest degree; the face and neck are broad in manner, but yet equal in finish to an ivory miniature. The dress is white satin, painted in most perfect imitation of the material. — No. 426. 'The Baroness Lionel de Rothschild and Children' is by the same lady, and in the same style. There are many figures in this inimitable composition—the principal, that of a lady dressed in blue velvet, surrounded by children, and an infant in a cradle near her. The beauty of these valuable miniatures is much heightened by the manner of circumstancing the figures—these, for instance, being in a room, the rich and elegant furniture of which is disposed and detailed with infinite address.

No. 427. 'Portrait of Ambrose Hussay, Esq., High Sheriff of the County of Wilts, 1841,' Mrs. W. CARPENTER. A full-length portrait of a gentleman in a court-dress, but treated with so much graceful simplicity as to counteract all ceremony and stiffness. The importance of the figure is somewhat diminished by the large folds of the curtain behind; the style, however, of the work is such as many professors of the other sex might imitate with advantage.

No. 432. 'Shrimpers and Mentors on the Sands of St. Michael, Normandy,' E. W. COOKE. An extensive plain of sand is opened before us, here and there diversified with stagnant pools left by the tide. We see in the distance the famous Mont St. Michel breaking the line of the horizon. The figures in the lower part of the canvas are some shrimpers, and a man upon horseback: a grey horse, to which this artist seems as much attached as Wouvermans. This composition, as far as it goes, is the best we have ever seen by this artist, who has here remedied many of the defects we have observed in preceding works; it is indeed a view of a high degree of merit.

No. 447. 'Cleopatra,' Mrs. W. CARPENTER. She is recumbent on a couch, and supported by cushions; a Nubian slave stands by her, hold-

ing a nautilus shell mounted as a drinking-cup. The drawing of the figure is skilful, and in character it is markedly coincident with his-torical truth.

No. 449. 'Portrait of Mrs. Coningham,' J. LINNELL. The simplicity of this gentleman's portraits approaches, perhaps, a little too near the homely. This, however, "simple though it be," is a beautiful work, and one of the best in colour we have ever seen from his pencil.

No. 452. 'The Finishing Touch,' R. FARRIER. A lady of a certain age attired in the manner of the latter part of the last century, is applying "the finishing touch" of carmine before a look-ing-glass, previously to joining some friends who are waiting for her in an adjoining room. This is a very pointed satire, extremely well rounded off in composition, and most carefully followed out in the painting.

No. 453. 'The Church of Stamford-on-Avon, Warwickshire,' D. ROBERTS, R.A. The simple interior of an English country church, coloured with all the sweetness which constitutes a main beauty in the works of this celebrated painter, under whose hand the most commonplace elements become highly picturesque. There are ancient monuments in the church, and abundance of stained glass, which has its full value in contrast with the plainness of the architecture.

No. 456. 'The Gamekeeper's Lodge,' J. STARK. The lodge is an unimportant feature of the picture, the principal objects of which are some fine oaks and birch trees, surrounded by scenery much like that of Windsor Park. Every care has been exercised to give distinc-tive character to the trees, and with the best result, but a defect in the work is its want of fresh and cool colour.

No. 457. 'A Girl of Sorrento Spinning,' W. COLLINS, R.A. She stands on a terrace hold-ing some flax, which, with the aid of her knee, she is twisting into thread; the same method practised by the earliest generations of man-kind. She looks sufficiently Italian, and the landscape is Italian, pointing at once to a nationality without any broad and vulgar sugges tion — so often deemed necessary to instruct the spectator. The landscape, after the manner of the artist, is put in with un-qualified local colour.

No. 459. 'Jaques and the Wounded Deer,' C. STONHOUSE. This is too tame for the pri-meval aspect of the scenery befitting the sub-ject. The trees here seem to have been planted, and the water to be artificial. The dark me-tallic green hue of the foliage is such as is never seen in the generous colour of forest trees. Brughel and others afford examples of this, but such eccentricities are not to be followed. "Nous avons changé tout cela, nous autres— et tant mieux."

No. 462. 'The Smuggler's Retreat,' J. HAR-WOOD. There is not enough here to constitute a retreat, the smuggler himself filling the can-

vas; the picture is high; the detail is, there-fore, not visible, but the colour appears brilliant.

No. 463. A. ELMORE. The narrative here relates to the future, and points to the past. A young monk, recently pro-fessed, is seated at the door of his convent, while his former companions are seen at a short distance in full enjoyment of their favourite relaxations; there is a deep senti-ment in the history, but, from the position of the picture, it is difficult to speak of the manner of its execution. That it is good, how-ever, we have no doubt; for the artist mani-fested considerable ability prior to his visit to Italy, where he has passed two or three years; and, from some examples recently exhibited at the British Institution, we are justified in considering that his time has not been ill spent. He sends but one picture to the Royal Academy, and that picture should cer-tainly have been better hung. It is sadly dis-heartening to a young artist, after years of anxious toil and anxious hope, to find that, as far as the constituted judges are concerned, his hopes blighted and his toil of none avail. Mr. Elmore will, nevertheless, get over this barrier in his way, grievous and injurious though it be.

No. 464. 'Italian Bowlers—scene in the Court-yard of an Osteria,' R. M'INNES. This is a large picture, comprehending many figures, which, together with the scene of action, are characteristic of the country and the class of men among whom bowling is a favourite amusement; the whole is, undoubtedly, very near to the life, but the work is cut up by un-meaning shadows, so harsh and positive as to be spots in the picture.

No. 465. 'Portrait of the late Sir John Jacob Buxton, Bart.,' H. P. BRIGGS, R.A. Marked by the breadth and firmness of this gentleman's usual manner, but we observe generally, in those portraits, that the studied roundness of the head is never carried into the figure: this is an error of practice so inveterate, that sometimes likeness in the other parts of the person is entirely overlooked.

No. 467. 'Pal Al, or Scotch Hop,' J. E. LAUDER. Some children are assembled before the door of a cottage, amusing themselves with this game, which is too well known to require description here; other figures stand near, adult and aged, variously disposed; all drawn with extreme force and perfect accuracy, and painted with a corresponding power. Colour is sparingly used; the effect, however, of the work would not be injured by this, but that it is too flat in general colour, and much weakened by the manner of painting the distant trees.

No. 468. 'Going to Service,' R. REDGRAVE, A.R.A. Great ingenuity has been exerted to render the story perfect; every part of the canvas contains some allusion to the main incident, thrown in so judiciously as to ap-

pear in the proper place. A girl is about to leave her home in the country to proceed to town, to a place procured for her at Lady Fashion's, somewhere at the west-end; and her mother, an invalid, gives her excellent advice touching the temptations to which she is about to be exposed, while her younger sister takes leave with tears. Effective narrative and delineative truth have been the artist's principal view here, and his purpose is perfectly answered. Each of the figures sustains perfectly the part allotted to it, without the slightest impertinence to interrupt the smooth currency of the history.

No. 470. ' Tintern Abbey — Evening,' H. JUTSUM. The materials of this composition are such as we find in the simplest water-colour drawings. The river is a principal object in the picture: on the right bank of it is seen the ruins of Tintern among trees, and thrown into shadow. Upon the right of the picture are some trees put in with a firm and full pencil; and on the left a portion of the foreground lighted into rich and warm colour. This artist gives an excellent account of the locality. The work is executed with a sweetness rarely surpassed.

No. 471. ' Sorrento, Bay of Naples,' W. LINTON. We view the sea from a terrace; it lies below in deep shadow, which extends too positively to the houses on the right of the picture. Vesuvius appears in the distance, which is rendered with a soft and aerial effect.

No. 472. ' Waterfall at St. Nighton's Keive, near Tintagel, Cornwall,' D. MACLISE, R.A. Notwithstanding the title, the substance of the picture is a female figure—a maiden crossing a rocky and rapid current, carrying on her head a brown pitcher of water. On the right of the composition is the cascade, falling from precipices which seem to enclose the water-bearer. Nothing can exceed the beauty of drawing, painting, and expression, shown by the figure; but, unless it be a portrait thus romantically circumstanced, the dress is by no means in character with the vocation and the condition of life to which the damsel should belong. The dress, arranged in every fold to a nicety, and the style of presence, are those of a maiden of condition rusticating for amusement. The gushing current, the stones, and impending banks, are inimitably drawn, as is also the whining and dripping-wet dog, the faithful *poursuivant* of her infirm footsteps.

No. 473. ' Portrait of Robert Bald, Esq., F.R.S.E., &c.,' J. W. GORDON, A.R.A. In this excellent work the universal dark or red-curtain background is rejected for a plain light background, by which the figure is skilfully relieved. He is seated in a plain chair, and holds a letter. The head is among the very best that have of late years been produced: it is round, full; and the features, full of the glow of life, express a consciousness of your presence.

No. 474. ' An old Pollard,' A. PRIEST. The venerable and failing tree is apparently a willow, decaying by the side of a river, overshadowed by foliage, against which it is made to tell too conspicuously; but the work is too high for closer inspection.

No. 478. ' Digby Cayley, Esq.,' B. R. FAULKENER. A three-quarter length portrait, standing with, what seems to be, a plaid thrown over the arm. The figure is endowed with an easy movement, extremely difficult of expression in portraiture, wherein there is so much that is conventional, that, after the acquisition of a certain degree of practical facility, artists, solely occupied in the production of portraits, paint little more than the heads of their sitters, and, for the rest, depend on experience.

No 481. ' Portrait of Mrs. W. W. Ogbourne,' J. LUCAS. The lady is leaning upon a stone balustrade, in a position perfectly natural. The arms and hands are finely drawn, and the whole is easy and unaffected.

No. 483. ' Interior of the Cathedral at Pisa, with the Lamp, the oscillations of which are said to have suggested to Galileo the idea of the measurement of time by the Pendulum; he is supposed to be contemplating its movement,' S. A. HART, R.A. An interior, extremely insipid, from being nearly all white. The very large bronze lamp hangs in the middle, and Galileo stands below. But little, at best, could be made of the subject, and even here there is nothing suggestive of the supposed incident.

No. 485. ' The Sailor, engaged to Marry after his next Voyage, returns with a Sickness that carries him to his Grave,' T. UWINS, R.A.

"Still long she nursed him: tender thoughts meantime
Were interchanged, and hopes and views sublime,—
To her he came to die."

The subject is derived from Crabbe's " Borough," and the feeling of the lines has been faithfully transferred to the canvas. The scene is a cottage interior, presented in the subdued effect of half light. The dying sailor is seated on a chair, and beside him kneels his betrothed, grasping his hand in an agony of despair on beholding his eye becoming fixed in death. The artist has felt the full force of the description. We read Crabbe's story in the picture, which has, within it, the point that renders all description beyond unnecessary. It is a most beautiful, although a most painful, picture.

No. 499. ' Portrait of Mrs. Romeo Coates, lady of R. Coates, Esq.,' H. LILLEY. This is a full-length, and is a fine style of female portrait, though the artist has communicated to his figure a movement too epic to set the spectator at ease with her. The work has been designed and executed in the best manner, save the background, which looks artificial, but yet is well adapted to throw out the figure.

No. 501. ' The Castle and Village of Ehrenburg, near the Moselle,' C. DEANE. The lower part of the canvas is filled by some houses of the village, picturesque in some degree, as is the greater part of the domestic architecture

in the district where the scene lies; beyond these, at a little distance, rises the castle, but it is thrown in, in a manner fatally cold and opaque. Much more assuredly might have been made of the view; the near houses are hard and inharmonious in colour, and the eye ought to have been conducted to and from the buildings on both sides by some connecting objects.

No. 502. 'An Incident in the Life of Napoleon,' G. HARVEY. The canvas here speaks out and at once; the story is definite and intelligible. The anecdote is given in the catalogue, but it is superfluous. The scene is one on which a battle has been fought; it is a moonlight night, and Napoleon, accompanied only by one or two of his staff, passing near a body, alarmed the faithful dog watching by his dead master, which is represented as growling in defiance at Napoleon. The subject is powerfully handled, but the picture is badly coloured, although the effect is good; and this was equally attainable with colour of greater truth and purity.

No. 504. 'A Moorish Girl.' A. GEDDES, A.R.A. A life-sized head and bust, but distinguishable as Moorish in nothing except colour. The features are such as we see daily, and might be afforded by an ordinary model.

No. 505. 'The Infant Moses and his Mother,' W. ETTY, R.A. There is little of sentiment or remote allusion in this picture; it describes a simple act, the exposure of the child by his mother, who is yet stooping over him, as lying before her. The work is in fact a study of a woman stooping, painted in the average manner of the author.

No. 506. 'The Gipsy Camp,' H. J. BODDING-TON. They are encamped in a lane, and have chosen the shade of some overhanging oaks, whereof the picture is mainly constituted. This work evinces great improvement in the style of the artist; it is throughout harmoniously coloured, and the trees are successful in imitation of nature.

No. 507. 'Portrait of William Sharman Crawford, Esq., M.P.,' J. P. KNIGHT, A. This portrait is powerful and effective; every part is firmly painted.

No. 508. 'The Supper at Emmaus,' J. LINNELL. In this frequently-painted subject, the moment chosen is that of breaking the bread: here also it is the point of time selected. The Saviour is seated between the two to whom he offers the bread, at which instant their eyes are opened; he is seated with his back to the remaining light in the sky, the day being far spent; but these circumstances scarcely justify the very positive shadow thrown over the features, the purpose of which is not sufficiently evident: if it have only reference to the opposing light, it is too heavy; if it be otherwise intended, the distinction between the Saviour and the other figures is, with respect to substance, not sufficiently made out. The work is the result of deep feeling, and the recognition by Cleopas and the other is pointedly told.

No. 512. 'Portrait of Miss Revel,' J. G. MIDDLETON. This is a portrait that would acquire distinction, even among many of much higher pretensions; the head is a charming study, and the entire figure is richly endowed with feminine grace.{

No. 513. 'Gipsies Reposing,' J. HAYES. This is more like a party rusticating, *à la Bohemienne*, than veritable gipsies. However well a picture may be executed, such a departure from truth is at once destructive of its principal interest. The subject is by no means adapted for a picture so large. The artist would succeed better on a smaller scale.

No. 516. 'Angelica descending to the Earth from the Flying Horse, after she had been rescued by Ruggiero from being devoured by the Sea Monster,' J. SEVERN. In painting poetry, it is not a mere literal reduction from the text that we look for; the artist must essay to catch the inspiration of the poet, otherwise his picture is a mere inanimate production. The subject of this work is from Ariosto, but it is too literally read from the poem. There is in the composition everything that ought to be there, but the whole comes forward with a propriety tediously prosaic. Ruggiero is setting down Angelica, a naked figure, very like the Venus. This, *in se*, may be no fault; but all similar reminiscences should be studiously avoided. The classic grace, severe truth, and exceeding purity of Mr. Severn are universally admitted; they are unfortunately qualities far too rare in modern Art, and it may be that we do unwisely in seeming to censure a system we would fain see more general; but a little more study of nature may be most serviceable added to a thorough knowledge of Art.

No. 518. 'Watering Cattle—Evening,' T. S. COOPER. This picture is painted with all the sweetness of the earlier works of the artist, and combines some of the best qualities of the English and Dutch schools; many of the defects of which we have had to complain are here remedied: the sky is pure, airy, and bright; and the foreground colours are relieved of a certain heaviness observable in preceding pictures. It consists of a few cows, some water, and a willow-tree, all charmingly described. In the last there prevails, however, too much sharpness of touch.

No. 519. 'The Lady Margaret Lyttleton,' F. GRANT, A. A small full-length, the lady being seated on a bank beneath a tree. She is habited in white, and in a manner extremely simple. We cannot speak too highly of this little portrait: it is purely national in style; strongly so; and, in its approach to the sweetness of Reynolds, will stand a comparison with the best works of its class.

No. 520. 'Tintagel Castle, the Birthplace of Arthur,' W. COLLINGWOOD. A rocky nook in an iron-bound coast, with the castle in the distance. A storm is here attempted, with a sea breaking furiously against the cliffs; but in effect and in manner it would be dif-

ficult to point out a more signal failure. It is matter of extreme surprise that such pictures should at all be received, and, having been admitted, should be exposed in places so favourable as this occupies.

No. 523. 'Portrait of John Wilson, Esq., Professor of Moral Philosophy, Edinburgh,' R. S. Lauder. Years ago, Christopher North (*splendide mendax*) told us of his growing infirmities, but he seems suddenly grown green again—" *neque viget quicquam simile aut secundum.*" That long hair becomes him, but by no means that austerity of countenance, which is a misconstruction on the part of the artist, who otherwise has done his sitter ample justice, and carried the portrait even to a picture. He looks too much in the mood to criticise—pray heaven he had no book of ours before him when to the eye of the painter he looked thus ! Yet it will not be difficult to perceive how completely that stern brow might unbend, and the young, generous, and kindly heart of the great critic shine upon it.

Not 530. 'Mrs. Strutt and Child,' F. Grant, A. A small portrait, with the figure at full length, seated on a bank and under a tree, the child standing by the lady. In feeling and execution this is so much like the other small portrait already spoken of, as apparently to form a pendant to it. It is even more beautiful than the other : the background is free, but incomparably coloured and wrought.

No. 531. 'On Derwent Water, looking towards Borrowdale,' W. J. Blacklock. Lake scenery, with portions of it tolerably painted ; but there are in the foreground two trees dotted into the picture in a manner extremely offensive to the eye ; they are comparable to nothing in nature : the object is *nicety* and a clean touch ; but if nature and breadth be not substituted, works brought forward in such a style can bear no value.

No. 533. 'On the River Lynn, North Devon,' P. W. Elen. A close wooded subject. The distant hills are shown with creditable feeling, and the trees of the middle of the picture are effective ; but the rocks in the foreground are painted up to be spots in the picture. It is most strange that in compositions formed of similar materials the like error is so often observable.

No. 534. 'The Last Appeal,' F. Stone. One of those gentle subjects so full of the graceful sentiment, in picturing which, the artist is so distinguished. The chaste propriety which marks every part of this work is beyond all praise. The story of the picture is told with a truth and judgment that we have seldom seen surpassed : the youth has been rejected more than once ; the rejection has eaten into his heart ; the passion has entwined itself with his existence, grown with his growth, strengthened with his strength ; his worn and anxious face contrasts with the full, soft, and (but for a time) melancholy features of the girl, who has not jilted or coquetted, but cannot love him :

she has told him so frequently, but he has hoped and despaired so often, that he ventured to hope once more. His dress bespeaks him a student ; a poet certainly, for love and poetry are one ; there is intense feeling and power in his agitated features ; and she is sorry, very sorry, but she cannot give him her heart, and is too simple and too pure to give her hand without it. We congratulate Mr. Stone on another triumph ; the conception and execution of this picture are most admirable—touching, and full of the best expression ; reading a page of life and character, and most emphatically telling a story.

No. 535. 'Portrait of Mrs. Cuppage,' R. Rothwell. The female portraits of this gentleman are distinguished by the intensity with which the laughing eyes look out of the shadow to which he usually consigns them. A smile plays upon this face, but it is piquant and graceful, not insipid and vulgar. The artist attaches himself but little to conventionalities ; we would gladly say the same of others.

No. 536. * * * W. Bowness—
" The course of true love never did run smooth."
A picture which may mean anything within the catalogue of human misery. A girl is sitting in a very desponding situation ; the figure is round and comes well forward, but there is much bad drawing, which is especially conspicuous in the arms.

No. 539. 'Pont d'Ai, Val d'Aoste,' J. D. Harding. That this is a beautiful picture is sufficiently evident, notwithstanding the height at which it is placed : this cannot be accidental, and is therefore the more to be lamented. The composition is rich, with the most picturesque mountain scenery. Down the valley a stream toils onward, overhung by cliffs and impeded by rocks, offering many points of beauty, on which the artist has dwelt with the best effect. The detail of the work it is impossible to discern, but its high merits ought to have gained it a lower place : we feel no hesitation in again most decidedly complaining of this injustice exercised towards one of the most accomplished landscape-painters of the country, and one of the most exquisite pictures in the collection. If the indignity were designed as a hint to Mr. Harding that his attempt to compete with artists in oils is to be disputed by other means than contrast, the attempt will fail. He has mettle not to be crushed by a blow or two from weapons in hands to which circumstances give only a temporary power.

No. 540. 'Portrait of Mrs. John Charretie,' J. P. Knight, A. The face is so treated as to convey to the spectator the idea that the lady labours under a slight degree of alarm.

No. 541. 'Christ stilleth the Tempest,' J. Martin. A great proportion of the canvas is occupied by a raging sea, bounded by a shore of rugged cliffs, beyond which is seen the city. Around the boat, containing Jesus and his Disciples, the sea has risen so high as to extinguish

all probability of a vessel living in it five minutes : this may be done the better to show the miracle, but it could have been equally well done consistently with natural truth. The colour of the water is opaque, unnatural, and laid on in sweeping lines. It is impossible to imagine water rolling in such huge billows in a space so confined ; it is also difficult to suppose such a difference between the boat and the vastness of these whelming waves.

No. 543. ' The Old Romance,' T. CRANE. Two ladies seated on a garden terrace, the one reading to the other the romance. It is a work of high merit ; great skill is displayed, especially in the lower figure seated on the broad stone pavement. The costume is of the latter part of the last century ; the colour of the dress of the lady who is listening is heavy to a degree ; the picture otherwise is of a most pleasing character.

No. 546. ' Scenery near Crediton, Devonshire,' F. R. LEE, R.A. Assuredly the productions of this very accomplished painter do him infinite honour. The beauty of this picture is not to be surpassed : it is legitimately national in everything ; it is constituted of native scenery, painted in the sweetest style born of our own school. The canvas is rather large, and very full of objects. From the nearest part of the picture a road winds downward till lost among the trees below, beyond which we have an extensive view over a various tract of country ranging to extreme distance, where objects are superseded by atmospheric depth. The utmost strength of colour is lavished upon every part of the picture, but so skilfully is it diversified, that the sweetest accord is everywhere prevalent.

No. 547. ' Prayers in the Desert,' W. MULLER. The largest figure picture we have yet seen, as resulting from this gentleman's wanderings in the East. The story of the devotion of these Mussulmauns is most impressively told : it is early morning—the desert is around them, and they have spread their mat and set themselves toward the East, bowed in prayer ; the sky is dark behind them, for the gloom of night still lingers in the West. The Osmanli never buy pictures : it is contrary to the dictates of the Koran ; but should this state of things ever change, this would be one of the first a Mussulmaun would seek to possess. Some of the figures stand, others kneel, and some are cast upon the earth ; but in all the earnestness of devotion is exquisitely painted. The picture is very beautiful, touching, and effective. It will add to the fame by which the zeal, industry, and genius of the painter have been already rewarded.

No. 548. ' The Return of the Prodigal Son,' W. SIMSON. The prodigal son is received by his father at the threshold of his home, which, contrary to truth, seems to be built like a Greek temple. It was customary in earlier times to give domestic architecture in scriptural subjects a classic character, an error which has found its way into works of the present day, by artists who will not think for themselves. Two simple figures are not enough to describe the reception of the prodigal son ; the rehearsal is imperfect without allusion to the festivity by which the event was celebrated.

No. 549. ' Portrait of a Young Lady,' R. R. REINAGLE, R.A. An unaffected portrait, carefully painted in the draperies. With respect to the eyes, the likeness may have required the light touches which make them so prominent, and communicate to them an appearance of alarm. The left hand is raised, the wrist of which has in some degree the semblance of being broken.

No. 550. ' An Italian Boy with Guinea-pigs,' H. PICKERSGILL. This is called a village scene. The boy carries before him the accustomed box, containing his exhibition, which has attracted the curiosity of some of the village children : near him stands a group of girls, one of whom carries a basket of linen on her head. These figures are effectively disposed, and stand in perfect relation with each other. Of the *Italian* boy, it may be observed that he is too English : he is not sufficiently distinguished from those around him.

No. 553. ' The Poor Teacher.' R. REDGRAVE. A. The profound sensibility thrown into this figure must render it a theme of applause with all who see it. "The poor teacher" seems to be an orphan of parents who have moved in a superior circle of society. She is seated in the school-room, the theatre of her drudgery, and near her stands a cup of tea and a spare slice of bread and butter. There is in her downcast countenance a burthen of melancholy, resulting from a sinking of the heart ; and her pale countenance and attenuated hands proclaim a frame already the prey of disease. This is one of the " aside" passages in the melodrama of every-day life, but it is not the less deep and moving. Like the genius of the Eastern tale, who dived even to the centre of the earth for its most precious gems, this artist searches the human heart for its most touching moods. Rarely do we find a picture, at all tolerable, so simple and so unaided by accessories ; this, however, is one which has been so richly inwrought with the purest alloy, that its peculiar value must remain undiminished, to what comparisons soever it may be subjected.

No. 554. ' St. Benedetto looking towards Fusina,' J. M. W. TURNER, R.A. When it is said that this is one of the Italian views of this artist, its composition may at once be understood : a canal occupying nearly the breadth of the canvas, a few gondolas, distant buildings, and the sun at an elevation of forty-five degrees. This painter was precocious, and the fruits of his early autumn have been gathered, and he seems accordingly to be in the dotage of his art before his *physique* shows its weight of years. Now, this picture, in its mere effect, is very beautiful : but it

exhibits, *passim passimque*, that lofty contempt of moderate finish which destroys all good intelligence between the artist and the spectator. It was in this class of subject that Mr. Turner, some years since, produced inimitable pictures, near which his latest productions are not worthy of being seen.

No. 556. 'Portrait of the Right Honourable Lord Plunket (late Chancellor of Ireland),' R. Rothwell. The head, itself a striking subject, is among the most beautiful we have ever seen in colour and execution; indeed the artist seems to have walked long with Anthony Vandyke, and not in vain has he sat under his mantle. Time will mellow this study into charming harmony of tones.

No. 557. 'Florimel in the Cottage of the Witch,' F. R. Pickersgill. Florimel is seated on the floor, as are also the Witch and her son, who asks his mother respecting Florimel. The subject is from the "Faerie Queen," and the artist has laboriously confined himself to a statement of this simple fact, which he does broadly enough. There is too little of the poetry of Spenser in the work—too much of daily association. The substantial manner in which the figures are put in, and the force with which their observations are directed to Florimel, together with all absence of poetical feeling, show the artist better qualified for strong prose than poetry.

No. 559. 'Portrait of Copley Fielding, Esq.,' W. Boxall. A small portrait, but exquisite in management and execution. The figure is thin, and the hair gray; he is seated with a sketch before him.

No. 561. 'Festival of Bacchus,' E. V. Rippingille. In this highly classical composition the simplicity of mythological worship and the innocence of ancient pastoral life are amply illustrated. The canvas is covered with figures, but unfortunately the picture is too high to admit of an examination of the jealous nicety with which every object seems to be made out. The mere gathering of the materials for such a work is an immense tax upon the most fertile imagination, and, having procured them, their adaptation is an exercise for the most patient ingenuity. In the centre of the picture is an icon of the bifronted Bacchus, around which are assembled those immediately engaged in the orgies. The most conspicuously beautiful group is formed by three virgins, kneeling while offering the primitial wine, in what seem to be *pateræ* of opal; the grace, beauty, and originality of these figures are beyond all praise. On their right are some *fistulatores*, blowing amain in honour of the deity; and on the left some philosophers discussing the humanities, while observing the gambols of some sportive children. The picture abounds with passages of the utmost beauty, and every part of it supplies evidence of intense study, and declares its author gifted with a mind fraught with the richest imagery.

No. 562. 'Italy,' W. D. Kennedy. This is a very large work, consisting of a principal compartment with two wings. Italy here is modern every-day Italy, done up into a *festa* held in the open air by some peasantry. The artist has very injudiciously accompanied his title by the lines from Byron

———— "Italy's a pleasant place to me,
Who love to see the sun shine every day;
And vines, not nailed to walls, from tree to tree
Festooned, much like the back scene of a play," &c.

This, we say, is injudicious, because the spirit of the picture is not the spirit of the verse. Some of the figures are well drawn, but the colour and shadows are highly objectionable. Take, for instance, the woman dancing. There is no shadow on that portion of her legs seen below the dress; again, the carnation of the man with whom she dances is anything but like nature: in short, the style resembles that of some of those flat and ill-coloured frescoes that abound in every part of Italy. The subject is not adapted for so large a canvas; had it been drawn on a small scale, and well coloured and finished, it would have made, with some modifications, an agreeable production. The picture, then, we consider a failure; not so much from want of talent in the artist as from his having taken up a set of false principles. The figures seem cut out of pasteboard, without light and shade, colour or rotundity. This may be called simplicity, largeness, or style, for aught we know; but it is a false Art, and this work furnishes an unquestionable proof of it.

No. 566. 'The Spectator's Club,' A. Morton. The subject is found in the first and second number of the "Spectator," and furnishes here an agreeable and select *conversazione*. The figures are all seated, and although every charm of expression and execution be thrown into the work, there is yet a want of relief to the monotony of the line of heads, and the exclusively sedentary position of all the members. Even, however, with the fault we mention, it is a beautiful production.

No. 568. 'An English Green Lane, near Kenilworth, Warwickshire,' H. Jutsum. The objects here compose in a manner extremely effective. The foreground is much broken, affording an opportunity for variety of tint, of which the artist has advantageously availed himself. It is shaded by some lofty trees, pencilled with richness, breadth, and freedom, and drawn with a close observation of nature.

No. 569. 'The Leicestershire Lass,' G. Clint. The "parlour," we presume, of a country inn in the neighbourhood of Melton is here intended; the figures, one or two redcoated Nimrods and the waitress of the house: the former toasting the latter. It is a vulgar and ungraceful subject, such as under any circumstances could not be really pleasing.

No. 576. 'Portrait of the late Sir Philip Bowes Vere Broke, Bart., R.N.,' S. Lane. A

portrait, we believe, of the gallant officer who distinguished himself by the capture of the American frigate Chesapeake. It is a full-length quarter-deck composition : the figure is in full-dress uniform, holding a sword in the right hand, and is painted and relieved in a very skilful manner.

No. 577. 'The Thames,' E. W. COOKE. The view seems to have been taken somewhere below Gravesend. It is high water, and a brig is coming up, besides which we see many other vessels pursuing various courses. There is a breeze on the river, but the smoke from a steamer at a little distance, and the sailing of the vessels, do not seem to coincide in showing it as from the same point. The work is not so pleasing as many others we have seen by the same hand.

No. 579. 'The Heroine of Saragossa,' B. R. HAYDON. The rampart is of course the scene here, and the tumult of battle is perfectly and powerfully set forth. The picture is large, and the heroine is about to fire the gun, near which she stands. It is a subject capable of much stirring effect, and the artist has thrown into it great spirit and diversity of character. But the promise is mightier than the perform-ance; and the painter is greater in theory than he is in practice.

No. 580. 'The Reduced House,' N. J. CROW-LEY. It is intended to show the departure of a young man, as, says an accompanying motto, " to seek his fortune;" but there is a want of distinct point about the work, which leaves the spectator under the impression that the youth is only leaving home on a journey. Neverthe-less, it exhibits some fine feeling and striking character, and is painted with much ability.

No. 582. ' Canute the Great rebuking his Courtiers,' J. MARTIN. A gorgeously-co-loured assemblage are here represented on the seashore, seated within reach of the turbulent waves. The colours are forced to their utmost power, and in a manner never seen in natural reflections. The entire force of the sea seems to be directed against the King. In looking along the coast it is evident that the breakers come in heavily, but they do not seem to be in perspective force according with the volume of water in the foreground. The colour also and motion of the water are given without suf-ficient reference to nature. The dull and opaque clouds weigh heavily on the composi-tion, and the red-and-yellow streaks of light are productive of evil effect.

OCTAGON ROOM.

Let our readers call to mind the famous sen-tence of Dante—

" All hope abandon ye who enter here,"

and the gate over which it was written. The Royal Academy should copy it, and print it above the door-way that leads into a small chamber, turning out of a "bit" of passage, between the Great Room and the Middle Room. Reader, you will miss it if you do not " look sharp." Alas ! for the unhappy artists who are condemned to this purgatory. We transcribe their names with regret, because in so doing we extend the knowledge of the in-dignity to which they have been subjected. Here, however, and we say it without hesita-tion, are some of the best productions of the British school—of men who will be famous when their unenlightened or unjust judges are forgotten. Why have they been crammed in here? It would be difficult to find an answer that we should not feel grieved to give.

No. 591. 'The Fortune-teller,' C. STON-HOUSE. A clever and characteristic work; the best by this artist, who is certainly not in favour with the Academy. The incident is from the "Vicar of Wakefield," where "his girls" consult the gipsy at the door. The two figures are graceful, but too tall in pro-portion to their little brother who stands be-side them. The picture would have been more valuable if the foliage and background objects had not been so sharp and positive.

No. 592. ' Clelia,' Mrs. CRIDDLE. A pretty, pleasing, and graceful composition, by an ac-complished lady.

No. 596. ' Coast Scene, near Watchet, So-mersetshire,' W. H. BACH. A picture of rocks : on the right of the composition, they are sub-stantial and firm, and tell well in opposition to the other parts of the picture.

No. 597. 'The Countess of Derby defending Lathom House, when besieged by Fairfax,' F. R. STEPHANOFF. The Countess is commanding a sally to be made ; there is too much ease and unconcern in her countenance, for even the bravest man in such a situation must have had a shade of anxiety on his brow. The cavaliers beside Captain Farmer are drawing their swords : this is unnecessary here, even to ex-press deep devotion. The chaplain and chil-dren are ready to join in prayer with the Countess for the success of the attack on the besiegers. The effect of the picture is good, and every stress is laid upon the principal cir-cumstance. Mr. Stephanoff's compositions always contain much to admire ; the only fault of his oil-paintings is, that they look too much like water-colour drawings. Surely the qualities of tone and texture are worth an effort ; his works would be greatly improved by a tincture of those qualities.

No. 598. ' In the Via Mala—Pass of the Splugen, Switzerland,' G. A. FRIPP. A large picture of wild Swiss scenery—the course of a mountain torrent forcing its passage amid rocks and precipices. The background ob-jects are well painted, but their shadows have equal strength with those of the foreground, which is too much cut up.

No. 601. 'A Scene from the *Merry Wives of Windsor*,' W. P. FRITH. This excellent and va-luable work is completely and utterly destroyed

by its position—a circumstance for which it is impossible to account, for its merits must have been obvious, at even a partial glance, to the most heedless indifferent observer. The mystery is enhanced by the fact that, last year, a picture by the same masterly hand was hung on the line, where it was universally admired, and purchased on the first day of the opening. Indeed, to our own knowledge, it would have found half a score of purchasers. Mr. Frith's reputation was therefore considered secure ; at least, it appeared certain that no one but himself could lessen or impair it. Yet how vain are all human calculations ; a single thoughtless, careless, or prejudiced decision has destroyed the fruits of a whole year, as effectually as a sudden blight will perish the prospect of a field rich with the promise of harvest. It will not be so, however, if the expectation created by the production of last year should lead a judicious judge to make inquiry for the results of this year, and, when found, shall really look closely and narrowly into the picture. He will find that Mr. Frith has made a great advance ; that wise patronage induced an effort to wrestle with a more difficult subject; and that success has followed a most honourable attempt. To paint from Shakspere at all requires no ordinary courage ; but to paint *Falstaff* is a very bold thing. Comparative failure under such circumstances would not have been discreditable : we should at least have honoured the motive ; but to triumph is indeed an achievement. Mr. Frith will encounter fairer or wiser "hangers" next year, and his lost position will be restored to him. In all respects this is a good picture : the fat knight is most happily transcribed from Shakspere ; the merry dames are capitally pictured ; and "sweet *Anne Page*" is as exquisitely perfect a creature as any English artist has ever painted. The minor characters are all admirable—*Bardolph*, *Pistol*, the boy, *Sir Hugh*—all, in short, are copies out of the immortal poet—copies accurate and true. Our readers must take our word for all this (and long before they come to it they will have been enabled to ascertain how far it may be depended on), for it is utterly impossible they can so examine it as to be enabled to judge for themselves. As if to put an unequivocal ban upon Mr. Frith's picture, it is hung beside a work somewhat similar in general character, but so miserable as to excite marvel how it came to be hung at all. It is numbered 612, and called 'The Tarantella of Naples'—a perpetration of the very worst kind.

No. 602. 'Cattle at Pasture,' T. S. COOPER. The principal object of this picture is a bull ; but all the minor accessories are made essential to the composition. It is the best work of Mr. T. S. Cooper ; the best work, of its class, of the English school ; and a work that vies with those great pictures of centuries of descent for which small fortunes are given in exchange. It is really too bad to see such a noble work thus dishonoured—a work that any member of the Academy might have been proud to acknowledge as his production.

No. 606. 'The Village Coquette,' G. LANCE. The observations applied to Cooper's picture apply equally to this. It is a *chef-d'œuvre* of its class ; and the most meritorious production of the excellent artist.

No. 613. 'The Lords of the Congregation taking the Oath of the Covenant,' A. CHISHOLM. Not sufficiently finished, but manifesting considerable labour, thought, and ability in composition, and full of striking and interesting facts.

No. 614. 'The Highland Home,' A. JOHNSTON. A Highlander amusing himself with his child at the door of his home, which seems to be embosomed among the hills. The head of the man is admirably drawn, but, generally, the picture is less effective than usual with this artist. Still it is infinitely too good for the position it is made to occupy.

No. 617. 'Bern Castle, on the Moselle,' H. GRITTEN. A landscape of very considerable merit, manifesting decided improvement.

No. 626. 'A Soldier relating a Tale of War to Joan of Arc and her Parents,' H. J. TOWNSEND. A very forcible and interesting design, exhibiting judicious thought and care in composition, and arranged with no inconsiderable skill ; but by no means sufficiently finished. It supplies evidences of power ample enough to deal with a noble subject, and gives satisfactory assurance of ability to carry out a lofty purpose ; but as a completed work this cannot be considered.

No. 629. 'Harbour Scenery,' W. A. KNELL. Composed of a boat and a few hulks, apparently in the Medway. This picture is executed with great force and descriptive power. The water is full of motion of that kind which declares the prevalence of wind.

No. 634. 'The Empty Cradle,' FANNY M'IAN. A young mother is here represented sitting by the "empty cradle," an incident not the less touching that it is common—an occurrence of every day. This gifted and accomplished lady has thrown into the figure the most perfect expression of grief subdued. It is very sad to see so chaste and expressive a composition condemned to such a hole ; the more especially as gallantry towards a lady might have led to a scrutiny of her solitary offering to the Gallery. If it had been looked at, it would have had a better place ; it will touch the hearts of all who do look upon it by its exquisite pathos. But then they must peer into it closely, or mounted on stilts, for a most pathetic episode will otherwise be lost. The story is told by the tiny infant's shoe, which the bereaved mother holds in her hand. This single thought speaks a volume ; yet, where it is hung, Mrs. M'Ian might as well have made the sad mourner clutch a snuff-box in her fist.

No. 636. ' Lucy Ashton and Ravenswood visiting Blind Alice,' C. BROCKY. This work wants relief in every way; the figures are heavy, and the entire aspect is singularly sombre.

No. 638. * * * J. DUJARDIN, jun.

"Oh! dear, what can the matter be,
Johnny's so long at the fair?"

A female figure standing by a window much in the spirit of the lines. The picture is judiciously made out.

No. 640. ' The Introduction of Sir Piercie Shafton to Halbert Glendinning,' A. EGG. Every part of this excellent production declares the finest feeling for the most attractive beauties of Art, and a power of hand equal to their accomplishment. The Halbert Glendinning is accurately read from the text; but the bearing and presence of Sir Piercie is scarcely brought up to the intention of Scott. The drawing and painting in every part are those of one gifted with the rarest abilities; one who is as sure to make his way to the highest place in Art, as years are to pass over his head. He has been doomed to do penance in this hole—for the crime of painting an admirable picture; but his work has found a purchaser nevertheless. He will soon have more commissions than he can execute, or we shall eschew prophecy.

No. 645. " Scene from the *Merry Wives of Windsor*,' T. BRIDGFORD. A work of much merit, full of point and character; well drawn and coloured, and excellent as a composition.

[1] No opinion is necessary to establish the fact that a position in this room is equivalent to a sentence of excommunication; it is a brand upon the brow that may not be removed until years have passed. Many visitors never enter it at all; we have, indeed, met with persons who have regularly visited and examined the exhibition, during the last three or four years, without being aware of the existence of this " Octagon Room." Others peep into it, give a hasty glance along the walls, and retreat under the impression that its contents are worthless. Even those whose business is to view and criticise " the hole," abandon it in despair; here, for example, is the mode in which the critic of the *Spectator* shuns the doomed chamber :—

"The pictures in that dark hole, the Octagon room, are invisible; it ought not to be used as a place of exhibition, for few persons enter it; and those who do, can see nothing but the gloss of paint on the pictures."

The omission of all notice of this room is not to be pardoned in one whose duty it was to offer some amends to certain artists for the neglect or injustice under which they were suffering—perhaps to their ruin; but it will surprise no one to learn that very few visitors, having no purpose but enjoyment, think it worth their while to do more than take three steps across it and three steps back again—quite satisfied that if there be anything to see they cannot see it. Yet, as we shall presently show, some of the best paintings of modern times have been squeezed into this cave of despair.

[2] A feather thrown into the air will show how the wind blows; and we may, with reason, apprehend the danger of the Royal Academy refusing to entertain proposals for great changes, when suggestions for small improvements are rejected. Year after year we have felt it our duty to protest against excluding, from the "private view" of the Exhibition, persons whose business it is to publish strictures upon it in the public newspapers. The system is equally unwise and unjust. The Academy is now, we believe, the only Institution in existence that not only offers no compliment to the press, but affects to scorn it. A few years ago the principle was precisely the same in the Houses of Lords and Commons; the presence of a reporter was, indeed, tolerated, but it was assumed that he was not " committing a breach of privilege" and taking notes; he was allowed no sort of advantage to facilitate his purpose, but thrust among the crowd, where he used his pencil as he best could. At length legislators, in both houses, reasoned that what was done might as well be done properly; arrived at the conclusion, that their speeches might be better reported by giving elbow-room to reporters; and two galleries were erected expressly for their accommodation. Similar enlightenment has not yet travelled so far as Trafalgar-square. Into the galleries of the Royal Academy, for the seventy-fifth time, the persons appointed to criticise the collection pushed their way, on Monday the 8th, after payment of one shilling each at the door. The rooms were, as usual, crammed with visitors; every picture of importance was barred from sight by a dense mass; it was, in fact, utterly impossible to see —and of course, therefore, to review—the collection; yet the parties who were to forestal public opinion, and, in a great degree, to determine the estimation in which the exhibitors were to be held, were forced to leave the gallery and prepare their "Report"—1st, upon insufficient information; 2ndly, under the influence of exceeding fatigue; 3rdly, with tempers annoyed and exasperated by what is considered uncorteous or insulting treatment. We may be accepted as authorities upon the subject—and we say, without hesitation, that so long as this absurd and most evil principle is adhered to, so long will the Royal Academy have an enemy—neither powerless nor idle— in every conductor of the public press. Can we, in any other manner, account for the following passages— grossly illiberal and unjust—appearing in a journal of high respectability and large circulation :—

"No exhibition of the Royal Academy within our memory has possessed less interest or produced a feebler impression than the present: it has but few salient points, and those not of the most striking character. * * * * Superannuated Academicians are privileged to parade their incapacity in the most conspicuous manner, moving the many to mirth and the few to pity, and proclaiming the gross injustice of the Academy in the arrangement of the exhibition."

Believing it our duty to endeavour to arrest this evil—under the effects of which, not only the Academy, but the artists generally, and the Arts in Great Britain suffer—we addressed the Council, through the President, and applied for admission to the private view— making our application " *chiefly, because as that which has never been asked, cannot be said to have been refused, it may remain doubtful if the Royal Academy willingly deny to the public press the advantage conceded to it by all other institutions, and which, in the case of the Royal Academy, is especially needed to secure cool and competent judgment.*" To this application, we received a prompt and courteous reply, declining to comply with our request—" *as it had never been the practice of the Royal Academy to issue official invitations to any class, or to distinguish the gentlemen connected with the public press from other visitors.*" This is indeed a resolution greatly to be deplored—out of an obstinate adherence to which much evil has

arisen, and much more evil is destined to arise. It is a copy from the dark ages—a solitary blot on the true liberality of the age. If the principle had been carried out in all things—the "sure it was always so" principle—the human mind would have been as stationary as an oyster. The Royal Academy will do well to remember, that if Gatton and Old Sarum had been abandoned—and parliamentary representatives accorded to Manchester and Birmingham—there would have been no large besom to sweep a congregation of boroughs into schedule A. It was the objection to sacrifice a little to wisdom and justice that brought in the Reform Bill. The refusal to admit to the private view writers for the public press—the only " critics," be it remembered, who communicate between artists and the public—is sufficiently impolitic and unjust. We use the term " UNJUST," because the Royal Academy are not merely conservators of their own interests—to " do what they will with their own ;" they are intrusted with the reputations and the properties of some hundreds of artists, whose only mode of augmenting both is to appear in advantageous positions before the world. In this *quarrel* with the public press—for such it is—an evil spirit is evoked by no means injurious only to the Royal Academy. But more than this. The " practice of the Royal Academy" not having been to deviate an inch from old custom, or to allow the entrance of any modern improvement, other evils inevitably follow ; for example : admission to the private view was refused to the honorary secretaries of the Art-Union of London —who, indirectly, had in their hands £8000 or £9000 to spend within its walls. This mattered little to the great artists of the body, who had no unsold works in the collection ; but it was a serious grievance to some who, having eschewed Suffolk-street, looked to the Academy for some counterbalancing advantages. The holder of the £400 prize did indeed obtain admission, but it was by the private introduction of a member; the honorary secretaries procured it for him, and the result was an addition of £400 to the worldly wealth of Mr. Charles Landseer. This year there was a more than usually strong reason why the Academy should have facilitated the objects of the London Art-Union. Suddenly—and we humbly think absurdly—in consequence of the death of the Duke of Sussex, the opening of the Gallery in Trafalgar-square was postponed for a week. What was the consequence? Several prizeholders, who had visited London for no other purpose but to select their pictures, not considering it worth their while to prolong their stay for seven days, went to Suffolk-street, and laid out their money there, paying £200 for a sheet of canvas covered by Mr. Allen ; and a huge imitation of unnatural light, by a Mr. Jacobs, or Jacobi—a German or Frenchman, of no note ; and this is upholding and encouraging British Art. This evil we distinctly charge to the account of the Royal Academy.

³ SIR,—As by the accounts in the public papers we find that nearly a thousand pictures were rejected from the exhibition of the Royal Academy from want of room, you will, doubtless, receive many communications, suggesting some plan for the prevention of this evil in future. Without further apology, I will lay before you a scheme which (as it appears to me) will, without injury to any one, completely remedy, not only the sad rejections of meritorious works, but the still more fatal system of hanging which prevails at all the exhibitions—*avowedly* from the crowd of pictures sent. I propose that the National Gallery (that is, the wing unoccupied by the Royal Academy,) shall be employed for the modern artists in a precisely similar manner to that adopted in the Louvre at the present moment, namely, that the old pictures shall be boarded over and

the new ones hung in front of them. It would be impertinent in me to point out to any one of common sense the advantages of this arrangement, and I know your good feeling towards the artists too well to doubt your most strenuous advocacy of any measure brought forward for their amelioration.

If, in answer to this proposition, any one should say, the public must not be deprived of the old masters to suit the necessities of the moderns, I reply—Let the exhibition take place during the holidays of the attendants of the National Gallery, when it is closed from the public altogether, and let this new Exhibition be *a free one*, so that the public are in every way the gainers.

A petition, which will, in due time, be laid before the proper authorities, is preparing, and we firmly rely on your powerful support and that of every well-wisher to the Arts. That every member of the Royal Academy will sign this " Artists' Petition" there cannot be the slightest doubt, as it is so good an opportunity for proving the sincerity of their *yearly repeated* avowal— " We deplore the necessity for returning your picture, but our want of room entails this upon you," and upon 700 or 800 others, whose wives and families are perhaps in want of bread, and their getting that bread or not depends, in many cases, on the exhibition of their works. Strong indeed must the reason be that could hold the hand of any artist—academician or other—from a memorial of this description, if his signature could advance it one step towards its avowed and evident object, the relief of a body of men struggling in a profession, the difficulties of which—at all times great enough—are now increased twenty-fold by the numbers of aspirants to its honours.

If you will give publicity to this in the next ART-UNION, so that the feeling of the profession may be obtained on this important point, you will greatly oblige,
A SUFFERER BY THE EXHIBITION.

⁴ Ample space there certainly is not. The works of several members are this year very disadvantageously hung—far below the eye. It is thus with two of Mr. Uwins's beautiful pictures, with two of Etty's also, and with two of David Roberts. Moreover, it is known that when the supply of works designed for exhibition was found so greatly to exceed the space at command, a proposal was made, and at once acceded to, that each member who had sent in his full number should withdraw one picture. This was done. The fact is creditable to the Academy, but the relief it afforded was very small indeed ; probably about six pictures were hung that would have been otherwise rejected.

⁵ How humbled must an Englishman feel in walking over the Académie des Beaux Arts—a leading glory of modern Paris. It is a work of vast magnitude, in which splendour and taste have gone hand in hand ; it is enriched by a collection of rare antiques. Here are collected the earliest and the later efforts of the pupils sent by the nation, as students, to Italy ; here are schools, models, and lectures, open to every applicant ; here is ample room for every purpose to which Art can be applied, or from which it can derive aid or illustration. Compared with our own miserable den in Trafalgar-square, it is—we shame to suggest a comparison. But the Arts in France have long been the fostered children of France. The wonder is, that the artists of Great Britain, notwithstanding their disadvantages, have not only kept pace with their neighbours, but have, with two or three brilliant exceptions, very far surpassed them. Let England do for Art, during the next ten years, what France has done for it during the last forty, and we may defy the " pick and choose" of all Europe.

⁶ This is at all times a painful and embarrassing subject. Let us notice a collection of pictures when and where we will, it is sure to furnish a stumblingblock we cannot get over. Under the best and safest arrangements that could be made, many mistakes would occur,

and much discontent inevitably arise. Nay, if an arch-angel were to hang an exhibition, some exhibiters would be dissatisfied. We doubt if universal contentment would ensue if it were possible to let every artist choose his own place, and hang his picture as best pleased him. A pleasant illustration is told of the Royal Hibernian Academy:—A certain member had once a year abused the hangers there; at last, they resolved, in professional phrase, to—*let him hang himself;* and he did; and when the exhibition opened, he was louder than ever in protesting he had never been hung so badly in all his life. Seriously, however, much allowance should be made for the honest differences of opinion that may exist as to the merits of a work. That which A B may consider execrable, C D may hold to be one of the finest pictures ever painted. This is no imagined notion; the thing occurs every day, or every hour of the day, in an exhibition-room. One is not obliged to consult merely public criticisms for opinions as opposite as light and darkness; he will have marvellous contradictions among every group that gathers round a work of note. It would be too bad to deny to "hangers," who discharge a most irksome, toilsome, and thankless duty, the freedom of thought each would claim for himself. It is admitted on all hands, that the hanging at the Royal Academy is by many degrees "fairer" than it is elsewhere. Yet, however willing to attribute to accident some embarrassing difficulty, or *peculiar* judgment, the positions occupied by—not a few—pictures in the Exhibition this year, we cannot but lament that genuine merit should be made liable to ruin by any cause whatever.

⁷ While considering this branch of our subject, it may be well to inquire why the Royal Academy has no law by which it may rid itself of useless members? Two of the "Academicians" and two of the "Associates" appear annually in the list; but never among the exhibiters.

⁸ Among these "great artists" are men truly great; the world knows it; men who may contest for glory with the most famous of the old masters. On some future occasion we may be enabled to introduce them to our readers. Some of them are scarcely known in England, even by name. It is unnecessary to say that, although we were unable to make acquaintance with them at the Louvre—and the Luxembourg contains only their earlier and not best works—we did not quit Paris without endeavouring to form an accurate estimate of their value. This is only to be done by visiting *private* collections of pictures, and the *ateliers* of the artists. The former are very easy of access; and the latter may be reached with little difficulty. But these are topics that must be reserved for occasions when we may command greater space.

⁹ It is our duty to remark that the Catalogue has been revised in a very slovenly manner. It is full of errors—some of them of a very gross character—names misspelt, wrong addresses given, numbers confused, and, in some instances, names one never heard of substituted for those of the actual artists. This is quite unpardonable, seeing that a very large income is derived from this source.

¹⁰ An engraving from this beautiful and interesting picture is now in course of publication by Mr. Moon. It is from the burin of Mr. Cousins, and is unquestionably—considered as the joint production of two great artists—fully worthy of the occasion that called it forth, and honourable to the Nation as a work of Art. It will be our duty to review the print next month.

¹¹ Mr. Turner must permit us to urge objections against his poetry with less hesitation than we do against his painting. For some years the source of his information in this way seems to have been some abominable perpetration in the manner of "blank verse," called "Fallacies of Hope"—a mass of thorough nonsense, utterly unintelligible and ungrammatical. Possibly the wretched verses may have had some deleterious influence on the painter's mind—may have cast a spell over a great genius. Oh! that he would go back to nature!

¹² Concerning the treatment of this subject we have received the following letter, which we cannot for a moment hesitate to print—without, however, agreeing with the fair writer, and leaving the matter open to Mr. Duncan, who will, no doubt, be prepared with his "Authorities."

MR. EDITOR,—I claim, as one of your oldest subscribers, that you will print this letter. In the present Exhibition is a picture, No. 263, of 'Prince Charles,' painted by Mr. Duncan. I am a lineal descendant of Flora Macdonald, and as such, cannot help expressing my surprise and sorrow to find that any man who bears so distinguished a Scottish name as *Duncan*, would dare to attempt to falsify Scottish history, or traduce the spotless memory of Flora Macdonald as he has done. When that lady assisted his Royal Highness to escape, she was attended *only* by her *servant, Neil Mackeachin* (ancestor to the late *Marshal Macdonald*), and escape was effected by those *two alone,* and the Prince wore at the time a *woman's dress.* If Duncan's picture be right, the Hanoverians of that day would had good reason for suspecting the virtue of Miss Macdonald; but the fair fame of that lady was as untarnished as the bravery of the house from whence she sprung. I am, Sir, your humble servant,
4, Edgware-road. MARY MACDONALD.

¹³ It is very pleasant to state that this work has been purchased by the Duke of Wellington, for the sum, we understand, of 600 guineas. The Duke knows a good picture; and must, we imagine, be a pretty good authority as to the truth of the treatment this subject has received. The purchase is indeed a high compliment to the abilities and industry of the artist.

¹⁴ It is only just to state that this picture is painted with the medium prepared by Mr. Miller; and for which he has more than once challenged a trial in the advertising columns of the ART-UNION Few who look upon this work will hesitate to believe that its peculiar brilliancy is derived from some unusual means; what those means really are, it is the duty of every artist to inquire and ascertain.

¹⁵ Everybody will remember the story of the painter who was commissioned to paint the passage of the Israelites through the Red Sea, and who produced a sheet of red-coloured canvas; demanding the imagination to picture the Israelites as having passed over, and the Egyptians as all drowned.

"On Aesthetical Criticism as Applied to Works of Art"

Fraser's Magazine 28 (July 1843), 72–79

ON ÆSTHETICAL CRITICISM AS APPLIED TO WORKS OF ART.

As many of our readers may not understand the meaning of the word *æsthetics*, since it has not been commonly used in this country many years, we shall follow the good old rule of first defining our term. The word is taken from the Greek αισθησις, perception. Baumgarten, a professor in the university of Frankfort-on-the-Oder, first used this term to designate a branch of philosophy by which to establish correct principles of criticism in relation to the beautiful. Germany, France, Italy, and lately England, have used the word—not always correctly. Criticism on art is at the lowest ebb in this country, consisting of very little more than the application of a catalogue of cant terms and phrases, many of them conveying no definite ideas, and but few of them distinctly understood by those who use them most frequently. The general taste in pictorial art is almost as low as the criticism. There are exceptions, just numerous enough to prove the rule. Italy retains a morbid feeling for what is really high and expressive of the uses of this great department of intellectuality, and vents in apostrophes, phrases redolent of superlatives, and in sickly admiration, her moribund recollections, without producing one worthy supporter of her Medicean days. France shines in affectation, bombast, and supposititious analysis; and her exhibitions give no promise that the fine collection of the Louvre will make any impression on her artists. Germany gives promises both in art and in criticism; and the study of æsthetics among her students has raised the whole standard of her taste—her sculpture and painting. In accordance with their prevailing love for mysticism, the criticism of the Germans has been carried into a *terra incognita*. The esoterical æsthetical doctrines have been worried by

them into depths darker than Erebus, and the bewildered and benighted reader is remorselessly made to follow,

" O'er bog or steep, through strait, rough,
 dense, or rare,
With head, hands, wings, or feet, pursues his way,
And swims, or sinks, or wades, or creeps,
 or flies :
At length a universal hubbub wild
Of stunning sounds, and voices all confused,
Borne through the hollow dark, assaults
 his ear
With loudest vehemence——"

Astonished and tired, he wends his way to the nearest coast, " bordering on light," and, having recovered in some degree his composure, finds that he has been mesmerised into a mystical verboseness, without positive thought, which leaves no recollection. The principles of art, whether æsthetical or practical, are, like the laws which rule the mental and physical creation, positive and intelligible ; but no sooner is the simplicity and majesty of truth deserted than the human intellect wanders into mists which are beyond her boundary, and, at best, terminate in a delusive mirage, which seems to promise all we want, and, when' followed, recedes, producing nothing but appearances, toil, and disappointment. Notwithstanding, if the chaff be carefully separated, there is much that is sound and useful in German criticism, and which will set an example by which the science may be placed on a firm foundation.

Mrs. Jameson, in her preface to the translation of Waagen's *Essay on the Genius of Rubens*, takes Sir Joshua Reynolds to task for telling the students of the Royal Academy that, by dint of study, labour, perseverance, and certain rules of art, any one of them might become a great artist. That her objection is perfectly sound, there can be no doubt, because the painter, as well as the poet, is born with facilities for acquiring their art. She correctly designates genius " inborn and heaven - bestowed." No word has been more abused. Every rhymster, scraper on the fiddle, ranter on the stage, caricaturist of nature, and every puppy who scratches with

a pencil, or stains canvass with a whirlpool of colours, is, in this utilitarian country, styled a genius, and made, if possible, more conceited, or, if R.A. in such daubing, more stolidly vicious than ever.

Genius is an intellectual faculty, which enables the possessor of it to produce with power, facility, and elegance, what another cannot effect with any degree of study or perseverance. The bent of that genius may be in music, poetry, construction, painting, &c. &c. Education may accelerate, direct in the right course, and enable genius to soar to excellence, but education cannot create the faculty. Genius without instruction, without the aid of adventitious circumstances, never carried an art or a science from its rudiments to its acme. Perfection, like confidence, is a plant of slow growth, and requires constant and careful culture, the seed being good, the soil fertile, with that attention, the fruits will approach perfection. Art, science, and literature, have been virtually insulted in this country, by giving to mediocrity the highest of titles, that of genius. It may be questioned whether England ever possessed a painter to whom the title of genius in a high and extended sense can justly be given. Many may fairly claim to be placed in the next classes, as possessing considerable talent, great vigour, the æsthetical sense uncertainly developed, though at times shining forth with considerable lustre.

One leading characteristic of genius is its being in advance of the age in which it lives. The degree of advance in any particular line decides the elevation on which it stands, not only in its own age, but in comparison with ages past, and that in which we live, and apply the test. A careful examination of the uses which have, or might have, been made of the *principia* established by it will enable us to judge how far by them we had been enabled to penetrate into the fields of knowledge. The greatest geniuses have invariably burst through the circumstances influencing those around them, and concentrated the whole power of their minds on establishing those principles which are founded on the immutable laws which govern the world. Pythagoras and Euclid

are examples. We are, however, ignorant how much the former was indebted to the knowledge of the East, where he had been as a soldier. Their originality was manifest amidst surrounding circumstances not favourable to the developement of truths so vast and sound, that they can only terminate with time.

Leaving the examples of science, we will touch on those of art. Though Xerxes burnt Athens, the Greeks were conquerors. Their natural powers of mind and fervid temperament were instigated to action by Pericles. Phidias received the impulse from the circumstances by which he was surrounded and by the galaxy of men who were his contemporaries, some of whom maintained the possibility of man attaining mental and personal perfection. Homer and Æschylus had preceded him, and sculpture was no new art. But as Phidias left, as it were, unnoticed the inflexible superficies, the assumption, not the reality of dignity, the meagre or exaggerated outline and the geometrical draperies of his predecessors substituting the reverse, and applying all his energies and intellectual power to typify the deities of his country, thus applying corporeality to the perfection of ideal and imaginative forms, the effect of his works on his countrymen and on succeeding generations proves that he was directed by that esoterical and æsthetical sentiment, without which art loses its vitality and is lowered to mechanism and correctness of eye. Sculpture and painting must go nearly *pari passu*, therefore we may conclude that among the contemporary painters some felt and embodied the meaning and moral dignity of their art, as well as the greatest, though not the first of sculptors. In those great artists and their immediate schools the moral sense stamped on the executive parts of their works a perfection of form which never has and never can be produced where that feeling does not exist.

Whatever high imaginings any mind has been capable of, progressive steps have been required to enable that mind to delineate its conceptions; therefore, when schools of art are spoken of, the meaning must be that some individual, leaving the manner and routine of the conceptions of his master, adopts a higher system, shewing a more profound esoterical and æsthetical feeling than those who preceded him, and to whom his age and country defer. The heads of the great schools, like the founders of families, are generally the greatest men of all their followers, while those very men excelled both the masters and scholars of the schools in which they were brought up, as Raffaelle da Urbino left Perugino far behind.

It is unquestionably an act of justice to *the individual* to allow weight to the influence of the character of the age in which he lived, and of the peculiar circumstances by which he was surrounded; but we much doubt the propriety of judging of the artist, as an artist, by any rules but those which are universal and fundamental. The approximation to esoterical and æsthetical delineation of the subject, taken in its deepest, highest, and most extended sense, must ever be the test by which to appreciate a work of art. We do not refer to those inanities, vulgarities, affectations, and feeble parodies of beautiful nature, which constitute the mass of pictorial merchandise or the coverings of our Academy walls. The only sound saying of that *Micromegas* Louis XIV. on seeing his palace-walls disgraced by some of them was, " *Otes moi ces mâgots là.*" No excellence in the mechanical part of a picture can compensate for *ces mâgots là;* there are some in our National Gallery better suited to a brothel than to instruct the people in the real uses of art to a nation.

Dr. Waagen, well known for his volumes on art and artists in England, has lately attempted, in an *Essay on the Life and Genius of Rubens*, to establish a sounder quality of criticism, and selected that painter for his example. Had he selected him to discuss his claims on esoterical and æsthetical principles, *without* reference to any external influences, he could not have chosen more judiciously; but superadding them as principles by which to form his judgment, the force of his intention is destroyed, and criticism on art is made secondary to the criticism on the individual. The test should have been twofold, — one referring to the unchangeable esoterical and æsthetical principles; then modifying the

deduction by reference to the country, times, and peculiar circumstances, by which the artist was surrounded.

Rubens was, without doubt, a great painter; what claims he possesses to the title of a great æsthetical artist must be determined by his works. No man was ever less influenced by the circumstances which surrounded him than Rubens. All the painters who had preceded him, all contemporaries were passed by him, not without notice but without borrowing from them. He remained eight years in Italy, and studied at Rome and elsewhere the remnants of ancient art and the works of Raffaelle, Michael Angelo, Titian, &c., and never shewed himself to be indebted even to a fragment, and left that country without imbibing any of the refinements in feeling, the elevation of sentiment, or the ideal beauty to be found in their works. The state of neither his native nor any other country seemed to influence him; his individual characteristics of mind and temperament were from first to last stamped on his works, even a superior education did not modify them. He was incapable of copying the works of other masters which he admired, and translated the heads and characters of Leonardo da Vinci into Flemish. The characteristics of Rubens affording the illustration required, we shall not put ourselves under any obligation to Dr. Waagen, whose estimate is a sad jumble of truth and extraneous twaddle, but offer our own. The leading characteristic of the mind of Rubens was general power and capacity. He attained superiority in whatever he attempted. He was a painter, courtier, diplomatist, linguist, generally

informed, conscious of his capability, and self-confident. Common sense kept the reins of those great qualities well in hand. His imagination was powerful, but not refined; the faculty of invention ready, with great facility of resource, supported by a sanguine and energetic temperament, calling into action affectionate and generous feelings. His temper was cheerful and buoyant, but the esoterical sense for the elevated, the beautiful, the intense in sentiment, was comparatively weak.

Thus we see conscious power stamped on all his works, and great daring, even to delineating "The Last Judgment," but all characterised by deficiency in esoterical and æsthetical feeling, and, consequently, wanting in that beauty of form and feature which can emanate only from it. In a few instances, like angels' visits, seldom and far between, he has soared into the regions of elevated sentiment and portrayed it;* but his nature being unable to sustain him in such an ethereal atmosphere, he returned to his natural sphere, not quickened by the hallowed fire which bore him there to try and retain the lofty station he had won. Rubens can never be considered as standing in the highest class. Raffaelle was an esoterical, æsthetical, intellectual, reflective painter, who spiritualised his art; Rubens, possessing vigour as yet unparalleled, dragged down with unsparing hand art to his own earthly conceptions, and revelled on a throne

" Which far
Outshone the wealth of Ormus or of Ind,
Or where the gorgeous East with richest
hand

* The following criticism was given by Madame de Humboldt to Dr. Waagen:— " From this general criticism we may except the picture in the Capitolo Prioral of the Escurial, in which the Virgin is represented as standing on the globe and trampling on a serpent, which is writhing beneath her feet. The Virgin is a tall, slender, and dignified figure; a heavenly crown, with the rays of glory, just touches her head; she looks like the queen of heaven, and inspires at once veneration and awe. Two angels, most lovely infant forms, stand on the clouds close to her side, the one holding a palm, the other a wreath of laurel. The expression in the countenance of the Virgin is that of adoration and gratitude; there is something unearthly and inspired in the soul which looks out from her eyes; her dress falls from her waist in rich folds, and a white veil covers her bosom. This picture is so beautiful, in such noble keeping, and so free from that disagreeable voluptuousness which characterises Rubens' females in general, that it can be contemplated and dwelt on with delight, although hanging on the wall with a Raffaelle and a Guido; while it possesses all the advantages which belonged so exclusively to the manner of Rubens—the most blooming flesh-tints, the loveliest colouring."

Showers on her kings barbaric pearl and
gold."

Even from that throne he too often
descended,

" Bowing lowly down
To bestial gods."

At other times he seemed de-
lighted to

" Welcome joy and feast,
Midnight shout and revelry,
Tipsy dance and jollity."—*Comus.*

When called on to exercise his in-
genuity in allegorical and emble-
matical compositions he fails, either
producing parodies so devoid of
sense, or containing such a rabble
rout of personifications male and fe-
male, young and old, some in a state
of nudity, others connected with
them in rich and stiff brocades, ruffs,
or armour, as to excite sometimes
laughter, sometimes pity. The al-
legory, so called in Whitehall, defies
all explanation, and the spectator
gazes on the strange assemblage
wondering who the ladies are em-
bracing, who those are, holding
crowns over a youthful prince, what
all the gods and goddesses of the
heathen mythology are about, why
Temperance tramples on Rapaci-
ousness, what Hercules aims at kneel-
ing on a snake-headed lady, what
naked person Minerva is above, and
what she intends to do to it. Most
of these miscalled allegories are me-
lodramatic jumbles, and are to be
tolerated only for the excellence of
the execution. The mind of Ru-
bens was not sufficiently quiescent
and plastic to receive impressions,
but so vigorous as to implant his
own undisciplined and inexhaustible
mental population on the canvass,
shewing beyond dispute that his
classical education and his eight
years' companionship with the refine-
ments of the art of ancient Greece
and modern Italy had only been ad-
mired with the eye, but had made no
impression on the mind. Notwith-
standing he wrote a dissertation on
the use of the study of ancient art,

he never improved either his outline
or drawing. The statues of the
Grecian sculptors never led him to
combine elegance with force and ac-
tivity in his manly forms, nor grace,
lightness, and loveliness, in his deli-
neations of female beauties; to the
last his heroes, heroines, gods, and
goddesses, were of the truest Flemish
breed. The general *contour* of his
mental manifestations was eminently
dramatic, ranging from the truly
tragic, through the theatrical, to the
melodramatic and the whimsical.
Algarotti thus expresses his estimate
of him as an artist:—

" Rubens was not so violent in his ac-
tion as Tintoretto, softer in his chiaro-
scuro than Caravaggio; he was not so
rich in his compositions as Paolo Vero-
nese, nor so light and elegant in his
touch. Titian was truer in his carna-
tions and Vandyke more delicate; his
colours were more transparent, the har-
mony of them equal while their depth
was greater. His strength and grandeur
of style superior to them all."

If to that be added that his pen-
cilling was full and mellow, the
handling free and decided beyond
any other painter, the gradations true,
and so positive that they seem never
to have been gone over twice, and
every touch the result of a definite
intention, it will be admitted that he
might have entered the lists with the
greatest artists, and that, if in the
highest department he would not
have carried off the palm, in the
practical part he was unrivalled.

Thus Rubens is a fine example of
a great painter not æsthetical in his
practice of the art, but essentially so
in his theoretical expressions of it.
His friend Franciscus Junius dedi-
cated to him his work, written in
Latin, on ancient art, and inculcates
throughout æsthetical considera-
tions.* The explanation of the in-
congruity can only be explained by
supposing that Rubens understood
the doctrine when he read it, but
was so constituted as never to have
felt it. Not so Raffaelle, he under-

* " Pictures which are judged sweeter than any picture, pictures surpassing the
apprehension and art of man, workes that are sayd to be done by an unspeakable way
of art, delicately, divinely, unfeisably, insinuate nothing els but that there is some-
thing in them which doth not proceed from the laborious curiositie prescribed by the
rules of art, and that the free spirit of the artificer, marking how Nature sporteth her-
self in such an infinite varietie of things, undertooke to do the same."—P. 331.
Ed. 1638, Franciscus Junius.
" Having now seene alreadie wherein the chiefe comelinesse of grace doth consist,

stood it profoundly, and practically carried it to the highest perfection hitherto attained. Volterra, Domenichino, Guido, Gherlandaio, Correggio, Sebastianus Venetus del Piombo, and numbers more, manifested the sense of the æsthetical. They were Italians. Murillo in Spain, Le Sueur, Juvenet, and a few more in a minor degree in France, have proved their possession of it. When the passions and affections of the soul are to be delineated, we can neither quote the Low Countries nor Holland, but express the belief that the sentiment does exist in this country, and only requires to be awakened, schooled, and cultivated.

The taste of the English people is not favourable to the highest walks of art, not from a want of mental capacity to appreciate them, but because they have had few opportunities of contemplating them. Since our National Gallery has been opened to the people, it has been an object of attraction on every day considered by them as a holyday. Even the generality of the upper classes admire more pictures distinguished for high finishing and homely subjects, or landscapes, than those manifesting the esoterical feeling (for the object of the art) and the æsthetical sentiment displayed. Let us not suppose that this nation is the only one which has shewn a deficiency in appreciating the highest efforts of artists. The ancients were as bad. Pliny (lib. xxxv. cap. x.) tells us that Pyreicus was celebrated for his excellency in artistical dexterity, and painted barbers, cobblers' shops, asses, provender both for men and animals, and what we term objects of *still life*, and consequently had given to him the sobriquet of Rhyparographus, and that those works were so admired and coveted

that they sold better than the finest pictures of the greatest masters.

The only stimulus ever given by the nation to call into action the talent of our artists is now offered to them through a board of commissioners. We look in vain for one *living* historical painter whose works command sufficient confidence in his mental and practical powers to commence the work—to regenerate the degraded arts of England. Excellence in the art requires not only superior intelligence, but a great developement of peculiar faculties, borne on by a deep sense and feeling for the ends to be produced by the successful manifestation of the powers bestowed by Providence. A high sense of the value of *truth* in all representations ; to that must be added an education embracing, at least, a correct and current knowledge of several arts and sciences, and that historical knowledge which, in addition to mere facts, superadds an apprehension of the feelings, manners, costume, bearing, and mental state of periods and persons. If Longinus be right, and we think he is, the mind of a great artist must be cast in the mould of true magnificence, or it cannot even conceive the sublime or the beautiful ; and unless its habitual conduct be noble and elevated, never can it delineate the truly æsthetical.

Our artists have a prospect before them only paralleled by the Vatican. The scope offered to them is coequal with the highest aspirations. The history, the poetry, the deeds of a mighty nation ranging through a thousand years. This is encouraging, and promoting the fine arts ; this is an attempt worthy of England to commemorate the blessings bestowed on her by an overruling Providence, to recall the incidents to the memories of generations yet unborn, to stimu-

and how by a glorious conquest it doth sweetly enthrall and captivate the hearts of men with the lovely chaines of due admiration and amazement ; having likewise considered by the way that this grace hath no greater enemy than affectation ; it is left only that we should examine by what means it may be obtained, although we dare not presume to give any precepts of it ; which, in the opinion of Tully and Quintilian, is altogether impossible, since it is certaine that this grace is not a perfection of art proceeding merely from art, but rather a perfection proceeding from a consummate art, as it busieth itself about things that are suitable to our nature. So must, then, art and nature concur to the constitution of this grace. A perfect art must be wisely applied to what we are most given to by nature."—P. 333.

late them to keep for ever burning the flame of their country's glory by adding their own acts as inexhaustible fuel. These mementos are within the walls of the senate-house, and must act, except on the basest minds, as continual monitors. The progress and completion of the work must tend to raise the standard of national taste, if those to whom the superintendence is intrusted keep only one object in view, the esoterical, æsthetical, and practical manifestations of art. It may be a question, if the subjects should be left to the choice of artists. All the events of importance cannot be delineated ; those which constitute the axes on which the greatest steps to civilisation have turned should undoubtedly be selected, and with them clear expositions of their political and moral meaning, so that the artist may have the real sense and prospective connexion of the subject. No allegory should be permitted, as militating against the majesty of truth. The selection of the subjects would require deep historical information, combined with a knowledge of art; so that events impossible to delineate may not be attempted. The deliberation of the commissioners ought to decide those points. In the selection of the poetical subjects the severest morality should be upheld, and a pure and even holy meaning should irradiate every subject.

Sculpture has advanced in England far before the sister art. Henry Baily yet survives, and by the fostering hand of his country may have some reparation made him for the harvest of sorrows entailed on him by the cold and heartless indifferentism of those who delayed his remuneration, for the sculptures intended for the royal palace. Hereafter he will be styled the Praxiteles of England. There are others following in the same class whose works would mark the state of sculpture, and not dishonour the noble building intended to be decorated.

We see no reason why the art of die-sinking should not be promoted, and Wyon called on to give proofs for a stupendous work which should place his name beyond Hedlinger, the Hamerini and Andrieu ; he has given such consummate proofs of

taste and talent as to leave no fear of failure, but excite the highest confidence of success. There may be other native artists in that line who only require encouragement to come forward. The proposal to delineate on fresco is a daring one. Is it the best medium on which to fulfil the great objects of art ? Is it capable of permitting the completion of all the *science* which a great pictorial representation ought to embrace ? A calm examination of the frescoes now extant should be made by judicious persons, accompanied by artists of acknowledged information, and a report sent in to the commissioners of the state of them as to durableness, colour, the degree of perfection to which the scientific details have been able to be carried, and the manner in which they effect their intended objects. Our climate, the nature and degree of light, and other local matters, require much consideration, and demand the attention of the artist when considering the disposition of his work.

Fresco - painting was adopted in Italy on account of the comparative cheapness, and not because it was the best substance on which to work. *All* the frescoes in Italy are either faded or perished. Those in damp situations are virtually obliterated, particularly at Mantua and Venice. The Cupid and Psyche, by Raffaelle, in a palace *near the Tiber, is evanescing*. The frescoes by Paolo Veronese, called the Vandremini, were sold in London for a few pounds each, being nearly colourless. These facts lead to the belief, that this climate and the contiguity of the Thames is not adapted to the use of fresco-painting.

Should some of the works be in fresco and some in oil, we suggest that thick panels of oak, well saturated in a solution of sulphate of copper, and united with Jeffry's marine glue, should be used, as they would, in all probability, endure as long as the building, and when thus prepared no insect would touch them. The eucalyptus of Australia might afford the largest panels, and when prepared be even more imperishable than the oak. Canvass, first prepared by immersion in the solution, and then coated on the back with the

marine glue, might make an imperishable surface. We offer these observations with much diffidence, but with the feeling of a duty, since they may prove useful, or lead to more mature suggestions.*

Before we close these remarks, we would fain observe, that the artists who are selected to enter the lists of fame have a high and arduous struggle. Now the minds of men so occupied ought to be relieved as much as possible from corroding anxiety,

the unfailing attendant on deficiency of worldly means. Our artists and authors are not celebrated for their wealth; there ought, therefore, to be agreements by which each artist should receive stipulated portions of his remuneration in accordance with the state of the work; the periodical payments to be one-third short of the whole amount, which last third should not be paid until the completion.

* Both Jeffry's marine glue and Margary's solution are patents; but as both have been tested to the utmost by the Admiralty, and are consequently before the public, we may be excused the liberty we have taken in suggesting so novel an adaptation of them in conjunction.

"The Cartoons. Westminster Hall"

Art-Union 5 (August 1843), 207–12

The MARQUIS OF LANSDOWNE,
SIR ROBERT PEEL, Bart.,
SAMUEL ROGERS, Esq.,
SIR RICHARD WESTMACOTT,
RICHARD COOK, Esq.,
WILLIAM ETTY, Esq.

The Cartoons, submitted, were in number 140, and the judges awarded the eleven prizes to the following artists :*

Premiums of £300

To EDWARD ARMITAGE—subject, 'Cæsar's Invasion of Britain.'

To GEORGE FREDERICK WATTS—subject, 'Caractacus led in Triumph through the streets of Rome.'

To CHARLES WEST COPE—subject, 'First Trial by Jury.'

Premiums of £200

To JOHN CALLCOTT HORSLEY—subject, 'St. Augustine preaching to Ethelbert and Bertha, his Christian Queen.'

To JOHN Z. BELL—subject, 'The Cardinal Bourchier urging the Dowager Queen of Edward IV. to give up from Sanctuary the Duke of York.'

To HENRY J. TOWNSEND—subject 'The Fight for the Beacon.'

Premiums of £100

To W. E. FROST—subject, 'Una alarmed by the Fauns and Satyrs.'

To E. T. PARRIS—subject, 'Joseph of Arimathea converting the Britons.'

To H. C. SELOUS—subject, 'Boadicea haranguing the Iceni.'

To JOHN BRIDGES—subject, 'Alfred submitting his Code of Laws for the approval of the Witan.'

To JOSEPH SEVERN—subject, 'Eleanor saves the Life of her Husband (afterwards Edward I.) by sucking the Poison from the wound in his arm.'

The judges, it should be observed, expressly state that " the order of names in each class is merely according to the order of the numbers in the catalogue," and they preface their award by this significant and most gratifying announcement :—

" The undersigned (the six judges), who have been appointed to decide on the relative merit of the drawings in the present exhibition, beg leave to state that, notwithstanding the inferiority of certain performances —a consequence unavoidable in an open competition, a great portion of the works are, in their opinion, highly creditable to the country. The undersigned are the more desirous to express this opinion, since the number of premiums offered, however liberal, was found to be by no means equal to the number of approved productions."

The judges were not content with merely thus intimating a wish ; they have acted upon it ; and have since bestowed REWARDS upon the following TEN artists—a reward of £100 to each :—

To F. HOWARD—subject, 'Una coming to seek the assistance of Gloriana : an allegory of the Reformed Religion seeking the assistance of England.'

To G. V. RIPPINGILLE—subject, 'The Seven Acts of Mercy. Una and the Red Cross Knight led by Mercy to the Hospital of the Seven Virtues.'

THE CARTOONS.
WESTMINSTER HALL.

IT is glorious to see the new birth of British Art dated from the Old Hall at Westminster. The "ancient of days" has never been devoted to a nobler or a holier purpose!

Previous to commenting upon the worthiest exhibition that ever took place within the walls of any building in England, it will be well to remind the reader of the circumstances under which it has taken place, and the object contemplated :—

" The Commissioners appointed by the Queen for the purpose of inquiring first, whether, on the rebuilding of her Majesty's Palace at Westminster, wherein her Parliament is wont to assemble, advantage might not be taken of the opportunity thereby afforded of promoting and encouraging the Fine Arts in the United Kingdom ; and, secondly, in what manner an object of so much importance might be most effectually promoted,"

issued an advertisement in April last, intimating their desire to ascertain

" whether Fresco painting might be applied with advantage to the decoration of the Houses of Parliament."

With this view they gave notice—

" That three premiums of £300 each, three premiums of £200 each, and five premiums of £100 each, will be given to the artists who shall furnish cartoons which shall respectively be deemed worthy of one or other of the said premiums by judges to be appointed to decide on the relative merit of the works.

" The drawings are to be executed in chalk, or in charcoal, or in some similar material, but without colours.

" The size of the drawings is to be not less than ten, nor more than fifteen feet in their longest dimension ; the figures are to be not less than the size of life.

" Each artist is at liberty to select his subject from British History, or from the works of Spenser, Shakspere, or Milton.

The time fixed for sending in the Cartoons was the first week in June, the place selected for their exhibition was Westminster Hall, and the judges appointed to award the prizes were—

* It is worthy of remark that, of the eleven prizes, ten appertain to history ; the eleventh being a theme from Spenser. This is curious ; it is no doubt the result of accident, but may lead artists to believe (what we shall not be sorry to see) that the finest subjects for Art are to be found in British history.

449

To F. R. PICKERSGILL—subject, 'The Death of King Lear.'

To Sir W. C. ROSS, R.A.—subject, 'The Angel Discoursing with Adam.'

To HENRY HOWARD, R.A.—subject, 'Man beset by contending Passions.'

To F. R. STEPHANOFF—subject, 'The Brothers releasing the Lady from the Enchanted Chair.'

To JOHN GREEN WALLER—subject, 'The Brothers driving out Comus and his Rabble.'

To W. C. THOMAS—subject, 'St. Augustine preaching to the Britons.'

To MARSHALL CLAXTON—subject, 'Alfred in the disguise of a Harper in the Danish Camp.'

To EDWARD CORBOULD—subject, 'The Plague of London, A.D. 1349.'

The one hundred and forty cartoons were publicly exhibited at Westminster Hall, by private view, on Saturday the 1st July; to visitors paying 1s. each, during the fortnight between Monday the 3rd July, and Monday the 17th; and to the public generally, free of charge, after that day, excepting Saturdays, when the charge of 1s. is to be made upon each visitor. The exhibition thus arranged is now open.

So much for the facts connected with the first attempt of the British Government to foster British Art. Let us now see how it has been met, what have been its consequences, and what are likely to be its results.

In a word, the issue has been ENTIRELY SATISFACTORY—giving much at which to rejoice, and either literally nothing or next to nothing calculated to cause regret.

There appears to be but one opinion—the connoisseur, the critic, and the public all concurring—as to the high merit of the collection as a whole. Of course, out of 140 works, contributed by about 120 artists, there will be many mediocre, and some so lamentably wretched as to excite wonder what conceivable obtusity of intellect could have sent them to the Hall.* But a very considerable proportion of them are good; several are of high merit; and a few are of very rare excellence.

This is saying much; for be it now and always remembered, that we are speaking of a *first* effort in a new style; let us only imagine what the next attempt will be, and then argue from what we may take for granted will be supplied to us by a third invitation, when both those who invite and and those who are invited will have learned much from the experience they are now both working without. We say, without the least hesitation, that if the plan so worthily began be but effectually carried out, and arrangements are made to have a similar TRIAL annually, for the next six years (when the structure may be expected to be ready for the actual work), our British school will be by that time at the head of the schools of Europe. Even now we should not shame to place a selected forty of these cartoons beside forty pictures chosen from

* Perhaps it was necessary that, on this occasion, no offered work should have been rejected. But, we trust, when a case of the kind again occurs, a wholesome discretion will be exercised over the works that are to form a public exhibition.

the Luxembourg or Versailles; although in these places they have been commissioned, painted, and paid for by the nation, and our artists produced their works with very little certainty, and with many heavy misgivings, as to the receipt of any reward for hard labour and great sacrifices.

For ourselves, although our hopes from English artists have been always strong, and our estimate of what they have achieved proportionably high, we had little expectation of examining a collection of which the country may be so justly proud. It far surpasses our most sanguine hopes; and we believe this to be the general impression.

We congratulate then, first, her most Gracious Majesty, who will rejoice to find that " the commission" was not appointed in vain; next, the commissioners, whose arrangements have been wisely, judiciously, and liberally made; next, the artists, who have established their right to the high standing for which " the profession" has been long uselessly contending; and next, the country, for which a new glory may be said to have been obtained. Above all, we congratulate Prince Albert, whose high hopes have not been disappointed; to his Royal Highness the triumph is a signal one; for our readers must remember how, when first promulgated, the plan of frescoes was laughed at, as a German idea that never could be worked out in England.

Before we proceed to notice the works exhibited, some remarks appear to be necessary. If the judges, by their award, have not given universal satisfaction, they have gone very near to do it. No one suspects them to have been influenced by other than the purest motives; and those who may, in two or three instances, differ from them as to the estimates they form, willingly allow for variations of taste, and feel assured that, all things considered, the trial could not have terminated in a more satisfactory manner. We refer to the ELEVEN PRIZES,—for in bestowing subsequent awards there can be no doubt other considerations than those of actual merit weighed with the judges.* Perhaps these considerations *ought* to have had weight: we

* It was perhaps not unreasonable to expect that consideration would be given to other claims than those of actual merit; but if this principle did guide the judges, we humbly submit that they should have bestowed a thought upon a veteran artist, who in contributing two cartoons made a great effort and a large sacrifice, and whose works are certainly not inferior to some of those to which awards of £100 have been made. We are by no means a partisan of Mr. Haydon's, nor can we be classed among the admirers of his paintings; but we cannot help regretting that upon this occasion there was no memory of the bold battle he has been fighting all his life for HIGH ART—to bring about the very consummation we have lived to see. He may have fought occasionally with awkward and unseemly weapons, and defeated his own purpose by the mode in which he went to work; but assuredly he has done more than any living painter to arouse the public mind, and to prepare it for the wonderful change we have now seen effectually wrought. It is, therefore, greatly to be lamented that that which ought to have been remembered should have been forgotten. We lament it upon all accounts; lately we believe Mr. Haydon was disposed to use the pencil more and the pen less, and to abandon a perpetual snarling at success, be-

cannot say; but we regret, for the sake of the Royal Academy, that it was thought desirable to include two of its members in the NEW LIST; if they were not entitled to partake of the feast, they should not have been made content with the scraps left at the banquet. It will do far more harm, in the public mind, to have the fountain of honour and the great teacher of the Art considered by an afterthought, than if its advances had been rejected altogether; and it is sufficiently notorious, that the failure of the members of the Royal Academy to obtain a single prize has been a subject of triumph to its adversaries, who point to the fact as affording conclusive evidence of the alleged inferiority of the body. Nothing can be more unjust, or indeed more false and malicious. Of the Royal Academy, those who competed were just those who ought, for their own sakes and for the honour of the Institution, to have attempted nothing of the kind. It is, unquestionably, to be lamented as an evil that will operate to the disadvantage of the Royal Academy for many years to come, that the members who were capable of producing cartoons, and might have secured prizes, shrunk from the contest. It was understood, long ago, that the great national effort for the promotion of the Fine Arts in Great Britain was to have no aid from the Royal Academy. From time to time we have presumed to warn the Royal Academy of the risk they were incurring: they have abided the issue, and they must take the consequences. We have no desire to make this article offensive, and therefore do not speculate upon what those consequences may be; but, assuredly, the public will put its own construction upon the fact, that no prize, large or small, was awarded to any member of the Royal Academy.†

We shall have frequent occasion to consider the mighty influences which this cartoon competition may have upon the Arts and the artists of our country; and to consider also another very startling fact—that A majority of THE PRIZE-GAINERS WERE MADE KNOWN TO US FOR THE FIRST TIME IN WESTMINSTER HALL!

This exhibition must go so far to set at rest the questioned ability of British artists to deal with that department of the profession to which they have been deemed unequal by the illiberal abroad and the ignorant at home. We remember that when the question of manufacturing designs was

cause it was not success accomplished in the best way. We greatly fear that his animosity will be stirred up by this exclusion (an exclusion which we do certainly say ought not to have occurred). As a proof that it will be so, or has been so, we copy the following advertisement from the *Times* of Friday:—

" CARTOONS, WESTMINSTER HALL.—The people are respectfully required to look at Cartoon 23 (' The Curse'), and 118 (' Edward the Black Prince'), and are appealed to if Mr. Haydon has been justly treated, to have no reward."

† We believe no prize has been obtained by a member of any society; neither the Society of British Artists, nor the Societies of Painters in Water-Colours. It is worthy of remark that among the eleven prize-gainers there are four members of the Etching Club — Cope, Townsend, Severn, and Horsley.

before the House of Commons it was seriously stated that there was among us a want of intellectual qualification for the production of designs; the same, up to the last hour before the opening of Westminster Hall, has been insisted on with regard to their powers in the highest walk of Art. But to this senseless and impertinent detraction, their reply has been most triumphant. We long ago expressed conviction that many of our most distinguished painters would not compete. Had they contributed to the catalogue, the exhibition would have been such as, under all circumstances, no other country could have surpassed; as it is, there are passages of Art which, glorified by the *prestige* of some great name, would be the admiration of all beholders.

And be it remembered many of these beautiful productions are the works of persons who never before attempted a cartoon, who knew not whether they were to draw upon paper or cloth; and such being their measure of success in dealing with materials so new, what might not be expected from a second effort, after having benefited by experience? Those cartoons are the best which are free from what is considered the classic manner; this is enough to show that, on each mind pursuing nature in its own way, originality must be the result. The weakness is with ourselves, not the want of variety in nature. If it can be satisfactorily shown that Raffaelle and the other *magnates* of the Italian schools have left nothing undone—that they were so far the favourites of Nature and Art that they have effected all that Nature can accomplish and Art display—then are the Germans right in aiming at a transcript from their style, and then would the best decorations that could embellish the walls of the Houses of Parliament be copies from their works. This would be to show, on the one hand, that the entire circle of human nature was bound up in Greek and Italian nature; and on the other, demonstrate the truth of the sage theory of our amateurs, that Greek and Italian artists possessed some faculty of which all the rest of the world were deficient.

In reviewing the collected works, we shall pass over those concerning which we can say nothing either agreeable to the producer or useful to the public. We shall give the names of the artists, because although, very properly, they are exhibited without fixed ownership, the producers of all are generally known. We may observe, however, that, in giving them to the respective artists, we trust to the statements communicated to us; for although pretty familiar with the style of each, and not very likely to attribute *pictures* to wrong painters, we were completely astray in our guesses at the authorship of several of the cartoons. A few are not to be mistaken; but in a vast number of cases it would be impossible to trace the style of the painter in the cartoon. We look upon this as of great importance, for if the fact be really so, there can have been but little " mannerism."

It is but just to observe, what indeed is acknowledged by all with whom we have conversed, that to the enlightened views of PRINCE

ALBERT this country is indebted—mainly, perhaps it would not be too much to say solely—for this mode of instructing and refining the mass of the people; and it must be peculiarly gratifying to the Queen to find that this most legitimate and rational activity of the husband of her choice promises to become a powerful instrument of good. The office of the Commissioners on the Fine Arts is comparatively restricted, being confined to the decoration of a single building; but the success of the experiment which they have had the courage to make will not be lost on future occasions. It will now no longer be doubted that the Arts can have a moral influence. It will now no longer be a question whether or not the people *can* take an interest in works of Art. The artists themselves will feel their power, and from decorators of boudoirs will be elevated to responsible teachers of taste and morals, and it may be to public benefactors. An opportunity will again be afforded next year for the display of their efforts in this noble calling; but we trust that, on that occasion, when it appears there will be no other rewards than the selection of some artists for the works required (an arrangement, by the way, upon which we hold ourselves free to comment), the Committee of Arrangement will be directed to exclude such absurdly-inefficient performances as some of those now (happily not prominent) in Westminster Hall. It is, we repeat, misplaced indulgence to offer such abortive attempts to observation, and it is cruel to suffer uneducated eyes to be vitiated.

Penny catalogues have been provided, but the poorest people prefer the sixpenny, or pirated threepenny ones, and examine the drawings attentively, while they occasionally refer to the descriptions and quotations. The catalogue not being voluminous, there was no necessity for curtailing quotations which related directly to the subject; and it has been observed that, in addition to the useful purpose of illustrating the Cartoons, these catalogues are the means of introducing thousands of readers for the first time to the language of some of our best poets.

In consequence of the mode of arrangement of the Cartoons, the historical portion constitutes again a pictorial illustration of many important events recorded by the writers who are quoted, and many a reader is stimulated to inquire further. The influence on general taste is more remote but not less certain. The public at large, and perhaps we may add cultivated observers, require the aid of association and an acquaintance with the story of a picture to invite their attention in the first instance; the contemplation of it as a work of Art is a different and a somewhat later operation of the mind; but the attention being once invited, the eye is gradually educated, and thus, in the instance of the uneducated observer, the habit of comparing degrees of excellence, and of discerning the elements of beauty in composition and forms, is by degrees acquired. We have, therefore, in this exhibition, an instance of the Arts doing good directly and indirectly, and on a large scale; and our legislators may be convinced of the possibility of their salutary influence by the success even of their first experiment.

No. 8. * * * * RIVIERE. A nameless subject, and a difficult one; but, nevertheless, treated with much ability. It is from " Paradise Regained."

"Heaven open'd, and in likeness of a dove
The spirit descended."

The figures are a wreath of angels, who derive too much weight and substance from so much of the cartoon being left blank. The opening of Heaven might have been more definitely shown: as far as it has been carried it is meritorious, but we consider it but a fragment of the idea to be gathered from the lines.

No. 10. 'Una alarmed by the Fauns and Satyrs,' W. E. FROST. This, as one of the prizes of the third class, is worthy its distinction. The fauns and satyrs, alarmed at the cries of Una overtaken by Sansloy, quit their sports near the bower of Sylvanus, to ascertain the cause of the shrieks. On their appearance the paynim departs, and they pay their rude homage to Una, who is terrified by their glad demonstrations of devotion. In the subject it will be understood there is nothing that could be turned to the account of the sublime. The force of the verse goes to describe the wild emotions to which the wood-born people have given themselves up. The main character, therefore, of the work is movement, which has been effectively made out. We find Una circumstanced according to the lines :—

"The doubtful damsell dare not yet committ
Her single person to their barbarous truth;
But still 'twixt feare and hope amazed does sitt,
Late learn'd what harm to hasty trust ensu'th."

She is therefore seated on the ground, and, following the lines,

"all prostrate upon the lowly playne,
Doe kiss her feete, and fawne on her with count'nance fayne ——"

One of the satyrs is on the ground near her, as if to kiss her feet, but the purpose is not sufficiently apparent; therefore the cartoon would have been improved by the omission of the allusion thus managed. The intellectual point of the composition is the contrast between Una and the satyrs, which ought to have been more effectively widened by a higher degree of refinement thrown into the features of the former; a consideration made imperative by the manner of representing the latter, who have been studied, not according to the somewhat loose description of Spenser, but after the finished model of the ' Dancing Faun.'

No. 11. 'Una coming to seek the assistance of Gloriana: an Allegory of the Reformed Religion seeking the assistance of England,' F. HOWARD. The subject is found in the letter written by Spenser to Raleigh, in order to describe the point of the poem. The scene is the court of the Queen of the Fairies, whereat a " tall, clownish young man" presents himself, to solicit the achievement of any adventure which during the feast might happen; and this being granted,

he seats himself upon the floor to abide his time. Shorly afterwards appears the lady in mourning, mounted on a white ass, soliciting the aid of the Faerie Queene. The Faerie Queene is presented in the likeness of Queen Victoria, who occupies the centre, having on her left the lady, and the dwarf leading the destrier for the appointed knight. For the number of figures here introduced there is want of space: we cannot conceive so many persons, together with animals, conveniently arranged within so limited an area—thus are lost the state and ceremony which should characterise such a scene. The drawing is generally good, and roundness is well described without much effort ; but there is a want of force and decision, which leaves the whole very ill defined.

No. 13. ' The Seven Acts of Mercy,' E. V. RIP-PINGILLE. The subject is from the " Faerie Queene," book I., canto 10. Mercy leading Una and the Redcrosse Knight to the Hospital of the Seven Virtues. This is designed as a compliment to the Queen, whose portrait, very successfully drawn, is given to one of the principal figures. We question, however, the good taste of the introduction. The composition may be said to be in parts, the whole forming a beautiful epitome of the description in the text, wherein is portrayed each charity individually. Mercy, Una, and St. George are received by the principal of the hospital, who, on his knee, acknowledges Mercy its patroness. The numerous other figures are skilfully distributed and grouped, each being, endowed with a powerful intelligence, contributing its quota to the sphere in which it is placed. The chief hospitaller and his assistants are habited in the monastic dress : the heads of some of these figures are admirably conceived. The equipment of the Redcrosse Knight might be objected to, if the allusion to King Arthur were to be set up as determining chronology ; but the allegory points to the armour of the Christian described by St. Paul in his Epistle to the Ephesians— " Wherefore take unto you the whole armour of God, that ye may be able to withstand in the evil day, and, having done all, to stand. Stand, therefore, having your loins girt about with truth, and having on the breastplate of righteousness." Thus we know not how the spirit of the subject could have been better sustained in this figure.

No. 16. ' The Death of Lear,' F. R. PICKERS-GILL. To the author of this cartoon £100 have been awarded on the second distribution, and most justly, as its merits are of a high class. It is distinguished by great breadth and power of execution ; the chiar'oscuro is commonplace, but it is the best style of commonplace. The costume has been carefully studied ; it is appropriate, and severely shorn of the unmeaning embellishments so highly valued among artists of the present time. It may be said, however, of Lear that he is not sufficiently enfeebled : the eyes seem but closed in sleep ; the features are yet full, and of a healthful firmness, bespeaking within a vigour, freshness, and decision of intellect yet equal to mighty purpose, in the government of a kingdom. He is here assuredly dead too soon, and he looks too well in death.

No. 20. ' King John,' S. HART. R.A. The prominent figures are Constance, King Philip, the Bastard, Austria, &c. Constance is suing reproachfully to King Philip, while the two last are engaged aside ; a division which is fatal to the unity of purpose which should prevail among the prime components. The figures stand forward from a background, so uncompromisingly white as to throw over the whole an indescribable tone of flatness and insipidity. The drawing is faulty, especially that of the Bastard, who stands with his back to the spectator. It is, moreover, an utter departure from probability, for the Bastard is actually collaring Austria.

No. 23. ' Tempest,' Act 1, Scene 1, BOSTOCK. Ferdinand approaching the cave of Prospero, spirited onward by Ariel. The scene have been most carefully elaborated, but the scene is so alphabetically rendered as to turn into prose the mystic conceit of the Swan of Avon.

No. 25. ' Scene from Snakespere's *King Lear*, Act 1, Scene 4,' WRIGHT. There is much to praise in the grouping here, although managed upon a principle so often exercised as to become monotonous ; the effect, however, is feeble, so much so (if the intention go not beyond this) as to create an apprehension for the result, if the composition were to be so painted. We cannot pass the cartoon without allusion to the costume. The paraphernalia of feathers, ermine, and their accompaniments, are not proper to scenes from *Lear*. Much of this is copied from the stage, generally the very worst example to follow : it is impossible that a man in any profession can stand still ; if he be not continually searching and inquiring for himself, he is assuredly losing ground.

No. 26. ' The Death of King Lear,' POOLE. " Look on her, look—her lips,— Look there, look there!" (*He dies.*)

The eye is fascinated by a crown upon a death's head, nor can it escape the dread mockery, seek relief in what part soever of the composition it may. We learn here that Lear has long been virtually dead, before this his physical decease. What were to him the ills of life, have made their way roughly over his features, for death has not yet had time to deal so hardly with them. So fraught with horror is this figure, that it seems to have been dug from the grave, to fulfil a part in giving a lesson of mortification to presumptuous humanity. By his rigid severity and denial, the artist refers us to his character, by which alone he is content to be tried. Here, indeed, is the vast force of the work : he has striven for originality, and has been so successful, that, amid vicious and reckless imitation, he has produced a work which achieves for him a yet higher position in the ranks of his profession. He seeks his sublime in the essence of the horrible ; but in his manner of relation there are qualities independent of his keen apprehension of this, which will turn to profitable account after he has assured himself that the least agreeable effect of Art is to shudder under its power.

No. 27. ' Constance in the Tent of the French King,' CROWLEY. We would gladly have seen the diligent study and power of drawing shown in this composition exerted on a better theme; for to the spectator the subject is mute, treat it as you may : his memory must be quickened by a long quotation, and then he must compare the passage and the ideal embodiment; moreover, it is not of importance sufficient for an occasion of this kind. The last remark will apply to others; but we make it directly in reference to this, because the work exhibits powers of a high order. Constance is on the ground in a position by no means graceful; now this is not absolute, since there is a discretion afforded by the words,

> ———— " here I and sorrow sit,
> Here is my throne; bid kings bow to it."

Salisbury is a middle age reality, and the kings without the tent form an admirable passage.

No. 31. ' The Angel Raphael discoursing with Adam,' Sir W. Ross, R A. The three figures are seated in the bower, the pair side by side, and opposite to the

> ———— " sociable spirit that de'gned
> To travel with Tobias."

The innocent state of the parents of mankind has never been more felicitously alluded to than here. The angel is robed, and, maugre a degree of stiffness, there is yet much grandeur in the figure, which is opposed to the undraped figures of Adam and Eve, and, aided by the feeling thrown into them, points attention at once to the happy state of which the poet so often and so emphatically speaks. Adam is seated, intent upon the argument of his angel visitant; Eve is toward the spectator, and fondling a lamb. Eve has been rarely more happily rendered. It is an exquisite figure of a perfect woman.

No. 33. ' The Curse,' B. R. HAYDON.' The judgment of Adam and Eve in Paradise is here represented. The " Son Vicegerent" is seated on the right; Adam, Eve, and the Serpent occupy the centre ; and on the left is seated Satan. With respect to the presence of Satan, the author seems to have travelled beyond the text, unless we are to consider the composition particularly to typify Heaven, Earth, and Hell; and here at once closes to the mind the vast range which has been opened to it by another treatment of the subject. The accompanying extract is—

> " But whom send I to judge them, whom but thee,
> Viceregent Son? To thee I have transferred
> All judgments, whether in Heaven, in earth, or hell."

The circumstances of the right hand portion of the cartoon declare that part to have been wrought out from the judgment, and passages in connexion with it; but we find there nothing to suggest the introduction of Satan, a method of treatment which strips the cartoon of the virtue it possesses as derived from Milton, by wrapping the subject in allegory. It is sufficiently difficult to work up to his imagery with any degree of success ; to allegorize upon his verse seems to say it is not sufficiently rich. Of the detail of the work we could not limit ourselves to say little, and to speak of it at great length we have not space.

No. 34. ' Samson Agonistes,' T. LANDSEER.

> "*Delilah.* Let me approach, at least, and touch thy hand.
> *Samson.* At distance—I forgive thee—go with that."

Samson is here very prominent, coming forward in strong relief against the sky. He is seated, surrounded by his friends ; Delilah standing near him. He is colossal in the flesh, a treatment which has little to do with the beautiful; it is enough that we believe him a strong man, without this vulgar record of his strength. We could, without this striking contrast between him and those around him, believe him equal to bear off the gates of Gaza ; and without this, that enough of strength was left him to destroy the edifice in which his enemies were assembled. Delilah has all the beauty ascribed to her by Samson, but none of the character which a true estimation of Eastern impersonation ought to give. She is somewhat too sylph-like : there is about her nothing of the appearance of the " Philistian matron."

No. 36. GEDDES. The same subject exhibited in a cartoon in the centre screen, whereon its position is most unfavourable for examination, in consequence of the embarrassment arising from cross lights. Samson is, of course, the principal figure; but his importance is much diminished by what seems the trunk of a palm tree rising near him. A group on the right appears extremely well put together, and effectively finished.

No. 37. ' Satan Vanquished,' ARCHER. A passage in the war waged by Michael and Gabriel, and their host, against Satan and the powers of hell, as related by Raphael to Adam. Satan is borne off on the shields of his followers, on whose part great effort is necessary to support him : this is a description of solidity and weight directly relative to human substance, and little consonant with the idea conveyed by the words :—

> ———— " the *ethereal substance* clos'd,
> Not long divisible."

Milton's description of the battles of the angels abounds with immediate deductions from human warfare; we cannot, therefore, censure the artist because he is weak on the same side as the poet—
" Thus measuring things in heaven by things on earth."
A main defect in the cartoon is its deficiency of movement ; the wound of Satan could not thus have stayed the efforts of both sides. Another striking error is, that in general appearance and equipment the whole, on supercial examination, look much like some of the tribes of Gauls or Britons.

No. 40. ' Third Part of King Henry VI., Act 2, Scene 5,' WELD TAYLOR. Descriptive of the horrors of civil war, as in that part of the play enacted by the son who had slain his father, and the father who had slain his son. The selection of the subject is judicious ; but it is one extremely difficult to deal with in any manner sufficient to elucidate the argument.

No. 41. ' Samson in Captivity,' BURTON.

> *Chorus.* ———" Can this be he,
> That heroic, that renown'd
> Irresistible Samson ? "

Samson is bowed down in affliction, while two figures stand wondering at and lamenting his fallen state. The effect of the work is admirable throughout, and Samson is characterised with a feeling corresponding with that of the verse, but about the figures, although put in with force and breadth, there is too much both of *la jeune France* and *la Grece antique.*

No. 45. 'Man beset by contending Passions,' HOWARD, R.A. The best of the productions of this gentleman we have of late seen ; it is light and sketchy, the material (sized cloth) on which it is executed being highly favourable to its free style ; circumstances, however, incline us to think that in colour and finish many of its best qualities would pass away. Man, the principal figure, is urged on, we are told in the catalogue, by Pride, Ambition, Anger ; restrained by Love and Pity ; pursued by Grief, Hate, Envy, Revenge, Fear ; buoyed up by Hope ; chained to the earth by Despair ; Reason overthrown ; Horror in the midst. All this is tolerably legible — a high merit in works of this class ; but some of the impersonations are untrue, as, for instance, Reason, whose character is that of an evil passion.

No. 48. 'Samson bringing down the House upon the Philistines,' BELL. Samson is between the pillars, which are yielding to his mighty efforts. One of the Philistines he has cast on the floor before him, an incident detracting from the force of the composition, which is intended to be centred in Samson ; in a work like this one additional figure cannot aid the story.

No. 49. ' Lines written at a solemn Music,' O'NEIL. The lines are among Milton's Odes, and the impersonations are the "Voice and Verse," joining their " passion'd accord "—

" Around the sapphire-colour'd throne,
To him who sits thereon,
With saintly shout and solemn jubilee."

If the design and treatment of this cartoon were entirely original, it would place the author in a high rank among the professors of sacred poetry ; it *is*, however, in the manner of the Italian frescoes, yet displays, nevertheless, a fine apprehension of all that is elevated in feeling and sentiment.

No. 51. * * * A. E. CHALON, R.A. The Hesperides, according to the epilogue to *Comus,* "singing about the golden tree." In these three figures the flesh is substituted for the spirit.

No. 53. ' The Expulsion of Sin and Rebellion,' STEVENS. A number of headlong figures, grouped circularly, as if designed for a bas-relief ; the *vis cadendi* is, however, wanting ; this and much else has been sacrificed to neatness of arrangement. The features are deficient of all expression of pain, confusion, defeat, and consequent infernal ire and disappointment ; as opposed to this the glory of the Messiah pursuing is insufficiently upheld.

No. 55. 'The Expulsion out of Paradise,' H. CORBOULD. Nothing new is attempted. Adam is supporting Eve in their reluctant departure from the happy seat. The expelling angel is behind them. Milton's idea of the expulsion was by no means so tangible as this. The returning cherubim are described

——— " Gliding meteorous, as evening mist
Risen from a river o'er the marish glides,
And gathers ground fast at the labourers heel
Homeward returning."

Eve is given up to grief ; but the expression of Adam has in it a somewhat of resistance. The drawing of the former has many beauties ; but the head is like some of Reynolds's female portraits. The drawing of the male figure is objectionable.

No. 57. ' Sabrina releasing the Lady,' J. WOOD. The manner and composition resemble very much those of a design for a bas-relief—the drapery, particularly that of Sabrina, has this appearance. The costume of the brothers sorts ill with the classic tone of the other figures, and their heads are portraits, unmodified from every day studies ; the very measure of the verse ought to have suggested something different.

No. 58. ' Satan discovered in the Garden of Eden,' CORBOULD, jun. Satan has started up in his own form ; Adam and Eve are asleep on the ground, and the angels occupy a position on the left. The figures are made out with all care for elegance of form and action—the head of one of the angels resembles that of the ' Paris' of Canova.

No. 60. ' The Brothers releasing the Lady from the Enchanted Chair,' STEPHANOFF. This cartoon is very agreeably composed, and distinguished by much sweetness of manner, but the faces of the brothers, the lady, and the shepherd, appear to have been drawn from one model, and that a female one ; a circumstance which has thrown an expression so feminine into the faces of the two first that it might be thought they were rather playing, than in earnest with their weapons. In respect of expression the work is deficient, but it is otherwise graced by many valuable points. This is one of the works to which £100 have been awarded.

No. 63. ' The Brothers driving out Comus and his Rabble,' WALLER. There is much grace in the management of the chiar'oscuro, but with respect to the life of the work the brothers are here as much too heavy and loutish as we find them elsewhere too feminine. They are rushing down steps in pursuit of the band of Comus with a very improbable precipitation. On the right of the composition lies one of the latter with a head very similar to one worn by one of Michael Angelo's demoniacal impersonations.

No 64. ' Caesar's first Invasion of Britain,' EDWARD ARMITAGE. To the author of this work, as one of the first-class prizes, three hundred pounds were awarded. It is obvious, at the first glance, that the mind has been well strung up to the subject during its execution, and even to its completion. The drawing has all the square and decided character of the modern French school, and is well adapted to give force to such a scene ; but it cannot be doubted that in colour it would lose much of its positive effect. The main feature of the cartoon is, as it should be, violent action, described by lines crossing each other at all angles ; the movement is throughout the whole extremely well sustained. The position of Caesar himself is, however, a very questionable one, for he appears circumstanced rather as after a defeat than before a victory. Much has been sacrificed to get a likeness of him ; we have his head consequently presented in profile, as upon coins ; he is, therefore, uncovered, in front of a determined enemy—a circumstance very improbable, as it is also improbable that he should be alone while urging on the standard-bearer or those near him. The figure is also deficient of dignity and self-possession—not that the occasion would not justify some degree of confusion in another commander, but it is not

consistent with the character of Cæsar. The
Britons do not appear in sufficient numbers to
justify the backwardness of the Romans, and it
is not sufficient to suppose them in imposing mul-
titudes. The merits of the work are many and
masterly; there is life and nerve in all the limbs,
and the expressisn of each countenance is suited
to the action of the body. The figures are moved
by variety of intent, all contributing to the main
purpose, with the exception of him who is re-
straining the horse, and his object is not appa-
rent. The work is one of high promise, and, we
trust, is the precursor of yet better things.*
No. 66. 'The Introduction of Christianity into
England,' F. HOWARD. An excellent subject,
skilfully composed and drawn with great accu-
racy, but wanting in descriptive power of that
kind which marks time and locality. The action
of Paul is too declamatory—deficient of solemn
earnestness. The composition is drawn upon
sized cloth in a free manner, without the addition
of white chalk.
No. 70. 'Joseph of Arimathea converting the
Britons,' E. T. PARRIS. Joseph is a most suc-
cessful study as a picture of Christian humility.
He is surrounded by the people and their priests,
and seems even to have broken in upon a Druid-
ical festival, for he is preaching under the sacred
tree. One of the priests is penetrated with the
Divine truth, while another is mocking the
preacher, and endeavouring to dissuade one of
the audience, who seems moved by his exhorta-
tions. This cartoon gained a prize of one hundred
pounds. If somewhat deficient in power, it is a
production of much grace; pure in conception, and
manifesting a fine feeling for eloquent and
expressive beauty.
No. 72. 'Council of Ancient Britons,' BROWN.
A chief is seated under an oak listening to the
addresses of a priest. Besides these the group
comprehends a bard, armour-bearer, dogs, &c.
The style of the work is vigorous, and its
character powerful.
No. 74. 'Boadicea, Queen of the Iceni, ani-
mating the Britons previous to the last Battle
with the Romans under Suetonius,' WARD. The
effect of the heroine's address is manifested by
the motions of those around her: one strings his
bow, another draws his sword, and all are moved
to action. This is one of the few works that we
marvel to have seen passed over. It is fine in
conception, accurate in drawing, the figures are
skilfully balanced, and the grouping is excellent.
The fault of the work is the too great prominence

* Mr. Armitage, although a very young man, has for
some years resided in France, where he has been, and
is, a pupil of De la Roche. This fact has given rise to
a very general suspicion that the hand of the master
has been at work upon the cartoon; and we have heard
it distinctly, and on several occasions, stated, that the
drawing was actually made in the studio of the great
French painter. This it is our duty to contradict.
While in Paris, in May last, we saw Mr. Armitage at
work upon his cartoon, in his own studio, a mile or two
distant from that of M. De la Roche. The judges very
properly availed themselves of a provision by which
they were entitled to call upon any artist whose work
was executed abroad to produce another. Mr. Armi-
tage has, therefore, executed another cartoon; it

given to the attendant, who (with his back to the
spectator) reins in the champing steed. But
there is ample to compensate for this defect; the
figure of Boadicea is admirable, an impassioned
yet a dignified heroine. The merits of this work
are undoubtedly of a high order; and we be-
lieve artists and critics generally will agree with
us in preferring it to several upon which dis-
tinctions have been conferred. We shall remind
Mr. Ward of the beautiful conduct of Flaxman,
when worsted in a struggle for the gold medal
of the Royal Academy, by Engleheart—a very
worthless competitor:—" I determined," he says,
" to redouble my exertions, and put it, if pos-
sible, beyond the power of any one to make mis-
takes for the future."
No. 76. 'Caractacus before Claudius,' MORRIS.
There is everywhere evidence of care and re-
search. Claudius sits in state; he seems repre-
sented from authentic sources, and looks very
like a Roman emperor; but Caractacus is feeble
—he wants dignity and presence: there is nothing
in this version of him that would have induced
the Romans to exhibit him in triumph.
No. 78. 'Boadicea haranguing the Iceni,'
SELOUS. This production abounds with figures,
executed with great facility and mastery. The
name of the artist is but little known, but de-
serves to be more so. He is gifted with extra-
ordinary facility of drawing, which might ac-
quire the utmost force by being executed with
less attention to prettiness. Boadicea rises a co-
lumn amid her people, and is habited sufficiently
near to the description of Dion Cassius. The
composition is full of the movement which would
follow such a speech. The tone of the material
upon which this drawing is made is unquestion-
ably the most effective in the exhibition. Con-
sidered as a picture, without reference to its
qualities for fresco, it is a delicious work. The
female forms are pictured with amazing grace,
delicacy, and beauty. The grouping is most
skilfully managed, and with the expression of
each character has been introduced exactly the
natural and true feeling. No competitor has
better deserved the prize than Mr. Selous.
No. 84. 'Caractacus led in Triumph through
the streets of Rome,' G. F. WATTS. This is a
beautiful composition, in every respect worthy of
the distinction conceded to it. Caractacus is a
living presence; he sees and thinks—but la-
ments his fate too much; for, in considering
what he is, he ought not to forget what he has
been; he has, therefore, scarcely dignity enough.
The artist seems to have selected heads of every
variety, from the Briton to the Hindoo, and has
happily modified their expression respectively.
In this respect we may say the best conception
has been least worthily treated—that is, the head
of Caractacus himself. We know not why he has

has proved entirely satisfactory and established his
right to the premium. It is a very poetic conception,
very boldly treated. It represents a father protecting
his son with his shield, while with the other hand he
slings a stone at his opponent. The passions of revenge
and pity for the son are admirably expressed in the
old man's face.

been drawn with a forehead so narrow. If it is intentional, it is wrong in principle; and, with respect to proportion, it is too narrow for the cast of the face. There is little seen of the circumstance of a triumph, but the place of this is well supplied by the vitality of the figures; there are no trophies, no spoils; but the historical fact is well supported and brought forward in a manner sufficiently probable. This composition was not originally intended for this exhibition. Portions of the design were executed—perhaps the whole—two or three years ago, on another frame, as preparatory to being painted in oil. We mention this as a proof that, by returning frequently to a work with a " fresh eye," many of those glaring errors are avoided into which artists fall by too great a confidence in their powers of rapid execution,—which so often means bad composition and faulty drawing.

No. 92. ' St. Augustine preaching to the Britons,' THOMAS. The work of a young artist of high and undoubted genius, who is destined to occupy prominent professional rank. In our June number we passed some comments on two works in sculpture in the den of the Royal Academy, to which was affixed a name we had not previously encountered. It was with considerable surprise we learned that he is also the producer of this fine cartoon. There is a noble feeling in the composition; a degree of rare eloquence in the expression, and sound knowledge in the treatment of it.

No. 98. ' The Introduction of Christianity into England,' NIXON. The first interview of Augustine with Ethelbert, King of Kent, is here represented. The artist has dwelt with good effect upon the anxious persuasions of the Christian Queen; the costume of the period has also been profitably studied.

No. 100. ' St. Augustine preaching to Ethelbert and Bertha, his Christian Queen,' HORSLEY. Ethelbert is seated, with Bertha by his side, while St. Augustine is emphatically addressing the king, into whose features there is thrown a refined and acute reasoning faculty which accords ill with the firmness with which he would yet cling to his infidelity. He is sorely pressed by the expositions of the preacher on the one hand, seconded by the prayers and entreaties of Bertha on the other, and grasps his axe in nerving himself to resist both influences. This axe, by the way, is by no means out of place, for the Saxons went armed even to their feasts. The figure of Augustine is energetic; but the shadow which is concentred on him, had been better, more distributed in the composition. This drawing derives much value from the effective style of many of its heads. It ranks in the second class of the prize list, and has consequently obtained an award of two hundred pounds.

No. 101. ' Augustine, a Monk, with forty others, sent by Gregory to Britain, introduces Christianity among the Anglo-Saxons,' SAVAGE. The spectator is at once struck with the arrangement in this drawing. The monks and their audience form a semicircle round an oak, and

the distribution is so formal as to outweigh whatever excellence the work may otherwise possess.

No. 102. ' Alfred the Great,' FOGGO. The argument is based on an anecdote related of Alfred during his wars with the Danes. While besieging Hastings, the Danish leader, in Exeter, the wife of the latter is a second time taken prisoner, and led before him with an urgent desire on the part of the people that the atrocities perpetrated by Hastings should be avenged by her death; but she is a second time liberated by Alfred. There is much truth in the action of the work, but the greater porton of it is so elaborately worked into shadow, that the wife of the Dane looks a spot in the picture. There is no graduation of light: the eye passes at once from prominent light to the depth of shadow, or rather hesitates to do so; so repugnant throughout the whole course of nature are violent transitions.

No. 103. * * * CLAXTON. This is the story of Alfred penetrating into the camp of the Danes as a harper. A striking variety of character is given, and perhaps Alfred himself is less pleasing than many of those by whom he is surrounded. If mere harping had been his object in visiting the Danes, he might pass for an enthusiastic " son of the string;" but his real purpose should have been the paramount theme, but yet, with such features as he has, this could not have been effectively narrated; for he is assuredly Alfred the minstrel,—not Alfred the king and daring spy. There is, however, otherwise much probability in the character and arrangement of the scene. The Danes wore, we believe, longer hair than is here given to them, were usually habited in black, and considered by the Saxons as too much addicted to dandyism; the prince, however, is a very plain person, and scarcely sufficiently distinguished from the piratical band around him. The artist insists upon their other infirmities—play and the wine cup. Their disposition to the latter is shown by some of them who are quaffing with a " thirst quite Danish." In the whole composition there is very considerable merit; and some of the figures may be classed with the more perfect drawings in the collection. Indeed but for the failure of the Alfred it must have secured a prize.

No. 104. ' Alfred the Great submitting his Code of Laws for the approval of the Witan,' BRIDGES. To the author of this work was awarded a premium of the third class; it is an admirable subject, and might have been treated with better effect. Alfred, his Queen, and Prince Edward occupy the centre of the drawing, and around them are disposed groups formed of the great officers and dignitaries of the realm. There is in the countenance and attitude of Alfred a listlessnsss ill-befitting the occasion; this even extends to many of the others, who are not sufficiently alive to the interest and importance of the matter. On the right of the King are seated the Ealdormen, Thanes, Cymri, and Celtic vassals,

&c., and on the left the Abbot Grimbold, &c. Here also Alfred is a failure.

No. 105. ' First Trial by Jury,' COPE. An imaginary subject, but none better or more appropriate could be found; its execution has entitled the artist to a premium of the first class— £300. The trial is held *sub Jove*. Alfred himself presides, seated on the right; while on the left of the cartoon are assembled the " twelve good men and true;" the centre being occupied by the prisoner, the body of the murdered man, &c. &c. The artist has limited himself to a narrative of the simple fact; whereas we submit, that so good a subject afforded opportunity of extensive allusion to the benefits of trial by jury. It is not necessary that if a man be a prisoner he should also be a criminal; but the aspect of the prisoner in this case is so much against him that we cannot help thinking Alfred, in his justice, must, in his charge to the jury, have endeavoured to divest their minds of prejudice; for assuredly the accused belongs to

" A race of men with foreheads villanous low."

The murdered man has left a wife and child, who are addressing evidence to the jury, into whose features more of inquiry might have effectively been thrown. Alfred is again a failure; he does not look like a man to make head against the Danes; the features should have been distinguished from all around, as much as he himself was in advance of the time in which he lived. To this drawing, shadow is almost entirely denied, and with injurious effect, for much force could have otherwise been communicated to it. The work will bear these slight objections, for, as a whole, it is the most excellent production contained in the Old Hall; and as such it is regarded by all classes—the refined and the ignorant. The group in the centre—the widow and her orphan boy—is a most eloquent reading; and the "Twelve" are admirably composed and contrasted. The cartoon is, moreover, drawn with great skill. It has elevated Mr. Cope to a high professional rank.

No. 106. ' Edith finding the Body of Harold after the Battle of Hastings,' BARKER. Two monks, Osgod Croppe and Ailric the Childe Maister, having obtained permission to search for the body of Harold, could not distinguish it among the heaps of slain; they therefore sent for Edith, the mistress of Harold, to aid them, which she did, and discovered the body. Her distress and the circumstances of the discovery form the subject, which is well made out, but the whole is of a singularly low tone.

No. 108. ' The Death of William Rufus,' BARRAUD. The arrow has struck him in the breast, and he is placed in such a position with regard to Tyrrel that we must suppose him to have turned or moved forward, even allowing the shaft to have previously struck the tree, before we can account for his being struck in front. The figure is too slight, but parts of the horse are admirably drawn.

No. 109. ' Thomas a'Becket refusing to sign the Constitutions of Clarendon,' M'MANUS. The Constitutions of Clarendon were drawn up for the purpose of subjecting the Church to a paramount authority. The bishops, beginning with " Rodger York," have subscribed their names, but a'Becket refuses, and his declaration is received by the barons with disapprobation, insomuch that they address their hands to their weapons. The circumstances of the passage are clearly told; in the figures of the Barons (the one who holds the pen, especially) much talent is manifested. But the countenance of a'Becket is singularly unpropitious—while that of one of his attendants approaches the grotesque.

No. 111. * * * SEVERN. A version of the anecdote of Eleanor sucking the poison from the wound in the arm of her husband. That love of the *nudo*, so prevalent in the schools, has extended Edward nearly naked in the middle of the cartoon. The figure, however, is extremely well drawn. Eleanor is bending over him with her lips to the wound, while warriors on one side, and ladies on the other, are anxiously waiting the result. Edward still grasps his sword, on which is inscribed *Christo dedicatus*. This is a circumstance scarcely in keeping with the prevalent feeling. This cartoon is distinguished by mastery in drawing and composition, insomuch as to entitle its author to a prize of £100. It has given pleasure to many to find Mr. Severn among the prize-gainers; he has fought stoutly for frescoes from the moment the idea of their introduction was first broached among us.

No. 113. ' Sir William Wallace,' FOGGO. The execution of Wallace is represented in this composition, or at least the last preparations for it. Edward I., who was present at the execution, on seeing some monks about to administer the last offices of religion to the prisoner, ordered them to depart, when the Archbishop of Canterbury declared that he himself would offer spiritual consolation to Wallace. The cartoon contains a multitude of figures elaborately drawn, but as a whole it wants breadth.

No. 116. ' Bruce's Escape on the Retreat from Dalry,' F. HOWARD. A composition full of spirit and energetic life. Bruce is beset by three of Lorn's followers, who simultaneously throw themselves upon him from a crag, under which he was obliged to pass. He is mounted on a spirited horse, and struggling with his three assailants, who are clinging to him and the horse. The firm riding of the figure and its nervous action are beyond all praise. The drawing is slight, but most effective; the right leg of the rider is finely described as nervously pressing the flank of the horse. This obtained a prize of £100 among those of the second distribution.

No. 118. ' Edward the Black Prince entering London through Southwark, with John, King of France, taken prisoner at the Battle of Poictiers,' B. R. HAYDON. The spectator is struck with the crowded appearance of this cartoon. Edward is mounted on a small black horse, and John rides a white horse of great power and spirit. The artist has fallen into the error of giving black

armour to Edward, as supporting the assumption that he received the epithet "black" from this circumstance; but the first authentic mention of Edward as the "Black Prince" does not occur until *the second year of the reign of Richard II.*, in a parliamentary paper. On this subject Froissart says, that in consequence of his invincible valour, and victories so disastrous to the French, he was called *Le Noir*, but affords no data in support of the vulgar supposition of his wearing black armour. He may at tournaments in England have worn a sable surcoat with ostrich feathers upon it; but in battle he appeared with a coloured surcoat, embroidered with the arms of England. Sir S. Meyrick, in his work upon armour, has examined the merits of the epithet, but is not of opinion that its application arose from the colour of the armour. The prince and the king on their respective horses ride unusually low; so much so that, apparently, a moderately tall foreground figure would stand only about a head shorter than the former. The scene is laid in the streets of Southwark; the windows are crowded with spectators, and the rear is closed by a train of knights and men-at-arms.

No. 122. 'The Plague of London,' E. CORBOULD. This drawing has been made upon a blue ground, with (we presume) the view of aiding the intensity of the subject; but in this it fails, for the effect of the work is by no means served by it. The composition and drawing, however, cannot be affected, and these are of a high order of excellence. There are no scenes of poignant horror, but the picture is nevertheless stamped with abundant truth. One of the city crosses rises in the middle of the drawing, before which an ecclesiastic is exhorting the people to faith and repentance, while around him are lying the dying and the dead. On the right is seen a remarkable figure, distinguished by great graphic power: it is that of a woman recently dead. Near the centre kneels a lady lamenting a husband or lover: she is intended to give force to the scene by contrast, for she is richly habited, but she is, we may say, a spot in the work, as materially injuring the general effect. This work is marked by positive vigour and independence of style, and achieves for its author rank and consideration in his profession. It has gained a prize of £100.

No. 124. 'The Cardinal Bourchier urging the Queen of Edward IV. to give up from Sanctuary the Duke of York,' BELL. The artist has studied accuracy in every part of this work, so much so, as to appear timidity in some parts. It is a relief to meet with such a subject not overdone in costume and accessories. The personages are presented precisely as the incident might have taken place. The queen looks her refusal to the cardinal, and the child in apprehension seeks the protection of his mother. The figures are endowed with the valuable qualities of roundness and solidity, and the story is told with sufficient perspicuity. This work entitles its author to a prize of £200.

No. 128. 'The Fight for the Beacon,' TOWNSEND. This powerful and effective production illustrates no given fact, but is composed after a passage in Southey's "Lives of the Admirals," describing in earlier times the descents of the pirates on the coast, on which occasions the beacons were important, as instrumental in alarming the country. In this case the beacon is placed on a tower which the pirates are attempting by escalade against a very determined defence. The beacon fire overhead is giving forth its volume of black smoke, anxiously tended by a man who is clinging to the staff while the conflict is going on below. In the principal figure, a fierce and gigantic Northman, there is too great a display of anatomy, even allowing everything for violent exertion: however, the main virtues of the work sink all minor objections and rank it as a production of the highest class. There is in the attack and defence an earnestness of purpose impressing the mind with emotion proportionate to its reality. Two hundred pounds have been awarded to the artist. The work may be taken as a sure augury of an enduring fame. The artist must, ere long, hold rank the most elevated. It is worthy of note that this subject does not, strictly speaking, come within the limits laid down by the commissioners in their rules. We are glad to find they have no disposition to a literal adherence to them. This fact opens a vast volume to future competitors.

No. 133. 'Act of Heroism of Sir Philip Sidney,' BURBACK. This is the anecdote of Sidney refusing to drink the water which was brought him, on seeing near him a wounded soldier, whose necessity he thought greater than his, and to whom, accordingly, he desired that it might be given. The background is extremely dark, without any apparent purpose; the artist has relied entirely upon this depth for his effect, which shows this to be rather an experiment than the result of profitable study. We allude to it, chiefly because the subject is a fine one, and of a class we desire to see adopted.

No. 135. * * *, DAVIS. The subject of this cartoon is the humanity of General Monk and the Lord Mayor of London, Sir John Lawrence, during the prevalence of the plague. In the front of the cartoon a woman has cast herself in despair on the bodies of her husband and child; and on the left is another impressive passage—a man raving mad under the influence of disease, who has escaped from his nurse, and is rushing naked into the street. On the right of the composition is the Lord Mayor, who is giving a box of medicines to a girl, and behind the principal group is a physician busy in the work of humanity. The pestilence is powerfully described in the woman lamenting her husband and child, and its utmost horrors in the raving figure on the left. There are parts of the work that possess very high merit; but the whole is considerably injured by the formal, official address of the Lord Mayor.

Thus, although we have noticed a large proportion of the 140 cartoons, we have passed by seve-

ral without notice. They are such—at least to
our thinking—as do no credit to the producers ;
and which we again express our regret to see ex-
hibited at all. To prepare a cartoon requires very
considerable outlay—not alone in the mere ma-
terial to be covered, but in obtaining necessary
models. And, moreover, it demands a large ex-
penditure of time. To imagine that a cartoon 12
feet by 10 can be completed with as much rapid-
ity as a slight oil sketch is a grievous mistake.
The work must be inevitably tested by its own
genuine worth ; no apology for bad drawing can
be made by brilliant colouring—the cartoon must
be THE NAKED TRUTH !

Of the value of these studies to our school, then,
too large an estimate can scarcely be formed.

Even this one experiment will have wonder-
fully advanced it ; and when a second, a third,
and a fourth time, our Artists have been subjected
to a similar severe test SIMILARLY ENCOU-
RAGED—we boldly affirm we shall be in a posi-
tion to "try a fall" with the world, upon any
ground that may be selected.

But then comes the question, are our British
Artists to be " similarly encouraged ? " The an-
swer ought to depend upon the proof whether
this first experiment has been successful or un-
successful.

We must content ourselves for the present
with directing attention to an advertisement in
our first page. It was received just on the eve
of our going to press ; and we are unable to give
it the consideration to which it is entitled. It
appears that the next exhibition will consist of
examples of actual fresco as well as of car-
toons ; and that no premiums will be
given to successful candidates, but that their
recompense will be employment in paint-
ting the Houses of Parliament. We cannot
avoid a passing expression of regret that at
least *one* more experiment is not to be
tried before bringing matters so fully to the rigid
test. But a whole year of preparation is before
the artist. Genius and industry may work won-
ders within that year.

Review of
John Ruskin's *Modern Painters*

Athenaeum (February 3, 1844), 105–07; (February 10, 1844), 132–33

Modern Painters: their Superiority in the Art of Landscape Painting to all the Ancient Masters proved, &c.. By a Graduate of Oxford. Smith, Elder & Co.

THERE is too much reasoning in this book, without the higher qualities of reasoning, which are clearness and conclusiveness, subordination of parts, and able summation of the whole : perhaps we should have said, too much parade of logic and too little real power. Yet it is a clever book—neither less nor more. It exhibits what may recommend it to many readers, some characteristics of Hazlitt's style—boldness and brilliancy, bigotry amidst liberality, and great acuteness amid still greater blindness. Whether the author be an Oxford Graduate or no, he appears beyond doubt an under-graduate in Criticism, —a very "freshman ;" sanguine and self-confident, he would cut the Gordian knot with a bulrush, like one of those ambitious youths who undertake the trisection of an angle, or the duplication of the cube, while they are still tingling from the schoolmaster's rod, and have scarce surmounted the *pons asinorum.* Were his age, indeed, as green as his judgment, good result might hereafter flow from his energies, well directed ; but we suspect his opinions to be inveterate, however immature. He declares himself an artist ; the being which, when not a prodigious advantage, is a prodigious disadvantage to any writer on art : professional prejudices, pet systems—*idola specûs*—corporate or selfish interests, narrow artistic principles, or none, almost always characterize the criticism of an artist : his "soul lives in an alley," even if one of palaces ; and even if it takes the air by times, its route is, like that of a steam-engine, along a given track-way ; but with a certainty and celerity so far forth unrivalable. We should guess our author a *water-colourist,* too, from the tone of his critiques ; this we do not charge as a positive disqualification, however : Reynolds, who painted little besides portraits, wrote better upon high Art than Barry, who seldom painted anything beneath historical subjects. The volume before us illustrates, at all events, our former position. Here we find an artist-critic pronouncing—what? let us put his infallible dogma, like a papal bull, into a decree by itself. Not that the old landscape-painters are neither unmatched nor unmatchable—not that they are full of imperfection, are quite mis-appreciated, and much over-praised—not that they are inferior to the moderns—our author does not allege this—but, that they are all but *utterly contemptible ;* that they possess one bare and second-rate merit alone ! that, on the other hand, there is scarce one perfection which the moderns want, scarce a defect which they have ; and that, in brief, Mr. J. W. Turner is supreme Art personified, the God of Landscape-painting incarnate ! To characterize such hyperbolical sentiments, the very expressive, though vulgar, adage becomes feeble—our enthusiast " goes" the whole *hoggery* itself at a mouthful. We cannot call his paradoxes mere madness—they exhibit too much method ; but among what may be entitled sane absurdities, none half so preposterous were ever put forth by an otherwise sensible person. Are we to believe the everlasting hills stand upon false bases ? Are brilliant meteors to shine hereafter as fixed stars of the firmament, instead of those immortal luminaries which have hitherto borne the name ? True, the world has sometimes persisted many ages in an error ; but when Sabeanism was exploded the sun and moon were not pronounced " contemptible," nor were men bid fall down and adore—fire-flies !

It is plain enough, however, what produced this volume of heterodox criticism. Extreme opinions make a great "sensation ;" they require less mental grasp to comprehend them, far less mental power to sustain them—excitement being a source of inspiration. The rabid democrat will disembogue a thundering cataract of foam upon aristocratical abuses ; the patrician will pour forth a vial of sparkling froth and wrath upon that hydra-headed monster, republicanism : how many persons can see the merits *or* defects of each extreme ; how few its merits *and* defects ; how much fewer still can by potent reasoning and persuasive eloquence make others see them ! We have heard it argued very plausibly, that Michael Angelo was no painter—heard him cried down into a mere terrific caricaturist, his sublime proved ridiculous, his imaginativeness fond extravagance—*id est,* when his censors fell into caricature, extravagance, and the ridiculous-sublime themselves. They could with like ease prove, to the uninitiated, Wilkie a better manipulator than Teniers, a greater dramatist than Raffael, a richer humourist than Hogarth, a skilfuller sketcher than Rembrandt, a sweeter colourist than Correggio, &c. &c. ; but we have seldom indeed met even a professed connoisseur able to appreciate the Florentine or the Scottish master precisely, and seldomer still to make readers appreciate him. Hear Fuseli talk of Michael, and Mengs of Raffael, you will think them the so-called archangels become artists ; hear our Oxford Graduate talk of Mr.

Turner, and you will suspect that either St. Luke, the patron of painting, must have rapt the artist into the seventh heaven, or St. Luke, the patron of lunatics, must have carried off the author! What more light-headed rhodomontade could be scrawled, except upon the walls, or hallooed, except through the wards, of Bedlam, than the annexed passage presents us? It is just not blasphemous because it is crackbrained:—

"With respect to the great artist whose works have formed the chief subject of this treatise, the duty of the press is clear. *He is above all criticism, beyond all animadversion, and beyond all praise. His works are not to be received as in any way subjects or matters of opinion; but of* FAITH. We are not to approach them to be pleased; but to be taught: not to form a judgment; but to receive a lesson. Our periodical writers, therefore, may save themselves the trouble either of blaming or praising: their duty is not to pronounce opinions upon the work of a man who has walked with nature threescore years; but to impress upon the public the respect with which they are to be received, and to make request to him, on the part of the people of England, that he would now touch no unimportant work—that he would not spend time on slight or small pictures, but give to the nation a series of grand, consistent, systematic, and completed poems, using no means nor vehicle capable of any kind of change. We do not presume to form even so much as a wish, or an idea, respecting the manner or matter of anything proceeding from his hand. We desire only that he would follow out his own thoughts and intents of heart, without reference to any human authority. But we request, in all humility, that those thoughts may be seriously and loftily given; and that the whole power of his unequalled intellect may be exerted in the production of such works as may remain for ever for the teaching of the nations. *In all that he says, we believe; in all that he does, we trust.* It is therefore that we pray him to utter nothing lightly—to do nothing regardlessly. He stands upon an eminence, from which he looks back over the universe of God, and forward over the generations of men. Let every work of his hand, be a history of the one, and a lesson to the other. *Let each exertion of his mighty mind be both hymn and prophecy,*—adoration to the Deity,—*revelation to mankind.*"

That this elsewhere rational writer was in his "lunes" when composing the above passage is clear from its palpable incongruities: if opinions are not to be pronounced upon the works of a man who has walked with Nature threescore years, if we are neither to praise nor blame him, why all the opinions and praises poured forth upon him and his work by our author? If we are to impress the public with respect for Mr. Turner's pictures, will our Oxford logician tell us *how*, without praise and opinions? One sentence contains a wish that Mr. Turner would not do such and such things; the next sentence denies all wish even to form a wish regarding any such things; and the next sentence again wishes that "he would follow out his own thoughts and intents,"—though these should

lead him peradventure (for all he does *must* be right) to do the very things wished *not* to be done by the first sentence! Here's a choice specimen of Oxonian dialectics; here's a sample of the "reasoning power" which often distinguishes this volume. We have scarce been just to the above passage however: will our readers believe their eyes when they see that the fourth consecutive sentence exhibits another aberration, nay, a double aberration within half a sentence, two aberrations entangled together? Peruse it once more—"But we request, in all humility, that those thoughts may be seriously and loftily given." What! you will not presume to form even so much as a *wish*—yet you *request!* You will not presume to form even an *idea* "respecting the *manner* of anything proceeding from his hand," yet you have an idea its manner should be serious and lofty! Again, you desire he would proceed "without reference to any human authority," yet you refer him "in all humility" to your own hint! Nay, as we live, both the next sentences give each other the logical lie too: let us repeat them. "In all that he says we believe, in all that he does we trust."—"It is therefore that we pray him to utter nothing lightly, to do nothing regardlessly." Why, for Idol-Bel and Dagon's sake, if you trust in all he does can't you let him do as he pleases? How is it possible he can utter anything lightly or regardlessly if he *be* such an impeccable? Moreover, when he can paint histories of the universe, and give lessons to future time, how can you suppose he will descend to illustrate Boboli Gardens and Annuals of the Season? When both a psalmist and a prophet—an evangelist into the bargain—wherefore insinuate with "all humility" that he whistles off "hymns" after a light fashion, and vents "revelations" in a regardless manner? We will answer our own question: Mr. Turner's doxology, desirous that his last paragraph should out-do all the rest, yet exhausted by his antecedent efforts, has here wrought his eloquence up to an unnatural pitch; and hence cannot, in his paroxysm of panegyric, distinguish between genuine heartfelt praise and wild hallelujahs. He reminds us of a Whirling Dervish, who at the end of his well-sustained reel falls, with a higher jump and a shriller shriek, into a fit.

We shall quote, for more than amusement's sake, a few other of the inconsistencies promiscuously and plenteously scattered through the volume. The chief purpose—to heap terms of abuse, and derision, and disdain upon the Old Masters*—is often fulfilled with a verve and a glibness as if the author had been a graduate of Billingsgate, instead of Oxford: *tone* he declares "the first and nearly the last concession" they must expect from him (p. 99); and even this

* Rubens, indeed, obtains grace—because like Turner.

merit he conjectures the probable result of some " mere technical secret, gained at the expense of a thousand falsehoods and omissions" (p. 180). But his preface—written after his book we surmise—makes a very different last concession from the first : " Let it be remembered that only a portion of the work is now presented to the public ; and it must not be supposed because in that particular portion I have spoken in constant depreciation, that I have no feeling of other excellencies, of which cognizance can only be taken in future parts of the work." What his future parts may accomplish we cannot tell ; what his immediate efforts should, seems plain— a second volume, parallel to the first, and a running recantation of its errors. Such a prose palinode would cost such an adept at self-conviction little trouble. Here we have another brief specimen : " Power is never wasted. A nut may be cracked by a steam-engine, but it has not, in being so, been the subject of the power of the engine !" No, nor if the Carron Foundry at full work cast a single toy-cannon, power is not wasted. If, indeed, our Oxford logician's head were cracked, like the nut, by a steam-engine, we might admit the power wasted ; because the fracture seems superfluous. Again, p. 75, we find truths pronounced "valueless in proportion as they are general," though pronounced a page earlier right in practice ! Now for some few other examples of *Turneromania*, and volcanic eruptions from the crater of a fervent imagination :—

" Turner—glorious in conception—unfathomable in knowledge—solitary in power—with the elements waiting upon his will, and the night and the morning obedient to his call, sent as a prophet of God to reveal to men the mysteries of His universe, standing, like the great angel of the Apocalypse, clothed with a cloud, and with a rainbow upon his head, and with the sun and stars given into his hand. * * But let us take with Turner the last and greatest step of all. Thank heaven we are in sunshine again,—and what sunshine ! Not the lurid, gloomy, plague-like, oppression of Canaletti, but white, flashing fulness of dazzling light, which the waves drink and the clouds breathe, bounding and burning in intensity of joy. That sky—it is a very visible infinity—liquid, measureless, unfathomable, panting and melting through the chasms in the long fields of snow-white, flaked, slow-moving vapour, that guide the eye along their multitudinous waves down to the islanded rest of the Euganean hills. Do we dream, or does the white forked sail drift nearer, and nearer yet, diminishing the blue sea between us with the fulness of its wings ? It pauses now ; but the quivering of its bright reflection troubles the shadows of the sea, those azure, fathomless depths of crystal mystery, on which the swiftness of the poised gondola, floats double, its black beak lifted like the crest of a dark ocean bird, its scarlet draperies flashed back from the kindling surface, and its bent oar breaking the radiant water into a dust of gold. Dream-like and dim, but glorious, the unnumbered palaces lift their shafts out of the hollow sea—pale ranks of motionless flame—their mighty towers sent up to heaven like tongues of more eager fire,—their grey domes looming vast and dark, like eclipsed worlds,—their sculptured arabesques and purple marble fading farther and fainter, league beyond league, lost in the light of distance. Detail after detail, thought beyond thought, you find and feel them through the radiant mystery, inexhaustible as indistinct, beautiful, but never all revealed ; secret in fulness, confused in symmetry, as nature herself is to the bewildered and foiled glance, giving out of that indistinctness, and through that confusion, the perpetual newness of the infinite and the beautiful."

Speaking of Mr. Turner's ' War' (vide *Athen.* No. 759), he has the hardihood to assert—

" There was not one hue in this whole picture which was not far below what nature would have used in the same circumstances, nor was there one inharmonious or at variance with the rest ;—the stormy blood-red of the horizon, the scarlet of the breaking sunlight, the rich crimson browns of the wet and illumined sea-weed, the pure gold and purple of the upper sky, and, shed through it all, the deep passage of solemn blue, where the cold moonlight fell on one pensive spot of the limitless shore—all were given with harmony as perfect as their colour was intense ; and if, instead of passing, as I doubt not you did, in the hurry of your unreflecting prejudice, you had paused but so much as one quarter of an hour before the picture, you would have found the sense of air and space blended with every line, and breathing in every cloud, and every colour instinct and radiant with visible, glowing, absorbing light."

The same painter's *palpitating* light (?) seems to have inflicted a sort of sun-stroke on its worshipper :—

" There is the motion, the actual wave and radiation of the darted beam—not the dull universal daylight, which falls on the landscape without life, or direction, or speculation, equal on all things, and dead on all things ; but the breathing, animated, exulting light, which feels, and receives, and rejoices, and acts —which chooses one thing and rejects another— which seeks, and finds, and loses again—leaping from rock to rock, from leaf to leaf, from wave to wave— glowing, or flashing, or scintillating, according to what it strikes, or in its holier mood, absorbing and enfolding all things in the deep fulness of its repose, and then again losing itself in bewilderment, and doubt, and dimness ; or perishing and passing away, entangled in drifting mist, or melted into melancholy air, but still,—kindling or declining, sparkling or still, it is the living light, which breathes in its deepest, most entranced rest, which sleeps, but never dies."

All this said of painted light ! As Addison's schoolmistress exclaimed—" Bless us ! eight volumes about *potatos !*" But at p. 163, even Mr. Turner's *figures* are defended ; at p. 321 it is shown that geology might be lectured upon from one of his landscapes as from Nature herself ; while at p. 300 his hills are complimented by the somewhat awkward encomium that we never get to their top " without being *tired* with our walk." " Cuyp, on the other hand, could paint close truth of everything except

ground and water [at p. 189 he painted false *skies*] with decision and success; but then, he has not the slightest idea of the word beautiful" (p. 89). "A pencil-scratch of Wilkie's, on the back of a letter, is a greater and a better picture—and I use the term picture in its full sense—than the most laboured and luminous canvas that ever left the easel of Gerard Dow." With what justice might the Modern Painters cry out on reading these ludicrous exaggerations—Heaven defend us from such a defender as this!

Sound opinions resemble pine-trees; the roughest shaking only strengthens their hold: we do not dislike to have our most deep-implanted, long-cherished convictions blustered against every now and then, with all the force of new-sprung enthusiasm for other tenets—if ours be rotten at root, the sooner they are eradicated the better, we would gladly get rid of them. Nay, let us make a large concession, in proof of our being unprejudiced; it has always been our opinion, that but few *landscapes* by the ancient masters deserve to rank among first-rate productions of art. Seldom, indeed, did we meet upon our rather excursive tours, from Brittany to Bohemia, from the Baltic to the Mediterranean, a painted land or water piece half so beautiful as a bed of March violets, or the sparkle of a mountain-rill; one glimpse at ocean through a pocket spyglass gave us more pleasure than all the "Marines" by Joseph Vernet in the Louvre, a blank Alpine heath had for us more varied charms than all the bottle-green landscapes Paul Brill ever produced. We shall go yet farther with our concessions: even Claude's performances have often left little deeper impressions upon us than so many glass-windows —they are panes of pictorial glazing, smooth, transparent, and bright surfaces, which seem less to delineate the aerial perspective than to let it through them from the scene itself behind, such is their magic mechanism,—but display, in general, few merits besides. Had our author been content to reduce popular reverence on this subject within just bounds, we should have approved his efforts, but when he pronounces Claude, Salvator, and Poussin "contemptible" (page 6)—when in the same unscrupulous style he bespatters all the old landscapes with foul epithets, like a "Legion Club," it only proves his language stronger than his judgment. We love straightforward opinions expressed in strenuous diction—always understood, however, that the boldness should not spring from the blindness—else we hate them as so much hollow noise, we regard them as so many oracles uttered by Roger Bacon's brazen head—trumpet-tongued impostures. Laughably enough, this railer and perpetual scoffer at these Ancient Masters protests against ridicule being thrown upon his modern idols! He observes, with extreme soreness,—

"There is nothing so high in art but that a scurrile jest can reach it, and often, the greater the work, the easier it is to *turn it into ridicule.* To appreciate the science of Turner's colour would require the study of a life, but to laugh at it requires little more than the knowledge that yoke of egg is yellow, and spinage green; a fund of critical information on which the remarks of most of our leading periodicals have been of late years exclusively based. We shall, however, in spite of the sulphur and treacle criticisms of our Scotch connoisseurs, and the eggs and spinage of our English ones, endeavour to test the works of this great colourist by a knowledge of nature somewhat more extensive than is to be gained by an acquaintance, however familiar, with the apothecary's shop, or the dinner table."

Yet his own very next paragraph is a tissue of Sardonic jests about Poussin's 'La Riccia,' amongst which "brick-red" takes the place of Scotch sulphur, and "*dots in the sky with a stalk to them*" that of English spinach and eggs! A few pages onward we find this polite critique: "There is no man living more cautious and sparing in the use of pure colour than Turner. To say that he never perpetrates anything like the blue excrescences of foreground, or hills shot *like a housekeeper's best silk gown* with blue and red, which certain of our celebrated artists consider the essence of the sublime, would be but a poor compliment" (p. 129); and again, speaking of Turner's 'Mercury and Argus,' "the reader can scarcely fail to remember at once sundry works in contradistinction to this, with great names attached to them, in which the sky is a sheer piece of *plumbers' and glaziers' work*, and should be valued per yard, with heavy extra charge for ultra-marine; skies, in which the raw, meaningless colour is shaded steadily and perseveringly down, passing through the pink into the yellow, *as a young lady shades her worsted*, to the successful production of a *very handsome oil-cloth*, but certainly not of a picture" (p. 131). This is the philosophical reasoner who would not condescend to a jest? this is the thin-skinned critic who deprecates the shafts of ridicule! Why, not merely his most amusing passages, but far the most effective portions of his volume—those which will convince and seduce and cajole many readers where his argument would fail—are the numberless burlesque similitudes and ludicrous analogies sprinkled through his critiques, to disparage by all means, whether foul or fair, the Ancient Masters! But more of this hereafter.

Modern Painters : their Superiority in the Art of Landscape Painting to all the Ancient Masters proved, &c. By a Graduate of Oxford.
[Second Notice.]

MODERN artists may deem it their interest to decry old pictures, as competing with their own productions, and lowering their market prices: that this has been, and is often done, both at

home and abroad, we ourselves can testify—we have heard the leperous distilment drop word by word into a purchaser's ears, till we could perceive his taste was poisoned. Miserable selfishness! wise enough, perhaps, for its generation, but short-sighted for the future welfare of Art, if painters feel any care about it. They do not see that depreciating those time-honoured works, from which their profession derives its chief glory, discredits *it*, and therefore degrades themselves. Let modern poets lead the ignorant world to think Spenser a frigid, allegorical fancymonger, Milton a sounding brass, full of pompous blare and flare, like Azazel's trumpet, Shakspeare a false god—a mere quintessence of dust, whom patriotism, prejudice, and custom have deified—were it possible such opinions could be held, and modern poets could be so asinine as to bray them forth with effect, would not the poetic art itself fall into disrepute? would not its present and future cultivators lose the ancestral honours those names reflected upon their order? But in the semi-poetic art, Painting, the world is still more persuadeable, because perplexed by the merits of mechanism, about which craftsmen alone can decide. Painters, we fear, will learn too soon that their vocation has need of all its past renown, when Middle-Class patronage has made them wholesale manufacturers for those Brimmagem picture-markets —the Art-Unions.

We do not impute to our author any sordid or self-interested motive of the kind above-said: indeed, he bows himself almost as prostrate before the shrines of Michaelangelo and Raffael, and other demi-deified historic painters, as before the image of Turner, which he hath set up: it is only their brethren Landscapists he would pelt down from their pedestals or disfigure where they stand. Let him, and his aiders and abettors, if he has such among the craft, reflect whether this may peradventure tend to its eventual profit or loss. Once sacrifice the outworks, and the citadel itself, maugre its many towers of strength, will be endangered. A Cambridge Graduate might ere long come forward, and prove the whole Art a terrible waste of power, toil, and time,—employing supereminent genius like Raffael's and Michael's to produce "illustrations" on perishable plaster, panel, canvas, or paper, and even Turner's omnipotential abilities to decorate our drawing-rooms, dazzle our eyes, and at best instruct the mind by an immeasurable roundabout through the senses. Art, like religion, has its freethinkers no less than implicit believers: thus, we can get but one response from discriminative, unbiassed critics, when we ask their opinion of Mr. Turner's gorgeous performances —silence and a shrug! Were our author to change sides (which fanatics oftenest do), we should in all likelihood find him delitigating

just as copiously and as loudly against his present idol; perhaps somewhat after this fashion—" He has debauched his visual taste by the use of stimulant colours—such is the common fate both of schools and individual painters, they begin with a small indulgence and end with inordinate excess:—his pictures, to say the most of them, are a beautiful splish-splash of splendid tints—they resemble dishes of gold and silver fish, in a sauce of ultramarine, and garnished with marigolds, orange-peel, &c. If to produce a maximum of effect by a minimum of means be the touchstone of artistic power, how many among these brilliant things would it not prove brazen counterfeits? All the richest and brightest pigments mingled together to produce a mere luxurious *olla podrida* for the corrupt ocular taste, is, so far forth, a mark of artistic incompetence. Some of his pictures have no extractable meaning—others an absurd one when found: thus a man up to the mid-leg in ruddle, his eyes fixed on a distant ball of gambouge, means ' War,' ' The Exile and the Rock Limpet,' ' Buonaparte at St. Helena,' everything and nothing!'" We warrant, too, our convert could, if the maggot bit him, spin as fine a harangue about Claude's wonderful works as Turner's.

But reverting to the subject of new fangledness *versus* old-fangledness. Has it never struck this exclaimer against antiquated taste, that if there be persons who admire old things because they are old, there be other persons likewise, who admire new things because they are new? Aye, and that the lovers of novelty, compared with their antagonists, might count ten noses for one? Whilst here and there a bookish, baldpate old gentleman, whose brain is as barren as the dust on his shelves—a dilettante medal-hunter, or greyheaded mouser in archæological nooks and burrows, amidst vermin, darkness, and dirt—while a score or two, perhaps, of such oddities make up that class of respectable laughing-stocks called antiquarians—perverse, we will add, and preposterous creatures, who, like certain among Dante's condemned wretches, seem to have their heads turned backwards; upon the other hand, all the frivolous and all the fickle, all the superficial and all the sensual —*id est*, the major portion of mankind, detesting what the aforesaid small minority loves (and for the self-same profound reason, because old things *are* old)—idolize whatever exhibits the gloss and glitter of new manufacture about it, however garish and futile, trashy and flashy the production. Let us ask this *Wotton*, so fain to do fierce battle for Modern Pictures, whether he thinks a spick-span florid gewgaw, from the easel of a fashionable artist, in a frosted-gilt frame, or a dull antique in a worm-eaten rim of deal, would have more admirers? His candour, we doubt not, will admit—the gewgaw.

Well might Platonic philosophers make a butterfly an emblem of the Soul! It illustrates that of most human beings.

Such is an Englishman's bias to be gulled, that rather than remain long undeluded by some one else, he gulls himself. We cannot but believe our author has got wilfully into a labyrinth, that he may enjoy the pleasure of transient bewilderment, and of bewildering others who may follow him. His own ingenuity will get him out—perhaps into a deeper and deeper still: it was our province to warn the green geese from the decoy whither the wild goose whistled them. Yet we may have taken superfluous trouble—it had been enough perchance to state his pictorial creed, which declares that the most erratic genius among all Modern Painters exhibits in his works a consolidated fund of perfections without the shadow of a single fault! Monomania could scarce go much farther—after this the Ancient Masters might feel such idle breath could not blast their laurels were it ever so freezing and blustrous.

Nevertheless, as we said at first, the book before us contains a great deal of cleverness, and a good deal of truth, even amidst its manifold inconsistencies. Thus, although it begins with pronouncing Claude, Salvator, and Poussin contemptible, it ends with eating up about half that oracle : " All others [except Backhuysen and Vandervelde] of the ancients have real power of some kind or another, either solemnity of intention as the Poussins, or refinement of feeling as Claude, or high imitative accuracy as Cuyp and Paul Potter, or rapid power of execution, as Salvator; there is something in all which ought to be admired, and of which, if exclusively contemplated, *no degree of admiration, however enthusiastic, is unaccountable or unnatural,*" p. 338. Then follows a caper of the genuine Quixote justifying his exception abovesaid : " But Vandervelde and Backhuysen have *no* power, no redeeming quality of mind; their works are neither reflective, nor eclectic, nor imitative; they have neither tone, nor execution, nor colour, nor composition, nor any artistical merit to recommend them; and they present not even a deceptive, much less a real resemblance of nature." Hey, hey, the devil rides upon a fiddlestick! as Falstaff says to his hostess in a pasty, what next? But the second volume promised, and which we hope may come, even if from the moon, will no doubt repeal this fulmination against Vandervelde and Backhuysen, or at least publish another bull to correct the present infallible decree. Let us hope likewise, that the author will, meantime, should he have the power, take the trouble of acquainting himself with those Ancient Masters whom he criticizes, for he appears by his confessions, voluntary and involuntary, *quam proximè* igno-

rant about them. How such a grand-tourist as he proclaims himself should not say one word of the sublime Pitti Salvators, Nicolas Poussin's 'Great Flood,' Gaspar's *chefs-d'œuvre* in San Martino, the Brera Giorgione, the Fesch Rembrandt, the Camuccini Titian, various fine Claudes and magnificent Cuyps throughout England, numberless other splendid landscapes everywhere, puzzles conjecture, or rather is plain enough : we will not call him as he calls Canaletti, a " shameless asserter of whatever was most convenient to him," but his little information respecting the Old Masters qualified him well to condemn them, because much knowledge had made him far more cautious—or had given him, if no qualms of criticism, perhaps some of conscience. He finds just the basis that suits his temple raised to divine Mr. Turner—his *Turnerion*—with a cella behind it for all other Modern Painters—in a few Claudes, most of which abler connoisseurs than ourselves deem second-rate, or apocryphal, specimens, and a few Salvators, Poussins, &c., which *he* deems first-rate, whether apocryphal or not, at the London and Dulwich Galleries. Yet even on this narrow ground we might perplex his self-complacence by a very simple question—where is the oil-picture from Mr. Turner's hand equal to the worst Claude of the National Collection? Let him spend no more logic demonstrating what vile things the old Landscapes are, how and why and wherefore they are beneath the modern,—but just point us out that one oil-work of his impeccable that can justly compete *even* with the ' St. Ursula!'

This brings us near our conclusion. We apprehend the Oxford Graduate, despite his enormous apparatus of axioms, postulates, lemmas, categories, divisions, and subdivisions, has omitted the true principles of landscape-painting, or if mentioned, has misunderstood their value and virtue. He seems to think landscapes should be, throughout their details, little facsimiles of real objects, and that no other merit surpasses minute faithfulness. He cannot conceive, for example, the ' St. Ursula,' with its buckram waves, hopping figures, and false perspective, nevertheless a far more excellent work than ' The Exile and the Rock Limpet,' were this as faithful as he imagines it. He professes, indeed, a noble disdain of servile imitation in art, but half his book is a ding-dong against the Ancient Masters on its sole account —Salvator's rocks are not stratified, Poussin's leaves not botanical, Cuyp's clouds not cirrostrate, &c.—none of those artists exhibit what he and the newspaper critics call " truthfulness to nature." He would have geologic landscape-painters, dendrologic, meteorologic, and doubtless entomologic, ichthyologic, every kind of physiologic painter, united in the same person ; yet alas for true poetic art amidst all these

learned Thebans! No, landscape-painting must not be reduced to mere portraiture—portraiture of inanimate substances—*Denner*-like portraiture of the Earth's face, with all its wrinkles and pimples, line by line, shade by shade. As we have said elsewhere, if people want to see Nature let them go and look at *herself;* wherefore should they come to see her at second-hand on a poor little piece of plastered canvas? We disapprove the "natural style" in painting, not because we dislike Nature, but because we adore her; she is so far above any imitation of her, that the very best disappoints us and dissatisfies. Ancient landscapists took a broader, deeper, higher, view of their art: they neglected particular traits, and gave only general features: thus they attained mass, and force, harmonious union, and simple effect, the elements of grandeur and beauty. Modern artists travel more—peregrination is now easier than it was to the ancients, and commoner: of course modern landscapes are, for this reason, more varied in subject, more accurate in details,—to which likewise the number of illustrated volumes and the extension of "physiologic" knowledge conduce: such merits and all they involve, do those they adorn honour enough, without any need to attempt exalting them by disparaging their predecessors. Our author himself does not deny the latter super-eminent *tone*, perhaps unaware how much his term would embrace—tone of composition as well as of colour; they possess both equally, and how much its tone of composition elevates or depresses a work, he might learn by a comparison between the general outlines of Paradise Lost and those of Paradise and the Peri.

We shall end with a pretty long quotation to prove he has mistaken himself no less than the Ancient Masters; his forte is the very reverse of sound reasoning, *videlicet*—fine writing. Popular taste runs, now-a-days, a vast deal too headlong towards *Description*, that lowest among literary merits; but albeit page succeeds page of eloquent skimble-skamble in this vein, albeit the "pure and holy" slang of sentimentalism often bespots his best descriptive passages, still they are his happiest, and preferable, because spontaneous ebullitions, to the beautiful balderdash elaborated with such efforts by many a renowned provider of it for public consumption:—

" It had been wild weather when I left Rome, and all across the Campagna the clouds were sweeping in sulphurous blue, with a clap of thunder or two, and breaking gleams of sun along the Claudian aqueduct, lighting up the infinity of its arches like the bridge of chaos. But as I climbed the long slope of the Alban mount, the storm swept finally to the north, and the noble outline of the domes of Albano and graceful darkness of its ilex grove rose against pure streaks of alternate blue and amber, the upper sky gradually flushing through the last fragments of rain-cloud in deep, palpitating azure, half æther and half dew. The noon-day sun came slanting down the rocky slopes of La Riccia, and its masses of entangled and tall foliage, whose autumnal tints were mixed with the wet verdure of a thousand evergreens, were penetrated with it as with rain. I cannot call it colour, it was conflagration. Purple, and crimson and scarlet, like the curtains of God's tabernacle, the rejoicing trees sank into the valley in showers of light, every separate leaf quivering with buoyant and burning life; each, as it turned to reflect or to transmit the sun-beam, first a torch and then an emerald. Far up into the recesses of the valley, the green vistas arched like the hollows of mighty waves of some crystalline sea, with the arbutus flowers dashed along their flanks for foam, and silver flakes of orange spray tossed into the air around them, breaking over the grey walls of rock into a thousand separate stars, fading and kindling alternately as the weak wind lifted and let them fall. Every glade of grass burned like the golden floor of heaven, opening in sudden gleams as the foliage broke and closed above it, as sheet-lightning opens in a cloud at sunset; the motionless masses of dark rock —dark though flushed with scarlet lichen,—casting their quiet shadows across its restless radiance, the fountain underneath them filling its marble hollow with blue mist and fitful sound, and over all—the multitudinous bars of amber and rose, the sacred clouds that have no darkness, and only exist to illumine, were seen in fathomless intervals between the solemn and orbed repose of the stone pines, passing to lose themselves in the last, white, blinding lustre of the measureless line where the Campagna melted into the blaze of the sea."

from

"Progress of Art"

Westminster Review 41 (March 1844), 73–109

ART. II.—1. *The Hand-Book of Taste, or how to observe Works of Art, especially Cartoons, Pictures, and Statues.* By Fabius Pictor. Longman.

2. *The Present State of Ecclesiastical Architecture in England.* By A. Welby Pugin. C. Dolman, 61 New Bond street.

THERE are few subjects which are just now exciting more attention in England than the present state of the Fine Arts, and few on which more has been said and written; but still it does not appear that any satisfactory conclusion has been arrived at on the subject, or that either the public or the artists themselves understand better what is wanted, or what would be the best means of improving their condition or enabling Englishmen to do something more creditable to the nation than has hitherto been produced. In the meanwhile the demand for art is as universal as the interest it excites, and whether it be for the statue or painting with which the rich man ornaments his dwelling, or for the 'Penny Magazine' or 'Illustrated News,' which find their way into the poorest cottage, every class are enjoying the luxury; and it is of an importance not easily over-rated that a right direction should be given to this new-born taste in the nation, working for good or evil to an extent which defies the calculation of the boldest intellect.

It is not, however, we fear, in this point of view that the government at present regard the question, and the parliamentary committees that have been appointed, and the royal commissions that have been issued, seemed to have conceived that it was only the wounded vanity of the nation at seeing herself surpassed in art by Bavaria and other continental states, that made her now demand rescue from the disgrace; and the consequence is, that, having ascertained that art was at a singularly low ebb in this country (which all the world knew before they were appointed), they have determined to follow in the steps of the Germans, and try and rival what they conceive to be the splendid school of art that has recently arisen there. The experiment is now being proceeded with, and though it would be presumption to prophesy that it cannot be successful, we have very strong doubts of its realizing the expectations of its sanguine promoters.

At the recent exhibition of cartoons that took place in Westminster Hall in consequence of this resolution, the nation were astonished and delighted to find that English artists could produce as good designs as either the French or Germans, and all

have been willing to hail with joy the new era thus opened
to art. They have not paused to consider that what could
so easily be done by some dozens of artists who never before
thought on the subject, or never attempted that style of art, must
indeed be a very small and very easy exercise of intellect.
They, indeed, who agree with the committee, that, after reward-
ing the original eleven, there were still ten more so nearly equal
to them that it would be unjust if they too were not rewarded, may
rejoice in the nation possessing such a band of Raphaels, and
thank the commissioners for having been instrumental in bring-
ing to light such a mass of hidden talent, which, God knows, no
man in England ever before dreamt of our possessing, and
which certainly never showed itself in the annual exhibitions,
or in any paintings these artists had hitherto produced. For
ourselves the experiment goes far to prove that it is as easy for
an educated artist to produce cleverly grouped pictures of this sort
as it would be for any educated man to produce as good verses
as ever Pope or Dryden wrote, provided it be understood that
knowledge of the subject, and sense, and wit, are not required
to form a necessary ingredient in the composition. He knows
little of the long thought, and toil, and pain, with which great
works are produced by even the greatest geniuses, who fancies
that the stuff of immortality may be found in what is done so
easily and by so many.

What appears to us, in the present state of matters, to be more
wanted than cartoons, is a correcter knowledge of what true art
really is—what are its purposes and objects—and by what means
these are to be reached. Till a clearer knowledge is obtained
on these points than at present seems to exist, we fear that
nothing that is really great or good will be done, and it is to this
object that we propose to dedicate the following pages; and
though we cannot hope within the narrow limits of an article to
examine any one of these objects as we should wish, we still hope
to be able to place some parts of the subject in a clear light,
and to turn attention to others that are often overlooked entirely.

A century ago, painting, as an art practised by Englishmen,
could scarcely be said to exist in England; and it is now little
more than eighty years since the first public exhibition of paint-
ings took place. At that period the attention of the public (if
the small body of men who then interested themselves in art may
be so called) was more strongly directed to the subject than at
any subsequent period till the present, and with strong grounds
for hope; for that age produced Reynolds, West, Gainsborough
and Wilson, and Hogarth, and Flaxman,—men who raised British

art from nothing to a palmy state it has not again reached, much less surpassed. The produce of all the excitement of that time was the establishment of the Royal Academy; and the public, satisfied that in this creation they had done all that was required to insure the prosperity of the arts, forgot the subject, and relapsed into their former indifference; while the academy, feeling secure in its monopoly, and its members discouraged by their inability to rival the great Italian masters, or even the contemporary continental schools, sunk into a corporation of portrait painters, and left British art to seek its inspiration where it could; and as long as their own pencils were fully employed, the academicians seem never to have sought to direct or guide the taste and patronage of the nation to a better and higher style of art than what each individual found most profitable. Both artists and patrons seem to have tacitly acknowledged the impossibility of rivalling their great prototypes, and have even been content to allow that in all that concerned art the French were our superiors, and that we could never hope (for some good reason or other unexplained) to possess a gallery like the Louvre or to create one like that of the Luxembourg or Versailles. The French with all their loud boastings of pre-eminence have not been able to excite in us a spirit of rivalry, nor their sneers at the " Nation boutiquiére " to rouse us to an energetic attempt to prove that the epithet was unmerited. But when Bavaria, a kingdom which stood lower than ourselves in the scale of artistic eminence, roused itself from its lethargy, and in a few short years, under the patronage of an enlightened prince, and without any greater advantages of climate (to which we are so fond of ascribing our deficiencies), produced a school of art which, whether it be really great or not, has at least led to most brilliant results and given employment to hundreds of artists in every corner of Germany, England could no longer remain apathetic, but began to shake off her lethargy and to dream of the possibility of doing so likewise.

This at least has been the proximate cause; but, if we are not much mistaken, there is a deeper and more home-felt feeling, which, though not so apparent, is the real cause of the present working in men's minds on this subject. If this feeling does exist, we may hope for something great and good, which will scarcely result from rivalling the Germans or copying the Italians or the Greeks.

The first expression of this new-born feeling was one of wrath against the poor old academy, on whom many were inclined to lay the whole blame of the depressed state of art in this country, and to demand that it should rescue us from the

opprobrium ; since then, however, the feeling has become stronger and more general, and it being admitted that the academy is incapable of doing anything, the subject has been taken up by the nation at large, and something will be done, and, if we are not mistaken, done successfully ;—for, looking at what we have accomplished in literature, and the success that has ultimately attended every undertaking to which the energies of the nation have been fairly directed, there is strong ground for hope : but it is almost equally certain, that, before the right path is hit upon, many errors will be committed, and much money and talent be wasted ; for, like a man suddenly startled in the dark from a sound sleep, we are yet rubbing our eyes, and trying to collect our scattered senses ; but the chances are we take a wrong direction, and break our shins more than once before we find a light, or are thoroughly awake.

In all inquiries of this sort, one of the principal difficulties is to ascertain what is the real cause of the evil ; once the seat and cause of the disease ascertained, the physician has little difficulty in prescribing a remedy. But, in the present instance, no two persons scarcely are agreed as to what is the real cause of our ill success in art. If an artist is asked the question, his invariable reply is, " want of patronage," and his partizans re-echo the sentiment. If a gentleman, not particularly interested in the subject, is asked, he answers, " the climate is unfavourable ; " and these two causes, under various names, and with such modifications as the idiosyncrasy of the respondent may suggest, fill the one with hope that the evil may be remedied, and satisfy the other that it is no use troubling himself about the matter.

Yet it can scarcely be the former, for no class of artists of any kind were ever more employed or more liberally rewarded and made such fortunes, as our architects, and yet architecture is at a lower ebb in this country than either painting or sculpture ; and it is a question that has often been mooted, whether more money is not annually spent in this country on pictures than in the highest days of Italian art? Certainly more paintings are now produced and purchased than at any preceding period, and it is scarcely assumed that any great painter is among us creating great works of art which the public cannot understand, and which will only be appreciated when too late to benefit the artist ; such things have happened in this country, but could scarcely occur now when the demand for art is so great and universal.

Of course no artist thinks his merits sufficiently acknowledged or rewarded ; but there is a wide difference of opinion on this

subject between them and the public, and one, we fear, that will not be easily reconciled.

The artist in the present day has an advantage with regard to patronage that scarcely ever existed before; he is not subject to the taste and caprice of one great patron, but, in whatever style of art he feels himself most at home, he is, if successful, sure to find admirers among the public; as the literary men of the present day are sure of finding readers, and, not like their predecessors, forced to flatter and fawn on some great man who would kindly condescend to patronize their works. The absence of this system has produced a far healthier tone in literature, and its re-adoption now would be as prejudicial to artists as it was to poets in former days. What our artists, however, demand is not this, but government patronage; and in this, we fear, they will be much disappointed : the government of this free country have too much to occupy their minds in the struggle for place or party ever to give that attention to the subject that is requisite; and the continual change of persons in power, and the consequent continual change of tastes and opinions, render it singularly unfit, by its very constitution, for the steady following out of any great system of encouragement of art.

A king or prince might do more; but, in this country, he can only do it as an individual, and not as the absolute monarchs of other countries, who have the resources of their nations more at command. It is to the public that our artists must learn to look for support (as our literary men have learned some time ago). The public are willing to purchase and patronize whatever they can understand, or whatever speaks to their tastes or to their feelings. But they will not buy imitations of other schools when originals are to be had, nor will they buy paintings which nobody understands the meaning of but the painter, if indeed he does, which is not always clear.

The " climate" may be dismissed in a very few words. We acknowledge that Germany and France have done something in art, yet their climate is scarcely more favourable than ours, and the Dutch have produced a school of paintings which, in the estimation of our amateurs, rivals (if indeed its productions are not more valuable than) that of the Italians ; and yet the climate of Holland is certainly worse than our own. But it is absurd to talk of climate, or of the chilling effects of modern habits and tastes to a people who have produced such a literature as ours. It is absurd to say that the countrymen of Spenser, or Shakspere, or Milton, or the contemporaries of Scott, Byron, or Coleridge, or Wordsworth are crushed by climate ; or that there is anything to prevent our painting as well as those men wrote. If we cannot

yet boast of a Raphael or a Michael Angelo, we may rest satisfied
with the comfortable assurance that there is nothing to prevent
our having painters as great as Shakspere or Milton were as
poets; and if we have no Camuccini, or Cornelius, or De la Roche,
we may at least have painters of equal merit with modern authors.
It is true, however, that the climate is not favourable for the
production of naked statues or for the employment of Doric por-
ticos; nor is our religion favourable to the revival of saints and
Madonnas; and were there no other sources of the Kalon but
these, we might well despair. But our literati, after long wander-
ing in the same paths in which our artists have now lost themselves,
have at least discovered other sources of inspiration than the
mere reproduction of classic models, and have restored our lite-
rature to the rank it holds. Till our artists have done something
of the same sort, there is, we fear, but little hope of progress
or improvement.

Among the causes of encouragement which are dwelt upon
by those who look more hopefully on the state of British art,
there is none that is more continually referred to, or insisted on
more strongly, than the advantages we possess in our knowledge
of the great works of antiquity, and of what was done that was
great and worthy of imitation in the middle ages: and while we
possess on the one hand the Elgin marbles, and on the other
such noble collections of pictures by the old masters as exist in
this, and other countries to which we have access, no reasoning,
at first sight, appears more specious than to suppose that, with
all this knowledge, we have only to start from the culminating
point which the arts of Greece just reached at their highest
period of perfection, and, starting from this, to surpass all that
has been done. And, as a corollary to this, artists fancy that,
by copying the statues and reproducing the porticos of Greece,
we are reviving Grecian art, and may, by persevering in this
course, at least produce as beautiful things as the ancients; and
some even hope that, by adding our knowledge to theirs, and the
power of our civilization to the then less refined polity, we may
surpass them. Those, however, who reason in this way, appear
to us to have only glanced at the surface of the question, and to
know but little of Grecian art, or of what in fact it really consisted.
It was not with Grecian artists a thing borrowed from others, or
something apart from their feelings or polity, but really and wholly
the expression of the faith, the feeling, and the poetry of the
nation.

Favoured by the most genial climate, and inhabiting the most
romantic region on the face of the globe, it was almost impossible
that a young and healthful nation like the Dorians could struggle

on to independence and civilization without accumulating those images of beauty and of glory, which afterwards shone forth in such splendour; yet they struggled on for centuries before these assumed a fixed or real form that could be embodied for the future. Hesiod first preluded with a glorious drama, and gathering together some of the floating images of beauty with which the minds of his compatriots were teeming, wove them into his early song. But it was Homer who first embodied the poetry of his race, in that immortal song which has been the glory of his nation and the delight of all succeeding generations. It has been disputed whether such an individual as Homer ever lived, and whether this be true or not, the doubt, though scarcely tenable, in this instance shadows forth a truth of no small importance. The Iliad was not the creation of an individual, but of the Greek nation; Homer, however, first fixed, in song, those ideas which had long been struggling for utterance; and, embodying the traditions of the Greeks with their religion and their poetry, built the substructure on which the edifice of Grecian art was raised; and whether this was afterwards moulded into the dramas of Sophocles, Æschylus, or Euripides, or expressed in the lyrics of Pindar or Anacreon,—whether it found a tangible shape and form in the works of Phidias or Praxeteles, or was presented to the eye in the colours of Polygnotus, or of Zeuxis,—all these were but different modes of the same feeling, the result of a sincere and enthusiastic adoration of what was great and beautiful in art.

The form once given, it required but time to complete the superstructure, though it might never have attained its glorious perfection had not other circumstances combined to add to its beauty. Had the Persian never appeared at Marathon or Thermopylæ, had Salamis and Platea never witnessed those glorious triumphs of patriotism, the mind of Greece might never have risen to that exalted pitch which impressed so noble a stamp on all her after acts; and her poetry and her arts, as the voices through which her sentiments of freedom and of glory found an utterance, would never have acquired that power and purity which is the essence of all the productions of those young days, whether we have it now in the works of her poets or her painters, her sculptors or architects.

The flame once kindled, the emulation and rivalry between the different states was sufficient to keep up the blaze, and in this respect again Greece was fortunate; but it required a greater and more glorious cause than this to produce such poetry and such art as Greece has bequeathed to us.

A similar expression of national feeling and of national religion produced the architecture and the arts of our mediæval ancestors, which were nothing more than the reflex and expression of the poetry and power of the people, written in a language which all then understood, and were interested in. And it was a state of things among the young republics of Italy, not very dissimilar from that which had existed in Greece, that produced the Italian school. A man who studies philosophically the history of those times might easily predicate in what respects Italian art would differ from Grecian, as being the product of a people less purely patriotic; of a nation that, with much of the vigour of youth, inherited many of the vices of decay; expressing a philosophy less exalted, and a religion which had temporarily lost much of its purity and perfection. For it is true that in the arts of a country its history is written, and that they are much more faithful interpreters of it than the chronology of its kings; in them the nation speaks for itself, without constraint; and though not quite so self-evident, at first sight, as in the case of Greece or Italy, we will endeavour to show that they speak of us as clearly and distinctly as in any other country.

When in England there shall exist a social state similar to what existed in Greece and Italy at the times we refer to, we may expect similar effects in art as in everything else; but he has studied the philosophy of art to little purpose who expects that circumstances and causes so widely different as those that now exist in this country can reproduce what other causes produced in other times.

Are, then, the Elgin marbles and our Italian paintings of no use to us? and has all the money and trouble they have cost us been spent in vain? Most certainly not! As a means of education they are invaluable—as a means to refine the mind, to point out truth as the highest aim, and simplicity as one of the leading characteristics of the highest style of art; for all this, and much more, they are to us of the highest value, but the moment we begin to copy them they lose these properties, and instead of rivalling them we sink into manufacturing machines.

It sounds almost like silliness to remark (though the fact is so often lost sight of) that we are neither Greeks nor Italians, that our religion is not theirs, our feelings of a widely different class, and that our civilization has taken a very different character from theirs; yet we are a great and powerful people, and our history will bear comparison with the history of the proudest nations of the earth; and in literature and science we may be equalled, but few will admit that we have any superior.

Had we turned our attention to the fine arts, and left them only to express what we believed or felt, they might ere this have been as creditable to us as our other works; but they have, till lately, been entirely neglected, and now, when we are turning our attention to them, it is only with a view to imitation.

One other circumstance of vital importance seems to have been overlooked,—that the Greeks as a nation, as well as the Italians, gave their whole energies to the cultivation of the *fine arts*, while we, on the contrary, have devoted ours to cultivate the *useful arts*; and it is a problem that yet remains to be solved, whether any nation can succeed in successfully cultivating both. Certain it is that no nation yet has, and we believe we might add no individual; still there is no *à priori* impossibility in the matter, though it appears, at the same time, to be tolerably certain that the fine arts of so utilitarian a nation as we are must, to be successful, take a much more prosaic turn than the poetic *abandon*, that characterized the glorious days of Pericles and Leo X. Everything with us has, for some centuries back, been taking a more and more practical turn, from which art will scarcely be able to escape. Eloquence, when not addressed to the vulgar and ignorant, has had her wings sadly clipt, and now its highest flight consists of merely the best arranged digest of facts stated in the clearest and fewest words possible. Philosophy admits of no brilliant speculations, no cherished dreams, or bright imaginations. Experience and mathematically deduced conclusions are all that can now be admitted within her narrow portals, and even in religion a cold spirit of inquiry has succeeded to the unsuspecting faith and all confiding trust of former days.

For more than three centuries this spirit has been gaining ground with us, and every year becoming more and more essentially a part of the public mind. Friar Bacon was our Hesiod, and he of Verulam our Homer, who first gave being and form to the gods of our idolatry—the first who fixed the belief, and directed the mind of the people into the path which they have since so steadily followed; Galileo was the Thespis of our civilization; while Kepler, Newton, and Locke, like the three great dramatists of the Greeks, moulded and brought to perfection that great branch of our glorious triumphs which Watt and Arkwright, like Phidias and Ictinus, reduced to fixed and tangible shapes.

There are no doubt many who regret that the civilization of modern Europe should have taken so prosaic a turn, and who would forego our philosophy and our steam engines for a new Parnassus with its legends, or a Parthenon with all its architectural perfections.

We confess we have small sympathy with these *laudatores tem-*

poris acti: but whether they or we are right is not now ·the question—the thing is done; we are a practical people, worshippers of reason and truth, and cannot now go back and become followers of their sister imagination, or admirers of what we do not believe, and know not to be true. Our energies are and have been for centuries directed to the practical arts, and the same perfection and progress is visible in them now, that was seen in the fine arts of Greece or Italy in their best and most glorious days. Everything that is now done—every ship, for instance, that is built, every engine or machine made—is, or is meant to be, an improvement on all that was done before: the shipbuilder does not pause first to consider whether his vessel shall be built to look like a Roman triremis or a Venetian galley, and then consider how he may still avail himself of modern improvements and purposes in this disguise; on the contrary, he adopts every improvement that is introduced from every country, and dispenses with every form that is not absolutely necessary, and every ornament that would interfere with his construction— and he has produced or is producing a thing more sublime than a Greek statue. Go and look at a ship reposing in calm security and conscious power alone on the pathless and almost boundless ocean; or see her in the storm struggling in her might with the fiercest displays of elemental war, and acknowledge that we are a great and powerful race, and dare to conceive and do things before which the minds of the ancients would sink in terrified abasement.

What would now be thought of an engineer who, in constructing a steam engine, should try to make it look like a watermill or a horse-gin, or some equally irrelevant object? This is not the course they pursue, but every engine is better than its predecessors, though only perhaps in some detail; almost the whole nation still are employed, or at least interested in perfecting steam machines, and our progress surprises sometimes ourselves. If there is to us no poetry in them, it will not be so in succeeding generations, for mankind will learn to envy those who lived in these times and took a part in the great progress of knowledge and power that marks the present century. In the last and greatest of our mechanical triumphs—the creation of the railway locomotive—we have surpassed all that was done before; but it is too near for us to see its greatness: we smell the oil and see the smoke—and more than this, we know the men that invented and the men that make these things, and they are not sublime ;—no more were the semi-barbarous hordes who sat down before Troy; but distance has almost deified them, and we certainly deserve more of posterity than either they or their bard.

It is by thus doing with the useful arts what the Greeks did to arrive at perfection in the fine arts, that we have achieved such triumphs. Thus every new work is an improvement on all that was done before — every step is forward. The artisan now watches the progress of his art with the same intense anxiety as in former days the artist devoted to the creation of new beauties in his: there is no retrocession, no wandering about without any aim or fixed purpose, no copying now from Greece, then from Rome, or from Italy, or Germany, or India. There is a meaning and a purpose in all that is done. Power and knowledge are gained daily; and the accumulative energy of nations is advancing science and art to a point that the boldest imagination cannot reach or even conceive.

It is painful to turn from the contemplation of what we have done by well-directed energy in this path, to contemplate our doings in Art properly so called, which, if it be too strong a term to say they are disgraceful to us, must still be allowed to be utterly unworthy of a great and civilized people. But in this we are not singular, for nations, our contemporaries, though loud in their boastings, are not much better off; and, though they paint acres of showy pictures, have no more real art and no more feeling for it than ourselves. Of all modern nations the Dutch alone have escaped, or nearly so, from the vicious system we have been trying to expose. When the Reformation changed their religion they left off painting saints and martyrs, but they neither stopped painting altogether, as we and the Germans did, nor did they, as the French, turn at once to copy the Italians. Of the latter the good Hollanders had little knowledge, and still less sympathy for their productions; Dutch artists, therefore, fortunately free from extraneous influence, went on painting subjects that interested them and their employers; the sea with its ships, the village with its fun and festivals, and scenes of still life or domestic interests; and if they attempted history they painted their distinguished men and women dressed as they had dressed, and doing as they had done. It was by following this path that the Dutch worked out a school which even now divides with the Italian the admiration of all Europe. Among collectors Dutch pictures generally fetch a higher price than pictures of the same relative value in the more elevated schools, and this without their possessing one single quality which writers on æthetics are in the habit of enumerating as requisite for the production of art; but to make up for this they possess originality, and what is of more importance, truth—truth to nature and to the feelings of the artist who produced them; and though we might wish they had been of a more elevated class, all must

acknowledge the charm that arises from these circumstances. And can we not do what Dutchmen have done? There is little doubt that we can do that, at least, and more if we chose to follow the same path. We are a more refined and better educated people ; our chivalrous history, and, above all, our national literature, afford us higher and purer sources of inspiration than they could command; and then there is more demand for art and more leisure to enjoy it in this country than ever existed in Holland. Yet we have hitherto effected but little; for instead of doing as they did, we attempted to start at once from the high grade of Grecian or of Mediæval art, and, as might have been foreseen, we failed. It was not in us nor in our sympathies or our feelings ; there are no sources of such inspiration about us. We have attempted a flight from the top of the ladder; we must now go back and begin at the bottom. We must build houses and churches which shall be nothing but houses and churches; we must paint and carve men and women who will be only such, acting as we act, and feeling as we feel; if we paint saints we scarcely believe in, and gods and goddesses we laugh at, and heroes we neither understand or have any sympathy with, it is not likely we shall ever do anything great.

But we have around us other sources of inspiration equal to those that any people ever possessed, and such as will never be exhausted or worked out. No nation ever loved inanimate nature more than we do, or had more opportunities of cultivating our admiration both by land and by sea : but were there nothing else, the novel position in which the chivalry of the middle ages has placed women in our society, is a source of which the ancients knew nothing. Our novelists have seized it, and out of it created a new literature which is read with avidity by every class, and works for good or evil on almost every mind; but our artists think a naked Venus or a Greek triumph, or a saint or martyr, or a holy family, is a thing more likely to interest us modern practical Protestants ; and the consequence is we care as little for such art as we would care for literature if it were filled with the same stuff.

Hogarth, and Wilkie, and Gainsborough, and Landseer, and some other of our painters have followed the track we would point out, and they have been by far the most successful, and the only ones whose works will in all probability outlive the fashion which produced the others; their works will be understood and admired when Reynolds, and Lawrence, and others are remembered and admired only as portrait painters : for these men spoke of things they knew and felt in a language we can understand, and which will not be lost. Yet they were not great men, nor such

men even as we have a right to expect will one day devote them-
selves to art. Hogarth cannot stand higher than Butler in our
literature, nor could Wilkie take a higher relative place than Allan
Ramsay. There are many steps yet unoccupied between Butler
and Shakspere; and the sister throne to that of Burns is still
vacant for him who has the courage and the power to mount it.
But if our artists would strive in that way, they must recollect
how these great men gained their immortality — it was not by
copying.

The career of Wilkie is a pointed illustration of what we have
adduced. An indifferent draftsman and bad colourist, his great
and well-merited celebrity rests entirely on the homeful nature of
his subjects, and the truth to nature, and the feeling with which
they were treated; but Wilkie was not a great or strong-minded
man, and it was almost impossible that he could escape the con-
tamination of his school: had he remained in England the com-
mon sense of the people and the applause they always award to
English works might have kept him free. But his journey
to the continent sealed his doom as it has done that of many
before him: he became a copyist, an imitator of Rembrandt
and Velasquez, and the result we all know too well. Had he tra-
velled in his youth it is probable he never would have risen above
mediocrity; but in the prime of his life and zenith of his talents,
though the effects were painful, the false system could not alto-
gether destroy him, and he sometimes looked back to his own
home and own feelings for his inspiration, and the charm re-
appeared. Still the curse of his age was upon him, and he was
fast sinking into an academician when he died.

We believe we have now as great men among our artists as
Wilkie—men who feel as deeply and read human nature as truly:
but, instead of expressing what they or their compatriots feel or
know, they are following a false system which can lead to nothing,
for there is no truth in it.

Our painters complain bitterly of the unpicturesqueness of mo-
dern costumes, and are fond of pleading this as an excuse for their
imitations of the classics and Italians. Yet our men fight as
bravely, do as great things, and in these strange costumes im-
press their contemporaries with as much awe and respect as ever
the most classically clad Greek or Roman did his countrymen;
and our women, too, feel as strongly, and express, if we mistake
not, their feelings of grief or joy with equal distinctness and
power.

The costume on the living subject renders no men or women
ridiculous, nor prevents them from expressing or doing all that is
great or dignified in them, and if we do not find these qualities in

our paintings we must look elsewhere for the cause. Be this, however, as it may, painters have been laughed out of the absurdity of painting our kings and statesmen in Roman armour and Roman togas, as was the fashion in the days of Charles the Second or William the Third; but though the public would not now tolerate portraits of Queen Victoria or Prince Albert in these heroic costumes, it is strange, though true, that our sculptors are so far behind the painters that they have not yet shaken off the false fashion. Canova's Napoleon was stark naked; and George the Fourth rides, *sans culottes*, on a horse without a saddle or stirrups, with nothing on but a blanket draped over his shoulders, and a few laurel leaves for a hat; Canning stands in an analagous costume in New Palace yard; and every square exhibits like strange doings, not to mention the funny things in St Paul's and Westminster Abbey.

Chantrey did much to reform this, and most of his statues are dressed somewhat as the persons they represent were in life (though he is not guiltless of togas), and we have no allegories or gods and goddesses in his works. His first great production was the 'Sleeping Children' at Lichfield, and had he been able to follow up this purely English style of art, he might have rescued English sculpture from the neglect under which it now labours; but unfortunately, the design of that work was not his own, and either from inability to go on in this line, or because he found it more profitable, he sank into a mere portrait sculptor; and we still expect the man who is to Anglicize the art.

Some fifteen years ago, a common working mason, Thom, a native of the land of Burns, made a stride in the right path, which narrowly escaped being successful. His statues of 'Tam O'Shanter' and 'Souter Johnny' excited more attention and elicited more praise from the public than any works of either Flaxman, or Nollekens, or Chantrey (except, perhaps, the 'Children' alluded to), and this merely because they were national and true to nature. They were in the lowest walk, and far from being the best that might have been produced in that walk; yet it shows how eagerly we grasp at what is right in art—that, in spite of all the prejudices of our education, these statues, with all their defects should have created the sensation they did; and even now they are more visited—copies of them are more common in Britain than of any work of sculpture, ancient or modern.

In France and Germany they certainly have done more in art than we have done of late years, though scarcely, as we said before, with more success.

When France awoke from the dream of the middle ages, she recommenced art by copying. In literature, Corneille and

Racine put Frenchmen into Greek dresses, and by hampering themselves with the unities and other necessary difficulties of the Greek theatre, they and their contemporaries thought they had rivalled, or indeed improved upon the great dramatists of Greece. We, and even their countrymen, now begin to perceive how falsely : that what is good in them is French, and that all that would be Greek is bad. Yet the French are now glorying that they are doing in architecture exactly what their dramatists did in the drama; and in the Madelaine, by hiding a French Christian church in the skeleton of a classic temple, they think they are rivalling the works of antiquity; and it may be a century before we, or at least they, learn to laugh at this.

In painting, their greatest man, N. Poussin, began by translating Raphael into French, and with more success than falls to the lot of most copyists ; and Le Seur and Le Brun went on transplanting these exotics to the soil of France. But nothing individual or native seems to have been attempted till the glorious events of the empire, so flattering to the vanity of the nation, first led her artists to believe that representations of them might be as interesting as would be copies of the antique, and so it has proved; and some paintings by Gros, Gérard and H. Vernet might have led to a better era, had they been able to shake off entirely the fetters which their academy and the copying school of David had heaped upon them, which even now their most promising artists cannot break, though every annual exhibition proves that the most successful works are those which differ the most widely from the classic schools.

We are, however, sufficiently aware of the errors of the French school, and have too little sympathy with its extravagances to be in much danger of being hurt by its example; but it is not so with the modern school of the Germans, which is now held up for our admiration on all hands, and virtually forms the model on which we are moulding all that is now going to be done for art in this country.

It is scarcely more than twenty years that some German artists assembled at Rome had taste enough to admire the works of the great masters found there, and vanity enough to think they could rival them. A prince was found impressed with the same belief, and since that time unbounded have been the orders given, and equally so the quantity painted, and all in the highest walks of art. The boldness of the attempt, and the brilliancy of the effect produced, have dazzled the eyes of all Europe; and as no time has been allowed for pause or reflection, the world has not known whether most to admire the liberality or taste of the prince or the boldness and genius of these modern Raphaels and Michael Angelos, who, in twenty years, have produced out of nothing a

school of art and works rivalling the best days of Greece or Italy.

But is this really the case? Cornelius has painted acres with scenes from the heathen mythology—with gods he does not believe in—heroes he cannot feel with—and men and women, whom he can neither identify himself with or feel any sympathy for; still they are clever, artist-like productions. He has studied the marbles and paintings of the ancients; he knows in what lines Raphael grouped his figures to produce his effects, and has learnt by heart the rules of colour from the Bologna school. These, intelligence and long study have taught him to combine; and if we are content to dispense with truth and feeling, these will serve our purpose; but if so, the prize poem of an Oxford student should be preferred to a song of Burns, or to the best effusions of a Shelley, a Wordsworth, or a Coleridge.

And so it is with the rest; some paint Christian subjects, and so does Cornelius when told to do so. In fact most of them are ready to execute any order confided to them, Pagan or Christian, portrait or landscape, whichever is most in demand or best paid, they are ready for. We will not presume to say they have not succeeded, or may not succeed; the voice of Europe is against us; but if they have, we have seen a spectacle that never was seen before, either in poetry or the arts, of men producing great things that they have not felt, and influencing others by uttering what they do not believe.

Overbeck, and Hess, and Hermann, and one or two others, have restricted themselves almost entirely to religious subjects, and from (we believe) religious feeling, so if anything was good it might be expected from them, had they attempted to express the sentiments they feel; but, on the contrary, they have gone back to the old stiff school of drawing, the glories, and quaint devices, and old architecture of the old German and Italian schools, and having copied their forms they think they have given the substance;—as if a poem printed on bad paper, in old black letter, and as badly got up as in former days, would on that account, without any further merit, rival the productions of Chaucer or of Spenser. In their paintings we have angels playing on fiddles and guitars, and saints with glories, and all the old strange emblems, when none of the painters hesitated to introduce the first person in the Trinity. All these were things which, in the simple faith of an ignorant age, were not only excusable, but respectable, as the expression of the highest faith in art the painter knew; but in an educated man in the nineteenth century the former are puerile absurdities, and the latter a piece of blasphemy as disgraceful to the artist as to the public or patron who admires it

There are men among these Germans who can and have painted good pictures, such as Lessing's ' Convent in the Snow ;' Kaulbach has painted some German scenes that rival our Hogarth's ; and others occasionally descend from their hobby to truth and nature, but their productions are good, precisely in the ratio in which they are opposed to the principles of the Munich Academy.

The last work of the Germans, and their greatest, has been the erection of the Walhalla; and such has been the enthusiasm and admiration this has excited throughout all Europe, that sober-minded members of parliament have begun to talk of our doing something like it, and we believe that a grant from parliament for that purpose would not only be unopposed, but generally approved of. Yet, if we can do nothing better than re-erect, in a Christian country, a temple built for and dedicated to the worship of a heathen goddess, and this as the only means we can think of for doing honour to our Christian fellow-citizens, we confess we shall not be sorry to see the project lie dormant some time longer.

However beautiful the Parthenon may be, the Walhalla does not express one single feeling of the persons it is built to commemorate, nor of those who erected it, except the great truth that they had no art, and if the architect has been as successful as he is generally allowed to have been, he has proved that since the days of Phidias and Ictinus art and civilization have stood still, and religion changed for the worse. For even where the original Greek afforded no copy, owing to the ruined state of the interior, some figures of a different character have been introduced, but these were not, as one might expect, borrowed from the Chrisitian religion; no ! but from the barbarous mythology of the Scandinavian tribes. For what, then, have these men lived whose busts are stuck against the wall— "authors, architects, painters, philosophers, and heroes ?" If we ask the building, the answer is, they lived in vain; they have left no trace, and nothing has been done worthy of notice since the days of Pericles and Wodin. An equivocal compliment, it must be confessed, to the illustrious, but the best and most meaning that modern art can bestow.

It may, however, be urged, that pictures and statues, and even architecture in this form, are at best mere luxuries, and that if we are pleased and gratified with the production of our artists, the object sought after is attained, and nothing more is required. It is sad to think how often this argument is practically urged, and that, in consequence, those means which might be most efficiently employed to educate and elevate the minds of the people are degraded into mere sensual gratification. But even

should this be the case with regard to painting and sculpture, it is certainly not so with regard to architecture, using the word in its fullest sense; this last is a necessary art, one we cannot do without, and on which our comfort, if not our very existence depends. We cannot do without houses to live in—public buildings and halls for assemblies or the transaction of public business; and, above all, we require the assistance of this art in erecting churches, places in which we may conveniently congregate for worship, and which, at the same time, will mark the honour and respect with which we regard everything dedicated to so sacred a purpose. Notwithstanding this, however, and though the whole nation have and always have had an interest, not only in the private edifices, but in the public buildings erected throughout the kingdom,—while the knowledge and enjoyment of the sister arts have been confined to the affluent and the educated, still architecture is with us at present in a worse position than either of the others, its professors have less title to the name of artists, and its best productions can only claim as their highest praise to be correct copies, or at most, successful adaptations of some other buildings erected in former times, for purposes totally different from anything we at present require.

The cause of this, we believe, will be found to lie, even more directly than in the other arts, in the system of copying, to the exclusion of all original thinking, or, indeed, of common sense; and the reason why this should be so fearfully prevalent in architecture will be found to be principally in the anomalous system in which not only the patrons of art, but the artists themselves have been educated in England.

Since the time of the Reformation, the education of every gentleman's son has been what is termed strictly classical, a knowledge of Latin and Greek has always been considered as an indispensable qualification to the title of an educated man, and, generally speaking, to the exclusion of every other knowledge.

At the public schools the same absurd system is still pursued; and though private institutions have somewhat deviated from this practice, still the interest of public bodies has hitherto maintained a predominant influence over the education of all classes.

Every boy at the age at which he commences his career in life is intimately acquainted with Cæsar and Livy, while the chances are he never read a word of Hume or the military records of his own country: he knows the greater part of Virgil by heart, while it certainly is not his master's fault if he knows more of Milton than his name; and he is flogged into admiring the bad

plays of Terence, while if he knows anything of Shakspere, it must have been by stealth and out of school that he acquired this knowledge. He is carefully taught the names and properties of every god and goddess of the heathen mythology, their various adventures, and " filthy amours ; " but he is left to pick up from his mother, or how or where he can, what little knowledge he may acquire of the Bible or of the history and tenets of his own religion ; his education, in short, is strictly and purely heathen, though in a country professing Christianity. Though some shake off the trammels of this false system, the mass of the nation, in the pleasure or business that follow their school years, have no leisure for other pursuits till the season is past, and if then called upon to think on the subject, the attainments and recollections of younger days return with the power and vividness of deeply-rooted prejudices, which few, very few, have the strength to shake off. In his youth he has been taught a literature he cannot adapt, a history he cannot apply ; and little wonder therefore if, in his maturer years, he tries an architecture totally unsuited to his climate and worse than useless for his purposes. Did the evil consequences of this system stop here, it would not be so serious as it really is ; but thus it is, that in trying to copy and adapt the classical types, we have learnt to be mere copyists ; and when we turn our attention to the Italian or Mediæval styles, the false system still clings to us, and correctness of copying is still the greatest merit of every design.

The same absurd system poisoned our literature for more than a century and a half, though, fortunately for us, we have seen both the beginning and end of its influence there. Shakspere was the last of our great men that escaped it : his own learning was small, and, fortunately for him, his contemporaries had not then forgotten that native art had existed in England as well as in other countries, nor learnt to believe that it could only exist in foreign lands and ancient times. It is true nothing could have destroyed the might of his genius ; but had he lived later, we should have been obliged to seek for his gold in the ore of plagiarism instead of having it pure and brilliant from his own crucible. This, however, was not the case with his successor Milton ; his vast learning and admiration for the ancients induced him to put his great Christian epic into the heathen garb of its great prototypes, and nine-tenths of the faults that can fairly be found in this work are attributable to this great mistake. Had he known neither Homer or Virgil, but sung his higher theme in the purity and power in which he felt it in his own heart, his poem would probably have surpassed the productions of his predecessors as far as his subject surpassed them, or as the accumulated poetry of

Christianity to which he was to give utterance surpassed the accumulated fables of the heathen.

'Paradise Lost,' however, had sufficient power to rivet the chains of copying on all that came after it, and from Milton's time till Cowper first dared to sing of English thoughts and English feelings, and the giant hand of the peasant Burns tore to pieces the flimsy web of conventional criticism in which the corpse of English poetry had been wound.

If any one will take the trouble of reading the ' Cato' of Addison, the 'Seasons' of Thomson, the 'Blenheim' of Phillips, or indeed any of the thousand and one poems about Damon and Daphne, or Phillis, or Chloris, or Mars, or Cupid, which formed the staple commodity of poets of that age, he will be able to form a tolerably correct idea of the merit or absurdity of the classical productions of our architects, while the washy imitations of the old English ballads, on which Johnson was so witty, will afford a standard by which he may judge of our modern Gothic churches and mansions, always bearing in mind this distinction, that the one is an innocent trifle, the other a positive and expensive inconvenience. A poet may indulge himself in harmless flirtations with dryads and water nymphs without hurting any one; but a habitation must be either in reality very unclassical or very uninhabitable in this climate, and the whole race of porticos only serve to encumber our streets and darken our windows.

A better state of things has arisen in literature, and our poets are now content to write in English of what they think and feel ; and it is not difficult to foresee that we are on the eve of a revolution in art, similar to that which has taken place in poetry, and we only wait the hand of a man of genius and originality enough to set the example and point out the way that all may follow him, though it is true that no one man will be able to effect this, but it must be the result of long-continued experience and exertion, not only on the part of the artists, but of the patrons with them.

If, however, it is to a mistaken system of education that we can trace the principal causes of the degraded state of art in this country, the same reasoning that points out the cause of the disease, points, as we said before, towards the means of cure ; and were a proper system of artistic education adopted in England, we should not be long before its effects would be felt in every branch of art.

The two universities might do much. They might, with little difficulty, lay a foundation of knowledge in the minds of young men who pass through them, which would, in nine cases out of ten, enable the man to become, not an artist, certainly—that is

not wanted—but at least a competent judge of art, which on the part of an educated man, would be of much more importance to his country. This seems to have been one of the great objects of their institution, but so completely have the universities been diverted from the purposes for which they were originally intended, that it is a true but melancholy fact that, since the Reformation, they have done nothing for art, either in the way of teaching or promoting it. Richly and nobly endowed, and inheriting from their founders all the privileges that could be desired for the cultivation of art and science in all their branches,—undisturbed by civil wars or political changes—an island of peace in the troubled ocean of the world—what might they not have done during the three centuries they have been held by Protestants?—a tithe of their revenues set aside for these purposes might have formed galleries and libraries rivalling those of the Vatican or Florence; and museums might have been collected such as the world does not know. What is the fact? Their libraries were given them, and ungraciously received, and scarcely a fitting building erected to store them in; and neither university possesses a picture worth looking at; except at Cambridge,—a few left by a patriotic nobleman, who knew the university well enough to take care also to leave money to build a place to put them in (as Dr Radcliffe had done with his library at Oxford): and as for statues, go to Oxford and see its statue gallery there; a low damp room, badly lit by one ill-placed window, and there their only collection of Roman antiquities stand in a circle on a few old scaffolding boards. Most of these are inferior, though some may be good, if placed in a light in which they could be seen; and even this wretched collection was presented by a dowager countess to the richest university in the world, and one that devotes itself exclusively to the study of classical antiquity.

Neither university possesses a school in which the theory or practice of any branch of art is taught, and has not even a course of lectures, nor any means by which a young man may either be taught or can acquire the requisite knowledge on this class of subjects.

What they inherited from the dark ages they have tried to preserve without, if possible, ever going one step beyond what then existed; and because only the books of the ancients were then known, the universities have resisted the auxiliary aid which modern arts would afford in completing the limited system of education proposed. To take one instance among a thousand: there is not a tutor in either university who would not shudder at the idea of his pupil not knowing every

word of Virgil's description of the death of Laocöon. Every schoolboy has been tutored or flogged into an admiration of it; but has any boy ever been taken by his master to see a caste of the famous sculptured group, or had its beauties and its power pointed out to him?

Masters and tutors would laugh at the proposal; yet it is still a matter of doubt whether the marble or the verse contain the original creation, and the marble certainly speaks a more intelligible language than the verse of the Latin poet, and to almost every boy would convey a clearer and better idea of the scene than the ill-understood lines. If we are taught the poem for the purpose of elevating and purifying our thoughts, and to give us an insight into classical taste and elegance, the statue would, in almost every case, be a better guide than the poem; and boys, who hate the book, could easily be made to admire the statue, and would return with delight to the one because they loved the other.

But no! whatever your disposition, or whatever your feeling, to one, and one only, of the muses shall you devote yourself. Should you in after life turn your attention to her sisters, you have first to learn their language, which is not that you have been taught; and fortunate, indeed, is the individual, who before a cold contact with the world, or the still more chilling lapse of years has deadened his feelings of enjoyment, has leisure or is able to re-educate himself, to understand that language without difficulty and read it with freedom.*

One other inconvenience of this system is, that when an Englishman does acquire a knowledge of art, it is not in England that he obtains it, but in France, where the information is seasoned with praises of the genius of the "*grande nation*," their school of art, their galleries, &c.; or in Italy, where it is the climate, the history, and the *bell'anima* of the people; or in Germany, where the glory is ascribed to the academies, to patronage, to metaphysics, and heaven knows what;— in short, to anything and everything that England has not; the traveller returns to his own country, not only convinced that art does not exist there, but that it cannot be produced within our seas; and so strong is

* The two colleges which at present form the university of London, being founded more in accordance with the spirit of the age, seem inclined, as far as they can, to rectify this error on the part of the older universities, and to restore the faculty of arts which has perished there; and for this purpose have established lectures on architecture and other branches of the arts, which certainly will do good, and are a step in the right path, but they have not the influence, nor can they remedy the defects of the great national institutions.

this feeling among the educated classes of the country, that parliament was last year on the point of sanctioning an importation of a colony of Germans to paint our national frescos. Every one knows how many of our public statues and monuments have foreign names engraved on their pedestals; and even at this moment foreigners are employed to erect statues to our great men, which, though they may be creditable to the persons represented, are certainly not so to the country.

from

"The Royal Academy.
The Seventy-sixth Exhibition"

Art-Union 6 (June 1844), 153–72

THE ROYAL ACADEMY.

THE SEVENTY-SIXTH EXHIBITION.

"Imitations produce pain or pleasure, not because they are mistaken for realities, but because they bring realities to mind."—Johnson's Preface to Shakespere.

THE Seventy-sixth Exhibition of the Royal Academy was opened to the public on Monday, the 6th of May. On the Friday preceding, there was, we believe, as usual, a "private view." On the day after, there was the customary feast of reason and flow of soul at the heavily-laden dinner-table. Among the guests was Prince Albert; the gallery having been previously honoured by the presence of her Majesty. On Monday, shillings obtained admissions for persons whose business it is to report upon the collection; and who had to push their way through crowds to get hurried peeps at objects it was their desire and their duty to examine carefully and to scrutinize narrowly. The members of the Royal Academy are, no doubt, "wise in their generation;" but their wisdom is not of the kind which characterizes high and enlightened minds. They persist in excluding all "judges" who do not arrive with heavily-laden pockets. The wedding garment must be of purple and fine linen; the eminence derived from mind is a passport through its doors far less effectual than twelve copper pennies. Shrewd and sensible people—generous in nothing! The usual result has followed; every public journalist "cries the Exhibition down," as far as he can; taking note of all its weak points and slurring over all matters that may be serviceable to the Institution—the only Institution in Great Britain *as yet* empowered to confer honours and distinctions upon the professors of Art. We say "as yet;" for, as surely as we write, a time is approaching when this Institution will be remodelled by the application of force from without; that it ought to be so, is universally admitted everywhere (save within its walls), and by everybody (except those who are, or *think they are*, interested in maintaining its exclusive and most illiberal character). WE HAVE REASON TO KNOW THAT ARRANGEMENTS ARE IN CONTEMPLATION TO RENDER THE ROYAL ACADEMY MORE WORTHY OF THE COUNTRY AND THE AGE. It is high time that such should be the case; that the ungenial and narrow-minded spirit which so extensively prevails over its councils

should be schooled into a knowledge that what might have been proper enough in the "dark ages" of British Art will not do in the middle of the nineteenth century. It is by no means fitting that half-a-dozen artists should retain *the whole power* by which a profession is to be elevated or depressed;[*] the members of which profession now-a-days consist of twenty times more than they did when that power was conferred upon a selected few. Monopolies of all sorts are falling away; the Royal Academy is nearly the last. It has made no useful move of any kind for nearly eighty years; and it will undoubtedly continue without a stir, until impelled forward by a force to which it will yield most unwillingly—resisting as long as it shall be able so to do. The evil obstinacy which perseveres in refusing all courtesy to the press supplies the text upon which we write;[†] the poor policy, however, is but a sample of the mode in which the Royal Academy is conducted. All attempts to introduce salutary changes into this close corporation are frustrated by the few who rule its destinies; and it may be accepted as one of the signs of the times that we—who have, during many years, fought earnestly against its assailants, in the hope that reformation would proceed from those who could reform it most safely—feel it an imperative duty to call upon the Legislature to take the care of British Art

[*] We speak of "half a dozen," because, although the body consists of forty artists, we have good reason to believe that a very large majority would advocate the changes rendered necessary by time, but for the pertinacity of a few of the older members, who obstinately adhere to ancient laws, and cannot, or will not, perceive the wisdom of, in the smallest degree, altering any one of them. They forget, or do not consider, that it was the stern resolve to maintain Gatton and Old Sarum in all their "purity" which produced the Reform Bill, with its schedules A. and B. There is an old though vulgar saying, "a stitch in time saves nine," which certain members of the Royal Academy appear never to have heard of.

[†] We have upon several occasions complained of the miserable position in which all writers for the public press are placed by this absurd and insulting system of exclusion. Last year, we made a formal application for admission to the private view: it was made in vain; and we are not likely to submit ourselves again to the humiliating ceremony of a refusal. Every newspaper contains some such introduction to the Review as this, which we copy from the *Spectator:*—"The first glimpse is not inspiriting: as one jostles on, through the crowd that chokes the narrow gangways of the small suite of stifling apartments, to reach the great room at the end, the prospect above the heads of the visitors is dreary enough: a waste of gaudy canvas in gilded compartments glares on the walls, studded with representations of the human face, mostly made to look anything but divine. Here and there a large landscape or some huge history-piece intervenes; serving rather to reconcile one to the surrounding display of dress and upholstery, than to induce regret at the fewness of these ambitious attempts." The ordinary visitor can form but a limited notion of the misery to which "a critic" visiting the gallery is subjected—misery which incapacitates him utterly from judging fairly, not to say generously, of the collection. If he desires to see the pictures which he ought especially to see, it is only by rudely jostling or pushing before ladies; mind and body are both wearied and worn out when he takes pen in hand to describe the results of casual glances. Yet the Royal Academy is the only public Institution in the world which refuses a concession—dictated alike by policy and justice; although in none is there so great a necessity for such advantages as can only lead to sound judgment.

into its own hands; utterly hopeless that any improvement will issue out of the good sense, wisdom, or liberality of the Members themselves.

Already a society — the Artists' Institute, consisting of nearly FOUR HUNDRED artists — is busily at work, doing that which the Royal Academy ought long since to have done. It is sapping the foundations of the old Institution, and the older members thereof are perfectly conscious that such is the fact. Yet what has followed? Three or four of its members joined that society—they have been commanded to withdraw from it. A public meeting was held (to petition the Legislature in reference to Art-Union societies). It was called, and the expenses incident to it were defrayed, by the Artists' Institute. The Academy held itself aloof, as we shall show elsewhere; however, many of the members of the Academy signed it at the eleventh hour. The work, if done, will be done by this "unauthorized and unacknowledged body." Other acts of still greater importance will follow, and a ray of intelligence may dawn upon the old corporation, when active, zealous, and intelligent members of the profession have opened the doors by which Improvement will enter.

But there is another BODY—working with less ostentation but greater certainty, and with infinitely more powerful effect ;—from the " Royal Commission of Fine Arts " the real "reform" will come.* It is now all but certain that the Government designs to do for British Art something more than "to consider how far it may be promoted by rebuilding the Houses of Parliament."

These observations are forced from us—forced from us by the conviction that the Royal Academy will do nothing, *of themselves,* to render their constitution more commensurate with the altered character of the age. We are very sure, then, that—within a short period from this date — " suggestions " will issue from the Royal Commission that will be much more effectual than protests of public writers and examples of artists' institutes. When there ensues a far more sweeping reform of the Academy than we have ever contemplated—perhaps greatly more sweeping than we should advise—it will be our duty to remind the members of the warnings of their adversaries and the counsels of their friends, equally rejected and despised.

Unhappily, the character of the Royal Academy has been too frequently assailed without judgment or discretion. It is not very rare to find the members thereof described as "inferior artists"—a palpable untruth, inasmuch as, with two or three exceptions, they consist of men of high genius, and,

what is something, of estimable and irreproachable characters. Such statements have been put forth by public journalists in mere anger, without thought that the purpose of improving the Society by urging fair and reasonable objections was thus defeated. This has been the deplorable error of the press generally. It is needless to say that into so discreditable a mistake we have never fallen. But we can no longer conceal our conviction that the public voice, as well as the rational demands of the profession at large, must be listened to. Within the last three or four years circumstances, as regards the Arts in this country, have been essentially altered. Tens of thousands have been taught to feel interested in all matters that appertain to them. Much of this is, no doubt, owing to Art-Union Societies, which exist in nearly all the provinces of the kingdom. But events of still greater importance are affording daily proofs that the guardians and teachers of Art must keep somewhat in advance of their scholars. The Royal Academy is, we repeat, the only body that has made no move forward. Even the Society of Antiquaries (which, from the nature of their pursuits, and, as it were, the very constitution of their minds, might have been expected to be the last to adopt the principal of self-reform) is adopting many salutary changes; among the rest, the issue of a monthly pamphlet, containing reports of proceedings at the weekly meetings.

We ask again, can the Royal Academy be so foolish as to imagine that what they refuse to do of themselves will not be done for them? Entertaining, as we unquestionably do, a sincere conviction that to a selected body of artists ought to be confided the charge of maintaining the interests, sustaining the character, and preserving the high station of the profession, we should see with great regret any attempts to revolutionize the government of the Royal Academy; but there is a time when REVOLUTION *is to be avoided only by* REFORM. In reference to the Royal Academy, we are sure THAT TIME IS FULLY COME.

The Exhibition (1844) contains 1410 works, the contributions of 750 professional and 15 honorary members. It is known that a very large number of offerings were rejected " for want of room." We have heard it stated, indeed, that they amounted to nearly 1500.* Yet no effort has been made by the Royal Academy to obtain augmented space. Who can doubt that, if proper steps had been taken, the whole of the building in Trafalgar-square would have been dedicated to British Art for the months of May and June? Who will hesitate to believe that, as long as the walls afford ample accommodation for the Members, other influences than theirs must be resorted to to provide a re-

* Lord MAHON and the Right Hon. T. B. MACAULAY have been added to the Fine Arts Commission. They are gentlemen of matured taste and cultivated minds—both of them distinguished as men of letters. These additions are to the honour of the Government.

* This appears almost incredible; but it will be recollected that annually the number rejected at the British Institution has been as great as, or greater than, the number hung on its walls.

medy? Who can avoid arriving at the conclusion that the Royal Commission—now the guardians of British Art—will direct their attention to prevent the annual recurrence of a sad evil, disgraceful to our national character?

EAST ROOM.

No. 9. 'Portrait of W. Harrison Ainsworth, Esq.,' D. MACLISE, R.A. This is a small portrait: the subject is seated in a high-backed, carved chair. The pose and entire arrangement are as simple as can well be, the object of the artist having been to give to the person ease and movement, and to the features earnestness and inquiry; and in this he has perfectly succeeded. The likeness is not to be mistaken.

No. 10. * * * A. SOLOMON. The artist has fallen into the affectation of denying his picture a title. We have to observe, once for all in such cases, that this prevalent absurdity does not affect the mind of the spectator favourably, either towards the painter or his picture. The subject of the production is so commonplace that, perhaps, titles for such have been long ago exhausted. It is a love-scene, or rather a lover urging his suit to his mistress.

No. 11. 'Ostend,' J. M. W. TURNER, R.A. Well as the place is known, the picture is not suggestive of any recollection of it; this, however, is the last part of the artist's purpose, who has long since forsaken the world of forms. We are, nevertheless, be it at once said, at Ostend; but the precise whereabouts is not in a moment discernible. All we are required to see is water, clouds, *light*—to recognise their fugitive effects. Now, those who have marked the spray of the sea falling in the sunshine must have been struck by its surpassing brilliancy. A passage of this kind is here presented, and certainly with as much success as can be achieved by the palette-knife and a little white paint. This and other things are here attempted; which, to apprehend at all, the spectator must sit down for some time before the work.

No. 13. 'The Otter speared—portrait of the Earl of Aberdeen's Otter-hound,' E. LANDSEER, R.A. A very large composition, and one which must rank among the most important productions of the entire career of this artist in his own peculiar walk of Art. It is, in short, a pyramid of dogs, formed thus:—We have a fragment of the river-bank, against which the huntsman of the pack is standing, bearing high above his head the otter, pierced by a long spear, which, of course, collects around him the whole pack of otter-hounds, some in the water at his feet, others on the bank above him, and others climbing and leaping around him. This picture far transcends all other efforts, ancient or modern, at portraiture of canine character. We are told it is (that is, in variety) a portrait

of Lord Aberdeen's otter-hound, which seems to be an animal of most grave and eremitical features, but very earnest in pursuit, and curiously formed for swimming. The picture is wonderful in colour.

No. 14. 'The Madness of Hercules,' G. PATTEN, A. This is a very large picture, in which Hercules is seen in a furious paroxysm, dashing to the ground one of his own children, while his wife, kneeling before him with extended arms, implores its life. There is in the picture display of very good drawing, but something more than that is requisite. This is a most difficult subject to invest with interest. We cannot better describe the figure than by saying it is the Farnese Hercules in violent action. The countenance is unworthy of the character, inasmuch as we see there no indication of anything promotive of human good. The artist has painted Hercules after the old proverb, *ex pede Herculem*, varying his reading to *ex corpore*. The Farnese Hercules, after all, we look at, as an admirable specimen of a muscular man, but without one spark of divine fire; modelled, we might suppose, in compliment to some such hero as the Roman emperor whose grand feat was to slay an ox with his fist. It was consistent with ancient usage to commit as much as possible to mere form; but as this cannot re-act the whole story of miracle, either Christian or Heathen, here it was the failure.

No. 19. 'Dr. Whewell, Master of Trinity College, Cambridge,' Mrs. W. CARPENTER. The subject is attired in robes, and standing resting one hand on the head of a cast or bust. The treatment is simple, unaffected, and well calculated to give importance to the head.

No. 20. 'Portrait of the Marchioness of Douro,' J. R. SWINTON. A work of considerable merit, by an artist with whose name we are unacquainted.

No. 21. 'Fishing-boats bringing a disabled ship into Port Rysdael,' J. M. W. TURNER, R.A. This work is more definite and contains more local colour than any we have of late seen by the artist. Nothing of the port is visible, nor is it very obvious how the crowd of boats are bringing the vessel in, or that they are even doing so at all; there is, however, something less of vapour than we have been accustomed to.

No. 23. 'Masquerading,' F. CRANE. A child attempting to attire herself in her mother's gown, of the fashion of a hundred years ago. The picture is small, but it is drawn and coloured with much taste and spirit.

No. 25. 'The Balcony,' J. J. CHALON, R.A. The balcony is on the right of the picture, on which a lady is seen with a parasol; but this part of the composition is quite superseded in interest by an obtrusive shrub on the left. The picture demands little notice, and less praise.

No. 27. 'Portrait of Master Boydell Graves,' J. WOOD. A small and brightly-toned portrait of an extremely interesting character.

No. 31. 'Scene from "Comus,"' C. R. LESLIE, R.A. This is a composition for a fresco (the fresco in the summer-house at Buckingham Palace), but the style of subject is not that in which this artist can best do justice to himself. The scene has changed to the stately palace, set out "in all manner of deliciousness;" the lady is seated in the chair, and resists the temptation of Comus. His solicitation, and the repugnancy of the lady, are the points dwelt upon, and successfully dealt with. In the female figure there is much sweetness to give force to her loathing rejection of the glass: there is, nevertheless, an unforgotten theatrical character about the composition, and a carelessness unusual in the works of the painter—as evidence of which we need only instance the very faulty drawing of the boy on the left of the picture. Moreover, it is not matter of congratulation that such an artist should indicate a paucity of inventive faculty by copying himself.

No. 33. 'A Fruit Piece,' R. COLLS. Composed of grapes, black and white, with other fruit, and a casket; agreeably arranged, but too freely painted for a subject rendered valuable only by extreme care and delicacy of treatment.

No. 37. 'Portraits of Mr. and Mrs. Webster,' T. WEBSTER, A. This little picture would in its way be a gem in any collection; it is composed of the portraits of the father and mother of the artist, and painted to commemorate the fiftieth anniversary of their marriage. The figures are seated close together, and the head of Mrs. Webster is a study unexcelled by any similar effort, ancient or modern.

No. 38. 'The Courier,' R. FARRIER. A boy performing the office of village postman; besides his letter-bag he carries at his back a bandbox and other items. The little work is a return to the earlier excellence of the painter.

No. 43. 'The Lady and Child of J. Spencer Smith, Esq.,' F. R. SAY. One of the most effective pictures of its class in the Exhibition.

No. 44. 'A Lift on the Way Home,' W. F. WITHERINGTON, R.A. A party of Welsh peasants are here returning from market, some of whom are permitted to travel homeward in a cart which stops to receive them. This work is distinctly an improvement upon recent productions of the artist. The scene of the incident is a valley shut in by crags and mountains; and, had these been painted with somewhat more of warmth to support the colouring of the figures, the picture had been much better than it is.

No. 45. 'Evening—Coast of Yorkshire,' A. CLINT. A section of the beach shut in by a cliff, beyond the angle of which the sun is hanging over a misty horizon; it is low water, and boats and figures occupy the foreground. There is much truth, and some, perhaps venial, trick in making out the effect. The picture is by no means so simply brilliant as other works by the same hand.

No. 46. 'Ambleteuse, on the French Coast,' J. WILSON. The black squalls of this artist all look as if painted on the spot, and in great haste lest the tempest should "blow over" before he had worked up to the effect. The present view is exemplary of greater patience, as showing something more of detail than usual. It is a calm—most truly felt and worked out—some boats bespread with idle canvas and a few figures are all we have here presented.

No. 47. 'Gipsies Encamped,' A. GILBERT. A close-wooded nook with a pool of water: the gipsies are the least interesting part of the picture. It looks much as if studied from a veritable locality.

No. 48. 'Heloise,' C. L. EASTLAKE, R.A. This picture is of the highest class of Art—it challenges comparison with the works of the greatest masters. The figure is seated, loosely attired in a robe of bright crimson silk, and holds a book on which the right hand rests, but from which the face is raised and turned towards the right shoulder. There is no trick of shadow, the light is that of broad day, with just as much of gradation as the daylight gives for the rounding of the features; the whole is most unshrinkingly brought forward with the most triumphant effect of brilliancy. The life and presence of the figure impress the spectator deeply, and he is led into communion with the mind which is written in the face, insomuch as to be lifted beyond hearing of the voice of our grosser nature. The head is the result of deep thought and intense study; each feature has been separately and carefully canvassed, and thus been made to contribute to that which is the essence of didactic art. In style the picture inclines to the German school, but without anything of German harshness or hardness of outline. It brings to mind also some of the daylight pictures of the Italian masters, as for instance the Flora of Titian in the Florentine Gallery. The work is unquestionably as near perfection as any work of Art can be. It is one of the British glories of the nineteenth century.

No. 49. 'Espartero Duque de la Victoria,' J. PARTRIDGE. This is one of the best portraits we have seen by this painter. It is full-length, with much severe earnestness of purpose in the features.

No. 56. 'The Lady of Colonel Michael and Children,' Mrs. W. CARPENTER. The works of this lady are full of life and spirit; these figures are admirably rounded and substantial.

No. 58. 'Prince Rupert routing the Besiegers at Newark, on the Morning of the 22nd of March, 1644,' A. COOPER, R.A. The main incident is a combat between two horsemen, one mounted on a grey horse and the other on a black. The horses, as usual, are finely portrayed, while the cavaliers are not so well cared for, the face of him on the black horse being markedly out of drawing. Numerous horsemen are also seen variously disposed in the background.

No. 60. 'A Rapid Stream,' F. CRESWICK. A river evidently swollen to a broad volume in the winter, but now shrunk within a groove, as it were, worn in its rocky bed down which it

pursues its course, overshaded by trees such as can find support on the almost bare rocks which rise on the sides of the bed. Nothing can excel the truth with which the rocks are painted, and we are most happy to observe in the foliage a return to the freshness of nature.

No. 62. 'Rain, Steam, and Speed—the Great Western Railway,' J. M. W. TURNER, R.A. Few artists have studied nature more closely than Turner—but with what profit there is a divided opinion—it is at least agreed on all hands that his enunciation of what he sees is often in a language of mysticism. It is true, here we see the train approaching, and it may be asked why "steam" was thought worthy of being catalogued : this has been done because the artist has deemed it worth while to show steam in opposition to rain.

No. 66. 'Portrait of the Right Rev. the Bishop of Llandaff,' Sir M. A. SHEE, P.R.A. Distinguished by all the breadth and clearness of the President's works, although there is a blackness in the shadows which with age will become yet more opaque and hard.

No. 67. ' Portrait of her Most Gracious Majesty Queen Victoria,' F. NEWENHAM. This portrait was painted in 1842 for the Junior United Service Club. The Queen is standing, and habited in a crimson velvet robe, open in front, beneath which is seen a dress of white satin ; the charm the artist has sought to convey is rather that of grace than dignity : to this, however, the arrangement of the left hand resting on a balustrade does not contribute.

No. 71. 'Portrait of Lady Joddrell,' S. WEST. A work of considerable merit ; skilfully arranged, with a view to set off to best advantage the fair face of a fine woman, and executed with much ability.

No. 72. 'Portrait of the Very Rev. — Bruce Knight, Dean of Llandaff,' Sir M. A. SHEE, P.R.A. There is much of reality in this work, which is a half-length, seated. Unusual care has been bestowed upon the accessaries ; so much so, that a round table on the left of the composition is brought so forward as to injure the importance of the figure.

No. 73. ' John Knox Reproving the Ladies of Queen Mary's Court,' A. E. CHALON, R.A. It is not to be expected that this gentleman, having devoted his life to the practice of another line of Art, could at once distinguish himself in historical narrative. This production will, therefore, be regarded as a mere *capriccio*, which the friends of the painter had rather see any where else than in the prominent position it occupies. John Knox, after having reproved the Queen, and left her "bubbling and greeting," is now admonishing " her four Lady Maries." But the great preacher is here reduced to something below the level of an ill-enacted *Shylock ;* and, indeed, nothing more favourable can be said of any of the other characters. In the manner of the picture there is a nervous affectation of dash which displays weakness rather than force.

No. 75. * * * F. WILLIAMS. Instead of a title a vapid quotation is printed after the name, according to which we are to consider that the girl we here see with her back turned towards us, and looking from a window, " once has loved." All that can be said in the case is, that the figure is well dealt with as to the effect of moonlight.

No. 76. 'Richard Creed, Esq.' H. W. PHILLIPS. The breadths of flesh tone in this portrait have been left clear and brilliant ; but there is yet a slight severity in some of the lines.

No. 78. 'A Stiff Breeze,' Sir A. W. CALLCOTT, R.A. The stiff breeze we may presume to be off the land, since there is but little motion in the water. All who look upon this picture must confess themselves charmed first by its admirable simplicity, and next by its severe truth. The only objects presented are something like a Rotterdam *schuyt ;* and in the middle distance a ship of the line putting about to stand off the land. The exquisite painter " runs free " with Backhuysen and Vandevelde, and outsails both on their own misty Zuyder Zee. The spectator is deeply impressed with the truth of this picture : the gentle surging of the water acted upon by the wind uniform from a given point, the beautiful gradation of distance, and the respirable atmosphere are all points, any one of which would give value to a work of this kind. The veritable simplicity of nature in painting is, in these days of gaud and tinsel, a virtue of rare occurrence.

No. 79. 'The Lord Forester,' F. GRANT, A. This is a full-length portrait, and the subject is presented in peer's robes. The work is by no means distinguished by the qualities which mark the female portraits by the same hand.

No. 83. 'The Hon. Mrs. Adeane,' Mrs. W. CARPENTER. This is not a stiff-dress portrait. The lady is seated and habited in a flowered satin robe, and wears on her shoulders a slight covering of black lace. The pose is easy and graceful to a degree.

No. 84. 'Sir Walter Scott and his Youngest Daughter,' Sir W. ALLAN, R.A. We may presume them to be in a cabinet at Abbotsford, since the wall is hung with relic specimens of ancient weapons. The lady is seated at a table writing, while Sir Walter, who is standing, seems to be dictating. This is intended for a portrait of Scott as he was but shortly previous to his decease ; the character of rapid thought and keen observation is gone ; for these the artist has successfully substituted a tone of deep reflection.

No. 85. ' Sheep-washing—Scene in Devonshire,' H. J. BODDINGTON. The " scene " is a river side, shaded by luxuriant trees. There is much improvement in the works of this artist. The picture is a successful imitation of nature.

No. 86. 'Yorick and the Fille de Chambre,' T. H. WILSON. Although two persons are mentioned, but one appears. It is the fille de chambre, with her bandbox, waiting on

the landing of the stairs. There is much to praise in the impersonation. The model has been at once " seized," and effectively brought forward ; but she is not sufficiently French for those who have seen and studied the reality in its own sphere of action.

No. 87. ' Returning from Deer-stalking,' A. COOPER, R.A. This is a small picture : but in it we find many of those objections removed which we have felt and expressed with regard to other pictures by the same artist. The incident is one very frequently painted. The scene is a mountainous region in Scotland, and the deer-stalker with his pony, bearing a buck, are carefully descending the rocky path. The composition is altogether unaffected, and the ground, rocks, and sky are painted with due reference to fact.

No. 88. ' The Violet Seller,' S. WEBSTER. A study of great merit ; very simple in style ; but treated with due attention to nature. It is eloquent in character, containing an irresistible appeal to sympathy.

No. 95. ✴ ✴ ✴ A. E. CHALON, R.A. " And Herod and his men of war set Him at nought and mocked him, and arrayed Him in a gorgeous robe." Thus, the subject is a passage in the life of our Saviour, who alone constitutes the picture, if we may except a few heads dimly visible in the background. The picture is an absurd and most meagre allusion to the subject rather than a creditable attempt at composition. In an obvious anxiety for the nude, the figure is left uncovered, while round the neck is seen a cord, to which is attached behind " the gorgeous robe," falling in stiff damask folds more unmanageable than a Lely curtain. The work is otherwise faulty. The execution is lamentably poor ; but, as a portrait of the Saviour, it is a libel, offensive to Christians and injurious to Christianity, inasmuch as it depicts " the man" without in the least degree calling to mind the Deity.

No. 96. ' Scene from "Comus"'—Sabrina the nymph releases the Lady from the enchanted chair,' D. MACLISE, R.A. This is an example of vast fecundity of imagination, seconded by great power of hand : it is not, however, without its errors, and what these are, is instantly felt by the spectator. We cannot estimate such subjects according to the qualities we demand in social scenes : had it been treated in this feeling it would have been a marked failure. The observer, therefore, would exact something widely different, but without being able to describe his idea, and without knowing how far painting could follow it out. This picture may, therefore, be pronounced too " sculpturesque," and, perhaps, this may be termed an oversight of the artist : it will also be called brilliant, but cold. There is sufficient ground for such observations, and it seems to have been the care of the artist that it should be " sculpturesque." A close attention to the colour will show that the painter reverses the recipe for warm brilliancy : his principal figure

is cold and bright, and the extremities of his group are low warm tones. But we have not space to observe at length on all the purposes of the work : the main object has been to make the picture like a scene of enchantment or rather disenchantment ; and he has succeeded by this very coldness, for, had there been anything more of mortal warmth in it, the effect must of necessity have been impaired or lost. The design was intended for execution in fresco (it is one of the decorations of the Queen's summer house), and shows the nymph in the act of sprinkling the drops on the lady which are to undo the charm. The background is the dark sky of night, and the entire scene is presided over by the dew-distilling stars. The character of many of the heads is beautiful to a degree. It is admirable in composition and grouping— and all the accessories are carefully studied. The chair is a model of ingenious design. In short, although not, perhaps, the best work of Maclise, it is unquestionably a work of high genius.

No. 101. ' The Way over the Hill,' T. CRESWICK, A. A rugged and stony path over the hill-side, and a most curious piece of country to select as the subject of a picture, but showing, nevertheless, what may be done by a close adherence to nature.

No. 102. ' Disappointment,' E. LANDSEER, R.A. This picture, although one of high merit, exhibits less care than we have been accustomed to observe in the works of the artist. It represents a lady wearing a scarlet mantle trimmed with minever : she is seated, and her features have a melancholy cast, arising, as we may presume, from the non-arrival of some dear friend. A favourite dog sits near her, with his large dark eyes fixed upon her face as if sensible of her grief.

No. 110. ' Mrs. Bowyer Smith,' F. GRANT, A. A portrait of much simplicity and elegance : the lady wears a loose morning dress of lace disposed with much grace, but the hands are drawn too large.

No. 111. ' Morning — Boulogne,' W. COLLINS, R.A. The composition shows no part of the town, being merely a beach scene at low water looking seaward, the objects being boats and figures. The picture is large, and exhibits the best points of the artist's power.

No. 112. ' Portrait of James Pattison, Esq., M.P.,' J. LINNELL. A small half-length most unaffectedly circumstanced ; but it is to be observed of the portraits of this artist, that he has but one complexion for subjects of all ages, and that a tolerably stiff glaze of lake and yellow or some such mixture.

No. 114. ' An Interior at West Hill-house, Hastings,' W. COLLINGWOOD. A room with ancient furniture, of which the principal item is an *armoire ;* a positive triumph in this style of subject. The place is lighted by an ancient window, having the glass cut in geometrical figures ; and the admirable effect of the light shows that it has been closely copied from the room itself.

No. 115. ' Portrait of a Lady,' H. W. PICK-ERSGILL, R.A. A kit-kat presenting a front view of the figure, which is habited in a blue dress, with a black mantle.

No. 116. ' Portrait of R. M. Jaques, Esq.,' T. PHILLIPS, R.A. This portrait was executed for the Farmers' Club of Richmond, in York-shire. It is a three-quarter length, painted in the artist's best manner—the head especially is felicitously drawn ; the features are highly " argumentative."

No. 121. ' Portrait of the Right Hon. Sir Edward Ryan, late Chief Justice in Bengal,' Sir M. A. SHEE, P.R.A. A full-length por-trait, painted for the inhabitants of Calcutta. The figure is habited in scarlet robes, trimmed with ermine, and accompanied by accesso-ries effectively distributed, and substantially painted. The head looks small, but this may constitute a feature of resemblance.

No. 122. ' An Italian Port—Sunrise,' Sir A. W. CALLCOTT, R.A. This is a composition, but we have seen something like portions of it in pictures of Genoa. The spectator is placed upon a terrace, with palaces on his left, and a few trees on the right, with a centre prospective over the open sea, beyond which the rays of the sun is piercing the morning mist. The work is highly valuable, but it is not characterized by the charm which has fixed us in admiration before other similar works by the same hand.

No. 123. ' The Backbiter,' W. ETTY, R.A. The artist would be facetious, but we cannot laugh with him at a joke so dull. The " backbiter" is a huge green snake, about to " backbite" a nymph sleeping in an exposed position on the grass. She is, by the way, the most graceless of all the model train, being but a class study—*bis coctum*—and made into a pic-ture in fellowship with a green snake. We tremble not for her safety, for, by a strange mistake, the artist has made the reptile one of the harmless kind, and a specimen new to zoologists.

No. 127. ' Happy Hours,' W. D. KENNEDY. A somewhat long picture, having for its subject some Italian peasants resting in the shade. The materials are simple, and they are treated ac-cordingly, and with much sweetness in the colour and judgment in the dispositions.

No. 128. ' The Whistonian Controversy,' W. MULREADY, R.A. The excellence of this pic-ture is that of the very highest order of the *genre* class. The spectator is first struck by its brilliancy, so uniformly supported, yet so un-obtrusive. There are two principal figures, the one seated, and the other leaning over a small table, covered with a cloth of the richest hues, and painted in a manner that would have en-raptured Maes himself. The depth and ear-nestness of the argument is powerfully and pointedly described, and in a manner to give such value to the picture as to rate it a gem in whatever collection it may be placed. On the whole it may be pronounced the best work of this year's production. It cannot fail to aug-ment a reputation already high, if not of the very highest.

No. 129. ' Morning—an Italian Scene,' Sir A. W. CALLCOTT, R.A. A composition, con-stituted of a bridge stretched over a smooth and limpid river, in the foreground beyond which is seen the sea and a rocky coast, which, from the middle portion of the picture, retires into remote distance, that lies

" Under the opening eyelids of the morn."

No. 130. * * * W. ETTY, R.A. The author of this picture affords us no title ; we will, however, give it one, and call it ' A Mag-dalen,' for such is the subject. She is half draped, like the Townley Venus, but here ends the comparison. We are positively weary of these unchaste and ill-drawn figures, which Mr. Etty throws off his easel in such numbers. Why are his pictures " at home " so much in-ferior to his two exquisite productions at the Institution ?

No. 132. ' Brush, a Retriever, the property of Sir James Flower, Bart., M.P.,' A. COOPER, R.A. The dog is extremely well drawn, but the painting of his coat has given it the appear-ance of being wet. We have to complain also of the sky, which reminds us of Bassano's, as being green.

No. 133. ' Portrait of the late Sir Francis Burdett, Bart.,' Sir M. A. SHEE, P.R.A. One of the best heads we have of late seen by the President. The resemblance, however, is that of twenty years ago. Great care is evident in the colouring of the work.

No. 135. ' Portrait of the Right Hon. W. E. Gladstone,' J. LUCAS. The subject is drawn at three-quarter length, standing, and the resem-blance is readily recognisable.

No. 139. ' Portrait of the Most Rev. Dr. Murray, Catholic Archbishop of Dublin,' M. J. CROWLEY. This portrait is placed too high, but nevertheless it is obvious that great dili-gence has been employed in its execution. It seems to be accurately drawn, but the character of the archiepiscopal dress, and the light back-ground, give to the figure somewhat of effe-minacy.

No. 140. ' Portrait of a Lady,' J. WATSON GORDON, A. The lady is presented in a riding-habit, a most unbecoming costume for a merely half-length portrait ; such as it is, however, with the formal hat and heavy unrelieved jacket and skirt, the artist makes the most of it.

No. 141. ' Seaford, Sussex,' W. COLLINS, R.A. A coast scene, viewed from a break in the cliff, which is occupied by a group of three children, rigging their mimic ships. Hence we look down upon the sea and the entire strand as it rounds the bay to a distant headland. It will be observed of this picture that the line of water meets the sand in a manner too hard. This may be intended to show the tide flowing, but it is yet too severe. The group in the fore-ground is peculiarly happy—one of the artist's most felicitous copies of simple facts.

No. 142. ' Sir Walter Scott, in his early days, dining with one of the Blue-gown Beggars of

Edinburgh,' A. FRASER. "The mutton was excellent; so were the potatoes and whiskey," says the quotation from "Lockhart's Life of Scott;" true to the letter of which, the artist has placed upon the table a leg of mutton and a dish of potatoes, served in their jackets, which have been cracked in the boiling. We admit the difficulty of carrying the imagination back to even the youth of those whose faces are most familiar to us, but whom we may not have known in their spring-time. It is most difficult to fancy the white hair black, and the face full and round that is now chased by the graver of years. This is more difficult than to form a posthumous bust from indifferent portraits: we are not, therefore, disappointed at not finding in this picture a portrait of Scott in his youth, wherein could be recognised some relation to his old age. It is here forgotten that the mould of certain of the features does not change until the late period of the shrinking of the entire frame. The interior presents nothing of the wretchedness associable in idea with ordinary beggary. We can readily suppose that in early years an engagement with the blue-gown beggar was one he would not have forgotten, although in his anxious latter years, as he himself said, Lady Scott recorded all his engagements, affectingly adding, " Sed quis custodiet ipsam custodem?"

No. 145. 'The Intercepted Billet,' W. MULREADY, R.A. A small picture composed of two heads,—one that of an Italian noble of the palmy days of Venetian bravoism; the other that of his servant, who has just delivered to him a bouquet and a billet, intended for any hands rather than his. He clenches the flowers, and his eye is fixed in a muttered vow of vengeance. The style of the story is lucid and emphatic.

No. 146. 'The Cardinal,' W. ETTY, R.A. A small and admirable head, but a painful misnomer, unless the artist may intend it to represent a character from Dante's College of Hypocrites. If the red cape were painted out, and any other appropriate style of habiliment substituted, the wearer would sufficiently well represent a chief of banditti.

No. 147. 'The Catechist—Church of St. Onofrio, Rome, the Burial-place of Tasso,' W. COLLINS, R.A. This is among the best of the late productions of the painter; a benevolent-looking monk is hearing one or two children their catechism, while the mother sits apart, gratified at the ready responses. It is to be regretted that such striking resemblances exist between the children in all the pictures of this artist: in the present they are painted with the utmost sweetness of character, but they have the blue eyes of the north.

No. 149. 'An Irish Peasant awaiting her Husband's Return,' H. M. ANTHONY. She is seated near the fire, which is burning on the floor of the hut, throughout which are strewed numerous household items. In the style of

the picture there is a vacancy and affectation, and its flatness and want of depth are destructive of all agreeable effect; moreover, we cannot bear testimony to the truth in treatment the subject has received.

No. 151. 'Gipsies,' H. PILKINGTON. It is most singular that, in a subject so continually brought forward, so little attention is given to the real and peculiar traits of these people. The features of the figures in this work are anything but those of the sibyl priestesses.

No. 152. 'A Subject from "Comus," a portion of a scene described by the Attendant Spirit in the latter part of the poem,' W. ETTY, R.A. Here there is a company of ladies whom we must consider as the daughters of *Hesperus*,

" That sing about the golden tree."

It is a sketch for an intended fresco (to replace, we presume, the one painted in the Queen's summer-house). In considering this composition we are first struck by the extremely careless drawing everywhere prevalent, again by the total absence of grace in the Hesperides, and again by the extravagance of the entire composition. There are some passages of much beauty in the sketch, and we know that this painter has the power of executing a work composed entirely of beauties; but it would appear that we must consider these his waking efforts. The proverb allowed Homer to sleep sometimes, but it is to be feared that the slumbers of Mr. Etty are mesmeric dozings.

No. 156. 'The Raising of the Daughter of Jairus,' E. U. EDDIS. This is what is called a gallery picture, being composed of many life-sized figures. It is very unassuming in treatment, the artist having very properly dwelt on the sentiment and motive of the persons. The daughter of Jairus is here younger than she is generally painted, and does not come up to the term "damsel," by which Christ addresses her. Many of the heads are judiciously drawn, but they are all too European for such a subject. The head of the girl is, however, a triumph —true to Nature and to Art.

No. 161. 'Beatrice,' T. BRIDGFORD. A cleverly executed portrait, manifesting considerable talent and judgment ; but by no means recalling to memory the *Beatrice* of the immortal poet.

No. 164. 'Shylock,' J. PEMELL. The character of the head is too elevated for *Shylock*. It is too much the practice to make a study and then to give it a name, which seems to have been done in this case.

No. 165. 'Girl with Parrot,' D. MACLISE, R.A. She is drawn holding the parrot on her hand, and accompanied by a dog ; but by some oversight there is a forward movement given to the figure which is not communicated to the dog, nor apparently to the parrot. The picture is in an oval frame, and the young lady is surrounded by accessaries, which have too much the appearance of "hedging her in."

No. 170. 'Chapel in the Church of St. Jean, at Caen, Lower Normandy,' D. ROBERTS, R.A. A subject of much beauty and interest; one that has been frequently painted for the exhibitions at Paris, as well as for our own. The altar, with its furniture and altar-piece, is brought forward as the striking feature of the composition, and scarcely less beautiful are the painted windows with their subdued and almost blending tint. It is a Sunday, or at least a market-day, as we learn from the holiday head-dresses of the women. Mr. Roberts maintains his supremacy in this style. No living artist—of England at all events—can approach him.

No. 171. 'Portrait of T. R. Jefferson, Esq.,' T. PHILLIPS, R.A. By no means a good subject for a " telling portrait." The subject looks ill at ease, although it may be believed that the painter has made the most of it.

No. 176. 'The Marchioness of Waterford,' F. GRANT, A.R.A. A full-length dress portrait presenting the lady standing with her hand resting on a console. After a close observation of this gentleman's large portraits, we cannot find them in anywise comparable to his smaller works—so many of which are of the highest value.

No. 177. 'Jubal,' H. HOWARD, R.A. The subject is derived from Dryden's song for St. Cecilia's Day—

" When Jubal struck the corded shell,
His list'ning brethren stood around," &c.

The work is composed of many figures ; and we can look with indulgence on the failing efforts of a veteran in art, who, did he concentrate his powers on smaller works of one or two figures, would more easily avoid the errors to which he is exposed in larger productions.

No. 178. ' Lingiglia and Alasco—Maritime Alps,' W. LINTON. A view of a very picturesque coast, but somewhat tamely treated, being deficient of force in the foreground.

No. 180. ' Charles II. à New Shoreham, après la Bataille de Worcester,' C. JACQUAND. The story is that of Charles blessing the fisherman's children. It is an open scene on the beach—the time is evening, and the smallest remnant of the disc of the setting sun is just visible above the horizon. Charles looks, of course, pale and jaded, but too old : he is in the act of complying with the prayer of the fisherman's wife, and at the same time urged by the man himself to hasten his departure. The narrative is simply given, and the effect of the red light on the figures skilfully managed ; but in the painting of the seashore every propriety is outraged—in this there is not one passage of truth.

No. 182. ' Portrait of W. Charles Macready, Esq.,' the late H. P. BRIGGS, R.A. A right good picture, and an exceedingly impressive likeness. It may be considered as the latest work of Mr. Briggs, by whom it was left unfinished.

No. 187. 'The Day after the Wreck—a Dutch East Indiaman on shore in the Ooster Schelde: Zierikzee in the distance,' C. STANFIELD, R.A. The author of this wonderful picture accomplishes in it the *ne plus* of Art; as long as painting shall be valued for its unison with the divine melody of mysterious nature, so long must the work hold a foremost place among productions of its class. It is larger than those usually exhibited by the painter ; and the subject, although simple, is yet of a kind suited either for a large or a small composition. We have nothing to do with the beach ; the whole ground-surface of the picture is an expanse of water, and the painter shows us what he can do with such a subject. The utterly crippled but still majestic hulk, entirely shorn of her spars and cordage, seems to have been lightened, and to be just afloat ; her mainmast is standing almost bare, but her fore and mizen masts are gone within a few feet of the deck ; boats are out lending assistance, and one—the nearest object in the picture—is fishing one of the masts. The glory of the picture is the learning shown in the treatment of the water, which is yet chafing with somewhat of the unsubsided fury of the day before. Could we conceal the glimpse of the distant shore, the boats, the costume of the mariners, and even the broken ship herself, we see by the colour of the water and the formation of the waves that the shore is at hand, and that we have the ground at a very few fathoms ; and the appearances here are all as distinct from the deep-water sea-room of the North Sea as the immediate local colour of the latter is from that of the Mediterranean. *Water can have no shadow ;* any deep tone it may yield is the result of reflection. This grand and manifest truth is the principle whereon we see all Mr. Stanfield's seas painted ; and this, together with an unshrinkingly just appreciation of form, wins unbounded admiration of the philosophical demonstrations of his works.

No. 188. 'Charles I. à Holmby,' C. JACQUAND. Another work by the French artist who painted Charles II. embarking at Shoreham ; but the picture is in every respect much superior. The King is seated at table, and the likeness is very accurate ; Joyce, a most insolent-looking impersonation, is in the act of throwing aside a curtain, and is supposed to be pointing to the soldiers by whom he is accompanied. The arrangement is very bad, for we cannot believe that the King can see Joyce where the latter is standing.

No. 190. 'Portrait of the Rev. Sir Charles Farneby, Bart.,' Sir M. A. SHEE, P.R.A. The subject is habited in clerical robes, disposed in a manner to give importance to the figure. The address of the countenance abounds with animation and intelligence.

No. 196. 'Portrait of a Young Lady,' J. G. MIDDLETON. She is presented at full length, standing and playing with a cockatoo. There is much natural simplicity, and some

originality, in the style of this work—qualities highly appreciable in female portraiture of the present day.

No. 197. 'In the Cathedral at Modena during the Elevation of the Host,' S. A. HART, R.A. The elevation of the host takes place at an inner altar, which is strongly lighted by the morning sun while the principal portion of the interior is left in shadow. There is, undoubtedly, great accuracy in the effect, but there is also a looseness in the style of execution which sinks the work to the level of a sketch. In the near part of the composition there are many figures bent in devotion; but how mechanically correct soever they may be in distinctive nationalities, we yet want something of that grace, be it playful or severe, homely or refined, which never fails in a true transcript from nature.

No. 200. 'Evening,' J. WILSON, Jun. We are apprehensive that this young artist will lose himself amid the feeble stippling niceties of "finish;" his attention is decidedly more given to his grass than to the cows—making this part of his work rather like enamel than oil painting. The next picture (No. 201, 'Landscape and Cattle') is better in its effect, but is still marked by objectionable parts, arising from what is falsely assumed to be care.

No. 202. 'Jairus' Daughter Raised,' W. PONCIA. A production that has cost the artist much trouble, which he has bestowed in giving the figures the appearance of being cut out and pasted on a dark ground. In the dresses of his figures he would seem to insist that we now know no more of oriental history than our ancestors did three centuries ago.

No. 203. 'A Scene taken from the "Decamerone" of Boccaccio,' J. J. CHALON, R.A. It would appear that in this picture the artist has had in view the villa, a short distance from Florence, on the road to Fiesole, said to be the real retreat of the ten during the plague. The five cavaliers and their fair ladies are variously disposed round a fountain, the centre of a small circular *cour ornée* shut in with trim hedges, orange trees, and flowering shrubs. Now, there is in this picture some improvement on the extravagant style of recent pictures exhibited by the artist; but it is of little value, considered in reference either to conception or execution.

No. 204. 'Portrait of Matthew Prime Lucas, Esq., Alderman, President of the Free Watermen and Lightermen's Asylum,' J. P. KNIGHT, R.A. elect. This is an excellent portrait of a man well stricken in years, and every part of the person corresponds with the age of the features, which are distinguished by life and intelligence.

No. 205. 'Portrait of the Countess of Blessington,' Comte d'ORSAY. The countess is standing, examining a picture on an easel; and so perfect is the resemblance that the insertion of the name was unnecessary. The picture possesses very high merit as a work of Art.

No. 209. 'Portrait of a Lady,' W. GUSH. This is merely a head and bust; but it is coloured and drawn in a manner to give it much reality.

No. 210. 'Diffidence,' R. HANNAH. A study of infinite truth and power, being a girl, life-size, in a grey cloak, ringing a door-bell for the purpose of delivering a letter. Her diffidence is expressed by the hesitating way in which she pulls the bell; but the value of the work consists in the admirable management of the light, and the perfect relief of the figure, and the fidelity of imitation given to the texture of the draperies and accessories.

No. 211. 'John proclaiming the Messiah the Morning after the Baptism,' T. UWINS, R.A. The group consists of John, Andrew, and the nameless disciple, who occupy the foreground, while the Saviour is at a little distance, and is announced by John in the words, "Behold the Lamb of God!" On the head of Christ is what we may suppose the light of the Spirit, whence is deduced the effect of the picture. The figure of John, upon the right of the composition, is commanding and expressive, and those of the two adoring disciples show sufficiently the import of the declaration. This is the most valuable production this accomplished painter has of late years exhibited. He has caught the very spirit of the text. It is singular that a subject so peculiarly calculated for Art should have so long escaped the notice of the artist. But Mr. Uwins is a scholar as well as a painter, and when he selects a theme for his pencil recurs to other books than exhibition catalogues.

No. 212. 'Sketch from Nature,' E. J. COBBETT. Merely a grass field of uneven surface, shut in by hedges and trees; but so faithful in colour and gradation of tone as to show that the simplest materials, rendered literally, are, at least, interesting.

No. 213. 'Lane Scene, Durham — Frosty Morning,' J. M. RICHARDSON. A remarkably accurate copy of nature;—painted with considerable care and skill, as well as truth.

No. 214. 'On the Rhone, near Avignon,' W. LINTON. This view seems to be taken from the north or north-east of the city, which lies in the distance, so that we see only the ancient papal palace. The Rhone in its broad volume lies below the spectator; but, warm and dry as we know the soil of this country to be in summer, the artist has failed to convey its character in his treatment of the foreground.

No. 215. 'A Devonshire Lane,' F. R. LEE, R.A. A somewhat large picture; the foreground of which is flooded with the clear water of a little brook, which is painted with too much colour for the truth of reflection. The lane is carried forward in perspective, overshaded by tall trees; but it does not look so inviting as many of the "alleys green" we have seen by the same painter. On the left of the composition is a glimpse of open country, which does not enhance its value.

No. 216. 'Cupid,' T. DUNCAN, A. Cupid is here seen hovering under the shade of a tree, and is about to discharge an arrow at the spectator. The conceit is a very old one, and there is nothing in this version of it to give it a new interest.

No. 217. 'Magpie Island, near Henley-upon-Thames—Early Morning,' J. TENNANT. This work is placed very high; many much worse productions are ranged in more favourable positions. It is evident, even at such a distance, that the picture is one of considerable merit, but its details are not discernible.

No. 221. 'Motherly Fears,' F. S. CARY. A touching picture, exhibiting skill in execution, and good matter in treatment; but the figure is somewhat awkwardly bent.

No. 222. 'Confidence,' R. HANNAH. A pendant to a precedent work, entitled 'Diffidence;' but the feeling of the composition has less sentiment, although the narrative is as finished in its style. We have here a boy, who, in discharging the office of postman in the country, whistles aloud while pulling a door-bell with such "confidence" as almost to carry off the handle in his grasp. This is not less successful than the other, but it is less interesting.

No. 226. 'Portrait of a Lady,' R. R. REINAGLE, R.A. This portrait is marked by the extreme of bad taste; had its personal style been better, there had yet been much wanting in execution to render it a work of merit.

No. 227. 'The Sempstress,' R. REDGRAVE, A. This subject is supplied by Mr. Hood's "Song of the Shirt;" whence we have the verse which accompanies the title :—

" O, men, with sisters dear!
O, men, with mothers and wives!
It is not linen you're wearing out,
But human creatures' lives !"

It is half-past two o'clock in the morning, and the sempstress is yet at her needle ; and, although having plied it during the livelong day, is not yet preparing to betake herself to rest. The story is told in such a way as to approach the best feelings of the human heart : she is not a low-born drudge to proclaim her patient endurance to the vulgar world; her suffering is read only in the shrunken cheek, and the eye feverish and dim with watching. The work bears every evidence of attentive study, and is a worthy illustration of Mr. Hood's verses.

MIDDLE ROOM.

No. 232. 'Portrait of Rear-Admiral Tait,' J. WATSON GORDON, A. This is a picture rather than a portrait. We know nothing of the biography of the Rear-Admiral, but the artist presents him with such a look of salt-water earnestness as would have charmed even Hawser Trunnion of days gone by.

No. 233. 'The Pastime,' R. ROTHWELL. A young mother playing with her firstborn. A charming composition, treated with considerable skill.

No. 234. 'An Incendiary Fire,' F. R. LEE, R.A. This subject does not come off very happily. The fire is consuming a water-mill, breaking through the thatched roof, and playing over it amid the dark volume of the rising smoke. The wretched inmates have escaped with a few trifles of their household gear, and one or two of them are carrying water with a vain hope of arresting the progress of the flames. Now, it is a picturesque spot, and much rather had we that the artist had painted it in its prosperous tranquillity.

No. 235. 'Milking-time—Cows, the property of Charles Brett, Esq.,' A. D. COOPER. Can there be room for another constellation of the name of Cooper in the milky way? The cows are drawn with some knowledge, but we are unreasonable enough to require something more. We would, therefore, caution the young artist against mannerism in his sky and landscape.

No. 236. 'Rydale Water, Westmoreland,' A. VICKERS. A scene of much interest, composed of a breadth of water closed in by trees and high ground, but in colour too cold, and with something of the appearance of having been clipped into shape.

No. 237. 'A Scene on the West Coast of Guernsey,' W. E. DIGHTON. A work of high merit, constituted of very slight materials, being a mere seashore with a squall coming on, and a woman among the rocks in the foreground looking seaward for the boat of her absent husband. The description is full of impressive truth.

No. 238. 'The Wedding Morning—The Departure,' R. REDGRAVE, A. A domestic history, narrated in simple but well chosen terms. The agroupment is formed of many figures, the principal of which are the mother, her newly-married daughter, and son-in-law; the first of whom is at last overcome with grief at the departure of her child, who seems to cheer her with an assurance that the separation is only to be temporary; other members of the family also exhibit emotion, and all this is delicately and judiciously made out. The great merit of the work is its refined sentiment, deduced as it is from a class of subjects which so few artists can paint without vulgarizing.

No. 239. 'The Martyrdom of John Brown, of Priesthill, 1685,' T. DUNCAN, A. This subject is from "Patrick Walker's Life of Peden," a distant and obscure source, considering the admirable passages with which our popular literature abounds. The picture is literally rendered from the quoted passages—"She set the basin on the ground and tied up his head, and straightened his body and covered him with her plaid, and sat down and wept over him." The dead man is foreshortened in a manner intended for effect, but the effect is a disagreeable one. Immediately behind the principal figures is a cottage, the perspective of

which is not accurate. The picture will not enhance Mr. Duncan's reputation.

No. 240. 'The Sacrifice of Noah,' T. Mog-ford. This work occupies a high place in the room; near to Noah on the left is a well composed and executed group, but the patriarch himself does not appear to be of them, and this is the main defect of a work which seems otherwise to have some merit.

No. 245. 'Portrait of Charles Pott, Esq.,' S. Lawrence. The subject is an elderly gentleman seated : the head is most skilfully drawn, and the countenance life-like and full of meaning.

No. 248. 'King Joash shooting the "Arrow of Deliverance,"' W. Dyce. A production of great power, and (we say it with much pleasure) of striking originality. The composition is made out of but two figures—Elisha, and Joash the King of Israel : and upon the merits of these figures alone the artist trusts for the value of his work. Joash is kneeling, and has drawn the arrow to its head, as about to shoot it from the "window to the eastward," and behind is Elisha, with his hands outstretched over the King. We could have wished Elisha to have been more marked in character, to have been, as it were, more signal among men—as he should have been whose bones even had the power of restoring life. The drawing of the two figures is most perfect ; but it is not sufficiently remembered that at this time Elisha was sick of the malady of which he died. He is not only old in face, but age is marked in his person, and particularly, as it should be, in his hands. We have long contended for Oriental character as a propriety in Scriptural art ; and we are rejoiced to be enabled to point to a triumphant example of what we mean in these figures, especially in the King, in whom is assembled the best personal points of the Oriental—as he now is and as he was in the days of Solomon. Joash wears a girdle and short drapery, precisely in the manner of the figures in the Egyptian relics, a circumstance showing research after authorities for costume; without which an artist can never accomplish truth. In fine, this picture ranks high among the most original works we have ever seen; and is honourable to British Art, as one of the few really grand productions of our school.

No. 249. 'Pilgrimage to Mecca,' F. Biard. The artist is a member of the French school, and those who only occasionally see his works will recognise in this picture a very decided change of style. The canvas is crowded with pilgrims of every caste and hue of the eastern Mussulman population; and all this is well enough ; but in the movement of the entire caravan there is a want of life and spirit, which deprives the work of all the interest which should have been made to attach to such a scene. In execution the work is extremely dry, hard, and toneless.

No. 250. * * * W. S. P. Henderson. A small picture, representing a female figure in a deep reverie leaning against the huge bole of a beech-tree. The little work is agreeable in colour and effect.

No. 253. 'Van Tromp, going about to please his Masters, ships a Sea, getting a good Wetting,' J. M. W. Turner, R.A. It often happens, in the pictures of this artist, that the professed subject constitutes the least remarkable feature on the canvas. We see here a boat carrying a full spread of canvas, going so many knots, and with certain indications of shipping a sea at her quarter, where we must suppose Van Tromp to be standing. We cannot admit Mr. Turner's accuracy here; he ought, for the sake of general probability, to have placed Van Tromp at the bow of his boat. Again we would ask, as this event must have taken place in the North Sea, why does not the artist make a difference between Dutch and Venetian scenery, or at least the seas and skies of these widely-apart countries ?

No. 257. 'A Lady,' T. H. Illidge. This is a full-length portrait, worked up in every part into a near approach to reality. The lady wears a crimson velvet robe over a satin slip, and is, upon the whole, somewhat too much *costumée*; but the work is, nevertheless, one of high merit in all respects.

No. 258. 'A Patriarch,' W. Collins, R.A. An old man, life-sized, and draped judiciously for broad effect. The head, face, and grizzled beard have been studied to good purpose ; in short, although not altogether in the style of the artist, the work is one of the best of his recent productions.

No. 259. 'The Pedlar,' T. Webster. He is displaying his stock to two country girls and their mother : one of the former he is tempting to the purchase of a small glass by a display of her own features in it; the other is narrowly examining a white scarf. The subject is commonplace, but it is treated with much natural feeling.

No. 260. 'A Persian Gentleman receiving a Letter, while his Servant waits with his Kallahan or Smoking Apparatus,' S. A. Hart, R.A. This is a small work, but superior to most of the pictures recently exhibited by this artist. The head of the Persian is carefully painted, and the production altogether is so much preferable in style to others with which we cannot help comparing it, that we should not say it was by the same hand.

No. 261. 'Sunset, on the Gelt, Cumberland,' W. Blacklock. A well-selected subject, painted with much firmness and natural effect.

No. 262. 'Nymphs Dancing,' W. E. Frost. A production rich with mellow and harmonious colour : one of the nymphs is dancing, surrounded by her companions seated on the grass, forming groups, with some admirably drawn brown faun-like figures. There is yet a charm in this kind of poetry when it approaches at all the spirit of the classics.

No. 263. 'Portrait of Miss Flora Billasis, in

an Indian dress of a Parsee Girl,' A. Geddes, A. The dress is of red silk, and the head is covered with a cap resembling that worn by Greek women. The costume tells well here from the judicious treatment it has received at the hands of the artist.

No. 264. 'Palpitation,' C. W. Cope. The receipt of letters is at all times a home subject of anxiety to the female bosom. Here, we may presume the little hope indulged under circumstances not uncommon to young ladies. There is an outside and an inside to the picture —inside, that is within the door which is ajar, we see a young lady anxiously waiting the answer about to be given by the postman to the servant inquiring for letters. The extreme anxiety pictured in the girl's countenance enlists the best wishes of the spectator on her side—he shares her solicitude: and this is a good criterion of the excellence of the picture.

No. 265. ''Tis but Fancy's Sketch,' W. Etty, R.A. A work of infinite beauty, composed of five nymphs making an open-air toilette, and binding their hair with flowers. The colour in this production, which is not large, is abundantly rich without being obtrusive, and the impersonations much superior to others on these walls by the same artist, some of which are characterized by coarseness and vulgarity. In the heads here there are beauty and variety, and in the figures ease and grace. No other work of Mr. Etty, in the Exhibition, is at all comparable to it—indeed, but few that he has of late years produced. Mr. Etty has misquoted the passage which gives a title to his picture. Moreover, it occurs, not in an "old song," but in a modern poem by a living writer.

No. 266. 'Portrait of Miss Ward,' G. Patten, A. The lady is leaning on a bank, simply attired; but the dress is too much cut up for good effect, and the face looks somewhat out of drawing.

No. 267. 'Portrait of Sir James Flower, Bart., M.P.,' J. Simpson. A gentleman in a military uniform, drawn at half length, standing, and otherwise simply treated; the head is forcibly drawn, and well coloured.

No. 271. 'Portrait of W. R. Ramsay, Esq.,' J. Watson Gordon. The figure is presented in a red coat and other items necessary to complete the hunting costume; but it assuredly could not have been the choice of the artist to circumstance his subject in a manner telling so much to his disadvantage.

No. 272. 'Coming Events cast their Shadows before,' E. Landseer, R.A. It is not very clear how the discourse is intended to illustrate the text. The scene at first conveys the idea of a winter in a northern region; but then there is a lake, and that is not frozen. However, the story is of a stag that has come down the shore of the lake, where he stands in expectation of the landing of another stag which is swimming over; his head and gallant antlers are seen. The animals have

defied each other from the opposite banks, and he that is waiting on the shore is loudly repeating his challenge. The effect is that of moonlight, but the moon does not appear in the picture. There is, consequently, a shadow cast by the stag; but if this be the only allusion to the proverb, it is not a happy illustration; if any other be intended it must be yet less so. With respect to the scene—the first impression it conveys to the mind is that of a frigid sunless region; but this is contradicted by the water and the impress of the animal's footsteps on the shore. If, therefore, the work proposes merely a moonlight night in the Highlands of Scotland, in this view the argument is unquestionably ill-grounded. Still, with these few and comparatively unimportant drawbacks, the picture is a noble and a beautiful one, and will rank among the highest of its class that has been produced in this country or in any other, at any time.

No. 273. 'Beggars of the Roman Campagna,' E. V. Rippingille. Two females with children, and not in the immediate exercise of their ancient and honoured vocation. We do not, therefore, hear " Un quattrino per l'amor di Dio," for they are lying at length and leisure, abiding their time and their patrons. The figures are highly characteristic, and closely descriptive of the parties.

No. 275. 'Children of Sonnino, Italy,' E. V. Rippingille. The one standing and the other sitting by a fountain—always a picturesque object in Italian scenery. There is an originality in this and in the preceding work which must strike even ordinary observers, and a truth in the general representations which cannot fail to interest all to whom Italy and its inhabitants may be in anywise known.

No. 276. * * * C. W. Cope. The subject of this picture is the last verse in St. Matthew of Christ's charge to his disciples: "And whosoever shall give to drink unto one of these little ones a cup of cold water only in the name of a disciple, verily, I say unto you, he shall in nowise lose his reward." Many figures are thrown into the composition, and of these some are endowed with moving eloquence; but the entire character of the work is not of a cast sufficiently elevated for the text—presenting to the mind rather a scene of daily charity than realizing the spirit of the verse. We admire the work in composition, drawing, and effect, but not as a translation from Scripture.

No. 277. 'Scene from "Undine,"' D. Maclise, R.A. "Undine, passing through the enchanted forest, encounters the wood-demon Kuhelborn. The young knight Huldbrand protects her from his fury and from the malice of the gnomes." Undine is mounted on a horse, and Huldbrand is in the act of drawing his sword in her defence against the dark and fearful apparition that seems hovering over her. This is a small picture, rich in its main conception, and most appositely redundant in its details. Undine's path through the forest is

beset with gnomes above, lurking in each branch, and below behind every stone; and the arrangement alone of these grotesque figures would be a sufficient task for an imagination of considerable power. The composition is entirely in the spirit of German poetry, and somewhat more than we like in that of German painting; but this is an affectation in which this accomplished artist can afford to indulge.

No. 278. 'Maternal Love,' G. PATTEN. A mother and her two children, both boys, one of whom, while she caresses the other, has much the appearance of being about to fall head foremost to the ground. The picture is consequently a misnomer; a loving mother would be more careful of her child. The colour of the picture is rich and glowing, like the manner of some of the old masters.

No. 279. 'Portrait of Peyton Blakiston, M.D., F.R.S., Fellow of the College of Physicians, Physician to the Birmingham General Hospital,' W. C. T. DOBSON. A portrait of very high merit. The figure is standing, and wears a red robe, beneath which is seen the ordinary dress. The head, for its roundness and expression, is a most successful study—such a one as we rarely see equalled.

No. 285. 'Maternal Affection,' H. W. PICKERSGILL, R.A. These are portraits treated as a picture: the lady wears a Greek dress, and the whole has somewhat of a scenic air. It is, nevertheless, highly pleasing; and the work is painted with a rich effect.

No. 286. 'The Thames near Gravesend,' A. VICKERS. There is something solid and earnest in the execution of this work. The view is low on the canvas, like the banks of the river in some of the innumerable reaches below Gravesend. The tide is running up, and bearing with it a sloop and some other vessels. The water is agitated by a strong breeze, but neither the vessels nor the trees sustain this effect—an oversight, injuring the value of the picture.

No. 287. 'The Return of the Dove to the Ark,' C. LANDSEER, A.R.A. This is a subject requiring talent of the highest class to bring it forward in the manner here attempted. The interior of the ark is presented—reminding us of a well-found travelling menagerie; indeed it is painful to see labour so ill bestowed as it is in this picture. Of the thousand and one ways of delivering a narrative this artist has taken the driest and most matter-of-fact. Noah and his family are disposed without purpose or effect; the dove has just returned, and the olive branch is pointed out to him by one of his sons. In the character of the figures there is nothing that is not hourly before the public eye; they are, in short, drawn as if Noah and his children had been natives of these islands, with complexions toned by modern habits of life. We might swear that we know the "sitters" every one — the models that answer for all nations, the Ethiopian only excepted. This is a deplorable evil, but one

grievously common; the artist often seeming to care nothing whatever for truth, considering prettiness of effect infinitely more "saleable" than accuracy. The plan may answer very well in delineating objects of still life; Mr. Charles Landseer may paint over and over again his carved cabinet, his iron jewel-box, his solitary parchment-deed, and his few other bits of antique; but it must be otherwise when he aims at producing works of a high class and painting human beings, with a view to develop the passions and exhibit the sensations by which they are influenced. Here, then, is a lamentable failure—figures made up of models at so much per hour, sitting in the midst of selections from the Surrey Zoological Gardens. And these studies of common scraps we are to suppose characteristic of the "world before the flood." A hundred times more imagination than the painter possesses would be necessary before a spectator could conceive himself anywhere but where he is.

No. 288. 'Mr. Thomas Chapman,' Mrs. W. CARPENTER. This is among the least pretending productions of its class we have ever seen. The subject is habited with a Quaker-like simplicity, he is drawn at full length standing, and the pose is firm and natural.

No. 292. 'Portrait of Lady Constance Gertrude Leveson Gower, youngest Daughter of the Duke and Duchess of Sutherland,' F. HEUSS. The young lady is seated at a pianoforte, looking out of the picture in a manner absurd and affected to the last degree. There is much pretension about the portrait, but the style of the figure is wanting in grace, and the whole arrangement is deficient of taste.

No. 296. 'Going to the Hay-field,' D. COX. A very simple *morceau*, much in the feeling of this gentleman's water-colour works. All we see is a man mounted on a horse and leading another, making his way along a road through the fields. The ground of the picture is sketchy, but strikingly natural; the sky is also sketchy, but it is by no means fit to accompany the rest of the picture.

No. 298. 'A Mountain Torrent,' T. CRESWICK, A. A deep feeling of poetry runs through the whole of this description. The torrent comes rushing onward, amid a wilderness of volcanic rocks, and retiring from the foreground the eye traces its course closed in by hills, enveloped in a distant storm cloud, which is driving before it the affrighted birds from their accustomed shelter. The water has a peculiar character, often seen in the late works of this artist: it is of the dark and sullen hue of that of the rivers in the Highlands of Scotland. The natural and accurate forms of rocks have never before been painted as by this artist: each of his works is in this respect an admirable geological transcript of the locality presented.

No. 299. 'On the Thames, near Great Marlow, Bucks,' E. J. NIEMANN. A small picture, containing many points of excellence. The simple objects of which it is constituted com-

pose well, being, as the principal a group of trees, thrown up against the evening sky. The trees are touched with decision, and left with a broad effect; but other portions of the picture are " niggled."

No. 303. 'The Holy Family,' P. DELAROCHE. In composition, sentimental drawing, and technical excellence, this work is equal to many of the highly-vaunted pictures of the old schools. The Virgin stands with the infant in her arms, and behind them is seen Joseph, reclining on a bank; the head of the last figure (the pose is very different) will remind the spectator of a head given to the same impersonation in Titian's small ' Holy Family' at Florence; be that as it may, in painting the subject M. Delaroche has not vainly challenged comparisons to which of necessity the picture would give rise. Had he never painted anything else, this beautiful production would at once rank him among the greatest of religious painters. In the spirit of many a classical Mythos he has equalled the ancients in singing, and must therefore be admitted one of their choir. In contemplating the exquisite tenderness of this inimitable work, we are at once referred, not to the many famous versions of the subject, but to the few—even those that are always uppermost in the memory when the subject is alluded to. In this picture we are borne back in some degree not to Raffaelle, but to his masters—if so we may speak—those by the study of whom he enriched and ennobled his style—Masaccio, and even some of those who painted the mind before they painted the body. These are the men with whom a certain section of the profession maintain that painting revived, and after whom it again died; a proposition that carries with it its own refutation. The work of M. Delaroche is equalled by but very few versions of this most difficult subject, either in early or later times. We rejoice to welcome it into our Royal Academy, for it will teach valuable lessons to many a British artist. Let them boast that they have studied it, and profited by the study.*

No. 304. 'The Medway, with Upnor Castle —Evening,' E. W. COOKE. We cannot avoid noticing the further improvement in the works of this marine painter. The river occupies the breadth of the canvas, bearing on its smooth stream a few becalmed craft, the drooping sails of which sufficiently declare the want of wind:

* It was with exceeding regret we found this noble example of Art placed not in accordance with its intrinsic merit—to say nothing of the *right* of the great painter of France to courtesy at the hands of the artists of England. It was entitled to the place of honour in the principal room, and that place would have been assigned to it if the generous and liberal feelings of the " Hangers" had been permitted full sway. Sure we are, that if any one of our own leading artists sent a contribution to the Louvre the best position in the gallery would have been occupied by it. Surely, the Royal Academy of Great Britain can afford generosity to foreign competitors for honours. They do not seem to think so, however, for every foreign artist who has sent a contribution to our Exhibition has been treated "scurvily." It is no wonder that we have so few.

beyond these is the shore of the river and objects on it, diminished by distance. The colour is rich, harmonious, and appropriate; and we may class the work as among the most successful of its accomplished author.

No. 305. ' The Painter's Holiday,' F. DANBY, A. A most homely title to a conception of much sublimity—a sunset of rare excellence—a fine example of poetical painting. 'The Painter's Holiday' (or rather, we may say, the commencement of his relaxation) is the twilight; and he is here seen (having been compelled, by the deepening shadows of surrounding hills, to throw aside his pencil) in steady contemplation of a scene so magnificent as to fix others in admiration as well as himself. The composition shows a region of most picturesque character, abounding with every diversity of mountainous feature—hills sinking as it were in their own increasing shadows, and yet aspiring upwards to share all that is left of the sun's declining light. Embosomed in this enchanting wilderness lies a lake repeating the soft light of the sky, and thence the eye is led to a distance painted with infinite skill and purity of tone. The atmosphere in this work is painted with the most perfect accuracy: if there be a fault in it, it is that the red warmth of the picture is too decided throughout.

No. 306. 'The Ten Virgins,' J. E. LAUDER. If a mere literal rendering of the parable may constitute a high value in painting from it, then is this work one of peculiar excellence. The wise virgins are standing with their lamps lighted and ready to meet the bridegroom, while the five foolish virgins are—some yet sleeping, and others begging oil of those who had provided for themselves. It is also night—midnight it may be; and the utmost care has been exerted to secure perfect candlelight effect in the manner of Della Notte. This is very well: we cannot hope for positive inspiration in painting these incidents, but we should at least endeavour to give the highest, not the lowest, value to the class of subject.

No. 307. ' Landscape,' F. WATTS. A large composition-like production, consisting of a weedy pond and some large trees, painted in the peculiarly bold style of this artist. The work is hung high, which precludes a close examination of its merits.

No. 310. ' Othello,' A. RANKLEY. This work is also placed high, but its general treatment is sufficiently discernible. Othello is soliloquising over Desdemona—he holds a lamp whence the light descends on himself and the surrounding objects. Among other defects of the picture a want of dignity is conspicuous.

No. 312. 'Mary Queen of Scots returning from the Chase to Stirling Castle,' R. ANSDELL. The party are in the courtyard of the castle; the Queen, mounted and surrounded by attendants, is about to descend from her horse. This, the principal group, constitutes the picture, and everything not immediately relative

to it weakens the general effect; there is, in short, a considerable space of canvas yet to be filled to give due importance to the scene.

No. 313. 'A Reminiscence of Rome,' F. WILLIAMS. It does not appear of what precise complexion the "reminiscence" may be. We are introduced to what we may believe to be the studio of the painter, who has thrown his arm round the waist of a good-looking model. There is some good drawing in the picture; but there is a strong leaven of modern Italian colour in it, which, as a manner, will be of no service to the painter.

No. 315. 'The Ford—a Scene in Inverness-shire,' A. COOPER, R.A. There is a marked difference between the style of this picture and that of the whole of the other works lately exhibited by this gentleman. A small herd of cows are passing the ford. It is not often that he paints cows: the animals, however, are well drawn, and in the landscape there is more nature than we generally see in his backgrounds. It is not much inferior to the works of his namesake.

No. 316. 'The Lady Prudhoe,' F. GRANT, A. It cannot be denied that an imitation of Reynolds, in any degree successful, must, to say the least, be a pleasing picture. This is a small full-length, similar to two exhibited by the artist last year. The figure is in simple attire, seated, and relieved by a landscape background very freely painted. It is a beautiful production of taste and feeling—in which there is no fashion that can become stale. The flesh-colour is fresh, clear, and skilfully supported by the background, which is so like some of Sir Joshua's that we may almost call it a copy.

No. 317. 'Joe Willet taking Leave of Dolly Varden,' R. W. BUSS. By no means so felicitous a translation as others we have seen by the same hand. The smith's shop is the scene of the leave-taking. Dolly, according to the text, has had recourse to the corners of her apron; she is "measuring the sides and smoothing out the wrinkles." This picture will strike the spectator as containing more of the spirit of stage effect than of spontaneous nature.

No. 318. 'Portrait of Admiral Lord Colville,' J. P. KNIGHT, R.A. elect. The subject is presented in naval uniform, over which is thrown a cloak. The painting of the face shows much care, and the artist seems to have made the most of features not strikingly marked.

No. 319. 'Claverhouse ordering Morton to be carried out and shot for having given refuge to Balfour of Burley,' R. S. LAUDER. Claverhouse is yet seated, while he refuses to be moved by the petition for the life of young Morton. Edith, "she who was most interested in his fatal decision," has already fallen on the pavement of the hall, and we think prematurely, for Claverhouse has not yet finished the few words in which he couched his refusal. The picture is large, which is one of its disadvantages: the subject is better calculated for a smaller canvas. The grouping comprehends many figures, which are painted with unequal power; and, upon the whole, the work is not an advance upon recent productions of the painter.

No. 321. 'Scene of the Vintage among the Ruins of the Palace of the Cæsars, Farnese, Rome,' T. F. WALMISLEY. The vintage scene forms but a small portion of the interest, which is rather centred in the character of the locality. There are some passages of much truth in the work (professedly painted from nature), but the effect has been injudiciously chosen.

No. 323. 'Evening,' C. SIMS. This work is placed very high, although as far as can be seen it seems to be a production of merit.

No. 325. 'Portraits of Two Arabian Horses, the Property of, and painted for, H. R. H. Prince Albert,' T. WOODWARD. They are only the heads of the animals, treated with some originality, as being fed by a lady in a Greek dress. They are drawn and painted with the utmost care, and bear the impress of their descent.

No. 327. 'View on the Coast of Normandy,' — GUDIN. The style of this picture is very different from that of the bright and carefully finished works of his earlier time. This is in its technicalities something like what we might have expected from Gainsborough, had he turned marine painter; and it is, perhaps, this feeling that has induced M. Gudin to send it to our Exhibition. The picture is of high merit, although curious and not strictly natural, for here M. Gudin displays rather his power in *chique* than his knowledge of nature. The scene is a low coast, with a returning tide, and a ship lying on the beach high and dry. The time is what we should at first sight determine to be twilight; but on a second glance the sun is seen yet some degrees above the horizon, but he is nevertheless denied all power of adding to the light of the subject: and here we are at issue with the celebrated author of this eccentric picture.

No. 328. 'One of the Interviews that took place between John Knox and Mary Queen of Scots, respecting her Marriage with Darnley,' W. P. FRITH. The interest of this work is centred in the figure of Knox, which is clearly worthy of his memory—in fact so forcibly is he drawn that the rest of the composition seems feeble by comparison. He has been admonishing the Queen, "who began again to weep and sob with great bitterness, whereon the superintendent, who was a man of mild and gentle spirit, tried to mitigate her grief and resentment." The artist has placed the superintendent on his knees before the Queen, a passage very liable to misconstruction. The stern reformer stands apart, regarding with inflexible severity the burst of grief to which the Queen gave way before him; in this feeling the figure is admirably conceived, but it is unsupported by the rest of the story. This work sustains, though it will not enhance, the reputation of the excellent artist, whose other contribution to the Exhibition we greatly prefer to this.

No. 330. 'The Mall, Kensington Gravel-pits,' W. MULREADY. This little picture, we learn, from the catalogue, was painted in 1811. The materials of the composition, as may be conceived, are simple, but it has that solid appearance of reality which can only be communicated to a work by accurate study of the *locale* itself. It is distinguished by great breadth, yet there is a singularly nice finish, only apparent on a close examination of the picture. Thirty-three years is nearly the half of the span allotted to human life, and there are not many of the profession who, having acquired a reputation equal to that of Mr. Mulready, could so confidently point attention to works of so early a period of their career.

No. 331. 'Evening,' A. MONTAGUE. A graceful and most agreeable landscape, highly creditable to an artist of rising reputation.

No. 332. 'Shoeing,' E. LANDSEER, R.A. The interior of a smith's forge—the smith shoeing a horse. For wonderful accuracy, as a literal copy of facts, this picture has, perhaps, never been surpassed. But as an acquisition to the man of taste—as an example of the high purpose of painting—it is, to our minds, of comparatively small value.

No. 333. 'Mrs. Kingsmill and Son,' H. W. PHILLIPS. The lady is seated with her son by her side. It is a small-sized work, remarkable for its simplicity and its clear flesh colour.

No. 334. 'Near the Mall, Kensington Gravel-pits,' W. MULREADY. A pendant to 'The Mall,' and painted in the following year, 1812. This little picture has much the feeling and character of the other. Both are gems of rare value.

No. 336. 'Portrait of a Young Lady,' B. R. FAULKNER. A work of a high class of merit. The young lady is habited in a velvet dress of a light olive hue, and leans on the base of a column. The pose is one of the most perfect ease, and the head is drawn and painted in a manner which gives animation and intelligence to the expression.

No. 341. 'His Majesty Louis Philippe,' G. P. A. HEALEY. It would be difficult to fail entirely in the portrait of a personage possessing features so marked as those of the King of the French : the likeness is, therefore, at once recognisable ; but the work in colour and other points is very defective.

No. 342. 'Geneviève,' C. W. COPE, A. Coleridge's poem supplies the subject, the chosen passage being :—

" She leaned against the armed man,
 The statue of the armed knight ;
 She stood and listened to my harp
 Amid the lingering light."

Difficult as it is to work up to the thrilling sentiment of the poetry, the artist has, nevertheless, deeply felt its charm. Geneviève stands leaning against an ancient tomb, whereon is sculptured the effigy of a crusader. The male figure is seated nearer the spectator, and instead of a harp the artist has put into his

hand a guitar, which we cannot think an improvement of the text. Without injury to the picture, the latter figure might have been made less shadowy—more substantial. The work, however, amply sustains the high reputation of the excellent artist.

No. 343. 'Repose,' T. S. COOPER. An ox, a goat, and a couple of sheep : the first animal is standing in opposition to a soft and warm evening atmosphere in a manner which brings him forward in all his roundness and substance. The most valuable pictures by this gentleman are those which are without trees. This is an entirely open landscape, and will bear comparison with the works in this style of the most celebrated painters of any time. We have occasionally had to complain of the cold unsympathizing character of the foregrounds in preceding works ; this is, however, in a great degree remedied here.

No. 344. 'Scene on the Tummel,' T. CRESWICK, A. The stream, in the foreground, is making its way forward amid rocks and loose stones ; but, following its course upwards, we lose it among trees, beyond which arise hills, which fall back into distance. The objects take their places in the composition with a more agreeable ease than in many of the painter's more imposing works.

No. 345. 'Venice—Maria della Salute,' J. M. W. TURNER, R.A. Once more we
 " listen to the herald of the sea."
We are in sight of Venice, and not in what the Germans call a "love-boat," that is, a gondola, but in a stout sea-boat—we can see the Dogana and St. Mark's, but all the rest is left to the "playful" imagination. This is not the way that Mr. Turner treated Venice a few years ago : it is only, we think, three years since he exhibited the same object, from almost the same point of view, but painted in detail, and with ineffable sweetness. The last picture he painted in this manner we desperately fear he will never again equal—we speak in reference to Venetian scenery.

No. 346. 'Portrait of H. R. H. the reigning Duke of Saxe-Cobourg and Gotha,' J. LUCAS. This portrait of the elder brother of Prince Albert was painted in 1842, by command of her Majesty. The Duke presents a striking resemblance to the Prince : he wears the light-blue uniform in which he usually appeared upon occasions of ceremony. The pose of the figure is easy and graceful.

No. 349. 'Flight of Polish Refugees,' N. FRIEDLANDER. The figures are life-sized, and seated under a rock. The picture is high, so that a close inspection is out of the question : it is, however, sufficiently obvious that the picture is deficient of spirit, and coloured in very bad taste.

No. 350. 'Portraits of Mrs. Yates and Son,' T. M. JOY. This lady is painted at full length, and about to ascend some steps leading to a terrace in a garden, accompanied by her son, whom she leads, holding by the hand. The

figure is endowed with graceful movement, and the features with sweetness of expression. The work is one of much excellence.

No. 351. 'Sancho Panza in the Apartment of the Duchess,' C. R. Leslie, R.A. This composition will be remembered as having been already painted by Mr. Leslie: the former picture is extensively known through the valuable engraving which it has supplied. Sancho is, as before, seated on a low stool addressing the duchess, with his finger raised oracularly before his nose: this figure is admirably painted, and eminently imbued with the *vis comica* of the character. We learn at once that he is the lion of the party—their cynosure for the time being; and such are the scenes in which this artist excels. Poetical painting is by no means his strong side—even in painting from Shakspere he is unequal; but his readings from Cervantes and Molière are unrivalled. We cannot therefore, in this instance, regret that he has gone over familiar ground. The composition of the picture has undergone several very striking improvements—a consequence of renewed consideration; and the style is comparatively free from the cold chalky colour, which impairs so many of the painters recent works—result of his profound worship of the manner of Constable.

No. 353. 'Landscape,' H. Jutsum. One of the good productions of this always agreeable and often highly excellent artist. The view shows a moorland country, diversified by hill and dale, through which winds a small river, whence the banks tend gradually upwards. The foreground is made out with a nice finish, showing abundance of blooming heather and ferns: some of this we could well have spared, for the sake of a little more of the accustomed breadth that distinguishes his former works. The sky and distance are painted with a rare display of knowledge and fine feeling; and, although the work is not equal in sweetness to others ('Tintern Abbey' for instance) by the same hand, it is a production of great merit.

No. 354. 'Ruined Norman Doorway in Norfolk,' T. C. Dibdin. This is the first oil picture we have seen by the artist, professedly a painter in water-colours. The subject is simple, but it is well drawn and coloured.

No. 355. 'The Lesson,' Fanny M'Ian. This is altogether the most aspiring production we have yet seen from the easel of any of our lady artists: it is in fact a picture that would do honour to some of the best of our antiquarian painters. The lesson is given in archery to a young lady by a holy hermit, who himself was once, according to the lines which accompany the title, an accomplished bowman. The subject is supplied by "ane auld romaunt," and there is also a spirit beyond the mere lesson; for

> "More deidlie farre is ye shafte that flees
> From ye noble damzelle's hazel eyees
> Than that she sends from ye bendet yewe,
> Though ye eremit (ance an archer trewe)
> Her maister had bin in ye mysterie."

And this spirit has been successfully preserved in the picture. We remark of this lady's works that each succeeding production is generally superior to those that have gone before it —a rare merit now-a-days. She is worthy of all praise, and of all honour in her profession.

No. 356. 'Approach to Venice,' J. M. W. Turner, R.A. The effect here purposed is that described by Byron in the oft-quoted lines—

> "The moon is up, and yet it is not night;
> The sun as yet disputes the day with her."

It is, as usual, a gala picture, with boats painted of the most lively hues. That which we may suppose to be Venice lies ahead in red mist; and so generally indistinct is the view that it might serve for the approach to any low-lying city open to the sea.

No. 357. 'Portrait of his Excellency Count Mensdorff Ponilly,' J. Lucas. An officer in a hussar uniform, possessing features of a very marked formation, only something short of the impressive character of the Hettmann Platow; he is well stricken in years, and there is so much life in the whole figure that it must be a likeness.

No. 358. 'Portrait of Lord Francis Egerton,' G. Patten, A. A work upon which has been bestowed the utmost care with the best results. The figure is habited in a fur coat, and seated in a well-chosen position. Nothing is allowed to interfere with the head, which is well rounded, and the features are expressive and very like the estimable original.

No. 363. 'Portrait of General the Honourable Sir Edward Paget, G.C.B., Governor of Chelsea Hospital, &c.,' J. P. Knight, R.A. Elect. The colouring of the face is very low in tone, and the dark side is almost lost in the breadth of the shade. The subject is plainly attired, wearing only the ribbon of the Bath.

No. 364. 'Sir Thomas More and his Daughter,' J. R. Herbert, A. The particular incident constituting the point of this most valuable picture is mentioned in "Roper's Life of Sir Thomas More;" and records briefly that, looking one day from the window of his prison, he saw four monks (who had also refused to take the oath of supremacy) going to execution, and regretted that he could not accompany them. "Look," said he to his daughter, "looke, Megge, dost thou not see that these blessed fathers be now going as cherefully to their deathes as bridegrooms to their marriage?" The father and daughter stand by the grated window, the former in the act of speaking as calmly looking down and pointing to the crowd below, while the latter fervently casts her eyes upwards. The old man shows a tranquil and pious interest in the procession; it has no terrors for him; his eye rests with curious inquiry on what he sees; but not so Margaret: she turns her eyes from that, the sight of which fills her with apprehensions of the fate of her father. These two figures are most skilfully drawn and painted; the pose of each is firm without seeming fixed; each is an ani-

mated intelligence most distinctly expressing its relative feeling. The room in which they stand is scantily furnished, but they have no need of accessaries. It is a noble and beautiful work, and very fortunate is the possessor of it. On the whole, we may consider it the *chef d'œuvre* of the accomplished artist; the true feeling for Art is obvious in the treatment of so simple but so eloquent a subject.

No. 365. ' Evening before Rain at Sea,' W. A. KNELL. A stiff breeze prevails here, and its influence is efficiently shown as well in the painting of the water as in that of the boats. The work is one of high merit as regards the sea and craft; with respect to the sky it is admirable in its chiar' oscuro, and portentous rather of wind than rain ; but the uniform yellow and lilac hue of the clouds is far from natural.

No. 366. ' On the Tees near Rokeby,' J. M. YOUNGMAN. A fragment of river-side scenery closed in by trees painted in a manner decided and effective. One of the pleasantest landscapes in the collection.

No. 367. ' Undine,' R. S. LAUDER. This is little more than a class study of a female figure seated at the brink of a stream, and shut in by a screen of trees. She may, by such latitude of imagination as we are often called upon to recognise, be Undine, Dorothea, the shade-loving Amaryllis, or even the singing Lurley. A figure thus circumstanced is often only more or less the likeness of a model; and as such this must be considered ; but it is skilfully drawn.

No. 368. ' Temple on the Island of Philoe, called Sareer Pharaon or the Bed of Pharaoh, on the Nile, Nubia,' D. ROBERTS, R.A. On the elevated bank of the river stand the remains of the temple, being the columns of the façade. The immediate parts of the picture show the stream smoothly gliding onward and bearing with it some boats which are tended in their course by some picturesque figures. The view is closed by mountains brightened by the declining sun. We may remark of the pictures painted by this gentleman from scenery in Egypt and adjacent countries that they very often consist of subjects having only historical interest, and which very few other artists could invest with any pictorial beauty. This is the work of a veritable man of genius.

No. 370. ' The Redhead, Forfarshire,' J. WILSON. A section of an iron-bound coast at high water, with the wind off the sea and a vessel driving in under the cliffs. The water is, as usual, extremely well painted.

No. 371. ' Eve at the Fountain,' W. ETTY, R.A. A nude female figure seated on the ground. We never should have divined this to be " Eve at the Fountain," seeing there is no fountain. Little, indeed, of graceful presence does the painter allow our first mother—if this be his idea of her. The figure, in fact, like so many others by this artist, is a mere unpurposed study, and one of the least pleasing.

No. 372. ' Portrait of John Gibson, Esq., R.A.,' P. WILLIAMS. This portrait has been painted at Rome, where both artists are sojourning, we may say settled. The features are very like those of the subject, who is represented in his studio dress, wearing on his head the red Turkish cap called a fez, and grasping a handful of modelling tools. The work has in it much of the Italian style of art. It is a decidedly good portrait.

No. 373. ' Portrait of Captain Colin Mackenzie, Madras Army, lately a hostage in Caubool, in his Affghan dress,' J. SANT. This gentleman, we believe, is one of those who were present upon the occasion of the fatal conference when Sir W. Macnaughten was shot. He is presented at full length ; the costume is imposing and most effectively painted, but the head wants force.

No. 377. ' The Water Pitcher,' A. GEDDES, A. A girl filling a pitcher at a rill; she is life-sized, and in the drawing of the head there is roundness and animation.

No. 378. ' Portrait of David Salomons, Esq.,' J. P. KNIGHT, R.A. Elect. It is evident that the artist has had difficulty in dealing with his subject. He may have secured a likeness, which is, perhaps, the utmost that could be made of the portrait.

No. 379. ' Hawthornden—The Royal Visit, 14th Sept., 1842,' Sir W. ALLAN, R.A. The mere title might induce the idea of a work displaying parade and ceremony, but it is not so : we see looking over the parapet at the top of the cliff the Queen and Prince Albert. The work is not worthy of the able and accomplished artist, and will not sustain the high reputation he has acquired.

No. 380. ' The Brothers releasing the Lady from the Enchanted Chair,' F. P. STEPHANOFF. This is an oil painting from the cartoon exhibited by this artist at Westminster Hall. The composition does not come out very favourably in colour ; indeed it is here seen to less advantage than in the cartoon. Many of the faces seem to be studied from the same model ; and that we might fancy to be a female one.

No. 381. ' A Portrait,' S. DENNING. The smaller productions of this gentleman are exquisite, but in mere portraiture we do not recognise the same excellence.

No. 382. ' The Parting of Robert Burns and his Mary,' C. LUCY. The incident is related in " Cunningham's Life of Burns ;" upon this occasion the lovers parted and never again met. The artist has followed the letter of the text, but the work hangs so high that we cannot see with what spirit he has worked it out.

No. 383. ' Heath Scene, with Shepherd unfolding Sheep,' J. DEARMAN. This picture is also too high for inspection; it has, however, at a distance, much the appearance of being painted in accordance with nature. Others by the same hand, seen to greater advantage, justify us in classing him highly among English landscape-painters.

No. 384. 'Rebekah receiving the Presents from Abraham's Servant,' J. P. PHILLIPS. The chief merit in this work is the judicious colour seen in some parts of it. In the style of the work there is nothing beyond commonplace features and costume. It is not an advance on former works.

No. 385. 'The Good Samaritan,' C. LUCY. "He fell among thieves, who stripped him of his raiment." This is the point of the parable insisted on by the artist; we have therefore a nude, foreshortened study, brought forward in a manner to show as much as possible a capability of drawing the figure. It is most singular that so many of our painters, who aspire to work from the highest sources of subject matter, rarely get beyond one idea of the passage they select.

No. 388. 'Trial of the Seven Bishops,' J. R. HERBERT, A. This is the most important work as yet produced by this very able artist. The subject is one to which there are few who could render justice, but he has acquitted himself in a manner to establish his reputation as a historical painter in this particular *genre*, should he never again address himself to any similar subject: it is, however, to be hoped that this is but the beginning of a series. The spectator is first struck with the peculiarly *easy* manner of the entire composition, and again with its familiar daylight effect; its agreeable breadth, unbroken by any of the wholly unnecessary, and sometimes preposterous, shadows thrown into works of this kind for the sake of that vitiated *gusto*—without which, it would seem, no similar picture can, in an ordinary way, be painted. Over the canvas a hundred and fifty figures are disposed with masterly skill, and coloured in hues subdued into most perfect harmony. The moment chosen is that of the declaration of the verdict, "Not Guilty," "at which there were several great shouts in the court and throughout the hall." We rejoice to observe, that the artist has spared no research in order to render his work as perfect as possible. Every impersonation, therefore, prominently figuring in the scene, for whose features there remains any authority, is a portrait. Also, with respect to costume, great care seems to have been exercised. But few really meritorious works of this class have been produced by members of the British school. We hesitate not to say that this picture will maintain a high consideration; no matter how many of a similar class may be destined to follow it. The subject is one of the deepest interest; perhaps our country's history does not afford one more worthy to be commemorated by the artist. The event was, as it were, the fixing the seal to the great charter of our liberties; for, until the evil purpose of the Second James was defeated by the resistance of the prelates of the Reformed Church, our civil and religious rights were mere uncertainties, depending on the breath of a weak or vicious monarch. The verdict delivered in the old court at Westminster, by

"twelve good men and true," established the Protestant faith in England; and not only did it achieve that great triumph—it secured us against encroachments of arbitrary power, that would have made us slaves instead of freemen. The selection of such subjects is honourable to the painter.*

WEST ROOM.

No. 389. 'The Fatal Letter of Charles I. Intercepted by Cromwell and Ireton,' H. J. TOWNSEND. Cromwell and Ireton are life-sized half-lengths. The former holds the letter, and is meditating his stern resolve. The effect is that of candlelight, a lantern being suspended near Cromwell. It is exceedingly well composed. The story is told with emphasis and remarkable force. The portrait of Cromwell may be somewhat too heroic; but it is the reading of the character which a painter of history is bound to give it. The expression is fine—true to the time and circumstances. All the accessaries—they are, however, few and of no great importance—are well made out; in no way interfering with the main incident. The figures are life-size, or beyond it. The work altogether is calculated to advance the reputation of one of the most rising artists of the day—an artist who is rising not less by strength of genius and vigour of intellect than by thorough study, continual labour, and productive industry.

No. 392. 'Jeanie Dean's Interview with her Sister Effie, in the Tolbooth, after her Condemnation,' J. HAYES. The narrative is sufficiently distinct. One sister comes to visit the other in prison; they meet, and, as a natural consequence, clasp each other in a strong and convulsive embrace. The artist has overstudied poor Effie's prison abode: had he not given so many objects he would have left his composition in better case, and have enhanced the interest of the figures.

No. 394. 'A Monk,' G. WILLIAMS. This is a large figure, but it is nevertheless difficult to see in what way the monk is engaged; and this is a point which ought always to be distinct, as far as a figure is clearly discernible. The head has been advantageously studied, but the colour is faulty.

No. 395. 'Tasso reciting his "Jerusalem Delivered" to the Princess Leonora D'Este,' J. HOLLINS, A. The figures are life-sized—a decided error in dealing with such a subject, by no means sufficiently important for such treatment. Tasso is seated on the left and Leonora on the right of the picture, both dressed and circumstanced in a way that leads the spectator to suppose the purpose of the work is a mere display of the brightest coloured satins or silks. This might have been well spared, for it is entirely overlooked in seeking for the

* We may state that this picture is about to be engraved. It will supply a "National Print"—we augur for it a popularity equal to that of any modern publication. It is to the credit of a provincial publisher—Mr. Agnew of Manchester—that he has undertaken to produce a work of so much importance and value.

animus of a picture. We should not, moreover, have recognised poor Tasso in the gay and *fade*-looking cavalier before us. We had rather have seen any simple attempt at truth in respect of the unfortunate and amiable author of the "Gerusalemme" than an overdone and soulless study of drapery.

No. 396. 'Mrs. Holland,' J. HOLLINS, A. A small full-length of an elderly lady, seated in a contemplative position. The arrangement is well managed, and the figure successfully drawn and coloured.

No. 398. 'A Devonshire Village,' F. R. LEE, R.A. We have seen many truly valuable pictures by this gentleman; but he has not recently been happy in his selection of subjects. This roadside view is not wanting in interest, but it does not tell in his hands. Of the village we see only a house or two, one of which is built in a commanding position on the bank overlooking the road. The centre of the composition is occupied by a tree, which comes out effectively; but there is about the whole a rawness of colour and signs of hasty execution which are prejudicial to the work.

No. 399. 'Jacob refusing to let Benjamin go,' J. HARWOOD. If the conception of the subject were as good as the execution there would be little to condemn; but the author classes his work with the multitude of those which depart not from the beaten track of legitimate monotony. The same character prevails in the mass of our scriptural productions.

No. 401. 'On the Lleder, North Wales— Study from Nature,' M. F. WITHERINGTON, R.A. The best we have seen of these river scenes by this gentleman. The stream is shrunk to a small compass in its rocky channel. The large stones are in some degree prominently spotty, but the other parts of the view keep their assigned places.

No. 403. 'A Group, representing the late Countess of Denbigh, with two of her Ladyship's Daughters—the Lady Augusta Fielding, and the Lady Jane; with the Hon. Mr. Charles Fielding, and a Newfoundland Dog,' W. BRADLEY. The whole being full-length figures, this is necessarily a large work, and one in which there is room for display of skill and taste in grouping and arrangement. It seems to be a manner with the artist to keep his figures of a cold and even chalky tone, yet, with this defect, the composition is distinguished by many beauties, and possesses the merit of original and intellectual treatment.

No. 409. 'A Nasmyth, Esq.,' F. GRANT, A. A portrait of a gentleman on a three-quarter canvas: as a male head, it is not only the best we have ever seen by this gentleman, but equal to the best works of our school.

No. 411. 'Study from Nature of a Forest Mare and Foal,' H. B. CHALON. A good work by a veteran in Art, in this particular style; an artist who was among the earliest to depict the noble animal with fidelity, and yet with poetical truth; and who continues to paint with much nature, force, and valuable effect. No.

414 is a picture of 'Terriers at a Rabbit-hole,' by the same excellent hand.

No. 412. 'The Infant St. John, with Honeycomb,' T. W. GUILLOD. A most absurd association: the child is seated, and recognisable as the infant St. John from accustomed circumstance; but he is lifting the honeycomb in a manner more according with the lowest *genre* than consistent with a sacred subject.

No. 414. 'Scene from the Early Life of Goldsmith,' E. M. WARD. The story turns upon Goldsmith's musical talent, by means of which he made himself so agreeable to "the merry poor of Flanders," that he travelled through the country subsisting on the meagre reward they rendered him for his performances. His instrument, as is known, was the flute; and he is here represented playing to a family assembled for relaxation at their cottage door. So descriptive is the detail of the composition, that we see at once the ramifications of their genealogical tree—as much of it, that is to say, as is given, comprehending the present race from grandfather to grandchild. Goldsmith is immediately recognisable, but he is certainly too well dressed for this epoch of his life. And we may remark of the cottagers that, inasmuch as there are strong national Flemish characteristics, they appear somewhat too English for the scene. The production is one of very high merit, and its skilful arrangement will add to the reputation of its author. Mr. Ward is one of the "rising artists" of our time, one who is on the sure and safe road to professional distinction. His works never exhibit carelessness in execution; they are marked by wisely-directed labour. His studies are derived from nature, and his subjects from the treasure-house of our best writers. He thinks as well as works: he is not content to pursue the beaten track in which so many have trodden before him; but looks out for a new path that shall open up new prospects, and secure that which is so seldom sought for—originality of theme. This is an advantage on which too much stress cannot be laid.

No. 417. 'A Norwegian Girl,' H. B. ZEIGLER. A very life-like picture, apparently painted in on the spot; it has the marks of truth.

No. 420. 'Boaz and Ruth,' H. N. O'NEIL. We cannot say that in this work the artist in anywise approaches the feeling shown in some of his recent pictures: his manner of relief is the same as heretofore; his figures stand in direct opposition to the sky, or a very light background: this, however, is not so much the objection, as a straggling method of arrangement, whence we should infer that his power does not extend to complicated grouping. A Jewish cast of feature is given to Ruth with some success; but neither she nor Boaz go beyond the accepted tameness of our school in this department of Art. The expression accorded to Ruth is disagreeable; it resembles rather a fair Israelite of Holywell-street, than the beautiful portrait of the inspired writer. The gleaners, too, seem dressed too much in "their best."

We presume earnestly to caution the artist against degenerating into "prettiness."

No. 423. 'The Keeper's Companions,' A. H. CORBOULD. A shooting pony, dogs, and a fowling-piece, painted with good effect, and apparently with accuracy, for the work is placed too high for inspection.

No. 424. 'Portrait of the Hon. and Rev. Baptist Noel,' G. PATTEN, A. The figure has the appearance of one ill at ease in the position in which he is drawn. The treatment is upon the principle of giving force to the head.

No. 425. 'Lady Jane Grey summoned to her Execution,' E. D. LEAHY. This is a work of labour, and, as the production of much thought and industry, may not be dismissed lightly. With many points of merit, much good execution, and with evidence of considerable study, it is yet liable to the objection that a much smaller canvas would have answered perfectly well for rendering all the important points of the subject. It is not of sufficient value for the space it occupies here, and will, we hope, occupy elsewhere. The artist exhibits mind in many of his works, it is evidenced indeed in this, which we cannot think altogether successful. A production upon which so much time and industry must have been expended claims, however, a generous consideration.

No. 426. 'The Ploughed Field,' F. R. LEE, R.A. The tenor of this subject seems more suited to the genius of the artist than that of most of his other works on these walls. The picture is composed of more than the title would imply. The "ploughed field," or rather a small section of it, lies in the foreground, beyond which the eye passes to a middle and remote distance, coloured with more truth than is seen in the works above alluded to. In this description of landscape, in short, the artist declares his power to lie. He has, it is true, shown some admirable avenue scenes; but in these there is a monotony which cannot be charged to views like his 'Ploughed Field.'

No. 427. 'The Highland Lament,' A. JOHNSTON. A work of deep and touching sentiment, professedly composed from Campbell's lines—

" O, heard ye yon pibroch sound sad in the gale,
 Where the band cometh slowly with weeping and wail?"

The time is evening, and the fading light adds to the solemn effect of the narrative, which is also much assisted by the scene of the incident, —a few yards of a high and yet ascending path, —whence the eye but partially pierces the increasing gloom which envelops the lower lands. The foremost of the "band" are the piper and the chief mourner; the approach of the others, indeed, is only indicated; and most successfully has the artist endowed these figures with expression of grief. So nicely balanced is the composition, that not only do we sympathize with its spirit, but it moves us with the never-ending interest of wishing to know more of the personal history of the defunct and the survivors.

No. 428. 'Portrait of Thomas Carlyle, Esq.,' J. LINNELL. The twilight and ruminating solitude of this work are more in accordance with sentimental composition than portraiture; the face, also, is more than usually ruddy with the glaze which this artist uniformly applies to all his portraits.

No. 429. 'Interior of the Lady Chapel, Church of St. Pierre, at Caen, Lower Normandy,' D. ROBERTS, R.A. This rich Gothic interior is admirably represented, with its painted glass and decorated altar, over which is a figure of the Virgin, so striking as at once to recal the place to the recollection of those who may have seen it. There is less light in the subject than in those generally chosen by Mr. Roberts.

No. 430. 'Venice Quay—Ducal Palace,' J. M. W. TURNER, R.A. The view, as one of the artist's present series, is taken from the water: the quay lies upon the right, at which we see a crowd of red boats; the palace closes the distance. It is just sufficiently distinct to admit of recognition of its Moorish architecture. The effect is the favourite hazy light of this painter.

No. 431. 'From the old Scottish song of " Get up and Bar the Door,"' A. FRASER. The passage selected is—

" O up then startit our gudeman,
 And an angry man was he:
Wad ye kiss my wife before my face,
 And scaud me wi' puddin' bree?"

The gudewife and the stranger, who, with his arm round her, is about to salute her, occupy the centre of the canvas. We had been more content had the painter justified these attentions by rendering her a little more attractive. It is true she is, after all, but a "gudewife;" yet her position does not necessarily imply the coarseness with which she is described. The fact is literally rendered, but the style of the work is too sketchy.

No. 432. 'Columbus—The First Sight of Land,' J. A. HOUSTON. The incident is described in Washington Irving's " Life of Columbus." The first intimation of his immediate approach to land was a light so dimly seen in the darkness of the night, that, being doubtful of the reality, he called to Pedro Gutierrez, gentleman of the King's bedchamber, and inquired whether he saw a light in that direction. The two figures are made out by an artificial light. The pose of Gutierrez wants dignity; the drawing, however, is correct, but the subject needs prominent point. We confess we looked for a more successful effort at the hands of this artist.

No. 433. 'Looking into the Sacristy of the Cathedral of Santa Maria dei Fiori, at Florence —the Sacristan announcing by a bell to persons waiting in the Church the approach of a Priest to say Mass,' S. A. HART, R.A. This church is the scene of the *Festa dei Fiori*, held at Florence at least once a year. All that is here presented is the doorway into the sacristy, at which we see the sacristan.

No. 434. 'Pyramids of Ghizeh—Sunset,' D. ROBERTS, R.A. The picture is constituted of two pyramids only, but the work is made sufficiently valuable by the way in which the golden light of the sun is broken upon them, contrasting with the ground, which is now in shadow. The view clearly exhibits that pyramid which shows at its apex another course of stone. Life is given to the scene by an Arab cavalcade, extending from the foreground till lost amid the irregularities of the distance.

No. 435. 'Thirgell Brook, Yorkshire,' W. OLIVER. The brook, the least important feature of the composition, distributes its scant stream in the foreground, which is at once closed by a screen of tall trees, forming, altogether, an effective subject. The trees are in parts well painted, but they are put together in a manner indicative of having been made out from free sketches.

No. 437. 'Moved by a Feather—Tickled by a Straw,' W. CARPENTER, jun. There is a degree of affectation in this description which were best avoided in giving a title for a catalogue. The subject is a black boy playing with a monkey : the former is creditably drawn, but the latter has too much of the human feature.

No. 438. 'Scene from "Le Bourgeois Gentilhomme"—Monsieur Jourdain le Maître Tailleur, les Garçons Tailleurs, &c. &c,' T. M. JOY. In a subject of this kind we cannot help the *mise-en-scène* arising in recollection ; the comparison is, however, not disadvantageous to the artist, inasmuch as he has sought to invest his characters with rather the business of life than the business of the stage : we have, therefore, a scene from "Le Bourgeois Gentilhomme"—reduced from the eccentricities of acting to the probabilities of real life. The master tailor says to his satellites, "Mettez cet habit à Monsieur de la manière que vous faites aux personnes de qualité." And the quality-air assumed by M. Jourdain is by no means overdone. Few artists have been more successful in treating such subjects. Mr. Joy seizes the grotesque in character, but never offends by caricature. He seems to have a keen relish for humour, but his delineations of it are subdued by good sense and correct taste. His power to work out his conceptions is unquestionable. Here we have evidence of high finish, which never degenerates into elaborate minuteness of touch. His works prove his industry, but do not leave the impression that labour is made to supply the place of genius.

No. 440. 'Villa of Lucullus at Misenum,' W. L. LEITCH. This is a large picture, reminding the spectator somewhat of the works of the older landscape-painters ; and the materials of the composition render the resemblance the more striking, as consisting precisely of such objects as they were accustomed to bring together. We presume it is intended to show rather the site of the villa indicated by the ruins in the foreground—the title led us to look for a restoration. The middle and distance of the work are well painted, but the shadows of the foreground are too much forced. There are some figures presented in the (so called) classic taste. If the picture shows us the villa in ruins as now existing, a few modern figures had told much better in contrast. There are many parts of the work indicative of high ability.

No. 441. 'Portrait of his Grace the Duke of Devonshire, K.G., and Lord Lieutenant of the County of Derby,' T. ELLERBY. The resemblance is striking, but the figure is stiffened into an excessively prim formality.

No. 442. 'Portrait of George Field, Esq,' S. DRUMMOND, A. This we presume is the gentleman who has contributed so much to the palette by his chemical skill and learning. The portrait is the best of the recent productions of the artist.

No. 442. 'La Fleur's Departure from Montreuil,' E. M. WARD. From the "Sentimental Journey." "C'est un garçon de bonne fortune," said the landlord, pointing through the window to half-a-dozen wenches who had got round La Fleur, and were most kindly taking their leave of him, as the postillion was leading out the horses. By these, then, is La Fleur surrounded, kissing their proffered hands, and assuring them he will bring them pardons from Rome. All the inhabitants of the hotel —and even the *batterie de cuisine*—seem to have come forth to witness the lamented departure of the general favourite, who, says the landlord, in discourse to Sterne, as contemplating the scene from the window, has one misfortune, which is, that he is always in love. The spirit of this work is closely in unison with that of the text, and the entire round of impersonation is perfectly characteristic : in short, the picture must add to the growing reputation of the painter. It is another "fact" to sustain the opinion we have expressed of his merit. Subjects so treated are sure to "tell :" they speak home to the universal heart.

No. 450. 'Morning,' J. MARTIN. A seaside view, wherein the shore, as rounding the bay, is seen to rise, from a cliff, behind which the sun is rising. The foreground is of that rough and rocky aspect so commonly seen in the works of this artist ; but he is less accustomed to deal with the peculiarities of the sea than he is with those of the land, and his portraiture of it is not happy.

No. 451. 'Line-of-battle Ship in a Gale, shortening Sail after Sunset,' C. H. SEAFORTH. There is no appearance here of what we understand by a "gale." The sea lies in streaks of dirty water, without colour or transparency, and the whole is executed in a manner extremely hard and inharmonious.

No. 453. * * * * S. A. HART, R.A. The subject of the picture is allusive to the captivity of James I. of Scotland, who, on his passage from Scotland to France, was in-

tercepted by a vessel of Henry IV. of England, and detained a prisoner at Windsor. His prison was the Round Tower, from the window of which he saw, for the first time, the Lady Jane Beaufort, who is the principal figure, and represented gathering flowers. This is a style of Art which this gentleman does not often practise, but we cannot speak of his success in it. The work is poor to a degree in composition, and not better in colour.

No. 460. 'Her Majesty's Beagles,' W. and H. BARRAUD. The huntsman is mounted on a horse of many good points, but the picture is too high to speak of the curious-looking dogs by which he is surrounded.

No. 461. 'Anglers on the Loire,' J. D. HARDING. A most unassuming title for the most beautiful and important picture which this artist has ever exhibited. The anglers have nothing to do with the interest, which centres in a most picturesque bridge and numerous houses on both sides of the river. The canvas is large, and comprehends an extended view, wherein the various objects are treated with a feeling productive of the best effect. The water is lustrous, has depth and current, and is carried to distance with infinite mastery; it is, in short, a work of the utmost power in its particular way; and cannot fail to obtain for the painter in this class of Art a reputation as high as that he has acquired in his own (hitherto) peculiar department of it. There will be but one opinion of the work—it will be universally ranked with the happiest achievements the collection contains.

No. 462. 'Scene from "The Devil upon Two Sticks,"' A. EGG. This is a production of the very highest mind; skilful in composition, and admirable in execution. It will sustain a reputation already prominent; and justifies our expectation of seeing the painter, ere long, occupying a place in the highest professional rank. Nevertheless, we cannot avoid hoping that this subject will be the last of his selecting from a source upon which he has, perhaps, drawn too largely. We entreat that he resort for themes to worthier sources. History is open to him: one would almost think it a sealed book to our young men of genius. What have we in this admirably executed work—so full of good drawing, rich colouring, and expression characteristic and true? What but two—hussies, a silly youth, their victim, and a roguish innkeeper?—materials upon which *mind* has been thrown away.

No. 463. 'Evening,' J. MARTIN. A composition skilfully put together, and possessing many beauties of effect, but perhaps too cold in colour. The sky seems unworthy of the rest of the work.

No. 469. 'Antwerp, from the Scheldt — Morning,' E. W. COOKE. The view is taken from the side of the river opposite to Antwerp, and a little higher up. We see, therefore, the town in distance, with its lofty spire. This side of the river is without interest, but the artist has moored a boat or two at hand: the scene is at once tranquil and brilliant, and of that character in which the artist excels. The sky is beautifully painted, and the water is deep, limpid, and flowing. We rejoice to perceive a manifest improvement in the works exhibited by the artist this year.

No. 470. 'A Study from Nature,' H. LE JEUNE. There is something here to admire, but whether a boy or a girl is not decided. A second figure is that of a child. The little picture is rich in colour, but too indefinite.

No. 472. 'A Wounded Soldier returned to his Family, visited by a Sister of Charity,' F. GOODALL. The wounded man lies upon a couch, watched by his wife with anxious care; while on the other side of her is her child, whom she rocks in its wooden cradle. The wound is desperate, and her pallid cheek betrays the fears that wring her heart. Her mother stands near, and calls her attention to the entrance of the sister, who is the bearer of assistance in some acceptable shape. A group of unconscious children are playing on the left of the composition, described with a force which few other artists can show. The colour of the whole is, as usual, beautiful and harmonious; perhaps the nice finish of recent works is not observable here. The subject is not so fortunate as some others with which the young and accomplished painter has been accustomed to deal; nevertheless, the work is one of the best productions of the age and country, and is worthy of a reputation—of the very highest.

No. 480. 'Trial of the Earl of Strafford, for High Treason,' T. A. WOOLNOTH. We have here the hazardous experiment of a young artist—a work of exceeding labour, for which a recompense, either of fame or of fortune, could scarcely have been expected; for the difficulties are great and many, and, if overcome, the conquest is not at once apparent, but can be estimated only by a long and close inspection, which in an exhibition can seldom be received. Few will take the time or the trouble to consider how much labour has been expended upon such a picture, the research that has been requisite, the authorities that have been consulted, the industry that has been exerted in search of truth. Looked at casually, and with indifference, this picture presents only an assemblage of heads, with two or three prominent personages in the foreground. Examined carefully, however, it will supply evidence of great talent. There are abundant proofs of enthusiastic zeal in contending with unpropitious materials, of enduring energy in working them into shape, and of indomitable perseverance in bringing an allotted task to completion. We augur great things hereafter from this effort, and accept it as a pledge that fame will be achieved by its producer.

No. 481. 'An Italian Minstrel,' A. GEDDES, A. An Italian boy, with a hurdy-gurdy, supposed to be begging of some one at a window. The character and expression are unexception-

able. It is the best production under this name in the Exhibition.

No. 482. 'Tea-table Talk,' W. D. KENNEDY. Two ancient maidens, pictured to the life, whose "fresh and fairy looks" have, even years ago, faded into the sere and yellow leaf, are discussing the merits of dress, when one is unutterably shocked at the over-rouging of the other. The anecdote is inimitably told, in a pithy and original way.

No. 485. 'On the Lys, at Ghent,' G. L. STANFIELD. A fragment of architecture, descriptive of the general appearance of this ancient place. It is curious as well as interesting; a very beautiful work.

No. 486. 'Summer's Afternoon,' T. CRESWICK, A. From certain detail, which is absent here, but found in the works of this artist which seem closely imitated from nature, we conclude this picture to be a composition. The arrangement consists of a group of trees, raised against a clear, warm sky, and a river, the water of which is disposed in the immediate parts of the canvas. We are glad to observe that Mr. Creswick is returning to colour in his foliage; and it is to be hoped he will resume the winning freshness of tint which characterized his productions a few years ago.

No. 487. 'Portrait of Mr. Plumer Ward,' the late H. P. BRIGGS, R.A. The features are somewhat two young for the author of "Tremaine." The expression is that of the most intense and searching penetration : it is a head that the spectator would gladly escape with one glance; and, in respect of life and mind, is one of the finest portraits we have ever seen; but in colour it is unhappily cold.

No. 490. 'Portrait of W. Mulready, Esq., R.A.,' M. MULREADY. There is a great deal of originality in the circumstancing of the figure. The portrait is a small three-quarter length seated, and seen almost in profile against a very plain background.

No. 491. 'The Squire describing some Passages in his Town Life—a Scene from the "Vicar of Wakefield,"' W. P. FRITH. The squire is seated very much at his ease, with Mrs. Primrose on his right, and Olivia and her sister on the other side of the fire. The former of the two sisters is listening attentively to his anecdotes, while the latter proceeds quietly with her work. These two figures in themselves constitute a picture, so much beauty and sweetness do they present; and herein lies the strength of the production, which is also in other respects one of a very high order. It is, indeed, admirable as a composition, and of rare excellence in execution. A story has never been more emphatically told : the accomplished artist has caught the very spirit of the scene. We hope, however, he will in future select subjects that have greater novelty.

No. 497. 'Portrait of the Marquis of Exeter, K.G., &c.,' J. SANT. A full-length, sitting; treated with much pompous circumstance, but yet, by no means, a meritorious work.

No. 504. 'The Gipsy Family,' W. SIMSON. By no means in the spirit of such a scene. So unlike are the figures in character to members of this race, that they remind us of the lord of the manor and his young wife "gipsying" for amusement.

No. 505. 'The Course of True Love never did run smooth,' F. STONE. This is the title of a picture, which is also accompanied by three lines from the 23rd Ode of the First Book of Horace, and of course, as usual, printed wrong —two errors in one line is nothing for the Royal Academy catalogue. For the credit of the body, some competent person should be employed to revise it. The lines are :—

> " Sic visum Veneri; cui placet impares
> Formas atque animos sub juga ahenea
> Sævo mittere cum joco'! "

The mistake, however, we can scarcely regret. It is a just punishment of the artist, who was guilty of the pedantry of introducing " scholarship" into a production so purely and simply English—rustic English. The picture contains four figures—two youths and two maidens--who, in the spirit of true love, have quarrelled, and without any immediate prospect of reconciliation. The girls are beautifully drawn and admirably charactered ; but the work, upon the whole, is not of the completed purpose of some of the excellent artist's previous works.

It is, of course, highly and beautifully wrought in its details : the countenaces of the two girls are the very perfection of finish. The most skilful miniature-painter could not have carried them further.

No. 507. 'View on Shooter's Hill, Kent,' J. PEEL. A small woody scene, closely studied from nature, and with much talent in execution.

No. 511. 'Salvator Rosa's first Cartoon on the Walls of Certoza, near Naples,' W. SIMSON. Young Salvator has been caught in the fact of drawing on the walls of the porch, and falls under the reprobation at once of his mother and the monks. The principal figures are very forcible, and the anecdote is clearly told. The monk is a well-studied figure, as also is the hapless Salvator. The picture has been executed with much care, and is in all respects calculated to extend the reputation of the painter.

No. 514. 'Louise,' R. S. LAUDER. Another glee-maiden, with a crowd of listeners to her affecting lay. There is much that is beautiful is this work, but it wants light.

No. 515. 'Portrait of a Young Lady as a Peasant Girl,' E. U. EDDIS. The head and upper parts of this little figure are particularly striking ; but the feet are coarse, bony, and those of a much older child.

No. 520. 'Mill on the Lake of Como,' G. E. HERING. This is a close scene ; the mill is most picturesquely situated on the right of the picture, which is somewhat too high for examination. We catch a glimpse, however, of very beautifully painted distance, and know,

from previous productions of the artist, that this must possess considerable excellence.

No. 522. 'Rienzi in the Forum,' A. ELMORE. It is absolutely refreshing to turn to a picture like this, after having been dosed, *usque ad nauseam*, with " Gil Blas," Don Quixote," and the "Vicar of Wakefield." Rienzi is here addressing a crowd assembled around him; Petrarch is at his side, attentively listening to the energetic eloquence which is flowing from his lips. It is a work of very great and marked original power; each figure is most carefully studied, and the distribution of the characters has been made with due regard to effective composition: it raises its author to a very high rank among the living painters of our school. We foresaw, indeed, long ago, that he was sure to achieve fame, inasmuch as he was steadily and systematically pursuing the right road to excellence. A few stumbling-stones were flung in his way —last year at the Royal Academy, and this year at the British Institution—he has manfully overstepped them, and no evil circumstance can now arrest his onward progress. His future success will depend entirely on himself.

No. 523. ' Oude Scheldt—Texel Island, looking towards Nieuwe Diep and the Zuider Zee,' C. STANFIELD, R.A. A much smaller picture than ' The Day after the Wreck,' but equally beautiful in all that constitutes the subject. The day is dull and windy, and the latter effect is wonderfully exemplified in the driving clouds; the sailing of some near small craft; but, above all, in the astonishing movement and clearness of the water, which is painted with a triumphant challenge to the closest comparison with nature, even to the slightest beading on the crests of the waves. We may say of this artist that before his time water has never before been so painted, and, as approaching as closely to the reality as painting admits of, can never be excelled.

No. 528. ' The Pear-tree Well—a romantic well on the banks of the Kelvin, near Glasgow,' J. G. GILBERT. Three figures are here brought out from a dark background by means of an artificial light, according to the principle of some of the earlier Italian masters. The figures are well drawn and the effect is powerful.

No. 529. 'The Blind Fiddler,' R. HUSKINSON. He is playing and singing at a stable-door, whence is protruded a horse's head. This class of subject can be relished only by a taste of the lowest kind.

No. 531. 'Scene on board a Steamer crossing from Havre to Honfleur,' F. BIARD. M. Biard, we know, can paint better pictures than this, but it would seem that he rates our taste at no higher standard. To his work, as that of a foreigner of some talent, has been accorded a place of honour; but we had thought better of him had we not seen his production so closely. The subject shows the utmost inconveniences of a crowd of passengers going to Honfleur, midway in their *trajet*, with a heavy sea rolling into the estuary of the Seine. This most disgusting production, which does not rise beyond the very lowest caricature, we doubt not has been rejected by the good taste of the French people as not fit to garnish the walls of the lowest cabaret.

No. 543. 'The Theory of Gravitation suggested to Sir Isaac Newton by the Fall of an Apple,' H. BARRAUD. A figure, which we may suppose to represent Newton, sits holding an apple in his hand, and beyond this there is no appropriate allusion.

No. 544. 'The Lady Arthur Lennox,' F. GRANT, A. The lady stands in an unstudied attitude, and dressed in a manner equally simple. The colour and expression are highly successful.

No. 551. 'The Moors beleaguered by the Spaniards in the City of Valencia,' F. P. POOLE. A picture which manifests great power; it is sufficient to sustain, though it will fail to enhance, the reputation which the artist established last year. That which was then original is now, however, only a repetition; and, moreover, we receive from it a hint to guard the accomplished painter against the danger of "mannerism,"—the shoals upon which so many fine minds have been wrecked. The principal figure in this work is that of the Moorish governor, a cruel and relentless man, who held the city against the besiegers till the last extremity. He stands amid a crowd of the inhabitants, dying and dead. A mother stands at his side, imploring his attention to the wasted form of her child dying of hunger; but he himself, already ghastly with suffering, disdains to cast a look upon the dying child. It is early daybreak; the beacon lights are as yet unextinguished, and famishing wretches are rising from their hard beds upon the city walls. The work is eloquent—but eloquent of misery. It cannot be seen without pain. The spectator partakes of the sufferings of those on whom he looks. So far the object of the artist has been answered; but a mind great as his should have aimed at a loftier purpose. As an example of masterly skill in depicting human agony, the merit of the picture is unquestionable; it tells a fearful story; and its moral may be the wretchedness and the wickedness of war. Still, we cannot but lament that a painter of so much power should not have exerted that power in order to achieve a nobler end.

No. 552. 'The Tomb of Christ immediately after the Resurrection,' F. DANBY, A. " And he said unto them, be not affrighted: ye seek Jesus of Nazareth, which was crucified: he is risen: he is not here." These are the words addressed by " the young man who was sitting on the right side, clothed in a long white garment," addressed to Mary Magdalene, and Mary the mother of James. The time being early morning the whole field is in shade, except the tomb, and here the artist has shown his wonderful command of material in painting light. The angel is placed in a dazzling sheen,

represented with a truth which cannot be excelled.

No. 557. 'The Vicar of Wakefield Addressing Olivia, after one of Squire Thornhill's Visits to the Vicarage,' J. HOLLINS, A. With respect to the mere mechanique of the Art there is much to praise in this picture, but the faces are singularly forbidding. When shall we see the last of the Vicar? Our artists look only to each other for hints for subjects.

OCTAGON ROOM.

We repeat the observations we have thrice made during the last three years: it is most unfair and unjust to hang pictures in this chamber—"the condemned hole" of the Academy. Unfortunately, the evil doom of unhappy wights—who are here gibbeted and not exhibited—receives additional torture from the fact that it contains some pictures which, to receive justice, should be hung on the line in the Great Room. Two or three painters, however, appear as if they enjoyed a prescriptive right to it. Last year Mr. Lance was here exposed; this year *his only contribution* to the collection is thus disposed of. It is a picture that would do honour to any member of the Royal Academy. Mr. Sydney Cooper's best work is again here (he has but one other in the Exhibition). Here, too, is *the only offering* of M'Innes. Here also is M'Ian's solitary effort. There are at least a dozen other artists who have been thus smothered — whose excellence no one will deny, and whose claim to worthier stations no member of the Academy will for a moment call in question. It may be expedient (if the apartment is opened at all) to hang in it some good works, in order that the mark of ignominy may not be instantly apparent; but how much more satisfactory would it be to find works by the members occupying it, in lieu of productions (some of them, as we have shown, *single ones*) by artists who can less safely afford the ban of a whole twelvemonth. It is difficult to conceive upon what principle the hanging here is conducted. Last year, for instance, here Mr. Frith's only picture was placed; the year before he had a capital position; and this year he enjoys one of the stations usually allotted to men who are considered among the earliest candidates to obtain admission into the Academy. The chamber is fit for nothing but to hold hats and umbrellas. And this the Academy knows well, for we have never seen here a production by any one of its members.

No. 558. 'Luther Listening to the Sacred Ballad,' R. M'INNES. The ballad (one of the great reformer's discourses versified by Paul Spretter) is sung under his window to a crowd of listeners, and Luther himself appears at the window. The canvas is crowded with figures and objects, which seem to enfeeble the main purpose. The artist, however, must be content to be judged by what he has done rather than by what he now exhibits—for, of his picture, so placed, a very limited judgment can be formed.

No. 562. 'The Fountain of Youth.' This work appears without a name: if it be accidental, it is highly reprehensible, inasmuch as the production is one of many beauties; and this is another of the numerous evidences in favour of a proper revision of the Royal Academy catalogue—the most incorrect that falls into our hands. The picture is much like one of Giorgione's garden scenes: it affects intimately the Italian style, and shows (as far as we can see) elegant taste and graceful drawing.

No. 563. 'The New Ballad,' T. S. COOPER. The title had led us to think that the artist had forsaken the pastoral and adopted a new style of composition; but no—it is the Dorcas of the picture whom the ballad concerns. A herd of cows, a cowshed, and trees constitute the objects, and it is to be wished the trees had been omitted. We need not ask, with Menalcas, to whom the cows belong—*verum Ægonis*—that is, they are clearly Cooper's.

No. 571. 'The Grandmother's Blessing,' G. LANCE. So little does this work show of the painter's wonted manner, that we should scarcely have recognised him here. The composition is constituted of three fine figures carefully painted; the head of the principal, a young lacemaker, being absolutely beautiful. The story is eloquently and happily told.

No. 577. * * * R. R. M'IAN. Another excellent production put positively out of the way; the evil of having a picture at all in the Octagon Room is sufficient, without its being, moreover, absolutely shelved. The subject is one of the most critical passages in the life of Prince Charles Edward—that is, his concealment and protection by the "seven men of Glenmoriston," at a time when £30,000 were offered for him dead or alive. Hugh Chisholm (one of the seven) has slain a dragoon who was bearing despatches to Fort Augustus, and, becoming possessed of the papers, they are now in course of examination, and one of his faithful band is seen in the act of cutting the proclamation with his dirk. The artist has given no title to his work, and it requires none, so clearly are the facts made out.

No. 579. 'Vintage Scene in Southern Italy,' W. SEVERN. The two most prominent figures seen here were contributed by the artist in a plate to the volume of "Etched Thoughts." The picture is characterized by much more freshness than we have seen in his old pictures.

No. 581. 'Portrait of Mrs. Cunningham,' J. LINNELL. A full-length of the size usually painted by Mr. Linnell. We have to congratulate him on the better feeling evinced in the flesh colour. It is more like nature than the universal ruddy glaze thrown over all his faces—an assertion that all persons are of one complexion—a fallacy which no charm of Art can make us forget.

No. 588. 'Heath Scene,' JAMES STARK. One of only two offerings by this always excellent artist has been sent to the condemned hole ; the other is equally ill-placed. Yet on other occasions the abilities of one of our truest and best English painters of landscape seems to have been rightly estimated—usually he has been here accorded ample justice. This picture will sustain his high reputation, and give exceeding pleasure to all who will take the trouble look for it.

No. 590. 'Sketching from Nature—a Bull in the Foreground," T. WOODWARD. A painter has been assiduously sketching from nature, when a bull quietly walks up to him, upsets his easel, scatters his materials, and plays at peep-bo with himself round a tree. The subject is, thus, extremely poor—so poor as to be contemptible, and, consequently, the ability which marks all the works of this artist has been here thrown away. We have a fine example of skill in drawing and powers of execution wasted upon worthless matter.

No. 595. 'A Lee Shore—Gale Increasing,' J. WILSON. This picture has been adjudged as not requiring a strong light, and has been, accordingly, placed immediately under the window ; yet even in this place it strikes the spectator as a work of much power.

No. 603. 'St. Valentine's Morning,' W. KIDD. An elderly gentleman is here exhibited in boisterous mirth over a valentine, apparently intended for one of the ladies of the party. The figures are vulgar, and the style is tinctured strongly with caricature.

No. 606. 'The Firstborn,' G. H. HARRISON. A cottage door—young parents with their firstborn. The picture exhibits considerable ability, telling its story with marked emphasis, the main incident being true to nature. The surrounding objects, however, disturb the harmony of the scene. The garden is too full of flowers, and the flowers are too bright. The artist, indeed, appears to have considered these the principal parts of his picture.

No. 616. 'The Parting,' R. FARRIER. The old story of a young man having enlisted, and now taking leave of his mother and sisters. The style of the work is hard and edgy, but there is some point in the leave-taking.

No. 619. 'Christ at the Tomb of Lazarus,' M. CLAXTON. The most important character in the scene is the least successful. The Saviour is as much a failure as can be well imagined in the essence of the representation. The features—indeed, the heads generally of the picture—are most objectionable. Yet the work has merits in composition and breadth, and also in colour, the harmonies of which do not seem to have resulted from principle, otherwise this excellence would have been general. The artist would do well to re-paint the head of Christ, for the expression is inconceivably poor.

DRAWINGS AND MINIATURES.

In this room, as usual, objects as opposite as any two things can be are thrown together without the slightest regard to harmony of arrangement. The drawings and miniatures should, unquestionably, receive a room to themselves :—as they will do when the nation has accorded space sufficient to render justice to British Art.

No. 629. 'Portrait of Miss Jameson,' A. E. CHALON, R.A. The thin sketchy style of this artist seems to have had its day. The lady is presented standing, and has received at the hands of the painter a somewhat better complexion than he is accustomed to give even to ladies.

No. 638. 'Portrait of Mrs. Legh Richmond,' J. BOSTOCK. A miniature carefully drawn and coloured. The figure is full-length, seated.

No. 668. 'Master Johnstone, Son of Lieut.-Col. Johnstone,' T. CARRICK. We recognise more warmth of hue in this miniature than the artist usually gives ; and this must be regarded as an improvement, for his colour is often too cold.

No. 694. 'Mrs. Russell and her Child,' R. THORBURN. The lady is painted at full length, holding the child in her arms. This is a production of infinite beauty, and, like all the portraits of this artist, circumstanced and treated rather as a picture than a portrait ; we are, accordingly, reminded of a Madonna—the St. Sixtus, or some other similarly presented. The old-school style is carried even into the colour, which is too uniform.

No. 696. 'Portrait of a Gentleman,' J. S. TEMPLETON. We regret to find the contributions of this excellent artist so limited in number. This is a right good example of the art, and does him credit ; but it is not sufficient to uphold his character for industry as well as ability.

No. 700. 'The Rev. R. W. Baxter,' Sir W. J. NEWTON. The head of this miniature is brilliant to a degree, but it is of the kind that shows deference to nature. The features picture most successfully a mind within.

No. 701. 'Portrait of W. Collins, R.A.,' H. COLLEN. An excellent portrait, and a striking likeness.

No. 705. 'Portrait of a Lady,' C. COUZENS. A full length, simply treated, but made out much in the manner and with the richness of oil painting.

No. 706. 'Henry Cubitt, Esq., of Catton,' T. CARRICK. In this miniature is admirably shown the intelligence and reality of life. In execution it is distinguished by the peculiar excellence of the painter.

No. 713. 'The Hon. Mrs. Rashleigh,' R. THORBURN. The subject is drawn at full length, and seated in a pose of the most perfect ease and grace. This work is an instance of the utmost brilliancy in miniature painting. We may observe of the faces of this artist, that they are never relaxed into unmeaning simper.

The countenance of this figure is full of intense inquiry, and at once engages the attention of the spectator.

No. 714. 'Portrait of Mrs. Thomas Wheeler,' Miss A. COLE. The production of a fine mind. All the works of this lady—both drawings and miniatures—are marked by qualities of considerable excellence.

No. 747. 'Major-General C. Macleod,' T. CARRICK. Never were aged features more admirably drawn than by this artist, inasmuch as he succeeds in putting in all the markings of the countenance without losing breadth, and employs shade in any quantity without becoming heavy and opaque. The face here has these qualities in an eminent degree.

No. 748. 'Her Grace the Duchess of Buccleuch,' Sir W. C. ROSS, R.A. This miniature, which seems to be set in a large buckle or clasp, shows only the head and bust. The flesh colour is pure and transparent, and the general character of the work is that of much sweetness.

No. 755. 'Portrait of Thomas Uwins, Esq., R.A.,' T. BRIDGFORD. An excellent drawing, and a good likeness of the estimable painter. The artist also exhibits a portrait—No. 800—of Mr. Eastlake, which is, perhaps, a still more striking resemblance.

No. 760. 'The Marchioness of Douro,' Sir W. C. ROSS, R.A. The lady is attired in scarlet velvet of unsurpassable brilliancy: the texture is inimitable—but here the eye rests. The head and neck look dull, for it is impossible to paint up flesh to accompany a hue so dazzling: this is, in short, a study of red velvet.

No. 771. 'The Marriage of her Majesty and Prince Albert,' Sir W. J. NEWTON. We were much astonished on observing that the catalogue signified this very large composition to be painted on ivory — a work comprehending fourteen full-length portraits, and measuring two feet and a half by two feet, or thereabout! The ivory is, therefore, consequently joined, and by some nice process which renders the junction imperceptible. The portraits, besides those of her Majesty and the Prince, are of course those of the royal and distinguished personages immediately surrounding the altar, as the Queen Dowager, the Dukes of Sussex and Cambridge, the Duchesses of Kent and Cambridge, &c. &c. With regard to likeness, all these portraits are most successful; and, for so large a painting on ivory, the finish is wonderfully sustained throughout. The work indeed is a striking example of industry, for the labour bestowed upon it must have been immense; not less, perhaps, than would have been required to produce an oil painting ten times the size. As a record of a very important and interesting event, the picture is worthy of all praise; the "facts" are copied with singular accuracy; every individual of the group is recognised in an instant; and as a work of Art its merits are of the very highest order. Its attraction in this room is, as will be supposed, paramount.

No. 784. 'Portrait of the Rev. R. H. Gray,

M.A.,' Miss M. HUCKLEBRIDGE. In this, and other works by the same graceful hand, we recognise striking resemblances, and at the same time accord to them very high merit as productions of Art. In the miniatures of this accomplished lady there is always a fortunate blending of delicacy with force; the likenesses are copied with accuracy; yet, while retaining all the leading characteristics of features, bestowing upon them of refinement just enough and no more.

No. 803. 'Selina, Viscountess Milton,' Sir W. C. ROSS, R.A. A lady and child: the face of the latter is beautiful in colour, but the prominent arm of the former is wanting in form and play of outline. The draperies and objects are painted with the nicest care.

No. 804. 'The Hon. Mrs. Norton's Family,' R. THORBURN. A group of three boys, composed and painted in the feeling of the school of Reynolds. They are resting on a bank, under the shade of a tree, apparently after having been playing cricket. The picture (for such we must call it) is rich and harmonious in colour, and its depth and freedom are altogether new in miniature.

No. 817. 'Daniel O'Connell, Esq., M.P.,' T. CARRICK. The artist has somewhat refined upon Mr. O'Connell's features, and perhaps not to his advantage; the portrait is, however, readily recognisable. The colour is a little too clear, and the age of the miniature is not that of the original.

No. 823. 'The late Sir Francis Burdett, Bart.,' Sir W. C. ROSS, R.A. Sir Francis is in his library, attired in the manner usual with him for years, that is, wearing light-coloured smallclothes and topboots—the high tone of which diminishes the value of the head. The likeness is very striking, but the features are so highly coloured as to look flushed.

No. 846. 'Portrait of the Marchioness of Waterford,' J. HAYTER. A very beautiful drawing, in the style which Mr. Hayter has made almost exclusively his own.

No. 849. 'The Right Rev. the Lord Bishop of London,' T. CARRICK. The face is, as usual, beautifully worked up; but in this case the figure has been too little cared for, as it does not sufficiently support the head.

No. 856. 'Portraits of Two Sisters,' Sir W. C. ROSS, R.A. They are standing together, relieved by a garden background: there is about the figures something of homeliness rather than grace. The positions are well chosen and easy, and the details made out with the utmost nicety.

No. 867. 'Portraits of Mrs. Adey and the Misses Adey,' Miss M. GILLIES. A composition characterized by a forcible and decided style. The flesh colour, however, is heavy, and the background, which is too dark, wants the relief of transparency.

No. 893. 'The Cascatelli, near Rome,' J. UWINS. This and its "companion," No. 919, 'A Scene in Devonshire,' are beautiful water-

colour drawings ; but the artist ought to have been a more extensive contributor to the Exhibition.

No. 899. 'Portrait of Mrs. Ridgway, of Richmond,' A. E. CHALON, R.A. There is a strangely mannered similarity in all the faces of this artist. The lady is attired in white muslin, which is drawn with a freedom of outline which gives a most preposterous bulk to the figure.

No. 916. 'Portrait of the late George Knott, Esq., Mrs. Knott and Family, of Bohun Lodge, East Barnet,' A. E. CHALON, R.A. We cannot believe that the artist intends a drawing like this to be finished, if so it is an assumption which we cannot understand. Five or six figures enter into the composition, flat and insipid beyond description, and setting at nought everything that is valuable in drawing.

No. 938. 'Lady Marcus Hill, and the Hon. Miss Hill,' E. D. SMITH. The lady is attired in black velvet, and presented at full length ; the carriage of the figure is distinguished by ease and grace, and the features are drawn with much sweetness of expression. The drawing is upon cardboard, but it has all the richness and finish of an ivory miniature.

No. 943. 'Peter Borthwick, Esq., M.P.,' E. D. SMITH. A three-quarter length figure, upon cardboard : the features are life-like and intelligent, and the rest of the person is forcibly drawn and relieved in a manner to give roundness and substance.

No. 948. 'Don Quixote Disputing with the Barber,' J. GILBERT. It is too bad to see here a work that would do honour to many an artist who "sits in judgment." Mr. Gilbert has produced pictures that would put to shame half the contents of the Exhibition, if so placed as to be appreciated.

W.M. Thackeray

"May Gambols;
or, Titmarsh in the Picture-Galleries"

Fraser's Magazine 29 (June 1844), 700–16

THE readers of this miscellany may, perhaps, have remarked that always, at the May season and the period of the exhibitions, our eccentric correspondent Titmarsh seems to be seized with a double fit of eccentricity, and to break out into such violent fantastical gambols as might cause us to be alarmed did we not know him to be harmless, and induce us to doubt of his reason but that the fit is generally brief, and passes off after the first excitement occasioned by visiting the picture-galleries. It was in one of these fits, some years since, that he announced in this Magazine his own suicide, which we know to be absurd, for he has drawn many hundred guineas from us since :—on the same occasion he described his debts and sojourn at a respectable hotel, in which it seems he has never set his foot. But these hallucinations pass away with May, and next month he will, no doubt, be calmer, or, at least, not more absurd than usual. Some disappointments occurring to himself, and the refusal of his great picture of "Heliogabalus" in the year 1803 (which caused his retirement from practice as a painter), may account for his extreme bitterness against some of the chief artists in this, or any other school or country. Thus we have him in these pages abusing Raphael ; in the very last month he fell foul of Rubens, and in the present paper he actually pooh-poohs Sir Martin Shee and some of the Royal Academy. This is too much. " *Cœlum ipsum*," as Horace says, " *petimus stultitiâ.*" But we will quote no more the well-known words of the Epicurean bard.

We only add that we do not feel in the least bound by any one of the opinions here brought forward, from most of which, except where the writer contradicts himself and so saves us the trouble, we cordially dissent ; and perhaps the reader had best pass on to the next article, omitting all perusal of this, excepting, of course the editorial notice of—O. Y.

Jack Straw's Castle, Hampstead,
May 25.

THIS is written in the midst of a general desolation and discouragement of the honest practitioners who dwell in the dingy first-floors about Middlesex Hospital and Soho. The long-haired ones are tearing their lanky locks ; the velvet-coated sons of genius are plunged in despair ; the law has ordered the suppression of Art-Unions, and the wheel of Fortune has suddenly and cruelly been made to stand still. When the dreadful news came that the kindly, harmless Art-lottery was to be put an end to, although Derby-lotteries are advertised in every gin-shop in London, and every ruffian in the City may gamble at his leisure, the men of the brush and palette convoked a tumultuous meeting, where, amidst tears, shrieks, and wrath, the cruelty of their case was debated. Wyse of Waterford calmly presided over the stormy bladder-squeezers, the insulted wielders of the knife and maulstick. Wyse soothed their angry spirits with words of wisdom and hope. He stood up in the assembly of the legislators of the land and pointed out their wrongs. The painters' friend, the kind old Lansdowne, lifted up his cordial voice among the peers of England, and asked for protection for the children of Raphael and Apelles. No one said nay. All pitied the misfortune of the painters ; even Lord Brougham was stilled into compassion, and the voice of Vaux was only heard in sobs.

These are days of darkness, but there is hope in the vista ; the lottery-subscription lies in limbo, but it shall be released therefrom and flourish, exuberantly revivified, in future years. Had the ruin been consummated, this hand should have withered rather than have attempted to inscribe jokes concerning it. No. *Fraser* is the artists' friend, their mild parent. While his Royal Highness Prince Albert dines with the Academicians, the rest of painters, less fortunate, are patronised by her majesty REGINA.

Yes, in spite of the Art-Union accident, there is hope for the painters. Sir Martin Archer Shee thinks that the prince's condescension in dining with the Academy will do incalculable benefit to the art. Henceforth its position is assured in the world.

This august patronage, the president says, evincing the sympathy of the higher classes, must awaken the interest of the low; and the public (the ignorant rogues!) will thus learn to appreciate what they have not cared for hitherto. Interested! of course they will be. O Academicians! ask the public to dinner and you will see how much interested they will be. We are authorised to state that next year any person who will send in his name will have a cover provided; Trafalgar Square is to be awned in, plates are to be laid for 250,000, one of the new basins is to be filled with turtle and the other with cold punch. The president and the *élite* are to sit upon Nelson's pillar, while rows of benches, stretching as far as the Union Club, Northumberland House, and St. Martin's Church, will accommodate the vulgar. Mr. Toole is to have a speaking-trumpet; and a twenty-four-pounder to be discharged at each toast.

There are other symptoms of awakening interest in the public mind. The readers of newspapers will remark this year that the leaders of public opinion have devoted an unusually large space and print to reviews of the fine arts. They have been employing critics, who, though they contradict each other a good deal, are yet evidently better acquainted with the subject than critics of old used to be when gentlemen of the profession were instructed to report on a fire, or an Old Bailey trial, or a Greek play, or an opera, or a boxing-match, or a picture-gallery, as their turn came. Read now the *Times*, the *Chronicle*, the *Post* (especially the *Post*, of which the painting critiques have been very good), and it will be seen that the critic knows his business, and from the length of his articles it may be conjectured that the public is interested in knowing what he has to say. This is all, probably, from the prince having dined at the Academy. The nation did not care for pictures until then—until the nobility taught us; gracious nobility! Above all, what a compliment to the public!

As one looks round the rooms of the Royal Academy, one cannot but deplore the fate of the poor fellows who have been speculating upon the Art-Unions; and yet in the act of grief there is a lurking satisfaction. The poor fellows can't sell their pieces; that is a pity. But why did the poor fellows paint such fiddle-faddle pictures? They catered for the *bourgeois*, the sly rogues! they know honest John Bull's taste, and simple admiration of namby-pamby, and so they supplied him with an article that was just likely to suit him. In like manner savages are supplied with glass beads; children are accommodated with toys and trash, by dexterous speculators who know their market. Well, I am sorry that the painting speculators have had a stop put to their little venture, and that the ugly law against lotteries has stepped in and seized upon the twelve thousand pounds, which was to furnish many a hungry British Raphael with a coat and a beefsteak. Many a Mrs. Raphael, who was looking out for a new dress, or a trip to Margate or Boulogne for the summer, must forego the pleasure, and remain in dingy Newman Street. Many little ones will go back to Turnham Green academies and not carry the amount of last half-year's bill in the trunk; many a landlord will bully about the non-payment of the rent; and a vast number of frame-makers will look wistfully at their carving and gilding as it returns after the exhibition to Mr. Tinto, Charlotte Street, along with poor Tinto's picture from the *Vicar of Wakefield* that he made sure of selling to an Art-Union prizeman. This is the pathetic side of the question. My heart is tender, and I weep for the honest painters peering dismally at the twelve thousand pounds like hungry boys do at a tart-shop.

But—here stern justice interposes, and the MAN having relented the CRITIC raises his inexorable voice—but, I say, the enemies of Art-Unions have had some reason for their complaints, and I fear it is too true that the effect of those institutions, as far as they have gone hitherto, has not been mightily favourable to the cause of art. One day, by custom, no doubt, the public taste will grow better, and as the man who begins by intoxicating himself with a glass of gin finishes sometimes by easily absorbing a bottle; as the law-student, who at first is tired with a chapter of Blackstone, will presently swallow

you down with pleasure a whole volume of Chitty; as EDUCATION, in a word, advances, it is humbly to be hoped that the great and generous British public will not be so easily satisfied as at present, and will ask for a better article for its money.

Meanwhile, their taste being pitiable, the artists supply them with poor stuff—pretty cheap tawdry toys and gimcracks in place of august and beautiful objects of art. It is always the case. I do not mean to say that the literary men are a bit better. Poor fellows of the pen and pencil! we must live. The public likes light literature and we write it. Here am I writing magazine jokes and follies, and why? Because the public like such, will purchase no other. Otherwise, as Mr. Nickisson, and all who are acquainted with M. A. Titmarsh in private know, my real inclinations would lead me to write works upon mathematics, geology, and chemistry, varying them in my lighter hours with little playful treatises on questions of political economy, epic poems, and essays on the Æolic digamma. So, in fact, these severe rebukes with which I am about to belabour my neighbour must be taken, as they are given, in a humble and friendly spirit; they are not actuated by pride, but by deep sympathy. Just as we read in holy Mr. Newman's life of Saint Stephen Harding, that it was the custom among the godly Cistercian monks (in the good old times, which holy Newman would restore) to assemble every morning in full chapter; and there, after each monk had made his confession, it was free to—nay, it was strictly enjoined on—any other brother to rise and say, "Brother So-and-so hath not told all his sins; our dear brother has forgotten that yesterday he ate his split-peas with too much gormandise;" or, "This morning he did indecently rejoice over his water-gruel," or what not. — These real Christians were called upon to inform, not only of themselves, but to be informers over each other; and, the information being given, the brother informed against thanked his brother the informer, and laid himself down on the desk, and was flagellated with gratitude. Sweet friends! be you like the Cistercians! Brother Michael Angelo is going to inform

against you. Get ready your garments and prepare for flagellation. Brother Michael Angelo is about to lay on and spare not.

Brother Michael lifts up his voice against the young painters collectively in the first place, afterwards individually, when he will also take leave to tickle them with the wholesome stripes of the flagellum. In the first place, then (and my heart is so tender that, rather than begin the operation, I have been beating about the bush for more than a page, of which page the reader is cordially requested to omit the perusal, as it is not the least to the purpose), I say that the young painters of England, whose uprise this Magazine and this critic were the first to hail, asserting loudly their superiority over the pompous old sham-classical big-wigs of the Academy—the young painters of England *are not doing their duty.* They are going backwards, or rather, they are flinging themselves under the wheels of that great golden Juggernaut of an Art-Union. The thought of the money is leading them astray; they are poets no longer, but money-hunters. They paint down to the level of the public intelligence, rather than seek to elevate the public to them. Why do these great geniuses fail in their duty of instruction? Why, knowing better things, do they serve out such awful twaddle as we have from them? Alas! it is not for art they paint, but for the Art-Union.

The first dear brother I shall take the liberty to request to get ready for operation is brother Charles Landseer. Brother Charles has sinned. He has grievously sinned. And we will begin with this miserable sinner, and administer to him admonition in a friendly, though most fierce and cutting manner.

The subject of brother Charles Landseer's crime is this. The sinner has said to himself, "The British public likes domestic pieces. They will have nothing *but* domestic pieces. I will give them one, and of a new sort. Suppose I paint a picture that must make a hit. My picture will have every sort of interest. It shall interest the religious public; it shall interest the domestic public; it shall interest the amateur for the cleverness of its painting; it shall interest little boys and girls, for I will introduce

no end of animals, camels, monkeys, elephants, and cockatoos; it shall interest sentimental young ladies, for I will take care to have a pretty little episode for them. I will take the town by storm, in a word." This is what I conceive was passing in brother Charles Landseer's sinful soul when he conceived and executed his NOAH'S ARK IN A DOMESTIC POINT OF VIEW.

Noah and his family (with some supplemental young children, very sweetly painted) are seated in the ark, and a port-hole is opened, out of which one of the sons is looking at the now peaceful waters. The sunshine enters the huge repository of the life of the world, and the dove has just flown in with an olive-branch and nestles in the bosom of one of the daughters of Noah; the patriarch and his aged partner are lifting up their venerable eyes in thankfulness; the children stand around, the peaceful labourer and the brown huntsman each testifying his devotion after his fashion. The animals round about participate in the joyful nature of the scene, their instinct seems to tell them that the hour of their deliverance is near.

There, the picture is described romantically and in the best of language. Now let us proceed to examine the poetry critically and to see what its claims are. Well, the ark is a great subject. The history from which we have our account of it, from a poet surely demands a reverend treatment; a blacksmith roaring from the desk of a conventicle may treat it familiarly, but an educated artist ought surely to approach such a theme with respect. The point here is only urged æsthetically. As a matter of *taste*, then (and the present humble writer has no business to speak on any other), such a manner of treating the subject is certainly reprehensible. The ark is vulgarised here and reduced to the proportions of a Calais steamer. The passengers are rejoicing: they are glad to get away. Their live animals are about them no more nor less sublime than so many cattle or horses in loose boxes. The parrots perched on the hoop yonder have as little signification as a set of birds in a cage at the Zoological Gardens; the very dove becomes neither more nor less than

the *pet* of the pretty girl represented in the centre of the picture. All the greatness of the subject is lost; and, putting the historical nature of the personages out of the question, they have little more interest than a group of any emigrants in the hold of a ship, who rouse and rally at the sound of "Land ho!"

Why, if all great themes of poetry are to be treated in this way, the art would be easy. We might have Hector shaving himself before going out to fight Achilles, as, undoubtedly, the Trojan hero did; Priam in a cotton nightcap asleep in a four-poster on the night of the sack of Troy, Hecuba, of course, by his side, with curl-papers, and her *tour de tête* on the toilet-glass. We might have Dido's maid coming after her mistress in the shower with pattens and an umbrella; or Cleopatra's page guttling the figs in the basket which had brought the asp that killed the mistress of Antony. Absurd trivialities, or pretty trivialities, are nothing to the question; those I have adduced here are absurd, but they are just as poetical as prettiness, not a whit less degrading and commonplace. No painter has a right to treat great historical subjects in such a fashion; and though the public are sure to admire, and young ladies, in raptures, look on at the darling of a dove, and little boys in delight cry, "Look, papa, at the parroquets!"—"Law, ma, what big trunks the elephants have!" it yet behoves the critic to say this is an unpoetical piece, and severely to reprehend the unhappy perpetrator thereof.

I know brother Charles will appeal. I know it will be pleaded in his favour that the picture is capitally painted, some of the figures very pretty; two, that of the old woman and the boy looking out, quite grand in drawing and colour; the picture charming for its silvery tone and agreeable pleasantry of colour. All this is true. BUT he has sinned, he has greatly sinned; let him acknowledge his fault in the presence of the chapter, and receive the customary and wholesome reward thereof,—

Frater Redgrave is the next malefactor whose sins deserve a reprobation. In the namby-pamby line his errors are very sad. Has he not been already warned in this very miscel-

lany of his propensity to small sentiment? Has he corrected himself of that grievous tendency? No: his weakness grows more and more upon him, and he is now more sinful than ever. One of his pictures is taken from the most startling lyric in our language, the " Song of the Shirt," a song as bitter and manly as it is exquisitely soft and tender, a song of which the humour draws tears.*

Mr. Redgrave has illustrated every thing except the humour, the manliness, and the bitterness of the song. He has only depicted the tender, good-natured part of it. It is impossible to quarrel with the philanthropy of the painter. His shirt-maker sits by her little neat bed, work, working away. You may see how late it is, for the candle is nearly burnt out, the clock (capital poetic notion!) says what o'clock it is, the grey-streaked dawn is rising over the opposite house seen through the cheerless casement, and where (from a light which it has in its window) you may imagine that another poor shirt-maker is toiling too. The one before us is pretty, pale, and wan; she turns up the whites of her fine, fatigued eyes to the little ceiling. She is ill, as the artist has shewn us by a fine stroke of genius—a parcel of medicine-bottles on the mantel-piece! The picture is carefully and cleverly painted—extremely popular —gazed at with vast interest by most spectators. Is it, however, a poetical subject? Yes, Hood has shewn that it can be made one, but by surprising turns of thought brought to bear upon it, strange, terrible, unexpected lights of humour which he has flung upon it. And, to "trump" this tremendous card, Mr. Redgrave gives us this picture; his points being the clock, which tells the time of day, the vials which shew the poor girl takes physic, and such other vast labours of intellect!

Mr. Redgrave's other picture, the " Marriage Morning," is also inspired by that milk-and-water of human kindness, the flavour of which is so insipid to the roast-beef intellect. This is a scene of a marriage morn-ing, the bride is taking leave of her mamma after the ceremony, and that amiable lady, reclining in an easy chair, is invoking benedictions upon the parting couple, and has a hand of her daughter and her son-in-law clasped in each of hers. She is smiling sadly, restraining her natural sorrow, which will break out so soon as the post-chaise you see through the window, and on which the footman is piling the nuptial luggage, shall have driven off to Salt Hill, or Rose Cottage, Richmond, which I recommend. The bride's father, a venerable, bald-headed gentleman, with a most benignant, though slow-coachish look, is trying to console poor Anna Maria, the unmarried sister, who is losing the companion of her youth. Never mind, Anna Maria, my dear, your turn will come too; there is a young gentleman making a speech in the parlour to the health of the new-married pair, who, I lay a wager, will be struck by your fine eyes, and be for serving you as your sister has been treated. This small fable is worked out with great care in a picture in which there is much clever and conscientious painting, from which, however, I must confess I derive little pleasure. The sentiment and colour of the picture somehow coincide; the eye rests upon a variety of neat tints of pale drab, pale green, pale brown, pale puce colour, of a sickly warmth, not pleasant to the eye. The drawing is feeble, the expression of the faces pretty, but lackadaisical. The penance I would order Mr. Redgrave should be a pint of port wine to be taken daily, and a devilled kidney every morning for breakfast before beginning to paint.

A little of the devil, too, would do Mr. Frank Stone no harm. He, too, is growing dangerously sentimental. His picture, with a quotation from Horace, " Mæcenas atavis edite regibus," represents a sort of game of tender cross-purposes, very difficult to describe in print. Suppose two lads, Jocky and Tommy, and two lasses, Jenny and Jessamy. They are placed thus : —

* How is it that none of the papers have noticed the astonishing poem by Mr. Hood in the May number of his magazine, to which our language contains no parallel? —M. A. T.

Jessamy.	Jenny.	Tommy. Jocky.
	A dog.	

Now Jocky is making love to Jenny in an easy, off-hand sort of way, and though, or, perhaps, *because* he doesn't care for her much, is evidently delighting the young woman. She looks round, with a pleased smile on her fresh, plump cheeks, and turns slightly towards heaven a sweet little *retroussé* nose, and twiddles her fingers (most exquisitely these hands are drawn and painted, by the way) in the most contented way. But, ah! how little does she heed Tommy, who, standing behind Jocky, reclining against a porch, is looking and longing for this light-hearted Jenny. And, oh! why does Tommy cast such sheep's eyes upon Jenny, when by her side sits *Jessamy*, the tender and romantic, the dark-eyed and raven-haired being, whose treasures of affection are flung at heedless Tommy's feet? All the world is interested in Jessamy; her face is beautiful, her look of despairing love is so exquisitely tender, that it touches every spectator; and the ladies are unanimous in wondering how Tommy can throw himself away upon that simpering Jenny, when such a superior creature as Jessamy is to be had for the asking. But such is the way of the world, and Tommy will marry, simply because everybody tells him not.

Thus far for the sentiment of the picture. The details are very good; there is too much stippling and show of finish, perhaps, in the handling, and the painting might have been more substantial and lost nothing. But the colour is good, the group very well composed, the variety of expression excellent. There is great passion, as well as charming delicacy, in the disappointed maiden's face; much fine appreciation of character in the easy, smiling triumph of the rival; and, although this sentence was commenced with the express determination of rating Mr. Stone soundly, lo! it is finished without a word of blame. Well, let's vent our anger on the dog. That *is* very bad, and seems to have no more bones than an apple-dumpling. It is only because the artist has been painting disappointed lovers a great deal of late, that one is disposed to grumble, not at the work, but the want of variety of subject.

As a sentimental picture, the best and truest, to my taste, is that by Mr. Webster, the " Portraits of Mr. and Mrs. Webster," painted to celebrate their fiftieth wedding-day. Such a charming old couple were never seen. There is delightful grace, sentiment, and purity, in these two gentle, kindly heads; much more sentiment and grace than even in Mr. Eastlake's " Heloise," a face which the artist has painted over and over again; a beautiful woman, but tiresome, unearthly, unsubstantial, and no more like Heloise than like the Duke of Wellington. If the late Mr. Pope's epistle be correct, Eloisa was a most unmistakeable woman; this is a substanceless, passionless, solemn, mystical apparition; but I doubt if a woman be not the more poetical being of the two.

Being on the subject of sentimental pictures, Mr. Delaroche's great " Holy Family" must be mentioned here; and, if there is reason to quarrel with the unsatisfactory nature of English sentiment, in truth it appears that the French are not much better provided with the high poetical quality. This picture has all the outside of poetry, all the costume of religion, all the prettiness and primness of the new German dandy-pietistical school. It is an agreeable compound of Correggio and Raphael, with a strong dash of Overbeck; it is painted as clean and pretty as a tulip on a dessert-plate, the lines made out so neatly that none can mistake them. The drawing good, the female face as pretty and demure as can be, her drapery of spotless blue, and the man's of approved red, the infant as pink as strawberries and cream, every leaf of the tree sweetly drawn, and the trunk of the most delicate dove-coloured grey. All these merits the picture has; it is a well-appointed picture. But is that all? Is that enough to make a poet? There are lines in the Oxford prize poems that are smooth as Pope's; and it is notorious that, for colouring, there is no painting like the Chinese. But I hope the French artists have better men springing up among them than the president of the French Academy at Rome,

Biard, the Hogarthian painter, whose slave-trade picture was so noble, has sent us a couple of pieces, which both, in their way, deserve merit. The one is an Arabian caravan moving over a brickdust-coloured desert, under a red, arid sky. The picture is lifelike, and so far poetical that it seems to tell the truth. Then there is a steam-boat disaster, with every variety of sea-sickness, laughably painted. Shuddering soldiery, sprawling dandies, Englishmen, Savoyards, guitars, lovers, monkeys,— a dreadful confusion of qualmish people, whose agonies will put the most philanthropic observer into good humour. Biard's "Havre Packet" is much more praiseworthy in my mind than Delaroche's "Holy Family;" for I deny the merit of failing greatly in pictures, the great merit is to succeed. There is no greater error, surely, than that received dictum of the ambitious, to aim at high things; it is best to do what you mean to do; better to kill a crow than to miss an eagle.

As the French artists are sending in their works from across the water, why, for the honour of England, will not some of our painters let the Parisians know that here, too, are men whose genius is worthy of appreciation? They may be the best draughtsmen in the world, but they have no draughtsman like Maclise, they have no colourist like Etty, they have no painter like MULREADY, above all, whose name I beg the printer to place in the largest capitals, and to surround with a wreath of laurels. Mr. Mulready was crowned in this Magazine once before. Here again he is proclaimed. It looks like extravagance, or flattery, for the blushing critic to tell his real mind about the "Whistonian Controversy."

And yet, as the truth must be told, why not say it now at once? I believe this to be one of the finest cabinet pictures in the world. It seems to me to possess an assemblage of excellences so rare, to be in drawing so admirable, in expression so fine, in finish so exquisite, in composition so beautiful, in humour and beauty of expression so delightful, that I can't but ask where is a good picture if this be not one. And, in enumerating all the above perfections,

I find I have forgotten the greatest of all, the colour; it is quite original this,— brilliant, rich, astonishingly luminous, and intense. The pictures of Van Eyck are not more brilliant in tone than this magnificent combination of blazing reds, browns, and purples. I know of no scheme of colour like it, and heartily trust that time will preserve it; when this little picture, and some of its fellows, will be purchased as eagerly as a Hemlinck or a Gerard Douw is bought nowadays. If Mr. Mulready has a mind to the Grand Cross of the Legion of Honour, he has but to send this picture to Paris next year, and with the recommendation of *Fraser's Magazine*, the affair is settled. Meanwhile it is pleasant to know that the artist (although his work will fetch ten times as much money a hundred years hence) has not been ill rewarded, as times go, for his trouble and genius.

We have another great and original colourist among us, as luscious as Rubens, as rich almost as Titian, Mr. Etty; and every year the exhibition sparkles with magnificent little canvasses, the works of this indefatigable strenuous admirer of rude Beauty. The form is not quite so sublime as the colour in this artist's paintings; the female figure is often rather too expansively treated, it swells here and there to the proportions of the Caffrarian, rather than the Medicean, Venus; but, in colour, little can be conceived that is more voluptuously beautiful. This year introduces us to one of the artist's noblest compositions, a classical and pictorial *orgy*, as it were,— a magnificent vision of rich colours and beautiful forms,—a grand feast of sensual poetry. The verses from *Comus*, which the painter has taken to illustrate, have the same character :—

" All amidst the gardens fair
Of Hesperus and his daughters three,
That sing about the golden tree,
Along the crisped shades and bowers,
Revels the spruce and jocund spring.
Beds of hyacinths and roses,
Where young Adonis oft reposes,
Waxing well of his deep wound,
In slumber soft and on the ground
Sadly sits the Assyrian queen ;
But far above in spangled sheen,
Celestial Cupid, her famed son, advanced,
Holds his dear Psyche sweet entranced."

It is a dream rather than a reality, the words and images purposely indistinct and incoherent. In the same way the painter has made the beautiful figures sweep before us in a haze of golden sunshine. This picture is one of a series to be painted in fresco, and to decorate the walls of a summerhouse in the gardens of Buckingham Palace, for which edifice Mr. Maclise and Mr. Leslie have also made paintings.

That of Mr. Leslie's is too homely. He is a prose painter. His kind, buxom young lass has none of the look of Milton's lady, that charming compound of the saint and the fine lady — that sweet impersonation of the chivalric mythology — an angel, but with her sixteen quarterings — a countess descended from the skies. Leslie's lady has no such high breeding, the Comus above her looks as if he might revel on ale; a rustic seducer, with an air of rude, hob-nailed health. Nor are the demons and fantastic figures introduced imaginative enough; they are fellows with masks from Covent Garden. Compare the two figures at the sides of the picture with the two Cupids of Mr. Etty. In the former there is no fancy. The latter are two flowers of poetry; there are no words to characterise those two delicious little figures, no more than to describe a little air of Mozart, which, once heard, remains with you for ever; or a new flower, or a phrase of Keats or Tennyson, which blooms out upon you suddenly, astonishing as much as it pleases. Well, in endeavouring to account for his admiration, the critic pumps for words in vain; if he uses such as he finds, he runs the risk of being considered intolerably pert and affected; silent pleasure, therefore, best beseems him; but this I know, that were my humble recommendations attended to at court, when the pictures are put in the pleasure-house, her sacred majesty, giving a splendid banquet to welcome them and the painters, should touch Mr. Etty on the left shoulder and say, "Rise, my knight of the Bath, for painting the left-hand Cupid;" and the Emperor of Russia (being likewise present) should tap him on the right shoulder, exclaiming, "Rise, my knight of the Eagle, for the left-hand Cupid."

Mr. Maclise's Comus picture is wonderful for the variety of its design, and has, too, a high poetry of its own. All the figures are here still and solemn as in a tableau; the lady still on her unearthly snaky chair, Sabrina still stooping over her. On one side the brothers, and opposite the solemn attendant spirit; round these interminable groups and vistas of fairy beings, twining in a thousand attitudes of grace, and sparkling white and bloodless against a leaden blue sky. It is the most poetical of the artist's pictures, the most extraordinary exhibition of his proper skill. Is it true that the artists are only to receive three hundred guineas a-piece for these noble compositions? Why, a print-seller would give more, and artists should not be allowed to paint simply for the honour of decorating a royal summerhouse.

Among the poetical pictures of the Exhibition should be mentioned with especial praise Mr. Cope's delightful " Charity," than the female figures in which Raphael scarce painted any thing more charmingly beautiful. And Mr. Cope has this merit, that his work is no prim imitation of the stiff old Cimabue and Giotto manner, no aping of the crisp draperies and hard outlines of the missal illuminations, without which the religious artist would have us believe religious expression is impossible. It is pleasant after seeing the wretched caricature of old-world usages which stare us in the face in every quarter of London now — little dumpy Saxon chapels built in raw brick, spick and span *bandbox* churches of the pointed Norman style for Cockneys in zephyr coats to assemble in, new old painted windows of the twelfth century, tessellated pavements of the Byzantine school, gimcrack imitations of the Golden Legend printed with red letters, and crosses, and quaint figures stolen out of Norman missals — to find artists aiming at the Beautiful and Pure without thinking it necessary to resort to these paltry archæological quackeries, which have no Faith, no Truth, no Life in them; but which give us ceremony in lieu of reality, and insist on forms as if they were the conditions of belief.

Lest the reader should misunderstand the cause of this anger, we beg him to take the trouble to cross Pall

Mall to St. James's Street, where objects of art are likewise exhibited; he will see the reason of our wrath. Here are all the ornamental artists of England sending in their works, and what are they?—All imitations. The Alhambra here; the Temple Church there; here a Gothic saint; yonder a Saxon altar-rail; farther on a sprawling rococo of Louis XV.; all worked neatly and cleverly enough, but with no originality, no honesty of thought. The twelfth century revived in Mr. Crockford's bazar, forsooth! with examples of every century except our own. It would be worth while for some one to write an essay, shewing how astonishingly Sir Walter Scott * has influenced the world; how he changed the character of novelists, then of historians, whom he brought from their philosophy to the study of pageantry and costume; how the artists then began to fall back into the middle ages and the architects to follow; until now behold we have Mr. Newman and his congregation of Littlemore marching out with taper and crosier, and falling down to worship St. Willibald, and St. Winnibald, and St. Walberga the Saxon virgin. But Mr. Cope's picture is leading the reader rather farther than a critique about exhibitions has any right to divert him, and let us walk soberly back to Trafalgar Square.

Remark the beautiful figures of the children in Mr. Cope's picture (276), the fainting one, and the golden-haired infant at the gate. It is a noble and touching Scripture illustration. The artist's other picture, " Geneviève," is not so successful; the faces seem to have been painted from a dirty palette, the evening tints of the sky are as smoky as a sunset in St. James's Park; the composition unpleasant, and not enough to fill the surface of canvass.

Mr. Herbert's picture of " The Trial of the Seven Bishops" is painted with better attention to costume that most English painters are disposed to pay. The characters in our artist's history-pieces, as indeed on our theatres, do not look commonly accustomed to the dresses

which they assume; wear them awkwardly, take liberties of alteration and adjustment, and spoil thereby the truth of the delineation. The French artists, on the canvass or the boards, understand this branch of their art much better. Look at M. Biard's " Mecca Pilgrims," how carefully and accurately they are attired; or go to the French play and see Cartigny in a Hogarthian dress. He wears it as though he had been born a hundred years back — looks the old marquess to perfection. In this attention to dress, Mr. Herbert's picture is very praiseworthy; the men are quite at home in their quaint coats and periwigs of James the Second's time; the ladies at ease in their stiff, long-waisted gowns, their fans, and their queer caps and patches. And the picture is pleasing from the extreme brightness and cleanliness of the painting. All looks as neat and fresh as Sam Pepys when he turned out in his new suit, his lady in her satin and brocade. But here the praise must stop. The great concourse of people delineated, the bishops and the jury, the judges and the sheriffs, the halberdiers and the fine ladies, seem very little interested in the transaction in which they are engaged, and look as if they were assembled rather for show than business. Nor, indeed, is the artist much in fault. Painters have not fair play in these parade pictures. It is only with us that Reform-banquets, or views of the House of Lords at the passing of the Slopperton Railwaybill, or Coronation Processions, obtain favour; in which vast numbers of public characters are grouped unreally together, and politics are made to give an interest to art.

Mr. Herbert's picture of " Sir Thomas More and his Daughter watching from the prisoner's room in the Tower four Monks led away to Execution," is not the most elaborate, perhaps, but the very best of this painter's works. It is full of grace, and sentiment, and religious unction. You see that the painter's heart is in the scenes which he represents. The countenances of the two figures are finely conceived; the

* Or more properly Goethe. Goetz von Berlichingen was the father of the Scottish romances, and Scott remained constant to that mode, while the greater artist tried a thousand others.

sorrowful, anxious beauty of the daughter's face, the resigned humility of the martyr at her side, and the accessories or properties of the pious little drama are cleverly and poetically introduced ; such as mystic sentences of hope and trust inscribed by former sufferers on the walls, the prisoner's rosary and book of prayers to the Virgin that lie on his bed. These types and emblems of the main story are not obtruded, but serve to increase the interest of the action ; just as you hear in a concerted piece of music a single instrument playing its little plaintive part alone, and yet belonging to the whole.

If you want to see a picture where costume is *not* represented, behold Mr. Lauder's "Claverhouse ordering Morton to Execution." There sits Claverhouse in the centre in a Kean wig and ringlets, such as was never worn in any age of this world, except at the theatre in 1816, and he scowls with a true melo-dramatic ferocity ; and he lifts a sign-post of a finger towards Morton, who forthwith begins to writhe and struggle into an attitude in the midst of a group of subordinate, cuirassed, buff - coated gentry. Morton is represented in tights, slippers, and a tunic ; something after the fashion of Retzch's figures in *Faust* (which are refinements of costumes worn a century and a half before the days when Charles disported at Tillietudlem ;) and he, too, must proceed to scowl and frown " with a flashing eye and a distended nostril," as they say in the novels, — as Gomersal scowls at Widdicomb before the combat between those two chiefs begins ; and while they are measuring each other according to the stage wont, from the toe of the yellow boot up to the tip of the stage-wig. There is a tragedy heroine in Mr. Lauder's picture, striking her attitude too, to complete the scene. It is entirely unnatural, theatrical, of the Davidgian, nay, Richardsonian drama, and all such attempts at effect must be reprehended by the stern critic. When such a cool practitioner as Claverhouse ordered a gentleman to be shot, he would not put himself into an attitude : when such a quiet gentleman as Morton received the unpleasant communication in the midst of a company of grenadiers who must overpower him, and of ladies to whom his resistance would be unpleasant, he would act like a man and go out quietly, not stop to rant and fume like a fellow in a booth. I believe it is in Mr. Henningsen's book that there is a story of Zumalacarreguy, Don Carlos's Dundee, who, sitting at table with a Christino prisoner, smoking cigars and playing picquet very quietly, received a communication which he handed over to the Christino. " Your people," says he, " have shot one of my officers, and I have promised reprisals ; I am sorry to say, my dear general, that I must execute you in twenty minutes !" And so the two gentlemen finished their game at picquet, and parted company — the one to inspect his lines, the other for the court-yard hard by, where a file of grenadiers was waiting to receive his excellency —with mutual politeness and regret. It was the fortune of war. There was no help for it ; no need of ranting and stamping, which would ill become any person of good breeding.

The Scotch artists have a tragic taste ; and we should mention with especial praise Mr. Duncan's picture with the agreeable epigraph, " She set the bairn on the ground and tied up his head, and straighted his body, and covered him with her plaid, and lay down and wept over him." The extract is from Walker's *Life of Peden ;* the martyrdom was done on the body of a boy by one of those bloody troopers whom we have seen in Mr. Lauder's picture carrying off poor shrieking Morton. Mr. Duncan's picture is very fine,—dark, rich, and deep in sentiment ; the woman is painted with some of Rubens' swelling lines (such as may be seen in some of his best Magdalens), and with their rich tones of grey. If a certain extremely heavy Cupid poising in the air by a miracle be the other picture of Mr. Duncan's, it can be only said that his tragedy is better than his lightsome compositions — an arrow from yonder lad would bruise the recipient black and blue.

Another admirable picture of a Scotch artist is 427, " The Highland Lament," by Alexander Johnston. It is a shame to put such a picture in such a place. It hangs on the ground almost invisible, while dozens of tawdry portraits are staring at

you on the line. Could Mr. Johnston's picture be but seen properly, its great beauty and merit would not fail to strike hundreds of visitors who pass it over now. A Highland piper comes running forward, playing some wild lament on his dismal instrument; the women follow after, wailing and sad; the mournful procession winds over a dismal moor. The picture is as clever for its fine treatment and colour, for the grace and action of the figures, as it is curious as an illustration of national manners.

In speaking of the Scotch painters, the Wilkie-like pictures of Mr. Fraser, with their peculiar *smeary* manner, their richness of tone, and their pleasant effect and humour, should not be passed over; while those of Mr. Geddes and Sir William Allan may be omitted with perfect propriety. The latter represents her majesty and Prince Albert perched on a rock; the former has a figure from Walter Scott, of very little interest to any but the parties concerned.

Among the Irish painters we remark two portraits by Mr. Crowley, representing Mrs. Aikenhead, superior*ess* of the Sisters of Charity in Ireland, who gives a very favourable picture of the Society — for it is impossible to conceive an abbess more comfortable, kind, and healthy-looking; and a portrait of Dr. Murray, Roman Catholic archbishop of Dublin, not a good picture of a fine, benevolent, and venerable head. We do not know whether the painter of 149, " An Irish Peasant awaiting her Husband's return," Mr. Anthony, is an Irishman; but it is a pretty sad picture, which well characterises the poverty, the affection, and the wretchedness of the poor Irish cabin, and tells sweetly and modestly a plaintive story. The largest work in the exhibition is from the pencil of an Irishman, Mr. Leahy, " Lady Jane Grey praying before execution." One cannot but admire the courage of artists who paint great works upon these tragic subjects; great works quite unfitted for any private room, and scarcely suited to any public one. But, large as it is, it may be said (without any playing upon words) that the work grows upon estimation. The painting is hard, and incomplete;

but the principal figure excellent: the face, especially, is finely painted, and full of great beauty. Also, in the Irish pictures may be included Mr. Solomon Hart's Persian gentleman smoking a *calahan*,— a sly hit at the learned sergeant, member for Cork, who has often done the same thing.

Mr. Maclise's little scene from *Undine* does not seem to us German in character, as some of the critics call it, because it is clear and hard in line. What German artist is there who can draw with this astonishing vigour, precision, and variety of attitude? The picture is one of admirable and delightful fancy. The swarms of solemn little fairies crowding round Undine and her somewhat theatrical lover, may keep a spectator for hours employed in pleasure and wonder. They look to be the real portraits of the little people, sketched by the painter in some visit to their country. There is, especially, on a branch in the top corner of the picture, a conversation going on between a fairy and a squirrel (who is a fairy too), which must have been taken from nature, or Mother Bunch's delightful super-nature. How awful their great glassy blue eyes are! How they peer out from under grass, and out of flowers, and from twigs and branches, and swing off over the tree-top, singing shrill little fairy choruses! We must have the *Fairy Tales* illustrated by this gentleman, that is clear; he is the only person, except Tieck, of Dresden, who knows any thing about them.—Yes, there *is* some one else; and a word may be introduced here in welcome to the admirable young designer, whose hand has lately been employed to illustrate the columns of our facetious friend (and the friend of everybody) *Punch*. This young artist (who has avowed his name, a very well-known one, that of DOYLE,) has poured into *Punch's* columns a series of drawings quite extraordinary for their fancy, their variety, their beauty, and fun. It is the true genius of fairy-land, of burlesque which never loses sight of beauty. Friend *Punch's* very wrapper is quite a marvel in this way, at which we can never look without discovering some new little quip of humour or pleasant frolic of grace.

And if we have had reason to com-

plain of Mr. Leslie's "Comus" as deficient in poetry, what person is there that will not welcome " Sancho," although we have seen him before almost in the same attitude, employed in the same way, recounting his adventures to the kind, smiling duchess, as she sits in state? There is only the sour old duenna, who refuses to be amused, and nothing has ever amused her these sixty years. But the ladies are all charmed, and tittering with one another; the black slave who leans against the pillar has gone off in an honest fit of downright laughter. Even the little dog, the wonderful little Blenheim, by the lady's side, would laugh if she could (but, alas! it is impossible), as the other little dog is said to have done on the singular occasion when " the cow jumped over the moon." * The glory of dulness is in Sancho's face. I don't believe there is a man in the world—no, not even in the House of Commons—so stupid as that. On the Whig side there is, certainly,—but no, it is best not to make comparisons which fall short of the mark. This is, indeed, the Sancho that Cervantes drew.

Although the editor of this Magazine had made a solemn condition with the writer of this notice that no pictures taken from the *Vicar of Wakefield* or *Gil Blas* should, by any favour or pretence, be noticed in the review; yet, as the great picture of Mr. Mulready compelled the infraction of the rule, rushing through our resolve by the indomitable force of genius, we must, as the line is broken, present other Vicars, Thornhills, and Olivias, to walk in and promenade themselves in our columns, in spite of the vain placards at the entrance, "VICARS OF WAKEFIELD NOT ADMITTED." In the first place, let the Rev. Dr. Primrose and Miss Primrose walk up in Mr. Hollins' company. The vicar is mildly expostulating with his daughter regarding the attentions of Squire Thornhill. He looks mildly, too mild; she looks ill-humoured, very sulky. Is it about the scolding, or the squire? The figures are very nicely painted; but they do not look accustomed (the lady especially) to the dresses they

wear. After them come Mrs. Primrose, the Misses, and the young Masters Primrose, presented by Mr. Frith in his pretty picture (491). Squire Thornhill sits at his ease, and recounts his town adventures to the ladies; the beautiful Olivia is quite lost in love with the slim red-coated dandy; her sister is listening with respect; but, above all, the old lady and children hearken with wonder. These latter are charming figures, as, indeed, are all in the picture. As for Gil Blas,— but we shall be resolute about *him*. Certain Gil Blas there are in the exhibition eating ollapodridas, and what not. Not a word, however, shall be said regarding any one of them.

Among the figure-pieces Mr. Ward's Lafleur must not be forgotten, which is pleasant, lively, and smartly drawn and painted; nor Mr. Gilbert's "Pear-tree well," which contains three graceful classical figures, which are rich in effect and colour; nor Mr. MacInnes' good picture of Luther listening to the sacred ballad (the reformer is shut up in the octagon-room); nor a picture of Oliver Goldsmith on his rambles, playing the flute at a peasant's door, in which the colour is very pretty; the character of the French peasants not French at all, and the poet's figure easy, correct, and well drawn.

Among more serious subjects may be mentioned with praise Mr. Dyce's two fierce figures, representing King Joash shooting the arrow of deliverance, which if the critics call "French," because they are well and carefully drawn, Mr. Dyce may be proud of being a Frenchman. Mr. Lauder's " Wise and Foolish Virgins" is a fine composition; the colour sombre and mysterious; some of the figures extremely graceful, and the sentiment of the picture excellent. This is a picture which would infallibly have had a chance of a prize, if the poor, dear Art-Union were free to act.

Mr. Elmore's " Rienzi addressing the People" is one of the very best pictures in the gallery. It is well and agreeably coloured, bright, pleasing, and airy. A group of people are gathered round the tribune, who addresses them among Roman ruins

* " Qualia prospiciens Catulus ferit æthera risu
 Ipsaque trans lunæ cornua Vacca salit."— LUCRETIUS.

under a clear blue sky. The grouping is very good; the figures rich and picturesque in attitude and costume. There is a group in front of a mother and child, who are thinking of any thing but Rienzi and liberty; who, perhaps, ought not to be so prominent as they take away from the purpose of the picture, but who are beautiful wherever they are. And the picture is further to be remarked for the clear, steady, and honest painting which distinguishes it.

What is to be said of Mr. Poole's "Moors beleaguered in Valencia?" A clever hideous picture in the very worst taste; disease and desperation characteristically illustrated. The Spaniards beleaguer the town, and every body is starving. Mothers with dry breasts unable to nourish infants; old men, with lean ribs and blood-shot eyes, moaning on the pavement; brown young skeletons pacing up and down the rampart, some raving, all desperate. Such is the agreeable theme which the painter has taken up. It is worse than last year, when the artist only painted the plague of London. Some *did* recover from that. All these Moors will be dead before another day, and the vultures will fatten on their lean carcasses, and pick out their red-hot eyeballs. Why do young men indulge in these horrors? Young poets and romancers often do so and fancy they are exhibiting "power;" whereas nothing is so easy. Any man with mere instinct can succeed in the brutal in art. The coarse fury of Zurbaran and Morales is as far below the sweet and beneficent calm of Murillo as a butcher is beneath a hero. Don't let us have any more of these hideous .exhibitions — these Ghoul festivals. It may be remembered that Amina in the *Arabian Nights*, who liked churchyard suppers, could only eat a grain of rice when she came to natural food. There is a good deal of sly satire in the apologue which might be applied to many (especially French) literary and pictorial artists of the convulsionary school.

We must not take leave of the compositions without mentioning Mr. Landseer's wonderful "Shoeing" and stag; the latter the most poetical, the former the most dexterous, perhaps, of the works of this accomplished painter. The latter picture, at a little distance, expands almost into the size of nature. The enormous stag by the side of a great blue northern lake stalks over the snow down to the shore, whither his mate is coming through the water to join him. Snowy mountains bend round the lonely landscape, the stars are shining out keenly in the deep icy blue over head; in a word, your teeth begin to chatter as you look at the picture, and it can't properly be seen without a great-coat. The donkey and the horse in the shoeing picture are prodigious imitations of nature; the blacksmith only becomes impalpable. There is a charming portrait in the great room by the same artist in which the same defect may be remarked. A lady is represented with two dogs in her lap; the dogs look real; the lady a thin unsubstantial vision of a beautiful woman. You ought to see the landscape through her.

Amongst the landscape-painters, Mr. Stanfield has really painted this year better than any former year— a difficult matter. The pictures are admirable, the drawing of the water wonderful, the look of freshness, and breeze, and motion conveyed with delightful skill. All Mr. Creswick's pictures will be seen with pleasure, especially the delicious "Summer Evening;" the most airy and clear, and also the most poetical of his landscapes. The fine "Evening Scene" of Danby also seems to have the extent and splendour, and to suggest the solemn feelings of a vast mountain-scene at sunset. The admirers of Sir Augustus Callcott's soft, golden landscapes will here find some of his most delightful pieces. Mr. Roberts has painted his best in his Nile scene, and his French architectural pieces are of scarce inferior merit. Mr. Lee, Mr. Witherington, and Mr. Leitch, have contributed works, shewing all their well-known qualities and skill. And as for Mr. Turner, he has out-prodigied almost all former prodigies. He has made a picture with real rain, behind which is real sunshine, and you expect a rainbow every minute. Meanwhile, there comes a train down upon you, really moving at the rate of fifty miles an hour, and which the reader had best make haste to see, lest it

should dash out of the picture, and be away up Charing Cross through the wall opposite. All these wonders are performed with means not less wonderful than the effects are. The rain, in the astounding picture called " Rain—Steam—Speed," is composed of dabs of dirty putty *slapped* on to the canvass with a trowel; the sunshine scintillates out of very thick, smeary lumps of chrome yellow. The shadows are produced by cool tones of crimson lake, and quiet glazings of vermilion, although the fire in the steam-engine *looks* as if it were red. I am not prepared to say that it is not painted with cobalt and pea-green. And as for the manner in which the "*Speed*" is done, of that the less said the better,—only it is a positive fact that there is a steam-coach going fifty miles an hour. The world has never seen any thing like this picture.

In respect of the portraits of the Exhibition, if Royal Academicians will take the word of the *Morning Post*, the *Morning Chronicle*, the *Spectator*, and, far above all, of *Fraser's Magazine*, they will pause a little before they hang such a noble portrait as that of W. Conyngham, Esq. by Samuel Lawrence, away out of sight, while some of their own paltry canvasses meet the spectator nose to nose. The man with the glove of Titian in the Louvre has evidently inspired Mr. Lawrence, and his picture is so far an imitation; but what then? it is better to imitate great things well, than to imitate a simpering barber's dummy, like No. 10,000, let us say, or to perpetrate yonder horror,—weak, but, oh! how heavy, smeared, flat, pink and red, grinning, ill-drawn portraits (such as Nos. 99,999, and 99,999d) which the old Academicians perpetrate. You are right to keep the best picture in the room out of the way, to be sure; it would sternly frown your simpering unfortunates out of countenance; but let us have at least a chance of seeing the good pictures. Have one room, say, for the Academicians, and another for the clever artists. Diminish your number of exhibited pictures to six, if you like, but give the young men a chance. It is pitiful to see their works pushed out of sight, and to be offered what you give us in exchange.

This does not apply to all the esquires who paint portraits; but, with regard to the names of the delinquents, it is best to be silent, lest a shewing up of them should have a terrible effect on the otherwise worthy men, and drive them to an untimely desperation. So I shall say little about the portraits, mentioning merely that Mr. Grant has one or two, a small one especially, of great beauty and lady-like grace; and one very bad one, such as that of Lord Forrester. Mr. Pickersgill has some good heads; the little portrait of Mr. Ainsworth by Mr. Maclise is as clever and like as the artist knows how to make it. Mr. Middleton has some female heads especially beautiful. Mrs. Carpenter is one of the most manly painters in the Exhibition; and if you walk into the miniature-room, you may look at the delicious little gems from the pencil of Sir William Ross, those still more graceful and poetical by Mr. Thorburn, and the delightful coxcombries of Mr. Chalon. I have found out a proper task for that gentleman, and hereby propose that he should illustrate *Coningsby*.

In the statue-room, Mr. Gibson's classic group attracts attention and deserves praise; and the busts of Parker, Macdonald, Behnes, and other well-known portrait-sculptors, have all their usual finish, skill, and charm.

At the Water-Colour Gallery the pleased spectator lingers as usual delighted, surrounded by the pleasantest drawings and the most genteel company. It requires no small courage to walk through that avenue of plush breeches with which the lobby is lined, and to pass two files of whiskered men in canes and huge calves, who contemptuously regard us poor fellows with Bluchers and gingham umbrellas. But these passed, you are in the best society. Bishops, I have remarked, frequent this Gallery in venerable numbers; likewise dignified clergymen with rosettes; Quakeresses, also, in dove-coloured silks meekly changing colour; squires and their families from the country; and it is a fact, that you never can enter the Gallery without seeing a wonderfully pretty girl. This fact merits to be generally known, and is

alone worth the price of the article.

I suspect that there are some people from the country who admire Mr. Prout still ; those fresh, honest, unalloyed country appetites ! There are the Prout Nurembergs and Venices still ; the awnings, the water-posts, and the red-capped bargemen drawn with a reed pen ; but we *blasés* young *roués* about London get tired of these simple dishes, and must have more excitement. There, too, are Mr. Hill's stags with pink stomachs, his spinach pastures and mottled farm-houses ; also innumerable windy downs and heaths by Mr. Copley Fielding ;—in the which breezy flats I have so often wandered before with burnt - sienna ploughboys, that the walk is no longer tempting.

Not so, however, the marine pieces of Mr. Bentley. That gentleman, to our thinking, has never painted so well. Witness his " Indiaman towed up the Thames (53), his " Signalling the Pilot" (161), and his admirable view of " Mount St. Michel" (127), in which the vessel quite dances and falls on the water. He deserves to divide the prize with Mr. Stanfield at the Academy.

All the works of a clever young landscape - painter, Mr. G. A. Fripp, may be looked at with pleasure ; they shew great talent, no small dexterity, and genuine enthusiastic love of nature. Mr. Alfred Fripp, a figure-painter, merits likewise very much praise ; his works are not complete as yet, but his style is thoughtful, dramatic, and original.

Mr. Hunt's dramas of one or two characters are as entertaining and curious as ever. His " Outcast" is amazingly fine, and tragic in cha-racter. His " Sick Cigar-boy," a wonderful delineation of nausea. Look at the picture of the toilette, in which, with the parlour-tongs, Betty, the housemaid, is curling little miss's hair : there is a dish of yellow soap in that drawing, and an old comb and brush, the fidelity of which make the delicate beholder shudder. On one of the screens there are some " birds nests," out of which I am sur-prised no spectator has yet stolen any of the eggs—you have but to stoop down and take them.

Mr. Taylor's delightful drawings are even more than ordinarily clever.

His " Houseless Wanderers " is worthy of Hogarth in humour ; most deliciously coloured and treated. " The Gleaner" is full of sunshine ; the larder quite a curiosity, as shew-ing the ease, truth, and dexterity, with which the artist washes in his flowing delineations from nature. In his dogs, you don't know which most to admire, the fidelity with which the animals are painted, or the ease with which they are done.

This gift of facility Mr. Cattermole also possesses to an amazing extent. As pieces of effect, his " Porch " and " Rook- Shooting " are as wonderful as they are pleasing. His large picture of " Monks in a Refectory " is very fine ; rich, original, and sober in colour ; excellent in sentiment and general grouping ; in individual atti-tude and drawing not sufficiently correct. As the figures are much smaller than those in the refectory, these faults are less visible in the magnificent " Battle for the Bridge," a composition, perhaps, the most com-plete that the artist has yet produced. The landscape is painted as grandly as Salvator ; the sky wonderfully airy, the sunshine shining through the glades of the wood, the huge trees rocking and swaying as the breeze rushes by them ; the battling figures are full of hurry, fire, and tumult. All these things are rather indicated by the painter than defined by him ; but such hints are enough from such a genius. The charmed and capti-vated imagination is quite ready to supply what else is wanting.

Mr. Frederick Nash has some un-pretending, homely, exquisitely faith-ful scenes in the Rhine country. " Boppart," " Bacharach," &c. of which a sojourner in those charming districts will always be glad to have a reminiscence. Mr. Joseph Nash has not some of the cleverest of his mannerisms, nor Mr. Lake Price the best of his smart, dandified, utterly unnatural exteriors. By far the best designs of this kind are the Windsor and Buckingham Palace sketches of Mr. Douglas Morison, executed with curious fidelity and skill. There is the dining hall in Buckingham Palace, with all the portraits, all the candles in all the chandeliers ; the China gimcracks over the mantel-piece, the dinner - table set out, the napkins folded mitrewise, the round water-

glasses, the sherry-glasses, the champagne ditto, and all in a space not so big as two pages of this Magazine. There is the Queen's own chamber at Windsor, her Majesty's piano, her royal writing-table, an escritoir with pigeon-holes, where the august papers are probably kept; and very curious, clever, and ugly all these pictures of furniture are too, and will be a model for the avoidance of upholsterers in coming ages.

Mr. John William Wright's sweet female figures must not be passed over; nor the pleasant Stothard-like drawings of his veteran namesake. The "Gipsies" of Mr. Oakley will also be looked at with pleasure; and this gentleman may be complimented as likely to rival the Richmonds and the Chalons "in another place," where may be seen a very good full-length portrait drawn by him.

The exhibition of the New Society of Water-colour Painters has grown to be quite as handsome and agreeable as that of its mamma, the old society in Pall Mall East. Those who remember the first ventures of this little band of painters, to whom the gates of the elder gallery were hopelessly shut, must be glad to see the progress the younger branch has made; and we have every reason to congratulate ourselves that instead of one pleasant exhibition annually, the amateur can recreate himself now with two. Many of the pictures here are of very great merit.

Mr. Warren's Egyptian pictures are clever, and only need to be agreeable where he takes a pretty subject, such as that of the "Egyptian Lady" (150); his work is pretty sure to be followed by that welcome little ticket of emerald green in the corner, which announces that a purchaser has made his appearance. But the eye is little interested by views of yellow deserts and sheikhs, and woolly-headed warriors with ugly wooden swords.

And yet mere taste, grace, and beauty, won't always succeed; witness Mr. Absalon's drawings, of which few—far too few—boast the green seal, and which are one and all of them charming. There is one in the first room from the "V-c-r of W-kef-ld" (we are determined not to write that name again), which is delightfully composed, and a fresh, happy picture of a country fête. "The Dartmoor Turf-gatherers" (87), is still better; the picture is full of air, grace, pretty drawing, and brilliant colour, and yet no green seal. "A Little Sulky;" "The Devonshire Cottage-door;" "The Widow on the Stile;" "The Stocking-knitter;" are all, too, excellent in their way, and bear the artist's *cachet* of gentle and amiable grace. But the drawings, in point of execution, do not go far enough; they are not sufficiently bright to attract the eyes of that great and respectable body of amateurs who love no end of cobalt, carmine, stippling, and plenty of emerald-green, and vermilion; they are not made out sufficiently in line to rank as pictures.

Behold how Mr. Corbould can work when he likes—how *he* can work you off the carmine stippling! In his large piece, "The Britons Deploring the Departure of the Romans," there is much very fine and extraordinary cleverness of pencil. Witness the draperies of the two women, which are painted with so much cleverness and beauty, that, indeed, one regrets that one of them has not got a little drapery more. The same tender regret pervades the bosom while looking at that of Joan of Arc, "while engaged in the servile offices of her situation as a menial at an inn, ruminating upon the distressing state of France." Her "servile situation" seems to be that of an ostler at the establishment in question, for she is leading down a couple of animals to drink; and as for "the distressing state of France," it ought not, surely, to affect such a fat little comfortable simple-looking undressed body. Bating the figure of Joan, who looks as pretty as a young lady out of the last novel, bating, I say, baiting Joan, who never rode horses, depend on't, in that genteel way, the picture is exceedingly skilful, and much better in colour than Mr. Corbould's former works.

Mr. Wehnert's great drawing is a failure, but an honourable defeat. It shews great power and mastery over the material with which he works. He has two pretty German figures in the fore-room: "The Innkeeper's Daughter" (38); and "Perdita and Florizel" (316). Perhaps

he is the author of the pretty arabesques with which the Society have this year ornamented their list of pictures; he has a German name, and *English* artists can have no need to be copying from the Dusseldorf's embellishments to decorate their catalogues.

Mr. Haghe's great drawing of the "Death of Zurbaran," is not interesting from any peculiar fineness of expression in the faces of the actors who figure in this gloomy scene; but it is largely and boldly painted, in deep sombre washes of colours, with none of the niggling prettinesses to which artists in water-colours seemed forced to resort in order to bring their pictures to a high state of finish. Here the figures and the draperies look as if they were laid down at once with a bold yet careful certainty of hand. The effect of the piece is very fine, the figures grandly grouped. Among all the water-colour painters we know of none who can wield the brush like Mr. Haghe, with his skill, his breadth, and his certainty.

Mr. Jenkins' beautiful female figure in the drawing called "Love" (123), must be mentioned with especial praise; it is charming in design, colour, and sentiment. An-other female figure, "The Girl at the Stile," by the same artist, has not equal finish, roundness, and completeness, but the same sentiment of tender grace and beauty.

Mr. Bright's landscape-drawings are exceedingly clever, but there is too much of the drawing-master in the handling, too much dash, skurry, sharp cleverness of execution. Him Mr. Jutsum follows with cleverness not quite equal, and mannerism still greater. After the performance of which the eye reposes gracefully upon some pleasant evening scenes by Mr. Duncan (3, 10); and the delightful "Shady Lane" of Mr. Youngman. Mr. Boys' pictures will be always looked at and admired for the skill and correctness of a hand which, in drawing, is not inferior to that of Canaletti.

As for Suffolk Street, that delicious retreat may or may not be still open. I have been there, but was frightened from the place by the sight of Haydon's Napoleon, with his vast head, his large body, and his little legs, staring out upon the Indigo sea, in a grass-green coat. Nervous people avoid that sight, and the Emperor remains in Suffolk Street as lonely as at St. Helena.

"The Art Exhibition
in Westminster Hall"

New Monthly Magazine 71 (August 1844), 549–57

THE ART EXHIBITION IN WESTMINSTER HALL.

Something to think on—shapes and sorceries—
Phantasmas dire—wracked thew and holocaust—
Spitfire and dragon—centaur, ghoul, and griffin—
Ho! THE MERRIE CRICKETT.

THE royal commissioners, who have had the management of this exhi-
bition, inform us that they have excluded certain works on account of
the inexperience they betrayed in the practice of fresco painting. It is a
grievous thing that they did not carry their prohibition one step further,
and exclude every work that betrayed hopeless ignorance of the com-
monest elements of art. We believe we are capable of generous emotions
towards the man who commits even the most disgraceful failure on
canvass—but these frescos! these cartoons and encaustics!—would that
they had impossible names to split the pen in the agony of transcription,
so that the ink might gush forth and blot them out for ever, to the eter-
nal confusion of the scared yet vigilant printer!

Oh! good and gullible Public, how happy and tranquil you look,
moving in gentle procession through that royal hall, with great pictures
on all sides of you, and a magnificent roof over head, of carved Irish oak,
while your faithful representatives are closeted in laborious committees at
one end, and English justice is sitting solemnly in the wainscot. Oh!
lively and credulous Public, whom it is a great joy to see thus bestowing
your pleasant leisure upon the hues and forms of art, do not suppose that
we are so ungrateful as not to rejoice at meeting you here—even here in
Westminster Hall, looking at sundry and various Canutes and Boadiceas,
who are glaring down upon you like so many Polyphemuses, from the draped
screen. We seldom meet, Oh Public; and now that you are permitted to
enter a grand national exhibition upon a flooring of the finest velvet,
prepared and laid down expressly for your own use; believe us, when we
say that we congratulate you and ourselves upon the event. It is a great
fact—a greater great fact than all the Leagues that ever agitated the
world. It is the first advance out of Cimmerian night into the broad
day of intellectual cultivation. You are almost blinded by the sudden
blaze, Oh Public. You rub your eyes, and laugh—and then, a big bright
drop tumbles out over the fringe, and you laugh again! Then you
hardly know what to do with your working-jacket—it looks so villanous,
you think! amidst the superfinery of your neighbours. No—you are
wrong, very wrong, dear Public—it is the noblest costume there! Move
on—gaze till you wink again with satiated wonder and delight—these
things are execrable, as you shall learn by and bye, in good time,
when our wise legislature shall have thrown open all public institutions
to you, and you shall have got a little practical knowledge—but in the
meanwhile enjoy yourself to the full! It is a holiday for you, these
ghastly unspeculative chalks, these dim stony frescos and bleary encaus-
tics. It is a fine galantie-show, happy Public—so give free vent to your
amazement and ecstasy, and return grin for grin to all the grisly slate-
faced monstrosities that look so horribly at you from the walls.

The finest thing in the Hall is to see this same easy-natured Public
creeping through with hesitating step, and that profound air of thought-

fulness, natural to it under new circumstances. Freize-coat and woollen jacket—paper-cap and fur-cap—spotted calico gowns and silk shawls—thin, frail, genteel gauze handkerchiefs on sunburnt shoulders—worsted mittens and dim black bonnets, all mixed up in "admired disorder." There is hope for Art in this ! What if the Exhibition be a collection of unmitigated trash ? *This* is the redeeming, hopeful feature—this patient interest which the people are beginning to take in art, this slow, but certain education which they are picking up from every new effort that is rightly and honestly directed to the cultivation of a sound national taste.

We are aware that allowances ought to be made for our artists, on the ground of the novelty of these styles. We are aware also that the theoretical spectator grants much larger allowances on this ground than the case demands. We are willing to grant all that, and more ; but unless we are prepared to admit that early attempts in fresco and encaustic painting (for it is not pretended that the cartoon presents any difficulty) must necessarily be made at the total expense of drawing, colouring, and expression, we cannot, by any imaginable sliding scale of allowances, account for the wholesale failure of the Exhibition. There are exceptions, which we shall notice ; but these exceptions dropped out, the rest belongs to that populous class of productions, which criticism abandons in despair of a definition, and which auctioneers and picture-dealers have long since felicitously grouped under the scientific term—*rubbish.*

The artist who can produce a successful picture in oils *ought* to succeed, after a single experiment, in fresco. There is no mystery in it, beyond that of decision. It admits of no re-touching, and each effect must be struck out at once. The moment the colour is laid on, it is seized and crystallised. This is the whole secret upon which so many elaborate apologies have been raised on behalf of our artists. All that is necessary, is to make a sketch, exactly drawn and coloured, and copy it mechanically on the mortar. But this process, simple and obvious as it is, has baffled nine-tenths of the persons who have as yet attempted fresco in this country.

It would be idle to waste time, however, over points so familiar to every practical painter ; therefore begging the Reader to accompany us into Westminster Hall, we will proceed at once to a closer examination of the actual contents of this remarkable exhibition.

There are, altogether, 183 items in the catalogue. Of these there are 84 paintings and cartoons. The rest consist of sculpture. For the sake of order, we will begin with the cartoons.

"Boadicea leading her troops against the Roman army"—No. 3—by Thomas Davidson, possesses the extensive merit of being upwards of eleven feet in height, and fourteen in width. This was a great surface to chalk—but the white face of Boadicea demanded space. The figure of the Queen is utterly out of drawing, and this monster defect, rearing itself in the middle of the scene, is rendered still more glaring by her majesty's singularly ghastly aspect. Mr. Ford Madox Brown takes up still greater room with "The Body of Harold brought to William the Conqueror after the Battle"—No. 7. This cartoon is thirteen feet by fifteen ! If that be not large enough for the genius of Mr. Ford Madox Brown, he cannot do better than apply to the proprietor of the Surrey Gardens for the use of his Titanic canvass. As to the body of Harold, it is no body at all, but

a bundle of empty clothes carried by some soldiers, who are making believe that it is mighty heavy. The violence and sputtering convulsions in the faces of the figures are preserved from being excessively funny by being excessively disgusting. The heads are not those of men but of baboons. " Adam and Eve"—No. 84—by the same grotesque pencil is an illustration of Milton after the manner of Cruikshank.

No. 15—by George Page—of more modest dimensions, is a " Group of Fallen Angels." One or two of these heads have some promise in them, but the drawing is indescribably bad. An enormous cartoon, by Douglas Guset—No. 30—" The Signing of Magna Charta," displays ambition in the conception, but is a perfect flat in execution. The figures have neither mind nor body—a heap of mere outlines. There is also an awful specimen by Martin—No. 39—"the Trial of Canute." This is one of his multitudinous pictures, rendered conspicuously frightful by the total absence of colour. How comes Mr. Martin to furnish the simple-lived Canute with a palace of such gigantic dimensions ? These Saxon colonnades stretching out to immensity, and these myriads of people, with tossing arms and straining eyeballs, are indispensable to Mr. Martin's notions of sublimity. This is his way of expressing passion and tragic power. He transfers the emotion of the scene, whatever it may be, into the buildings and the crowds, and forgets that amidst these huge masses of stone and draperies the subject is absolutely smothered. It would be impossible, without the help of the catalogue, to form the most remote speculation as to what was meant by this extraordinary concourse of figures ; and even with the catalogue one can hardly make out what it is all about, the principal figure being rendered perfectly insignificant by the surrounding concourse of men and women—and such men and women, too ! The human figure was always a terrible stumbling block to Mr. Martin ; but he never before produced such a huddle of humanity as the man in this cartoon with his head on his arm.

" The Death of Wat Tyler"—No. 47—by Stephanoff, is a bolder drawing than might have been expected from this artist ; but even in sober chalk, and Smithfield history, he fritters away his subject by the exquisite foppery of his details. This production wants all the sterling attributes of the cartoon—power, breadth, solidity. W. B. Spence— No. 61—gives us Wat Tyler in another phase of his life, with his associates rushing into the Tower in search of the tax-gatherer. Here is a gang of grim, half-starved wretches, with furious spasms in their throats and eyes, so miserable and wolfish in their looks as to make us pity the poor tax-gatherer should he fall into their clutches, although we do not hesitate to acknowledge that we have no compassion for tax-gatherers in general. Now all these horrible distortions of men might pass for subtlety in the artist, but for the poverty and scratchiness of the drawing which, if we had any doubts, would dispose of them at once.

Notwithstanding all that we have said, however, there are a few cartoons of real merit. " A Scene from the Tempest"—No. 21.—by Salter, is one of the best. The attitudes of Prospero and Miranda, looking out over the sea, with the monster Caliban scowling behind, are full of truth and character. The consciousness of power in Prospero is well preserved, and there is great delicacy and beauty in Miranda's head and bust ; but by a singular defect in the treatment the expression of the lower part of

her figure is so mean that it is impossible to reconcile it with the aristocratic grace of her features.

" Marguerite of Anjou and her Son, guided by an Outlawed Man"— No. 26—by J. West, is elaborately finished. The surfaces possess the delicacy and softness of enamel. But these are not the characteristics of the cartoon, which demands simplicity and a flowing hand. Finesse and minuteness of pencil are here wholly out of place, and have the effect of betraying want of power in the artist. The inevitable consequences are palpable in this drawing, which has no historical character whatever, which tells no story, and might as well apply to any one else as to Marguerite of Anjou. The composition is indistinct—the outlaw is a hundredfold too fine a gentleman for the circumstances in which he is placed—and the grouping is of the maudlin, tinsel, theatrical school.

" Ophelia"—No. 45—by Armitage, who obtained the first prize last year, ably sustains the great promise of the artist. It is the most poetical cartoon in the collection, full of beauty in sentiment, tone and treatment. The expression of Ophelia's face and figure relates the whole history, and the back-ground of drooping trees heightens the pathos with exquisite suggestiveness. They fall round her like a gush of tears. The only defect in the whole is in the drawing of the left arm, which is too short.

There is considerable talent in " the Throne of Intellect"—No. 52— by W. C. Thomas. The drawing is clever, and the imagination brought to bear upon the subject is rich and chaste. Perfect harmony of tone is preserved throughout. It is curious that an oil painting of the same subject, by the same artist—No. 55—will not bear comparison with the loftier power displayed in the cartoon.

" The Death of Thomas à Becket"—No. 64—by J. Cross, is a grand work of art, the numerous figures introduced upon the scene are vigorously conceived and admirably massed. The high and solemn courage embodied in the figure of Becket,—the subdued expression of the weeping monk beside him—the soldier in the back-ground with the uplifted battle-axe, are individually very fine, powerfully contrasted, and skilfully worked into the general composition. The head of the monk, who is arresting the arm of the soldier, is common-place rather than faulty, and the only positive defect in the whole is in the attitude of the soldier who is rushing upon Becket. No man could throw such energy into his right arm extended in this fierce way while his left leg was thrown back to such a distance. Let Mr. Cross try this attitude himself, and if he takes up a position in front of any gentleman who knows any thing of " the noble art of self-defence," he will soon find out his mistake.

Let us now turn to the Frescos.

" A Landscape and Figures"—No. 5—by A. Aglio, is an experiment to see how hot colours put on in absolute defiance of nature, would look in an arabesque border that very closely resembles a dim specimen of French paper-hanging. Mr. Bendixen's " Law and its Attributes"—No. 6— professes to exhibit a new method of painting adapted for walls, and invented by the artist. The effect is agreeable, but the artist deceives himself in supposing it to be his own invention. The means are the same as all the rest, depending, however, in their manipulation, on the taste of the artist. " Prayer"—No. 9—by J. C. Horsley is a pretty

head, deficient in strength. The head is placed against a still blue ground, in which there has evidently been an alteration, a piece of drapery which originally hung round the face being displaced. Mr. Horsley ought to know that frescos will not bear experiments of this kind with impunity. " Peace"—No. 63—by the same artist, is more successful. The tone is in excellent keeping with the subject ; the drapery of the figure fine, and the expression of the head beautiful. " Beatrice Cenci"—No. 20—by J. Z. Bell, is a deplorable failure—notwithstanding that it is the work of an artist who received a 200*l.* prize last year. There is some beauty of expression in the " Fair Rosamond" of Corbould— No. 12—The head and figure are good, and in spite of the flutter of details by which the *oneness* of the subject is scattered and confused, the conception is highly poetical. The colouring is sad and monotonous, diffusing a sense of desolation and hopelessness over the scene, in perfect keeping with the miserable story ; but, unfortunately, this very monotony injures the effect in the handling. The dreariness and pettiness of the accessories spoil what would otherwise have been a very striking production.

There is an " Act of Mercy"—No. 13—by Riviere, without a particle of thought or expression ;— a " Boadicea" — No. 18 — by Warren, thoroughly abominable ;—two heads—Nos. 16 and 17—by Jerome and Auber, which look exactly like copies from prints, a description which will apply with equal propriety to Nos. 20, 22, and 23, by Barker and Aglio, jun. There is also a great oil painting by Riviere—No. 25—remarkable only for its plagiarisms, the most outrageous of which are a boy from Raphael, and the head of a dog from Landseer. Mr. Riviere is certainly right, when he makes use of other men's ideas, to select the best.

There are many pieces which scarcely deserve special praise or censure. Such is the " Overthrow of the Druids"—No. 14—by Morris, a study in oil for fresco. There is merit in the conception, and nothing more. He has another piece, rather better—No. 19—" the Discovery of the Body of Harold." The three white tints in the centre are well managed, and the expression of Edith on discovering the body is not deficient in pathos. But the drawing is villanous—the body of Harold is too short, and the protrusion of Edith's right knee quite absurd. There is a "Wounded Greek"—No. 28—by Stephanoff, very pretty, and very like a water colour drawing, but, for a fresco, wanting boldness of treatment and strength of character. " The Combat"—No. 29—by Hancock, is a direful piece of inextricable confusion. Mr. Hancock's notions of colour are curious. Here he gives us saddle, mountain and sky exactly the same tint. " Peace"—No. 31—by Bendixen, very soft, but deficient in brilliancy. " The Meeting of Jacob and Rachel"—No. 53—by Cope, not equal to the expectation. excited by the name of the artist. The Rachel very beautiful, but that is all. There is no story, no action, all is dingy and indistinct. " The Death of Abel"—No. 56—by Claxton, a strange conglomeration, the principal result of which is to show the artist's ignorance of perspective. Compare the sheep's head on the altar with the figures in the foreground. Was Abel a brown man? The only thing worthy of approbation in this ill-drawn piece is the flying figure of Cain rushing wildly along the horizon. " The Building of Oxford University" —No. 59—by the same artist, is a higher effort, and less faulty both in

colouring and drawing. But it is florid without power or solidity—like a painting on gauze.

Of all the frescos in the collection the painting of " Sir Thomas More and his Daughter"—No. 60—by Hart, is the most vexatiously disappointing. At the first glance it looks like a great scene; a moment's examination satisfies you that it is deficient in every element of greatness. " Milton Dictating to his ¦Daughters"—No. 62—by Bridges, is a bold picture, in which the draperies are every thing, and the poetical humanities nothing. It is quite wonderful how completely out of drawing is every single articulation of this fresco. The artist surely must have proceeded consistently on some radically false principle to have succeeded so entirely in this uniformity of error. The knees of Milton's daughters are as fat as pillions—their shoulders narrow and mean. But we might make up our minds to deformities of that nature if the limbs of the ladies did not make such strange angles, and if the artist had not made one of them blind! Even the draperies, taking the false direction of the limbs beneath, are false themselves. They are brilliantly coloured, but fall into impossible folds.

" King John signing Magna Charta"—No. 68—by Parris, is a gorgeous piece of colour ; but it wants character. We miss in the king the air of a man who is doing a thing upon compulsion. " Bertha"—No. 73—by Bass, resembles nothing which we know of so closely as a badly painted glass window. There are other frescos which must be left to rot into the oblivion which unquestionably awaits sundry cartoons to which we have not even referred. But there are three or four frescos which we have not yet named, but in which the whole strength of the exhibition may be said to live.

At the head of these for magical effects of colour, for beauty and variety of execution and completeness of details, may be placed " The Knight"—No. 74—by Maclise. The silvery figure of the knight standing in the centre, while the armourer is finishing his equipment—the weeping posture of the lady at his side—the departure of the troop seen through an open window, where the thoughtful page stands mournfully enough, but with true loyalty, holding the bridle of the ready caparisoned horse—tell the whole story at once. But it grows more and more upon the spectator as he carefully examines the wonderful items of which the picture is composed—the colours so brilliant yet subdued, and the artful management of the light and shade. Amongst the points of minor artistical interest to which attention may be directed, are the rich crimson handle of the sword, standing out from the dark background, and the details of the knight's armour. It is curious amidst so much excellence of every kind to detect a palpable bit of false drawing—the left knee of the armourer. It is the only fault we can find with a work which, as a whole, is one of the most brilliant Maclise has yet produced. We are not entirely satisfied, however, that it can be fairly considered a legitimate fresco. The material is there certainly, but it is equally certain that the artist has, in a variety of places—such as all the spots of light on the armour—retouched the painting to bring out his effects with greater strength and brightness. These additional touches of paint have not entered into the lime and become part of the fresco by the process of crystallisation, and are consequently liable to be rubbed off;

nor can they be supposed, under any circumstances, to be capable of equal preservation with the solid colour on which they lie. If this be the case, the durability of this exquisite work is very doubtful.

Next to this in general merit, we are disposed to place "Loyalty"— No. 51—by Redgrave, the greatest work of the artist we have ever seen. The subject is that of "Catherine Douglas barring the door against the assassins of James I." In drawing, colour, and conception, this fresco is exceedingly clever. The head, perhaps, is not sufficiently intellectual, and the shadows from the face are too opaque; but the final expression is very grand and striking nevertheless, and the drapery is admirable. It is altogether a capital specimen of the capabilities of the art and the power of the artist.

Armitage supplies two frescos, totally different in character from all the rest, and not at all calculated to fix or captivate the eyes of our wondering public on their slow progress through the hall. But they are great works for all that, well worthy of being looked upon as models of the particular style they embody. These are a "Study"—No 48—and a "Bohemian Fortune Teller"—No. 49. They are merely heads, and look very coarse and heavy. But this is their distinctive merit. They are full of power,— massive, bold, energetic, and towering over the conventionalities of modern art. They remind us at once of the frescos of Paul Veronese, by the very breadth and vital energy of their execution. Mr. Armitage thoroughly understands his art, and seems as yet to be merely playing with the thunderbolts which he will hereafter wield with daring sublimity of hand.

Our artists seem to shrink from the mystery of encaustic painting. There are but two specimens in the collection : "A Sketch"—No. 7—by Brown—very dull and hazy; and the "Fates"—No. 46—by Armitage, a large and heavy production. It has been objected to this picture that it is too much in the style of the French school. Let us here venture to suggest that here this style is a signal merit. English art lacks the very characteristics which are so conspicuous in French art—distinctness of strength and tone—characteristics which are especially demanded in encaustic painting. We admit that we do not think highly of the conception of this picture. The "Fates" of Mr. Armitage are huge fat women, slumbering over their work, and deficient in the poetical feeling, the corded sinew, and weird aspect we look for in the "Sisters Three." But the tone of the picture is grand—the colours are massively disposed— the drawing is very clever—and the drapery faultless.

There is not another specimen of any kind on the walls of the Exhibition which is really worthy even of separate condemnation. To the sculpture then we must look for what remains of interest in the collection; and here, we are happy to say, there is scarcely occasion for a word of censure. We have no recollection of an exhibition of modern sculpture in London, containing so many specimens of first-rate excellence.

"St. George and the Dragon"—No. 93—by Hamilton and M'Carthy, is a noble study, very perfect in detail, and spirited in action. The group is boldly composed—and there is great power and life in dragon, horse, and rider. "Canute rebuking his Flatterers"—No. 98—by Lucas, is carefully conceived; and "Lilla preserving the life of Edwin by the sacrifice of his own"—No. 99—by the same artist, is a master-piece.

The action portrayed is very grand and energetic—perhaps a little deficient in the articulation of the energy in the legs; but the varied emotion of the three figures, and the fearful attitude in which they are entwined, are presented with wonderful force. The best view of this fine group is from the side, where the spectator catches in full the body and head of Lilla.

"The Earl of Marlborough"—No. 103—by Sibson, is curious for the elaboration of the details; as also his "Lord Bacon"—No. 104—with this difference, however, that in the former the frippery of lace and cord and tassel, help out the character of the man, while in the latter, they stifle it. It is well enough with Marlborough—but in Bacon the intellect ought to be paramount over the costume. Still we applaud Bacon's dress in the marble, as we would a highly-finished piece of needlework.

There is fine character in the "Eagle-slayer"—No. 106—by Bell, although we should be glad to see our sculptors depend rather more on their own resources than thus turning for ideas to the antique. "Milton dictating to his Daughters"—No. 108—by Woodington, is the best group on a subject which has produced several other similar groups in the Hall. The character of the poet is well expressed, and the heads of his amanuenses are exceedingly delicate. Lough has a gigantic mass of figures, called "The Mourners"—No. 129—in which a wife is represented discovering the lifeless body of her husband on a field of battle, with his charger standing over him. The horse is good, but there is too much violence and confusion in the rest of the group, the effect of the whole is perplexing. "A Falconer," by Carew—No. 136—is finely executed; but, like most of these subjects, it owes its principal merit to antiquity. It is a close imitation of the Apollo. The very next figure—No. 137 —"Richard Cœur de Lion planting the English standard on the walls of Acre," by Westmacott, affords a most suggestive contrast. Free, bold, and original, the composition of this figure is grand and flowing, owes nothing to the antique, and indicates the proper class of subjects, and mode of treatment to which our English artists should more frequently direct their attention. Lough delights in lofty groups that scale the skies. He too often mistakes height and size, for strength and grandeur. Here is a second most terrible piece of confusion, by which he proposes to represent "Edward I. creating a knight-banneret on the field of battle"—the fortunate man and his horse being both at the moment on the point of death. It is not alone that there are so many distracting details in this group, as to render it impossible for the spectator to embrace the whole subject in any convenient space of time usually assigned to such matters, but that the treatment of them is in some instances faulty, and in all exaggerated. The attitude in which the group is taken is not merely false, but impossible. The king could no more sit as he does here (under the special circumstances), than he could balance himself on the point of a needle. In addition to which the figure is totally destitute of interest. According to the action, as it presents itself to the eye, the king must have himself unhorsed the man he is about to knight. It is a sad jumble throughout.

"Richard I. of England"—No. 140—by James Wyatt, is a noble specimen of anatomy and composition. The horse is splendid—the blood of the creature seems almost to put it into motion. Some of the details, too, of the king are fine, especially the chain armour on his left arm. "A

Girl at Prayer"—No. 151—by Mac Dowell, ought not to be passed over; it is a most poetical conception. " A Youth at a Stream"—No. 155— and "Ino and the Infant Bacchus"—No. 156—both by Foley, are extremely meritorious. The "Youth" is very expressive and full of playfulness; but, if any fault is to be found, it is that he is deficient in the "wantonness" ascribed to him by the poet. "Ino and Bacchus" are effective and characteristic, and would have been still more so if Ino had not been rendered quite so serious. "Eve"—No. 165—by Marshall, is pretty. She is plucking the fruit and looking unutterable things!

We have not noticed all the sculpture that is worthy of notice, because we have the fear of all periodicals in our thoughts—the fear of exceeding our limits. But we may add generally that the sculpture nobly redeems the reputation of living art in this collection. For the rest, and to prevent the possibility of strangers and foreigners having an opportunity of ascertaining how ill some amongst us can paint, we would advise the commissioners to shut up this galantie-show with as little delay as possible— *or, to inform the people of foreign countries that only one or two of our distinguished artists have condescended to contribute to it.* One course the other is necessary to rescue us from the disgrace of having produced the worst Exhibition of cartoons and frescos that was ever got together in this or any other country, at any period in the history of the world.

J.B. Pyne

"The Nomenclature
of Pictorial Art.
Part VIII. — Style"

Art-Union 6 (September 1844), 284–85; 6 (October 1844), 305–06;
6 (December 1844), 348–50

THE NOMENCLATURE OF PICTORIAL ART.

By J. B. Pyne.

Part VIII.—Style.

The term style, and which is a very comprehensive one, is not here intended to be taken in that occasional and arbitrary sense of the word which implies a certain class of work, such as history, landscape, portraiture, &c.; but as comprehending the different modes of treatment, and particular character and impression, of which either class of subject may be susceptible; and as the same term is applied to different persons' general tone of speaking or writing, such as first, high, grand, and impressive; second, learned, imaginative, and elegant; third, close, compact, and literal; and fourth, little, mean, and quibbling.

These several styles are so closely analogous to those of painting that some of them may, with perfect propriety, be carried from the description of one art to that of the other, and convey a most correct impression of the general character of any particular work.

The first of these styles belongs—and not so much to the subjects themselves as to the mode of treating them—to the historical compositions of Michael Angelo and Raffaelle, and the landscapes of Nichola Poussin ; the second to the best works of Claude and of our own Turner ; the third to those of Terburg, Hobbema, and Ruysdael ; and the fourth and last, to the productions of the whole pigmy swarm of pettifogging " minutia-mongers " of the Dutch—particularly—and every other school: they are too numerous to recollect, and too insignificant to respect ; are the copiers rather than the imitators of nature ; and occupy about the same rank in Art as does the cheese-mite in natural history.

The highest province of style, and its most legitimate tendency, is to elevate and sublime ; and it would be a rather obvious question with some whether works at the lowest point of depression can be properly said to have any style ; but as tastes vary between the utmost purity and grossness, so style is acknowledged to include within its range, works of a grovelling as well as of a soaring character.

Man, while he may feel a very natural repugnance at the associateship, cannot deny to the idiot a place within the natural limits of his species ; therefore the low style in pictorial art, the doggerel in poetry, the hobbling and toddling dance of the Chinese, and the " Newgate Calendar " in literature, must be allowed to go hand in hand as co-representatives of the lowest possible state of their several arts.

The bare subject of a picture—when not involving the human passions, or the incidents in the histories of man—may be considered as addressing itself merely to the senses ; but style is capable of lifting it into the high regions of the imagination ; of creating passion and feeling out of things in themselves passionless ; and, through the legitimate operation of analogy and our sympathies, it wraps the sunny and genial landscape —equally with subjects from human life—within the warmest recesses of our hearts and our memories; which become purified and sublimed by a companionship with those high impressions, which radiate a work conceived under elevation of purpose, and consummated by high style. On the other hand, a defective and inappropriate style may degrade to worse than commonplace one of the grandest scenes in nature, or reduced to a melancholy ridicule and contempt, one of the sublimest passages in the history of man. Breughel and Brill, by the adoption of a mean style—at least in their second-rate pictures—have made themselves unworthily eminent by a desecration of fine natural scenery, for which they neither of them would appear to have had the slightest feeling, according to the critical voice of the present age ; although, at the time at which they painted, they enjoyed an extended reputation and high employment; neither of which had been accorded them if, instead of the sixteenth, they had worked in the nineteenth century. The works of the younger Nasmyth, Smith of Chichester, and Barret of the time of Wilson, *whenever a really fine scene form the subject,* fall under the same censure.

Our own cabinet-sized National Gallery contains numerous works in which the abasement of subject by style is eminently conspicuous ; perhaps in no one instance more so than the picture by Caravaggio, of ' Christ and his Disciples at Emaus,' unless it may be allowed to cede in humiliation and pictorial twaddle to West's ' Healing the Sick,' of the same collection.

Of this subject, as treated by Caravaggio, it were difficult to speak in terms sufficiently mild and dispassionate to avoid the charge of prejudice ; it is one for which the master was totally unfitted in temperament, and unequal in power ; and it unavoidably sunk and became desecrated under the coarse feeling and hard-handed style of a man who was, notwithstanding, capable of raising a common incident even beyond that point of excellence and interest attainable by a painter of double his calibre for dignity and sentiment of a more sublime cast.

The want of that action and diversity of character, which of themselves are capable of giving interest and effect to some lower subjects, renders this (the ' Last Supper'), and some others of quietude and dignity, inefficient in the hands of any but the most powerful ; and, while it would be difficult to think of any individual painter who could have treated the picture in question with less propriety of style, it would be equally hazardous to name one capable of raising it by high style to that position, short of which such subjects had better remain for ever unpainted.

The style of composition, character, and colour of Rubens, would have at once destroyed the melancholy grandeur and simple dignity of the scene. His gross and bulbous contours would have ill-suited the manly and muscular moulds of the apostles ; and the chances are, that his Christ would have had in it too much of royalty, and too little of divinity to suit the character of the man of many troubles and acquainted with grief, as well as the

Redeemer of the moral world. The admirers of the technical beauties into which colour and canvas are convertible had been, perhaps, thrown into ecstasies ; but the moralist and philosopher, with the man of matured high taste, had sighed over the perverted and misapplied powers of the most beautiful colourist in the world.

It is always pleasanter to have to notice great successes than to even allude to failures ; and a satisfaction to see a man of moderate powers shine in his proper sphere, rather than to witness the humiliation of a really great one, in going out of his own natural walk to fail.

Caravaggio's 'Locksmith,' in the Dulwich Gallery, may, therefore, be said to be as extraordinary an instance of consummate success, as the picture just noticed is one of signal failure. Here the coarse and impetuous Milanese had but to follow the torrent of his own rugged and eccentric genius, and, with a fine piece of racy and characteristic nature before him, to secure the happiest results.

This man's career—though a short one, for he died at about forty—forms one of the numerous instances which prove that a man's greatest chance of success lies in his following out steadily and resolutely the peculiar bent of his own inclination as to style, instead of falling in with that which may happen to be the vogue of the day, which may have to last but a few years longer, or be about to be relinquished by an ever-changeful public, immediately upon the appearance of the next powerfully-wielded style that may be introduced in anything like a matured state, by a strong hand and a strong head.

While upon this topic, it may not be entirely irrelevant to notice some few points that militate against this adoption and following out by the younger portion of the profession, of that one particular style for which they may be fitted by nature more than any other.

Much of the advice upon this head, which falls to the lot of a young man upon entering, and some time after he may follow the profession of a painter, savours too much of that inflation which characterizes the speeches at public dinners, and has the same unlucky effect of blowing up rather than feeding and sustaining the imagination. The grand style, the whole grand style, and nothing but the grand style, is preached by the artistical authorities, to the exclusion of everything else, as heresies to be eschewed ; while they, the advisers, tread in private the snug and profitable paths of the low styles, and smile at the thousand lightheaded Quixotes, who may be engaging as many windmills, thus ready made for their amusement.

If a young painter read, he is still in the same predicament. The writers upon Art have been mostly history and portrait painters ; and while the subject-matter has been, as a matter of course, history and portrait, it is hardly unfair to say that, in nine cases out of ten, they have seldom ceased to twaddle, except when they may have thought it time to rave. Landscape has, up to the present century, either remained untouched, as beneath the stilted pen of the grand-style men ; has been doubted the capability of being treated upon the same grand principles as history pictures ; or has been denounced as mean, paltry, and debased.

The happy consequence is, that the whole range of external nature—as coming within the rapidly-increasing powers of the landscape-painter—has been left to speak from out her sublime solitudes,

armed with the voice of Deity itself. The impressions derived by the painter of landscape have consequently come fresh from the ample volume of nature ; and if, amongst its votaries, no one have as yet been been found sufficiently inspired to ring out a merry peal to the laughing face of sunny May, or roll a solemn dirge for the falling year— if no one amongst the painters themselves have as yet felt equal to sing the intense sublimity of light, the varied fulness of living day, or the solemn stillness of the broad brown night—we have still escaped the twaddle of a school, the professors of which, from a duty rather than fresh impulse, may have been tempted to wheeze out some few small notes to the genius of landscape, and for the inspiration of its painters. The poet alone has done joyously that which the cold history-painter writer, in his mistaken policy, had refused ; while the radiant productions in landscape of the last half-century, have lit up a sunny corner in every man's heart, gemmed with recollections of God's brilliant creation, and unspotted with human passion or deformity : and this, in despite of a feigned contempt, an intentionally interested neglect, and an unfair, as well as unwise attempt at its degradation, by those who, holding the reins of Art in their own hands, have endeavoured to guide its patronage home to their own establishments only.

Beautiful as are the literary works of Sir Joshua Reynolds, cautious and courtly as they are ; he has not been able to withstand the opportunity they furnished him, of launching some most ungenerous and unphilosophic doubts against landscape-painting ; though it was left for the coarser but less subtle Barry to attempt the degradation of the landscape painter himself.

These are among the mistakes only of great men. Another of Reynolds's was certainly his advice on a "mode of study." This bears upon our immediate purpose ; and commencing with a display of the difficulty of giving advice on such a subject, ends by a proof of the difficulty in the advice given.

Its leading defect consists in a limitation of the range of styles proper for cultivation, and the erection of one—although the highest—as the only legitimate.

Its absurdity lies in the supposition, that a number of men, all differently constituted in point of temperament and power, should be capable of pursuing it with effect or advantage.

The great danger to be feared from its adoption would be, that we become—like a Continental neighbour—a nation of mediocre history painters, to the exclusion of the numerous walks in the art, all, more or less, ennobling to the passions and sentiments of that great portion of the diversified human race, who may by possibility sigh— and that most innocently—for something less than the sublimities of Michael Angelo, or the divine works of the milder Raffaelle.

That advice, on the contrary, which can have only the chance of utility to a young student upon entering life, is that which may be founded upon a close knowledge of his individual temperament, moral feeling, particular aspirations, and apparent amount of power ; and should proceed upon these grounds, whether he go to Rome for three years, or take an attic in Newman-street ; whether he fall back upon the pastoral quietude of the country, or—feeling that next to the instinctive love of

life is to be amongst the living—open his studio in one of the great arteries of the living and eternally pulsating Metropolis.

The true generic character of a youth's mind, if not that particular amount of power it be likely he may ultimately acquire, can be discerned; not so much from what he may have achieved in the schools of an academy, as from an examination of his private folios or desk at home, the habits and recreations of his leisure, with a library list of his favourite authors, and a hundred other individual peculiarities apparent to none but his closest associates.

There is in artistical temperament an idiosyncrasy, which in each particular form, instance, and amount, requires a distinct treatment, to ensure a *maximum*, ultimate, artistical development, and success; and although the advice generally given, may be the best poss ble to be followed by one constituted in every respect to become a painter of history, and that in "the grand style," yet, to any one else, it is as a false light held up by marauders on a seashore, by which a noble ship may be wrecked and plundered, as an artist may be of a success, and happiness, and utility to the world in the practice of a still noble, though more humble walk of Art, of which he may form the head.

"Man cannot live by bread alone;" and the mental appetite, which requires for its occasional refreshment works in the humble walks, may be in a more healthy state than that which can digest only those in the highest: the mental as well as the animal of our species is omnivorous, requiring nothing in its necessarily varied food, but that it be good of its sort.

As nature is infinite, so is there room for an infinity of styles; and those of a distinct, generic, and nervous propriety and character, at once derivable from, attributable to, and comparable with the select and admirable in nature, are the sustaining elements upon which true taste delights, and from which it derives its vitality, refreshes its forces, and, ultimately maturing, learns almost instinctively to refuse the mixed, merely technical, and consequently incongruous productions of those whose hands only have been cultivated, to the neglect of their heads: and who, having in themselves no very forward impulse or capacity for any style, are ready to execute, at the commissioned suggestions of a patron, works in any walk of Art, and in any style, from the grand downwards.

The division of labour, which is now in this country entertained no less as a feeling than as a principle, has worked its miracles in nearly all the productive arts; and, by following it out in painting as well as the inferior arts, an ascendancy can only be gained, or, once gained, securely kept. As well may it be expected to make a breach in an enemy's wall, by dispersing shot over its entire surface, as that consummate and accomplished Art may be realized by directing the energies of a painter, though of ever so huge a calibre, upon the whole and varied face of Art.

This may sound puerile and illiberal to those who preach the potency of intellect and its infinite extensibility, with the omnipotence of genius, and the many other most comfortable notions, the frothy though high-sounding emanations of our still more huge egotism; but it is more consistent to imagine, if ever perfect Art be attained, that it will result from a well-directed concentration upon some one style, of the whole gathered resources of

some powerful mind; and, if Art is more difficult than some other things, the greater necessity may there be for this concentration of a painter's powers.

Coming back to the different distinct species of style, and their value upon different classes of subjects, in the hands of the painter, it is easy to imagine that there may be by possibility some scenes in nature even beyond the grasp of Art; but there does not exist one coming within its proper acknowledged range, that may not have its true character, either of simplicity, beauty, or grandeur, augmented and stamped more unequivocally upon the imagination by style; and still more so with human incidents and human passions. Style is capable of adding all the possible augmentation of interest and vivid impression of which a catastrophe is susceptible.

Style, like treatment in painting, is involved in and rises out of the disposition or general ordinance of every power incidental to the Art.

It commences with conception; is conspicuous in design, drawing, invention, expression, composition, light and shade, and colouring; it is augmented by even execution, and greatly affected by situation and circumstance, its highest accomplishment resulting in dignity and full and correct passion.

Nothing short of the most profound study of nature, in its mind, matter, and movement, and that by an intellect ever prone to so inexhaustible a theme for research, can give a power over the subtleties, beauties, and sublimities of style—subtle in the genial and cheering landscape and the best familiar life scenes of the Dutch and the English; beautiful in the landscapes of Claude, the histories of Raffaelle, and more especially in the classical sculptures of the ancients; and sublime in the landscapes of N. Poussin, and the terrible and grand scriptural creations of the lofty Florentine.

THE three great distinctive styles, and of which it were easy to name examples, would appear to be the simple, the beautiful, and the grand. Beyond the extreme verge of this, may be placed the sublime, and of that, the coarse, low, or puerile.

The beautiful thus stands midway amongst the three styles, trenched upon by grandeur upon the one hand, and by simplicity on the other; far into both which styles it occasionally carries its influence, without losing much of its own character. The instances, therefore, of comparative beauty are numerous. Not so, however, with the terrible sublime. Placed at the extreme verge of high excellence, it may be entered by the grand on one hand only; there is nothing beyond to affect it. And, independently of the difficulty of its achievement, there are few minds capable of its conception; hence partly the cause of its rareness: for a man in attempting the sublime may fall beneath the grand, and so on downwards through the whole scale of style, more readily than ascend it through accident, as it is more likely that one may fall down a precipice than fall up even a ladder.

The legitimate province of a high style in painting, like that of the drama, is to give, in its fullest tone and vigour, a picture of the possible, pure, and abstract passion of a scene or an individual, rather than that amount of apparent passion which may have accompanied the actual occurrence; for some

of the finest points in history, if given on the
stage or the canvas, as they may have been ac-
tually performed by the original actors, with no
other accompaniments for their embellishment
than the commonplaces of actual season and cir-
cumstance attending them, may make but sorry
subjects for the painter, and anything but pleasing
or exciting representations for the imagination.

The moral intercourse of man follows the same
direction when passion or feeling forms the im-
pulse; and, to descend to the every-day business
of life, a written effusion of gratitude warms in
proportion to the distance between the object and
the writer, and very naturally and properly would
be likely to beggar any verbal acknowledgment
for an act of common liberality, or one resulting
from the strongest affection. It is not the less
sincere because the more ardently expressed, but
on the contrary.

A lover before his mistress is proverbially mute:
if otherwise, the depth of his affection may be
doubted, as leaving him sufficient self-possession
to be eloquent; while his written effusions are as
proverbially warm; breathing the depth and inten-
sity no less than the sincerity of his feeling.

This depth, and intensity, and sincerity, form,
when applied to the general passions by the painter,
the sublime and all-absorbing truth of a high style.
The difficulty of its study increases with the pro-
gress of society; and its value in Art naturally
increases with its rarity. The passions of man
become locked up by education, and the strong
curb of the *nil admiranda* augments his power of
controlling the expression of them. The civilized
diplomatist erects himself into an animated post;
and the chief of savage life either paints or tattoos
the face into a living enigma; and both for the
same purpose—that of deceiving his fellow man,
and defying him to fathom the actual workings of
his mind; a state of things which leaves the pain-
ter of abstract passion comparatively in the dark.

The child alone—with some few instances in more
impulsive and natural woman—remains for the
study of the painter; and although the grander
expressions, if left to nature, may be expected to
develop themselves more fully in maturity, yet
one seldom or ever meets in manhood with the
pure and unalloyed majesty of an infant's frown,
or the inspiring and joyous abandonment of its
full-blown laugh. To express the perfect repose
of sleep seems the almost exclusive privilege of in-
fancy and childhood, compared with which the
slumbers of manhood are a drowsy thraldom,
rather than that still and calm mean state between
life and death; that debatable ground upon which
all animate nature meets to avert the one and se-
cure the other; not the actual point of repose,
but a struggle round about it; and the oscillations
over which carry the would-be sleeper and dreamer
far into that sphere of emotion and muscular
movement which may be called waking. An indi-
vidual, therefore, of strong and prompt impulse, is,
to a painter, an object of the highest interest, an
intimacy with which can hardly be cultivated at
too high a price.

As there has been much division of opinion and
consequent controversy on the particular manner
of work or execution, degree of finish, and chro-
matic ornament necessary or admissible, in a really
great style of painting; it may be interesting, if
not useful, to examine a little further into such a
question (for question it remains), in an article on
style.

It may be best—as a ground for argument—to
take the two extremes of high and low style; as,
should those be taken which approximate them
only, doubts may the more readily creep in, and
opinions obtain, which (having in them a degree
only of the erroneous, with beauty to recommend
them) may be difficult to shake off. For we daily
bow to what is not wholly and radically wrong,
much in the same manner as man may be daily
tempted to indulge in what is only hurtful, while
he would at once revolt at a deadly poison.

It may be readily conceived that what the world
generally looks upon as high finish, beautiful
colour, splendid effects of chiaroscuro, and dexte-
rous execution, are as inadmissible in the highest
style, as they are most assuredly the qualities
which alone constitute the value of works in the
lowest; and the suggestion as naturally arises,
that what forms the very aliment of the one,
without which it cannot exist, and upon which it
grounds its only claims on the admiration, cannot
become the proper constituent of the other.

As so few painters have produced what is essen-
tially of the very highest order, it would be con-
summate presumption to attempt laying down an
only road to so high an end; and the charge of
such presumption I do not intend to incur; but
the task of discovering, first, what does not lead to
it, and afterwards that which may militate against
it, is comparatively easy; and many may be found
with powers peculiarly fitted for such a purpose,
could these powers be directed into the proper
channel for the inquiry.

To commence, therefore, let us for a moment
imagine before us a first-rate picture of still-life,
as the representative of the lowest acknowledged
walk in painting.

It is exquisitely composed as to the arrangement
of lines, and general disposition of objects; the
colour is deep, rich, transparent, and luminous: a
picture of gems, it glows the gem of still-life pictures.

The whole world has been ransacked, if not
plundered, to contribute its material glories.
Crowns torn from the brows of kings radiate its
centre, and the crystal vase rises up in classic ele-
gance from the polished and clear shadows of its
background. The light of pearly sky shoots
athwart the group, and meets the pearls of earth,
the pearls of price; while suns and constellations
of diamonds flash their pure light through this
heaven of gems.

What is the result? The eye is charmed, but
the imagination not only slumbers, but refuses to
be awakened; the passions remain still as the dark
waters of a well,—they do not even vibrate. The
eye and curiosity are alone at work; every inch of
the canvas is pored over with a quiet delight, and
the single flaw or imperfection in the imitation,
which would be sufficient to break the weak charm,
is undiscoverable.

We leave, then, without much regret, the inno-
cent sensualities of the low style, and come to a
work which may represent the interests of the
higher.

The one chosen is a picture of another order,
from out which the profoundly intense and severe
gaze of the Founder of the Universe rests upon
you, as conceived by one of His master spirits. It
is the ' Logos of Da Vinci!'*

* This extraordinary work, before which none can
remain unaffected, and many quail, is lately engraved
(in small), and is in the possession of Philip John Miles,
Esq., near Bristol, from whose possession an attempt

What is the result of a communion with this picture, as compared with the first?

The mind, at first, is slightly disposed to cower before the darkened splendour of its lofty and divine expression. The whole imagination is filled; the faculties are absorbed in the sublimity of the work. The upraised hand of the Deity, which is of an almost unapproachable grandeur of form, would command the stillest attention of itself.

In the state of mind, then, raised by a contemplation of this great work, the eye and the curiosity have no leisure to search for finish; the beauties of colour, of execution, and light and shade, with their fascinating inthralment, are not there; and if they were, would be felt as misapplied, impertinent, and obtrusive, while full floods of the sublimest image are pouring into the mind a solemn torrent of absorbing and high sensation.

It is barely possible, that altogether a finer instance may have been selected to represent the great or high style, as this is a picture of a single figure only, and that reaching but to the middle; but sufficient has been perhaps shown by it to prove, that exciting an interest so much superior to, while possessing none of the qualities forming the value of the first work, it does not depend on them for its effect. The next inference to be drawn is, that, filling the imagination to repletion without them, they would be useless, if not worse than useless, as no faculty is left sufficiently disengaged for their appreciation. And if it be for a moment suggested, that such a work may as well have added to it the purely ornamental qualities, for the pleasures of persons unable to enjoy those of the higher order, the answer may be, that there are other works to an infinite number of a purely ornamental character, which extend from the lower walks, upwards, to within half way towards the highest, to which such ornamental attributes are natural and appropriate; and to which works it were judicious to confine them, rather than desecrate the sacred region of the sublime, for a class—a small class I hope—of persons, who are only to be tickled into admiration by dexterous finish, sensually rich colour, flippant execution, and a high varnish.

One of the strongest arguments perhaps for the omission—in works of a high style—of what is purely ornamental, rises out of the fact, that while the mind is sublimed by high passion, it is not distinctly conscious of anything but what immediately causes it. This is universally the case, and is limited only by the various character and power of the minds operated on. Thus, a weak mind would be thrown into a state of admiration by less materials than would a strong one; and that which would produce the feeling of sublimity on one mind, may fail to produce the same impression on another of a higher courage and firmness. So much is this the case, that the *nil admiranda* is cultivated, as a mode of exhibiting an artificial high mind, and high courage.

The aristocracy of savage life cultivates the same power, along with an indifference to bodily pain; and to no other circumstance may be attributed the perfect self-possession and absence of all excitement, displayed by some savage chiefs, who some years since were introduced here, to the wonders of a civilized metropolis.

was made to remove it by the offer of an enormous sum, though not a too large one, by Napoleon Bonaparte.

As has been said before, the mind, when sublimed by high passion, is not distinctly conscious of anything but that which immediately produces it; and when this feeling is carried to excess, so that the capacity of the mind is more than filled, it, as it may be said, overruns, and exhibits delirium, terror, or ecstasy of some character or other, and does not in that state see distinctly or connectedly those things which at first produced such feelings.

This latter and maximised state of feeling can never be expected to be produced by any work of Art, or it would furnish grounds—though slight ones —for a decided absence of all the ornamental qualities in works of high pretension. The first state of the mind is, on the contrary, frequently experienced before works of a very lofty order,—a state in which it is barely conscious of anything but what is immediately productive of its temporary elevation.

From this view of the case it may, on a superficial examination, appear barely warrantable to slight the *accessories* of a picture in the high style, but could not possibly apply to the *principal actors and objects in any work*, though some writers of authority have condemned finish when carried out of the lower and ornamental styles, have maintained the propriety of sacrificing the finish and identity of everything but the principal objects in a work, and have preached breadth of *manner* as conducive, at least, to elevation of style.

It may be safely said, in answer to this, that the elevated feeling already alluded to can only be raised—and that very rarely—by the utmost completion being given to those objects intended to raise it; and, fortunately for this side of the argument, we have numerous examples of this straightforward and consistent completion and finish in most of the highest works that have descended to us: witness those that are near us, of Da Vinci, Raffaelle, Piombo, and others, in which appear the most consummate care and elaboration, not only in the principal objects, but carried through the most trifling accessories, as well as the skies and backgrounds.

It would appear that the great error most manifest in those works which may be said to only border on greatness, is not the finish, but the introduction of those passages which, if finished, militate against the sentiment of a work, or, unfinished, mars the consistent unity and completeness of the whole, and, in a great measure, dissipates that voluntary illusion which we feel inclined to favour rather than repress, when contemplating a first-rate production.

What more than this should put an end to the infinity of argument as to the *degree* of finish or *uniformity* of finish in high style, is the circumstance, that an object once introduced can never be so slighted as to keep it from the eye; it can never be either finished or unfinished out of a picture; and the time and talent wasted on such arguments, and an endeavour to carry them out in practice—by trifling and temporising with a fine subject—could be much more profitably employed if devoted to an inquiry as to what to select for, and what discard from any particular composition.

After a work is cleared of everything which may not be immediately connected with the complete development of the incident, and necessary to the augmentation of its general character and passion, it would be a matter of very great delicacy to limit its finish, though very easy to assume a point far-

ther than which negligence might not with propriety be carried.

Vagueness in painting, as in speaking and writing, will always be taken as a sure indication of a want of knowledge of, and a power over the subject; and with painting, in particular, nothing can be expected to strike the imagination forcibly unless pronounced firmly.

In some subjects gloom may be required, in others mystery and confusion; but if their production be not accompanied with the necessary finish, and apparent perfect knowledge of their parts, the result will generally be attributed to vacillation, indecision, and weakness in the painter, rather than evidence of that "judicious sacrifice" of accessories to principals, held by some to favour a high style; a matter about which the public knows little, and cares less; a subject the propriety and utility of which the best connoisseurs have but unwillingly admitted, and never highly appreciated; and a fragile and inefficient machinery, which the first-rate painter has never condescended to employ in works of magnitude; and which was intended, and has since been found, to carry its irresistible impressions home to the imagination of man, instead of the minds of some few lovers of eccentric mannerism and dexterity.

A landscape or marine painter, while his mind may be scudding through the torn and scattered drift of the storm sky, or revelling and panting amongst the high and sunny cirrus of our upper heavens,—skirting the foggy shore, or reeling over the mad and living surges of the heaving deep,—may feel such things to be pictorially impossible, without a very large license for vague and indefinite painting : a license oftener taken by the painter than granted by the patron, used more as a sorry refuge for weakness than acknowledged as an exhibition of strength, and adopted generally under the sanction of a mistaken application of the phrase, " judicious sacrifice."

To wind up these remarks upon finish, as conducive to or destructive of high style, it may be tolerably safe to conclude, that no degree of finish—if by finish be meant completeness—can injure it; but that affected mannerism, flippancy, littleness, and executive finesse may.

Indeed, these latter qualities are in most cases used to disguise the want of completeness, and are more valued by the shallow lover of Art than the consummate connoisseur, who, upon their exhibition in a work of any pretension, is at once disposed to question its apparent excellence, feeling them to be nearly incompatible with high Art.

An examination of the slight and finished works of Teniers—though certainly not even savouring of high style—may in some measure prove the incompatibility of extreme dexterity and extreme completeness.

It must be at once felt, therefore, in calling to mind the works of this painter, that the slightest of them possess the most of that off-hand flippant touch, and dexterous manner, which so distinguish them from those of every other master; and that those qualities leave them in the exact proportion as they become more finished, until at their maximum of completeness they are not distinguishable *by these qualities alone* from the pictures of other men.

LANDSCAPE, like all the other walks in painting, has its several distinct styles—the lowest admissible one the SIMPLE ; the medial one the BEAUTIFUL ; and the highest the SUBLIME. All below the first is unacknowledged and valueless ; and anything above the last has never been attained, nor, from the nature of things, ever will.

Beyond the sublime, in the range of feelings to which the mind of man is susceptible, lies the dread region of the terrible. It is created by the real alone, and nothing short of the actual in nature can produce it, even for a moment.

It will be acknowledged at once that, of all modes of rendering an imitation of an event, the stage possesses the greatest power. It has the advantage of uniting the concentrated capabilities of painting, poetry, and music. Instead of being limited, like painting, to the representation of one moment of time, and those incidents, out of the many, which took place only in such moment, the mind is prepared by a continued run of events for the development of some grand burst of tragedy—the poetry uttered by the choicest language of passion, the picture formed of living man, under the highest emotion, and relieved upon a background of music, rushing in harmonious surges, or gliding through thrilling melodies from one appropriate and sustaining character of pathos to another, as the subject may demand. Yet, with all this, though the terrible may be represented, the emotion is not conveyed to the mind of the spectator. The actor himself cannot feel terror and act. And, if any amount of feeling beyond the sublime could be communicated to the mind of an audience, all would be wild emotion—all would be in a state of terror.

I have seen in the course of my life two or three persons leave a theatre under considerable excitement ; and have known some others make a promise never to go into one again to see a tragedy ; but never witnessed one instance of simple terror.

Far less, then, can a picture, a poem, or a piece of sculpture excite the dread emotion. It is fortunate that, while this emotion is incompatible with imitation, it is not one of the objects of Art. To wish for the power of producing it would be parallel with the wish of the landscape-painter for a white which should be equal to sunlight. Grant both, and we should have our feelings harrowed by some pictures, and our eyes blinded by others, while it would involve the destruction of Art itself.

Amongst a number of men, however, who would sacrifice the whole of a life to the pursuit of an art, it is not strange that some may overrate its capabilities, and challenge for it powers not only of an extraordinary character, which it may have, but such as are incompatible with Art itself, and which it would be unfortunate if Art could possess.

It may be imagined by some that this limiting of the province of Art, and cutting down its imagined proportions, is unamiable ; and mischievous, as abating the high artistic aspirations of those who may be only able to hit one object, by aiming at another ; as a person may, by throwing stones at the moon, be able ultimately to hit the church weathercock. But is it not rather useful to at once dissipate an absurdity, and go straightforward to that which, though rarely attained, is attainable ? It may be urged, notwithstanding, that by attempting the terrible you may hit the sublime ; but it is more consonant with experience to imagine that by such a process it is the sublime allies itself so frequently with the ridiculous, and the too ardent mind with failure.

Much of the misconception as to what may be done in painting proceeds directly from what is asserted to have been done by some of the old painters: their fine gold has been gilded by the writers on Art and the holders of pictures.

It would appear, that when a picture is once set down or rather set up to be praised, every successive writer has thought it his duty and interest to transcend either in matter or words, or both, whatever may have been said before upon the same subject, until you may imagine the poor picture, though a good one, blushing under its undue weight of clumsy laudation. Much in the same manner, and with equally respectable motives, a London brewer writes up XX ale; a second makes the same article XXX; and a third, in order to transcend his competitors, writes XXXX: so that, unless brewers have a much higher scale of morals than ours, we may expect in the course of a short time to see a huge sign-board filled with X's, and at the bottom, " Ale."

It is frequent that one sees this twenty-X style of criticism applied to pictures, which are described as realizing the terrible, to be in a " terrible gusto," &c.; and a young painter, feeling that such a description has remained for a few centuries uncontradicted, deferentially puts it down as true, and then goes to work on the terrible principle. Much safer are those who, commencing with the simple and gentler emotions which they may really feel and appreciate in early life, put off the grander attempts until an acquaintance with the sublimer passions — only to be acquired after maturity, through, perhaps, adversity and intense study— shall fit them for graver and more weighty themes.

The first, or lowest, recognisable style of landscape—and the production of works lower than which would not entitle the producer to the title of painter—is the simple. This country, more than any other at the present time, abounds in painters of this class: produced partly from an innate love of landscape, common to Englishmen, and partly from the particular character of that class of persons who are the picture buyers of the present age.

The English, as a nation, are also a portrait-loving people. Immediately a man emerges into position and consequence, he has his portrait painted, then that of his wife, and afterwards perhaps—if not too numerous—those of his children. To this amiable disposition, and the existence of the portrait-painters, are we indebted for the first germ of a taste towards painting in many, and afterwards liberal patrons of the Fine Arts. His next act of encouragement to the painter is to commission a portrait of his horse, then his dogs, and perchance a favourite old servant. When this last takes place, and long before the inspired painter of history or poetry is employed, comes the turn of the landscape-painter, who is commissioned for a portrait of the house, with a bran new front, smooth lawn, salmon-coloured walks, and laurel trees. Should not the love of pictures and picture-frames stop here, the landscape-painter is employed again : there is a portrait of a favourite fishing spot to be done, with this never-failing injunction : " No storms, young gentlemen ; none of your sunsets or sunrises, or scarlet skies, Mr. Painter ; indeed, no nonsense of any sort ; but a true picture of the place, with the little bit of worn grass in front, as it will bring poetical associations into my mind." With this description of employment, it will not be wondered at that so few landscape-painters ever go beyond the simple, nor that so many even stop short of that point : for the road to grand landscape is of vast extent, and barren of profit until the end be reached ; while the lower styles furnish provender to the mere colt in Art, as the lower animals are furnished with legs as soon as born.

The chief constituents of the simple, in landscape, are an atmosphere, with its gentler phenomena ; effects varying between quietude and briskness ; correct harmony of colour, with no discords or oppositions for the sake of effect, as they would destroy simplicity and produce a mixed work ; select but not very elegant forms ; and altogether conducted with an unobtrusive but straightforward execution, and such as will admit of the naturalness and peculiar character of objects, without descending to that over-minuteness which, accompanying even a moderate number of parts, detracts from simplicity, and is seldom obtained but at the sacrifice of some other and more important points of naturalness, upon which simplicity depends.

A work possessing this character may strike some as being no very GREAT achievement, nor would it ; but it might be justly described as " broad, clear, simple, and natural," which is no mean praise, and could not be challenged for many works out of a hundred of any nation of painters in existence.

The simple should not aim at too much point ; nor is it intended to stir up emotion beyond a pleasant satisfaction, and a quiet delight. It may be not inappropriately described as the smile of Art, which would be at once put to flight by its broad laugh, its frown, or its tempest of emotion.

In drawing an estimate of one's own works, or those of others whether living or dead, whether by some esteemed master or one perfectly unknown, it should always be borne distinctly in mind, that any productions in landscape which may fall short of this power of raising in the human mind those first gentle emanations of feeling, those first trillings of emotion which constitute delight, must remain in the same rank with still-life paintings, more than which they are not. No elaboration or detail, no polish of surface or textual dislocation and ruggedness, can lift it from the low sphere to which its want of purpose had condemned it. On the contrary : the more minute, the more would it approximate that kind of art necessary to the embellishment of a work on natural history or botany, and with which a " figured" tulip or daisy, on a white paper background, would challenge an equal value, while its utility may be even greater.

It is too often lost sight of that there are as many sorts of naturalness as there are expressions to be worked out of landscape nature; and which form its different styles. The first is the naturalness of detail, with which and to which the greater part of the public confound and refer all naturalness. It is the necessary and first study of the pupil, and can never with safety be lost sight of, any more than the finished and passionate writer, in the higher styles of his art, can throw overboard the rules of orthography, with which it admits a very close analogy. There is the naturalness of forms, as contributing to certain expressions or movements of the mind, quite apart from those accidental or general forms which may attach to particular and individual objects as well as species; so that one may readily acknowledge that, for some particular picture *of a certain expression*, there may be one particular form of object more appropriate than any other ; and that any other form, to be introduced in lieu of it, might weaken by so much such certain expression of the picture, and the *naturalness* of such expression.

It is equally the same with colour; though its diffusion over the whole surface of a picture, its being the first thing seen on approaching a work, and its more generally appreciated blandishments, would tempt one to say, that with colour it is still more the case than with light and shade, which, however, contributes, by its capability of communicating expression, as much as the other constituents of accomplished Art.

They all add to or take from the general impression, according as they are judiciously or injudiciously managed; and that work must inevitably strike the most complete and heaviest blow, to the single expression of which every minute part is made to administer, just as much so as that a sober man, with a straightforward and undeviating step, will be sure to achieve a greater distance on any given road than a drunken one, who pays more than occasional visits, first to one side and then to the other.

If the addition, then, of expression, even in its first stages, is necessary to elevate " Furniture Art" into " Fine Art;" and if expression, or if that which in a picture of landscape will dispose the mind to emotion, is only a higher kind of naturalness, any thing in Art below the simple is a grovelling below nature, and not a struggle with it; a wallowing in the ditches of creation, from which one's works rise repulsive and debased.

No. 61 in our National Gallery, by Claude, and called a small landscape with figures, is a perfect instance of the simple. In figure No. 23, in the same collection, by Coreggio (Antonio Allegri), putting aside the title of the picture, would be a most consummate instance of the simple. Many of Wilson's finest pictures are to be attributed to this style; though the two large ones in this gallery are of a different and higher order, particularly that known as ' The Niobe.' The head of ' A Laughing Girl,' in the Dulwich Gallery, by Murillo, presents another fine instance.

Between the simple and the beautiful, as styles, there exists a broad line of demarcation; and though the first addresses itself to, and wins the suffrage of, the greater number of tastes, the production of the latter has been, and perhaps ever will be, considered by many the greatest triumph of Art.

Amongst the ancients, and of whose works the least perishable—those of sculpture—have only descended to us in any thing like a perfect state, this style would seem to have been almost exclusively attempted: with the occasionally grand their limits are marked. The sublimities are conjectural, and raised only under the incessant patter of the critics, to whom we have bowed consent without feeling conviction, for quietness' sake only. The grandest head of the ancients veils itself before the intensity of gaze and omnipotent expression of ' The Logos' of Da Vinci.

Perfect structural form, mental capacity, and high moral expression, seem to mark the constituents of the beautiful in Fine Art.

Sentiment varying between the tranquil and gay, within a lower scale of naturalness, constitutes the simple.

Power and passion support the sublime.

Claude, amongst deceased landscape-painters, claims more than any other the power of creating the beautiful. It is the great essential of his style. Most of even his worst works have in them something of this fine feeling. He would appear to have been impressed with that state of nature alone which constitutes it, and only to have missed it in his early pictures, or his unfortunate or overcast moments. He never touched upon the verge of the vulgar; descended merely as an amusement to the simple; and never by any accident or even struggle reached the grand. Whenever the term " grand landscape," or " sublime landscape by Claude," occurs in Fine-Art writers, one may feel assured that it refers to a large picture, or that it is a piece of the twenty-X style of writing, or both one and the other.

The utmost degree of richness and fulness of harmony in colour, composition, and chiaro'scuro, are compatible with, though they do not necessarily constitute of themselves, the beautiful. It is easily conceivable that they would interrupt the production of the simple, and weaken the grand and sublime.

It is that perfectly full, sustained, and beautiful harmony in colour — that picturesqueness and flowing character in the general composition— that bland light and shade, and a too elegant intention in the design of the single figures—all contributing to, and of right belonging to, the beautiful, which prevents so many of the extraordinary productions of Rubens from reaching the grand. There is in them too little of weight and sedateness for the grand, and too much of the gorgeous for the simple. It may be said of most of them, in addition, that their beauty becomes equivocal from their grossness.

Estimating them by their colour alone, against which nearly every other quality is at war, they may be said to vie with, if not to transcend, every thing ever thrown by genius before the throne of Art.

To the pictures of Murillo, where the subjects demand a style of grandeur or sublimity, much of the same objections equally applies. His colouring in them is mostly beautiful; and his characters peasant-like, and would have better suited the low-simple. Whenever grandeur is at all successfully attempted, it is by merely increasing the darks; in which instances—unlike those by Rembrandt—his otherwise beautiful colour becomes deteriorated.

The picture No. 13 in the National Gallery, is a melancholy instance of the first position; and No. 176, ' St. John,' of the last.

Some of Cuyp's best works may be cited as successful instances of the low beautiful, as Claude's have been of the high, though we have none in public to refer to.

If there is a broad line of demarcation between the simple and the beautiful, there is a still broader one between the beautiful and sublime.

It would appear that in Art, as in the physical world, the greatest heights are attainable only through the form of the cone; and that not only are there few amongst us so constituted as to be able to reach the greatest elevations, but that at such altitudes there is room but for the few.

Had Da Vinci endured he might perhaps have occupied that enviable point alone; as it is, he shares it with but few, and, unchallenged, sustains his position by fewer works than any of his fellows.

His one picture, which in the whole world of Art stands peerless, has been already mentioned, and fortunately remains in our own country. And it is to be fervently hoped will ultimately form the sun of our National Gallery.

It is unfortunate for those whose aspirations are for high Art, that there are in our public galleries

so few works which reach the grand; and none
which enable one to realize those sublime emotions
held by the language of criticism to be the power
of the finest works on the Continent.

The one, perhaps, possessing the greatest pre-
tensions, is No 1 of the National Gallery, 'The
Resurrection of Lazarus,' by Sebastiano del
Piombo. The authorized catalogue says, " The
composition of this grand picture was entirely the
work of Buonarotti, and the execution of the figure
of Lazarus rejects the claim of every other hand."
It is, notwithstanding, most deferentially sug-
gested, that the one quality contributing more than
any other to to the grand style in this picture is the
colour; and that the greater part of the compo-
sition is confused: the principal personage, that
of Christ, if not inadequately conceived, poorly
carried out, coarse in features and expression, and
unideal and unimpressive in form, stature, and the
minor parts of its drawing. The figure of Lazarus,
upon which so much of the importance of this pic-
ture has been based, is a miserable piece of dis-
proportion, with a head scarcely large enough for
an ornament to its body, and arms not much larger
than fins, had the figure been a fish instead of a man.
The invention throughout the picture is poor, if not
commonplace, and consisting of some really fine
conversational heads, a little holding of noses, and
the attempt of Lazarus to disengage with the great
toe of one foot the bandages which wrap the other,
are altogether not quite in subordination to the
particular incident which forms the subject, and in
which should be made to concentrate the interest
of the picture.

By-play of this description may be not only
admissible but requisite in a large composition,
when made completely secondary to a well-sus-
tained principal interest; but when a picture
boasts nothing more forcible than that which in a
a powerful work might stand for by-play, it
must or should cease to be considered a first-rate
work. A little of this by-play does very well in
pictures, as well as in conversation; but what
would be thought of a visitor, or a lecturer—for a
painting bears a greater analogy to the last—who,
upon entering your room, should, without saying
a word, point over his left shoulder, then put the
thumb to his nose, and, taking a seat by the fire,
motion you to silence?

Grand style in landscape results from the same
causes which produced it in the other walks—the
exhibition of its passion, or those states of nature
which, upon contemplating, raises high emotion in
the human mind.

Nichola Poussin appears to be the prime master
of this style. His ' Phocion' in the Natural Gal-
lery is a fine instance of it. Some few of Gaspar
Poussin's works rise to it ; and those of Salva-
tor's, though but seldom.

The more than contemplated and admissible
length to which this essay has run compels the
termination of it, with very much left unsaid
which is necessary to the subject. The order of
precedency of the different styles shall end it ; as
they exist, in consequence, appreciation, and ac-
tual utility. It will be readily felt that, between
the three great generic and distinctive styles others
naturally fall in, and that each is again modified
by being either coarse or refined.

Refined. ⎰ SUBLIME. / *Grand.* / BEAUTIFUL. / *Characteristic.* / SIMPLE. ⎱ Coarse.

"The Progress and Patronage of British Art"

Art-Union 6 (November 1844), 323–25

THE PROGRESS AND PATRONAGE OF BRITISH ART.

In our former number we traced the progress of the Fine Arts in England unto the close of the reign of William IV. Avoiding all discussion of the causes of their general development—proceeding as these do from the natural tendency of the mind, which seeks to give form and a species of existence to ideal conception; or else nurtured by that desire of social and individual improvement common to all—we sought rather to fix attention upon those more prominent facts which a rapid glance over the history of British Art enabled us to present as the most important in its career.

The accession of her Majesty was hailed with the customary adulation. The commencement of a new reign is the birthday of a people; and as men readily forget the past, because no longer in their power to use it for their advantage, or because our bygone felicity is seldom recalled except as induced by contrast, or that the sorrow which has shadowed our days becomes gradually enlivened by Hope the ever-merciful attendant upon the steps of man; so, in this, as in all former instances, the impressions of a reign now swept into eternity were effaced by the more welcome anticipation of the coming greatness of the future. Delusion must be a powerful, active promoter of human happiness; at least so we should judge from the cheerful, energetic self-devotion of its disciples; and the history of popular delusions is in a great degree the history of England. But all was not delusion in this respect; for although the prophecy that literature would procure authors the rivals of the reign of Elizabeth, or as distinguished as those who gave eminence to that of Anne, was not likely to be realized, yet the hope of its intellectual advancement in sisterly companionship with Art was natural and becoming, as well from the consideration of the general condition of the people, as from the higher qualities and endowments of the possessor of the throne. For it was well known that her Majesty regarded Art with the taste of an educated, the feeling of an intellectual mind; that she was largely conversant with its best productions, and was desirous to give it that national importance concurring and consequent upon the condition of a great people. Nor was this an example to be neglected, an impulse given to recoil impassive. The seed was not destined to fall on barren ground; a great change had taken place in public opinion; the galleries and national collections thrown open to the people had been thronged with crowds orderly and attentive, who had viewed them with interest, and had returned to them with respect. If the productions of the Fine Arts are not familiar to the lower classes, it is the consequence of their neglect by the higher. Who have a greater interest in the extension of such resources of rational amusement than the poor? With whose sympathies are they more intwined? To whom do they appeal with more of truth, and if haply viewed with wonder, to whom are they more the moral law and the religious feeling? But the change we have noticed was not of one class, it pervaded all; it was not confined to the leading cities, but extended to those of secondary rank.

A society was first established in London whose particular object was "the Encouragement of British Art." It met at the house of Mr. Dominick Colnaghi, a name deservedly respected, and held in congenial remembrance with the pleasure of his pursuits. The purpose was good, the rules efficient, the names it heralded not unknown; but whether before its time, or not observant of it,—whether from too much self-confidence, or through an excess of bashfulness which restrained the necessary active exertion for its success; or the consequence of an indolence unrestrained in every respect,—certain it is that, from an established fact, it dwindled into a gentlemanly conversational recollection: its sphere of utility became daily more imaginative, until, small by degrees and beautifully less, it mildly evaporated, and in a manner died by the bland absorption of the Art-Union. This latter Society was soon established, and every year has shown how well grounded were its prospects of aiding and encouraging British Art. In Scotland similar Associations had been earlier formed; and in Dublin the Royal Irish Art-Union may be cited as not alone calculated to encourage Art, but to extend and to consolidate the blessings of social peace. It has opened there a new source of influence and of enjoyment, an enlarged field of honourable occupation, and has become a neutral ground whereon all classes may meet, uninfluenced by the passions of party, and freed from the trammels of sectarian feeling. The most important indication of what may be the future condition of the Fine Arts is undoubtedly, however, the recognition of their existence by the State. The Royal Commission has already done much good, directly and indirectly—by ascertaining the present state of British Art—by giving it a wide scope for exertion and for a becoming purpose—by showing how much its productions can interest every class of the community—by adding fresco, to us almost a new, certainly an untried, branch of Art; and by seeking to raise a palace suitable to the present age, and the high purposes for which it is erected. Nor is this all. You cannot associate education with genius, and expect the result will be profitless and barren. Nature is not so improvident to man. As we sow the seed, which, for a time hidden, in due time rises, brightening our fields

with harvest, so also by the communion of kindred minds are great truths elicited, which, scattered abroad by every channel of opinion, revive it may be in an after age, yet still more productive, still more richly abundant, to be garnered up for the well-being and progressive advancement of nations for ages and ages to come. Accident often determines the career of man, but no truth ever fell to earth without ultimate good. Cowley became a poet by perusing Spenser's "Fairy Queen;" Reynolds, an artist by circumstance almost as casual; and, if genius be great powers accidentally determined to a particular direction, we may fairly hope for its more general development, as the means for its encouragement become enlarged, and its productions better understood. The Royal Commission occasioned the Cartoon Exhibition, the recent Exhibition of Works in Fresco and Sculpture, and that of Ornamental Designs. There was here much failure, much success; but who can say, thus far canst thou go, and no farther; and here shall ambition be stayed? We know not the spirits we may have called into action—the energy which applause may nerve to higher exertion, nor yet the struggle of the mind for future eminence which momentary failure may have evoked. We are never so conscious of, never so earnest in the exercise of our powers, as when we strive for advancement amid competitors, with the conviction, whatever may be our destiny, that it is within the compass of our will to be the creators of our own. The chances of life are not in our power, their right direction is; and if men were more willing to worship at the altar of intellectual power, rather than to bow down in childish superstition before the image of good fortune, human motives would be more elevated, human action more energetic, and human progress more assured.

One great good, the consequence of the Royal Commission, is already apparent. It has revived the discussion of questions too often neglected, or familiar only to the frequenters of schools of Art. The right appreciation of imitative works must depend upon our accurate knowledge of the principles upon which they are conducted. Judgment must otherwise be accidental, a chance gift, or random speculation, expressed in cant words and technical terms, not very dissimilar from the general tone of household criticism of the day. It is in this respect that the third Report of the Commissioners deserves especial attention, as containing Mr. Hallam's observations on the principles which may regulate the selection of subjects for painting in the Palace at Westminster; Lord Mahon's letter on the same subject; and the same considered with reference to the nature and various styles of the formative arts, by the Secretary. The interest this discussion has excited, not only by its subject matter, but from the names there with connected, induces us to abridge these papers, and to review the general arguments they contain.

After stating the object of the Commission, and offering some remarks upon the causes which may have tended to discourage the cultivation, at least in large pictures, of that higher style we call historical, Mr. Hallam proceeds to discuss the question as to the principles which should regulate the selection of subjects. And here, to prevent the misapprehension that exists upon the opinions Mr. Hallam has expressed, and which, no doubt, has been simply casual, and not at all inconsiderate, we shall endeavour to put the case in his own words fairly and freely before our readers. Mr. Hallam then considers this question with reference to two most important points, *the right decoration of the Palace, and the development of native genius in historical painting*, by productions which may be ranked as *works of Art*, and thereby raise the character of the English as a school of painting and sculpture among mankind. Now, here two difficulties arise. First, in the choice of subject; secondly, in its technical treatment. Does English history supply the painter with subjects in accordance with the exigencies of the latter? Can they be both so united that the Palace shall be held appropriately decorated, and the picture considered a work of Art, conducted upon the principles of the best schools. Hereupon issue is joined. In large works of painting, Mr. Hallam is of opinion that, whether in fresco or in oil, it appears to be more than doubtful whether the artist should, in all instances and in all parts of the building, be confined to British history. It requires no skill, he adds, to have observed that, " in the selection and management of subjects, a painter will prefer, wherever his choice is truly free, those which give most scope for the beauties of his art. Among these we may, of course, reckon such as exhibit the human form, to a considerable degree, uncovered; such as throw it into action, and excite the sympathy of the spectator by the ideas of energy and grace; such as intermingle female beauty, without which pictures, at least a series of them, will generally be unattractive; such as furnish the eye with the repose of massy and broad draperies, which is strictly a physical pleasure, and for want of which we soon turn away from many representations of modern events, however creditable to the artist; such as are consistent with landscape and other accessories. Now, if we turn our attention to British history, do we find any very great number of subjects which supply the painter with these elements of his composition? I must observe here, that by subjects from British history I mean events sufficiently important to have been recorded, and not such as may be suggested by the pages of the historian to the artist's imagination. As the sole argument for limited selection appears to be grounded on the advantage of association with our historical reminiscences, it can hardly extend to the creations of a painter, even though he may attach real names to the figures on his canvas. And I would here remark, by the way, that the subject of one of the prize cartoons, a work in most respects of great merit, appears objectionable upon this theory of historical illus-

tration ; since the ' First Trial by Jury' is not only an event nowhere recorded, but one which no antiquary will deem possible as there exhibited. Nor should any event, as I presume, be deemed historical in this point of view which was, as it were, episodical, and which forms no link in the sequence of causation, affecting only a few persons, great as they may be for fame and rank, without influencing the main stream of public affairs. Even some stories not without relation to the course of general history, and which no writer would omit, might not appear prominent enough for selection, where the illustration of ancestral times should be the leading aim. Yet these might be among the fittest themes for a painter's composition. To take a single example, I should think the ' Rencontre between Margaret of Anjou and the Robber, after the Battle of Hexham,' upon the verge of what should be admissible as English history, in this particular application to the Houses of Parliament. This well-known story perhaps I would not reject, not as being well known, which does not seem sufficient, but as having somewhat of a public importance, according to the common, possibly fabulous, report of those times. I should, however, did it rest upon my judgment, very much hesitate to admit the ' Penance of Jane Shore,' because no public consequence ensued from it, though I can easily conceive it might furnish a beautiful picture. In these two cases it may be remarked, in passing, a female form would be predominant ; but for the most part our history, as might be supposed, does not afford any plentiful harvest of what is so essential in historic painting. In fact, the most beautiful and interesting women in English history must be painted, if at all, on the scaffold. In this part of my observations I do not anticipate much difference of opinion. Some indeed have, perhaps, a notion that nothing but parliamentary, or at least civil, history should be commemorated on these walls. But the majority would probably be willing to let Trafalgar or Waterloo find a place, and, in general, whatever we read and recollect from Cæsar to the present day. Yet with this extension it may be much suspected that really good subjects would not be found over numerous. Battles we have, of course, but I cannot reckon battle-pieces the greatest style of historic art ; and, since the introduction of field artillery and scarlet uniforms, they are much less adapted to it than they were. Versailles may show us what this is good for. And as to coronations, processions, meetings of princes or generals, and all over-crowded pictures, they will hardly answer the end which we have in view, of displaying the genius of a truly great painter, should we be fortunate enough to possess one." For the remainder of Mr. Hallam's opinions upon this subject, we must refer our readers to his letter in the Report alluded to, and proceed to place before them the leading argument in the reply of Lord Mahon.

"Towards Mr. Hallam," writes his lordship, " I entertain the highest respect and regard, and I sincerely distrust, as I ought, my own judgment on any historical subject which he sees in a different view ; but when I find even so eminent an authority declare, in reference to our new Houses of Parliament, that ' it does appear to him more than doubtful whether the artist should, in all instances and in all parts of the building, be confined to our own British history,' I must own how entirely and how strongly I venture to dissent from that opinion. Frst, let us consider for a moment what our own British history really is. It is the narrative of a race who, from a low and humble origin, roaming as painted savages over their barren hills, or exposed to sale for slaves in the market-place, have gradually, in the course of ages, obtained perhaps the very first place among the nations ; who at home have known how to combine, beyond any other people, the greatest security to property with the greatest freedom of action ; who have given tokens, such as no lapse of time and no violence of revolutions could efface, of valour, of virtue, of eloquence, of scientific discovery, and artistic skill; who abroad have tried their strength against every other power, and have never been found inferior ; who have proved as successful in the as glorious rivalry of knowledge and benevolence. * * * Can it be, that after exploits whose fame has filled the globe, and which have conquered or colonized no small portion of it, our history affords no sufficient materials for the adornment even of a single edifice amongst us?" His lordship next cites, in reply to the artistic objections of Mr. Hallam, with respect to battle scenes since " the introduction of field artillery and scarlet uniforms," the subjects which our conquests both in Canada and India would afford, such as the death scene of Wolfe, and those that the long train of our Indian successes in the arts of war and peace would supply, by the delineation of the graceful and well-formed, but scarcely-clad Hindoos. With respect to the point raised,—" That for any attractive series of historical pictures," it is essential to " intermingle female beauty ;" which Mr. Hallam thinks a strict adherence to our authentic records will not adequately supply, " as the most beautiful and interesting women in English history must be painted, if at all, upon the scaffold," —Lord Mahon asks,—" Are we to have any state trials ?" If we are, could there be a nobler female figure for an artist than the scene which another member of the Commission has so well described :—

"There, on that awful day,
Counsel of friends, all human help denied,
All but from her, who sits the pen to guide,
Like that sweet saint who sat by Russell's side,
Under the judgment-seat."

Such are the chief points of the discussion between Mr. Hallam and Lord Mahon : one of great interest and of much import to the Arts. We may rationally encourage hopes of social progress, when an incidental point in a particular pursuit can thus win the attention of men so honoured. To Mr. Hallam and Lord Mahon, and, perchance, a few more, this age will owe whatever it may hereafter possess of literary distinction. An age ambitious of the fame of pos-

terity, but which we believe will be considered as simply one of transition, that spread, rather than added to knowledge; active, frequently from vanity; tolerant, generally through fear; affecting fondness of the wise, but always worshipping the expedient, and whose mobility oft encouraged the doubt of its faith in the opinions it upheld; which took from the past its veneration, and from the future its hope.

We shall now endeavour to review the subject in detail, to ascertain the principles upon which historical composition rests, and try whether it be not possible to reconcile the most appropriate system of decoration of the New Houses of Parliament with strict compliance to the rules conducive to the highest style of Art. And here we are bound to confess that, whilst our wishes are with Lord Mahon, our fears are with Mr. Hallam, and we feel that, if his refutation be to come, it must come from the brush of the artist, and not from the pens of his critics. There is no judgment like the judgment of facts: one successful picture will dissipate conjecture, and render argument useless. Dr. Lardner lectured to prove the impossibility of steam navigation to America; but the Great Western anchored at New York, and the Doctor sat refuted. First, as to choice of subject, which, says Sir Joshua Reynolds, should, in pictures such as we now require, " be either some eminent instance of heroic action, or suffering. There must be something either in the action or in the object, in which men are universally concerned, and which powerfully strikes upon the public sympathy." "No event," says Mr. Hallam, " should in this point of view be deemed historical, which was, as it were, episodical, and which forms no link in the sequence of causation, affecting only a few persons, great as they might be for fame and rank, without influencing the main stream of public affairs." To these opinions we should think no objection can be urged, for in the decoration of the New Houses of Parliament we do not seek to form a series of mere picture galleries; embellishment alone is not desired, but propriety, harmony, fitness of design, a species of intelligent consecutive narration, pictures which shall be the history of the past, identified with the purpose of the building, illustrative of the people. But it is said, your choice of subjects, instead of being limited, is liberal. Let us see. Remember it is essential they be strictly confined to British history. Independent of the conditions above cited with respect to historical composition, there are others deserving of attention. The subject of pictures may be derived from history, but they are not consequently historical in the purest meaning of that term as regards works of Art. Every one accustomed to reflect upon this point will feel conscious of the difference existing between pictures which represent the ' Trial of Charles I.,' the ' Judgment of Russell,' or those which depict the adventures of Charles II., and of the Young Pretender. The former possess the requisite interest: they form a sequence in the chain of causation, illustrate a period, and are events in which men are universally concerned. Whereas the others, though received as historic truths, have an incidental, a personal, a relative interest, possess a romantic character, a poetic feeling, better suited for men's hearths than national palaces. The first may be termed material, the second pictorial compositions; but the latter cannot well be converted into the former, for by what we call pictorial, we mean pictures in which imagination is greatly blended with fact, resembling history, but the history of the novels and romances of Sir Walter Scott. We do not say these should be entirely excluded, but they should not predominate. Works of Art, when not mere translations from nature or common life, must greatly depend in the treatment of subject, upon memory and the imagination. We can never by these means represent events exactly as they did occur; we therefore should select subjects where the latter can be employed in such conjunction with the former that the event as seen may have all the verisimilitude of fact, the circumstance real, and its action natural. Again, no subject, we submit, should be selected which rests merely on tradition; and is no more historical than the early fictions and myths of the history of Rome.

For example, no subjects are more popular than those of the ' First Trial by Jury,' and ' Milton Dictating to his Daughters.'

Now, with regard to the first, we have already shown in our number for September, 1843, that no such institution as represented in the cartoon ever existed at the period to which it was referred; and we have on this point the high satisfaction of Mr. Hallam's authority in stating, this subject appears objectionable upon this theory of historical illustration, since the ' First Trial by Jury' is not only an event nowhere recorded, but which no antiquary will deem possible as there exhibited. With respect to the second, we have great doubts of the fact, not that Milton dictated, but that his daughters transcribed. Their duteous character has not passed without suspicion. We have the evidence of the nuncupative will, and the sworn evidence of the poet's brother, Christopher, that he complained " that his daughters were careless of him, being blind, and made nothing of deserting him;" and that they " were undutiful and unkind." His last wife purchased his good opinion by her savoury messes of pottage. Moreover, if Johnson be correct, and he is supported by Todd, Hawkins, and Mitford, there was a cause more cogent—*they could not write!!* " That, in his intellectual hour, Milton called for his daughters to secure what came may be questioned; for, unluckily, it happens to be known that his daughters were never taught to write; nor would he have been obliged, as is universally confessed, to have employed any casual visitor in disburdening his memory if his daughters could have performed the office." We do not say that subjects such as this, of which at least the truth is hopefully presumable, should

be invariably disallowed; but we do feel that caution should be exercised, and that the dignity of history should not be sacrificed to pictorial effect. Next to the difficulty in the choice of subject is the mode of treatment. And here we observe the singular anomaly of a nation seeking, by the principles which brought the Arts to perfection at one period of civilization, to realize effects according to ideas peculiar to another and a more advanced social condition, the latter based upon institutions and customs both opposing and distinct. The result is a conventional agreement often inconsistent, not unfrequently ignorant, generally ineffective. We will contrast the views in this respect of the Greeks and the English. The Greeks were the worshippers of the beautiful; they had the most religious veneration for the systematic and the fitting, and tasked themselves to produce an entire and intellectual harmony of the inward and outward being. The natural symmetry of the Greeks furnished the rules of proportion to the sculptor, and their beautiful works operated by a natural reaction upon the former. The laws even of the Thebans ordained the imitation of the beautiful alone; and the regulations which governed the erection of statues to the victors at the Olympic games were directed to the same end. The statue of the god, when intended for the temple, was executed in the hieratic style; but when otherwise it was redolent of the utmost perfection of physical excellence. Ideal was more sought than truthful resemblance; and it was only to the warrior who had thrice borne away the laurel that an iconic or portrait statue was dedicated. Drapery was always employed as the expression of artistic power; and all exhibited taste, judgment, skilful imitation, and adaption. Now, compare this system with our own!! We seek perfection in works of Art, but forbid the ideal; our statues must be iconic—nature servilely copied. Our costume, the least artistic of any, must be retained; even the very deformity of the body must be seen. George III. retains his pigtail; Lord Nelson, his one arm; and if our heroes die, and are entombed in the recollections of a grateful country with patches on their eyes, and wooden legs, both must be indicated, if not determinately expressed. Seeking to reconcile opposing principles, we fall too frequently into an unintelligent convention; and invention, miserably limited, is eked out by the wretched resources of allegory. Moreover, all is contrast and variance. George III. is the English gentleman in the Windsor uniform. George IV. not so, but the Roman Emperor in appropriate costume. The Duke of Wellington in the east, is the very contrast of the Duke of Wellington in the west, and sits in a conventional style neither Greek nor English, unbooted and "*unbeknown.*" What beauty, order, harmony, and effect would ensue, by the adoption of purely classic style,—heroic as regards statues, truthful as concerns history, elevating the Arts in all. On these points we must, however, earnestly direct the attention of our readers to Mr. Eastlake's letter: valuable as all his contributions to the literature of Art are, this has a particular claim upon attention. His knowledge is so extensive, his style so exact, and his experience of the works of the great masters of all schools so evident by the purity, feeling, and elevated dignity of his own, that we feel it to be a benefit conferred not upon the artists of one, but of all countries to place thus, as far as our limits will allow, this contribution before them. There are some further limitations in historical composition not undeserving of attention. Perfect fidelity in a work of Art from the description whence it proceeds it is impossible to expect. Art has now assumed a far wider range than that within which it was restricted by the ancients, and its attempts have been ambitious and equivocal. An historical fact may be suitable or unsuitable to painting—the historian may so convey the details as to render them unpictorial—yet the genius of the artist may make but a portion of the story expressive of the whole. As the succession of time is the sphere of the poet, so space is that of the painter. "He has," says Sir Joshua, "but one sentence to utter, one moment to exhibit;" he cannot fix attention by description, or instruct by detail, but must narrate in one event the sequence of many causes, and the passions of several in the actions of few. A painter has often less resources than a poet; the latter may copy his description from nature, but the former, in reproducing the scene described, has to produce a discretionary effect from faint and fleeting images. In like manner, in reproducing the scenes of history, the artist must frequently be guided by his narrative; yet what imagination could be inspired by Smollett? But, nevertheless, history must be expressively told, and instantly understood; for it is on the first glance of a work of Art that the greatest effect depends; and whenever the spectator is obliged to take the trouble of reflecting and deliberating on it, he soon ceases to be interested. The character of the hero, or leading personage, must be expressed by external appearance, and grandeur of thought by refinement in portraiture; and all must be exercised with caution lest it lead to the sacrifice of truth. Such are our claims upon the artist.

We have dwelt at length upon this subject; at all times it is the duty of the press to instruct opinion; but it is more particularly the duty of this journal to be watchful upon every question relative to the Arts. To endeavour to obtain works of the highest style of Art is due to the public; to show the difficulties which may arise is due to the artist. Inconsiderate censure is readily indulged; and the fame of eminent painters is not to be sacrificed to unauthorized or inconsistent expectations. If asked, upon a general review of the subject, are we precluded by any causes we have detailed from expecting the completion of the new Houses in a manner calculated to raise the character of the British school of Art amongst nations? we reply, no. We rely upon the genius of our artists. We ask

only for great caution in the selection of subjects; and that no picture should be executed which has not first been seen in the cartoon. That excellence of the highest class should be sought; and the reward be becoming the purpose and the nation. The general tone of thought in such paintings should be ethical, producive of moral emotion, conceived in a patriotic spirit; and pleasing effect should be combined with intellectual gratification. For sculpture, we trust neither Art nor Nature will be sacrificed to frivolous antiquarian details. A statue is not erected for one, but for all ages; and the hero and the statesman should be recalled not in a contemporary spirit, but as they may assume their rank in the veneration of posterity. Public works should educate public taste; and if false opinions with regard to Art prevail, it is the duty of the Government boldly to confront them. To restrain committees upon public monuments is impossible: to use the language of a recent author, "They represent a great necessity!"—a necessity, we trust, the Royal Commission will supply. We have referred to the practice of the Greeks in the conduction of public works; and feel we cannot do better on this point than conclude in the words of Mr. Eastlake :—

"The lapse of ages can make no alteration in such principles. It is still unreasonable to look for all the details of history in the Arts which are the sisters of poetry; it is still unquestionable that each must seek its proper excellence, in order to assert its rank in the scale of human attainments; and that, in proportion as the sphere is circumscribed, the characteristic aim which constitutes style requires to be guarded with especial jealousy. In considering the question whether Art should be sacrificed to mere facts, or these to Art, it should be remembered that historical details can be preserved by other records than by representation, and by other modes of representation than by the highest, but that the essential objects of the Fine Arts can be attained by no other means except their own."

We here close our sketch of the Progress and Patronage of the Fine Arts in England. We have traced them from their rise at a period of imperfect civilization, and their progress to another of the highest comparative refinement. Once the companions only of the rich, now the instruction and the solace of all. Once viewed with wonder, now studied with intellectual respect. Once a ray of genius which illumined only the palace, now a light shedding its beneficent influence in every dwelling of the land. Even so should it be; even so should education spread, so should moral truth increase. Wretched is that people which has no communion of social feeling, no point of general concord; where class stands apart from class in the isolation of selfish interest and selfish pride. Of necessity, division will be engendered by political and individual interest; and by such divisions Carthage was subdued and Rome fell. United by one common faith, and enjoying the blessings of equal laws, we trust it is reserved for our countrymen to be further united, not by equality of fortune, but by the

equality of intellectual enjoyments, and the refinement inseparable from cultivated pursuits. Should the present reign ensure even but the progress towards this, it will be one to which the glories of Elizabeth are but as painted triumphs; and the eminence of that of Anne, an evanescent dream. We have struggled for freedom in religion, and now worship in a spirit of toleration, tending to unity and peace. We have established a political system, calculated beyond any other to give freedom to thought, impart energy to action, and secure genius its reward. We have learned the necessity of education, and feel daily the duty of strengthening those social affections which bind all classes of society together, and are in truth the cords of man. We have yet to experience the benefit derived from the silent influence of opinions and habits proceeding from sound principles widely diffused, and addressed to an active, practical, and reflecting people. This fruit can only be garnered in the future, as its seed can only be husbanded to perfection by the gradual influence of Time. As the stars fulfil their courses, as the waves still roll as when the voice first went forth, which called them into being, and fixed the limit wherein they should be stayed; as the seasons return in unvaried beauty upon earth, so also do those eternal and divine truths which accompanied the birth of human life still exist, still progress to elevate the mind, and refine the feelings, by the union of Faith with Reason, and the associations of SCIENCE, LITERATURE, and ART.

"The Future of British Art"

Art-Union 7 (January 1845), 5–7

THE FUTURE OF BRITISH ART.

THE question, What will be the probable future condition of British Art—which possesses so much general interest, and which by association, awakens a feeling almost personal in its most favourable solution—cannot, perhaps, be with more propriety considered than at the commencement of a NEW YEAR. It is the period when in every varied condition of life we review the past; when our impressions of the space traversed are the most vivid; when reason, disenthralled from momentary passions, is less partial; and we trace the results of action, even as they who recal the memory of the dead, with feelings of pride chastened by regret, and of regret mitigated by hope. Now, the law which governs men in their individual character is applicable also to their social: we examine our own career, we scrutinize national progress for the same end—the means may be different, but the purpose is identical—moral good. In one case observation is exercised towards the formation of character; in the other it is directed towards the general condition of mental pursuit; in both the design is to ensure advancement. So great is the tendency of the mind, however, to individualize its action, that in extensive views of human life the process of inquiry becomes inducted upon principles strictly analogous to persons. Hence it is, that narrow, limited zeal is engendered, which writes the history of civilization with the spirit of party; and that events are commented upon, not as the results of general causes, but as particular incidents. Apart, however, from these considerations, the knowledge of our comparative national condition, as regards intellectual qualities, competing power, commercial greatness, social advantage or disparity, is, of all destined to the public service, the most important. No great state can exist without it: even China has felt its influence, and we doubt not it has power at Timbuctoo. But not to any nation is this knowledge of so much importance as our own. An insular people are apt too devoutly to worship that wisdom which never goes abroad. Their government, their schools, their arts, their modes of sale and barter, may be all good, but they are inclined too fondly to revere them as the best. If wealthy, they purchase the excellence they want; if poor, they despise it; if trading, they estimate it not according to its intrinsic qualities, but their market. Now, the evil consequences of this system we have felt.

Relying upon the excellence of our institutions, we neglected education; treating the productions of Art as simple articles of commerce, we have left them, like hay, straw, bricks, and cotton, to find a market where they could; and, proud of mechanical power, we have used it like a brute force,—separated from invention, unconnected with design. Thus, like Frankenstein, we have been punished by the demon of our own creation. To place this subject more clearly before our readers, we have in former numbers sketched the progress of British Art, and shall now consider its present condition, and possible future state.

The progress of Art upon the Continent, and in England, is the result of very different causes. Christian Art arose in Italy from the religion which placed that favoured land at the head of modern civilization. As that religion spread, Art was honoured, kings were its patrons, mighty princes its protectors. With the people it became a religious feeling. Not dissimilar was its condition in Germany and France. But in England, Art, at least "for the million," was ever an alien. Religion withdrew its support, the State never gave it; and from the Heptarchy to George IV., only three kings owned its influence. For centuries it was but the pride and the property of the court and the nobility. To what cause, then, are we to ascribe its recent importance? Not, as some would induce us to believe, to the increase of luxury, but the extension of education. Art is a property now inherited by the rich, and worked for by the poor;—appreciated as a source of recreation, and acknowledged as a power of commercial prosperity. Still we cannot regard its present condition with unmixed satisfaction. It bears the fruit of rapid and peculiar culture, and shows the consequence of its neglect by religion and the State. Let us consider it under two great divisions—Æsthetic, or the Fine Arts; and Art Decorative and Ornamental. And, first, as to History and Portraits.

HISTORICAL PAINTING in England is a melancholy subject to consider. One would naturally suppose that, among an educated and refined class, the higher branches of Art would be cherished. Yet it is not so. Whether this may be ascribed to the increasing energy of theological discussion, to the keen excitement of politics, or the all-absorbing worship of fashion, we know not; but this much is evident—the public are too much occupied to spare one moment for the more serious and important branches of Art. Were it otherwise, there can exist no doubt but that talent could be found to meet the demand. The Exhibition of last year proves this. The pictures of ' Rienzi Haranguing,' ' Luther Listening to one of his Hymns,' and others, might be cited to refute opinions uttered not from knowledge, but hazarded to put a gloss upon neglect. But how, after the efforts unsuccessfully made to produce and establish historic painting, can we expect their continuance whilst Memory recalls Hilton perishing from disappointment, and when we can now see five pictures by a living artist rescued from the neglect of England by the zeal

of the Scottish Academy—pictures which would do honour to any age, and which now grace the walls of the Edinburgh Royal Institution?

PORTRAIT PAINTING, once so pre-eminent, is now failing in its importance. Rising artists too often paint portraits, but not pictures; since no portrait can be considered as a valuable tribute to Art, unless, without any reference to resemblance, it is in itself a fine transcript of human nature. Since the days of Sir Joshua, England has been unapproached in pictures of this description, combining that which is endeared unto friends, and most valuable to every mind to which the Fine Arts are a feeling. Few things, indeed, can be more important in Art than the development of mental expression; and still fewer are those objects upon which the mind so willingly lingers, as upon those breathing representations of men whose attainments have improved, gratified, or enriched mankind. Yet, if regression be manifest here, is the artist only to be blamed? We think not. He is, like all other men, subject to the humour of the times; and now, as every one will have a likeness, and one to order, and at as cheap a rate as possible, and with the least possible delay, can it be matter of surprise that, thus cabbined and cribbed and left without a choice, the painter should be slight, rapid, and dexterous?

LANDSCAPE PAINTING, in oil and water, has been long eminent in England, both for its truth and poetic merit; and there are examples of the latter which probably are equal to any ever produced at any period of Art. Nor is theirs a limited expression: the sublime, the terrific, the enchanting aspect of nature, the solitude of waste, and each domestic rural scene, are all reproduced with a refined success. Their technical treatment is equal to their conceptive feeling; their chiaro'scuro is unrivalled; for these works require only to be seen, through the medium of engravings taken from them, to prove how perfect they are by thus rendering the effect in black and white. We refer particularly to Turner, whose greater works have connected the English school with the storied honours of the past,—evincing as these do the fidelity which recalls, the poetic spirit which enhances, local scenery, combined with that historic and natural interest which gives a picture a place at once in refined enjoyments and in human life. Whatever, however, the ability of the artist, it must, more or less, be affected by the condition of public taste. Actuated by this, if not derived, painting should give a stimulus to moral, religious, and political improvement, and tend to promote the virtues by consecrating the great examples of mankind. But is this its destiny? Has it been so? Do we not too often find a well-painted cabinet, a piece of china, or a chair, call forth more admiration than subjects important to social welfare? It is not that this class of Art is bad: on the contrary, it has great merit; and if perfect execution be carried throughout a work, with fine colour, expression, and true perspective, the result must be valuable. Here, however, the failure unfortunately generally is, that everything is painted better than the figures and the flesh, so that the manual often completely surpersedes the intellectual. Light pictures are also too much esteemed for their mere quality of whiteness, without any consideration of tone, colour, or general effect; for, if the objects be presented to the eye but in a tolerably faithful degree, the spectator rarely inquires further. High distinction is attainable in this style, although it can never be the first; and even that must be purchased by effort pushed to the utmost and a great outlay of time. And will the public, as it thinks now, repay the artist for such long and laborious exertion? In the saddest spirit of truth, we reply, we believe not. Nevertheless, that Art at the present time is degenerating, we deny; its tendency is to a familiar, lowering style, in which the dexterity for painting mechanical objects is held of more value than the precious results obtained by highly-cultivated mental intelligence. This we think may be received as a just view of the present condition of Art in its higher branches; the possible future advance we shall consider hereafter, and now proceed to examine its state and prospects as applied to DECORATIVE and ORNAMENTAL purposes.

One would naturally suppose that a people so devoutly commercial as the English would seek not alone its extension, would desire not only to create a market in every spot inhabited by man, but to hold the command of that market by every means within their power. This gratifying fact, however, is disproved by every document. Our commerce, indeed, seems to ebb from civilization, and to flow with greater force the more it streams towards savage life. In European countries it declines; with the swarth African, the Chinese, and Hindoo, it increases. This applies chiefly to articles of clothing. For notwithstanding our resources, the enormous capital employed, our great power in' machinery, the enterprise of our merchants, the skill and unceasing industry of our artisans, it was urgently asserted that our manufactures were excluded from the Continent by their inferiority in the arts of design, and overborne by the pressure of foreign goods, introduced into the United Kingdom solely from that cause. This created alarm, the Board of Trade became excited, even Downing-street was moved. A committee of the House of Commons was appointed in 1836, which amply justified whatever a frightened interest had expressed. Mr. Martin, the celebrated painter, complained of the want of correct design in the china trade; Mr. Papworth, of its absence in the interior decorative architecture of houses, and in furniture; and Mr. Cockerell, of the adoption of bad styles of architecture arising from a similar want of educated information. Nor was this all. It was shown that all ideas of originality were abandoned by our manufacturers; that, whatever the article of trade, its design was either a direct piracy, or to be pirated

at the shortest notice; that to blend, imitate, or distort the productions of others, was a prevailing rule. It was their bread, of which they buttered both sides. Nor can it be said they were entirely to blame. Whatever the manufacture, however liberal the manufacturer's expenditure for designs from the best artists (of which, excepting in the higher branches of trade, as goldsmiths, &c., there were but few), they had no protection for capital thus employed. If Rundell and Bridge engaged Flaxman, Baily, Howard, or Stothard, at an outlay of £1000 per annum, within one month the design was copied, with but slight alterations, by the meanest competitor. In decorative iron work; in all branches of the silk trade; calico-printing, paper-hanging, the practice was the same. Thus no man felt disposed to secure talent the profit upon which he could never call his own. And such was the state of the law then—that it recognised no property in design! This was, perhaps, natural, the State never having considered the Arts of Design worth a statesman's notice. But it was not less ruinous. There were also other reasons. Except in cases where the first artists were engaged, none existed who could supply the manufacturers with original patterns. Such as were produced were generally those of men employed on the premises, or half-raw boys, the sons of some foreman engaged, unacquainted with all but the merest elements of drawing, devoid of all educated taste, uninstructed by any examples but those common in the trade; ignorant of proportion, perspective, form, and continuity of outline, beauty of colour, and unblessed with any the slightest knowledge of it as a question of science. At the best the designer was left to grope on unassisted, and his work was the mere result of talent unguided by knowledge.

With respect to the state of trade, nothing could be worse. One artist of great eminence showed that chasing was at quite as low an ebb as it was some twenty years ago, another stated, upon complaining that a design y Stothard was spoiled by the artisan, he was answered, "Sir, in this country we can never get beyond a teapot!" while in the case of drawings from such works as the Elgin marbles, to be afterwards executed as a frieze on paper, Mr. Crabb, a decorator, excellently explained the difficulties in his way, and proved the great superiority of the French in all details of this business, and his requisite reliance upon them. It signified very little who was examined, the evidence was throughout the same. We could manufacture, but we could not design. The east and west of London, Spitalfields, Coventry, Manchester, Birmingham, all were represented, and this truth was manifest, that although we might compete, and did, with the French in material, in particular colours, and other details, yet that our goods, particularly silk, and fancy articles of commerce, were either universally copied from the French, or were otherwise avowedly inferior. Thus the spectacle was exhibited of a nation enabled to produce a better article as regards material, yet unable to

compete, and even excluded from competition, with the foreign artist, and that upon their own land, by a want of knowledge in design! Nay, more: it was the patron of that artist, to the acknowledged detriment of its own trade. Indeed, the whole affair was a scramble; patterns imported from France were manufactured off hand; the sole desire was to get possession of the market, even for one day, and to sell at the cheapest rate, at the lowest expenditure. Every one admitted the evil; all, even to the humblest workman, felt its deplorable effects. Now, what was the cause?—The want of a SCHOOL OF DESIGN. We were as men endowed with every attribute of physical power, yet unendowed with reason to give that power effect:—like the barbaric chiefs of old, in whose domains the precious metals abounded, but who suffered them to pass into the possession of every trader, from inability to use them properly themselves. This evil was so clearly established, not only by the Report of the Committee of Arts and Manufactures, by one subsequently made to the Board of Trade by Mr. Dyce, and the concurrent testimony of the best informed men, that the Government resolved upon the foundation of a permanent school for the education of men, principally for the application of Art to manufactures and the higher branches of trade and professions.

The importance of the connexion between Manufactures and Arts has always been admitted. In Greece great artists arose from the manufacturing districts; it is apparent from all their works that those artists who had failed in the higher branches applied themselves to the lower; and we have admirable works, of a minute and minor kind, which were executed by men who had been employed upon a much larger scale, and attempted higher things. Schools of Design were first introduced into France by Colbert, under the auspices of Louis XIV.; and from that period have been widely diffused. In Germany and Bavaria similar establishments have been formed, the efficacy of which has been greatly increased by their several "Industrial Associations." Yet for us—a peculiarly manufacturing nation, to whom the connexion between Art and Manufactures is most important, and whom it behoves, were it only from motives of mercantile interest, to encourage Art for the protection and the promotion of commercial industry—no such institution had existed. The School of Design at Somerset-house was consequently opened; and, considering its great importance, we shall now detail the objects it has in view. First, it proceeds upon a principle well established in relation to every direction of the mind,—that to elicit genius, or make it the power it may become, you must educate it. The rule applicable to law, to medical science, from the commonest to the lowest pursuits, is still as stringently applicable to Art. Every great artist of the past went through a rigid course of study; every book upon the subject proves this; every aberration from the system attests its necessity. Who designed in the

middle ages? Raffaelle. From whom sprung even the debased system called the style of Louis XIV.—more correctly that of his successor? From the examples of Ornamental Art, executed by the Grecians, Romans, and Italians, long accredited as the offspring of high and cultivated taste, as practised by Michael Angelo and Cellini, as designed by Le Pautre, and given in valuable documeuts by Piranesi. The style of Louis XIV. was the Roman style, with a more sumptuous expression.

It was by such men, then, that of old the ornaments of palaces, the works to be produced in the loom, in silver, bronze, iron, and wood, were designed. It is to raise up men, if possible such men—at all events men trained in the discipline of such examples—that the Directors of these Schools labour. A rigid course of instruction is adopted; the pupils are taught to draw ornament and the figure; the best works, and the purest models, are supplied; the classic style is adopted as the best; only the most beautiful forms are placed before them; the power of light and shade, the use of chalk, the laws of chiaroscuro, and of colour in all its details, are made a daily study, and the most assiduous practice. The education of all is necessarily the same; but as they acquire a knowledge of drawing they have copies placed before them, and their attention is directed to the class of ornament and its application most likely to be conducive to their several future occupations. What that occupation may be is not, however, incumbent upon the School to decide. Their mission is the cultivation of taste, the communication of knowledge, the training of the mind by the discipline of great examples. It is the genius of the pupil, and the wants of the manufacturer, that must determine the employment of the knowledge here obtained. This is well known; and not to derive the advantages this School affords to the capitalist, because it does not supply the practised workman, is not only in the way of all improvement, but of all sane reasoning. In France, where many artists are employed, it happens, particularly with reference to the loom, that they also are generally the *metteurs en carte*, but this has never been the case here; and whatever advantage may be derived from this practice time doubtless will secure. Still less can it be expected that artists can at once be reared; but this School can, nay, does rear excellent workmen as ornamentists, and numbers of practical designers have derived great advantage from their study of Art within its walls. The Queen's summer-house has been already partly painted by one pupil in a style far exceeding the work of any foreign artist employed in this country; others are engaged rapidly as ornamentists, or as teachers in local schools, where the head masters are always, where it is possible, artists of the higher class. Of the silent, gradual influence of this system upon the formation of public taste there can be no doubt. Fashion may counteract its efficacy, and will; but "a breath can make this, as a breath has made." The generation for whose dresses Kent designed the five orders of architecture! we have not the least doubt, has been succeeded by another whose silks and cottons may be made far more attractive by designs from Somerset-house, of a more becoming, more artistic, and less ambitious character. Let not, therefore, those who make, or those who sell, lay the flattering unction to their souls, that the public has no taste, and that there is no wisdom in the manufacture of any article of design, and that the old pattern—the time-worn system—is the best. Such opinions may suit the warehouse or the counter—is in accordance with the limited capacity of those to whom the present gain is the be-all, and the end-all here; but, *eppure si muove*, opinion advances; and such men will be found, in the dim and dusty waste of their own silent, desolate premises, the becoming memorials of a system they had not the genius to break through, and hardly the cunning to make profitable to their own ends.

Turn we now to the Future of British Art. Like every human prospect, it is one of mingled hopes and fear. Yet assuredly it has more of hope. The gloom that has hung over and accompanied the course of British Art, like mists which gather round the sun, and which seldom fail as it advances to make more palpable the beauty of that luminary whose glory they cannot wholly hide, is now far spent. Religion has become more tolerant of her productions, the state more anxious to promote and to protect them, the people more impressed by their humanizing influence, more anxious to extend it, to make Art a companion of their pleasure, the enlivener of their homes, and an additional power for the furtherance of honourable ambition. Our artists have proved they are equal to national undertakings, and anxious to redeem the past. The schools of France and England seem to evince more original talent than other countries, more novelty in style and conception, although not always equal care in execution. The schools in the other parts of Europe fluctuate between Albert Dürer and Raffaelle, without the originality of the one, or the beauty and completeness of the other. The evil consequent upon the present state of opinion the Future of British Art will assuredly correct. The demand for works of small value, and at a very low price, the besetting public sin of the present day, will become exhausted from the higher calls for monumental works which we think await the artist; for, as ripple expands into ripple, so from circle to circle does the influence of example, and from the throne to the cottage we are convinced there is now a higher conception and a more generous appreciation of the object and purposes of Art than have ever heretofore existed. Of the advantage of combining industry with education in the Mechanical Arts, as now so ably conducted at the School of Design, none can doubt: it must produce refinements in the liberal; nor can one be carried to perfection without being accompanied in a great degree by the other. The spirit of the age, says Beattie, affects all the Arts; and the minds of men, being once roused from their

lethargy and put into a fermentation, turn them-
selves on all sides, and carry improvements
throughout all branches of mental pursuit. The
more the Arts advance the more sociable do men
become. As they extend, the political condition
of a people becomes more assured, factions are
less inveterate, controversy less hateful, revolu-
tions less tragical, authority less severe, and sedi-
tions less frequent.

" A taste for the Fine Arts," says Lord Kames,
"goes hand in hand with the moral sense, to
which, indeed it is nearly allied : both of them
discover what is right, and what is wrong ;
fashion, temper, and education may vitiate both,
or preserve them pure and untainted : neither of
them are arbitrary or local, being rooted in hu-
man nature, and common to all men." A diligent
study of the classics might teach us, that Rome
was vitiated by her Arts, and not by her Asiatic
luxuries ; but a diligent study of human nature
will assure us the Arts, created by the intellect,
will advance with the intellectual destiny of man.
That destiny is progress. The material world is
governed by fixed laws : the spiritual is an effu-
sion of light from perfection to perfection. The
mighty orbs of heaven still roll in the vastness
of space, in the sphere designed by the Eternal
Wisdom, at whose word they arose; worlds
themselves, to give light, and be a theme of won-
der and of praise, to others. Beauty the most
exquisite—in outline the most varied ; of every
hue and combination of colour; of form the
most diverse, clothed with every attribute of
gracefulness and strength—invests the earth. In
equal wisdom, with an unerring adaptation of
nature unto clime, every class of the animal
creation attests its Maker. But to these a fixed
law of life, an immutable destiny is given. It
is not so with man : endowed with the highest
powers, taught to aspire to the noblest ends, his
mind is free ; he is a law unto himself ; his des-
tiny is the work of his own will. To him the
past is time, the future is eternity, his moral
state of being is created coequal with his pro-
gressive condition, and the soul, conscious of
this law, bursts from the frame of clay,

" Wrapt round its struggling powers."

No age can transmit to its successor the heri-
tage of the human mind, in the condition it was
received. Thought, which creates opinion, re-
fines as it progresses, becomes more enlarged in
its conceptions, better founded, and more dif-
fused. From the social union of men, from their
daily habitual intercourse, a gradual progression
of manners and opinions originates, which no-
thing can retard. In the general history of civi-
lization it will be found that it is the silent, gra-
dual succession of causes, rather than the fear of
powerful influences, which has largely affected
the condition of a people. If we review
the past, who can doubt society has advanced ?
if we consider our own powers, who can doubt
we must continue to advance ? We have hope,
we have confidence, in the times to be : in the
future of social condition, of government, lite-
rature, science, and the FUTURE OF BRITISH
ART.

from

"The Royal Academy.
Seventy-seventh Exhibition. 1845"

Art-Union 7 (June 1845), 179–96

THE ROYAL ACADEMY.

SEVENTY-SEVENTH EXHIBITION. 1845.

THE Seventy-seventh Exhibition of the Royal Academy consists of 1470 works—of which 146 are in sculpture.* On the whole, it has not been —and cannot be—regarded as satisfactory; the SENIORS in Art have done little; nor can the JUNIORS (with a few cheering exceptions) be said to have done much. We trust the former will make amends by "reporting progress" in Westminster Hall; it is known, indeed, that the absence of two or three from the walls in Trafalgar-square is the consequence of labour for the approaching Exhibition, under the auspices of the Royal Commission. Still, we think, care should have been taken to have avoided so comparatively weak a gathering as this—which our great National Demonstration of the year presents. MACLISE is altogether absent; MULREADY sends but one small picture—"painted in 1830;" E. LANDSEER, usually a contributor of five or six, furnishes only one; UWINS has no more—and his one is, we regret to say, "a repetition;" while of the Associates we have nothing from COPE and DYCE, and barely one each from the other men of mark among the subalterns in rank of the Academy. The consequence has been that aspirants for honours hereafter have had good chances; the members, not having had pictures of their own to place "upon the line," have been compelled to make selections from the Profession at large; many, therefore, are fortunate enough to have had their pictures seen and appreciated—in some instances to the serious damage of "distinguished neighbours."

Yet, again, there are some singular mistakes, for which—making all due allowance for difficulties of various kinds in the way of "hanging"— it is impossible to account. Two or three painters have been here elevated to positions which they cannot keep; while others who are looked upon, universally, as among the safest candidates for academic glories find "the black mark" fixed upon their works. It is always irksome to refer to such errors—in judgment; by becoming explicit on the subject we should augment the injury; visitors, generally, however, will

* Last year there were exhibited 1410; in 1813, there were 1530; in 1812, there were 1409; in 1811, there were 1313; in 1810, there were 1240; in 1839, there were 1390; in 1838, there were 1382. The number, therefore, has not materially increased; nor can it increase, until the space has been augmented.

not hesitate to join us in protesting against certain "blunders," which, being too obvious to escape notice, will be perceived by all. There is one circumstance, in especial, however, to which we feel bound to allude. M. VERBOCKHOVEN, of Brussels—the great Belgian animal-painter, whose ability admits of no question, although many will hesitate to concede that he rivals the great animal-painter of England—sent two pictures to our Exhibition. One of them has been treated with less indignity than the other; but one is so placed—above the first door of entrance—as to be utterly ruined for any useful purpose, being, indeed, injurious rather than beneficial to the artist's fame. We do not hesitate to assert that this act is disreputable to the Royal Abademy, and disgraceful to England; it is mean and ungenerous to an extent that would discredit a company of chapmen in "soft goods," who, fearing their new patterns migh be prejudiced by being placed in juxtaposition with those of a rival "house," thrust the offerings of competitors into a dark corner. On the Continent, men speak of "John Bull" as a selfish animal, who applies the narrow habits of trade to things far higher and holier; his reputation abroad is not likely to be changed by the conduct of the British Royal Academy, who do not find the word "generous" in their vocabulary; and in whose view the Fine Arts are no more the Arts "Liberal" than the Arts which manufacture tobacco-pipes and tenpenny nails. Year after year some distinguished foreigner—placed by universal suffrage at the head of the Profession in his own country—has contributed to our Exhibition; in every instance he has been treated with marked contumely. We have reason to *know* that, if any of our leading painters send their works to France or to Germany, they will be received in a manner honourable and not degrading to the country in which they appear. During a recent visit to Paris—and in the course of conversation with some of the great minds there—we endeavoured to determine this point; and saw it was deemed a close approach to insult to conceive it possible that so scandalous a procedure could be tolerated in France. It has been our earnest hope to see an interchange of kindly sentiments between England and the countries of the Continent; we may teach, but we may also learn, much; and in the Arts it is above all things essential to follow that which elevates and refines. The tone of the German press as regards Art in England has been essentially altered of late; and we presume to say this advantage has mainly resulted from our efforts. We hope to produce, and believe we shall produce, an equal improvement in French criticism upon English works (at present it is deplorably unjust and ignorant); we have reason to believe that, at all events, we have already stirred up a desire for inquiry concerning the matter, and that ere long we shall have to report an entire change as to the mode in which we are treated by our neighbours. The best and surest way to bring about this "consummation"

is for our English artists to exhibit at the Louvre; we promise them a very different fate from that which they bestow upon competitors insulted in Trafalgar-square; and we beg to assure the latest victim to a miserably mistaken policy—M. Verbockhoven—that the Royal Academy no more represents the enlightened spirit of the existing age in England, than the sedan-chair of our granddame does the speed of transit in the nineteenth century.

It is essential to add, that M. Verbockhoven is by no means the only foreign painter "elevated" or "depressed," by the hangers of the Royal Academy :—look among the gathering cobwebs at the ceiling, or through the dust about your feet, and "you shall see" the contributions of half-a-dozen other confiding foreigners who had calculated upon honours to be received at the liberal hands of generous Albion !

The evils to which we have thus made reference do not lie upon the surface; it is otherwise with those which regard THE MULTIPLICITY OF PORTRAITS. This year the "blots" seem, and we believe are, more numerous than ever—human forms and faces, of all conceivable expressions, literally covering the walls of "the great room." North, south, east, and west, above the line of living and moving heads (and on the opening day it was impossible to see any thing below them), are quadrupled rows of copies of patrons of portrait-painters; here and there you notice some "touch of history"—in one sense elevated —but carry your eye round the huge apartment, and you see a crowded assemblage of inanities, of whom the world knows, and for whom it cares, nothing.

In order to exhibit this evil in the strongest light, we made a drawing of one of the four sides of the Great Room (above THE LINE)—the side which the visitor first sees on entering. The other sides are still more objectionable; so that that, in printing this cut, we, at least, give the

case fairly. The side here pictured contains just forty pictures, of which twenty-eight are portraits—several of them full length; of the pictures not portraits seven of the twelve are placed at the top of the room, close to the ceiling; and the other five are pushed into the two corners. The portraits we have left black; the pictures not portraits, white; but we ought, perhaps, to have made some of them piebald, for four out of the twelve are "fancy portraits."

We have said that the other sides are "more objectionable;" the left wall contains 27 pictures, 22 of which are portraits; on the right wall are hung 26 pictures, 25 of which are portraits. Matters are much the same in the "middle room;" not quite so bad in the "west room;" in the "octagon room" there is *but one portrait!* Yet in the least honourable rooms—above the line, *i. e.*, in the places entirely occupied by portraits in the great room—are such admirable pictures as those of Stone, Egg, Müller,

Gilbert, and a store of other excellent artists— men of genius, whose genius would be respected and acknowledged by any other academy in the world.

It was our intention to have taken accurate measurement of the four walls of the great room, in order to show exactly the number of square feet occupied by the portraits, and those covered by pictures not portraits. The calculation would be certainly curious, perhaps instructive. We may do so next month.

The several "ROOMS" are just as they have been for some years past :—the octagon hole is again in requisition, although, certainly, this year notoriously needless ; a few good pictures—none by Academic Dignitaries—are once more thrust into it by way of lessons to aspiring youths to be humble-minded, and not to HOPE too much ; but of meritorious works so sacrificed there are not many—not more, perhaps, than might have been fitted into the twelve square feet of "the line"

occupied by 'Mr. Robertson's Little Wonder winning the Derby in the year 1840'—a picture painted, we presume, for the tap-room of Tom Spring, or the smoking-closet of Mr. Pontefract Gully. Men like Mr. Howard may exhibit miserable examples of mediocrity; they can paint no better; and the half-a-dozen of his peers may have the common excuse for showing daubs—"*Il faut vivre*"; but there is no pardon to be granted for exposing a vulgar piece of canvas representing jockeys beating up their horses to the winning-post; to say nothing of the space it so unworthily occupies being possessed to the exclusion of really meritorious performances.

On the first day, when the crowd and the dust effectually kept us from the sight of all works on or under "the line," we were, as we have intimated, compelled to look only round the walls above; and a pleasant sight it was! Our visits subsequently have been more successful—having paid some six or seven shillings for liberty to enter before reasonable people breakfast, we have as often found the rooms empty; and, therefore, trust we shall be enabled to introduce our readers to the pictures, and the pictures to our readers. For the ability to do so, however, we give no thanks to the Royal Academy; that most generous and liberal body still asserts it claim to be the only public Society or Institution in Great Britain which resolutely keeps out critics as long as it can; and, as we are not fortunate enough to inherit a title—or to possess any, except that which our brain has "sweated" to obtain—we pushed our way into the room on Monday, May the 5th; after Friday had been given to the Queen and her suite; Saturday to the buyers and the dinner; and *Sunday* to such persons as it would have been impolitic—perhaps—to have refused.*

ALL "Buyers," however, were not admitted to the dinner, neither were they to the "private view;" for the Honorary Secretaries of the Art-Union of London, who were, either directly or indirectly, making purchases to the amount of, it may be, £2000, were not among the "buyers"

to whom it was considered an honour to bow; they entered on Monday; and we saw them, with the critics of the several daily journals, painfully pushing through crowds to have the privilege of seeing and buying. But this was a matter of small moment to the Royal Academy: such works, by its members, as they would buy were all "sold" previous to the public opening; and such, by its members, as were "unsold" had little chance of being bought by them.

* The following letter, published in the *Times*, has received no answer:—
"TO THE EDITOR OF THE TIMES.
"SIR,—Can you assist me in the following dilemma?
"Is a visit to the Exhibition of the Royal Academy a rational, Christianlike, and proper amusement for the afternoon of Sunday, after attending divine service in the morning—ay or no?
"If it be, why am I and my class excluded on that day?
"If it be not, why were 'their Royal Highnesses the Duke and Duchess of Cambridge, Prince George, the Hereditary Grand Duke and Duchess of Mecklenburgh-Strelitz (attended by Mr. Edmond Mildmay), and the Grand Duchess Stephanie of Baden, accompanied by the Marchioness of Douglas, and attended by the Baroness de Strumfeder,' as per 'Court Circular,' admitted?
"Yours, &c.,
"A CLERK,
"May 12." "Who never leaves Business until Dusk.
It would be out of the question, we presume, for critics to ask for the Sunday—like the Duchess of Mecklenburgh-Strelitz, and "Mr. Edmond Mildmay," and the Grand Duchess Stephanie of Baden, and the Marchioness of Douglas; but, if there were anything to hope for, they might hope for admission at nine o'clock instead of twelve, on the day of public view.

W.M. Thackeray

"Picture Gossip:
In a Letter from
Michael Angelo Titmarsh"

Fraser's Magazine 31 (June 1845), 713–24

PICTURE GOSSIP: IN A LETTER FROM MICHAEL ANGELO TITMARSH,

ALL ILLUSTRISSIMO SIGNOR, IL MIO SIGNOR COLENDISSIMO,
AUGUSTO HA ARVÉ, PITTORE IN ROMA.

I AM going to fulfil the promise, my dear Augusto, which I uttered, with a faltering voice and streaming eyes, before I stepped into the jingling old courier's vehicle, which was to bear me from Rome to Florence. Can I forget that night—that parting? Gaunter stood by so affected, that for the last quarter of an hour he did not swear once; Flake's emotion exhibited itself in audible sobs; Jellyson said naught, but thrust a bundle of Torlonia's four-baiocchi cigars into the hand of the departing friend; and you yourself were so deeply agitated by the event, that you took four glasses of absinthe to string up your nerves for the fatal moment. Strange vision of past days!—for vision it seems to me now. And have I been in Rome really and truly? Have I seen the great works of my Christian namesake of the Buonarotti family, and the light arcades of the Vatican? Have I seen the glorious Apollo, and that other divine fiddle-player whom Raphael painted? Yes—and the English dandies swaggering on the Pincian Hill! Yes—and have eaten woodcocks and drank Ovieto hard by the huge, broad-shouldered Pantheon Portico, in the comfortable parlours of the Falcone. Do you recollect that speech I made at Bertini's in proposing the health of the Pope of Rome on Christmas-day?—do you remember it? *I* don't. But his holiness, no doubt, heard of the oration, and was flattered by the compliment of the illustrious English traveller.

I went to the exhibition of the Royal Academy lately, and all these reminiscences rushed back on a sudden with affecting volubility; not that there was anything in or out of the gallery which put me specially in mind of sumptuous and liberal Rome; but in the great room was a picture of a fellow in a broad Roman hat, in a velvet Roman coat, and large yellow mustachios, and that prodigious scowl which young artists assume when sitting for their portraits—he was one of our set at Rome; and the scenes of the winter came back pathetically to my mind,

and all the friends of that season,—Orifice and his sentimental songs; Father Giraldo and his poodle, and MacBrick, the trump of bankers. Hence the determination to write this letter; but the hand is crabbed, and the postage is dear, and instead of despatching it by the mail, I shall send it to you by means of the printer, knowing well that *Fraser's Magazine* is eagerly read at Rome, and not (on account of its morality) excluded in the *Index Expurgatorius*.

And it will be doubly agreeable to me to write to you regarding the fine arts in England, because I know, my dear Augusto, that you have a thorough contempt for my opinion—indeed, for that of all persons, excepting, of course, one whose name is already written in this sentence. Such, however, is not the feeling respecting my critical powers in this country; *here* they know the merit of Michael Angelo Titmarsh better, and they say, " He paints so badly, that, hang it! he *must* be a good judge;" in the latter part of which opinion, of course, I agree.

You should have seen the consternation of the fellows at my arrival!—of our dear brethren who thought I was safe at Rome for the season, and that their works, exhibited in May, would be spared the dreadful ordeal of my ferocious eye. When I entered the club-room in St. Martin's Lane, and called for a glass of brandy-and-water like a bomb-shell, you should have seen the terror of some of the artists assembled! They knew that the frightful projectile just launched into their club-room must *burst* in the natural course of things. Who would be struck down by the explosion? was the thought of every one. Some of the hypocrites welcomed me meanly back, some of the timid trembled, some of the savage and guilty muttered curses at my arrival. You should have seen the ferocious looks of Daggerly, for example, as he scowled at me from the supper-table, and clutched the trenchant weapon with which he was dissevering his toasted cheese.

From the period of my arrival un-

til that of the opening of the various galleries, I maintained with the artists every proper affability, but still was not too familiar. It is the custom of their friends before their pictures are sent in to the exhibitions, to visit the painter's works at their private studios, and there encourage them by saying, " Bravo, Jones (I don't mean Jones, R.A., for I defy any man to say bravo to *him*, but Jones in general) !" "Tomkins, this is your greatest work!" "Smith, my boy, they must elect you an associate for this!"—and so forth. These harmless banalities of compliment pass between the painters and their friends on such occasions. I, myself, have uttered many such civil phrases in former years under like circumstances. But it is different now. Fame has its privations as well as its pleasures. The friend may see his companions in private, but the JUDGE must not pay visits to his clients. I staid away from the *ateliers* of all the artists (at least, I only visited one, kindly telling him that he didn't count as an artist at all), would only see their pictures in the public galleries, and judge them in the fair race with their neighbours. This announcement and conduct of mine filled all the Berners Street and Fitzroy Square district with terror.

As I am writing this after having had my fill of their works, so publicly exhibited in the country, at a distance from catalogues, my only book of reference being an orchard whereof the trees are now bursting into full blossom,—it is probable that my remarks will be rather general than particular, that I shall only discourse about those pictures which I especially remember, or, indeed, upon any other point suitable to my honour and your delectation.

I went round the galleries with a young friend of mine, who, like yourself at present, has been a student of "High Art" at Rome. He had been a pupil of Monsieur Ingres, at Paris. He could draw rude figures of eight feet high to a nicety, and had produced many heroic compositions of that pleasing class and size, to the great profit of the paper-stretchers both in Paris and Rome. He came back from the latter place a year since, with his beard and mustachios

of course. He could find no room in all Newman Street and Soho big enough to hold him and his genius, and was turned out of a decent house because, for the purposes of art, he wished to batter down the partition-wall between the two drawing-rooms he had. His great cartoon last year (whether it was Caractacus before Claudius, or a scene from the *Vicar of Wakefield*, I won't say) failed somehow. He was a good deal cut up by the defeat, and went into the country to his relations, from whom he returned after a while, with his mustachios shaved, clean linen, and other signs of depression. He said (with a hollow laugh) he should not commence on his great canvass this year, and so gave up the completion of his composition of " Boadicea addressing the Iceni : quite a novel subject, which, with that ingenuity and profound reading which distinguishes his brethren, he had determined to take up.

Well, sir, this youth and I went to the exhibitions together, and I watched his behaviour before the pictures. At the tragic, swaggering, theatrical, historical pictures, he yawned ; before some of the grand, flashy landscapes, he stood without the least emotion ; but before some quiet scenes of humour or pathos, or some easy little copy of nature, the youth stood in pleased contemplation, the nails of his highlows seemed to be screwed into the floor there, and his face dimpled over with grins.

" These little pictures," said he, on being questioned, "are worth a hundred times more than the big ones. In the latter you see signs of ignorance of every kind, weakness of hand, poverty of invention, carelessness of drawing, lamentable imbecility of thought. Their heroism is borrowed from the theatre, their sentiment is so maudlin that it makes you sick. I see no symptoms of thought or of minds strong and genuine enough to cope with elevated subjects. No individuality, no novelty, the decencies of costume (my friend did not mean that the figures we were looking at were naked, like Mr. Etty's, but that they were dressed out of all historical propriety) are disregarded ; the people are striking attitudes, as at the Coburg. There is something painful to

me in this *naïve* exhibition of incompetency, this imbecility that is so unconscious of its own failure. If, however, the aspiring men don't succeed, the modest do; and what they have really seen or experienced, our artists can depict with successful accuracy and delightful skill. Hence," says he, " I would sooner have So-and-so's little sketch ('A Donkey on a Common') than What-d'ye-call-'em's enormous picture ('Sir Walter Manny and the Crusaders discovering Nova Scotia),' and prefer yonder unpretending sketch, 'Shrimp-Catchers, Morning,' (how exquisitely the long and level sands are touched off! how beautifully the morning light touches the countenances of the fishermen, and illumines the rosy features of the shrimps!) to yonder pretensious illustration from Spenser, 'Sir Botibol rescues Una from Sir Uglimore in the Cave of the Enchantress Ichthyosaura.'"

I am only mentioning another's opinion of these pictures, and would not of course, for my own part, wish to give pain by provoking comparisons that must be disagreeable to some persons. But I could not help agreeing with my young friend, and saying, " Well, then, in the name of goodness, my dear fellow, if you only like what is real, and natural, and unaffected—if upon such works you gaze with delight, while from more pretensious performers you turn away with weariness, why the deuce must *you* be in the heroic vein? Why don't you *do* what you like?" The young man turned round on the iron-heel of his high-lows, and walked downstairs clinking them sulkily.

There are a variety of classes and divisions into which the works of our geniuses may be separated. There are the heroic pictures, the theatrical-heroic, the religious, the historical-sentimental, the historical-familiar, the namby-pamby, and so forth.

Among the heroic pictures of course Mr. Haydon's ranks the first, its size and pretensions call for that place. It roars out to you as it were with a Titanic voice from among all the competition to public favour, "Come and look at me." A broad-shouldered, swaggering, hulking archangel, with those rolling eyes and distending nostrils which belong to the species of sublime caricature, stands scowling on a sphere from which the devil is just descending bound earthwards. Planets, comets, and other astronomical phenomena, roll and blaze round the pair and flame in the new blue sky. There is something burly and bold in this resolute genius which will attack only enormous subjects, which will deal with nothing but the epic, something respectable even in the defeats of such characters. I was looking the other day at Southampton at a stout gentleman in a green coat and white hat, who a year or two since fully believed that he could walk upon the water, and set off in the presence of a great concourse of people upon his supermarine journey. There is no need to tell you that the poor fellow got a wetting and sank amidst the jeers of all his beholders. I think somehow they should not have laughed at that honest ducked gentleman, they should have respected the faith and simplicity which led him unhesitatingly to venture upon that watery experiment; and so, instead of laughing at Haydon, which you and I were just about to do, let us check our jocularity, and give him credit for his great earnestness of purpose. I begin to find the world growing more pathetic daily, and laugh less every year of my life. Why laugh at idle hopes, or vain purposes, or utter blundering self-confidence? Let us be gentle with them henceforth, who knows whether there may not be something of the sort *chez nous?* But I am wandering from Haydon and his big picture. Let us hope somebody will buy. Who, I cannot tell; it will not do for a chapel; it is too big for a house: I have it—it might answer to hang up over a caravan at a fair, if a travelling orrery were exhibited inside.

This may be sheer impertinence and error, the picture may suit some tastes, it does *The Times* for instance, which pronounces it to be a noble work of the highest art; whereas the *Post* won't believe a bit, and passes it by with scorn. What a comfort it is that there are different tastes then, and that almost all artists have thus a chance of getting a livelihood somehow! There is Martin, for another instance, with his

brace of pictures about Adam and Eve, which I would venture to place in the theatrical-heroic class. One looks at those strange pieces and wonders how people can be found to admire, and yet they do. Grave old people, with chains and seals, look dumb-foundered into those vast perspectives, and think the apex of the sublime is reached there. In one of Sir Bulwer Lytton's novels there is a passage to that effect. I forget where, but there is a new edition of them coming out in single volumes, and am positive you will find the sentiment somewhere; they come up to his conceptions of the sublime, they answer his ideas of beauty of the Beautiful as he writes with a large B. He is himself an artist and a man of genius. What right have we poor devils to question such an authority? Do you recollect how we used to laugh in the Capitol at the Domenichino Sybil which this same author praises so enthusiastically? a wooden, pink-faced, goggle-eyed, ogling creature, we said it was, with no more beauty or sentiment than a wax doll. But this was our conceit, dear Augusto; on subjects of art, perhaps, there is no reasoning after all: or who can tell why children have a passion for lollypops, and this man worships beef while t'other adores mutton? To the child lollypops may be the truthful and beautiful, and why should not some men find Martin's pictures as much to their taste as Milton?

Another instance of the blessed variety of tastes may be mentioned here advantageously; while, as you have seen, *The Times* awards the palm to Haydon, and Sir Lytton exalts Martin as the greatest painter of the English school, *The Chronicle*, quite as well informed, no doubt, says that Mr. Eddis is the great genius of the present season, and that his picture of Moses's mother parting with him before leaving him in the bulrushes is a great and noble composition.

This critic must have a taste for the neat and agreeable, that is clear. Mr. Eddis's picture is nicely coloured; the figures in fine clean draperies, the sky a bright clean colour; Moses's mother is a handsome woman; and as she holds her child to her breast for the last time, and lifts up her fine eyes to heaven, the beholder may be reasonably moved by a decent *bourgeois* compassion; a handsome woman parting from her child is always an object of proper sympathy: but as for the greatness of the picture as a work of art, that is another question of tastes again. This picture seemed to me to be essentially a prose composition, not a poetical one. It tells you no more than you can see. It has no more wonder or poetry about it than a police report or a newspaper paragraph, and should be placed, as I take it, in the historic-sentimental school, which is pretty much followed in England—nay, as close as possible to the namby-pamby quarter.

Of the latter sort there are some illustrious examples; and as it is the fashion for critics to award prizes, I would for my part cheerfully award the prize of a new silver tea-spoon to Mr. Redgrave, that champion of suffering female innocence, for his "Governess." That picture is more decidedly *spoony* than, perhaps, any other of this present season; and the subject seems to be a favourite with the artist. We have had the "Governess" one year before, or a variation of her under the name of "The Teacher," or *vice versâ*. The Teacher's young pupils are at play in the garden, she sits sadly in the school-room, there she sits, poor dear!—the piano is open beside her, and (oh, harrowing thought!) "Home, sweet home!" is open in the music-book. She sits and thinks of that dear place, with a sheet of black-edged note-paper in her hand. They have brought her her tea and bread and butter on a tray. She has drunk the tea, *she has not tasted the bread and butter*. There is pathos for you! there is art! This is, indeed, a love for lollypops with a vengeance, a regular babyhood of taste, about which a man with a manly stomach may be allowed to protest a little peevishly, and implore the public to give up such puling food.

There is a gentleman in the Octagon Room who, to be sure, runs Mr. Redgrave rather hard, and should have a silver pap-spoon at any rate, if the tea-spoon is irrevocably awarded to his rival. The Octagon Room prize is a picture called the "Arrival of the Overland Mail." A lady is

in her bedchamber, a portrait of her husband, Major Jones, (cherished lord of that bridal apartment, with its drab-curtained bed), hangs on the wainscot in the distance, and you see his red coat and mustachios gleaming there between the wardrobe and the washhand-stand. But where is his lady? She is on her knees by the bedside, her face has sunk into the feather-bed; her hands are clasped agonisingly together; a most tremendous black-edged letter has just arrived by the overland mail. It is all up with Jones. Well, let us hope she will marry again, and get over her grief for poor J.

Is not there something *naïve* and simple in this downright way of exciting compassion? I saw people looking at this pair of pictures evidently with yearning hearts. The great geniuses who invented them have not, you see, toiled in vain. They can command the sympathies of the public, they have gained Art-Union prizes let us hope, as well as those humble imaginary ones which I have just awarded, and yet my heart is not naturally hard, though it refuses to be moved by such means as are here employed.

If the simple statement of a death is to harrow up the feelings, or to claim the tributary tear, *mon Dieu!* a man ought to howl every morning over the newspaper obituary. If we are to cry for every governess who leaves home, what a fund of pathos *The Times* advertisements would afford daily; we might weep down whole columns of close type. I have said before I am growing more inclined to the pathetic daily, but let us in the name of goodness make a stand somewhere, or the namby-pamby of the world will become unendurable; and we shall melt away in a deluge of blubber. This drivelling, hysterical sentimentality, it is surely the critic's duty to grin down, to shake any man roughly by the shoulder who seems dangerously affected by it, and, not sparing his feelings in the least, tell him he is a fool for his pains, to have no more respect for those who invent it, but expose their error with all the downrightness that is necessary.

By far the prettiest of the maudlin pictures is Mr. Stone's "Premier Pas." It is that old, pretty, rococo, fantastic, Jenny and Jessamy couple, whose loves the painter has been chronicling any time these five years, and whom he has spied out at various wells, porches, &c. The lad is making love with all his might, and the maiden is in a pretty confusion—her heart flutters, and she only seems to spin. She drinks in the warm words of the young fellow with a pleasant conviction of the invincibility of her charms. He appeals nervously, and tugs at a pink which is growing up the porch-side. It is that pink, somehow, which has saved the picture from being decidedly namby-pamby. There is something new, fresh, and delicate about the little incident of the flower. It redeems Jenny, and renders that young prig, Jessamy, bearable. The picture is very nicely painted, according to the careful artist's wont. The neck and hands of the girl are especially pretty. The lad's face is effeminate and imbecile, but his velveteen breeches are painted with great vigour and strength.

This artist's picture of the "Queen and Ophelia" is in a much higher walk of art. There may be doubts about Ophelia. She is too pretty to my taste. Her dress (especially the black bands round her arms) too elaborately conspicuous and coquettish. The queen is a noble dramatic head and attitude. Ophelia seems to be looking at us, the audience, and in a pretty attitude expressly to captivate us. The queen is only thinking about the crazed girl, and Hamlet, and her own gloomy affairs, and has quite forgotten her own noble beauty and superb presence. The colour of the picture struck me as quite new, sedate, but bright and very agreeable; the chequered light and shadow is made cleverly to aid in forming the composition; it is very picturesque and good. It is by far the best of Mr. Stone's works, and in the best line. Good-by, Jenny and Jessamy; we hope never to see you again—no more rococo rustics, no more namby-pamby: the man who can paint the queen of Hamlet must forsake henceforth such fiddle-faddle company.

By the way, has any Shaksperian commentator ever remarked how fond the queen really was of her

second husband, the excellent Claudius? How courteous and kind the latter always was towards her? So excellent a family-man ought to be pardoned a few errors in consideration of his admirable behaviour to his wife. He *did* go a little far, certainly, but then it was to possess a jewel of a woman.

More pictures indicating a fine appreciation of the tragic sentiment are to be found in the Exhibition. Among them may be mentioned specially Mr. Johnson's picture of " Lord Russell taking the Communion in Prison before Execution." The story is finely told here, the group large and noble. The figure of the kneeling wife, who looks at her husband meekly engaged in the last sacred office, is very good indeed; and the little episode of the gaoler, who looks out into the yard indifferent, seems to me to give evidence of a true dramatic genius. In *Hamlet*, how those indifferent remarks of Guildenstern and Rosencrantz, at the end, bring out the main figures and deepen the surrounding gloom of the tragedy!

In Mr. Frith's admirable picture of the " Good Pastor," from Goldsmith, there is some sentiment of a very quiet, refined, Sir - Roger - de Coverley-like sort—not too much of it—it is indicated rather than expressed. " Sentiment, sir," Walker of the *Original* used to say,—" sentiment, sir, is like garlic in made dishes: it should be felt every where and seen nowhere."

Now, I won't say that Mr. Frith's sentiment is like garlic, or provoke any other savoury comparison regarding it; but say, in a word, this is one of the pictures I would like to have sent abroad to be exhibited at a European congress of painters, to shew what an English artist can do. The young painter seems to me to have had a thorough comprehension of his subject and his own abilities. And what a rare quality is this, to know what you can do! An ass will go and take the grand historic walk, while, with lowly wisdom, Mr. Frith prefers the lowly path where there are plenty of flowers growing, and children prattling along the walks. This is the sort of picture that is good to paint nowadays —kindly, beautiful, inspiring delicate sympathies, and awakening

tender good-humour. It is a comfort to have such a companion as that in a study to look up at when your eyes are tired with work, and to refresh you with its gentle, quiet good-fellowship. I can see it now, as I shut my own eyes, displayed faithfully on the camera obscura of the brain—the dear old parson with his congregation of old and young clustered round him; the little ones plucking him by the gown, with wondering eyes, half-roguery, half-terror; the smoke is curling up from the cottage-chimneys in a peaceful, Sabbath-sort of way; the three village quidnuncs are chattering together at the churchyard · stile; there's a poor girl seated there on a stone, who has been crossed in love evidently, and looks anxiously to the parson for a little doubtful consolation. That's the real sort of sentiment—there's no need of a great, clumsy, black-edged letter to placard her misery, as it were, after Mr. Redgrave's fashion; the sentiment is only the more sincere for being unobtrusive, and the spectator gives his compassion the more readily, because the unfortunate object makes no coarse demands upon his pity.

The painting of this picture is exceedingly clever and dexterous. One or two of the foremost figures are painted with the breadth and pearly delicacy of Greuze. The three village politicians, in the back-ground, might have been touched by Teniers, so neat, brisk, and sharp is the execution of the artist's facile brush.

Mr. Frost (a new name, I think, in the Catalogue) has given us a picture of " Sabrina," which is so pretty that I heartily hope it has not been purchased for the collection from *Comus*, which adorns the Buckingham Palace summerhouse. It is worthy of a better place and price than our royal patrons appear to be disposed to give for the works of English arts. What victims have those poor fellows been of this awful patronage! Great has been the commotion in the pictorial world, dear Augusto, regarding the fate of those frescoes which royalty was pleased to order, which it condescended to purchase at a price that no poor amateur would have the face to offer. Think of the greatest patronage in the world giving forty pounds for pictures worth four hun-

dred — condescending to buy works from humble men who could not refuse, and paying for them below their value! Think of august powers and principalities ordering the works of such a great man as Etty to be hacked out of the palace wall—that was a slap in the face to every artist in England; and I can agree with the conclusion come to by an indignant poet of *Punch's* band, who says, for his part,—

" I will not toil for queen and crown,
 If princely patrons spurn me down ;
 I will not ask for royal job—
 Let my Mæcenas be A SNOB !"

This is, however, a delicate, an awful subject, over which loyal subjects like you and I had best mourn in silence; but the fate of Etty's noble picture of last year made me tremble lest Frost should be similarly nipped; and I hope more genuine patronage for this promising young painter. His picture is like a mixture of very good Hilton and Howard raised to a state of genius. There is sameness in the heads, but great grace and beauty—a fine sweeping movement in the composition of the beautiful fairy figures, undulating gracefully through the stream, while the lilies lie gracefully overhead. There is another submarine picture of " Nymphs cajoling Young Hylas," which contains a great deal of very clever imitations of Boucher.

That youthful Goodall, whose early attempts promised so much, is not quite realising those promises I think, and is cajoled, like Hylas before mentioned, by dangerous beauty. His " Connemara Girls going to Market" are a vast deal too clean and pretty for such females. They laugh and simper in much too genteel a manner; they are washing such pretty white feet as I don't think are common about Leenane or Ballynalinch, and would be better at ease in white satin slippers than trudging up Croaghpatrick. There is a luxury of geographical knowledge for you! I have not done with it yet. Stop till we come to Roberts's " View of Jerusalem," and Muller's pictures of " Rhodes," and " Xanthus," and " Telmessus." This artist's sketches are excellent; like nature, and like Decamps, that best of painters of

Oriental life and colours. In the pictures the artist forgets the brilliancy of colour which is so conspicuous in his sketches, and " Telmessus" looks as grey and heavy as Dover in March.

Mr. Pickersgill (not the Academician, by any means) deserves great praise for two very poetical pieces; one from Spenser, I think (Sir Botibol let us say, as before, with somebody in some hag's cave) ; another called the " Four Ages," which has still better grace and sentiment. This artist, too, is evidently one of the disciples of Hilton ; and another, who has also, as it seems to me, studied with advantage that graceful and agreeable English painter, Mr. Hook, whose " Song of the Olden Time" is hung up in the Octagon Closet, and makes a sunshine in that exceedingly shady place. The female figure is faulty, but charming (many charmers have their little faults, it is said); the old bard who is singing the song of the olden time a most venerable, agreeable, and handsome old minstrel. In Alnaschar-like moods a man fancies himself a noble patron, and munificent rewarder of artists; in which case I should like to possess myself of the works of these two young men, and give them four times as large a price as the —— gave for pictures five times as good as theirs.

I suppose Mr. Eastlake's composition from *Comus* is the contribution in which *he* has been mulcted, in company with his celebrated brother artists, for the famous Buckingham Palace pavilion. Working for nothing is very well ; but to work for a good, honest, remunerating price is, perhaps, the best way, after all. I can't help thinking that the artist's courage has failed him over his *Comus* picture. Time and pains he has given, that is quite evident. The picture is prodigiously laboured, and hatched, and tickled up with a Chinese minuteness; but there is a woeful lack of *vis* in the work. That poor labourer has kept his promise, has worked the given number of hours; but he has had no food all the while, and has executed his job in a somewhat faint manner. This face of the lady is pure and beautiful; but we have seen it at any time these ten years, with its red transpa-

rent shadows, its mouth in which butter wouldn't melt, and its beautiful brown madder hair. She is getting rather tedious, that sweet, irreproachable creature, that is the fact. She may be an angel; but sky-blue, my wicked senses tell me, is a feeble sort of drink, and men require stronger nourishment.

Mr. Eastlake's picture is a prim, mystic, cruciform composition. The lady languishes in the middle; an angel is consoling her, and embracing her with an arm out of joint; little rows of cherubs stand on each side the angels and the lady,—wonderful little children, with blue or brown beady eyes, and sweet little flossy curly hair, and no muscles or bones, as becomes such supernatural beings, no doubt. I have seen similar little darlings in the toy-shops in the Lowther Arcade for a shilling, with just such pink cheeks and round eyes, their bodies formed out of cotton wool, and their extremities veiled in silver paper. Well; it is as well, perhaps, that Etty's jovial nymphs should not come into such a company. Good Lord! how they would astonish the weak nerves of Mr. Eastlake's *précieuse* young lady!

Quite unabashed by the squeamishness exhibited in the highest quarter (as the newspapers call it), Mr. Etty goes on rejoicing in his old fashion. Perhaps he is worse than ever this year, and despises *nec dulces amores nec choreas*, because certain great personages are offended. Perhaps, this year, his ladies and Cupids *are* a little *hazardés*; his Venuses expand more than ever in the line of Hottentot beauty; his drawing and colouring are still more audacious than they were; patches of red shine on the cheeks of his blowsy nymphs; his idea of form goes to the verge of monstrosity. If you look at the pictures closely (and, considering all things, it requires some courage to do so), the forms disappear; feet and hands are scumbled away, and distances appear to be dabs and blotches of lakes, and brown, and ultramarine. It must be confessed, that some of these pictures would *not* be suitable to hang up every where—in a young ladies' school, for instance. But, how rich and superb is the colour! Did Titian paint better, or Rubens as well? There is a nymph and child

in the left corner of the Great Room, sitting, without the slightest fear of catching cold, in a sort of moonlight, of which the colour appears to me to be as rich and wonderful as Titian's best—"Bacchus and Ariadne," for instance—and better than Rubens's. There is a little head of a boy in a blue dress (for once in a way) which kills every picture in the room, out-stares all the red-coated generals, out-blazes Mrs. Thwaites and her diamonds (who has the place of honour); and has that unmistakeable, inestimable, indescribable mark of the GREAT painter about it, which makes the soul of a man kindle up as he sees it, and owns that there is Genius. How delightful it is to feel that shock, and how few are the works of art that can give it!

The author of that sybilline book of mystic rhymes, the unrevealed bard of the *Fallacies of Hope*, is as great as usual, vibrating between the absurd and the sublime, until the eye grows dazzled in watching him, and can't really tell in what region he is. If Etty's colour is wild and mysterious, looking here as if smeared with the finger, and there with the palette-knife, what can be said about Turner? Go up and look at one of his pictures, and you laugh at yourself and at him, and at the picture, and that wonderful amateur who is invariably found to give a thousand pounds for it, or more—some sum wild, prodigious, unheard-of, monstrous, like the picture itself. All about the author of the *Fallacies of Hope* is a mysterious extravaganza; price, poem, purchaser, picture. Look at the latter for a little time, and it begins to affect you too,—to mesmerise you. It is revealed to you; and, as it is said in the East, the magicians make children see the sultauns, carpet-bearers, tents, &c., in a spot of ink in their hands; so the magician, Joseph Mallard, makes you see what he likes on a board, that to the first view is merely dabbed over with occasionally streaks of yellow, and flicked here and there with vermilion. The vermilion blotches become little boats full of harpooners and gondolas, with a deal of music going on on board. That is not a smear of purple you see yonder, but a beautiful whale, whose tail has just slapped a half-dozen whale-boats into perdition;

and as for what you fancied to be a few ziz-zag lines spattered on the canvass at hap-hazard, look! they turn out to be a ship with all her sails; the captain and his crew are clearly visible in the ship's bows; and you may distinctly see the oil-casks getting ready under the superintendence of that man with the red whiskers and the cast in his eye; who is, of course, the chief mate. In a word, I say that Turner is a great and awful mystery to me. I don't like to contemplate him too much, lest I should actually begin to believe in his poetry as well as his paintings, and fancy the *Fallacies of Hope* to be one of the finest poems in the world.

Now Stanfield has no mysticism or oracularity about him. You can see what he means at once. His style is as simple and manly as a seaman's song. One of the most dexterous, he is also one of the most careful of painters. Every year his works are more elaborated, and you are surprised to find a progress in an artist who had seemed to reach his acmé before. His battle of frigates this year is a brilliant, sparkling pageant of naval war. His great picture of the "Mole of Ancona," fresh, healthy, and bright as breeze and sea can make it. There are better pieces still by this painter, to my mind; one in the first room, especially, — a Dutch landscape, with a warm, sunny tone upon it, worthy of Cuyp and Callcott. Who is G. Stanfield, an exhibitor and evidently a pupil of the Royal Academician? Can it be a son of that gent? If so, the father has a worthy heir to his name and honours. G. Stanfield's Dutch picture may be looked at by the side of his father's.

Roberts has also distinguished himself and advanced in skill, great as his care had been and powerful his effects before. "The Ruins of Karnac" is the most poetical of this painter's works, I think. A vast and awful scene of gloomy Egyptian ruin! the sun lights up tremendous lines of edifices, which were only parts formerly of the enormous city of the hundred gates; long lines of camels come over the reddening desert, and camps are set by the side of the glowing pools. This is a good picture to gaze at, and to fill your eyes and thoughts with grandiose ideas of Eastern life.

This gentleman's large picture of "Jerusalem" did not satisfy me so much. It is yet very faithful; any body who had visited this place must see the careful fidelity with which the artist has mapped the rocks and valleys and laid down the lines of the buildings; but the picture has, to my eyes, too green and trim a look; the mosques and houses look fresh and new, instead of being mouldering, old, sun-baked edifices of glaring stone rising amidst wretchedness and ruin. There is not, to my mind, that sad, fatal aspect, which the city presents from whatever quarter you view it, and which haunts a man who has seen it ever after with an impression of terror. Perhaps in the spring for a little while, at which season the sketch for this picture was painted, the country round about may look very cheerful. When we saw it in autumn, the mountains that stand round about Jerusalem were not green, but ghastly piles of hot rock, patched here and there with yellow, weedy herbage. A cactus or a few bleak olive-trees made up the vegetation of the wretched, gloomy landscape; whereas in Mr. Roberts's picture the valley of Jehoshaphat looks like a glade in a park, and the hills, up to the gates, are carpeted with verdure.

Being on the subject of Jerusalem, here may be mentioned with praise Mr. Hart's picture of a Jewish ceremony, with a Hebrew name I have forgotten. This piece is exceedingly bright and pleasing in colour, odd and novel as a representation of manners and costume, a striking and agreeable picture. I don't think as much can be said for the same artist's "Sir Thomas More going to Execution." Miss More is crying on papa's neck, pa looks up to heaven, halberdiers look fierce, &c.: all the regular adjuncts and property of pictorial tragedy are here brought into play. But nobody cares, that is the fact; and one fancies the designer himself cannot have cared much for the orthodox historical group whose misfortunes he was depicting.

These pictures are like boy's hexameters at school. Every lad of decent parts in the sixth form has a knack of turning out great quan-

tities of respectable verse, without blunders, and with scarce any mental labour; but these verses are not the least like poetry, any more than the great Academical paintings of the artists are like great painting. You want something more than a composition, and a set of costumes and figures decently posed and studied. If these were all, for instance, Mr. Charles Landseer's picture of "Charles I. before the Battle of Edge Hill," would be a good work of art. Charles stands at a tree before the inn-door, officers are round about, the little princes are playing with a little dog, as becomes their youth and innocence, rows of soldiers appear in red coats, nobody seems to have any thing particular to do, except the royal martyr, who is looking at a bone of ham that a girl out of the inn has hold of.

Now this is all very well, but you want something more than this in an historic picture, which should have its parts, characters, varieties, and climax like a drama. You don't want the *Deus intersit* for no other purpose than to look at a knuckle of ham; and here is a piece well composed, and (bating a little want of life in the figures) well drawn, brightly and pleasantly painted, as all this artist's works are, all the parts and accessories studied and executed with care and skill, and yet meaning nothing—the part of Hamlet omitted. The king in this attitude (with the baton in his hand, simpering at the bacon aforesaid) has no more of the heroic in him than the pork he contemplates, and he deserves to lose every battle he fights. I prefer the artist's other still-life pictures to this. He has a couple more, professedly so called, very cleverly executed and capital cabinet pieces.

Strange to say, I have not one picture to remark upon taken from the *Vicar of Wakefield.* Mr. Ward has a very good Hogarthian work, with some little extravagance and caricature, representing Johnson waiting in Lord Chesterfield's antechamber, among a crowd of hangers-on and petitioners, who are sulky, or yawning, or neglected, while a pretty Italian singer comes out, having evidently had a very satisfactory interview with his lordship, and who (to lose no time) is arranging another rendezvous with another

admirer. This story is very well, coarsely, and humorously told, and is as racy as a chapter out of Smollett. There is a yawning chaplain, whose head is full of humour; and a pathetic episode of a widow and pretty child, in which the artist has not succeeded so well.

There is great delicacy and beauty in Mr. Herbert's picture of "Pope Gregory teaching Children to Sing." His Holiness lies on his sofa languidly beating time over his book. He does not look strong enough to use the scourge in his hands, and with which the painter says he used to correct his little choristers. Two ghostly aides-de-camp in the shape of worn, handsome, shaven ascetic friars, stand behind the pontiff demurely; and all the choristers are in full song, with their mouths as wide open as a nest of young birds when the mother comes. The painter seems to me to have acquired the true spirit of the middle-age devotion. All his works have unction; and the prim, subdued, ascetic race, which forms the charm and mystery of the missal-illuminations, and which has operated to convert some imaginative minds from the new to the old faith.

And, by way of a wonder, behold a devotional picture from Mr. Edwin Landseer, "A Shepherd Praying at a Cross in the Fields." I suppose the Sabbath church-bells are ringing from the city far away in the plain. Do you remember the beautiful lines of Uhland?

" Es ist der tag des Herrn
Ich bin allein auf weitern Flur
Noch eine Morgen-glocke nur
Und stille nah und fern.

Anbetend kine ich hier
O süsses Graun geheimes Wehn
Als knieten viele Ungesehn
Und beteten mit mir."

Here is a noble and touching pictorial illustration of them — of Sabbath repose and *recueillement* — an almost endless flock of sheep lies around the pious pastor; the sun shines peacefully over the vast fertile plain; blue mountains keep watch in the distance; and the sky above is serenely clear. I think this is the highest flight of poetry the painter has dared to take yet. The numbers and variety of attitude and expression

in that flock of sheep quite startle the spectator as he examines them. The picture is a wonder of skill.

How richly the good pictures cluster at this end of the room! There is a little Mulready, of which the colour blazes out like sapphires and rubies; a pair of Leslies — one called the "Heiress" — one a scene from Molière — both delightful :— these are flanked by the magnificent nymphs of Etty, before mentioned. What school of art in Europe, or what age, can shew better painters than these in their various lines? The young men do well, but the elders do best still. No wonder the English pictures are fetching their thousands of guineas at the sales. They deserve these great prices as well as the best works of the Hollanders.

I am sure that three such pictures as Mr. Webster's "Dame's School" ought to entitle the proprietor to pay the income-tax. There is a little caricature in some of the children's faces; but the schoolmistress is a perfect figure, most admirably natural, humorous, and sentimental. The picture is beautifully painted, full of air, of delightful harmony and tone.

There are works by Creswick that can hardly be praised too much. One particularly, called "A Place to be Remembered," which no lover of pictures can see and forget. Danby's great "Evening Scene" has portions which are not surpassed by Cuyp or Claude; and a noble landscape of Lee's, among several others—a height with some trees and a great expanse of country beneath.

From the fine pictures you come to the class which are very nearly being fine pictures. In this I would enumerate a landscape or two by Collins. Mr. Leigh's "Polyphemus," of which the landscape part is very good, and only the figure questionable; and let us say Mr. Elmore's "Origin of the Guelf and Ghibelline Factions," which contains excellent passages, and admirable drawing and dexterity, but fails to strike as a whole somehow. There is not sufficient purpose in it, or the story is not enough to interest, or, though the parts are excellent, the whole is somewhere deficient.

There is very little comedy in the Exhibition, most of the young artists tending to the sentimental rather than the ludicrous. Leslie's scene from Molière is the best comedy. Collins's "Fetching the Doctor" is also delightful fun. The greatest farce, however, is Chalon's picture with an Italian title, "B. Virgine col," &c. Impudence never went beyond this. The infant's hair has been curled into ringlets, the mother sits on her chair with painted cheeks and a Haymarket leer. The picture might serve for the oratory of an opera girl.

Among the portraits, Knight's and Watson Gordon's are the best. A "Mr. Pigeon" by the former hangs in the place of honour usually devoted to our gracious Prince, and is a fine rich state picture. Even better are there by Mr. Watson Gordon: one representing a gentleman in black silk stockings whose name has escaped the memory of your humble servant; another, a fine portrait of Mr. De Quincy, the opium-eater. Mr. Lawrence's heads, solemn and solidly painted, look out at you from their frames, though they be ever so high placed, and push out of sight the works of more flimsy but successful practitioners. A portrait of great power and richness of colour is that of Mr. Lopez by Linnell. Mr. Grant is the favourite; but a very unsound painter to my mind, painting like a brilliant and graceful amateur rather than a serious artist. But there is a quiet refinement and beauty about his female heads, which no other painter can perhaps give, and charms in spite of many errors. Is it Count D'Orsay, or is it Mr. Ainsworth, that the former has painted? Two peas are not more alike than these two illustrious characters.

In the miniature-room, Mr. Richmond's drawings are of so grand and noble a character, that they fill the eye as much as full-length canvasses. Nothing can be finer than Mrs. Fry and the grey-haired lady in black velvet. There is a certain severe, respectable, Exeter-Hall look about most of this artist's pictures, that the observer may compare with the Catholic physiognomies of Mr. Herbert: see his picture of Mr. Pugin, for instance; it tells of chants and cathedrals, as Mr. Richmond's work somehow does of Clapham Common and

the May meetings. The genius of May Fair fires the bosom of Chalon, the tea party, the quadrille, the hair-dresser, the tailor, and the flunky. All Ross's miniatures sparkle with his wonderful and minute skill; Carrick's are excellent; Thorburn's almost take the rank of historical pictures. In his picture of two sisters one has almost the most beautiful head in the world; and his picture of Prince Albert, clothed in red and leaning on a torquoise sabre, has ennobled that fine head, and given his royal highness's pale features an air of sunburnt and warlike vigour. Miss Corbaux, too, has painted one of the loveliest heads ever seen. Perhaps this is the pleasantest room of the whole, for you are sure to meet your friends here; kind faces smile at you from the ivory; and features of fair creatures, oh! how * *

* * *

Here the eccentric author breaks into a rhapsody of thirteen pages regarding No. 2576, Mrs. Major Blogg, who was formerly Miss Poddy of Cheltenham, whom it appears that Michael Angelo knew and admired.

The feelings of the Poddy family might be hurt, and the jealousy of Major Blogg aroused, were we to print Titmarsh's rapturous description of that lady; nor, indeed, can we give him any further space, seeing that this is nearly the last page of the *Magazine*. He concludes by a withering denunciation of most of the statues in the vault where they are buried; praising, however, the children, Paul and Virginia, the head of Bayly's nymph, and M'Dowall's boy. He remarks the honest character of the English countenance as exhibited in the busts, and contrasts it with Louis Philippe's head by Jones, on whom, both as a sculptor and a singer, he bestows great praise. He indignantly remonstrates with the committee for putting by far the finest female bust in the room, No. 1434, by Powers of Florence, in a situation where it cannot be seen; and, quitting the gallery finally, says he must go before he leaves town and give one more look at Hunt's "Boy at Prayers," in the Water-Colour Exhibition, which he pronounces to be the finest serious work of the year.

"The Place of the Fine Arts in the Natural System of Society"

Douglas Jerrold's Shilling Magazine 6 (July 31, 1847), 72–81

THE PLACE OF THE FINE ARTS IN THE NATURAL SYSTEM OF SOCIETY.

"WE live in an artificial state of society," is a common assertion, though the boundaries between it and the natural state are not defined nor illustrated. In common language, Nature and Civilisation are opposed to each other—the latter being regarded as an exotic, a forced growth of political skill, a magnificent product of art, in no wise governed by the same natural laws as the original brute condition of mankind, nor formed by the same creative hand which placed the race originally on the earth. Like the locomotive or the ship, civilisation is said to be a contrivance of an individual or a succession of individuals—of some gifted, wise, and foreseeing legislators, who established rules for conduct leading to improvement, and constituted it the duty of a governing class to enforce them on the observance of the vulgar multitude. Reflection suggests a doubt of the accuracy of this theory. The instant our attention is directed to the subject, we perceive that the sexes always preserve their distinguishing characteristics. They are physically and morally different now as at the beginning, and their union is at all times the basis of the whole society. One leading fact, then—one great natural law—lies equally at the foundation of society in its earliest and its most advanced stages. Is the whole vast and complicated, beautiful and various, superstructure of modern society the spontaneous growth of the same great fact, or the artificial contrivance. of a succession of lawgivers?

That certain aspiring men have continually attempted to model society, must at once be admitted ; that they succeeded in restraining and modifying its exuberant form, and have checked its growth, must also be granted ; but that they are therefore the authors of civilisation is no more true, than that the man who fells, and lops, and squares the lofty oak makes the timber of the forest. That they have interposed between Nature and individuals a great barrier of legislation, expressly to ward off the natural consequences of action, and generate the belief that they are the guardians and protectors of mankind, is abundantly obvious ; but through and behind this barrier the forbidden communication always practically takes place, and it guards neither individuals nor society from the consequences of the natural laws which established diversity of sex. Nature every day loudly and plainly answers the querist that the barrier, for the end proposed, is the most flimsy, worthless, costly contrivance that ever men loaded themselves with. Thus, amongst the many moral and political truths willingly assented to by the people, and forced on the still incredulous statesman by the rapid progress of population within the last half century, there is none clearer or of greater importance than that he is not the author of social progress nor of civilisation. This assertion requires illustration.

One of the most effectual instruments of social progress and modern civilisation is the Press ; which legislation, far from having created or fostered, has, from the time at least of Wolsey,

regarded as a terrible enemy, and laboured incessantly to chain to its own chariot-wheels. It has failed. Star Chambers and libel laws, censorships and pensions, have mutilated and poisoned, but could not kill. It has survived the malignity of Parliaments and the arrogance of kings, and has triumphed over both. It has become the ruling influence of society, and has everywhere been useful, truthful, and enlightened, in proportion as it has escaped the fetters of the law and the trammels of patronage. Another powerful aid to civilisation is the steam-engine, particularly when applied to locomotion. Never, perhaps, in the world were eighteen millions of human beings more uninterruptedly tranquil, and confident in the results of their own exertions, than the inhabitants of Great Britain during the last ten years. Their contentment is mainly owing to the rapidity and freedom of communication between one part of the island and another. The inhabitants of every part have been almost instantly informed of what the inhabitants of every other part were doing, and that their distant fellow-subjects, like themselves, were unassailed and secure. They have also been informed of everything done by the government, and at no time have they dreaded from that powerful organisation any sudden or violent invasion of their rights. Legislation, by subjecting the promoters of private enterprise to monstrous expenses, by absurd standing orders, ridiculous precautions, and erroneous judgments, has done much to impede locomotion, and nothing to promote it. Gas, too, spreading by night a light half like that of day through every nook and cranny, every closed-up court and crooked alley, in our old and inconveniently built towns and cities, has, as it were, kept every man always under the eye of the public, and has contributed much to put an end to those violent outrages for which, only a few years ago, our towns were somewhat remarkable. We might run through a score or more of the most remarkable mechanical inventions of modern times, and show their influence in repressing crimes, promoting social order, and bringing about civilisation; though, as in the case of the Press, they have often been the means of effecting it in direct opposition to the lawgiver. These examples are, however, sufficient to confirm the assertion, that civilisation, whatever be its origin, and whatever hand may guide it, is not the child of political or legislative wisdom.

One other leading fact we must briefly advert to. Division of labour, or the exclusive devotion of individuals to particular employments, is undoubtedly a great means of carrying forward the human race. In one or two instances, the legislator, seizing hold of the fact after division of labour has come into existence, has endeavoured, as in India, to confine it under a few denominations, and has divided the people into castes, appropriating to them different occupations. His success has produced stagnation. Society ceased to be progressive, and became the victim of nations amongst whom the establishment of castes had not suppressed emulation and subdued energy. Division of labour is as completely a natural phenomenon as the diversity of sex. No legislator establishes or promotes it. Man, in all countries and ages, has taken one species of occupation, and Woman another. The aged too, and the young, in all stages of society, have other

occupations than the robust, and those who are mature in years
and strength. Climate, situation, and peculiarity of disposition—
other sources of division of labour—lead one man to be a wine
grower, another an iron-founder, a fattener of cattle, a miner, a
painter, a poet, or an inventor ; and thus, as population increases
in any given space, these natural circumstances, for ever existing,
continually enforce and maintain a progressive extension of
division of labour, to the benefit and civilisation of all.

This principle has been generally considered in its single rela-
tion of influencing the production of wealth, and its moral effects,
though equally beneficial, have been disregarded. Commerce,
which binds nations together in amity, is the result of terrestrial
division of labour, diversity of climate and situation. Rival
governments and statesmen only interrupt the peace and friend-
ship that terrestrial division of labour is continually promoting.
The mutual dependence of man on man in the same country,
caused by no one completing, of himself and unaided, any piece
of work, begets civility and friendship. It establishes a relation
of mutual service and mutual kindness between the butcher and
the grazier, the farmer and the miller, the spinner and the
weaver, and between all the industrial classes. They cannot live
without one another. The right hand might as well quarrel with
the left, as the shipwright with the sailor, or the tanner with the
shoemaker. Division of labour substitutes friendly and just
relations, for jealousy, envy, and fear, and contributes to check
crime and promote virtue.

Population, as it increases, carries with it a continual extension
of the principle of division of labour. It calls new classes of
industrious men into existence. New arts spring up, new wealth
is created, and new relations are established between individuals
and nations. Old laws are continually found to be incompatible
with the progress of society, and noxious to human welfare.
Does society accommodate itself to the old institutions ? No : it
bursts them asunder, and they fall away like withes from the arm
of the strong man. The lawgiver always essays to bind them on
anew, and may succeed, with some relaxation or change of form ;
but it is only to restore the incompatibility between him and Nature,
and at no distant day compel society to destroy his new chains.

The progress of society, against the will of the lawmaker over-
turning his institutions, has, in modern times, been very marked.
It is one of the moral phenomena of the age. The increase of
dissenters and catholics made the laws to preserve the dominion
of the state-church unbearable, and test acts and penal disabilities
were rent asunder and trampled under foot. A wonderful increase
of population, forming several new and great towns, made the old
system of representation inadequate. Did society reduce itself to
the size prescribed by the lawgiver ? Quite the contrary : he was
compelled to adapt his law to the new circumstances. He yielded,
indeed, as little as possible, and coupled his compliance with regis-
tration, rate-paying clauses, and other foolish restrictions, to supply
evidence hereafter of his present imbecility when they follow the
fate of the boroughs in schedule A. Still later, the increase of
the manufacturing classes made the laws which confined them for

their supply of food to the land owned by the lawmakers, a complete nuisance ; and though the lawgivers thought their pecuniary interest and their power at stake, they were compelled to abolish the Corn Laws.

We need not advert, for further illustrations of this important principle, to the abolition of slavery, and the great limitation of capital and other punishments, which the progress of knowledge and the instrumentality of the Press have forced on an unwilling legislature. A lawgiver may now and then be found who gives an impulse to social progress, but the true characteristic of legislators, in relation to the onward moving masses, is holding back ; and this characteristic is not altered by such rare exceptions to the rule as that of Joseph the Second. In the great majority of cases, the natural progress of society has necessarily swept away old laws to bring about improvement. That this depends on natural circumstances is certain, from the progress being nearly simultaneous and consentaneous throughout civilised society. Steadily have the nations of Europe marched almost abreast, one now and then going faster and farther than the other ; but in most of the great natural features of civilisation, such as the increase of knowledge and the division of labour, they more nearly resemble each other than they differ in their political features. The lawgiver has always been at work trying to build up *a superstructure of his own* on the natural foundation of society, and to make us believe that he is the great architect of the whole ; but the same power which laid them carries on the building, and is continually toppling down the little buttresses, and bursting asunder the little bonds by which he tries to cramp and deform the lordly temple. Society is, at places and times, limited and distorted by conventionalities derived from his regulations not yet out-grown, and by laws still in existence. They extend, however, only to small portions of the structure ; they are not essential, they are only adjuncts. All its main beams, as well as its foundations—division of labour, as well as diversity of sex—commerce, with all its consequences of money, agency, credit, &c.,—as well as climate, inequalities of wealth (within certain limits,) as well as variety of talents and disposition ; the progress of knowledge, as well as the multiplication of the species—are all natural, not artificial. If they are not legal, or recognised and sanctioned by the lawgiver, they ought to be, and in the end must be, in their fullest freedom and perfect growth.

There is only one point on which any doubt can be entertained. It is usually supposed, and said, that political power protects property, and that without property, and without protection for property, there would be no civilisation. Admitting the two latter circumstances, the fact that the labourers of Europe, who produce all its wealth, have little or nothing, while a number of other classes, by means of taxation and other political contrivances, are secured in opulence, it is clear that political power only protects one species of property ; and it may be doubted whether its most injurious action be not its habitual violation of the natural rights of property in the labourer. It tries to protect, we admit, the right of property which it creates, as when it secures to Lord Ellenborough, or the Rev. Mr. Thurlow, the income which it

bestows on them in the shape of fees or tithes ; but such a right of property is evidently founded on some fixed exactions, and is that violation of the property of the industrious classes which dooms them to indigence.

Our conclusions—to sum them up—are, that there are two systems of society, one superinduced on the other—the natural and the political ; and that the former is continually out-growing and casting aside the latter. Civilisation is the result of the former, and is opposed to the latter—not to nature. Political society, not civilisation, is artificial. The natural system is infinitely powerful compared to the parasitical system wound around it. These points established by rather a long introduction, we come to the theme for the sake of which it was written.

Where is the place of the Fine Arts in the natural system of society ? Exotics in our country, patronised by the throne, or by those who sit around it ; Sculpture especially, next Painting and Music, having at present their home chiefly in courts, or amongst the politically great ; having little or no connexion with the industrious masses, and dove-tailing not in with them who compose, almost exclusively, the natural system of society—the Fine Arts, as now cultivated, form, and have long formed, a part of the political system. Their professors, as the rule, are dependent on the state, or those who derive power from its regulations. They seek pensions and cry aloud for patronage. They are not content, like merchants, and farmers, and manufacturers, with the support of the public. Their situation is one of dependence, and they are too often the flatterers of the politically great. Whatever they might have been in Greece, in modern Europe they are, in the main, anti-democratic. Some well-known exceptions only establish the rule. Our practical purpose is to invite attention to the arts of Sculpture, Music, and Painting; under this relation to point out their place in the natural system of society, and excite the professors of these arts, for their own honour and advantage, to occupy it.

Literature has shown them the way, and has taken with her, hand in hand, the democratic and diffusive art of engraving. Books, embellished and illustrated with the greatest care, journals and newspapers of all descriptions, are now published at a cost which brings them within the reach of the humblest classes. Authors, like farmers and cotton-print makers, begin to rely on the masses as their best customers. This has effected a great revolution in literature itself. As long as the opulent only were its patrons, it was too often stuffed with foolish errors and false refinement. The aspirations of the poor, and the hopes of the humble, as well as their sufferings, were only lampooned. Their honest efforts to improve their condition, and take a higher place in society, were continually snubbed by the tuft-hunters of literature. They were continually admonished to remain in their condition, and not imitate their betters in acquirements, dress, manners, and language. Literature has now become more manly and independent. Looking to a world-wide market, it must please all customers, and can only do that by being natural. By becoming cheap, it became essentially comprehensive and vigorous, healthy, pure, and truthful. To every class it imparts instruction and amusement. There are hardly any so low but they are cheered

in their solitude and their social hours by some kind of reading, or by hearing at second-hand the tales, the jokes, the anecdotes, the information, that are gathered from the journals. In the great natural system of society, and in that division of labour which springs from diversity of sex and diversity of climate, and which pervades the world, literature has taken its appropriate place. No longer the handmaid of any class, it ministers to the pleasures of those who supply food and clothing, quite as much as to those who sit on the throne and direct public affairs. It has outgrown alike the fetters and the blandishments of the politically great, and stands recognised, before the face of Heaven, the helpmate and friend, a part and parcel of the toiling masses.

Of Sculpture nothing like this can be said even in Italy. It provides plaster casts and models of some of the favourites of the people. The busts of Milton, Byron, Scott, Nelson, &c., are now generally accessible, and are cheap and lasting mementos of the noble-minded men the people admire. But in general, clothed in antique drapery, speaking in allegories that only the learned can read, Sculpture only fills the niches of Christian churches, and emblazons the tomb-stones of Christians with figures that are as foreign to the thoughts and life of the Englishman as to those of the Sandwich Islander. To neither our climate nor our manners is Sculpture yet reconciled. She was at home in Greece, where the mythology she still embodies was the creed of the people; where the human figure, unimpeded by dress, was continually exhibited in all its attitudes and vigour; where every man was a practical connoisseur of muscular development, as he is here of mechanical skill; and where a bright pure atmosphere preserved the finest touches of the chisel in all their original sharpness. In old Rome too, and in modern Italy also, at the revival of the art, where the mythology of the Greeks and the earliest impressions of Christianity were to some extent traditionally preserved, Sculpture was congenial to the then form of society, and did adapt itself to the habits and feelings of the people. Costly in her productions, and speaking only to the initiated few, except as she preserves the forms of national heroes, including the heroes of industry, Sculpture, as now cultivated, seems to have no place in the natural system of society. That system is now developing with amazing rapidity; and to find a place in it, to be honoured by the multitude, she must, like the earthenware manufacturer, perform her task by ministering to their wants. She must not confine herself to the halls of the great—she must ennoble the workshop. She must leave the monsters of fable, the allegories of an irregular fancy, and an ignorant faith, and the garb of a foreign people, to fix in imperishable marble the improvements, the hopes, and the faith of our own people. She must help to raise up and improve the democracy. She must return to labour some reward for the subsistence, the clothing, and the shelter which labour supplies, or she will pass, as society goes onward, into the oblivion which has fallen on the useless Greek fire, and the lost imperial Tyrian dye.

Painting, though diverted from her place by those who preferred the historical to the domestic—the school of West to that of Hogarth—is getting more amongst the people than Sculpture. It

is less, however, by her mere works on the canvas, than by her designs for the burin, that she fills the place destined for her in the natural system of society. By both, however, she now appeals to other classes than kings and senators, generals and admirals ; and to other feelings than those of admiration for factitious heroes, and of superstitious reverence for mystical or supernatural events. By her vivid representations of rags and roofless cabins—of the daring violators of custom-house regulations—of the victims of game-laws—of criminals, the offspring of legal injustice—by her bold satires of the foolish eccentricities of men armed with power, or endowed with wealth, she has become a great teacher on the side of Nature, and the auxiliary of honest labour. Her charms are prized accordingly. Her fearless exposures have been a great help to liberty. Now that she seeks rewards from administering to the enjoyments of the multitude, she too has become generous and truthful, and is scoffed at when she yet lends her pallet to gild and hide the chains of superstition, or consecrate the deeds of the despot and the man-slayer.

Music, though universally diffused, is less cultivated for the masses than the few. Most of her original compositions are for the great, and only descend to the vulgar when the rich are tired of them. Those who have witnessed the effects of Music amongst different classes, will hardly think that her natural home is the Opera-House. The poorly-fed and hard-worked German student is an enthusiast for music. The infant in arms, and the girl that bears it, dance with delight at the merry sounds of the street musicians. The tired soldier on his march is cheered by a brisk strathspey. The sailor, heaving and treading round with the capstan, works with double spirit when the band plays. After a day's toil, it refreshes and exhilarates the peasant and the artisan. But music at the Opera, for those who are cloyed with pleasure— who come sweltering in food and wine from the clubs—is only adding to a surfeit : it is heaping pleasure on pleasure, till the overloaded sensorium loses all sensibility. The concord of sweet sounds has to struggle for inlet amidst a tumult of feverish sensations, and is often lost in noise. Music, like literature, is in its proper place when it is ministering to the enjoyment of the toiling masses. It seems felt and appreciated when it escapes from the Opera-House to the street, and is really prized and honoured when it becomes at once popular and vulgar.

In the natural system of society, art must administer to art. Noisome smells of necessary preparations must be overcome by the perfumer. His skill receives only a small part of its due application when it is limited to the toilette. It must sweeten the workshop and rob the manufactory of the effluvia which makes it offensive and injurious. So, the proper office of Music is to cheer the labourer. Every man-of-war, every regiment, has a band. Why should not every factory have its orchestra ? Why are the ears of workmen to be for ever tortured, when the noises might be made musical or overborne by music ? The natural office of the Fine Arts is not merely to add to the pleasures of the opulent, but to diffuse enjoyment amidst the workers. Their professors limit their utility and degrade them from their higher station when they

adapt themselves and their works only to the politically great. Classes pass away ; industrious man lives for ever. Great wealth, high rank, political power, are but the ephemeral creations of a political system that is fast wearing out ; and if the Fine Arts would win a durable hold on the affections of mankind, they must be adapted, not to decaying classes, but to the ever-living multitude.

If events in our own society ; if the progress of the people and the success of literature, from being adapted to the wants of the multitude, make no impression on the professors of Scripture, painting, and music, let them cast their eyes across the Atlantic. There, within a few days' sail or steaming, is a population speaking our language, which promises, while many artists now budding into reputation will still be alive, to amount to more than 100,000,000. Amongst that mighty people there are few or none of those classes for whom the Fine Arts have been exclusively cultivated here. So cultivated, they can have no success there ; and instead of sharing in the wealth and power of that great nation, they will be cast aside as the mere accessories and ornaments to a worn-out political system. We are aware of the many temptations which, in the present distribution of property, induce professors and artists of all kinds to worship wealth ; but the main gist of our argument is, that the few wealthy have it not in their power, in the long run, to bestow equal rewards to the industrious, though less wealthy many. On the whole, literary men and artists, who work for the great public, are better rewarded now than ever they were, when they ate the bitter bread of royal and noble patronage. Unfortunately the Fine Arts have been tempted and perverted by the politically great. Springing from nature—for Music, Sculpture, and Painting are not decreed and regulated by law—they really belong to the natural system of society, and their sole end and destination, their true place in that great system, is to give pleasure to those who minister to the physical wants of the community.

"The Progress of British Art"

Art-Union 10 (January 1848), 3 – 4

THE PROGRESS OF BRITISH ART.

N attentively considering the Progress of the Arts in England, we cannot fail to notice the many adverse circumstances of their past career. From the Conquest to the Reformation, Art was advanced by the Roman Catholic church, which sought here, as in all countries inheriting her ritual, to confirm the doctrines of Religion by the influence of the Imagination. At the Reformation, this ceased. Court patronage was limited; National encouragement there was none. Former sovereigns had protected the court painter; Elizabeth did no more; she valued Art as it flattered her vanity, and the people as they ministered to her power. Had her Government even been disposed to encourage what fanaticism was so anxious to destroy, the time was not favourable, for the Nation was brutalised by civil wars, distracted by religious faction, or devoted solely to maritime enterprise. There was a contest for public rights, a reformed church, and national independence; and in such days the Arts could hardly flourish. They had done so in other lands, under circumstances more depressing, or not greatly dissimilar; but public opinion, had there united the Church, the Government, and the People, for their advance; and it is only by these means that High Art can be promoted. In Italy and France, Art was the charmed ground which swayed the most adverse passions by its spell. It might be supposed, at later periods, in days of comparative tranquillity, that Painting and Sculpture would have been evoked to record the actions of the past, and that dynasties would not have decayed, have been trodden down by the crushing foot of Time, or generation after generation swept silently away, without a monument, a sign of their respect, for noble actions or great men. But it was so. The truth is, the invariable policy of the Government was to encourage our Individuality, which we love intensely, and never to interfere in matters extra-parochial or purely intellectual, in relation to National Education or National Art. The Church, too, never swerved from her first resolution, and always held a whitewashed wall as far more orthodox than any ever decorated by Masaccio, Raphael, or Correggio. Thus, pictures in churches being proscribed lest they should seduce the mind to idolatry, Government having no desire to do what a Joint Stock Company or individuals could effect as well; and our national irritability being apt to betake itself to "Public Meetings," and the great examples of "Hampden and of Sydney," for support, at the mere mention of the words "the active interference" of Government—the Fine Arts in England, from the days of Elizabeth to those of Victoria, have been forced to beg their bread at the hands of private patronage. Charles the First and George the Third sought, indeed, their more active promotion—the first from taste, the latter from principle; and it is from the days of Sir Joshua Reynolds we must date the advancement we now witness.

The Church has ceased to deliver over pictures to the civil power as heretics she was bound to proscribe, and to commit them, as Savonarola did, with pious madness, to the flames.

Government has recognised and is fulfilling its duty. There is no want of private patronage. The disposition of the people is such as every true lover of Art must have long desired. Even a "Joint Stock Company," that incarnation of our national mutuality and individuality, now exists as an "Art-Union" in every large town. The disposition and the time are favourable; but it is only by right means adapted to right ends we can hope for success. High Art, for National purposes,—as a means of Education; as the annalist of our History; as the inculcator of Moral Truths; as the promoter of Commerce; the agent towards Social Refinement;—this only is worth promoting, worth struggling for to promote. Let us review the ground we occupy in this respect, and examine how far our present position will justify our confidence in the future "PROGRESS OF BRITISH ART."

We place, for this purpose, THE ROYAL ACADEMY first: and consider its latest EXHIBITION. What is the excellence you seek—the ideal you would realize in painting? In Design—Nature, Truth, Poetry. In Form—beauty; in Colour—harmony, strength, brilliancy of tints, soft and gradual transitions, such as our bounteous earth displays, her shadowy offspring. Gave the Royal Academy no evidence of this? Then for themes, motives, the indicators of the artist's mind. Do we not seek the Landscape as if we breathed there; marked the distance as if the eye could traverse its receding depth; saw the clouds surging o'er the vast expanse of heaven; could watch a world fade beneath the dewy tints of even, or arise again in beauty beneath the hazy light of morn? Do we not desire also those emanations of High Art, Christian in their origin and design, conceptive illustrations of those scenes where He who more than human, yet not less Divine,—in whose heart the fulness of Love, Peace, and Justice dwelt,—and whose mind so pure, so deep, so strong, so holy, gave strength to the weak, made the timid brave, the heartless beneficent, and men of slow tongue full of power and persuasion? Do we not require also realisations of the past events of our own History, that drama of human greatness, of which Shakspere and Jonson were the poets, and of which the world has been the theatre? Are we beyond the lessons taught by the Romance of Social life, with its incidents so blended with the affections, its action but a page torn from the book of Nature? Did not the Royal Academy present works in all these departments, the themes well chosen and well treated? There was no mark of a distinctive school, but there was the freshness of Nature, the freedom of the mind nourished by her truths. Moreover, the exhibitors were, for the most part, young; and we cannot but think if even that eternal artistic quotation—"Sir Joshua," had been present, HE would have borne able and ready witness to the PROGRESS of the ENGLISH SCHOOL, and to the Academic system here taught, free alike from the Archæological pedantry of the Germans, and the classic fripperies of the French.

True it is that, in his love of High Art, he might have sought for greater indications of the Historic Style; but the Sir Joshuas of all periods should remember that Artists must live, and so long as Government requires little, the Church and Public Institutions less, Art must consult the individual,—who is satisfied with the portraits of the domestic circle, and the pictures of " Genre " wherewith to decorate his Hall. Ambition is a great incentive to action; so also is necessity. Men are lawyers upon calculation, Artists from impulse; one flourishes by the viciousness of human nature, the other through its refinement. If a Nation be indifferent to Art, its professors must still live. There may be weeping and gnashing of teeth, but Genius is subdued in time, and works for the requirements of the household. Our daily duty is daily bread. We adapt ourselves to the circle in which we move. Who would discourse of Homer or of Dante with a dull vain man, to whom no ideas are great but the diseased conceptions of his own mind. Who would cry " Base Lucre " on the Stock Exchange? We cannot reproach Artists with devotion to the lower departments of Art until we have provided them with a sphere of action in the higher.

The EXHIBITION AT WESTMINSTER HALL we consider the most important of the year; and although opinions of PROGRESS in this respect must necessarily be somewhat hypothetical, we believe the following to be well founded:—" The evidence of ability afforded," say the Commissioners, "has been most satisfactory; we remark that several of the Artists, who had before distinguished themselves in Cartoon drawing, have shown, by their works on this occasion, that they are well qualified to execute Oil Pictures on a large scale "

We next refer to ARCHITECTURAL IMPROVEMENTS; and have no reason to modify the opinions we before expressed as to a more generally diffused taste. The new wing of Buckingham Palace, will be soon completed from designs by Mr. Blore. It has the approbation of Lord John Russell, Lord Morpeth, Lord Lincoln, and Lord Ellesmere. The British Museum belongs apparently to that class whose curse it is to be neither praised nor blamed. We write beneath its ban. The Carlton, the Army and Navy club will present " rifacciamenti " of the Library of St. Mark, and the Cornaro Palace, Venice. The Museum of Economic Geology, by Mr. Pennethorne, in the Italian style, will possess one lofty doorway boldly designed and elaborately ornamented. These constitute our national works.

Whilst on this subject we would urgently press upon the people the discouragement of all projects for cheap public buildings. High Art, is most Art, —is alone Art,—a Joint Stock Company, may build by " Contract Art," individuals by " Caprice Art," but a nation only can, by " Pure Art,"—every example of parsimonious inability erected by a Government, retards refinement, debases taste, and disgusts genius. Let any man the most indifferent or the most bigoted, view the "Flâneur" who gapes listlessly, the " True Briton," who sneers conceitedly over all he sees in Continental States, be honestly put to the " question," and without the slightest torture he must admit the great superiority of Foreign Public Edifices over those of his own land. Too idle to ascertain the cause, they would both ascribe it to the inability of our Architects. This however is frequently unjust. The inability is want of power, of adequate means, a well regulated system. We re-

quire an efficient Board of Public Works, upon whose responsibility these should be erected. We want a more sound state of public opinion, a deeper sense of the importance of High Art towards the refinement of the people. Is there no hope of this? We reply—Yes, the means are at work, they will ensure the desired end, the seed is sown, the harvest will be gathered in, our bread is cast upon the waters, it will return to us after many days.

The NATIONAL GALLERY is daily thronged by a multitude struggling through imperfect powers, to the conception of the Truthful and the Beautiful in Art. Mr. Vernon's munificent gift will place before them, many works of the masters of their own land. In 1845, 160,791, in 1846, 170,879, visitors were admitted to Hampton Court alone. Nor can it be said they went:—

' Not for the Pictures, but the Porter there.'

for no one can have mingled among them, and not have retired proud of the order, the respect, the intelligent interest observable in the mass.

Go into the cottages of the poor, or of the humbler middle classes, and you will find a desire for their adornment with a higher class of engravings. Go into the mansions of the wealthy, and it is not now solely what is costly, what is manufactured, won at Lady L—'s raffle, or purchased at Peter Coxe's auction, which is shown you, but a work of art, on which the mind rests and the imagination dwells, alike from its merit and its associations. The same patronage on the part of the higher classes to artists of merit is extended; on the part of manufacturers a similar desire to encourage Design; and there is hardly a shop in the metropolis that does not evince proofs of greater originality, and more successful imitation. The best pictures at the exhibitions are soonest sold; copies—heretofore, originals—of the old masters, are now out of the market.

THE SCHOOL OF DESIGN too long subject to disquietude from within, which crippled its utility, has been now remodelled, and we trust a system that will combine technical power with the knowledge which lectures and daily class-teaching impart of the principles of the laws of beauty in design, together with their application to special branches of Industrial Art, and the general conditions necessary to be observed in order to render the execution of a design practicable, will be adopted and consistently maintained. It is idle to suppose the Industrial have no connection with the Fine Arts; they are as twin sisters. They are founded on similar principles, allied with the same feelings, have their origin in an equal refinement of the faculties are conducive to the one end.

The Fine Arts appeal to Memory and the Imagination; awaken the sense of the Beautiful, and tend towards the perfection of judgment, on all comprised within their sphere. The Industrial is the same power, imparting to matters of utility beauty of form, and associate harmony of colour. They blend more with the daily wants of life; and enter more immediately into the transfer of commercial wealth. Raphael designed for them at Rome; Rubens directed the industry of the workshops of Flanders; Richelieu patronised, Colbert protected, Florence rewarded them; it is in England alone they have been hitherto neglected.

Here we must close our review. We admit its imperfections, we acknowledge it to be superficial, indicating rather the course of the stream by what floats on its surface, than by observations on its sources and its current. But to this we are re-

stricted. Yet let not these be considered as in vain. Who could have prefigured the greatness of any nation, by opinions formed in its origin? The shepherd huts of Athens, the robber confederacy of Rome, the first Pontificate, hardly known beyond its episcopal domain! Florence, Genoa, Venice, a colony cast upon a coast, or driven there as outcasts, a horde located by the beauty of the plain—were not these the seats of power, of Literature, Science, Art? How hardly shall men outlive the influence of their citizens! The dynasty of the Egyptian is an ill-told tale; the conquests of Alexander are no more to us than a romance; the kingdom the Saracens founded exists but upon the map. Islamism, which threatened to reduce the world still lingers only by the forbearance of its states. Of all their glories, what has survived? ART!—in that Egypt is present—by that we yet trace the conquest of the Macedonian, the irruption of the Saracen; and when the Moslem shall be driven back by the onward step of European interests, you will read the history of a destroyed faith, in the ruins of the Mosque. There is no period more exciting, which possesses greater characteristics, higher poetic features, than the History of the Dominion of the Moors in Spain. It was mighty, brave, enduring, but the dynasty of the Caliphs fell beneath the superstitious courage of Christendom. Where do you now trace their influence? In Literature and Art—the Alhambra, and ballad poetry of Spain.

Thus Art is as History, and this it is which imparts to its ruins their moral grandeur. But it is the misfortune of nations strictly commercial, to allow their interest to centre in matters purely of that nature. This begets an egoism unknown to the empires of old. We barter, we construct, we wage war, make peace—solely for our own ends. The chivalry of conquest is no more; the glory of enterprise has ceased; all we now calculate upon is gain. We daily feel the want of a lever to uplift this selfishness, and to free the thoughts of man from the habitual worship of self. As a people, we are remarkable more for the power of the individual Will in its continually sustained action, than by impetuosity of passion. Our refinement and intellectual progress is rather the work of reason than of the imagination; our convictions are deduced, not transmitted, or if so, are retained by our abiding faith in their original correctness. To such a people, when once the moral influence of Art is known, her future course is certain. We shall not make it the symbol of superstition as the Egyptian, nor reduce it to the mere badge of conquest as the Roman; it will be the sign with us of a pure Faith, an enlightened Government, instructed classes. If there be any sorrow, if there be any strife, Art is the record which links us lovingly with the past; that neutral ground whereon men meet with the heart and the aspect of friendliness and union. Democracy and aristocracy here unite; the favourite and the outcast of fortune; and before her works, the followers of opposing dogmas stand mutually imbibing that doctrine which emanated from heaven, to unite all beneath—the doctrine of Peace on earth, and of Good Will towards men. For what are the highest aims of Art but to express intellectual Truth, intellectual Beauty, intellectual Faith; and even as the individual struggles towards the perfection of this in himself, should a Government seek to advance it in a Nation; since without moral, political progress there is none. Time rolls stealth-

ily onwards, and every year sweeps from the earth its masses to the grave. Has that man ever lived who would not be remembered? Should we as a nation so live, that we leave no records but those which commerce transmits? Rather let us so live, that alike by our monuments as in our laws, the future dwellers of the earth may say,—they were a people over whose dominion the sun never set, but whose conquests were not like those of the Roman and the Arabian, of the sword—but the acquirements of commerce, refined by the influence of Religion, and the PROGRESS of the ARTS of PEACE.

"The National Gallery"

Art-Union 10 (February 1848), 60

THE NATIONAL GALLERY.

The National Gallery has received the acquisition of a picture by J. M. W. Turner, R.A. The subject is a view of the Dogana, Venice, and is well known to the amateurs of Art as one of the numerous and valuable collection of pictures of our native school formed by Robert Vernon, Esq., of Pall Mall. The reception and exhibition of a picture painted by this great artist into a gallery free to the entire population, is an occurrence in the artistic world of more than ordinary moment. If it had been painted by any other of our distinguished painters, there would be elucidated in its execution the received principles which have been the foundation of the greater part of the works of Pictorial Art, that have emanated since its revival, more than three centuries ago. Although the subject is one inferior in rank to historical composition, yet as it is capable of being invested with a considerable amount of ideality; it generates at once a comparison with the great master of landscape, Claude, in some degree; but infinitely more so with the universal painter of Venetian views, Canaletti; and, by a very happy tact, it is placed proximate to a pair of his recognised and original productions. To compare Turner's picture with either of these masters would be a labour of supererogation, because Turner is not the pupil of any school, nor the willing follower of preconceived ideas. His art is eminently imaginative, a creation of his own, unfettered by any laws enacted by theorists, untrammelled save by the precepts of perspective truth, and its inviolable application to natural scenes. On the first development of his powers the change was too sudden not to shock the conventionalities which had taken root in the public mind, as the absolute acquirements composing a painter's skill; and Turner appeared at an epoch when Art was certainly not otherwise comprehended. Neither the universal faculty of vision, nor literary accomplishment, nor an extensive reading of the history of Art-productions and the lives of its most renowned professors, can give a ready perception of the value of any deviation from the stringent exactions which have been commonly acknowledged to constitute the basis of Art-excellence. Thus has our endowed countryman been long misunderstood, and not unfrequently condemned, from this misunderstanding.

The appearance of Turner's picture in the National Gallery is a fortuitous occurrence in Art-instruction for " the many." Being placed among the works of the greatest masters that have hitherto arisen, it is impossible but that his vast and original genius will be strictly analysed and rigidly investigated. On the walls of the gallery it stands forth to the inquiring gaze of visitors, arriving fully armed with the sarcasms of a legion of small critics, and already baited to excess by the prejudiced and partial votaries of ancient Art.

To speak of Claude with any phraseology, devoid of adulation, is with the mass a sin approaching to heresy; and it is possibly neither wise nor justifiable to follow the romantic track of the graduate of Oxford, or attempt, like the author of " The Principles and Practice of Art," to show, in examples, how the compositions of this great master could be improved. For a great master Claude undoubtedly stands, and great he will always remain, as the leader and forerunner of poetical landscape painting, whatever genius or talent is now existing, or may hereafter be elicited.

Doubtless Claude never enjoyed the advantages of those beauteous combinations of the aerial elements which the skies of Britain so lavishly offer; and it is impossible to shrink from remarking upon the tameness, and somewhat mechanical forms of the clouds which Claude painted: the real excellence of his skies depends on the simple purity and truth of tone that reigns throughout. On the contrary, in Turner we have an unceasing variation of lines, and combination of the masses of clouds, full of movement or breeze, if exacted by the subject, always floating in redundancy of elegant form, and buoyant as the vapoury element of their creation. From this sky of Venice indicating both daylight and sunny effulgence, let the visitors to the National Gallery withdraw their eyes from proximity to the canvas, and retire six or seven feet from its surface. Look then at this sky, and you become sensitive to its freshness; you can understand the daylight of southern climes, breathe the rarefaction of its pure atmosphere, and feel elasticity of mind and limb pervade the whole being. With this joyous influence now seek the inner room, and contemplate the magnificent Claudes, magnificent even in the gradual decay of their primitive lustre. You may bow to the severe fidelity of hue, and render due homage to the classical grandeur of their composition; but the air is placid, the skies formally beautiful: there is no respiration, there is no vitality. To look at Venice in the Canaletti pictures, after viewing the "Turners," and a turn to the right hand brings them in view, you may see Venice daguerrotyped, invested with mere common place reality; but for daylight, or atmosphere, or truth of natural tint, the fancy reverts to the belief that you are looking at the " City of the Sea," from a glazed window of one of its decayed, abandoned, and desolate *Palazzi* thickly dimmed with the undisturbed dirt and exhalations of a couple of centuries. Since the pictures of Canaletti are universal favourites among collectors of every calibre, whether possessors of extensive galleries or merely the owners of a few drawing-room decorations, (and it matters little whether genuine or spurious, from their all avowing the same principle of treatment in light and shade,) it will be but a demand for justice to Turner, to examine some general details of execution they possess. The question might be asked if it were consistent with reality, that in broad daylight, with an Italian sun radiating on the face of a building, there should exist a murky blackened shade on the side forming the return from the angle,—or is it not the clique of low Art, violating Nature, for the sake of effect? That it is so performed in the utter ignorance of Art and its capabilities, is triumphantly displayed by Turner, who has lavished the lustre of light every where on his subject, circulating round, and in, and about every part of the architectural objects in the combined scene of the Dogana and the adjacent islands of the Lido. Then the reflections of these Marble Palaces and Temples of Christian Worship, how illusive do they appear in the aqueous stream that glides along, and how bewitchingly a few stray, apparently accidental, thin streaks of colour, actually forming small prominences on the surface of the canvas, give perfect movement and ripple to the lucid blue waters of the Adriatic. It would be absurd to institute comparison with the painting of the water of the Grand Canal, in the neighbouring picture by Canaletti; the succession of small

regular curved lines, like the scales of a salmon or carp, to imply motion on the surface, is mere child's play, a pitiful excuse for the absence of natural verisimilitude. In Turner's representation of the transparent element there is little colour; the elongated reflections from the dazzling buildings, and from the groups of boats and figures, occupy nearly the whole of space devoted to its treatment, broken only by some occasional touches of pure blue, which would be offensively intense, if they were not governed by a group of small inanimate objects, most artistically placed on the slip of Quay in the foreground. The dazzling and brilliant bit of orange, although scarcely more than a speck, with its other small adjuncts of positive colour, harmonise the whole of the cool hues of the foreground; the warm tones of the boats and figures in the central portion, contribute their consequence to balance the cool grey in the extreme distance, forming a scale of colour redolent of glowing brilliancy, pregnant with the more perfect involutions of chiaro scuro, lavished on the canvas with a power of hand spurning the agency of dark shades, and darker shadows.

The unlearned in Art will more readily appreciate the grandeur of talent and extent of genius in this picture; because they will judge naturally, and from the impression it creates. The amateur who blindly pins his faith to some dogma of former invention, or system of manipulation, may find the task more difficult, and affect to sneer out of the mental dilemma. The day is past for gaining the representation of light by the contrast of darkness in Pictorial Art; the trick is worn out. We all know that the glorious luminary of Heaven sheds its powerful rays over the broad face of the Earth, lighting those surfaces, which do not receive them direct, by a reflected brilliancy. Turner is the pupil of Nature, and if ever an artist appeared to depict her enchanting scenes, with sunbeams on his pencil, it is Turner.

The accession of Mr. Vernon's pictures to the public collection will identify the British School among the European Schools of Art, and render it no longer a question of pretension. With the official recognition of the influence of the Fine Arts upon the morality, refinement, and commercial prosperity of the people, surely the time is arrived when no mean parsimony of motive, or urgency of monetary difficulty, should retard the establishment of a National Gallery, upon a basis worthy of the greatness of the nation. To conduct so grand a purpose with the certainty of successful result, demands at the outset, the founding of a determined system of progress, to the final destination of the Institution. Hitherto it appears to have been a perfect matter of uncertainty, if not, of occasional impulse or caprice, when, and what additions should be made to the collection: consequently, many valuable opportunities have been allowed to glide tranquilly away, perhaps never again to offer. Shortly after the founding of the National Gallery by the purchase of Mr. Angerstein's pictures, the collection formed by the late Lord Radstock was brought to public sale. A number of capital works were included in it, besides a few of the highest importance. Mr. Seguin, the then Keeper, waited on Lord Liverpool, to urge the purchase of some of the examples, to be added to the National Gallery; Mr. Byng, the late member for Middlesex, was present at the interview. Lord Liverpool declined advancing any sum from the public purse, urging the impropriety of the act,

when considerable distress existed in Manchester, but Mr. Byng interfered, and proposed to purchase two of the most renowned pictures; one, a " Holy Family " by Julio Romano, and the other, a Portrait by Parmegiano, and to keep them until the Government would feel justified in making the acquisition. Mr. Byng purchased these two works at the sale, and they remained in his possession, and have since his demise, passed to his successor. Many other occasions have subsequently arisen, with equally fruitless indifference; the total number of pictures which have been purchased by the Trustees since the foundation in 1824, amounting to no more than twenty-nine, up to the present period. As regret for past omissions tends to no other useful end than giving a more enlarged impetus to future operations, it becomes useless to dwell upon a subject so uninviting. The dispersion of the Redleaf Collection, which will take place in the spring of the present year, is one of those rare opportunities, it may be hoped, which will not be passed by with indifference; but that our National Gallery will be largely endowed with the fine works therein comprised. The small number of examples we possess of the Dutch and Flemish school is discreditable to a Public Gallery belonging to a Nation, and the more so from the widely apparent advantage it would operate on our own School of Painting; which, whatever may be written, enforced, or dogmatised about High Art, is essentially of a different scale, perfectly analogous with the principles and theories of the ancient Dutch and Flemish Painters. Yet the acquisition of the Jan Stein and the Wouwermans offered by Lord Ellesmere was negatived, notwithstanding the gallery does not possess a single example of these great masters; and the two which were thus made attainable, are unquestionably among their finest and most important productions.

The impediments which have hitherto operated against the accession of many remarkable works of Art to the gallery, have undoubtedly been the sensitiveness of the Trustees in choice, and the tardiness or disinclination of the Treasury authorities to advance the amount of money required. The observation made by Sir R. Peel, shortly after the purchase of the picture attributed to Holbein, that " in future the Trustees would avail themselves of the opinions of competent persons," appears, if it were acted upon, to be the only feasible process to restore animation after the long inertness of action. The public could not be otherwise than fully satisfied if a jury (as our French neighbours term it) were assembled to give judgment on works of Art proposed to be purchased for the National Collection; the constitution of that jury might not be a matter very feasible; but the difficulty could no doubt be overcome; it would, as a matter of course, consist of artists and connoisseurs, aided by competent and honourable picture-dealers, who would be paid for their opinions.

Since the foregoing was written, the " Turner " has been shifted to the opposite small room, and is now hung beneath the Canaletti bequeathed by Dr. Simmons. The dazzling brilliancy of our great Painter appears to overwhelm every picture in the predicament of juxta-position with it, and will probably not now find a final resting-place.

John Eagles

"Subjects for Pictures.
A Letter to Eusebius"

Blackwood's Edinburgh Magazine 63 (February 1848), 176–92

DEAR EUSEBIUS, — Your letter of inquiry reached me at Gratian's, just at the moment we were setting off to pay a visit of a few days to our friend the Curate, who had ensconced himself in happiness and a curacy about an easy day's ride from his former abode. From that quarter I have no news to tell you, but that the winning affability even of Gratian cannot obtain a smile or look of acknowledgment from Lydia Prateapace. She passes him in scorn. We found the Curate and his bride on his little lawn, before the door of the prettiest of clerical residences. She was reading to him, and that I know will please you; for I have often heard you say that a woman's reading inspires the best repose of thought, and gives both sweetness and dignity to reflection; that then the true listener is passive under the fascination and sense of all loveliness, and his ideas rise the fairer, as the flowers grow the brighter that bend to the music of the sweet-voiced brook. If every reviewer had such a reader, criticism would fall merciful as the "gentle dew,"—ink would lose its blackness. They rose to greet us with the best of welcomes; and like less happy lovers,

"That day they read no more."

The house is simply, yet elegantly furnished. To the little library with its well-filled shelves of classical and English literature, female fingers had lent a grace—there were flowers, and the familiarity of work, to humanise the severest author in this living depository of the thoughts of all ages. The spirit of Plato might look through his mesmerised binding and smile. The busts of ancient poets seemed to scent the fragrance, and bow their heads thankful. I could not resist the pleasure of patting our old acquaintance Catullus on the back, as I passed, which Gratian saw, and said—"Ay, ay, that's the rogue to whom I sacrificed swine." A few spaces unoccupied by books, were filled with choice prints from pictures by Raffaele. The most appropriate was the "School of

Athens," not the least pleasing that portrait of the "gentle musician." The Curate saw how much these prints attracted my notice, and said that he would give me a treat on the morrow, as he expected a package of prints all framed and glazed, which a wealthy relative, with whom, however, he added, he was not very well acquainted, had sent him—and he expected us to attend the unpacking. It is a present, he said, to furnish my curacy, but I know nothing of the giver's taste. I wished at the time, that my friend Eusebius had been present at the unpacking; for I did not augur much of the collection, and I thought the grace of his, that is of your wit, Eusebius, might be wanted either in admiration or apology. For if you happened not to like the picture,

"I'll warrant you'll find an excuse for the glass."

Shall I describe to you our doings and our sayings on this occasion? imagine the case before us — and in the words of another old song,

"It is our opening day."

Well—it is opened—now, Eusebius, I will not particularise the contents. The giver, it is to be presumed, with the patriotic view of encouraging native art, had confined his choice, and had made his selection, entirely from the works of modern English painters and engravers. And do not imagine that I am here about to indulge in any morose and severe criticism, and say, all were bad. On the contrary, the works showed very great artistic skill of both kinds; indeed, the work of the needle and graver exhibited a miraculous power of translation. That the subjects were such as generally give pleasure, cannot be denied; they are widely purchased, go where you will, in every country town as in the metropolis; the printsellers' windows scarcely exhibit any other. These prints were therefore according to the general taste,—and therefore the Curate must be expected to be highly gratified with

his present. Perhaps he was—but he certainly looked puzzled ; and the first thing he said was, that he did not know what to do with them. "Are they not framed and glazed?" said Gratian : "hang them up, by all means." "Yes," said the bride, delightfully ready to assume the conjugal defence, "but where? You would not have me put the horses and dogs. in my boudoir ; and the other rooms of our nest have already pictures so out of character that these would only be emblems of disagreement; and I am sure you would not wish to see any thing of that nature here—yet." But let me, Eusebius, take the order of conversation.

GRATIAN.—There is a queen tamer of all animals, and though I would not like to see the Curate's wife among the monsters, I doubt not she could always charm away any discordance these pictures might give. And look now at the noble face of that honest and well-educated horse. He would be a gentleman of rank among the houyhnhnms. I love his placid face. He reminds me of my old pet bay Peter, and many a mile has he carried his old master that was so fond of him. I have ridden him over gorse and road many a long day. He lived to be upwards of thirty-three, and enjoyed a good bite and annuity, in a fat paddock, the last seven or eight years of his life.

AQUILIUS.—Gratian's benevolence, you see, regulates his tastes: he loves all creatures, but especially the dumb : he speaks to them, and makes eloquent answers for them. You know he has a theory respecting their language.

CURATE.—And Gratian is happy therein : I wish I had more taste of this kind, for these things are very beautiful in themselves ; they are honest-looking creatures. In that I have been like Berni :

"Piacevangli i cavalli
Assai, ma si passava del vidcre,
Che modo non avea da comparalli."

LYDIA.—If they are honest, there are some sly ones too. What say you to this law-suit of Landseer's ? I think I could make a pet of the judge.

AQUILIUS.—Great as Landseer is, I like this but little. The picture

was surprisingly painted, but when you have admired the handiwork, there is an end. The satire is not good : something sketchy may have suited the wit, but the labour bestowed makes it serious: we want the shortness of fable to pass off the "*animali parlanti.*"

CURATE.—Gratian, who ought to order a composition picture of "The Happy Family" all living in concord, knows all the race, in and out of kennel, and should tell us if these dogs are not a little out of due proportion one with the other.

GRATIAN.—I think they are; but do not imagine I could bear to look upon the "Happy Family," though the piece were painted by Landseer. I never saw them in a cage but I longed to disenchant them of the terror of their keeper. They all looked as if they could eat each other up if they dared. No, no—no convent and nunnery of heterogeneous natures, that long to quarrel, and would tear each other to pieces but for fear of their superior. I love natural instincts, and am sure the "Happy family" must have been sadly tortured to forget them.

CURATE.—I certainly admire these animal portraits, they seem to be very like the creatures ; but I really have no gallery-menagerie where I can put them. They appear to me to have been painted to adorn the stable residences of noblemen, gentlemen of the turf and kennel. You smile, Aquilius, but I mean it not to their disparage, for in such places they might amuse in many an idle hour, and give new zest to the favourite pursuits.

AQUILIUS.—I only smiled at the thought, that though many such noblemen and gentlemen "go to the dogs," they would not quite like to see them among the "family portraits," and was therefore pleased at your appropriating these productions to the stable and the kennel. I am not surprised that you do not know what to do with them. I believe Morland was the first who introduced pigs into a drawing-room ; for my own part, I ever thought them better in a sty.

GRATIAN.—Hold there, I won't allow any one to rub my pigs' backs

but myself, and you know I have a brace of Morlands, pigs too, in my dressing-room.

LYDIA.—And if the pictures in any degree make you treat your animals more kindly, Morland deserves praise; and, in that case, all such works should be encouraged by the " Society for the Prevention of Cruelty to Animals."

AQUILIUS.—If Gratian is kind of his own nature, his familiarity with all creatures is of another kinship than such as art can bestow. He would have given a litter of straw to Morland himself, had he met him in one of his unfortunate predicaments, and thus have made him happy. But I fear we are not quite safe in thus commending our choice artists, on the score of the humanity they are likely to encourage.

CURATE. — Why not? Has not Landseer dedicated to "the Humane Society" the portrait of the noble Retriever; and is that not his " chief mourner," promoting affection between man and beast?

GRATIAN.—" *O si sic omnia!* " I love all field sports, and river sports too; but it is when horse, dog, and man all agree in the pleasure, and the bit of cruelty—for such, I suppose, we must admit it to be—is kept out of sight as much as possible, that we are willing to adopt the Benthamite principle into the sporting code, " the greatest happiness to the greatest number." Yet I don't like to refine away feeling in this way, and say, many enjoy, and one poor creature is hunted. I rather put it all upon nature. There is an instinct to hunt and be hunted, and perhaps there is a reciprocal pleasure. I like our good old sporting songs; they dwell upon the health and enjoyment of refreshing animation, the sociality, the good humour (and sometimes with a nice touch of pity too) of sport; they take no pleasure in dwelling upon the hard, the cruel necessity.

AQUILIUS.—Then are our ballad-makers more tender-hearted than our painters !

GRATIAN.—And there is need they should be; for some of our painters, and not only ours, but of all countries, have, to my mind, too much indulged in representations of cruelty. I have

often wondered how many of the old pictures, your martyrdoms of saints, came to be painted. Who could take pleasure in looking at them?

CURATE.—The best were works of high genius, and were painted for religious places; and though cruelty is necessary to the story of martyrdom, it is seldom made the subject—it is the triumph, the angelic choir, and the crown, and the sublime faith,—all combine to make the sublime subject; the mere act then becomes but the accessory; and such pictures, seen in their proper places—the chapels for which they were painted, and with the mind under a religious impression —are of the noblest interest, of most improving contemplation. I have heard such pictures condemned, because they have been seen in uncongenial places, and under antagonistic impressions. They are not for banquet-rooms, nor ball-rooms; nor to be commingled with the low-life subjects of the Dutch school, nor amidst the *omnium-gatherum* of galleries. The art cannot offer a higher pleasure than the contemplation of these sublime productions of Italian genius, seen when and where they should be exhibited, and alone. I have seen some that make their own sanctity, which seems to spread from them in a divine light, and diffuse itself into the outer obscure, in which all that is unfitting and minute is buried; and the great work of mind has created its own architecture, and filled it with the religious awe under which we gaze and wonder. And are we not the better?

AQUILIUS.—I fear this age of domestic life is against the reproduction of such works. All that can adorn the home, the house, and not the temple, we make the object of emulous search. Even our churches, if they would be allowed to receive such works, open as they are but an hour or so in the week, could scarcely have influence, and make such creations felt. In Italy, the passer-by has but to draw aside the curtain, and enter, and receive the influence. In such places, the martyrdoms of saints gave conviction of the holiness of faith, the beauty and power of devotion.

GRATIAN.—True; you will teach me the more to admire old Italian art.

I confess, the great power you describe has but seldom come home to my feelings ; perhaps they are naturally more congenial with home subjects ; and I have been too often disgusted with pictures of horrors. A friend of mine I once found copying a picture of the flaying a saint. There was a man unconcernedly tearing away his skin ; and the raw flesh was portrayed, I dare say, to the life. He told me it was a fine picture. I maintained that it was too natural. It was, in fact, a bad picture, for the subject was cruelty; unconcealed, detestable cruelty, not made the means of exhibiting holy fortitude. There was nothing in it to avert the absolute disgust such a sight must raise. I would as soon live in the shambles, or in a dissecting-room, as have such a picture before my eyes continually. My friend thought only of the painting ; the naturalness and the skill that drew it and coloured it to the quick—not to the life. I have seen so many of the Italian pictures of a gloomy cast, that, for my part, I have rather enjoyed the cheerful domestic scenes of life and landscape of the best Flemish masters, and English too.

CURATE.—Art has no power of injunction, or the hand of many an artist would be stayed from perilling a profanation. Minds of all grades have been employed in the profession. The Italians have not been exempted from a corruption of taste and of power. Yet, without question, the grandest and the most touching creations of art have been the work of Italian hands, and the conceptions of Italian minds. I fear I am telling but admitted truisms.

AQUILIUS.—I know not that. I doubt if the pre-eminence will be admitted as established. What works do our collectors mostly purchase— your men of taste, your caterers for our National Gallery, those to whose taste and discernment not only our artists, but the public, are expected to bow ? We have heard a great deal of late of encouraging the fine arts. We have had a premier supposed to be supreme in taste. Nay, as if he would cultivate the nation's taste, show the importance of art, encourage collecting, and teach how to collect, has he not, of late, opened his house

almost to the public, and exhibited his collection ; and what did it show ? doubtless, beautiful specimens of art, but specimens of the great, the sublime, the pathetic ? Alas, no ! I did not see mention made of a single Italian picture. Now, what would you think of the taste of a man who should profess to collect a library of poets, and should omit Homer, and Æschylus, and Dante, and point with pride to the neatly-bound volumes of the minor poets, and show you nothing higher than the " Pastor Fido," or the " Gentle Shepherd ? "

LYDIA.—Or in a musical library should discard Handel ?

GRATIAN. —Well, that is strange, certainly ; but if we are becoming a more home-comfort-seeking people, is it not right to encourage the production of works for that *home market ?* I cannot agree to put in the background our more domestic artists— and at least they avoid the fault of choosing disgusting subjects.

AQUILIUS.—Do they ? I am not quite sure of that : we shall see. I suspect they fail more in that respect than you will gladly admit.

GRATIAN.—Now, what fault can you find with my favourite Landseer ? Do you not like to see the faithful, poor dumb creatures ennobled by his pencil, and made, as they ought to be in life, the humble companions of mankind?

CURATE.—If humble, not ennobled !

GRATIAN.—Master Curate, do you not read — " Before honour cometh humility ? "

AQUILIUS.—I agree with you, Gratian. I quite love his pictures : they are wonderfully executed, with surprising truth, and in general his subjects, if not high, are pleasing. Yet I hardly know how to say, in general. there are so many exceptions. I could wish he were a little less cruel.

LYDIA.—Cruel ! how can that be ? his pet dogs, his generous dogs, and horses, and that macaw, and the familiar monkey, and that dear begging dog. The most gentle-minded lady I am acquainted with is working it in tambour—and has been a twelve-month about it !

GRATIAN.—And has he not a high poetic feeling ? Can you object to

the " Sanctuary," and the " Combat,"
— I believe that is the title of the
picture — where the stag is waiting
for his rival ?

AQUILIUS.—They are most beau-
tiful, they are poetical ; there is not
an inch of canvass in either that you
could say should have a touch more
or less. The scenery sympathises
with the creatures ; it is their wild
domain, and they are left to their own
instincts. There is no exhibition of
man's craft there, let them enjoy their
freedom. Even in the more doubtful
" Sanctuary," we have the assurance
that it *is* a " Sanctuary ;" but I see,
Gratian, that your memory is giving
you a hint of some exception. What
think you of the fox — not hunted as
you would have him painted, wherein
" the field" would be the sport—but
just entering the steel trap, where
you see the dead rabbit, and think
the fox will be overmatched by man's
cruel cunning ?

GRATIAN.—Why, I had rather
hunt him in open field, and give him
a chance than trap him.

CURATE.—Even Reynard might
say with Ajax, if man must be his
enemy—

" Εν δε φαει και ολεσσον."

GRATIAN.—I give up that picture ;
it is not a pleasing subject.

LYDIA.—I am sure you must like his
" Bolton Abbey in the Olden Time."

AQUILIUS.—What! with its whole-
sale slaughter of fish, flesh, and fowl,
to feed the gross feeders of the con-
vent ? I take no pleasure in it : I
could take part with the " melancholy
Jacques," and rate "the fat and
greasy" ones in good round terms.
Who wishes a picture of a larder ?

LYDIA.— Here is his "Hawking
Party ; " will not this please you ?
You at least see the health and joy of
the sporting : are not the hawkers de-
lighted ?

AQUILIUS.—So much the worse,
for their part in the transaction is
quite subordinate—in the back ground.
What is the prominent subject?—the
bloody murder of the poor heron. It
should have been the accident; it is
made the cruel principal : without
being squeamishly tender-hearted, I
shall never look upon that picture
with pleasure. In how different a
manner did Wouverman paint his

hawking parties ! He represented
them as scenes in which ladies might
participate—the domain, the man-
sion-gate, the retinue, the grace, the
beauty, the cheering exercise, the
pleasure of all, even the animals en-
gaged : he does not make the bloody
death the subject.

GRATIAN.—I must confess Wouver-
man's was the better choice. You
seem prepared with a collection of
examples.

AQUILIUS.—In this I am only
taking what is before me ; but worse
remains for more severe remarks.
You have, I see, the " Otter Hunt,"—
is it possible that picture can give
you any pleasure? What is the senti-
ment of it ?—debasing cruelty. I say
debasing, because it puts human
nature in the very worst position : the
dogs are using their instinct, and are
even then defrauded of their game,
which the huntsman holds up con-
spicuously in the picture, (and which
is in fact the subject), stuck through
with his spear, and writhing in agony.
Surely this cannot be

" The dainty dish
To set before the Queen."

It is said to be in her Majesty's pos-
session. There is in Lucian a de-
scription of a picture of a Centaur
and his family, a magnificent group :
the father centaur is holding up a
lion's skin to the gaze of his young
progeny, to excite them to deeds of
courage. If this poor agonised death-
writhing otter is to be perpetually
before the eyes of our young princes,
they will not learn much good from
the lesson. For my own part, I look
upon the picture with entire disgust,
and would on no account have it
before my eyes. I know not in what
mood I could be to endure it.

LYDIA.—I think we really may
dispense with the hanging up this
picture anywhere. I cannot bear to
look at it. It is a picture to teach
cruelty. As a test of its impropriety,
imagine it placed as an ornament in
our Sunday school : we should have
the children brought up savages.

CURATE.—Thanks, dearest Lydia.
I well knew this picture would not be
to your taste ; we will, at all events, set
it aside. Happy are we, that our
women of England can be mothers of

heroes, without being inured to the cruelty of bull-fights. A Spanish lady, describing an exhibition of the kind, remarked how glorious was the sight, for there were thirteen horses and one man killed. I suspect Aquilius will not quite approve of the "Deer-Stalking" lately exhibited at the Academy.

AQUILIUS.—Certainly not; and for the same reason. It puts man in a degrading position; and our sympathy is for the poor creatures who fly terrified, not seeing their skulking enemies; and one poor creature is knocked over in his wild flight. It is admirably painted; the scene all we could wish; but the story is bad—the moral bad. You look at the picture without feeling a common desire with the hunters: you wish them away. You have their object put before you basely: their attitudes are mean. It is not a work, great as it is in art, that ought to give pleasure.

GRATIAN.—And yet you are not displeased reading Mr Scrope's "Deer-Stalking?" It is only putting his words on canvass.

CURATE.—True; but are they faithfully put? and even so, words and paint are not the same; their power is different. The description of language passes on; you are not allowed to dwell too long on what, if seen embodied, would but shock you, by its being arrested, and made permanent. I remember the description. You at first scarcely know if there is a deer or not; it is only the experienced eye can discover the motion of the ear, or some speck of the creature, at a distance. You enter into the breathless caution of the hunter—his steady and earnest hope; but you see not, or only for a moment, the skulking attitude. The poet—for the prose is poetry—touches with a light and delicate hand that which the less discriminating painter grasps, holds firm, and fixes as his subject.

AQUILIUS.—A just remark. The sentiment is thus made both cruel and mean.

GRATIAN.—Come, then, let us have something we can entirely praise, by the hand of this prince of animal painters. You will at least admire his "Peace" and "War," those two most beautiful and poetical pictures.

AQUILIUS.—The "Peace"—yes. It is most happy; and perhaps the "War," if we take the moral rightly. It might be bought by the Peace Society. Every one must acknowledge the great beauty and feeling of these pictures. I confess, however, I seldom look upon battle-pieces with much pleasure. The horrors of war are not for the drawing-room; and where they are painted for public position, they are generally in very bad taste. I do not mean here to allude to the companion to Mr Landseer's "Peace."

GRATIAN.—How seldom you see a battle-piece,—that is, a battle! You have some one or more incidents of a battle; but, as a whole, it is not represented. I have no idea of a battle, on which depends the fate of empires, from the exhibition of a grenadier running his bayonet through a prostrate foe, a few dead men, and a couple of horses, one rearing and one dead. Such are the usual representations of battles.

AQUILIUS.—Yes—vulgar battles; vulgarising the most important events in history: and yet I do not believe it to be impossible to represent a battle poetically, and more truly, than by such incident as Gratian has described, though the regimentals be most accurately painted—and the gold lace has a great charm for the multitude. And perhaps it was in deference to this common taste, that the chief prize was given to the "Battle of Meeanee" in Westminster Hall.

LYDIA.—I rejoice to listen to the criticism. We will not have battle-pieces in our boudoir; Curates and their wives are for peace. I go with the poet—

" Le lance rotte, gli scudi spezzati,
 L'insigne polverose, e le bandiere,
 I destrier morti, i corpi arrovesciati
 Fan spettacolo orribile a vedere :
 I combattenti insieme mescolati,
 Senza governo, o ordine di schiere,
 Veder sossopra andare, or questi, or quelle,
 A'riguardanti arricciar fa i capelli."

CURATE.—I take my old part of translator, and thus render it, perhaps Aquilius will think too freely, at least in the conclusion—

Lances and shields of broken chivalry,
Banners and ensigns trampled from their glory
Down in the dust—Oh ! woe too sad to see,
Rider and horse fallen dead in heaps all gory;

Leaderless squadrons, one tumultuous sea
Of ruin! Death sole hero of the story.
And such is war—oh sight the heart to rend,
And make our rooted hair to stand on end!

AQUILIUS.—Your verse shall not disenchant me of my criticism upon this bad habit of seeing his subject, into which so great a painter has fallen. After what has been said, I shall not surprise you by objecting to his " Van Amburgh and his Beasts," painted for his Grace the Duke of Wellington—the shrinking, retreating, cowed animals, whom one would wish to see in their wilder or nobler natures. And certainly the painter has made a very poor figure of the tamer : you are angry with the lions and tigers for being afraid of him. He should have been less conspicuous. Poor beasts! within bars, no escape from the hot iron! I had rather see a representation of the tamer within the bars, and the beasts out, longing to get at him. There is a very happy subject for a picture of this kind in the hymn to Aphrodite —where the goddess descends on Ida, and all the savage beasts come fawning about her, when, with a motion of her hand, she dismisses them to pair in the forests. Such noble animals, crouching in obeisance and willing servitude to a divinity, to beauty, and to innocence, make a picture of a finer sentiment. This taming reduces the dignity of the brute, without raising the man.

CURATE.—The tamed animals are not honoured in their portraiture ; nor is it much consolation that the great duke beholds their quailing. Statius attempted a consoling compliment of this kind, upon the occasion of a much admired beast, " Leo Mansuetus," being killed by the blow of a flying tigress, in the presence of the emperor. After describing the scene, he adds—

" Magna tamen subiti tecum solatia lethi
Victe feres, quod te mœsti, Populusque Patresque,
Ceu notus caderes tristi Gladiator arena,
Ingemuere mori: magni quod Cæsaris ora
Inter tot Scythias, Libycasque, et littore Rheni,
Et Pharia de gente feras, quas perdere vile est,
Unius amissi tetigit jactura leonis."

AQUILIUS.—We are rivals in rhyme, and you know I freely translate :

perhaps you will admit this as a version—

Yet this your consolation, ye poor beasts,
Whene'er the duke his guests illustrious feasts,
Th' illustrious guests, as an uncommon treat,
Shall see the lions, while they talk and eat.
Oft from their plates shall lift their half-filled jaws,
To wonder at your whiskers, manes, and claws,
And only wish, the painter to rebuke,
To see Van Amburgh killed before the duke.

GRATIAN.—I am umpire : that is not a version, but a perversion.

AQUILIUS.—Then it the better suits the picture. I must, however, admit that, to criticise at all, there is need to be out of the fascination of the work. It is quite marvellous in power. We are treating of subjects for pictures, and consequently their sentiment—the why they should or should not please. It is to be regretted that so great an artist should not *always* well conceive the poetry of sentiment.

CURATE.—We are not yet really lovers of art, or we should not be so confined in our taste. The excellence of this one painter excludes others from their due praise, and patronage too. Go to our exhibitions, you are surprised at the number of our artists: look at the printsellers' windows, and you would wonder at their fewness. I cannot remember, at this moment, a print from a work of any modern British painter, of moral importance and dignified sentiment.

LYDIA.—There is one of Mr Eastlake's, his beautiful scriptural subject.

AQUILIUS.—True ; but we have not yet emancipated the nation from their puritan horror of sacred subjects —which are, after all, the greatest and best. We import these from the Germans.

GRATIAN.—We have been a nation of country gentlemen—fond of fieldsports : and this our national character has had much to do with our taste in art. Hence nothing answers so well as horses and dogs.

CURATE.—Yet I am inclined to say " cave canem." By the bye, why do the old painters, Paul Veronese, for instance, in his celebrated large picture of the marriage feast, introduce great dogs, where they evidently should not be? I have

met lately, somewhere, with the supposition that the bones which the painters calcined to make dryers were the bones thrown under the tables for the dogs, and that such was the practice. But there is a passage in "Laurentius Pignorius de servis," which seems altogether to contradict the notion, and indeed to reprove painters who introduced these large dogs in their pictures; and particularly, it should seem, one who represented Lazarus and the dogs in the same room with Dives. His argument is curious—that the dogs which were admitted upon these occasions were little pet animals, and that it is so shown by the passage in chap. xv. verse 27, of St Matthew, where they are said to pick up the *crumbs*, and that it is shown to have been so by ancient sculpture. He says that this introduction is become such an admitted taste, that whoever would be bold enough to set himself against it would in vain endeavour to correct the bad taste of the painter. It is a curious passage,—I have the book here, and will turn to it : I read it only the other day. Here it is, and I more readily offer it as it speaks sensibly of a disgusting subject, unfit for painting.

"Erant autem et qui pone januam canem pictum haberent, ut apud Petronium Trimalcio. At quid ad hæc pictores nostri qui in triclinio divitis Lazarum delineant? Potestne quidquam ineptius aut cogitari aut fingi? scilicet janitores admississent hominem scatentem ulceribus, dorso ipsi luituri quidquid oculos nauseabundi domini offendisset. Canes vero immanes illi Villatici et Venatici, num oblectabant cœnantem dominum? Apage! Catelli quidem in deliciis tricliniaribus habiti sunt, ut testatur mulier Chananœa apud Mattheum, et indicant sculpturæ antiquorum marmorum: Cæterum Molossos, et ejus generis reliquos, nemo in convictum, nisi amens aut rusticus recepisset. At quisquis pictorum nostrorum pene omnium pravitatem corrigere voluerit, otium desperaverit omnino: adeo ineruditi sunt, adeo cognitionem omnem antiquitatis turpiter abjecerunt."

GRATIAN.—I suppose the little pets admitted to the table were the small Melitan dogs, such as Lucian speaks of in his "Private Tutor." The Greek philosopher and teacher was requested by the lady of the house in which he was tutor to take charge of her dear little pet, which, being carried in his arms as he was stuffed into the back carriage with the packages and lady's maids, disgraced the philosopher by watering his beard.

AQUILIUS.—A kind of King Charles's breed. I remember a gentleman telling me, many years ago, that he was dining in Rome with Cardinal York, and one of these little creatures was handed round after dinner, upon which occasion the cardinal said, "Take care of him, for he and I are the last of the breed."

LYDIA.—Poor creatures! that is a touching anecdote. It ought to be written under Vandyke's celebrated picture of the unfortunate Charles and his family, in which the breed are so conspicuous. I think my sweet Pompey is one of them, notwithstanding the cardinal's protest, and I shall love the little pet the more for the royal familiarity of his race. I must have his portrait.

CURATE.—Or his statue, that he may rival Pompey the Great. Why his picture? has not Landseer painted him to the life in that fine picture where he is all play, with the ribbon about him to show whose pet he is, and the great mastiff lying so quiet, stretched out below him? It is his very portrait, and when he dies you should get the print, and I have his epitaph for you to write under it.—

In marble statue the Great Pompey lives,
Life to the little Pompey Landseer gives.
And little Pompey play'd the Roman's part,
And almost won a world—his Lydia's heart :
Then died, to prove that dogs shall have their day,
And men no more, whatever parts they play.
Great Cæsar at his feet in painted state—
Shall little Pompey envy Pompey great.
How true the pencil, and no truer pen,
Alike the history paints of dogs and men.

AQUILIUS.—Do you mean to be the general epitaph-maker for your church-yard? Take care you infringe not on the sexton's privilege.

GRATIAN.—If we discuss this matter farther, we shall have Aquilius and the Curate diverging into their poetics; so, my dear good lady, I must look at your flower - garden :

here now, an arm for an old man; and—have you an orchard?—I can help you there a little. And a word in your ear—depend upon it, wherever there is an orchard there should be a pig or two in it. Come, I must look at your stock; we'll talk about pictures after tea. See, my friend Curate, I'm off with your wife; not quite so active as a harlequin, but you and Aquilius may follow as pantaloon and clown. So let us keep up the merry farce: no,—entertainment of life, and I dont care who best plays the fool.

Now, Eusebius, what shall I do? will you have an interlude? Your wit will reply that you have had one already. Will you have music? Yes, I think you said, but your's is all on one string. Shall it be as a chorus in a Greek play? Why do dogs howl at music? They have an intuitive suspicion of what the strings are made, and think they might as well begin by tolling the bell for themselves, or rehearse the howl! The interlude is over—while we are asking about it, the bell rings, the tea-things are removed—and the prints laid on chairs round the room. We resume the discussion.

AQUILIUS.—I have been considering what are the most popular subjects as we see them exhibited in the shop windows, and I find that even Landseer has his rival in the popular approbation. Go where you will you see specimens of the style—mawkish sentimentality, Goody Families, Benevolent Visitors, Teaching Children. There is nothing more detestable than these milk-and-water affectations of human kindnesses; all the personages are fools, and as far as their little senses will let them, hypocrites. Whence do these Puritan performances come?—the lamentable thought is, where do they go?—a man cannot paint above himself. A soft artist paints soft things.

LYDIA.—Don't mention the things! I am sure they make hypocrites. I saw one the other day in a cottage; it was of the "Benevolent Visitors"—I am not sure of the title; if any good ladies gave it, it was a vile vanity; if bought as a compliment, it was a worse corruption.

GRATIAN.—Do you know that we have historical painters for modern saintology, and that a picture was

actually painted of St Joanna Southcote, for the chapel at Newington Butts, in a sky-blue dress, leading the devil with a long chain, like a dancing bear, surrounded by adoring angels? I met with the anecdote in a very amusing book of Mr Duncan's, the "Literary Conglomerate," wherein he treats of the subjects of pictures.

AQUILIUS.—I know it; I only quarrel with him for classing Hogarth with the comic painters. To me, he is the most tragic of all modern, I would almost say of all painters. The tragic power of two of the series of "Marriage à la mode," is not surpassed in art. The murdered husband, the one: the other, the death of the adulteress. They are too tragic for any position but a public gallery. He was the greatest of moral painters; and the most serious, the gravest of satirists. He is so close to the real tragedies of life, and his moral is so distinct, that he seems to have aimed at teaching rather than pleasing. And perhaps, if the truth were known, it might be that he has in no small degree improved the world in its humanities. He has pictured vice odious in the eyes of the pure, but not so as to quench their pity; and has made it so wonderfully human, that we shudder as we acknowledge the liabilities of our nature. He exhibited strongly that man is the instrument of his own punishment, and that there was no need of painted monsters and demons to persecute him. He showed the scorpion that stings himself to death. He brought the thunder and lightning, the whirlwind, not from the clouds to expend their power on the fair face of the earth, but out of the heart, to drive and crush the criminals with their own tempestuous passions. And is not this tragic power? is such a man to be classed among the painters of drolls? His pictures would convert into sermons, and would you call the preacher of them a buffoon?

GRATIAN.—There is, indeed, little drollery in Hogarth: even his wit was a sharp sword, so sharp that the spectator is wounded, and dangerously, before he is aware of it.

CURATE.—I could not live comfortably in a room with his prints. I

would possess them in my library as I would Crabbe's Tales, but would not have them always before my eye. Nor would I, indeed, some of the finest works of man's genius—as Raffaele's "Incendio." I would have them to refer to, but a home is, or ought to be, too gentle for such disturbance.

GRATIAN.—There is an anecdote told of Fuseli, that when on a visit to some friend at Birmingham, a lady in a party said to him—"Oh, Mr Fuseli, you should have been here last week, there was such a subject for your pencil, a man was taken up for eating a live cat."—"Madam," said the veritable Fuseli, "I paint terrors, not horrors." For my own part, life has so many terrors, and horrors too, that I should prefer mitigating their effect, by having more constantly before me the agreeabilities—pleasant domestic scenes, soft landscapes, or such gay scenes and figures as my favourite Teniers occasionally painted, or the sunny De Hooge; or why not bring forward some of our pleasant home-scene English painters? Did you not see, and quite love, that little delight of a picture, the hay-making scene in the Vicar of Wakefield, by our own, and who will be the wide world's own, Mulready? Such scenes ravish me. Did you not long to walk quietly round and look in the vicar's face, as he and Mrs Primrose sat apart with their backs to you? Mulready, you see, had the sense to leave something to the imagination.

AQUILIUS.—Yes, pictures of this kind have a very great charm : they are for us in our domestic mood, and that is our general mood—they should gently move our love and pity. But I cannot conceive a greater mistake than to make "familiar life" as it is called, doleful, uncheerful subjects, that are out of the rule of love and pity, very easily run into the class of terror ; there is scarcely a between, and if one—it is insipidity.

GRATIAN.—Now, I shall probably commit an offence against general taste if I confess that, in my eyes, Wilkie is very apt to paint insipid subjects. He seems too often to have been led to a matter of fact, because it had some accessories that would paint rather well, than because

the fact was worth telling, either for its moral or its amusement. Some of his pieces, notwithstanding their excellent painting and perfectly graphic power, rather displease me. I never could take any interest in his celebrated "Blind Fiddler." It may be nature, but there is nothing to touch the feelings in it : had I been present, I should not have given the man a sixpence. And as for the hideous grimace-making boy, I could have laid the stick with pleasure on his back. I don't think I could ever have kissed the ugly child.

AQUILIUS.—Wilkie was a man of great observation, great good sense, manifest proof of which his correspondence sets forth ; but that necessary virtue of a painter of familiar life, which he possessed in so great a degree, observation, led him oftener to look for character than beauty. Oddity would strike him before regularity. Nor was he a cheerful painter. His "Blind Man's Buff," is contrived to be without hilarity, and it is singularly unfortunate in the sharp angles of hips and elbows. His best picture of this kind is certainly the "Chelsea Pensioners"—or "Battle of Waterloo," very finely painted ; but there is an acting joy in it,—it is joy staid in its motion, and bid sit for its portrait. So his "Village Wake" in our national gallery, is not joyous as a whole ; the figures are spots, and the mass of the picture is dingy. Pictures, like poems, should not only be fair but touching, "dulcia sunto," and this is more imperatively essential to domestic scenes. The story should always be worth telling. Painters seem to have taken it into their heads that any thing, which presents a good means for exhibiting light and shade and colour, makes a picture. If an incident or a scene be not worth *seeing*, it is not worth painting.

GRATIAN.—That is never more true than when they are figure pieces. Our likings and our antipathies are stronger in all representations of the ways and manners of men, than in all the varieties of other nature. We can bear a low and mean landscape, but degraded humanity seldom is, and never ought to be pleasing.

CURATE.—Aristotle determines that brutishness is worse than vice. Vice

is a part of our nature, but brutishness unhumanises the whole nature. It is certainly astonishing that painters can take a delight, not having a moral end in the performances, to select the low scenes—the utter degradation of civilisation, and therefore worse than any savage state—as subjects for pictures. How is it that in a drawing-room a connoisseur will look with complacency—more than complacency—upon a painted representation of beastly boors drinking, whose presence, and the whole odour of which scene, in the reality, he would rush from with entire disgust?

AQUILIUS.—Yet I must, in a great measure, acquit the Dutch and Flemish school of such an accusation. The painters who worked these abominations were really but few, — the majority aim to represent innocent cheerfulness. How often is Teniers delightful in his clear refreshing skies, cheerful as the music to which his happy party are dancing, in the brightness of a day as vigorous as themselves. Cheerfulness, rational repose, and sweetest home affections, often make the subjects of their pictures; and these impart a like pleasantness, a like sympathy, in the mind of the spectator. Having such a variety of these pleasantries and sympathies to choose from, it is astonishing that any artist should select for his canvass a subject unpleasing and even disgusting. I remember, a great many years ago, a picture exhibited, I think at the Academy, which at the time was thought a wonder, and, I believe, sold for a great deal of money. It was "The Sore Leg," by Heaphy;—there was the drawing off of the plaster, and the horrors of the disease painted to the life, and the pain. Is it possible that, for the mere art of the doing, any human being, unless he were a surgeon, should receive the slightest pleasure from such a picture? It is enough to mention one of the kind; but there have been many.

LYDIA.—I dare say, then, you will, with me, disapprove of such a subject as "The Cut Finger." Surely it is very disagreeable.

GRATIAN. — Entirely so; but he painted a much worse thing than that. I do not see why any country gentleman should take pleasure in seeing

such a "Rent Day," as this celebrated artist has painted. There is a painful embarrassment, uncomfortable miscalculation, reluctant payments, much more dissatisfaction than joy. I really cannot quite forgive him for making the principal figure hump-backed. This is not the characteristic of toil, labour, and industry. Doubtless the figure is from nature; but he never preferred beauty of form, when character stood by. But there is one of his pictures I consider perfectly brutish—for it is a scene arising out of that brutishness which is the necessary result of artificial and civilised life; which, unless for a moral purpose, it is best to keep out of sight,—at least in all that pertains to the ornament of domestic life. I allude to his picture, "Distraining for Rent." It is a subject only fit for the contemplation of a bailiff, to keep his heart in its proper case-hardened state, by familiarising him with the miseries of his profession. I have been told that Wilkie did not approve of this subject, but that it was given him as a commission, which he could not well refuse.

AQUILIUS.—I would have all such subjects prohibited by Act of Parliament. Have a committee of humanity, (we can do nothing now without committees,) and fine the offending artists. Is the man of business, in this weary turmoil of the daily world, to return to his house, after his labour is over, and see upon his walls nothing but scenes of distress, of poverty, of misery, of hard-heartedness—when he should indulge his sight and his mind with every thing that would tend to refresh his worn spirits, avert painful fears, either for himself or others, and should tune himself, by visible objects of rational hilarity, into the full and free harmonies of a vigorous courage, and health of social nature? His eye should not rest upon the miseries of "Distraining for Rent," Heaphy's "Sore Legs," no, nor even "Cut Fingers." In this wayfaring world of many mishaps, however homely be the inns, let them be clean and cheerful, that we may set out again in an uncertain sky, where we must expect storms, with beautiful thoughts for our companions; that, by encou-

ragement of a confiding reception, become winged angels, with a radiant plumage, brightening all before our path, and seen brightest and most heavenly under a lowering cloud.

LYDIA.—Thanks, Aquilius, you are poetical, and therefore most true; so low and mean thoughts — what! are they to accompany us, whether they show themselves in words or in pictures? I fear me, they are bad angels, and are doing their evil mission in our hearts, alas! and in our actions. It has been said, as an encouragement to our charity, that "men have received angels unawares." It may be said, too, as a warning lest we receive evil, that men may receive demons unawares. Beautiful Una—the lion licked your feet because you were so pure, so good.

Shall I tell it to you, Eusebius? Yes, your eyes will glisten as they read, for dearly do you love happiness. Here the Curate drew his bride, his wife, closer to him, kissed her honest forehead, and rested his cheek upon it for a little space, and with a low voice murmured, — "My beautiful Una." He then turned to us with a smile, and I think the smallest indication of moisture in his eye, which might have been more but that the bright angel of his thought had cleared it away, and said,—Excuse me; yet, to be honest, excuse is not needed: my two dearest of friends must and do rejoice in the loving truth of my happiness.

GRATIAN.—No, no, my good friend, don't make excuse, it would be our shame were it needed. You have given us one subject for a picture, whose interest should set my brushes in motion were I twenty years younger, and might hope to succeed. But this I will say, my memory has a picture gallery of her own, and in it will this little piece have a good place. Now, I like this conversation on art, because you know I have been all my life a dauber of canvass — dauber! even Aquilius, who has so much addicted himself to the art, has praised some of my performances. I have painted many a sign for good-natured landlords, in odd places, where my fishing excursions have led me'; and old Hill, honest old Hill, the fisher of Millslade, has a bit of canvass of mine, the

remembrance of a day, which I believe he will treasure a little for my sake, and more for its truth, to his last day. I must show the Curate's wife old Hill. I hit him off well,—am proud of that portrait, and often look at my old companion from my easy chair. I sometimes now dabble with my tube colours, and make a dash at my remembrances of river scenes. Nature and I have been familiar many a long year. I love the breezy hill, and the free large moor, that takes up the winds and tosses them down the grooved sides, to go off in their own communing with the waterfalls. I love, too, the quiet brook, and rivers stealing their way by green meadows, and the elms, that stand like outposts on the banks, keepers of the river. Have we not, in our discussion, too much omitted to speak of landscape,— even including the sea-shores? And in landscape we certainly have painters that please. As a true fisherman and painter-naturalist I could not resist, the other day, purchasing Lewis's river scenes. How happily—the more happily because his execution is so unstudied, so accidental—does Lewis, with his etching and mezzotint effects, put you into the very heart of river scenery; and then how truly do you trace it upwards and downwards. We have some good landscape painters.

AQUILIUS.—We have; and of late years they have greatly improved in subjects. They at least now look for what is beautiful. The old dead stump, the dunghill, and horse and cart, the pig and the donkey, are no longer considered to be the requisites for English landscape. One has seen publications called English landscape, which must give foreigners a very miserable idea of our country. Cottage scenery, too, has had its day. The old well is dry—the girl married, it is to be hoped, and the pitcher broken. The lane and gipsies, the cross sticks and the crock, are not dissolving but dissolved views. In time, the turnpike road and ruddled sheep going to the butcher will be thought but ill to represent the pastoral. When the mutton has been eaten up—and I hope the artists get their fair share—I wish they would be satisfied, and know when they have had

enough. The Act of Parliament we spoke of, should exclude creatures with the ruddle on their backs, and butcher-boys, aud men in smock-frocks and low hats, and pitchforks. We have had enough of this kind of pastoral; they are not the "gentle shepherds," that should people the Arcadia within England, or any other. I would have Rosalind and her farm, without the clown. The French and Dresden china shepherds and shepherdesses, as we see them prettily smiling, and garlanding their pet lambs, as something extra parochial, and *sui generis*, show at least this happiness, that they do not eat their bread by the sweat of their brows. All landscape that reminds you of " the curse of the earth, of the dire necessity of toil, of the beggarly destitution test," of dingy earths and dirty weather, are, you may be sure, far out of the hearing of Pan's pipe. He does not adjust his lips to music for the overseer and exciseman, nor rate collectors. Nay, when Pan retires to visit his estate in Arcadia, and Robin Hood reigns, he will have no such ink-horn gentry partake of his venison. The freedom of nature loves not the visible restrictions of law. I would be bold enough to lay it down as a truth, that it is as possible to get poetry out of the earth, as swedes and mangel-wurzel. Let landscape painters look to it, lest they get into bad habits before the act is out, and, of a hard necessity, incur the penalty.

GRATIAN.—Stay, stay,—where are you running to? Surely if a painter takes a *bonâ fide* view, you would not have him turn the milk-maid out of the field, to bring in Diana and her train.

AQUILIUS.—Views! oh, I thought we were speaking of Pastoral. That is quite another thing; I am somewhat of Fuseli's opinion, who said, speaking contemptuously, "I mean those things called Views."

CURATE.—But you will admit, Aquilius, that we have real scenes that are very beautiful, always pleasing to look at, and therefore fit to be painted. Is there not our lake scenery?

AQUILIUS.—There is; and as our subject is art, I should say such scenery

is more valuable for what it suggests, than for what it actually represents in the painter's mirror. In fact, nature offers with both hands: it requires a nice discretion to tell which hand holds the true treasure. She may purposely show you the ornament to deceive.

" So may the outward shows be least themselves,
The world is still deceived with ornament."

It was the leaden casket, in which was hidden the perfect beauty of Portia; there was the choice, and made with a judgment that won the prize, and took the inheritance of Belmont.

" You that choose not by the *view*,
Chance as fair, and choose as true."

Would you take away from landscape painters the high privilege of genius? —invention—which you allow to historical painters? You do this, if you do not grant to the fullest extent the suggestive character of nature. The musician takes music from the air, which is his raw material; the conception, which works from mere sounds the perfect mystery of power, to shake, to raise, and melt to pity and to love the whole soul, belongs to the mind. And so, for the more perfect work of landscape, the mind must add of its own immortal store, the keeper and dispenser of which is genius.

CURATE.—You would raise landscape painting to the dignity of a creative, from the lower grade of an imitative art.

AQUILIUS.—I would do more; I would make it creative, not only in things like, but, to speak boldly at once, in things unlike itself; but, nevertheless, perfectly congenial; and to be adopted as a recognised mark of submission of all matter to mind, which alone is privileged to diffuse itself over and into all nature, and to animate it with a soul — life; and when that is superadded, and then only, is the sympathy complete between external nature and ourselves. I care not for art that is not creative, that does not construct poetry. From all that is most soft and tender, to all that is most great and rugged, from the sweet to the awful and sublime, there

is in all art, whether it be of land-scape, or historical, (which embraces the poetical), a dominion bounded only by the limitations of the original power with which genius is gifted. Why may there not be a Michael Angelo for trees, as for the human form? Nay, I verily believe, that those landscapes would have the greatest fascination, where there would be, in fact, the greatest un-likeness to usually recognised nature, both in form and colour, provided one part were in keeping with another, so as to bring the whole within the idea of the natural; and where the conception is clearly expressed, and is worthy the dignity of feeling. Hence, suggestive nature is the best nature. We want not height and magnitude, vast distances: if we have the science of form and colour, the materials need not be vast, let them only be sug-gestive.

GRATIAN.—You laid down some such theory with regard to colour, as a means of telling the story, in your late paper on Rubens. I could not but agree with you there. I see now how you would extend the subject. We certainly do talk too much about " *the* truth of nature," not consider-ing sufficiently how many truths there are.

CURATE.—And what a great truth there is that is of our own making, greater than all the others; for, ac-cording to the showing of Aquilius, it comes of a divine gift, of the creative faculty, under a higher power; works the wonders in poetry, painting, music, and architecture, fittest for our admiration and our improvement. It is surprising that our landscape paint-ers have not seen this walk within their reach; nearly all confine them-selves to the imitative.

GRATIAN.—But in that they have raised their pretensions. We had nothing great or poetical in the least degree in landscape, before Wilson; nay, to a late period, our landscape subjects were of the most limited range. They do now go at least to beautiful nature, and while we have such painters of landscape as Cres-wick and Stanfield, and Lee, and Danby, (but there you will say is an advance into a higher walk,) for my own part, I shall hesitate before I give my vote for your more perfect ideal.

AQUILIUS.—The works of the painters you mention are beautiful, fascinatingly so, both from the cha-racter of their chosen scenery, and their agreeable manner of represent-ing it. And I rejoice to see, that even these are advancing, are dis-carding something or other of the old recipes every year. We have at last some better English scenery. We must no longer refer to Gains-borough as *the* painter of English landscape; we find it not, that is, true English scenery, in his pictures, nor in his " studies."

GRATIAN. — And yet he painted nature, and came upon the world that began to be sick of the attempts at your ideal compositions, the prince of whom, and who won the prize over Wilson, was Smith of Chichester.

AQUILIUS.—Oh, do not dignify his presumptions with the name of ideal.

GRATIAN.—I can't give up Gains-borough, his sweet cottage scenery, with his groups of rustic figures.

AQUILIUS. — Was there nothing better within the realms of England than beggary and poverty, rags and brambles,—her highest industry, the cart and the plough,—her wealth in stock, the pig, poultry, and donkey?

GRATIAN.—But it was the taste of the day; even our aristocracy were painted not as ideal, but as real shep-herds and shepherdesses. A few years ago, there was a picture fished out of some lumber room, where it ought to have been buried till it had rotted, of George the Third's family group, as cottagers' children, playing in the dirt before a mud hovel. It was by Gainsborough, and I believe was held at a high price.

AQUILIUS. — This was a descent from the non-natural pastoral of the by-gone age, to the low natural, from which art derived but little benefit. Goldsmith very aptly and wittily satirised the transition state in the Primrose family-group, in which each individual adopted a singular inde-pendence. Venus, Cupids, an Amazon, and Alexander the Great, with Dr Primrose, holding his books on the Whistonian controversy.

CURATE.—One would rather ima-gine that Goldsmith was severe upon

the practice of an earlier date. There are several pictures at Hampton Court, and one large one, if I remember, on the stair-wall, in which the statesmen of the day represent the deities of the heathen mythology.

LYDIA.—Yes, and I remember a very ridiculous smaller picture, a portrait of Queen Elizabeth—but it affects the historical. The queen and her train enter on one side of the piece, and on the other Juno, Venus, and Minerva. The goddesses are in every respect outdone, and start with astonishment,—Juno at the superior power, Minerva, the superior wisdom, and Venus the superior beauty of the queen. There must be something very curious in the nature of taste: seeing such pictures, one cannot but reflect, that though they are now perfectly ridiculous, they could not have been so when they were painted. They were men of understanding who sat for their portraits in these whimsical characters; and the queen—it is surprising!—there is surely something involved in it, that history does not touch.

GRATIAN.—It is the more surprising, as Holbein had painted, and his works were before their eyes.

AQUILIUS.—It would be not undeserving curiosity to sift the history of allegory—what is the cause that it was then so generally accepted in Europe; infected the poetry and painting of every civilised country. The new aspect of religion had much to do with it: images, pictures, particularly the earlier, representing the Deity, and the Virgin, had become objects of hatred—of persecution. And thus the arts made their escape into the regions of allegory.

CURATE.—Chilling regions, in which even genius with all his natural glow was frost-bitten. An escape from what was believed to what could not be believed. It was the cold fit of the ague of superstition.

GRATIAN.—The devotion of the early painters produced, what nothing but devotion could produce; theirs was a true devotion, notwithstanding the superstition contained in it. The iconoclast spirit has scarcely been yet laid. As we rise from the prostrate position of our fears, the more readily shall we acknowledge the spirituality of the early painters. They are daily approximating a more just estimation. But we are wandering; we were speaking of landscape: surely, it is difficult to find a subject that shall be altogether unpleasing. I do not remember ever to have seen an outdoor scene, unless it might have been in a town, that did not please with some beauty or other.

AQUILIUS.—Indeed! then I think you must have been led away by some associations, in which art had but little share. You have loved " A southerly wind and a cloudy sky," as the song says, for the sport offered. Be not shocked, Gratian, at the confession, but the truth is, that I see very many outward scenes, that not only give me no pleasure but pain. Shall I confess a still more shocking heterodoxy; I have but little love for the scenery of the country!—am very often displeased with what offers itself, and becomes the common picture. Even in what is denominated a beautiful country, I look more for its suggestive materials in form and colour than for whole scenes. If pictures are to be no more than what we see—even landscapes, the art is not creative; and an imitative, uncreative art, leaves the best faculties of the mind unemployed. What is art without enthusiasm?—and you may be sure that no painter of views, and nothing more, was ever an enthusiast. It is the part of enthusiasm not to copy, but to make. Is it more startling if I assert, that the ideal is more true than the natural? Yet am I convinced that it is so. The natural requires the comparison of the eye; the ideal, as it is the work of the mind, will not be controlled by any comparison, but such as mind can bring. It commands the organ of sight, and teaches it. We all have more or less of this creative faculty; the education of the world is against it, for it is a world of much business, more of doing than of thinking, and more of thinking about what is foreign to feeling, than what cherishes it till it embodies itself in imagination. The rising faculty becomes suppressed. More or less all are born poets—to make, to combine, to imagine, to create; but very early does the time come with most of us, when we are

commanded to put away, as the world calls it, the " childish things."

LYDIA.—Oh, I believe it—the infant's dream is a creation, and perhaps as beautiful as we know it must be pleasing, for there are no smiles like infant smiles.

CURATE.—And past that age, when the external world has given its lessons in pictures, which in practice and education we only imitate, do we not find the impressions then made of a goodness, a beauty, not realised and acknowledged in advanced life, as existing actually in the scenes themselves?

AQUILIUS.—At the earlier time, we take up little but what is consonant to our affections; the minor detail is an after lesson: but as to this "natural" of landscapes, which seems to have so long held our artists and amateurs under an infatuation—as they construe it—this mindless thing,—after all what is its petty truth? Could the boy who hides himself under a hedge to read his Robinson Crusoe, put on canvass the pictures his imagination paints, do you think they would be exactly of the skies and the fields every day before his eyes? A year or two older, when he shall feel his spirit begin to glow with a sense of beauty, with the incessant love and heroism of best manhood—see him under the shade of some wide-spreading oak devouring the pages of befitting romance, " The Seven Champions of Christendom," the tale of castles of enchantments, of giants, and forlorn damsels to be rescued. Do you not credit his mind's painting for other scenes, in colour and design, than any he ever saw? The fabulous is in him, and he must create, or look on nothing. He will take no sheep for a dragon, nor farmer Plod-acre for an enchanter, nor the village usher for an armed knight. The overseer will not be his redresser of wrongs. There is vision in his day-dream, but it is painting to the mind's eye; and imagination must be the great enchanter to conjure up a new country, raise rocks, and build him castles; nay, in his action to run to the rescue, he has a speed beyond his limbs' power, an arm that has been charmed with new strength. Now is he not quite out of the locality, the movement and power of any world he

ever saw, of any world to whose laws of motion and of willing he has ever yet been subject? Take his pictures—look at them well; for I will suppose them painted to your sight : nay, put yourself in his place and paint them yourself—forgetting before you do so all you have ever heard said about landscape painting. Have you them? then tell me, are they untrue? No, no, you will admit they are beautiful truth. The lover paints with all a poet's accuracy, but not like Denner. Now, if this mind-vision be not destroyed,—if the man remain the poet, he will not be satisfied with the common transcript of what, as far as enjoyment goes, he can more fully enjoy without art. He will have a craving for the ideal painting, for more truths and perhaps higher truths than the sketch-book can afford. And if he cultivate his taste, and practise the art too, he will find in nature a thousand beauties before hidden, that while he was the view-seeker, he saw not; he will be cognisant of the suggestive elements, the grammar of his mind and of his art, by which he will express thoughts and feelings, of a truth that is in him, and in all, only to be embodied by a creation.

CURATE.—I fear the patrons of art are not on your side. Does not encouragement go in a contrary direction?

GRATIAN.—Patrons of art are too often mere lovers of furniture,—have not seriously considered art, nor cultivated taste. And if it be a fault, it is not altogether their own; it is in character with genius to be in advance, and to teach, and by its own works. It is that there is a want of cultivation, of serious study, among artists themselves. If the patron could dictate, he would himself be the maker, the poet, the painter, the musician,— excellence of every kind precedes the taste to appreciate it. It makes the taste as well as the work : my friend Aquilius has made me a convert. I had not considered art, as it should be viewed, as a means of, as one of the languages of poetry. In truth, I have loved pictures more for their reminiscences than their independent power; and have therefore chiefly fixed my attention on views—actual scenery, with all its particulars.

AQUILIUS.—What is high, what is great enough wholly to possess the mind, is not of particulars; like our religion, in this it is for all ages, all countries, and must not by adopting the particular, the peculiar one, diminish the catholicity of its empire. "The golden age" is, wherever or however embodied, a creation; and as no present age ever showed any thing like it, that is, visibly so,—what is seen must be nothing more than the elements out of which it may be made.—The golden age—where all is beauty, all is perfect! Purest should be the mind that would desire to see it.

CURATE.—The golden age, if you mean by it the happy age, is but one field for art; you seem for the moment to forget, that we are so constituted as to feel a certain pleasure from terror, from fear—from the deepest tragedy—from what moves us to shed tears of pity, as well as what soothes to repose, or excites to gaiety.

AQUILIUS.—Not so—but as we commenced to discuss chiefly the agreeability of subjects for pictures, let me be allowed to add, that I question if what is disgusting should not be excluded from even the tragic, perhaps chiefly from what is tragic. Cruelty even is not necessarily disgusting; it becomes so when meanness is added to it, and there is not a certain greatness in it. There might be a greatness even in deformity, and where it is not gratuitously given, but for a purpose.

CURATE. — Yet, has not Raffaele been censured for the painfully distorted features of the Possessed Boy in his "Transfiguration."

AQUILIUS.—And it has with some show of truth (for who would like to speak more positively against the judgment of Raffaele) been thought that Domenichino, who borrowed this subject from him, has improved the interest by rendering the face of the lunatic one of extreme beauty!

The Curate was here called away upon his parochial duties, and our discussion for the present terminated. Will it amuse you, Eusebius? If not, you have incurred the penalty of reading it, by not making one of our party. Yours ever,

AQUILIUS.